THE AHMANSON FOUNDATION
has endowed this imprint
to honor the memory of
FRANKLIN D. MURPHY
who for half a century
served arts and letters,
beauty and learning, in
equal measure by shaping
with a brilliant devotion
those institutions upon
which they rely.

The publisher gratefully acknowledges the generous contribution to this book provided by the Art Endowment Fund of the University of California Press Foundation, which is supported by a major gift from the Ahmanson Foundation.

Theories and

Documents of

Contemporary Art

Second Edition

Kristine Stiles and Peter Selz

THEORIES AND DOCUMENTS OF CONTEMPORARY ART

A Sourcebook of Artists' Writings

Second Edition, Revised and Expanded

By Kristine Stiles

University of California Press | Berkeley, Los Angeles, London

Dedicated to the memory of Herschel B. Chipp

University of California Press, one of the most distinguished university presses in the United States, enriches lives around the world by advancing scholarship in the humanities, social sciences, and natural sciences. Its activities are supported by the UC Press Foundation and by philanthropic contributions from individuals and institutions. For more information, visit www.ucpress.edu.

University of California Press
Berkeley and Los Angeles, California

University of California Press, Ltd.
London, England

Library of Congress Cataloging-in-Publication Data

Theories and documents of contemporary art : a sourcebook of artists' writings / [edited by] Kristine Stiles and Peter Selz. — 2nd ed., rev. and expanded.
 p. cm.
 Includes bibliographical references and index.
 ISBN 978-0-520-25374-2 (cloth : alk. paper) — ISBN 978-0-520-25718-4 (pbk. : alk. paper)
 1. Art, Modern—20th century. 2. Art, Modern—21st century. 3. Art, Modern—20th century—Sources. 4. Art, Modern—21st century—Sources. I. Stiles, Kristine. II. Selz, Peter Howard, 1919- III. Title: Sourcebook of artists' writings.
 N6490.T492 2012
 709.04'9—dc23 2011038212

Manufactured in the United States of America

21 20 19 18 17 16 15 14 13 12
10 9 8 7 6 5 4 3 2 1

The paper used in this publication meets the minimum requirements of ANSI/NISO Z39.48-1992 (R 1997) (*Permanence of Paper*).

CONTENTS

2. GEOMETRIC ABSTRACTION

6. INSTALLATIONS, ENVIRONMENTS, AND SITES

The Bibliography may be downloaded at www.ucpress.edu/go/theories.

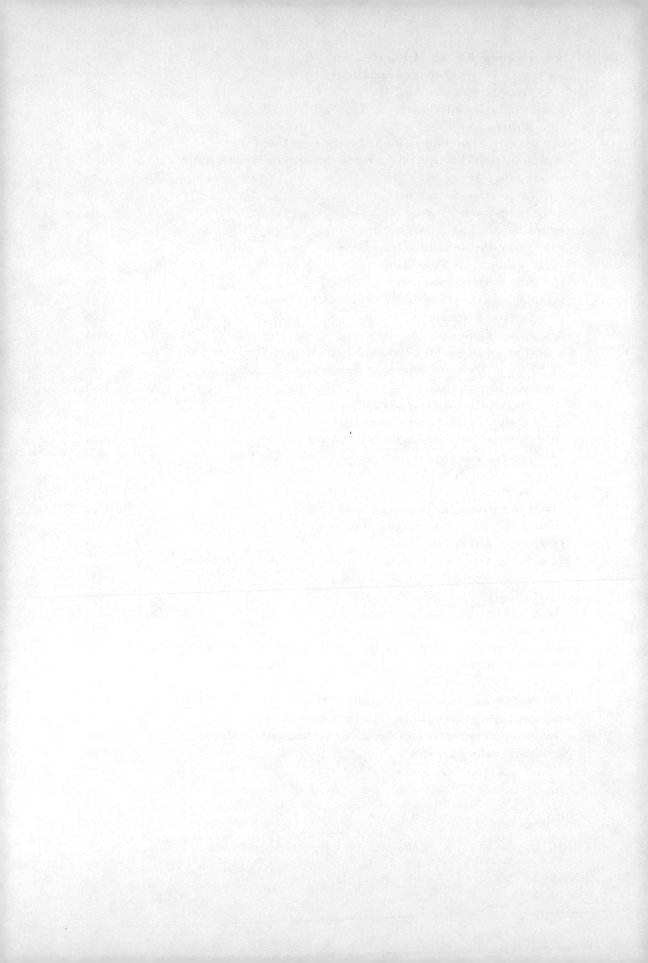

PREFACE TO
THE SECOND EDITION

Kristine Stiles

With recent increased attention to the critical aesthetic and political work of artists throughout the world, it was difficult to choose additions for this revised edition. Printing constraints made the process all the more challenging especially as binding limitations dictated that only about two hundred pages could be added to the revised edition. My aim in selecting new texts became twofold: to right some oversights in the first edition and to provide an introduction to the exciting new voices that have garnered attention since the early 1990s. Rather than simply tack on new texts to the end of each chapter, I inserted each new selection into the semichronological narrative of the first edition in order to maintain cohesion. This decision necessitated revising every chapter introduction, including those of Peter Selz, my collaborator on the first edition. The result is a completely updated book that builds on the strengths of the first edition with fresh introductions.

Despite the page restrictions, there are more than one hundred new selections in this revised edition, including interviews and writings by artists neglected in the first edition, older artists who have gained increased prominence, and younger artists who have emerged during the past two decades. The new texts represent artists who come from some thirty nations around the world, from Africa, Asia, Australia, and the Middle East, Western and Eastern Europe, Russia and Eurasia, and the Americas. Some selections are published here for the first time; others have been reprinted. No essays were dropped from the first edition.

The roster of media discussed is as diverse as the artists themselves, including traditional painting and sculpture, performance, installation, conceptual art, video, multimedia works, digital art, and virtual reality. Several generalizations can be made about new tendencies that have emerged since the first edition: artists working in figurative painting far outpaced the number working in abstraction; there has been a demonstrable increase in attention to material culture and everyday life; installation art has been widely adapted throughout the world as a flexible medium able to accommodate a wide diversity of forms in an infinite number of locales, physical circumstances, and economic exigencies; the use of moving-image, multimedia installations in particular has grown exponentially; experiments in technology, from virtual reality, genetics, and

bio–art to sentient computers, continue apace; performance art remains strong, especially in nations emerging from political strife and/or where there are struggles for equality and identity founded on ethnicity, race, gender, and sexuality; and an increase in artists' collectives has expanded the potential of conceptual art.

In addition to the many new texts in this second edition, forty-five new images appear in this volume. Some of these illustrations may be considered "image/texts" with the artist's writing about the pictured work functioning as a caption. I borrowed the idea from Francesca Richer and Matthew Rosenzweig, who edited *No. 1: First Works by 362 Artists* (2006).[1] They assembled images and comments by artists in response to the question: "What was your first work of art?" In their responses, artists did not always interpret the idea of "first" as the originating work in their practices; instead, they often selected the work that most represented the overarching form of their philosophical and aesthetic aims.

An example of such an image/text is that by Guillermo Gómez-Peña (see chap. 8), one of the most prolific artist-theorists of the late twentieth and early twenty-first centuries. His commentary accompanies an illustration of *The Loneliness of the Immigrant* (1979), the first performance he made upon arriving in the United States from Mexico. Gómez-Peña describes his feelings of invisibility in the U.S., the paradoxical emotional twin of the immigrant's hyper-visibility and awareness of ethnic difference in a foreign place. I included Gómez-Peña's writing from *No. 1* for how it succinctly conveys the constellation of experiences that he later theorized as "border identity." Such image/texts provide a new and different literary format in this second edition. They complement the statements, interviews, and essays, as well as both the old and new illustrations with their conventional captions.

As I wrote in the preface to the first edition, no book can "be all things to all readers," and that is certainly true of this enlarged edition. So many new artists have come to world attention over the past twenty-some years, that it would be impossible to include them all.

This second edition was initiated by Deborah Kirshman at University of California Press, and Peter Selz gave his blessing to the revised volume. Sue Heinemann was a patient and astute editor who offered many ideas for selections and shouldered the burden of keeping the publication on course, and I simply could not have completed this revision without her. Thanks also to Rose Vekony for taking over as editor at a critical moment and shepherding the book to publication. I would also like to thank Jennifer Knox White, who copyedited the revised introductions, and to acknowledge Mitali Routh and Corina Apostol for assistance in researching some of the selections; Jasmina Tumbas for assembling much of the new bibliography; Erin Hanas and Mitali for helping with page proofs; and Erica Lee for gathering the new permissions and helping with the bibliography. Duke University provided research funds in support of the publication.

PREFACE TO
THE FIRST EDITION

Kristine Stiles

This book is the third in a series beginning with *Theories of Modern Art,* edited by Herschel B. Chipp with contributions by Peter Selz and Joshua C. Taylor. Chipp's book was begun in 1958 and published in 1968. Taylor's *Nineteenth-Century Theories of Art,* begun in 1970, was published posthumously in 1987.[1] Like its two predecessors, this book took more than a decade to complete, and has been prepared as a general guide for use by students, art historians, and all others interested in artists' theories since 1945.

While no book, including the present volume, can be all things to all readers, several criteria helped shape the choice of selections. We sought to include texts that had a wide impact in the field and that contributed to the initiation or dissolution of an artistic movement; texts addressed to aesthetic and art historical canons; discussions of new media and technology, considerations of gender, race, class, sexuality, and other diversity issues; and methodological strategies ranging from formalist to feminist and modernist to postmodernist. Some texts have been translated into English for the first time; others have never been published; several selections are obscure; others have been reprinted widely. The extensive corpus of theoretical writing amassed by some artists made selection exceedingly difficult and unavoidably a topic of debate.

The chronological arrangement of the chapters conforms to widespread pedagogical and critical tendencies to organize and teach art in periodizing decades and stylistic movements. Each chapter introduction offers an overview of the cultural contexts and intellectual milieus in which the texts originated, but is neither a comprehensive history of artistic movements, nor a complete biographical guide to the artists who authored them, nor a textual exegesis of the selected theories. While the sequence of the chapters loosely represents a chronology of artistic movements since 1945, the internal contents of each are arranged synchronically. They contain related theories spanning five decades and demonstrate the continuous, coincident, interconnected, and conflicted interpretive strategies of several generations. The contrast within each chapter parallels the multiplicity of aesthetic strategies found in all historical moments, and each chapter itself becomes a rudimentary model for mediating the false unities often suggested by simplified stylistic and historical chronologies.

The structure of the book invites comparisons not only through time but across

chapters. Each chapter underscores the interdependence of artistic practices and artists' tendencies to work in a variety of media for different purposes. An artist like Joseph Beuys, for example, appears in chapter 7, "Process," to emphasize the interrelatedness of his work, which spans traditional painting and sculpture and moves into installation, performance, and teaching. Laurie Anderson, conventionally associated with performance, appears in chapter 5, "Art and Technology," because her theoretical concerns inform the use of technology in art. Chapter 6, "Environments, Sites, and Installations," includes such seemingly disparate artists as Isamu Noguchi and Robert Smithson, all of whom made contributions to site-specific projects. Readers are encouraged to use the book in a cross-referential manner. No chapter stands independent from another, and artists, their manifold activities, and the categories employed to organize them are conceptualized as fluid.

Some readers may be surprised to find that this book contains no chapter on "political art." Although this topic has become increasingly popular, it is an awkward, if not forced, category. All texts bear the ideological burden of the theoretical aims of the writer, however thoroughly those theories may be framed in aesthetic terms. Each chapter in this book, each selection and its relation to another, is an ideological formation with political consequences. For example, Daniel Buren's theory of the origins, use, and meaning of his striped canvas works appears in chapter 2, "Geometric Abstraction," along with texts by Yves Klein and Piero Manzoni suggesting the evolution of monochrome painting from geometric abstraction into performance and conceptual works, and with a feminist theory on collage and the decorative tradition by Miriam Schapiro and Melissa Meyer. By creating such juxtapositions, we seek to demonstrate the parallels between competing formal concerns and between very different social and cultural aims and values. In this way, the structure of each chapter and the inclusion of every text have political import.

In keeping with the intensive exchange and collaboration between artists in the United States and Europe since World War II, this book differs distinctly from anthologies devoted primarily to American artists.[2] Although the number and length of selections originally planned for this book had to be cut, and texts were abridged that strongly resisted editing, this volume often presents fuller excerpts than have other anthologies.[3] Also, with few exceptions, selections in this book are by the artists themselves, whereas most other anthologies focus on the works of theorists and critics.[4] This book is also unprecedented in its diversity, giving voice to the theories of women, ethnic minorities, and the most experimental of artists.[5] Yet despite its diversity, the book rarely reaches beyond the U.S. and Europe. Why? Quite simply, art history changed in the course of assembling the book, which was already too large to accommodate a global media explosion that gave unparalleled access to the theories of artists around the world.

Chipp opened the preface to *Theories of Modern Art* with this comment: "This book came into being in response to a need . . . for access to the fundamental theoretical documents of twentieth-century art . . . published in now obscure publications . . . often extremely difficult and sometimes impossible to find." The present book transpired in entirely different intellectual and historical circumstances. What Chipp experienced

as a problem of information access is now a question of information management, owing to the profusion of texts made available through low-cost printing and sophisticated computer databases. Furthermore, the very notion that a text might be considered fundamental or possess "intrinsic qualities"—a phrase employed by Robert L. Herbert to assert the significance of writings he included in *Modern Artists on Art: Ten Unabridged Essays* (1964)—was called into question by feminists, theorists of multiculturalism, and others who identified the patriarchal and racial bias of Western culture and the institutionalization of certain privileged discourses.[6]

Chipp's certainty in fundamentals and Herbert's faith in intrinsic qualities are now questionable editorial positions, for such concepts deny the interplay of social forces that contribute to the relativity of meaning. Similarly, the mere selection of an artist's writings for inclusion in this book confers qualities on the piece that then imply that it is a fundamental text. But selection reflects the subjectivity and values of the editors and the community of beliefs, customs, technologies, institutions, and experiences within which it was formed. Texts themselves manifest signs of such fluctuating forces, showing the concept of quality to be historically mutable.

Regardless of the multifarious conditions guiding the selection process, any ordering entails the systematization of specialized fragments into a hybrid that becomes a "synthetic object of knowledge" at once reductive and stable, as Barbara Maria Stafford has pointed out. She notes that such constructs inevitably misrepresent the transitory nature of things but that "the refusal to compare and connect members with categories [leads] either to incoherence or to radical relativism."[7] Recognition of both the need for order and selection and the continually changing criteria for such endeavors is a strength of this book. These texts are rich samples of a complex body of thought in Europe and the United States since 1945 that will form the basis for an expanded discussion about art and culture globally in the twenty-first century.

As Richard Shiff has cautioned, "The first rule of critical interpretation is to reflect on one's own means."[8] The final form of this book reflects the dynamic process of collaboration. In 1981 Peter Selz first suggested the book as a companion to Chipp's *Theories of Modern Art,* to which he and Taylor had contributed. Just as Selz had been Taylor's student, so was Kristine Stiles still a doctoral candidate studying with Selz and Chipp when Selz proposed their collaboration. Increasing differences in ideology, aesthetic concepts, methodological approaches, and theoretical values, and finally changing professional roles all contributed to the lively debate about the texts that finally make up this book, and to the time the volume took to complete. Throughout, we have shared the belief that artists' theories provide unparalleled access to visual knowledge and are a unique source for qualitative change in human experience.

A book that required a decade to produce is indebted to the efforts of many individuals. William J. McClung, the original editorial director at University of California Press, responded enthusiastically to the initial proposal. Together with Lorna Price, who edited it, he shepherded the early manuscript through two changes in format. But Deborah Kirshman, fine arts editor, finally returned the book to its original format. We are deeply grateful for her insight, patience, persistence, and steady guidance in bringing this project to completion and publication. We would also like to thank the

Lannan Foundation and its director, Lisa Lyons, for their support and assistance. Leslie Blitman but most especially Lynne dal Poggetto expertly researched and obtained permissions for both illustrations and artists' selections. Lynne's careful organization and spirited hard work made our task as editors infinitely easier. Scott Norton's editorial expertise and astute attention to the refinements and nuance of meanings completed the project with finesse.

The late Herschel B. Chipp offered valuable advice in the early stages of the book. We are indebted to Eugenie Candau, librarian for the San Francisco Museum of Modern Art, who gave generously of her time and the significant resources of the library that she has so expertly built and administered.

Selz received several University of California, Berkeley, Faculty Research Grants to work on this book. He wishes to acknowledge Nan Hill, Elise Breall, Ruben Cordova, Lydia Matthews, and Carole Selz for assistance in compiling the material for this book. Stiles received a grant from Duke University Arts and Science Research Council for completion of the manuscript. She thanks Edward Shanken, James Rolleston, Robert Jensen, and Julia Walker for valuable comments on the manuscript. Her student research assistants included Marylu Bunting, Christopher Fehlinger, Hunter Gatewood, Cory Greenberg, Lynn Kellmanson, David Little, Jane McFadden, Michael Thomas, and Valerie Hillings. Rebecca Katz completed the bibliography. Charlotte Cousins and Hunter Gatewood assisted in editorial revisions and proofed the manuscript. Mark D. Hasencamp deserves special recognition for financial, editorial, and emotional support during the early years of work on this book.

GENERAL INTRODUCTION TO THE SECOND EDITION

Kristine Stiles

In the late 1960s the Scottish artist Mark Boyle voiced what might be considered the doubts of many artists about the ability to explain artistic intention:

> In a condition of adamant doubt you are asked for explanations when all you want is for someone to explain anything. And you are asked for purposes when you are learning to accept that a purpose is not going to emerge ever. And you are asked for a statement of intent when the head seethes with all your fluctuating statements of the past instantly and meticulously taken down and which you use constantly, with increasing derision, in evidence against yourself.[1]

At that time both art and art history were undergoing significant changes, with the emergence of conceptual art and performance, which challenged the conventional art object, and with the theoretical and methodological practices of art history coming under intense scrutiny. Yet, despite the plethora of aesthetic theories published by artists and the ubiquity of theoretical exegesis in general, the study of artists' texts had declined—a situation that the first edition of this book addressed by revitalizing interest in artists' writings.

Encompassing a range of views, from the mid-twentieth to the early twenty-first century, this book confirms unprecedented transformations in the structure of the visual arts, the identity of a work of art, and the perception of what it means to be an artist. *Theories and Documents of Contemporary Art* contains many of the most challenging aesthetic ideas of the past six and a half decades, writings that have been instrumental in instigating new ways of thinking in the visual arts. Searching for a means to describe these changes, theorists from the humanities to the sciences have often referred to Thomas Kuhn's concept of "paradigm shift," a term he articulated in *The Structure of Scientific Revolutions* (1962), to explain how permutations, modifications, and breaks in the epistemological foundations of a discipline alter its practices and beliefs.[2] At the same time, developments in critical theory and cultural studies have offered new methodological models that have contributed to these changes. The selections in this volume are inevitably part of wider cultural formations affecting the status of theory within art historiography and cultural studies, themselves in varying states of transition. A cursory

overview of the surrounding intellectual and art historical practices against which these texts must be considered is thus in order.

By the end of the 1950s and into the early 1960s, with the advent of happenings, Fluxus, Pop art, and incipient conceptual and body art, artists initiated a sweeping examination of the institutions of art and art history then dominated by the formalist criticism of Clement Greenberg. Arguably the most influential critic in the immediate post-1945 period, Greenberg popularized the term "modernism" and applied it to a wide variety of artistic practices and kinds of representation. In his essays "Avant-Garde and Kitsch" (1939) and "Towards a Newer Laocoon" (1940), Greenberg began to lay out what would become the defining characteristics of his aesthetics, arguing that "advanced" art progressed from greater to lesser complexity.[3] The resulting autonomous object functioned as a mode of cultural resistance to the totalitarian tendencies of both the right and the left, and to the degradation of value by popular cultural objects, or "kitsch" (the German term for disposable, poorly designed consumer products). Elaborating and restating Kant's transhistorical aesthetic model in his essay "Modernist Painting" (1961), Greenberg wrote: "The essence of Modernism lies . . . in the use of the characteristic methods of a discipline to criticize the discipline itself. . . . What had to be exhibited and made explicit was that which was unique and irreducible not only in art in general but also in each particular art. Each art had to determine, through the operations peculiar to itself, the effects peculiar and exclusive to itself."[4]

Greenberg required each artistic medium to become self-referential, divested of all extraneous elements including narrative and illusion, and able to move from abstraction to universal essence. Such a view is summarized in his comment about the aims, conditions, and trajectory of "advanced" painting: "It has been established by now, it would seem, that the irreducibility of pictorial art consists in but two constitutive conventions or norms: flatness and the delimitation of flatness."[5] Greenberg presented a concept that collapsed the variegated projects of the diverse early European avant-gardes into a homogeneous "modernism" bereft of social and direct political engagement. His progressively more reductive approach to art failed to reflect either the historical situation or the rich ways in which new media grew out of traditional painting and sculpture during the first four decades of the twentieth century. Despite the limits of his version of "modernism," Greenberg's formula has been widely adapted by scholars, critics, and students alike to characterize the pre-1945 avant-gardes.

Such a modernism has been thoroughly debated throughout the humanities, sciences, and social sciences, and theorists have drawn on both modernist and postmodernist models. A cursory sketch of these is instructive. The modernist paradigm is generally understood to reflect rational liberal humanism and a belief in progress established during the Enlightenment. This perspective presupposes the possibility of objectivity grounded in fundamental, intrinsic, and universal (or classic) transcendent values and essential, autonomous, and self-sufficient objects, texts, and actions.[6] In contrast, a postmodernist perspective views these same constructs as contingent, insufficient, and lacking transcendence, and progress is understood to be a teleological concept that lends narrative coherency to change through time.

The advent of postmodernist contingency placed modernist objectivity in doubt. Identity and human subjectivity were no longer understood as unified but rather viewed

as polymorphous, fragmented, and without center. While in modernism the meanings of signs and symbols were relatively fixed, poststructural theory deconstructed signs as ambiguous, arbitrary, and shifting, understanding spheres of culture to be interconnected and knowledge to be constructed and determined by relationships of power. The homogeneity of privileged, universal discourse in modernism gave way to a conception of social heterogeneity and a multicultural perspective that required constant vigilance in matters of gender, sexuality, class, and race. Finally, the modernist belief in truth was replaced by alternatives ranging from radical relativism to negotiated concepts of truth.[7] According to Fredric Jameson, one of the principal apologists for postmodernism, it was a "mediatory concept . . . descriptive of a whole series of different cultural phenomena . . . [and] a principle for the analysis of cultural texts . . . [as well as] a working system that can show the general ideological function of all these features taken together."[8]

Regardless of debate over these worldviews, few have doubted that an epistemological shift has been in process for several decades. The unprecedented expansion of media in the visual arts has contributed, at least in part, to the alteration of the very category "visual art," which now encompasses everything from painting and sculpture to hybrid forms in previously unthinkable materials: the human body in performance, invisible matter (gases), energy (telepathy), large-scale projects and earthworks in remote landscapes and urban centers, interventions in social and political institutions, and computer and other electronic works, including virtual reality and bio-art. Artists have created postcards, records, books (which differ from traditional *livres d'artistes*), and websites, and, although once marginalized, video, film, photography, and digital works are completely accepted. A large body of literature has emerged on all of these media.

Artists' theoretical strategies have been as instrumental as their works of art in initiating the debates over new approaches, media, and contending worldviews. Artists have adapted an assortment of textual practices ranging from manifestos to expository descriptions of projects; from brief to lengthy statements; from press releases to poems, diaries, and letters; from grant proposals to conversational modes such as interviews, panels, and symposia; and from blogs and tweets to Facebook postings. The interview became particularly popular in the numerous artist-published and -edited journals that proliferated during the 1970s and 1980s. But while the interview provides access to spontaneous thought inaccessible in more self-conscious theoretical discourse, it seldom matches the rigor of critical writing. Dialogue, such as that between the sculptor Carl Andre and the photographer, filmmaker, and theorist Hollis Frampton, offers still another kind of text.[9] Some texts inhabit a space between literary and artistic genres, becoming both theory and art. Finally, not all artists write, and some almost never grant interviews. Cy Twombly, for whom the poet and critic Heiner Bastian comments in this book, is a good example, even though Twombly spoke about his art before he died. Nevertheless, his silence was instructive, serving as a cultural example of reserve in a period of spectacle and the cacophony of many voices.

Given the profusion of artists' writings since World War II, the long neglect of these texts is surprising, especially as artists' theories buttressed the wholesale reexamination of the theoretical and methodological practices of art history.[10] The questions contemporary artists raised challenged notions of how art is understood in any period, and

since the 1970s, art historians, too, have become increasingly skeptical of the inherited assumptions guiding their profession. Timothy J. Clark, for example, advocated a history of art founded in social and political milieus, harking back to Aby Warburg's and Alois Riegl's social histories of art, and offering a bold challenge to Greenbergian formalism.[11] In 1977 Svetlana Alpers asked, "Is Art History?" Her answer was to identify three concepts shaping art historiography: the centrality of individual artistic authority, its link to the creation of unique objects, and the hierarchical position of painting and sculpture in cultural production.[12]

In the winter of 1982 the *Art Journal* devoted a special issue to "the crisis in the discipline," and in 1986 Richard Spear, then editor-in-chief of the *Art Bulletin,* the prestigious journal of the College Art Association, inaugurated an important series on the state of art historical research. In this series, William Hood aired the pervasive disquiet within the discipline when he observed that while writers on Renaissance art "could work in the comforting security of knowing that neither they nor their readers seriously questioned their competence . . . modern writers . . . may no longer bundle themselves in *gemütlich* self-confidence."[13] The insecurity reflected in Hood's words was heightened when Marxism, once the most formidable theoretical opponent of formalism, was itself called into question with the end of the Cold War and the fall of the Berlin Wall on November 9, 1989.

This general instability, however, launched a vigorous debate over methodology and the application of critical theory to art history. An interdisciplinary combination of theoretical constructs drawn from linguistics, semiotics, Marxism, feminism, anthropology, social history, psychoanalysis, and other disciplines, critical theory joined poststructural philosophy in a critique of the Enlightenment. Together these formed the basis of postmodernism. Postmodern critical theory received such widespread academic legitimacy in the 1980s that W. J. T. Mitchell from the University of Chicago could state: "Any literature department that does not have a 'theorist' of some sort on its faculty is clearly out of step . . . [for] the general assumption is that everyone has a theory that governs his or her practice, and the only issue is whether one is self-conscious about that theory."[14]

A veritable "theory industry" emerged in the 1980s that was not unrelated to the "culture industry" described by the German philosophers Theodor Adorno and Max Horkheimer in the mid-1940s.[15] The theory industry absorbed many modes of intellectual production in scholarly discourse, confirming the German philosopher Hans Magnus Enzensberger's suspicion that the culture industry was connected to the production of a "consciousness industry."[16] Originally a powerful tool of analysis, critical theory was often rendered little more than a form of discursive rhetoric by its overproduction in the academy, which disarmed and reabsorbed it into the language-machine of the theory industry. The literary critic Edward W. Said described this phenomenon as the self-absorbed conversation of the "3,000 specialists" writing for themselves.[17]

It is a paradox of intellectual history that theory gained such hegemony precisely during the period when authority was written out of authorship. Roland Barthes disembodied the author and claimed authority only for language in "The Death of the Author" (1968).[18] In "What Is an Author?" (1969), Michel Foucault argued that the author is necessary only to "the existence, circulation, and operation of discourses" that

subsume the author.[19] Ironically, in being *the* writers to write authority out of authorship, Foucault and Barthes ensured their own precisely on the site of its negation.

Related shifts in authority can be seen in artists' claims. In 1943 artistic authority could still be stated with the confidence expressed by Adolph Gottlieb and Mark Rothko, who wrote, "It is our function as artists to make the spectator see the world our way—not his way."[20] By 1966, however, Allan Kaprow, a creator of happenings in the United States, revealed a fully altered mood: "Once, the task of the artist was to make good art; now it is to avoid making art of any kind. Once, the public and critics had to be shown; now the latter are full of authority and the artists are full of doubt."[21] However pervasive Kaprow's doubt, by the 1980s even that authority had become a "fiction," the term Brian Wallis, then an editor of *Art in America,* used to describe the artists' writings he included in *Blasted Allegories:*

> In place of aesthetic innovation, these writers employ appropriation and reinscription of existing voices, styles, and genres; in place of the coherence of the conventional text, they favor a form which is fragmentary, inconclusive, digressive, and interpenetrated with other texts; in place of the omnipotent author, they acknowledge a collectivity of voices and active participation of the reader; in place of the new or the original, they accept an understanding of language and stories as "already written" and shaped by social and political conditions.[22]

Certainly, his view echoed the ways in which critical theory sharply questioned the status of texts, the role of subjects who speak through—or are actualized in—them, and the presumption that texts no longer represent disembodied objects of objective discourse.

As Henry Louis Gates Jr. observed in *The Signifying Monkey* (1988), his landmark study of African American literature: "Theory can serve to mystify [and] further distance [readers] from the primary texts that should be, indeed must be, the critic's primary concern."[23] Or, as Bertolt Brecht said, "The means must be asked what the end is."[24] Edward Said's attention to the relation between power and knowledge in a historical period when academic theories predominated is instructive: "Knowledge . . . means surveying a civilization from its origins to . . . its decline [which] means *being able to do that.*" To create knowledge is thus to assume a superior position a priori to the object under observation, is to render that object "vulnerable to scrutiny," and to transform that object into a stable fact that can be dominated—"to have authority over it . . . as we know it." In this sense, the instrumental value of critical theory in the late twentieth century reconfigured relations among artists, critics, and art historians in large measure because theory assumed a position superior to art. "The most important thing about . . . theory," Said noted, "was that it worked, and worked staggeringly well."[25]

In the early 1990s theorists vacillated between using theory as an anchor on the one hand and a shifting miasma of circulating texts signifying disempowerment and disinformation on the other. For, as Richard Shiff has asked, if authors have no authority over the relationship between their works and their ideas—philosophical questions about intentional fallacies (and all such pretenses to objectivity) notwithstanding—who does? What does it mean to deny the authenticity of the artist as subject of his or her own

discourse? To fictionalize his or her thoughts? To flatten out the difference between a text's cognitive linearity, its narrative, its argumentative structure, and the synchronicity of its pictorial representation?[26]

The displacement of authorial authority by theory was successful particularly in the area of artists' texts, a category of theory to which the new methodological and theoretical practices seldom have been applied. Indeed, neglect is one of the most powerful, and nearly invisible, forces for maintaining authority, a fact illustrated by one of the standard jokes among art historians, "The best artist is a dead artist." Dead artists don't talk back. The meaning of the art and theory of dead artists may be coopted and read through an infinite number of narratives without the contradicting authority of a living being. When authority itself is denied, then the competition for the most artful narrative is a competition for authority over the text and the work of art. In other words, critics may retain the authorial voice.

Live artists debate, refute, or outright reject interpretation of their work. This is precisely what Georgia O'Keeffe did during her life when she repeatedly denied critical interpretations of both the erotic content and feminist intent of her work. Andy Warhol, too, although notorious for his claim that both his identity and his work were mirrors across which any reflection might pass, recognized that "You Can't Argue with Your Scrapbook"—a phrase that serves as the title of the first chapter of *The Philosophy of Andy Warhol* (1975).[27] Although Warhol tried, in Gertrude Stein's words, to create a persona of "no there, there," the scrapbook, like his writings, refutes his absence and retains the authority to connect metonymically to the material evidence of his life— however constructed that image.

The failure until recently to address the issues raised by artists' theories was particularly obvious when one considered the vast corpus of writings by artists who pioneered, among other genres, conceptual art. While the near-absence of critical discussion of these texts was visible enough in literature and other cultural studies that increasingly took works of art as the subjects of their inquiry, it was inexcusable in art history—a lacuna that was quickly addressed after the first edition of this book.

Even more troublesome is the problem posed when a text, as a conceptual work of art, becomes an art object. Simultaneously text and object, such a work of art is also an object of theoretical discourse. As such, it is frequently subsumed into the concept of art inherited from Romanticism in which artists and their works are considered subjectivist, intuitional, and irrational. Namely, the text-object as "art" object is stripped of its conventional authority as theoretical language, as an instrument of reason. As the feminist theorist Alison M. Jaggar once pointed out, Western philosophical tradition identifies emotions "as potentially or actually subversive of knowledge," and "reason rather than emotion has been regarded as the indispensable faculty for acquiring knowledge."[28] Thus when theory by artists becomes art, emotion is read to triumph over reason and knowledge.

The French philosopher Jean-François Lyotard's thoughts on Joseph Kosuth's collected writings offer a perspective on the problem of how Western epistemology inscribes deep divisions between reason (as expressed in language) and emotion (as conveyed by art): "Kosuth can write 'theoretical' texts because he knows that this sort of writing, in

spite of its cognitive and referential claim, also conceals some gesture and remainder—that it is no more transparent than a picture. . . . For commenting—that is, thinking and writing—is again and already an art."[29] Although Lyotard acknowledged the source of both writing and art-making in the psychological conditions of subjectivity, he risked relegating Kosuth's theory (which he set off in quotation marks) to a form of discourse interchangeable with emotion, thereby calling into question Kosuth's ability to reason as a theorist by force of his agency as an artist. This skepticism was subtle but perceptible, and it undermined Kosuth's ideas by eroding their basis in logic and philosophical systems of knowledge. Any artist's absorption of both "theory" and "practice" into a continuous production changes the very terms of the argument.[30]

In 1969 Kosuth himself called into question the artist's responsibility for the meaning of work when he recalled a remark by Richard Serra, who stated: "I do not make art, I am engaged in an activity; if someone wants to call it art, that's his business, but it's not up to me to decide that. That's all figured out later." Kosuth commented: "Serra . . . is very much aware of the implications of his work. If Serra is indeed just 'figuring out what lead does' . . . why should *anyone* think of [his work] as art? If he doesn't take the responsibility for it being art, who can, or should? . . . How is it then that we know about 'his activity'? Because he has told us it is art by his actions *after* 'his activity' has taken place. That is, by the fact he is with several galleries, puts the physical residue of his activity in museums (and sells them to art collectors)."[31] Kosuth underscored how problematic and contradictory an artist's statement may be. But he also emphasized how much a text contributes to the meaning of a work and to what extent an artist is responsible for its historical and institutional reception.

Almost thirty years later, in 1998, the South African artist Marlene Dumas offered a different answer to the question of authority and artistic responsibility:

> I write about art because I am a believer.
> I believe
> In the power
> Of words
> Especially the
> WRITTEN WORD. . . .
> I write about my own work because I want to speak for myself . . .
> I write because I am amused by the politics of interpretation.[32]

In contrast to Serra, Dumas sought to wrest verbal control over the meaning of her art, underlining her distanced amusement at critics and their "politics of interpretation." Her determination to intervene in the reception of her work evinces contemporary artists' increasing resolve to express the intellectual content of their art. Dumas's statement also signifies the changed conditions for the reception of critical theory globally, which artists, intellectuals, and the general public alike have assimilated, resulting in a range of varied and nuanced approaches to forms of visual thought.

Certainly, since the first edition of this book, globalization of the art world has increased in tandem with interest in a theorization of the visual equivalent to critical

theory throughout the humanities, sciences, and social sciences—a phenomenon that W. J. T. Mitchell described in 1992 as the "pictorial turn."[33] Paralleling the widespread attention to the role of the visual in creating and augmenting knowledge, the revolution in communication technology has made artists' images and writings readily accessible online, through blogs, tweets, podcasts, Facebook, and other sources, and new work can immediately reach a global audience through a variety of websites, including social media such as YouTube and Flickr.

With expanded theories of the visual and a progressively more self-conscious international art world, postcolonial theory accrued relevance, providing critical insight into and awareness of alternative ways to address art production worldwide in a global market for images. While nascent postcolonial theory dates from the end of the eighteenth century, in the immediate post–World War II period it was greatly expanded by such writers as W. E. B. Du Bois, an American sociologist, historian, and civil rights activist; Frantz Fanon, a Martinique psychiatrist and theorist active in the Algerian Liberation Movement; and Aimé Césaire, a Martinique poet and politician.[34] Edward Said's *Orientalism* (1978) offered a sustained critique of imperialism and its cultural effects, elaborated on by such influential scholars as Gayatri Chakravorty Spivak, Kwame Anthony Appiah, Stuart Hall, and Homi Bhabha.

Postcolonial theory has been especially significant in the context of the plethora of international art exhibitions beginning in the 1990s. The stage for a more ecumenical and inclusive view of world art had been set already in 1951 with the founding of the São Paulo Biennial, the second international biennial, after the Venice Biennale (founded in 1895). A shift from emphasis on the art of Western Europe and the United States to the contemporary art of other nations began to take place. That history formed the background for a 1984 essay by the German-born Brazilian critic, curator, and intellectual Paulo Herkenhoff entitled "Having Europe for Lunch: A Recipe for Brazilian Art."[35] Taking his leitmotif from Brazilian poet Oswald de Andrade's renowned 1928 *Manifesto Antropófaga* (Cannibal Manifesto), Herkenhoff urged the colonized to devour the colonizer in order to produce alternative, hybrid identities and cultures. Herkenhoff's call was answered, in part, by the curator Jean-Hubert Martin, who mounted *Magiciens de la terre* in 1989 at the Centre Georges Pompidou in Paris, an exhibition aimed at countering colonialist, hegemonic versions of art, as well as the Western stigmatization of indigenous cultures as "primitive," and at showing the sources of Western avant-garde art in a wide variety of cultures throughout the world. While making an important contribution to these goals, the exhibition was criticized, nevertheless, for what some perceived as a continuation of the Western ethnocentric perspective.

Answering such critiques, the Nigerian-born curator Okwui Enwezor, director of *Trade Routes: History and Geography,* the post-apartheid Second Johannesburg Biennale (1997), set out to "explore how culture and space have been historically displaced by colonisation, migration, and technology . . . [and] how innovative practices have led to redefinitions and inventions of our notions of expression, with shifts in the language and discourses of art."[36] Enwezor's general concern with "decolonialization as one of the principal events of the twentieth century" is critical to the transformation of art into global practice.[37] Together with the artist, poet, curator, and art historian Olu Oguibe, Enwezor edited and wrote for the anthology *Reading the Contemporary* (1999).

The two developed "a new critical language and method for the evaluation of contemporary African art," while acknowledging its place in the international arena.[38] Other scholars and artists grappling with the globalized postcolonial world have written on topics ranging from the Latin American avant-garde to the impact of technology on art internationally, and from world expressions of feminism to conceptualism.[39]

Still other scholars grappled with defining modernism and its relation to the art of emerging globalism. In *Real Spaces* (2003) the art historian David Summers attempted to draw diverse topics together in such themes as "facture," "places," "images," "planarity," and "virtuality," identifying these constructs as contributing to the construction of modernism globally.[40] The Australian art historian Terry Smith approached a definition of the global contemporary art scene with a formula of three overlapping tendencies: "retro-sensationalism," or "remodernism" (namely, a return to modernism); the "postcolonial turn"; and art that "remixes elements of the first two currents, but with less . . . regard for their fading power structures and styles of struggle."[41] Focusing specifically on the effects of globalization, Silvia von Bennigsen, Irene Gludowacz, and Susanne van Hagen asked prominent artists, collectors, museum directors, and gallerists around the world, "How is the art world reacting to globalization?" and "How do art and globalization relate to each other?"[42]

In a contemporary art world that is increasingly global, some ask: "What does that mean for art history?" This is the question the art historian James Elkins posed: "What is the shape, or what are the shapes, of art history across the world? Is it becoming global—that is, does it have a recognizable form wherever it is practiced? Can the methods, concepts, and purposes of Western art history be suitable for art outside of Europe and North America? And if not, are there alternatives that are compatible with existing modes of art history?"[43] Elkins offered arguments both for understanding art history as several different practices and for considering it a single, fairly cohesive enterprise.

How global perspective combines with regional ones is evident in work that followed the "velvet revolutions" of late 1989 in Eastern Europe, as well in the Soviet Union after its demise in 1991. Artists, curators, critics, and art historians from nations formerly closed to international exchange have sought to reexamine their histories and the effects of the Cold War. For example, in the project "Political Practices of (post-) Yugoslav Art," begun in 2006, four independent cultural collectives and organizations "collaborated in multidisciplinary researching, mapping, and analyzing of the historical, sociopolitical and economic conditions that led to [the] current constellation of art practices or intellectual and cultural production in [the] post-Socialist space of . . . [the] former Yugoslavia."[44] A related project, initiated by the art historian Dóra Hegyi, the director of tranzit.hu in Budapest, Hungary, was entitled "Art always has its consequences." Hegyi assembled an international consortium "to create and disseminate knowledge about paradigmatic socially engaged art and visual culture practices in Central and Eastern Europe, including their relationships towards the wider European context both in the past and in the present."[45]

In the past two decades similar projects have surfaced all over the world, from Central America to post–Tiananmen Square China. For example, the Chinese artist Ai Weiwei (see chap. 9) coedited the seminal *Black Cover Book* (1994), *White Cover Book*

(1995), and *Grey Cover Book* (1997), a series of catalogues providing "exhibition space" for Chinese avant-garde artists and initiating dialogue on their concerns. In 2000 Ai co-curated with Feng Boyi the provocative exhibition *Fuck Off,* which opened as an alternative to the Third Shanghai Biennale but was quickly shut down, although it then garnered international press attention. In a series of photographs posted with his blogs, Ai announced his independence from globalization, Chinese nationalist repression, and the marketplace, giving a symbolic "finger" to the White House, the Chinese Imperial Palace, and the viewer.

On the other side of the globe, in 1999 in San José, Costa Rica, Virginia Pérez-Ratton (1955–2010) founded TEOR/éTica, "a space for art + thought." As its director, she helped establish this influential alternative space in Central America, which has not only mounted exhibitions but also promoted dialogue by publishing artists' writings and sponsoring workshops and discussions. Another acknowledged hub for Central American artists is the Museo de Arte de El Salvador (MARTE), which has attracted young artists and collectors, fostering dialogue through its blog as well as its exhibits.

Related to this lively contemporary art scene in Central America was the public art project "inSITE," launched in 1992 as a collaborative undertaking between San Diego and Tijuana. Intellectuals and artists from throughout the world came to the U.S./Mexico border to participate in inSITE's exhibitions. Over two hundred projects were installed, each year attending to a different theme and curated by different intellectuals, such as the Cuban curator Osvaldo Sánchez Crespo. Themes included installation (1992), site specificity (1994), public space (1997), processes of cultural practice (2000), and so on. In 2005 inSITE partnered with the San Diego Museum of Art and the Centro Cultural Tijuana to present the exhibition *Farsites: Urban Crisis and Domestic Symptoms in Recent Contemporary Art.* Curated by the Brazilian Adriano Pedrosa, *Farsites* included over fifty artists from the Americas, Europe, and Africa.

Modern art in the Middle East dates to colonialism, while the Middle East broadly defined by some as reaching from Senegal in North Africa to the steppes of Central Asia, and by others as the Islamic world, including Malaya and Indonesia, has a long history. But it was the destruction of the World Trade Towers on September 11, 2001, and the advent of wars in Iraq and Afghanistan that brought the Western art world's attention to contemporary works in the Middle East, especially ones concerning the conflict between Israel and the Palestinians. Contemporary Middle Eastern artists from a wide variety of faiths, from Druze and Bedouin to Jewish, Christian, and Muslim, have addressed the militarization of society and grappled with Western scrutiny of their work, reigniting issues of imperialism and empire. In the West, lack of knowledge about art in the region has been met with a range of exhibitions, symposia, and publications, including, in 2009 alone, the show *Hanging Fire: Contemporary Art from Pakistan* at the Asia Society in New York, the symposium "Contemporary Art in the Middle East" at Tate Britain and Tate Modern, and the book *Contemporary Art in the Middle East*, which is one of a series on contemporary art around the world, such as Kamal Boullata's *Palestinian Art: From 1850 to the Present.*[46]

This second, enlarged edition of *Theories and Documents of Contemporary Art* contributes to the exuberance of art in the twenty-first century and the many parallel conversations emerging throughout the world about what it means to belong to a global

community of exchange. Yet, as the artist Luis Camnitzer already observed in 1982, there is an underbelly to this "exchange." Camnitzer offered a searing critique of the simultaneously revolutionary and mercantile artist "with a vision for the world," who through "luck" and "manipulation" increased his "sales," acquiring "more and better means of production . . . [and] gaining access to other audiences, [as well as to] an international public."[47] The embodiment of globalization himself, the German-born Camnitzer grew up in Uruguay, where he became a citizen, and moved to the United States in 1964. As Jane Farver wrote in her introduction to a retrospective of his work at the Lehman College Art Gallery in New York, "Like his life, his art is grounded in three continents and reflects his transcultural experience. For Camnitzer, political awareness is crucial to understanding one's environment and making strategies for ethnically based actions. Art is his instrument of choice to implement those strategies."[48] The culmination of Camnitzer's international education and experiences is a deep understanding of the advantages and pitfalls of a cosmopolitan life and the economies of globalization that homogenize difference, from culture to politics.

Artists' theories, statements, and manifestos, such as that of Camnitzer, are a part of the material evidence and conceptual apparatus of their work, and must be understood as an integral component of art historical and critical theory. Artists' texts provide access to the reconstruction of culture-specific visual and textual discourses, especially where other kinds of corroborative information are absent. Texts assist in the comprehension of the relations between art-making and history even though meaning may be indeterminate and texts, like visual images, are not fixed referents. In this regard, theoretical explications may range from multifaceted interpretive readings of intention to positivist methods that offer apparently coherent narratives of empirical evidence. Wherever theory appears along this spectrum, texts recapture discourse about the social relations and function of art in culture, questions about the enterprise of interpretation notwithstanding. Artists' writings are as much a part of the construction of visual knowledge as are works of art.

Artists' theories provide multiple avenues to both the ahistorical and historically specific allusions of art, to say nothing of the primary role they play in comprehending the work itself. In a period fraught with contradictory social and cultural conditions, political ideologies, and textual and visual practices, artists' theories are part of the process through which cognition and perception become a record of human experience and consciousness. Art is culturally determined and changes in time. But it also has a "philosophical" element, Jean-François Lyotard observed, and that element "always . . . turns into a trans-historical truth . . . [that] poses the question of what art has at stake." What art has at stake, Lyotard argued, "is something that's extraordinarily serious [and leads to] a primary interest in the most fundamental philosophical question of all: 'Why does something happen rather than nothing?'"[49]

1 GESTURAL ABSTRACTION

Peter Selz and Kristine Stiles

The dominant art mode during and after World War II has been labeled as Abstract Expressionism, action painting, lyrical abstraction, *tachisme, art informel, art autre,* and a host of other terms. Characterized by an intensely personal and subjective response by artists to the medium and the working process, it was an art in which painters and sculptors were engaged in the search for their own identity. In a universe described by existentialists as absurd, the artist carried the romantic quest for the self, sincerity, and emotional authenticity into a world of uncertainty, placing great value on risk-taking, discovery, and adventure into the unknown. Painters and sculptors manifested an attitude that the Cubist Juan Gris had described earlier: "You are lost the instant you know what the result will be."

In the aftermath of fascist domination in Europe and in the face of the increasing rigidity of authoritarian communism in Stalinist Russia, artists everywhere felt the need to establish a sense of personal autonomy. Auschwitz and Hiroshima were cataclysms of such monstrous proportions that they could elicit little direct commentary from visual artists. Indeed, responding to the Romanian poet Paul Celan's poem "Death Fugue" (1944–45), which recalled the Nazi death camps, the German philosopher Theodor Adorno wrote, "After Auschwitz, to write a poem is barbaric." Adorno's comment suggested the impossibility of making art after the apparent collapse of liberal humanism. The dilemma posed by the conformity encouraged by mechanized mass culture and the growth and plethora of media added to the artist's sense of alienation and need for individual expression. The artist's own work became paramount. The very fact that paintings and sculptures were still handmade objects also became significant, emphasizing the particular quality, material, and facture of each.

The French writer and politician André Malraux observed that "modern art was doubtlessly born on the day when the idea of art and that of beauty were separated" and suggested that Francisco de Goya might have been the starting point (see chap. 3). During the nineteenth century, having abandoned the subject matter of history, artists also became dubious about narration, realism, and verisimilitude. With the aesthetics of Cubism and Expressionism in the early twentieth century, the notion of art serving

primarily as a source of visual pleasure was largely relinquished. In the period between the world wars, many abstractionists employed geometric forms such as circles, squares, and cubes (see chap. 2). By mid-century, however, many artists, though by no means all, rejected these forms as being too closely related to science and technology, too formalistic, and too impersonal. As the century progressed, artists increasingly broke with traditional aesthetics and with conventional values and ideas. The repudiation of traditional means was not entirely without precedent, but related to what Wassily Kandinsky, the first "abstract expressionist," had called an "art of internal necessity."

Although perceptible differences existed in both theory and praxis, similar attitudes toward art arose at approximately the same time in Europe and the United States, reflecting the increasingly unified culture of the Western world in the postwar era. Surrealism, with its emphasis on the personal psychology of the artist, had been the primary avant-garde movement in Europe between the world wars. The Surrealists' desire for unpremeditated spontaneity held the promise of creative freedom, and their groundbreaking attitudes and work were of pivotal importance in the postwar period, not only on both sides of the Atlantic, but also in other parts of the world. Some artists emphasized gesture and an aesthetic of incompleteness, exhibiting the Surrealists' investigation of expressive meaning through ambiguity. At times this exploration turned toward new and unexpected figuration, as in the work of Alberto Giacometti, Jean Dubuffet, and the CoBrA artists (see chap. 3). But for all such artists, the existential act of making became essential, and increasingly the dialogue between artist and consumer became a necessary element in the completion of the work.

Many American artists who came to public attention after World War II had been developing their personal styles during a long period of gestation in the 1930s, when the government's Works Progress Administration (WPA) program not only provided work but also promoted aesthetic and intellectual exchange among artists. Within this community, painters and sculptors discussed Marxist theories and political action, as well as the social and individual purposes of their art. Rejecting American regionalist scene painting, such artists argued that Social Realism was inadequate to address the current human and societal crisis. After the 1939 Hitler-Stalin pact, however, artists and intellectuals in the United States and Western Europe became increasingly disenchanted with political engagement. Differentiating the artist from the politically identified individual and feeling that art was too important to be used as a tool, Robert Motherwell wrote in 1944: "The socialist is to free the working class from the domination of property, so that the spiritual can be possessed by all. The function of the artist is to make actual the spiritual, so that it is there to be possessed."[1] Older forms of expression were no longer held to be valid. Only revolutionary methods could arrive at revolutionary solutions, and artists of this period called for nothing less.

Before or during the war, many of the Surrealists—André Breton, Marcel Duchamp, André Masson, Max Ernst, Yves Tanguy, Kurt Seligmann, Leonora Carrington, Salvador Dalí, Joan Miró, and Matta—had come to the United States. Their work—above all, Miró's evocative and poetic abstractions—had been admired in New York galleries and museums. But soon they walked the same streets, frequented the same restaurants, and attended the same art openings as American artists. Once in contact with these established artists, scarcely older than they were themselves, many American painters

and sculptors began to evolve artistically in ways that partly continued the European tradition. The tragedy of the fall of France in 1940 affected American artists and intellectuals as profoundly as it did the Europeans. Noting the impact of the Surrealists on the American painters, the critic Dore Ashton, in her contextual analysis of the New York School, wrote: "Myth, metamorphosis, risk, event painting—these liberated possibilities were little by little impressing themselves upon the troubled psyches of many New York painters."[2]

Nevertheless, the "new American painters," as they were to be called, were somewhat ambivalent toward European art, and many urged a decisive break with Western traditions. Few, however, went as far as Clyfford Still, who, although well versed in European modernism, expressed extreme hostility in a 1959 statement: "The fog has been thickened, not lifted by those who . . . looked back to the Old World for means to extend their authority in this newer land. . . . But that ultimate in irony—the Armory Show of 1913—had dumped on us the combined and sterile conclusions of Western European decadence."[3] Although most American painters did not show such animosity, many did search beyond the contemporary European horizon, hoping to find affirmation in tribal art, ancient civilizations, and other cultures. Barnett Newman studied the art of indigenous groups in Oceania and the pre-Columbian Americas; Jackson Pollock explored Native American painting and dance; Mark Rothko immersed himself in Greek mythology; Adolph Gottlieb examined prehistoric petroglyphs; and Mark Tobey was deeply influenced by Baha'ism and Zen.

At the same time, many artists of the New York School felt themselves cut off from a society that had more immediate concerns than art in the postwar era. In fact American artists, even more than their European colleagues, felt a lack of recognition and financial support from the public. In abandoning the expectation of fame and fortune, however, many felt liberated to follow their own inner necessity and to take risks in the creation of original art forms. In large lofts in lower Manhattan, some began to paint in enormous formats, far exceeding the space limitations of the private apartments of potential collectors, and, in dialogue with their art, reenacted what they conceived as the drama of contemporary experience.

Jackson Pollock (1912–56), the most celebrated American painter of this period, came to New York from the West. His early work was influenced by his teacher Thomas Hart Benton and by the Mexican muralists, but Pollock soon adopted aspects of Surrealist practice and Jungian theory as well. By the late 1940s Pollock was pouring paint freely onto canvases placed on his studio floor. His artistic decisions were made during the working process, and the resulting paintings evoked rhythm in action. He was one of a number of American painters to move from salon-size paintings to large-scale, almost mural-size works.

Barnett Newman (b. U.S., 1905–70), a man of searching intellect and a sharp polemicist, pared painting down to large, flat planes of color divided by geometric stripes, or what he called "zips." Warning against the dangers of decoration in abstract art, Newman proposed uncharted paths to unravel the "mystery of life and death." He also presented the unconventional idea that in human history "the aesthetic act always precedes the social one."[4] Newman considered the new American art to be concerned with both chaos and the transcendental.

Mark Rothko (1903–70), who was born in Russia and grew up in Oregon, studied at Yale University on a scholarship before attending the Art Students League in New York, where he studied painting. His early expressionist style revealed the influence of Max Weber, his chief teacher. Then, after a period indebted to Surrealism and searching for a meaningful mythology, Rothko began to paint visually vibrating, highly saturated color planes. In the brief passage quoted in this volume, he explained that his painting needed to be large in order to place the viewer intimately into the picture space itself.[5] At the end of his life, Rothko completed fourteen large paintings for an ecumenical sanctuary in Houston. Eliminating all references to subject matter, but retaining the triptych shapes for his almost monochromatic dark paintings, he succeeded in evoking undefined yet universal meanings and emotions.

Robert Motherwell (1915–91), one of the youngest of the original New York School artists, was born in the state of Washington and, before turning to painting, studied philosophy, literature, criticism, and art history at Stanford and Columbia Universities. In New York he became a personal friend of the French émigré Surrealist painters and a guiding force, as both an artist and a theorist, in the search for post-Surrealist ideas. In his own work Motherwell achieved a synthesis of free exploration and a rational sense of form and order. In "Beyond the Aesthetic," a key essay of 1946, he demarcated the path of the artist as proceeding toward ordered chaos.

Helen Frankenthaler (b. U.S., 1928–2011), who belonged to the second generation of Abstract Expressionists, was deeply impressed by Pollock's technique of pouring paint directly onto canvas. She originated a stain-painting technique in which she let light-colored pigments flow onto unprimed canvas, saturating it and integrating color, surface, and support in a single unit. Her flat surfaces and staining method, as well as her alliance with Clement Greenberg's formalist theories and advocacy of "post-painterly abstraction," established Frankenthaler as the leader of color-field painting, which would be further developed by artists such as Morris Louis and Kenneth Noland (see chap. 2).

Along with Frankenthaler, Lee Krasner, and Grace Hartigan, Joan Mitchell (1925–92), born and trained in Chicago, was one of the few women to join the ranks of the American Abstract Expressionists. In the 1950s, like her friend and mentor Sam Francis, Mitchell immigrated to France, where she became a member of the expatriate artist community. A landscape painter by inclination but an abstract painter by formal inheritance, she made loosely brushed, highly expressive gestural paintings, infused by evocative sensations of the water, trees, and rocks in her garden in Vétheuil, not far from Claude Monet's water garden in Giverny.

Another expatriate, Cy Twombly (1928–2011) moved from the United States to Italy in 1957. Characterized by loose, gestural marks or scribbles that elicit comparisons to both calligraphy and graffiti, his imagery conveys a sense of disorder even as it often seeks to evoke ancient myths. Some have argued that Twombly's indiscernible gestural writing attempts to convey the presence of the void, the nothingness of Zen, and is comparable to the hermetic symbolism of the French Symbolist poet Stéphane Mallarmé. In light of Twombly's reticence to ascribe meaning to his work, the German poet Heiner Bastian (b. 1943) offers additional insights into Twombly's elusive oeuvre.

American sculptors maturing in the 1930s and 1940s experimented with form in space in a manner appropriate to the new age. Isamu Noguchi combined the Romanian

sculptor Constantin Brancusi's sense of form with elements drawn from his own Asian heritage. Eventually he directed much of his energy to creating new sculptural sites (see chap. 6). Others adapted concepts and techniques from the Cubist-Constructivist tradition. No longer limited to the established conventions of either building up form in clay or plaster or carving it away in stone or wood, many of these sculptors used welding techniques to draw in open space. Working with metal in this way, Ibram Lassaw, David Smith, David Hare, Theodore Roszak, Herbert Ferber, Seymour Lipton, Richard Lippold, and others created sculpture in which space—the void—became an essential element of form.

Among these sculptors, David Smith (1906–65) made some of the most significant contributions. Born in Indiana and trained as a painter, Smith was both personally and programmatically close to the Abstract Expressionist painters. Like many of them, he was profoundly influenced by avant-garde European art. He eventually combined American technology with innovations in welded construction introduced by the Spanish sculptor Julio González (who taught Pablo Picasso to weld). Smith created a series of works that became increasingly abstract in form and universal in content. His metal sculptures ranged from calligraphic drawings in space to solid geometric forms interpreted as poetic yet tough metaphors for American vernacular culture in the industrial age. Smith wrote in an affirmative language of belonging to his own time and of the unpredictability of the final product, elegizing a Whitmanesque sense of freedom and luxuriating in the intellectual and the sensual.

Louise Bourgeois (1911–2010) was born in Paris and worked there as a painter before moving in 1938 to New York, where she began making sculptures and installations. She employed numerous wooden forms that, although abstract, carry anthropomorphic figurative associations. Bourgeois also used a variety of other materials, including marble, plaster, bronze, rubber, and plastics. Her enigmatic objects and installations were often autobiographical, emphasizing sexuality and trauma as major themes. In a 1988 interview by the art historian Donald Kuspit, Bourgeois discussed her working method, artistic concerns, and thoughts about feminism.

The interaction between artists and critics was of great importance in the heady years of ascendancy of the New York School. Discussions took place in artists' studios, cafeterias, bars, and the Artists' Club. Notable among the critics were Clement Greenberg and Harold Rosenberg, both of whom had been associated with the left-wing literati before turning to art criticism. Their writing helped to legitimize the new American painting, which was initially unpopular with the public because of the conceptual difficulty posed by abstraction. Greenberg, who had originally aspired to become a painter himself, had studied with the German-born American painter Hans Hofmann in the early 1940s. In his criticism, he adopted many of Hofmann's influential "laws" about abstract painting and the significance of the two-dimensional picture plane, which emphasized flatness as a property of painting. Greenberg expressed his passion for the art he supported by ranking artists, often in subjective and arbitrary ways, but his discriminating taste made him a perceptive advocate of Pollock and Smith, among other artists. From the 1960s on, Greenberg became increasingly doctrinaire, adhering strictly to the formalist tradition of Heinrich Wölfflin and Roger Fry and the precepts of logical positivism.

The writings of Hofmann, Rosenberg, and Greenberg are represented in Herschel B. Chipp's *Theories of Modern Art.*[6] Arguing that Greenberg's formalist approach considered "art in a vacuum," Rosenberg contended that art and art criticism could be forms of social action. A onetime editor of the left-wing journal *Art Front* (1934–37), Rosenberg supported the revolutionary character of the new painting in perspicacious essays and reviews for *Art News* and then for the *New Yorker,* for which he wrote the art column from 1967 until his death in 1978. Rosenberg introduced the term "action painting" into the vocabulary of art history in 1952, in reference to Pollock's approach and process. He also described the spontaneous act of the painter confronting the canvas as tantamount to a moral act.

The American art historian Alfred H. Barr Jr. (1902–81) was the founding director of the Museum of Modern Art in New York, established in 1929 as the first museum devoted to all forms of modern visual art. Because of the museum's preeminent position in the art world, its major exhibition *The New American Painting,* shown in eight European countries between 1958 and 1959, gave this work official sanction and contributed to the international ascendancy of American painting. In his preface to the exhibition's catalogue, Barr made specific connections between existentialist thought and this new art, which he associated with both commitment and anxiety. He also claimed that it demonstrated "a freedom in a world in which freedom connotes a political attitude."

The critic Max Kozloff also interpreted the new gestural abstraction as closely related to American political ideology, despite many artists' own belief that their work was independent of the body politic. He pointed out: "The most concerted accomplishment of American art occurred during precisely the same period as the burgeoning chasm of American world hegemony."[7] Though the Abstract Expressionists had separated themselves from political engagement since the Hitler-Stalin pact of 1939, their work found support in the political and cultural establishment. It was sent abroad, Kozloff asserted, as "evidence of America's coming of creative age,"[8] with the aim of propagandizing U.S. democracy over Soviet communism by pitting freedom of expression against its suppression behind the Iron Curtain. A year after the publication of Kozloff's "American Painting during the Cold War," Eva Cockcroft, an American artist, muralist, and art historian, examined the same issue from a Marxist point of view.[9] In 1983 the French art historian Serge Guilbaut published a polemical treatise in which he argued that through a sequence of accommodations and co-options the Abstract Expressionists worked hand in glove with the American Cold War establishment. He entitled his book *How New York Stole the Idea of Modern Art.*[10]

In Europe the situation was very different. After years of occupation and suppression, the end of World War II in 1945 signaled a renewal of all aspects of life, including literature and the arts. With most Surrealist artists in exile, that movement, so central before the war, had less presence, and the geometric abstractions of Piet Mondrian and his followers initially seemed to have little relevance after the catastrophes of the war. Although a new figuration was an essential aspect of postwar art in Europe (see chap. 3), *art informel* offered greater possibilities for diverse, spontaneous expression. Yet when compared to painting in the United States, European gestural abstraction seemed less aggressive and more inwardly directed, in large measure due to limited studio space and shortages of materials, both of which required the European paintings to be considerably smaller.

After the war Paris continued to function as the center of European art until the 1960s. For a brief time a group calling itself "young painters of the French tradition" attempted to combine the color of Pierre Bonnard and Henri Matisse with the structure of Cubism to produce a harmonious abstraction. But many artists and commentators felt that harmony was not what the postwar experience called for. More radical voices, like that of the critic Michel Tapié (b. France, 1909–87), spoke out against the encumbrances of the great classical tradition, which left no room, he argued, for "all the meaningful ecstasy of life and mystery." Tapié invoked the lessons of Dada and Surrealism to promote an art that took risks, abandoned security, and attempted to touch "the ambiguous and transcendental reality that is ours."

Galerie René Drouin was the focal point of the most provocative new manifestations in Paris. Even before the city's liberation from Nazi occupation, Drouin had organized exhibitions of work by Jean Dubuffet, Jean Fautrier, Wols, Hans Hartung, Henri Michaux, and Georges Mathieu. Mathieu, who organized many exhibitions of both American and European art, theorized extensively about art and philosophy and, beginning in 1952, painted with great speed, energy, and spontaneity in front of huge audiences. Some U.S. critics considered his public actions to be vulgarizations of the existential angst and privacy of the artist, but Mathieu was respected and acknowledged throughout the rest of the world and widely celebrated in France. His actions are often identified as a precursor of performance art (see chap. 8).

Wols (Alfred Otto Wolfgang Schulze; b. Germany, 1913–51) had studied music and architecture but was largely self-taught as a painter. He also practiced photography, wrote poetry, and was keenly interested in biology and geology. While living in France during the war, he was interned several times, and he died in Paris at the age of thirty-eight, after many years of heavy drinking. Comparing Wols with Pollock, the German art historian Werner Haftmann wrote: "Because of their unprecedented acceptance of the terrible events of the desolate years before and during the war, the lives and works of Wols and Pollock seem to provide documentary evidence of that period. Pollock was rebellious, Wols passive and resigned; he merely recorded whatever happened to him— not the simple facts of his life, but the images which streamed from his wounded soul."[11]

Henri Michaux (b. Belgium, 1899–1984), a writer known primarily for his poetry, was also a self-taught draftsman who created enigmatic signs by making doodles and traces with a brush. The Mexican Nobel laureate Octavio Paz considered Michaux's images to be absent of "conceptual burdens and closer in the realm of language to onomatopoeia than to words." Michaux believed in total anarchic freedom, using drugs such as mescaline to provoke new insights and heightened states of awareness. His "signs" were aimed at tapping into the unconscious and operating as vibrations of psychic improvisation.

In Italy many groups of lyrical abstractionists emerged after the overthrow of fascism, with a number of leading personalities appearing in the 1950s. In Milan, Lucio Fontana (1899–1968) was at the center of the new experimentation. Born in Argentina and educated in Milan, he made sculptures in ceramic and cement that bridged between art and craft. During World War II he returned to Buenos Aires, where he became a central figure in the dynamic modernist movement in Argentina. Together with other artists and his students there, he published the "Manifesto blanco" (White Manifesto)

in 1946, a text that insisted that "change is an essential condition of existence." Conceiving of a total transformation of life, the prophetic manifesto cited recent discoveries in the sciences, called for "an art that is in greater harmony with the needs of the new spirit," and identified a new age in which "painted canvas and standing plaster figures no longer have any reason to exist." Fontana propounded a "four-dimensional" art based on the unity of time and space, an art that could be brought about only if reason were kept subordinate to the unconscious. On his return to Milan, Fontana became the founder of the spatialist movement and created some of the first abstract environments. Around 1950 he began piercing and then slashing his canvases with holes, introducing actual space as part of the painting. His work resonated strongly with younger Italian painters, monochrome painters throughout Europe, the German ZERO group (see chaps. 2, 5), and later with artists associated with the international Arte Povera movement, which flourished especially in Italy in the late 1960s and 1970s (see chap. 7).

Emilio Vedova (b. Italy, 1919–2006) and Alberto Burri (b. Italy, 1915–95) came to public attention in Venice and Rome, respectively. Vedova's work exhibited the dual impact of Tintoretto and Umberto Boccioni. By the early 1950s he had established his own form of action painting, producing dynamic abstract works that responded directly to his working on the picture surface. Setting out to liberate the picture from the wall, he also made freestanding paintings on panels of wood and metal in the *Plurimi* series (1962–65), an early example of environmental art that anticipated installation. In a brief essay of 1948, Vedova stated his thoughts about the tensions and difficulties of being a contemporary artist and of having to lead the way toward a new and unknown art.

Burri trained as a physician in Rome and began painting as a prisoner of war in Texas. By the early 1950s the former surgeon was making paintings out of old tattered flour sacks, to which he applied trickles of red paint, recalling the blood-stained bandages of war victims. During a long and productive career, Burri worked with a great variety of materials, including burned wooden sheets, industrial plastics, battered tin plates, and large scorched pieces of fiberboard. His abstractions often contained references to the real world, from wounded bodies to (in later works) the earth's surface. In their emphasis on process, Burri's paintings anticipated Arte Povera as well as assemblage, especially the work of Robert Rauschenberg, who visited Burri in the early 1950s with Cy Twombly.

After the collapse of the Third Reich, German culture arrived at what was called *Stunde Null* (zero hour). Many prominent artists had left Germany, and others had died during the Nazi era. One survivor, Willi Baumeister (1889–1955), had painted mural-like pictures related to the work of the French Purists before the war and then, during the Nazi period, ideograms that, although they resembled prehistoric writing, were imaginary characters culled from his psyche. In his semiautobiographical book *Das Unbekannte in der Kunst* (The Unknown in Art), written during the war and first published in 1947, Baumeister differentiated art from nature and defined the aim of art as a search for enigma and the unknown. Like many artists of his period, Baumeister studied the Tao and Eastern philosophy.

Artists living in Spain under the dictatorship of General Francisco Franco suffered considerably less repression than did their counterparts in Germany under Adolf Hitler, and after the war important groups such as Dau al Cet in Barcelona (1948) and El Paso

in Madrid (1957) were able to organize. In spite of the cultural isolation that occurred during Franco's regime, visual artists created distinctive work related to international modes of the era. Antoni Tàpies (b. Spain, 1923–2012) began working in a heavy textural style in the 1950s, recalling *matiéristes* (matter painters) such as Dubuffet, Fautrier, and Nicolas de Staël. But Tàpies also embedded or concealed found objects in his paintings, evoking ambiguous associations. In his 1971 essay "I Am a Catalan," he communicated his awareness of the precarious situation in his country and the obligation of the artist to "prepare the groundwork for new, positive knowledge . . . capable of giving our world a new direction."

By the mid-1950s *informel* painting had spread throughout Eastern Europe, namely Czechoslovakia, Yugoslavia, and Poland, during a period of considerable intellectual and cultural freedom. One of the leading spirits of the movement for freedom in the Eastern Bloc was Tadeusz Kantor (b. Poland, 1915–90). After the war Kantor, who worked in theater before turning to painting, created an experimental theater in Kraków that shared many characteristics with the theater of cruelty and theater of the absurd theorized by the French actor, poet, and artist Antonin Artaud. Kantor's work in all disciplines was characterized by innovation, risk, uncertainty, and rebellion. In a poem written in 1955, he identified painting as a "living organism," a "demonstration of life," and a "spectacle . . . which holds me bound in passionate expectation of the unknown epilogue."

Artists associated with gestural abstraction in the decades following the halcyon years of Abstract Expressionism (1940s to early 1960s) augmented its existential underpinning with multiple themes and philosophical directions and, eventually, postmodernist pluralism. The works of the Danish painter, sculptor, and architect Per Kirkeby (b. 1938) and the U.S. painter and printmaker Pat Steir (b. 1940) are exemplary of post–Abstract Expressionist developments. Kirkeby participated in happenings and Fluxus (see chap. 8) in the early 1960s, when he also became an experimental filmmaker and an accomplished poet and novelist. Despite his opposition to lyrical abstraction in the 1950s, by the 1970s he was working in a related style, interlocking and overlapping broad swatches of paint that appeared infused with light. Kirkeby has discussed the mysterious quality of physical layers in a painting and noted that the "light of ambivalence is a heavenly one."

Steir evolved a hybrid style coupling her broad study of art history with influences from minimalism and conceptual art (see chaps. 2 and 9). Her monochromatic canvases of the 1970s included graphs as well as crossed-out images of flowers, simultaneously presenting and denying representation while referring to her feminist politics. In the 1980s Steir divided her canvases into grids, filling each box with a different image in a different style. Then, with her *Waterfall* series (1988–), Steir turned explicitly to expressionistic abstraction, depicting the gravitational forces of cascading water through spontaneous gestural splashes of paint, in a process informed by her study of Taoist principles of chance and change.

Joan Snyder (b. U.S., 1940) studied sociology before becoming a painter and earning an MFA from Rutgers University in 1966. Rebelling against the restraint of minimalism and color-field painting and eschewing the heroics of Abstract Expressionism, she concentrated on the abstract quality of individual brushmarks in "stroke paintings" (1969–73). She soon began adding found and collaged objects, including natural matter

(such as mud, sticks, and herbs), to her paintings, as well as fragments of text and dia-ristic writings. Increasingly, Snyder brought her social activism, environmentalism, feminism, and lesbian sexuality into the content of her art. Mixing both abstraction and representation in her works since the 1990s, Snyder took up themes of violence (especially against women), death, grief, mourning, and memory.

Like Snyder, Elizabeth Murray (b. U.S., 1940–2007) played a critical role in reinstat-ing painting as a viable medium in the 1970s, after it had been widely proclaimed "dead" by influential critics and artists alike. In her whimsical structures Murray joined cub-istic structures to biomorphic Surrealist forms and played with Frank Stella's use of shaped canvases (see chap. 2), fitting hers together like puzzles. Painted in strong, bright colors, her works bear humorous titles that hint at connections to her personal life. *Yikes* (1982), for example, suggests a red cup from which topples the brown-and-white form of, perhaps, spilled cappuccino. Through such references to domesticity, Murray linked feminist considerations to popular culture and Pop art, anticipating the feminist edge of expressionist painters like Suzanne McClelland, who mixed figuration with loose brush, bright colors, and provocative themes. In 2005 Murray became the fourth woman artist to receive a retrospective at the Museum of Modern Art in New York.[12]

Murray's work can be both funny and poignant. In contrast, the gestural images of Anselm Kiefer (b. Germany, 1945) are sober comments on German history, the land, myth, and the world of the artist. He came to wide attention in the 1980s in the context of Neo-Expressionism, a revival by a younger generation of mostly German artists of the colorful, gestural, and content-laden style of early-twentieth-century German Expressionism—a style that had been suppressed under the Nazis and was not publicly exhibited in Germany until Documenta I in 1955. Influenced by his mentor Joseph Beuys (see chap. 7), Kiefer introduced a visual discourse on fascism and used extra-artistic materials like straw, as well as clay, wire, and lead, to produce large-scale paint-ings, handmade books, and installations, all with a dominating physical presence. Like action painters of a previous generation, Kiefer believes that artists must take risks and assume responsibilities for both art and history.

Born a year after Kiefer, David Reed (b. U.S., 1946) addressed the history of his own country differently. While simulating and synthesizing New York School gestural painting and minimalism, Reed deemphasized the emotional touch of the artist. Cre-ating seemingly mechanically produced canvases, he used acrid colors to express some-thing of the technological luminescence of television and film, which had such a de-termining impact on the development of American culture after World War II. After deploying computer-generated montage to edit images of his own paintings into scenes from Alfred Hitchcock's film *Vertigo,* Reed returned to his "photo-expressionism," depicting voluptuous brushstrokes in vibrant colors applied with scalpel-like precision. Reed has noted that he is interested in how Barnett Newman combined "conception and execution, control and impulse," developing a "double awareness" that required him to be both spontaneous and self-conscious.[13]

Fiona Rae, who was born in 1963 in Hong Kong and moved to England in 1970, has, like Reed, been interested in the cinematic synthesis of images. Approaching paint-ing as a series of filmic edits, Rae sampled art historical precedents, appropriating forms and rejecting emotional intensity for a cool but painterly style. Her work, which includes

signs, symbols, scratches, and marks suggestive of graffiti, nods to Disney as much as to Pollock. The artist Damien Hirst (see chap. 4) selected Rae's work for inclusion in the 1988 exhibition *Freeze*, which launched her as one of the Young British Artists (YBAs) who dominated the international art market of the 1990s. Choosing to work in a traditional medium, Rae has noted that painting poses the greatest challenge "to be fresh and original in the 21st century."[14]

The large-scale paintings of Julie Mehretu (b. 1970) visualize the interconnectedness of twenty-first-century nomadic migrations and diasporas. Born in Ethiopia, Mehretu grew up in Michigan, before studying in Senegal, Michigan, and Rhode Island. With its substructure of interpenetrating expressive black lines, dashes, dots, marks, and erasures overlaid with carefully drawn graphic lines and often brilliantly colored geometric forms or eccentric abstract shapes, Mehretu's work has been viewed in multiple ways—as a kind of visual map or diagram of social space; as a narrative on urban planning and the negotiation of power; as an ambiguous compositional maelstrom of architectural forms suggestive of the swirling cacophony of public life; and as energetic postmodern landscapes dense with information and activity. Through dissonant competing symbols, flags, and logos, she portrays the restless clash of disparate circumstances that characterize globalization, much as Mark Bradford creates expressionistic paintings, infused with elements of collage, to depict the multiracial, multilingual cultural influences and experiences of living in Los Angeles. While Bradford is best known for cartographic-like images that recall the interest of the Situationist International (see chap. 8) in the psychogeographic impact of cities on their inhabitants, he has also translated this content into videos, photographs, installations, and performance, making art as hybrid as life is in the twenty-first century.

JACKSON POLLOCK Guggenheim Application (1947)

I intend to paint large movable pictures which will function between the easel and mural. I have set a precedent in this genre in a large painting for Miss Peggy Guggenheim which was installed in her house and was later shown in the "Large Scale Painting" show at the Museum of Modern Art. It is at present at Yale University.

I believe the easel picture to be a dying form, and the tendency of modern feeling is towards the wall picture or mural. I believe the time is not yet ripe for a full transition from easel to mural. The pictures I contemplate painting would constitute a halfway state, an attempt to point out the direction of the future, without arriving there completely.

Interview with William Wright (1950)

WILLIAM WRIGHT: Mr. Pollock, in your opinion, what is the meaning of modern art?

JACKSON POLLOCK: Modern art to me is nothing more than the expression of contemporary aims of the age that we're living in.

WW: Did the classical artists have any means of expressing their age?

JP: Yes, they did it very well. All cultures have had means and techniques of expressing their immediate aims—the Chinese, the Renaissance, all cultures. The thing that interests me is that today painters do not have to go to a subject matter outside of themselves. Most modern painters work from a different source. They work from within.

WW: Would you say that the modern artist has more or less isolated the quality which made the classical works of art valuable, that he's isolated it and uses it in a purer form?

JP: Ah—the good ones have, yes.

WW: Mr. Pollock, there's been a good deal of controversy and a great many comments have been made regarding your method of painting. Is there something you'd like to tell us about that?

JP: My opinion is that new needs need new techniques. And the modern artists have found new ways and new means of making their statements. It seems to me that the modern painter cannot express this age, the airplane, the atom bomb, the radio, in the old forms of the Renaissance or of any other past culture. Each age finds its own technique.

WW: Which would also mean that the layman and the critic would have to develop their ability to interpret the new techniques.

JP: Yes—that always somehow follows. I mean, the strangeness will wear off and I think we will discover the deeper meanings in modern art.

WW: I suppose every time you are approached by a layman they ask you how they should look at a Pollock painting, or any other modern painting—what they look for—how do they learn to appreciate modern art?

JP: I think they should not look for, but look passively—and try to receive what the

* Jackson Pollock, excerpt from application for Solomon R. Guggenheim Fellowship (1947), quoted in Francis V. O'Connor and Eugene Victor Thaw, eds., *Pollock: A Catalogue Raisonné* 4 (New Haven: Yale University Press, 1978), 238. By permission of Yale University Press.

** Jackson Pollock, excerpts from an interview with William Wright (1950), in Francis V. O'Connor and Eugene Victor Thaw, eds., *Pollock: A Catalogue Raisonné* 4 (New Haven: Yale University Press, 1978), 248–51. By permission of Yale University Press. This interview was conducted for a radio program by Wright, Pollock's neighbor in East Hampton. It was broadcast only one time, on radio station WERI, Westerly, Rhode Island, in 1951.

Jackson Pollock painting *Number 32*, Springs, Long Island, 1950. Photo by Hans Namuth.
© 2012 Hans Namuth Ltd., New York.

painting has to offer and not bring a subject matter or preconceived idea of what they are to be looking for.

WW: Would it be true to say that the artist is painting from the unconscious, and the—canvas must act as the unconscious of the person who views it?

JP: Most of the paint I use is a liquid, flowing kind of paint. The brushes I use are used more as sticks rather than brushes—the brush doesn't touch the surface of the canvas, it's just above.

ww: Would it be possible for you to explain the advantage of using a stick with paint—liquid paint rather than a brush on canvas?

jp: Well, I'm able to be more free and to have greater freedom and move about the canvas, with greater ease.

ww: Well, isn't it more difficult to control than a brush? I mean, isn't there more a possibility of getting too much paint or splattering or any number of things? Using a brush, you put the paint right where you want it and you know exactly what it's going to look like.

jp: No, I don't think so . . . with experience—it seems to be possible to control the flow of the paint, to a great extent, and I don't use—I don't use the accident—'cause I deny the accident.

ww: I believe it was Freud who said there's no such thing as an accident. Is that what you mean?

jp: I suppose that's generally what I mean.

ww: Then, you don't actually have a preconceived image of a canvas in your mind?

jp: Well, not exactly—no—because it hasn't been created, you see. Something new—it's quite different from working, say, from a still life where you set up objects and work directly from them. I do have a general notion of what I'm about and what the results will be.

ww: That does away, entirely, with all preliminary sketches?

jp: Yes, I approach painting in the same sense as one approaches drawing: that is, it's direct. I don't work from drawings, I don't make sketches and drawings and color sketches into a final painting. Painting, I think, today—the more immediate, the more direct—the greater the possibilities of making a direct—of making a statement. . . .

ww: Well, now, Mr. Pollock, would you care to comment on modern painting as a whole? What is your feeling about your contemporaries?

jp: Well, painting today certainly seems very vibrant, very alive, very exciting. Five or six of my contemporaries around New York are doing very vital work, and the direction that painting seems to be taking.

BARNETT NEWMAN The Plasmic Image (1943–45)

The subject matter of creation is chaos. The present feeling seems to be that the artist is concerned with form, color, and spatial arrangement. This objective approach to art reduces it to a kind of ornament. The whole attitude of abstract painting has been such that it has reduced painting to an ornamental art whereby the picture surface is broken up in geometrical fashion into a new kind of design-image. It is a decorative art built on a slogan of purism where the attempt is made for an unworldly statement.

The failure of abstract painting is due to the confusion that exists in the understanding of primitive art [as well as that] concerning the nature of abstraction. It is now a widespread notion that primitive art is abstract, and that the strength in the primitive statement arises from this tendency toward abstraction. An examination of primitive cultures, however, shows that many traditions were realistic . . . [and] there always existed . . . a strict division between the geometric abstraction used in the decorative arts and the art of that culture. It is known

* Barnett Newman, excerpts from part I of "The Plasmic Image" (1943–45), in John P. O'Neill, ed., *Barnett Newman: Selected Writings and Interviews* (New York: Alfred A. Knopf, 1990), 139–40. Reprinted by permission. © 2012 The Barnett Newman Foundation, New York/Artists Rights Society (ARS), New York.

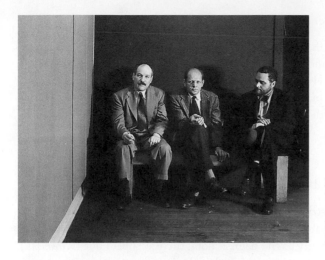

Barnett Newman, Jackson Pollock, and Tony Smith, sitting next to *Vir Heroicus Sublimis,* Betty Parson Gallery, 1951. Photo by Hans Namuth. © 2012 Hans Namuth Ltd., New York.

that strict geometry was the province of women members of primitive tribes, who used these devices in their weaving, pottery, etc. . . . The men, in most tribes the practicing artists, always employed a symbolic, even a realistic, form of expression.

In primitive tribes distortion was used as a device whereby the artist could create symbols. Clarity will be gained if we define abstracion in the strict terms of the abstract painter, as a field of painting concerned with geometric forms, and if we separate this concept from distortion. One of the serious mistakes made by artists and art critics has been the confusion over the nature of distortion, the easy assumption that any distortion from the realistic form is an abstraction of that form. . . .

All artists, whether primitive or sophisticated, have been involved in the handling of chaos. The painter of the new movement clearly understands the separation between abstraction and the art of the abstract. He is therefore not concerned with geometric forms per se but in creating forms that by their abstract nature carry some abstract intellectual content.

There is an attempt being made to assign a surrealist explanation to the use these painters make of abstract forms. . . . [But] surrealism is interested in a dream world that will penetrate the human psyche. To that extent it is a mundane expression. . . . The present painter is concerned not with his own feelings or with the mystery of his own personality but with the penetration into the world-mystery. His imagination is therefore attempting to dig into metaphysical secrets. To that extent his art is concerned with the sublime. It is a religious art which through symbols will catch the basic truth of life, which is its sense of tragedy.

The present painter can be said to work with chaos not only in the sense that he is handling the chaos of a blank picture plane but also in that he is handling a chaos of form. In trying to go beyond the visible and the known world he is working with forms that are unknown even to him. He is therefore engaged in a true act of discovery in the creation of new forms and symbols that will have the living quality of creation. No matter what the psychologists say these forms arise from, that they are the inevitable expression of the unconscious, the present painter is not concerned with the process. Herein lies the difference between him and the surrealists. At the same time, in his desire, in his will to set down the ordered truth, that is the expression of his attitude toward the mystery of life and death, it can be said that the artist like a true creator is delving into chaos. It is precisely this that makes him an artist, for the Creator in creating the world began with the same material—for the artist tried to wrest truth from the void.

MARK ROTHKO I Paint Very Large Pictures (1951)

I paint very large pictures. I realize that historically the function of painting large pictures is painting something very grandiose and pompous. The reason I paint them, however—I think it applies to other painters I know—is precisely because I want to be very intimate and human. To paint a small picture is to place yourself outside your experience, to look upon an experience as a stereopticon view with a reducing glass. However you paint the larger pictures, you are in it. It isn't something you command.

ROBERT MOTHERWELL Beyond the Aesthetic (1946)

For the goal which lies beyond the strictly aesthetic the French artists say the "unknown" or the "new," after Baudelaire and Rimbaud; Mondrian used to say "true reality." "Structure" or "gestalt" may be more accurate: reality has no degrees nor is there a "super" one (*surréalisme*). Still, terminology is unimportant. Structures are found in the interaction of the body-mind and the external world; and the body-mind is active and aggressive in finding them. As Picasso says, there is no use looking at random: to find is the thing.

The aesthetic is the sine qua non for art: if a work is not aesthetic, it is not art by definition. But in this stage of the creative process, the strictly aesthetic—which is the sensuous aspect of the world—ceases to be the chief end in view. The function of the aesthetic instead becomes that of a medium, a means for getting at the infinite background of feeling in order to condense it into an object of perception. We feel through the senses, and everyone knows that the content of art is feeling; it is the creation of an object for sensing that is the artist's task; and it is the qualities of this object that constitute its felt content. Feelings are just how things feel to us; in the old-fashioned sense of these words, feelings are neither "objective" nor "subjective," but both, since all "objects" or "things" are the result of an interaction between the body-mind and the external world. "Body-mind" and "external world" are themselves sharp concepts only for the purposes of critical discourse, and from the standpoint of a stone are perhaps valid but certainly unimportant distinctions. It is natural to rearrange or invent in order to bring about states of feeling that we like, just as a new tenant refurnishes a house.

The passions are a kind of thirst, inexorable and intense, for certain feelings or felt states. To find or invent "objects" (which are, more strictly speaking, relational structures) whose felt quality satisfies the passions—that for me is the activity of the artist, an activity which does not cease even in sleep. No wonder the artist is constantly placing and displacing, relating and rupturing relations; his task is to find a complex of qualities whose feeling is just right—veering toward the unknown and chaos, yet ordered and related in order to be apprehended.

The activity of the artist makes him less socially conditioned and more human. It is then that he is disposed to revolution. Society stands against anarchy; the artist stands for the human against society; society therefore treats him as an anarchist. Society's logic is faulty, but its intimation of an enemy is not. Still, the social conflict with society is an incidental obstacle in the artist's path.

It is Cézanne's feeling that determined the form of his pictorial structure. It is his pictorial

 * Mark Rothko, excerpt from "A Symposium on How to Combine Architecture, Painting and Sculpture," *Interiors* 110, no. 10 (May 1951): 104. © 1951 Interiors. © 2012 Kate Rothko-Prizel and Christopher Rothko/Artists Rights Society (ARS), New York.

 ** Robert Motherwell, excerpts from "Beyond the Aesthetic," *Design* 47, no. 8 (April 1946): 38–39. Reprinted by permission of the Dedalus Foundation, Inc.

structure that gives off his feeling. If all his pictorial structures were to disappear from the world, so would a certain feeling. . . .

Feelings must have a medium in order to function at all; in the same way, thought must have symbols. It is the medium, or the specific configuration of the medium that we call a work of art that brings feeling into being, just as do responses to the objects of the external world. Apart from the struggle to endure—as Spinoza says, substance is no stronger than its existence—the changes that we desire in the world, public or private, are in the interest of feeling. The medium of painting is such changing and ordering on an ideal plane, ideal in that the medium is more tractable, subtle, and capable of emphasis (abstraction is a kind of emphasis) than everyday life.

Drama moves us: conflict is an inherent pattern in reality. Harmony moves us too: faced as we are with ever imminent disorder. It is a powerful ideal. Van Gogh's drama and Seurat's silent harmony were born in the same country and epoch: but they do not contradict one another; they refer to different patterns among those which constitute reality. In them the projection of the human has become so desocialized as to take on the aspect of the unknown. Yet what seems more familiar when we confront it? . . .

But the most common error among the whole-hearted abstractionists nowadays is to mistake the medium for an end in itself, instead of a means.

On the other hand, the surrealists erred in supposing that one can do without a medium, that in attacking the medium one does not destroy just one means for getting into the unknown. Color and space relations constitute such a means because from them can be made structures which exhibit the various patterns of reality.

Like the cubists before them, the abstractionists felt a beautiful thing in perceiving how the medium can, of its own accord, carry one into the unknown, that is to the discovery of new structures. What an inspiration the medium is. . . .

Like Rimbaud before them, the surrealists abandoned the aesthetic altogether; it takes a certain courage to leave poetry for Africa. They revealed their insight as essentially moral in never forgetting for a moment that most living is a process of conforming to an established order which is inhuman in its drives and consequences. Their hatred sustained them through all the humiliating situations in which the modern artist finds himself, and led them to perceptions beyond the reach of more passive souls. For them true "poetry" was freedom from mechanical social responses. No wonder they loved the work of children and the insane—if not the creatures themselves.

In the end one must agree with Rilke when he says that with "nothing can one touch a work of art so little as with critical words: they always come down to more or less happy misunderstandings." It was Marcel Duchamp who was critical, when he drew a moustache on the *Mona Lisa*. And so was Mondrian when he dreamt of the dissolution of painting, sculpture, and architecture into a transcendent ensemble.

HELEN FRANKENTHALER Interview with Henry Geldzahler (1965)

HENRY GELDZAHLER: How did you first get into painting?

HELEN FRANKENTHALER: When I was fifteen I started going to the Museum (of Modern Art) and a couple of galleries, mostly because of Tamayo, because he was teaching at my high

* Henry Geldzahler, excerpts from "Interview with Helen Frankenthaler," *Artforum* 4, no. 2 (October 1965): 36–38. By permission of the interviewer and the publisher.

school, Dalton. He was my first friend who was a painter. The first gallery I went into was the one in which he showed (Valentine Dudensing). In my early teens, it was my sister Marge who took me around the Museum; she took me to see Dalí's melting watches. It was the first time I really looked and I was astonished.

By the time I got to Bennington (March, 1946), I was quite involved in painting because of Tamayo. . . . He taught me how to stretch a canvas, mix mediums. I still have my pictures in his colors, blues, ochres, watermelon reds. I didn't know he derived from Picasso. He thought I was a good student—and I made such good Tamayos! . . . Once out of the Tamayo atmosphere I dropped the style. . . . At Bennington . . . Paul Feeley had just come back, after the war. I'd say his involvement then was with American-style Cubism; not so much Villon and Feininger as Max Weber. But he had a great eye; a marvelous teacher with a passionate curiosity about painting. His interest in Cubism encouraged me and that was my concern for three and a half years until I graduated. I could "do" a Braque still life—I'm not being presumptuous—I don't mean I *did* a Braque still life, but I got—felt emotionally and intellectually—the style thoroughly. . . .

HG: What did you look at that was totally abstract?

HF: Total abstraction was something intellectual to me. I didn't feel it; I could talk about Mondrian but it didn't occur to me to do it. I saw a Dubuffet show at Pierre Matisse in the late forties and came back with a new vocabulary. Also when Baziotes won the Carnegie (1948) there was a reproduction in the *Times*. I remember bringing it to class. It was a source of bewilderment, delineated configurations that seemed to come out of Cubism. It was something new. Those were the tastes of a whole dimension that was to come, much more abstract and allover and I didn't see much more of it until I came to New York. I would go to the old Guggenheim to look at Kandinsky. I liked the early abstractions but the later ones I didn't like at all. . . .

HG: When did you first see Pollock?

HF: The first Pollock show I saw was in 1951 at Betty Parsons Gallery, early in the fall, probably September or October. It was staggering. I really felt surrounded. I went with Clement Greenberg who threw me into the room and seemed to say "swim." By then I had been exposed to enough of it so it hit me and had magic but didn't puzzle me to the point of stopping my feelings.

HG: Did it affect your work?

HF: No, not immediately, within months. I went out to Springs and saw Pollock and his work, not only the shows. In 1951 I looked at de Kooning as much as at Pollock. Earlier Kandinsky and Gorky had led me into what is now called "Abstract Expressionist" painting; but these came after all the Cubist training and exercise. It all combined to push me on. Like Cubism which it came out of, painting in the de Kooning, Gorky idiom was first revealing, then inhibiting to me. I felt many more possibilities in Pollock's work. That is, I looked at and was influenced by both Pollock and de Kooning and eventually felt that there were many more possibilities for me out of the Pollock vocabulary. De Kooning made enclosed linear shapes and "applied" the brush. Pollock used shoulder and ropes and ignored the edges and corners. I felt I could stretch more in the Pollock framework. I found that in Pollock I also responded to a certain Surreal element—the understated image that was really present: animals, thoughts, jungles, expressions. You could become a de Kooning disciple or satellite or mirror, but you could *depart* from Pollock. . . . The younger painters were polarized one way or the other. At first it was all of us together, young and honoring our mentors. We were the second generation, they were the first. Then, we "broke up" according to sensibilities. . . .

HG: Is there anything in your work still of Cubism?

HF: Yes, I still, when I judge my own pictures (either while I'm working or after I think it's finished) determine if they work in a certain kind of space through shape or color.

I think all totally abstract pictures—the best ones that really come off—Newman, Pollock, Noland—have tremendous space; perspective space despite the emphasis on flat surface. For example, in Noland a band of yellow in relation to a band of blue and one of orange can move in depth although they are married to the surface. This has become a familiar explanation, but few people really see and feel it that way. The way an inch of space behind a banjo in a 1912 Picasso has depth. And the ones that go dead and static can't be read that way; they don't move. In my work, because of color and shape a lot is read in the landscape sense. . . .

HG: Has the art world changed since the early '50s?

HF: I think when you're really painting, involved in a painting, what goes on in the art world doesn't matter. When you're making what you have to you're totally involved in the act. . . .

When we were all showing at Tibor de Nagy in the early fifties, none of us expected to sell pictures. A few people knew your work. There was a handful of people you could talk to in your studio, a small orbit. Outside, there were *Art News, Arts Digest,* the *Times,* and the Parsons Gallery, Janis, Kootz, Egan. Johnny Myers at Tibor was the first to take the younger artists, in a railroad flat on 53rd Street, between Second and Third, before 10th Street or the Stable.

Sometimes I think the worst thing is the current "worldliness" of the whole scene. It is the most deceptive, corrupting, transient thing, full of kicks and fun but so little to do with what it's all really about. . . . It has to do with our time, a desperate pact about the power of immediate in-ness. But I feel less and less concerned with this as an issue. So what? No threat.

HG: Was there any postwar European painting you were interested in?

HF: Miró. Matisse. But more Miró. As I've said I've been touched, in the work of Miró and Pollock, by a Surrealist—by Surrealist I mean "associative"—quality. It's what comes through in association after your eye has experienced the surface as a great picture; it is incidental but can be enriching. Gorky too has affected me this way, but in Gorky, though it fascinated me, it often got in my way. I was too much aware of, let's say, what read as sex organs arranged in a room. I liked the big 1961 Miró "Blue II" in the Guggenheim show several years ago very much. . . . It isn't the image that makes it work for me, it is that they are great abstract pictures. I leave it out of my own pictures more and more as I become increasingly involved with colors and shapes. But it is still there.

HG: How do you name your pictures?

HF: I'm very poor at naming them. I don't like numbers because I don't remember them. . . . I usually name them for an image that seems to come out of the pictures like *Blue Territory,* or I look and see *Scattered Shapes,* or *Red Burden.* I don't like sentimental titles. . . . One names a picture in order to refer to it. . . . It's more difficult to title more abstract pictures.

HG: Do you start your pictures with a plan or look in mind?

HF: I will sometimes start a picture feeling "What will happen if I work with three blues and another color, and maybe more or less of the other color than the combined blues?" And very often midway through the picture I have to change the basis of the experience. Or I add and add to the canvas. And if it's over-worked and beyond help I throw it away.

I used to try to work from a given, made shape. But I'm less involved now with the

shape as such. I'm much more apt to be surprised that pink and green within these shapes are doing something. After '51–'54 I had a long involvement with lines and black. Then that got played out.

HG: What do you mean by gesture?

HF: When I say gesture, my gesture, I mean what my mark is. I think there is something now I am still working out in paint; it is a struggle for me to both discard and retain what is gestural and personal, "Signature." I have been trying, and the process began without my knowing it, to stop relying on gesture, but it is a struggle. "Gesture" must appear out of necessity not habit. I don't start with a color order but find the color as I go.

I'd rather risk an ugly surprise than rely on things I know I can do. The whole business of spotting; the small area of color in a big canvas; how edges meet; how accidents are controlled; all this fascinates me, though it is often where I am most facile and most seducible by my own talent.

The gesture today is surely more purely abstract than it was. There is a certain moment when one can look so pure that the result is emptiness—many readings of a work of art are eliminated and you are left with one note that may be real and pure but it's only that, one shaft. For example, the best Mondrians, Newmans, Nolands, or Louises are deep and beautiful and get better and better. But I think that many of the camp followers are empty.

When you first saw a Cubist or Impressionist picture there was a whole way of instructing the eye or the subconscious. Dabs of color had to stand for real things; it was an abstraction of a guitar or of a hillside. The opposite is going on now. If you have bands of blue, green and pink, the mind doesn't think sky, grass and flesh. These are colors and the question is what are they doing with themselves and with each other. Sentiment and nuance are being squeezed out so that if something is not altogether flatly painted then there might be a hint of edge, chiaroscuro, shadow and if one wants just that pure thing these associations get in the way.

HG: How do you feel about being a woman painter?

HF: Obviously, first I am involved in painting not the who and how. I wonder if my pictures are more "lyrical" (that loaded word!) because I'm a woman. Looking at my paintings as if they were painted by a woman is superficial, a side issue, like looking at Klines and saying they are bohemian. The making of serious painting is difficult and complicated for all serious painters. One must be oneself, whatever.

JOAN MITCHELL Interview with Yves Michaud (1986)

YVES MICHAUD: What inspires you to paint?

JOAN MITCHELL: When I was sick, they moved me to a room with a window and suddenly through the window I saw two fir trees in a park, and the grey sky, and the beautiful grey rain, and I was so happy. It had something to do with being alive. I could see the pine trees, and I felt I could paint. If I could see them, I felt I would paint a painting. Last year, I could not paint. For a while I did not react to anything. All I saw was a white metallic color.

YM: When you started again painting, you painted dying sunflowers. I remember that you said to me then: "At least, I can feel them." . . .

* Yves Michaud, excerpts from "Conversations with Joan Mitchell, January 12, 1986," in *Joan Mitchell: New Paintings* (New York: Xavier Fourcade, 1986), n.p. By permission of Yves Michaud and the Joan Mitchell Foundation.

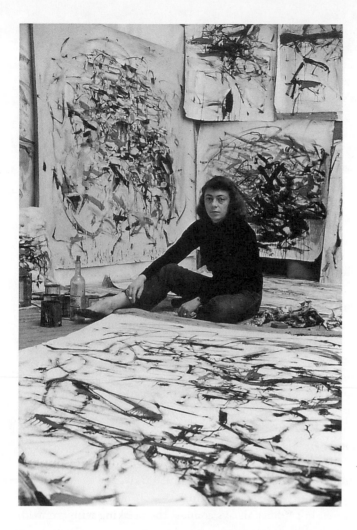

Joan Mitchell in her New York
studio in the 1950s. Photographer
unknown. Courtesy Robert
Miller Gallery, New York.

JM: Sunflowers are something I feel very intensely. They look so wonderful when young
and they are so very moving when they are dying. I don't like fields of sunflowers. I like them
alone or, of course, painted by Van Gogh.

YM: You talk of feeling, existing, living. . . .

JM: Feeling, existing, living, I think it's all the same, except for quality. Existing is
survival; it does not mean necessarily feeling. You can say good morning, good evening.
Feeling is something more: it's feeling your existence. It's not just survival. Painting is a
means of feeling "living." . . . Painting is the only art form except still photography which
is without time. Music takes time to listen to and ends, writing takes time and ends, movies
end, ideas and even sculpture take time. Painting does not. It never ends, it is the only thing
that is both continuous and still. Then I can be very happy. It's a still place. It's like one word,
one image. . . .

YM: What do you want from a painting?

JM: I am trying to achieve anything I can. I don't set out to achieve a specific thing,
perhaps to catch motion or to catch a feeling. Call it layer painting, gestural painting, easel
painting or whatever you want. I paint oil on canvas—without an easel. Conventional meth-

ods. I do not condense things. I try to eliminate clichés, extraneous material. I try to make it exact. My painting is not an allegory or a story. It is more like a poem.

YM: But what is the meaning of a picture?

JM: What it means? It seems very clear what it means. I can't say it but the painting makes it clear. If I don't know, then it's not working. If it seems right to me, then it has a meaning, but I can't tell you what meaning. I can't be more specific than that. It works when it means something, when I don't question it any more.

YM: Whom do you paint for?

JM: I suppose I must paint for me and my dogs. We are in the studio and they watch. I said painting is not motion, it is not in time. I think any involvement of any kind is to forget not being alive. Painting is one of those things. I am alive, we are alive, we are not aware of what is coming next. I am afraid of death. Abandonment is death also. I mean: somebody leaves and other people also leave. I never say goodbye to people. Somebody comes for dinner and then leaves. I am very nervous. Because the leaving is the worst part. Often in my mind, they have already left before they have come. I guess this is why everyone is reproduced in my imaginary photograph album.

YM: When and how do you paint?

JM: I often paint during the night but I have nothing to do with night. I like the light. I prefer the daylight. I also work in the afternoon, I check what I have done the night before. Certain colors change enormously with electric light. . . .

YM: When is a painting finished?

JM: When it stops questioning me. Sometimes I don't know what to do with it. Sometimes I don't know exactly what I want. I check it out, recheck it for days or weeks. Sometimes there is more to do on it. Sometimes I am afraid of ruining what I have. Sometimes I am lazy, I don't finish it or I don't push it far enough. Sometimes I think it's a painting.

YM: Why do you prefer to talk of painting when you are in your studio?

JM: There I exist in painting. In some other place I exist differently.

YM: So you suggest that your identity is in your painting?

JM: I find a certain recognition but I don't always connect the painting with me, with that person I hear on the tape, although the ideas are familiar. I imagine a sort of scaffolding made of painting stretchers around a lot of colored chaos as an identity. I am an outsider, I happen to live in France, I am an alien. So for my identity I need to know where I am, to look at maps. I want to know where the north is, and Vétheuil, and New York, and what street I am on.

YM: Do you recognize yourself in your paintings? Are they a part of you, or an image, or something specially connected with you?

JM: I don't know. I have often questioned, "Did I do that?" on seeing a painting of mine unexpectedly in some place. It has become disconnected. Once they leave the studio, they go and it is another sort of abandonment. When my paintings left my studio for New York recently, I was in the garden and the trees and the garden were beautiful and there was a beautiful light and I saw the paintings moving. A big strong man moved them with great ease and I saw all their colors behind the trees moving and it was like a parade and I was happy. I did not feel abandoned for a change. But a painting is not part of me. Because when I do paint, I am not aware of myself. As I said before, I am "no hands," the painting is telling me what to do. So it is not really a part of me at all. It is part of something else. Communication is very difficult.

I want to paint the feeling of a space. It might be an enclosed space, it might be a vast space. It might be an object working with Hofmann's phrase "push and pull," the structure, the light, the space, the color.

YM: What about your type of painting, your style or your technique?

JM: Abstract is not a style. I simply want to make a surface work. This is just a use of space and form: it's an ambivalence of forms and space. Style in painting has to do with labels. Lots of painters are obsessed with inventing something. When I was young, it never occurred to me to invent. All I wanted to do was paint. I was so and still I am in such adulation of great painters. If you study a Matisse, the way paint is put on and the way he puts on white, that's painting technique. I wanted to put on paint like Matisse. I worked hard at that a very long time ago. Someone said to me recently with surprise: "But you don't paint in 'series,' you paint pictures, each painting is different." And I thought: no, I paint paintings.

CY TWOMBLY Comments by Heiner Bastian (1989)

> *Do not move*
> *Let the wind speak*
> *that is paradise.*
> *. . . the verb is "see," not "walk on"*
> Ezra Pound

The written word is the figure of gradual acquisition, the impatient and invisible Fury of return. It is always there before we are, even when we move on. We break it and it still remains, speaking within us with the immanence of all things. It defends itself in the name of speechlessness, and yet asserts itself in the desire to forget. The connotation of the written word is its possessiveness, that inner monologue of endless transitions, of analogies. And only for moments is all that is inexpressible an empty mirror, the desire for a sense that can merge in it without speech. Without description, without echo; the desire for the intrinsicality of a thing, which cannot come to be, unless we give away something of ourselves: the Fury of a hermetic language. The empty mirror holds an ephemeral form, the root of meaning, held by nothing more than this moment of affect that makes us "speechless," that cannot be lost in the network of semantic relationships: "the interruption of our inner monologue" (Barthes).

No artist has in his work, as radically as Cy Twombly, substituted language for an expression that suspends and interrupts the discourse, the rhetoric of occidental culture. Twombly insists on the transparency of the most transient of all forms, the state of conception and comprehension, when the form itself is the untranslatable event. His work is a school of sensitivity. Beyond all isms, vogues, unceasingly changing innovations of the moment, this work perseveres with a concept of time and space, in which inextinguishable moments evoke the essence of myths as lived life.

While other famous contemporaries are oriented to immediate reflection of the present and to overcoming "art and life duality" or to the revelation in dramatic self-expression, Twombly mistrusted and resisted these aesthetic-social impulses as new, unserviceable hermeneutics. References to the great poetic form of Ezra Pound are probably the only recognizable

* Heiner Bastian, "Comments," in *Cy Twombly: 24 Short Pieces* (Munich: Schirmer/Mosel Verlag, 1989). Translation by Melanie Flemming. By permission of the author. The series *24 Short Pieces* was created in 1973.

Cy Twombly, *24 Short Pieces #1,* 1973, pencil drawing. From *Cy Twombly: 24 Short Pieces,* text by Heiner Bastian (Munich: Schirmer/Mosel, 1989). By permission of the artist.

influence in his work. It is an archetype of man who like Ulysses, dares to set forth onto unknown seas and therefore sings of uncertainty, which constitutes an antipodic hope of discovery for Pound, and the synthesis of a beauty, "that he searches for outside himself, that he perceives, only to be transformed perhaps into what he has sought."

In the yearning for beauty that would correspond to the "truth" of myths and at the same time could be a condition of life and work, Twombly's oeuvre is similar to the work of Pound, just as in its complex sensitivity. In Twombly's insisting on a non-descriptive line, that is nothing more than the event of its inner manifestation, an additional affinity to the ideogrammatic working methods of Pound can be seen. This work is not an epic, but rather a constant series of events, which do not seek a phenomenologically defined culture, but its roots: an untamable, ephemeral enchantment. Pyramus and Thisbe are separated by a veil, but only a moment of whispering reaches them in the strangely wavering oblivion of time.

Constantly different in extent and in their thematic association or openness, many beautiful series of drawings have evolved in the work of Cy Twombly since 1957. Not even the famous, early cycles "Poems to the Sea" from 1959 and "Letter of Resignation" from 1959/64 have been completely and adequately published to this day. We can only hope, that this book will engender the complete publication that has long been necessary. It was initially stimulated by Katharina Schmidt's wonderful catalogue for Bonn, in which many of Twombly's series were introduced in extensive excerpts.

The cycles of Twombly's drawings were created in very different places, a striking number of which were on sea-coasts, on islands during temporary stays. A coherent iconographic-progressive treatment of the theme lends them their thematic cohesion. "Poetic miniatures" or "a form of poetry" could very well entitle most of these series of small format.

One can imagine the drawings "24 Short Pieces" as moments of a journey through a changing landscape of changing seasons. But at the same time they are the memory, the subjective recollection of what was seen. But finally they do not tell us how something could have been. In a deep space without degrees—the place of their origin—with flowing transitions between memory and projection, between the intellect and sureness of the hand, they assume their own reality. No metaphysics and axiomatics lead us behind the unrecognizable space of this physiognomy, because its written words have disappeared. The lightness, the transparent materiality is only an apollonic image of reflection, no more than an echo.

The picture is a reality without insight. And therefore every process of conception and imagination while viewing a picture begins with the figure of resistance, with the description:

" . . . never will we know"; a language, but what is speaking? Twombly's rare, fascinating space permits no interpretation. Something always seems left out, blurred, made invisible, but only just barely, so that even this invisible something that should hide is intentionally visible. Twombly's line, his stroke have established a completely new characteristic in post-abstract painting. They do not cross the boundaries of the imagination, they only inflame. Between almost nothing and nothing this line achieves a peculiarly firm hold, an affect that strives for the figure of sensitivity and makes the "drawing" as explanatory structure disappear. Line and stroke constantly and ironically seem to regret that it was not done better, but also that it could not have been done better anyway. If what produced this sensitivity was at some point a landscape, for example, then it seems to us as if we now listened to the music of this landscape.

The first drawing of "24 Short Pieces" begins with a brief, subtly condensed graphic hatching in the lower third of the empty space. The hatching marks off and holds the space. It is just there without revealing, it is virulent, and it breaks any contemplation. It represents itself and is therefore without designation. Not until the following drawings does something "happen": flashes of forms appear against accentuated concealment, a coming to life. Stroke and line open themselves topically.

Twombly organizes the entire cycle in intervals. Out of the fragile consistency of a small form, out of a coloured line loud density develops and the physiognomy of eruptive tumult. In these few drawings this "coming to life" is also the psychological postulate against oblivion. The hand leads the pencil passionately through the wet, almost white priming layer. It is a means of "inscription" that does not cease and knows enough of itself to succeed without language, without visible control.

Between drawings that are almost empty, with the most transparent of all traces, and drawings with the densest of structures, which completely take possession of the pictorial space, there reigns a clandestine irritation, the excitement of genesis, progression, and inconspicuous economy. Although this irritation cannot be read it is still present, and it is irreversible as in all of Twombly's work. What is generated in the paintings is syncretistic action as temporal unity, is divided in these drawings into moments, into 24 short pieces.

In each drawing a perceivable new beginning of the entire event can be read. An intellectual exchange of horizons, along which the imagination moves without hierarchies in thematic chords, stops, and breaks. The sea is lost in fog, the sign in oblivion, reflection in aphorisms—a different landscape emerges out of the fog. Maybe this is one possible reading, among others. The last drawing is nothing other than a kind of finale, then again it is solely a return to the metaphor of the original form. The "24 Short Pieces" describe nothing and do not seek to define, but they say, each for itself: thus it is and here it is, it cannot be said differently, thus it is written, written in water.

DAVID SMITH Statements, Writings (1947–52)

Yes, masterpieces are made today. Masterpieces are only works of art that people especially like. The twentieth century has produced very many. Present day contemporary America is producing masterpieces—a virile, aggressive, increasing number of painters and sculptors not

* David Smith, excerpts from "Statements, Writings" (1947–52), in Cleve Gray, ed., *David Smith by David Smith* (New York: Holt, Rinehart, and Winston, 1968), 123, 132, 133. Text © Estate of David Smith/Licensed by VAGA, New York, NY. © 1968 Holt, Rinehart, and Winston. Reprinted by permission of Henry Holt and Company.

before produced here. Let us not be intimidated by the pretending authorities who write books and term only this or that *Mona Lisa* as the only masterpiece. Masterpieces are only especially considered works of art. They occur now and they occurred 30,000 years ago.

Art is a paradox that has no laws to bind it. Laws set can always be violated. That confuses the pragmatic mind. There may exist conventionalized terminologies and common designations for periods, but no rules bind, either to the material substances from which it [art] is made or the mental process of its concept. It is created by man's imagination in relation to his time. When art exists, it becomes tradition. When it is created, it represents a unity that did not exist before.

I feel no tradition. I feel great spaces.

I feel my own time. I am disconnected.

I belong to no mores—no party—no religion—no school of thought—no institution.

I feel raw freedom and my own identity. I feel a belligerence to museums, critics, art historians, aesthetes and the so called cultural forces in a commercial order. . . .

I believe that my time is the most important in the world. That the art of my time is the most important art. That the art before my time has no immediate contribution to my aesthetics since that art is history explaining past behaviour, but not necessarily offering solutions to my problems. Art is not divorced from life. It is dialectic. It is ever changing and in revolt to the past. It has existed from the minds of free men for less than a century. Prior to this the direction of art was dictated by minds other than the artist for exploitation and commercial use. . . . The freedom of man's mind to celebrate his own feeling by a work of art parallels his social revolt from bondage. I believe that art is yet to be born and that freedom and equality are yet to be born.

If you ask me why I make sculpture, I must answer that it is my way of life, my balance, and my justification for being.

If you ask me for whom do I make art, I will say that it is for all who approach it without prejudice. My world, the objects I see are the same for all men of good will. The race for survival I share with all men who work for existence. . . .

I like outdoor sculpture and the most practical thing for outdoor sculpture is stainless steel, and I make them and I polish them in such a way that on a dull day, they take on the dull blue, or the color of the sky in the late afternoon sun, the glow, golden like the rays, the colors of nature. And in a particular sense, I have used atmosphere in a reflective way on the surfaces. They are colored by the sky and the surroundings, the green or blue of water. Some are down by the water and some are by the mountains. They reflect the colors. They are designed for outdoors.

LOUISE BOURGEOIS Interview with Donald Kuspit (1988)

LOUISE BOURGEOIS: I knew the Surrealists socially. They were my elders. Marcel Duchamp could have been my father. The Surrealists had a gallery called Gradiva, which was near the building where I lived. I saw them every day after lunch, when I was a student. They were of course famous artists. They were father figures. . . .

* Donald Kuspit, excerpts from "Interview with Louise Bourgeois," in *Bourgeois* (New York: Vintage, 1988), 31, 43–44, 69–70, 72–74, 81. By permission of the interviewer and Louise Bourgeois Trust/Licensed by VAGA, New York, NY.

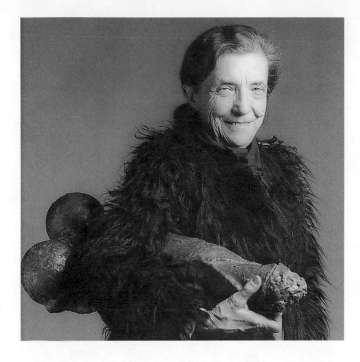

Louise Bourgeois, 1982. Photo by Robert Mapplethorpe. Copyright © The Robert Mapplethorpe Foundation. Courtesy Art + Commerce.

DONALD KUSPIT: Do you feel an affinity with their ideas, with the notion of the work of art as a kind of manufactured dream?

LB: I have never mentioned the word *dream* in discussing my art, while they talked about the dream all the time. I don't dream. You might say I work under a spell, I truly value the spell. I have the privilege of being able to enter the spell, to enter this very arid land where you are likely to find your birthright. To express yourself is your birthright. In the spell I can express myself. . . .

First I work on a drawing, then I will translate the concept into cardboard and then into corrugated cardboard. Here, let me show you. I get hooked on a subject and I make sketches and drawings. It means the obsession is going to last for several months. Then it will disappear, and reappear several years later. I am involved in a kind of spiral, a spiral motion of motivation. The material itself, stone or wood, does not interest me as such. It is a means; it is not the end. You do not make sculpture because you like wood. That is absurd. You make sculpture because the wood allows you to express something that another material does not allow you to.

DK: You seem to move from sketch to cardboard model to corrugated cardboard model to wood to stone. And you apparently feel free to stop at any one point in the process and dig into that material, to linger with it and work with it. Is that correct?

LB: Yes.

DK: In other words, sometimes the sculpture ends at the wood stage, and sometimes at the stone stage.

LB: That is true. But at each stage it is sculpture. Every part of the series belongs to it, from the smallest sketch to the marble.

DK: But you seem to prefer the marble. You seem to prefer the hardest material, the material with the most resistance.

LB: Yes, I would say that. I think I do express myself best in marble. It permits one to say certain things that cannot obviously be said in other materials.

DK: What kind of things?

LB: Persistence, repetition, the things that drive you toward tenacity, that force you to be tenacious. I am a tenacious person.

DK: I'm aware of that.

LB: Art comes from life. Art comes from the problem you have in seducing birds, men, snakes—anything you want. It is like a Corneille tragedy, where everybody is pursuing somebody else. You like A, and A likes D, and D likes. . . . Being a daughter of Voltaire and having an education in the eighteenth-century rationalists, I believe that if you work enough, the world is going to get better. If I work like a dog on all these . . . contraptions, I am going to get the bird I want. . . .

I contemplate the penetrated cube for a long time. Then I try to express what I have to say, how I am going to translate what I have to say to it. I try to translate my problem into the stone. The drilling begins the process by negating the stone. The problem is how to complete the negation, to take away from the stone, without altogether destroying it, but overcoming it, conquering it. The cube no longer exists as a pure form for contemplation; it becomes an image. I take it over with my fantasy, my life force. I put it to the use of my unconscious. . . .

DK: Let's talk about your current status in the New York art world. You must be aware of the fact that you have become an important symbol for many New York artists. You are an older artist who has finally had serious recognition, after great persistence. Your tenacity, as you call it, has succeeded. And you are a woman artist, which has made your success even more important, even more necessary, to feminists. To many people, you are a beacon of hope in a dark, difficult, male-chauvinist art world.

LB: I am totally unaware of that, of any of it.

DK: Certainly you must be aware of your own struggle for recognition; you must have some feelings about it. You must remember the crowds of women artists who came to the opening of your retrospective at the Museum of Modern Art, who celebrated you. You have become a symbol like Georgia O'Keeffe. Your work has been called a "rallying point" for feminist artists. Even if you are not aware of this, how do you respond to the idea of it? Are you a feminist? What do you think of feminism in the art world? How do you respond to the idea of being an important woman artist?

LB: Well, I don't think it is particularly flattering. . . . My feminism expresses itself in an intense interest in what women do. But I'm a complete loner. It doesn't help me to associate with people; it really doesn't help me. What helps me is to realize my own disabilities and to expose them. Another very sad statement is that I truly like only the people who help me. It is a very, very sad statement.

DK: But you don't feel there is any special prejudice against women artists?

LB: No. Many artists have been ignored. This is the problem. To be ignored is not the same as to be discriminated against. I don't think many are discriminated against, but many are certainly ignored. It is part of the situation of man being a wolf to man; it is part of the way man is a wolf to man.

DK: You were really not interested in success?

LB: No, I was not. That is why I have lasted so long. I have ridden out my success because it was not really the purpose of my work to be successful. My work will outlive its success, be more enduring and stronger than success. I was never disappointed when I never had suc-

cess, which is why I never destroyed any of my work. Many artists destroy their work not because it is bad, but because it is not successful—because other people aren't interested in it, because other people don't attend to it. When the dealers finally began to look me up, finally came to me, all my work was there. It was on the shelves. I will admit that I now take better care of it than I did. I used to just let it sit, untouched, gathering dust. I have a cannibalistic attitude to my work. I would let it sit until I could use it to make new work. It had to reach a certain state of familiarity. Then I could incorporate it in a new work. I had already worked on it, and this prepared it to be worked on further, once I had assimilated it, digested what I myself had done. . . .

DK: What do you think about modern art in general, if you want to talk about it generally? How do you see yourself in the history of modern art?

LB: I am not interested in art history, in the academics of styles, a succession of fads. Art is not about art. Art is about life, and that sums it up. This remark is made to the whole academy of artists who have attempted to derive the art of the late eighties, to try to relate it to the study of the history of art, which has nothing to do with art. It has to do with appropriation. It has to do with the attempt to prove that you can do better than the next one, and that a famous art history teacher is better than the common artist. If you are a historian, you have to have the dignity of a historian. You don't have to prove that you are better than the artist.

But I can say this. I studied in Paris in the thirties at a time when artists had ateliers that were open to students. My favorite teachers among many were Fernand Léger, Othon Friesz and Paul Colin. Michel Leiris and André Breton were also part of my education. Also, I taught for a long time and was given many honorary doctorates. Flattering as it is, it has little to do with my ongoing self-expression. Also, I valued my friendships with Corbusier, Duchamp, and Miró, Arp, Brancusi and Franz Kline and Warhol. Today I value my friendships with Robert Mapplethorpe and Gary Indiana.

DK: Which artists do you like?

LB: I like Francis Bacon best, because Francis Bacon has terrific problems, and he knows that he is not going to solve them, but he knows also that he can escape from day to day and stay alive, and he does that because his work gives him a kick. And also, Bacon is not self-indulgent. Some people will say, "What do you mean by that? He always paints the same picture." That's true—he always paints the same picture, because he is driven. But he is not self-indulgent. Never.

DK: Apart from your history of involvement with modern artists, what does modern art as such mean to you?

LB: What modern art means is that you have to keep finding new ways to express yourself, to express the problems, that there are no settled ways, no fixed approach. This is a painful situation, and modern art is about this painful situation of having no absolutely definite way of expressing yourself. This is why modern art will continue, because this condition remains; it is the modern human condition.

DK: Do you feel modern art has a special relationship to the painful difficulty of self-expression in the modern world?

LB: Definitely. It is about the hurt of not being able to express yourself properly, to express your intimate relations, your unconscious, to trust the world enough to express yourself directly in it. It is about trying to be sane in this situation, of being tentatively and temporarily sane by expressing yourself. All art comes from terrific failures and terrific needs that we have. It is about the difficulty of being a self because one is neglected. Everywhere in the modern

world there is neglect, the need to be recognized, which is not satisfied. Art is a way of recognizing oneself, which is why it will always be modern.

ALFRED H. BARR The New American Painting (1952)

Painted at arm's length, with large gestures, [the paintings in the MoMA show *The New American Painting*] challenge both the painter and the observer. They envelop the eye, they seem immanent. They are often as big as mural paintings, but their scale as well as their lack of illusionistic depth are only coincidentally related to architectural decoration. Their flatness is, rather, a consequence of the artist's concern with the actual painting process as his prime instrument of expression, a concern which also tends to eliminate imitative suggestion of the forms, textures, colours and spaces of the real world, since these might compete with the primary reality of paint on canvas.

As a consequence, rather than by intent, most of the paintings seem abstract. Yet they are never formalistic or non-objective in spirit. Nor is there (in theory) any preoccupation with the traditional aesthetics of "plastic values," composition, quality of line, beauty of surface, harmony of colour. When these occur in the paintings—and they often do—it is the result of a struggle for order almost as intuitive as the initial chaos with which the paintings begin.

Despite the high degree of abstraction, the painters insist that they are deeply involved with subject matter or content. The content, however, is never explicit or obvious even when recognizable forms emerge, as in certain paintings by de Kooning, Baziotes, and Gottlieb. Rarely do any conscious associations explain the emotions of fear, gaiety, anger, violence, or tranquility which these paintings transmit or suggest.

In short these painters, as a matter of principle, do nothing deliberately in their work to make "communication" easy. Yet in spite of their intransigence, their following increases, largely because the paintings themselves have a sensuous, emotional, aesthetic and at times almost mystical power which works and can be overwhelming. . . .

Many [of these artists] feel that their painting is a stubborn, difficult, even desperate effort to discover the "self" or "reality," an effort to which the whole personality should be recklessly committed: *I paint, therefore I am.* Confronting a blank canvas they attempt "to grasp authentic being by action, decision, a leap of faith," to use Karl Jaspers' Existential phrase.

Indeed one often hears Existentialist echoes in their words, but their "anxiety," their "commitment," their "dreadful freedom" concern their work primarily. They defiantly reject the conventional values of the society which surrounds them, but they are not politically *engagés* even though their paintings have been praised and condemned as symbolic demonstrations of freedom in a world in which freedom connotes a political attitude.

In recent years, some of the painters have been impressed by the Japanese Zen philosophy with its transcendental humour and its exploration of the self through intuition. Yet, though Existentialism and Zen have afforded some encouragement and sanction to the artists, their art itself has been affected only sporadically by these philosophies (by contrast with that of the older painter, Mark Tobey, whose abstract painting has been deeply and directly influenced by Tao and Zen).

Surrealism, both philosophically and technically, had a more direct effect upon the painting of the group. Particularly in the early days of the movement, during the war, several

* Alfred H. Barr, excerpts from "Is Modern Art Communistic?" *New York Times Magazine,* sec. 6 (December 14, 1952), 22–23, 28–30. © 1952 The New York Times Company. Reprinted by permission.

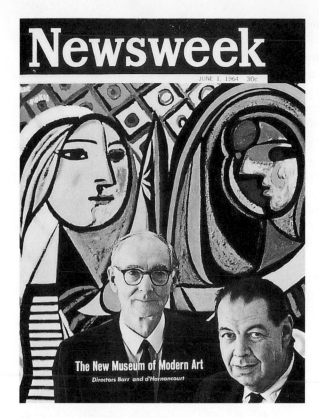

Alfred H. Barr and René d'Harnoncourt, directors of the Museum of Modern Art, 1964. Photo © Burt Glinn/Magnum Photos. From *Newsweek,* June 1, 1964, © 1964 Newsweek, Inc. All rights reserved. Used by permission and protected by the Copyright Laws of the United States.

painters were influenced by André Breton's programme of "pure psychic automatism . . . in the absence of all control exercised by reason and outside of all aesthetic and moral preoccupation." Automatism was, and still is, widely used as a technique but rarely without some control or subsequent revision. And from the first Breton's dependence upon Freudian and Marxian sanctions seemed less relevant than Jung's concern with myth and archaic symbol. . . .

Abstract Expressionism, a phrase used ephemerally in Berlin in 1919, was re-invented (by the writer) about 1929 to designate Kandinsky's early abstractions that in certain ways do anticipate the American movement—to which the term was first applied in 1946. However, almost to a man, the painters in this show deny that their work is "abstract," at least in any pure, programmatic sense; and they rightly reject any significant association with German Expressionism, a movement recently much exhibited in America.

MICHEL TAPIÉ *An Other Art* (1952)

Everything has been called into question once more since that cascade of revolution going from Impressionism to Dada and Surrealism: we are beginning to realize what that means, and at which point this total review has caused the epoch in which we live to be especially thrilling. After centuries, if not a millennium, during which conditions evolved so slowly

* Michel Tapié, excerpt from *Un art autre: où il s'agit de nouveaux dévidages du réel* (Paris: Gabriel-Giraud, 1952). Translation by Elise L. G. Breall. Reprinted by permission.

that in the normal rhythm of life, chance could not be perceived, and in which artistic problems (even ethic-aesthetic ones) were safe, . . . an entire system of certainty has collapsed. The ossified and ossifying false order made room for the most fertile and intoxicating anarchy, which, in its heightened fits of enthusiasm marches toward a new order, a new system of ideas about the range of our potential becoming. It is, after all, shocking to know that one is going to the unknown (it must always be like this for the creators, but it has never been so explicitly evident), and at this point we still find St. John of the Cross to give us the most pertinent advice: "In order to go to a place where you have not been, you must take an unfamiliar route." The academy has died, has it not?

The problems do not consist of replacing a figurative theme with an absence of theme, which is called abstract, non-figurative or non-objective, but really to create a work, with or without a theme, in front of which—be it aggressiveness, banality or sheer physical contact—one perceives gradually that one's customary hold on the situation has been lost. One is . . . called to enter [into either] ecstasy or madness for one's traditional criteria, one after the other, have been abandoned. Nevertheless such a work carries with it an invitation to adventure—in the true sense of the word "adventure"—that is to say something not known, where it is really impossible to predict how things will go, where it will be the spectator who is left to move to the next station which may be of infinitesimal or astounding violence. . . .

Observations of Michel Tapié (1956)

In this time, one seems more attracted by space than by form. At the very least, in other times, it was with form that one began in order to condition space; now it is space through which one can engender form. Those who have been able to condition new forms, lucidly or unconsciously, have conceived them out of space, as though space were a womb, a place of departure, from which discovery, ambiguity, and contradiction make a veritable magic autre born of autre structures.

Today it is not a question of whether art should be abstract, concrete, or poetic: it can be all of these things. However, what it should do, and must do, is express profoundly and sincerely the message of a humanity that is its own, the ambiguous and transcendental reality that is ours.

WOLS Aphorisms (1944)

Perfect concentration is possible only when you are not. You can obtain the maximum concentration achievable by man reclining, eyes closed. At the slightest disturbance from outside, dispersion, diffusion, sets in. If you are erect, your legs take away part of your strength. When your eyes are open, concentration grows fainter. External, visible results increase proportionately to your distance from the perfect state. Needless to say, the most beautiful works are the least manifest. Brilliant great works (visible everywhere) are cheap, require some external efforts, give relief, but are not worth the trouble.

* Michel Tapié, excerpt from Paul and Esther Jenkins, eds., *Observations of Michel Tapié* (New York: George Wittenborn, 1956), 15–16. By permission of Paul Jenkins.

** Wols, "Aphorisms" (1944), excerpt from Werner Haftmann, ed., *Wols,* with essays by Jean-Paul Sartre and Henri-Pierre Roche (New York: Harry N. Abrams, 1965), 152–53. By permission of Harry N. Abrams, Inc. © 2012 Artists Rights Society (ARS), New York/ADAGP, Paris.

At Cassis the stones, the fish
the rocks seen through a magnifying glass,
the salt of the sea, and the sky
made me forget that man is important,
they urged me to turn my back
on the chaos of human affairs
they showed me eternity
in the little waves of the harbor
which are always the same without being the same.
Nothing can be explained, all we know is the appearances.
All loves lead to one love, and
beyond all personal loves
there is the nameless love,
the great mystery,
the Absolute,
X
Tao
God
the cosmos
the Holy Ghost
the One
the Infinite.
The Abstract that permeates all things
is ungraspable.
In every moment
in every thing
eternity is present

HENRI MICHAUX Movements (1950–51)

Movements of dislocation and inner exasperation more than marching movements
movements of explosion, of refusal, of spindling out in every direction
of unwholesome attractions, of impossible desires
of appeasement of the flesh struck on the neck headless
movements
What good's a head when you're overflowing?
Movements of rewinding, of inward coilings waiting for something better
movements of inner shields
movements in myriad fountains
residual movements
movements in place of other movements which cannot be shown but which inhabit the
 mind
of dust

* Henri Michaux, "Movements, 1950–51, in the Solomon R. Guggenheim," in *Henri Michaux* (Paris: Centre Georges Pompidou and Gallimard, 1978), 69–71. © 2012 Artists Rights Society (ARS), New York/ADAGP, Paris.

Henri Michaux, *Movements,* 1950–51, ink on paper.
© 2012 Artists Rights Society (ARS), New York/
ADAGP, Paris.

of stars
of erosion
of crumblings
and movements of vain latencies. . . .

I'm not too sure what they are, these signs that I've produced. I am perhaps the least fit to speak of them, close to them as I am. I had covered twelve hundred pages with them and was aware only of their surge and flow when René Bertelé got hold of them and, cautiously, reflectively, discovered that they seemed to form sequences . . . and so this book came about, more his work than mine.

But what of the signs? It was like this: I had been urged to go back to composing ideograms, which I had been doing on and off for twenty years and which pursuit seems indeed to be part of my destiny, but only as a lure and fascination. Over and over again I had abandoned them for lack of any real success.

I tried once more, but gradually the forms "in movement" supplanted the constructed forms, the consciously composed characters. Why? I enjoyed doing them more. Their movement became my movement. The more there were of them, the more I existed. The more of them I wanted. Creating them, I became quite other. I invaded my body (my centres of action and repose). It's often a bit remote from my head, my body. I held it now, tingling, electric. Like a rider on a galloping horse which together make but one. I was possessed by movements, on edge with these forms which came to me rhythmically. Often one rhythm ruled the page, sometimes several pages in succession, and the more numerous were the signs that appeared (one day there were close on five thousand), the more alive they were.

Although this—must I say experiment?—may be repeated by many, I should like to warn anyone who prizes personal explanations that I see here the reward of indolence.

The greater part of my life, stretched out on my bed for interminable hours of which I never tired, I imparted motion to one or two or three forms, but always one more quickly, more to the fore, more diabolically quickly than any other. Instead of exalting it, investing it

with riches, happiness, earthly goods as they are called, I gave it, as very poor as it remained in other respects, I instilled in it a quite extraordinary mobility of which I was the counterpart and the motor, albeit unmoving and slothful. Electrified it, while I myself was the despair of active people or the object of their scorn.

All I have done here is to repeat, sort of, on paper, in Indian ink, some of the innumerable minutes of my useless life. . . .

R.B. points out that in this book drawing and writing are not equivalent, the former being freer and the latter more dense.

There's nothing astonishing about that. They are not the same age. The drawings, quite new in me, especially these, in the very process of being born, in the state of innocence, of surprise; but the words, the words came afterwards, afterwards, always afterwards . . . and after so many others. How could they set me free? On the contrary, it is through having freed me from words, those tenacious partners, that the drawings are frisky and almost joyous, that their movements came buoyantly to me even in exasperation. And so I see in them a new language, spurning the verbal, and so I see them as *liberators*.

Whoever, having perused my signs, is led by my example to create signs himself according to his being and his needs will, unless I am very much mistaken, discover a source of exhilaration, a release such as he has never known, a disencrustation, a new life open to him, a writing unhoped for, affording relief, in which he will be able at last to express himself far from words, words, the words of others.

LUCIO FONTANA Manifesto blanco (1946)

Art is now in a period of latency. There is a force that man is incapable of manifesting. We are expressing it in literary form in this manifesto. Therefore we ask all of the world's scientists—who know that art is necessary for the life of the species—to direct a part of their investigations toward the discovery of this luminous malleable substance and toward the creation of instruments capable of producing sounds that will permit the development of four-dimensional art.

We will supply the experimenters with the necessary documentation. Ideas cannot be rejected. Their seeds are found in society and thinkers and artists then give them expression.

All things come of necessity and have value for their time.

The transformations of the material means of life have determined man's psychic states all throughout history. The system that has directed civilization from its very beginnings is in transformation. Its place is progressively being taken by a system opposed to it in essence and in all of its forms. All of the life conditions of society and of every individual will be transformed. Every man will live a life based upon an integrated organization of labor. The enormous discoveries of science are gravitating toward this new organization of life. The discovery of new physical forces and the control of matter and space will gradually impose new conditions that have not been previously known to man in the entirety of the course of history. The application of these discoveries to all of the modalities of life will produce a modification in the nature of man. Man will take on a new psychic structure.

* Bernardo Arias, Horacio Cazeneuve, Marcos Ridman, Pablo Arias, Rodolfo Burgos, Enrique Benito, César Bernal, Luis Coll, Alfredo Hansen, and Jorge Rocamonte, "Manifesto blanco" (1946), trans. Guido Ballo, in Ballo, *Lucio Fontana* (New York: Praeger, 1971), 185–89. By permission of Teresita Fontana and the Fundacione Lucio Fontana, Milan, and Henry Holt and Company. The manifesto, composed in Buenos Aires in 1946, is not actually signed by Lucio Fontana, though it was written under his direction.

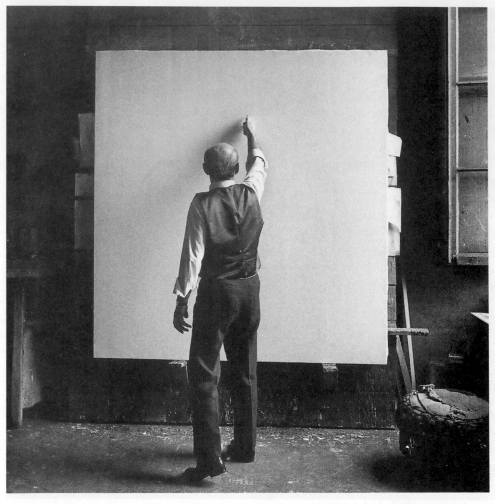

Lucio Fontana painting in his studio. Photo by Ugo Mulas. From *Lucio Fontana* (Munich: Prestel, 1983).

We are living in the mechanical age. Painted canvas and standing plaster figures no longer have any reason to exist.

What is needed is a change in both essence and form. What is needed is the supercession of painting, sculpture, poetry and music. It is necessary to have an art that is in greater harmony with the needs of the new spirit.

The fundamental conditions of modern art can clearly be seen in the 13th century, when the representation of space first began. The great masters who appeared one after the other gave ever new thrust to this tendency. In all of the following centuries space was represented with ever greater scope. The Baroque masters effected a qualitative change in this direction. They represented space with a grandiosity that has still not been superseded and they enriched the plastic arts with the notion of time. Their figures seem to abandon the picture plane and to continue the represented movements out into space. This came about as a consequence of the concept of existence that man was in the process of developing. For the first time in history, the physics of this period expressed nature in terms of dynamics. As a beginning and a foundation for the understanding of the universe, it was determined that movement is an innate condition of matter.

Art continued to develop in the direction of movement. Music maintained its hegemony for two centuries and from the time of Impressionism onwards it developed along lines parallel to the lines of development of the plastic arts. *From that time onwards the evolution of man has been a march toward movement as it develops in time and space. In painting we see a progressive elimination of the elements that do not permit the impression of dynamism.*

The Impressionists sacrificed drawing and composition. Other elements were eliminated by Futurism and still others lost their importance and were subordinated to sensation. Futurism adopted movement as the only principle and the only goal. The Cubists denied that their painting was dynamic, but the essence of Cubism is the vision of nature in movement.

When music and sculpture unified their developments in Impressionism, music based itself upon plastic sensations, and painting seemed to dissolve into an atmosphere of sound. In the majority of the works of Rodin, it can be noted that the volumes seem to rotate in this same ambience of sound. His work is essentially dynamic and it often arrives at an exacerbation of movement. And recently haven't we seen an intuition of the "form" of sound in Schoenberg and a superimposition or a correlation of "sonorial planes" in Scriabin? The similarity between Stravinsky's forms and Cubist planimetry is obvious. Modern art found itself in a moment of transition in which it was necessary to break with the art of the past in order to make way for new concepts. This state of affairs, seen synthetically, is the passage from abstraction to dynamism. Finding itself in the very middle of this transition, art was not able entirely to liberate itself from the heredity of the Renaissance. The same materials and the same disciplines were used for the expression of a sensibility that had been entirely transformed.

Man has exhausted pictorial and sculptural forms. These experiences and their oppressive repetition show that these arts have remained stagnating in values that are extraneous to our civilization and that cannot be further developed in the future.

The quiet life has disappeared. The notion of speed is constant in human life. The artistic era of paints and paralyzed forms is over.

Man is becoming constantly more insensitive to images nailed down without any indication of vitality. The old immobile images no longer satisfy the needs of the new man who has been bred on the necessity of action and in an era of coexistence with machines that impose a constant dynamism upon him. The aesthetic of organic movement has replaced the empty aesthetic of stationary forms. We invoke this change that has taken place in the nature of man, both morally and psychically, and in all of his relationships and activities, and we abandon the use of the known forms of art in order to move toward the development of an art based upon the unity of space and time.

The new art takes its elements from nature. Existence, nature, and matter form a perfect unity. They develop in space and time. Change is an essential condition of existence. Movement—the property of evolving and developing—is the basic condition of matter. Matter exists in movement and only in movement. Its development is eternal. In nature, color and sound are found only as a part of matter.

The simultaneous movement of the phenomena of matter, color, and sound is what gives wholeness to the new art.

Volumes of color develop in space and take on successive forms. Sound is to be produced by means that are still unknown. Musical instruments do not correspond to the necessity of vast sonorities and they do not produce sensations of sufficient breadth.

Voluminous changing forms are to be constructed out of some mobile, plastic substance. Arranged in space, they are to act in terms of synchronic form and to integrate dynamic images.

Thus we exalt nature in all of its essence. Matter in movement manifests its total and eter-

nal existence, developing itself in space and time, and adopting the various states of existence as it changes. We conceive of man and his new meeting with nature in terms of his need to bind himself to nature in order to rediscover the use of his original values. What we want is an exact understanding of the primary values of existence, and for this reason we infuse art with the substantial values of nature.

All artistic concepts come from the subconscious. The plastic arts developed on the basis of the forms of nature. The manifestations of the subconscious fully adapted themselves to them since they were determined by the idealistic concept of existence. Materialistic consciousness, or rather the need that things be clearly demonstrable, requires that the forms of art rise up directly from the individual, and that all adaptation to natural forms be suppressed. An art based upon forms created by the subconscious and then balanced by reason constitutes a real expression of being and a synthesis of the historical moment. The position of the rationalistic artists is a false position. With their attempt to impose rationality and to negate the function of the subconscious, they merely manage to make its presence less visible. In all of their works, we note that this faculty has had its part.

Reason does not create. In the creation of forms, its function is subordinate to the function of the subconscious. In all of his activities man functions with the totality of his faculties. The free development of all of them is a fundamental condition in the creation and interpretation of the new art. Analysis and synthesis, meditation and spontaneity, construction and sensation are values that work together for its integration into a functional unity. And its development through experience is the only road that leads to a complete manifestation of being.

Society suppresses the separation of its forces and integrates them into one more powerful force. Modern science bases itself upon the progressive unification of its various branches. Humanity reunites its values and its knowledge. This is a movement that has deep roots in several centuries of the development of history. This new state of consciousness gives rise to an integral art in which being functions and manifests itself in all of its totality. After several centuries of analytic artistic development, we have come to the moment for synthesis. At first the separation was necessary. Today it constitutes a disintegration of the unity that has been conceived of.

We think of synthesis as a sum of physical elements: color, sound, movement, time, and space—synthesis as the completion of a psycho-physical unity. Color, the element of space; sound, the element of time; and movement that develops in time and space; there are the fundamental forms of the new art that contains the four dimensions of existence. Time and space.

Both the creation and the interpretation of the new art require the functioning of all of man's energies. Being manifests itself as a whole and with the fullness of its vitality.

EMILIO VEDOVA It's Not So Easy to Paint a Nose (1948)

Talking about our paintings means talking about our life, deciding what we stand for . . .

Many people wonder why the painter is interested in so many things far from painting. Why does he experiment? Why doesn't he continue painting "Sunday," a flower or a girl with blue eyes? Why does he ruin his life with lines and colors that have so little to do with existing reality?

It's clear the establishment doesn't like us; and it's no wonder the painter, unable to recognize himself in the existing moral standards, enters a kind of quarantine, a solitary confinement

* Emilio Vedova, "It's Not So Easy to Paint a Nose," excerpt from "Dipingere un naso non e cosi semplice," in *Il Mattino del Popolo* (Venice) 1 (February 1948). By permission of the author.

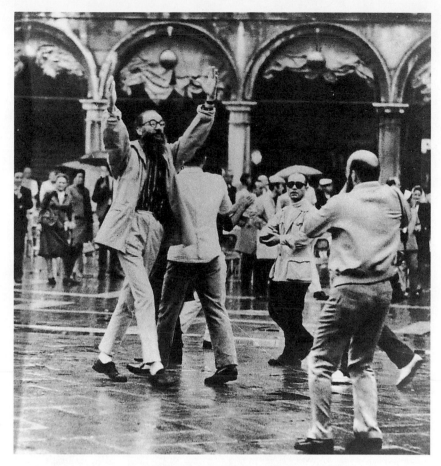

Emilio Vedova in the Piazza San Marco, Venice, 1968. Photo by Ugo Mulas. Courtesy Studio Vedova.

where he can contemplate all the possibilities of action. It's useless to talk about his hundred wounds: longing for a lucid security, he wears his life out and may even destroy his final hopes. Yet in this tense moment, the painter is once again free to choose. Painting—acting means . . . going beyond the conventions that have lost their hope; it means constructing, in a primordial sense, a reason to believe. It is then that our paintings are born—so full of renunciation. But they are inevitably poor and unadorned, and to those who cannot read them they no longer seem to be paintings.

Many people can't imagine painting as the expression of a human being who thinks differently. If they could understand "the Chinese" of our pictures, they would read in them the sadness of every day and sense their liberation and renunciation. . . . Our painting is this alone: we went ahead and created a grammar because along the way we created life.

Most people stare at us as though we were strange beasts or scandal-makers, but they fail to hear our protest. They don't realize that the act of painting is the sum total of our hopes. They don't understand that we must make extreme, unknown revelations through the distinct lines of our paintings.

They think we are in a state of crisis. But we prefer living the temptation of every day, rather than fall victim to the idleness that makes life a series of cowardly acts.

Alberto Burri at Porto Nuovo, 1955. Photo by Minsa Craig. By permission of the photographer.

ALBERTO BURRI Words Are No Help (1955)

Words are no help to me when I try to speak about my painting.

It is an irreducible presence that refuses to be converted into any other form of expression.

It is a presence both imminent and active.

This is what it stands for: to exist so as to signify and to exist so as to paint.

My painting is a reality which is part of myself, a reality that I cannot reveal in words.

It would be easier for me to say what does *not* need to be painted, what does not pertain to painting, what I exclude from my work sometimes with deliberate violence, sometimes with satisfaction.

* Alberto Burri, "Words Are No Help," in Andrew Carnduff Ritchie, ed., *The New Decade* (New York: Museum of Modern Art, 1955), 82. By permission of the author and the publisher.

Were I master of an exact and less threadbare terminology, were I a marvelously alert and enlightened critic, I still could not verbally establish a close connection with my painting; my words would be marginal notes upon the truth within the canvas. For years pictures have led me, and my work is just a way of stimulating the drive.

I can only say this: painting for me is a freedom attained, constantly consolidated, vigilantly guarded so as to draw from it the power to paint more.

WILLI BAUMEISTER *The Unknown in Art* (1947)

The original artist leaves the known as well as knowledge behind. He penetrates to the point of zero. This is where his exalted condition begins. . . .

The unknown that confronts artists at the beginning does not repel them. . . . Artists are unique because of their audacity and inventiveness. Painters who are swept along without finding themselves reflect these original values. Through these second-raters and their followers style makes its appearance. It is the characteristic of the second-rater that he recognizes the newly discovered values as an area that can be cultivated and harvested.

The truly original artist actually does not see. As he thrusts into the unknown with each work he cannot predict what he will discover. He can neither foresee the final form of the individual work nor survey his whole life work, no matter how sure he is of himself. In contrast, the followers know what they want because they have completed models in front of them.

Even when the artist carves or paints, moved by an incomprehensible act of volition and in full consciousness of his action, he will welcome the surprise that develops in his hand. Trusting in simple existence, he possesses the intensity that assures consistency and leads him along a path without compromise. Because he does not comply with a tangible model, and believing in the preexistence of his work, he can create original, unique, artistic values. . . .

On the artistic summit experience and application are left behind. The artist is solely conscious of his own state; he is able to induce this condition by neglecting nothing. He makes no decisions, but his own center brings about his harvest. There is no dissonance for him. He can wait until today's dissonance becomes tomorrow's harmony. He will feel and notice the resistance that only brings about a more complex consistency. He is the organ of the universal to which he is responsible. In the artistic zone general order, material growth, and the concept of freedom are unified. And freedom is always renewed in the face of resistance.

An ultimate value circles around this complete unity: The self-engendered vision.

* Willi Baumeister, excerpt from *Das Unbekannte in der Kunst* (Stuttgart: Curt E. Schwab, 1947), 155–57. Translation by Peter Selz. By permission of Archiv Baumeister, Stuttgart.

ANTONI TÀPIES I Am a Catalan (1971)

If I paint as I paint it is first of all because I am Catalan. But like so many others, I am affected by the political drama of all of Spain. Even against my will, it shows up in my work. I think I can consider myself a materialist, even if I have to explain the nuance of this expression. I refer to the structure of materials. I like to imagine it in the light of current knowledge, and to go from a particularized matter to a generalized one. Thus I would like to be able to change the global vision that people have of the world: one can—starting with a knowledge of matter—reach other levels: the social, political, aesthetic levels. Painting is a way of reflecting on life—and reflection is more active than simple contemplation. It is the manifestation of a will to discern reality, to dig into it, to collaborate in its discovery and in its understanding. To paint is also to create reality.

Like a researcher in his laboratory, I am the first spectator of the suggestions drawn from the materials. I unleash their expressive possibilities, even if I do not have a very clear idea of what I am going to do. As I go along with my work I formulate my thought, and from this struggle between what I want and the reality of the material—from this tension—is born an equilibrium.

There is sometimes in my work a refusal of certain realities: artificial realities, entirely fabricated needs. There is, for example, the world of advertising and its colors. Unconsciously I seek and imagine another color, a dramatic, deep color capable of expressing essential values. I have to rediscover the true color of the world, as it is when not denatured by banal advertising. The color does not exist in itself. I need an interior color.

There are certain times when the artist should, in order to defend authentic human values, join in the public demonstrations of other men. When he returns to his studio and when he takes up his work again, when he paints, it is the same combat he pursues. I want to inscribe in my painting all the difficulties of my country, even if I must displease: suffering, painful experiences, prison, an act of revolt. Art must live reality.

The value of an artist resides in the complex sum of ideas, of sentiments, of examples (sometimes bad) which he succeeds in communicating. It is not surprising therefore that sometimes he has his heart set on revealing himself completely naked not only through his work, but also in all his actions, in all his expressions, including his words. Perhaps this ensemble represents his true work. And his canvases, his sculptures, or his poems—"partial" works—become, certainly, much more intelligible in the perspective of the complex whole.

There is a tendency to consider that the most remarkable trait of contemporary artists is their attitude of revolt and of contestation against conventional values. Often this attitude passes for a basic trait of the temperament of the artist. And sometimes even society puts up with this idea as with a negative but charming review.

Evidently, power, order and authority persist in believing themselves alone capable of positive acts. But the positive propositions of the artist are in fact much more subversive than his critics; but he is forbidden to speak of them, even to allude to them. When one is finally able, time having passed, to explain these propositions, they are considered over-labored works due to what are then called fantasies and the "excesses" of our visions of things. That is why the artistic form predominant today is an art-critique, almost an art-caricature. It is certainly important that such an art exists, but unfortunately this art has become little by little banal,

* Antoni Tàpies, "I Am a Catalan," from "Declaracions," in *La pràctica de l'art* (Barcelona: Edicions Ariel, 1971), 39–43. By permission of the Fundació Antoni Tàpies, Barcelona.

repetitive, facile. Artistic works, in order to be complete, should also, in spite of the difficulties present, go to the bottom of things; they should prepare the groundwork for new, positive knowledge, for a violent philosophical and ethical knowledge capable of giving our world a new direction.

Artistic feeling has deep connections to mystical feelings. Bertrand Russell thinks that there is a particular wisdom that can be obtained only through a certain mysticism. According to Russell, the spirit of veneration peculiar to mysticism can inspire and aid the attentive and patient search for truth to which the man of science commits himself.

This mystical consciousness—almost undefinable—seems fundamental for an artist. It is like a "suffering" of reality, a state of constant hypersensitivity to everything which surrounds us, good and bad, light and darkness. It is like a voyage to the center of the universe which furnishes the perspective necessary for placing all the things of life in their real dimension.

If one believes that art can constitute a means of obtaining knowledge, then it is absurd to reproach the artist for becoming involved in morals or politics. The only authentic knowledge is born of universal love. When we love, we suffer all the forms of oppression of all the dictatorships; and we desire to fight for liberty, for justice and for all that fosters human dignity.

Sometimes in my work there is an homage to insignificant objects: paper, cardboard, refuse. . . . As Jacques Dupin has said, the hand of the artist has only intervened so to speak to collect them, to save them from loss, from fatigue, from being torn up, from the footprints of man and those of time. Because everywhere in the world today values are upside down, this maneuver can be effective. The idea that the artist is never interested in "beautiful" or "important" things is so widespread that it can be positive and interesting to show that we prefer what today passes for ugly, poor, stupid, or absurd (at least by those who only find "serious" or "important" the weddings of princesses, football championships, elections, university presidents, or voyages to the moon). Tirelessly we must try to habituate the public to consider that there are a thousand things worthy of being classified in the category of art, that is to say, of man. Many things, as small as they might at first appear, become, seen in the full light of day, infinitely greater and more worthy of respect than all the things conventionally judged important. It is also necessary to show that one can do [so] without admiring or fearing those who parade about on the heights indifferent to those who remain below. These touches of humility in my work are marks of protestation. As Joan Teixidor has so rightly said, it is not a question simply of an "intimate history" but of an "instinct for justice and peace" which serves as a megaphone of a collective situation.

One must always guard against demanding of a work of art solutions, or even allusions, to immediate or too concrete problems. Rather, art treats general and fundamental lines, elementary schemes, global visions. If this armor is solid, all the rest can easily find its place like pieces of a puzzle once one has guessed the figure that they should form. There are those who judge proud and haughty this concept of art. Such a judgment is radically false. The man of science finds himself in this position and no one holds it against him. To shed some light on my proposal, I shall quote this answer of Bertrand Russell to a society for the protection of animals which asked him to join its campaign against fox-hunting in England. It seems enlightening to me. "Entirely in agreement with you," he said. "But I am so involved in my campaign for the prohibition of atomic weapons that I cannot concern myself with anything else. And since a nuclear war would probably kill all animals, it seems to me that I am already fighting for your cause."

I have never believed in the intrinsic value of art. In itself it seems to me to be nothing. What is important is its role as a spur, a springboard, which helps us attain knowledge. I also

find it ridiculous that some people want to "enrich" it by an overabundance of colors, of composition, of work. . . . The work of art is a simple support of meditation, an artifice serving to fix the attention, to stabilize or excite the mind; its value can only be judged by its results.

Painting and the Void (1985)

Metaphors of space have always been introduced into painting, the play of fullness and emptiness, volumes, surfaces, light and shade. . . . And, in recent painting in particular, the notion of "emptiness" has assumed great significance.

Perhaps it is a phenomenon which is not limited to painting. It seems obvious that contrary to other periods with styles marked by excess, in the course of this century it has been forced into the realm of art, poetry, architecture, drawing and even clothing . . . , a taste for anything which suggests emptiness, for large spaces with few ornaments, and even for a certain "poverty."

The reasons are many, and of unequal value. Of course, for many years there was the influence of the rationalist and functional aesthetic on architecture and drawing, as well as a semi-Nordic, semi-Germanic preference for lightness, clarity and hygiene. On the other hand, there is also the attraction exercised by Japan, with its atmosphere of stillness.

There were also reasons of lesser significance, such as the fact of considering that the search for a *minimum* constituted a good stratagem for ending once and for all the matter of commercialism characterized by excessively "materialized," solid or even "furnished" products. But this does not exhaust the explanation for this attraction.

This interest in emptiness, in nothingness, is found in many disciplines; in particular in an important sector of modern philosophy. We know, for example, that the philosophers such as Heidegger or Sartre have, at a given moment, made nothingness the center of their thought, and that Heidegger even went so far as to say that "existence is the extreme nothingness which is simultaneously copiousness."

TADEUSZ KANTOR
Representation Loses More and More Its Charm (1955)

"Representation"
loses more and more its charm.
To create painting is
in itself
a living organism,
moving like
a hive.
Space which retracts violently
condenses forms

* Antoni Tàpies, "The Painting and the Void" (1985), in *Tàpies: Celebració de la mel,* trans. Cathy Douglas and Patricia Mathews (Barcelona: Fundació Antoni Tàpies, 1993), 41–46. By permission of the Fundació Antoni Tàpies, Barcelona. There are several different versions of this essay. See also Carmen Gimenez, ed., *Tàpies* (New York: Solomon R. Guggenheim Museum, 1995), 60–65.

** Tadeusz Kantor, excerpt from "Carnet des notes" (1955), in *Tadeusz Kantor Metamorphoses* (Paris: Galerie de France, 1982), 23–35. Translation by Peter Selz. By permission of Maria Kantor.

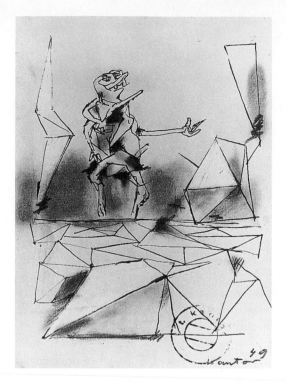

Tadeusz Kantor, *Metamorphosis,* 1949, grease
pencil, pastel, and ink on paper. Courtesy
Galerie de France, Paris.

to dimensions of molecules
to the limit of the "impossible."
In this dreadful
movement
the speed of making decisions
and of interventions,
the spontaneity of the behavior
constantly grazes
risk.
Danger connected with phenomena
ignored,
scorned,
inhibited in the lowest regions
of human activity
refusing all rational classification.
It is art that will rediscover the reason for being
and its rank.
It is risk which is the origin of this
great adventure,
of this game which situates itself
always at the limit of the risk
and whose outcome—despite rules—
remains forever unforseeable.
 . . . Painting becomes a demonstration of life,

a depository of diverse activities.
I am fascinated by this play of chance
with *matter,*
this battle without victories or defeats
this spectacle, in which I do not at all play the principal character,
and which holds me bound in passionate expectation
of the unknown epilogue.

PER KIRKEBY *Bravura* (1982)

Synopsis

. . . What I am after is "bravura, an attempt to do something beyond the truth." Therefore classicism pops up all the time, the unhappy side of classicism, the manneristic side. The whole quotation is, "The great vice of the present-day is bravura, an attempt to do something beyond the truth," and it comes from a well-known letter by Constable. And means just the opposite. But I do not seek truth before bravura, I seek it on the other side. Naturally it is a bad risk to run, the eternal insecurity, where nothing is measurable, no solid standard exists any longer, and one can hardly discern the difference between commercial bravura and true trapdoor, but it is the only way of escaping good taste and narrow certification. The light of ambivalence is a heavenly one.

By the way, Constable's landscapes are carried out in a bravura that seems completely unlikely to the landscape painters of today. . . .

Klee and the Vikings

I believe that painting, in our meaning, is structures. Each application of paint to a surface is a structure. This is, of course, self-evident, but a superstructure of meaning can occur. One can have various motives for doing it. And here that difficult motif comes in. I believe that a ruthless accumulation of structure reworkings leads to one meeting one's motif. One's life-motif, so to speak. That which one has and does not know that one has it. A sort of geology, as when, in a constant process, sedimentation and erosion makes the earth we live on like it is now, without any meaning in itself in a rational sense, but accepted as that upon which we live in this life. . . .

Caption

Painting is laying layer upon layer. Without exception it is fundamental to all painted pictures even if they look as if they were done in one movement. The movement has always crossed its own track somewhere. It is easy to understand that a picture is layer upon layer when it comes to Picabia's puzzle pictures or my own material works, but it is difficult with the "synchronous." By the "synchronous," I mean all those pictures where all the layers aim at the

* Per Kirkeby, excerpts from *Bravura* (Eindhoven: Stedelijk Van Abbe Museum, 1982), 7, 55, 83–84. Translation by Peter Shield. By permission of the author and the publisher.

same picture, where the underpainting and following layers—glazed or not—fall on top of each other. The "unsynchronous" are the ones where each new layer is a new picture. It is like geological strata with cracks and discordances. But each new layer, however furious, is always infected and coloured by the underlying one. Even when it is slates where the previous layer is completely removed physically, wiped off.

Thus it is with all pictures, there are many layers, and with good reason an analysis nearly always deals only with the last. The last layer in a superficial sense. But how then can one talk of what one cannot see, the overpainted or wiped-off layers, how to go about for example, photographs that are like slates with layers which no longer exist. The answer is that they exist nevertheless, taken up into the visible layer by a rubbing-off, but the problem, on the whole, is how one deals with the visible layer. The angle-sure, viewpoint-seeking and in the worst sense "analytic" intercourse with the picture. This method does not call up the invisible layers. The invocatory tone of intercourse is the "synthetic," which does not seek results immediately but treats the picture sensually and then allows the apparently most unreasonable associations to grow. In this way invisible layers in oneself are invoked, and this is the only kind of invisible layer in the picture which allows itself to be invoked. This is "unscientific" and apparently uncontrollable and subjective. But the subjective is to a large extent the common; the invisible, subterranean layers are fertile soil for the great common pictures.

PAT STEIR Interview with Barbara Weidle (1998)

BARBARA WEIDLE: From the early self-portraits to the waterfall paintings, your development seems to be completely logical. Did you know from the beginning what you were looking for?

PAT STEIR: No. Quite the opposite. I didn't know at all. I only knew, unconsciously, my playing field, which [was] my own mind and my own soul. I only knew a . . . mental list of questions. For me all paintings are self-portraits. From the most intellectual abstract art to the most literal art. All works of art are self-portraits. So the self-portraits are just a sign of beginning unconsciously. My art is a life journey. Slowly I eliminated questions for myself. Not because they were answered necessarily but simply because they lost their interest as a question.

BW: So what were the questions?

PS: I don't know. An unconscious or a preconscious list, a visual list. A group of visual possibilities that presented themselves to me at the beginning. It seemed that in the beginning everything was a possibility for me. Slowly, over thirty years I narrowed the list of questions. I am at a point where the paintings are about figuration but look abstract. About two opposites. Within that they contain the whole group of subjects I started with. . . .

There is [another] dichotomy I am dealing with today. The dichotomy of image and material. A painted image is the object and the paint itself is always the subject. In fact, I threw the paint at the canvas, the same as I do now. An objectification of the painted image joking, the painted image saying "ha ha you are not real, only I, the paint, am real." . . .

* Barbara Weidle, "Interview with Pat Steir" (1998), in Jan Yau, *Dazzling Water, Dazzling Light* (Seattle: University of Washington Press, 2000), 68–76. © Barbara Weidle, Weidle Verlag, Bonn. Courtesy Pat Steir/Cheim & Read, New York.

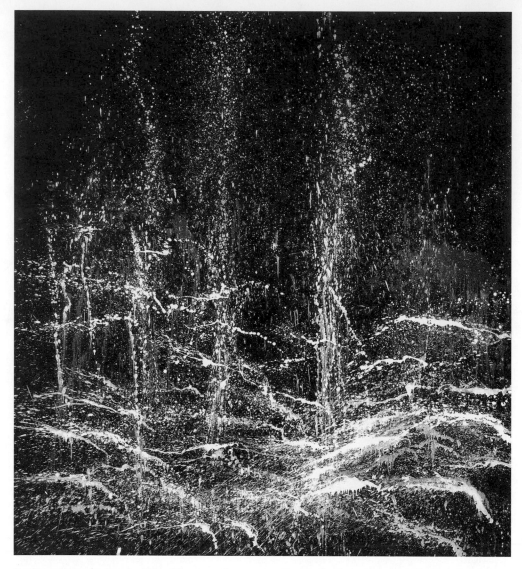

Pat Steir, *September Evening Waterfall,* 1991, oil on canvas. © 2012 Pat Steir. Courtesy Cheim & Read, New York.

BW: Minimal Art was important for you. A lot of your friends are Minimal artists. How do you see your own position in this context?

PS: I think that my work through the seventies contained too many elements to be seen as minimalist influenced. It was anti-minimalist influenced. The greatest influence for me was conceptual art. . . .

BW: Though there is a strong element of randomness in your painting process, for me the waterfall paintings have a surprising clearness, order. Gravity is very important for these paintings. And in opposition to Pollock's paintings they have a certain direction.

PS: Because thirty years later I am still involved with the idea of conceptual art. And I wanted to make paintings that made themselves, although I have a lot of control. Because

once you do something for a while, you gain control over it. But I wanted paintings that made themselves and so they needed gravity, they needed to have that. Also these paintings are in some way anti-Pollock. Because Pollock closed the field of painting. I am saying, hey, wait a minute. There is another way to approach this. . . .

I wanted to use a symbol of abstraction. I felt that the drip was the icon, the unreserved, "uncontrolled" but stylized drip is the icon of all of abstract painting. I want to turn that drip into a "picture." A picture of something. What could it be but a waterfall? There was also a second motif when I was doing the Breughel painting; I started to look at Japonism because of my interest in passions of Impressionism, and the influence of Japanese art on modernism and Japonism itself as a style. Later I looked at Chinese painting and I got into the motif behind the calligraphy and painting of Japan. Which is very similar to the motif behind abstract painting. For example, a painting will be called "Monk Looking at a Waterfall," and when you look at the painting first you see mountains, trees, everything. The monk is smaller than a fly. Later I began to communicate with various calligraphers and began to learn more about the process.

BW: Pollock has a lot of chaos in his paintings, they are very vital, there is no direction. Yours have a certain direction and order.

PS: I can't make chaos. I've tried my whole life. In the early paintings I tried to make chaos. And they look completely ordered. Like the notes in the margin of a child's notebook. I can't make chaos. I can only make order. Let's say that my paintings are really painted the way something grows; nature is in its way with chaos very orderly.

BW: Water is a very important subject for you. . . .

PS: Water has no permanent form. Water has a form and water is formless. . . .

A waterfall is always beginning and always ending and never beginning and never ending. So it's symbolically the sign for death and birth. When we think of the idea of rebirth we usually think of one person dying and the same person being reborn. Another way is to think one person dies and another is born. And rebirth is rebirth of life, of nature, of earth. So the water symbolizes all that. But it also symbolizes in Zen 'You are the wave, you are the water' You *are* the wave, you *are* the water. Form and formless. You are both, not one or the other, and also not either. These paintings carry the mythology and mystery of that. . . .

The wave paintings have an additional element. And that is the circle. The form of the circle. And that circle is the circle that I can draw with my arm. That's my freehand circle. The circle of me. . . .

The waterfall paintings, I just paint them. I don't even look at them. I sit in a chair and concentrate. And after a while I mix some paint, don't even pay attention to how I mix the paint, don't keep a record, mix and throw it on the canvas, off of the brush. And then the bottom I do like that. Just throw on the paint from the bottom. I don't even look at the paintings. Just make them.

BW: But you thought about the color before?

PS: I am talking just about the black and white, the first paintings. Then, the second group, I was looking at Tibetan art. . . . I began to think about the colors in the Tibetan paintings. And then I thought about the color. Yes. At first they were red, yellow, blue. Opposites. Then I used secondary colors. Then I got very fancy. . . . I thought more about where I would make the mark and what kind of mark I make. I can't say the earlier waterfalls weren't premeditated but the purity of thought was very short. These took a long time. Because of the color. They are very slow. To mix the color. Because I only had one chance. *Coastal Winter,*

China Waterfall, that little painting is the most difficult one I ever did. I love that painting. . . . To do such a one with so little on it. To keep little on it. I had to wait a long time to know where I would have to make the mark. To know where it would be and how it would be and then to suddenly leap up and do it.

BW: And how do you decide that it's right and finished?

PS: Let's say it fulfills my questions. Even if it's not a good painting. I can tell when it's finished. It answers the questions I set up to do. Either very well or not very well. So I set it up with limitations the way a conceptual artist does. So that I know what I'll do and what I won't do. With *September Evening Waterfall,* I said I am only going to throw the paint up, I am not going to pour it down.

BW: So you always make the decisions before and then you just act.

PS: Yes. Like a calligrapher. That's how their process is. And I automatically unconsciously use that process. Where you look at the thing and think what you are going to do and then you do it. Maybe you don't do it well, but you do it. You did it. It's over. One chance. . . .

One of the things about the waterfall paintings is that they have a lot in common with photography. Because they freeze time. But I am not really after frozen time. I don't want to make film. It's a moment really captured. It's a moment standing still, but only a moment. . . . I want it to be one of those moments. I want them to be those moments, when you look out and you don't know what's happening because you can't really see it. But you know what it is. An abstract moment. The cat stands dazed in the sunlight. Drunk with light. Total abstraction. . . .

For example. Going to look at the ocean late at night. And just looking into black. I had a house at the beach, I did that very often. And then I would just look into the black. I couldn't see anything at all. Except I knew where I was because I walked there. And in that moment something flies down from the sky. Or suddenly the moon comes out from a cloud and you see white water. White on the top. But not a lot, just some. And then it's gone. So I am interested not only in those moments of frozen time but mostly in seeing them. In how they are seen. I am interested in the abstraction of all-seeing. . . .

BW: Beauty was not always a subject for you as a painter. But the waterfall paintings, beside the randomness, concept, action became very beautiful.

PS: Yes. Beauty became important for me. It happened accidentally at first that the paintings looked beautiful. I wasn't after beauty and I was surprised to see that some of them did look beautiful. But now I want them to be beautiful. Yes, it became a big interest. Because light became interesting to me. And I think every painter who is interested in light is interested in beauty, it sort of follows. . . .

I think people are afraid of beauty in painting, beauty in art for another reason. And that is if you see something really beautiful there is a desire to hold it, to hold the moment. And as soon as you want to hold that moment you realize that life is temporary. That you can't. And so every time you see beauty along with that beauty comes that sense of disappointment of life passing. If you ignore the idea of something beautiful you ignore the idea of that pain of trying to keep it. I think that, just now this fear is very pronounced at the end of the century and at the end of the last century as well. . . .

BW: You started with the water and the waterfall and now in your new body of work it's the whole cosmos.

PS: It's just one little step after the other. This idea refers to Chinese painting where the waterfall is so small and the monk is like a flea. Whereas in my waterfall paintings the water-

falls are the whole painting. They are in one way more figurative and anyone can see that. And in another way they are more abstract and you can't see it. But the interest in the cosmos must have to do with some mythology that you probably don't know when you are a small child until you get older. I think I am getting more connected to the idea. My parents died young. I am older than my father ever got to be. And my mother died when she was sixty-eight. So according to their time schedule I don't have much time left. And I think that makes me interested in the cosmos. In the tiny little bitness of each being and also in the idea of beauty. Because I think, the more tiny you see yourself the more you see yourself as part of everything rather than everything spinning around you; it's just all spinning and you are too. And that's sort of how I see it now.

JOAN SNYDER Statements (1969–2004)

I was a survivor. I basically raised myself.[1]

.

I have discovered that everything in my work relates to my life and all the important changes in my work are related to changes in my life, the most dramatic being summer 1969 when I was deciding whether to get married and was also struggling to do the grid layer stroke paintings. The transition was most clear in terms of life decisions.[2]

.

Anatomy of paintings—more not less—layers—not abstraction—not stripping away to make simple statement—image—finding richness inside—discovering anatomy of work.[3]

.

Female sensibility is layers, words, membranes, cotton, cloth, rope, repetition, bodies, wet, opening, closing, repetition, lists, lifestories, grids, destroying them, houses, intimacy, doorways, breasts, vaginas, flow, strong, building, putting together many disparate elements, repetition, red, pink, black, earth colors, the sun, the moon, roots, skins, walls, yellow flowers, streams, puzzles, questions, stuffing, sewing, fluffing, satin hearts, tearing, tying, decorating, baking, feeding, holding, listening, seeing thru the layers, oil, varnish, shellac, jell, paste, glue, seeds, thread, more, not less, repetition. . . . [4]

.

Just before I made *White Layers with Red Rectangle* . . . I was sitting in my studio on Mulberry Street looking at one of my paintings and trying desperately to figure out what I wanted and what I wasn't getting. Then I looked at the wall underneath the canvas. The lower half of the studio walls was tongue and groove boards painted white. They made a vertical grid, and there

 * Joan Snyder, statements from *Joan Snyder* © 2005 Joan Snyder and Hayden Herrera (Published by Harry N. Abrams, Inc. All Rights Reserved) and other noted sources.
 1. Joan Snyder, interviewed by Hayden Herrera, 1978, 1988, 2004, in Herrera, *Joan Snyder,* with an essay by Jenni Sorkin and an introduction by Norman L. Kleeblatt (New York: Harry N. Abrams, 2004), 17.
 2. Snyder, 1972 notebook/diary entry, quoted in Herrera, *Snyder,* 25.
 3. Snyder, 1969 diary entry, quoted in Herrera, *Snyder,* 25.
 4. Artist's statement, 1976, in Snyder's personal archive, quoted in Herrera, *Snyder,* 25, 27.

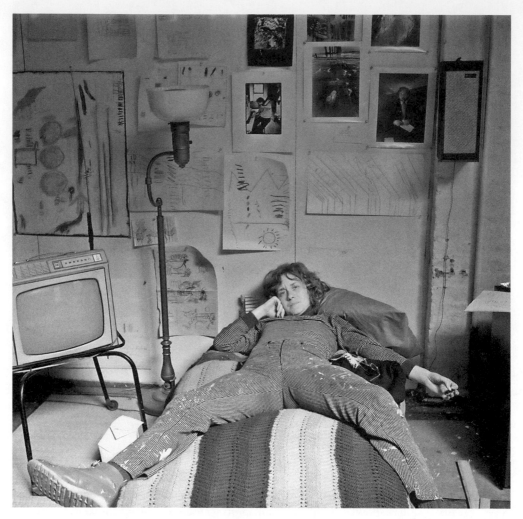

Joan Snyder in studio, May 1973. Photo by Larry Fink. © Larry Fink.

were these little delicate drips coming down from my canvas. I looked at the wall and the drips and said, "Oh, my God, that's what I want my paintings to look like!" It was a revelation.[5]

.

Attempting a further search into the anatomy of a painting—how strokes break down. How paint on the painting is used to make other strokes taking from one part of a painting and using it on another. . . . My work has always been involved in exposure as in the anatomy of a stroke—showing exposing different parts different sections—looking at paint and painting from a different angle—the subject matter is the paint and the paint speaks of human needs etc. the paint exposes and the paint covers up.[6]

.

5. Snyder, interviewed by Herrera, in Herrera, *Snyder,* 28.
6. Snyder, notebook entries, quoted in Herrera, *Snyder,* 29.

I sometimes say I can hear colors. Different colors have different sounds and different meanings to me. . . . When I made the stroke paintings I was picking my palette in a paint store. There is no overall color plan, but sometimes you know you are going to use certain colors predominately. I always have to let it happen. It's like jazz, you can bring on a trumpet when you least expect it or some kind of little piano riff.[7]

.

The strokes in my paintings speak of my life and experiences They are sometimes soft . . . they sometimes laugh and are often violent . . . they bleed and cry and struggle to tell my story with marks and colors and lines and shapes. I speak of love and anguish, of fear and mostly of hope.[8]

.

I'd get bored if I did the same thing over and over. My work changes a lot, which to some people is shocking and upsetting. . . . I did [the stroke paintings]. Everybody loved them, and I stopped doing them. They had become easy. They were Snyders. I had to move on.[9]

.

In some of our discussions [in a consciousness-raising group], we were asking, was there a female esthetic or wasn't there? And I was one of those who was out to prove that there was, that our work comes out of our lives, and that women's experiences are somehow different from men's experiences, so our work is going to be different.[10]

.

It was women artists who pumped the blood back into the art world in the '70s and '80s. . . . At the height of the Pop and Minimal movements, we were making other art—art that was personal, autobiographical, expressionistic, narrative, and political. It was women using words, cutting, pasting, building layer upon layer of material, experimenting with new material, and, to paraphrase Hilton Kramer, filling up those surfaces with everything we could lay our hands on. This was called Feminist Art. This was what the art of the 1980s was finally about, appropriated by the most famous male artists of the decade. They were called heroic for bringing expression and the personal to their art. We were called Feminist (which was, of course, a dirty word). They called it neo-expressionist. Except it wasn't neo to us.[11]

.

I think about drawing and realize that for me it is really only a means to an end. I draw to make studies of paintings, to make lists of ideas, materials and colors, to talk to myself.

I rarely think of a drawing as something that will be displayed. My drawings are the skeletons upon which I plan to add muscle and bones and flesh. But sometimes, because pencil and paper doesn't keep my interest for too long, I add more and more to the simple drawing

7. Snyder, interviewed by Herrera, in Herrera, *Snyder,* 31.
8. Artist's statement, 1972, in Snyder's personal archive, quoted in Herrera, *Snyder,* 33.
9. Snyder, interviewed by Herrera, in Herrera, *Snyder,* 33.
10. Ibid., 37.
11. Joan Snyder, "It Wasn't Neo to Us," *Journal of the Rutgers University Libraries* 54, no. 1 (June 1992), 34–35; quoted in Herrera, *Snyder,* 38.

and it turns into a painting on paper. The drawings, done quickly, roughly, almost unconsciously, can and frequently do precede my painting ideas by two or three years.[12]

.

I have a lot of building up to do before I can really let go with the painting. Then it reaches a point when you know that you are about to peak with it, and you really fly with it. That's when the magic happens and that's when I'm not thinking anymore. I've done all my thinking. I've done all the really hard work. I've done the plotting and planning and then I'm just riding on automatic pilot and that's when the beautiful, magical things happen and when they happen I'm so excited. It's like being on a drug or something. You are no longer present with the thinking about mechanicals or even content, you are just painting, like pure painting.[13]

.

Suddenly I looked at my paintings and I realized I hadn't used what I consider to be real color in my paintings for years. After all the death and darkness I wanted to bring color back into the work, so I said, "Come on, you've got to make a red painting."[14]

.

My newest body of work, done over the last three years, has been . . . I want to use the words "pure" and "magic" with all the meanings that the words "pure" and "magic" imply. . . . I am still seeking clarity, a purity, an essence, but have never been willing to sacrifice the ritual, the need for the deep, the rich, the dark—the wild wake of the brush and the often organic application of materials—and always working consciously to be in control and out.[15]

.

I couldn't do political paintings. There's so much horror going on in the world, so much devastation . . . but what I can do—I consciously decided to go back to a very feminist sensibility, to bring a feminine energy and some kind of beauty back into the world, which I think we desperately need. I felt it was the only kind of offering I could make, and that's really what I've been doing for two years now. Male energy is killing us. I want my work to be an answer to some of that.[16]

.

Painting certainly keeps my life in equilibrium. I do it because it's one of the things that I do really well. I'm proud of myself when I'm doing it. When I'm painting I'm the healthiest person. I'm like a little kid. My paintings are full of hope.[17]

.

My work has been absolutely faithful to me.[18]

12. Artist's statement, 1988, in Snyder's personal archive, quoted in Herrera, *Snyder,* 41.
13. Snyder, interviewed by Herrera, in Herrera, *Snyder,* 42.
14. Ibid., 56.
15. Joan Snyder, artist statement, in *Primary Fields,* exh. cat. (New York: Robert Miller Gallery, 2001); quoted in Herrera, *Snyder,* 57.
16. Snyder, interviewed by Herrera, in Herrera, *Snyder,* 60.
17. Ibid., 61.
18. Snyder, on notebook drawing of a heart, quoted in Herrera, *Snyder,* 61.

ELIZABETH MURRAY Statement (2003)

Most artists have trouble talking about their work. I make the paintings, I don't talk about them—it's really a nonverbal language. I suppose you could compare paintings to music, except music is linear. You start listening, and themes recur and repeat in the same way they do in paintings, but you don't have to deal with music all at once; with a painting you see it all immediately and at one time. Apart from that, I believe the way you experience painting and music is similar. As you look, you begin to see repetition, you begin to see how the arrangements of elements are zones that relate to each other. . . .

The big, main shapes in [my] paintings are worked out in advance. They're put together from behind; I can take them off the wall and make certain changes, but the process of making the shapes is all done in drawings. I start in a little notebook, where I do drawings until I get a set of shapes piling on top of each other that seem exciting or interesting. Next I make big drawings on sheets of paper that then go to the carpenter, who makes wooden forms that I stretch the canvas on. So the boundaries are given, but I can do anything I want inside the shapes. The image and color develop totally in the process that begins when I put the canvas on and put the paint down.

These paintings sometimes feel like constructing fences to me, like a sort of Irish wall of stones where you get to peek through the stones and see little bits of light. Putting them together is kind of like building with blocks, except I do it on paper first. There's actually another aspect to it: I didn't want things to be woven together. I wanted them to kind of butt up against each other. I have no idea why that seemed interesting to me. When I started to make them bigger, clearly it would have been easy to get them to shove into each other or even overlap. But I just didn't want to do that. I wanted to have that problem of having these different shapes and different zones together. I get certain areas to feel right, or maybe one shape to feel right. Once it does, I'll go on to the next. I put them together in this kind of linear way. And once I've got everything in one zone sort of dealt with, I start trying to get different zones to work together. I want these things to resolve in a way that I don't quite understand, and maybe you won't quite understand, but I want them to be resolved. There is a kind of unity that I want with them. I think that when I've felt finished with them, it's happened through color. I wanted this color—it was very clear to me and still is. I want it to be very, very intense.

ANSELM KIEFER Structures Are No Longer Valid (1985)

Structures are no longer valid. The class that established structures is gone. This makes our profession so difficult: we must do both; we have to establish rules and simultaneously fight against them. . . .

On the one hand Europe has lost its class structure and on the other hand an ongoing

* Elizabeth Murray, excerpts from "Elizabeth Murray" (March 12, 2003), in Judith Olch Richards, *Inside the Studio: Two Decades of Talks with Artists in New York* (New York: Independent Curators International, 2004), 282–85. By permission of the author and the publisher. © Elizabeth Murray, courtesy PaceWildenstein, New York.

** Anselm Kiefer, excerpts from *Ein Gespräch: Joseph Beuys, Jannis Kounellis, Anselm Kiefer, Enzo Cucchi,* ed. Jacqueline Burckhardt (Zurich: Parkett Verlag, 1986), 12, 15, 22, 24, 25, 26, 34, 37, 39, 40, 41, 48–49, 53, 64, 112–13, 119, 120, 131, 169. Translated by Peter Selz. By permission of the author and the publisher. The title used here comes from Kiefer's words in this conversation, which was moderated by Jean-Christophe Ammann and took place in Basel in June and October 1985.

transformation has taken place due to American influence on Europe after World War II in the realms of technology and the media. Kounellis says that America has no culture, but I believe that it does and that its culture is predicated on the media: a tradition of media and information. Europe has a culture with a tradition of history. . . .

Kandinsky was connected with the Brücke and the Blue Rider: they had a concept and created a reality. But I prefer Fautrier with his suffering and self-absorption. And his purpose in bringing about changes was just as strong. As a result I see in Fautrier a stronger paradigm than in Kandinsky. . . .

I perceive Existentialism as a necessity of decision. This is the essential aspect of Existentialism and simultaneously the most subversive factor. . . .

Perspective and Impressionism were tentative attempts to deal with the world of appearance because of a fear to look inside. Cubism is structure and order. Now both epidermis and order are no longer possible. . . . The accidental aspects of Impressionist composition are to be understood as a reaction. And the reaction of Cézanne is to be seen as a response to Impressionism. One cannot simply disregard Impressionism. As a dialectic antithesis it was important. The Impressionists had the idea of dissolution; they wanted to represent light, not bodies and not shadows, but light for itself. Frequently I find this tedious, but there is an idea behind it: Atomization is a modern idea. . . .

Mondrian began with his paintings of the seashore, with blue trees and the cathedral. These paintings were totally symbolist paintings. . . . Until the very end (and unlike van Doesburg and other de Stijl artists) Mondrian remains a Symbolist and an Expressionist. . . .

I do not believe that there is an external element to be disrupted now. The situation is different from the period of the Dadaists. There is nothing to overthrow now, because everything has been co-opted. To be subversive now in the sense of Dadaism would be reactionary, because now it would be the attitude of model students. . . .

In 1968 the end of art was announced, but this was for political reasons and for the wrong reasons. At that time it was believed that as long as there were only formal relationships, one did not have to deal with a luxury such as art. . . .

Fascism and war brought about stagnation. This continued during the period of reconstruction. Later there was an attempt at revolution which never happened. It was too late and nothing has changed. . . .

When I went to school there was Pop Art. The Americans dismissed us from our responsibilities. They mailed us Care packages and Democracy. The search for our own identity was postponed. After the "time of misfortune" as it has been called euphemistically, one thought in 1946 to begin anew. Even now we talk about the "Point Zero." But this is not possible; this is nonsense. The past is tabulated because to confront it would necessitate denial and disgust. . . .

The Germans always had difficulties with their identity. Either it was too much and too loud, or it was hidden and too subservient. The French always had a healthy self-confidence. When they spoke of a "grande nation" it was not dangerous. De Gaulle could say on Martinique: "Behind me is the ocean. In front of me is France." . . .

When one speaks of Israel, one must, of course, speak about the intellectual concept. There are no visual representations in the Bible or the Kabbala, but only intellectual concepts. . . . The Bible says: "In the Beginning was the Word." Therefore only the letters were sacred, never pictures. One could play with the letters of the Bible, change them around until they yield results. For the Jews the world, the whole cosmos, is in the letter. . . .

Painting is a fact which is comprehended by the glance. Literature is more like a river. . . . To put it differently, painting is quiescence. . . .

There is a reciprocal action between the work of art and the viewer. The river changes the work of art and criticism can also change the artist. . . . There are so many ideas afloat, any of them could have triggered the work of art. It is impossible to determine exactly if the idea has been transmitted by the critic, or if the work itself has determined its outcome. . . .

I am able only to do what stirs me. I want to perceive with my senses things which at the moment are not generally perceived. I do not share, as yet, Beuys's consciousness or hope that all people are moving to a certain point where they all become artists. I am of the opinion that there are artists and non-artists. I think that this is the way it always was and always will be. I do not believe that we are in the center of the world. It is possible that there are gods who do not relate to humans. As an artist, I believe that it is possible to depict these forces. I know it sounds absurd when I say that man can perceive some things and adumbrate powers, which do not relate to him. But perhaps the artist, unlike the non-artist, is able to do just that. . . .

I want to say something about Picasso as a revolutionary. A revolution in the history of art is a reflection of the history of society. Art cannot revolutionize society. It is a reflection of that revolution. . . .

You [Joseph Beuys] have revolutionized art. But I do not see that you have revolutionized society directly. You have depicted what has not yet existed. . . .

Art and life are not two separate realms, but they have shifted out of phase with each other. . . .

Why have our standards fallen so low? Why do we have all these ugly things which nobody needs? Industrial manufacture and new materials have led to truly unlimited possibilities of forms. There are no longer any natural constraints which depend on materials such as wood and stone. We simply manufacture everything that is technically possible and lack new structures on which to base our decisions. . . .

Until the artist is dead, we are not able to determine his work in all its dimensions.

DAVID REED Statement (1996)

The way I construct a painting doesn't have to do with composition. If a painting is composed it is treated as a whole, with borders that separate it from the world and parts that relate to each other internally. Instead, I want the borders of my paintings to imply extension. I paint thinking of film—camera movements, pans and zooms, cuts between camera angles, a changing focus, fades and flashbacks.

My paintings are becoming a bit more rectangular now, but generally I have worked in long, extreme formats, whether horizontal or vertical. This was one way to avoid traditional composition; I wanted viewers to feel that they were putting the paintings together themselves. I love it when people see my paintings and they're off-balance. I like it when a painting doesn't balance, doesn't make sense. The long format breaks the composition apart. Critics have written that the format of my paintings refers to CinemaScope, the film format, and I agree that there's a connection, though I wasn't consciously thinking about it. To me, the best part of CinemaScope is the edge of the frame. Motion either from the camera or within the scene is

* David Reed, excerpts from "David Reed" (April 2, 1996), in Judith Olch Richards, *Inside the Studio: Two Decades of Talks with Artists in New York* (New York: Independent Curators International, 2004), 170–73. By permission of the artist, the author, and the publisher.

what is important, not composition. . . . I try to involve a viewer by breaking out of the boundaries of the painting, out of the frame, invading the room, going sideways, being active. I want these effects to work psychologically as well as spatially, so that emotions are activated.

I've always admired the way some painters physically break the framing border. I've discovered that another kind of breakout can occur *inside* the frame: a mental breakout. The painting can seem to crack open, creating leaks out into the room. References to video, film, or photography further help this breakout by invoking various types of movement, physical and virtual. These connections to newer media offer alternatives to traditional painting language. Since these media move or imply movement, they represent continuity in a different way—continuities of both time and space. Events, even objects, are cut together or apart in time. The edge loses its physicality. Instead of a boundary, an end, it implies extension. The surface is not bound. It is a screen that can open in any direction. . . .

I'm fascinated by lurid, artificial color. We all spend quite a bit of time looking at this kind of color, on our computers and TV sets and at the movies. Something in it appeals to us—means something to us psychologically. There are new colors that don't yet have clear meanings. It's so amazing that there are new colors in the world and artists can be the ones to define them. Painting has a great tradition of using color and giving it meaning. These old meanings and techniques can be combined with this new artificial color. Caravaggio would have happily given the arm he didn't paint with for a tube of Phthalo Green. And I can barely imagine what Andrea del Sarto would have done with permanent rose and his cobalt blue as changeant colors. I love it that we get to be the ones to exercise the new connotations of color. . . .

My paintings are about movement, certainly—movement made still. They're getting closer to being human, almost embodied—it's as if light were becoming a body. I think they have a lot to do with a kind of changing being, a coming into consciousness, coming into form. That's one of my advantages as an abstract painter: the Baroque painters depicted objects by having the light falling on them, they had to use their range of value to model forms, they couldn't have light turning into an object in the way that I can. Since my paintings are abstract, I can have light, I can have form, and I can make them, in various degrees, turn into each other. It seems to me that this is the way our lives are now: the boundaries of our bodies aren't really there anymore. Sometimes I wear a hearing aid, so I feel like I'm part machine. Certainly when we're watching a movie, empathizing, when we're using a camera or a computer, we become part machine. So we have a strange relation to our bodies now, and to our consciousness. Where do we begin? Where do we end? What are we becoming?

FIONA RAE Interview with Simon Wallis (2003)

FIONA RAE: I abandoned a lot of the more figurative drawing and fragmented imagery for a while, but it's something I've started to include again. That's why I've selected this particular group of paintings from 1990/1991 to start the exhibition.

SIMON WALLIS: Why did that imagery get abandoned?

FR: I suppose at times you decide to pursue certain lines of enquiry, and that kind of

* Fiona Rae, excerpts from "Interview with Simon Wallis," in *Fiona Rae* (Nîmes, France: Carré d'Art—Musée d'art contemporain de Nîmes, 2003), 67–74. By permission of the interviewer. © Fiona Rae, courtesy Pace-Wildenstein, New York. © Carré d'Art—Musée d'art contemporain de Nîmes, France, 2003.

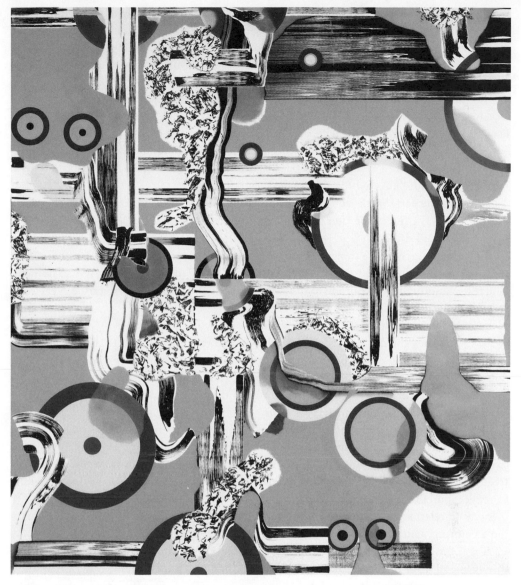

Fiona Rae, *Male Nurse,* 1997, oil and acrylic on canvas. © Fiona Rae, courtesy PaceWildenstein, New York.

impure imagery didn't fit in. I really became concerned with a more abstract space for a while. But working is like traveling along a spiral, as you're passing by you can lean down and pick something up from the past and then carry on round. I think it's more like that than any form of linear progression that only looks straight ahead. . . .

I have this vocabulary that I've appropriated and made my own in some way and that I can go and revisit at any time. . . .

Although I looked at all kinds of different languages—painting languages and ways of making images—I didn't simply quote them, I reinvented them in some way and made them my own. Things always passed through my hands; it wasn't just a kind of cool Gold-

smiths, postmodern representation of someone else's work. It was a way of proceeding when it felt like things were dead, buried and long gone. It allowed me to pick something back up and somehow jump-start it, making it possible for me to make a painting. . . .

I felt I had to be very questioning and self-aware, in order to justify my desire to paint. . . .

I thought the way that I would be able to make a painting would be if it embodied my anxiety about how to make it—if the result itself was something to do with that ambivalence. My paintings reflect my own state of mind, which is often one of uneasiness. . . .

I'm always reluctant to make a final decision on anything, and although the paintings are definitely finished I really like the idea that it could all shift again in the next moment. It's a get-out clause. . . .

sw: All the early works you've left as untitled, as if you didn't want their meaning deciphered too easily. But in the later works, the narrative becomes palpable and the titles begin to refer to things directly.

fr: They suggest something don't they? I thought it was time to come clean about what some of my intentions were and in the end that was a more fun and exciting way of doing it. The title is another mark I can add to the painting, but I don't intend it to override everything else.

sw: There's a violent visual quality to your early work.

fr: Yes, they do look aggressive when I look at them now—I used to think the various paint marks were fighting it out within the painting, but with nobody quite managing to dominate. In a way I still think that happens but it's a more subtle, refined struggle now.

sw: In particular, the black and white series, the ones that have visual static, seem to recreate a sense of anxiety within the viewer.

fr: That was my intention, I wanted them to be very unsettling, no clear or solid ground, nothing to rely on. I was living in a flat hundreds of feet above London, a bit like living in a space ship. There was no sense of the real to comfort and reassure, no pavements, roads, or trees. It seemed a truly contemporary experience and I wanted the paintings I was making to reflect something of that. . . .

sw: In relation to your own work, I know you use the computer in the process of making a painting, when did that start?

fr: I got a Mac half way through making my black paintings, but all I could do was scan things in and print them out, like a photocopier. It was when I started making the paintings with fonts in them that I began to use a computer properly. Even so, it's useful only up to a certain point. . . . Something that looks good on a computer screen, or even on the printout, doesn't necessarily look good once it's ten metres long.

I don't use the computer to work out the drawing or other marks; somehow the way a bit of drawing may look on the screen has nothing to do with its physicality on the canvas, it still seems very divorced to me.

Computers are useful in the way they make things visible that I wouldn't have thought of otherwise, like shadows and flares on things. . . .

sw: What other things begin to filter through and have a visual impact on your work?

fr: All kinds of things. The beginnings of movies nowadays, the way the titles invent a glimpse of deep space, something like that must have had an effect on me. The ways things look in Photoshop. . . . I was looking at an astronomy photograph of the night sky which Dan [Perfect] found for me on the Internet. There's an amazing randomness to the ways the stars

and planets are scattered, which you couldn't invent. I've got some complete tat [junk] in the studio—it doesn't matter whether or not I actually like something, it could still be useful. I've got some Chinese posters, I think they're New Year's posters, pinned up on the wall—they're super lurid and kitsch looking, with ribbons and stuff. I've been looking at Dürer and Bosch—it's a surprise how contemporary they look next to other things lying around in the studio, like a cover of an X-Men comic or a poster for *Monsters Inc.* Or maybe it's the other way round and they show how most things around us aren't really that new, but go back hundreds of years . . .

SW: What about the notion of improvisation in your work?

FR: Well that's definitely still there. I used to improvise everything but then what is improvisation? It's always based on some kind of prior knowledge isn't it? . . .

SW: What do you feel about the place of painting in relation to all the technological changes that have occurred in the last ten years, has it changed what you might produce a painting for?

FR: I think that there's always going to be something that a painting can do, that a movie can't do, that a computer can't do, that the poster in the street can't do. I'm not quite sure how to characterise it, maybe it comes back to the personal or individual touch or moment, its success or failure. Painting is a romantic, magical thing although I never thought I'd say that!

JULIE MEHRETU Interview with Lawrence Chua (2005)

JULIE MEHRETU: In the past, all my work has evolved from one painting to the next. Little by little I'd bring more and more elements into the painting. I worked with this whole idea that the drawn marks behave as characters, individuals. The characters keep evolving and changing through the painting. But I think with the last group of paintings, I have been able to take this language that I've been developing, in all its many parts, and really bring it to a head, almost like a crescendo. I was really trying to make some sense out of this situation we're in and I felt I had the means, that language to do so, but then afterward when I went back into the studio to make new work, as clearly as everything had crystallized and come together previously, it all disintegrated and fell out from under me. I think those cycles of clarity and confusion are just part of the creative process. The map and the layering and the reason I was actually physically making the paintings all had had a clear and specific meaning in the work. The questions that have come up for me now are, Can I still make the paintings in this way, can they continue to evolve and be meaningful given my changing perspective and response to the world? What is still interesting to me about the layering or even the actual physical process, the visual language of the marks themselves? How can I continue to make paintings? Basically I feel like I don't know how to translate what's going on in my head. When I look at the work and the way I was thinking about it before, it feels like we were dealing with such a different social condition. . . .

Of course it sounds naive, but before the Bush Administration and September 11, there was this underlying feeling that the world was progressing in a particular way and different cities were developing and morphing into this kind of unified pseudo-capitalist dream,

* Excerpted from the interview "Julie Mehretu by Lawrence Chua," *BOMB* 91 (Spring 2005): 24–31. © Bomb Magazine, New Art Publications, and its Contributors. All rights reserved. The BOMB Digital Archive can be viewed at www.bombsite.com. Also by permission of the interviewer and the artist.

or something. It was easy to go back to certain utopian ideas about the way that things could develop, even though it was obvious that there were so many obstacles, intense violence, and injustices, that this was not a true reality: the American economy being so huge and doing so well, the development of the EU, the rapid growth of the Chinese economy, the quickly changing economy and development of India, the democratization of Nigeria, air flights going back and forth everywhere. That false perspective and weird hope just was crushed in the last few years. The way the U.S. has responded, especially with the war in Iraq, has put the world into a different place. I'm not so interested right now in tying Lagos and New York into a morphed experience without bringing this new and different context into the mix. Right now it just feels like this big knot of all these different tendencies. It's coming out in my drawings a lot; they look like these nests or gnarled webs. Space is deflated and conflated. I'm still trying to understand it myself.

LAWRENCE CHUA: A distinct conception of space has emerged since that collapse you were talking about. If you read some of the reports about what Baghdad looks like today, there's this sense that there's one enclave that's very protected, almost a miniature American shopping mall, and that enclave is set within the context of a very turbulent city. . . .

JM: What I am interested in are these plural events that seem worlds apart happening and being experienced at the same time, and the relationship between those places, or existing in between that. It's hard because I don't like to only talk about the U.S. exporting those types of ideas, but also how those ambitions are imported to places. Iraq as a situation is such a quagmire. I was talking to a friend who works at the State Department who was saying that this is basically going to be the largest embassy for the U.S., the largest foreign embassy that they plan on building . . . the extreme capitalist colonial palace in the middle of the worst dysfunctional condition. So you have to think that there's a colonial mission, or something similar to one. That is something we were talking about in the studio also. . . .

Working in the studio, that's something that I just intuitively go to. I'm attracted to those drawings because I think they work to embody a certain kind of ideology or a dream. They seem like a calling to some higher way of living or being. They seem visionary in that way. The spaces and built legacy of the drawings become these very directed places that nurture and take care of large groups of people in a grander ideal way. Not only can they take care of society, be the containers for us to operate and conduct business in, but they are almost acting out those events for us as well.

LC: . . . What you're saying reminds me of the way that the stadium produces its own sort of reality but one that has gone on to mediate the way we look at the world as spectators. Your newer paintings incorporate elements of various stadia in the world. Is this the first time you're really interested in a particular typology?

JM: Yes and no. I am intrigued by the stadium for all the reasons you just talked about: it's become the arena for everything that happens and that we consume. Having spent time in Istanbul, Germany, Australia and then back in the States, I was really interested in how our whole experience of viewing the world and the war was mediated through the television and newspapers. It felt almost like following a match or a sporting event. That's reductive, I know, but it was interesting because you could feel a nationalist sensibility in the responses to the war, even in the dissenting perspective. . . . I was interested in the kind of discussions everyone was having; we were talking about it as if it was happening in this massive arena. It felt like the whole world had been reduced to that kind of space. I just kept wondering, how could that happen, how could that look, how could I build that feeling? I started collecting stadium

plans, as many as I could, built or unbuilt. I brought them all together in the studio and tried to build one mega-stadium out of all the drawings, tying and weaving them together. I also collected different kinds of signage from everywhere I went, street rags, billboards. I wanted to bring nationalist signage, sports signage, street signage and conflate them into one abstract language, and then have these characters, these kind of riotous drawings exist within that. In the stadia paintings there seems like there's this big event occurring that's very orderly and makes a lot of sense, that there will be an outcome that we can either cheer or oppose, but that doesn't really happen in the painting. . . .

LC: I want to talk about your working methodologies. You've always approached painting in an architectonic way, but it seems like the new work is even more concerned with structure and the production of space. Have things changed noticeably for you with the newer work?

JM: . . . I have a better understanding of architectural language and its history. I've also grown with my language and am able to put a lot more thought into how to approach a particular idea or perspective or experience and translate that into a painting. There's this big part of the language that's so intuitive or self-conscious; I'm struggling with the idea of how to make work about a particular time when it's really also a very internal work.

LC: By "internal" do you mean how that time affects your daily life?

JM: Yeah. Or while I think about images and I look at images and have them all over the studio, I'm using abstraction to make the work. The development of that abstract language is a very subconscious, intuitive thing. That doesn't mean I don't ever try to take apart the pieces of that language and look at them, but I'm struggling with how you find the in-between. How can abstraction really articulate something that's happening? When you make a picture of a condition, how can it make sense of that condition?

LC: Has the importance of your characters, and all the different elements you use, changed in the work?

JM: Earlier on I would think of each mark as having a characteristic or an identity. Each mark would have its own society and would socialize and was, let's say, a social agent. Then the architectural language came in to give me a place for these characters. It made a link into the world that we inhabit so that it wasn't just this no-place in which these characters socialized. It also created a sense of time, created a certain kind of social history for the characters. The characters, now, instead of being all these different kinds of little individual agents, have become more like swarms. Before I was interested in how these individual agents would come together and create a whole and effect some kind of change. Now it's also, how did these bigger events happen by the gathering of all these marks? What is the phenomenon being created by these massive changes in the painting? How is it impacting them? . . .

 The architectural language serves as a marker to the type and the history of the space, but the characters make the space and break it down. They actually complicate the space in the painting. For example, a bunch of dashes or marks will enter the painting a certain way and then another group of marks enters it another way to completely contradict that. It's becoming more interesting to me how they're getting spatially complicated and formally complicated in terms of different vanishing points, but also how those become different perspectives within the space and impact exactly how the painting can be read. . . .

 The structure, the architecture, the information and the visual signage that goes into my work changes in the context of what's going on in the world and impacting me. Then there's this other subconscious kind of drawing, this other activity that takes place, that is

interacting with everything that is changing, and it's the relationship between the two that really pushes me. And why abstraction? There are so many other ways to make paintings about these conditions that I'm drawn to. But there's something that's hard to speak about that abstraction gives me access to. . . .

Even though I collect and work with images in the studio they don't enter the work directly. Instead I'm trying to create my own language. It's the reason I use the language of European abstraction in my work. I am interested in those ideas because I grew up looking at that type of work, but also not taking any of it at face value. It is as big a part of me as Chinese calligraphy or Ethiopian illuminated manuscripts. The more I understand any kind of work the more I see myself conceptually borrowing from it. Going to the Met and seeing particular paintings over and over inevitably becomes a part of my language. Abstraction in that way allows for all those various places to find expression.

2 GEOMETRIC ABSTRACTION

Kristine Stiles

The most contentious theoretical debates in art criticism after 1945 concerned the interpretation of geometric abstraction and its relation to the concepts and objectives attributed to modernism and postmodernism. Until the 1980s, however, artists seldom used either term to describe their work, as both represent homogeneous sets of values and periodizing frameworks inadequate to explicating an artist's range of concerns.

Earlier in the twentieth century, following World War I, many geometric abstractionists adopted the term "concrete" and formed international organizations emphasizing the material plastic elements of their medium. In 1929, for example, in Paris, the Uruguayan painter Joaquín Torres García cofounded the group Cercle et Carré (Circle and Square), which started an eponymous journal the following year. Cercle et Carré merged in 1931 with the larger group Abstraction–Création (founded in February 1931), whose members included Antoine Pevsner, Sophie Taeuber-Arp, Max Bill, Lucio Fontana, Josef Albers, Jean Arp, and Wassily Kandinsky, and which published five issues of the yearbook *Abstraction-Création: Art non-figuratif* from 1932 to 1936.[1] Arp and Kandinsky used the term "concrete" to describe their aims, taking the word from Theo van Doesburg, who had introduced it in 1930: "We are inaugurating the period of pure painting, by constructing the **spirit** form: the period of concretization of the creative spirit. Concrete painting, not abstract, because nothing is more concrete . . . than a line, a colour, or a surface."[2] The term "concrete" emphasized the physical coextension of artistic objects, processes, and media with the actual world. Shifting the linguistic denotation helped differentiate the connotative aspects of their practice from the illusionism implicit in the terms "abstract" (suggesting metaphorical representations of nature) and "nonobjective" (images of mental concepts). Moreover, consolidating their abstract practices under the concept of the concrete enabled artists to unite against the effort by three entirely different political ideologies to institutionalize Social Realism: communism in Russia, where abstraction was attacked as capitalist; fascism in Germany, where abstraction was charged as decadent and Bolshevik; and capitalism in the United States, where abstraction was assaulted as socialist and communist.

Boris Mikhailov (b. Ukraine, 1938), a self-taught photographer who became well known in Eastern Europe and Russia for his photomontages and photographs of ordi-

nary people, would satirize the debate between geometric abstraction and Socialist Realism in his photomontage series *On the Color Backgrounds* (c. 1960). This work combines a Suprematist abstraction with the image of a poor, old, and perhaps homeless peasant woman to pose a critique of both the potential elitism of the concrete abstract image and the inability of socialism to eradicate poverty. By juxtaposing painting and photography, Mikhailov also comments on the two media's different cultural valences: painting being considered a fine art and photography, a mass-media technology. In the 1980s Mikhailov would launch a visual critique of the emergence of capitalism in the former Soviet Union as the "mask of beauty" and a false promise for the masses.

After World War II, references to concrete art initially surfaced in discussions regarding geometric abstraction in Paris. In 1945 Galerie René Drouin held a series of exhibitions that opened with *Art concret.* The following year Auguste Herbin, Albert Gleizes, Jean Gorin, and others launched the first annual exhibition of the Salon des Réalités Nouvelles, devoted to "abstract/concrete/constructivist/non-figurative art." In 1948 Galerie Denise René exhibited abstract art in a constructive style derived from Russian Constructivism in an exhibition that brought together work by Albers, Bill, Gorin, Herbin, Camille Graeser, Karl Gerstner, Richard Mortensen, Fritz Glarner, and Richard Paul Lohse, many of whom were involved in the concrete art movement in Switzerland.

Max Bill (b. Switzerland, 1908–94), a student at the Bauhaus from 1927 to 1929, became a principal theorist of concrete art and concrete poetry, founding *abstrakt-konkret,* the monthly bulletin for the Galerie des Eaux Vives in Zurich in 1944.[3] Trained not only in art and architecture but also in science and technology, Bill was an educator and a politician. In the early 1950s he cofounded and directed the Hochschule für Gestaltung in Ulm, Germany, an advanced technical school synthesizing art and science and specializing in research and training for design in architecture, town planning, and visual communication. The Hochschule pioneered instruction in cybernetics and communication theory, and employed such faculty as Friedrich Vordemberge-Gildewart, a German artist who had been associated with De Stijl, Cercle et Carré, and Abstraction-Création, and the German aesthetician and concrete poet Max Bense, who taught "information aesthetics." Bill's theories of perpetual motion and his attention to mathematics as a structure for visualizing spatial dimensionalities anticipated the concrete art movements in Brazil in the 1950s as much as kinetic, optical, minimal, and conceptual art in the United States in the 1960s.

A committed, socially engaged artist, Richard Paul Lohse (b. Switzerland, 1902–88) considered art to be the "sublimated and critical echo to the structures of civilization."[4] In 1937 Lohse cofounded Allianz, an association of modern Swiss artists in Zurich. Trained as a graphic designer and painter, he made his first modular and serial works between 1942 and 1944. These paintings, which treated the picture field as a structure of interrelated color modules, connections, and parallels, drew on mathematics and used row symmetry and asymmetry. His serial systems anticipated many of the formal issues identified with minimalism and process art in the 1960s. Although Lohse contributed to the publication *abstrakt-konkret* from 1944 to 1958, he did not adopt the term "concrete," but rather described his work as "systematic, methodical, or rational art." From 1947 to 1955 he edited and designed the Swiss architectural magazine *Bauen und Wohnen*

(Building and Living) and from 1958 to 1965 coedited *Neue Grafik* (New Graphic Design) with Josef Müller-Brockmann, Hans Neuburg, and Carlo Vivarelli. On his eighty-fifth birthday, Lohse was made a Commander of the Order of Arts and Letters of the French Republic by the French minister of culture.

Joaquín Torres García was the first vigorous advocate of concrete art and geometric abstraction in South America. Returning to his native Uruguay in 1934 after almost forty years in the United States and Europe, he mentored the Uruguayan painters Carmelo Arden Quin and Rhod Rothfuss, who, together with Gyula Košice and others, formed the group Arte Concreto Invención (Concrete Art Invention) in Buenos Aires in 1945. Their work was characterized in particular by shaped paintings that predated Frank Stella's shaped canvases of the 1960s by fifteen years. Another member of the group, the Argentinean artist Diyi Laañ, used the frame itself as the composition, painting her unusually shaped frames and leaving an empty space where the canvas would have been.

Gyula Košice (b. Czechoslovakia, 1924) and Carmelo Arden Quin (b. Uruguay, 1913–2010) organized Grupo Madí in Buenos Aires in 1946 and authored the "Madí Manifesto" the same year, outlining an approach to painting and sculpture that would blur the distinction between the two media. Košice, born Fernando Fallik in Košice, Czechoslovakia, had moved to Argentina at the age of four and in 1944 had changed his name to reflect his Slovakian and Hungarian origins. A prolific theorist and poet, Košice published extensively and produced eight issues of the magazine *Arte Madí Universal*. In 1946 he began to use neon gas to make "luminance structures" and by 1949 was working with water and light to make "hydrokinetic" sculptures. Quin, who had moved to Buenos Aires in 1938 to study philosophy and law, had collaborated with writers and painters in the publication of various journals like *Sinesia* and *El Universitario* before joining Košice and others to found Madí and its predecessors.

Concrete art was as crucial to the development of experimental art in Brazil as it was in Argentina. Two groups that formed there in 1952 shaped the future of Latin American abstraction for several generations. Grupo Ruptura in São Paulo issued the "Ruptura Manifesto" in 1952, signed by Waldemar Cordeiro, Luís Sacilotto, Lothar Charoux, Geraldo de Barros, Kazmer Féjer, Leopoldo Haar, and Anatol Wladyslaw. Advancing theories put forth by van Doesburg and Bill, and rejecting the Surrealists' interest in the artist's psyche, Grupo Ruptura eschewed artistic subjectivity, emphasized objectivity and structure, subordinated color, and eliminated figuration. Grupo Frente, founded by the Argentinean painter Ivan Serpa in Rio de Janeiro, included Aluísio Carvão, João José da Costa, César and Hélio Oiticica, Lygia Pape, and Décio Vieira, and it held its first and second exhibitions in Rio in 1953 and 1955. According to the Brazilian-born artist and writer Simone Osthoff, "the theoretical polarization between a 'functionalist' tendency in São Paulo and a 'vitalist' tendency in Rio de Janeiro resulted in the creation in 1959 of the Neoconcrete Art movement in Rio," but not before Grupo Ruptura criticized Grupo Frente for lacking formal rigor.[5] Grupo Ruptura disbanded that year, and many artists belonging to Grupo Frente signed the "Neo-Concrete Manifesto" authored by the Brazilian poet Ferreira Gullar (José Ribamar Ferreira, b. 1930). Signatories included the sculptors Franz Weissmann and Amílcar de Castro, the painter Lygia Clark, and the poets Theon Spanudis and Reynaldo Jardim. Although Hércules

Barsotti and Willys de Castro did not sign, they both joined sometime later.[6] The *First Exhibition of Neo-Concrete Art* was held in Rio at the Museu de Arte Moderna in 1959. Gullar would go on to become an influential art theorist, who wrote "Theory of the Non-Object" in 1959, anticipating themes in minimal, conceptual, and process art of the 1960s with its emphasis on perception and phenomenology.[7]

Lygia Clark (b. Brazil, 1920–88) had studied landscape architecture in Brazil in the early 1950s, before studying painting with Fernand Léger in Paris. By the late 1950s, back in Brazil, she began to produce interactive sculptures in paper and metal, works that anticipated her body-centered series *Nostalgia of the Body* (1964–68), composed of wearable objects (like goggles, masks, gloves, and suits) intended to instigate psychological as well as interpersonal experiences. In 1968, the year in which the military government suspended constitutional rights in Brazil, Clark introduced *Organic or Ephemeral Architectures,* using what she called "relational objects" to help patients with mental disorders heal emotionally.[8] As the critic Guy Brett pointed out, the kinetic interaction Clark set into motion with her relational objects emphasized "actual energy," as differentiated from the virtual movement of much optical art, and encouraged participants to use their "own energy" in becoming self-aware.[9]

By 1960 Hélio Oiticica (b. Brazil, 1937–80), who had joined Grupo Frente in 1955, before exhibiting with the Neo-Concrete movement, had begun analyzing color in multisensorial spaces and theorizing about it in such articles as "Color, Time and Structure" (1960) and "Releasing Painting into Space" (1962). Calling for artists' active involvement in politics, Oiticica created several series of alternative artworks requiring collective engagement, including *Núcleos* (1960–63), vibrantly colored environmental mazes, and *Parangolés,* capelike architectural sculptures worn by participants and derived from samba and festival. His interest in Brazilian identity was the primary theme of his installation *Tropicália* (1967), a key work for the countercultural Tropicalist movement, which emerged at the end of the 1960s. Recalling José Oswald de Andrade's "Anthropophagist Manifesto" (1928), which called for the cultural absorption of European modernism in Brazil in order for a hybrid, superior national body to emerge, Oiticica aimed at the integration of the fine arts and indigenous culture.

In 1968 Guy Brett wrote that both Oiticica and Clark fused the "Western aesthetic canon that privileges vision and metaphysical knowledge, and Afro-Indigenous oral traditions in which knowledge and history are encoded in the body and ritual is profoundly concrete."[10] Both artists also anticipated aspects of minimal, conceptual, process, and performance art of the 1960s and 1970s. Oiticica's work would eventually inspire similar installations by the British artist Liam Gillick, associated with the Young British Artists movement of the late 1980s and 1990s; and Clark's "relational" work would inform the French critic Nicolas Bourriaud's theory of relational aesthetics.[11]

In Italy the divergent stylistic developments in constructivist, concrete, and geometric abstraction came together in the theory and practice of Lucio Fontana (see chap. 1), who had belonged to Abstraction-Création in Europe, as well as to the circle of artists associated with Arte Concreto Invención in Argentina. Among Fontana's many manifestos is his "Manifesto spazialismo," published in Milan in 1948, the very year the painter Gillo Dorfles formed the MAC (Movimento arte concreta, or Concrete Art Movement) there, with fellow Italians Bruno Munari, Atanasio Soldati, and Gianni Monnet.

In the United States, Charles Biederman (1906–2004) introduced the terms "concretionist" and "structurist" to describe his work. Biederman, a member of American Abstract Artists,[12] had an abiding interest in the aesthetic and political implications raised by Piet Mondrian in his investigation of the plastic structure of art. Biederman's book *Art as the Evolution of Visual Knowledge* (1948) had a wide influence, both in the United States and, even more so, elsewhere. Eli Bornstein, a Canadian painter, founded the journal *The Structurist* in Saskatoon in 1960 and published in its first issue Biederman's essay "The Real and the Mystic in Art and Science," a study of the relation between science and Mondrian's theories of art. Bornstein also published writings by European abstractionists like Jean Gorin, intellectuals like the art historian Erwin Panofsky and the psychologist Abraham Maslow, and the novelist, essayist, and playwright Arthur Koestler. Biederman's ideas also had an impact in the Netherlands, where the Dutch painter Joost Balijeu published the journal *Structure* from 1958 to 1964. Drawing parallels between art, stucturalist linguistics, and philosophy, Biederman's theories attracted artists like Jan Schoonhoven, Herman de Vries, Carel Visser, Peter Struycken, and Ad Dekkers.

Like Mondrian and Biederman, Ad Dekkers (b. Netherlands, 1938–74) joined problems of system, intuition, and structure to nature, or what he called "the laws that control the world." He displayed his study of the harmonious balance and counterbalance of form in monochromatic (often white) sculptures, reliefs, and paintings. In his extremely reductivist geometric abstraction, he moved toward the tabula rasa, or zero point, that many artists reached in the 1950s. In the early 1960s he was associated with the group Nul and its publication *o = Nul* (1961–64), edited by de Vries, Schoonhoven, Henk Peeters, and others. Their exploration of the concrete surface and structural issues raised by geometric and monochrome paintings and panels drew them increasingly to questions of light, movement, spectacle, and the interaction of art with the environment, concerns that coincided with those of Piero Manzoni, Yves Klein, and the German ZERO group.

The French literary critic and philosopher Roland Barthes theorized that a zero point had been reached in writing after World War II: "Now here is an example of a mode of writing whose function is no longer only communication or expression, but the imposition of something beyond language, which is both History and the stand we take in it."[13] Similarly, having achieved concrete forms sufficient unto themselves, artists such as the members of Nul and ZERO could only determine the meaning of their work in the interrelation between it, history, and experience. The exhibition *Monochrome Malerei* (1960), organized by the architectural historian Udo Kultermann in Germany, celebrated the "degree zero" marked by the monochrome, a style of painting that had begun with Alexander Rodchenko's triptych *Pure Red Color, Pure Yellow Color, Pure Blue Color* in 1921.

In the late 1950s and 1960s the Italians Giuseppe Capogrossi, Enrico Castellani, and Manzoni took up investigations into monochromatic painting, kinetic sculpture, and light environments. Concern with the concrete reality of art led Manzoni (1933–63) to create his *Achromes* (1957–59)—white canvases to which he applied various common materials (cotton balls, cloth, etc.), which he uniformly painted over in white. In 1959, with Castellani, Manzoni founded Galleria Azimut in Milan and the art journal *Azimut* (1959–60), which introduced such European and American avant-garde artists as the

Nouveaux Réalistes, the ZERO group (with whom Manzoni and Castellani collaborated), Robert Rauschenberg, and Jasper Johns. Eventually, Manzoni abandoned painting for a more conceptual and performative direction. In 1961, exposing the economic basis of aesthetics, he offered ninety tins of his excrement, which he titled *Merda d'artista* (Artist's Shit) and sold for the daily market price of gold.[14] Like Andy Warhol in New York and Klein in Paris, Manzoni satirized the cult of artistic personality that propelled the art market, parodied overdetermined cultural notions regarding creative genius, and highlighted the paradoxical separation of value as a mental construct from value as an economic principle based on classed objects.[15]

Yves Klein (b. France, 1928–62) began making monochrome paintings in the mid-1950s, soon refining much of his art to a single color, which he called "International Klein Blue" (IKB). In these monochromes, he attempted to imply infinite space and the immateriality of the void. Proceeding logically, he presented an exhibition entitled *The Specialization of Sensibility from the State of Prime Matter to the State of Stabilized Pictorial Sensibility,* also known as *The Void,* at Galerie Iris Clert in Paris on April 28, 1958. For this exhibition, he emptied the gallery and whitewashed the walls in order to psychically impregnate the space with his aura. Increasingly conceptualizing painting, Klein created *Ritual for the Relinquishment of the Immaterial Pictorial Sensitivity Zone* (1957–59). In this painting for the mind, he enumerated steps for the identification of the cognitive aspect of perception that shapes visual experience and imagination.

One of the artists that Udo Kultermann had included in the exhibition *Monochrome Malerei* was Yayoi Kusama (b. Japan, 1929), who had been unaware of the concrete movement in Europe and Latin America. But coming from an entirely different orientation to abstraction, Kusama had arrived at abstract paintings covered with dots when she was only a child. The allover dot patterns, which she eventually referred to in the late 1950s as "infinity nets," represented her lifelong struggle with hallucinations and mental illness and would be translated into a host of media over the years. After moving to the United States in 1957, Kusama gained the attention of a range of influential artists, from Mark Rothko, Barnett Newman, Joseph Cornell, and Donald Judd to artists involved in happenings and installation art, including Claes Oldenburg, whose soft sculptures were directly inspired by Kusama's soft sculptures covered with dots made in the early 1960s. Kusama used her "infinity nets" in happenings, antiwar protests, and other public, participatory actions, bridging abstract painting with sculpture, installation, performance, and film. In 1973 she returned to Japan, living, working, and writing as an outpatient in a psychiatric hospital there.

The tension between the autonomous work of art and its contingency to historical circumstance, intimated by Barthes, is best reflected in the twin practice of Ad Reinhardt (b. U.S., 1913–67): his highly political and polemical writings and cartoons, published in such journals as *P.M., Critique, Art News, Art International,* and *Dissent,* and his monochromatic paintings dating from the early 1950s and culminating in the *Black Paintings* (1960–66). While New York School gestural abstraction and European *art informel* synthesized Cubism, Expressionism, and Surrealism in order to recuperate the psychological and existential content of early-twentieth-century avant-gardes, Reinhardt's geometric abstraction arrived at a unified, highly saturated color surface, or field painting. Although Reinhardt insisted that his paintings represented "art as art and

nothing but art," his deep interest in Eastern metaphysics suggested otherwise. The following note by Richard Wilhelm to Hexagram 22, "Grace," of the *I Ching,* provides a provocative source for Reinhardt's theory: "The hexagram shows . . . tranquility of pure contemplation. When desire is silenced and the will comes to rest, the world-as-idea becomes manifest. In this aspect the world is beautiful and removed from the struggle for existence. This is the world of art."[16] The congruence between Reinhardt's idea of "art as art and nothing but art" and the teachings of the *I Ching* has been over-looked but is worth further consideration.

Reinhardt's flat monochrome surfaces sometimes were described as "hard-edge," a term coined by the Los Angeles critic Jules Langsner in 1959 to identify paintings and sculptures characterized by a geometric clarity, even surfaces, and simplicity of design.[17] The term "hard-edge" was also applied to the paintings and sculptures of Ellsworth Kelly (b. U.S., 1923), whose shaped constructions and simple painted forms, bright primary colors, and smooth surfaces evolved while the artist lived in Paris (1948–54). Kelly's careful study of the patterns and structure of light and shadow in nature resulted in constructions, tableaux-reliefs, and monochrome paintings in the European geometric and concrete tradition.

Paradoxically, the soft edges of Helen Frankenthaler's stain paintings (see chap. 1), begun in 1952, also provided the impetus for the hard-edge painting of the 1960s. She synthesized Jackson Pollock's pour technique, Hans Hofmann's theory of the "push-pull" dynamics of color and form, and Clement Greenberg's theories of modernism. Greenberg even argued that the "hardness" of "post-painterly abstraction" derived from the "softness" of her gestural abstraction rather than from the geometric linearity of "Mondrian, the Bauhaus, Suprematism, or anything else that came before."[18] In 1954 Greenberg introduced Kenneth Noland (b. U.S., 1924–2010) to Frankenthaler. Noland had met Greenberg at Black Mountain College, where he had studied with Ilya Bolotowsky and learned about the Bauhaus and Mondrian. Together with Morris Louis, Noland went on to advance Frankenthaler's stain technique, and both artists, along with Gene Davis and others, would be identified as the Washington Color School.

Greenberg played an equally important role in the development and careers of the sculptors Anne Truitt (b. U.S., 1921–2004) and Anthony Caro (b. U.K., 1924). Truitt, who lived and worked in Washington, D.C., began to produce vertical, rectangular painted-wood structures in 1961. Although Greenberg later claimed that she launched minimalism, Truitt rejected this attribution and insisted that she "struggled all [her] life to get maximum meaning in the simplest possible form."[19] Caro, who began as a figurative sculptor and was a part-time assistant to Henry Moore between 1951 and 1953, met Truitt, Noland, Frankenthaler, David Smith, and Robert Motherwell in 1959. The same year, Greenberg encouraged him to move into abstraction. While Caro and Truitt were both indebted to Greenberg's theories, their work also reflected the Cubist-Constructivist tradition informing the elegant simplicity, geometry, and unity of the sculpture of Eduardo Chillida, Mathias Goeritz, Helen Escobedo, José de Rivera, and David Smith.

The lively discussion surrounding all of these artists' works in the 1960s revived interest in optical problems and the representation of virtual movement by such painters as Josef Albers, Victor Vasarely, and Bridget Riley. Born in Germany, Albers (1888–

1976) received his training at the Bauhaus, becoming a master teacher there in 1925. He emigrated to the United States in 1933 and taught at Black Mountain College, later joining Yale University's art department. In his celebrated series of paintings *Homage to the Square,* a large body of work begun in 1949 and continuing until his death, Albers explored the interrelationship of physiological and psychological perceptions provoked by color and form.

Like Albers, Victor Vasarely (b. Hungary, 1906–97) came out of the Bauhaus tradition, having studied decorative patterns, visual puzzles (or "surface kinetics"), industrial design, advertising, graphic arts, and problems in the psychology of perception at the Műhely Academy, known as the "Budapest Bauhaus," before he moved to France. In 1955 he wrote the "Yellow Manifesto," an early text linking abstraction and kinetics, for the influential exhibition *Le mouvement* at Galerie Denise René in Paris. Later, at the height of the Pop art movement, Vasarely began to have inexpensive reproductions of his optical experiments produced as multiples. Their enormous popularity supported Vasarely's aim to integrate art and society by making fine art economically accessible. Ironically, Marxist and formalist critics alike criticized such work for its popular appeal, claiming that Vasarely had abandoned the presumably higher principles of fine art for commercial gain. Their sense of superiority obscured Vasarely's many significant theoretical and aesthetic contributions to the history of art for many years—as it did those of Bridget Riley.

Riley (b. U.K., 1931) first came to international attention in 1965, when the Museum of Modern Art in New York mounted the exhibition *The Responsive Eye.* She then became the first woman to win the coveted International Prize for Painting at the Venice Biennale, in 1968. The visual and intellectual rigor of her dynamic patterns and the sensation of movement, figure-ground ambiguities, illusions, and afterimages that they produced brought Riley rapid commercial success.

Similarly optical, but with an entirely different aesthetic aim and theoretical purpose, the "Black Paintings" of Frank Stella (b. U.S., 1936), first exhibited in 1959, consisted of uniform, regulated black enamel stripes on raw canvas. In each, the stripes reiterate the shape of the canvas, whether cruciform, diamond, square, or rectangle. By repeating the geometric structure of the painting itself, Stella strove to eliminate the "relational" figure-ground basis of European illusionistic spatial traditions in order to arrive at a "nonrelational" image. He also questioned the arbitrary division between painting and sculpture, extending painting from the wall by using three-inch stretcher bars to emphasize the object status of the work. Initially severely reductive, Stella's art owed a historical debt to formalism while simultaneously posing its greatest challenge. Eventually his paintings would reach out several feet from the wall into the surrounding space, becoming increasingly sculptural and baroque in shape, as well as expressive in color and gestural mark. Stella analyzed his process in *Working Space* (1986), a study of the influence of Caravaggio and Baroque conceptions of space on the development of modern abstraction.

Donald Judd (b. U.S., 1928–94) also explored and theorized about the ambiguity of the object status of art, both as a sculptor and as a critic. Judd studied painting at the Art Students League and philosophy at Columbia University, where he went on to receive a master's in art history in 1962,working with the art historian Meyer Schapiro.

Taking the nonreferential, concrete materiality of his own objects as a starting point, Judd argued, in his 1965 article "Specific Objects," that the art identified with minimalism, literalism, ABC art, and systemic painting had demonstrated the "insufficiencies" and historical overdetermination of painting and sculpture. He emphasized the "new three-dimensionality" of works that included "real space," got rid of "the problem of illusionism," and introduced "all sorts of materials and colors."[20] In a 1966 interview by the critic Bruce Glaser, Judd and Stella discussed the central aesthetic aims of their work.

Other artists associated with the kinds of art that Judd theorized as "specific objects"—and the Brazilian critic Ferreira Gullar, before him, called "non-objects"—included the poet-sculptor Carl Andre (b. U.S., 1935), the sculptor Dan Flavin (b. U.S., 1933–96), and the architect-sculptor Tony Smith (b. U.S., 1912–80). Andre abandoned the pedestal and rejected the vertical basis of traditional sculpture by placing modular forms horizontally on the floor in permutational units, following his formula "form = structure = place." Flavin used fluorescent tubing to create neutral lines of light organized in various configurations that resemble light drawings defining the surrounding space. Smith had studied architecture at the New Bauhaus in Chicago (1937–38) and had been an apprentice to Frank Lloyd Wright (1938–40) before taking up sculpture. His *Die* (1962/1968), a black cube, became the prototypical minimalist object.

These and similar artists were included in two important exhibitions in New York in 1966: *Primary Structures,* organized by Kynaston McShine at the Jewish Museum, and *Systemic Painting,* organized by Lawrence Alloway at the Solomon R. Guggenheim Museum. These artists' works revealed how art depends on context, environment, and placement for its meaning and reception, and linked minimalism to the development of conceptual, process, performance, and site-specific art. The objects, theories, and practices of the artist Robert Morris (see chap. 7) also provide instructive examples of this intersection, which was decried by the art historian Michael Fried in his influential essay "Art and Objecthood" (1967). Rejecting such art as "situationalist," Fried argued that the "viewer-inclusive" conditionality of such objects rendered them inherently "theatrical," and that this "situationality" was "alien" to the aims, traditions, and values of the visual arts; he therefore called for the "defeat" of such work.[21]

Although often associated with minimalism for her attention to planar surfaces, symmetry, grids, and other geometric forms, the Canadian-born painter Agnes Martin (1912–2004), who moved to the United States in 1931, maintained a distant identification with that movement. In the 1950s she abandoned her representational approach of the previous decade and moved into organic abstraction influenced by the Surrealist and myth-inspired works of Adolph Gottlieb and William Baziotes. In 1959 she began creating diaphanous monochromatic surfaces overlaid with graphite pencil grids. She stopped painting to write between 1967 and 1973, but then returned to geometric abstraction.

Brice Marden (b. U.S., 1938) matured as an artist in the milieu of minimalism. He produced his first vertical, rectangular monochrome panels in encaustic in the winter of 1964–65. He then painted diptychs and triptychs, the panels of which—arranged either horizontally or vertically—formed austere single-color sections in analogous hues and values. A distinctive feature of some of Marden's monochromes was the narrow

unpainted space that he left at the bottom of each work, into which he let drips spill from the thick, smooth surface above. These painterly edges underscored the route his painting traveled, from gestural expressionism and color-field painting to minimalism. While staunchly defending the object status of his paintings, Marden acknowledged the mystery and metaphysical relationships evoked by his works, sharing some of the visual concerns and politics of the French group Support-Surfaces (1966–74), which included Louis Cane, Daniel Dezeuze, and Claude Viallat.[22] After a 1983 trip to Thailand, Sri Lanka, and India, and increasingly interested in Asian philosophy, Marden changed his style from monochrome painting to a sinuous, curving gestural abstraction.

Daniel Buren (b. France, 1938) belonged, between 1966 and 1968, to the Paris-based Groupe BMPT, whose name was derived from the first letters of the last names of its members: Buren, Olivier Mosset, Michel Parmentier, and Niele Toroni. At the Salon de la Jeune Peinture in 1967, the group protested painting as a game of aesthetic representation, presenting their geometric works outside of traditional museum and gallery spaces—in the street, on billboards, and in the metro—and urging the public to "become intelligent" about the cultural problems of painting:

> Because painting is a game,
> Because painting is the application (consciously or otherwise) of the rules
> of composition,
> Because painting is the freezing of movement,
> Because painting is the representation (or interpretation or appropriation
> or disputation or presentation) of objects,
> Because painting is a springboard for the imagination,
> Because painting is spiritual illustration,
> Because painting is justification,
> Because painting serves an end,
> Because to paint is to give aesthetic value to flowers, women, eroticism, the
> daily environment, art, Dadaism, psychoanalysis and the war in Vietnam,
> *We are not painters.*[23]

To this end, Buren standardized his canvases into a uniform representation consisting of a repeatable format: he purchased fabric normally used for café awnings in which vertical stripes of white canvas alternated with color bands 8.7 centimeters (about $3\frac{1}{2}$ inches) wide, the color dictated by the cloth available. Neither defining his objects as art nor denying them that status, Buren in this way offered a visual critique of the ideological conditions of artistic production, from the artist's studio to gallery and museum installations. His thorough study of cultural production has ranged from the materials and forms of visual practice, to art in the service of cultural institutions, and to the role of art as decoration for architectural adornment.

Dorothea Rockburne has also been concerned with a structural approach to painting and its object-like contingency to a wall. Born in Canada in 1932, she was educated in Montreal at the École des Beaux-Arts and the Museum School, before receiving a scholarship to attend Black Mountain College in North Carolina in 1950. There she studied painting, music, and dance, as well as mathematics. In the late 1960s Rockburne began to apply mathematical set theory (used to define the totality of all points or numbers that

satisfy a given condition) to three-dimensional paintings installed in configurations that reached off the wall. By the early 1970s she was producing painting installations of folded linen, inspired by her interest in art and science as well as the body in performance. In her *Golden Section Paintings* (1974) she coated linen with gesso on one side and varnish on the other, then cut and folded it according to the ancient geometric principle of the golden ratio, and finally glued everything into a structure and attached it to the wall with Velcro. Expanding this approach to what she sometimes called "wall drawings," Rockburne would create an array of works at the intersection of art, science, and mysticism.

Too often, the visual appearance of abstract geometric painting and sculpture has belied the aesthetic and political conflicts the works suggest; tensions between the aesthetic aims of formalism; the context-specific, viewer-inclusive political agenda of minimalism, process art, and conceptual art; and the historical concerns of those interested in the implications of pattern and decoration. The paintings of Alfred Jensen (b. Guatemala, 1903–81) anticipated many of these concerns. Jensen, often described as a citizen of the world who traveled extensively and spoke five languages, was nonetheless associated with the New York School of painters. His thick impasto representations of numbers, symbols, and geometric patterns were informed by a voracious study of various scientific, cultural, and metaphysical systems, including those described in Leonardo da Vinci's writings, the *I Ching,* Goethe's *Theory of Colors* (1810), and John Eric Sydney Thompson's *Maya Hieroglyphic Writing* (1950), as well as theories of electromagnetics, Pythagorean geometry, space flight, Greek architecture, and numerology. Jensen's idiosyncratic paintings grew out of his studies with Hans Hofmann and bridged European geometric and New York School gestural abstraction. He also anticipated minimalist systems-based works and techniques of appropriation associated with postmodernist practices.

Eschewing symbolic connotations, the architectonically constructed paintings of Sean Scully (b. Ireland, 1945) evoke elements of the visible world, as the title of the artist's 2001 exhibition *Walls, Windows, Horizons* suggests. With their interlocking sets of horizontal and vertical stripes, organized in color panels and painted in thickly applied oil that produces highly textured surfaces, Scully's paintings reside at the intersection of geometric and gestural abstraction. Often monumental in size, his works may refer to such natural phenomena as light. "I am trying to give light a feeling of body," the artist has explained. "The words light and spirit are interchangeable in my opinion. I'm trying to capture something that has a classical stillness and at the same time has enough emotion or dissonance to create an unresolved quality."[24]

From a different perspective, Scully's geometric patterns recall the feminist reexamination of decorative traditions in art, architecture, and crafts in the mid-1970s— research that sought to foster a nonhierarchical, nonelitist, nontranscendental, gender-inclusive art. The opening of the Islamic wing at the Metropolitan Museum of Art in New York in 1975 introduced visitors to a multiplicity of Asian and Middle Eastern ceramic tiles, manuscript illuminations, and other instances of geometric composition exemplifying the historical decorative tradition to which this thread of 1970s geometric abstraction was indebted. Artists like Valerie Jaudon, Joyce Kozloff, Howardena Pindell, Miriam Schapiro, Robert Kushner, Robert Zakanitch, Kim MacConnel, Lucas Samaras, and others investigated traditional American quilts, anonymous African and

Native American basket and pottery patterns, Asian fabric design, and other sources of visual imagery related to the abstract geometric tradition.

A pioneer in feminist art, education, and theory, Miriam Schapiro (b. Canada, 1923) attended the State University of Iowa, where she met and married the U.S. painter Paul Brach in 1946. She began as a hard-edge abstractionist and was included in the Jewish Museum's exhibition *Toward a New Abstraction* in 1963, before joining the University of California, San Diego, faculty in 1967. Three years later she met Judy Chicago, with whom she cofounded and codirected the Feminist Art Program at the California Institute of the Arts in Valencia (1971–73). Schapiro and Chicago also organized the *Womanhouse* exhibition in a Hollywood mansion in 1972. Emphasizing collaboration as an aesthetic and political strategy, Schapiro and the painter Robert Zakanitch organized the first meeting of the Pattern and Decoration group in New York in January 1975. Schapiro also helped found the feminist collective that published *Heresies,* a journal on art and politics, starting in 1977.[25]

In a 1978 *Heresies* article, Schapiro and the painter Melissa Meyer (b. U.S., 1947) coined the term "femmage." Meyer—like Schapiro, a member of the Heresies Collective—had earned her BS (1968) and MA (1975) degrees from New York University. She wondered why so many women made collage, a question motivated in part by the anonymous scrapbooks she had collected from flea markets and elsewhere. Recognizing that these scrapbooks themselves were examples of collage, Meyer and Schapiro researched the tradition of collecting, recycling, saving, transforming, and commemorating that had resulted in women's production of devotional pieces, quilts, embroidery, piecework, appliqué, weaving, tatting, scrapbooks, and visual diaries. Their research culminated in the *Heresies* article "Waste Not, Want Not: An Inquiry into What Women Saved and Assembled—Femmage," for which Meyer designed the layout.

In the same issue of *Heresies,* over a decade before discussion of diversity and multiculturalism became widespread, Joyce Kozloff (U.S., b. 1942) and Valerie Jaudon (U.S., b. 1945) analyzed a bias against decorative and ornamental art in their essay "Art Hysterical Notions of Progress and Culture" (1978). This essay exposed what they identified as the patriarchal, colonialist, imperialist, sexist, and racist foundations of Western art history, criticism, and theory. Kozloff earned an MFA from Columbia University in 1967 and taught extensively throughout the United States. For many years she did artworks for urban transportation systems, receiving public commissions for the Harvard Square subway station in Cambridge, Massachusetts (1979–85), and the International Arrivals Building at San Francisco Airport (1982–83), among others. Jaudon, who had attended Mississippi State College for Women and the Memphis Academy of Art before studying abroad in Mexico City and London, created paintings that combined decorative patterns with the architectural austerity and interlaced grids of minimalism.

The debates over geometric abstraction and decorative painting reflected a broader rethinking of traditional historical forms and modernist avant-garde aims by artists in the 1980s, as poststructuralist theories of postmodernity announced a change in attitude about the progressive production of avant-garde styles. In a continuing critique of the notion of originality, some artists rejected the idea of "new" forms, appropriating images from the past to present an ironical pastiche of originality in the present. With a BA from Yale University (1975) and an MFA from the University of New Orleans (1978),

the painter-critic Peter Halley (b. U.S., 1953) typified the university-trained artist who had matured in a cultural climate dominated by critical theory. Drawing eclectically from a plurality of visual and theoretical models, his theory and practice provided visual testimony to the cultural critique offered by Michel Foucault, Roland Barthes, and Jean Baudrillard. Dubbed a "Neo-Geo" painter by critics, Halley quoted the whole of twentieth-century geometric abstraction, observing: "One can refer to it as either postmodernism or as neo-modernism, but what is characteristic of this order is that the elements of modernism are hyper-realized. They are reduced to their pure formal state and are denuded of any last vestiges of life or meaning. They are re-deployed in a system of self-referentiality which is itself a hyper-realization of the modernist dream of revolutionary renewal. In post- or neo-modernism, the syntactical elements do not change. . . . Art is replaced by its double, by objects and images duplicating the 'art-effect.' "[26] At the end of the twentieth century, Halley's theory and practice joined modernists' material practices to postmodernists' skepticism of history as a construct.

In the abstract sculptures and installations of Anish Kapoor, enigma both tempers and augments postmodern doubt. Born in India in 1954, Kapoor came to wide public attention in the 1980s with odd, geometrically shaped sculptures powdered with brilliant monochromatic colors that borrowed their intense hues from pigments found in the markets of Bombay (Mumbai), where Kapoor grew up. Before settling in London, where he studied art, Kapoor had also lived on a kibbutz in Israel. In the 1990s he turned to marble carved with smooth, undulating shapes and cavities, or simple blocks of quarried stone punctured with holes, evoking the feeling of peering into the abyss. His outdoor sculpture *Cloud Gate* (2004), in Chicago's Millennium Park, is a 110-ton arched and rounded form, forged of highly polished stainless-steel plates. It both reflects the surrounding buildings and sky and permits the public to pass beneath it. Similarly, the artist's 2001 *Sky Mirror* (refashioned for New York's Rockefeller Center in 2006) is a highly polished convex piece of stainless steel that functions like a reflecting lens, capturing views of the cityscape around it.

While Kapoor draws on Western and Asian philosophy and cultures to produce works of exquisite beauty and mystery, Odili Donald Odita—who was born in Nigeria in 1966 but grew up and was educated in the United States—fuses Western and African sources to create vibrantly colored abstract paintings and environments of experiential depth and complexity. Odita's paintings are composed of hard-edged irregular bands, waves, and vectorlike elongated triangles and trapezoids, deployed in subtle variations of color or juxtapositions of complementary colors that vibrate visually. While Odita's works recall the textiles and body decoration of the Nigerian Igbo, he uses digital technologies to design the intersecting planes that create the sense of infinite spatial recess and dynamism evoked by his large-scale, site-specific installations. Odita's vigorous abstract structural patterns serve as metaphors for what he calls the "fusion of cultures where things that seem faraway and disparate have the ability to function within an almost seamless flow," where the subtle national and cultural tensions that characterize the twenty-first century can be resolved. Odita has also expressed his ideas as a curator and critic, writing with fellow Nigerians Olu Oguibe, Iké Udé, and Okwui Enwezor for Enwezor's journal *Nka: Journal of Contemporary African Art*.

BORIS MIKHAILOV
From the Series "On the Color Backgrounds" (2005)

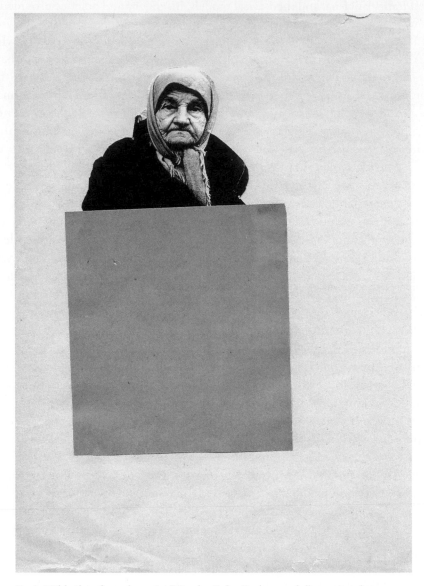

Boris Mikhailov, from the series "On the Color Backgrounds," c. 1960, photo-montage. © 2012 Boris Mikhailov/Artists Rights Society (ARS), New York/VG Bild-Kunst, Germany. Courtesy Sprovieri Progetti, London.

It was the time when the abyss between photographers and painters was enormous. This work was a probe where I, photographer—"pariah dog"—tried to invade the strange territory of Art.

* Boris Mikhailov, "From the series 'On the Color Backgrounds,' " in Francesca Richer and Matthew Rosen-zweig, eds., *No. 1: First Works by 362 Artists* (New York: D.A.P./Distributed Art Publishers, 2005), 242. By permission of the artist, courtesy Sprovieri Progetti, London, and the publisher. © 2012 Boris Mikhailov/Artists Rights Society (ARS), New York/VG Bild-Kunst, Germany.

And even now, it is very agreeable for me to realize that this image could compete with the ideas of painters.

Russian culture is based on two visual traditions which I segregate as so important—icons and suprematism. And maybe, therefore, the old woman begging for money at the church parapet was connected, by the red square, with Malevich. I was so glad and proud of myself—I could bind real life and art.

Certainly, this composition tells neither about suprematism nor about icons . . . It tells about the old woman, standing at the great tribune, which was associated with party leaders, who usually stood there to make speeches . . . If the corner of the red paper piece were raised, you would see the outstretched appealing arm . . .

The photo is from the series "On the Color Backgrounds," in which banal images were superimposed on children's colored paper to create an ironic feeling.

MAX BILL Concrete Art (1936–49)

We call "Concrete Art" works of art which are created according to a technique and laws which are entirely appropriate to them, without taking external support from experiential nature or from its transformation, that is to say, without the intervention of a process of abstraction.

Concrete Art is autonomous in its specificity. It is the expression of the human spirit, destined for the human spirit, and should possess that clarity and that perfection which one expects from works of the human spirit.

It is by means of concrete painting and sculpture that those achievements which permit visual perception materialize.

The instruments of this realization are color, space, light, movement. In giving form to these elements, one creates new realities. Abstract ideas which previously existed only in the mind are made visible in a concrete form.

Concrete Art, when it is true to itself, is the pure expression of harmonious measure and law. It organizes systems and gives life to these arrangements, through the means of art. It is real and intellectual, anaturalist while being close to nature. It tends toward the universal and yet cultivates the unique, it rejects individuality, but for the benefit of the individual.

The Mathematical Approach in Contemporary Art (1949)

By a mathematical approach to art it is hardly necessary to say I do not mean any fanciful ideas for turning out art by some ingenious system of ready reckoning with the aid of mathematical formulas. So far as composition is concerned every former school of art can be said to have had a more or less mathematical basis. There are also many trends in modern art which rely on the same sort of empirical calculations. These, together with the artist's own individual scales of value, are just part of the ordinary elementary principles of design for estab-

* Max Bill, "Concrete Art," in *Zeitprobleme in der Schweizer Malerei und Plastik* (1936); revised for *Zürcher Konkrete Kunst* (1949); reprinted in *Max Bill* (Buffalo: Buffalo Fine Arts Academy, 1974), 47. Translation by Peter Selz. By permission of the author and the Buffalo Fine Arts Academy.

** Max Bill, excerpts from "The Mathematical Approach in Contemporary Art," in *Werk* 3 (1949); reprinted in *Arts and Architecture* 71, no. 8 (August 1954): 20–21, and in *Max Bill* (Buffalo: Buffalo Fine Arts Academy, 1974), 89–100. By permission of the author and the Buffalo Fine Arts Academy.

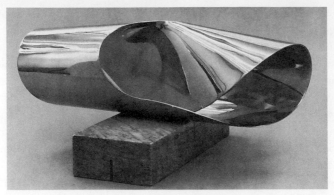

Max Bill, *Endless Ribbon from a Ring I,* 1947–49 (executed 1960), gilded copper on crystalline base. Hirshhorn Museum and Sculpture Garden, Washington, D.C. © 2012 Max Bill Estate/Artists Rights Society (ARS), New York/PRO LITTERIS, Zurich

lishing the proper relationship between component volumes; that is to say for imparting harmony to the whole. Yet it cannot be denied that these same methods have suffered considerable deterioration since the time when mathematics was the foundation of all forms of artistic expression and the covert link between cult and cosmos. Nor have they seen any progressive development from the days of the ancient Egyptians until quite recently, if we except the discovery of perspective during the Renaissance. This is a system which, by means of pure calculation and artificial reconstruction, enables objects to be reproduced in what is called "true-to-life" facsimile by setting them in an illusory field of space. Perspective certainly presented an entirely new aspect of reality to human consciousness, but one of its consequences was that the artist's primal image was debased into mere naturalistic replica of his subject. Therewith the decadence of painting, both as a symbolic art and an art of free construction, may be said to have begun. . . .

I am convinced it is possible to evolve a new form of art in which the artist's work could be founded to quite a substantial degree on a mathematical line of approach to its content. This proposal has, of course, aroused the most vehement opposition. It is objected that art has nothing to do with mathematics; that mathematics, besides being by its very nature as dry as dust and as unemotional, is a branch of speculative thought and as such in direct antithesis to those emotive values inherent in aesthetics; and finally that anything approaching ratiocination is repugnant, indeed positively injurious to art, which is purely a matter of feeling. Yet art plainly calls for both feeling and reasoning. In support of this assertion the familiar example of Johann Sebastian Bach may be credited; for Bach employed mathematical formulas to fashion the raw material known to us as sound into the exquisite harmonies of his sublime fugues. And it is worth mentioning that, although mathematics had by then fallen into disuse for composition in both his own and the other arts, mathematical and theological books stood side by side on the shelves of his library.

It is mankind's ability to reason which makes it possible to coordinate emotional values in such a way that what we call art ensues. Now in every picture the basis of its composition is geometry or in other words the means of determining the mutual relationship of its compo-

nent parts either on plane or in space. Thus, just as mathematics provides us with a primary method of cognition, and can therefore enable us to apprehend our physical surroundings, so, too, some of its basic elements will furnish us with laws to appraise the interactions of separate objects, or groups of objects, one to another. . . .

It must not be supposed that an art based on the principles of mathematics, such as I have just adumbrated, is in any sense the same thing as a plastic or pictorial interpretation of the latter. Indeed, it employs virtually none of the resources implicit in the term "Pure Mathematics." The art in question can, perhaps, best be defined as the building up of significant patterns from the ever changing relations, rhythms and proportions of abstract forms, each one of which, having its own causality, is tantamount to a law unto itself. As such, it presents some analogy to mathematics itself where every fresh advance had its immaculate conception in the brain of one or other of the great pioneers. Thus Euclidian geometry no longer possesses more than a limited validity in modern science, and it has an equally restricted utility in modern art. The concept of a Finite Infinity offers yet another parallel. For this essential guide to the speculations of contemporary physicists has likewise become an essential factor in the consciousness of contemporary artists. These, then, are the general lines on which art is daily creating new symbols: symbols that may have their sources in antiquity but which meet the aesthetic-emotional needs of our time in a way hardly any other form of expression can hope to realize.

Things having no apparent connection with mankind's daily needs—the mystery enveloping all mathematical problems; the inexplicability of space—space that can stagger us by beginning on one side and ending in a completely changed aspect on the other, which somehow manages to remain that selfsame side; the remoteness or nearness of infinity—infinity which may be found doubling back from the far horizon to present itself to us as immediately at hand; limitations without boundaries; disjunctive and disparate multiplicities constituting coherent and unified entities; identical shapes rendered wholly diverse by the merest inflection; fields of attraction that fluctuate in strength; or, again, the square in all its robust solidity; parallels that intersect; straight lines untroubled by any relativity and ellipses which form straight lines at every point of their curves—can yet be fraught with the greatest moment. For though these evocations might seem only the phantasmagorical figments of the artist's inward vision they are, notwithstanding, the projections of latent forces; forces that may be active or inert, in part revealed, inchoate or still unfathomed, which we are unconsciously at grips with every day of our lives; in fact that music of the spheres which underlies each man-made system and every law of nature it is within our power to discern.

Hence all such visionary elements help to furnish art with a fresh content. Far from creating a new formalism, as is often erroneously asserted, what these can yield us is something far transcending surface values since they not only embody form as beauty, but also form in which intuitions or ideas or conjectures have taken visible substance. The primordial forces contained in those elements call forth intimations of the occult controls which govern the cosmic structure; and these can be made to reflect a semblance of the universe as we have learned to picture it today: an image that is no mere transcript of this invisible world but a systematization of it ideographically conveyed to our senses.

It may, perhaps, be contended that the result of this would be to reduce art to a branch of metaphysical philosophy. But I see no likelihood of that for philosophy is speculative thought of a special kind which can only be made intelligible through the use of words. Mental concepts are not as yet directly communicable to our apprehension without the medium of

language; though they might ultimately become so by the medium of art. Hence I assume that art could be made a unique vehicle for the direct transmission of ideas, because if these were expressed by pictures or plastically there would be no danger of their original meaning being perverted . . . by whatever fallacious interpretations particular individuals chance to put on them. Thus the more succinctly a train of thought was expounded and the more comprehensive the unity of its basic idea, the closer it would approximate the prerequisites of the Mathematical Approach to Art. So the nearer we can attain to the first cause or primal core of things by these means, the more universal will the scope of art become—more universal, that is, by being free to express itself directly and without ambivalence; and likewise forthright and immediate in its impact on our sensibility.

To which, no doubt, a further objection will be raised that this is no longer art; though it could equally well be maintained that this alone was art. . . .

Although this new ideology of art is focused on a spectral field of vision this is one where the mind can still find access. It is a field in which some degree of stability may be found, but in which, too, unknown quantities, indefinable factors will inevitably be encountered. In the ever-shifting frontier zones of this nebular realm new perspectives are continually opening up to invite the artist's creative analysis. The difference between the traditional conception of art and that just defined is much the same as exists between the laws of Archimedes and those we owe Einstein and other outstanding modern physicists. Archimedes remains our authority in a good many contingencies though no longer in all of them. Phidias, Raphael, and Seurat produced works of art that characterize their several epochs for us because each made full use of such means of expression as his own age afforded him. But since their days the orbit of human vision has widened and art has annexed fresh territories which were formerly denied to it. In one of these recently conquered domains the artist is now free to exploit the untapped resources of that vast new field of inspiration I have described with the means our age vouchsafes him and in a spirit proper to its genius. And despite the fact the basis of this Mathematical Approach to Art is in reason, its dynamic content is able to launch us on astral flights which soar into unknown and still uncharted regions of the imagination.

RICHARD PAUL LOHSE Lines of Development (1943–72)

Forms of an individual character are superseded by objective elements.

The pictorial field is a structured field. Formal structure becomes color structure.

Color series provide laws for formal expression.

Themes take over the function of the element.

The many contains the possibility of the individual.

Aesthetic freedom, equilibrium are transformed into predetermination, the forcefulness of the static/tectonic into one of the kinetic/flexible.

The microstructure of the concretion of the first hour becomes a macrostructure of multiplicity, its harmony determined by methods of combination.

Expression is determined by anonymity of means, unlimitedness of structural laws, relativity of dimensions, capability of expansion, and flexibility.

Machine and expression are developed simultaneously; the method represents itself, it *is* the image.

* Richard Paul Lohse, excerpts from "Lines of Development" (1943–72), in *Documenta 7,* vol. 1 (Kassel: Documenta, 1982), 441. By permission of the Richard Paul Lohse Foundation.

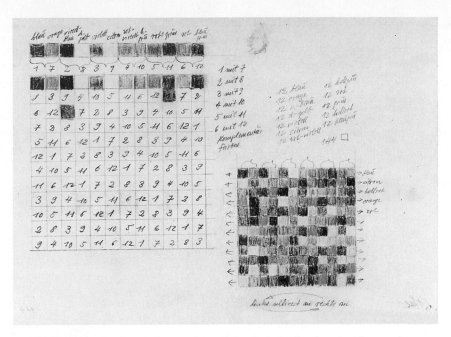

Richard Paul Lohse, *Continually interpenetrating range of colors based on a serial system from 1–12*, 1944, pencil and colored pencil on tracing paper. Photo by Jeanne-Pierre Kuhn. © Richard Paul Lohse Foundation, Zurich.

Significant are image-organizing structures in which each part is identical to all parts and beginning and end of image formation are congruent.

Integration of limits gives the unlimited.

Individual expression lies in the choice of methods, in the manipulation of provisions.

Aesthetic value is no longer the result of equilibrium, but the result of provisions.

The task consists in developing systems which make lucid and combinable, flexible arrangements possible.

There is no definition of aesthetic without a definition of its social basis.

The rational principle of every epoch possesses only one expression adequate to it.

Every method is determined by time and expresses itself via an original temporal structure, the sum of being, consciousness and action.

Serial and modular design methods, by their dialectical character, are parallels to expression and activity in a new social reality.

Forms of expression in a non-hierarchical society correspond to that society in its visual exposition: flexible, transparent, their methods and results controllable.

Art obtains its social value as an instrument of recognition.

Systematic design is an analogous parallel to the structures of our contemporary state of life, civilization—although identical [to civilization], it [systematic design] simultaneously calls the social effectiveness of this state into question. By the use of objective means, the transparency of its methods, the possibility of its predictability, the formation of structures that are both based on laws and unlimited, its thinking and working methods are exemplary in their aim to change our environment.

GYULA KOŠICE Madí Manifesto (1946)

Madí art can be identified by the organization of elements peculiar to each art in its continuum. It contains presence, movable dynamic arrangement, development of the theme itself, lucidity and plurality as absolute values, and is, therefore, free from interference by the phenomena of expression, representation and meaning.

Madí *drawing* is an arrangement of dots and lines on a surface.

Madí *painting,* colour and two-dimensionality. Uneven and irregular frame, flat surface, and curved or concave surface. Articulated surfaces with lineal, rotating and changing movement.

Madí *sculpture,* three-dimensional, no colour. Total form and solid shapes with contour, articulated, rotating, changing movement, etc.

Madí *architecture,* environment and mobile movable forms.

Madí *music,* recording of sounds in the golden section.

Madí *poetry,* invented proposition, concepts and images which are untranslatable by means other than language. Pure conceptual happening.

Madí *theatre,* movable scenery, invented dialogue.

Madí *novel and short story,* characters and events outside specific time and space, or in totally invented time and space.

Madí *dance,* body and movements circumscribed within a restricted space, without music. . . .

To sum up, pre-Madí art:

A scholastic, idealist historicism

An irrational concept

An academic technique

A false, static and unilateral composition

A work lacking in essential utility

A consciousness paralysed by insoluble contradictions; impervious to the permanent renovation in technique and style

Madí stands against all this. It confirms man's constant all-absorbing desire to invent and construct objects within absolute eternal human values, in his struggle to construct a new classless society, which liberates energy, masters time and space in all senses, and dominates matter to the limit. Without basic descriptions of its total organization, it is impossible to construct the object or bring it into the continuity of creation. So the concept of invention is defined in the field of technique and the concept creation as a totally defined essence.

For Madí-ism, invention is an internal, superable 'method,' and creation is an unchangeable totality. Madí, therefore, INVENTS AND CREATES.

* Gyula Košice, excerpt from "Madí Manifesto" (1946), reprinted in Dawn Ades, *Art in Latin America: The Modern Era, 1820–1980,* with contributions by Guy Bett, Stanton Loomis Catlin, and Rosemary O'Neill (New Haven and London: Yale University Press and South Bank Centre, 1989), 330. By permission of the author and the publisher.

GRUPO RUPTURA The Ruptura Manifesto (1952)

old art was great when it was intelligent.

however, our intelligence cannot be the same as Leonardo's.

history has taken a qualitative leap:

continuity is no longer possible!

- those who create new forms out of old principles

now we can distinguish

- those who create new forms out of new principles

why?

because the scientific naturalism of the Renaissance—the process of rendering the (three-
dimensional) external world on a (two-dimensional) plane—has exhausted
its historical task

it was crisis

it was renovation

today the new can be accurately differentiated from the old, when parting with the old,
and for this reason we can affirm:

the old is

- all varieties and hybrids of naturalism;
- the mere negation of naturalism, i.e., the "wrong" naturalism of children, the
insane, the "primitive," the expressionists, the surrealists etc.;
- the hedonistic nonfigurativism spawned by gratuitous taste that seeks the mere
excitement of pleasure or displeasure

the new is

- all expressions based on the new art principles;
- all experiences that tend to renewal of the fundamental values of visual art (space-time,
movement, and matter);
- the artistic intuition endowed with clear and intelligent principles as well as great pos-
sibilities of practical development;
- to bestow on art a definite place within the scope of contemporary spiritual work,
while considering art as a means of knowledge deducible from concepts, situating
it above opinion and demanding, for its review, a previous knowledge.

modern art is not ignorance; we are against ignorance.

* Lothar Charoux, Waldemar Cordeiro, Geraldo de Barros, Kazmer Féjer, Leopoldo Haar, Luís Sacilotto, and
Anatol Wladyslaw, "Manifesto ruptura," published in 1952 on the occasion of the exhibition of the Grupo Ruptura
at the Museu de Arte Moderna de São Paulo; reprinted as "ruptura," in *Correio Paulistano* (São Paulo), supp. (11
January 1953), 3; reprinted in English in Mari Carmen Ramírez and Héctor Olea, *Inverted Utopias: Avant-Garde Art
in Latin America* (New Haven: Yale University Press in association with the Museum of Fine Arts, Houston, 2004),
494. Courtesy Analívia Cordeiro, Fabiana de Barros and Sicardi Gallery, Peter Fejer, Valter Sacilotto, and the
publishers.

FERREIRA GULLAR et al. Neo-Concrete Manifesto (1959)

The term *neo-Concrete* indicates a position vis-à-vis nonfigurative "geometric" art (Neo-Plasticism, Constructivism, Suprematism, the Ulm School), and, in particular, concrete art taken to a dangerous rationalist extreme. The painters, sculptors, engravers, and writers participating in [this] first Neo-Concrete Exhibition—as a result of their artistic experiences—are reviewing the current theoretical positions adopted with respect to concrete art. This is because none adequately "covers" the expressive potential opened up by such experiences.

Born with Cubism in reaction to the Impressionist dissolution of pictorial language, it was natural that geometric art should adopt a position diametrically opposed to the technical and allusive laissez-faire nature of the painting of the time. Advances in physics and mechanics widened the horizons of objective thought and led those responsible for deepening this artistic revolution to an ever-increasing rationalization of the processes and purposes of painting. Mechanical notions of construction applied to works of art invaded the language of painters and sculptors, generating, in turn, equally extremist reactions of a retrograde nature, such as magical realism or the irrational irruptions Dada and Surrealism.

However, there is no doubt that, despite the consecration of the objectivity of science and the precision of mechanics, true artists—such as, for example, [Piet] Mondrian and [Nikolaus] Pevsner—overcame the limits imposed by theory in their daily struggle against expression to produce a work. But the production of these artists has always been interpreted with reference to theoretical principles which their work, in fact, denied. We propose that Neo-Plasticism, Constructivism, and the other similar movements should be reevaluated with reference to their power of expression rather than to the theories on which they based their art. If we claim to be able to understand Mondrian's art by examining his theories, we would have to conclude one of two things. Either we believe that it is possible for art to be part and parcel of everyday life—and Mondrian's work takes the first steps in this direction—or we would conclude that such a thing is impossible, in which case his work fails in its aims. Either the vertical and the horizontal planes really are the fundamental rhythms of the universe and the work of Mondrian is the application of that universal principle, or the principle is flawed and his oeuvre is founded on an illusion. Nevertheless, the work of Mondrian exists, alive and fertile, in spite of such theoretical contradictions. There would be no point in seeing Mondrian as the destroyer of surface, plane, and line if we do not connect with the new space built by his destruction.

The same can be said of [Georges] Vantongerloo and Pevsner. It does not matter what mathematical equations are at the root of a piece of sculpture or of a painting by Vantongerloo. It is only when someone sees the work of art that its rhythms and colors have meaning. The fact that Pevsner used figures of descriptive geometry as his starting points is irrelevant in light of the new space that his sculptures gave birth to and the cosmic-organic expression that his works reveal. To establish the relationships between artistic objects and scientific instruments, as well as between the intuition of the artist and the objective thought of the physicist and the engineer might have a specific cultural interest. But, from the aesthetic point

* Ferreira Gullar, Franz Weissmann, Lygia Clark, Lygia Pape, Amilcar de Castro, Theon Spanudis, and Reynaldo Jardim, excerpts from "Manifesto neoconcreto," *Jornal do Brasil* (Rio de Janeiro), supp. (22 March 1959), 4–5; reprinted in English in Mari Carmen Ramírez and Héctor Olea, *Inverted Utopias: Avant-Garde Art in Latin America* (New Haven: Yale University Press in association with the Museum of Fine Arts, Houston, 2004), 496–97. Courtesy Ferreira Gullar, Cultural Association "The World of Lygia Clark," Proeto Lygia Pape—Cultural Association, and the publishers.

of view, the interesting thing about art is that it transcends such considerations and creates and reveals a universe of existential significance.

[Kasimir] Malevich, because he recognized the primacy of "pure sensibility in art," spared his theoretical definitions the limitations of rationalism and mechanistic trends and gave his painting a transcendental dimension that makes him very relevant today. But Malevich paid dearly for the courage he showed in simultaneously opposing figurativism and mechanistic abstraction. To this day, certain rationalist theoreticians consider him an ingenuous person who never properly understood the true meaning of the new plasticism . . . In fact, Malevich's "geometric" painting already expresses a lack of satisfaction, a will to transcend the rational and the sensory, that today manifests itself irrepressibly. **Neo-Concrete art,** born out of the need to express the complex reality of modern humanity inside the structural language of a new plasticity, denies the validity of scientific and positivist attitudes in art and raises the question of expression, incorporating the new "verbal" dimensions created by Constructivist nonfigurative art. Rationalism robs art of its autonomy and substitutes the artwork's own nontransferable qualities with notions of scientific objectivity; thus the concepts of form, space, time, and structure—which in the language of the arts have an existential, emotional, and affective significance—are confused with the theoretical approach that science makes of them. In the name of prejudices that philosophers today denounce ([Maurice] Merleau-Ponty, [Ernst] Cassirer, [Susanne] Langer) and that are no longer upheld in any intellectual field beginning with modern biology, which now has gone beyond Pavlovian conditioning, the concrete rationalists still think of human beings as machines and seek to limit art to the expression of this theoretical reality.

We do not conceive of a work of art as a "machine" or as an "object," but as a *quasi-corpus;* that is to say, something that amounts to more than the sum of its constituent elements; something that analysis may break down into various elements but that can only be thoroughly understood by phenomenological means. We believe that a work of art represents more than the material from which it is made, and not because of any extra-terrestrial quality it might have: it represents more because it transcends mechanical relationships (objectified in Gestalt psychology) and generates a tacit signification (Merleau-Ponty) stemming from the work itself. If we needed a simile for an objectively considered work of art, we would not find one, therefore, in machines or in objects, but only in living organisms, as Langer and V[ladimir] Weidlé have said. However, such a comparison would still not be able to express adequately the specific reality of the aesthetic organism.

This is because a work of art does not just occupy a particular locus in objective space, but transcends it to become something meaningfully new that the objective notions of time, space, form, structure, color, etc., are not sufficient in themselves to explain. The difficulty of using precise terminology to express a world that is not so easily described by such notions did not stop art critics from indiscriminately using words that fall short of the complexity of artworks. Science and technology had a big influence here, to the extent that today, roles are inverted, and certain artists, confused by this terminology, try to use objective notions as a creative method in their art.

Inevitably, artists such as these only get as far as illustrating ideas a priori, because they are restricted by a method that from the beginning prescribes the result. The concrete rationalist artist eschews the creativity of intuition and thinks of himself as an objective body in objective space. His paintings demand nothing more of themselves than the stimulus/reaction response of the viewer; the artist's work speaks to the eye as an instrument and not as a human organ capable of interaction with the world; the artist speaks to the eye-machine and not to the eye-body.

It is because a work of art transcends mechanical space that, in it, the notions of cause and effect lose any validity. Furthermore, the notions of time, space, form, and color are so integrated—by the very fact that they did not exist beforehand, as notions, as art—that it is impossible to say art could be broken down into its constituent parts. **Neo-Concrete art** affirms the absolute integration of those elements, believes that the "geometric" vocabulary that it uses can express complex human realities as proved by many of the works of Mondrian, Malevich, Pevsner, [Naum] Gabo, Sofie Tauber-Arp, etc. Even though these artists at times confused the concept of form-mechanics with that of form-expression, we must make clear that, in the language of art, the so-called geometric forms lose the objective character of geometry and turn into vehicles for the imagination. The Gestalt, given that it is a causal psychology, is also insufficient to allow us to understand a phenomenon that dissolves space and form as causally determined realities and creates a new time and *spatialization of the work of art*. By spatialization, we mean that the work of art *continuously makes itself present,* in a dynamic reaction with the impulse that generated it and of which *it is already the origin.* And if such a reaction leads us back to the starting point, it is because Neo-Concrete art aims to rekindle the primal experience. Neo-Concrete art lays the foundations for a new expressive space. . . .

The participants in the first Neo-Concrete Exhibition are not part of a "group." They are not linked to each other by dogmatic principles. The incontestable affinity of the research they have been involved in within various fields brought them together and to this exhibition. Their commitment is firstly to their own particular experience, and they will be together for as long as the deep affinity that brought them together exists.

LYGIA CLARK The Death of the Plane (1960)

The plane is a concept created by man for practical purposes: to satisfy his need for balance. The square, which is an abstract creation, is a product of the plane. By arbitrarily defining the limits of space, the square has given man a totally false and rational sense of his own reality. This is what has led to conflicting concepts such as high and low, back and front—all of which have helped to destroy man's sense of the whole. It is also how man projected the transcendent part of his nature, giving it the name of God. Man therefore addressed the issue of his existence by inventing a mirror of his own spirituality.

The square became suffused with a magical spirituality when the artist perceived it as being capable of communicating a total vision of the universe. But *the plane is dead.* The philosophical idea that man projected upon it no longer satisfies him—all that is left is the idea of an external God, one who is outside of man.

When man realized that he was dealing with a poetics about himself that was being projected outwardly, he suddenly understood that he had to integrate that poetics back into himself—making it an inseparable part of his own being.

This integration led him to destroy the rectangular sense of painting. We then swallowed that shattered rectangle and absorbed it into ourselves. In earlier times, when an artist stood before a rectangle, he projected himself into it, and in so doing layered his own transcendence over the surface.

* Lygia Clark, "A morte do plano," in Lygia Clark et al., *Lygia Clark* (Rio de Janeiro: FUNARTE, 1980), 13; reprinted in English in Mari Carmen Ramírez and Héctor Olea, *Inverted Utopias: Avant-Garde Art in Latin America* (New Haven: Yale University Press in association with Museum of Fine Arts, Houston, 2004), 524–25. Courtesy Cultural Association "The World of Lygia Clark" and the publishers.

When we eliminate the plane's role in support of expression, we become aware of the concept of unity as a living and organic whole. We are a whole. And the time has now come to gather up all the fragments of the kaleidoscope in which the concept of man lay in shards.

We submerge ourselves in the totality of the cosmos. We are an integral part of that cosmos, vulnerable on all sides—which in turn cease to be sides: high and low; right and left; back and front. Even good and evil: one more among the fragments that are thus transformed.

Contemporary man can escape the laws of spiritual gravity and learn to float in the cosmic reality as he does in his own innermost reality. He feels overcome by vertigo. The props that support him fall far beyond his reach. He feels like a toddler who must learn to balance himself in order to survive. The primal experience begins.

HÉLIO OITICICA Colour, Time and Structure (1960)

With the sense of colour-time, the transformation of structure became essential. Already, it was no longer possible to use the plane, that old-fashioned element of representation, even when virtualised, because of its 'a priori' connotation of a surface to be painted. Structure rotates, then, in space, becoming itself also temporal: 'structure time.' Structure and colour are inseparable here, as are time and space, and the fusion of these four elements, which I consider dimensions of a single phenomenon, come about in the work.

Dimensions: Colour, Structure, Space, Time

It is not an 'interlocking' of these elements which takes place here, but a fusion, which exists already from the first creative moment; fusion, not juxtaposition. 'Fusion' is organic, whereas juxtaposition implies a profoundly analytical dispersal of elements.

COLOUR

To pigment-based colour, material and opaque by itself, I attempt to give the sense of light. The sense of light can be given to every primary colour, and other colours derived from them, as well as to white and to grey; however, for this experience one must give pre-eminence to those colours most open to light: colour-light: white, yellow, orange, red-light.

White is the ideal colour-light, the synthesis-light of all colours. It is the most static, favouring silent, dense metaphysical duration. The meeting of the two different whites occurs in a muffled way, one having more whiteness, and the other, naturally, more opaqueness, tending to greyish tone. Grey is, therefore, little used, because it is already born from this unevenness of luminosity between one white and another. White, however, does not lose its sense in this unevenness and, for this reason, there remains from grey a role in another sense, which I will speak of when I come to this colour. The whites which confront each other are pure, without mixture, hence also their difference from a grey neutrality.

* Hélio Oiticica, excerpt from "Cor, tempo e estrutura," *Jornal do Brasil* (Rio de Janeiro), Sunday supp. (26 November 1960); reprinted in Jane Alison, ed., *Colour After Klein: Re-thinking Colour in Modern and Contemporary Art* (London: Barbican Art Gallery and Black Dog Publishing, 2005), 166–68. Courtesy Projeto Hélio Oiticica.

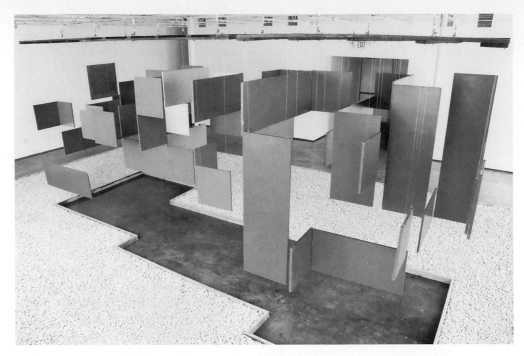

Hélio Oiticica, *Grande Núcleo, with NC3, NC4, and NC6,* 1960–66, oil and resin on wood fiberboard. Courtesy of Projeto Hélio Oiticica.

Yellow, contrary to white, is the least synthetic, possessing a strong optical pulsation and tending towards real space, detaching itself from the material structure, and expanding itself. Its tendency is towards the sign, in a deeper sense, and towards the optical signal, in a superficial sense. It is necessary to note that the meaning of the signal does not matter here, since coloured structures function organically, in a fusion of elements, and are a separate organism from the physical world, from the surrounding space-world. The meaning of the signal would be that of a return to the real world, being, thus, a trivial experience, consisting only of the signalising and virtualising of real space. The meaning of the signal, here, is one of internal direction, for the structure and in relation to its elements, the sign being its profound non-optical, temporal expression. Contrary to white, yellow also resembles a more physical light, more closely related to earthly light. The important thing here is the temporal light sense of colour; otherwise it would still be a representation of light.

Orange is a median colour par excellence, not only in relation to yellow and red, but in the spectrum of colours: its spectrum is grey. It possesses its own characteristics which distinguish it from dark-yolk-yellow and red-light. Its possibilities still remain to be explored within this experiment. Red-light distinguishes itself from blood-red, which is darker, and possesses special characteristics within this experiment. It is neither light-red nor sanguineous vibrant-red, but a more purified red, luminous without arriving at orange since it possesses qualities of red. For this very reason, in the spectrum, it is found in the category of dark colours; but pigmentarily it is hot and open to light. It possesses a grave, cavernous sense of dense light.

The other derivative and primary colours: blue, green, violet, purple and grey, can be intensified towards light, but are by nature opaque colours, closed to light, except grey, which is characterised by its neutrality in relation to light. . . .

The development of structure occurs to the extent to which colour, transformed into colour-light and having found its own time, reveals structure in its interior, leaving it bare. Since colour is colour-time, it would be consistent for structure to be equivalent, to become 'structure time'. Space is indispensable as a dimension of the work, but, by the fact of already existing in itself, it does not pose a problem; the problem, here, is the inclusion of time in the structural genesis of the work. The secular surface of the plane, upon which a space of representation was built, is shorn of all representational reference by the fact that the colour planes enter from the outside until they meet at a certain line. Thus, the plane is broken virtually, but continues to exist as an 'a priori' support. Afterwards, the rectangle is broken, since the planes which before adjoined one another now begin to slide organically. The wall does not serve here as background, but as extraneous, unlimited space, though necessary to the vision of the work. The work is closed within itself as an organic whole, instead of sliding over the wall, or superimposing itself upon it. Structure is then carried into space, rotating 180 degrees about itself, this being the definitive step towards the meeting of its temporality with that of colour; here the spectator does not see only one side, in static contemplation, but tends towards action going around, completing its orbit, in a pluridimensional perception of the work. From then on, development occurs in the direction of appreciating all positions of vision and the research into the dimensions of the work: colour, structure, space and time.

TIME

Colour and structure having arrived at purity, at the primary creative—state static par excellence—of non-representation, it was necessary for them to become independent possessing their own laws. Then the concept of time emerges as the primordial factor of the work. But time, here, is an active element: duration. In representational painting, the sense of space was contemplative, and that of time, mechanical. Space was of a kind which represented fictional space on the canvas, the canvas worked as a window, a field of representation of real space. Time, then, was simply mechanical: the time interval between one figure and another, or of the relation between the figure and perspectival space; in any case, it was the time of figures in a three-dimensional space, which was made two-dimensional on the canvas. Well, from the moment that the plane of the canvas began to function actively, the sense of time necessarily entered as the principal new factor of non-representation.

There then emerges the concept of the 'non-object'—a term invented and theorised by Ferreira Gullar, a more appropriate term than 'picture'—since the structure is no longer one-sided like a picture, but pluridimensional. In the work of art, however, time takes on a special meaning, different from the meanings which it has in other branches of knowledge; it has close ties with philosophy and the laws of perception, but what characterises time in the work of art is its symbolic signification of man's inner relation to the world, an existential relation.

Faced with the non-object, man no longer meditates through static contemplation, but finds his living time as he becomes involved, in a univocal relationship, with the time of the work. Here he is, even closer to 'pure vitality' than Mondrian envisaged. Man lives the polarities of his own cosmic destiny. He is not only metaphysical, but rather, cosmic, the beginning and the end.

As we already saw, the concept of space also changes with the development of painting, and it would be tedious to trace this development here. Let us start here with Mondrian, for whom space was static; not symmetrically static, but static relative to representational space. In opposition to the 'dynamism' of futurism, which was an 'inside the canvas' dynamism, Mondrian's static-dynamic is the immobilisation of this inside-the-canvas and the virtual dynamisation of its horizontal-vertical structure. Mondrian does not conceive time; his space is still that of representation. The concretists still conceive time as mechanical and in this sense . . . they take a step backwards. In their intellectual and analytic conception, space cannot take on a temporal vitality and retains residues of representation. However, it is not my intention to conduct a historical overview of concrete art, but to show the difference between the 'non-object' and a typical 'concrete' work. While the first is dynamic, temporal, the other is static, analytical. To these four elements which I call dimensions: colour, time, structure, and space, I would add one more which, without being a fundamental dimension, is a global expression, born of the unity of the work and of its significance: infinite dimension, not in the sense that the work could dissolve to infinitude, but in the sense of unlimitedness, of 'non-particularity,' which exists in the relation between full and empty, different colour levels, spatial direction, temporal duration, etc. At present, I am pondering on two parallel directions, which are taken in the work and which complement each other: one, of an architectural kind, and the other of a musical kind, and the relations between them. The architectural sense appears most accentuated in the 'maquettes' and in the 'large paintings.' The musical sense, in the *Equali* or in the *Nuclei*. . . . The predominant relationship in the *Equali* is musical, not because the pieces generate counterpoint or eurythmics, akin to music, or have relations of this kind with it: musicality is not 'lent' to the work, but rather is born from its essence. In reality, it is very close to the essence of music. In the *Grand Nucleus,* the parts are not equal and the relationship is more complex, in fact unforeseen. Since the idea occurs in three-dimensional space, it is tempting to associate it with sculpture, but this association is, upon further analysis, superficial, and can only trivialise the experience. It would be more accurate, though still superficial, to speak of 'painting in space.' In the 'large paintings' and 'maquettes,' the architectural relation shows itself as predominant and evident, by virtue of the appearance here of the 'human scale.' The 'large paintings' stand on the floor and are 1.70 metres high, enough to envelop us in their life-experience, and the 'maquettes' are true pieces of architecture, some in a labyrinthine sense, others with rotating panels. What matters, in these 'maquettes,' is the 'simultaneity' (musical element) of the colours between themselves, as the spectator goes around and becomes involved in its structure. It is then noticeable that, ever since the first 'non-object' launched into space, a tendency already showed itself towards a 'life-experience of colour,' neither totally contemplative, nor totally organic, but cosmic. What matters is not the mathematical or rhythmical relationship of colour, or one measured by physical processes, but colour's value. A pure orange is orange, but if placed in relation to other colours, it will be a light-red or dark-yellow, or another shade of orange; its sense changes according to the structure which contains it, and its value, born of the intuitive dialogue of the artist with the work, in its genesis, varies intimately from work to work. Colour is, therefore, value, as are the other elements of the work; vehicle for 'life-experiences' of all kinds ('life-experience,' here, in an all-encompassing, not vitalist, sense of the word). The genesis of the work of art is to such a degree connected to and experienced by the artist, that it is no longer possible to separate matter from spirit, because, as Merleau-Ponty points out, matter

and spirit are dialectics of a single phenomenon. The artist's guiding and creative element is intuition; as Klee once said, "in the final analysis the work of art is intuition, and intuition cannot be surpassed."

CHARLES BIEDERMAN
The Real and the Mystic in Art and Science (1956–59)

Author's Note: In fairness to the reader and myself, I should point out that the more than three decades that have passed since the publication of the following article have resulted in critical changes in my views. Those interested should read my Search for New Arts *(1979) and subsequent publications.*

Piet Mondrian is the great painter since Paul Cézanne. Yet a most unusual aspect of this artist's views has been ignored by the many who acknowledge him. In his final and Neoplastic period he claimed that the "evolution" of art had already ended, and that art as we know it was approaching an "abyss," after which it will disappear. This attitude is an extremely serious error. Neoplastic art is indeed oriented to achieving the end of art as we know it. The Neoplastic prediction of an "abyss" is correct; here the primary concern will be with the theoretical foundation on which Neoplasticism rests this and other of its contentions. The reason for concentrating on this form of art rather than on any of the others that prevail is that it brings into the light of analysis neglected problems that face all art today. . . .

Part I

What were the general arguments Mondrian employed to attain his view of reality? . . . [I]n later writings he used the term "capricious." Nature, he noted, is forever changing and so forever in a state of disequilibrium. The ever-changing imperfections of the natural are replaced by the unchanging perfection of the absolute. The "true" reality of "nature" is timeless. Mondrian thus established two different aspects of nature. There is the imperfect *visible reality* contrasted to the perfect *invisible super-reality*. There is now a "pure plastic vision" which leads to "pure abstract relations," a timeless, universal, absolute reality. The "twisted" *form relations* of the "natural" are replaced by *pure relations* alone. We have thus arrived at the "true," the super-reality which the imperfect forms and colors of visible nature "veil" from our awareness. We "break completely," Mondrian flatly declares, with "optical vision."

For confirmation of his view of art, Mondrian appealed to the example of modern science. Repeatedly he states that the new "objectivity" of art, as opposed to the "subjectivity" of figurative or natural vision, is similar to that practised in science. Both fields, he says, seek an "abstract" reality.

During the first two decades of our century, the last years of which saw the Neoplastic theory formed, there occurred the tremendous discoveries of science into the intimate structure of nature. No less than empirical proof seemed to reveal that optical appearances were but a "veil," beneath which resided the true reality of nature. Science conveyed this knowledge to us with instrumental means, the senses alone being wholly inadequate to discern the new reality. All this stood the test of verification, since the scientific method is open to instru-

* Charles Biederman, excerpts from "The Real and the Mystic in Art and Science" (1956–59), *The Structurist* (University of Saskatchewan, Saskatoon) 1 (1960–61): 14–31. By permission of the Estate of Charles Biederman and the publisher.

mental sensory inspection by anyone. Verification of Mondrian's reality assertions, however, is impossible. They are personal beliefs, bereft of sensory verification open to anyone. This implies some critical decisions. Either we must regard as arbitrary any reality view not supported by empirical (sensory) confirmation, and Mondrian denies the only such confirmation open to art—the optical reality—or else we must deny the necessity for such references altogether. If this latter view prevails, the consequences are disastrous. Nothing will prevent anyone from claiming any notion of reality he pleases, and maintaining that it too is veiled by sensory nature. In this situation, since the artist is without empirical or sensory confirmation, without the extra-neural instruments of the scientist to go beyond the sensory sensation, *all reliable means for establishing reality criteria cease to exist.* It then becomes impossible for *any* artist to ascertain the validity of any other artist's reality view, including his own. Art has become introverted. The artist is free to conjure whatever reality he pleases, seemingly beyond the reach of inquiry by all others. This is precisely the condition of art throughout our century.

If Mondrian appealed to science or confirmation of his Neoplastic reality, in actuality he led art in precisely the opposite direction—arbitrary determination of nature's reality. This artist, it is necessary to note, matured under the severe canalization of Calvinist dogma with its universalism. Later, and for the rest of his life, he was to look to Oriental and other forms of mystic beliefs. All these searches for absolutes are of a piece with Neoplasticism. In this connection our understanding is furthered by awareness of the repercussions that followed the great scientific discoveries early in our century. If science was producing spectacular glimpses into the intimate structure of nature, considerable confusion arose as a result. Both in and out of science there were those who were discovering idealism, universalism, spiritualism, religionism, all said to be confirmed by the new scientific discoveries of nature structure. Such interpretations left a deep mark on both science and art. Artists were embracing mysticism, religion, occultism, magic, and many in science itself were adopting similar attitudes. It was then not difficult for Mondrian to regard much "scientific" talk as substantiation of his own views, even to the extent of asserting that science confirmed "theosophical doctrine." Art "discloses," he concluded, what science had already discovered, that the senses "veil" the true reality; art is like science.

One has to note, then, that there is not some one scientific attitude. There are a number of such views, just as there are many views of art. It is necessary, therefore, to discern the view of science to which the particular scientist or artist ascribes. By denouncing the old security in the senses, the instrumental perceptions of scientists opened the gates to every conceivable, ethereal interpretation of reality, including some made by eminent scientists. . . .

Obviously, the artist, unlike the scientist with his instruments, is without extra-neural means for penetrating the "veil." Mondrian, along with other De Stijl artists, had an answer for this. He distinguished science as a "technological" mode of reality inquiry, in contrast to the artist's non-materialistic method of "pure thought." In place of nature perception there is now only the act of "recollection." That is, with his "inner vision" the artist simply recalls the universal, unchangeable, pure plastic reality. In such a manner the position of "non-nature" is attained.

Reality, in this view, occupies an autonomous existence within the artist's head. The difficulty is that under these circumstances it is possible for anything to manifest itself. Mere logic, however logical, only rationalizes, it offers no verifications. Such logic, then, must assume the convenience of being autonomous in order to justify its reality view, a liberty Mondrian claimed. If Neoplasticism willingly compares itself to the effort of science, it cannot risk submission to that verification which any genuine science willingly accepts.

The above involves the problem of the artist's method of abstracting from nature. When the source is sensory, abstraction involves what the artist selects, relates and rejects in nature. Such was the source of Mondrian's pre-Neoplastic works. One can follow and evaluate the abstractions that led to the art. Later, however, he claims to negate all aspects of sensory nature. He proposes to go "beyond nature," by means of the "destruction" of what is "natural," that is, the destruction of the "three-dimensional," the "natural order." He not only negates the object reality aspect, but also the very structural characteristics of nature. *In other words, he not only denies the forms which nature creates, but also the very method by which nature creates forms.* This is a complete structural rejection of nature. Nature is found structurally erroneous because it lacks correspondence to an art structured on the basis of denying nature's structure in the first place!

What Mondrian does is to reverse the *natural* order of abstraction. Instead of beginning his abstractions from nature, he begins them from his art, to thus judge the structural reality of visible nature. This is accomplished by regarding the art and the logic attributed to it as "autonomous" and, therefore, the supreme unchallengeable determinants of what constitutes reality. Essentially, such an attitude rejects any restraints contrary to the artist's personal reality predilections. All past forms of transcendentalist art, as well as "modern" art, have been rationalized in this manner. Yet one can say, without risk of reasonable contradiction, that no artist has ever been able to cease abstracting from nature, it being impossible. *"Negating" the structural characteristics of nature is but one possible method for abstracting from nature.* Nature remains the genetic source for all forms of the abstractions of art, whatever the artist may do.

If it was Mondrian's intention to "exclude" all semblance of "form," what he actually did was to increasingly limit the characteristics derived from nature form. An artist can limit the dimensional structure of nature in applying it to his work, but he cannot exclude such structure completely unless he pursues this limiting process to its ultimate point of zero. Then, and only then, can all aspects of nature be finally excluded, but then art has disappeared too. . . .

Part IV

Certain scientists see nature as illusion and reality. Certain artists see nature in two aspects too. But one is the limited reality view of nature as objects, the other as a creative process, an immense extension of our experience of nature and art. And, in spite of certain physicists, the visible world is as real as it ever was. More than that, the artists who have followed in the path of Monet and Cézanne have, to the contrary of science, extended the reality of the visible world.

How to resolve the discrepancies between science and art? It is said that science seeks to break down categories, such as "things" and "forms," to replace them with a "common background" covering "all experience." But this is presumptuous. Not all the sciences combined could ever cover all human experience. Perhaps it is necessary to reject a silent assumption about reality. From the cave man to the present, whether as magician, religionist, philosopher or scientist, man has always assumed that reality is some one thing. Thus the visible world had to be displaced by the atomic one. Thus scientists shrank one end of experience, in order to extend it at the other end. Does not the change from the "concrete" to the atomic reveal nature as *creative reality transformations* from one level to another? Do not art and science disclose nature as a many-faceted reality each a part of nature's entirety, one grand creative process? Reality defracts into a plurality, the oneness of reality is replaced by the oneness of creation.

Creation becomes fundamental to the comprehension of nature and man. Reality is but the means to the ultimate experience—creation.

Creation seen as fundamental is to experience reality in its multiple aspects, to see nature as a dynamic structural process. *From this view, the so-called illusions within an illusion on the visible level appear as manifestations of the creative dynamics of this nature level.* From this view, the so-called "disorder" and "indeterminism" appear instead as manifestations of nature's creative *order*. One could then understand why a huge mass of particles responds to the static demands of mathematics, while at the same time, each *individual* particle performs a diversity of dynamic activities that do not respond to the mechanical or mathematical, because they are creative. One could then understand why such a limited number of basic elements in nature, possibly more limited than we suppose, is capable of manifesting such infinite creative diversity.

Within this vast process of constant creation, man responds as he does because he alone of all that exists in nature is possessed of the necessity to achieve the supreme experience of nature, and of his own nature—life as a constant, conscious evolution of creation. If life is created, it remains above all, creative.

AD DEKKERS Statement (1973)

Following an asymmetric period (1959–1963) in which my work originated in an intuitive approach of the equilibrium, I was confronted with a problem inasmuch as we experience symmetry as such only in a plane area. The moment one starts working with three dimensions, the light is bound to impart an asymmetrical aspect to the symmetrically stratified form.

For this problem I found a—probably also temporary—solution by resorting to the laws that control the world of geometric forms. These laws are, for all practical purposes, independent of my own arbitrary interference. Before this new course toward a law-governed buildup of the form, my work in fact still consisted of variations on an arbitrary approach. It was based on a manner of composition which, in essence, was merely sublimated arbitrariness. At present, I no longer balance the values of contrasting elements such as "large" against "small" or "red" against "white," but I work in accordance with geometric laws. For example, given a square, there are two alternatives: one can either draw the inscribed or the circumscribed circle of the square. The circle may then be broken down in a number of stages of genesis of which one or two or any appropriate number may be shown to the end of achieving the clearest possible over-all effect. All this is familiar to mathematicians, it is true, but the novel character of it lies, to my mind, in the fact that in my work these mathematical laws acquire an added power of visual expressiveness. It has never been, and never will be, my intention to merely elucidate mathematical problems—this would bespeak a mixing-up of two heterogeneous elements, viz. mathematics and visual research. On the face, there may be an accidental likeness between my work and geometrical forms, but fundamentally there is a great disparity. What I am concerned with is the visual impact of my work on the spectator. My objective is to visually bring out in the chaos of given possibilities one specific aspect, to make visually predictable a shifting or transformation process of forms, to investigate in what manner light acts in a groove, on an edge, upon a surface.

Through the use of disconnected elements which I accumulate in consecutive stages, the enclosing forms act as a framework—together with the white, they serve to scan the various

* Ad Dekkers, untitled statement, *Flash Art* 39 (February 1973): 11. By permission of Daniel Dekkers and the publisher.

faces as well as the work as a whole. Thus the relief has both a linear and a plastic effect. Since I now work in consonance with the built-in laws, I am able to create an object that, in its final stage, is symmetrical as to its formal buildup, but asymmetrical in its stratification as a plastic object.

Having worked with asymmetric as well as symmetric forms and not being satisfied with the final results of either, I have now adopted the rules of geometrical laws; this enables me to work in either way or to combine both methods. Thereby I have now achieved greater freedom and have gained more possibilities. Since I work entirely in plastic forms to the extent that the back side of the object is, in terms of function, equally important as the front or the sides (which is not the case with the relief) and working from the idea that, in consequence, the boundary of the object is in fact that of a volume, I can estimate the measure of thickness on the basis of length and width. This again offers me additional possibilities in that I can omit parts of the outer surfaces such as e.g. a side or a top face.

PIERO MANZONI For the Discovery of a Zone of Images (1957)

A common vice among artists—or rather bad artists—is a certain kind of mental cowardice because of which they refuse to take up any position whatsoever, invoking a misunderstood notion of the freedom of art, or other equally crass commonplaces.

Since they have an extremely vague idea of art the result is generally that they finish up by confusing art with vagueness itself.

It's therefore necessary to clarify as far as possible what we mean by art, so that we can find a guideline along which to work and make judgments.

The work of art has its origin in an unconscious impulse that springs from a collective substrata of universal values common to all men, from which all men draw their gestures, and from which the artist derives the "archai" of organic existence. Every man of his own accord extracts the human element from this base, without realising it, and in an elementary and immediate way. Where the artist is concerned it is a question of the conscious immersion in himself through which, once he has got beyond the individual and contingent level, he can probe deep down to reach the living germ of total humanity. Everything that is humanly communicable is derived from this, and it is through the discovery of the psychic substrata that all men have in common that the relationship of author-work-spectator is made possible. In this way the work of art has the totemic value of living myth, without symbolic or descriptive dispersion: it is a primary and direct expression.

The foundations of the universal value of art are given to us now by psychology. This is the common base that enables art to sink its roots to the origins before man and to discover the primary myths of humanity.

The artist must confront these myths and reduce them, by means of amorphous and confused materials, to clear images.

Since these are atavistic forces that have their origins in the subconscious, the work of art takes on a magical significance.

On the other hand, art has always had a religious value, from the first artist-sorcerer to the pagan and Christian myth, etc.

The key point today is to establish the universal validity of individual mythology.

* Piero Manzoni, "For the Discovery of a Zone of Images" (Spring 1957), *Azimuth* 2 (1960); reprinted in *Piero Manzoni* (London: Tate Gallery, 1974), 16–17. By permission of Archivio Opera Piero Manzoni, Milan, and the Tate.

Piero Manzoni, *Merda d'artista,* 1961. The artist holds one of ninety cans of "artist's shit" (30 grams per can) without artificial preservatives, "made in Italy." Photo by Ole Bjørndal Bagger. Courtesy Archivio Opera Piero Manzoni, Milan.

The artistic moment is therefore that in which the discovery of preconscious universal myths comes about, and in the reduction of these into the form of images.

It is clear that if the artist is to be able to bring to light zones of myth that are authentic and virginal he must have both an extreme degree of self-awareness and the gifts of iron precision and logic.

To arrive at such a discovery, fruit of a long and precious education, involves a whole field of precise technique. The artist must immerse himself in his own anxiety, dredging up everything that is alien, imposed or personal in the derogatory sense, in order to arrive at the authentic zone of values.

So it is obvious that at first glance there would seem to be a paradox: the more we immerse ourselves in ourselves, the more open we become, since the closer we get to the germ of our totality the closer we are to the germ of totality of all men.

We can therefore say that subjective invention is the only means of discovering objective reality, the only means that gives us the possibility of communication between men.

There comes a point where individual mythology and universal mythology are identical.

In this context it is clear that there can be no concern with symbolism and description, memories, misty impressions of childhood, pictoricism, sentimentalism: all this must be absolutely excluded. So must every hedonistic repetition of arguments that have already been exhausted, since the man who continues to trifle with myths that have already been discovered is an aesthete, and worse.

Abstractions and references must be totally avoided. In our freedom of invention we must succeed in constructing a world that can be measured only in its own terms.

We absolutely cannot consider the picture as a space onto which to project our mental scenography. It is the area of freedom in which we search for the discovery of our first images.

Images which are as absolute as possible, which cannot be valued for that which they record, explain and express, but only for that which they are to be.

YVES KLEIN
Ritual for the Relinquishment of the
Immaterial Pictorial Sensitivity Zones (1957–59)

The immaterial pictorial sensitivity zones of Yves Klein the Monochrome are relinquished against a certain weight of fine gold. Seven series of these pictural immaterial zones all numbered exist already; for each zone relinquished a receipt is given. This receipt indicates the exact weight of pure gold which is the material value correspondent to the immaterial acquired.

The zones are transferable by their owner. (See rules on each receipt.)

Every possible buyer of an immaterial pictorial sensitivity zone must realize that the fact that he accepts a receipt for the price which he has paid takes away all authentic immaterial value from the work, although it is in his possession.

In order that the fundamental immaterial value of the zone belong to him and become a part of him, he must solemnly burn his receipt, after his first and last name, his address and the date of the purchase have been written on the stub of the receipt book.

In case the buyer wishes this act of integration of the work of art with himself to take place, Yves Klein must, in the presence of an Art Museum Director, or an Art Gallery Expert, or an Art Critic, plus two witnesses, throw half of the gold received in the ocean, into a river or in some place in nature where this gold cannot be retrieved by anyone.

From this moment on, the immaterial pictorial sensitivity zone belongs to the buyer absolutely and intrinsically.

The zones having been relinquished in this way are not any more transferable by their owner.

YAYOI KUSAMA Interview by Grady Turner (1999)

YAYOI KASUMA: My artwork is an expression of my life, particularly of my mental disease. . . .

I was hospitalized at the mental hospital in Tokyo in 1975 where I have resided ever since. I chose to live here on the advice of a psychiatrist. He suggested I paint pictures in the hospital while undergoing medical treatment. This happened after I had been traveling through Europe, staging my fashion shows in Rome, Paris, Belgium and Germany. . . .

I [also] work at my condominium-turned-studio near the hospital as well as at a studio I've been renting for some years, which is just a few minutes' walk from the hospital. I also created a large sculpture in the big yard of the hospital—a store-bought rowboat completely covered with stuffed canvas protuberances. I have made about five or six hundred large sculptures so far. . . .

My art originates from hallucinations only I can see. I translate the hallucinations and obsessional images that plague me into sculptures and paintings. All my works in pastels are the products of obsessional neurosis and are therefore inextricably connected to my disease. I create pieces even when I don't see hallucinations, though. . . .

* Yves Klein, "*Ritual for the Relinquishment of the Immaterial Pictorial Sensitivity Zones*" (1957–59), in *Yves Klein 1928–1962: A Retrospective* (Houston and New York: Institute for the Arts, Rice University, and Arts Publisher, 1982), 207. By permission of Rotraut Klein-Moquay.

** Excerpted from the interview "Yayoi Kusama by Grady Turner," *BOMB* 66 (Winter 1999): 62–69. © Bomb Magazine, New Art Publications, and its Contributors. All rights reserved. The BOMB Digital Archive can be viewed at www.bombsite.com. Also by permission of the interviewer.

My mother was a shrewd businesswoman, always horrendously busy at her work. I believe she contributed a great deal to the success of the family business. But she was extremely violent. She hated to see me painting, so she destroyed the canvases I was working on. I have been painting pictures since I was about ten years old when I first started seeing hallucinations.

I made them in huge quantity. Even before I started to paint, I was different from other children. My mother beat me and kicked me on the derrière every day, irritated that I was always painting. She forced me to help the employees, even when I had to study for my term exam. I was so exhausted that I felt very insecure at times.

My father, a womanizer, was often absent from home. He was a gentle-hearted person, but having married into my mother's family and being always under my mother's financial control, he did not have a place in the home. He must have felt that he had lost face completely.

My eldest brother was also against my painting pictures. All of my siblings told me to become a collector rather than a painter. . . .

I went to Kyoto simply to flee from my mother's violence. I rarely attended classes at the school there; I found the school too conservative and the instructors out of touch with the reality of the modern era. I was painting pictures in the dormitory instead of attending classes. Because my mother was so vehemently against my becoming an artist, I became emotionally unstable and suffered a nervous breakdown. It was around this time, or in my later teens, that I began to receive psychiatric treatment. By translating hallucinations and fear of hallucinations into paintings, I have been trying to cure my disease. . . .

I am an obsessional artist. People may call me otherwise, but I simply let them do as they please. I consider myself a heretic of the art world. I think only of myself when I make my artwork. Affected by the obsession that has been lodged in my body, I created pieces in quick succession for my new "-isms." . . .

So many ideas were coming forth one after another in my mind that sometimes I had trouble knowing what to do with them. In addition to making painting, sculpture and avant-garde fashion, I made a film called *Kusama's Self-Obliteration*. . . .

By obliterating one's individual self, one returns to the infinite universe. . . .

As an obsessional artist I fear everything I see. At one time, I dreaded everything I was making. The armchair thickly covered in phalluses was my psychosomatic work, done when I had a fear of sexual vision. . . .

GRADY TURNER: As with the happenings, there are a number of collage photographs in which you include yourself with your "compulsion furniture." The most famous may be the image of you posed nude on your couch [*Accumulation No. 2*] in imitation of a pinup girl, covered in polka dots. Behind the couch are infinity nets paintings and the floor is strewn with pasta.

YK: Polka dots symbolize disease. The couch bristled with phalluses. The macaroni-strewn floor symbolizes fear of sex and food, while the nets symbolize horror toward infinity of the universe. We cannot live without the air. . . .

GT: While you did reasonably well as a young artist in New York, you were eclipsed by male artists whose work was similar—one thinks immediately of Claes Oldenburg's soft sculptures and Samaras's mirrored environments, not to mention Warhol's serial images. How did their success affect you?

YK: Those male artists were simply imitating my illness. I participated in a group show held at the Green Gallery in June 1962 with Robert Morris, Warhol, George Segal, James

Rosenquist and Oldenburg who I hold in high regard. Oldenburg showed a papier-mâché sculpture then. The Green Gallery offered me a chance to hold a solo show in September of the same year, but unfortunately I had to decline due to lack of money. During that summer, Oldenburg was working fast to create soft sculptures similar to mine using machine-sewn forms. When I went to the opening of his solo show held at the Green Gallery the same year, his wife led me to his piece *Calendar* and said to the effect, "Yayoi, I am sorry we took your idea." I was surprised to see the work almost identical to my sculpture.

GT: You staged dozens of happenings—what you called "body festivals"—in your studio and in public spaces around New York. Some were sites of authority, such as MoMA or Wall Street. Other sites, such as Tompkins Square Park and Washington Square Park, were associated with New York's psychedelic hippie culture. What was your role in these?

YK: I played the role of high priestess and painted the nude bodies of models on the stage with polka dots in five colors. When a happening was staged at Times Square under my direction, a huge crowd flocked to it. I was never nude, publicly or privately. At the homosexual orgies I directed, I always stayed at a safe place with a manager in the studio to avoid being arrested by police. The studio would have been thrown into utter confusion if I were arrested. The police were primarily after a bribe. When I was arrested while directing a happening on Wall Street and taken into police custody, they demanded that I pay them if I wanted to be set free. Bribes ranged from $400 to $1,000. Since I paid them every time I was arrested, my happenings ended up as a good out-of-the-way place for them to make money.

GT: Why were the performers nude?

YK: Painting bodies with the patterns of Kusama's hallucinations obliterated their individual selves and returned them to the infinite universe. This is magic.

AD REINHARDT Twelve Rules for a New Academy (1953)

Evil and error in art are art's own "uses" and "actions." The sins and sufferings of art are always its own improper involvements and mixtures, its own mindless realisms and expressionisms.

The humiliation and trivialization of art in America during the last three decades have been the easy exploitations and eager popularizations of art by the American artists themselves. Ashcan and Armory expressionists mixed their art up with life muckraking and art marketing. Social and surreal expressionists of the thirties used art as an "action on the public," but succeeded mainly in expressing themselves, and abstract expressionists of the forties and fifties, using art initially as a "self-expression," succeeded in acting upon the whole world. The business boom of the twenties orphaned the alienated artist, but the Great Depression of the thirties witnessed the tender engagement of art to government. Ten years after that, the ardent marriage of art and business and war was celebrated with Pepsi-Cola in ceremonial contests called "Artists for Victory" at America's greatest museum of art. By the fifties, armies of art's offsprings were off to school and Sunday school, crusading for art education and religious decoration.

From "Artists for Ashcan and Dust Bowl" to "Artist for America-First and Social Security" to "Artists for Victory" to "Artists for Action in Business, Religion, and Education," the portrait

 * Ad Reinhardt, excerpts from "Twelve Rules for a New Academy" (1953), in *Art News* 56, no. 3 (May 1957): 37–38, 56; reprinted in Barbara Rose, ed., *Art as Art: The Selected Writings of Ad Reinhardt* (1975; Berkeley: University of California Press, 1991), 203–7. © Anna Reinhardt.

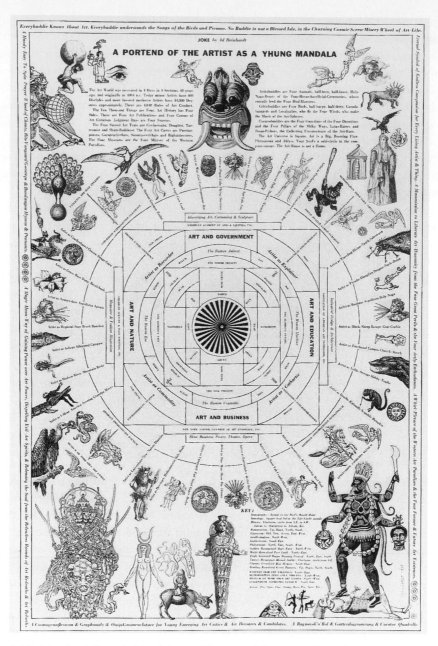

Ad Reinhardt, *A Portend of the Artist as a Yhung Mandala,* 1956, collage. © Anna
Reinhardt. Photo courtesy The Pace Gallery, New York.

of the artist in America in the twentieth century shapes up into a figure resembling Al Capp's
Available Jones, who is always available to anyone, any time, for anything at all, at any price.

(The "ice has been broken," the ivory tower flooded by unschooled professionals, the walls
of the academy washed out by schooled primitives, and the sanctum sanctorum blasphemed
by fauve folk, Bauhaus bacchuses, and housebroken samurai.)

The conception of art as "fine," "high," "noble," "free," "liberal," and "ideal" has always

been academic. The argument of free or fine artists has never been between art and something else, but "between true art and art submitted to some other, quite different, values." "There are not two arts, there is only one." "No man can embrace true art till he has explored and cast out false art." The academy of art, whether the Western or Eastern ideal, has always aimed at "the correction of the artist," not "the enlightenment of the public." The idea of the "academy" of art in the seventeenth century, of "aesthetics" in the eighteenth, of the "independence" of art in the nineteenth, and of the "purity" of art in the twentieth, restate, in those centuries in Europe and America, the same "one point of view." Fine art can only be defined as exclusive, negative, absolute, and timeless. It is not practical, useful, related, applicable, or subservient to anything else. Fine art has its own thought, its own history and tradition, its own reason, its own discipline. It has its own "integrity" and not someone else's "integration" with something else.

Fine art is not "a means of making a living" or "a way of living a life." Art that is a matter of life and death cannot be fine or free art. An artist who dedicates his life to art, burdens his art with his life and his life with his art. "Art is Art, and Life is Life."

The "tradition" of art is art "out of time," art made fine, art emptied and purified of all other-than-art meanings, and a museum of fine art should exclude everything but fine art. The art tradition stands as the antique-present model of what has been achieved and what does not need to be achieved again. Tradition shows the artist what not to do. "Reason" in art shows what art is not. "Higher education for the artist should be 'liberal,' 'free' and the 'learning of greatness.' " "To teach and enlighten is the task of wise and virtuous men." "No greater painter was ever self-taught." "Artists must learn and learn to forget their learning." "The way to know is to forget."

"The guardian of the true tradition in art" is the academy of fine art: "to give certain rules to our art and to render it pure." The first rule and absolute standard of fine art, and painting, which is the highest and freest art, is the purity of it. The more uses, relations, and "additions" a painting has, the less pure it is. The more stuff in it, the busier the work of art, the worse it is. "More is less."

The less an artist thinks in non-artistic terms and the less he exploits the easy, common skills, the more of an artist he is. "The less an artist obtrudes himself in his painting, the purer and clearer his aims." The less exposed a painting is to a chance public, the better. "Less is more."

The Six Traditions to be studied are: (1) the pure icon; (2) pure perspective, pure line, and pure brushwork; (3) the pure landscape; (4) the pure portrait; (5) the pure still life; (6) pure form, pure color, and pure monochrome. "Study ten thousand paintings and walk ten thousand miles." "Externally keep yourself away from all relationships, and internally, have no hankerings in your heart." "The pure old men of old slept without dreams and waked without anxiety."

The Six General Canons or the Six Noes to be memorized are: (1) No realism or existentialism. "When the vulgar and commonplace dominate, the spirit subsides." (2) No impressionism. "The artist should once and forever emancipate himself from the bondage of appearance." "The eye is a menace to clear sight." (3) No expressionism or surrealism. "The laying bare of oneself," autobiographically or socially, "is obscene." (4) No fauvism, primitivism, or brute art. "Art begins with the getting rid of nature." (5) No constructivism, sculpture, plasticism, or graphic arts. No collage, paste, paper, sand, or string. "Sculpture is a very mechanical exercise causing much perspiration, which, mingling with grit, turns into mud." (6) No "trompe-l'oeil," interior decoration, or architecture. The ordinary qualities and common sensitivities of these activities lie outside free and intellectual art.

The Twelve Technical Rules (or How to Achieve the Twelve Things to Avoid) to be followed are:

1. No texture. Texture is naturalistic or mechanical and is a vulgar quality, especially pigment texture or impasto. Palette knifing, canvas-stabbing, paint scumbling and other action techniques are unintelligent and to be avoided. No accidents or automatism.

2. No brushwork or calligraphy. Handwriting, hand-working and hand-jerking are personal and in poor taste. No signature or trademarking. "Brushwork should be invisible." "One should never let the influence of evil demons gain control of the brush."

3. No sketching or drawing. Everything, where to begin and where to end, should be worked out in the mind beforehand. "In painting the idea should exist in the mind before the brush is taken up." No line or outline. "Madmen see outlines and therefore they draw them." A line is a figure, a "square is a face." No shading or streaking.

4. No forms. "The finest has no shape." No figure or fore- or background. No volume or mass, no cylinder, sphere or cone, or cube or boogie-woogie. No push or pull. "No shape or substance."

5. No design. "Design is everywhere."

6. No colors. "Color blinds." "Colors are an aspect of appearance and so only of the surface." Colors are barbaric, unstable, suggest life, "cannot be completely controlled," and "should be concealed." Colors are a "distracting embellishment." No white. "White is a color and all colors." White is "antiseptic and not artistic, appropriate and pleasing for kitchen fixtures, and hardly the medium for expressing truth and beauty." White on white is "a transition from pigment to light" and "a screen for the projection of light" and "moving" pictures.

7. No light. No bright or direct light in or over the painting. Dim, late afternoon absorbent twilight is best outside. No chiaroscuro, "the malodorant reality of craftsmen, beggars, topers with rags and wrinkles."

8. No space. Space should be empty, should not project, and should not be flat. "The painting should be behind the picture frame." The frame should isolate and protect the painting from its surroundings. Space divisions within the painting should not be seen.

9. No time. "Clock-time or man's time is inconsequential." There is no ancient or modern, no past or future in art. "A work of art is always present." The present is the future of the past, not the past of the future. "Now and long ago are one."

10. No size or scale. Breadth and depth of thought and feeling in art have no relation to physical size. Large sizes are aggressive, positivist, intemperate, venal, and graceless.

11. No movement. "Everything else is on the move. Art should be still."

12. No object, no subject, no matter. No symbols, images, or signs. Neither pleasure nor paint. No mindless working or mindless non-working. No chess-playing.

Supplementary regulations to be followed are: No easel or palette. Low, flat, sturdy benches work well. Brushes should be new, clean, flat, even, one-inch wide, and strong. "If the heart is upright, the brush is firm." No noise. "The brush should pass over the surface lightly and smoothly" and silently. No rubbing or scraping. Paint should be permanent, free of impurities, mixed into and stored in jars. The scent should be "pure spirits of turpentine, unadulterated and freshly distilled." "The glue should be as clear and clean as possible." Canvas is better than silk or paper, and linen is better than cotton. There should be no shine in the finish. Gloss reflects and relates to the changing surroundings. "A picture is finished when all traces of the means used to bring about the end have disappeared."

The fine-art studio should have a "raintight roof" and be twenty-five feet wide and thirty feet long, with extra space for storage and sink. Paintings should be stored away and not

continually looked at. The ceiling should be twelve feet high. The studio should be separate from the rest of the school.

The fine artists should have a fine mind, "free of all passion, ill-will and delusion."

The fine artist need not sit cross-legged.

25 Lines of Words on Art: Statement (1958)

1. ART IS ART. EVERYTHING ELSE IS EVERYTHING ELSE.
2. ART-AS-ART. ART FROM ART. ART ON ART. ART OF ART. ART FOR ART. ART BEYOND ART. ARTLESS ARTIFICE.
3. PAINTERS' PAINTING. PAINTING'S PAINTERS. PAINTERS' PAINTERS.
4. PAINTING THAT "CANNOT BE TAKEN HOLD OF," THAT "CANNOT BE USED," THAT "CANNOT BE SOLD."
5. PAINTING "ABOUT WHICH NO QUESTIONS CAN BE ASKED."
6. PAINTING AS "NOT AS A LIKENESS OF ANYTHING ON EARTH."
7. ICON AS IMAGE AS IDEA AS SYMBOL AS IDEAL AS FORM AS ICON.
8. ICON AS DEVICE, DIAGRAM, EMBLEM, FRAME, GAME, SIGN, SPECTACLE, ETC.
9. DEVICE AS EMPTY. DIAGRAM AS DEAD. EMBLEM AS ARCHETYPE. FRAME AS (OF) MIND. SIGN AS FORECAST. SPECTACLE AS INVISIBLE.
10. PAINTING AS ABSOLUTE SYMMETRY, PURE REASON, RIGHTNESS.
11. PAINTING AS CENTRAL, FRONTAL, REGULAR, REPETITIVE.
12. PREFORMULATION, PREFORMALIZATION, FORMALISM, REPAINTING.
13. FORMS INTO UNIFORM INTO FORMLESSNESS. STYLE AS RECURRENCE.
14. LIGHT AS REAPPEARANCE, DULLNESS. COLOR AS BLACK, EMPTY.
15. SPACE AS HALVED, TRIPARTED, QUARTERED, QUINQUESECTIONED, ETC., AS ONE.
16. VERTICALITY AND HORIZONTALITY, RECTILINEARITY, PARALLELISM, STASIS.
17. OUTLINES, MONOTONES, BLANKNESS, QUIESCENCE, PREMEDITATION.
18. BRUSHWORK THAT BRUSHES OUT BRUSHWORK.
19. MATTER ONLY TO THE MIND.
20. THE STRICTEST FORMULA FOR THE FREEST ARTISTIC FREEDOM.
21. THE EASIEST ROUTINE TO THE DIFFICULTY.
22. THE MOST COMMON MEAN TO THE MOST UNCOMMON END.
23. THE EXTREMELY IMPERSONAL WAY FOR THE TRULY PERSONAL.
24. THE COMPLETEST CONTROL FOR THE PUREST SPONTANEITY.
25. THE MOST UNIVERSAL PATH TO THE MOST UNIQUE. AND VICE-VERSA.

The Black-Square Paintings (1963)

A square (*neutral, shapeless*) canvas, five feet wide, five feet high, as high as a man, as wide as a man's outstretched arms (*not large, not small, sizeless*), trisected (*no composition*), one horizontal form negating one vertical form (*formless, no top, no bottom, directionless*), three (*more or less*)

 * Ad Reinhardt, "25 Lines of Words on Art: Statement," *It Is* 1 (Spring 1958): 42; reprinted in Barbara Rose, ed., *Art-as-Art: The Selected Writings of Ad Reinhardt* (1975; Berkeley: University of California Press, 1991), 51–52. © Anna Reinhardt.

 ** Ad Reinhardt, "The Black-Square Paintings," originally published as "Autocritique de Reinhardt," in *Iris-Time* (Paris newsletter of the Iris Clert Galerie), 10 June 1963; reprinted in Barbara Rose, ed., *Art-as-Art: The Selected Writings of Ad Reinhardt* (1975; Berkeley: University of California Press, 1991), 82–83. © Anna Reinhardt.

dark (*lightless*) no-contrasting (*colorless*) colors, brushwork brushed out to remove brushwork, a matte, flat, free-hand painted surface (*glossless, textureless, non-linear, no hard edge, no soft edge*) which does not reflect its surroundings—a pure, abstract, non-objective, timeless, spaceless, changeless, relationless, disinterested painting—an object that is self-conscious (*no unconsciousness*) ideal, transcendent, aware of no thing but art (*absolutely no anti-art*). (1961)

The painting leaves the studio as a purist, abstract, non-objective object of art, returns as a record of everyday (*surrealist, expressionist*) experience ("*chance*" spots, defacements, hand-markings, accident—"happenings," scratches), and is repainted, restored into a new painting painted in the same old way (*negating the negation of art*), again and again, over and over again, until it is just "right" again. (1960)

A clearly defined object, independent and separate from all other objects and circumstances, in which we cannot see whatever we choose or make of it anything we want, whose meaning is not detachable or translatable. A free, unmanipulated and unmanipulatable, useless, unmarketable, irreducible, unphotographable, unreproducible, inexplicable icon. A non-entertainment, not for art commerce or mass-art publics, non-expressionist, not for oneself. (1955)

ELLSWORTH KELLY Notes of 1969

In 1949, I ceased figurative painting and began works that were object oriented.

The drawings from plant life seem to be a bridge to the way of seeing that brought about the paintings in 1949 that are the basis for all my later work.

After arriving in Paris in 1948, I realized that figurative painting and also abstract painting (though my knowledge of the latter was very limited) as I had known it in the 20th century no longer interested me as a solution to my own problems. I wanted to give up easel painting which I felt was too personal.

All the art since the Renaissance seemed too men-oriented. I liked (the) object quality. An Egyptian pyramid, a Sung vase, the Romanesque church appealed to me. The forms found in the vaulting of a cathedral or even a splatter of tar on the road seemed more valid and instructive and a more voluptuous experience than either geometric or action paintings.

Instead of making a picture that was an interpretation of a thing seen, or a picture of invented content, I found an object and "presented" it as itself alone. My first object was "Window, Museum of Modern Art, Paris" done in 1949.

After constructing "Window" with two canvases and a wood frame, I realized that from then on painting as I had known it was finished for me. The new works were to be objects, unsigned, anonymous.

Everywhere I looked, everything I saw became something to be made, and it had to be exactly as it was, with nothing added. It was a new freedom; there was no longer the need to compose. The subject was there already made, and I could take from everything. It all belonged to me: a glass roof of a factory with its broken and patched panels, lines on a road map, a corner of a Braque painting, paper fragments in the street. It was all the same: anything goes.

I felt that everything is beautiful but that which man tries intentionally to make beautiful, that the work of an ordinary bricklayer is more valid than the artwork of all but a very few artists.

* Ellsworth Kelly, "Notes of 1969," in *Ellsworth Kelly* (Amsterdam: Stedelijk Museum, 1980), 30–34. By permission of the author and the publisher. Text slightly revised by Kelly in 1993.

The form of my painting is the content.

My work is made of single or multiple panels: rectangle, curved or square. I am less interested in marks on the panels than the "presence" of the panels themselves. In "Red, Yellow, Blue," the square panels present color. It was made to exist forever in the present, it is an idea and can be repeated anytime in the future.

I began to draw from plant life and found the flat leaf forms were easier to do than thighs and breasts. I wanted to flatten. The plant drawings from that time until now have always been linear. They are exact observations of the form of the leaf or flower or fruit seen. Nothing is changed or added; no shading, no surface marking. They are not an approximation of the thing seen nor are they a personal expression or an abstraction. They are an impersonal observation of the form. When I applied the procedure to other things such as the vaulting of Notre Dame or a patch of tar on the road, the subject of the drawings and the subsequent paintings were not recognizable even though they were exact copies of the thing seen. I wanted to use things that had no pictorial use.

My work is about structure. It has never been a reaction to Abstract Expressionism. I saw the Abstract Expressionists for the first time in 1954. My line of influence has been the "structure" of the things I liked: French Romanesque architecture, Byzantine, Egyptian, and Oriental art, Van Gogh, Cézanne, Monet, Klee, Picasso, Beckmann.

I admired and felt the anonymous structure of the work of Brancusi, Vantongerloo, Arp, and Taeuber-Arp whose studios I visited. Their work reinforced my own ideas for the creation of a Pre-Renaissance, European type art: its anonymous stone work, the object quality of the artifacts, the fact that the work was more important than the artist's personality.

Audubon, the Pre-Columbian Indians, and Calder. Of the Europeans, I most admired the way Picasso, Klee, and Brancusi "made" their art. Contrary to what has been said about me, Mondrian and Matisse did not interest me when I was in Paris. Mondrian could not be seen in Paris and when I did see them [his paintings] in Holland in 1963, I thought their structure too rigid and intellectual.

When I left Paris in 1954, I saw no art that was being "made" like mine and returning to the U.S. I found no one "making" art that way either.

In my own work, I have never been interested in painterliness (or what I find is) a very personal handwriting, putting marks on canvas. My work is a different way of seeing and making something and which has a different use.

In my painting, negative space is never arbitrary (I believe lithographs to be colored marks printed on a ground—the paper and the measure of the ground and the marks are to be considered of equal importance). In my painting, the painting is the subject rather than the subject, the painting.

When I was a child, I spent all my spare time looking at birds and insects (beetles). My color use, and the object quality of the "painting," and the use of fragmentation is closer to birds and beetles and fish than it is to De Stijl or the Constructivists.

Looking through an aperture (a door or a window) is a way that I have been able to isolate or fragment a single form. My first memory of focusing through an aperture occurred when I was around twelve years old. One evening, passing the lighted window of a house, I was fascinated by red, blue, and black shapes inside a room. But when I went up and looked in, I saw a red couch, a blue drape and a black table. The shapes had disappeared. I had to retreat to see them again.

Making art has first of all to do with honesty. My first lesson was to see objectively, to erase all "meaning" of the thing seen. Then only could the real meaning of it be understood and felt.

KENNETH NOLAND

Color, Format, and Abstract Art: Interview by Diane Waldman (1977)

DIANE WALDMAN: Both you and Morris Louis were beginning to develop your own styles in the 1950s. You saw some of the values of Abstract Expressionism but also reacted against its self-conscious mannerisms.

KENNETH NOLAND: I think we realized that you didn't have to assert yourself as a personality in order to be personally expressive. We felt that we could deal solely with esthetic issues, with the meaning of abstraction, without sacrificing individuality—or quality.

But there was something else that the Abstract Expressionists taught us: they began to use something besides the conventional means of art; to want other kinds of paint, or kinds of canvas, or ways of making pictures that weren't the usual ways. Some of the next generation, the Pop artists, picked up this attitude and began to put actual things into art.

We were making abstract art, but we wanted to simplify the selection of materials, and to use them in a very economical way. To get to raw canvas, to use the canvas unstretched—to use it in more basic or fundamental ways, to use it as fabric rather than as a stretched surface.

To use paint, thinner and more economically, to find new paints, from the industrial system, like plastics. This is something that artists have always done. They've always used a minimum of the means of technology in any period. Art has never used the maximum of technology, only the least. Paint and canvas, or paint and wood, or clay, or stone, or waste steel, or paper. We've all of us had an instinct to use a minimum means.

DW: Is that how you got to a plastic-based paint, like Magna, because it afforded a way to thin the paint?

KN: Thin it, use it in the same way as dye. Thinness reveals color. There are two things that go on in art. There's getting to the essential material and a design that's inherent in the use of the material, and also an essential level of expressiveness, a precise way of saying something rather than a complicated way. Hemingway said about writing that a writer who has to go on and on and on and on about something wasn't sure of what he was writing about. That if he really knew his subject, he could say it concisely. And that's something you have to work at, you have to search and work and practice.

DW: We've talked about things like tactility and the nap of the canvas and color opacity. When you worked on the first paintings, the first major statement—the circles of the '50s— were you concerned with these qualities at that time, or was that something that you grew more and more sensitive to as the paintings took you in that direction?

KN: I became more sensitive to it by practice. You *knew* these things, but as a student you didn't have a sense of how to get hold of these various qualities to make abstract paintings. That's true of all young artists, or young writers, or young anybody. You can see the results of how somebody else has achieved something and you think you can understand it because you can recognize what's been done. But when you begin to handle the stuff, you stumble and fumble. Art is a practice, it is an art. It takes a long time.

We talk about art with quotation marks, but we also use the word art to mean artfulness. If you say somebody's artful you mean that they're skilled or that they have finesse. Or

* Diane Waldman, excerpt from "Color, Format and Abstract Art: An Interview with Kenneth Noland by Diane Waldman," *Art in America* 65, no. 3 (May–June 1977): 99–105. By permission of the interviewer, the artist, and the publisher.

we say "arty" to mean somebody who can manipulate things, that they're artful, or in a way almost sly. We're suspicious of skilled people. It can have a negative connotation, being artful or arty.

DW: Do you consider it negative?

KN: No, I don't, not in its true sense. I like artfulness, I like it in athletes, in musicians. Or just grace. Like most everyone, I like people who are graceful, people who are well-spoken. But often we are still suspicious of artful, skillful people.

DW: Because we confuse it with something that seems facile?

KN: Too facile.

DW: But, in effect, isn't that skillfulness or that artfulness just a learning process that one can build on? Isn't it true that the more you learned about the possibilities of manipulating paint and texture and color and canvas, the more the possibilities grew? You kept building. For example, in the new paintings you've changed—you've changed shape, you've changed color.

KN: I've found this necessary, to avoid repeating a learned skill in a manipulative way. I've had to watch that, but not so much now as I did when I was younger. I'm sure all artists know that they must change in order not to rely just on skill or finesse.

DW: Aren't you taking a certain risk in your new paintings in working with a form that appears to be something that isn't as precise as the forms that you've used before? The circle has a platonic implication, the chevron has symmetry, the stripes and plaids are uniform rectangular fields. Even though the offset chevrons suggest the new pictures, aren't the new paintings a departure in that you are not overtly referring to a "set" form?

KN: Yes. It occurred to me early that symmetry was not a closed issue—nor was asymmetry. I've known about that ever since I worked on symmetrical pictures or used symmetry as a "given." It's been on my mind—what would something be like if it were unbalanced? It's been a vexing question for a long time. But it took the experience of working with radical kinds of symmetry, not just a rectangle, but a diamond shape, as well as extreme extensions of shapes, before I finally came to the idea of everything being unbalanced, nothing vertical, nothing horizontal, nothing parallel. I came to the fact that unbalancing has its own order. In a peculiar way, it can still end up feeling symmetrical. I don't know but what the very nature of our response to art is experienced symmetrically.

DW: You've mentioned that the more recent of your new shaped canvases begin to have a sense of the circle again.

KN: Yes. There's a rotary movement, no longer the sense of a field. I've had to bear down on the activity of the shapes, therefore the color is more structural than before. As the shape assumed more emphasis in my recent work, and I began to use fewer colors, I began to increase the density of the colors, so that the alignment of color was replaced by the volume and density of color.

DW: Your most recent paintings are not huge; has your concept of scale changed?

KN: No. I think part of the individual's right to be creative and expressive, for our generation, was to declare large spaces for art. Abstract art in particular began to spread and occupy more space as entities, and that demand for space went along with the instinct to make the art as "bright" as possible, which still exists. Once the battle for space was won, we felt we could begin to paint smaller, more compactly. Hans Hofmann was significant in this respect because he didn't paint huge pictures. He painted compact pictures, used more tactility and substance than spread or field. Subsequently Olitski extended this.

I think that sculpture recently has been involved with that same impulse. Sculpture doesn't necessarily have to be so big; it can get dense and carry expressive force in terms of compactness.

DW: Has your friendship with a number of prominent sculptors influenced you to make sculpture?

KN: The artists that I have been related to have been working friends and personal friends such as Morris Louis, Jules Olitski, Tony Caro, David Smith. Because of a long relationship with David Smith and then because Tony Caro lived and worked in Bennington for several years, I began to try my hand at sculpture.

DW: How did that affect the recent shaped paintings? They seem to me to have more volume, more weight, more density, more texture, more cuts, than your first group of shaped works (1975).

KN: Actually they are more compact.

DW: But I still don't think of your paintings as so-called shaped canvases. They're not built out, they don't become quasi-reliefs, half-sculpture, half-painting, or use the rectangle of the wall as a field to contain the shapes of the canvas.

KN: Yes, I want my pictures to stay intact, included in their own boundaries. Paintings have their own boundaries, their own zones, their own limits. The wall could become an issue if it were allowed to shape the space of a painting.

DW: Unless I'm mistaken, I don't see you painting a sculpture. That is, taking qualities in your painting and adding them to sculpture.

KN: I've tried, but it doesn't work. Tony Caro and I tried to collaborate at several points and it hasn't been successful. As a matter of fact, recently Tony has made sculpture that I have painted. He has to make the sculpture before I can paint it. That means that the form is taking precedence—that the material takes precedence as a form, rather than color establishing the form. It's not going too well but I'm working on it.

There's something about color that is so abstract that it is difficult for it to function in conjunction with solid form. Because if color really worked three-dimensionally as color, it would have worked three-dimensionally as art. It would have worked better in billboards or machinery that we see outside. But it hasn't really worked successfully in an artistic or expressive sense. Color has properties of weight, density, transparency, and so forth. And when it also has to be compatible with things that have an actual density, a given form, it's very difficult. It's difficult enough to get color to work with the form that's necessary to make paintings, let alone something that is three-dimensional, with those other added factors.

DW: A lot of polychrome sculpture that I've seen has been unsuccessful because the color has worked against the material.

KN: Caro's painted sculpture works because it's painted one color. And the color *does* help enhance the abstract, expressive qualities of the form. Tim Scott is the only sculptor so far who has used color three-dimensionally in, I think, a successful way.

DW: But you see it as a real problem.

KN: It's such a problem I'm not even interested in it! If you get involved with color, the factors can become just as actual as those of weight and density. It's just as real. The slight difference of transparency in colors can be the difference of a thousand pounds of actual material.

DW: In terms of that change in density or change in texture, when you apply a color to canvas, when you buff it down with a buffing machine, when you build up another surface with gels or with varnishes or whatever, do you do that to alter the relationship of the colors?

KN: Well, it's a simple fact, when you move from one color space to another color space, that if there's a value contrast you get a strong optical illusion. Strong value contrast can be expressive and dramatic, like the difference between high or low volume or the low keys and the high keys on the piano. But normally a composer doesn't go just from one extreme to the other. There are ranges of things, two notes being hit side by side, for example. Either or both are possible.

Actually, if you're moving from one flat color to another flat color, if there's a difference of texture—if one is matte and the other is shiny—that contrast of tactility can keep them visually in the same dimension. It keeps them adjacent—side by side.

Another reason is that a matte color and a shiny, transparent color are emotionally different. If something is warm and fuzzy and dense we have a kind of emotional response to that. If something is clear and you can see through it, like yellow or green or red can be, we have a different emotional sensation from that. So there's an expressive difference you can get that gives you more expressive range.

DW: I've noticed that the mood of your paintings changes from painting to painting depending on the selection and textures of the colors. And that no two paintings—given the fact that you often use a similar motif—ever look alike. Nor can one ever react identically to those paintings.

KN: It's precisely color that makes it possible to use the same motifs.

DW: Can you be more specific about the mood of the paintings on either an emotional or referential level, with regard to the meaning of color?

KN: We tend to discount a lot of meaning that goes on in life that's non-verbal. Color can convey a total range of mood and expression, of one's experiences in life, without having to give it descriptive or literary qualities.

DW: Color can be mood, can convey human meaning. These color moods can be the essence of abstract art. One other question to do with the shaped canvases: insofar as shaping was one of the last decisions that you always made, cropping when you finished painting, from the time of the circles all the way up to now, could that have influenced your decision to move away from the square or rectangular formats that you used for so long?

KN: Well, it had to do with getting the color to do different things. It turns out that certain picture shapes don't allow you to use different kinds of quantity distributions of color for different expressions. The quantities and configurations of colors are as important as the colors themselves. When I first started painting circles, I went fairly quickly to a 6-foot-square module. I think de Kooning said in an interview or artists' discussion that he only wanted to make gestures as big as his arm could reach. It struck me that he was saying his physical size had to do with the expressive size of the pictures he wanted to make. And as far as I know, when I got to the 6-foot-square size, it was right in terms of myself and wasn't too much of a field. Or it *was* a field, yet it was still physical. And that's why I used it for so long. Most all the chevrons and a majority of the circles are 6 feet square. Then, from having chosen that size, I could work in many different scales—I could make the different bands of the circles smaller or larger, or thinner or wider, which would change the internal scale of the works. Later, I varied the size of the shapes themselves: sometimes I would make 3-foot, 4-foot, 7-foot, 8-foot, 9-foot and up to 10-foot sizes. It made it possible to vary all different degrees of size along with differences of scale.

Those decisions began to influence all my later work. The horizontal paintings were the ones where I varied the formats the most—I made them extremely long or fat or square,

varying the sizes *and* scales, to put everything through permutations. That was a very liberating thing. And that, I guess, really has to do with cropping, also.

DW: What about cutting up or subdividing whole fields, as you did with the plaids?

KN: That actually took place in the horizontal stripe pictures, too.

DW: When, in the horizontal stripe paintings, the structure of the painting was generated more by the color than by "layout," it seemed to me that's when you got the freedom to cut the shapes of the pictures however you wanted from the entire field, rather than just cropping the perimeters (as in the circles, for example). So this allowed you to change the basic shape of the painting altogether—just as in the recent work.

KN: The plaids, too, could be shaped out of a field depending on where I wanted a different emphasis to occur for expressive reasons. A color could be on an edge of a picture or inside the space of a picture: the question of top, bottom, left, right became totally flexible as did the question of parallel or vertical or horizontal. Diane, that was more than a good question, that was an insight.

DW: So in those paintings, the cutting and shaping was a basic and final decision of how the painting was to look.

KN: These things always happen in strange ways. You can say after the fact what you're doing, but, believe me, you can't project it ahead. It has to be worked through before you can recognize what it was that you were looking for. It's a search; it's not like getting a brainstorm.

DW: You mean it's a real labor.

KN: It's work, yes, it comes out of the practice of painting, the practice of your art.

ANNE TRUITT *Daybook: The Journal of an Artist* (1974–79)

The straight lines with which human beings have marked the land are impositions of a different intelligence, abstract in this arena of the natural. Looking down at these facts, I began to see my life as somewhere between these two orders of the natural and the abstract, belonging entirely neither to the one nor to the other.

In my work as an artist I am accustomed to sustaining such tensions: A familiar position between my senses, which are natural, and my intuition of an order they both mask and illuminate. When I draw a straight line or conceive of an arrangement of tangible elements all my own, I inevitably impose my own order on matter. I actualize this order, rendering it accessible to my senses. It is not so accessible until actualized.

An eye for this order is crucial for an artist. I notice that as I live from day to day, observing and feeling what goes on both inside and outside myself, certain aspects of what is happening adhere to me, as if magnetized by a center of psychic gravity. I have learned to trust this center, to rely on its acuity and to go along with its choices although the center itself remains mysterious to me. I sometimes feel as if I *recognize* my own experience. It is a feeling akin to that of unexpectedly meeting a friend in a strange place, of being at once startled and satisfied—startled to find outside myself what feels native to me, satisfied to be so met. It is exhilarating.

I have found that this process of selection, over which I have virtually no control, isolates

* Anne Truitt, excerpts (1974–79) from *Daybook: The Journal of an Artist* (Middlesex: Penguin, 1982), 10–11, 23–24, 40–41, 51–52, 81–82, 96, 115, 117, 128, 179–80, 200–201. By permission of the author.

those aspects of my experience that are most essential to me in my work because they echo my own attunement to what life presents me. It is as if there are external equivalents for truths which I already in some mysterious way know. In order to catch these equivalents, I have to stay "turned on" all the time, to keep my receptivity to what is around me totally open. Preconception is fatal to this process. Vulnerability is implicit in it; pain, inevitable. . . .

I do not understand why I seem able to make what people call art. For many long years I struggled to learn how to do it, and I don't even know why I struggled. Then, in 1961, at the age of forty, it became clear to me that I was doing work I respected within my own strictest standards. Furthermore, I found this work respected by those whose understanding of art I valued. My first, instinctive reaction to this new situation was, if I'm an artist, being an artist isn't so fancy because it's just me. But now, thirteen years later, there seems to be more to it than that. It isn't "just me." A simplistic attitude toward the course of my life no longer serves.

The "just me" reaction was, I think, an instinctive disavowal of the social role of the artist. A life-saving disavowal. I refused, and still refuse, the inflated definition of artists as special people with special prerogatives and special excuses. If artists embrace this view of themselves, they necessarily have to attend to its perpetuation. They have to live it out. Their time and energy are consumed for social purposes. Artists then make decisions in terms of a role defined by others, falling into their power and serving to illustrate their theories. The Renaissance focused this social attention on the artist's individuality, and the focus persists today in a curious form that on the one hand inflates artists' egoistic concept of themselves and on the other places them at the mercy of the social forces on which they become dependent. Artists can suffer terribly in this dilemma. It is taxing to think out and then maintain a view of one's self that is realistic. The pressure to earn a living confronts a fickle public taste. Artists have to please whim to live on their art. They stand in fearful danger of looking to this taste to define their working decisions. Sometime during the course of their development, they have to forge a character subtle enough to nourish and protect and foster the growth of the part of themselves that makes art, and at the same time practical enough to deal with the world pragmatically. They have to maintain a position between care of themselves and care of their work in the world, just as they have to sustain the delicate tension between intuition and sensory information.

This leads to the uncomfortable conclusion that artists *are,* in this sense, special because they are intrinsically involved in a difficult balance not so blatantly precarious in other professions. The lawyer and the doctor *practice* their callings. The plumber and the carpenter *know* what they will be called upon to do. They do not have to spin their work out of themselves, discover its laws, and then present themselves turned inside out to the public gaze. . . .

I am only just now realizing how inorganic, unnatural, my work is. Like the straight lines on the desert, what is clearest in me bears no relation to what I see around me. This is paradoxical, since everything I make in the studio is a distillation of direct experience, sometimes even specific visual experience. *Nanticoke,* which I've never been able to make, is two whole instantaneous "takes" of a bridge and marsh on the Eastern Shore of Maryland, one from childhood superimposed by a second from adulthood. Someday, I hope, these will fuse and come through definitively.

The terms of the experience and the terms of the work itself are totally different. But if the work is successful—I cannot ever know whether it is or not—the experience becomes the work and, through the work, is accessible to others with its original force. For me, this process is mysterious. It's like not knowing where you're going but knowing how to get there. . . .

Wood is haunting me. In 1961, I thought of making bare, unpainted wooden sculptures

for the outdoors. On the National Cathedral grounds in Washington there is a carved wooden bench honed to honey color by weather. It stands under a tree, and so could a sculpture; this was my thought last spring as I ran my fingers over the pure, bare surface of the bench. I have been thinking about Japanese wood and the heavenly order of humble materials.

I come to the point of using steel, and simply cannot. It's like the marriage proposal of a perfectly eligible man who just isn't loveable. It is wood I love.

So any outdoor works, if they materialize, will not be heroic contemporary sculptures in the current tradition of David Smith. They will disintegrate in time at something comparable to the rate at which we human beings disintegrate, and with the same obvious subjection to its effects. They will not pretend to stand above the human span, but they won't be quite as short-lived. They may outlive several generations.

All my sculptures have these qualities, inherent in wood itself. Placing them outdoors would simply shift the balance of power into the hands of time. . . .

I remember how startled I was when, early in 1962, I realized that I was becoming obsessed with color as having meaning not only in counterpoint to the structures of fences and the bulks of weights—which were, I had thought, my primary concern—but also in itself, as holding meaning all on its own. As I worked along, making the sculptures as they appeared in my mind's eye, I slowly came to realize that what I was actually trying to do was to take paintings off the wall, to set color free in three dimensions for its own sake. This was analogous to my feeling for the freedom of my own body and my own being, as if in some mysterious way I felt myself to *be* color. This feeling grew steadily stronger until the setback of my experience in Japan when, in despair that my work no longer materialized somewhere in my head, I began to concentrate on the constructivist aspects of form, for me a kind of intellectual exercise. When we came back to America in 1967, I returned home to myself as well as to my country, abandoned all play with form for the austerity of the columnar structure, and let the color, which must have been gathering force within me somewhere, stream down over the columns on its own terms.

When I conceive a new sculpture, there is a magical period in which we seem to fall in love with one another. This explains to me why, when I was in Yaddo and deprived of my large pieces, I felt lonely with the same quality of loneliness I would feel for a missing lover. This mutual exchange is one of exploration on my part, and, it seems to me, on the sculpture's also. Its life is its own. I receive it. And after the sculpture stands free, finished, I have the feeling of "oh, it was *you,*" akin to the feeling with which I always recognized my babies when I first saw them, having made their acquaintance before their birth. This feeling of recognition lasts only a second or two, but is my ample reward. . . .

Certain concepts seem to *choose* to come into existence. For example, in 1962 I saw clearly, walked around in my mind and decided not to make, a 6' × 6' × 6' black sculpture. I can see it now perfectly plainly in the loft room of my Twining Court studio, just to the right of the entrance and illuminated from the hay-loft door beyond. A few years later, I read that Tony Smith had made exactly this sculpture; and somewhat later I saw a picture of it. I have never met Tony Smith, nor has he met me. On the evidence, I can only assume that we caught the same concept. . . .

The Renaissance emphasis on the individuality of the artist has been so compounded by the contemporary fascination with personalities that artists stand in danger of plucking the feathers of their own breast, licking up the drops of blood as they do so, and preening themselves on their courage. It is not surprising that some come to suicide, the final screw on this spiral of self-exploitation. And particularly sad because the artist's impulse is inherently generous. But what artists have to give and want to give is rarely matched and met. The public,

themselves deprived of the feeling of community that grants due proportion to everyone's self-expression, yearn over the artist in some special way because he or she seems to have the magic to wrench color and meaning from their bleached lives. The artist gives them themselves. They can even buy themselves. . . .

There is an appalling amount of mechanical work in the artist's life: lists of works with dimensions, prices, owners, provenances; lists of exhibitions with dates and places; bibliographical material; lists of supplies bought, storage facilities used. Records pile on records. This tedious, detailed work, which steadily increases if the artist exhibits to any extent, had been something of a surprise to me. It is all very well to be entranced by working in the studio, but that has to be backed up by the common sense and industry required to run a small business. In trying to gauge the capacity of young artists to achieve their ambition, I always look to see whether they seem to have this ability to organize their lives into an order that will not only set their hands free in the studio but also meet the demands their work will make upon them when it leaves the studio. . . .

It was not my eyes or my mind that learned. It was my body. I fell in love with the process of art, and I've never fallen out of it. I even loved the discomforts. At first my arms ached and trembled for an hour or so after carving stone; I remember sitting on the bus on the way home and feeling them shake uncontrollably. My blouse size increased by one as my shoulders broadened with muscle. My whole center of gravity changed. I learned to move from a center of strength and balance just below my navel. From this place, I could lift stones and I could touch the surface of clay as lightly as a butterfly's wing. . . .

The new balance my children's maturity is bringing to my life makes me wonder about the differences that seem to be surfacing between the artist in me and the mother. The artist struggles to hold the strict position she has found keeps her work to a line she values, while the mother is trying to grow by adjusting to the rapidly changing conditions my children present me as they move out on what seems to my schematic mind a sharply rising trajectory: They are learning a great deal about a great many aspects of life very fast. What they apparently expect from me is a point of view. They ask questions and they want what answers I can give. The artist's answers are only rarely useful to them. And the positions from which they ask are often different from those I have been in myself, so I have to use my imagination to empathize. This is taxing. At the same time I must maintain a center in myself so that what I say is honest. In order to do this, I have to examine and reexamine my own experience and apply it as best I can, inevitably at an angle oblique to theirs. What I am finding is that the artist is too strait and too self-centered, too idiosyncratic, and that the mother is not as useful as she once was. She is too nearsighted and wishes the children to remain within arm's reach. I am wondering now if some third person—who is neither artist nor mother, as yet unknown, unnameable—has developed behind my back. Perhaps the person whose first feeling when she saw her grandson's face was respect? If so, her mode of being is tentative.

In some curious way difficult to put my finger on, my generation of women suffer from a subtle sorrow that stiffens us against just such abandonment to the pleasures of the moment. A legacy, perhaps, from the Victorian rigidity that in America bypassed the Edwardian frivolity and descended to us in the form of standards precluding pagan joy. Many of us have been lonely too, deprived by our male peers of that sensitivity they had to brutalize out of themselves in order to undergo the Second World War. Confronted by the probability of their own deaths, it seems to me that many of the most percipient men of my generation killed off those parts of themselves that were most vulnerable to pain, and thus lost forever a delicacy of feeling on which intimacy depends. To a less tragic extent, we women also had to harden ourselves and stood to lose with them the vulnerability that is one of the guardians of the human spirit.

ANTHONY CARO A Discussion with Peter Fuller (1979)

PETER FULLER: Michael Fried thinks that your later, abstract works . . . are almost metaphors for bodily experience. He refers to their "rootedness in certain basic facts about being in the world, in particular about possessing a body," and argues "the changes that took place in (Caro's) art in late 1959 and early 1960 . . . were not the result of any shift of fundamental aspirations." Another major commentator on your work, William Rubin, dismisses this as "purely speculative." Who is right?

ANTHONY CARO: The critics who have influenced me the most by coming to the studio and talking about my work are Greenberg and Fried, not Rubin and Fried. I am not responsible for what any critics write. However, in this case, Fried is right: the changes took place because I had reached a sculptural impasse. My aspirations and beliefs about being in the world or the value of human life have not undergone fundamental changes since I was an undergraduate and spent time sorting these things out for myself. . . .

In my beliefs about sculpture I am very conscious that it has to do with physicality. I don't think it is possible to divorce sculpture from the making of objects. Back in the 1960s I found certain materials, like plaster and plastics, difficult and unpleasant to cope with simply because they do not have enough physical reality. It is not clear enough where the skin of them—not the skin, the surface of them—resides. They are flat-white in that kind of unreal way that you can't tell exactly where they are; the appearance of them also gives no indication of their mass or weight. I needed to use a material that you could identify that it was there. I do not believe that the "otherness" of a sculpture—and by that I mean what differentiates a sculpture from an object—should reside just within the material itself. I find that insufficiently significant: there's a tremendous "otherness" in a looking-glass for example. "Otherness" should be born in relationships. . . .

Certain things about the physical world and certain things about what it is like to be in a body are tied up together. Verticality, horizontality, gravity, all of these pertain both to the outside physical world and to the fact that we have bodies, as evidently does the size of a sculpture. These things are of importance in both my early figurative and the later abstract sculpture. In the abstract sculptures they are crucial. . . .

PF: Do you really think that the "highest art" is "about art"? I value Rothko for the way in which his forms express experience.

AC: Art, music and poetry are about what it is like to be alive. That almost goes without saying; depth of human content is what raises art to its most profound level. But that human content resides and finds expression within the language of the medium. The language artists use has to be the language of the subject: that is not the language of everyday life. The language we use in sculpture is the language of sculpture: that has to do with materials, shapes, intervals and so on. . . .

I am a sculptor: I try to form meaning out of bits of steel. . . .

To the spectator a sculpture or a painting for that matter is essentially a surrogate for another person. Therefore it *has* to be expressive. Abstract art which is not expressive becomes arbitrary or decorative. Sculptures or paintings which are figurative and not expressive are at least about figures, but abstract sculpture which is not expressive is just itself, the metal or

* Anthony Caro, excerpts from "Anthony Caro—A Discussion with Peter Fuller" (1979), trans. Horst Ludwig, in Dieter Blume, Elke Blume, and Eva-Maria Timpe, *Steel Sculptures 1960–1980,* vol. 3 of *Anthony Caro: Catalogue Raisonné* (Cologne: Verlag Galerie Wentzel, 1981), 31–47. By permission of the author.

stone or wood it is made of and it is for this reason that so much bad, inexpressive abstract sculpture *is* more vacuous than its realistic counterpart which at least portrays something. . . .

In abstract art its subject matter, not its content, is art. But if you want to talk about content, don't miss the affirmation, the joy, even ecstasy of life lived, in Hofmann's late abstractions. Art comes from art: I remember going to the Matisse show and seeing how Matisse had taken one of his own paintings, worked from it and transformed it, and that had led on to the next one and the next.

PF: In your early period did you ever think your engineering knowledge would be of use to you as a sculptor?

AC: No. . . . Henry Moore and David Smith, ten years later, were, in different ways, my fathers in sculpture. I suppose I felt something of a love/hate relationship for both of them, particularly Henry who taught me a great deal at a very important time of my development. David Smith was killed in '65. I was never really close to him personally: he was 18 years older than me. They were both father figures. One's feelings are so mixed in these situations: you're immensely grateful for what you learned from them, at the same time . . .

But Henry and I belong to very different generations. I don't think there is a great deal in common in terms of sculpture. Since I worked for him I have not had close contact sculpturally. But then David Smith and I never got down to talking about sculpture. . . .

PF: Were you aware of the great influence which America had on many aspects of British cultural life at that time?

AC: You bet! But a lot of what I thought America was like before I went was blasted by my trip. I had been fed on Lawrence Alloway's concept of America: that was a very Madison Avenue, advertising kind of version. I remember talking to a photographer who wanted to go to the States to be "planed smooth as a board." That was the expression he used! When I got there I found it wasn't a bit like that: it wasn't a slick, whizz-kid culture at all.

PF: Had you met Clement Greenberg before you went over?

AC: Yes, but it was after I had applied for my Ford Scholarship.

PF: The changes in your work after your American trip are well-known. But what was influencing you? How far was Greenberg involved in your sculptural conversion?

AC: Greenberg was totally involved. He more or less told me my art wasn't up to the mark. He came to see me in my London studio. He spent all day with me talking about art and at the end of the day he had said a lot of things that I had not heard before. I had wanted him to see my work because I had never had a really good criticism of it, a really clear eye looking at it. A lot of what he said hit home, but he also left me with a great deal of hope. I had come to the end of a certain way of working; I didn't know where to go. He offered some sort of pointer.

PF: It could be said that by stripping you of your expressionism he "planed you smooth as a board"!

AC: No, he clarified things for me. And thanks to him I began to learn to trust my feelings in art.

PF: Apart from Greenberg who had the most influence on this change?

AC: Noland, he was my age. I saw one of his first target shows in New York and I thought very highly of it. I liked him as a human being. I talked to him about art and about life one night till six in the morning when his train left for Washington. Noland was an ordinary guy: his clothes, the way he talked, were not extravagant in any way, and yet I had evidence he was also a very good artist. For me this was something unexpected; I had learnt to expect

artists of my age to express themselves well verbally or be poetic or look the right sort of character. This sort of charisma was and doubtless in some circles still is the sign by which one recognised the artist! Noland reaffirmed for me that you put your poetry or your feeling into your work, not into your lifestyle.

PF: Wasn't Smith involved in your conversion?

AC: I had detected Smith was a pretty good artist from the few photographs of his work I had seen. When I got to America in 1959 I did not go to his place: but I did see one or two works by him and I met him twice. But the influence of Smith did not really hit me until '63 to '65 when I went to Bolton Landing and saw perhaps 80 of his sculptures in his field and made many visits to his studio.

PF: What did you value in Smith's sculpture?

AC: Character, personal expressiveness, delicacy of touch, sculptural intelligence, immense sculptural intelligence! . . .

Of course his "creation of radically new expressive forms" mattered to me. . . . Anyhow the socialist bit was David's spiel. He intentionally took up a simplistic position in his conversation. "I'm just a welder," he used to say. He consistently made the most intelligent decisions in his sculpture and yet he hated art-talk: he stressed his role as a maker perhaps because he was embarrassed by his own artistry; saying he was just a welder was his defence. He liked to go into Bolton Landing for relaxation and there was even talk about him running for mayor. His place was very isolated and it must have been very lonely there. He used to go down to Lake George and drink with loggers and local people. Since David died I have talked to some old friends in whom he confided, and they have confirmed what I suspected; although David never showed what went on in his mind, he *was* paying attention to every sculptural or artistic thing that was happening. But publicly he never let on. . . . He talked instead about "being a welder." What a smokescreen! He was a highly sophisticated man. . . .

PF: Why did you decide to make Smith rather than Moore your "father figure" in sculpture in the 1960s?

AC: It was not so much a decision as a question of growth. When I was at Moore's studio I was still a student, and in the figurative sculptures I made in the years after I worked for Moore I strove to find a voice of my own. When I turned to making abstract welded steel sculptures it is true that I used many of the same materials as Smith but I was not so much directly influenced by him in the early 1960s as trying to do something very different from him.

PF: You introduced a new set of sculptural conventions, including emphasis on horizontality rather than verticality; apparent "dematerialisation" of the stuff you used; and absence of an illusionary interior; paint; welding; an absence of a pedestal, and so on. Why do you think [these] things were significant?

AC: Look at history. Sculpture was bogged down by its adherence to the monumental and monolith, by its own self-importance. To release sculpture from the totem, to try to cut away some of its rhetoric and bring it into a more direct relation to the spectator *has* helped free it a bit. Its physicality is less underlined than it used to be. All that is what I would like to think I have been a part of. . . .

PF: You have abolished interiority even more thoroughly; beyond the thickness of the steel your works have no insides. They could only have been made in a culture where concepts of dematerialisation and lack of interiority meant something.

AC: Your questions contain so much speculating and theorising about the sort of society we have that it seems we are getting really far away from the point of either my sculpture or

my attitude. Like Berger, you are trying to use art as a handle for something else. And your interview with me becomes a vehicle for propagating your views of society.

PF: Nonsense! Your sculptures aren't just things but also potentially meaningful images realized in a particular time and place. Greenberg himself said, "It ought to be unnecessary to say that Caro's originality is more than a question of stylistic or formal ingenuity." But he does not say *why* it is unnecessary to say that. I think this is a *necessary* question.

AC: It is unnecessary because worthwhile art includes human passions, intense feelings and imagination and the highest human aspiration. I would have thought, as Greenberg obviously did, that it was unnecessary to add that.

PF: In contrast to, say, the early Smith, you appear neither aware nor critical of the historical phenomena reflected in your work. You accept them with passivity.

AC: My job is making sculpture; and by that I mean using visual means to say what I, a man living now, in 1978, feel like. And that can incorporate, as well as my emotional life, my living in London, and visiting the USA and any other experiences that have gone to enrich or delete from the sum total of being a human person. Add to that the practical logic of my trade. My tools, the steel I work with sometimes too heavy to manhandle, the need for triangulation to make things stand up; also my knowledge of the history of and my experience of sculpture. In the same way Matisse's art was to do with his women, flowers, color, paint: all of these things, and to do with when and where he lived. People have asked me, "What does your sculpture mean?" It is an expression of my feeling. The meaning in art is implicit, not explicit; and to require explanations suggests a real discomfort with the visual. I wish people would trust their feelings more when making or looking at art. Then the programmed and literary approach and response would begin to disappear from painting and sculpture and their interpretation. Of course I realize there are more important things than my feelings and by the same token more important things than art: whether people have enough to eat, war and death, love, the life of a single human being. I am not denying the importance of the quality of life for everyone. But in my art my job is not the discussion of social problems.

PF: What is your job?

AC: My job is to make the best sculpture I can. By doing this, rather than by being a member of committees, or trying to exert influence in art-politics or even taking part in the neverending debate about what is wrong with the art scene in England, I believe I can help to keep sculpture alive and kicking and keep art moving. My job is to do with *art*, with pure delight, with the communication of feeling, with the enrichment for a short time of those who look at it, just as I myself am enriched for a while when I read a sonnet of Shakespeare's. I cannot hope for more. I cannot hope to change the injustice in the world, and in my art I am not overtly concerned with that or with anything like it.

JOSEF ALBERS The Origin of Art (1964)

THE ORIGIN OF ART:
The discrepancy between physical fact
and psychic effect

* Josef Albers, "The Origin of Art," in *Josef Albers: Homage to the Square* (New York: Museum of Modern Art, 1964), n.p. Reprinted by permission of The Museum of Modern Art, New York. © 2012 The Josef and Anni Albers Foundation/Artists Rights Society (ARS), New York.

THE CONTENT OF ART:
Visual formulation of our reaction
to life

THE MEASURE OF ART:
The ratio of effort to effect

THE AIM OF ART:
Revelation and evocation of vision

On My *Homage to the Square* (1964)

Seeing several of these paintings next to each other
makes it obvious that each painting
is an instrumentation in its own.

This means that they all are of different palettes,
and, therefore, so to speak, of different climates.

Choice of the colors used, as well as their order, is
aimed at an interaction—
influencing and changing each other forth and back.

Thus, character and feeling alter from painting to painting
without any additional "hand writing"
or, so-called, texture.

Though the underlying symmetrical and quasi-concentric
order of squares remains the same in all paintings
—in proportion and placement—
these same squares group or single themselves,
connect and separate in many different ways.

In consequence, they move forth and back, in and out,
and grow up and down and near and far, as well as enlarged and diminished.
All this, to proclaim color autonomy
as a means of a plastic organization.

The Color in My Paintings (1964)

They are juxtaposed for various and changing visual effects. They are to challenge or to echo
each other, to support or oppose one another. The contacts, respectively boundaries, between
them may vary from soft to hard touches, may mean pull and push besides clashes, but also
embracing, intersecting, penetrating.

Despite an even and mostly opaque application, the colors will appear above or below each

* Josef Albers, "On My *Homage to the Square*," in *Josef Albers: Homage to the Square* (New York: Museum of Modern Art, 1964), n.p. Reprinted by permission of The Museum of Modern Art, New York. © 2012 The Josef and Anni Albers Foundation/Artists Rights Society (ARS), New York.

** Josef Albers, "The Color in My Paintings" in *Josef Albers: Homage to the Square* (New York: Museum of Modern Art, 1964), n.p. Reprinted by permission of The Museum of Modern Art, New York. © 2012 The Josef and Anni Albers Foundation/Artists Rights Society (ARS), New York.

other, in front or behind, or side by side on the same level. They correspond in concord as well as in discord, which happens between both, groups and singles.

Such action, reaction, interaction—or interdependence—is sought in order to make obvious how colors influence and change each other: that the same color, for instance—with different grounds or neighbors—looks different. But also, that different colors can be made to look alike. It is to show that 3 colors can be read as 4, and similarly 3 colors as 2, and also 4 as 2.

Such color deceptions prove that we see colors almost never unrelated to each other and therefore unchanged; that color is changing continually: with changing light, with changing shape and placement, and with quantity which denotes either amount (a real extension) or number (recurrence). And just as influential are changes in perception depending on changes of mood, and consequently of receptiveness.

All this will make [us] aware of an exciting discrepancy between physical fact and psychic effect of color.

But besides relatedness and influence I should like to see that my colors remain, as much as possible, a "face"—their own "face," as it was achieved—uniquely—and I believe consciously—in Pompeian wall-paintings—by admitting coexistence of such polarities as being dependent and independent—being dividual and individual.

Often, with paintings, more attention is drawn to the outer, physical, structure of the color means than to the inner, functional, structure of the color action as described above. Here now follow a few details of the technical manipulation of the colorants which in my painting usually are oil paints and only rarely casein paints.

Compared with the use of paint in most painting today, here the technique is kept unusually simple, or more precisely, as uncomplicated as possible.

On a ground of the whitest white available—half or less absorbent—and built up in layers— on the rough side of panels of untempered masonite—paint is applied with a palette knife directly from the tube to the panel and as thin and even as possible in one primary coat. Consequently there is no under or over painting or modeling or glazing and no added texture—so-called.

As a rule there is no additional mixing either, not with other colors nor with painting media. Only a few mixtures—so far with white only—were unavoidable: for tones of red, as pink and rose, and for very high tints of blue, not available in tubes.

As a result this kind of painting presents an inlay (intarsia) of primary thin paint films—not layered, laminated, nor mixed wet, half or more dry, paint skins.

Such homogenous thin and primary films will dry, that is, oxidize, of course, evenly—and so without physical and/or chemical complication—to a healthy, durable paint surface of increasing luminosity.

VICTOR VASARELY Notes for a Manifesto (1955)

Here are the determining facts of the past which tie us together and which, among others, interest us: "plastic" triumphs over anecdote (Manet)—the first geometrization of the exterior world (Cézanne)—the conquest of pure color (Matisse)—the explosion of representation (Picasso)—exterior vision changes into interior vision (Kandinsky)—a branch of painting dissolves into architecture, becoming polychromatic (Mondrian)—departure from the large

* Victor Vasarely, "Notes for a Manifesto," in *Mouvement II* (Paris: Galerie Denise René, 1955); reprinted in Italo Mussa, *Victor Vasarely,* I Maestri del Novecento (Florence: Sansoni Editore, 1980), 92. Translation by Martha Nichols. © 2012 Artists Rights Society (ARS), New York/ADAGP, Paris.

Victor Vasarely, 1967. Photo courtesy
Arras Gallery Ltd., New York.

plastic synthetics (Le Corbusier)—new plastic alphabets (Arp, Taeuber, Magnelli, Herbin)—abandoning volume for SPACE (Calder). . . . The desire for a new conception was affirmed in the recent past by the invention of PURE COMPOSITION and by the choice of UNITY, which we will discuss later. Parallel to the decline of painting's ancestral technique, followed experimentation with *new materials* (chemical applications) and adoption of *new tools* (discovery of physics). . . . *Presently, we are headed towards the complete abandonment of routine, towards the integration of sculpture and the conquest of the plane's SUPERIOR DIMENSIONS.*

From the beginning, abstraction examined and enlarged its compositional elements. Soon, *form-color* invaded the entire two-dimensional surface; this metamorphosis led the painting-object, by way of architecture, to a spatial universe of polychromy. • However, an extra-architectural solution was already proposed and we deliberately broke with the neo-plastic law. • PURE COMPOSITION is still a plastic plane where rigorous abstract elements, hardly numerous and expressed in few colors (matte or glossy) possess, on the whole surface the same complete plastic quality: POSITIVE-NEGATIVE. But, by the effect of opposed perspectives, these elements give birth to and make vanish in turn a "spatial feeling" and thus, the illusion of *motion* and *duration*. • FORM AND COLOR ARE ONE. Form can only exist when indicated by a colored quality. Color is only quality when unlimited in form. The line (drawing, contour) is a fiction which belongs not to one, but to two form-colors at the same time. It does not engender form-colors, it results from their meeting. • *Two necessarily contrasted form-colors constitute PLASTIC UNITY, thus the UNITY of the creation: eternal duality of all things, recognized finally as inseparable.* It is the coupling of affirmation and negation. Measurable and immeasurable, unity is both physical and metaphysical. It is the conception of the material, the mathematical structure of the Universe, as its spiritual superstructure. *Unity* is the absence of BEAUTY, the first form of sensitivity. Conceived with art, it constitutes *the work,* poetic equivalent of the World that it signifies. The simplest example of plastic unity is the square (or rectangle) with its complement *"contrast" or the two-dimensional plane with its complement "surrounding space."*

After these succinct explanations, we propose the following definition: *upon the straight line—horizontal and vertical—depends all creative speculation.* Two parallels forming the frame define the plane, or cut out part of the space. *FRAMING IS CREATING FROM NEW AND RECREATING ALL ART FROM THE PAST.* • In the considerably expanded technique of the plastic artist, the plane remains the place of first conception. The *small format* in pure composition constitutes the departure from a recreation of multiple two-dimensional functions (large format, fresco,

tapestry, engraving). But we are already discovering new orientation. • The SLIDE will be to painting what the record is to music: manageable, faithful, complex, in other words a document, a work tool, a work. It will constitute a new transitional function between the fixed image and the future moving image. • THE SCREEN IS PLANE BUT, ALLOWING MOTION, IT IS ALSO SPACE. It does not have two, but four dimensions. Thanks to unity, the illusive "motion-duration" of pure composition, in the new dimension offered by the screen, becomes real motion. The *Lozenge,* another expression of "square-plane unity," equals square + space + motion = duration. The *Ellipsis,* another expression of "circle-plane unity," equals circle + space + motion + duration. • Other innumerable multiform and multicolored unities result in the infinite range of formal expression. "Depth" gives us the relative scale. The "distant" condenses, the "near" dilates, reacting thus on the COLOR-LIGHT quality. *We possess, therefore, both the tool and the technique, and finally the science for attempting the plastic-cinétique adventure.* Geometry (square, circle, triangle, etc.), chemistry (cadmium, chrome, cobalt, etc.) and physics (coordinates, spectrum, colorimeter, etc.) represent some *constants.* We consider them as quantities; our measure, our sensitivity, our art, will make qualities from them. (It is not a question here of "Euclidean" or "Einsteinian," but the artist's own geometry which functions marvelously without precise calculations.) • The animation of the Plastic develops nowadays in three distinct manners: 1) Motion in an architectural synthesis, where a spatial and monumental plastic work is conceived such that metamorphoses operate there through the displacement of the spectator's point of view.—2) Automatic plastic objects which—while possessing an intrinsic quality—serve primarily as a means of animation at the moment of filming.— Finally, 3) *The methodological investment of the CINEMATOGRAPHIC DOMAIN by abstract discipline. We are at the dawn of a great age. THE ERA OF PLASTIC PROJECTIONS ON FLAT AND DEEP SCREENS, IN DAYLIGHT OR DARKNESS, BEGINS.*

The art product extends from "the pleasant, useful object" to "Art for Art's sake," from "good taste" to the "transcendent." The entirety of plastic activities is inscribed in a vast perspective in gradations: decorative arts—fashion—advertising and propaganda by the image—decorations from big demonstrations of Industry, Festivals, Sports—sets from shows—polychromatic factory models—road signs and urbanization—documentary art film—recreative museum—art edition—synthesis of plastic Arts—finally, the search for the authentic avant-garde. In these diverse disciplines, the personal accent does not necessarily signify authenticity. And besides, we are not qualified in our time to decide about the major or minor character of these different manifestations of the plastic arts. There are some arrière-garde talents, just as there are insufficiencies in the avant-garde. But neither the valuable work—if it is immutable or retrograde—nor the advanced work—if it is mediocre—counts for posterity. • *The effect of the art product on us ranges (with some differences of intensity and quality) from small pleasure to the shock of Beauty. These diverse sensations are produced first of all in our emotive being by engendering the feeling of well-being or of tragedy. In this way, the goal of Art is almost attained.* Analysis, comprehension of a message depend on our knowledge and our degree of culture. Since only entities of art from the past are intelligible, since not everyone is permitted to study contemporary art in depth, *in place of its "comprehension" we advocate its "presence." With sensitivity being a faculty proper to humans, our messages will certainly reach the average person naturally through his/her emotive receptivity.* Indeed, we cannot indefinitely leave the work of art's enjoyment to the elite of connoisseurs. The art of today is headed towards generous forms, hopefully recreatable; the art of tomorrow will be common treasure or it will not be. • Traditions degenerate, ordinary forms of painting perish on condemned paths. Time judges and eliminates, renovation proceeds from a rupture and the demonstration of *authenticity* is discontinuous and unforeseen. It is painful, but mandatory, to abandon old values in order to assure the possession of new

ones. Our position changed; our ethics, our aesthetic must in turn change. If the idea of the plastic work resided before in an artisanal process and in the myth of the "unique piece," *it is rediscovered today in the conception of possible* RECREATION, MULTIPLICATION *and* EXPANSION. Is the immense diffusion of literary or musical works carried out to the detriment of their unicity and quality? • The majestic chain of fixed images on two dimensions extends from Lascaux to the abstracts . . . the future holds happiness for us in the new, moving and touching, plastic beauty.

BRIDGET RILEY Statement (c. 1968)

My final paintings are the intimate dialogue between my total being and the visual agents which constitute the medium. My intentions have not changed. I have always tried to realize visual and emotional energies simultaneously from the medium. My paintings are, of course, concerned with generating visual sensations, but certainly not to the exclusion of emotion. One of my aims is that these two responses shall be experienced as *one and the same.*

The changes in my recent work are developments of my earlier work. Those were concerned with principles of repose and disturbance. That is to say, in each of them a particular situation was stated visually. Certain elements within that situation remained constant. Others precipitated the destruction of themselves by themselves. Recurrently, as a result of the cyclic movement of repose, disturbance, and repose, the original situation was restated. This led me to a deeper involvement with the structure of contradiction and paradox in my more recent work. These relationships in visual terms concern such things as fast and slow movements, warm and cold colour, focal and open space, repetition *opposed* to "event," repetition *as* "event," increase and decrease, static and active, black opposed to white, greys as sequences harmonizing these polarities.

My direction is continually conditioned by my responses to the particular work in progress at any given moment. I am articulating the potentialities latent in the premise I have selected to work from. I believe that a work of art is essentially distinguished by the *transformation* of the elements involved.

I am sometimes asked "What is your objective?" and this I cannot truthfully answer. I work "from" something rather than "towards" something. It is a process of discovery and I will not impose a convenient dogma, however attractive. Any artist worth consideration is aware that there is art beyond art-movements and slogans, that dogma can never encompass the creative process. There is art beyond Op art, an art which engages the whole personality and draws a similarly total response from society.

FRANK STELLA The Pratt Lecture (1960)

There are two problems in painting. One is to find out what painting is and the other is to find out how to make a painting. The first is learning something and the second is making something.

* Bridget Riley, untitled statement (c. 1968), in Maurice de Sausmarez, *Bridget Riley* (Greenwich, Conn.: New York Graphic Society, 1970), 91. By permission of the artist.
** Frank Stella, excerpt from "The Pratt Lecture" (January or February 1960), in *Frank Stella: The Black Paintings* (Baltimore: Baltimore Museum of Art, 1976), 78. By permission of the author.

Frank Stella, in his studio working on *Getty Tomb* (second version), 1959. Photo by Hollis Frampton. Courtesy the Estate of Hollis Frampton.

One learns about painting by looking at and imitating other painters. I can't stress enough how important it is, if you are interested at all in painting, to look and to look a great deal at painting. There is no other way to find out about painting. After looking comes imitating. In my own case it was at first largely a technical immersion. How did Kline put down that color? Brush or knife or both? Why did Guston leave the canvas bare at the edges? Why did H. Frankenthaler use unsized canvas? And so on. Then, and this was the most dangerous part, I began to try to imitate the intellectual and emotional processes of the painters I saw. So that rainy winter days in the city would force me to paint Gandy Brodies, as a bright clear day at the shore would invariably lead me to De Staels. I would discover rose madder and add orange to make a Hofmann. Fortunately, one can stand only so much of this sort of thing. I got tired of other people's painting and began to make my own paintings. I found, however, that I not only got tired of looking at my own paintings but that I also didn't like painting them at all. The painterly problems of what to put here and there and how to do it to make it go with what was already there, became more and more difficult and the solutions more and more unsatisfactory. Until finally it became obvious that there had to be a better way.

There were two problems which had to be faced. One was spatial and the other methodological. In the first case I had to do something about relational painting, i.e., the balancing of the various parts of the painting with and against each other. The obvious answer was symmetry—make it the same all over. The question still remained, though, of how to do this in depth. A symmetrical image or configuration symmetrically placed on an open ground is not balanced out in the illusionistic space. The solution I arrived at, and there are probably quite a few, although I only know of one other, color density, forces illusionistic space out of the painting at constant intervals by using a regulated pattern. The remaining problem was simply to find a method of paint application which followed and complemented the design solution. This was done by using the house painter's technique and tools.

DONALD JUDD Specific Objects (1965)

Half or more of the best new work in the last few years has been neither painting nor sculpture. Usually it has been related, closely or distantly, to one or the other. The work is diverse, and much in it that is not in painting and sculpture is also diverse. But there are some things that occur nearly in common.

The new three-dimensional work doesn't constitute a movement, school or style. The common aspects are too general and too little common to define a movement. The differences are greater than the similarities. The similarities are selected from the work: they aren't a movement's first principles or delimiting rules. Three-dimensionality is not as near being simply a container as painting and sculpture have seemed to be, but it tends to that. But now painting and sculpture are less neutral, less containers, more defined, not undeniable and unavoidable. They are particular forms circumscribed after all, producing fairly definite qualities. Much of the motivation in the new work is to get clear of these forms. The use of three dimensions is an obvious alternative. It opens to anything. . . .

The objections to painting and sculpture are going to sound more intolerant than they are. There are qualifications. The disinterest in painting and sculpture is a disinterest in doing it again, not in it as it is being done by those who developed the last advanced versions The new work exceeds painting in plain power, but power isn't the only consideration, though the difference between it and expression can't be too great either. There are other ways than power and form in which one kind of art can be more or less than another. Finally, a flat and rectangular surface is too handy to give up. Some things can be done only on a flat surface. Lichtenstein's representation of a representation is a good instance. But this work which is neither painting nor sculpture challenges both. It will have to be taken into account by new artists. It will probably change painting and sculpture.

The main thing wrong with painting is that it is a rectangular plane placed flat against the wall. A rectangle is a shape itself; it is obviously the whole shape; it determines and limits the arrangement of whatever is on or inside of it. In work before 1946 the edges of the rectangle are a boundary, the end of the picture. The composition must react to the edges and the rectangle must be unified, but the shape of the rectangle is not stressed; the parts are more important, and the relationships of color and form occur among them. In the paintings of Pollock, Rothko, Still and Newman, and more recently of Reinhardt and Noland, the rectangle is emphasized. The elements inside the rectangle are broad and simple and correspond closely to the rectangle. The shapes and surface are only those which can occur plausibly within and on a rectangular plane. The parts are few and so subordinate to the unity as not to be parts in any ordinary sense. A painting is nearly an entity, one thing, and not the indefinable sum of a group of entities and references. The one thing overpowers the earlier painting. It also establishes the rectangle as a definite form: it is no longer a fairly neutral limit. A form can be used only in so many ways. The rectangular plane is given a life span. The simplicity required to emphasize the rectangle limits the arrangements possible within it. The sense of singleness also has a duration, but it is only beginning and has a better future outside of painting. Its occurrence in painting now looks like a beginning, in which new forms are often made from earlier schemes and materials.

 * Donald Judd, excerpts from "Specific Objects," *Arts Yearbook 8* (1965); reprinted in *Donald Judd: Complete Writings 1959–1975: Gallery Reviews, Book Reviews, Articles, Letters to the Editor, Reports, Statements, Complaints* (Halifax and New York: Press of the Nova Scotia College of Art and Design and New York University Press, 1975), 181–89. By permission of the Donald Judd Estate.

The plane is also emphasized and nearly single. It is clearly a plane one or two inches in front of another plane, the wall, and parallel to it. The relationship of the two planes is specific; it is a form. Everything on or slightly in the plane of the painting must be arranged laterally. . . .

It's possible that not much can be done with both an upright rectangular plane and an absence of space. Anything on a surface has space behind it. Two colors on the same surface almost always lie on different depths. An even color, especially in oil paint, covering all or much of a painting is almost always both flat and infinitely spatial. The space is shallow in all of the work in which the rectangular plane is stressed. Rothko's space is shallow and the soft rectangles are parallel to the plane, but the space is almost traditionally illusionistic. In Reinhardt's paintings, just back from the plane of the canvas, there is a flat plane and this seems in turn indefinitely deep. Pollock's paint is obviously on the canvas, and the space is mainly that made by any marks on a surface, so that it is not very descriptive and illusionistic. Noland's concentric bands are not as specifically paint-on-a-surface as Pollock's paint, but the bands flatten the literal space more. As flat and unillusionistic as Noland's paintings are, the bands do advance and recede. Even a single circle will warp the surface to it, will have a little space behind it. . . .

The new work obviously resembles sculpture more than it does painting, but it is nearer to painting. . . .

Most sculpture is made part by part, by addition, composed. The main parts remain fairly discrete. They and the small parts are a collection of variations, slight through great. There are hierarchies of clarity and strength and of proximity to one or two main ideas. Wood and metal are the usual materials, either alone or together, and if together it is without much of a contrast. There is seldom any color. The middling contrast and the natural monochrome are general and help to unify the parts.

There is little of any of this in the new three-dimensional work. So far the most obvious difference within this diverse work is between that which is something of an object, a single thing, and that which is open and extended, more or less environmental. There isn't as great a difference in their nature as in their appearance. . . .

Painting and sculpture have become set forms. A fair amount of their meaning isn't credible. The use of three dimensions isn't the use of a given form. There hasn't been enough time and work to see limits. So far, considered most widely, three dimensions are mostly a space to move into. The characteristics of three dimensions are those of only a small amount of work, little compared to painting and sculpture. A few of the more general aspects may persist, such as the work's being like an object or being specific, but other characteristics are bound to develop. Since its range is so wide, three-dimensional work will probably divide into a number of forms. At any rate, it will be larger than painting and much larger than sculpture, which, compared to painting, is fairly particular, much nearer to what is usually called a form, having a certain kind of form. Because the nature of three dimensions isn't set, given beforehand, something credible can be made, almost anything. Of course something can be done within a given form, such as painting, but with some narrowness and less strength and variation. Since sculpture isn't so general a form, it can probably be only what it is now— which means that if it changes a great deal it will be something else; so it is finished.

Three dimensions are real space. That gets rid of the problem of illusionism and of literal space, space in and around marks and colors—which is riddance of one of the salient and most objectionable relics of European art. The several limits of painting are no longer present. A work can be as powerful as it can be thought to be. Actual space is intrinsically more powerful and specific than paint on a flat surface. Obviously, anything in three dimensions can be

any shape, regular or irregular, and can have any relation to the wall, floor, ceiling, room, rooms or exterior or none at all. Any material can be used, as is or painted.

A work needs only to be interesting. Most works finally have one quality. In earlier art the complexity was displayed and built the quality. In recent painting the complexity was in the format and the few main shapes, which had been made according to various interests and problems. . . . The thing as a whole, its quality as a whole, is what is interesting. The main things are alone and are more intense, clear and powerful. They are not diluted by an inherited format, variations of a form, mild contrasts and connecting parts and areas. European art had to represent a space and its contents as well as have sufficient unity and aesthetic interest. Abstract painting before 1946 and most subsequent painting kept the representational subordination of the whole to its parts. Sculpture still does. In the new work the shape, image, color and surface are single and not partial and scattered. There aren't any neutral or moderate areas or parts, any connections or transitional areas. . . .

The use of three dimensions makes it possible to use all sorts of materials and colors. Most of the work involves new materials, either recent inventions or things not used before in art. Little was done until lately with the wide range of industrial products. Almost nothing has been done with industrial techniques and, because of the cost, probably won't be for some time. Art could be mass-produced, and processes otherwise unavailable, such as stamping, could be used. Dan Flavin, who uses fluorescent lights, has appropriated the results of industrial production. Materials vary greatly and are simply materials—formica, aluminum, cold-rolled steel, plexiglas, red and common brass, and so forth. They are specific. If they are used directly, they are more specific. Also, they are usually aggressive. There is an objectivity to the obdurate identity of a material. Also, of course, the qualities of materials—hard mass, soft mass, thickness of $\frac{1}{32}$, $\frac{1}{16}$, $\frac{1}{8}$ inch, pliability, slickness, translucency, dullness—have unobjective uses. The vinyl of Oldenburg's soft objects looks the same as ever, slick, flaccid and a little disagreeable, and is objective, but it is pliable and can be sewn and stuffed with air and kapok and hung or set down, sagging or collapsing. Most of the new materials are not as accessible as oil on canvas and are hard to relate to one another. They aren't obviously art. The form of a work of art and its materials are closely related. In earlier work the structure and the imagery were executed in some neutral and homogeneous material. Since not many things are lumps, there are problems in combining the different surfaces and colors and in relating the parts so as not to weaken the unity.

Three-dimensional work usually doesn't involve ordinary anthropomorphic imagery. If there is a reference it is single and explicit.

FRANK STELLA AND DONALD JUDD
Questions to Stella and Judd by Bruce Glaser (1966)

BRUCE GLASER: There are characteristics in your work that bring to mind styles from the early part of this century. Is it fair to say that the relative simplicity of Malevich, the Constructivists, Mondrian, the Neo-Plasticists, and the Purists is a precedent for your painting and sculpture, or are you really departing from these earlier movements?

* Bruce Glaser, excerpts from "Questions to Stella and Judd," *Art News* 65, no. 5 (September 1966): 55–61. By permission of the author and the publisher. © 1966 ARTnews, LLC, September.

FRANK STELLA: There's always been a trend toward simpler painting and it was bound to happen one way or another. Whenever painting gets complicated, like Abstract Expressionism, or Surrealism, there's going to be someone who's not painting complicated paintings, someone who's trying to simplify. . . . You're always related to something. I'm related to the more geometric, or simpler, painting, but the motivation doesn't have anything to do with that kind of European geometric painting. I think the obvious comparison with my work would be Vasarely, and I can't think of anything I like less. . . . Mine has less illusionism than Vasarely's, but the Groupe de Recherche d'Art Visuel actually painted all the patterns before I did—all the basic designs that are in my painting—not the way I did it, but you can find the schemes of the sketches I made for my own paintings in work by Vasarely and that group in France over the last seven or eight years. I didn't even know about it, and in spite of the fact that they used those ideas, those basic schemes, it still doesn't have anything to do with my painting. I find all that European geometric painting—sort of post–Max Bill school—a kind of curiosity—very dreary.

DONALD JUDD: There's an enormous break between that work and other present work in the U.S., despite similarity in patterns or anything. The scale itself is just one thing to pin down. Vasarely's work has a smaller scale and a great deal of composition and qualities that European geometric painting of the 20's and 30's had. He is part of a continuous development from the 30's, and he was doing it himself then.

FS: The other thing is that the European geometric painters really strive for what I call relational painting. The basis of their whole idea is balance. You do something in one corner and you balance it with something in the other corner. Now the "new painting" is being characterized as symmetrical. Ken Noland has put things in the center and I'll use a symmetrical pattern, but we use symmetry in a different way. It's nonrelational. In the newer American painting we strive to get the thing in the middle, and symmetrical, but just to get a kind of force, just to get the thing on the canvas. The balance factor isn't important. We're not trying to jockey everything around.

BG: What is the "thing" you're getting on the canvas?

FS: I guess you'd have to describe it as the image, either the image or the scheme. Ken Noland would use concentric circles; he'd want to get them in the middle because it's the easiest way to get them there, and he wants them there in the front, on the surface of the canvas. If you're that much involved with the surface of anything, you're bound to find symmetry the most natural means. As soon as you use any kind of relational placement for symmetry, you get into a terrible kind of fussiness, which is the one thing that most of the painters now want to avoid. When you're always making these delicate balances, it seems to present too many problems; it becomes sort of arch. . . .

DJ: I'm interested in spareness, but I don't think it has any connection to symmetry.

FS: Actually, your work is really symmetrical. How can you avoid it when you take a box situation? The only piece I can think of that deals with any kind of symmetry is one box with a plane cut out.

DJ: But I don't have any ideas as to symmetry. My things are symmetrical because, as you said, I wanted to get rid of any compositional effects, and the obvious way to do it is to be symmetrical.

BG: Why do you want to avoid compositional effects?

DJ: Well, those effects tend to carry with them all the structures, values, feelings of the whole European tradition. It suits me fine if that's all down the drain. When Vasarely has

optical effects within the squares, they're never enough, and he has to have at least three or four squares, slanted, tilted inside each other, and all arranged. That is about five times more composition and juggling than he needs.

BG: It's too busy?

DJ: It is in terms of somebody like Larry Poons. Vasarely's composition has the effect of order and quality that traditional European painting had, which I find pretty objectionable. . . . The objection is not that Vasarely's busy, but that in his multiplicity there's a certain structure that has qualities I don't like. . . . The qualities of European art so far. They're innumerable and complex, but the main way of saying it is that they're linked up with a philosophy—rationalism, rationalistic philosophy.

BG: Descartes?

DJ: Yes.

BG: And you mean to say that your work is apart from rationalism?

DJ: Yes. All that art is based on systems built beforehand, *a priori* systems; they express a certain type of thinking and logic that is pretty much discredited now as a way of finding out what the world's like.

BG: Discredited by whom? By empiricists?

DJ: Scientists, both philosophers and scientists.

BG: What is the alternative to a rationalistic system in your method? It's often said that your work is preconceived, that you plan it out before you do it. Isn't that a rationalistic method?

DJ: Not necessarily. That's much smaller. When you think it out as you work on it, or you think it out beforehand, it's a much smaller problem than the nature of the work. *What* you want to express is a much bigger thing than *how* you may go at it. Larry Poons works out the dots somewhat as he goes along; he figures out a scheme beforehand and also makes changes as he goes along. Obviously I can't make many changes, though I do what I can when I get stuck.

BG: In other words, you might be referring to an antirationalist position before you actually start making the work of art.

DJ: I'm making it for a quality that *I* think is interesting and more or less true. And the quality involved in Vasarely's kind of composition isn't true to me.

BG: Could you be specific about how your own work reflects an antirationalistic point of view?

DJ: The parts are unrelational.

BG: If there's nothing to relate, then you can't be rational about it because it's just there?

DJ: Yes.

BG: Then it's almost an abdication of logical thinking.

DJ: I don't have anything against using some sort of logic. That's simple. But when you start relating parts, in the first place, you're assuming you have a vague whole—the rectangle of the canvas—and definite parts, which is all screwed up, because you should have a definite *whole* and maybe no parts, or very few. The parts are always more important than the whole.

BG: And you want the whole to be more important than the parts?

DJ: Yes. The whole's it. The big problem is to maintain the sense of the whole thing. . . . Painting's been going toward that for a long time. A lot of people, like Oldenburg for instance, have a "whole" effect to their work.

FS: But we're all still left with structural or compositional elements. The problems aren't

any different. I still have to compose a picture, and if you make an object you have to organize the structure. I don't think our work is that radical in any sense because you don't find any really new compositional or structural element. I don't know if that exists. It's like the idea of a color you haven't seen before. Does something exist that's as radical as a diagonal that's not a diagonal? Or a straight line or a compositional element that you can't describe? . . .

DJ: That's true; there's always going to be something in one's work that's been around for a long time, but the fact that compositional arrangement isn't important is rather new. Composition is obviously very important to Vasarely, but all I'm interested in is having a work interesting to me as a whole. I don't think there's any way you can juggle a composition that would make it more interesting in terms of the parts. . . . You see, the big problem is that anything that is not absolutely plain begins to have parts in some way. The thing is to be able to work and do different things and yet not break up the wholeness that a piece has. . . .

BG: You've written about the predominance of chance in Robert Morris's work. Is this element in your pieces too?

DJ: Yes. Pollock and those people represent actual chance; by now it's better to make that a foregone conclusion—you don't have to mimic chance. You use a simple form that doesn't look like either order or disorder. We recognize that the world is ninety percent chance and accident. Earlier painting was saying that there's more order in the scheme of things than we admit now, like Poussin saying order underlies nature. Poussin's order is anthropomorphic. Now there are no preconceived notions. Take a simple form—say a box—and it does have an order, but it's not so ordered that that's the dominant quality. The more parts a thing has, the more important order becomes, and finally order becomes more important than anything else.

BG: There are several other characteristics that accompany the prevalence of symmetry and simplicity in the new work. There's a very finished look to it, a complete negation of the painterly approach. Twentieth-century painting has been concerned mainly with emphasizing the artist's presence in the work, often with an unfinished quality by which one can participate in the experience of the artist, the process of painting the picture. You deny all this, too; your work has an industrial look, a non-man-made look.

FS: The artist's tools or the traditional artist's brush and maybe even oil paint are all disappearing very quickly. We use mostly commercial paint, and we generally tend toward larger brushes. In a way, Abstract Expressionism started all this. De Kooning used house painters' brushes and house painters' techniques.

BG: Pollock used commercial paint.

FS: Yes, the aluminum paint. What happened, at least for me, is that when I first started painting I would see Pollock, de Kooning, and the one thing they all had that I didn't have was an art school background. They were brought up on drawing and they all ended up painting or drawing with the brush. They got away from the smaller brushes and, in an attempt to free themselves, they got involved in commercial paint and house-painting brushes. Still it was basically drawing with paint, which has characterized almost all twentieth-century painting. The way my own painting was going, drawing was less and less necessary. It was the one thing I wasn't going to do. I wasn't going to draw with the brush.

BG: What induced this conclusion that drawing wasn't necessary any more?

FS: Well, you have a brush and you've got paint on the brush, and you ask yourself why you're doing whatever it is you're doing, what inflection you're actually going to make with the brush and with the paint that's on the end of the brush. It's like handwriting. And I found

out that I just didn't have anything to say in those terms. I didn't want to make variations; I didn't want to record a path. I wanted to get the paint out of the can and onto the canvas. I knew a wise guy who used to make fun of my painting, but he didn't like the Abstract Expressionists either. He said they would be good painters if they could only keep the paint as good as it is in the can. And that's what I tried to do. I tried to keep the paint as good as it was in the can.

BG: Are you implying that you are trying to destroy painting?

FS: It's just that you can't go back. It's not a question of destroying anything. If something's used up, something's done, something's over with, what's the point of getting involved with it?

DJ: Root, hog, or die.

BG: Are you suggesting that there are no more solutions to, or no more problems that exist in painting?

FS: Well, it seems to me we have problems. When Morris Louis showed in 1958, everybody (*Art News,* Tom Hess) dismissed his work as thin, merely decorative. They still do. Louis is the really interesting case. In every sense his instincts were Abstract Expressionist, and he was terribly involved with all of that, but he felt he had to move, too. I always get into arguments with people who want to retain the old values in painting—the humanistic values that they always find on the canvas. If you pin them down, they always end up asserting that there is something there besides the paint on the canvas. My painting is based on the fact that only what can be seen there *is* there. It really is an object. Any painting is an object and anyone who gets involved enough in this finally has to face up to the objectness of whatever it is that he's doing. He is making a thing. All that should be taken for granted. If the painting were lean enough, accurate enough, or right enough, you would just be able to look at it. All I want anyone to get out of my paintings, and all I ever get out of them, is the fact that you can see the whole idea without any confusion. . . . What you see is what you see. . . .

BG: But some would claim that the visual effect is minimal, that you're just giving us one color or a symmetrical grouping of lines. A nineteenth-century landscape painting would presumably offer more pleasure, simply because it's more complicated.

DJ: I don't think it's more complicated.

FS: No, because what you're saying essentially is that a nineteenth-century landscape is more complicated because there are two things working—deep space and the way it's painted. You can see how it's done and read the figures in the space. Then take Ken Noland's painting, for example, which is just a few stains on the ground. If you want to look at the depths, there are just as many problematic spaces. And some of them are extremely complicated technically; you can worry and wonder how he painted the way he did.

DJ: Old master painting has a great reputation for being profound, universal, and all that, and it isn't necessarily.

FS: But I don't know how to get around the part that they just wanted to make something pleasurable to look at, because even if that's what I want, I also want my painting to be so you can't *avoid* the fact that it's supposed to be entirely visual.

BG: You've been quoted, Frank, as saying that you want to get sentimentality out of painting.

FS: I hope I didn't say that. I think what I said is that sentiment wasn't necessary. I didn't think then, and I don't now, that it's necessary to make paintings that will interest people in the sense that they can keep going back to explore painterly detail. One could stand in front of any Abstract-Expressionist work for a long time, and walk back and forth, and inspect the

depths of the pigment and the inflection and all the painterly brushwork for hours. But I wouldn't particularly want to do that and also I wouldn't ask anyone to do that in front of my paintings. To go further, I would like to prohibit them from doing that in front of my painting. That's why I make the paintings the way they are, more or less. . . .

There's something awful about that "economy of means." I don't know why, but I resent that immediately. I don't go out of my way to be economical. It's hard to explain what exactly it is I'm motivated by, but I don't think people are motivated by reduction. It would be nice if we were, but actually, I'm motivated by the desire to make something, and I go about it in the way that seems best.

DJ: You're getting rid of the things that people used to think were essential to art. But that reduction is only incidental. I object to the whole reduction idea, because it's only reduction of those things someone doesn't want. If my work is reductionist it's because it doesn't have the elements that people thought should be there. But it has other elements that I like. Take Noland again. You can think of the things he doesn't have in his paintings, but there's a whole list of things that he *does* have that painting didn't have before. Why is it necessarily a reduction?

FS: You want to get rid of things that get you into trouble. As you keep painting you find things are getting in your way a lot and those are the things that you try to get out of the way. You might be spilling a lot of blue paint, and because there's something wrong with that particular paint, you don't use it any more, or you find a better thinner or better nails. There's a lot of striving for better materials, I'm afraid. I don't know how good that is.

DJ: There's nothing sacrosanct about materials.

FS: I lose sight of the fact that my paintings are on canvas, even though I know I'm painting on canvas, and I just see my paintings. I don't get terribly hung up over the canvas itself. If the visual act taking place on the canvas is strong enough, I don't get a very strong sense of the material quality of the canvas. It sort of disappears. I don't like things that stress the material qualities. I get so I don't even like Ken Noland's paintings (even though I like them a lot). Sometimes all that bare canvas gets me down, just because there's so much of it; the physical quality of the cotton duck gets in the way.

BG: Don, would it be fair to say that your approach is a nihilistic one, in view of your wish to get rid of various elements?

DJ: No, I don't consider it nihilistic or negative or cool or anything else. Also I don't think my objection to the Western tradition is a positive quality of my work. It's just something I don't want to do, that's all. I want to do something else. . . .

BG: Don't you see art as kind of evolutionary? You talk about what art was and then you say it's old hat, it's all over now.

DJ: It's old hat because it involves all those beliefs you really can't accept in life. You don't want to work with it any more. It's not that any of that work has suddenly become mad in itself. If I get hold of a Piero della Francesca, that's fine.

I wanted to say something about this painterly thing. It certainly involves a relationship between what's outside—nature or a figure or something—and the artist's actually painting that thing, his particular feeling at the time. This is just one area of feeling, and I, for one, am not interested in it for my own work. I can't do anything with it. It's been fully exploited and I don't see why the painterly relationship exclusively should stand for art. . . .

FS: Let's take painterly simply to mean Abstract Expressionism, to make it easier. Those painters were obviously involved in what they were doing as they were doing it, and now in

what Don does, and I guess in what I do, a lot of the effort is directed toward the end. We believe that we can find the end, and that a painting can be finished. The Abstract Expressionists always felt the painting's being finished was very problematical. We'd more readily say that our paintings were finished and say, well, it's either a failure or it's not, instead of saying, well, maybe it's not really finished.

BG: You're saying that the painting is almost completely conceptualized before it's made, that you can devise a diagram in your mind and put it on canvas. Maybe it would be adequate to simply verbalize this image and give it to the public rather than giving them your painting?

FS: A diagram is not a painting; it's as simple as that. I can make a painting from a diagram, but can you? Can the public? It can just remain a diagram if that's all I do, or if it's a verbalization it can just remain a verbalization. Clement Greenberg talked about the ideas or possibilities of painting in, I think, the *After Abstract Expressionism* article, and he allows a blank canvas to be an idea for a painting. It might not be a *good* idea, but it's certainly valid. Yves Klein did the empty gallery. He sold air, and that was a conceptualized art, I guess.

BG: *Reductio ad absurdum.*

FS: Not absurd enough, though.

DJ: Even if you can plan the thing completely ahead of time, you still don't know what it looks like until it's right there. You may turn out to be totally wrong once you have gone to all the trouble of building this thing.

FS: Yes, and also that's what you want to do. You actually want to see the thing. That's what motivates you to do it in the first place, to see what it's going to look like. . . .

BG: Frank, your stretchers are thicker than the usual. When your canvases are shaped or cut out in the center, this gives them a distinctly sculptural presence.

FS: I make the canvas deeper than ordinarily, but I began accidentally. I turned one-by-threes on edge to make a quick frame, and then I liked it. When you stand directly in front of the painting it gives it just enough depth to hold it off the wall; you're conscious of this sort of shadow, just enough depth to emphasize the surface. In other words, it makes it more like a painting and less like an object, by stressing the surface.

DJ: I thought of Frank's aluminum paintings as slabs, in a way. . . .

BG: Do you think the frequent use of the word "presence" in critical writing about your kind of work has something to do with the nature of the objects you make, as if to suggest there is something more enigmatic about them than previous works of art?

FS: You can't say that your work has more of this or that than somebody else's. It's a matter of terminology. De Kooning or Al Held paint "tough" paintings and we would have to paint with "presence," I guess. It's just another way of describing.

BG: Nobody's really attempted to develop some new terminology to deal with the problems of these paintings.

FS: But that's what I mean. Sometimes I think our paintings *are* a little bit different, but on the other hand it seems that they're still dealing with the same old problems of making art. I don't see why everyone seems so desperately in need of a new terminology, and I don't see what there is in our work that needs a new terminology either to explain or to evaluate it. It's art, or it wants to be art, or it asks to be considered as art, and therefore the terms we have for discussing art are probably good enough. You could say that the terms used so far to discuss and evaluate art are pretty grim; you could make a very good case for that. But nonetheless, I imagine there's nothing specific in our work that asks for new terms, any more than any other art.

CARL ANDRE Preface to Stripe Painting (1959)

Art excludes the unnecessary. Frank Stella has found it necessary to paint stripes.
There is nothing else in his painting.
Frank Stella is not interested in expression or sensitivity. He is interested in the
necessities of painting.
Symbols are counters passed among people. Frank Stella's painting is not sym-
bolic. His stripes are the paths of brush on canvas. These paths lead only into
painting.

Poem (1966)

```
beam . . . room
beam
clay beam
edge clay beam
grid edge clay beam
bond grid edge clay beam
path bond grid edge clay beam
reef
slab reef
wall slab reef
bead wall slab reef
cell bead wall slab reef
rock cell bead wall slab reef
root
heel root
line heel root
rate line heel root
dike rate line heel root
sill dike rate line heel root
room
time room
hill time room
inch hill time room
rack inch hill time room
mass rack inch hill time room
```

DAN FLAVIN Some Remarks . . . Excerpts from a Spleenish Journal (1966)

As I have said for several years, I believe that art is shedding its vaunted mystery for a common
sense of keenly realized decoration. Symbolizing is dwindling—becoming slight. We are
pressing downward toward no art—a mutual sense of psychologically indifferent decoration—
a neutral pleasure of seeing known to everyone.

I know now that I can reiterate any part of my fluorescent light system as adequate. Ele-

* Carl Andre, "Preface to Stripe Painting," in Dorothy C. Miller, ed., *Sixteen Americans,* with statements by artists and others (New York: Museum of Modern Art, 1959), 76. By permission of the artist and the publisher.

** Carl Andre, untitled poem from the 1966 exhibition *Primary Structures* at Jewish Museum, New York. By permission of the artist.

*** Dan Flavin, "Some Remarks . . . Excerpts from a Spleenish Journal," *Artforum* 5, no. 4 (December 1966): 27–29. By permission of the publisher. © 2012 Estate of Dan Flavin/Artists Rights Society (ARS), New York.

ments of parts of that system simply alter in situation installation. They lack the look of a history. I sense no stylistic or structural development of any significance within my proposal— only shifts in partitive emphasis—modifying and addable without intrinsic change.

All my diagrams, even the oldest, seem applicable again and continually. It is as though my system synonymizes its past, present and future states without incurring a loss of relevance. It is curious to feel self-denied of a progressing development, if only for a few years.

Electric light is just another instrument. I have no desire to contrive fantasies mediumistically or sociologically over it or beyond it. Future art and the lack of that would surely reduce such squandered speculations to silly trivia anyhow. . . .

The lamps will go out (as they should, no doubt). Somehow I believe that the changing standard lighting system should support my idea within it. I will try to maintain myself this way. It may work out. The medium bears the artist. . . .

In the beginning, and for some time thereafter, I, too, was taken with easy, almost exclusive recognitions of fluorescent light as image. Now I know that the physical fluorescent light tube has never dissolved or disappeared by entering the physical field of its own light. . . . At first sight, it appeared to do that, especially when massed tightly with reciprocal glass reflections resulting as within "the nominal three" [space, time, matter] but then, with a harder look, one saw that each tube maintained steady and distinct contours despite its internal act of ultraviolet light which caused the inner fluorescent coating of its glass container to emit the visible light. The physical fact of the tube as object in place prevailed whether switched on or off. (In spite of my emphasis here on the actuality of fluorescent light, I still feel that the composite term "image-object" best describes my use of the medium.)

What I have written further explains (it even alters) notions contained in the last paragraphs of " . . . in daylight or cool white" and denies current interest on my part in what appears to be metaphysical thought about light and related visual activity.

My drawing is not at all inventive about itself. It is an instrument not a resultant. . . .

If sophisticated contacts in contemporary society, phenomena and/or media are to be accomplished for art, we will have to opt for artists who are educated more or less inclusively. The preciously limited environment of art schools must be abandoned altogether. Universities will have to permit artists to wander in their curricula with or without degree responsibility. Science and technology might be as permissive. Other areas and disciplines also. . . .

I know of no occupation in American life so meaningless and unproductive as that of art critic. . . .

As you know, artists are reluctant usually to have their working intentions pinned down to explicit remarks which they regard as limiting of thought process and the fact of the work before (or even after) it can be seen.

Also, artists shun the semblance of substitute verbal sham. Their aches after honesty often produce the familiar symptoms of bad humor of "serious" artists—what everyone learned to detest about those real men who stridently gabbed out their art through the heat, smoke and stale beer of the Cedar Bar Syndrome, a decade ago.

TONY SMITH Conversations with Samuel Wagstaff Jr. (1966)

In their "International Style in Architecture" (1932), H. R. Hitchcock and Philip Johnson said that the style was characterized, among other things, by ordering the plan through structural regularity, rather than through unilateral symmetry. I had been familiar with the root rectangles of Jay Hambidge's *Dynamic Symmetry* since before I started high school. I had no experience in architecture and the notion of planning according to regular Bays, although all over the place, hadn't occurred to me. In painting, however, as I tried more and more schemes, I reduced the size of the format. I painted dozens of 8" × 10" panels, and began to use a 2-inch square module instead of the application of areas based upon the root rectangles. . . .

I view art as something vast. I think highway systems fall down because they are not art. Art today is an art of postage stamps. I love the Secretariat Building of the U.N., placed like a salute. In terms of scale, we have less art per square mile, per capita, than any society ever had. We are puny. In an English village there was always the cathedral. There is nothing to look at between the Bennington Monument and the George Washington Bridge. We now have stylization. In Hackensack a huge gas tank is all underground. I think of art in a public context and not in terms of mobility of works of art. Art is just there. I'm temperamentally more inclined to mural painting, especially that of the Mexican, Orozco. I like the way a huge area holds onto a surface in the same way a state does on a map.

.

I'm interested in the inscrutability and the mysteriousness of the thing. Something obvious on the face of it (like a washing machine or a pump), is of no further interest. A Bennington earthenware jar, for instance, has subtlety of color, largeness of form, a general suggestion of substance, generosity, is calm and reassuring—qualities which take it beyond pure utility. It continues to nourish us time and time again. We can't see it in a second, we continue to read it. There is something absurd in the fact that you can go back to a cube in this same way. It doesn't seem to be an ordinary mechanical experience. When I start to design, it's almost always corny and then naturally moves toward economy.

.

When I was a child of four I visited the Pueblos in New Mexico. Back in the East, I made models of them with cardboard boxes. While still quite young I associated the forms of these complexes with the block houses that Wright built in and around Los Angeles in the early twenties. Later I associated them with Cubism, and quite recently thought of the dwellings at Mesa Verde in relationship to the High Court Building at Chandigarh. They seem to have been a continuing reference, even though they were never in my consciousness except as that. In any case they seemed real to me in a way that buildings of our own society did not.

.

I'm not aware of how light and shadow falls on my pieces. I'm just aware of basic form. I'm interested in the thing, not in the effects—pyramids are only geometry, not an effect.

.

* Samuel Wagstaff Jr., "Talking with Tony Smith: 'I view art as something vast,'" *Artforum* 5, no. 4 (December 1966): 14–19. By permission of the publisher and the Estate of Tony Smith.

My speculations with plane and solid geometry and crystal forms led me to making models for sculpture, but what I did always made use of the 90-degree angle, like De Stijl. I only began to use more advanced relationships of solids after working with Wright and then related the thirty- and sixty-degree angles to the ninety-degree angles.

· · · · · ·

We think in two dimensions—horizontally and vertically. Any angle off that is very hard to remember. For that reason I make models—drawings would be impossible.

· · · · · ·

I'm very interested in Topology, the mathematics of surfaces, Euclidian geometry, line and plane relationships. "Rubber sheet geometry," where facts are more primary than distances and angles, is more elemental but more sophisticated than plane geometry.

· · · · · ·

When I was teaching at Cooper Union in the first year or two of the fifties, someone told me how I could get onto the unfinished New Jersey Turnpike. I took three students and drove them somewhere in the Meadows to New Brunswick. It was a dark night and there were no lights or shoulder markers, lines, railings, or anything at all except the dark pavement moving through the landscape of the flats, rimmed by hills in the distance, but punctuated by stacks, towers, fumes, and colored lights. This drive was a revealing experience. The road and much of the landscape was artificial, and yet it couldn't be called a work of art. On the other hand, it did something for me that art had never done. At first I didn't know what it was, but its effect was to liberate me from many of the views I had had about art. It seemed that there had been a reality there which had not had any expression in art.

The experience on the road was something mapped out but not socially recognized. I thought to myself, it ought to be clear that's the end of art. Most painting looks pretty pictorial after that. There is no way you can frame it, you just have to experience it. Later I discovered some abandoned airstrips in Europe—abandoned works, Surrealist landscapes, something that had nothing to do with any function, created worlds without tradition. Artificial landscape without cultural precedent began to dawn on me. There is a drill ground in Nuremberg, large enough to accommodate two million men. The entire field is enclosed with high embankments and towers. The concrete approach is three sixteen-inch steps, one above the other, stretching for a mile or so.

I think of the piece as pretty much in a certain size and related to ordinary everyday measurements—doorways in buildings, beds, etc. All the pieces were seen in greenery in the past. I might change a piece which was to be on a plaza to accommodate its scale, size, and color. *Generation* is the first piece I thought of as a citified monumental expression. I don't think of it as personal or subjective. I attempted to make it as urbane and objective as possible.

AGNES MARTIN The Untroubled Mind (1972)

People think that painting is about color
It's mostly composition

* Agnes Martin with Ann Wilson, "The Untroubled Mind" (sections of which come from notes for a lecture given by Martin at Cornell University in January 1972), *Flash Art* 41 (June 1973): 6–8; reprinted in *Agnes Martin* (Philadelphia: Institute of Contemporary Art, University of Pennsylvania, 1973), 17–24. By permission of Agnes Martin and the publishers.

It's composition that's the whole thing
The classic image—
Two late Tang dishes, one with a flower image
one empty. The empty form goes all the way to heaven.
It is the classic form—lighter weight.
My work is anti-nature
The four-story mountain
You will not think form, space, line, contour
Just a suggestion of nature gives weight
light and heavy
light like a feather
you get light enough and you levitate.
When I say it's alive, it's inspired
alive
inspiration and life are equivalents and they come from
outside.
Beauty is pervasive
inspiration is pervasive
We say this rose is beautiful
and when this rose is destroyed then we have lost something
so that beauty has been lost
when the rose is destroyed we grieve
but really beauty is unattached
and a clear mind sees it
the rose represents nature
but it isn't the rose
beauty is unattached; it's inspiration—it's inspiration
The development of sensibility, the response to beauty
In early childhood, when the mind is untroubled, is when
inspiration is most possible
The little child just sitting in the snow
The education of children—social development is contradictory
to aesthetic development. Nature is conquest, possession,
eating, sleeping, procreation. It is not aesthetic, not the kind
of inspiration I'm interested in
nature is the wheel.
When you get off the wheel you're looking out
You stand with your back to the turmoil
You never rest with nature, it's a hungry thing
every animal that you meet is hungry
not that I don't believe in eating
But I just want to make the distinction between
Art and eating
This painting I like because you can get in there and rest
The satisfaction of appetite happens to be impossible
The satisfaction of appetite is frustrating.
So it's always better to be a little bit hungry
That way you contradict the necessity.

Not that I'm for asceticism
But the absolute trick in life is to find rest.
If there's life in the composition it stimulates your life moments
your happy moments; your brain is stimulated.
Saint Augustine says that milk doesn't come from the mother
I painted a painting called *Milk River*
Cows don't give milk if they don't have grass and water
Tremendous meaning of that is that painters can't give
Anything to the observer
People get what they need from a painting
The painter need not die because of responsibility
When you have inspiration and represent inspiration
The observer makes the painting.
The painter has no responsibility to stimulate his needs
It's all an enormous process
No suffering is unnecessary
All of it is only enlightening. This is life
Asceticism is a mistake
sought out suffering is a mistake
But what comes to you free is enlightening
I used to paint mountains here in New Mexico and I thought
my mountains looked like ant hills.
I saw the plains driving out of New Mexico and I thought the
plain had it
just the plane
If you draw a diagonal, that's loose at both ends
I don't like circles—too expanding
When I draw horizontals
you see this big plane and you have certain feelings like
you're expanding over the plane
Anything can be painted without representation.
I don't believe in influence
Unless it's you yourself following your own track
Why you'd never get anywhere
I don't believe in the eclectic
I believe in the recurrence
That this is a return to classicism
Classicism is not about people
and this work is not about the world.
We called Greek classicism Idealism
Idealism sounds like something you can strive for
They didn't strive for idealism at all
Just follow what Plato has to say
Classicists are people that look out with their back to the world.
It represents something that isn't possible in the world
More perfection than is possible in the world
it's as unsubjective as possible

The ideal in America is the natural man
The conqueror, the one that can accumulate
The one who overcomes disadvantages, strength, courage
Whereas inspiration, classical art depends on inspiration
The Sylphides. I depend on the muses
Muses come and help me now. It exists in the mind
Before it's represented on paper it exists in the mind
The point. It doesn't exist in the world.
The classic is cool
a classical period
it is cool because it is impersonal
the detached and impersonal.
If a person goes walking in the mountains that is not detached
and impersonal, he's just looking back.
Being detached and impersonal is related to freedom
That's the answer for inspiration
The untroubled mind.
Plato says that all that exists are shadows.
To a detached person the complication of the involved life
is like chaos
If you don't like the chaos you're a classicist
If you like it you're a romanticist
Someone said all human emotion is an idea
Painting is not about ideas or personal emotion
When I was painting in New York I was not so clear about that
Now I'm very clear that the object is freedom
not political freedom, which is the echo
Not freedom from social mores
freedom from mastery and slavery
freedom from what's dragging you down
Freedom from right and wrong
In Genesis Eve ate the apple of knowledge
of good and evil
when you give up the idea of right and wrong
you don't get anything
What you do is get rid of everything
freedom from ideas and responsibility.
If you live by inspiration then you do what comes to you
you can't live the moral life, you have to obey destiny
You can't live the inspired life and live the conventions
You can't make promises
The future's a blank page
I pretended I was looking at the blank page
I used to look in my mind for the unwritten page
If my mind was empty enough I could see it
I didn't paint the plane
I just drew this horizontal line

Then I found out about all the other lines
But I realized what I liked was the horizontal line.
Then I painted the two rectangles
correct composition
If they're just right
You can't get away from what you have to do
They arrive at an interior balance
like there shouldn't need to be anything added
People see a color that's not there
our responses are stimulated
I'm painting them for direct light
With these rectangles I didn't know at the time exactly why
I painted those rectangles
From Isaiah, about inspiration
"surely the people is grass"
You go down to the river
you're just like me
an orange leaf is floating
you're just like me
Then I drew all those rectangles. All the people were like
those rectangles
they are just like grass
That's the way to freedom
If you can imagine you're a grain of sand
you know the rock ages.
If you imagine that your rock
rock of ages cleft from me
let me hide myself in thee
you don't have to worry
If you can imagine that you're a rock
all your troubles fall away
It's consolation
Sand is better
you're so much smaller as a grain of sand
We are so much less
These paintings are about freedom from the cares of this world
from worldliness
not religion. You don't have to be religious to have inspirations
Senility is looking back with nostalgia
senility is lack of inspiration in life
Art restimulates inspirations and awakens sensibilities
that's the function of art.
A boy whenever he had a problem
he called this rock up out of the mud
he turned into a rock
he summoned a vision of quiet
The idea is independence and solitude

nothing religious in my retirement
religion from my point of view
it's about this grass
The grass enjoyed it when the wind blew
It really enjoyed the wind leaning this way and that
So the grass thought the wind is a great comfort
Besides that it blows the clouds here which makes rain
In fact we owe all our self being to the wind
We should tell the wind our gratitude
perhaps if we fall down and abase ourselves
We can get more—we can avoid suffering
that's religion
solitude and independence for a free mind.
Nothing that happens in your life makes inspiration
When your eyes are open
You see beauty in anything
Blake's right about there's no difference
between the whole thing
and one thing
freedom from suffering
suffering is necessary for freedom from suffering
first you have to find out about what you're suffering from.
My painting is about impotence
We are ineffectual
In a big picture a blade of grass amounts to not very much
worries fall off you when you can believe that
pride is in abeyance when you think that.
One thing I've got a good grip on is remorse
The whole wave
It applies to life the wave
As it was in the beginning, there was no division
and no separation
don't look at the stars. Then your mind goes freely—way, way
beyond
look between the rain
the drops are insular
try to remember before you were born
the conqueror will fight with you
If there's no one else around.
I am constantly tempted to think that I can help save myself
by looking into my mind I can see what's there
by bringing thoughts to the surface of my mind I can watch
them dissolve
I can see my ego and see its intentions
I can see that it is the same as all nature
I can see that it is myself and impotent
like all nature; impotent in the process of dissolution

of ego, of itself. I can see that its main intention is the
conquest and destruction of ego, of self; and can only go back
and forth in constant battle with itself; repeating itself.
It would be an endless battle if it were all up to ego
because it does not destroy and is not destroyed by itself
It is like a wave
it makes itself up; it rushes forward getting nowhere really
It crashes, withdraws and makes itself up again
pulls itself together with pride
towers with pride
rushes forward into imaginary conquest
crashes in frustration
withdraws with remorse and repentance
pulls itself together with new resolution
individually and collectively the same
children trained in pride and patriotism
towering in national spirit
charging in conquest
Victory and defeat and frustration
withdrawing and repentance
then once more pride
the wheel of life
pride
conquest
Victory defeat frustration
remorse repentance
resolution
pride
More people at an earlier age see the conqueror in themselves
then see the way out in another process, the real defeat of
ego in which we have no part
The dissolution of ego in reality as it was in the beginning
as it was before we were separate and insular
the process we call destiny
in which we are the material to be dissolved
We eat
We procreate
We die
We can see the process and recognize suffering as the defeat of
ego by the process of destiny
We can relinquish pride, conquest, remorse and resolution
inevitably as destiny unfolds
cradled on the mountain I can rest
Solitude and freedom are the same
under every fallen leaf.
Others do not really exist in solitude. I do not exist
no thinking of others even when they are there; no interruption

a mystic and a solitary person are the same
night, shelterless, wandering
I, like the deer, looked
finding less and less
living is grazing
memory is chewing cud
wandering away from everything
giving up everything
not me anymore, any of it
retired ego, wandering
on the mountain; no more
conquests; no longer an enemy to anyone
ego retired, wandering
no longer a friend, master, slave; all the opposites dead to
the world and himself unresponsible
perhaps I can now really enjoy sailing
adventure in the dark
very exciting
beast seems to be stretched out dead.
He is very mild.
I will not be seeking adventure but it might happen I suppose
Inspired action is destiny
our feet are in the paths of righteousness
the paths that our feet take are marked
As the river runs to the sea
and the plant grows to the sun
So do we flow and grow and exist
ecstasy playing with Sylphides angels
As long as I look in my mind and see nothing at all
The Sylphides have the beast captured and are grooming him
very pleasant sun, that is what destiny is like
It is like grooming
The idea—the sudden realization of the destruction of
innocence by ego.
In solitude there is consolation
thinking of others and myself, even plants,
I am immediately apprehensive
because my solitude has been interrupted
solitude, inspiration
Westward down the mountain
I am nothing absolutely
There is this other thing going on
the purification of reality
that is all that is happening
all that happens is that process;
not nature; the dissolution of nature
the error is in thinking we have

a part to play in the process
As long as we think that, we are in resistance
I can see that I have nothing to do with the process
It is very pleasant
The all of all, reality, mind
the process of destiny
like the ocean full to the brim
like a dignified journey with no trouble and no goal on and on
Solitude
other than nature
smiling
Everyone is chosen and everyone knows it
including animals and plants
There is only the all of the all
everything is that
every infinitesimal thought and action is part and parcel of
a wonderful victory
"freedom on the mountain a glimpse of victory"
We seem to be winning and losing,
but in reality there is no losing
the wiggle of a worm as important as the assassination of a
president
I want to talk to you about "the work," art work
I will speak of inspiration, the studio, viewing art work, friends
of art, and artists' temperaments.
But your interest and mine is really "the work"—works of art
Art work is very important in the way that I will try to
show when I speak about inspiration.
I have sometimes put myself ahead of my work in my mind and
have suffered in consequence.
I thought me, me; and I suffered
I thought I was important. I was taught to think that. I was
taught "You are important; people are important beyond
anything else."
But thinking that I suffered very much
I thought that I was big and "the work" was small. It is not
possible to go on that way. To think I am big is the work is big
the position of pride is not possible either
and to think I am small and the work is small, the position of
modesty, is not possible.
I will go on to inspiration and perhaps you will see what is
possible.
As I describe inspiration I do not want you to think I am
speaking of religion.
That which takes us by surprise—moments of happiness—
that is inspiration. Inspiration which is different from daily care.
Many people as adults are so startled by inspiration which is

different from daily care that they think they are unique
in having had it. Nothing could be further from the truth
Inspiration is there all the time
for everyone whose mind is not clouded over with thoughts
whether they realize it or not
Most people have no realization whatever of the moments in
Which they are inspired.
Inspiration is pervasive but not a power
It's a peaceful thing
It is a consolation even to plants and animals
Do you think that it is unique
If it were unique no one would be able to respond to your work
Do not think it is reserved for a few or anything like that
It is an untroubled mind.
Of course we know that an untroubled state of mind
cannot last so we say that inspiration comes and goes
but really it is there all the time waiting for us to be
untroubled again. We can therefore say that it is pervasive.
Young children are more untroubled than adults and have
many more inspirations. All the moments of inspiration
added together make what we call sensibility. The development
of sensibility is the most important thing for children
and adults but is much more possible in children. In
adults it would be more accurate to say that the awakening
to their sensibility is the most important thing. Some
parents put the development of social mores ahead of
aesthetic development. Small children are taken to the
park for social play; sent to nursery school and
headstart. But the little child sitting alone, perhaps
even neglected and forgotten, is the one open to
inspiration and the development of sensibility.

BRICE MARDEN Statements, Notes, and Interviews (1963–81)

The paintings are made in a highly subjective state within Spartan limitations. Within these strict confines, confines which I have painted myself into and intend to explore with no regrets, I try to give the viewer something to which he will react subjectively. I believe these are highly emotional paintings not to be admired for any technical or intellectual reason but to be felt. [1963]

.

Deep blue, bright earth red, deep rich middle green
The Mediterranean painting ended up a glad day-glo dirge for a great dancing lady. A spot

* Brice Marden, "Statements, Notes, and Interviews" (1963–81), in *Brice Marden: Paintings, Drawings and Prints 1975–1980* (London: Whitechapel Gallery, 1981), 54–57. By permission of the author and the publisher.

of deep mediterranean earth red is all that remains under an evasive flesh colour that fights its way back and forth between flesh life of death as a Daytona Beach tract house brown.

A right side: soft, very light, almost pissy green

—it must hold as a colour.

Colour as character

Colour as weight

Colour as colour

Colour as value

Colour as light reflector

Colour as subcolour

I paint paintings in panels. They are not colour panels. Colour and surfaces must work together. They are painted panels. A colour against a colour makes a colour situation.

How different situations work with each other.

How the colour relates to the outside edges of the painting.

What kind of tension exists across the shape of each panel. How these tensions relate across the whole plane of the painting.

Colour working as colour and value simultaneously.

A colour should turn back into itself.

It should reveal itself to you while, at the same time, it evades you.

I work with no specific theories or ideas.

I try to avoid interior decorating colour combinations.

A child mounts his tricycle and rides away into a tree [1971]

.

The rectangle, the plane, the structure, the picture are but sounding boards for a spirit. [1971–72]

.

I paint paintings made up of one, two, or three panels. I work from panel to panel. I will paint on one until I arrive at a colour that holds that plane. I move to another panel and paint until something is holding that plane that also interestingly relates to the other panels. I work the third, searching for a colour value that pulls the planes together into a plane that has aesthetic meaning. This process is not as simple as explained. There is much repainting of panels which follows no given order. The ideas of a painting can change quite fast and drastically or they can evolve very slowly. I want to have a dialogue with the painting: it works on me and I work on it. [1973]

.

We swam in the sea today as lovers. The sea was blue, so very blue, the blues of the Madonnas, those most precious blues. One look up and there are the rocks. Hydra rocks, the pines bending to the winds, echoing the bends the rocks have undergone for so many more years. Nature. Forces.

We turn together. I say, "What a beautiful hill, mountain." "I've seen it so often." But she is of it.

I am of the stuff to be of it, but, only through my work which, unfortunately (but I am young), is my life. Remember immersion—water—land—sky—the all.

Most unforgettable is the joy. The joy.

Must joy always be saddened?

Painters are amongst the priests—worker priests of the cult of man—searching to understand but never to know.

As a painter I believe in the indisputability of The Plane. [1974]

.

Painting creates a space on a wall. That space is the expression of the vision of the painter. The painter strives to make his expression explicit because he wants to affect man. By so doing he works to keep man's spirit alive. [1975]

.

I paint nature. I mean, I refer to nature. I accept nature as a reality; it's the best reference; it's what the painting's about. [1980]

.

Write about the edge as the place where we go from one to another, or stay still.

How going from one to another can move in rhythms.

Taking some thing through, one to another.

The edge: the balancing point.

Standing on the edge, staring straight into space, watching the spaces on the periphery, trying to encompass the whole.

What is the name of that place, the infinitesimal hinge between.

Wanting to show the whole of it. [1981]

DANIEL BUREN Beware! (1969)

I Warning

A concept may be understood as being "the general mental and abstract representation of an object." (See *Le Petit Robert Dictionary;* "an abstract general notion or conception"—*Dictionary of the English Language*.) Although this word is a matter for philosophical discussion, its meaning is still restricted; concept has never meant "horse." Now, considering the success that this word has obtained in art circles, considering what is and what will be grouped under this word, it seems necessary to begin by saying here what is meant by "concept" in para-artistic language.

We can distinguish [four] different meanings that we shall find in the various "conceptual" demonstrations, from which we shall proceed to draw [four] considerations that will serve as a warning.

1) *Concept = Project*. Certain works, which until now were considered only as rough outlines or drawings for works to be executed on another scale, will henceforth be raised to the rank of "concepts." That which was only a means becomes an end through the miraculous

* Daniel Buren, excerpts from "Beware!" ("Mise en garde!"), in *Konzeption/Conception,* translated by Charles Harrison and Peter Townsend (Leverkusen: Städtisches Museum, 1969); reprinted in *Studio International* 179, no. 920 (March 1970): 100–104; revised and reprinted in Ursula Meyer, *Conceptual Art* (New York: E. P. Dutton, 1972), 61–87; also in Daniel Buren, *5 Texts* (New York: John Weber Gallery and Jack Wendler Gallery, 1973), 10–22. By permission of the artist.

Daniel Buren, *Sandwichmen,* Paris, 1968, street action with men carrying sandwich boards of equal white and colored stripes (each stripe 8.7 cm). © Daniel Buren.

use of one word. There is absolutely no question of just any sort of concept, but quite simply of an object that cannot be made life-size through lack of technical or financial means.

2) *Concept = Mannerism.* Under the pretext of concept the anecdotal is going to flourish again and with it, academic art. . . .

It is a way—still another—for the artist to display his talents as conjurer. In a way, the vague concept of the word "concept" itself implies a return to Romanticism.

[2a) *Concept = Verbiage.* To lend support to their pseudocultural references and to their bluffing games, with a complacent display of questionable scholarship, certain artists attempt to explain to us what a conceptual art would be, could be, or should be—thus making a conceptual work. . . .]

3) *Concept = Idea = Art.* Lastly, more than one person will be tempted to take any sort of an "idea," to make art of it and to call it a "concept." It is this procedure which seems to us to be the most dangerous, because it is more difficult to dislodge, because it is very attractive, because it raises a problem that really does exist: how to dispose of the object? We shall attempt, as we proceed, to clarify this notion of object. Let us merely observe henceforth that it seems to us that to exhibit (*exposer*) or set forth a concept is, at the very least, a fundamental misconception right from the start and one which can, if one doesn't take care, involve us in a succession of false arguments. To exhibit a concept, or to use the word concept to signify art, comes to the same thing as putting the concept itself on a level with the object. This would be to suggest that we must think in terms of a "concept-object"—which would be an aberration. . . .

Vertically striped sheets of paper, the bands of which are 8.7 cms wide, alternate white and colored, are stuck over internal and external surfaces: walls, fences, display windows, etc.; and/or cloth/canvas support, vertical stripes, white and colored bands each 8.7 cms, the two ends covered with dull white paint.

I record that this is my work for the last four years, without any evolution or way out. This is the past: it does not imply either that it will be the same for another ten or fifteen years or that it will change tomorrow.

The perspective we are beginning to have, thanks to these past four years, allows a few considerations of the direct and indirect implications for the very conception of art. This apparent break (no research, or any formal evolution for four years) offers a platform that we shall situate at zero level, when the observations both internal (conceptual transformation as regards the action/praxis of a similar form) and external (work/production presented by others) are numerous and rendered all the easier as they are not invested in the various surrounding movements, but are rather derived from their absence.

Every act is political and, whether one is conscious of it or not, the presentation of one's work is no exception. Any production, any work of art is social, has a political significance. We are obliged to pass over the sociological aspect of the proposition before us due to lack of space and considerations of priority among the questions to be analyzed.

The points to be examined are described below and each will require to be examined separately and more thoroughly later. [This is still valid nowadays.]

a) *The Object, the Real, Illusion.* Any art tends to decipher the world, to visualize an emotion, nature, the subconscious, etc. . . . Can we pose a question rather than replying always in terms of hallucinations? This question would be: can one create something that is real, nonillusionistic, and therefore not an art-object? . . .

To do away with the object as an illusion—the real problem—through its replacement by a concept [or an idea]—utopian or ideal(istic) or imaginary solution—is to believe in a moon made of green cheese, to achieve one of those conjuring tricks so beloved of twentieth-century art. Moreover it can be affirmed, with reasonable confidence, that as soon as a concept is announced, and especially when it is "exhibited as art," under the desire to do away with the object, *one merely replaces it* in fact. The exhibited concept becomes *ideal-object,* which brings us once again to art as it is, i.e., the illusion of something and not the thing itself. In the same way that writing is less and less a matter of verbal transcription, painting should no longer be the vague vision/illusion, even mental, of a phenomenon (nature, subconsciousness, geometry . . .) but *VISUALITY of the painting itself.* In this way we arrive at a notion that is thus allied more to a method and not to any particular inspiration; a method which requires—in order to make a direct attack on the problems of the object properly so-called—that painting itself should create a mode, a specific system, that would no longer direct attention, but that is "produced to be looked at."

b) *The Form.* As to the internal structure of the proposition, the contradictions are removed from it; no "tragedy" occurs on the reading surface, no horizontal line, for example, chances to cut through a vertical line. Only the imaginary horizontal line of delimitation of the work at the top and at the bottom "exists," but in the same way that it "exists" only by mental reconstruction, it is mentally demolished simultaneously, as it is evident that the external size is arbitrary (a point that we shall explain later on).

The succession of vertical bands is also arranged methodically, always the same

[x,y,x,y,x,y,x,y,x,y,x, etc. . . .], thus creating no composition on the inside of the surface or area to be looked at, or, if you like, a minimum or zero or neutral composition. These notions are understood in relation to art in general and not through internal considerations. This neutral painting however is not freed from obligations. On the contrary, thanks to its neutrality or absence of style, it is extremely rich in information about itself (its exact position as regards other work) and especially information about other work; thanks to the absence of any formal problem its potency is all expended upon the realms of thought. One may also say that this painting no longer has any plastic character, but that it is *indicative* or *critical*. Among other things, indicative/critical of its own process. This zero/neutral degree of form is "binding" in the sense that the total absence of conflict eliminates all concealment (all mythification or secrecy) and consequently brings silence. One should not take neutral painting for uncommitted painting.

Lastly, this formal neutrality would not be formal at all if the internal structure of which we have just spoken (vertical white and colored bands) was linked to the external form (size of the surface presented to view). The internal structure being immutable, if the exterior form were equally so, one would soon arrive at the creation of a quasi-religious archetype which, instead of being neutral, would become burdened with a whole weight of meanings, one of which—and not the least—would be as the idealized image of neutrality. On the other hand, the continual variation of the external form implies that it has no influence on the internal structure, which remains the same in every case. The internal structure remains uncomposed and without conflict. If, however, the external form or shape did not vary, a conflict would immediately be established between the combination or fixed relationship of the bandwidths, their spacing (internal structure), and the general size of the work. This type of relationship would be inconsistent with an ambition to avoid the creation of an illusion. We would be presented with a problem all too clearly defined—here that of neutrality to zero degree—and no longer with the thing itself posing a question, in its own terms.

Finally, we believe confidently in the validity of a work or framework questioning its own existence, presented to the eye. . . .

Art is the form that it takes. The form must unceasingly renew itself to insure the development of what we call new art. A change of form has so often led us to speak of a new art that one might think that inner meaning and form were/are linked together in the mind of the majority—artists and critics. Now, if we start from the assumption that new, i.e., "other," art is in fact never more than the same thing in a new guise, the heart of the problem is exposed. To abandon the search for a new form at any price means trying to abandon the history of art as we know it: It means passing from the *Mythical* to the *Historical,* from the *Illusion* to the *Real.*

c) *Color.* In the same way that the work which we propose could not possibly be the image of some thing (except itself, of course), and for the reasons defined above could not possibly have a finalized external form, there cannot be one single and definitive color. The color, if it was fixed, would mythify the proposition and would become the zero degree of color X, just as there is navy blue, emerald green or canary yellow.

One color and one color only, repeated indefinitely or at least a great number of times, would then take on multiple and incongruous meanings. All the colors are therefore used simultaneously, without any order of preference, but systematically.

That said, we note that if the problem of form (as pole of interest) is dissolved by itself, the problem of color, considered as subordinate or as self-generating at the outset of the work and by the way it is used, is seen to be of great importance. The problem is to divest it of all emotional or anecdotal import. . . .

We can merely say that every time the proposition is put to the eye, only one color (repeated on one band out of two, the other being white) is visible and that it is without relation to the internal structure or the external form that supports it and that, consequently, it is established a priori that: white = red = black = blue = yellow = green = violet, etc.

d) *Repetition.* The consistency—i.e., the exposure to view in different places and at different times, as well as the personal work, for four years—obliges us to recognize manifest visual repetition at first glance. . . . This repetition provokes two apparently contradictory considerations: on the one hand, the reality of a certain form (described above), and on the other hand, its *canceling-out* by successive and identical confrontations, which themselves negate any originality that might be found in this form, despite the systematization of the work. . . .

This repetition, thus conceived, has the effect of reducing to a minimum the potency, however slight, of the proposed form such as it is, of revealing that the external form (shifting) has no effect on the internal structure (alternate repetition of the bands) and of highlighting the problem raised by the color in itself. This repetition also reveals in point of fact that visually there is *no formal evolution*—even though there is a change—and that, in the same way that no "tragedy" or composition or tension is to be seen in the clearly defined scope of the work exposed to view (or presented to the eye), no tragedy or tension is perceptible in relation to the creation itself. The tensions abolished in the very surface of the "picture" have also been abolished—up to now—in the time category of this production. *The repetition is the ineluctable means of legibility of the proposition itself.*

This is why, if certain isolated artistic forms have raised the problem of neutrality, they have never been pursued in depth to the full extent of their proper meaning. By remaining "unique" they have lost the neutrality we believe we can discern in them. (Among others, we are thinking of certain canvases by Cézanne, Mondrian, Pollock, Newman, Stella.)

Repetition also teaches us that there is no perfectibility. A work is at zero level or it is not at zero level. To approximate means nothing. In these terms, the few canvases of the artists mentioned can be considered only as empirical approaches to the problem. Because of their empiricism they have been unable to divert the course of the "history" of art, but have rather strengthened the idealistic nature of art history as a whole.

e) *Differences.* With reference to the preceding section, we may consider that repetition would be the right way (or one of the right ways) to put forward our work in the internal logic of its own endeavor. Repetition, apart from what its use revealed to us, should, in fact, be envisaged as a "method" and not as an end. A method that definitively rejects, as we have seen, any repetition of the mechanical type, i.e., the geometric repetition (superimposable in every way, including color) of a like thing (color + form/shape). . . . One could even say that it is these differences that make the repetition, and that it is not a question of doing the same in order to say that it is identical to the previous—which is a tautology (redundancy)—but rather a *repetition of differences with a view to a same (thing).* [This repetition is an attempt to cover, little by little, all the avenues of inquiry. One might equally say that the work is an attempt to close off in order the better to disclose.]

[e2) *Canceling-out.* . . .

The systematic repetition that allows the differences to become visible each time is used as a method and not considered as an end, in awareness of the danger that, in art, a form/thing—since there is a form/thing—can become, even if it is physically, aesthetically, objectively insignificant, an object of reference and of value. Furthermore, we can affirm that objects, apparently insignificant and reduced, are more greatly endangered than others of more elaborate appearance, and this is a result of (or thanks to) the fact that the object/idea/concept

of the artist is only considered from a single viewpoint (a real or ideal viewpoint . . .) and with a view to their consummation in the artistic milieu.

A repetition, which is ever divergent and nonmechanical, used as a method, allows a *systematic closing-off* and, in the same moment that things are closed off (*lest we should omit anything from our attempts at inquiry*) they are *canceled out. Canceled out through lack of importance.* One cannot rest content once and for all with a form that is insignificant and impersonal in itself— we have just exposed the danger of it. We know from experience, that is to say theoretically, that the system of art can extrapolate by licensing every kind of impersonal aspect to assume the role of model. Now, we can have no model, rest assured, unless it is a model of the model itself. Knowing what is ventured by the impersonal object, we must submit it—our method— to the test of repetition. This repetition should lead to its disappearance/obliteration. Disappearance in terms of significant form as much as insignificant form.

The possibility of the disappearance of form as a pole of interest—disappearance of the object as an image of something—is "visible" in the single work, but should also be visible through the total work, that is to say in our practice according to and in every situation.

What is being attempted, as we already understand, is the elimination of the imprint of form, together with the disappearance of form (of all form). This involves the disappearance of "signature," of style, of recollection/derivation. A unique work (in the original sense), by virtue of its character, will be *conserved.* The imprint exists in a way, which is evident/insistent at the moment when it is, like form itself, a response to a problem or the demonstration of a subject or the representation of an attitude. If, however, the "print" of the imprint presents itself as a possible means of canceling-out and not as something privileged/conserved—in fact, if the imprint, rather than being the glorious or triumphant demonstration of authorship, appears as a means of questioning its own disappearance/insignificance—one might then speak of canceling-out indeed; or, if you like, destruction of the imprint, as a sign of any value, through differentiated repetition of itself rendering void each time anew, or each time a little more, the value that it might previously have maintained. There must be no letup in the process of canceling-out, in order to "blow" the form/thing, its idea, its value, and its significance to the limits of possibility.

We can say . . . that the author/creator (we prefer the idea of "person responsible" or "producer") can "efface himself" behind the work that he makes (or that makes him), but that this would be no more than a good intention, consequent upon the work itself (and hence a minor consideration), unless one takes into consideration the endless canceling-out of the form itself, the ceaseless posing of the question of its presence; and then that of its disappearance. This going and coming, once again nonmechanical, never bears upon the succeeding stage in the process. Everyday phenomena alone remain perceptible, never the extraordinary.

e3) *Vulgarization.* The canceling-out, through successive repetitions in different locations of a proposition, of an identity that is constant by virtue of its difference in relation to a sameness, hints at that which is generally considered typical of a minor or bad art, that is to say *vulgarization* considered here as a method. It is a question of drawing out from its respectable shelter of originality or rarity a work which, in essence, aims at neither respect nor honors. The canceling-out or the disappearance of form through repetition gives rise to the appearance, at the same moment, of profuseness and ephemerality. The rarefaction of a thing produced augments its value (salable, visual, palpable . . .). We consider that the "vulgarization" of the work that concerns us is a matter of necessity, due to the fact that this work is made manifest only that it shall have being, and disappears in its own multiple being.

In art, banality soon becomes extraordinary. The instances are numerous. We consider

that at this time the essential risk that must be taken—a stage in our proposition—is the vulgarization of the work itself, in order to tire out every eye that stakes all on the satisfaction of a retinal (aesthetic) shock, however slight. *The visibility of this form must not attract the gaze.* Once the dwindling form/imprint/gesture has been rendered impotent/invisible, the proposition has/will have some chance to become dazzling. The repetition of a neutral form, such as we are attempting to grasp and to put into practice, does not lay emphasis upon the work, but rather tends to efface it. We should stress that the effacement involved is of interest to us insofar as it makes manifest, once again, the disappearance of form (in painting) as a pole of attraction of interest, that is to say makes manifest our questioning of the concept of the painting in particular and the concept of art in general.

This questioning is absolutely alien to the habits of responding, implies thousands of fresh responses, and implies therefore the end of formalism, the end of the mania for responding (art).

Vulgarization through repetition is already calling in question the further banality of art.]

f) *Anonymity.* . . . There emerges a relationship which itself leads to certain considerations; this is the relationship that may exist between the "creator" and the proposition we are attempting to define. First fact to be established: *he is no longer the owner of his work.* Furthermore, it is not *his* work, but *a* work. The neutrality of the purpose—painting as the subject of painting—and the absence from it of considerations of style forces us to acknowledge a certain anonymity. This is obviously not anonymity in the person who proposes this work, which once again would be to solve a problem by presenting it in a false light—why should we be concerned to know the name of the painter of the Avignon *Pietà*—but of *the anonymity of the work itself as presented.* This work being considered as common property, there can be no question of claiming the authorship thereof, possessively, in the sense that there are authentic paintings by Courbet and valueless forgeries. As we have remarked, the projection of the individual is nil; we cannot see how he could claim his work as *belonging* to him. In the same way we suggest that the same proposition made by X or Y would be identical to that made by the author of this text. If you like, the study of past work forces us to admit that there is no longer, as regards the form defined above—when it is presented—any truth or falsity in terms of conventional meaning that can be applied to both these terms relating to a work of art. [The making of the work has no more than a relative interest, and in consequence he who makes the work has no more than a relative, quasi-anecdotal interest and cannot at any time make use of it to glorify "his" product.] It may also be said that the work of which we speak, because neutral/anonymous, is indeed the work of someone, but that this someone has no importance whatsoever [since he never reveals himself], or, if you like, the importance he may have is totally archaic. Whether he signs "his" work or not, it nevertheless remains anonymous.

g) *The Viewpoint—the Location.* Lastly, one of the external consequences of our proposition is the problem raised by the location where the work is shown. In fact the work, as it is seen to be without composition and as it presents no accident to divert the eye, becomes itself the accident in relation to the place where it is presented. The indictment of any form considered *as such,* and the judgment against such forms on the facts established in the preceding paragraphs, leads us to question the finite space in which this form is seen. It is established that the proposition, in whatever location it be presented, does not "disturb" that location. The place in question appears as it is. It is seen in its actuality. This is partly due to the fact that the proposition is not distracting. Furthermore, being only its own subject matter, its own location is the proposition itself, which makes it possible to say, paradoxically: the proposition in question "has no real location."

In a certain sense, one of the characteristics of the proposition is to reveal the "container" in which it is sheltered. One also realizes that the influence of the location upon the significance of the work is as slight as that of the work upon the location.

This consideration, in course of work, has led us to present the proposition in a number of very varied places. If it is possible to imagine a constant relationship between the container (location) and the contents (the total proposition), this relationship is always annulled or re-invoked by the next presentation. This relationship then leads to two inextricably linked although apparently contradictory problems:

i) revelation of the location itself as a new space to be deciphered;

ii) the questioning of the proposition itself, insofar as its repetition . . . in different "contexts," visible from different viewpoints, leads us back to the central issue: What is exposed to view? What is the nature of it? The multifariousness of the locations where the proposition is visible permits us to assert the unassailable persistence that it displays in the very moment when its nonstyle appearance merges it with its support.

It is important to demonstrate that while remaining in a very well-defined cultural field—as if one could do otherwise—it is possible to go outside the cultural location in the primary sense (gallery, museum, catalogue . . .) without the proposition, considered as such, immediately giving way. This strengthens our conviction that the work proposed, insofar as it raises the question of viewpoint, is posing what is in effect a new question, since it has been commonly assumed that the answer follows as a matter of course.

We cannot get bogged down here in the implications of this idea: we will merely observe for the record that all the works that claim to do away with the object (Conceptual or otherwise) are essentially dependent *upon the single viewpoint* from which they are "visible," a priori considered (or even not considered at all) as ineluctable. A considerable number of works of art (the most exclusively idealist, e.g., Ready-mades of all kinds) "exist" only because the location in which they are seen is taken for granted as a matter of course.

In this way, the location assumes considerable importance by its fixity and its inevitability; becomes the "frame" (*and the security that presupposes*) at the very moment when they would have us believe that what takes place inside shatters all the existing frames (manacles) in the attaining of pure "freedom." A clear eye will recognize what is meant by freedom in art, but an eye that is a little less educated will see better what it is all about when it has adopted the following idea: that the location (outside or inside) where a work is seen is its frame (its *boundary*).

III Preamble

One might ask why so many precautions must be taken instead of merely putting one's work out in the normal fashion, leaving comment to the critics and other professional gossip columnists. The answer is very simple: complete rupture with art—such as it is envisaged, such as it is known, such as it is practiced—has become the only possible means of proceeding along the path of no return upon which thought must embark; and this requires a few explanations. This rupture requires as a first priority the revision of the history of art as we know it, or, if you like, its radical dissolution. Then if one rediscovers any *durable and indispensable criteria* they must be used not as a release from the need to imitate or to sublimate, but as a [reality] that should be restated. A [reality] in fact which, although already "discovered" would have to be challenged, therefore to be created. For it may be suggested that, at the present time [all the realities] that it has been possible to point out to us or that have been recognized, are not *known*. To recognize the existence of a problem certainly does not mean the same as

to know it. Indeed, if some problems have been solved empirically (or by rule of thumb), we cannot then say that we know them, because the very empiricism that presides over this kind of discovery obscures the solution in a maze of carefully maintained enigmas.

But artworks and the practice of art have served throughout, in a parallel direction, to signal the existence of certain problems. This recognition of their existence can be called practice. The exact knowledge of these problems will be called theory (not to be confused with all the aesthetic "theories" that have been bequeathed to us by the history of art).

It is this *knowledge* or *theory* that is now indispensable for a perspective upon the rupture— a rupture that can then pass into the realm of fact. *The mere recognition* of the existence of pertinent problems *will not suffice for us*. It may be affirmed that all art up to the present day has been created on the one hand only *empirically* and on the other out of idealistic thinking. If it is possible to think again or to think and create theoretically/scientifically, the *rupture* will be achieved and thus the word "art" will have lost the meanings—numerous and divergent— which at present encumber it. We can say, on the basis of the foregoing, that the rupture, if any, can be (can only be) epistemological. This rupture is/will be the resulting logic of a theoretical work at the moment when the history of art (which is still to be made) and its application are/will be envisaged theoretically: theory and theory alone, as we well know, can make possible a revolutionary practice. Furthermore, not only is/will theory be indissociable from its own practice, but again it may/will be able to give rise to other original kinds of practice.

Finally, as far as we are concerned, *it must be clearly understood that when theory is considered as producer/creator, the only theory or theoretic practice is the result presented/the painting* or, according to Althusser's definition: "Theory: a specific form of practice."

We are aware that this exposition of facts may be somewhat didactic; nevertheless we consider it indispensable to proceed in this way at this time.

DOROTHEA ROCKBURNE Statement (1995)

To give you some sense of part of my visual roots, I think it was in 1972 that I first saw Masaccio's frescoes in the church of Santa Maria del Carmine in Florence. I'd seen reproductions, but the frescoes themselves so stunned me that on returning to my hotel I just lay on the bed for three days feeling and thinking about them. These paintings pronounced a path, and in so doing changed my life. I could not get over their beauty. Masaccio invented the device of making a figure's eyes follow you around the room. Everybody studied in the church of the Carmine. Da Vinci studied in there. I'm sure he adopted Masaccio's invention of the eyes that follow you in the Mona Lisa. Everybody went there, from Van Gogh to the Russian Constructivists; they did drawings there and so did I. In one panel Saint Peter is reaching into the fish's mouth. Jesus is saying, "Give unto Caesar that which is Caesar's." He has told Peter he'll find coins there. The place is the Capernaum Gate. So, I did a two-layered panel painting in oil on linen called *The Capernaum Gate* (1984). I used Masaccio's diagonal device of Saint Peter reaching into the fish. This was the first painting I'd done on stretched linen since my student years. In early exhibitions, I used paper and chipboard to visualize concepts of set

* Excerpts from "Dorothea Rockburne" (April 3, 1995), in Judith Olch Richards, *Inside the Studio: Two Decades of Talks with Artists in New York* (New York: Independent Curators International, 2004), 154–57. By permission of the author and the publisher. © 2012 Dorothea Rockburne/Artists Rights Society (ARS), New York.

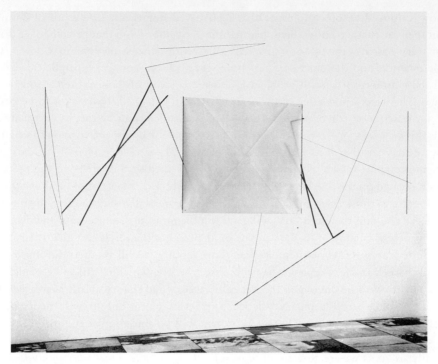

Dorothea Rockburne, *Neighborhood,* 1973, wall drawing, pencil, and colored pencil with vellum. The Museum of Modern Art, New York, gift of J. Frederic Byers III. © 2012 Dorothea Rockburne/Artists Rights Society (ARS), New York. Photo courtesy of the artist.

theory. That early work encompassed walls and whole rooms. It was quite a break from my recent past to go back to my roots in Montreal, to rediscover linen canvas, the moveable wall, as well as ancient pigments and their binders.

When I attended Black Mountain, most of the art teaching was left over from Josef Albers. It was, therefore, all about making dark colors come forward and light colors recede. I never liked that kind of color. It's as though color were unemployed and needed to be given a job: I think color has such great resonance and personality. It's an amazing thing to use. The way I work, I never mix colors: I keep the pigments pure. If I want to paint purple, I'll put a red glaze over blue.

In 1981 I did a group of works called "The White Angels." I was intrigued by a statement from Courbet, who, in reaction against the ecclesiastical work around him in nineteenth-century France, said "Show me an angel and I'll paint it." I thought it would be marvelous to do an abstract angel: since there were no people with big wings sitting around posing, angels were probably the first non-geometric abstraction in painting. *Dark Angel Aura* (1982) is painted in watercolor on vellum that's been soaked, stretched, and painted on both sides, one side in black, the other in silver, then folded and glued. None of the folding is arbitrary, it's based on topology—I study math, applying it to art. *Dark Angel Aura* was influenced by the gray work of Giotto in the Scrovegni Chapel. . . .

Artists have always used mathematics. Giotto's and Michelangelo's studies show that they employed geometry and math all the way along. I like to think I'm entering that grand tradition on some level. At a certain point, around 1960, I didn't like what I was doing in the

studio, so I stopped. Although I had several jobs at once, and a child, I had energy left over, so I began to take ballet classes at American Ballet Theater. That wasn't so difficult to do back then—in fact they advertised in the newspaper for people to take classes. From there I drifted down to the Judson Church, where I worked with Robert Rauschenberg, Robert Whitman, and other artist/choreographers. Although trained, I had never thought of myself as a dancer, but I did realize that we were dividing the floor and counting. Whenever I was in a performance, I always lost count: I was subtracting and dividing and trying to do the motions at the same time. Somehow or other this began to feed into my experience of math and painting, of visual, kinetic, and spatial divisions.

When my daughter could not understand new math, I said, "Oh, no problem," and I started to teach her. As I did, I began for the first time to visualize mathematics. That produced my work based on set theory. I never thought any of my work would be shown, women simply were not shown back then, but I continued doing equations visually, and people began to hear about this and began to ask to see work. Then I was asked to exhibit, because Eva Hesse, Jo Baer, and people like that were now exhibiting. I naturally began to work topologically. Math is some kind of odd ability I have that I've learned to incorporate into my work: I'm not a mathematician, yet math is so beautifully abstract and creative, it feeds my painting and my being. . . .

ALFRED JENSEN Statement (1970)

In painting I can achieve a sensation because as I paint I show the visual in its reciprocal relationships at interplay acted out between neighboring number structures. I also show the interplay that exists between number and color areas.

As a painter I can paint these correlations; but as a writer it is a very hard task for me to attempt in words what I think as a painter.

To explain the means of my art is to make you aware that the number structures I use are concretely arrived at. The conventional abstract numbers which are used in the associative manner of current mathematically based concepts are not employable in my way of arriving at the truth.

My art is concretely anchored in my pictures' content, there to stay for generations, there to be looked at by observers to come and to be contemplated and enjoyed by them. To explain specifically, I use Goethe's "Farbenlehre" as a point of departure. Goethe defines his light and dark elements as these are seen through a prism. Looking into the prism, he observes an interplay of changes in action fought out between a light border overlapping a dark edge as both are seen against their light background. Or as Goethe writes (I paraphrase): A change existing in polar oppositions between a dark overlapping a light edge as both are acting out the interplay of light and dark seen against a setting of a dark background.

I use multiplication, addition, and subtraction in painting a picture. I use this method because the square gives me the means of setting boundaries. I find in the square specific settings, divisible areas, number structures, possibilities of time measure and rhythm as well as the essential form of color which can be placed in the square to interplay with number forms.

The square's capacity latent in its arithmetical mean brings forth a reciprocal relation exist-

* Alfred Jensen, untitled statement, in *Art Now* 2, no. 4 (1970): n.p. © 2012 Estate of Alfred Jensen/Artists Rights Society (ARS), New York.

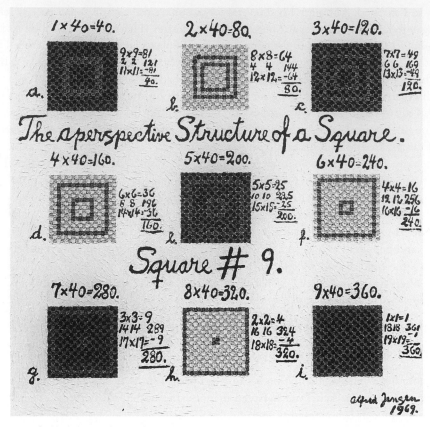

Alfred Jensen, *The Reciprocal Relation of Unity 40*, 1969, oil on canvas. Photo by Geoffrey Clements. By permission of the Estate of Alfred Jensen, courtesy The Pace Gallery, New York.

ing between the outwardly increasing area (forming a reciprocal unity that is measured across the median line) and the inwardly decreasing area of the square. This coordination of number structures enabled the archaic people to erect temples and pyramids.

SEAN SCULLY Statement (1987)

In 1970, when I was an art student, I made a trip to Morocco. When I came back I was making paintings with cutout strips of canvas, because what you see in Morocco is material in colored stripes, long flat bunches of it made of thin strands of wool. They dye strips of material, then hang them over a bar to dry in the shaded heat. Then they use them to make rugs.

I'd been making calligraphic paintings; soon I got into making the grids. The way it happened was, I made an allover striped painting that was square. Then I turned it and did it again, and I ended up with a grid. That was the structure I used for about five years. It raises an interesting point: what has gradually happened over the years is that the band or bar or

* Excerpts from "Sean Scully" (May 6, 1987), in Judith Olch Richards, *Inside the Studio: Two Decades of Talks with Artists in New York* (New York: Independent Curators International, 2004), 42–45. By permission of the author and the publisher. © 2012 Sean Scully/Artists Rights Society (ARS), New York/IVARO, Ireland.

stripe has become the subject matter. It's the thing I address. For me, it replaces the nude, or the bowl of fruit, the thing you paint. There is of course light and space in these paintings, but I don't set out to manufacture light and space. What I'm doing is painting the stripe as the subject. . . .

I've made lots of paintings where I've pushed forward some part of the painting, so those works have a real physicality about them, they're quite sculptural. Recently I've been making flat paintings, which has had a wonderful effect. It's amazing how, when you close up one possibility but subject the activity to the same kind of pressure, or apply the same sort of energy, as you did before, something else opens up. Painting flat has put more emphasis on color than on the drawing. The reason I did that was that the drawing in the three-dimensional works was somewhat limited by the fact that they were three-dimensional. By not allowing myself that sculptural facet, I've made something more apparent to myself. I guess that's why the grid started to come back into the work, and why I started to paint the space. I should say, however, that painting space isn't very interesting to me. The issue of painting abstraction isn't space, it's subject matter, how that subject matter is addressed, and how that produces content.

Color is something real natural to me. I think about structure a great deal, but color is purely intuitive. I hadn't used green for a long time, and I got scared of it; so I made some green paintings, and I made friends with green again. That's very simple for me. What's interested me in painting ever since my trip to Morocco is the horizontal and the vertical. That, of course, goes back through Mondrian and other artists before him, but I feel that those two directions represent the two primary ways that we can see images. In all my paintings there's a horizontal and a vertical. Really what's happened with the paintings is that the grid in the early work has been pulled apart. If you put the horizontal and vertical sections back together, you reconstruct a grid. . . .

The final thing to say about the stripe is that it's debased by everyday imagery. It's all over the place—in the subway, everywhere. It might have had a slight shock value when Barnett Newman was doing it (not that that was the first time that form had been used), but to my mind that gets in the way. Painting a stripe is like painting an apple: when Cézanne paints an apple, you look at the painting and say, "Oh, it's an apple," such an ordinary thing; but the way he paints it makes it so wonderful, so moving. Jazz can be moving that way too: successful jazz musicians may choose a very simple melody, but then they improvise. And it's the sense of what the melody should be, or usually is, that makes what they do so poignant.

This brings me back to my point about not making things work. That's why I don't try to make the paintings resolved in a design sense: I just try to make them be as much as they can be.

MIRIAM SCHAPIRO AND MELISSA MEYER

Waste Not/Want Not: An Inquiry into What Women Saved and Assembled—Femmage (1977–78)

Virginia Woolf talks about the loose, drifting material of life, describing how she would like to see it sorted and coalesced into a mold transparent enough to reflect the light of our life and yet aloof as a work of art. She makes us think of the paper lace, quills and beads, scraps

* Miriam Schapiro and Melissa Meyer, "Waste Not/Want Not: An Inquiry into What Women Saved and Assembled—Femmage," *Heresies* 1, no. 4 (Winter 1977–78): 66–69. By permission of the authors.

Waste Not

An Inquiry into What

Melissa Meyer

Want Not

Women Saved and Assembled

Miriam Schapiro

FEMMAGE

Virginia Woolf talks about the loose, drifting material of life, describing how she would like to see it sorted and coalesced into a mold transparent enough to reflect the light of our life and yet aloof as a work of art.[1] She makes us think of the paper lace, quills and beads, scraps of cloth, photographs, birthday cards, valentines and clippings, all of which inspired the visual imaginations of the women we write about.

In the eighteenth century, a nun in a German convent cuts delicate lace from thin parchment and pastes it around minutely detailed paintings of saints. Performing an act of devotion in the service of her God, she makes what later, in the secular world, are called the first valentines.

An Iroquois woman in 1775 sews five elliptical quillwork designs at the base of a black buckskin bag, quillwork borders at the top and additional moosehair embroidery at the bottom and sides.

Hannah Stockton, a New Jersey woman, in 1830 dips into her scrap bag in the tradition of waste not want not and finds just the right pieces with which to appliqué her quilt.

In the 1860s, Lady Filmer photographs the Prince of Wales and his shooting party. Later she cuts up these photos and creates a composition of them in her album, producing the first photocollage.[2]

Rita Reynolds, resident of Southend, England, keeps a scrapbook during World War II. In it she glues birthday cards, valentines and clippings from her local newspaper which record the progress of the war. As the world situation worsens, the scrapbook reflects its gravity.

Collage: a word invented in the twentieth century to describe an activity with an ancient history. Here are some associated definitions:
Collage: pictures assembled from assorted materials.
Collage: a French word after the verb *coller* which means pasting, sticking or gluing, as in application of wallpaper.
Assemblage: a collection of things, often combined in the round.
Assemblage: a specific technical procedure and form used in the literary and musical, as well as the plastic arts, but also a complex of attitudes and ideas . . . collage and related modes of construction manifest a predisposition that is characteristically modern.[3]
Découpage: (literally, cutting) a mode of decorating painted furniture with cutouts of flowers, fruit, etc. Also, the art of decorating surfaces with applied paper cutouts.
Photomontage: the method of making a composite picture by bringing photographs together in a single composition and arranging them, often by superimposing one part on another, so that they form a blended whole.

Melissa Meyer and Miriam Schapiro, "Waste Not/Want Not: An Inquiry into What Women Saved and Assembled—Femmage," collage/text in *Heresies* no. 4 (Winter 1977–78). Collage courtesy Melissa Meyer.

of cloth, photographs, birthday cards, valentines and clippings, all of which inspired the visual imaginations of the women we write about.

In the eighteenth century, a nun in a German convent cuts delicate lace from thin parchment and pastes it around minutely detailed paintings of saints. Performing an act of devotion in the service of her God, she makes what later, in the secular world, are called the first valentines.

An Iroquois woman in 1775 sews five elliptical quillwork designs at the base of a black buckskin bag, quillwork borders at the top and additional moosehair embroidery at the bottom and sides.

Hannah Stockton, a New Jersey woman, in 1830 dips into her scrap bag in the tradition of waste not want not and finds just the right pieces with which to appliqué her quilt.

In the 1860s, Lady Filmer photographs the Prince of Wales and his shooting party. Later she cuts up these photos and creates a composition of them in her album, producing the first photocollage.

Rita Reynolds, resident of Southend, England, keeps a scrapbook during World War II. In it she glues birthday cards, valentines and clippings from her local newspaper which record the progress of the war. As the world situation worsens, the scrapbook reflects its gravity.

Collage: a word invented in the twentieth century to describe an activity with an ancient history. Here are some associated definitions:
Collage: pictures assembled from assorted materials.

Collage: a French word after the verb *coller* which means pasting, sticking or gluing, as in application of wallpaper.

Assemblage: a collection of things, often combined in the round.

Assemblage: a specific technical procedure and form used in the literary and musical, as well as the plastic arts, but also a complex of attitudes and ideas. . . . Collage and related modes of construction manifest a predisposition that is characteristically modern.

Découpage: (literally, cutting) a mode of decorating painted furniture with cutouts of flowers, fruit, etc. Also, the art of decorating surfaces with applied paper cutouts.

Photomontage: the method of making a composite picture by bringing photographs together in a single composition and arranging them, often by superimposing one part on another, so that they form a blended whole.

Femmage: a word invented by us to include all of the above activities as they were practiced by women using traditional women's techniques to achieve their art—sewing, piecing, hooking, cutting, appliquéing, cooking and the like—activities also engaged in by men but assigned in history to women.

———————

Published information about the origins of collage is misleading. Picasso and Braque are credited with inventing it. Many artists made collage before they did, Picasso's father for one and Sonia Delaunay for another. When art historians mandate these beginnings at 1912, they exclude artists not in the mainstream. Art historians do not pay attention to the discoveries of non-Western artists, women artists or anonymous folk artists. All of these people make up the group we call *others.* It is exasperating to realize that the rigidities of modern critical language and thought prevent a direct response to the eloquence of art when it is made by *others.* . . .

Many of these ancestors were women who were ignored by the politics of art. . . .

Now that we women are beginning to document our culture, redressing our trivialization and adding our information to the recorded male facts and insights, it is necessary to point out the extraordinary works of art by women which despite their beauty are seen as leftovers of history. Aesthetic and technical contributions have simply been overlooked. Here, for example, we are concerned with the authenticity and energy in needlework.

When it becomes possible to appreciate a sewn object like a quilt (even though it was created for utilitarian purposes) because it employs thirty stitches to the inch, and uses color which by all standards is rich and evocative, contains silhouetted forms which are skillfully drawn and connects perfectly measured geometrical units of fabric, then it will be clear that woman's art invites a methodology of its own.

Women have always collected things and saved and recycled them because leftovers yielded nourishment in new forms. The decorative functional objects women made often spoke in a secret language, bore a covert imagery. When we read these images in needlework, in paintings, in quilts, rugs and scrapbooks, we sometimes find a cry for help, sometimes an allusion to a secret political alignment, sometimes a moving symbol about the relationships between men and women. We base our interpretations of the layered meanings in these works on what we know of our own lives—a sort of archaeological reconstruction and deciphering. . . .

Collected, saved and combined materials represented for such women acts of pride, desperation and necessity. Spiritual survival depended on the harboring of memories. Each cherished scrap of percale, muslin or chintz, each bead, each letter, each photograph, was a reminder of its place in a woman's life, similar to an entry in a journal or a diary. . . .

Women's culture is the framework for femmage, and makes it possible for us to understand

"combining" as the simultaneous reading of moosehair and beads, cut paper and paint or open-work and stitches. Our female culture also makes it possible to see these traditional aesthetic elements for what they are—the natural materials needed for spiritual, and often physical, survival.

In the past an important characteristic of femmage was that women worked for an audience of intimates. A woman artist-maker always had the assurance that her work was destined to be appreciated and admired. She worked for her relatives and friends and unless she exhibited in church bazaars and county fairs, her viewers were almost always people she knew. . . .

We feel that several criteria determine whether a work can be called femmage. Not all of them appear in a single object. However, the presence of at least half of them should allow the work to be appreciated as *femmage*.

1. It is a work by a woman. 2. The activities of saving and collecting are important ingredients. 3. Scraps are essential to the process and are recycled in the work. 4. The theme has a woman-life context. 5. The work has elements of covert imagery. 6. The theme of the work addresses itself to an audience of intimates. 7. It celebrates a private or public event. 8. A diarist's point of view is reflected in the work. 9. There is drawing and/or handwriting sewn in the work. 10. It contains silhouetted images which are fixed on other material. 11. Recognizable images appear in narrative sequence. 12. Abstract forms create a pattern. 13. The work contains photographs or other printed matter. 14. The work has a functional as well as an aesthetic life.

These criteria are based on visual observation of many works made by women in the past. We have already said that this art has been excluded from mainstream, but why is that so? What is mainstream? How may such an omission be corrected?

The works themselves were without status because the artists who made them were considered inferior by the historians who wrote about art and culture. Since the works were intimate and had no data or criticism attached to them and were often anonymous, how could these writers identify them as valid, mainstream history?

Mainstream is the codification of ideas for the illumination of history and the teaching of the young. What a shame that the young remain ignorant of the vitality of women's art. Yet the culture of women will remain unrecognized until women themselves regard their own past with fresh insight. To correct this situation, must we try to insert women's traditional art into mainstream? How will the authorities be convinced that what they consider low art is worth representing in history? The answer does not lie in mainstream at all, but in sharing women's information with women.

Toward this end we have evaluated a selection of women's art and looked for similar elements which appeared most frequently. As we recorded them, we discovered with pleasure that they presented a form in many guises—a form we call femmage.

VALERIE JAUDON AND JOYCE KOZLOFF
Art Hysterical Notions of Progress and Culture (1977–78)

As feminists and artists exploring the decorative in our own paintings, we were curious about the pejorative use of the word "decorative" in the contemporary art world. In rereading the basic texts of Modern Art, we came to realize that the prejudice against the decorative has a

* Valerie Jaudon and Joyce Kozloff, "Art Hysterical Notions of Progress and Culture," *Heresies* 1, no. 4 (Winter 1977–78): 38–42. By permission of the authors.

Valerie Jaudon and Joyce Kozloff, collaborative collage, 1994, with details from Jaudon's *Union* (1981, oil on canvas) and Kozloff's *16-Point Star Pattern I* (1975, gouache and colored pencil). Courtesy of the artists.

long history and is based on hierarchies: fine art above decorative art, Western art above non-Western art, men's art above women's art. By focusing on these hierarchies we discovered a disturbing belief system based on the moral superiority of the art of Western civilization.

We decided to write a piece about how *language* has been used to communicate this moral superiority. Certain words have been handed down unexamined from one generation to the next. We needed to take these words away from the art context to examine and decode them. They have colored our own history, our art training. We have had to rethink the underlying assumptions of our education.

Within the discipline of art history, the following words are continuously used to characterize what has been called "high art": man, mankind, the individual man, individuality, humans, humanity, the human figure, humanism, civilization, culture, the Greeks, the Romans, the English, Christianity, spirituality, transcendence, religion, nature, true form, science, logic, purity, evolution, revolution, progress, truth, freedom, creativity, action, war, virility, violence, brutality, dynamism, power and greatness.

In the same texts other words are used repeatedly in connection with so-called "low art": Africans, Orientals, Persians, Slovaks, peasants, the lower classes, women, children, savages, pagans, sensuality, pleasure, decadence, chaos, anarchy, impotence, exotica, eroticism, artifice, tattoos, cosmetics, ornament, decoration, carpets, weaving, patterns, domesticity, wallpaper, fabrics and furniture.

All of these words appear in the quotations found throughout this piece. The quotations are from the writings and statements of artists, art critics and art historians. We do not pretend to neutrality and do not supply the historical context for the quotations. These can be found in the existing histories of Modern Art. Our analysis is based on a personal, contemporary perspective.

War and Virility

Manifestoes of Modern Art often exhort artists to make violent, brutal work, and it is no accident that men such as Hirsh, Rivera, and Picasso like to think of their art as a metaphorical weapon. One of the longstanding targets of this weapon has been the decorative. The scorn for decoration epitomizes the machismo expressed by Le Corbusier, Gabo/Pevsner

and Marinetti/Sant'Elia. Their belligerence may take the form of an appeal to the machine aesthetic: the machine is idolized as a tool and symbol of progress, and technological progress is equated with reductivist, streamlined art. The instinct to purify exalts an order which is never described and condemns a chaos which is never explained.

.

Joseph Hirsh, from "Common Cause," D. W. Larink, 1949:
"The great artist has wielded his art as a magnificent weapon truly mightier than the sword . . ."

Diego Rivera, "The Revolutionary Spirit in Modern Art," 1932:
"I want to use my art as a weapon."

Pablo Picasso, "Statement about the Artist as a Political Being," 1945:
"No, painting is not done to decorate apartments. It is an instrument of war for attack and defense against the enemy."

Le Corbusier, "Guiding Principles of Town Planning," 1925:
"Decorative art is dead. . . . An immense, devastating brutal evolution has burned the bridges that link us with the past."

Naum Gabo and Antoine Pevsner, "Basic Principles of Constructivism," 1920:
"We reject the decorative line. We demand of every line in the work of art that it shall serve solely to define the inner directions of force in the body to be portrayed."

Filippo Tommaso Marinetti and Antonio Sant'Elia, "Futurist Architecture," 1914:
"The decorative must be abolished! . . . Let us throw away monuments, sidewalks, arcades, steps: let us sink squares into the ground, raise the level of the city."

El Lissitzky, "Ideological super-structure," 1929:
"Destruction of the traditional. . . . War has been declared on the aesthetic of chaos. An order that has entered fully into consciousness is called for."

"Manifesto of the Futurist Painters," 1910:
"The dead shall be buried in the earth's deepest bowels! The threshold of the future will be free of mummies! Make room for youth, for violence, for daring!"

.

Purity

In the polemics of Modern Art, "purity" represents the highest good. The more the elements of the work of art are pared down, reduced, the more visible the "purity." Here Greenberg equates reductivism with rationality and function. But it is never explained why or for whom art has to be functional, nor why reductivism is rational. Among artists as diverse as Sullivan, Ozenfant and de Kooning, we found the sexual metaphor of "stripping down" art and architecture to make them "nude" or "pure." The assumption is that the artist is male, and the work of art (object) female.

.

Clement Greenberg, "Detached Observations," 1976:
"The ultimate use of art is construed as being to provide the experience of aesthetic value, therefore art is to be stripped down towards this end. Hence, modernist 'functionalism,' 'essentialism' it could be called, the urge to 'purify' the medium, any medium. 'Purity' being construed as the most efficacious, efficient, economical employment of the medium for purposes of aesthetic value."

Louis Sullivan, "Ornament in Architecture," 1892:

"... it would be greatly for our aesthetic good, if we should refrain from the use of ornament for a period of years, in order that our thought might concentrate acutely upon the production of buildings well formed and comely in the nude."

Amédée Ozenfant, *Foundations of Modern Art,* 1931:

"Decoration can be revolting, but a naked body moves us by the harmony of its form."

Willem de Kooning, "What Abstract Art Means to Me," 1951:

"One of the most striking aspects of abstract art's appearance is her nakedness, an art stripped bare."

Purity in Art as a Holy Cause

Purity can also be sanctified as an aesthetic principle. Modern artists and their espousers sometimes sound like the new crusaders, declaring eternal or religious values. A favorite theme is that of cleansing art. The ecclesiastical metaphor of transcendence through purification (baptism) is used to uphold the "Greek" tradition (as in the van de Velde quotation) or the "Christian" tradition (as in the Loos quotation). Cleansing and purification are sometimes paired with an exalted view of the artist as a god, as in Apollinaire's desire to "deify personality."

.

Henry van de Velde, "Programme," 1903:

"As soon as the work of cleansing and sweeping out has been finished, as soon as the true form of things comes to light again, then strive with all the patience, all the spirit and the logic of the Greeks for the perfection of this form."

Adolf Loos, "Ornament and Crime," 1908:

"We have outgrown ornament: we have fought our way through to freedom from ornament. See, the time is nigh, fulfilment awaits us. Soon the streets of the city will glisten like white walls, like Zion, the holy city, the capital of heaven. Then fulfilment will be come."

Guillaume Apollinaire, *The Cubist Painters,* 1913:

"To insist on purity is to baptize instinct, to humanize art, and to deify personality."

The Superiority of Western Art

Throughout the literature of Western art there are racist assumptions that devalue the arts of other cultures. The ancient Greeks are upheld as the model, an Aryan ideal of order. Art in the Greco-Roman tradition is believed to represent superior values. Malraux uses the word "barbarian" and Fry the word "savages" to describe art and artists outside our tradition. The non-Western ideals of pleasure, meditation and loss of self are clearly not understood by the exponents of ego assertion, transcendence and dynamism.

.

David Hume, "Of National Characters" (on Africans), 1748:

"There scarcely ever was a civilized nation of that complexion nor even any individual, eminent either in action or speculation. No ingenious manufactures amongst them, no arts, no sciences."

Roger Fry, "The Art of the Bushmen," 1910:

"... it is to be noted that all the peoples whose drawing shows this peculiar power of visualization (sensual not conceptual) belong to what we call the lowest of savages, they are certainly the least civilizable, and the South African Bushmen are regarded by other native races in much the same way that we look upon negroes."

André Malraux, *The Voices of Silence*, 1953:

"Now a barbarian art can keep alive only in the environment of the barbarism it expresses . . . "

"... the Byzantine style, as the West saw it, was not the expression of a supreme value but merely a form of decoration."

Roger Fry, "The Munich Exhibition of Mohammedan Art," 1910:

"It cannot be denied that in course of time it [Islamic art] pandered to the besetting sin of the oriental craftsman, his intolerable patience and thoughtless industry."

Gustave von Grunebaum, *Medieval Islam*, 1945:

"Islam can hardly be called creative in the sense that the Greeks were creative in the fifth and fourth centuries B.C. or the Western world since the Renaissance, but its flavor is unmistakable . . . "

Sir Richard Westmacott, Professor of Sculpture, Royal Academy (quoted in *Rediscoveries in Art: Some Aspects of Taste, Fashion and Collecting in England and France*, Francis Haskell, 1976):

"... I think it impossible that any artist can look at the Nineveh marbles as works for study, for such they certainly are not: they are works of prescriptive art, like works of Egyptian art. No man would ever think of studying Egyptian art."

Adolf Loos, "Ornament and Crime," 1908:

"... No ornament can any longer be made today by anyone who lives on our cultural level.

"It is different with the individuals and peoples who have not yet reached this level."

"I can tolerate the ornaments of the Kaffir, the Persian, the Slovak peasant woman, my shoemaker's ornaments, for they all have no other way of attaining the high points of their existence. We have art, which has taken the place of ornament. After the toils and troubles of the day we go to Beethoven or to Tristan."

Fear of Racial Contamination, Impotence and Decadence

Racism is the other side of the coin of Exotica. Often underlying a fascination with the Orient, Indians, Africans and primitives is an urgent unspoken fear of infiltration, decadence and domination by the "mongrels" gathering impatiently at the gates of civilization. Ornamental objects from other cultures which appeared in Europe in the nineteenth century were clearly superior to Western machine-made products. How could the West maintain its notion of racial supremacy in the face of these objects? Loos's answer: by declaring that ornament itself was savage. Artists and aesthetes who would succumb to decorative impulses were considered impotent and/or decadent.

.

Adolf Loos, "Ornament and Crime," 1908:

"I have made the following discovery and I pass it on to the world: The evolution of culture is synonymous with the removal of ornament from utilitarian objects. I believed that with this discovery I was bringing joy to the world: it has not thanked me. People were sad and hung their heads. What depressed them was the realization that they could produce no new ornaments. Are we alone, the people of the nineteenth century, supposed to be unable to do what any Negro, all the races and periods

before us have been able to do? What mankind created without ornament in earlier millennia was thrown away without a thought and abandoned to destruction. We possess no joiner's benches from the Carolingian era, but every trifle that displays the least ornament has been collected and cleaned and palatial buildings have been erected to house it. Then people walked sadly about between the glass cases and felt ashamed of their impotence."

Amédée Ozenfant, *Foundations of Modern Art,* 1931:

"Let us beware lest the earnest effort of younger peoples relegates us to the necropolis of the effete nations, as mighty Rome did to the dilettantes of the Greek decadence, or the Gauls to worn-out Rome."

"Given many lions and few fleas, the lions are in no danger; but when the fleas multiply, how pitiful is the lions' lot!"

Albert Gleizes and Jean Metzinger, *Cubism,* 1912:

"As all preoccupation in art arises from the material employed, we ought to regard the decorative preoccupation, if we find it in a painter, as an anachronistic artifice, useful only to conceal impotence."

Maurice Barrés (on the Italian pre-Renaissance painters), 1897 (quoted in André Malraux, *The Voices of Silence*):

"And I can also see why aesthetes, enamored of the archaic, who have deliberately emasculated their virile emotions in quest of a more fragile grace, relish the poverty and pettiness of these minor artists."

Racism and Sexism

Racist and sexist attitudes characterize the same mentality. They sometimes appear in the same passage and are unconsciously paired, as when Read equates tattoos and cosmetics. The tattoo refers to strange, threatening customs of far-off places and mysterious people. Cosmetics, a form of self-ornamentation, is equated with self-objectification and inferiority (Schapiro). Racism and sexism ward off the potential power and vitality of the "other." Whereas nudity earlier alluded to woman as the object of male desire, here Malevich associates the nude female with savagery.

.

Herbert Read, *Art and Industry,* 1953:

"All ornament should be treated as suspect. I feel that a really civilized person would as soon tattoo his body as cover the form of a good work of art with meaningless ornament. Legitimate ornament I conceive as something like mascara and lipstick—something applied with discretion to make more precise the outlines of an already existing beauty."

Adolf Loos, "Ornament and Crime," 1908:

"The child is amoral. To our eyes, the Papuan is too. The Papuan kills his enemies and eats them. He is not a criminal. But when modern man kills someone and eats him he is either a criminal or a degenerate. The Papuan tattoos his skin, his boat, his paddles, in short everything he can lay hands on. He is not a criminal. The modern man who tattoos himself is either a criminal or a degenerate. There are prisons in which eighty percent of the inmates show tattoos. The tattooed who are not in prison are latent criminals or degenerate aristocrats. If someone who is tattooed dies at liberty, it means he has died a few years before committing a murder."

Meyer Schapiro, "The Social Bases of Art," 1936:

"A woman of this class [upper] is essentially an artist, like the painters whom she might patronize. Her daily life is filled with aesthetic choices: she buys clothes, ornaments, furniture, house decorations: she is constantly re-arranging herself as an aesthetic object."

Kasimir Malevich, "Suprematist Manifesto Unovis," 1924:

"... we don't want to be like those Negroes upon whom English culture bestowed the umbrella and top hat, and we don't want our wives to run around naked like savages in the garb of Venus!"

Iwan Bloch, *The Sexual Life of Our Time*, 1908:

"... [woman] possesses a greater interest in her immediate environment, in the finished product, in the decorative, the individual, and the concrete: man, on the other hand, exhibits a preference for the more remote, for that which is in process of construction or growth, for the useful, the general, and the abstract."

Leo Tolstoy, "What Is Art?" 1898:

"Real art, like the wife of an affectionate husband, needs no ornaments. But counterfeit art, like a prostitute, must always be decked out."

Hierarchy of High-Low Art

Since the art experts consider the "high arts" of Western men superior to all other forms of art, those arts done by non-Western people, low-class people and women are categorized as "minor arts," "primitive arts," "low arts," etc. A newer more subtle way for artists to elevate themselves to an elite position is to identify their work with "pure science," "pure mathematics," linguistics and philosophy. The myth that high art is for a select few perpetuates the hierarchy in the arts, and among people as well.

.

Clement Greenberg, "Avant-Garde and Kitsch," 1939:

"It will be objected that such art for the masses as folk art was developed under rudimentary conditions of production—and that a good deal of folk art is on a high level. Yes, it is—but folk art is not Athene, and it's Athene whom we want: formal culture with its infinity of aspects, its luxuriance, its large comprehension."

H. W. Janson, *History of Art*, 1962:

"... for the applied arts are more deeply enmeshed in our everyday lives and thus cater to a far wider public than do painting and sculpture, their purpose, as the name suggests, is to beautify the useful, an important and honourable one, no doubt, but of a lesser order than art pure and simple."

Amédée Ozenfant, *Foundations of Modern Art*, 1931:

"If we go on allowing the minor arts to think themselves the equal of Great Art, we shall soon be hail fellow to all sorts of domestic furniture. Each to his place! The decorators to the big shops, the artists on the next floor up, several floors up, as high as possible, on the pinnacles, higher even. For the time being, however, they sometimes do meet on the landings, the decorators having mounted at their heels, and numerous artists having come down on their hunkers."

Le Corbusier (Pierre Jeanneret) and Amédée Ozenfant, "On Cubism," 1918 (quoted in Ozenfant, *Foundations of Modern Art*):

"There is a hierarchy in the arts: decorative art at the bottom, and the human form at the top."

"Because we are men."

André Malraux, *The Voices of Silence*, 1953:

"The design of the carpet is wholly abstract: not so its color. Perhaps we shall soon discover that the sole reason why we call this art 'decorative' is that for us it has no history, no hierarchy, no meaning. Color reproduction may well lead us to review our ideas on this subject and rescue the masterwork from

the North African bazaar as Negro sculpture has been rescued from the curio-shop; in other words, liberate Islam from the odium of 'backwardness' and assign its due place (a minor one, not because the carpet never portrays Man, but because it does not express him) to this last manifestation of the undying East."

Barnett Newman, "The Ideographic Picture," 1947 (on the Kwakiutl artist):

"The abstract shape he used, his entire plastic language, was directed by a ritualistic will towards metaphysical understanding. The everyday realities he left to the toymakers; the pleasant play of nonobjective pattern to the women basket weavers."

Ursula Meyer, *Conceptual Art,* 1972:

"In the same sense that science is for scientists and philosophy is for philosophers, art is for artists."

Joseph Kosuth, "Introductory Note by the American Editor," 1970:

"In a sense, then, art has become as 'serious as science or philosophy' which doesn't have audiences either."

That Old Chestnut, "Humanism"

Humanism was once a radical doctrine opposing the authority of the church, but in our secular society it has come to defend the traditional idea of "mankind" and status quo attitudes. The "human values" such authorities demand of art depend on the use of particular subject matter or particular ideas of "human" expression. Without humanist content, ornament, pattern and ritual or decorative elaborations of production are condemned as inhuman, alien and empty. "The limits of the decorative," says Malraux, "can be precisely defined only in an age of humanistic art." We could rather say that the generalities of "humanist" sentiment characterize only a small part of world art, most of which is non-Western and decorative. But why should anyone prefer the false divisions of these writers, based on ethnic stereotypes, to a historical awareness of the interdependence of all "human" cultures?

.

Camille Mauclair, "La Réforme de l'art décoratif en France" (on the Impressionists), 1896:

"Decorative art has as its aesthetic and for its effect not to make one think of man, but of an order of things arranged by him: it is a descriptive and deforming art, a grouping of spectacles the essence of which is to be seen."

Rudolf Arnheim, *Art and Visual Perception,* 1954:

"Paintings or sculpture are self-contained statements about the nature of human existence in all its essential aspects. An ornament presented as a work of art becomes a fool's paradise, in which tragedy and discord are ignored and an easy peace reigns."

Hilton Kramer, "The Splendors and Chill of Islamic Art," 1975:

" . . . for those of us who seek in art something besides a bath of pleasurable sensation, so much of what it [the Metropolitan Museum's Islamic wing] houses is, frankly, so alien to the expectations and experience of Western sensibility."

"Perhaps with the passage of time, Islamic art will come to look less alien to us than it does today. I frankly doubt it—there are too many fundamental differences of spirit to be overcome."

" . . . there is small place indeed given to what looms so large in the Western imagination: the individualization of experience."

Sir Thomas Arnold, *Painting in Islam*, 1928:

"... *the painter was apparently willing to spend hours of work upon the delicate veining of the leaves of a tree ... but it does not seem to have occurred to him to devote the same pains and effort on the countenances of his human figures ... he appears to have been satisfied with the beautiful decorative effect he achieved.*"

André Malraux, *The Voices of Silence*, 1953:

"*The limits of the decorative can be precisely defined only in an age of humanistic art.*"

"*It was the individualization of destiny, this involuntary or unwitting imprint of his private drama on every man's face, that prevented Western art from becoming like Byzantine mosaics always transcendent, or like Buddhist sculpture obsessed with unity.*"

"*How could an Egyptian, an Assyrian or a Buddhist have shown his god nailed to a cross, without ruining his style?*"

Decoration and Domesticity

The antithesis of the violence and destruction idolized by Modern Art is the visual enhancement of the domestic environment. (If humanism is equated with dynamism, the decorative is seen to be synonymous with the static.) One method "modernism" has used to discredit its opponents has been to associate their work with carpets and wallpaper. Lacking engagement with "human form" or the "real world," the work of art must be stigmatized as decorative (Sedlmayr and Barnes/de Mazia). So decorative art is a code term signifying failed humanism. Artists such as Gleizes and Kandinsky, anxious to escape the tag of the decorative, connect their work to older, humanist aspirations.

.

Aldous Huxley on Pollock's *Cathedral*, 1947:

"*It seems like a panel for a wallpaper which is repeated indefinitely around the wall.*"

Wyndham Lewis, "Picasso" (on *Minotauromachy*), 1940:

"... *this confused, feeble, profusely decorated, romantic carpet.*"

The *Times* of London critic on Whistler, 1878:

"... *that these pictures only come one step nearer [to fine art] than a delicately tinted wallpaper.*"

Hans Sedlmayr, *Art in Crisis: The Lost Center*, 1948:

"*With Matisse, the human form was to have no more significance than a pattern on a wallpaper ...*"

Dr. Albert C. Barnes and Violette de Mazia, *The Art of Cézanne*, 1939:

"*Pattern, in Cézanne an instrument strictly subordinated to the expression of values inherent in the real world, becomes in cubism the entire aesthetic content, and this degradation of form leaves cubistic painting with no claim to any status higher than decoration.*"

Albert Gleizes, "Opinion" (on Cubism), 1913:

"*There is a certain imitative coefficient by which we may verify the legitimacy of our discoveries, avoid reducing the picture merely to the ornamental value of an arabesque or an Oriental carpet, and obtain an infinite variety which would otherwise be impossible.*"

Wassily Kandinsky, *Über das Geistige in der Kunst*, 1912:

"*If we begin at once to break the bonds that bind us to nature and to devote ourselves purely to combinations of pure color and independent form, we shall produce works which are mere geometric decoration, resembling something like a necktie or a carpet.*"

Certain modern artists express the desire for unlimited personal power. The aesthetics of "modernism"—its ego-mania, violence, purity-fixation and denial of all other routes to the truth—is highly authoritarian. The reductivist ideology suggests an inevitable, evolutionary survival of the (aesthetic) fittest. Reinhardt declares throughout his writings that all the world's art must culminate in his "pure" paintings. Ozenfant equates purism with a "superstate." Mendelsohn believes the advocates of the new art have a "right to exercise control."

.

Ad Reinhardt, "There Is Just One Painting," 1966:

 "There is just one art history, one art evolution, one art progress. There is just one aesthetics, just one art idea, one art meaning, just one principle, one force. There is just one truth in art, one form, one change, one secrecy."

Amédée Ozenfant, *Foundations of Modern Art,* 1931:

 "Purism is not an aesthetic, but a sort of super-aesthetic in the same way that the League of Nations is a superstate."

Erich Mendelsohn, "The Problem of a New Architecture," 1919:

 "The simultaneous process of revolutionary political decisions and radical changes in human relationships in economy and science and religion and art give belief in the new form, an a priori right to exercise control, and provide a justifiable basis for a rebirth amidst the misery produced by world-historical disaster."

Adolf Hitler, speech inaugurating the "Great Exhibition of German Art," 1937:

 "I have come to the final inalterable decision to clean house, just as I have done in the domain of political confusion . . . "

 "National-Socialist Germany, however, wants again a German Art, and this art shall and will be eternal value, as are all truly creative values of a people. . . . "

Frank Lloyd Wright, "Work Song," 1896:

 "I'LL THINK
 AS I'LL ACT
 AS I AM!
 NO DEED IN FASHION FOR SHAME
 NOR FOR FAME E'ER MAN MADE
 SHEATH THE NAKED WHITE BLADE
 MY ACT AS BECOMETH A MAN
 MY ACT
 ACTS THAT BECOMETH THE MAN"

We started by examining a specific attitude—the prejudice against the decorative in art—and found ourselves in a labyrinth of myth and mystification. By taking these quotes out of context we are not trying to hold these artists and writers up to ridicule. However, to continue reading them in an unquestioning spirit perpetuates their biases. The language of their statements is often dated—indeed, some of them are over a century old—but the sentiments they express still guide contemporary theory in art.

Modernism, the theory of Modern Art, claimed to break with Renaissance humanism. Yet both doctrines glorify the individual genius as the bearer of creativity. It seems worth

noting that such heroic genius has always appeared in the form of a white Western male. We, as artists, cannot solve these problems, but by speaking plainly we hope to reveal the inconsistencies in assumptions that too often have been accepted as "truth."

PETER HALLEY Notes on the Paintings (1982)

1. These are paintings of prisons, cells, and walls.
2. Here, the idealist square becomes the prison. Geometry is revealed as confinement.
3. The cell is a reminder of the apartment house, the hospital bed, the school desk—the isolated endpoints of industrial structure.
4. The paintings are a critique of idealist modernism. In the "color field" is placed a jail. The misty space of Rothko is walled up.
5. Underground conduits connect the units. "Vital fluids" flow in and out.
6. The "stucco" texture is a reminiscence of motel ceilings.
7. The Day-Glo paint is a signifier of "low budget mysticism." It is the afterglow of radiation.

Deployment of the Geometric (1984)

The deployment of the geometric dominates the landscape. Space is divided into discrete, isolated cells, explicitly determined as to extent and function. Cells are reached through complex networks of corridors and roadways that must be traveled at prescribed speeds and at prescribed times. The constant increase in the complexity and scale of these geometries continuously transforms the landscape.

Conduits supply various resources to the cells. Electricity, water, gas, communications lines, and, in some cases, even air, are piped in. The conduits are almost always buried underground, away from sight. The great networks of transportation give the illusion of tremendous movement and interaction. But the networks of conduits minimalize the need to leave the cells.

The regimentation of human movement, activity, and perception accompanies the geometric division of space. It is governed by the use of time-keeping devices, the application of standards of normalcy, and the police apparatus. In the factory, human movement is made to conform to rigorous spatial and temporal geometries. At the office, the endless recording of figures and statistics is presided over by clerical workers.

Along with the geometrization of the landscape, there occurs the geometrization of thought. Specific reality is displaced by the primacy of the model. And the model is in turn imposed on the landscape, further displacing reality in a process of ever more complete circularity.

Art, or what remains of art, has also been geometrized. But in art the geometric has been curiously associated with the transcendental. In Mondrian, Newman, even in Noland, the

* Peter Halley, "Notes on the Paintings" (1982), in *Effects* (Winter 1986); reprinted in *Collected Essays: 1981–1987* (Zurich and New York: Bruno Bischofberger Gallery and Sonnabend Gallery, 1989), 23. By permission of the author.
** Peter Halley, "Deployment of the Geometric" (1984), in *Effects* (Winter 1986); reprinted in *Collected Essays: 1981–1987* (Zurich and New York: Bruno Bischofberger Gallery and Sonnabend Gallery, 1989), 127–30. By permission of the author.

Peter Halley, *Two Cells with Conduit and Underground Chamber,* 1983, Day-Glo, acrylic, and Roll-a-Tex on canvas. By permission of the artist. Photo courtesy Gagosian Gallery, New York.

geometric is heralded as the timeless, the heroic, and the religious. Geometry, ironically, is deemed the privileged link to the nature it displaces.

In this way, geometric art has been made to justify the deployment of the geometric. It has linked the modern deployment of geometry to the wisdom of the ancients, to the tradition of religious truth, and to the esoteric meditative practices of non-Western cultures. Geometric art has served to hide the fact that the modern deployment of geometry is stranger than the strange myths of traditional societies. Geometric art has sought to convince us, despite all the evidence to the contrary, that the progress of geometry is humanistic, that it is part of the "march of civilization," that it embodies continuity with the past. In this, geometric art has succeeded completely. In so doing, it has helped make possible the second phase of geometrization (that coincides with the post-war period) in which coercion is replaced by fascination.

We are convinced. We volunteer. Today Foucauldian confinement is replaced by Baudrillardian deterrence. The worker need no longer be coerced into the factory. We sign up for body building at the health club. The prisoner need no longer be confined in the jail. We invest in condominiums. The madman need no longer wander the corridors of the asylum. We cruise the Interstates.

We are today enraptured by the very geometries that once represented coercive discipline. Today children sit for hours fascinated by the day-glo geometric displays of video games. Adolescents are enchanted by the arithmetic mysteries of their computers. As adults, we finally gain "access" to participation in our cybernetic hyperreal, with its charge cards, telephone answering machines, and professional hierarchies. Today we can live in "spectral suburbs" or simulated cities. We can play the corporate game, the entrepreneurial game, the investment game, or even the art game.

Now that we are enraptured by geometry, geometric art has disappeared. There is no need for any more Mardens or Rymans to convince us of the essential beauty of the geometric field embodied in the television set's glowing image. Today we have instead "figurative art" to convince us that the old humanist body hasn't disappeared (though it has). It is only now that geometric art has been discarded that it can begin to describe the deployment of the geometric.

ANISH KAPOOR Interview with John Tusa (2003)

ANISH KAPOOR: . . . I feel that one of the great currents in the contemporary experience of art is that it seems to come out of the experience of the author. That is to say whether we're talking about the surrealist experience or any inclination to expression—all of that is, dwells so to speak in the author. It seems to me that there's another route in which the artist looks for a content that is on the face of it abstract, but at a deeper level symbolic, and that that content is necessarily philosophical and religious. I think it's attempting to dig away at—without wanting to sound too pompous—at the great mystery of being. And that, while it has a route through my psychobiography, isn't based in it. . . .

Maybe it is my Indian roots that prompt me in that direction. Of course I see a connection thereby with the great art, the great minimal art of the sixties and seventies. The idea that the object in a sense has a language unto itself, and that its primary purpose in the world isn't interpretive; it is there as if sitting within its own world of meaning. As the so-to-speak next generation along, one wonders if that metaphoric language—or if one can turn that language into a metaphoric language—but not necessarily to do with how I see the world. . . .

It is saying that . . . a content arises out of certain seemingly formal considerations, considerations about form—about form, about material, about context—and that when that subject matter is sufficiently far away, something else occurs—maybe it's the role of the artist then, as I see it, to pursue, and that's something that one might call content. . . .

There's something imminent in the work but the circle is only completed by the viewer. Now that's a very different position from a work let us say with a subject matter, where the work itself, so to speak, has a complete circle of meaning and counterpoint. . . .

But here is an incomplete circle which says come and be involved. And without your involvement as a viewer there is no story. I believe that that's a complete kind of re-invention of the idea of art. . . .

But one doesn't make art for other people, even though I am very concerned with the viewer. It is in that abstract eye of the beholder that some circle . . . is completed. I in the end make art for myself. . . .

What one does in the studio in fact is to pose a series of problems to oneself. . . . And then . . . having made it I've got to look for some deeper meaning, for some reason for this thing to be in the world. . . .

Naming is one of those ways. Context is another of those ways. What happens, having made this object, if I put it next to another object? How does that change its reason for being in the world, its effect on the body? One of the phenomena that I've worked with over many years is darkness. Darkness is an idea that we all know about, in a way an idea about the absence of light. Very simple. What interests *me,* however, is the sense of the darkness that we carry within us, the darkness that's akin to one of the principal subjects of the sublime— terror. A work will only have that deep resonance that I try to indicate is there *if* the kind of darkness that I can generate, let's say in a block of stone with a cavity in it that's very dark, if the resonance that's in that stone is something that is resident in you already. That's to say that you are completing that circle, but perhaps without knowing that you're completing that

* Excerpts from "John Tusa Interview with the Sculptor Anish Kapoor," BBC Radio 3, broadcast 6 July 2003; transcript at http://www.bbc.co.uk/radio3/johntusainterview/kapoor_transcript.shtml. By permission of the interviewer, the artist, and the British Broadcasting Corporation.

Anish Kapoor, *Sky Mirror,* 2006, concave mirror of polished stainless steel, installed at Rockefeller Center, New York (presented by Tumi; organized by Public Art Fund and hosted by Tishman Speyer). Photo by Seong Kwon. Courtesy Public Art Fund, New York, and Gladstone Gallery, New York.

circle. It's not a verbal connection, but a bodily one. That's why sculpture occupies the same space as your body. . . .

It seems to me that, yes, the eye is a very very quick instrument, incredibly quick instrument—much quicker than the ear. The eye gets it immediately—seconds. And I'm interested I think in that moment of immediate recognition. An object lives in a space in a particular way, you walk into the space and then you say yes that's it, or that's not for me—whichever way it goes. . . . The theoretical stuff comes later, it's sort of irrelevant. I'm much more interested in the effect that the body has, or that the body receives if you like, from a work.

ODILI DONALD ODITA Third Color—Third Space (2008)

Color in itself has the possibility of mirroring the complexity of the world as much as it has the potential for being distinct.

The organization and patterning in the paintings are of my own design. In the paintings I continue to explore a metaphoric ability to address the human condition through pattern, structure and design, as well as for its possibility to trigger memory. The colors I use are personal: they reflect the collection of visions from my travels locally and globally. This is also one of the hardest aspects of my work as I try to derive the colors intuitively, hand-mixing and coordinating them along the way. In my process, I cannot make a color twice—it can only appear to be the same. This aspect is important to me as it highlights the specificity of differences that exist in the world of people and things.

What is most interesting to me is a fusion of cultures where things that seem faraway and disparate have the ability to function within an almost seamless flow. The fusion I seek is one that can represent a type of living within a world of difference. No matter the discord, I believe through art there is a way to weave the different parts into an existent whole, where metaphorically, the notion of a common humanity can be understood as real.

I want to expand upon painting to reinvestigate its inherent means, as well as contribute to its ongoing intellectual future. My commitment to painting has come with a growing understanding of quality and beauty that can be found through painting, and how beauty, when actualized, can communicate a complete consciousness.

Here is Now

At this time, I am still interested in how my paintings can look like the scrambled reception from a television set, a disconnect from recognizable imagery, and yet give one the sense of a familiarity located deep within one's own culture. In our overly mediated reality, I am all too aware of television and its doctored way of transmitting the information we consume on a minute-by-minute basis—a type of socio/cultural information that can successfully influence us in the ways that we think, act, see and feel within our environment. It is my intent to mimic this format through painting, but in my way the subversion I wish to conduct is a type of communication that speaks of Africa. It is evident that African culture is interwoven with western culture, and yet the continent continues to exist as a region denigrated in the mind of the entire world. I wish to re-channel the negative thinking around Africa, speak from the center of its present-ness, and expand upon what I know and understand about the history of this amazing and unquantifiable place.

* Odili Donald Odita, "Third Color—Third Space" (2008), artist statement on his website, http://www.odi lidonaldodita.com/statements/index.html. By permission of the author.

3 FIGURATION

Peter Selz and Kristine Stiles

Much of the writing on art following World War II equated modernism with abstraction and postulated an evolutionary progression that called for, in painting, ever greater reduction toward a flat surface of pure color relationships and, in sculpture, self-referentiality in terms of materials, size, surface, texture, and so on. But in art, as in literature, multiple strategies, methods, and approaches prevailed during this period, and in the work of a great many painters and sculptors the human image remained of central importance. The British sculptor Henry Moore expressed this position succinctly: "For me, sculpture remains based [on] and close to the human figure."[1] The American sculptor Leonard Baskin, using images from medieval and Renaissance prototypes, extolled the human form in almost prophetic language: "Our human frame, our gutted mansion, our enveloping sack of beef and ash is yet a glory. I hold the cracked mirror up to man."[2]

Belonging to an earlier, less disillusioned generation, the Cubist painter Fernand Léger (b. France, 1881–1955) was still, in 1945, imbued with faith in technology and hoped to establish a new, optimistic public art featuring the human body. Like Léger, Renato Guttuso (b. Italy, 1911–87) belonged to the Communist Party, which was less restrictive and more tolerant in Western Europe than in the Soviet Union, where strict adherence to Socialist Realism continued to be mandated.[3] Guttuso, a member of the Italian senate and a vociferous spokesman for the left, discussed the problem of Socialist Realism for progressive artists living in countries where a socialist reality did not exist.

Max Beckmann (b. Germany, 1884–1950), in contrast, was an individualist who never allied himself with any art movement and tried to remain apolitical. He was, nevertheless, deeply affected by the political turmoil of his time. His belief that artists may be able to deal with the inner life of men and women and the human condition by means of metaphor anticipated the concerns of the next generation.

Like Beckmann, the German-born philosopher and theologian Paul Tillich (1886–1965) fled the Nazis and went on to teach in the United States. Tillich's liberal theology dealt with the place of religion in an era characterized by skepticism and materialism. His lifelong interest in the visual arts and his existential awareness of anxiety, despair, and courage in the face of the unknown were very close to the stance of artists of the

time. He summarized his position in the preface to the catalogue for *New Images of Man,* an exhibition of new figuration at New York's Museum of Modern Art: "Like the more abstract artists of the period, these images take the human situation, indeed the human predicament, rather than the formal structure, as their starting point. Existence rather than essence is of greatest concern to them."[4]

The ceaseless search for a meaningful human image by Alberto Giacometti (b. Switzerland, 1901–66) paralleled the existentialist investigations of his close friend, the French philosopher and novelist Jean-Paul Sartre (1905–80). The existentialist "search for the absolute," together with awareness of the inevitable failure to attain it, had an indelible impact on both figurative and abstract artists of the era.

Coming from an essentially humanist tradition, André Malraux (b. France, 1901–76)—man of letters, novelist, archaeologist, adventurer, and eventual minister of cultural affairs for France—placed the work of Jean Fautrier (b. France, 1898–1964), especially his haunting series of abstract *Hostages* (1943–45), within a historical context of art expressing human suffering. Later, in 1951, Jean Dubuffet (b. France, 1901–85) pronounced his "anticultural positions" in a lecture given in Chicago, declaring his proximity to the forces of nature and to the irrational depths of the psyche and proclaiming the clairvoyant possibilities of painting. This lecture coincided with Dubuffet's completion of his *Corps de dames* (1950–51), a celebrated series of aggressive frontal nudes.

A member of the New York School (see chap. 1), Willem de Kooning (b. Netherlands, 1904–97) painted nonfigurative pictures for the greater part of his long career, but he came to feel that it would be absurd not to paint the figure. Picturing ferocious women with a loaded expressionist brush, he violently attacked traditional representations of the female figure. In London, at the same time, Francis Bacon (b. Ireland, 1909–92) painted violent crucifixions, screaming popes, entrapped male figures, and people in painful isolation and despair, all corresponding to the tragic personages in Samuel Beckett's plays. Between 1962 and 1979 Bacon gave seven interviews to the British art critic David Sylvester, which "may well have had as great an influence on painting during the last quarter of the present century as the critical writing of Ezra Pound and T. S. Eliot had on poetry of the 1920s and 1930s."[5]

In northern Europe, several rebellious and exuberant young artists with shared revolutionary attitudes organized the short-lived group CoBrA (1948–51), named for the three capital cities of their countries (Copenhagen, Brussels, and Amsterdam). The acronym was deliberately intended to evoke the aggressive, lethal snake. Opposed to the geometric abstraction that dominated contemporary museum exhibitions and gallery spaces, these artists created work rooted in Expressionism, Surrealism, ethnic and children's art, indigenous folk art, and the art of the insane. They believed in an art of the people and in collective action based on Marxist dialectics. Passionately devoted to freedom, they used spontaneous brushwork to create abstract images that nonetheless retained contact with mimetic sources. Over the years CoBrA's exhibitions and publications had a powerful resonance in Europe and beyond, and CoBrA artists Asger Jorn and Constant Nieuwenhuys eventually cofounded the Situationist International with Guy Debord and others (see chap. 8).

In 1948 CoBrA cofounder Constant Nieuwenhuys (b. Netherlands, 1920–2005) published his "Manifesto" in the journal *Reflex* (1948–49), a precursor to the influential

Cobra magazine (1949–51). Karel Appel (b. Netherlands, 1921–2006), another CoBrA cofounder, expressed a more impulsive approach to painting and overt political conviction, especially vivid in his painting *The Condemned* (1953), engendered by the execution of Ethel and Julius Rosenberg in New York in 1953. Willem Sandberg (b. Netherlands, 1897–1984), who directed Amsterdam's Stedelijk Museum from 1945 to 1962 and transformed it into one of the most innovative modern museums in postwar Europe, indicated in a poetic statement a change of direction from the formal nonobjective balance of Piet Mondrian to the urgent vitality of the CoBrA artists, relating this to the later political events of 1968.

In West Germany after the war, figurative painting was associated primarily with Nazi art or with the Socialist Realist art then being propagated in East Germany, the USSR, and throughout the Eastern Bloc, as well as in China. Most of the work being done in the Federal Republic was abstract, *informel,* or *tachiste,* parallel to the predominant art forms of France and the United States. But younger German artists, from both West and East Germany, were also reviving earlier traditions, such as German Expressionism, and uniting the figure and gestural abstraction. Among them, Georg Baselitz (Hans-Georg Kern; b. Germany, 1938) occupied a position of preeminence. Baselitz arrived in West Berlin from East Germany in 1957 and four years later published the "Pandemonic Manifesto," in which he attacked the dominant Western mode of abstraction in provocative, aggressive language with an appropriate staccato rhythm. He later began to paint figures upside down, stimulating viewer astonishment and challenging conventional ways of viewing figuration to illustrate its abstract elements of form, color, texture, and so on.

Using a totally different approach to the human figure, Michelangelo Pistoletto (b. Italy, 1933) made trompe l'oeil configurations by attaching drawn and photographed images to polished metal surfaces that reflected the viewer, thereby fusing art and reflected life. Earlier, the Italian Futurists had wanted to put the viewer into the center of the picture, an aim in which Pistoletto succeeded. His flat Plexiglas mirrors become environments in which the viewer provides the third dimension. Pistoletto also did street performances, created installations, and made "minus objects"—unique objects that, having been made, negate any reason to make them again: hence one less object (minus) in the world.

Although British painters have been described as notoriously individualistic, in 1976 R. B. Kitaj (Ronald Brooks; 1932–2007), an American expatriate and long-time London resident, postulated the notion of a "School of London," characterized by a renewed interest in the human figure and comprising Francis Bacon and a number of younger painters: Lucian Freud, Frank Auerbach, Leon Kossoff, Michael Andrews, David Hockney, and Kitaj himself. Kitaj had been a merchant seaman in his youth and studied art in his native Cleveland, as well as in New York, Vienna, and Oxford. His disjunctive and complex paintings evince his formidable knowledge of the histories of art, literature, and politics and of Jewish lore. Although he wanted to communicate an "art which is both good and more widely social" to a broad public, Kitaj was aware of the dilemma that "reducing complexity is a ruse."

David Hockney (b. U.K., 1937), a consummate draftsman, photographer, and designer of opera sets and costumes, as well as a painter, found his muse in Southern California, depicting the sunshine and swimming pools of Hollywood, its delights and deceptions,

and circles of gay intellectuals and artists. In 1964 he engaged in an informative conversation with Larry Rivers (b. U.S., 1923–2002)—one of the first New York painters of his generation to turn to the human figure and to attend to the vernacular as a source for irreverent, witty, and painterly works. The two artists debated the importance of communicating beauty as opposed to arousing interest through art.

Lucian Freud (1922–2011), the grandson of Sigmund Freud, was born in Berlin and immigrated with his immediate family to London in 1933. Freud's portraits and startling naked figures exemplify his search for truth in representation and the intensification of experience rather than the production of idealized nudes, as in painting in the European tradition of Jean-Auguste-Dominique Ingres and Frans Hals. The result of Freud's uncompromising approach to painting is a figuration of a brutal, raw force and gripping psychological insight into the personality of the figure.

Romare Bearden (1911–88), born in North Carolina but raised in New York's Harlem district, was one of the first African American artists to be recognized as part of the American avant-garde. The subjects of his colorful collages largely draw on his early recollections and the rituals of black urban and rural life. In a 1968 interview with Henri Ghent, Bearden spoke about the place of the black artist and black community in American art history, as well as his unique methods of working.

Alice Neel (b. U.S., 1900–1984), closer in age to Giacometti and de Kooning, has been described as an "expressionist realist." Her corrosive portraits, which demonstrate her decisive insight into human character, became a model for younger artists turning to figuration. In the early 1960s, when painting the figure became more widely accepted, Philip Pearlstein (b. U.S., 1924), Alfred Leslie, and many others turned toward various modes of realism. Pearlstein's representations of nudes and studio models, set in compressed spaces, give the sense of an utterly detached, unemotional remove and neutrality on the part of both the painter and the sitter. Pearlstein rejected the Greenbergian notion of the "flat picture plane" and the "roving point-of-view" and proposed an essentially academic fidelity to visual appearance, causing the art historian Linda Nochlin to describe him as the *chef d'école* of a newly dawning realism.[6]

Indeed, on seeing an early daguerreotype, Paul Delaroche, the nineteenth-century French painter of historical subjects and portraits, is reputed to have exclaimed, "From today, painting is dead!" Ever since its emergence, photography has had an ambivalent relationship with painting: the camera's easy attainment of likenesses has threatened or even at times appeared to usurp the genre of portraiture. Rather than compete with photography, however, the "Photorealist" painters adapted painting to the photograph.

Chuck Close (b. U.S., 1940), trained in the Abstract Expressionist style, turned to figuration in the mid-1960s and eventually felt that the ready-made imagery of photography could provide models for his work as a painter. His "main objective," he explained, was "to translate photographic information into paint information." By this, Close meant that he wanted to explore the intersection between the technological eye—the vision of the camera—and the human eye. In his paintings of gigantic, hieratic portrait heads, carefully constructed on a grid system, Close confronts the viewer with a paradox: the camera-perfect likeness depends on a mosaic of painted marks that in themselves are abstract.

Richard Estes (b. U.S., 1932) has been identified as the paradigmatic Photorealist for his talent in conveying realistic, objective visual information that appears to eschew subjective interpretation. In his paintings, as in the novels of the French writer and filmmaker Alain Robbe-Grillet, the phenomenological significance of the object is stressed above human psychology—a technique, ironically, used in psychoanalysis to arrive at subjective meaning. Estes's urban landscapes may derive from photographs, but in their finished, painted form they demonstrate a geometric balance and spatial complexity. Many of his unpopulated cityscapes, with their multiple mirrored surfaces, deal with the visual and psychological information overload of contemporary society.

Photographically accurate reflections in eyeglasses frequently heighten the complexity of the figurative portraits of Barkley L. Hendricks (b. U.S., 1945). This device draws space and light from the outside world into the painting even as the painted subject returns the observer's gaze. Hendricks started working with a camera in 1966, later studying with the documentary photographer Walker Evans at Yale University, where he earned his BFA and MFA. In his paintings Hendricks began focusing primarily on the realistic representation of African Americans, conveying his subjects' independence, humor, eroticism, individualism, and strength of character through clothing, stance, and expression. For example, in his life-size *Brilliantly Endowed (Self-Portrait)* (1977), Hendricks presents himself wearing only a jaunty white leather newsboy cap, glasses, jewelry, socks, and running shoes. He chews a toothpick while gazing defiantly and with cool suspicion, his right thumb touching his penis as if to articulate and question the "hypersexualized black body that continues to be codified and consumed around the globe."[7] Also a portrait painter, Kehinde Wiley, born in Los Angeles in 1977, has addressed similar themes in monumental pictures of contemporary African American subjects set against backgrounds of art historical motifs from various historical periods. For her part Elizabeth Peyton has painted portraits of white art-world and avant-garde celebrities such as Matthew Barney (see chap. 8).

A kind of photographic realism also distinguishes the paintings of Mark Tansey (b. U.S., 1949). The son of Richard G. Tansey, the editor of *Gardner's Art Through the Ages,* and Luraine Tansey, the slide librarian who created the first Universal Slide Classification System in 1969, the artist grew up imbued with art historical imagery. In the later 1970s he began painting monochromatic works with paradoxical and enigmatic imagery, commenting on and analyzing historical, theoretical, and everyday subject matter to challenge philosophical and aesthetic concepts. Placing modernist certainty in opposition to postmodernist relativism, Tansey attended to the conceptual conditions and questions of representation in tandem with contemporary discourses on the nature and conditions of painting. Playfully drawing on Surrealist techniques of chance, Tansey invented his own version of a "color wheel" with rows of terms that, when spun, gave him subjects for new work. He also used the Belgian Surrealist painter René Magritte's eight categories for putting objects in conceptual "crisis" within an image: isolation, modification, hybridization, scale change, accidental encounters, double-image puns, paradox, and double viewpoints. In *Action Painting II* (1984), a group of artists work at their easels *en plein air,* under an American flag, painting the action of a rocket taking off in the background. Tansey thus commented elliptically on how Abstract Expres-

sionism was used to promote democracy by the U.S. government bent on the arms race and on creating technology for mutually assured destruction (or MAD).

Using figuration to make a political point, Leon Golub (b. U.S., 1922–2004) achieved acclaim in the early 1980s for his big, unstretched canvases of mercenaries and interrogators. In the immediate postwar period Golub had belonged to a group of young Chicago artists who shared a deep concern with creating an existential human image of thwarted but inexorable endurance. During the 1960s he had also been one of the few painters in the United States to take American aggression in Vietnam as his subject. In a 1981 interview Golub, a highly verbal and articulate artist, discussed the meaning of the violence and coercion, torture and domination, and, above all, uses of power he pictured in his works.

Also consistently committed to the human figure, Nancy Spero (b. U.S., 1926–2009), like her husband, Golub, belonged to the iconoclastic avant-garde Momentum group in Chicago before moving to New York. By the late 1950s Spero was incorporating texts into her drawings, which assumed unusual antihierarchical, horizontal formats (her *Codex Artaud* is 20 inches high by 25 feet wide). Spero frequently addressed feminist issues in series, as in the *Torture of Women* and *Notes in Time on Women,* or political issues in series like *Torture in Chile* and *To the Revolution.* Many of her works contain ferocious images of overt sexuality in which women are not just victims but also protagonists.

Arnulf Rainer (b. Austria, 1929) employed a very different strategy of distortion. Like Dubuffet, he was fascinated with the art of psychotics. He also shared an interest in the irrational with the Viennese post-Surrealist painters and was associated with the Viennese Actionists (chap. 8). In his *Face Farces* of the later 1960s and 1970s, Rainer used photographs to capture his own grimaces, gestures, and exaggerated mimicry, and then overpainted them to create graphic images that combined body art and painting. His works are descendants of the grotesque and wild physiognomic distortions by the eccentric Viennese sculptor Franz Xaver Messerschmidt, whose sculptures Rainer studied.

The figures in the sculpture of Magdalena Abakanowicz (b. Poland, 1930) are usually headless or faceless. With her early "abakans," Abakanowicz helped to transform the ancient two-dimensional craft of weaving into the contemporary three-dimensional medium of fiber art. By 1980, when she represented Poland at the Venice Biennale, she was recognized as a major contemporary sculptor. Her works in fiber, and later in bronze, often consist of large groups of human figures that appear to be anonymous, androgynous, universal, and mysterious.

In 1982 the Italian art critic Achille Bonito Oliva gave the name *transavanguardia* to a group of Italian Neo-Expressionist artists interested in postmodern eclecticism, disjunctiveness, and nostalgic appropriation of past themes and styles. Among them were Sandro Chia, Enzo Cucchi, Mimmo Paladino, and Francesco Clemente. Whereas most of the Italian artists associated with Arte Povera in the late 1960s had broken with painting, the *transavanguardia* returned to the picture plane. Clemente (b. 1952), an artist of great versatility, has worked in acrylic, pastel, watercolor, tempera, woodcut, etching, and photography. His highly inventive works, which he has called "unknown ideograms," resemble arcane allegories alluding to myth, dream, fantasy, and identity, particularly as many of these works are self-portraits.

In the United States, Susan Rothenberg (b. 1945) began her career making abstract paintings, before turning to equine imagery in expressionistically painted figurative abstractions. Her horses appear to emerge like phantoms from the gesso ground of her gestural works. Eventually, she introduced parts of the human body into her paintings, which are characterized by a rigorous formal structure and the ambiguity of their message. Rothenberg came to be associated with the "new image" painters, a term popularized by a 1978 show of figurative work at the Whitney Museum of American Art.

The boisterous, heroically scaled paintings of Julian Schnabel (b. U.S., 1951) gained instant notoriety in the late 1970s, when he peppered his pictures with discontinuous fragments of images, attached such objects as broken crockery and antlers to his surfaces, and sometimes painted on velvet or oriental rugs. By 1980 the thirty-one-year-old Texan was given a solo exhibition at the Stedelijk Museum in Amsterdam, followed by major shows in Paris, London, and New York. His paintings were hailed for their "return to emotion, imagination and meaning" by some critics and disparaged as "big macho art" by others. In a 1983 statement Schnabel reflected on the viewer's relationship with the object, insisting that "there is altogether too much mediating going on" and that "the economic support structure and the artist's dependence on it are constructed and inherited and not amenable to simplistic adjustment." Schnabel has become an award-winning filmmaker while continuing to paint compelling works in the Abstract Expressionist tradition.

Using the tag "SAMO©," short for "same ol' shit," Jean-Michel Basquiat (b. U.S., 1960–88) and his school friend Al Diaz began writing enigmatic phrases as graffiti throughout lower Manhattan in 1977. The next year, Basquiat dropped out of high school, but in 1980 his paintings gained broad attention when they appeared in *The Times Square Show,* organized by Collaborative Projects (Colab), a group of experimental artists working in performance, installation, video, and graffiti art. By 1983 Basquiat's work was included in the Whitney Biennial, and he had become friends with Andy Warhol. He soon began to travel and exhibit internationally. Basquiat's paintings, covered in graffiti-like writing, poetry, and personal iconography (such as the crown), draw upon Haitian, Puerto Rican, and African American heritage, his interest in jazz, and the exploitation of African American athletes in U.S. culture, among other things. They present raw visual truths evoking the psychic pain of racism, often represented by depictions of the black body as a skeleton, testifying to the young artist's sense of emotional annihilation. Basquiat overdosed on heroin at the age of twenty-seven.

Almost a decade before Basquiat introduced graffiti into figurative painting, Philip Guston (1913–80), who was born in Canada but grew up in Los Angeles, shocked the art world by painting cartoonlike figures. Although Guston started out in the 1930s as a realist-expressionist painter, he turned to Abstract Expressionism in the 1950s and became known for his luminous, sensuous paintings. Explaining his subsequent return to figuration, he said: "When the 1960s came along, I was feeling split, schizophrenic. The war, what was happening in America, the brutality of the world. What kind of man I am, sitting at home, reading magazines, going into a frustrated fury about everything—and then going to my studio *to adjust a red to a blue.* I thought there must be some way I could do something about it."[8] Guston eventually found his way to a new subjective iconography infused with both anxiety and ferocity, painting a world peopled

with comic-book-like figures, often smoking and wearing Ku Klux Klan hoods, a world of living and dying in odd landscapes with strange fields of symbols.

Eric Fischl (b. U.S., 1948) has used figuration to show "the rift between what was experienced and what could not be said," growing up in Long Island, "against a back-drop of alcoholism and a country club culture obsessed with image over content."[9] His revelatory encounter with the sexual vulgarity depicted by painters associated with the Chicago group the Hairy Who eventually encouraged Fischl to picture the sordid aspects and ethical contradictions of middle-class American culture. Fischl was also indebted to Max Beckmann in creating his bold portrayals of the sexual habits and taboos, as well as crisis of values, in suburban life. In the 1990s and 2000s, Fischl began painting haunting images from his travels in India, Italy, and elsewhere, as well as pictures of the bloated middle-aged frolicking on boats and beaches and in scenes of erotic enticement and fornication.

Jörg Immendorff (b. Germany, 1945–2007) also focused on contemporary society in his paintings, but rather than explore the values of suburban life, he questioned the politics of a divided Germany. In his most famous series, *Café Deutschland,* begun in 1978, he addressed the postwar German political situation and corruption on both sides of the former Berlin Wall. His frenetic compositions relate to the German Expressionist tradition and to Neo-Expressionist art strategies. Like Bertolt Brecht's epic theater, with its *Verfremdungseffekt,* or distancing effect of estrangement and alienation, both Immendorff's and Fischl's paintings create a shock of recognition in the spectator without suggesting propagandistic solutions.

Perhaps the most directly political works of art created in the United States were the community murals that arose in the 1960s, originally in African American neighborhoods in Chicago and Spanish-speaking communities in Los Angeles, San Francisco, and San Diego. Telling the stories of the ethnic minorities that created them, the murals dealt with social and cultural issues and reached mass audiences within historically oppressed segments of American society. John Pitman Weber (b. U.S., 1942), who cofounded the Chicago Mural Group (later the Chicago Public Art Group) in 1970, coauthored the first book to describe in detail the history and actions of the community-based mural movement.[10] Judy Baca founded the first mural program in Los Angeles in 1974. Two years later, she founded the Social and Public Art Resource Center (SPARC), a community arts center in Venice, California, that was instrumental in the creation of the *Great Wall of Los Angeles.* Designed by Baca and one of the largest murals in the world, the *Great Wall* portrays the history of California from prehistory to the present. In 1988 Tom Bradley, then mayor of Los Angeles, commissioned Baca to create the Neighborhood Pride Program, a project that employed disadvantaged youth in the creation of more than eighty murals throughout the city.

The influence of the country's puritan heritage and new right-wing political activism led to disturbing infringements on free artistic expression in the United States in the late 1980s and 1990s. Andres Serrano (b. U.S., 1950), a Cuban American Catholic, was one of ten artists to win an Award in the Visual Arts from the Southeastern Center for Contemporary Art in 1988, a prize partly sponsored by the National Endowment for the Arts (NEA). The resulting traveling exhibition of his work included the photograph *Piss Christ* (1987), which showed a plastic crucifix immersed in a golden fluid identified

as Serrano's urine. This image launched a national controversy when fundamentalist Christians objected to the work as blasphemous and criticized the NEA for spending tax dollars to support such art. Serrano defended his work in statements about his own Catholic heritage. He then went on to produce exquisite Cibachrome series of equally controversial subjects, from Ku Klux Klan members wearing Kelly green hoods to corpses in the morgue.

The controversy over government funding for the arts did not end with Serrano. In 1989 the Corcoran Gallery of Art in Washington, D.C., canceled a posthumous retrospective of the work of the photographer Robert Mapplethorpe (b. U.S., 1946–89), fearing public controversy and economic reprisals from the NEA. In addition to photographs of flowers, self-portraits, and portraits of celebrities, the Mapplethorpe retrospective included controversial images of interracial coupling, male frontal nudity, children in explicit poses, and sadomasochistic homoerotic images. Also in 1989 Senator Jesse Helms, a North Carolina Republican, introduced legislation that would have prohibited federal funds from supporting materials deemed "obscene or indecent." That same year President George H. W. Bush's Flag Protection Act proposed to make desecration of the American flag a federal crime in response to an installation by "Dread" Scott Tyler at the School of the Art Institute of Chicago. Helms's bill did not pass, and the Supreme Court overruled Bush's proposed amendment, but sentiments against the rights of free speech provided by the First Amendment continued to cause many instances of restrictive legislation, as well as self-censorship by artists that interfered with their willingness to depict the human body.

As these events were taking place in Washington, D.C., the painter and performance artist Sherman Fleming (b. U.S., 1953) wrote about racism in the U.S. capital. Fleming, who had desegregated every school and college he had attended, painted rebuses— puzzles combining figures, symbols, and words—that presented the emotional impact of the inflammatory racial slur "nigger." "It's hard to maintain stability; it's hard to maintain tradition; it's very hard to live," he explained. "So when I do pieces, I am concerned with history, a part of history that is always left out."[11] In his performances, Fleming has evinced the need generations of African Americans have felt to appear "impeccable at all times" and its exhausting effect. Yet his phallic RodForce persona of the mid-1970s also built upon the model established by the singer James Brown, anticipating subversive new forms of self-representation by African American artists.

The issue of racial prejudice has also informed the work of two white South African artists who grew up under the apartheid system: Marlene Dumas (b. 1953) and William Kentridge (b. 1955). Dumas left South Africa for the Netherlands at the age of twenty-three after studying at the University of Cape Town (1972–75). Life and death, race, and sex are the prevailing themes of her art, often presented in sexually graphic images that combine eroticism with the annihilation of the subject, the latter mirroring the dehumanization implicit in racism. Dumas's poetic writing is as gripping as the pathos of her painted images, which range from ghostly figures to a white child with paint-stained hands (one black and one red), signifying the blood-stained hand of racism, to depictions of madness and sexual abuse. Throughout, Dumas probes moral and ethical issues and questions of truth.

Kentridge's partly autobiographical drawings and animations comment on power

relations in South Africa, from the control of politics, industry, and resources to segregation and racial injustice. For his films, Kentridge draws charcoal images consecutively on the same sheet of paper, photographing each drawing before erasing it. Subsequent images bear traces of the erasures, creating a pentimento effect that metaphorically points to the hidden histories of racism—a technique the artist relates to "erosion, growth, [and] dilapidation that . . . seeks to blot out events." Kentridge, who studied mime and theater as well as politics, African studies, and fine arts, cofounded the Junction Avenue Theatre Company, a racially integrated company dedicated to the theater of resistance, in 1975 and the film cooperative Free Filmmakers in 1988, both in Johannesburg. In 1997 he collaborated with Jane Taylor on the play *Ubu and the Truth Commission,* using Alfred Jarry's farce *Ubu Roi,* in which the crude Ubu character represents "a policeman for whom torture, murder, sex and food are all variations of a single gross appetite."[12] The play, which toured internationally, included testimony from the South African Truth and Reconciliation Commission's hearings and combined performance by live actors, puppetry, music, animation, and documentary footage.

The paintings of Luc Tuymans (b. Belgium, 1958) obliquely refer to colonialism (especially in the Belgian Congo), fascism and the Holocaust, and sexual abuse, as well as other inexplicable and disturbing experiences. Drawing on photographic and filmic techniques—he worked for three years as a filmmaker, studied art and art history, and then returned to painting—Tuymans has employed cropping, framing, sequencing, and close-ups to achieve hauntingly intense images of figures set in indistinguishable environments. His muted colors and foggy, unclear lines reinforce the unsettling effect of the vague content of his images.

Whereas Tuymans's "awareness of art history has led him to suggest the impossibility of originality,"[13] Shahzia Sikander (b. Pakistan, 1969) has created a new style by studying and rethinking miniature painting, a historical genre especially associated with the Middle East, India, and medieval Europe. Sikander earned a BFA from the National College of Arts in Lahore in 1992 and an MFA from the Rhode Island School of Design in 1995. She painstakingly renders figures, fauna and flora, architecture, and lush patterns and borders, using both conventional perspectival space and the ancient form of stacked perspective. Presenting contemporary imagery in what some consider an anachronistic, stylized genre of painting, Sikander comments on both contemporary history and methods of representation.

In stark contrast to Sikander's small-format, highly detailed approach, Jenny Saville (b. U.K., 1970) has created monumental depictions of distorted and overweight women, painted in broad brushstrokes with sweeping gestures. Saville's figures, which sometimes appear like flayed animal carcasses, have been compared to Francis Bacon's and Lucian Freud's grotesque representations, as well as to the voluptuous flesh visualized by Peter Paul Rubens. Interested in the alteration of the human form, Saville has pictured transgender bodies as well as ones changed by cosmetic surgery, deformity, and disease.

A 1993 self-portrait by Catherine Opie (b. U.S., 1961) shows the artist with an armband tattooed on her right bicep and a childlike drawing cut into and bleeding on her back: two stick figures in skirts holding hands in front of a house with a storm cloud overhead. A social documentary photographer, not unlike Nan Goldin, Opie has specialized in depicting those marginalized by their sexuality and their related gender

politics. Opie's work includes portraits of her friends in the Los Angeles S/M performance community, life-size Polaroid tributes to the gay, HIV-positive performance artist Ron Athey, and ordinary scenes of lesbian couples at home across the United States. In other series, Opie has photographed football players, surfers, freeways, malls, homes, and Wall Street, visualizing the social and built environments that contribute to the formation of identity.

Wangechi Mutu (b. Kenya, 1972) has also been concerned with the construction and reception of identity, using painting and collage techniques to produce elegant but distorted images of the black female body: mottled, scaly, full of lesions, and covered in feathers and ribbons, with grotesque yet alluring erotic and exotic features such as heads that stretch into octopus tentacles. Her figures are sexualized and racialized sites of colonial violence and voyeurism, presented in a context of postcolonial hybridity and with a feminist critique of gender, race, and class. Mutu's writing displays similar disjunctive traits, as she approaches narrative as she does her collages, installations, and performances: with dissociative descriptions of traumatic situations and incidents. Although educated in the United States, with a BFA from Cooper Union and an MFA from Yale University, her art remains grounded in the African Diasporic experience.

Distortion also characterizes the "Superflat" paintings, sculptures, films, and commercial objects produced by Takashi Murakami (b. Japan, 1962), who inspired a generation of artists in the 1990s and 2000s. Fascinated with *otaku* culture (Japanese *anime* [animation], *manga* [comic books], and video games), Murakami abandoned his intensive study of Nihonga (a style of Japanese painting dating from the late-nineteenth-century Meiji period) and turned to popular cultural forms. His work is especially associated with Japanese "cute" culture (figures like Hello Kitty) and cartoon figures derived from Poku culture (a term derived from "Pop" and "*otaku*"). Critiquing the dominance of Western cultural trends, and evoking the consequences of the atomic bomb with the nomenclature "Superflat," Murakami has declared that Japan "may be the future of the world. . . . From social mores to art and culture, everything is super two-dimensional."

From the perspective of M. F. Husain (Maqbool Fida Hussain, b. India, 1915–2011), the Muslim figurative and abstract painter and filmmaker known as the "Picasso of India," the world is anything but flat. In 2006 Husain began work on three major projects: the "history of Indian civilization from Mohenjedaro to Manmohan Singh," the "history of other civilizations dating back to Babylon," and "100 years of Indian cinema." After a career of over seventy years, which included fleeing to Qatar when his nude, erotic depictions of Hindu gods and goddesses were violently rejected by radical Hindu fundamentalist groups as blasphemous and his life threatened, Husain accepted Qatar citizenship in 2010, at the age of ninety-five, stating: "The dream is to go on as long as you are alive. . . . Whether my paintings are done in New York [or] Qatar, only the title has changed, nothing else. In my small way, I have told my own story, which I hope will remain [in] the hearts of millions of my countrymen."[14]

FERNAND LÉGER The Human Body Considered as an Object (1945)

One of the most damaging charges that can be made against contemporary modern artists is that their work is accepted only by a few initiates. The masses cannot understand them.

There are several reasons for this situation. The minority of privileged individuals who can be interested in these works is made up exclusively of people who have the leisure to see and look, to develop their sensibilities. They have free time at their disposal.

In 1936 and 1937, I had an opportunity to talk about these issues in working-class and community centers. "You work for the rich," they shouted bluntly at me. "We're not interested in you."

Their objection was wrong because it was too simplistic. The matter is a little more complicated.

The situation is created by the existing social order. Factory workers and clerks have very limited leisure time. They cannot be asked to spend their Sundays shut up in museums. Private galleries and museums close their doors at the very time when the workers leave their shops, their factories.

Everything is organized to keep them away from these sanctuaries. Time must be made available so that this majority of individuals can be interested in modern works. As soon as they have time, you will be able to watch the rapid development of their sensibilities.

The people have a poetic sense in themselves. They are the men who invent that ceaselessly renewed verbal poetry—slang. These men are endowed with a constantly creative imagination. "They transpose reality." What then do modern poets, artists, and painters do? They do the same thing. Our pictures are our slang; we transpose objects, forms, and colors. Then why don't we meet each other?

On the other hand, if you examine the backgrounds of creative artists, you will see that all or nearly all of them come out of a working-class or lower-middle-class background. So what? Between these two poles, however, there is a society that does absolutely nothing to bring about this meeting. . . .

The masses are rich in unsatisfied desires. They have a capacity for admiration and enthusiasm that can be sustained and developed in the direction of modern painting. Give them time to see, to look, to stroll around. It is inexcusable that after five years of war, the hardest war of all, men who have been heroic actors in this sad epic should not have their rightful turn in the sanctuaries. The coming peace must open wide for them doors that have remained closed until now. The ascent of the masses to beautiful works of art, to Beauty, will be the sign of a new time.

Of the various plastic tendencies that have developed during the past twenty-five years abstract art is the most important, the most interesting. It is not at all an experimental curiosity; it is an art with an intrinsic worth, one that has come to fruition and that responds to a demand, because a certain number of collectors are enthusiastic about this art. This proves that the abstract tendency is part of life.

I believe nevertheless that it has contributed all that it can contribute.

Creatively speaking, it seems to me to be at a standstill.

Its vitality was proved by its utilization in commerce and industry. For almost ten years

* Fernand Léger, excerpts from "The Human Body Considered as an Object" (1945), trans. Alexandra Anderson, in *Functions in Painting* (New York: Viking, 1973), 132–36. Originally published in French as *Fonctions de la peinture*. Copyright © 1965 Editions Gonthier. Reprinted by permission of Georges Borchardt, Inc., for Les Editions Denoël.

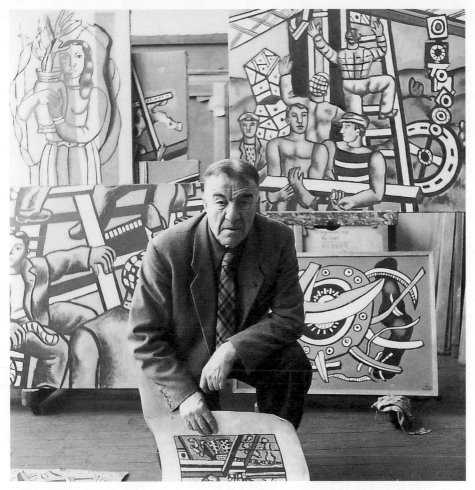

Fernand Léger in his studio, 1952. Photo by Willy Maywald, courtesy Association Willy Maywald, Maisons-Laffitte. © 2012 Artists Rights Society (ARS), New York/ADAGP, Paris.

we have seen issuing from factories linoleum printed with colored rectangles crudely imitating the most radical contributions made by those works. It is a mass adaptation; the cycle is complete.

Perhaps the future will rank this art among the "artificial paradises," but I doubt it. This tendency is dominated by the desire for perfection and total freedom that makes saints, heroes, and madmen. It is an extreme state where only a few creators and their admirers are able to hold their own. The danger of this formula lies in its very loftiness. Models, contrasts, objects have disappeared. What remains are very pure, very precise relationships, some colors, some lines, some empty spaces without depth. Respect for the narrow, rigid, sharp vertical place. It is a heroic attitude that flourishes in a cold greenhouse. It is true purism, incorruptible: Robespierre draped the goddess of Reason in it. It is indisputably a religion: it has its own saints, disciples, and heretics.

Modern life, tumultuous and full of speed, dynamic and full of contrasts, comes to batter furiously at this delicate and luminous edifice, which emerges coolly from chaos. Do not touch it: it is done; it had to be done, it will remain.

If its creative development seems to me at an end, this is not the case with its pictorial possibilities in architecture. Mural art, which was fully developed in the Middle Ages and during the Renaissance, has undergone a decline. Easel painting dominates the nineteenth and twentieth centuries.

It appears from certain social and artistic indicators that a renaissance of mural art is on the horizon. Monumental art can and must utilize this new conception, and expand it.

The young architects who are going to rebuild shattered Europe will have to look at things in this way. This art must be placed in the great structures. It is static through its very expression. It respects the wall, in contrast to a dynamic conception that itself destroys the wall.

It will be the measure of balance.

RENATO GUTTUSO On Realism, the Present, and Other Things (1957)

None of us has ever accepted, never wanted to propose the formula of "Socialist Realism," not even with the usual "differentiation" ["distinguo"]. Above all, because this formula identified itself in practice, not with an ideology (which has always been an influence in both a positive and negative sense . . .), but with a particular mode of painting that ignored the cultural inspirations of the present, [it is a formula] that in practice completely refuted the development of modern art from Goya to our time, following neither the truth nor the imitation of nature. Rather, it followed the terms of language, the conventions of bourgeois Verism, and went on developing itself at the level of the most superficial needs of the less evolved strata of the bourgeoisie (be it lower, middle or upper), while identifying itself with the most manneristic and commonplace sentiments, mentality, customs and argumentation of these class strata.

This pictorial style [maniera] (and I don't mean tendency or ideology) was the one presented to us in the examples of official Soviet painting. Exceptions to this type of work were rare and not of particular significance.

Taking that technical style [manierismo] as a starting point, a type of language of laureates was developed (outside of which even Raphael or Rembrandt would have been classified as amateurs); every discussion about theory was nullified. On the other hand, it was possible to find the motives for a critical elaboration [of Realism] in the critical literature (Lukács), in the critical texts of nineteenth century Realism (Chernyshevsky, etc.) or in the classical marxist literature (specifically in Engels, Lenin, Gramsci, Mao). Therefore, these texts served as contributions, indirect illuminations in the direction of a general theory of Realism.

Every discussion of "Socialist Realism" in the Soviet Union revolved around the issue of content, pure and simple (given that the technical level and the modes of expression were fixed according to the rules of a definitive academic canon); but the discussion did not revolve, and let's be careful about that, around a "definitive content."

The idea that the deciding factor in a work of art is its "definitive content" ["in definitiva il suo contenuto"] is not new for anyone (not for me either!). It is also true that such content cannot exist, and therefore cannot effect or determine anything, if it is not expressed in an authentic way.

Even today, the echo that comes to us from the Soviet Union regarding the discussions

* Renato Guttuso, "Del realismo del presente e altro," in *Paragone* 85 (Florence, 1957): 63–74. Translation by Nan Hill and Marco Lobascio. By permission of Archivi Guttuso.

about art and Socialist Realism is taking place, it seems to me, on the wrong ground, both for and against Socialist Realism. What would be more useful would be to carry out an in depth critical examination of artistic issues, of the origins of modern realism in the world. In other words, to give cultural nourishment to the need for an art of realism, which is alive and relevant in a socialist country. For reasons of tradition, history and the present, this is more urgent in the Soviet Union than any other place.

Furthermore, one could not before and cannot today speak reasonably about a *Socialist Realism* in a country such as ours where a socialist reality does not exist. (In such a context one can only talk about a social reality, even if advanced, and a socialist movement, even if advanced, directed toward realizing Socialism.) It is therefore difficult to speak about a realistic socialist art, if one is not in a socialist society that has reached that degree of flowering *[fioritura],* of expansive productive force, that generates a more elevated way of life, which is free from the restrictions connected with the "stage of necessity" *["fase della necessità"]*—a society in which everyone is capable of expressing individually a higher level of evolution.

The latter implied for us a freedom of inquiry and inspiration (and for the ones that did not have it, that was their problem)—motivating us to search for a reality as seen by socialists. This freedom meant (and means today) the ability to express sociality *[socialità]* from the inside of each issue that appeared before us—in other words, to see and express contemporary reality from the most modern point of view.

This is the condition of the *engagé* artist. There is no other way for him to feel, to study, to imagine, to be affected than by seeing/finding himself permanently merged with life and engaged in the task of grasping the movement/vitality [before him] that is simultaneously historical and atemporal, like everything that profoundly involves the human heart.

Engels said that Aeschylus illustrated social struggles by means of discussing moral conflicts. This process is the result of a correct, objective analysis of an ever-changing reality . . . and, as is its intention, creates a sense of awareness about that reality.

When the realist painters involved themselves in the treatment of particular themes, they chose the easiest and also the most "primary" way of [presenting them]. . . . We ourselves have consciously made use of these [themes] as expressive vehicles and we hold this to be a legitimate practice. This limited approach to painting was due, in the case of some artists, to a type of infantilism; for others, it was a form of polemical boasting, and for still others, it was a kind of spiritual catharsis; it was a desire to become barbarians, without, however, fully succeeding at it.

But even though this said barbarianism was not aided by any form of archeology or prehistory, it is to be seen as a form of avant-gardism." This "plague of our century" *[il "male del secolo"]* came about without our being able to do anything about it.

MAX BECKMANN Letters to a Woman Painter (1948)

The important thing is first of all to have a real love for the visible world that lies outside ourselves as well as to know the deep secret of what goes on within ourselves. For the visible

* Max Beckmann, excerpts from "Letters to a Woman Painter" (lecture delivered at Stephens College, Columbia, Missouri, January 1948), trans. Mathilde Q. Beckmann and Perry Rathbone, *College Art Journal* 9, no.1 (Autumn 1949): 39–43; reprinted in Peter Selz, *Max Beckmann* (New York: Museum of Modern Art, 1964), 132–34. By permission of the College Art Association, Inc. © 2012 Artists Rights Society (ARS), New York/VG Bild-Kunst, Bonn.

expression of the fight for humanity by far prevails. This is also true of the works presented in this exhibition with their distortions. All of them show traces of the battle for the human image they want to rediscover. They resist the temptation of tired relapses or premature solutions. They fight desperately over the image of man, and by producing shock and fascination in the observer, they communicate their own concern for threatened and struggling humanity. They show the smallness of man and his deep involvement in the past masses of inorganic matter out of which he tries to emerge with toil and pain; they demonstrate the controlling power of technical forms over man by dissecting him into parts and re-constructing him, as man does with nature. They reveal the hidden presence of animal trends in the unconscious and the primitive mass-man from which man comes and to which civilized mass-man may return. They dare to emphasize certain elements and parts of the natural figure and to leave out others in the desire to express something which nature hides. And if they depict the human face, they show that it is not simply given to us but that its human form itself is a matter of continuous struggle. There are demonic forces in every man which try to take possession of him, and the new image of man shows faces in which the state of being possessed is shockingly manifest. In others the fear of such possession or the anxiety at the thought of living is predominant, and again in others there are feelings of emptiness, meaninglessness and despair. But there are also courage, longing and hope, a reaching out into the unknown.

ALBERTO GIACOMETTI
What Interests Me about the Head: Interview with Jacques Dupin (1966)

What interests me most about the head—well, actually the whole head interests me, but I think I should now get to construct the eye as exactly as possible, and if I got that, if I got the base of the nose, the corner of the eye, well the whole curvature of the eyeball—from that everything else should develop. *[Why?]* Probably because, when I look at someone, I look at the eyes rather than at the mouth or the point of the nose. When you look at a human face you always look at the eyes. Even if you look at a cat, it always looks you in the eye. And even when you look at a blind man, you look where his eyes are, as if you could feel the eyes behind the lids. . . . The eye is something special insofar as it's almost as though made of a different material from the rest of the face. You could say that all the forms of the face are more or less unclear, are even very unclear; the point of the nose can hardly be defined at all in sculpture. Now the strange thing is, when you represent the eye precisely, you risk destroying exactly what you are after, namely the gaze. There are few artworks in which the gaze exists. . . . In none of my sculptures since the war have I represented the eye precisely. I indicate the position of the eye, I very often use a vertical line in place of the pupil and I draw the curve of the eyeball. And all this gives the impression of the gaze. But that's where the problems come in. . . . If I could get the curve of the eyeball right, then I would get the socket; if I could get the socket, I would get the base of the nose, the point of the nose, the nostrils, the mouth . . . and all of this together might just produce the gaze, without one's having to concentrate on the eye itself.

* Alberto Giacometti, excerpt from an interview with Jacques Dupin for the film *Alberto Giacometti* (Zurich, 1966) by Ernst Scheidegger and Peter Munger, cited in Reinhold Hohl, *Alberto Giacometti* (New York: Harry N. Abrams, 1971), 324; revised by Fondation Alberto and Annette Giacometti. © 2012 Giacometti Estate: Fondation Giacometti/VAGA, New York, NY/Artists Rights Society (ARS), New York.

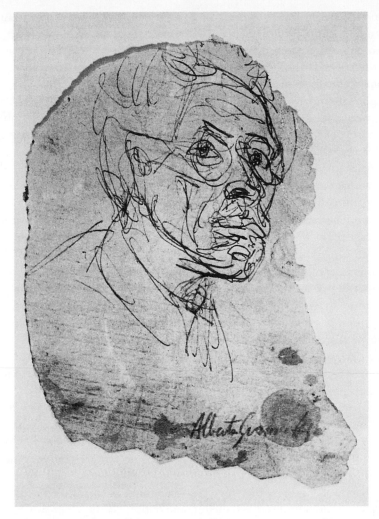

Alberto Giacometti, *Self-Portrait*, 1962, ballpoint pen on paper napkin.
© 2012 Giacometti Estate: Fondation Giacometti/VAGA, New York, NY/
Artists Rights Society (ARS), New York.

JEAN-PAUL SARTRE The Search for the Absolute (1948)

With Space . . . Giacometti has to make a man; he has to write movement into the total im-
mobility, unity into the infinite multiplicity, the absolute into the purely relative, the future
into the eternally present, the chatter of signs into the obstinate silence of things. Between

* Jean-Paul Sartre, excerpts from "La recherche de l'absolut," in *Le Temps Moderne* (Paris) 3, no. 28 (1948): 1,
153–63; reprinted as "The Search for the Absolute," in *Alberto Giacometti* (New York: Pierre Matisse Gallery, 1948).
Translation by Lionel Abel. The same catalogue contained Giacometti's "Letter to Pierre Matisse," explaining the
development of his work up to that point, as well as observations about the purposes of art. This letter is reprinted
in Herschel B. Chipp, Joshua C. Taylor, and Peter Selz, eds., *Theories of Modern Art* (Berkeley: University of Cali-
fornia Press, 1968), 598–603.

the model and the material there seems to be an unbridgeable chasm; yet the chasm exists for us only because Giacometti took hold of it. I do not know if we should regard him as a man who wants to impose a human stamp on space, or as a rock about to dream of the human. Or rather, he is the one and the other, and the mediation between them. The passion of sculpture is to make oneself totally spatial, so that from the depth of space, the statue of a man may sally forth. Thoughts of stone haunt Giacometti. Once he had a terror of emptiness; for months, he came and went with an abyss at his side; space had come to know through him its desolate sterility. Another time, it seemed to him that objects, dulled and dead, no longer touched the earth, he inhabited a floating universe, he knew in his flesh, and to the point of martyrdom, that there is neither high nor low in space, nor real contact between things; but, at the same time, he knew that the sculptor's task is to carve in this infinite archipelago the full form of the only being who can touch other beings. I know nobody as sensitive as he to the magic of faces and gestures; he regards them with a passionate desire, as if he were from another realm. But sometimes, tired of warfare, he tried to mineralize his fellows: he saw crowds advancing blindly towards him, rolling on the boulevards like the stones of an avalanche. Thus, each of his obsessions coincided with a task, an experiment, a way of feeling space. . . .

Why doesn't he try to achieve something perfect, relying on some reliable technique, instead of seeming to ignore his predecessors? But, for three thousand years, sculpture modelled only corpses. Sometimes they were laid out to sleep on tombs, sometimes they were seated on curule chairs, they were also perched on horses. . . .

So one must begin again from scratch. After three thousand years, the task of Giacometti and of contemporary sculptors is not to enrich the galleries with new works, but to prove that sculpture itself is possible. . . .

He has not had a single exhibition in fifteen years. Finally, having a show has become a necessity to him, but he is nevertheless disturbed; he writes to excuse himself: "It is mainly because I don't want to be thought of as sterile and incapable of achieving anything, as a dry branch almost; then too, it is from fear of poverty (which my attitude could very well involve), that I have brought these sculptures to their present point (in bronze and photographed) but I am not too happy about them; they represent something of what I intended just the same, not quite." What bothers him is that these moving outlines, always half-way between nothingness and being, always modified, bettered, destroyed and begun once more, setting out at last on their own and for good, are commencing a social career far from him. He will forget them. The marvellous unity of this life lies in its insistent search for the absolute.

This eager and obstinate worker does not like the resistance of stone, which moderates his movements. He has chosen for himself a material without weight, the most ductile, the most perishable, the most spiritual to hand: plaster. . . . Giacometti never speaks of eternity, never thinks of it. I like what he said to me one day about some statues he had just destroyed: "I was satisfied with them but they were made to last only a few hours." A few hours: like a dawn, a distress, an ephemera. But it is true that his figures, by the very fact that they have been fated to die in the very night wherein they were born, are, of all the sculptures I know, the only ones able to keep the ineffable grace of seeming perishable. Never was matter less eternal, more fragile, nearer to being human. The matter of Giacometti, that strange flour which gently powders and covers his studio, slips under his nails and into the deep furrows of his face, is the dust of space.

But space, even if naked, is still superabundant. Giacometti has a horror of the infinite. Not of the Pascalian infinite, of the infinitely great: there is another infinite, more devious, more secret, which slips away from divisibility: "In space," says Giacometti, "there is too

much." This too much is the pure and simple coexistence of parts in juxtaposition. Most sculptors let themselves be taken in by this; they confuse the flaccidness of extension with largesse, they put too much in their works, they delight in the fat curve of a marble hip, they spread out, thicken, and expand the human gesture. Giacometti knows that there is nothing redundant in a living man, because everything there is functional; he knows that space is a cancer on being, and eats everything; to sculpt, for him, is to take the fat off space; he compresses space, so as to drain off its exteriority. . . .

One has to learn a classical statue, or come near to it: at each moment one sees new details, the parts appear separately, then parts of the parts, one ends by getting lost. One does not approach a sculpture of Giacometti. Do not expect this breast to swell to the degree that you come close to it: it will not change, and you in approaching will have the strange impression that you are stamping on the nipples; we have intimations of them, we divine them, now we are on the point of seeing them: another step or two, and we are about to have them; one more step, and everything vanishes: there remain the corrugations of the plaster; these statues only permit themselves to be seen from a respectful distance. However, everything is there: the whiteness, the roundness, the elastic subsidence of a beautiful ripe breast. Everything except matter: at twenty paces one thinks one sees, but one does not observe the tedious desert of adipose tissue; it is suggested, outlined, meant, but not given. We know now what squeezer Giacometti used to compress space: there is only one: distance. He puts distance within reach of your hand, he thrusts before your eyes a distant woman—and she remains distant, even when you touch her with your fingertips. The breast glimpsed and hoped for will never expose itself: it is only a hope; these bodies have only as much matter as is necessary for making promises. "Nonetheless," some say, "that's not possible: it can't be that the same object can be seen from near and far at once." But it is not the same: it is the block of plaster which is near, the imaginary figure which is distant. "Even in contracting, the distance cannot get away from tridimensionality. But only breadth and depth are changed: the height remains intact." It is true. But it is also true that man possesses absolute dimensions in the eyes of other men. . . . If he moves away, I do not see him dwindling, but his qualities become more compact, while his "shape" remains constant; if he approaches, he does not become larger: the qualities expand. It must be admitted however, that the men and the women of Giacometti are nearer to us in height than in breadth: it is as if their size were in front of them. But Giacometti has elongated them deliberately. What must be understood is that these figures, who are wholly and all at once what they are, do not permit one to study them. As soon as I see them, they spring into my visual field as an idea before my mind; the idea alone possesses such immediate translucidity, the idea alone is at one stroke all that it is. Thus Giacometti has resolved in his own way the problem of the unity of the multiple: he has just suppressed multiplicity. It is the plaster or the bronze which can be divided: but this woman who moves within the indivisibility of an idea or of a sentiment has no parts, she appears totally and at once. It is to give sensible expression to this pure presence, to this gift of the self, to this instantaneous coming forth, that Giacometti resorts to elongation. The original movement of creation, that movement without duration, without parts, and so well imaged by these long, gracile limbs, traverses their Greco-like bodies, and raises them towards heaven. I recognize in them, more clearly than in an athlete of Praxiteles, the figure of man, the real beginning and absolute source of gesture. Giacometti has been able to give this matter the only truly human unity: the unity of the Act.

Such, I think, is the sort of Copernican revolution Giacometti has tried to introduce into sculpture. Before him the effort was to sculpt being, and that absolute melted away in an

infinity of appearances. He has chosen to sculpt the situated appearance, and he has shown that in this way the absolute may be attained. He shows us men and women already seen. But not already seen by him alone. These figures are already seen as the foreign language we try to learn is already spoken. Each one of them reveals man as one sees him to be, as he is for other men, as he appears in an intersubjective world, not, as I said above, to entangle himself at ten or twenty paces, but at a proper human distance; each shows us that man is not there first and to be seen afterwards, but that he is the being whose essence is to exist for others. In perceiving this woman of plaster, I encounter athwart her, my own glance, chilled. Hence the delightful disquiet that seeing her puts me in: I feel compelled and I do not know to what end or by whom until I discover that I am compelled to see, and by myself. And then, often enough Giacometti likes to put us at a loss by placing, for example, a distant head on top of a near body, so that we no longer know what position to take, or how to synthesize what we see. But even without this, his ambiguous images disconcert, breaking as they do with the most cherished habits of our eyes: we have become so accustomed to the sleek mute creatures, made to cure us of the illness of having bodies: these domestic powers kept an eye on us when we were children; they bore witness in the parks to the conviction that the world is not dangerous, that nothing happens to anybody, that actually all that had happened to them was to die at their birth. But to the bodies of Giacometti something has happened: do they come, we ask, from a concave mirror, from the fountain of youth, or from a camp of displaced persons? At first glance we seem to be up against the fleshless martyrs of Buchenwald. But a moment later we have a quite different conception; these fine and slender natures rise up to heaven, we seem to have come across a group of Ascensions, of Assumptions; they dance, they are dances, they are made of the same rarified matter as the glorious bodies that were promised us. And when we have come to contemplate this mystic thrust, these emaciated bodies expand, what we see before us belongs to earth. This martyr was only a woman. But a woman complete, glimpsed, furtively desired, a woman who moved away and passed, with the comic dignity of those long impotent and breakable girls that high-heeled slippers carry lazily from bed to their bath, with the tragic horror of the grimy victims of a fire, given, refused, near, far, a woman complete whose delicious plumpness is haunted by a secret thinness, and whose terrible thinness by a suave plumpness, a complete woman, in danger on this earth, and yet not utterly of this earth, and who lives and tells us of the astonishing adventure of the flesh, our adventure. For she, like us, was born.

But Giacometti remains dissatisfied. He could collect his wager at any time. He has only to decide that he has won. But this he cannot resolve to do, he puts off the decision from hour to hour and from day to day; sometimes, in the course of a night's work, he is ready to admit victory; in the morning everything is broken. Does he fear the boredom that lies on the other side of triumph, that boredom which chilled Hegel when he imprudently bolted his system? Or perhaps matter has revenged itself. This infinite divisibility that he thrust out of his work returns incessantly perhaps, to insert itself between him and his goal. The end is achieved; now one must do it a little better. And then a little better still; this new Achilles will never catch the tortoise; a sculptor must in one way or another be the scapegoat of space: if not in his work then in his life. But everything considered, there is between him and us a difference of position. He knows what he wants to do and this we do not know; but we know what he has succeeded in doing and which he does not notice: these statues are still more than half sunk in his flesh, he cannot see them; he has hardly made them when he is already dreaming of women still more slender, still longer and lighter, and it is thanks to what he has done that he forms the ideal in whose name he judges it to

be imperfect. He will never be finished with it; this is simply because a man is always beyond what he has done. "When I have finished," he says, "I shall write, I shall paint, I shall enjoy myself." But he will die before finishing. Is he in the right, or are we? He first, because, as da Vinci said, it is not good for an artist to feel satisfied. But we too, are right, and in the final accounting: Kafka, dying, wanted his books burned, and Dostoyevsky, in the last days of his life, dreamed of writing a sequel to Karamazov. Perhaps they both died wretched, the one thinking he had done nothing meritorious, the other that he would be forced to lie outside of the world before he had even been able to scratch its surface. Yet both had won, whatever they thought. Giacometti has won likewise, and he is perfectly well aware of it. Vainly does he hook himself to his statues like a miser to his treasure; in vain does he temporise, delay, find a hundred excuses for putting off the reckoning: men are going to come to his place to strip it, and carry off all his works, even to the plaster that covers his floor. He knows it: his hunted look gives him away: he knows that despite himself he has won and that he belongs to us.

JEAN FAUTRIER Preface to Exhibition Catalogue *Jean Fautrier* (1945)
by André Malraux

The art of the earliest *Hostages* remains still rational: human faces reduced to their most unadorned expression by the use of simplified yet dramatic contours, and by heavy leaden colors, forever reminiscent of death. Later, however, Fautrier leaves out the direct allusions to blood, the complicity of the corpse. Colors free from any rational link with torture replace the previous ones; at the same time a line which attempts to express tragedy without representing it, takes the place of the ravaged profiles. Now there are only lips reduced to nerves; there are only eyes which do not see. A hieroglyph of pain.

Are we always convinced? Are we not bothered by some of these pinks and tender greens that seem to belong to Fautrier's accommodation (apparent in all artists) with another part of himself? Does it not seem at times that the artist, his ultimate potential realized, may have tripped and fallen to the other side? Like Uccello whose genius was not recognized by his friend Donatello, when he saw the painter's celebrated canvas. Yet it may be precisely in these works, which are the least persuasive for some people where the artist's ultimate intensity is worked out in a moment of temporary solitude.

Modern art was doubtlessly born on the day when the idea of art and that of beauty were separated. Perhaps with Goya. . . . A less important but unique revolution occurred in our Twentieth Century: just as we are no longer able to see a work of art independent of its historical ramifications—no matter whether we want to admit it or not—we likewise have begun to view some paintings in terms of their maker's artistic history. It was not by accident that Picasso substituted dates for titles in his paintings. "Writers begin to think of their 'Collected Works' while writing," said Goethe. Painters likewise are beginning to paint their "Collected Works." Thus if each single *Hostage* is a valid painting, the meaning of *Hostages* at their fullest strength is inseparable from the space in which you see them gathered, where they are at the same time the damned of a coherent hell and moment of trapped evolution.

* André Malraux, excerpt from preface to *Jean Fautrier* (Paris: Galerie René Drouin, 1945); reprinted in *Jean Fautrier* (Paris: Musée d'art moderne de la Ville de Paris, 1964), n.p. Translation by Peter Selz. By permission of Florence Malraux.

Of how many painters of Fautrier's generation can it be said at this moment that they are in no one's debt? Here is an artist whose sharp turns over twenty years have always led him back to tragic themes—and always less by representation than by expression. A painter who has many painters as adversaries and many poets as admirers, yet whose art, daring and uneven, is of exemplary solitude. It is the first attempt to strip contemporary suffering down to discover its most moving ideograms to the point where this anguish has forcibly found its place in the world of eternal ideas.

JEAN DUBUFFET Anticultural Positions (1951)

I think, not only in the arts, but also in many other fields, an important change is taking place, now, in our time, in the frame of mind of many persons.

It seems to me that certain values, which had been considered for a long time as very certain and beyond discussion, begin now to appear doubtful, and even quite false, to many persons. And that, on the other hand, other values, which were neglected, or held in contempt, or even quite unknown, begin to appear of great worth.

I have the impression that a complete liquidation of all the ways of thinking, whose sum constituted what has been called humanism and has been fundamental for our culture since the Renaissance, is now taking place, or, at least, going to take place soon.

I think the increasing knowledge of the thinking of so called primitive peoples, during the past fifty years, has contributed a great deal to this change, and especially the acquaintance with works of art made by those peoples, which have much surprised and interested the occidental public.

It seems to me that especially many persons begin to ask themselves if the Occident has not many very important things to learn from these savages. May be, in many cases, their solutions and their ways of doing, which first appeared to us very rough, are more clever than ours. It may be ours are the rough ones. It may be refinement, cerebrations, depth of mind, are on their side, and not on ours.

Personally, I believe very much in values of savagery; I mean: instinct, passion, mood, violence, madness.

Now I don't mean to say that the Occident lacks these savage values. On the contrary! But I think that the values held up by our culture don't correspond to the real frame of mind of the Occident. I think that the culture of the Occident is a coat which does not fit him; which, in any case, doesn't fit him any more. I think this culture is very much like a dead language, without anything in common with the language spoken in the street. This culture drifts further and further from daily life. It is confined to certain small and dead circles, as a culture of mandarins. It no longer has real and living roots.

For myself, I aim for an art which would be in immediate connection with daily life, an art which would start from this daily life, and which would be a very direct and very sincere expression of our real life and our real moods.

I am going to enumerate several points, concerning the occidental culture, with which I don't agree.

* Jean Dubuffet, excerpts from "Anticultural Positions" (lecture presented at the Arts Club, Chicago, 1951); photostatic copy of original manuscript in library of Museum of Modern Art; reprinted in *J. Dubuffet* (New York: World House Gallery, 1960). © 2012 Artists Rights Society (ARS), New York/ADAGP, Paris.

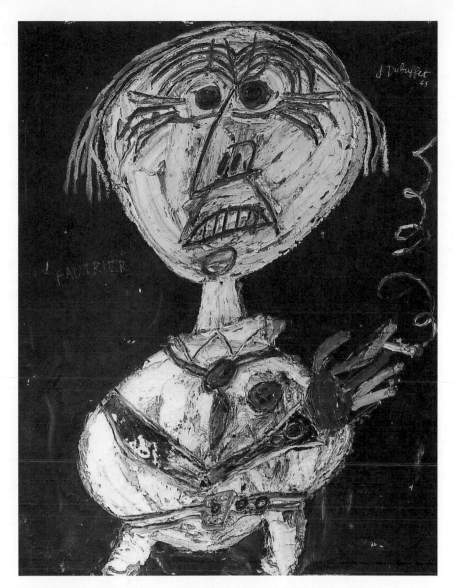

Jean Dubuffet, *Portrait of Fautrier,* 1947, oil on canvas. Collection of Dorothea and Natasha McKenna Elkon. Photo courtesy The Elkon Gallery, New York. © 2012 Artists Rights Society (ARS), New York/ADAGP, Paris.

1

One of the principal characteristics of Western culture is the belief that the nature of man is very different from the nature of other beings of the world. Custom has it that man cannot be identified, or compared in the least, with elements such as winds, trees, rivers—except humorously, and for poetic rhetorical figures.

The Western man has, at last, a great contempt for trees and rivers, and hates to be like them.

On the contrary, the so called primitive man loves and admires trees and rivers, and has a

great pleasure to be like them. He believes in a real similitude between man and trees and rivers. He has a very strong sense of continuity of all things, and especially between man and the rest of the world. Those primitive societies have surely much more respect than Western man for every being of the world; they have a feeling that the man is not the owner of the beings, but only one of them among the others.

2

My second point of disagreement [is this:] . . . Western man believes that the things he thinks exist outside exactly in the same way he thinks of them. He is convinced that the shape of the world is the same shape as his reason. He believes very strongly the basis of his reason is well founded, and especially the basis of his logic.

But the primitive man has rather an idea of weakness of reason and logic, and believes rather in other ways of getting knowledge of things. That is why he has so much esteem and so much admiration for the states of mind which we call madness. I must declare I have a great interest for madness; and I am convinced art has much to do with madness.

3

Now, third point. I want to talk about the great respect occidental culture has for elaborated ideas. I don't regard elaborated ideas as the best part of human function. I think ideas are rather a weakened rung in the ladder of mental process: something like a landing where the mental processes become impoverished, like an outside crust caused by cooling.

Ideas are like steam condensed into water by touching the level of reason and logic. I don't think the greatest value of mental function is to be found at this landing of ideas; and it is not at this landing that it interests me. I aim rather to capture the thought at a point of its development prior to this landing of elaborated ideas. The whole art, the whole literature and the whole philosophy of the Occident, rest on the landing of elaborated ideas. But my own art, and my own philosophy, lean entirely on stages more underground. I try always to catch the mental process at the deeper point of its roots, where, I am sure, the sap is much richer.

4

Now, fourth. Occidental culture is very fond of analysis, and I have no taste for analysis, and no confidence in it. One thinks everything can be known by way of dismantling it or dissecting it into all its parts, and studying separately each of these parts.

My own feeling is quite different. I am more disposed, on the contrary, to always recompose things. As soon as an object has been cut only into two parts, I have the impression it is lost for my study, I am further removed from this object instead of being nearer to it.

I have a very strong feeling that the sum of the parts does not equal the whole.

My inclination leads me, when I want to see something really well, to regard it with its surroundings, whole. If I want to know this pencil on the table, I don't look straight on the pencil, I look on the middle of the room, trying to include in my glance as many objects as possible.

If there is a tree in the country, I don't bring it into my laboratory to look at it under my microscope, because I think the wind which blows through its leaves is absolutely necessary for the knowledge of the tree and cannot be separated from it. Also the birds which are in

the branches, and even the song of these birds. My turn of mind is to join always more things surrounding the tree, and further, always more of the things which surround the things which surround the tree.

I have been a long time on this point, because I think this turn of mind is an important factor of the aspect of my art.

5

The fifth point, now, is that our culture is based on an enormous confidence in the language—and especially the written language; and belief in its ability to translate and elaborate thought. That appears to me a misapprehension. I have the impression, language is a rough, very rough stenography, a system of algebraic signs very rudimentary, which impairs thought instead of helping it. Speech is more concrete, animated by the sound of the voice, intonations, a cough, and even making a face and mimicry, and it seems to me more effective. Written language seems to me a bad instrument. As an instrument of expression, it seems to deliver only a dead remnant of thought, more or less as clinkers from the fire. As an instrument of elaboration, it seems to overload thought and falsify it.

I believe (and here I am in accord with the so called primitive civilizations) that painting is more concrete than the written word, and is a much more rich instrument for the expression and elaboration of thought.

I have just said, what interests me, in thought, is not the instant of transformation into formal ideas, but the moments preceding that.

My paintings can be regarded as a tentative language fitting for these areas of thought.

6

[Occidental culture] believes that there are beautiful objects and ugly objects, beautiful persons and ugly persons, beautiful places and ugly places, and so forth.

Not I. I believe beauty is nowhere. I consider this notion of beauty as completely false. I refuse absolutely to assent to this idea that there are ugly persons and ugly objects. This idea is for me stifling and revolting.

I think the Greeks are the ones, first, to purport that certain objects are more beautiful than others.

The so called savage nations don't believe in that at all. They don't understand when you speak to them of beauty.

This is the reason one calls them savage. The Western man gives the name of savage to one who doesn't understand that beautiful things and ugly things exist, and who doesn't care for that at all.

What is strange is that, for centuries and centuries, and still now more than ever, the men of the Occident dispute which are the beautiful things and which are the ugly ones. All are certain that beauty exists without doubt, but one cannot find two who agree about the objects which are endowed. And from one century to the next, it changes. Occidental culture declares beautiful, in each century, what it declared ugly in the preceding one. . . .

This idea of beauty is however one of the things our culture prizes most, and it is customary to consider this belief in beauty, and the respect for this beauty, as the ultimate justification of Western civilization, and the principle of civilization itself is involved with this notion of beauty.

I find this idea of beauty a meager and not very ingenious invention, and especially not very encouraging for man. It is distressing to think about people deprived of beauty because they have not a straight nose, or are too corpulent, or too old. I find even this idea that the world we live in is made up of ninety percent ugly things and ugly places, while things and places endowed with beauty are very rare and very difficult to meet, I must say, I find this idea not very exciting. It seems to me that the Western man will not suffer a great loss if he loses this idea. On the contrary, if he becomes aware that the world is able to become for any man a way of fascination and illumination, he will have made a good catch. I think such an idea will enrich life more than the Greek idea of beauty.

And now what happens with art? Art has been considered, since the Greeks, to have as its goal the creation of beautiful lines and beautiful color harmonies. If one abolishes this notion, what becomes of art?

I am going to tell you. Art, then, returns to its real function, much more significant than creating shapes and colors agreeable for a so called pleasure of the eyes.

I don't find this function, assembling colors in pleasing arrangements, very noble. If painting was only that, I should not lose one hour of my time in this activity. Art addresses itself to the mind, and not to the eyes. It has always been considered in this way by primitive peoples, and they are right. Art is a language, instrument of knowledge, instrument of expression.

I think, this enthusiasm about the written language, which I mentioned before, has been the reason our culture started to regard painting as a rough, rudimentary, and even contemptible language, good only for illiterate people. From that, culture invented as a rationalization for art, this myth of plastic beauty, is in my opinion an imposture. . . .

Painting is a language much more immediate, and, at the same time, much more charged with meaning. Painting operates through signs which are not abstract and incorporeal like words. The signs of painting are much closer to the objects themselves. Further, painting manipulates materials which are themselves living substances. That is why painting allows one to go much further than words do, in approaching things and conjuring them.

Painting can also, and it is very remarkable, conjure things more or less, as wanted. I mean: with more or less presence. That is to say: at different stages between being and not being.

At last, painting can conjure things not isolated, but linked to all that surrounds them: a great many things simultaneously.

On the other hand, painting is a very much more immediate language, and much more direct, than the language of words: much closer to the cry, or to the dance. That is why painting is a way of expression of our inner voices much more effective than that of words. . . .

Painting has a double advantage over language of words. First, painting conjures objects with greater strength, and comes much closer to them. Second, painting opens, to the inner dance of the painter's mind, a larger door to the outside. These two qualities of painting make it an extraordinary instrument of thought, or, if you will, an extraordinary instrument of clairvoyance, and also an extraordinary instrument to exteriorize this clairvoyance, and to permit us to comprehend it ourselves along with the painter.

Painting now, using these two powerful means, can illuminate the world with wonderful discoveries, can endow man with new myths and new mystics, and reveal, in infinite number, unsuspected aspects of things, and new values not yet perceived. Here is, I think, for artists, a much more worthy job than creating assemblages of shapes and colors pleasing for the eyes.

WILLEM DE KOONING
Content Is a Glimpse: Interview with David Sylvester (1963)

Certain artists and critics attacked me for painting the *Women,* but I felt that this was their problem, not mine. I don't really feel like a non-objective painter at all. Today, some artists feel they have to go back to the figure, and that word "figure" becomes such a ridiculous omen—if you pick up some paint with your brush and make somebody's nose with it, this is rather ridiculous when you think of it, theoretically or philosophically. It's really absurd to make an image, like a human image, with paint, today, when you think about it, since we have this problem of doing or not doing it. But then all of a sudden it was even more absurd not to do it. So I fear that I have to follow my desires.

The *Women* had to do with the female painted through all the ages, all of those idols, and maybe I was stuck to a certain extent; I couldn't go on. It did one thing for me: it eliminated composition, arrangement, relationships, light—all this silly talk about line, color and form— because that was the thing I wanted to get hold of. I put it in the center of the canvas because there was no reason to put it a bit on the side. So I thought I might as well stick to the idea that it's got two eyes, a nose and mouth and neck. I got to the anatomy and I felt myself almost getting flustered. I really could never get hold of it. It almost petered out. I never could complete it and when I think of it now, it wasn't such a bright idea. But I don't think artists have particularly bright ideas. Matisse's *Woman in a Red Blouse*—what an idea that is! Or the Cubists—when you think about it now, it is so silly to look at an object from many angles. Constructivism—open, not closed. It's very silly. It's good that they got those ideas because it was enough to make some of them great artists.

Painting the *Women* is a thing in art that has been done over and over—the idol, Venus, the nude. Rembrandt wanted to paint an old man, a wrinkled old guy—that was painting to him. Today artists are in a belated age of reason. They want to get hold of things. Take Mondrian; he was a fantastic artist. But when we read his ideas and his idea of Neo-Plasticism—pure plasticity—it's kind of silly. Not for him, but I think one could spend one's life having this desire to be in and outside at the same time. He could see a future life and a future city—not like me, who am absolutely not interested in seeing the future city. I'm perfectly happy to be alive now.

The *Women* became compulsive in the sense of not being able to get hold of it—it really is very funny to get stuck with a woman's knees, for instance. You say, "What the hell am I going to do with that now?"; it's really ridiculous. It may be that it fascinates me, that it isn't supposed to be done. A lot of people paint a figure because they feel it ought to be done, because since they're human beings themselves, they feel they ought to make another one, a substitute. I haven't got that interest at all. I really think it's sort of silly to do it. But the moment you take this attitude it's just as silly not to do it. . . .

Content is a glimpse of something, an encounter like a flash. It's very tiny—very tiny, content. When I was painting those figures, I was thinking about Gertrude Stein, as if they were ladies of Gertrude Stein—as if one of them would say, "How do you like me?" Then I could sustain this thing all the time because it could change all the time; she could almost get

* Willem de Kooning, excerpts from "Content Is a Glimpse . . . ," *Location* (New York) 1 (Spring 1963): 46–47. Originally, this piece was part of an interview conducted by David Sylvester with Willem de Kooning for the BBC. With permission of the British Broadcasting Corporation. © 2012 Lisa de Kooning.

upside down, or not be there, or come back again, she could be any size. Because this content could take care of almost anything that could happen.

I still have it now from fleeting things—like when one passes something, and it makes an impression, a simple stuff.

I wasn't concerned to get a particular kind of feeling. I look at them now and they seem vociferous and ferocious. I think it had to do with the idea of the idol, the oracle, and above all the hilariousness of it. I do think that if I don't look upon life that way, I won't know how to keep on being around.

I cut out a lot of mouths. First of all, I thought everything ought to have a mouth. Maybe it was like a pun. Maybe it's sexual. But whatever it is, I used to cut out a lot of mouths and then I painted those figures and then I put the mouth more or less in the place where it's supposed to be. It always turned out to be very beautiful and it helped me immensely to have this real thing. I don't know why I did it with the mouth. Maybe the grin—it's rather like the Mesopotamian idols, they always stand up straight, looking to the sky with this smile, like they were just astonished about the forces of nature you feel, not about problems they had with one another. That I was very conscious of—the smile was something to hang onto.

I wouldn't know what to do with the rest, with the hands, maybe, or some gesture, and then in the end it failed. But it didn't bother me because I had, in the end, given it up; I felt it was really an accomplishment. I took the attitude that I was going to succeed, and I also knew that this was just an illusion. I never was interested in how to make a good painting. For many years I was not interested in making a good painting—as one might say, "Now this is really a good painting" or a "perfect work." I didn't want to pin it down at all. I was interested in that before, but I found out it was not my nature. I didn't work on it with the idea of perfection, but to see how far one could go—but not with the idea of really doing it. With anxiousness and dedication to fright maybe, or ecstasy, like the Divine Comedy, to be like a performer: to see how long you can stay on the stage with that imaginary audience. . . .

FRANCIS BACON Interviews with David Sylvester (1966, 1971–73)

Interview 1, 1966

DAVID SYLVESTER: It's interesting that the photographic image you've worked from most of all isn't a scientific or a journalistic one but a very deliberate and famous work of art—the still of the screaming nanny from *Potemkin*.

FRANCIS BACON: It was a film I saw almost before I started to paint, and it deeply impressed me—I mean the whole film as well as the Odessa Steps sequence and this shot. I did hope at one time to make—it hasn't got any special psychological significance—I did hope one day to make the best painting of the human cry. I was not able to do it and it's much better in the Eisenstein and there it is. I think probably the best human cry in painting was made by Poussin. . . .

* David Sylvester, excerpts from *Interviews with Francis Bacon, 1962–1979* (London: Thames and Hudson, 1980), 130–67. By permission of the Estate of Francis Bacon, David Sylvester, Thames and Hudson, Ltd., and the British Broadcasting Corporation. The noted art critic David Sylvester conducted seven interviews with Francis Bacon between 1962 and 1979.

DS: You've used the Eisenstein image as a constant basis and you've done the same with the Velázquez *Innocent X,* and entirely through photographs and reproductions of it. And you've worked from reproductions of other old master paintings. Is there a great deal of difference between working from a photograph of a painting and from a photograph of reality?

FB: Well, with a painting it's an easier thing to do, because the problem's already been solved. The problem that you're setting up, of course, is another problem. I don't think that any of these things that I've done from other paintings actually have ever worked. . . .

DS: I want to ask whether your love of photographs makes you like reproductions as such. I mean, I've always had a suspicion that you're more stimulated by looking at reproductions of Velázquez or Rembrandt than at the originals.

FB: Well, of course, it's easier to pick them up in your own room than take the journey to the National Gallery, but I do nevertheless go a great deal to look at them in the National Gallery, because I want to see the colour, for one thing. But, if I'd got Rembrandts here all round the room, I wouldn't go to the National Gallery. . . .

DS: Up to now we've been talking about your working from photographs which were in existence and which you chose. And among them there have been old snapshots which you've used when doing a painting of someone you knew. But in recent years, when you've planned to do a painting of somebody, I believe you've tended to have a set of photographs taken especially.

FB: I have. Even in the case of friends who will come and pose. I've had photographs taken for portraits because I very much prefer working from the photographs than from them. It's true to say I couldn't attempt to do a portrait from photographs of somebody I didn't know. But, if I both know them and have photographs of them, I find it easier to work than actually having their presence in the room. I think that, if I have the presence of the image there, I am not able to drift so freely as I am able to through the photographic image. This may be just my own neurotic sense but I find it less inhibiting to work from them through memory and their photographs than actually having them seated there before me.

DS: You prefer to be alone?

FB: Totally alone. With their memory.

DS: Is that because the memory is more interesting or because the presence is disturbing?

FB: What I want to do is to distort the thing far beyond the appearance, but in the distortion to bring it back to a recording of the appearance.

DS: Are you saying that painting is almost a way of bringing somebody back, that the process of painting is almost like the process of recalling?

FB: I am saying it. And I think that the methods by which this is done are so artificial that the model before you, in my case, inhibits the artificiality by which this thing can be brought back.

DS: And what if someone you've already painted many times from memory and photographs sits for you?

FB: They inhibit me. They inhibit me because, if I like them, I don't want to practise before them the injury that I do to them in my work. I would rather practise the injury in private by which I think I can record the fact of them more clearly.

DS: In what sense do you conceive it as an injury?

FB: Because people believe—simple people at least—that the distortions of them are an injury to them—no matter how much they feel for or how much they like you.

DS: Don't you think their instinct is probably right?

FB: Possibly, possibly. I absolutely understand this. But tell me, who today has been able to record anything that comes across to us as a fact without causing deep injury to the image?

DS: Is it a part of your intention to try and create a tragic art?

FB: No. Of course, I think that, if one could find a valid myth today where there was the distance between grandeur and its fall of the tragedies of Aeschylus and Shakespeare, it would be tremendously helpful. But when you're outside a tradition, as every artist is today, one can only want to record one's own feelings about certain situations as closely to one's own nervous system as one possibly can. But in recording these things I may be one of those people who want the distances between what used to be called poverty and riches or between power and the opposite of power.

DS: There is, of course, one great traditional mythological and tragic subject you've painted very often, which is the Crucifixion.

FB: Well, there have been so very many great pictures in European art of the Crucifixion that it's a magnificent armature on which you can hang all types of feeling and sensation. You may say it's a curious thing for a non-religious person to take the Crucifixion, but I don't think that that has anything to do with it. The great Crucifixions that one knows of—one doesn't know whether they were painted by men who had religious beliefs. . . .

DS: It seems to be quite widely felt of the paintings of men alone in rooms that there's a sense of claustrophobia and unease about them that's rather horrific. Are you aware of that unease?

FB: I'm not aware of it. But most of those pictures were done of somebody who was always in a state of unease, and whether that has been conveyed through these pictures I don't know. But I suppose, in attempting to trap this image, that, as this man was very neurotic and almost hysterical, this may possibly have come across in the paintings. I've always hoped to put over things as directly and rawly as I possibly can, and perhaps, if a thing comes across directly, people feel that that is horrific. Because, if you say something very directly to somebody, they're sometimes offended, although it is a fact. Because people tend to be offended by facts, or what used to be called truth.

DS: On the other hand, it's not altogether stupid to attribute an obsession with horror to an artist who has done so many paintings of the human scream.

FB: You could say that a scream is a horrific image; in fact, I wanted to paint the scream more than the horror. I think, if I had really thought about what causes somebody to scream, it would have made the scream that I tried to paint more successful. Because I should in a sense have been more conscious of the horror that produced the scream. In fact they were too abstract. . . . I think that they come out of a desire for ordering and for returning fact onto the nervous system in a more violent way. Why, after the great artists, do people ever try to do anything again? Only because, from generation to generation, through what the great artists have done, the instincts change. And, as the instincts change, so there comes a renewal of the feeling of how can I remake this thing once again more clearly, more exactly, more violently. You see, I believe that art is recording. I think it's reporting. And I think that in abstract art, as there's no report, there's nothing other than the aesthetic of the painter and his few sensations. There's never any tension in it.

DS: You don't think it can convey feelings?

FB: I think it can convey very watered-down lyrical feelings, because I think any shapes can. But I don't think it can really convey feeling in the grand sense. . . .

I think it's possible that the onlooker can enter . . . into an abstract painting. But then anybody can enter more into what is called an undisciplined emotion, because, after all,

who loves a disastrous love affair or illness more than the spectator? He can enter into these things and feel he is participating and doing something about it. But that of course has nothing to do with what art is about. What you're talking about now is the entry of the spectator into the performance, and I think in abstract art perhaps they can enter more, because what they are offered is something weaker which they haven't got to combat.

DS: If abstract paintings are no more than pattern-making, how do you explain the fact that there are people like myself who have the same sort of visceral response to them at times as they have to figurative works?

FB: Fashion.

DS: You really think that?

FB: I think that only time tells about painting. No artist knows in his own lifetime whether what he does will be the slightest good, because I think it takes at least seventy-five to a hundred years before the thing begins to sort itself out from the theories that have been formed about it. And I think that most people enter a painting by the theory that has been formed about it and not by what it is. Fashion suggests that you should be moved by certain things and should not by others. This is the reason that even successful artists—and especially successful artists, you may say—have no idea whatever whether their work's any good or not, and will never know.

DS: Not long ago you bought a picture . . .

FB: By Michaux.

DS: . . . by Michaux, which was more or less abstract. I know you got tired of it in the end and sold it or gave it away, but what made you buy it?

FB: Well, firstly, I don't think it's abstract. I think Michaux is a very, very intelligent and conscious man, who is aware of exactly the situation that he is in. And I think that he has made the best *tachiste* or free marks that have been made. I think he is much better in that way, in making free marks, than Jackson Pollock.

DS: Can you say what gives you this feeling?

FB: What gives me the feeling is that it is more factual: it suggests more. Because after all, this painting, and most of his paintings, have always been about delayed ways of remaking the human image, through a mark which is totally outside an illustrational mark but yet always conveys you back to the human image—a human image generally dragging and trudging through deep ploughed fields, or something like that. They are about these images moving and falling and so on.

DS: Are you ever as moved by looking at a still life or a landscape by a great master as you are by looking at paintings of the human image? Does a Cézanne still life or landscape ever move you as much as a Cézanne portrait or nude? . . .

FB: Certainly landscapes interest me much less. I think art is an obsession with life and after all, as we are human beings, our greatest obsession is with ourselves. Then possibly with animals, and then with landscapes.

DS: You're really affirming the traditional hierarchy of subject matter by which history painting—painting of mythological and religious subjects—comes top and then portraits and then landscape and then still life.

FB: I would alter them round. I would say at the moment, as things are so difficult, that portraits come first.

DS: In fact, you've done very few paintings with several figures. Do you concentrate on the single figure because you find it more difficult?

FB: I think that the moment a number of figures become involved, you immediately

come on to the story-telling aspect of the relationships between figures. And that immediately sets up a kind of narrative. I always hope to be able to make a great number of figures without a narrative.

DS: As Cézanne does in the bathers?

FB: He does. . . .

DS: Talking about the situation in the way you do points, of course, to the very isolated position in which you're working. The isolation is obviously a great challenge, but do you also find it a frustration? Would you rather be one of a number of artists working in a similar direction?

FB: I think it would be more exciting to be one of a number of artists working together, and to be able to exchange. . . . I think it would be terribly nice to have someone to talk to. Today there is absolutely nobody to talk to. Perhaps I'm unlucky and don't know those people. Those I know always have very different attitudes to what I have. But I think that artists can in fact help one another. They can clarify the situation to one another. I've always thought of friendship as where two people really tear one another apart and perhaps in that way learn something from one another.

DS: Have you ever got anything from what's called destructive criticism made by critics?

FB: I think that destructive criticism, especially by other artists, is certainly the most helpful criticism. Even if, when you analyze it, you may feel that it's wrong, at least you analyze it and think about it. When people praise you, well, it's very pleasant to be praised, but it doesn't actually help you.

DS: Do you find you can bring yourself to make destructive criticism of your friends' work?

FB: Unfortunately, with most of them I can't if I want to keep them as friends.

DS: Do you find you can criticize their personalities and keep them as friends?

FB: It's easier, because people are less vain of their personalities than they are of their work. They feel in an odd way, I think, that they're not irrevocably committed to their personality, that they can work on it and change it, whereas the work that has gone out—nothing can be done about it. But I've always hoped to find another painter I could really talk to— somebody whose qualities and sensibility I'd really believe in—who really tore my things to bits and whose judgement I could actually believe in. I envy very much, for instance, going to another art, I envy very much the situation when Eliot and Pound and Yeats were all working together. And in fact Pound made a kind of caesarean operation on *The Waste Land;* he also had a very strong influence on Yeats—although both of them may have been very much better poets than Pound. I think it would be marvellous to have somebody who would say to you, "Do this, do that, don't do this, don't do that!" and give you the reasons. I think it would be very helpful.

DS: You feel you really could use that kind of help?

FB: I could. Very much. Yes, I long for people to tell me what to do, to tell me where I go wrong.

Interview 3, 1971–73

FB: When I was sixteen or seventeen, I went to Berlin, and of course I saw the Berlin of 1927 and 1928 where there was a wide open city, which was, in a way, very, very violent. Perhaps it was violent to me because I had come from Ireland, which was violent in the

military sense but not violent in the emotional sense, in the way Berlin was. And after Berlin I went to Paris, and then I lived all those disturbed years between then and the war which started in 1939. So I could say, perhaps, I have been accustomed to always living through forms of violence—which may or may not have an effect upon one, but I think probably does. But this violence of my life, the violence which I've lived amongst, I think it's different to the violence in painting. When talking about the violence of paint, it's nothing to do with the violence of war. It's to do with an attempt to remake the violence of reality itself. And the violence of reality is not only the simple violence meant when you say that a rose or something is violent, but it's the violence also of the suggestions within the image itself which can only be conveyed through paint. When I look at you across the table, I don't only see you but I see a whole emanation which has to do with personality and everything else. And to put that over in a painting, as I would like to be able to do in a portrait, means that it would appear violent in paint. We nearly always live through screens—a screened existence. And I sometimes think, when people say my work looks violent, that perhaps I have from time to time been able to clear away one or two of the veils or screens.

CONSTANT NIEUWENHUYS Manifesto (1948)

The dissolution of Western Classical culture is a phenomenon that can be understood only against the background of a social evolution which can end only in the total collapse of a principle of society thousands of years old and its replacement by a system whose laws are based on the immediate demands of human vitality. The influence the ruling classes have wielded over the creative consciousness in history has reduced art to an increasingly dependent position, until finally the real psychic function of that art was attainable only for a few spirits of genius who in their frustration and after a long struggle were able to break out of the conventions of form and rediscover the basic principles of all creative activity.

Together with the class society from which it emerged, this culture of the individual is faced by destruction too, as the former's institutions, kept alive artificially, offer no further opportunities for the creative imagination and only impede the free expression of human vitality. All the isms so typical of the last fifty years of art history represent so many attempts to bring new life to this culture and to adapt its aesthetic to the barren ground of its social environment. Modern art, suffering from a permanent tendency to the constructive, an obsession with objectivity (brought on by the disease that has destroyed our speculative idealizing culture), stands isolated and powerless in a society which seems bent on its own destruction. As the extension of a style created for a social elite, with the disappearance of that elite modern art has lost its social justification and is confronted only by the criticism formulated by a clique of connoisseurs and amateurs.

Western art, once the celebrator of emperors and popes, turned to serve the newly powerful bourgeoisie, becoming an instrument of the glorification of bourgeois ideals. Now that these ideals have become a fiction with the disappearance of their economic base, a new era is upon us, in which the whole matrix of cultural conventions loses its significance and a new freedom can be won from the most primary source of life. But, just as with a social revolution, this spiritual revolution cannot be enacted without conflict. Stubbornly the bourgeois mind

* Constant Nieuwenhuys, "Manifesto," *Reflex* (Amsterdam) 1 (September–October 1948), trans. Leonard Bright; reprinted in Willemijn Stokavis, *Cobra* (New York: Rizzoli, 1988), 29–31. By permission of the author.

clutches on to its aesthetic ideal and in a last, desperate effort employs all its wiles to convert the indifferent masses to the same belief. Taking advantage of the general lack of interest, suggestions are made of a special social need for what is referred to as "an ideal of beauty," all designed to prevent the flowering of a new, conflicting sense of beauty which emerges from the vital emotions.

As early as the end of World War I the dada movement tried by violent means to break away from the old ideal of beauty. Although this movement concentrated increasingly on the political arena, as the artists involved perceived that their struggle for freedom brought them into conflict with the laws that formed the very foundations of society, the vital power released by this confrontation also stimulated the birth of a new artistic vision.

In 1924 the Surrealist Manifesto appeared, revealing a hitherto hidden creative impulse— it seemed that a new source of inspiration had been discovered. But Breton's movement suffocated in its own intellectualism, without ever converting its basic principle into a tangible value. For Surrealism was an art of ideas and as such also infected by the disease of past class culture, while the movement failed to destroy the values this culture proclaimed in its own justification.

It is precisely this act of destruction that forms the key to the liberation of the human spirit from passivity. It is the basic pre-condition for the flowering of a people's art that encompasses everyone. The general social impotence, the passivity of the masses, are an indication of the brakes that cultural norms apply to the natural expression of the forces of life. For the satisfaction of this primitive need for vital expression is the driving force of life, the cure for every form of vital weakness. It transforms art into a power for spiritual health. As such it is the property of all and for this reason every limitation that reduces art to the preserve of a small group of specialists, connoisseurs, and virtuosi must be removed.

But this people's art is not an art that necessarily conforms to the norms set by the people, for they expect what they were brought up with, unless they have had the opportunity to experience something different. In other words, unless the people themselves are actively involved in the making of art. A people's art is a form of expression nourished only by a natural and therefore general urge to expression. Instead of solving problems posed by some preconceived aesthetic ideal, this art recognizes only the norms of expressivity, spontaneously directed by its own intuition. The great value of a people's art is that, precisely because it is the form of expression of the untrained, the greatest possible latitude is given the unconscious, thereby opening up ever wider perspectives for the comprehension of the secret of life. In the art of genius, too, Western Classical culture has recognized the value of the unconscious, for it was the unconscious which made possible a partial liberation from the conventions which bound art. But this could be achieved only after a long, personal process of development, and was always seen as revolutionary. The cycle of revolutionary deeds which we call the evolution of art has now entered its last phase: the loosening of stylistic conventions. Already weakened by Impressionism, laid bare by Cubism (and later by Constructivism and Neo-Plasticism), it signifies the end of art as a force of aesthetic idealism on a higher plane than

International Exhibition of Experimental Art CoBrA, Stedelijk Museum, Amsterdam, November 1949, with Constant Nieuwenhuys's *La Barricade* (1949) in back. Photo courtesy Stedelijk Museum, Amsterdam.

life. What we call "genius" is nothing else but the power of the individual to free himself from the ruling aesthetic and place himself above it. As this aesthetic loses its stranglehold, and with the disappearance of the exceptional personal performance, "genius" will become public property and the word "art" will acquire a completely new meaning. That is not to say that the expression of all people will take on a similar, generalized value, but that everyone will be able to express himself because the genius of the people, a fountain in which everyone can bathe, replaces the individual performance.

In this period of change, the role of the creative artist can only be that of the revolutionary: it is his duty to destroy the last remnants of an empty, irksome aesthetic, arousing the creative instincts still slumbering unconscious in the human mind. The masses, brought up with aesthetic conventions imposed from without, are as yet unaware of their creative potential. This will be stimulated by an art which does not define but suggests, by the arousal of associations and the speculations which come forth from them, creating a new and fantastic way of seeing. The onlooker's creative ability (inherent to human nature) will bring this new way of seeing within everyone's reach once aesthetic conventions cease to hinder the working of the unconscious.

Hitherto condemned to a purely passive role in our culture, the onlooker will himself become involved in the creative process. The interaction between creator and observer makes art of this kind a powerful stimulator in the birth of the creativity of the people. The ever greater dissolution and ever more overt impotence of our culture makes the struggle of today's creative artists easier than that of their predecessors—time is on their side. The phenomenon of "kitsch" has spread so quickly that today it overshadows more cultivated forms of expression, or else is so intimately interwoven with them that a demarcation line is difficult to draw. Thanks to these developments, the power of the old ideals of beauty is doomed to decay and eventually disappear and a new artistic principle, now coming into being, will automatically

replace them. This new principle is based on the total influence of matter on the creative spirit. This creative concept is not one of theories or forms, which could be described as solidified matter, but arises from the confrontation between the human spirit and raw materials that suggest forms and ideas.

Every definition of form restricts the material effect and with it the suggestion it projects. Suggestive art is materialistic art because only matter stimulates creative activity, while the more perfectly defined the form, the less active is the onlooker. Because we see the activation of the urge to create as art's most important task, in the coming period we will strive for the greatest possible materialistic and therefore greatest possible suggestive effect. Viewed in this light, the creative act is more important than that which it creates, while the latter will gain in significance the more it reveals the work which brought it into being and the less it appears as a polished end-product. The illusion has been shattered that a work of art has a fixed value: its value is dependent on the creative ability of the onlooker, which in turn is stimulated by the suggestions the work of art arouses. Only living art can activate the creative spirit, and only living art is of general significance. For only living art gives expression to the emotions, yearnings, reactions and ambitions which as a result of society's shortcomings we all share.

A living art makes no distinction between beautiful and ugly because it sets no aesthetic norms. The ugly which in the art of past centuries has come to supplement the beautiful is a permanent complaint against the unnatural class society and its aesthetic of virtuosity; it is a demonstration of the retarding and limiting influence of this aesthetic on the natural urge to create. If we observe forms of expression that include every stage of human life, for example that of a child (who has yet to be socially integrated), then we no longer find this distinction. The child knows of no law other than its spontaneous sensation of life and feels no need to express anything else. The same is true of primitive cultures, which is why they are so attractive to today's human beings, forced to live in a morbid atmosphere of unreality, lies and infertility. A new freedom is coming into being which will enable human beings to express themselves in accordance with their instincts. This change will deprive the artist of his special position and meet with stubborn resistance. For, as his individually won freedom becomes the possession of all, the artist's entire individual and social status will be undermined.

Our art is the art of a revolutionary period, simultaneously the reaction of a world going under and the herald of a new era. For this reason it does not conform to the ideals of the first, while those of the second have yet to be formulated. But it is the expression of a life force that is all the stronger for being resisted, and of considerable psychological significance in the struggle to establish a new society. The spirit of the bourgeoisie still permeates all areas of life, and now and then it even pretends to bring art to the people (a special people, that is, set to its hand).

But this art is too stale to serve as a drug any longer. The chalkings on pavements and walls clearly show that human beings were born to manifest themselves; now the struggle is in full swing against the power that would force them into the straitjacket of clerk or commoner and deprive them of this first vital need. A painting is not a composition of colour and line but an animal, a night, a scream, a human being, or all of these things together. The objective, abstracting spirit of the bourgeois world has reduced the painting to the means which brought it into being; the creative imagination, however, seeks to recognize every form and even in the sterile environment of the abstract it has created a new relationship with reality, turning on the suggestive power which every natural or artificial form possesses for the active onlooker. This suggestive power knows no limits and so one can say that after a period in which it meant nothing, art has now entered an era in which it means EVERYTHING.

The cultural vacuum has never been so strong or so widespread as after the last war, when the continuity of centuries of cultural evolution was broken by a single jerk of the string. The Surrealists, who in their rejection of the cultural order threw artistic expression overboard, experienced the disillusionment and bitterness of talent become useless in a destructive campaign against art, against a society which, though they recognized its responsibility, was still strong enough to be considered as theirs. However, painters after World War II see themselves confronted by a world of stage decors and false façades in which all lines of communication have been cut and all belief has vanished. The total lack of a future as a continuation of this world makes constructive thought impossible. Their only salvation is to turn their backs on the entire culture (including modern negativism, Surrealism and Existentialism). In this process of liberation it becomes increasingly apparent that this culture, unable to make artistic expression *possible,* can only make it *impossible.* The materialism of these painters did not lead, as bourgeois idealists had warned, to a spiritual void (like their own?), nor to creative impotence. On the contrary, for the first time every faculty of the human spirit was activated in a fertile relationship with matter. At the same time a process was started in which ties and specific cultural forms which in this phase still played a role were naturally thrown off, just as they were in other areas of life.

The problematic phase in the evolution of modern art has come to an end and is being followed by an experimental period. In other words, from the experience gained in this state of unlimited freedom, the rules are being formulated which will govern the new form of creativity. Come into being more or less unawares, in line with the laws of dialectics a new consciousness will follow.

KAREL APPEL My Paint Is Like a Rocket (c. 1953)

My paint is like a rocket which describes its own space. I try to make the impossible possible. What is happening I cannot foresee; it is a surprise. Painting, like passion, is an emotion full of truth and rings a living sound like the roar coming from the lion's breast.

To paint is to destroy what preceded. I never try to make a painting, but a chunk of life. It is a scream; it is a night; it is like a child; it is a tiger behind bars.

It's like this—you are in front of your canvas, your hand holds the paint, ready, raised. The canvas waits, waits, empty and white—but all the time it knows what it wants. So—what does it want, anyway? My hand comes near, my eyes begin to transform the waiting canvas; and when—with my hand holding the paint and my eyes seeing the forms—I touch the canvas, it trembles, it comes to life. The struggle begins, to harmonize canvas, eye, hand forms. New apparitions stalk the earth.

The Condemned (c. 1953)

Not burned yet, but already stricken by the waiting for the burning, which they know, for they are prepared. The man and the woman.

Are they easy martyrs devoted to a cause that was more than they themselves? Propaganda

* Karel Appel, excerpt (c. 1953) from Hugo Claus, *Karel Appel Painter* (New York: Harry N. Abrams, 1962), n.p. By permission of the artist and the publisher.

** Karel Appel, "The Condemned" (c. 1953), in Hugo Claus, *Karel Appel Painter* (New York: Harry N. Abrams, 1962), 152. By permission of the artist and the publisher.

material? Innocents? Traitors? This came earlier, these are questions which had reason and meaning before the door of the gas chamber existed. We do not forget these questions, but they have been blazed out of urgency by the glow of the approaching destruction.

The linking of man and woman, the union of beauty and horror that meanders through a life of seventy years, is broken; a new tie (of Siamese twins) joins these gray creatures who are to meet melting and roasting. They are still united in the glorying look of the world. Together they are gyrating toward ashes. They stand erect (as if pondering the prospect of the shock of the discharge), and still their blood makes the most of it. Gray blood. The accumulation of thoughts, feelings, sensations, rank and station, heat and solitude, money and vanity, faith and repentance and evil and premonitions of bitter kindness, this accumulation is congealing in gray. The shadow of the machine has drifted past. The machine is still standing in its place. They are stretching their bodies toward it. And we, what are we doing against the violence spat out by this defenselessness? Manners and manias are wrapped round our hides so closely, so clammily, that we refuse to answer all questions. Who will help here? Nobody, unless it be all of us together. Who will change this curse? No command, unless it be yours, neighbor.

I won't touch it,
thinks the man with the summer hat.
It's not for me,
sings the hangman with the reckless air.
We have no business here,
whisper the businessmen, no debt and
no claim.
And the respected spectators know:
"We are water, they are blood."
Alone in their cage,
in the duct, in the house of warmth
which calls the heat, now hard and fast.
Alone in the marrow, alone in the
maggots,
alone in the guts.
To the hell in the hide,
to the unknown weapon,
to the boiling point and murder.

WILLEM SANDBERG When Young (1971)

when young
i was fascinated by mondrian
lost no opportunity to study his work
eagerly read all publications by the stijl group

the bauhaus also impressed me at the time
only geometric and constructive art
existed in my mind

* Willem Sandberg, "When Young" (1971), in *Cobra and Contrasts: The Winston-Malbin Collection* (Detroit: The Detroit Institute of Arts, 1974), 25–27. By permission of Helga Sandberg, Zurich, and the Detroit Institute of Arts.

when 25 years later ('45)
i became director of the stedelijk
i put a mondrian in front of me
on the whitewashed walls of my office

mondrian's atmosphere
inundated the room
a beautiful red and green bavarian cupboard
had to leave

the period chairs round the table
were replaced by simpler ones

mondrian was my answer
to the feverish mysticism
of nazi ideology

just as a swimmer in a clear stream
is cleansed of all dirt from a long dark journey
so i felt invigorated and free

yet the constant fear
of five years' occupation
the horrors of oppression and torture
could not simply be washed off

the threats had bitten too deep in our flesh
the sounds of ss boots
tramping through forlorn streets at night
kept echoing in our ears
we were liberated yet haunted still

december '45 in london
i saw picasso's war paintings
terror and hunger
reflected on the tortured face
of his friend dora maar

i immediately brought the show to amsterdam
where it greatly impressed young artists
like appel constant and lucebert

the established artists
hurried back to their easels
in order to finish the still lifes
started before the upheaval

how would the generation
matured during those critical years
react to those fearful experiences?

i stayed on the lookout
eagerly followed the experiments of youngsters
in search for the reflex of the war

in 1948
i showed sculptures by germaine richier
and bought *l'homme orage*
for the museum

shortly afterward
corneille and appel came to see me
told about the new group
founded in paris
on a terrace near notre dame

artists from occupied capitals
COpenhagen BRussels Amsterdam (cobra)
wanted to demonstrate together
their spontaneous vitality
next fall in the stedelijk:
the first cobra show!

when the exhibition was mounted
i felt enchanted:
red roaring beasts black monsters
shouting from the museum walls
frightening visitors
who had come to enjoy "fine arts"

a black cage at the entrance
hung with manifestos by writers
outcries of poets against the establishment
infuriated the critics

newspaper headlines
strongly decried the scandal:
"insanity extolled as art!"
"tumult in a museum!"

in may '68
organizing an exhibition in paris
i assisted the student protest
on the left bank
i had the feeling of reviving cobra
on an enormous scale

was the cobra movement
the prefiguration of youth protest
which took place some twenty years later?

perhaps cobra—not without reason—
started in the shadow
of notre dame!

GEORG BASELITZ Pandemonic Manifesto I, 2d Version (1961)

The poets lay in the gutter,
their bodies in the morass.
The whole nation's spittle
floating on their soup.
They have grown between mucous membranes
into the root areas of men.
Their wings did not take them to heaven—
they have dipped their feathers in blood,
did not waste a single drop while writing—
but the wind carried their songs
that unsettled the faith . . .

The poets still raise their hands. Demonstrate changes?

Embitterments, impotences and negations don't reveal themselves through gesture.—About EMBARRASSMENTS! With a final truth in discharge, having broken with all those unable to wrap art in a SMELL.

The "externals" have practised art-historical additions, have spoken persistently of final strokes, have fallen in ecstasy too rapidly, have practised mystification with a collector's passion, have advanced through artistic performances. They stretched out on white bedsheets, did not rumple the beds of the survivors, they mistrusted the remains of the last homework, did not make apparent the sticky threads and have jeered at the infertile agitations. The rest of the story are examples. Blasphemy is with us, blastogenesis (blossoming of excrescences) is with us, paleness and blue are ours. Those escaped confinement to bed, their methods of simplification carried them ever higher on the crests of the waves, they found confirmation in the rock carvings in the Sahara, in the linear constructions of Egyptian reliefs or in the lycopod woods. No salute shall greet their friendliness here!

Geniuses have stretched to the sky—buried themselves in the liquid earth. The ice has broken underneath the misty labyrinth. Those are petrified who believe in fertility, who believe in it—who deny their fathers and venerate them. Fire furrows in the ice, crystal flowers, nets of needles, starry sky broken up.

Frozen nudes with skin crusts—spilled trail of blood. Bloated and deposited friendly ones. Perspective faces drawn by the moon on the rivers, faces on which the sewage waters drip. The toad that lives and licks the saliva of the singers. Crystal mountains glowing red. Homer, the water of your eyes in the mountain lake. Caught in the flourishes of the manuals who invented the method.

Conciliatory meditation—beginning with the contemplation of the smallest toe. On the horizon, in the most distant fog, one always sees faces. Under the blanket, something is shivering and trembling, behind the curtain, someone is laughing. *You see in my eyes* nature's altar, the carnal sacrifice, remains of food in the cesspool-pan, emanations from the bedsheets, blossoms on stumps and on roots, oriental light on the pearly teeth of the belles, cartilage, negative forms, shadow stains and wax drops. Marching up of the epileptics, orchestrations of the bloated, warted, gruel-like, and jellyfish creatures, limbs and interlaced erectile tissue.

* Georg Baselitz, "Pandemonic Manifesto I, 2d Version" (1961), in *Baselitz* (London: Whitechapel Gallery, 1983), 23–24. Retranslated here by the artist. © Georg Baselitz, Derneburg.

MICHELANGELO PISTOLETTO Plexiglass (1964)

The beginning and end of this story is the wall. For it is on the wall that pictures are hung; but mirrors are fixed there, too. I believe that Man's first real figurative experience is the recognition of his own image in the mirror: the fiction which comes closest to reality. But it is not long before the reflection begins to send back the same unknowns, the same questions, the same problems, as reality itself: unknowns and questions which Man is driven to re-propose in the form of pictures.

My first "question" on canvas was the reproduction of my own image: art was only barely accepted as a second reality. For some time my work went ahead intuitively in the attempt to bring closer together the two images—the one offered by the mirror and the one I myself proposed.

The conclusion was the superimposition of the picture directly on the mirror image.

The figurative object born of this action allows me to pursue my inquiry within the picture as within life, given that the two entities are figuratively connected. I do indeed find myself inside the picture, beyond the wall which is perforated (though not, of course, in a material sense) by the mirror. On the contrary, since I cannot enter it physically, if I am to inquire into the structure of art I must make the picture move outwards into reality, creating the "fiction" of being myself "beyond the looking glass."

At the present time it is easy to play on the identity between reality-object and art-object. A "thing" is not art: the expressed idea of that same "thing" may be.

Aesthetics and reality may be mutually identified; but each remains within its own autonomous life. The one cannot replace the other unless one or other gives up its need to exist. This is why I wish to conclude this presentation of my work by returning ideally to the wall. For it is on this idea of the wall that we may conveniently "hang" the idea of the picture, and to the latter that we may link the idea of the subject. For me at this time the "thing" is the structure of figurative expression, which I have accepted as reality. The physical invasion of the picture in the real environment (bringing with it the representation of the mirror) gives me the chance to introduce myself among the broken-down elements of figuration.

R. B. KITAJ Pearldiving (1976)

The single human figure is a swell thing to draw. It seems to be almost impossible to do it as well as maybe half a dozen blokes have in the past. I'm talking about skill and imagination that can be *seen to be done*. It is, to my way of thinking and in my own experience, the most difficult thing to do really well in the whole art. You don't have to believe me. It is there that the artist truly "shows his hand" for me. It is then that I can share in the virtue of failed ambition and the downright revelation of skill. I thought it would not be such a bad idea to assemble examples of these failures, not least because one is always being told how successful this thing is, or that thing is. I can never make those judgements (about exalted colour, for instance, or boxes, or holes in the ground) as well as others can.

I have always dwelled on the life and work of Charles Péguy who was so suspicious of what

 * Michelangelo Pistoletto, "Plexiglass," in *Michelangelo Pistoletto* (Turin: Galleria Gian Enzo Sperone, 1964); reprinted in *Pistoletto: A Minus Artist* (Florence: Hopefulmonster, 1988), 10. Translation by Paul Blanchard. By permission of the author and Galleria Sperone.

 ** R.B. Kitaj, "Pearldiving," in *The Human Clay* (London: Arts Council of Great Britain, 1976), n.p. By permission of the author and the publisher.

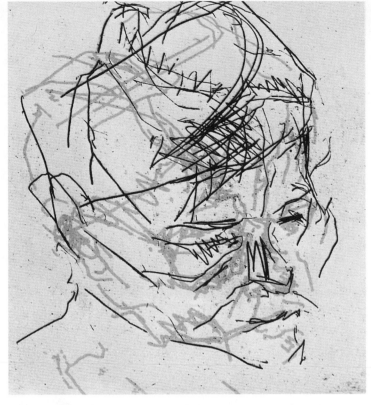

Frank Auerbach, *R. B. Kitaj,* 1980, etching. Courtesy Bernard Jacobson Gallery, London.

he called "angelism," which he thought to be the opposite of sanctity because it sought in eternal spirituality to leave the human condition behind. Like Péguy, I prefer "temporal salvation," but that leads me to make an important consideration:

It almost goes without saying, but a human image is only a part of the "sense" of a picture. It may only be like a first step. There will always be pictures whose complexity, difficulty, mystery will be ambitious enough to resemble patterns of human existence or speculative beyond what we know and expect. When I said at first that I was looking for examples of the basic art-idea, single figure invention, I do not mean to presume that a higher order is embraced there alone. In fact, the opposite may be the case for me. Ultimate skill and imagination would seem to assume a plenitude in painting when the "earthed" human image is compounded in the great compositions, enigmas, confessions, prophecies, sacraments, fragments, questions which have been and will be peculiar to the art of painting.

In Hannah Arendt's beautiful introduction to Benjamin, she likens that wonderful man to a pearl-diver who wrests what he can from the deep past, not to resuscitate the way it was and to contribute to the renewal of extinct ages, but because the rich and strange things he has found in the deep "suffer a sea-change" and survive in new form and shape. That is how I want to take human images to survive—as Arendt put it, " . . . as though they waited only for the pearl-diver who one day will come down to them and bring them up into the world of the living."

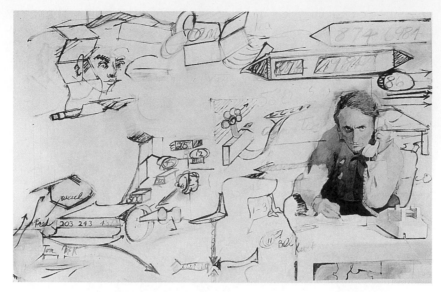

Larry Rivers, *On the Phone I,* 1981, acrylic on canvas. Art © Estate of Larry Rivers/ Licensed by VAGA, New York, NY.

DAVID HOCKNEY AND LARRY RIVERS
Beautiful or Interesting (1964)

Dear David,

We met one evening at the I.C.A. in London in May 1962. I delivered for you and some 200 others a pretty sad talk about the difficulty of recognizing "art" in my own work—my difficulty! After a lot of undressing I went on to predict that soon, by unavoidable and rapid evolution, the concerns and enthusiasm of the "young" would hardly touch me, oh and a lot more blah blah blah until the last tear. I remembered that you had very blonde hair that looked touched up and that when you were on your feet you looked down toward the floor quite a bit. Maybe my 1 hr. vaudeville routine was embarrassing. I think I was in my "I'm nothing! What is art? My enemies have been right all along and now everyone knows it and soon everyone will forget me" mood. . . . Many members of the London Art and Lit scene had already told me about how "mad and interesting" you were. . . . Kasmin, your gallery dealer, came to see me in Paris and when your name came up he just happened to have 500 photos of your work in his inside pocket. So meeting you was getting a look at the center of all these emanations. . . . After looking at these black and whites, considering our age differences and geographical dispositions, I did think that we walked the same gangplank and gang in the plank is used in the German sense of the word. AUSGANG—"the way out"—I suppose that could be a question even before the supposedly personal ones.

Did something like that pass through your mind on first looking into a Larry Rivers?

In order to make this double interview interesting for me and readable to "our vast public both here and abroad" I think our questions should go anywhere . . . anywhere and that our

* David Hockney and Larry Rivers, excerpts from "Beautiful or Interesting," *Art and Literature* 2 (Summer 1964): 94–117. By permission of the authors.

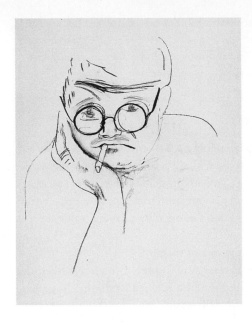

David Hockney, *Self-Portrait with Cigarette,* 1983, charcoal on paper. © David Hockney. Photo by Richard Schmidt.

natural strength and cunning combined with a sense of the absurdity of this situation will enable us to answer ANY that come along. . . .

I think you are older than you look. . . .

How old are you?

Would you prefer to have your work thought beautiful or interesting? . . .

When you are dressing for the evening in front of the mirror shaving or making your tie what are some of the things you do with your face? and what are some of the thoughts that go through your mind?

Can you think in what way these moments in front of the mirror and the things you do there (please describe) might with your translation be a factor in your work? (After all Tolstoy that marvelous heavyweight maintained a man's character develops from a reaction to his own face) and don't we agree that ART IS CHARACTER?

I have a painting of yours in mind which has on its left a male figure perhaps a magician or hypnotist. The head with eyes glaring is bent and the arms are up and thrown forward. Two inches from the outspread fingers are "rays" painted like lightning bolts which seem to be overcoming the victim on the right. I liked it. It was a curious mixture. The head of the male figure looked like something George Grosz paintings would have chosen from the bars in Berlin in the 20's.

The rest of the figure clothed in black was painted with little more than the desire to be recognized as a figure. The "rays" from the fingers were a painter's version of things we've seen all over the place: the comics, newspaper cartoons, the movies, etc. The place you chose for the pigment and the physical relationship between the various parts seemed like a sensitive digestion of certain abstract paintings but brought to a halt by the limits of your interest in the commonly experienced subject. I hope my view doesn't make you run for cover. I think I brought it up to make myself feel better about certain criticism directed at my work. . . . Don't you think we are teased into working by the desire for the physical realization of the peculiar and complicated phenomena residing in our experience???? Today's last but not least. . . . If you become conscious of what you are up to, however you conceive this and

realize you are already becoming the maker of a recognizable product do you become uncomfortable and begin looking for ways out? . . .

One more thing if you are coming east soon let me know, perhaps we can do a face-to-facer.

Larry Rivers

.

LARRY RIVERS: So now, David, it's East and we're doing a face-to-facer. This interview is very difficult—I mean, what do we accomplish? Maybe I have some curiosity for the workings of the mind of a painter whose work I feel some sympathy for, and maybe some relationship to my own work. You might have that curiosity about how someone else proceeds in the sex act, and how it compares to your own thing. I don't know if that has any value, except we can be funny about it.

DAVID HOCKNEY: You speak of painting as some sort of therapy?

LR: I don't think so. I feel miserable or happy either way. I guess I've always liked the idea of being an artist. I remember when I was young the idea seemed like a thrilling identification: Gee, I'm an artist. I liked that—maybe that's therapy. Is it?

DH: I think it's a bit like therapy for me. When I work I get carried away—when I don't, like now that I haven't done any work for more than a month, then I get pretty down. If I get working again I can forget sexy things for a while. . . .

LR: People like to think they paint because they have to paint but it might be for fifty other reasons. Now let me ask a serious-type question: would you prefer your work to be thought beautiful or interesting? To begin with would you rather it were thought beautiful?

DH: Putting it like that I think I'd rather have it thought beautiful. It sounds more final, it sounds as if it did something. Interesting sounds on its way there, whereas Beautiful can knock you out.

LR: "Beautiful" you connect with the old masters, except for someone like Bosch, sort of beautiful and interesting. I think "interesting" more like Duchamp coming along and cracking glass? You can't say that's beautiful—not in the way that Renoir's beautiful, although the idea may be.

DH: Surely it's now beautiful—first it was interesting now it's beautiful. . . .

Let's put it this way. Loads of people, particularly artists, hate pretty pictures. Now I've never met anyone who didn't like a pretty face. They don't complain that the face is too pretty, too beautiful and want something interesting. You go for the beautiful before the interesting. I don't really know what interesting means.

LR: I wonder whether when you step back and put a yellow somewhere you say, My God that's really beautiful. When I was younger that was what made me leave something. But now, it's not things looking beautiful anymore. It's particular things and it interests me because I want to do them.

DH: You asked me what I'd rather an audience thought. I think beautiful. . . .

I mean I'd rather look like a Greek god than Charles Laughton, wouldn't you?

LR: And the same thing for your work. But I must have had in mind—and there's a little spleen in it—that we are surrounded by a whole nation of artists in the other camp saying anything beautiful is soft, old-fashioned, and these sort of people are making the "interesting" works of art. . . .

Don't tell me Jackson Pollock when he put his hand on a painting thought it could

be beautiful. I think he thought leaving it might be sort of interesting. "I've put my hand on that painting"—not that he was the first to do it.

DH: Perhaps the most beautiful paintings are beautifully interesting.

LR: If you think of Titian and Michelangelo, of five centuries of work, there have been an awful lot of things that have come down to us which have been absolutely beautiful. In order to distinguish myself, in order to project myself into this history and river of art, at a certain point in my work I wanted to draw and paint like an old master. And those paintings I did to convince the whole fucking world that I could do it. All it did was to prove it wasn't so simple. . . . Whatever I do comes out of a certain choice, whereas a guy like Frank Stella— he may be very good—maybe it's beautiful and interesting, but he can never go to sleep knowing he can do the other thing—maybe it's not very important but I know that I can.

DH: I have no skill that can be measured like playing the piano.

LR: I would say that the equivalent in painting would be realism in the old master sense. . . .

DH: I tell you what I think: art schools teach the wrong things. They should teach— rendering.

LR: It's getting all mixed up now. They are inviting well-known artists to schools. I like to work with things you recognize, but there are people who have no use for it. Stella is making his line down the middle. . . . Noland doesn't. . . .

DH: You don't have to go to the class then. You don't need it. One day the guy who paints lines might suddenly not want to paint lines. Now if he had been to the rendering school. . . .

LR: The Hockney-Rivers Rendering School! I can do almost everything I want to do but I don't know how I could teach it. Technique becomes a thing like when a guy does exercises on the trumpet. I admire a man who can get around his instrument but that's only the beginning.

DH: FUCK
LR: JOHN
DH: TWO
LR: TENNIS
DH: LEGS
LR: TWO
DH: V
LR: ENGLAND
DH: NOTTING HILL
LR: CLAW
DH: LONG NAILS
LR: SEX
DH: QUEENS
LR: ENTRAILS
DH: NASTY
LR: GREENBERG
DH: ROTHKO
LR: DISCOVERY
DH: AMERICAN
LR: CAGE
DH: LIONS

LR: Now, David, are you conscious what you are up to? Are you becoming uncomfortable making a recognizable product? . . . Would you feel self-conscious repeating the same ideas? Take the work of a man like Rothko, who in the past eight or nine years hasn't changed that much. . . . You just know what to expect. Now I think he actually has got a product, a product we call a Mark Rothko. How do you feel about continuing to produce things which are supposedly David Hockneys?

DH: Rothko's a painter whose subject matter is very small—tiny—and he obviously thinks he can do everything he wants within his range and I suppose it's O.K. But I, for one, couldn't work in a range that tiny. . . .

LR: You could have an attitude that opened the range. It could make it impossible to stay within one confined area.

DH: I once painted four pictures and gave them all the same title, *Demonstrations of versatility.* They all had a sub-title and each was in a different style. Egyptian, illusionistic, flat—but looking at them later I realised the attitude is basically the same and you come to see yourself there a bit. . . .

LR: Those dedicated types who spend years of their life refining one image until it becomes more and more beautiful like a polished jewel. I don't mind that—some of those things can be marvelous, but there's something inherent in that position which critics talk about as if somehow it was a superior point of view, a more serious kind of approach. Now I'll give you a point—a painting I did in 1960, called *The Ace of Spades,* it is of an ace of spades, about six feet high; was hanging in the house of a man who collects people like Newman, Rothko, Noland. There happened to be a French painter there who people did not know knew me. A sort of spy. Greenberg, the critic then says: "Say, what's the idea of that painting? I mean, with this Rothko and Newman, what the hell's the idea of putting this thing up?" So I think the man who owned the collection says to Kenneth Noland who was there, "What do you think of it?" He said, "It's not very serious, is it?" Now I don't know whether that's true and in any case I've said things about him in the same way like that he goes from one thing to another. Now, do you feel some kind of reproach from that point of view? I mean in the presence of those kinds of works, do you feel that there is something flighty about yourself; there is something unconcentrated? Have you heard criticisms of your work where this attitude is held up against you?

DH: Oh sure, sure. I just think they're idiots and I don't bother with idiots. . . .

LR: There's one thing I want—I don't want my works to be confused with a cup. I want them to be recognizable as a work of mine not done by some artisan—this sounds snobbish—but I'd like them to be distinguishable from the objects in the world, something that is mine and different from a handle or a cup. Now, have you had any experience of that kind?

DH: Well actually it doesn't bother me. For instance I like very much Egyptian tomb paintings, that rigid style. . . . We don't know a thing about any individual artist. . . . I mean it's this anonymous style and I rather like that, and I like that thinking to rules. Tie yourself down to the rules. I suppose the modern equivalent is advertising. There are loads of people doing it and in the same *style.* . . . But things work like that in advertising, in two or three years people get bored and you have to think of something else. But it is a style people use and it's anonymous. That rather interests me a bit. I wouldn't be too worried if. . . .

LR: No one recognized it as your work?

DH: I couldn't do it really—to be honest I'd be quite pleased; but then I think I could do something in four different styles. . . .

LR: I think that is more an interesting position than the truth, because I really don't think you would do something that you weren't given the credit for.

DH: Yes—but there is a difference here in the way you paint and I paint. Often in a picture, in part of it, I've painted in a deliberately different style. To use one style here and a deliberately different style there . . . you can move within limits like in literature. . . .

LR: For instance I did some French money painting, on one side of this French money there is the Arc de Triomphe and in one of these versions of this series I rendered the Arc de Triomphe the way you would find in a kind of small-town newspaper. For a long time it bothered me, and then I said: My God, it could just be a quote! For instance if someone was writing a story they put the words of some character to give the point—so I left it in. So I don't mind doing that, but even the way you do that is purely personal. You can't do the whole of it that way, it would be giving up too much of yourself. I actually discussed this once with John Cage. He said he didn't care whether people knew it was his music or not—and I just didn't believe him.

DH: I agree with you—I wouldn't believe him—everyone has a bit of arrogance and would want to put his name down somewhere or other. If the concert was just called *Music, to be played at eight o'clock* I'd perhaps believe it. But it would take a lot of courage to do that.

LR: I think the idea is marvelous and I suppose courageous—but we can't use it, that's what it amounts to.

DH: Some arts are different perhaps—architects: some are famous, but some aren't and anyway people don't look at buildings like they look at pictures, do they? Architects don't put up a great sign saying: I did this, or a big signature in the wall. They don't do this; partly I suppose it's more functional, they're doing a job, anyway. I think artists are just that much more . . .

LR: Egocentric?

DH: Yes. Definitely more egocentric.

LR: And I suppose in the end I am more cynical. I don't think Art that important, or that beautiful or does that much for people.

LUCIAN FREUD Some Thoughts on Painting (1954)

My object in painting pictures is to try and move the senses by giving an intensification of reality. Whether this can be achieved depends on how intensely the painter understands and feels for the person or object of his choice. Because of this, painting is the only art in which the intuitive qualities of the artist may be more valuable to him than actual knowledge or intelligence.

The painter makes real to others his innermost feelings about all that he cares for. A secret becomes known to everyone who views the picture through the intensity with which it is felt. The painter must give a completely free rein to any feelings or sensations he may have and reject nothing to which he is naturally drawn. It is just this self-indulgence which acts for him as the discipline through which he discards what is inessential to him and so crystallises his tastes. A painter's tastes must grow out of what so obsesses him in life that he never has to ask himself what it is suitable for him to do in art. Only through a complete under-

* Lucian Freud, "Some Thoughts on Painting," *Encounter* III, no. I (July 1954): 23–24. By permission of the author.

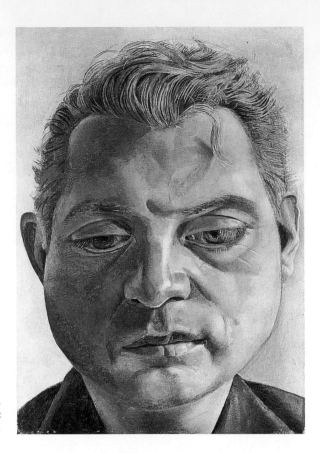

Lucian Freud, *Francis Bacon,* 1952, oil on copper. Courtesy the artist and Tate, London.

standing of his tastes can he free himself of any tendency to look at things with an eye to the way he can make them fit in with a ready-made conception. Unless this understanding is constantly alive, he will begin to see life simply as material for his particular line in art. He will look at something, and ask himself: "Can I make a picture by *me* out of this?" And so his work degenerates through no longer being the vehicle of his sensation. One might say that he has come to crystallise his art instead of his tastes, thereby insulating it from the emotion that could make it alive for others.

The painter's obsession with his subject is all that he needs to drive him to work. People are driven towards making works of art, not by familiarity with the process by which this is done, but by a necessity to communicate their feelings about the object of their choice with such intensity that these feelings become infectious. Yet the painter needs to put himself at a certain emotional distance from the subject in order to allow it to speak. He may smother it if he lets his passion for it overwhelm him while he is in the act of painting.

Painters who deny themselves the representation of life and limit their language to purely abstract forms, are depriving themselves of the possibility of provoking more than an aesthetic emotion.

Painters who use life itself as their subject-matter, working with the object in front of them, or constantly in mind, do so in order to translate life into art almost literally, as it were. The subject must be kept under closest observation: if this is done, day and night, the subject—he, she, or it—will eventually reveal the *all* without which selection itself is not possible; they will reveal it, through some and every facet of their lives or lack of life, through movements

and attitudes, through every variation from one moment to another. It is this very knowledge of life which can give art complete independence from life, an independence that is necessary because the picture in order to move us must never merely *remind* us of life, but must acquire a life of its own, precisely in order to *reflect* life. I say that one needs a complete knowledge of life in order to make the picture independent from life, because, when a painter has a distant adoration of nature, an awe of it, which stops him from examining it, he can only copy nature superficially, because he does not dare to change it.

A painter must think of everything he sees as being there entirely for his own use and pleasure. The artist who tries to serve nature is only an executive artist. And, since the model he so faithfully copies is not going to be hung up next to the picture, since the picture is going to be there on its own, it is of no interest whether it is an accurate copy of the model. Whether it will convince or not, depends entirely on what it is in itself, what is *there* to be seen. The model should only serve the very private function for the painter of providing the starting point for his excitement. The picture is *all* he feels about it, *all* he thinks worth preserving of it, *all* he invests it with. If all the qualities which a painter took from the model for his picture were really taken, no person could be painted twice.

The aura given out by a person or object is as much a part of them as their flesh. The effect that they make in space is as bound up with them as might be their colour or smell. The effect in space of two different human individuals can be as different as the effect of a candle and an electric light bulb. Therefore the painter must be as concerned with the air surrounding his subject as with that subject itself. It is through observation and perception of atmosphere that he can register the feeling that he wishes his painting to give out.

A moment of complete happiness never occurs in the creation of a work of art. The promise of it is felt in the act of creation but disappears towards the completion of the work. For it is then that the painter realises that it is only a picture he is painting. Until then he had almost dared to hope that the picture might spring to life. Were it not for this, the perfect painting might be painted, on the completion of which the painter could retire. It is this great insufficiency that drives him on. Thus the process of creation becomes necessary to the painter perhaps more than is the picture. The process in fact is habit-forming.

ROMARE BEARDEN Interview with Henri Ghent (1968)

ROMARE BEARDEN: I read a number of art books on the history of American painting and it's very seldom that Negro artists are mentioned. For instance, in my opinion, Henry O. Tanner is one of the four or five great American painters. And you never see his name mentioned. In Barbara Rose's latest book on painting from 1900 to the present nowhere is Tanner mentioned. And he's a better painter than Glackens or Prendergast; especially his late paintings, the ones he did in the late 20's and 30's, the small thing; Mert Simpson has a number of them. Only Rouault is comparable. . . . I don't think she [Rose] did it [not mentioning African American artists] out of any feeling that, well, I'm prejudiced and I'm not going to mention any. It's just not in the consciousness of a lot of people who are writing these things.

HENRI GHENT: Why do you think this is so?

* Henri Ghent, excerpts from transcript of an interview with Romare Bearden for the Archives of American Art, 29 June 1968. Microfilm reel 3196, Archives of American Art, Smithsonian Institution. By permission of the interviewer, the Estate of Romare Bearden, and the Archives of American Art.

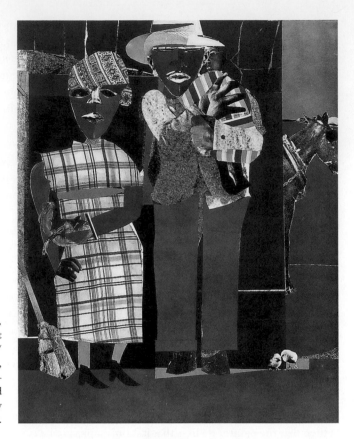

Romare Bearden, *Continuities*, 1969, collage on canvas. Art © Romare Bearden Foundation/ Licensed by VAGA, New York, NY. Photo by Colin Rae. Courtesy Berkeley Art Museum and Pacific Film Archive, University of California, Berkeley.

RB: I couldn't give a definite answer. But I think that Negroes themselves have to encourage, should have the same interest in artists that they might have in Negro basketball and baseball players—or now in politics and other things. This has to be pushed the same way. Just as I made the statement about Tanner. Maybe that would call someone's attention to him and they would really look into what this man accomplished. El Greco remained forgotten for three or four hundred years until around the turn of this century when he was rediscovered as one of the great masters of Baroque painting. So it's the same. Nor is the Negro ever equated in many of the paintings that I've mentioned in abstract expressionism. In this magazine which I received in the Archives it said "Finally America arrives in the abstract expressionist painting." But no one when you stop to think has ever equated abstract expressionism as a movement with jazz music. It's based on improvisation. The rhythms, the personal involvement all of this is part of the jazz experience. And many of the abstract expressionists would often play jazz music while they were painting, or at least were very interested in that art form. But here is an avenue I imagine that Negro critics themselves as they get into it are going to have to explore and open up these new dimensions to people. . . .

HG: Do you think that the Negro should now direct his efforts to the black community? That is, by exhibiting exclusively in black communities, colleges, universities, et cetera.

RB: Well, I don't think that this should be exclusively done but since so little of it has been done before I think that a great deal of effort should be made in this direction to make the communities, to use a cliché, more art conscious, or more aware of the Negro artist. And I think that in time this will make for a better artist because the artist can learn some of the feelings of the community about his work. To make an artist you need many hands and all

working together can make for something very meaningful. The Negro artists of the nineteenth century were not, you might say, Negro artists at all. They were people who were Negroes and artists and most of them lived abroad and their work was directed not to Negroes primarily or with the Negro in mind, but it was directed, like that of other American artists, to the patrons of art. This is what I mentioned earlier about Courbet. He thought about these things: to whom his work would be directed, and something about the social responsibilities of artists. This was a consideration of his and I think in a way that this is why I revere Courbet. And certainly I think this is part of the thing that the Negro artist has to do. And with that I don't think that the Negro community then should be exposed just to Negro artists, but that they begin to be involved in all of art, that they will see Egyptian art, that they will be acquainted then with African sculpture, and involved in a number of artistic experiences. . . .

Now, if I'm doing a collage, after I put down these rectangles I might paste a photograph, say, anything just to get me started, maybe a head, at certain—a few—places in the canvas that I've started. The type of photograph doesn't matter at all because this is going to be a hand or a little landscape that I put down just to get me started. As Delacroix said, a painting or drawing is developed by first putting down something and then the superimposition of ever more definite statements. That's how I start this thing: rectangles, pasting on this, and the superimposition of ever more definite statements. Now when I put this paper or the photograph on I try to move up and across the canvas, always moving up and across. If I tear anything I tear it up and across. What I'm trying to do then is establish a vertical and a horizontal control of the canvas. I don't like to get into too many slanting movements. When I do I regard this as a tilted rectangle and I try to find something that compensates right away for a slant or a tilt or a diagonal movement on the canvas. I like the language of what I'm trying to do to be as classical as possible but I don't want complete reductionism like a Malevich or white on white where you end up with an empty canvas. I am interested in flat painting and the things I told you that I studied—the Dutch, the early Sienese, or Byzantine painters; the great exponents of flat painting. Moreover I try to incorporate some of the techniques of documentary film or the camera eye into the art of painting. A lot of people have said to me that my use of overlapping planes and this flat space is similar to Cubism. Which is true. But however in the actual process of my composition I find myself as much involved with the methods of Dutchmen like de Hooch and Vermeer that I've mentioned as I do with any of the Cubists. What I like most about Cubism is this emphasis on the essentials of painting. And what I don't like about Cubism is I feel that a lot of it overcrowds the space. That is what sent me back to the Dutchmen, to the emphasis on this rectangle where I can stress these great vacant areas of the plane against the things that are busy—as in some of Picasso's collage drawings; or, of course, the work I told you I like so much, the Cubism and neo-plastic work of Mondrian. Of course, in a lot of the things that I have done like my crowded urban street scenes with a lot of people in them and a multiplicity of images I have tried to find other ways to get this plasticity that I want with my liking for the flat painting and the classical manner. Now also involved is the interplay between the photograph and the actual painting and I constantly find myself adjusting my color to the gray of the photograph so that there won't be too much disparity in color between them. However, I found that even in spite of the fact that I have to restrict my color, that just using a few colors can give me quite a range. For instance, in the Pompeian paintings they just used a red, a gray, and a black, and a few other colors; yet you feel the full range of color in those great paintings. In other words, what I try to do is relate all my colors to gray and then put in in a few places a few dissonant accents. I also have found that too bright a color—like in Art Nouveau and the

rest—after a while these color harmonies that seemed so interesting at first begin to wear, and what stands up the longest almost are paintings where you feel the absence of color. Like the Chinese paintings, done with just washes of gray or a very little touch of color. Or the paintings of Zurbaran in gray, you know, where you don't tire of a color harmony. And I also find that I'm constantly adjusting my color to things that I paint; bright sections of color and also the photographs that I will use—all this must be related so you feel that a harmony has been arrived at. Now I think that some of the things that underlie my process is the fact that a photographic image when it's taken out of its original content and put in a different space than you saw it in the magazine can have another meaning entirely. And then a work of art is not life itself. There's a certain artificiality about it and by cultivating the artificiality, or, in other words, by cultivating what is art, you make what you're doing seem more real. And so while my initial thing has been one of shock . . . to a lot of people, I think that other people upon reflection have found a great deal of artistic merit in the work, and often a great deal of social meaning other than what I actually attempted to put into the work itself.

ALICE NEEL Art Is a Form of History: Interview with Patricia Hills (1983)

Art is a form of history. That's only part of its function. But when I paint people, guess what I try for? Two things. One is the complete person. I used to blame myself for that, do you know why? Because Picasso had so many generalities. And mine were all—mostly a specific person. I think it was Shelley who said: "A poem is a moment's monument." Now, a painting is that, plus the fact that it is also the Zeitgeist, the spirit of the age. You see, I think one of the things I should be given credit for is that at the age of eighty-two I think I still produce definitive pictures with the feel of the era. Like the one of Richard, you know; caught in a block of ice—Richard in the Era of the Corporation. And these other eras are different eras. Like the '60s was the student revolution era. Up until now, I've managed to be able to reflect the Zeitgeist of all these different eras.

I see artists drop in every decade. They drop and they never get beyond there. That was one of the things wrong with the WPA show at Parsons in November, 1977. Hilton Kramer's attitude toward that show was absurd. You can't dismiss the Great Depression as having very little importance. He flattered me. He said at least I didn't join the crowd and do just the same thing they were all doing. He was right, in a way. Those people dropped, back in the '30s, and they never got over it. Many artists developed an attitude and a technique, and they never changed. Even though the world changed drastically, they kept right on doing the same thing.

The thing that always made me happiest in the world was to paint a good picture. It had nothing to do with selling it. Since I was so tied down, I thought it was all right, if you paint a good picture, to just put it on a shelf. I got so discouraged. I'm no good in the commercial world. I never was. But it's not all right. When I give lectures to these young people—for instance in Baltimore I was once on a symposium, and all they wanted to do was "to make it." And I said to them: "Don't you know that before you make it, you have to have something to make it with. I think to go to New York and SoHo right off is absurd; you should shop around yourself, see what it is. See what your art is, and then when you think you've made some discovery, go in and do it. But don't do like me, don't just put it on a shelf."

All experience is great providing you live through it. I would tell these classes of art stu-

* Patricia Hills, excerpts from an interview with Alice Neel, in Hills, *Alice Neel* (New York: Harry N. Abrams, 1983), 179–85. By permission of the publisher.

dents, the more experience you get, the better, if it doesn't kill you. But if it kills you, you've gone too far. That's all. You never learn anything like you learn it by experiencing it.

I even identified art with religion—when you just gave up everything for art. You gave up clothes, you gave up comfort, you gave up well-being, you gave up everything for art.

You know what art is? Art is a philosophy, and it's a great communication. I just saw George Segal lately. He has such a playful attitude toward art. He said he had fun doing something. And I can't remember ever having fun doing anything.

The hardest thing for me to accept is change all the time. The human race wants something they never can get: security. They can get relative security, you know. But everything keeps changing.

The favorite author of Georg Lukács was Thomas Mann, because Mann could see how sick the world was. But the sickness has now been transformed into junkiness. You see, the character of this era is its utter lack of values.

I have an intellect, so in between painting I know all the theory and I do have theories. But I never think of a theory when I work. You know what I enjoy almost the most of anything? Dividing up the canvas. When I was in high school I was very good at mathematics, and I love dividing up canvases. And then I don't want to clutter my mind with theories because I think theories, when you're working, hold you back. Because you try to get it into a Procrustean theory and it doesn't fit there. So you should just let yourself go in direct contact with what you see.

Art is two things: a search for a road and a search for freedom. It's very hard to get freedom. You know all these things in life keep crawling over you all the time, so it's very hard to feel free.

A good portrait of mine has even more than just the accurate features. It has some other thing. If I have any talent in relation to people, apart from planning the whole canvas, it is my identification with them. I get so identified when I paint them, when they go home I feel frightful. I have no self—I've gone into this other person. And by doing that, there's a kind of something I get that other artists don't get. Patricia Bailey said in a review of my exhibition at Graham in 1980: "Her work has been a way of diminishing her personal sense of separation from life." That's right. It is my way of overcoming the alienation. It's my ticket to reality. . . .

I could accept any humiliation myself, but my pure area was art, and there it was the truth. I told the truth the best I was able. I think that the best art is the art that makes the truest statement of when it was existing, both aesthetic, and political, and everything. For when it was existing Lenin preferred Balzac to any other Western writer because Balzac realized the importance of money and trade in life. Do you know *The Human Comedy*—about young men from the provinces who go to Paris to make their fortune? That is really what life is—*The Human Comedy*. And put together, that's what my paintings are.

Now, it's a dangerous thing that Claes Oldenburg got so famous just doing gadgets. That lipstick in front of Yale. It's the vulgarity of America that can be translated into just gadgets or just technique. It's pragmatism. William James. The fundamental philosophy of America.

We are a gadget-ridden people. But not that much. Not that much, because there are still people with souls. We cannot reduce ourselves to just a gadget. That will have a big fad for a while, because it's something new. And also it falls into that big pot out of which everything comes, and by which everybody is influenced. . . .

It's [Truth is] just my first principle. And somebody said to me: "But that's your subjective truth." And I said to them: "But I wouldn't have gotten so famous for my so-called subjective truth if it hadn't been in some way matched up with what is so, you know."

I think Chaim Soutine is great, but in one way he's an old-fashioned artist. He was so

ridden by his own vision that he did not see objective reality. Soutine is a very strange genius. He was duped by his own emotions. He could only do what he could do. He has a landscape where the whole thing is falling down. It's like a mental state. And yet it's a landscape and it's wonderful. Now Goya, though, saw objective reality much more than Soutine.

There is another thing about Soutine I didn't like. He still belonged to the generation who worked inside the frame. My painting always includes the frame as part of the composition. Soutine is just like Rembrandt, inside the frame.

Edvard Munch is a genius, too. They are the people I love: Goya, Soutine, Munch. But Munch I never saw in the beginning. I did a painting, and you'll swear that I was influenced by Munch, but I hadn't even heard of him yet.

I have a touch of Expressionism, but it never crosses out the analytical completely.

When I got psyched, my analyst said to me: "Why is it so important to be so honest in art?" I said: "It's not so important, it's just a privilege."

You know what Tom Paine said: "These are the times that try men's souls." Yes, sure, fair weather and winter soldiers. And you know what Thomas Jefferson said: "Ever so often, the tree of liberty must be watered by the blood of tyrants." That's nice, too, isn't it? . . .

I do not know if the truth that I have told will benefit the world in any way. I managed to do it at great cost to myself and perhaps to others. It is hard to go against the tide of one's time, milieu, and position. But at least I tried to reflect innocently the twentieth century and my feelings and perceptions as a girl and a woman. Not that I felt they were all that different from men's.

I did this at the expense of untold humiliations, but at least after my fashion I told the truth as I perceived it, and, considering the way one is bombarded by reality, did the best and most honest art of which I was capable.

I always was much more truthful and courageous on canvas.

I felt that profundity in art was the result of suffering and deprivation—but I am not sure that this is so.

Every person is a new universe unique with its own laws emphasizing some belief or phase of life immersed in time and rapidly passing by. Death, the great void of life, hangs over everyone.

I love, fear, and respect people and their struggle, especially in the rat race we live in today, becoming every moment fiercer, attaining epic proportions where murder and annihilation are the end.

I am psychologically involved and believe no matter how much we are overcome by our own advertising and commodities, man himself makes the world.

PHILIP PEARLSTEIN
Figure Paintings Today Are Not Made in Heaven (1962)

It seems madness on the part of any painter educated in the twentieth-century modes of picture-making to take as his subject the naked human figure, conceived as a self-contained entity possessed of its own dignity, existing in an inhabitable space, viewed from a single vantage point. For as artists we are too ambitious and conscious of too many levels of mean-

* Philip Pearlstein, "Figure Paintings Today Are Not Made in Heaven," *Art News* 61, no. 4 (Summer 1962): 39, 51–52. By permission of the author and the publisher. © 1962 ARTnews, LLC, Summer.

ing. The description of the surface of things seems unworthy. Most of us would rather be Freudian, Jungian, Joycean and portray the human by implication rather than imitation.

To many artists, Mondrian's late paintings are as close to describing nature and life forces as we should get. The Expressionist element in Abstract-Expressionism involves as much human emotion as is necessary, while a hard-edged stripe on a flat background is a mirror of the soul. "Anti-art" junk is an accurate description of our environment, and Happenings depict our states of mind.

Yet there will always be those who want to make paintings of the human form with its parts all where they should be, in spite of Progress.

Two tyrannies impose themselves on the artist who would try. One is the concept of the flat picture plane; the other may be termed the "roving point-of-view." Both have radically changed our way of seeing pictures and have conditioned those values that lead us to judge what a "convincing painting" is. We all bow low to them for it seems that we cannot overthrow them. But our battles with them sometimes produce paintings that are exciting in the resulting tensions. Unfortunately, too many easy compromises are being applauded in certain fashionable quarters. . . .

The game of painting the human figure today can be meaningful only if one deals squarely with the rules imposed on our sensibilities by our artistic progenitors. The greatest tyranny bequeathed us by the artists of the late nineteenth century is the sacrosanct concept of the flat picture plane. Among them, Gauguin, Seurat and Cézanne set up the major technical devices of twentieth-century painting which allow the flat surface to dominate. Gauguin reduced both form and environmental space to flat areas of color, the colors valued more for symbolism than illusionism. Seurat's solution, especially in his last works, was to place so strong an emphasis on the geometric scheme by which he divided the rectangle of the picture plane that, like the fifteenth-century Uccello and Piero, he created a mosaic of clearly outlined forms and spaces. While these are intelligible as volumetric figures in hollow spaces, they are essentially non-illusionistic in treatment.

Cézanne devised a system, most successful in his drawings and watercolors, of defining forms by indicating only the areas where two forms overlap in space. He created a kind of blueprint of spatial relationships; without describing the continuous surface of forms, he delineated only enough of the contours of forms to make them readable, leaving most of the paper blank. Though Cézanne's working method has proved fruitful, prefiguring Analytic Cubism, the "Plus-Minus" works of Mondrian and the drawings of Giacometti, it was his verbal dictums about geometry in nature that coalesced with the direction of Seurat and Gauguin to lead to the usual avant-garde insistence on flat geometry lying on flat picture planes.

Gauguin and his contemporaries reacted against the degenerate end of the illusionistic tradition that had passed its peak before the eighteenth century. Today we are shackled by their now seventy-year-old reaction.

A moralistic ban has been placed on spatial illusionism. But it is an arbitrary ban. The flatness of the picture plane is no more a truth than was the flatness of the world before Columbus. It's all a matter of how you look at it. . . .

The second great tyranny can be termed the "roving point-of-view," in contrast to the single vantage point determined by Brunelleschi around 1420. The late nineteenth century taught us that reality consists of constant change. As we move, the objects around us seem to change position; the world moves and things are constantly revealed in new aspects. Our visual experiences are usually cinematic sequences of not necessarily related views of details.

The Impressionists, Cubists and Futurists were all excruciatingly aware of this kinetic experience of reality and taught us ways of projecting it onto canvas. And the early Abstract-Expressionists taught us how to achieve this sense of swift urgent movement through paint forms alone, without reference to the objective world. Today it seems impossible to paint a canvas that is not conceived as a total field of action. . . .

Actually the roving point-of-view is the most venerable in history. In all primitive art, and such pictographic forms as Egyptian art, each represented element is viewed as if directly ahead. Only the proximity of the elements within a limited field relates them to one another. But even in Roman and early Renaissance attempts at illusionism, architectural groupings that are convincing at first glance, in their perspective construction, soon reveal details, balconies, windows and doors that recede at different angles from the walls they are part of, because each detail was seen for itself, not as part of a co-ordinated whole. It was Brunelleschi's invention of vanishing points located along a single horizon line in the picture that put spatial illusionism on the highway to the supreme single-vantage-point composition of Velázquez' *Las Meninas.* Seurat's *La Grande Jatte* disrupted the smooth ride. Picasso's *Les Demoiselles d'Avignon* blew up the roadbed. De Kooning's *Women* series, the image of the figure in the 1950s most acceptable to the avant-garde, was the end result. . . .

The naked human body is the most familiar of mental images, but we only think we know it. Our everyday factual view is of the clothed body, and on those occasions when our dirty mind will strip a person, it will see something idealized. Only the mature artist who works from a model is capable of seeing the body for itself, only he has the opportunity for prolonged viewing. If he brings along his remembered anatomy lessons, his vision will be confused. What he actually sees is a fascinating kaleidoscope of forms; these forms, arranged in a particular position in space, constantly assume other dimensions, other contours, and reveal other surfaces with the breathing, twitching, muscular tensing and relaxation of the model, and with the slightest change in viewing position of the observer's eyes. Each movement changes as well the way the form is revealed by light: the shadows, reflections and local colors are in constant flux. The relationship of the forms and colors of the figure to those of the background becomes mobile and tenuous. New sets of relationships continuously reveal themselves.

This experience in seeing can be as hypnotic as the swaying head of a cobra about to strike, and, if the artist so chooses, success in making some kind of faithful record of this experience can seem to be as important as it would be to avoid the cobra's strike. The experience, in fact, approaches the total identification with the image that the Indian artist achieved.

The rules of the game are determined when the artist decides what kind of faithful record of which aspect of the experience shall be made. For, regrettably, the artist cannot transmit the total experience. The displayed forms themselves become only a point of departure. While remaining faithful to his intention to record his visual experience, the artist working from a model is guided by his particular interests to concentrate on the forms, or on their spatial relationships, or on light or color. These interests tend to be mutually exclusive. The space interests of Charles Cajori, for example, are in no way related to the light and color interests of Paul Georges or Fairfield Porter. The paintings transcend mere description when these interests are intensely pursued. The paintings become explorations conducted in the full knowledge of the complex esthetic we have inherited. Today we cannot pretend to the innocence of earlier American realist artists who tended simply to ignore the inventions of twentieth-century painting. Nor does the problem relate to the visionary use of the human image made by such artists as Leonard Haskin who are involved more in meanings than in the process of picture-making.

The character of a work of art results from the technical devices used to form it, and the ultimate meaning and value of a work of art lie in the degree of technical accomplishment. The most fascinating subject matter becomes meaningless if the level of technical achievement is low, while a painting trite in subject becomes profound if a technical challenge has been met. As an artist I can accept no other basis for value judgments. Therefore, I am amazed when a distinguished abstract artist lumps together such divergent painters as Bischoff, Katz, and Lester Johnson, and dismisses them as "photographic." I see each as entirely different from the others: Bischoff paints dazzling displays of paint, Johnson paints generalized ideograms of figures, Katz portrays specific persons. My appraisal of their accomplishment depends on my interpretation of their working premise. Have they fought a good fight?

In the battle of painting the figure, to pry open the flat picture plane and control the roving eye, the weapons must be chosen carefully and wielded skillfully. A human being, a profound entity, is to be represented.

CHUCK CLOSE Interview with Cindy Nemser (1970)

CINDY NEMSER: Why did you decide to make photographic rather than life studies the subjects of your paintings?

CHUCK CLOSE: The decision evolved partly out of a problem I had with making a painting about how my eyes focused on a still life. When I focused on the pitcher in the foreground, it was sharp. Then when I looked at the drapery behind the pitcher it was in sharp focus, too. No matter where I looked all parts of the still life seemed to have equal focus. Now I knew this phenomenon was not true of natural vision since peripheral vision is always blurred. Suddenly it occurred to me that if I was really interested in the problem of focus, the best thing was to work from a photograph where all the information was nailed down and I could focus on blurred as well as sharp information.

CN: What made you choose photographs of heads?

CC: First of all, let me tell you the reasons that are *not* behind my decisions. I am not trying to make facsimiles of photographs. Neither am I interested in the icon of the head as a total image. I don't want the viewer to see the whole head at once and assume that that's the most important aspect of my painting. I am not making Pop personality posters like the ones they sell in the Village. That's why I choose to do portraits of my friends—individuals that most people will not recognize. I don't want the viewer to recognize the head of Castro and think he has understood my work.

CN: Well, if you are not interested in the humanistic aspect of the head, what are your faces all about?

CC: They have to do with the way a camera sees as opposed to the way the eye sees and with the look of a small photograph. My main objective is to translate photographic information into paint information.

CN: Could you clarify that statement?

CC: The camera is objective. When it records a face it can't make any hierarchical decisions about a nose being more important than a cheek. The camera is not aware of what it is

* Cindy Nemser, "Chuck Close: Interview with Cindy Nemser," *Artforum* 8, no. 5 (January 1970): 51–55. By permission of the interviewer, the artist, and the publisher.

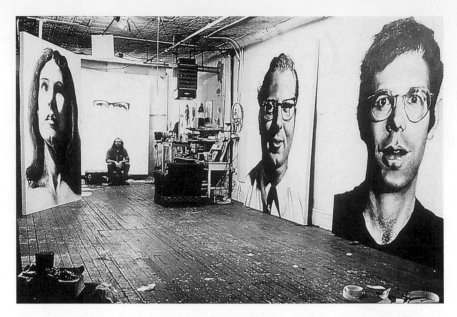

Chuck Close in his studio with (left to right): *Nancy,* 1968; *Keith,* 1970 (in process); *Joe,* 1969; and *Bob,* 1970 (all acrylic on canvas). © Chuck Close. Photo by Wayne Hollingsworth. Courtesy Pace Gallery, New York.

looking at. It just gets it all down. I want to deal with the image it has recorded which is black and white, two-dimensional, and loaded with surface detail.

CN: You know the camera can be manipulated too. Lenses can be changed and the amount of light adjusted.

CC: Right—but I never said the camera was truth. It is, however, a more accurate and more objective way of seeing.

CN: If your primary concern is dealing with photographic information, from a small photograph, why are your paintings so gigantic?

CC: The large scale allows me to deal with information that is overlooked in an eight-by-ten inch photograph without becoming excessively fussy. The large scale forces the viewer to read the surface of the painting differently. He has to scan the painting and look at it piece by piece in order to arrive at a feeling of the total head. It makes it difficult for the viewer to see the head as one whole image. In certain ways my work is related to that of the caricaturist who exaggerates particular differences between people to the point that one cannot ignore specific characteristics of the individual head.

CN: But, you are most concerned with sticking to a strict transmission of photographic fact.

CC: Yes, but to some extent I contradict this direct translation by blowing up my image. It is so large that it is impossible to ignore differences in features. Now a nose is not bent a fraction of an inch, but several inches. You can't ignore acne if it's spread out over three or four inches.

My large scale forces the viewer to focus on one area at a time. In that way he is made aware of the blurred areas that are seen with peripheral vision. Normally we never take those peripheral areas into account. When we focus on an area it is sharp. As we turn our

attention to adjacent areas they sharpen up too. In my work, the blurred areas don't come into focus, but they are too large to be ignored.

CN: Anton Ehrenzweig states that we are indebted to the artists past and present (and today also to the art of photography) for the limited awareness of perceptive distortions and chiaroscuro distortions of tone we now possess. Do you feel your paintings are adding to our perceptual knowledge?

CC: I don't know if I'm supplying any totally new information or whether it's just putting the focus on a new aspect of that information. You certainly know something about a forest by flying over it in an airplane, but it's not the same information you would get if you go through the forest and bump into the trees. In viewing my work, you can, by stepping back and looking at my paintings, get pretty much the standard, normal understanding of a head as a whole image. However, by including all the little surface details and enlarging them to the point that they cannot be overlooked, the viewer cannot help but scan the surface of the head a piece at a time. Hopefully, he gets a deeper knowledge of the forest by knowing what the individual trees look like.

CN: Scale is an important means for you to transmit photographic images into paint images. What other methods do you use to make this transformation?

CC: In order to come up with a mark-making technique which would make painting information stack up with photographic information, I tried to purge my work of as much of the baggage of traditional portrait painting as I could. To avoid a painterly brush stroke and surface, I use some pretty devious means, such as razor blades, electric drills and airbrushes. I also work as thinly as possible and I don't use white paint as it tends to build up and become chalky and opaque. In fact, in a nine-by-seven foot picture, I only use a couple of tablespoons of black paint to cover the entire canvas. I also have eliminated color from my work as it has too many associations with traditional Western art. However, I do intend to use color photographs as subjects in the future.

CN: Why did you feel it was necessary to eliminate so many elements from your paintings?

CC: I wanted to get past my own and the viewer's preconceived ideas as to what a painted head looks like. I don't want handed down, traditional concepts to interfere with the content of my work.

CN: Considering the size of your canvases, how do you establish the focus of your paintings?

CC: I start a painting by dealing with something that is in very sharp focus. This section will establish the focus for the rest of the work. From there, I move on to adjacent areas and establish the focus as I go. I rough in the greys till I see how the focus reads and gradually take it darker and darker. That's the advantage of spraying—you can get darker and darker in little jumps. The technique lends itself to a gradual transition of values from light to dark.

CN: With such large paintings, it must be hard to keep the tonalities and surface treatment consistent. . . . Don't you step back from time to time to see what is happening?

CC: No. I work very close and seldom step back as I'm not interested in the gestalt of the whole head but rather in getting involved in the process of translating its photographic parts into paint and blowing it up. I'm trying to find a way to get very small marks to become very big marks and read.

CN: You're almost a pointillist on a grand scale.

CC: Yes. Except that I'm much more interested in the kind of image produced by the photographic printing process than in the kind of image produced by the pointillism of Seurat.

The surface of a photographic image is so consistent and yet the dots of which it consists have nothing to do with the images they project.

CN: Why is the consistency of the surface so important to your work?

CC: If the surface information is consistent enough then the surface of the painting will disappear. Inconsistency draws attention to the surface itself and again interferes with the content of the work. It seems to me that the lesser Abstract Expressionists were so concerned with imitating the surface of Abstract Expressionist paintings, getting drips and splashes of color, that they could never get beyond the surface of the paint. The more important Abstract Expressionists never allow you to stop at the surface and look at the paint. Their painting marks always stacked up on some level to mean something else.

CN: What about other artists who work from photographs?

CC: Most of them have similar problems. In copying a flat surface, they get so involved with it that they can't get beyond it. I could never work like those artists who turn their photographs upside down and paint square by square. Their work becomes strictly a surface translation and because it's too difficult to sustain a consistent attitude towards a surface alone, some of the areas are painted differently from others. Then they call attention to themselves and the surface of the painting. They say, "Look at me—see how beautifully I'm painted."

CN: But you do not concern yourself with the image as a whole either. You also work from piece to piece and let the work grow out of the process.

CC: True, but even if I don't know what the finished painting will look like exactly, I'm still not going to stray too far from the information in the picture. After all, those big heads are real people from which the camera gets certain information.

CN: Then you would agree with E. H. Gombrich when he says that " . . . the problem of illusionist art is not that of forgetting what we know about the world. It is rather inventing compositions that work"?

CC: Exactly. I'm very interested in a nose as a shape. I'm also interested in its edges and the surface information scattered across it. Nevertheless, no matter how nice the shape or the tone, or how interesting the distribution of its surface information, if it's not like a nose and more specifically a particular person's nose, then it's wrong. That's one of the reasons I paint my friends' faces. They are yardsticks which help me to measure how well my marks read.

CN: Then capturing a likeness is an important part of your work?

CC: Well, I'm making a translation, and I want it to be as accurate as possible.

CN: Are there any artists working today whose art particularly interests you?

CC: It seems to me that the most serious work being done today is not figurative. Stella, Noland, Judd, Serra, Morris, Sonnier, and Saret are some of the painters and sculptors I most respect.

CN: Do you think that your work is related to theirs in any way?

CC: Yes. Even though my work looks very different, I feel a kinship with those artists who have rid themselves of painterly language, who have taken the sculpture off its pedestal, and who have allowed material to flop around on the floor. Like them, I am also more concerned with the process of transmitting information than in filling out a check list of the ingredients a portrait painting is supposed to contain. I too want to strip the viewer of the comfort of thinking that the traditional concepts of art he has been dragging around are automatically going to make him understand what art today is all about.

CN: But as a realistic artist don't you feel any kinship with other figurative artists?

CC: I have very little sympathy or interest in the figurative art being shown today, and I object to the lumping together of everybody who works from life or from photographs

under the title of realism or superrealism. The term is too vague and I see very few common denominators.

CN: But you still choose to make your statements via realistic images. How do you reconcile that fact with your antipathy towards realistic art?

CC: Don't get me wrong. I don't dislike the notion of figurative art, and I think it would be very wrong to conclude that the figure as a valid art form is no longer viable. However, I think it is useless to try and revive figurative art by pumping it full of outworn humanist notions.

CN: Well, if you see no hope for a return to the figure on a humanist basis, what importance does the figure have for you in terms of today's art?

CC: It seems to me that the figure can be used as a new source of information, but only if new devices and techniques are found which will bring another focus on it through new ways of realizing form. Without fulfilling this prerequisite, there is no chance for fresh figure painting no matter how many "return to the figure" exhibitions are assembled by basically anti-avant-garde museum curators or critics.

CN: What do you think are the necessary conditions to encourage a rebirth of figurative art?

CC: I believe that if the people who care to work with figuration could be left alone to work out their own problems, we may yet see some worthwhile art.

RICHARD ESTES Interview with Herbert Raymond (1974)

RICHARD ESTES: I always do an acrylic underpainting because I find it very easy to work with, because you can make a lot of changes. . . . But I find it very difficult to get a real finish with acrylic. It's not so much the blending, but just the colours; they don't seem to have the brilliance the oil paints have, the depth which you can get with oils. You can glaze, you can get finer details with the oil. It's really a superior technique to the acrylic. But acrylic is good just for a rough start. . . .

I've used air-brush, occasionally . . . I've had an awful lot of success with air-brush, there are some effects that you can get with air-brush that makes it worth while but I'd never consider painting a whole picture with an air brush. It's good for a very misty film over a layer of paint or something like that. You can get a more subtle blending with a brush. . . .

HERBERT RAYMOND: I want to get back to the kind of thing you were doing in advertising that may have influenced the painting.

RE: Well, I just did lay-outs mostly. These very quick magic-marker lay-outs . . . sketches of cars, of electric power plants, things like that, so maybe I was looking at a lot of these objects that you don't really look at in art museums or if you're art oriented too much you tend to ignore. . . .

HR: I'm curious about this working in the area between illusion and the objectness of the painting. . . . You said that a photo was not sufficiently an object. What is it about a painting that is more like a thing?

* Herbert Raymond, excerpts from "Richard Estes: Interview with Herbert Raymond," *Art and Artists* 9, no. 5 (August 1974): 24–29. By permission of the artist. Estes began the interview by recalling having seen things by Malcolm Morley in art magazines.

RE: I don't know exactly. Maybe there are hundreds of devices you can use to do that. You can probably do it with a photo too, if it's just the right print. But the object, it comes from all the old tricks of the painter, the tricks of the trade. The way you compose and design and relate things to one another, all the devices you can use to unify the picture.

HR: It seems to me some of the newer realists have spoken about anti-design or anticompositional qualities in their work, the accidental. Is that true for you?

RE: It's not true for me. I think they're probably saying things that they think sound like something they should say rather than what they really do. That's the trouble with talking about art, you throw all these words around and it can really muddy up things a bit. I rather suspect that most artists really don't know what they're doing in a verbal sense. I may say one thing to you and next month I'll say something different to somebody else. I don't think that I've changed, it's just that the words are different. Picasso refused to have interviews because he never really wanted to talk too much about it. Because he said that if he could do it in words he wouldn't bother painting a picture. . . .

I think it's a mistake to try and make everybody appreciate art, too. I think there are just some people that are tuned in to art and they don't have to be told anything about it and then other people that you can talk to till doom's day and they would never understand it. . . .

HR: Do you feel this kind of work is specifically American?

RE: It's unpremeditated. You don't think about making it American, it's just natural that it should be American. I don't really limit myself to American things. I don't see any reason why I shouldn't do anything that's interesting, no matter where it's at. . . .

Well, you just can't do something that's been done before. You can't do another Mona Lisa. No matter how beautiful it is it just can't be re-painted. It probably shouldn't even be looked at for 50 years because it can't even be seen any more. Ivan Karp once said that they should take the Mona Lisa and turn it to the wall and not let anybody see it for 50 years because the poor painting's tired of being looked at. It needs a rest.

HR: I suppose every new vision is an anti-poetic vision in terms of what had gone previously. It is a new poetry and there's something harsh about it. . . . Is that something of the excitement you feel about looking at and rendering those things that have been previously overlooked?

RE: That's part of it—and also everything that's happened before has a certain influence. You may not see it so much but, as far as 20th century artists are concerned . . . cubism . . . abstract expressionism they all narrowed down the picture plane to a certain extent and in a way this sort of opened up a possibility of a kind of painting. Something like this which, because of the reflections and things, sort of destroys that picture-box type—looking through a window type—vision and becomes more of a narrow or shallow picture plane. The painting is not flat, is not two-dimensional, it's sort of in a shallow plane—various planes overlapping a shallow area. . . .

HR: I sense a certain kinship between your work and the French new novelists and filmmakers like Godard—people who have made a very strong effort to eliminate the self as a feeling subject.

RE: That whole conflict was always in art; between Ingres and Delacroix you had the same thing working at the same time. There were these two feelings in art. . . .

HR: What kind of thing were you doing in school?

RE: Just the usual thing. Figures—they have the model and you just paint, nudes. Go to the art students' league and see exactly what I was doing. . . . I think it's a very good thing.

If I were ever going to teach a class that's what I'd have them do. I wouldn't ask them to do what I'm doing here or anything like that. I think that you should have a good solid thing called drawing. Probably to work with the figure would be the best way to learn that. . . . No art history or aesthetics or any of that, just beautiful drawing. I wouldn't allow them to read any art magazines.

HR: No art history, no sense of the tradition?

RE: Yes, but I think they can learn more about Rembrandt by simply copying a Rembrandt drawing than by reading a dozen books. And if they want art history I think they should go into museums and copy the paintings, they'd learn more about it that way than any other. . . .

HR: You think of yourself as a classicist?

RE: I think the abstract expressionist is the ultimate in romanticism. . . .

HR: Do you like their work—some of it?

RE: Well, some of it. Mainly, for me, I learn from it. When you think about it, there was this whole attitude about during the fifties—that whole period when people were isolated within themselves, and nobody related to anybody else. They were sort of egos—and then each ego was so individual; the automobile is another symbol of that. The whole idea of the automobile in American society came in at about that time: people isolated in these machines rather than public transportation. The artist is an ego: he doesn't have to relate to anything else outside his world.

HR: He has his own personal myth.

RE: His own myth. He doesn't depend on anything else. It's pure, his own ego. It's the competition, too. A whole lot of competition in winning: America's the best and the greatest, and abstract expressionism is the latest and the greatest . . . and that sort of expression; the whole Nixon idea, the whole idea that you're just going to win. It's all in that, I think.

HR: So your work is a reaction against elitism, artistic elitism, would you say?

RE: I think that art should not require an education to appreciate it. I don't think painting is successful if it has to be explained in any way to anybody, within certain limits.

HR: But you say yourself that you enjoy some abstract expressionist work.

RE: Yes—for what it is. Some of it is good despite the whole movement. These guys came from a period when they had a very solid background in painting and drawing. So a lot of thought came through. If you tried to teach anybody to be an abstract expressionist painter, it wouldn't work. It is a movement that probably could only last ten years because there's no possibility of there being a second or third generation because it had to be somebody like de Kooning who was painting realistically for 30 years and suddenly he just did it because he had a reaction to it.

HR: But that was in the air: it wasn't just de Kooning.

RE: It depended on the French. I think it came from the *idea* of the artist. It must have something to do with this worship of materialism too in a way, and the scientific mentality of the period, whereas there is no acceptance of anything mysterious at that time. They all had to be analytical, and provable and demonstrable.

HR: Abstract expressionism is a sign of that?

RE: I don't know—I'm just thinking off the top of my head. I just remember the painting was the object, and it had to be like music, and shouldn't depend on anything outside. It had to be a pure object and not have any kind of relation to anything real—that would tend to take away from its purity and from the greatest achievement of all: being able to create something out of nothing—like God. . . .

HR: You felt that the original abstract expressionists were more isolated, they weren't getting any nourishment from the outside world, is that what you're saying?

RE: They're too much the ivory tower idea, the artist locked in suffering and that out of all this agony he's producing these masterpieces that people worship like objects. Maybe it's a religious substitute, too. But it demands a lot of faith like a lot of religions.

HR: You don't see your own work as providing some sort of mystery?

RE: Well, I suppose it probably has to have those elements in it. It's just that I think you can be more interesting and more mysterious if you use what's out there in the world; you just don't try to create it out of your own head. Maybe if we were some sort of super mind way beyond what we are, we could do something like that—we could create something out of nothing. But I don't think man has ever created anything out of nothing. We just adapt these things we see to our own purposes. . . .

HR: What you're saying is that the real world is mystery enough.

RE: Just that what we select from the real world gives a pretty good indication of where we're at. There's such an infinity of things out there that it's the relationship or the ratio between what's there and what we are and this—the painting. It all adds up. It just provides more possibilities, that's all. I couldn't do these pictures 50 years ago because none of this existed 50 years ago. . . .

HR: And also the people who are trying to collapse art and life. That, you feel, can never be done.

RE: Well, because I just have a feeling that all great art is an illusion and really phoney. And really, not only painting, but music, theatre, novels, everything. Somebody made it up and it works within a limited format. In painting, there is a limited palette that you work with because it's rationed and limited. Compare the white out there in the park with the whitest white on my canvas and you'd see the difference. It's two-dimensional and within a fake frame.

HR: The old aestheticians used to say, there's got to be a distance between life and art and that is the excitement—the tension.

RE: It should have a certain grandness to it. Man fails in the attempt to be interesting because we always fail. But you try to do it. But we all die and eventually it's all over. Even the greatest things crumble.

HR: The tragic view. Is there a reason why you live in New York? And work in New York?

RE: Yes—I like it. I like cities and I get all frustrated with New York, and sometimes I would [like] to move away. But no matter where I went it would probably be worse. I think I'd get bored if I lived in a small town. And as far as big cities are concerned, I think New York is the most interesting. There's more variety here; it's a more exciting place to live. . . .

HR: In painting a detail that you don't quite see in the photograph, do you add what you know? A shape, for example?

RE: I find that I'm beginning to be able to do things that aren't in the photograph, simply because certain things are in my repertoire, so to speak. Like if I had to do a chrome strip—although in the photograph it may be just a white line—I know from tons of chrome strips I've done that I can put in certain little reflections and things that will make it more interesting. Just the nature of painting something brings it out sharper, too, because the brush gives a nice sharp line, and in a photograph it could be a fuzzy line. . . .

BARKLEY L. HENDRICKS Palette Scrapings (2007)

How Cool Is That?

How cool is that? Find your spot and sit like Carlos Castaneda did when he wrote several decades ago. Like Cézanne did when he painted his beloved Mont Sainte-Victoire. . . . On several occasions, I've had my people portraits referred to as "cool realism" or "cool representationalism." I certainly can live with being associated with anything having to cozy up to being called cool. . . .

Being a staunch, dyed-in-the-wool jazz fan . . . , there was a pride in keeping up with all things cool in North Philly around the late 1950s, 1960s, and 1970s. Musical taste, dress, and dialogue were all a reflection of the prevailing school of thought. Coolness and hipness went hand in hand; to be unhip was to be uncool. Needless to say, Miles Davis was the epitome of being cool. . . . My hipness later obligated me to seek out my favorite musicians with my developing photographic skills. Julian "Cannonball" Adderly, a sideman of Miles, was the initial inspiration. I won't list the number of artists I have had before my lens. Miles, however, provides one of the best stories and most poignant experiences. I was backstage at the Canandaigua Jazz Festival in upstate New York [and] I gave him one of my catalogues and told him I painted as well as he played, and he painted as well as I played the trumpet. Miles smiled. How cool was that?!

Art Pays

Art pays. My first commission was an erotic expression. An act that was purely from the minds of virgin adolescent young boys. For five cents, I was paid to draw a man and woman "doin' it." Never having "done it," I had to rely on Nick Ramos, the commissioner. The crude image was enough to ensure satisfaction, payment, and a suspension for Nick and Barry, since it was Barry's homework book in which the pencil illustration was inscribed. Easiest cash I ever made.

Women as Inspiration

Several paintings come with good color besides what's on their canvases. Robin (*Miss T*) scared the shit out of my mother when she told her "if she couldn't have me, no one would." . . . The portrait of Claire (*Claire*) . . . also was a cause for fear in both my mother and grandmother. A young blonde English woman meeting me in the former capital of the Confederacy, Danville, Virginia, made them quake a bit. However, my feisty grandpop James said, "Nobody better think about starting any stuff on his property." That was in 1971. Perhaps we were a new generation and it was the new South we were visiting. . . .

Part of the title in *Something Like a Bird: Double Barbara* is borrowed from the Charles Mingus LP title, *Something Like a Bird*. When I first met Barbara . . . she told me that her birds had died the night before. As I write about painting her portrait, I remember looking out the window of my studio at the rainbowed, shiny necks of a flock of pigeons perched on the roof. I used the

* Barkley L. Hendricks, excerpts from "Palette Scrapings" (2007), in Trevor Schoonmaker, ed., *Barkley L. Hendricks: Birth of the Cool* (Durham, NC: Nasher Museum of Art at Duke University, 2008), 89–113. Courtesy Barkley L. Hendricks.

iridescence of their feathers as reference material for the tight blue-black stretch pants. I added feathers around her eyes that mimicked the pageantry of the disco fashions of the day.

Basketball Series

While I was at Yale, one of the professors remarked about my basketball images having a Joseph Albers influence. I had to be very honest with my ignorance concerning my lack of knowledge about Mr. Albers's art and color theories. I did however take the color course given by Richard Lytle. Most of his curriculum was based on Albers's principle of color interaction. The class added to my deeper love and understanding of color in all of my art. However painting in the tropics *en plein air* proved to be the best teacher of all, for which I am one grateful and loving student.

Self-Portraits

"Since you are always around" was one of the descriptions I heard to define self-portraiture. I was not fascinated with myself as much as Rembrandt or depressed to the extent of Van Gogh. However at times, I could not resist myself as a subject. I used my head as the subject for a test canvas to enhance my skills with gold leaf and iridescent paints. My sister said to me one day, "You think you're slick, just wait, one day a woman is going to straighten you out." Ah, a great title for a painting, which is now a part of the Chrysler Museum's collection. . . . When Bobby Seale said, "Superman never saved any black folks" and I found a cheap Superman T-shirt, ta da! Another self-portrait op. . . .

[M]any people, old and young, where I grew up in Philadelphia and Virginia, only knew me as Butch. It seemed Barkley was a challenge to remember for both my father and me. So one of my small portrait heads is just called *Butch*. With *Brown Sugar Vine,* I was making a fashion statement. Vine was the name for a suit. Certainly my birthday suit qualified. A British friend called me her brown sugar after the Rolling Stones song. Again, ta da!

Miss T and Others

After my first visit to Rome, Italy, I returned with a head full of inspirations besides the icons and gold leaf. The paintings in the Uffizi in Florence were mindblowers. Especially one by Giovanni Moroni. The figure in a black, skin-tight outfit made me see the illusion of form and simplicity in a different light. I realized from that painting that I could handle volume with a minimum of detail and still pull off the desired perception of weight and solidity in a style I had never worked with before.

Lawdy Mama

Lawdy Mama was the portrait of my second cousin twice removed, Kathy Williams, not Angela Davis or Kathleen Cleaver. The title was inspired by lyrics from the songbook of Nina Simone about "sistas." My love of Greek and Roman icons had a great deal to do with the materials and composition of this work. In fact it was the first large-scale gold-leafed painting of my career. Beyond the inspiration it provided a wealth of knowledge and experience about the craft and art of gold leafing.

The Three Graces Theme

[My paintings] *Sir Charles, Alias Willie Harris; October's Gone, Goodnight; Bahsir;* and *Northern Lights* sprang from that direct influence. I also felt one pose was not enough for those particular subjects. There was the shine of the green leather coat and the "bling" of the gold teeth that inspired the title for the painting of the Boston-based brother. He was also in a double portrait I called *Yocks. Yock* was the name given to a dude who knew how to "rag." . . . Someone once referred to the figure I did in the *Northern Lights* painting as a pimp. It was his big hat and large fur-collared coat that was behind the assessment. I said I once saw Ronald Reagan in the same large fur-collared coat. Did that make him a pimp? You'll have to answer that one. Sometimes clothes do make the man. Hail to the chief.

Brothers from the Hood

When I went to the Pennsylvania Academy of the Fine Arts for four years for art, William Corbett went to another Pennsylvania institution for five years for armed robbery. Each time I would encounter him on my visits to the hood, he would ask, "Hey, man, you still drawing?" He would then tell me, "When I was in the joint, I did some art." On one occasion, he said in the pen upstate, "Us North Philly niggahs had to stick together."

Serpent's Tooth or Taps for Sherman B

My first instrument purchase was a trumpet. Hot out of the music shop Sherman stole it from . . . a childhood chum who lived up the block on Westmoreland Street. He was a not-to-be-trusted associate who was always double-crossing and pulling fast ones on us. Sherman had the reputation of being able to steal the color out of your shirt or the taste out of your food. . . . One day I got a knock on my studio door and it was Sherman with a shiny brass trumpet in a brown paper bag. He said, "Butch, do you want to buy a horn?" Being a major jazz lover, I always wanted to play some kind of instrument. I saw this as my chance. I didn't have too much guilt about the fact it was a "five-finger discounted" horn. He wanted fifty bucks, but took forty because it was all I had.

Since Sherman didn't provide the mouthpiece with the horn, I needed one. . . . I bought the first thing that was put in front of me. A mistake. . . . Nothing happened but swooshing wind sounds when I blew through that beautiful piece of brass. This went on for weeks. My frustration level moved me to do a painting of that attractive shiny yellow still life. After the painting was completed, I sold the painting and then I sold the horn.

Traveling

In May 1966 I was awarded the William Emlen Cresson traveling scholarship from the Pennsylvania Academy of the Fine Arts in Philadelphia. . . . It financed three months' travel and stay in Europe . . . to the major museums and art sights in Italy, France, Holland, Great Britain, Spain, Turkey, and Greece. There were several countries along the way that provided stopovers and adventures of the unforgettable kind.

The following year, 1967, I was the recipient of the Henry Scheidt Memorial Traveling Scholarship. Unlike the Cresson that was for European travel, the Scheidt was a passport with bucks for the planet. Mother Africa beckoned this time. So after landing back in Luxembourg,

I headed south to Morocco, and that got my travel started across Algeria, Tunis, and Libya to Egypt. These two awards were unquestionably the instigators of a life of global look-seeing.

MARK TANSEY Notes and Comments (1992)

On realism and representation:

I am not a realist painter. In the nineteenth century, photography co-opted the traditional function of realist painters, which was to make faithful renditions of "reality." Then the realist project was taken over by Modernist abstraction, as later evidenced in the title of Hans Hofmann's book *Search for the Real*. Minimalism tried to eliminate the gap between the artwork and the real. After that, the project itself dematerialized. But the problem for representation is to find the other functions beside capturing the real.

In my work, I'm searching for pictorial functions that are based on the idea that the painted picture knows itself to be metaphorical, rhetorical, transformational, fictional. I'm not doing pictures of things that actually exist in the world. The narratives never actually occurred. In contrast to the assertion of one reality, my work investigates how different realities interact and abrade. And the understanding is that the abrasions start within the medium itself.

I think of the painted picture as an embodiment of the very problem that we face with the notion "reality." The problem or question is, which reality? In a painted picture, is it the depicted reality, or the reality of the picture plane, or the multidimensional reality the artist and viewer exist in? That all three are involved points to the fact that pictures are inherently problematic. This problem is not one that can or ought to be eradicated by reductionist or purist solutions. We know that to successfully achieve the real is to destroy the medium; there is more to be achieved by using it than through its destruction.

On pictorial content:

In the late 1970s, what was particularly attractive about pictorial representation was that one faced an opening and extending realm of content rather than dematerialization, endgames, and prolonged swan songs. Difficulties lay in the long established and increasingly critical isolation of subject matter from art practice. Critical discourse and art education had restricted the notion of content to two pockets coalescing around formal and conceptual poles. To speak about subject matter in a picture simply was not done.

My feeling was that there was no longer any justification for these restrictions. Pictures should be able to function across the fullest range of content. The conceptual should be able to mingle with the formal and subject matter should enjoy intimate relations with both.

The notion of the crossroads:

By contrast to the flat, static, formal model for painting on one hand and conceptualism on the other, I found it useful to think in terms of a structurally dynamic model for pictorial

* Mark Tansey, excerpts from "Notes and Comments," in Arthur Danto, *Mark Tansey: Visions and Revisions* (New York: Harry N. Abrams, 1992), 127–35. By permission: © 1992 Arthur C. Danto. Published by Harry N. Abrams, Inc. All Rights Reserved.

content that could include both models as well as subject matter. The notion of a crossroads or an intersection of visible and invisible trajectories offered the most vital metaphor for a picture. It accommodates the fact that pictorial content is mostly invisible (that is, embodied in preconceptions that are conceptual, cultural, temporal, etc.). There is really very little that is visible in the format of a picture. The value of thinking in terms of a crossroads or pictorial intersection is that if not all that much is visible, then what little there is ought to involve vital trajectories and points of collision and encounter between a variety of cultural, formal, or figural systems.

On rift and resonance:

In my earlier work I was trying to learn how to bring meaning to the image, and was having difficulty activating the figure and image as a whole. Magritte's eight methods of bringing about the "crisis of the object"—isolation, modification, hybridization, scale change, accidental encounters, double-image puns, paradox, double viewpoints in one—came as a revelation. It made it apparent to me that crises and conflicts were results of oppositions and contradictions and these were what was necessary to activate or motivate a picture.

In my later work, the idea of crisis was tempered and extended to rift and resonance. For instance, a picture might be decoded by distinguishing rifts (contradictions, discrepancies, implausibilities) from resonance (plausible elements, structural similarities, shared characteristics, verifications). In fact the notion of rift and resonance is fundamental to the picture constructing process as well.

On the value of illustration:

If in paintings there have been problems in linking image and idea, one key may be found buried deep in the practice of illustration. Illustration, having been banished from high art as commercial and slavish to an assigned message, nevertheless is where art begins. The only significant difference that I can find at this point between illustration and art is that the former traditionally involves doing someone else's idea rather than one's own. But of particular value in good illustration is the function of embedding the idea in the image. It's common practice in contemporary art to rely heavily on critical supplements to provide the conceptual content. But in illustration, the critical content and image can be structured together metaphorically. This involves the invention or search for a new metaphoric structure that acts as a transformational link between the idea and image. For instance, reflection, as metaphoric structure, can link the idea of equivalence of opposites to an image where an object and its reflection are interchangeable. *Mont Sainte-Victoire* is an example of this.

Another value of illustration is its hyperfictional capacity. Because it is rhetorically out front, it has great latitude of reference and freedom to extend or condense space and time. It is not paralyzed with guilt about the impurities of reference or of metaphor. On the contrary, new metaphoric relations are its substance and aesthetic vehicle. It's at the door of metaphor that illustration transforms into "metaphoric redescription." Metaphoric redescription (Richard Rorty's term) is a function that is becoming increasingly interesting in light of the inadequacies of the term "representation," in that pictures don't actually *re*present anything. . . .

Rethinking representation:

More often than not, the critical response to painted representation labels it nostalgic or retrograde. Often this is appropriate. But there are other dimensions to this response. One is that behind the label nostalgic (or retrograde) is the valorizing of a narrow sense of the present. The word Postmodern in its most obvious sense is a temporal designation. If Postmodern practice is attempting to break from Modernism, why hasn't the notion of the narrow present been questioned? Is there a temporal chauvinism here that makes it possible for art discourse to ignore all other structures of time (cultural, biological, geological, physiological, cosmological, etc.)? If one can get beyond the prohibitionary reflex action, it might be possible to look more closely at the content of representational or other modes of art to see the degree to which they are sensitive and accountable to other structures of time. In this way specific artworks can create the rupture that the larger critical discourse seems to be resisting.

Given that the painted picture is a declassified medium (in Marshall McLuhan's sense—a medium that is no longer the dominant conduit or voice of power, unlike television or film) it can take on new functions. One of these can be as analogue to other representational media—in understanding the limits and sensitivities of one as it relates to those of another. We can use the painted picture as a way of studying its own modes of references, its ranges of sensitivity and insensitivity, its deceptions, by way of offering insights into the analogous functions of, for example, film, photography, and television.

I'd like to get a sense of the painted picture as a medium vital in its free range of reference and content. This is not to celebrate indiscrimination, but on the contrary, to make it possible to develop pictorial articulation involving a variety of syntaxes that would be interconnected and accountable rather than autonomous or indiscriminate.

At this point, it is apparent from Jasper Johns on that the separation of abstraction from representation from conceptualism is no longer compelling or convincing. Each are portions of an expanded notion of content that can be interfaced, emphasized, or deemphasized according to an artist's interests. The unique value of any artwork depends on how new metaphoric relations are structured within it.

But given this expanded content, the area that is as yet least explored and most in need of rethinking is the realm of representation. In contemporary art practice, notions of narrative, temporality, subject matter, illustration, and metaphor still remain simplistic and ill-informed.

This is not to recast representation as though it were again in exile. It's not as though art discourse is moving away from representation, or that textual criticality is situated hierarchically against or outside it. They are also forms of representation. What we have is a dialogue where the critique of one representation is by another. Art discourse is the clash of representations.

LEON GOLUB *The Mercenaries:* Interview with Matthew Baigell (1981)

MATTHEW BAIGELL: Why mercenaries? Where do they arise from?

LEON GOLUB: In a most direct way, they arise out of the contemporary world as given to us by the media: the uses of mercenaries or irregulars, the taking of irregular actions to enforce political ends. The mercenary is not a common subject of art, but is a near-universal

* Matthew Baigell, excerpts from "*The Mercenaries:* An Interview with Leon Golub," *Arts Magazine* 55, no. 9 (May 1981): 167–69. By permission of the interviewer, the artist, and the publisher.

means of establishing or maintaining control under volatile or up-for-grabs political cir-
cumstances. . . .

Identification is very precise in regard to *The Mercenaries*. Even though their function
is omni-directed or generalized in respect to specific political operations, their characteriza-
tion is precise as an investigation of psychic intention. The mercenaries are not identified as
American, Cuban, South African or Soviet, etc., but by the specifics of dress and guns and
other "instruments," and, more important, through the specifics of intention, implications of
violence, threat, of irregular means, the way they inflict themselves upon us. The mercenar-
ies are generalized within a larger milieu potentially occurring anywhere.

MB: It is both their precise and generalized natures that makes them so brutally effective
and such important statements for our time. For instance, their heroic scale is overpowering.
I can't see their feet and so I assume they are impinging on my space in a very frightening
way. I don't know where they are coming from, so it is hard to avoid or dodge them. The
viewer is catapulted into the intimidating presence of guns for hire. . . .

LG: I would like to comment on *The Mercenaries* in regard to the American situation. I
use the concept "mercenaries" not primarily as an American concept or only in relationship
to American power or actions, although their violent presence represents a magnitude which,
I think, corresponds to American global presence. Mercenaries point to the irregular use of
power. Power is conventionally asserted through governmental actions in public domains.
Unbridled authority is largely contained through institutional autonomy. If the police get out
of hand, perhaps the press will comment. The courts can check on the police, the legislature
on the executive branch, etc. So power is at least in part restrainable through a system of checks
and balances. Conventionally, mercenaries are viewed as hired hands for colonialist regimes,
white soldiers of fortune who are used to suppress Third World insurrections. There are calls
for "police" action by those authorities who either delegate themselves or are delegated "in-
formally" to do the dirty work which ruling elites find necessary. . . . There is always the
high probability of policing agencies running amok. In countries like Argentina and Chile,
the police or elements of the armed forces change costumes at the end of the day's work and,
in civilian garb, pick up "enemies of the state." They supposedly operate in the daytime as
regulars within official legal sanctions. At night or in the early morning they operate as ir-
regulars. These are the White or Death Squads. When I was traveling through Colombia
some years ago, the bus was stopped every so often by men in ordinary dress carrying guns.
They stretched a rope across the road and checked who was on the bus. They were some sort
of local armed gendarmerie. However, in appearance and in their rough assertion of author-
ity, they certainly approximated irregular and uncontrolled authority. . . .

I want to say something further here about *The Mercenaries* and American art. This
is an American art. I am an American artist. I think that a powerful society, generally speak-
ing, has a powerful art. It reflects not necessarily the goals of the society but, rather, the so-
ciety viewing its strengths, how successful it is and what it can get away with. What it reflects
is confidence. These kinds of figures in a strange way reflect American power and confidence.
This is an American presence, the projection of a very powerful society which intends to stay
Number One. The implications of confidence and the use of force are implied by these figures.
I don't think that figures of this kind—inflecting this kind of power—could come out of any
society that's not a dominant one. But it's also a society which is capable of letting the artist
state this kind of power. American art has the kind of confidence that, let's say, Soviet art
doesn't have. The USSR is a very powerful country, but Soviet art does not reflect that au-

thority, that power, that confidence. The circumstances which permit me to record this kind of art are part of American confidence.

MB: *The Mercenaries* can obviously be read on several levels of meaning. Why did you choose a realistic style?

LG: Over the years I have tried to objectify the nature of my work and these images are intended to be as objective as possible. What does this mean? Objective refers to correspondences to reality, to what is, to what occurs. Visual, perceptual objectivity locates identifiable references and is objective in recognizing correspondences, stipulated events, and political situations. Information access and communication is more simultaneous and speeded up than, say, 50 or 100 years ago. Because of speeded-up media access, our takes and reaction times are faster. Our perceptions have to accelerate in terms of the kind of processing that occurs through media, TV, newspapers, computers, things of this kind. I have in recent years used newspaper photographs and television and movies for the blatancy, for example, with which film projects images—how the scale of flesh, the scale of expression, is shoved at us in a flattening effect. This is particularly blatant in pornography. The freeze of a photographic gesture, the fix of an action, how an arm twists, how a smile gets momentarily stabilized or exaggerated—to try to get some of this is important. We have more variables, many more bits of information to deal with all the time. I attempt in these paintings to give some of the quality of media experience, a sense of tension and of abrupt immediacy. The photofix inflects the almost literal shaping of a figure, changes of movement or potential movement, and a sense of occurrence or event. . . .

I do not have the total conceptual framework for a painting in mind until the later stages. I orient the figures, their gestures, their glances, their intentions. I reinterpret these on the basis of changing body stances. For example, I intend a figure to act out a certain gesture. As I work, the psychic dimensions of that individual and what he portends might shift. The figure gets more or less menacing, more or less active. My original intentions shift considerably in the balancing of energies which move across the canvas. I may use drawings or parts of photographs enlarged through an opaque projector onto the vertical hanging canvas. A figure might develop from two or three or half a dozen photographs or drawings. Other figures are then located in stressed tension to the first. I then evolve the drawing to precise military dress, weapons, and, most important, intention. The problem becomes the reconstruction of a generic type, in these instances, mercenaries. If I indicate a gun, it's not a symbol of a gun—it's as gunlike and identifiable as I can make it. Items are factual in the sense that a gun is a fact, that a grin is a fact. The particular individual has to both typify and illustrate mercenaries and to appear to possess an idiosyncratic, singular existence. The figures are outlined and partially shaded in black paint. Then a coat of white paint is put on for highlights and lighter areas. I then apply layers of local colors to define skin, metal, wood, cloth, etc. The painting is then laid on the floor. Areas are partially dissolved with solvents and scraped with sculpture tools, more recently, a meat cleaver, to erode the paint skin. By so doing, I strip the canvas down to what one might call its bare bones. The canvas is stripped to its structural elements or, at least, to the eroded aspects of its most recent full-bodied appearance. I continue to reconstruct and erode until I get to the point where I have the canvas largely in play. That is to say, the different figures, their gestures, grins and leers, etc., are in some sort of achieved tension. Elements have to be continually adjusted. For example, I may have to change a glance or adjust the muzzle of a gun. I am also trying to retain a raw, brute look so that the events do not become oversynthesized. The paintings attain a porous appear-

ance which is crucial to their impact. By scraping off the paint, the image is made porous and what remains is the tooth of the canvas, literal stains of color, although the effect is strongly three-dimensional because of the original shading through light and dark. This is how the canvas breathes.

MB: Earlier, I indicated how *The Mercenaries* are related to one aspect of the history of American art. Where do you locate the series in contemporary art?

LG: They don't derive from any recent American sources. I have been influenced largely by non-western art, Greek and Roman art, and a range of media sources today.

MB: I would like to suggest a connection between your work and the activist universalism of Orozco.

LG: I was highly struck with his *Prometheus* in 1956 when I saw the mural at Pomona College, but his later paintings became too technocratic. The deformations are synthetic. But, for the most part, I have great respect for his power. . . .

I record the action, these particular kinds of actions. In this sense, it is a realist art because it essays to show power, to make power manifest as it is frequently encountered. It's not a call to action as much as it essays definition. This is how it is, this is how power is configured in events and actions, and perhaps this is how it's abstractly structured in our society.

There is a necessary ambiguity in my work between direct intention (to make domination explicit) and the complexity of events and "modernist" knowledge which blocks straightforward one-to-one explanation. Accessibility has to be built on critical assessments of the makeup of the contemporary world.

MB: Yet accessibility is very direct.

LG: *The Mercenaries* jump into our space of current possibility. These intrusions are drastic. There is seemingly no qualification by which intervention is mediated or recollected. It's like a spaceship that has dropped right in front of us and the obtrusive object impinges upon us immediately. We are suddenly right up against it.

NANCY SPERO Woman as Protagonist: Interview with Jeanne Siegel (1984)

JEANNE SIEGEL: When did you begin to participate in feminist activities?

NANCY SPERO: I got into the women's movement in the arts with the inception of WAR, Women Artists in Revolution, in '69, an offshoot of Art Workers' Coalition. Several of the women artists in WAR had been members of the radical feminist Red Stockings group in New York, mid-'60s. Their analysis of the women artists' situation within a radical men's group interested me greatly. Inevitably such discussion sessions led to affirming activist exhibitions and museum petitionings. Eight of us went to John Hightower at the Museum of Modern Art demanding parity. Then Lucy Lippard and three women artists started picketing actions at the Whitney early in 1970. They were the nucleus of a group of other women artists interested in challenging the status quo. Women artists were trying to figure out their status in the art world. One would think that the human spirit surpasses gender, that gender would not be a consideration in art production, but we found out that

* Jeanne Siegel, excerpts from "Nancy Spero: Woman as Protagonist," *Arts Magazine* 62, no. 1 (September 1987): 10–13. By permission of the author, the artist, and the publisher. Material in this interview was drawn by Siegel from a talk delivered by Spero in 1984 and from a conversation between the critic and the artist, also in 1984.

it was. So I started participating in the Ad Hoc [Committee of Women Artists] meetings, as there was going to be picketing at the Whitney. Lucy and Brenda Miller, Poppy Johnson, and Faith Ringgold had been putting Tampaxes around the museum, and raw white eggs and hard-boiled black eggs symbolizing white and black women artists. And I wrote an article about this action in *The Art Gallery* ("The Whitney and Women: The Embattled Museum").

We picketed the Whitney, standing outside in the cold with placards, speaking to passersby, interviewing visitors inside, explaining the disparity of female to male artists in the exhibition. Four percent women! And the percentages went up to 20 to 25 percent, and remains that way. I interviewed some of the curators at the Whitney at that time, and they explained these appalling statistics by saying they chose only "quality" work and by consensus. It made me realize how women artists are excluded from public discourse. I had felt excluded and thought that it was due to the nature of my work—that it wasn't mainstream, and that I was addressing issues that were really anathema to the New York scene. My work wasn't formal. It wasn't minimal. It was tending toward what could be defined as expressionist. . . .

I started working on paper and collage earlier in 1966. The "War Series" were initially paintings on [archival] drawing paper. I then tested some beautiful Japanese rice paper, and I couldn't work in the same way—scratching, scrubbing, and blurring the images. The rice paper was resistant to this method. So I began painting the figures on the [archival] drawing paper, and then cutting them out and collaging them onto the Japanese rice paper. And that was the start of it. It was just a technical difficulty that I was having with the work.

JS: Some of the finest early collages, Schwitters' for example, were quite small and intimate. You share a contemporary propensity for expanded collage with artists like Rauschenberg and Krasner. . . .

NS: The larger works are 20 inches high and run from 125 to 210 feet. . . . I am trying to put down some kind of extended history, report, or ritual. I think of these as perhaps cinematic in their movement in time. I even conceive of them as a visual equivalent of extended oral witnessing.

JS: And the big spaces?

NS: They are like time lapses and sequences. And it's space in which to move, to rest, and to go on. It's like the pauses in music. There's a certain rhythm, movement, a staccato or calm or a block of images, and then you temporarily stop. . . .

JS: What are some of the different ways you use text and letters?

NS: I use several different bulletin typewriters—old things with just upper case letters. . . . The larger letters are made from a range of wood type alphabets. I print each letter of the wood type separately with varying pressures. I often collage the typed information, frequently asymmetrically.

JS: How do the text and the image work together?

NS: They are set in tension with one another and are not illustrative in any way. For instance, when I used the texts of Antonin Artaud, I wanted them stressed or isolated from the images, loosely related but free-floating in space. "Torture of Women" puts together mythological references to torture, contemporary case histories of women political prisoners, etc., in a range of both quotations and image.

JS: Your first radical use of text was drawn from Artaud. One might ask, "Why Artaud?" Donald Kuspit (*Art in America,* January 1984) answered this way: "Artaud gave Spero the

confidence of criticality—the confidence of her outsider nervousness in the world, of her experience of the world as suppressive of existence." So you identified with Artaud as the outcast and then you played on his vulgarity. . . .

NS: Often, there is a juxtaposition of his writing and my head that more or less coalesced. The more vulgar the language, the more delicately I would inscribe it. . . . The lightweight paper gives a sort of floating form to the language amongst the scattered images.

JS: When you used Artaud's words, did you feel as if you were in collaboration with him?

NS: No. When I used Artaud quotes, I felt he would have hated me as a woman for doing this. I had that feeling during the four years I worked and fractured his texts. Now with the American woman poet, H.D., whose texts I used too, it wasn't an antagonist position. Not that I wasn't sympathetic to Artaud. His stuff moves me tremendously. . . .

 I think that if you don't use the body there is an absence. And to use the body embodies an idea. . . . The body is a symbol or a hieroglyph, in a sense, an extension of language. . . . I want the idea of a woman's body to transcend that which is a male ideal of women in a man-controlled world. The realities of war, primary power, the bomb, etc., are depicted in my work through the images of woman as victim of these catastrophic events. But what I suppose might be most subversive about the work is what I am trying to say in depicting the female body—that woman is not the "other"—that the female image is universal. And when I show difference, I want to show differences in women, women's rites of passage, rather than a man's rites of passage. Woman as protagonist. The woman on stage.

JS: Your sources for imagery are vast—icons such as the Venus of Willendorf, Helen of Egypt, archaic or Paleolithic figures. They included sky goddesses, a suckling she-wolf, athletes, mother and children. They range from 5000 BC to current newspaper clippings. In "Torture of Women" in 1976, you embrace the opposition of the timeless cruelty toward women to women placed on a pedestal—the unattainable woman which is the myth of the virgin. . . .

NS: These depictions of ancient goddesses along with images of contemporary women become palpable reminders of our relationship to the past and our memories of the past. The past and the present become inextricably interwoven. . . .

JS: There is nothing ironic in your depiction. Is it a glorification of women? Is it essentially a utopian view?

NS: While there is only occasional irony in my work, there is frequent humor and playfulness. For instance Sheela-na-gig, the Celtic goddess of fertility and destruction, is both beguiling, childlike, and funny, yet she has a frightening aspect as well. In "Notes in Time On Women" I copied a Greek vase painting of a nude woman carrying an enormous dildo—which is quite amusing. I don't think I am glorifying women so much as bringing women to "center stage" in active (not passive) roles. Perhaps this would be considered utopian. . . .

JS: Do you consider yourself an existentialist?

NS: Yes, somewhat. I am pretty pessimistic about the human condition and situation. Nevertheless, the work today is more buoyant and seemingly has a sense of utopian possibilities. I continue to insist on depicting woman as victim in rape or war but I also show women in control of our bodies—and thus of our space.

JS: Don't you think this change in attitude could have come, in part, from the sense of your own recognition?

NS: Definitely—that I had found my tongue, a dialogue, an end to the silence.

JS: With "The First Language," your work became nonverbal. That must have been a big decision.

NS: During the '70s, I had used so much language, from the Artaud works to "Notes in Time On Women" (93 references). On completion of that piece (210 feet long), I decided to try to do a large piece without language, using the language of gesture and motion.

JS: It seems that with the work in the early '80s where you've discarded text, you've introduced more color.

NS: I have. And where some of the earlier works, in grayed or metallic colors, were spare and the images distanced and isolated, now many of the female figures are full of activity and color.

JS: It's been fifteen years since you joined A.I.R., and you just left. Have your ideas on feminism changed radically over that time?

NS: No. It can be argued whether the art world is any more open to women artists today than it was in 1969–70 when WAR and the Ad Hoc committee of women artists made their first forays. Note the Guerrilla Girls!

JS: In discussing your work in *The Nation* in 1974, Lawrence Alloway prophetically said, "Though her subject matter is political, she does not assume immediate efficacy is possible in painting: she has no naive expectation of reform. . . . Spero is stricken by human behavior but does not assume that art can transcend history." Do you still feel the same way?

NS: I am still skeptical of the extent to which art enters into public discourse. I have attempted to do so with images and themes of public intent.

ARNULF RAINER *Face Farces* (1971)

During the sixties I drew faces day after day, faces which I had never seen, veiled and deformed, ugly grimaces, twisting profiles, comical diagrammatic schemes. During moments of intensive drawing these caricatures mirrored themselves into my own face muscles. I grimaced with them. So I decided one day to give autonomy to this parallel expression, to transform it from paper into flesh. But the nervous excitement, which comes over me when drawing, did not want to stop so readily. Only when I stood in front of a mirror did I succeed by lurching and tilting to bring about an intensive mimic monologue. I kept repeating these gestures. I had a great deal to relate to myself by means of these faces especially when under the influence of alcohol. When spectators were present my expressions were reduced to reticence.

In 1968 I frequently would sit in a photo booth and practice self mirror images which I then documented photographically. Curious types would always open the curtains and chase me away. Today I work with a photographer.

All the faces I formerly drew had impossible wrinkles, wrong creases and invented accents. These I missed in the photographs. When I smeared them on my cheeks, and went for a walk with them, I felt like a new man; but I was disappointed with the photographic documentation because I still saw always the old self.

It was only when I began to re-work the photos of my mimic "face farces" by drawing on

* Arnulf Rainer, "*Face Farces*," in *Arnulf Rainer* (Cologne: Galerie Ariadne, 1971). Translation by Peter Selz. By permission of the author.

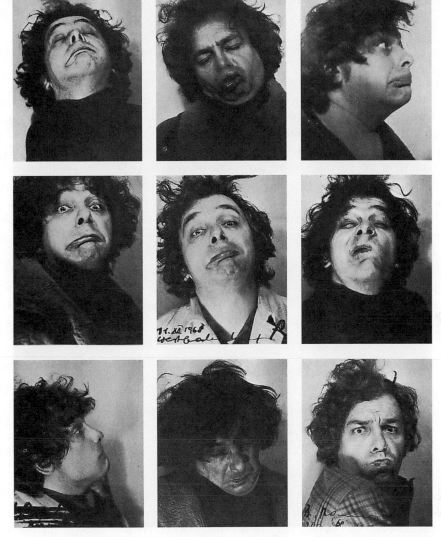

Arnulf Rainer, *Face Farces,* 1969, photographs. © Arnulf Rainer. Photo courtesy Galerie Ulysses, Vienna.

them, that I discovered the unexpected. All new, unknown people, who had been hiding inside myself, but who were not able to formulate my muscles by themselves.

In this way I fused the performing and the visual means of expression into a single art form, which has now occupied me for a number of years.

These anti-yoga tragic-comic poses, mannered clowneries and tired gestures without grace, chic or charm do not ask for a harmonious physical expression, but for a search for the un-limited possibilities and the unlikely people who are concealed in all of us.

MAGDALENA ABAKANOWICZ Statements (1979–94)

Soft

ONCE UPON A TIME

I was a small child, crouching over a swampy pond, watching tadpoles. Enormous, soon to become frogs, they swarmed around the bank. Through the thin membrane covering their distended bellies, the tangle of intestines was clearly visible. Heavy with the process of trans-formation, sluggish, they provoked one to reach for them. Pulled out onto shore with a stick, touched carelessly, the swollen bellies burst. The contents leaked out in a confusion of knots. Soon they were beset by flies. I sat there, my heart beating fast, shaken by what had happened. The destruction of soft life and the boundless mystery of the content of softness. It was just the same as confronting a broken stem with sap flowing out, provoked by an inexplicable inner process, a force only apparently understood. The never fully explored mystery of the interior, soft and perishable.

Many years later, that which was soft with a complex tissue became the material of my work. It gives me a feeling of closeness to and affinity with the world that I do not wish to explore other than by touching, feeling, and connecting with that part of myself which lies deepest.

BECOMING

Between myself and the material with which I create, no tool intervenes. I select it with my hands. I shape it with my hands. My hands transmit my energy to it. In translating idea into form, they always pass on to it something that eludes conceptualization. They reveal the unconscious.

INTERIOR

The shapes that I build are soft. They conceal within themselves the reasons for the softness. They conceal everything that I leave to the imagination. Neither through the eye nor the fingertips nor palm that informs the brain can this be explained. The inside has the same importance as the outer shell. Each time shaped as a consequence of the interior, or exterior as a consequence of the inside. Only together do they form a whole. The invisible interior which can only be guessed at is as important as when it opens for everyone, allowing physical penetration.

MEDITATION

To make something more durable than myself would add to the imperishable rubbish heaps of human ambitions, crowding the environment. If my thoughts and my imaginings, just

* Magdalena Abakanowicz, various excerpts: "Soft" (1979) from Mary Jane Jacob, ed., *Magdalena Abakanowicz* (New York: Abbeville Press, 1982), 102; "Unrepeatability" (1985), "Negev" (1987), and untitled (1989, 1992), all © Magdalena Abakanowicz, from Barbara Rose, ed., *Magdalena Abakanowicz* (New York: Harry N. Abrams, 1993), 128, 120, 164, 7; "Solitude" (1985) and untitled (1993, 1994), all © Magdalena Abakanowicz, sent by the artist to the editors, 19 July 1994. By permission of the artist and Abbeville Press.

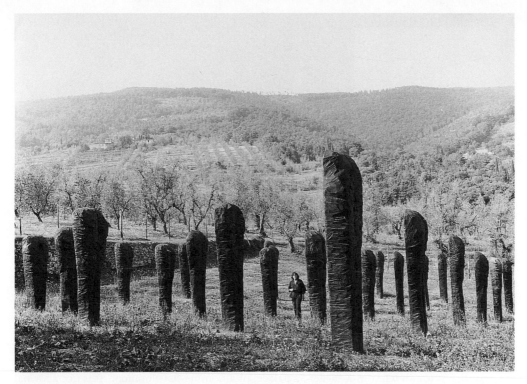

Magdalena Abakanowicz, *Katarsis,* 1985, bronze. Giuliano Gori Collection, Fattoria di Celle, Santomato di Pistoia, Italy. Photo by Artur Starewicz. By permission of the artist and the photographer.

as I, will turn to earth, so will the forms that I create and this is good. There is so little room.

COEXISTENCE

My forms are like successive layers of skin that I shed to mark the stages along my road. In each case they belong to me as intimately as I belong to them, so that we cannot be apart. I watch over their existence. Soft, they contain within an infinite quantity of possible shapes from which I choose only one as the right, meaningful form.

In exhibition rooms I create spaces for them in which they radiate the energy I have imbued them with. They exist together with me, dependent on me, I dependent on them. Coexisting, we continually create each other. Veiling my face, they are my face. Without me—like scattered parts of the body separated from the trunk—they are meaningless.

CONFESSION

Impermanence is a necessity of all that lives. It is a truth contained in a soft organism. How to give vent to this innate defeat of life other than by turning a lasting thought into perishable material?

Thought—a monument. Thought—a defense against disappearance. Timeless thought. A

perverse product of the soft tissue that will disintegrate, that one day will cease to connect. Expressed in material whose durability is related to the matter from which it came, it begins to really live—mortally. [1979]

.

Unrepeatability

I once observed mosquitoes swarming. In grey masses. Host upon host. Little creatures in slew of other little creatures. In incessant motion. Each preoccupied with its own spoor. Each different, distinct in details of shape. A horde emitting a common sound.

Were they mosquitoes or people? . . .

A crowd of people or birds, insects or leaves is a mysterious assemblage of variants of certain prototype. A riddle of nature's abhorrence of exact repetition or inability to produce it. Just as the human hand cannot repeat its own gesture I invoke this disturbing law, switching my own immobile herds into that rhythm. [1985]

.

Negev

My sculpture is free of the function of glorifying any doctrine, any religion, any individual. It is not decor for an interior, a garden, a palace, or a housing development. It is not a formal aesthetic experiment nor an interpretation of reality. . . . I transmit my experience of existential problems, embodied in my forms built into space. [1987]

.

I am in my time, as if inside a tightly enclosed balloon. Wherein one finds strange events I went through and others I conceived.

Longings, disappointments and fears teach me how to build their shapes. My imagination chooses. I move along the vision groping for detail after detail until I feel the whole shape. Then I stay with it. I fit the shape of my body to it. And again I move along the inner image. I examine it. I compare it to known objects. Finally, in tension and hastily I transform the vision into the real. Astonished by the result I reject it. Then I accept it. Independent of me it follows me, as another piece of the past, inside my balloon. [1989]

.

Perhaps at that time in Paradise while eating the forbidden apple they lost the balance proper to nature—as one loses the sense of smell or eyesight. And perhaps in the same moment they acquired the instinct of destruction of the surrounding world and of themselves.

Was there a mistake in the unfailing logic of nature or an act of will of an unknown power? [1992]

.

Solitude

Once I walked along the Avenue de l'Opéra during the evening rush hour. It is almost repulsive to feel another human being so close as to be a physical threat. A human being turned

into a crowd loses his human qualities. A crowd is only a thousand-times duplicated copy, a repetition, a multiplication. Among such a great number one person is extremely close and at the same time terribly distant. I summoned solitude and finally I escaped inside myself. [1985]

.

I wanted to tell you that art is the most harmless activity of mankind. But I suddenly recalled that art was often used for propaganda purposes by totalitarian systems. I wanted to tell you also about the extraordinary sensitivity of an artist, but I recalled that Hitler was a painter and Stalin used to write sonnets.

Art will remain the most astonishing activity of mankind born out of struggle between wisdom and madness, between dream and reality in our mind. Each scientific discovery opens doors behind which we are confronted with new closed doors. Art does not solve problems but makes us aware of their existence. It opens our eyes to see and our brain to imagine.

To have imagination and to be aware of it means to benefit from possessing an inner richness and a spontaneous and endless flood of images. It means to see the world in its entirety, since the point of the images is to show all that which escapes conceptualisation. [1993]

.

I lived in times which were extraordinary for their various forms of collective hate and collective adulation. Again and again enthusiastic marches worshipped leaders great and good and ideas which would bring happiness to all. When the beloved leaders turned out to be mass murderers they became objects of mass hate. And marches worshipped new leaders and new ideas. Masses, crowds can become subject of artistic expression. [1994]

FRANCESCO CLEMENTE Interview with Robin White (1981)

ROBIN WHITE: Do you think there's a kind of world culture now?

FRANCESCO CLEMENTE: There is a world culture, but it's not something full. There is an emptiness in which experiences connect with each other. The production of art is not as optimistic as it was. It's more—how do you say? Skeptical.

RW: Skeptical? How is it skeptical?

FC: It is skeptical and passionate at the same time. There is a skeptical attitude toward style and newness, which are the two vaccinations of the artist against the poisons of his intimate passions. It's again not so easy to understand what is going to happen, because the artists are all the time contradicting. I mean, you cannot know what I'm going to do in art, you cannot predict my work. For some time artists were involved with different problems, which were probably very necessary; they were very much involved with the systems of art, even if somehow maybe in a critical way. . . . We cannot have anymore a kind of optimism. If you want to know about mythology . . . what I'm interested in is just to travel through mythology, so that there is never any kind of dogmatic idea. I mean, there is a different attitude. . . .

The problem is that I don't refer to a conventional mythology, like de Chirico was referring to the classical mythology. In my case I don't know about any mythology, but I fall

* Francesco Clemente, excerpts from "Interview by Robin White at Crown Point Press, Oakland, California," *View* 3, no. 6 (November 1981), an issue devoted entirely to this interview. By permission of the artist and Crown Point Press (Point Publications). All rights reserved.

back again and again on images which belong to some mythology. The way it goes is just not to know about any, and to have faith in the possibility of the tradition of art to give truthfulness to any image you come across.

RW: So, in one sense, the images can be archetypal images. Do you believe in archetypal imagery?

FC: I believe in basic experiences we have to deal with, each of us. And so probably there are . . . but no, I don't believe in. . . . I don't want to sponsor a kind of dogmatic choice of archetypal images. I want to move all the time and so I don't refer all the time to the same context.

RW: But you do paint or draw images which come to have a kind of mythological significance. I just wondered if you believe that you as a human being and as an artist can tap into a special kind of consciousness.

FC: I believe that there are basic experiences like hunger, like death, like . . .

RW: Love, sex . . .

FC: Like sex, like—not actually sex; drop sex—like desire.

RW: Desire.

FC: Yes. They are there, even if nobody cares about them. So the experience of death, the experience of hunger or grief, of passion. . . .

I don't like the idea that any image you pick up is good, but . . . when you look to an image in art, you should be able also to be detached and feel a kind of irony. The problem in art is to be truthful and right at the same time. Art is not a religion, it's not a dogmatic thing, but images are very dogmatic sometimes. If you enlarge something, if you take a picture, then enlarge it and put it in an empty room, it would be a terribly hypnotic presence. I don't like that hypnotic presence. I like images to leave a kind of detachment in the person who looks at them.

RW: Is irony the same as detachment? What do you mean by irony?

FC: Well, just this, that you put what is said in the right proportion. Irony is just somebody who's truthful. Somebody who wants to tell you something that is true always has to have irony to let it have the right proportion, because even if something is relatively true, truth is a terribly heavy thing. I don't speak of absolutes, I speak of relativity, and still it's terribly heavy.

RW: Is humor ironic? Do you think of your work as humorous?

FC: I think art and humor are closely related. You find art and humor everywhere. They are like the skeleton of human culture. Our skeleton never changes; the skeleton of any human culture is art and humor—humor is a kind of short-circuit of wisdom.

RW: I want to ask about the pornographic nature of your work.

FC: There was an art dealer who came to my studio and looked at my work, and said, "They are very beautiful, but I have to ask you something." I said, "What?" and she said, "All artists have done pornographic work when they were old, and you are young." (*laughs*)

RW: So what did you tell her?

FC: I think I blushed.

RW: I looked up the word "pornography" and it comes from the French word "porno," meaning harlot, and "graphe," the Greek, to write. So it's written or drawn material that's intended to cause sexual excitement. So I was wondering if your drawings are intended to cause sexual excitement, if that's your intention. Because people do refer to them as pornographic. To me they don't seem pornographic.

FC: Well, all the painting which I find attractive is erotically attractive.

RW: All paintings, or all your paintings?

FC: No, all paintings. All good paintings.

RW: But the subject matter . . . speaking specifically about the subject matter of your paintings, is it deliberately erotic?

FC: Walking through Rome, you find big mouths vomiting water and teen-agers holding big fishes and groups of wet bodies. These are baroque fountains. They are as deliberately erotic as a machine can be. . . .

I have an idea of a kind of circuit of what I want to do. It seems that the ideogram—when the Chinese have to say "chair," they don't say chair. The ideogram doesn't depict a chair, but depicts a . . . I don't know, maybe the bamboo. I mean, the bamboo in the morning is taken to become the chair somehow. What they look for is the situation of what they want to depict, and they find out a kind of analogical train of things which is going on, and they depict one of those things, and nobody really knows why they choose that one and not another one. So I do ideograms. The way I work is exactly like ideograms.

RW: But that still implies that people have to know what the story is, or what the symbol is.

FC: No. In the ideogram I don't think anybody knows the whole story. It becomes just "chair," and probably most of the people totally forget about the old story.

RW: I see.

FC: That's why I did a drawing called "Naked Ideogram," because most of my ideograms are dressed up, they are like dressed in . . .

RW: Dressed up in costumes?

FC: In costumes. I make ideograms in costumes. And the costume is part of this analogical train of thought which brings forth the ideogram. . . .

I believe in this opposition of war/art. I believe that art is an embodiment of the anti-war. The body doesn't want to die, so the voice of the body is anti-war. So I think it's urgent to listen to the body's voice. I like this image that you don't have enemies, that you grow something not against something else, but just because it's there; it has to be done.

SUSAN ROTHENBERG When Asked If I'm an Expressionist (1982)

When asked if I'm an Expressionist, I've always said, "I suppose so." To me "Expressionism" means expressing a personal viewpoint about reality, but the word also means "juicy." I guess I'm a semi-Expressionist in terms of the visuals and surfaces of my paintings. That I've been placed in the new wave of Neo-Expressionism I find more confusing than the new painting itself. There is some awfully good painting going on, and it's a good time for painting—I like the energy and the heat that's around. But I find some of the rationalizations that some of the practitioners use awfully banal and young, and I'm also saturated with the untamed self-indulgence, the "young man addressing the world-body of knowledge" and the marketing aspects of the art world right now. It's all changed so much, even since 1978.

I think Expressionism just zipped in to fill the vacuum of Minimalism. Things rush into empty places and Minimal art had become an empty place. I'm interested in essences too,

* Susan Rothenberg, statement, in Carter Ratcliff, "Expressionism Today: An Artist's Symposium," *Art in America* 70, no. 11 (December 1982): 65, 139. By permission of the artist, the author, and the publisher.

which Minimalism was certainly about, taking things from the particular rather than the general. A lot of these younger people address general aspects of contemporary life. But sometimes it seems as if a lot of their information is not well digested or thought through. A little bit of heart and depth are missing. Those things are sacrificed for the sake of something else and it's that something else that I don't know about. Technically, some of the work is very good. I like what Julian is doing, what Cindy Sherman is doing.

I'm not a great museum goer or church hopper. Sometimes I find things I love—I just got knocked out by the great tall Bartholomew in the El Greco show, and the *View of Toledo*—it's so great to build up levels like that, to make a visionary landscape—but it's rare for me to have an awesome experience with art. I would rather go to the movies than to a museum. I've got some mis-match names that I relate to a lot—Giotto, Johns, Goya, Velázquez, Mondrian, Borofsky—some old, some new. My work comes right out of Jasper Johns's targets. In terms of goals, I'd like to be like Mondrian in the control I'd exert.

The way the horse image appeared in my paintings was not an intellectual procedure. Most of my work is not run through a rational part of my brain. It comes from a place in me that I don't choose to examine. I just let it come. I don't have any special affection for horses. A terrific cypress will do it for me too. But I knew that the horse is a powerful, recognizable thing, and that it would take care of my need for an image. For years I didn't give much thought to why I was using a horse. I just thought about wholes and parts, figures and space.

Then I did the human heads and hands. I started with 9-inch studies—mesmerizing at that size, and I suppose I connected to it because that's what I work with, a head and a hand, and I thought, why not paint it. Then I blew them up to 10 by 10 feet and they became very confrontational.

After the year of doing those enormous heads and hands, I felt I had finished with that problem. There were no variations that I was interested in exploring, and I thought I'd move to oil paints. When I taught myself oil painting, I was living on a creek in Long Island and there were boats parked out front. There were swans in the water. I started painting boats to learn how to use oils after a dozen years of acrylic.

What I think the work was starting to talk about is growing, taking journeys. The boat became a symbol to me—about the freedom I was feeling. Sailboats are beautiful—they're light and they depend on wind. They suggest qualities of light and atmospheric conditions. They started to lead me down a different avenue of painting. There is some kind of space now. Shadow and movement. Depth and resonance. At first I was horrified. "Christ—what is this, Neo-Impressionism?" But if I have to put black behind the swan so it will sit right there and look right, I do it. There need not be so strict an image and ground. Instead I had a figure and a sense of location.

In *10 Men,* I pared the idea of a group down so much that all that was left was a figure and a shadow. That figure has the quality of a Giacometti man in a big place. This has been re-marked on. I can remember a time when I would have gotten ruffled at the thought of being compared to Giacometti, because I thought he was old-fashioned and stylized, but certainly I now have enough sense of the problem and respect for a great artist to appreciate that if you are going to mess with the human body you're likely to run into him.

My paintings are still really visceral. It comes back to trying to invent new forms to stand in for the body since I don't want to make a realist painting. I wanted to get that body down in paint, free it from its anatomical confines. I'm very aware of my body in space—shoulders, frontal positions. I have a body language that is difficult to explain. A lot of my work is about

body orientation, both in the making of the work and in the sensing of space, comparing it to my own physical orientation.

I'm also teasing myself with some other problems. If I could paint a painting about New York City, how would I do it? If I wanted to paint a landscape, would I choose a panorama or a blade of grass? I'd like to do portraits. The paintings wouldn't be realistic. I'd probably do something weird. I'll need to make the human figure more specific, rather than addressing myself to the body orientation and gut-felt thing, which has been the raft on which I've floated for a long time.

JULIAN SCHNABEL Statements (1978, 1983)

I want my life to be embedded in my work, crushed into my painting, like a pressed car. If it's not, my work is just some stuff. When I'm away from it, I'm crippled. Without my relationship to what may seem like these inanimate objects, I am just an indulgent misfit. If the spirit of being isn't present in the face of this work, it should be destroyed because it's meaningless. I am not making some things. I am making a synonym for the truth with all its falsehoods, oblique as it is. I am making icons that present life in terms of our death. A bouquet of mistakes. [1978]

.

I wonder what purpose, if any, possesses an artist to make things?

Agony has many faces: violent, passive, loud or quiet, making possible readings that go forwards and backwards in time (marking a specific moment). Pictures made to be scrutinized separately, but always as a part (good period, bad one) of the whole that makes up the body of work that stands as the artist's attitude towards life.

This is important because if we believe that we are free to act, then we are not restricted to creating structures that always have a similar appearance (commonly called style), or bound by our own past to always work in a style dictated by that which preceded.

Works must describe themselves, the world, and their inner need to exist in a specific way. I suggest that style is the effect of character, armed with intensity, a sense of purpose, a method, a syntax that reveals the will and need to make something. Style is the fringe benefit of intention and action completed.

In my painting it is only that. It is not about style, not about other styles; style is available, depending on the demands and needs of a particular work. A painting can proceed from one's inspiration and be complete and successful in the sense that the need is materialized, the revelation realized. It may, at the same time, be inaccessible to the public addressed; for a time inaccessible to everybody.

For an artist in my position everybody is an unlikely number. Few are sufficiently free of preoccupations to see what is there. To see what is there takes real interest on the part of the viewer.

Presenting a work publicly invites its own situation; that of emanating information with its very own specific qualities and viewing time; the possibility of a direct relationship, one to one, between the viewer and the object, is an ideal rarely achieved; there are so many distractions.

* Julian Schnabel, statements (1978, 1983), in *Julian Schnabel: Paintings 1975–1987* (London: Whitechapel Gallery, 1986), 101–5. © 2012 Julian Schnabel/Artists Rights Society (ARS), New York.

People have a funny involvement with art. They are interested in it for many reasons that address their relationship to the world: what art means to them; their idea of what it means to others; their conception of the artist's intent; and, perhaps lastly, how they actually feel about it. Layer upon layer, obscuring a direct relationship with the object.

There is altogether too much mediating going on; too many words and ideas and theories come between the viewer and the object of contemplation. On the spot digestion and "interpretation" of a work of art by a critic/reporter, quick and witty reportage, serves to obfuscate meaning, as do the self-promotion of gallerists and the prestige and monetary interests of collectors, all riding on the back of the "unseen" undigested work itself, veiled as it is in so many ways. The artist is not guiltless in all this; the economic support structure and the artist's dependence on it are constructed and inherited and not amenable to simplistic adjustment.

But this economic aspect is a separate issue from the artist's intention as realized in his work. And there is definitely a distinction between an artist and his work.

How, then, is the viewer supposed to have a direct relationship with a work of art? How to filter out all the distractions, to arrive at its true nature—the mentality, sensibility and history embodied and revealed in the work?

This brings us to the problem of incongruity. I no longer expect people to understand me. I no longer expect my work to be understood as I understand it.

Time seems to be an issue: the time in which a work exists; its own lifetime; the life of the artist. One might say that the artist's ecstasy, the relation in the realization of his intention in the successful work have only a tangential relationship to the art itself, but I maintain that is disputable. The artist feels deeply the need for personal agreement—identity—between his intention and the result. Alive in the world he feels the natural need to live with others, to communicate something. The notion is one of making something, not for an audience, but with an awareness of the audience, some of whom are certainly not yet alive. The artist is necessarily involved with the idea of history, past and future. It is this chain of life, of objects made by artists, that I believe to be the artist's confidante and consolation within the quiet isolation that is the space created by art's incongruity to life; we live always with the absence of an immediate and easily available resolution of that incongruity. We are doomed to facile acceptance and dismissal of new and profound reifications of sense, history and feeling.

The true subject is meaning.

The description of the meaning of the work of art, the meaning to the artists who create them, the meaning of others' interpretations and what they have and do not have to do with the meaning (intention) of the work.

This meaning is my interest because it is my deepest desire for others to get the meaning of my work; nothing else, nothing less.

Only through the work can there be a recognition, a harmony of intention and revelation, artist and viewer communing. Making art is the only way some kinds of people mediate the world. It is the way they fit into the world. The work is ultimately a physical fact, a microcosm of the world for the artist, a handbook for others. It can only be constructed out of displaced love; the curiosity to know something (through the making) that is seemingly unknowable. Out of the acceptance of the finite terms (possibilities) of painting one achieves a self-respect. Through making objects one learns things about life that cannot be learned (or communicated) in any other way. It gets made out of the need for a direct, concrete truth that stays intact, available, as long as the work exists. It is a way of transgressing death. It reassures others of a stability, a sameness, a quality that is a recognition of a shared humanness and thought.

The materiality of a work of art is important only as long as it imparts a quality of being,

meaning, feeling, a recognition. It is appropriate only as long as it is true; it is modern only so long as it is true. Deeper than conversation, it has its own dignity.

Authorship and ownership of an idea or work are not identical. The artist creates a symbiotic relationship of author and sign, handmade, a gift to others to align himself with them in a common truth; a clearer realization of the world we live in, an individual attempt to cut out the static, the shit.

All components of the work are parts of a desire to transform the spirit; prior meanings, existing meanings, and newly attached meanings, all necessary to create in the work an accumulative meaning whose configuration is something no one has ever seen before. This doesn't mean you can't recognize it when you see it.

What artists can give to others, how they are of use in this life, is in their discovery of a point of convergence where the physical fact denotes a state of consciousness.

This is how art is generative. [1983]

JEAN-MICHEL BASQUIAT

From the Subways to SoHo: Interview with Henry Geldzahler (1983)

HENRY GELDZAHLER: Whose paintings do you like?

JEAN-MICHEL BASQUIAT: The more I paint the more I like everything.

HG: Do you feel a hectic need to get a lot of work done?

JMB: No. I just don't know what else to do with myself.

HG: Painting is your activity, and that's what you do . . .

JMB: Pretty much. A little socializing.

HG: Do you still draw a lot?

JMB: Yesterday was the first time I'd drawn in a long time. I'd been sort of living off this pile of drawings from last year, sticking them on paintings.

HG: Are you drawing on good paper now or do you not care about that?

JMB: For a while I was drawing on good paper, but now I've gone back to the bad stuff. I put matte medium on it. If you put matte medium on it, it seals it up, so it doesn't really matter.

HG: I've noticed in the recent work you've gone back to the idea of not caring how well stretched it is; part of the work seems to be casual . . .

JMB: Everything is well stretched even though it looks like it may not be. . . .

HG: If the color gets too beautiful, you retreat from it to something angrier and more basic . . .

JMB: I like the ones where I don't paint as much as others, where it's just a direct idea.

HG: Like the one I have upstairs.

JMB: Yeah. I don't think there's anything under that gold paint. Most of the pictures have one or two paintings under them. I'm worried that in the future, parts might fall off and some of the heads underneath might show through. . . .

HG: Do you do self-portraits?

JMB: Every once in a while, yeah.

* Henry Geldzahler, excerpts from "From the Subways to SoHo: Interview with Jean-Michel Basquiat," originally published in *INTERVIEW Magazine,* January 1983. Courtesy of Brant Publications, Inc. Reprinted in Rudy Chiappini, *Jean-Michel Basquiat* (Milan: Skira with Museo d'Arte Moderna Città di Lugano, 2005), 33–48.

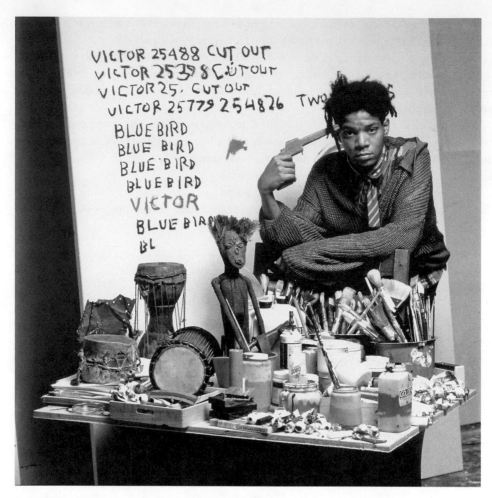

Jean-Michel Basquiat, 1987. Photo by Tseng Kwong Chi. © 1987 Muna Tseng Dance Project, Inc., New York.

HG: Do you think your family is proud of you?

JMB: Yeah, I guess so. . . .

HG: Do you find your personal life, your relationships with various women get into the work?

JMB: Occasionally, when I get mad at a woman, I'll do some great, awful painting about her. . . . There was a woman I went out with . . . I didn't like her after awhile of course, so I started painting her as Olympia. At the very end I cut the maid off.

HG: Who's harder to get along with, girlfriends or dealers?

JMB: They're about the same, actually.

HG: What about the list of pre-Socratic philosophers in the recent paintings, and the kinds of materials which get into your painting always, that derive not so much from Twombly, as from the same kind of synthetic thinking. Is that something you've done from your childhood, lists of things?

JMB: That was from going to Italy, and copying names out of tour books, and condensed histories.

HG: Is the impulse to know a lot, or is the impulse to copy out things that strike you?

JMB: Well, originally I wanted to copy the whole history down, but it was too tedious, so I just stuck to the cast of characters.

HG: So they're kind of indexes to encyclopedias that don't exist.

JMB: I just like the names.

HG: What is your subject matter?

JMB (pause): Royalty, heroism, and the streets. . . .

HG: I think "What are you studying" is a very good question to ask—because your work does reflect an interest in all kinds of intellectual areas that go beyond the streets, and it's the combination of the two.

JMB: It's more of a name-dropping thing.

HG: It's better than that. You could say that about Twombly, and yet somehow he drops the name from within. With your work it isn't just a casual list. It has some internal cohesion with what you are.

JMB: My favorite Twombly is *Apollo and the Artist,* with the big "Apollo" written across it.

HG: When I first met you, you were part of the club scene . . . the Mudd Club.

JMB: Yeah, I went there every night for two years. At that time I had no apartment, so I just used to go there to see what my prospects were.

HG: You used it like a bulletin board.

JMB: More like an answering service. . . .

HG: So you do want to live . . .

JMB: Oh yeah, of course I want to live. . . .

HG: Is there anger in your work now?

JMB: It's about 80% anger.

HG: But there's also humor.

JMB: People laugh when you fall on your ass. What's humor?

PHILIP GUSTON Philip Guston Talking (1978)

There are people who think that painters shouldn't talk. I know many people who feel that way, but that makes the painter into a sort of painting monkey. . . .

I feel that strongly believed in and stated convictions on art have a habit of tumbling and collapsing in front of the canvas, when the act of painting actually begins. Furthermore, I have found that painters of my generation are more candid and provocative in their casual talk and asides, and funnier too. Mark Rothko, after a mutual studio visit, said, "Phil, you're the best story teller around and I'm the best organ player." That was in 1957; I still wonder what he had in mind. So many articles appeared with words like sublime, and noble, and he says he's the best organ player around. Franz Kline, in a very easy bar conversation in the fifties, said, "You know what creating really is? To have the capacity to be embarrassed." And one of the better definitions about painting was Kline's. . . . He said, "You know, painting is like hands stuck in a mattress."

In a recent article which contrasts the work of a colour-field painter with mine, the painter

* Philip Guston, excerpts from "Philip Guston Talking" (lecture at the University of Minnesota, March 1978), in Renee McKee, ed., *Philip Guston* (London: Whitechapel Gallery, 1982), 49–56. By permission of Musa Mayer.

Philip Guston and Philip Roth, 1972. Photo by Barbara Sproul. Courtesy Musa Mayer.

is quoted as saying "A painting is made with coloured paint on a surface and what you see is what you see." This popular and melancholy cliché is so remote from my own concern. In my experience a painting is not made with colours and paint at all. I don't know what a painting is; who knows what sets off even the desire to paint? It might be things, thoughts, a memory, sensations, which have *nothing* to do directly with painting itself. They can come from anything and anywhere, a trifle, some detail observed, wondered about and, naturally from the previous painting. The painting is not on a surface, but on a plane which is imagined. It moves in a mind. It is not there physically at all. It is an illusion, a piece of magic, so what you see is not what you see. I suppose the same thing was true in the Renaissance. There is Leonardo da Vinci's famous statement that painting is a thing of the mind. I think that's right. I think that the idea of the pleasure of the eye is not merely limited, it isn't even possible. Everything means something. Anything in life or in art, any mark you make has meaning and the only question is, "what kind of meaning?" . . .

Years back, in the late '40s and early '50s, I felt that painting *could* respect itself, reduce itself to what was possible; that is, to paint only that which painting, through its own means, could express. I enjoyed that short-lived period. The reverberations of such paintings could be heard. But in time I tired of *this kind* of ambiguity. There were better things and too much sympathy was required from the maker as well as the all-too-willing viewer. Too much of a collaboration was going on. It was like a family club of art lovers. This disenchantment grew. I knew that I would need to test painting all over again in order to appease my desires for the clear and sharper enigma of solid forms in an imagined space, a world of tangible things, images, subjects, stories, like the way art always was. . . .

I was talking at Harvard and one graduate student thought that I was attacking minimal painting. I guess I had used the term "stripes" but I said, "No, you've got it all wrong." There would be absolutely no way to prove that paintings of things and objects, real and imagined, are better than stripes. One couldn't prove it, and I'd be the last to maintain that one could.

I thought I would never write anything down again.

Then I put on my cold wristwatch.

MUSA McKIM

Philip Guston and Musa McKim, *I thought I would never write anything down again,* mid-1970s, ink on paper. Courtesy Musa Mayer.

All I can say is that, when I leave the studio and get back to the house and think about what I did, then I like to think that I've left a world of people in the studio. A world of people. In fact they are more real than the world I see. I wouldn't enjoy being in the kitchen, looking out of the window at the studio while having a drink, thinking that I had simply left a world of relationships and stripes in these. So to know and how not to know is the greatest puzzle of all, finally. I think that we are primitive really, in spite of our knowing. It's a long, long preparation for a few moments of innocence.

I think that probably the most potent desire for a painter, an image-maker, is to see it. To see what the mind can think and imagine, to realize it for oneself, through oneself, as concretely as possible. I think that's the most powerful and at the same time the most archaic urge that has endured for about 25,000 years. In about 1961 or 1962 the urge for images became so powerful that I started a whole series of dark pictures, mostly just black and white. They were conceived as heads and objects.

After the show at the Jewish Museum in 1966, I knew I wanted to go on and to deal with concrete objects. I got stuck on shoes, shoes on the floor. I must have done hundreds of paintings of shoes, books, hands, buildings and cars, just everyday objects. And the more I did the more mysterious these objects became. The visible world, I think, is abstract and mysterious enough, I don't think one needs to depart from it in order to make art. This painting started out as a hand with a brush and it turned into a paw. So I started thinking about evolution, that is questions such as who was the being, the prehistoric man, who made the first line. I have a large collection of old rusty railroad nails, and they lie around on the table as paper

weights. They're big huge nails, and I just nailed one in to a piece of wood. I thought, how would it look *if*. That's a very powerful "If." . . .

I live out of town, and driving down to New York City I go down the West Side Highway. There are all these buildings that look as if they are marching. You know, by painting things they start to look strange and dopey. Also there was a desire, a powerful desire though an impossibility, to paint things as if one had never seen them before, as if one had come from another planet. How would you paint them; how would you realise them? It was really a tremendous period for me. I couldn't produce enough. I couldn't go to New York, to openings of friends of mine like Rothko, de Kooning, Newman. I would telephone Western Union with all kinds of lies such as that my teeth were falling out, or that I was sick. It was such a relief not to have anything to do with modern art. It felt as if a big boulder had been taken off my shoulders.

As a young boy I was an activist in radical politics, and although I am no longer an activist, I keep track of everything. In 1967–68 I became very disturbed by the war and the demonstrations. They became my subject matter and I was flooded by a memory. When I was about 17 to 18, I had done a whole series of paintings about the Ku Klux Klan, which was very powerful in Los Angeles at that time. The police department had what they called the Red Squad, the main purpose of which was to break up any attempts at unionizing. Remember this was 1932, 1933. I was working in a factory and became involved in a strike. The KKK helped in strike breaking so I did a whole series of paintings on the KKK. In fact I had a show of them in a bookshop in Hollywood, where I was working at that time. Some members of the Klan walked in, took the paintings off the wall and slashed them. Two were mutilated.

This was the beginning. They are self-portraits. I perceive myself as being behind a hood. In the new series of "hoods" my attempt was really not to illustrate, to do pictures of the KKK, as I had done earlier. The idea of evil fascinated me, and rather like Isaac Babel who had joined the Cossacks, lived with them and written stories about them, I almost tried to imagine that I was living with the Klan. What would it be like to be evil? To plan and plot. Then I started conceiving an imaginary city being overtaken by the Klan. I was like a movie director. I couldn't wait, I had hundreds of pictures in mind and when I left the studio I would make notes to myself, memos, "Put them all around the table, eating, drinking beer." Ideas and feelings kept coming so fast; I couldn't stop, I was sitting on the crest of a wave. In the picture *Cellar* I wondered what it would look like to have a bunch of figures, scared, diving down into a cellar. I painted it in about four hours without any erasures. And when it was done I said, "Ah . . . , so that's what it would look like." And that's what I mean about primitive art or cave art, so that's what it looks like. I want to see what it looks like. They call it art afterwards, you know. Then I started thinking that in this city, in which creatures or insects had taken over, or were running the world, there were bound to be artists. What would they paint? They would paint each other, or paint self-portraits. I did a whole series in which I made a spoof of the whole art world. I had hoods looking at field paintings, hoods being at art openings, hoods having discussions about colour. I had a good time. . . .

When these were shown, my painter friends in the New York School would come up to me and say, "Now what did you want to do that for?" It seemed to depress a lot of people. It was as though I had left the Church; I was excommunicated for a while. Two or three people were notable exceptions. One was Rosenberg, who I think wrote the only favourable review, a really interesting and knowing review in the *New Yorker*. The other person was Bill de Kooning. At the opening he grabbed me, hugged me and said he was envious, which was

flattering, because I regarded him as the best painter in the country and, in many ways, the only one. I mean he's a real mind and a real painter. "Philip," he said, "this isn't the subject. Do you know what the real subject is?" And we both said at the same time, "Freedom." Then we hugged each other again. Of course that's what it's about. *Freedom.* That's the only possession an artist has—freedom to do whatever you can imagine. Then I left for Europe, immediately after the show. The art critic from the *New York Times,* Hilton Kramer, gave me a whole page. He called it "From Mandarin to Stumblebum," and reproduced *The Studio,* which I think is a very sophisticated picture. I thought I had put in everything I knew about painting. But he thought, well, that's the end of him. He did a real hatchet job. I had asked the gallery not to send me any clippings, I just wanted to have a vacation. . . .

The few people who visit me are poets or writers, rather than painters, because I value their reactions. Looking at this painting, Clark Coolidge, a poet who lives about 30 miles away, said that [*Deluge*] looked as if an invisible presence had been there, but had left these objects and gone somewhere else. I like that kind of reaction, compared with reactions like "The green works, the blue doesn't work."

I didn't arrange this still life; it's just objects picked out from around the studio. It's called *Painter's Table.* It was fun to paint ashtrays and cigarette butts, which began to look like something else. I draw constantly when I paint, I'll take a week off and do hundreds of drawings. It's a form of germination. I don't follow drawings literally. Once in a while I will indulge in a very loose painting. By loose I don't mean deliberately loose, rather just not having too much on my mind and just stumbling on painting and seizing on whatever happens. I don't remember painting these heads drowning in a basement, that awful feeling of the basement being filled with water in a dream or nightmare.

I use the complete range of everything I've ever learned in painting: To be tight, to be loose, to be conscious, to be not conscious. Sometimes I make sketches of paintings, plan it out and change little in the doing of it. At others I start with nothing on my mind. Everything is possible, everything except dogma, of any kind. These are large pictures, about eleven feet in width. I put rubber castors on the ten foot painting table so that I can move from one part of the painting to the other part very easily, without losing my thought or urgency, and without stepping back to look at it. The worst thing in the world is to make judgements. What I always try to do is to eliminate, as much as possible, the time span between thinking and doing. The ideal is to think and to do at the same second, the same split second.

I ought to explain what I meant by trifles earlier. One morning my wife, after the rain, pointed out a spider that was making a marvellous web, so I started doing a number of web pictures with my wife and myself, and a lot of paraphernalia caught in the web. That's her on the right, with the hair coming down her forehead, and then I thought I'd put a shoe on her head. It's a terribly corny idea, but what can you do? It led to a whole series of paintings with both of us caught in the web. It felt good making a web, eleven feet across. I didn't study the web, I don't know what a web looks like. I just invented a web.

Sometimes changing a form is important. I remember that eye, the heavy-lidded eye, was originally shoes and legs upside down; at that point it bored me so I started taking it out and it became an eye, like an all-seeing eye in science fiction. It felt all right. Those two big fingers dangling down below puzzled me. The hand wrapped in the canvas didn't look right until I did the lines on the hand, as if it were a Greek sculpture or an ancient hand, not a realistic hand.

Well, this is a self-portrait. I had been painting all night. I went into the john, looked in

the mirror and saw that my eyes were all bloodshot. I came back, picked up a small brush, dipped it in red, and made my eyes bloodshot. Then the painting was finished.

You see, I look at my paintings, speculate about them. They baffle me, too. That's all I'm painting for.

ERIC FISCHL I Don't Think Expressionism Is the Issue (1982)

I don't think Expressionism is the issue. I think what's going on in painting now is coming out of national identities. People have withdrawn into their own histories to try to find meanings. So you have art that seems like it can only be made out of a sensibility identified as Italian. England is enjoying a kind of rebirth. France, as well. And Germany. When Italians and Germans go back into their history, they're going back to their strengths. A lot of American art is going back to sources, too—the '50s, Pop Art—which I don't think is going back far enough. As you go back farther than that, you get to a time when America was more isolated—when its strengths are not easy to find, because American artists were very influenced by Europeans. It's almost like a denial of American strength to go back into American history—say, 60 years. One thing I love about people like Dove and O'Keeffe and Hartley is that there is this kind of dumbness to their work, a directness—the difference between Dove's abstractions and Kandinsky's is so great. Dove's are so literal and nudgy. But I respond to that. I understand it. I find that those qualities are in my own work, that there is an awkwardness to the forms or to the narrative moment.

Expressionism has been important to me, though, especially the paintings of Max Beckmann. When I was an abstract painter, I found Beckmann's *The Departure* interesting, exciting, but I thought, forget it. I can't deal with this. Then one day I stopped in front of it and said, I'll just repeat back to myself what I'm seeing, and see if it makes sense. What I discovered was that I could grasp the intention of the picture exactly, without understanding the allegory, without knowing this or that figure was a particular mythical character. I could see it simply as a complete narrative, and the discovery of narrative painting was much more important to me than Expressionism as a style.

The Departure made me feel how bankrupt abstraction had become, that it had somehow gotten to the point where I didn't trust what I was seeing in an abstract painting. The image always seemed to mean something hidden, so that I had to know outside references in order to know the particular meaning of that painting. And there was Beckmann's *Departure,* a work of art whose meanings were all inside it. Its references weren't art references. They were cultural, so I could hook up certain parts of the image to political violence or historical moments or religious values—all those things that belong to the general culture. And I thought that was great. It made sense. I find Beckmann's mythical characters fascinating, but I don't find references to them in American culture or in my own education. I think about achieving that level of myth in my own work, somehow tapping that source, but it doesn't happen, for what I think are cultural reasons. America just doesn't have that wellspring of iconography.

The most interesting quality of Beckmann's story-telling is the psychological one—the relationships of men and women, and how those relationships expand, usually in a painting's outside panels. So personal matters have broad implications. They refer to social and political

* Eric Fischl, statement, in Carter Ratcliff, "Expressionism Today: An Artist's Symposium," *Art in America* 70, no. 11 (December 1982): 60–92. By permission of the artist, the author, and the publisher.

issues. And the range of Beckmann's pictorial language is so great. There'll be parts simply delineated with a black line, then filled in with a single flesh color, and other areas of the painting where he is psychologically investing a lot into an arm, a breast, a leg, a detail of a varicose vein on the back of a calf. This is where you can feel his obsession. I find that experientially rich, and I miss it in artists like Kirchner or Nolde, who give a flatter presentation of the whole event. The psychology of Beckmann's art is to possess the subject. It's unique.

The direct approach of the other Expressionists—not Beckmann—where the painter tries to put everything into one gesture, is unsubtle. I find that I need, now, to get quieter, to have parts of a painting be very quiet. So I'm becoming much tighter as I paint, which I wonder about, except that—I think about Degas, and how you can always tell what area of a canvas he was interested in. You know from a distance that a certain image is a vase, and on close inspection it turns out to be just a set of brushstrokes. Beckmann did that on psychological terms. His way of painting says that this character is less important than that one, or this part of the body is less important than that one.

Art is like theater. In theater, if you want to whisper, you have to whisper loudly enough so that the audience hears you, and the audience also has to know it's a whisper. So the artist has to be able to blow the subtleties up proportionately, and at the same time have them be recognized as subtle. It's what marks a good artist, even if he is painting badly. He has to tip his hand, to let you know he's a good artist painting badly. Ultimately, painting is a craft. There are better craftsmen and worse. After an Abstract Expressionist smears the canvas for 20 years, it's ridiculous for him to pretend he doesn't know what he's doing. He knows exactly what he's doing. By then, his craft has developed as far as it's going to develop, and it's a question of being a mature artist who works with the world in a certain way, who continues to work with it. It's important for a painter to have the formal means to deal with his vision of the world, but it also helps if that vision is an interesting one.

JÖRG IMMENDORFF Interview with Jörg Huber: Situation—Position (1983)

From the very beginning at the academy there was a political engagement which penetrated my work. At first it was on a rather emotional basis then it became increasingly conscious, directed against the politics of the (art) academy, against the conformism which ruled there. It was not for nothing that I painted the picture "Stop Painting." It was my reaction against academicism which went under the mantle of "tachism" and produced an (artistic) silence like the graveyard. This political engagement brought me in contact with several fellow students like Sigmar Polke in our motivation. . . .

As time went on, this moved beyond the realm of the academy. Günter Grass published a call against the Vietnam War in *Der Spiegel* which moved me so much that spontaneously I got together a list of signatures upon which I painted the German flag and an eagle. Beuys, Anatol, Palermo, and many others were among the signatures. For me this was a simple necessity grounded in the basis of my indignation. I was then, and I am now, convinced that it is not possible to separate art from politics, from what happens around us. There is not only the matter of aesthetics. . . .

In the Maoist period in '68, I represented a radical point of view where I demanded:

* Jörg Immendorff, excerpt from "Interview with Jörg Huber: Situation—Position," in *Immendorff* (Zurich: Kunsthaus Zurich, 1983), 36–52. Translation by Peter Selz. By permission of the artist and the interviewer.

"People, in a period which is so horrible, you cannot remain uninvolved!" I painted a picture such as "An Art Action," 1973, where workers questioned the art of Beuys and Palermo.

My form has changed, the attitude of my engagement has not. Important is the continuity of moral integrity. The immediate ideological point of view is totally unimportant. It is important under changing conditions to draw a *Position* in every *Situation* and to behave unequivocally—this especially in times when everything is relative and therefore has become soft. I see myself as a political painter because a political thread goes like a red thread through my life and work.

For me art, then and now, is the way to clarify my point of view and to represent it even if the inclination in the inner-directed realm has changed. . . .

In 1979–80, when together with friends I founded the Alternative Lists and ran for city council, I asked myself the question: Are you now going to become a political functionary? Or will you put your major action into art? The political work became a Full-Time-Job. Through my activity, in the student council and the Vietnam committees, I collected experiences and developed a talent for rhetoric. For that reason, I had to take leadership function everywhere.

Another point was just as important. I welcome all sensible and extra-parliamentary politics but I believe that one cannot make politics with art as I then understood it. I came to the conviction that this intention, to speak to the masses directly, does not bring about the expected effect and may even be an illusion.

It is not possible to have a direct effect on political events.

Formerly I thought that one could attack people directly, and shake them awake. However, after I determined that there is no guarantee for a quicker and more intensive communication, I took a step forward and concentrated on the materialist framework of art: galleries, *Kunsthäuser,* and museums, universities, media, and publications. . . . By participating in the art world, I became stronger and further ahead. I do not believe that art commerce sucks, like Dracula, the blood out of my pictures. If the work and the attitude of the artist is forceful, nothing can happen to them! However, I cannot say anything about the effect of individual paintings. These are open questions because as far as I know, there is no scientific market research along those lines. Therefore, I must hold to the unshakeable belief that the productive, creative, artistic form is the best form of Being. . . .

There is no clearly defined reading of my pictures. First of all, I must emphasize that it is not a matter of "understanding" the paintings. Several known pictorial signs create a first "skin contact" with the viewer. The second step, which opens an encounter, goes below the skin. That which goes under the skin is the sum of the painting: composition, technique and brushwork, colors, etc. . . . My pictures are not painted academic lectures. Their rhetoric is very different from that of the street. When formerly I painted the raised fist and the red flag, I thought to represent unequivocal symbols in the interest of the labor movement and these pictures were understood. Today, I no longer direct myself to a clearly defined audience—this relates to the involvement of the structure of class society—and I no longer ask in relation to my work: "For whom?" But: "What comes out of me?" The more intensive I formulate my point of view, the more readily will the Other receive the material with which he works. I begin with myself as the concerned one and use the world which is nourished by real experiences and delivers authentic optical material as information. I am no more isolated than my neighbor. We are all related in a large connected flow. This is the only means of real contact. An attitude which is too easily accessible can only result in short circuit.

In 1980, I organized in my basement the last underground exhibition of the New Painting

including the "Mühlheimer Freiheit" when this wave was not yet widely publicized. Soon after that came the rush of the art market. These young painters never had the chance to prove themselves. That is to say to exercise resistance and to create a basis for their work. The enticement to capitulate was too great. The temptation came too quickly and with that also the fact of their being co-opted ideologically. As against that I do not believe that there is authentic painting without morality, and I don't mean bourgeois morality: to feel and to practice resistance is a prerequisite for the condition for an art that will last.

I cannot expect from other painters what I understand personally as political painting. But I will not be subjected to the emotional brush swingers and rhythm dancers who think that there is deep feeling in every hair of the brush. One can be spontaneous and loose if one has a foundation.

I react like a seismograph to force, to pressure, to injustice but also to hope, to longing, and imagination: I react *as a painter.* My paintings represent by means of intensity and creativity which flow from me the smallest constellations for eyes that can see. The communication occurs by means of the material event of the painting not only the content. I use cheap unhealthy oil paint and end up with something fantastic. . . .

My joy, for instance, with a purple that I throw into the corner of a painting is so intimate and connected with so much happiness or boredom that an intensity will be expressed. During an act of painting, everything happens, variations playing themselves through, the rejection of everything sentimental up to the basic concepts. My art is not trendy. It is necessary painting, political not only through its objective message but also through its painterly realizations.

JOHN PITMAN WEBER Murals as People's Art (1971)

Art in Bourgeois Society

At the present time, perhaps especially in Chicago, there is virtually no contact between the "Fine Arts" and the poor. Low income people and especially national minority groups are systematically excluded from the creation of and therefore the enjoyment of most forms of cultural expression. This is particularly true of the visual arts. Through a complex process involving the antagonistic nature of their total experience with official "society" and in particular the schools, the children of the poor develop the conviction that they are unable to create, are lacking in talent and tradition, are cultural cripples. Art is placed on a high altar, out of reach, incomprehensible, and at the same time despised. Artists are considered "kooks," "weirdos," strange beasts indeed. This mixture of feelings, all negative, reflects both the loss of self-respect and self-confidence which results from powerlessness and an intuitive understanding that the rulers of industrial society have little use for the artist or his handmade expressions, except as conversation pieces or as the subject for the ultraluxurious hobby of collecting.

The artists meanwhile are almost totally cut off from communication with the mass of humanity. Curiously enough this state of affairs in general extends to the small number of artists who come from working class and minority backgrounds. The overwhelming majority of art-

* John Pitman Weber, excerpts from "Murals as People's Art," *Liberation* 16, no. 4 (September 1971): 42–46. By permission of the author.

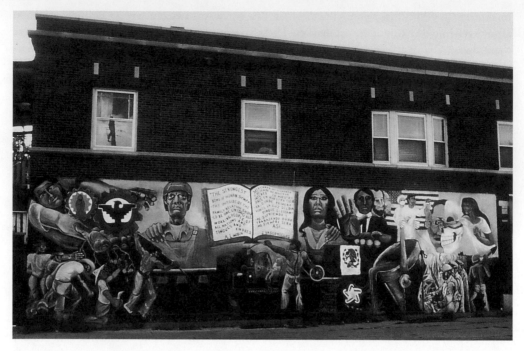

Ray Patlán, Vicente Mendoza, and José Nario, *History of Mexican American Workers,* 1974–75, mural in Blue Island, Illinois. Photo by James Prigoff. By permission of the artists and the photographer.

ists in this country are unemployed *as artists.* They earn their livings as teachers, taxicab drivers, etc. etc. Artists often explain their isolation and unemployment by an elitist theory of talent, intelligence and sensibility. There is a widespread conviction that the "masses" are incapable of understanding or of making art. Therefore, the artist's response to this situation has generally been to retreat further into a hermetic "art world," into art theory building (e.g. making "art history" rather than art) and private games, only to surface occasionally in a self-indulgent public provocation, which is increasingly ineffective also. Painters, poets, composers, all completely marginal, divorced from any mass audience, a small lumpen among petty bourgeois professionals, rationalizing their marginality by entertaining each other with the elitist theories they have been brought up on and by their boundless capacity for make-believe.

In bourgeois society art like everything else becomes a commodity. It loses its social nature as a free expression of collective experience. The artist is "free" from the control of patrons, but separated from possible social use, from any stable role, and subjected to a speculative market which inevitably leaves the majority without a livelihood.

The museums and galleries are class-exclusive institutions. The occasional use of art as a vehicle for protest by artists is impotent within the museum–gallery complex. To live for the chance to make one grand gesture in this privileged arena is a pitiful delusion, but a common one. For such protest is reduced to momentary sensation by the nature of the institutions within which it appears. The museums and galleries offer culture as a spectacle divorced from life and are willing to market any sensation, even protest, to their class–exclusive clientele.

Marginal individual commodity production is the essence of Bohemia and all its chronic tragi-comic anarchism. To change this situation more is needed than a change of subject mat-

ter or a change of style. Constructivism and Dada; Minimal Art and Pop. The brave challenges of one generation of artists reappear as nicely domesticated absurdities of another. The "revolutions" of the "art world" are stillborn because they remain within the narrow limits of that world. A fundamental change in the artist's relationship to society is needed.

Involvement in "the movement" does not at all solve this problem, even though it may change the artist's consciousness in essential ways. In the white section of the movement the artist often finds himself subjected to additional pressures to give up art. Why don't you write? one is told, you're too articulate to be a painter. Do cartoons for leaflets, do graphics for movement newspapers, design posters, buttons, banners. Anything to be *useful*. What is often demanded is leftist icons—"vanguard" art, "consciousness-raising" art. This means in effect art only for the movement and its intellectual student supporters: who else would buy a poster of Che? None of this "movement art" touches the basic problem of establishing contact with a proletarian mass audience.

For some of us, mural painting has meant the realization of a socially-politically significant role as artists. With all its difficulties, it is a liberation, a release. It is a path back to the life of humanity.

DISCOVERY

My first outdoor mural was painted in 1969 in the courtyard of St. Dominic's Church near the Cabrini–Green Housing Projects, working with a group of local teenagers. The wall dealt symbolically with the Black liberation struggle. It is called "All Power to the People." In that project for the first time, I was able to combine my life as an artist, a teacher and a socially-politically involved person all in one activity. Painting the mural was an extraordinary experience, a conversion. I found that I was able to create an imagery which spoke directly to ordinary people, which was accepted as their own by people separated from me by culture and by a long history of prejudice and oppression.

Many barriers can be crossed by an artist bringing commitment and vision to the work. The artist is transformed in the process of creating public art. He must abandon his private self-examination to speak as a citizen in society, and to become a voice for others. He is rewarded in becoming an artist for the people, by gaining a living relationship with the people.

This sense of wonder at the discovery of a new identity, a new relationship with others, is a deep and abiding feeling, shared by many muralists here in Chicago. . . .

The wall itself speaks for the artist and becomes a center of discussion. One cannot realize without actually witnessing it the extent, seriousness and intensity of response. The political-social issues symbolized in the mural are a starting point for far-ranging debates. The artist, however, by the nature of the case is unable to participate fully in this discussion. The artist works with his back to the street and those opposed to his viewpoint will often not voice their objections directly to him. Other conscious organizers in the community can maximize this opportunity to clarify ideas or can use the wall as a springboard for discussion of community issues.

Mural painting can only be done on a full-time basis. It is essential that the artist be on the scene regularly and have a strong ability to project to the community the nature of his theme, his concern and his craft. Security for the equipment and for the mural can only be based on community acceptance, comprehension and pride. If the community develops this acceptance and pride in the wall, then the mural becomes a focus and a symbol of the com-

munity (its resistance to Urban Renewal, a favored spot for rallies, etc.). The mural may also stimulate other efforts at community improvement—fight to get a playground, etc.

It can draw people together—greasers and hippies, young workers, mothers, street-gang members, church activists, small business people, etc. In some cases mural projects have played a role in establishing truces between rival street gangs. Public Art can play a concrete and symbolic role in building the united front.

In addition, a mural project, because of its visibility, wins access to the media. The artist has opportunities to rap on radio, in high schools, art schools, newspaper articles.

Think in Terms of the Majority

The need for a community base for community support must be emphasized over and over. Part of the nature of being public is to struggle for communication to the majority. In oppressed communities this is pretty straightforward. In a white community one is faced with the more complex task of fighting racism *and* "winning" a majority. This means actually dividing the community on the question of the wall, but placing racism in a minority position. . . . To put forward this question—race war or class struggle—in a community where almost everyone is uptight over impending "integration" (and in the absence of any active radical community organizing) might seem to preclude winning majority support. Images were carefully chosen on the basis of an analysis of the neighborhood: most were people of good will. A struggle went on during the entire period of work, mostly in the form of spontaneous debate, leading to a majority in favor of the wall. The isolation of the ultra-racist minority (on this issue) was shown by the immense success of the festive dedication party.

It would have been easy to design explicitly leftist imagery, but public murals are not posters. They are not and cannot be art for the movement alone. The movement, with some exceptions, has been correspondingly slow to recognize mural painting as a "serve the people" program and as political work. Because murals remain (and must remain several years to be worth the time invested) they must express long range struggles—the deep currents. And because they remain they have a slow, but potentially powerful effect on consciousness. Furthermore murals are specific. They exist in a *certain space* and in relation to a specific audience. Even the specific physical characteristics of each wall must be taken into account. . . . The socially oriented wall paintings of Chicago and several other cities . . . try to relate to people, to clarify ideas, to be a visual expression of the community. To those who hold the "political" character of our murals against us, I say that we are proud that our painting openly supports the people's struggles. Our politics has to do with community empowerment—returning art to the people as a means of communication and celebration.

The difference between content and non-content murals is a class difference. The nonobjective wall painting is the line of least resistance for the artist in seeking corporate support and for the city fathers in seeking an inexpensive way to beautify a deteriorating urban area.

Some abstractionists in turn claim that the figurative-symbolic works of Chicago and several other cities "talk down" to the audience. In answer, I wrote the following in our statement: "I aim to draw out of my experience of human events and of the physical environment certain symbols which are suggestive and associative rather than literal—which have resonance. *In public works,* it is essential that these symbols be readable by the intended audience, the people in the neighborhood." The effort to attain readability is not a process of "talking down" to people. It involves taking the audience seriously and art seriously as a vehicle for social communication. Public mural painting sets a high standard for the artist, who must

seek both to attain universality in his imagery, and to speak to a specific community which is often not his own. There is no room for self-indulgence. The basis of this work is sincere respect for the people; respect for self, and respect for art.

We believe there is no necessary contradiction between aesthetic, expressive and didactic aspects of art. We are not dogmatists; we know that we are only beginning to discover the possibilities of people's art. All that authentically draws on the people's life should have a place in it. . . .

There is much more to discuss: the need for greatly increased public funding, the problems of unity among black, brown and white artists. But I would rather end here with another quote from our statement:

> We want the walls of Chicago to be art galleries for the people. We are anxious to encourage more artists in all fields to *take to the streets,* to become involved, and to work for the people. Our murals will continue to speak of the liberation struggles of Black and Third World peoples; they will record history, speak of today and project toward the future. They will speak of an end to war, racism and repression, of love, of beauty and of life. We want to restore an image of full humanity to the people, to place art into its true context, into life.

JESSE HELMS
Senator Helms Objects to Taxpayers' Funding for Sacrilegious Art (1989)

Mr. President, . . . I do not know Mr. Andres Serrano, and I hope I never meet him because he is not an artist, he is a jerk.

Let us examine exactly what this bird did to get the American taxpayer to subsidize his $15,000 award through the so-called National Endowment for the Arts. Let me first say that if the Endowment has no better judgment than this, it ought to be abolished and all funds returned to the taxpayer.

What this Serrano fellow did to create this blasphemy was to fill a bottle with his own urine and then he stuck a crucifix—the Lord Jesus Christ on a cross—down in the urine, set the bottle on a table, and took a picture of it.

For that, the National Endowment for the Arts contributed to a $15,000 award to honor him as an artist.

I say again, Mr. President, he is not an artist. He is a jerk. He is taunting a large segment of the American people, just as others are, about their Christian faith. I resent it, and I do not hesitate to say so.

I am not going to call the name that he applied to this work of art. In naming it he sought to create indignation, and let there be no question that he succeeded in that regard.

It is all right for him to be a jerk but let him be a jerk on his own time and with his own resources. Do not dishonor the Lord. Again, I resent it and I think the vast majority of our American people resent the National Endowment for the Arts spending the taxpayers' money to honor this individual.

The Federal program which honored Mr. Serrano, called the Awards in Visual Arts, is supported by the National Endowment and administered by the Southeastern Center for Contemporary Arts. They call it SECCA and I am sorry to say it is in my home State.

* "Senator Helms Objects to Taxpayers' Funding for Sacrilegious Art," *Congressional Record,* Washington, D.C., 18 May 1989, vol. 135, no. 64.

United States Public Law No. 101-121.

After Mr. Serrano's selection, this deplorable photograph and some of his other works were exhibited in several cities around the country with the approval and the support of the National Endowment.

Horsefeathers. If we have sunk so low in this country as to tolerate and condone this sort of thing, then we have become a part of it.

The question is obvious. On what conceivable basis does anybody who would engage in such blasphemy and insensitivity toward the religious community deserve to be honored? The answer to that is that he does not. He deserves to be rebuked and ignored because he is not an artist. Anybody who would do such a despicable thing—and get a tax-subsidized award of $15,000 for it—well, it tells you something about the state of this Government and the way it spends our hard-earned tax dollars.

So no wonder all of the people calling my office are indignant. The Constitution may prevent the Government from prohibiting Mr. Serrano's—laughably, I will describe it—"artistic expression." But the Constitution certainly does not require the American taxpayers or the Federal Government to fund, promote, honor, approve, or condone it.

Mr. President, the National Endowment's procedures for selecting artists and works of art deserving of taxpayer support are badly, badly flawed if this is an example of the kind of programs they fund with taxpayers' money.

I have sent word to the Endowment that I want them to review their funding criteria to ensure abuses such as this never happen again. The preliminary report we got from one person with whom we talked was sort of "Down, boy, we know what we are doing."

Well, they do not know what they are doing. By promoting, approving, and funding Mr. Serrano's sacrilege, the National Endowment for the Arts has insulted the very precepts on which this country was founded. I say again, that as an American and as a taxpayer, I resent it.

ANDRES SERRANO Letter to the National Endowment for the Arts (1989)

I am concerned over recent events regarding the misrepresentation of my work in Congress and consequent treatment in the media. The cavalier and blasphemous intentions ascribed to me on the Congressional floor bear little semblance to reality. I am disturbed that the rush to judgment by certain members of Congress has been particularly swift and vindictive.

I am appalled by the claim of "anti-Christian bigotry" that has been attributed to my picture, "Piss Christ." The photograph, and the title itself, are ambiguously provocative but certainly not blasphemous. Over the years, I have addressed religion regularly in my art. My Catholic upbringing informs this work which helps me to redefine and personalize my relationship with God. My use of such bodily fluids as blood and urine in this context is parallel to Catholicism's obsession with "the body and blood of Christ." It is precisely in the exploration and juxtaposition of these symbols from which Christianity draws its strength. The photograph in question, like all my work, has multiple meanings and can be interpreted in various ways. So let us suppose that the picture is meant as a criticism of the billion dollar Christ-for-profit industry and the commercialization of spiritual values that permeates our society. That it is a condemnation of those who abuse the teachings of Christ for their own ignoble ends. Is the subject of religion so inviolate that it is not open to discussion? I think not.

In writing the Majority Opinion in the flag burning case, Justice William J. Brennan concluded, "We never before have held that the Government may insure that a symbol be used to express one view of that symbol or it's referents. . . . To conclude that the Government may permit designated symbols to be used to communicate only a limited set of messages would be to enter into territory having no discernible or defensible boundaries."

Artists often depend on the manipulation of symbols to present ideas and associations not always apparent in such symbols. If all such ideas and associations were evident there would be little need for artists to give expression to them. In short, there would be no need to make art.

Do we condemn the use of a swastika in a work of art that does not unequivocally denounce Nazism as anti-Semitic? Not when the artist is Jewish. Do we denounce as racist a painting or photograph that is demeaning to African-Americans? Not if the artist is Black. When art is decontextualised however, it can pose a problem and create misunderstanding.

Debate and dissension are at the heart of our democracy. In a free society ideas, even difficult ones, are not dangerous. The only danger lies in repressing them.

> Andres Serrano
> July 8, 1989
> New York City

ROBERT MAPPLETHORPE Interview with Janet Kardon (1988)

JANET KARDON: When you and Patti Smith were together in the early 1970s, you both spent a lot of time at Max's Kansas City.

ROBERT MAPPLETHORPE: I finished art school in 1970, arrived in Manhattan with Patti

* Andres Serrano, letter to Hugh Southern, acting chair of the National Endowment for the Arts, 8 July 1989. By permission of the author.

** Janet Kardon, excerpts from "Robert Mapplethorpe," in *Robert Mapplethorpe: The Perfect Moment* (Philadelphia: Institute of Contemporary Art, 1988), 23–29. By permission of the author and the publisher.

Smith, and checked into the Chelsea Hotel for a year or year and a half. We had the smallest room in the hotel, but it was what we could afford; and we had to pretend there was only one of us because it was too small for two people. We went to Max's Kansas City almost every night. We had lots of scarves and cheap clothes, and one of the more exciting things to do was dress up. . . .

Patti was doing readings at the time at St. Mark's, and I was doing collages, starting to take photographs, and also doing jewelry.

JK: Who was there?

RM: All kinds of people, but it was usually musicians, writers, trendy models, and some photographers—people who were becoming something that they never became. There were drag queens and people who were in Warhol movies, but were never really quite talented enough to do anything else.

JK: You were making collages and fetish objects. Where did you go to art school?

RM: I went to Pratt, where I did collages. I was also making photographic objects with material from pornographic magazines. At some point, I picked up a camera and started taking erotic pictures—so that I would have the right raw material and it would be more mine, instead of using other people's pictures. That was why I went into photography. It wasn't to take a pure photographic image, it was just to be able to work with more images.

JK: When you met Sam Wagstaff, were you using a camera?

RM: Yes. I met John McKendry a few years before that, and got more involved with photography through him; he was the curator of prints, drawings, and photographs at the Metropolitan Museum. Through him, I was exposed to photography in a way I had never been before, and I started to look at the photograph as a form in itself.

JK: Whose photographs did you look at?

RM: John did a show of the photosecessionists that was important to me. I think John bought me my first Polaroid camera. Even the earliest Polaroids I took have the same sensibility as the pictures I take now. Right from the beginning, before I knew much about photography, I had the same eyes. When I first started taking pictures, the vision was there. . . .

Well, unbeknownst to myself, I became a photographer. I never really wanted to be one in art school; it wasn't a high enough art form at that point. But then I realized that all kinds of things can be done within the context of photography, and it was also the perfect medium, or so it seemed, for the seventies and eighties, when everything was fast. If I were to make something that took weeks to do, I'd lose my enthusiasm. It would become an act of labor and the love would be gone. With photography, you zero in; you put a lot of energy into short periods, short moments, and then you go on to the next thing. It seems to allow you to function in a very contemporary way and still produce the material. It also allowed me to travel and still be productive. . . .

JK: It strikes me that your sitters appear to be very well prepared, even staged. It's never a casual shot, but then, you call photography fast. How long does a photo session take?

RM: Sometimes I need to know the people really well before I can get pictures, so that in itself is time consuming; but the actual portrait is done in two hours or so. . . .

I have to get my head in the right frame of mind to look at contacts and figure out which exactly is the right picture, and nobody can do that but me.

JK: How many will you shoot to get the right one?

RM: Usually five or six rolls. When I do commercial work, and I'm being paid a lot of money, I may stick extra film in, which isn't to say that I don't get to know the sitter. I may

do ten for the commissions, because I think people want more. Part of being a photographer is knowing when the subject is exhausted. I've found that other photographers are not very sensitive to that; they go on, and they overdo it. When I would be bored, they're still taking pictures. You put out a certain energy for photographs, and photographers often are not that sensitive to people. I think that pictures taken at the moment the subject feels most comfortable are the best.

JK: I don't quite understand why, but if somebody is born Catholic and they no longer practice, they still say, "I'm a lapsed Catholic." Christian objects and imagery surround you in your home, and you've actually made crosses. How else does that feed into the work? Or do you think it does at all?

RM: I think that it does in that being Catholic is manifest in a certain symmetry and approach. I like the form of a cross, I like its proportions. I arrange things in a Catholic way. But I think it's more subconscious at this point.

JK: Is it similar to the precise placement of ceremonial objects on an altarpiece?

RM: Yes. The early fetish things were kinds of altarpieces, but you don't say you're going to do an altarpiece. . . .

JK: So many of your photographs are frontal, similar to a trecento Madonna painting. You often use the word "perfection," and there is a kind of perfection about the work—a purity. It's often symmetrical, and in this way it relates to the crucifix.

RM: The work is very direct. I try not to have anything in the picture that is questionable. I don't want anything to come in at an angle that isn't supposed to come in at an angle.

JK: What do you mean?

RM: I think my pictures are the opposite of Garry Winogrand's.

JK: Would you ever take a snapshot?

RM: I have, but it's not what I do best. I photographed a party once in the Caribbean. I hated it. You try to get something out of it through a camera, but at a party I want to be at a party.

I just did a shoot in Louisiana, in the bayou. I don't want to be a wildlife photographer, but I wanted to do it once and see what it was about. . . .

But it's a lot of work. I need new equipment, because you can't get close enough in certain cases. Then I want to go to a game preserve and photograph, but that's going to be even harder. A lot of things sound better than they are. Your whole life in retrospect may well seem great, but the reality of it is different. . . .

JK: There's a purity to the flowers that makes them somewhat untouchable, removed, again Madonnalike, while the S & M pictures and the other sex pictures go to another extreme. Do you see them as different?

RM: No, I don't really think so. I think that the flowers have a certain—

JK: Are sexy?

RM: Not sexy, but weird. I don't want to use the word "weird," but they don't look like anyone else's flowers. They have a certain archness to them, a certain edge that flowers generally do not have.

JK: Do you think they're threatening? . . .

RM: I don't know how to describe them, but I don't think they're very different from body parts. Maybe I experiment a little more with flowers and inanimate objects because you don't have to worry about the subject being sensitive or worry about the personality. I don't think I see differently just because the subject changes. I couldn't have taken certain of the

early sex pictures if I wasn't sensitive to what could be in a given situation. I had to be flexible to the situations, and some of them are more formal and controlled because I had the opportunity to do that. With flowers, I can always juggle things around. It can take two hours to just set up the lights.

JK: Do you know what you want before you set up?

RM: No. If I click when I'm doing a day of flowers, I can get three or four pictures in one day.

JK: One day you'll work on flowers, and on another with models?

RM: I make an effort to. I get flowers sent to me, and I have to shoot them that day. Sometimes, I bring in a friend who's an art director to make it easier. When I've exhibited pictures, particularly at Robert Miller Gallery, I've tried to juxtapose a flower, then a picture of a cock, then a portrait, so that you could see they were the same. I just would like people to be able to get the real meaning. I did a picture of a guy with his finger up a cock. I think that for what it is, it's a perfect picture, because the hand gestures are beautiful. I know most people couldn't see the hand gestures, but compositionally I think it works. I think the hand gesture is beautiful. What it happens to be doing, it happens to be doing, but that's an aside.

JK: Let's look at it another way. You bestow elegance on a subject one would never consider as elegant—in the photographs of the cocks, for example. One might not say a cock was elegant.

RM: I might. . . . Because I'm not involved with some of the subjects I've photographed over and over again, such as Ken Moody, I can fall in love with the subject and not be personally involved. And I can photograph somebody that I don't like at all. There's one person in particular I photographed any number of times; as a person, he's horrible, but I couldn't take a bad picture of him. There was a sympathy in the studio, but outside I couldn't talk to him. He was disgusting. I might have flowers around and not bother to take a picture of them; and I like vases, but I like them without flowers. If I put them together, I love taking pictures of them, but it doesn't mean I love flowers. When you're working with a subject, I think you have to love it, but you don't have to love it afterward. I can do a commissioned portrait of somebody who's not my kind of person at all. . . .

JK: Let's talk about getting people comfortable. You do that very well. I think you have special skills with people.

RM: Other photographers approach the whole thing differently, but as a photographer you're collaborating with the subject. You're doing something together, and if you can make the person feel like that, that's when it works. I'm only half the act of taking pictures, if we're talking about portraiture, so it's a matter of having somebody just feel right about themselves and about how they're relating to you. Then you can get a magic moment out of them. In portraits, taking the actual picture is only half of it; developing your personality to a point where you can deal with all kinds of people—that's the other half. I think the greatest portrait photographer of all time was Nadar, and he was probably one of the most interesting, if not the most interesting, photographers ever. You can tell by the way the subjects give themselves to the camera that they're not sitting in the company of anyone other than their equal. They're not just doing something for a picture; they respect the photographer. Of course, in Nadar's time, it was often the first time they were being photographed, so that the whole experience was not just another photo session, which unfortunately is the case today, because everybody is so oversaturated with photography. It's not a secret, but I want to get more out of a person than someone else might.

JK: It seems to me you approach your subjects in a much friendlier way than someone

like Diane Arbus, who looks for the strangeness in people. You really want to find the very best in your subjects.

RM: That's the way I see it. I'm left with a diary of photographs I've taken over the years. I don't write, so that's it. I would rather go through the pages of my life, so to speak, and see people the way I would like to have seen them. Some of them are lies, some of them are nasty people, but they don't look nasty in the picture. But I would rather have a group of people that I wouldn't mind meeting, if I had never met them, to look back on as opposed to a collection of people I didn't like. That's my approach. Some people who've written about me have commented on nasty aspects in my photographs—that everybody's scowling. I've read very negative pieces written about the kinds of people I photograph and the look I get out of people, but I don't see it that way at all. . . .

JK: Obviously, the camera has a great ability to lie, but it's more difficult to make the camera lie if you have no backdrop, and if you have isolated a single subject to put in front of the camera.

RM: First of all, there's no voice, and the voice is important. If somebody doesn't have a nice voice or a nice manner, it is eliminated, and if they have a gesture that you don't like, you just don't photograph that gesture—or I don't. So, you can still lie.

JK: Do you like that about the camera?

RM: Yes. It's seen as a lie, but it's my truth, so it's not a lie to me. In the end, it's what I remember, and I would rather have pleasant memories. . . .

Have you ever seen the *X, Y,* and *Z* portfolios? *X* portfolio is thirteen sex pictures, *Y* is flowers, and *Z* is blacks. The earliest of the S & M pictures are in the *X* portfolio. They're small, they're 8 by 10s mounted to cards, and they come in a box. It may be interesting to have a wall in the exhibition with three rows of *X, Y,* and *Z*—but three rows all in one mass. It will cover a spectrum, certainly of the sex stuff, which might be a good way to do it. When they're hung like that, it's like a block. . . .

I think the work moves toward a kind of perfection. Over the years, the lighting has probably been controlled more, the precision is greater, but basically the vision is the same. It's just a matter of refining. . . .

Perfection means you don't question anything about the photograph. There are certain pictures I've taken in which you really can't move that leaf or that hand. It's where it should be, and you can't say it could have been there. There's nothing to question as in a great painting. I often have trouble with contemporary art because I find it's not perfect. It doesn't have to be anatomically correct to be perfect either. A Picasso portrait is perfect. It's just not questionable. In the best of my pictures, there's nothing to question—it's just there. And that's what I try to do. . . .

I was in art school when pop art was the rage. I was in academic art training at the time, and I wasn't following the trends; I was just doing my thing. But since I come out of that time, the Warhol influence is there.

I'm not talking so much about the product as the statement—I mean the fact that Warhol says "anything can be art," and then I can make pornography art. I think Duchamp is probably more important though. Certainly, Warhol comes from Duchamp, which is the opening up of a way of thinking, of possibilities.

JK: It's very intellectual, and it's not necessarily emotional or painterly, or expressionistic. It's in the other direction. Would you describe the black studies as being political, social, or intimate?

RM: They're probably all of that, but that's not their intent, that's not why they were taken.

JK: Why were they taken?

RM: They were taken because I hadn't seen pictures like that before. That's why one makes what one makes, because you want to see something you haven't seen before; it was a subject that nobody had used because it was loaded. It's no different than the pictures I did of sexuality; I think it's the same kind of work. I know somebody in New Orleans who photographs black men, too, but nobody's done it the way I do it.

JK: Do you put anything on their bodies?

RM: No. Sometimes they want to, but that's not what I like to do. . . . But I don't have any set formula. If somebody feels more comfortable putting oil on their body, I'm not going to stop them, but I try to dissuade them.

JK: Did Lisa Lyon?

RM: In certain pictures. But then, we were doing a whole book.

JK: In some of them I believe she had graphite on her body.

RM: Yes. In that case, we were trying to do every trick we could to have a book that worked, so I had no objection to any experimentation.

JK: Do you do black figures because white people would be somewhat shocked by looking at nude black bodies, or because black males might be considered sexual objects?

RM: Why did I? I don't know; I was attracted visually. That's the only reason I photographed them. But once I started, I realized there's a whole gap of visual things. There have been great photographs of naked black men in the history of photography, but they are very rare. Some of my favorite pictures happen to be the pictures of black men. I'm over that phase, I think; I'm not photographing anything naked these days. That isn't to say I won't again, but I haven't been concentrating on bodies recently. . . . I'm interested in experiencing the commercial photography world. I think it's at least as interesting. Once I've done something, I feel that I've done it. I get to a point where it's repetitive, another beautiful body. . . .

JK: Do you think there are things that haven't been said about your work that you would like people to think about?

RM: No, I don't really think like that. I guess I'd like the work to be seen more in the context of all mediums of art and not just photography. I don't like that isolation.

SHERMAN FLEMING

Living in a City of Monuments, Or Why
I No Longer Walk with an Erection (1990)

As an African-American male my quest for an empowering self-definition parallels the search for a political identity that is ironically characteristic of Washington [D.C.], the seat of world power. I vividly recall the twentieth anniversary of the march on Washington for civil rights in which Martin Luther King made his historic "I Have A Dream" speech, an occasion that, 20 years later, ushered in Jesse Jackson's presidential campaign. Recently numerous marches for women's equality and the right to control one's own body have intensified the vision of Washington as the site from which power is negotiated. . . .

* Sherman I. Fleming Jr., excerpts from "Living in a City of Monuments, Or Why I No Longer Walk with an Erection," *Washington Review* 16, no. 5 (February–March 1990): 5–7. By permission of the author.

Similarly, as all artists, I attempt to define myself in my work. I have tried to communicate that sense of Self particularly in my Peformance Art, the object-action through which I generated power. I created the pseudonym "RodForce," a label I used for 11 years, 1976–1987, as a self-empowering performance identity, one that not only served to parody the myth of black male sexual prowess but also aggressively confronted and intentionally conflicted with the burgeoning sexual conservatism that prevailed during the Reagan years, an oppressive reality that was all too transparent and could be easily penetrated beneath the pastel-colored shirts and the power yellow ties of the men that both put the lid on erotica and manipulated Washington. RodForce, a figure whose body performed feats of physical endurance and masculine prowess, who wore provocative clothing, and who postured erotically, emerged when the trend toward beautification of the body functioned as a vehicle to amass personal power. This repression of the sexual body through attention to the fitness body, characteristic of the 1980s, engendered an important sense of well-being through better health. But that "healthy body" also became a professional and commercial commodity in which looking powerful passed for being powerful. Regulation and exploitation followed in the form of a new economics of clothing, health and fitness clubs, and chic health-food emporiums. Michel Foucault has repeatedly described such regulation of sexuality in the machinations of economic and psychological controls.

The identity RodForce propelled me forward through this morass of repressed power-seeking bodies as the all-powerful Black Male, active in a city of Monuments essentialized by The Washington Monument: unyielding and invulnerable! The media representations of Blacks during the civil rights era shaped my adolescent views of an erotic male aesthetic. In addition, the media provided the forms through which I comprehended civil rights and particularly the ways in which, as a boy, I assumed male African-Americans exercised power. In this regard, popular culture produced my images and my heroes: the commanding intellectualism of Malcolm X; the spiritualism of Martin Luther King; the emotive eroticism of James Brown; and the physical endurability of the mythic John Henry. All these representations sifted through the electronic waves of radio and TV. In my youthful enthusiasm, these men seemed to have "conquered" the media and to have achieved a certain level of self-determination and self-empowerment.

Such are the fantasies of a boy in 1950s and 1960s America. However naive I might have been about the nature of power, I still understood that these "strong-men" walked a tightrope between noble character and buffoonery. For Malcolm X had clearly communicated that what one said was always subject to being reshaped by the media, particularly since he had been defined unjustly as an advocate of white genocide. So, although I admired the positive and powerful personas of these men, I also perceived that their identities were constructed by the media mythmakers for the consumers of culture, and that, in the blink of an eye, by the same mechanisms all of these men could be reduced (and inevitably were) to equally negative and mythic constructions: a violent lunatic, a womanizer, a fanatic partisan, and a plagiarizer. The actual social conditions that produce, encourage, and tolerate such pathetic manipulations of human identity and that, in their mythic structure, strip people of their humanity have been most recently exhibited in the tragic situation and performance of the former Washington Mayor, Marion Barry.

RodForce evoked intensity and invulnerability. RodForce was both Superman and Clown. As the stuff of myth, RodForce quickly became a prison of expectations—both of my own and those of my audience. RodForce could not keep it up. . . .

I began to realize that the joke was on me. I could not do justice to RodForce; no one

could. The erection could only be sustained through constant masturbation, concentration, or dominance. I had achieved a certain identity but, like the Washington Monument, in the theater of rumor and spectacle, I was standing alone.

At a certain point in my development, RodForce represented a dead-end. He was a response to the environment of my conditioning. As he matured and my understanding of the media and the place of the African-American male in American society changed, I could see that RodForce clearly was a one-dimensional construction like those caricatures of myth with which I had grown up. Whereas I was a contradictory, complex and vulnerable artist seeking a mode of expression that might allow me to escape solitude and to address the problem of control that all monolithic, monumental representations present. In order to evolve creatively and personally, I began to explore the undiscovered and uncontrollable multidimensions of a real experience. . . .

Nigger as Anti-Body (1990)

As an African-American growing up in the '60s and reaching adulthood in the late '70s, I became acutely aware of the aggressive denial of the term "Nigger." Coupled with Afro-America's desire for social access and economic parity was the persistence of the term Nigger. African-Americans' ideals were directed through two movements. The Civil Rights Movement, as represented by Martin Luther King, Jr., ushered in a non-violent attainment of integration and the dismantling of laws and practices that enforced racial separation. This was countered by the virulent and more rhetorically popular Black Power Movement, fueled by Malcolm X's doctrines, whose representatives included H. Rap Brown, Angela Davis, Huey Newton, and Bobby Seale. They espoused the notion of delivery of rights and freedoms on demand and aggressively assumed a posture, both fierce and sexual, that proposed getting those demands by any means necessary. The Black Power Movement's popularity declined as its ideology became more splintered and nebulous, whereupon its representatives, who had deftly used the media to purport their view, were in the end depicted by that same media as heretics and despots. Both movements denied the concept of Nigger in the traditional sense; that shiftless, ignorant, ugly being so adverse to and incapable of any progressive action. Instead they opted for the reinvention of the Black Man as everything the White Man was, if not more. During that period, Nigger became more derisive and more entrenched in our culture. Symbolizing tenacity, cunning, and power, it was quite an accolade if you were described as "a bad nigguh!" At present, I rarely hear the word Nigger uttered in any context; yet it is still present, a spook, as it were, haunting and permeating every facet of our comunity. It is possible that Nigger will never go away, in my lifetime, despite the wish for a free and idealistic public. Until we face Nigger in the light of day we will never attain a niggerless society of participation. Nigger-as-concept is shunned into darkness and if allowed to grow and fester like some fungus, will ultimately overtake us all. Or it could be exposed as part of the culture, examined and treated like an anti-body our own bodily systems produce and utilize. Is it possible, as Lenny Bruce comically suggested, that one could say "niggerniggerniggernigger" till "nigger" didn't mean anything anymore? This paper raises the issue of nigger-as-anti-body and the aestheticizing of Nigger as a way of healing both personal and public wounds.

Since the age of nine, I have obsessed over the word Nigger, but it seemed that I had already known it then, all my life. Webster's 3rd New International Dictionary defines the word

* Sherman I. Fleming Jr., excerpts from "Nigger as Anti-Body," special issue, "Art and Healing," ed. Kristine Stiles, *WhiteWalls: A Journal of Language and Art* 25 (Spring 1990): 54–60. By permission of the author.

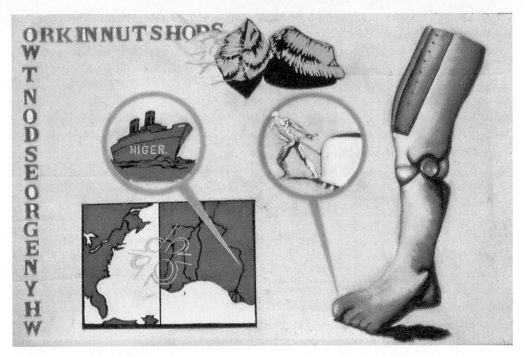

Sherman Fleming, *Why Negroes Don't Work in Nut Shops*, 1990, enamel on Naugahyde. By permission of the artist.

Nigger as "a member of any very dark skinned race—usually taken to be offensive." This was a curious phrasing: could it possibly refer to me? If anyone read it or knew about its reference, could they possibly identify me as "dark skinned and offensive"? Why was there such a need to define this word? Would those who used it need definition? Correct spelling? Webster's goes on to include variants on Nigger: niggard, niggardliness, niggardly, niggardness, nigger-baby, niggerbug, niggerchaser, niggerdaisy, niggerfish, niggergoose, niggergeese, niggerhead, niggercactus, niggerheaven, nigger in the woodpile, niggerpine, niggershooter, niggertoe, niggerweed, niggerwool, niggery, nigging, niggle, niggless, nigglite, niggling, niggly, and niggun. . . .

Language objectifies the world for empirical perception. Moreover, language, both spoken and written, is systematically controlled out of a necessity for its perception on socio-cultural and historical levels. Most systems are subordinate to language and only certain concepts can be expressed within the left-right/top-bottom narrative structure. Any other phenomenon remains outside the structure or is denied introduction. The language of racism, constituted of empirical systems, confirms the language structure. Nigger and its derivations are the concatenate of racism and empirical evidence, objectified by language. Language as a representor has to experience an alchemical process to reclaim the tragedy of the period (1953–present) and convey an immediate perception of the horror of emotions still felt as a phenomenon.

There were two events that changed the way in which I was to make visual art. In December 1987, I traveled to the Whitney Museum to see the exhibit, *Julian Schnabel: Paintings 1975–1987*. I was very much impressed with Schnabel's use of materials, especially in the large tarpaulin pieces. But the spareness of his rendering of pictorial space was disturbing. Monumentality, spare brushwork, and word-as-image were combined to give an immediate de-

signerly form that cued me to its fashionable and fleeting presence. Schnabel was doing the work of his time that paralleled his status. . . .

I also began to work with the combination of racial issues and my personal experience. For a number of years I was obsessed with just how to represent my status as an African-American. I felt that using language and image together was the key, but thus far my only results were word-image offset postcards. One in particular, *Why Negroes Don't Work in Nut Shops,* was done when a childhood friend jokingly stated that the racial slur "niggertoe" was the only name he knew for the brazil nut. So stunned was I that he had never heard of its proper label, that I created a rebus painting that read "niggertoe" when you combined one image together with the other. The image on the left recalled the Atlantic slave trade, and the image on the right depicted peonage and labor. The term "niggertoe" could only have been invented during this period of American history, underscoring the ability of language to objectify a people to the status of commodity.

Another racial slur was "Black on the Outside, White on the Inside." This was of particular importance to me. As an African-American who learned in predominantly white institutions and whose family lived in a predominantly white neighborhood, I was labeled an "oreo." In my painting, the Oreo against a leopardskin field heralds the action below. *Black on the Outside* is represented by a Black man; the light switch and side of beef evoke separation of culture and self. *White on the Inside* is represented by Elvis's portrait next to an inverted female figure inserting a tampon, suggesting the sexual availability and general ease one experiences when one is in, cool, with it, and hot!

The rebus both typifies the language structure and operates outside of it. By assigning language ideographs and pictographs, I change the perception of language from a passive intellectual process, a process which denies experience-horror, to an emotionally immediate action. Instead of the hierarchy of word over image, image and word are equivalent.

The horror of the "niggertoe" and the "oreo" could be perceived automatically as long as the images relate specifically to the cultural and psychological weight of the text. The rebus, originally meant as a children's game for learning to read, is the vehicle by which a horror may be examined.

At one time, "Nigger" would have sent me either into a raging frenzy or into fuming impotence. Now, with the series of rebus paintings, completed and in-process, I have taken control of this most taboo word of the English language, subverting it to make it my own, an artifact of my heritage, as it were. These paintings, plasticizing language and executed on a plastic material (naugahyde), are resilient and able to weather time and invite scrutiny like an emblematic tapestry or coat-of-arms. It's just that it no longer applies to me. Lessons can be relearned.

MARLENE DUMAS
Unsatisfied Desire and the untrustworthy Language of Art (1984)

Some people die of their own passion.
Some by the passion of others.

* Marlene Dumas, "Unsatisfied Desire and the untrustworthy Language of Art" (1984), in Dumas, *Sweet Nothings: Notes and Texts,* edited by Mariska van den Berg (Amsterdam: Galerie Paul Andriesse/Uitgeverij De Balie, 1998), 22. By permission of the author and the publisher.

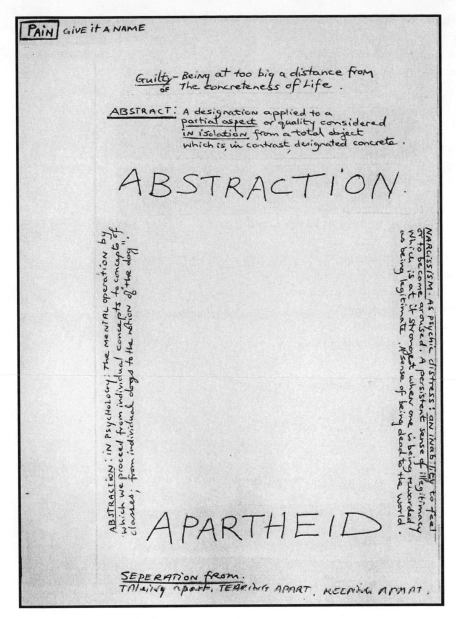

Marlene Dumas, handwritten 1982 text in her *Sweet Nothings: Notes and Texts* (Amsterdam: Galerie Paul Andriesse/Uitgeverij De Balie, 1998). By permission of the artist and the publisher.

And some simply die of illness
or another natural cause.
I am against it.

Art is not a mirror. Art is a translation
of that which you do not know, but of
which you want to convince others or
rather, that which no-one knows, but

by which everyone can be seduced to
believe that although 'it' is bad, 'it' is
good; it's good not to have what you
desire most.

I'll continue to cry for the doomed:
innocent brushstrokes, painterly
trances, the exotic other, love-fictions . . .
To lipread and name the silence;
to use the dream that torture will stop
when the prisoner talks.

Selling one's Soul to the Devil (1987)

ART
like an occult science is
an ancient ritual as dangerous
as the first flare of attraction
between two people—
an unreliable situation
with unpredictable consequences.

Waiting Rooms (need TV) (1989)

Models wait
for artists to give them meaning.
Girls (use to) wait
for boys.
Patients wait
for doctors . . .

ART waits for no-one.
ART cares for no-one.
ART doesn't speak unless
it's spoken to.
ART is only metaphorically
a language, not literary.
ART does not follow the rules
of language.
The arbitrary and the particular
resist generalisations
necessary

* Marlene Dumas, "Selling one's Soul to the Devil" (1987), in Dumas, *Sweet Nothings: Notes and Texts,* edited by Mariska van den Berg (Amsterdam: Galerie Paul Andriesse/Uitgeverij De Balie, 1998), 31. By permission of the author and the publisher.
** Marlene Dumas, "Waiting Rooms (need TV)" (1989), in Dumas, *Sweet Nothings: Notes and Texts,* edited by Mariska van den Berg (Amsterdam: Galerie Paul Andriesse/Uitgeverij De Balie, 1998), 47. By permission of the author and the publisher.

for logical communication.
ART loves her enemies
more than her protectors.
ART loves to know. Everything.
ART has never been innocent.
ART has always been mediated.
Life has always been complicated.
All art eventually becomes ART,
and solves nothing.

WILLIAM KENTRIDGE
Art in a State of Grace, Art in a State of Hope, Art in a State of Siege
(1986)

[. . .] The pictures I love are not for me

The great Impressionist and post-Impressionist works, like the paintings of Seurat, are those which give me the greatest pleasure. Immediate pleasure, in the sense of a feeling of well-being in the world. They are visions of a state of grace, of an achieved paradise.

Art in a state of grace

This state of grace is inadmissible to me. I know this is contradictory. The state of the world has not changed that much between the late nineteenth century and now in terms of human misery. There were factories near the park-like edge of the Seine where Seurat painted; in bad years the peasants starved in the countryside around Tiepolo's ceilings. But in their paintings the effect is not of history distorted but of a benevolent world.

It is one thing to be grateful for those lies and quite another to perpetuate them.

There are some artists, from Matisse through the colour field abstract painters, who have managed to maintain an innocence or blindness and continue working in this way to this day without bad faith gnawing at their work. I would love to able to work like this, but it is not possible.

This impossibility is complex. When I try, the pictures are terrible. Lyricism descends into kitsch or sentiment. Or else the nature of the image changes. Lyricism seems to need a certain self-confidence and clear conscience that I lack. The argument of course is nearly circular. If I could work in a lyrical way with colour or image perhaps that confidence would be there. Certainly I am very aware of the sophistry in ascribing a failure in painting to moral austerity.

Perhaps, working away from here in some European or rural haven, I would be able to paint apples and colours—but I doubt it. Here, more than in most other places, one's nose is

* William Kentridge, excerpts from "Art in a State of Grace, Art in a State of Hope, Art in a State of Siege" (lecture at Standard Bank International Festival of the Arts, Winter School, Grahamstown, South Africa, July 1986), in Carolyn Christov-Bakargiev, *William Kentridge* (Brussels: Société des Expositions du Palais des Beaux-Arts de Bruxelles, 1998), 55–57; reprinted in *William Kentridge* (London: Phaidon Press, 1999), 102–5. © William Kentridge. Courtesy the artist and Marian Goodman Gallery, New York.

rubbed in compromises every day. Certainly the compromises are more grotesque than most, but in essence I don't think they are greatly different from elsewhere.

It is always the peasants who pay; purity is a chimaera.

Art in a state of hope

Tatlin's *Monument to the Third International* (1919–20) is one of the greatest images of hope I know. I say image because although the monument existed as a model I know it only through photographs. These are enough. It is the project rather than the actual object that is moving. I imagine that the greying concrete pylons of the actual monument, a thousand feet high, would be monstrous. But there is in the image of Tatlin and his assistants clambering around the model, huge enough in itself, a hope and certainty that I can only envy. Such hope, particularly here and now, seems impossible. The failures of those hopes and ideals, their betrayals, are too powerful and too numerous. I cannot paint pictures of a future like that and believe in the pictures.

Which may not be necessary. Good propaganda can come from craft and conscientiousness rather than conviction, although it is hard. In the few posters I have designed on request, irony (the last refuge of the petit bourgeoisie) creeps through, and passion is reduced to a bitter joke. Ultimately my belief in the democratic socialist revolution is tainted. Not by doubting its need or desirability, but because it seems unwarranted optimism to think it will occur. Even if it did I do not know how I would fit into it.

Where does that leave me, with neither a belief in an attained (even partial) state of grace, nor with a belief in an immanent redemption here.

Art in a state of siege

Max Beckmann's painting *Death* (1938) is a beacon for endangered souls. It accepts the existence of a compromised society and yet does not rule out all meaning or value nor pretend these compromises should be ignored. It marks a spot where optimism is kept in check and nihilism is kept at bay. It is in this narrow gap that I see myself working—aware of and drawing sustenance from the anomaly of my position. At the edge of huge social upheavals yet also removed from them. Not able to be part of these upheavals nor to work as if they did not exist.

This position—neither active participant nor disinterested observer—is the starting point and the area of my work. It is not necessarily the subject of it. The work itself is so many excursions around the edge of this position.

After Auschwitz there is, alas, lyric poetry

This position, the arena in which I work (this fox hole it often feels like) is not a unique one. It is the condition of many people, if not all of us. I am just emphasizing it as it seems central to me. There is not a day or hour in which it does not present itself to me (not as anguish, that only too rarely, but as a nudge at least). And it is central to my activity of working. Other people I'm sure are aware of it but are able to work without it impinging on what they are doing.

Its central characteristic is disjunction. The fact that daily living is made up of a non-stop flow of incomplete contradictory elements, impulses and sensations.

But the arresting thing for me is not this disjunction itself, but the ease with which we accommodate it. It takes a massive personal shock for us to be more than momentarily moved. Turning from page three horror stories in the newspaper to the sports or arts pages is swift, and bad conscience, if it exists at all, lasts for only a moment.

This disease of urbanity

Urbanity, the refusal to be moved by the abominations we are surrounded by and involved with, hangs over us all. This question of how passion can be so fleeting and memory so short-lived gnaws at me constantly. It is a deep-rooted question.

As a child (I am a second child and hence a peace-maker; reconciling opposites has been a job for life) I remember the shock at realizing that a rage, which had been unquenchable a few minutes before and which it seemed could have as its outcome nothing less than the maiming of its object, had now drained, and that the anger now directed towards the offending person, though not less deserved, was now false. What happened to that anger, how could it just evaporate like that?

The questions now do not seem so different. What is the atmosphere in which we live that enables the shocks and clashes of daily life to leave us so calm? And the degree of calm is quite astonishing.

White guilt come home

White guilt is much maligned. Its most dominant feature is its rarity. It exists in small drops taken at infrequent intervals and its effects do not last for long. But the claim goes further than this. People far closer to the violence and misery still return out of the tear smoke and an hour later are cooking their dinners or watching the *A-Team* on television. . . .

Death through suffocation

The greatest danger is of a completed narrative, as in the dark moral engravings of the eighteenth and nineteenth centuries in which the image illustrates a story outside of itself. In these the finality of the story acts to shut the viewer out from it. An incompletion or awkwardness is needed; stories stop where they should continue, gaps are left for the viewer to bridge. This is not a prescription but rather a reflection on what has made certain narrative pictures (not just my own) intrigue me and others die a death. Certainly I think this is true of the great narrative visual works, from Goya's black paintings and the *Caprichos* to Beckmann's triptychs. One is captivated by trying to reduce to sense a riddle which has no answer, of joining in the play which the artist has offered and in so doing accepting his or her terms. This does not of course mean that anything goes.

I have no rules nor even principles for deciding what elements do fit together and which don't. At most I have strategies or tactics for arriving at them. But it is really only after the event that they can be assessed.

LUC TUYMANS Disenchantment (1991)

The small gap between the explanation of a picture and a picture itself provides the only possible perspective on painting. My comments refer only to its ambiguity. Behind some pictures there are ten other paintings from different years. I can't project myself completely into the picture; if I did that I wouldn't be detached enough to paint it. Explanations come later. Thinking and feeling and working out feelings are different elements, each with a rhetoric of its own. A memory-free zone arises between conception and execution.

The Loss of Painting

The model of the painting *Our New Quarters* was a photograph of the courtyard of Theresienstadt, beneath which a prisoner had written 'Our New Quarters.' . . . Anyone who enters the painting is imprisoned behind the writing. The picture and the sentence are two pictures that go against one another. They do not support one another. The picture destroys the word and the word destroys the picture. The destruction is projected into the picture, although we do not see the destruction. The new thing in the phrase 'Our New Quarters' was actually false hope. The picture is impossible, as one cannot deal with it as an individual. There is an idea of memory that is neither personal nor collective; it's just a picture of memory, a non-picture. The work develops an idea of loss and an idea of beauty. Beauty exists only as a perversion. It is calming. This is complete failure, complete terror. But it's also the right dimension. One does not win, one is not powerful, but the power of depicting something produces nothing but helplessness. . . .

SHAHZIA SIKANDER Nemesis: A Dialogue with Ian Berry (2004)

IAN BERRY: Even though your work [with miniature painting] was a confrontational break with an expected form, it was received with great success in Pakistan, and it has had a lasting impact on artists there.

SHAHZIA SIKANDER: Yes, I received a great deal of success in 1991–92 before I decided to come to the United States. I was the first to create visibility for the genre locally as well as internationally later on. Pakistan in the 1980s was very restrictive and in that context, the National College of Arts was a haven for free thinking and expression. It was a great place to be amidst the rest of Lahore and Zia's military regime. Military presence has a way of prevailing, and either you respond in ways that are reactive or that become subversive. It is only with distance that my responses have become clear—I was barely 17 at that time. The conventional approaches in the painting department pushed me towards miniature painting because no one else was interested in it. Its social context was so intriguing. It supposedly represented our heritage to us, yet we reacted to it with suspicion and ridicule.

 * Luc Tuymans, excerpts from "Disenchantment" (1991), in *Luc Tuymans* (Bern: Kunsthalle Bern, 1992), 11–36; translated by Shaun Whiteside; reprinted in *Luc Tuymans* (London: Phaidon Press, 2003), 112–43. © Luc Tuymans; courtesy Zeno X Gallery, Antwerp, and David Zwirner Gallery, New York.

 ** Ian Berry, excerpts from "Nemesis: A Dialogue with Shahzia Sikander," in *Opener 6: Shahzia Sikander: Nemesis* (Saratoga Springs, NY: Frances Young Tang Teaching Museum and Art Gallery, Skidmore College, 2004); online at http://www.shahziasikander.com/essay01.html. By permission of the interviewer and the artist. © 2004 Ian Berry.

I had grown up thinking of it as kitsch. My limited exposure was primarily through work produced for tourist consumption.

I found, and still find, the presentation and documentation of miniature painting to be very problematic. In fact, by its very nature the term miniature is laden with issues of imperialism, and is usually followed by a very descriptive, almost ethnographic definition. At this time I also started to explore language in relation to the formal symbols of mathematics and logic. This is a big part of my most recent drawing series: *51 Ways of Looking.* All this started to resonate with post-culturist theories, and I used that new information towards deconstructing the miniature. . . .

The question that came to mind was always about the discourse outside the canon. What is cultural imperialism? What is essentialism? What was the representation of the other? Could representation exist outside of the binary oppositions? What could be the third space, the in-between space? I was intrigued by the concept of role reversal, especially the distance that it could afford me as an artist. Finding myself immersed in the early 1990s politics of identity, I started experimenting with the semiotic nature of various symbols that could question stereotypes of certain feminine representations, such as hairstyle, and costume as in the sari, shalwar kameez, and chador. I began to see my identity as being fluid, something in flux. . . .

Most of the readings of my work focused on cultural definitions rather than the work itself. I became the spectacle in many reviews—it didn't help to have exaggerated information like making my own brushes, pigments, and paper floating around. I can clarify something here once and for all—I don't make my brushes or my pigments! I make my ideas and I try to express them in as many ways as possible. At that time I was driven by sharing as much as possible, perhaps in an attempt to shrink gaps of knowledge. But filling in the gaps doesn't necessarily change the assumptions people already are bringing to the equation.

IB: Did you make any work at this time that spoke directly about identity?

SS: I made a few works that specifically addressed the notion of identity as being fluid and unfixed, primarily in response to the rigid categories I found my work and myself being placed in or put in. Identity became theatrical, malleable through conditions such as production, location, duration, conventions of staging, reception of audience, the construction of the audience as well as the substance of the performance itself, including body language, gesture, etc. In one I dressed in braids and aggressive clothing and mapped my movements around an airport, observing how people react when there is a visual encounter that looks familiar and is not. In another, I wore a costume that disguised my body thus made me transparent at times. The work got read as a plea for liberation for women who are subjected to wearing veils. I am amazed even now how limited people's understanding is. Pakistan is not Iran and Iran is not Lebanon and Lebanon is not Saudi Arabia. My being from a so-called "Muslim" country often became my primary categorization. Unfortunately it still persists. . . .

I often see myself as a cultural anthropologist. I find open-ended encounters and narratives compelling and perhaps seek to express that more than anything else. Symbols, icons, and images are not automatically about one thing or one way of reading. A crucial reading for me has been the underlying exploration of beauty. The average response to my work usually includes 'beautiful.' For me, issues of aesthetics are always in flux in context to the genre of miniature. Its transformation from thing like kitsch to beautiful, low to high, craft to art,

regional to international, artisan to artist, group to individual. These are interesting ideas for me. I am always exploring questions such as: does beauty move towards formalism? Is beauty trivial? When does it become perverse? . . .

JENNY SAVILLE Interview with Simon Schama (2005)

JENNY SAVILLE: I'd wanted to do a large carcass for so many years after seeing Rembrandt's *Slaughtered Ox* and the Soutine carcasses. I saw two of them at The Royal Academy in London a couple of years ago. There was light emanating from the paint—the color jumped right out at you. There are these romantic stories of him pouring fresh blood over the meat. . . .

I had in my head this image of a traditional open-ribbed carcass that I wanted to paint, but when I walked through the gap in the slaughterhouse door with daylight coming in, I encountered this steaming beast that was half on the floor and half hanging on great meat hooks. It was half flesh/body and half carcass, the flesh was incredibly creamy with a taut twist to its torso. It was, like, spitting paint at me. . . .

I learned a lot from observing plastic surgery and looking at medical books and specimens. The paintings like *Ruben's Flap* and *Hyphen* with grafted flesh sections resulted from looking at these things. When you see the inside of the body, the half-inch thickness of flesh, there's a realization that it's a tangible substance, so paint mixed a flesh color suddenly became a kind of human paste. . . .

I try and think about the identity of the paint—how I could get this substance to read as, for example, sweaty flesh. I use a lot more oil now because it gives the paint movement. . . .

The influence of watching surgeons at work helped enormously with that. To see a surgeon's hand inside a body moving flesh around, you see a lot of damage and adjustment to the boundary of the body. It helped me think about paint as matter. I mix a lot of my paint in pots, in large quantities of various colors rather than just mixing off the palette as I work. You consider the cooler tones of a thigh compared to a hotter tone on the hands more—I try and think in terms of liquid flesh and light. . . .

When I'm doing one piece I could end up with three hundred pots, but I start with some core tones and work off from that and I shift the tones as I'm working by adding purer color. Depends how complicated the painting becomes and what's needed. . . .

I want to use paint in a sculptural way—I want it on the surface. I like that famous de Kooning quote, "Flesh was the reason oil paint was invented." Look at a Velázquez nude; he gets this incredible transparency of flesh with zinc white. You feel the body, the porcelain flesh. . . .

I try to find bodies that manifest in their flesh something of our contemporary age. I'm drawn to bodies that emanate a sort of state of in-betweeness: a hermaphrodite, a transvestite, a carcass, a half-alive/half-dead head. I don't paint portraits in a traditional sense at all. If they are portraits, they are portraits of an idea or a sensation. I've really felt this when I've worked from images of heads from forensic science books. The process of painting them is a sort of discovery of the landscape of their face. There's no personality as such, I never met

* Simon Schama, excerpts from "Interview with Jenny Saville," in *Jenny Saville* (New York: Rizzoli, 2005), 124–29. Used with permission from the interviewer and Rizzoli International Publications, Inc.

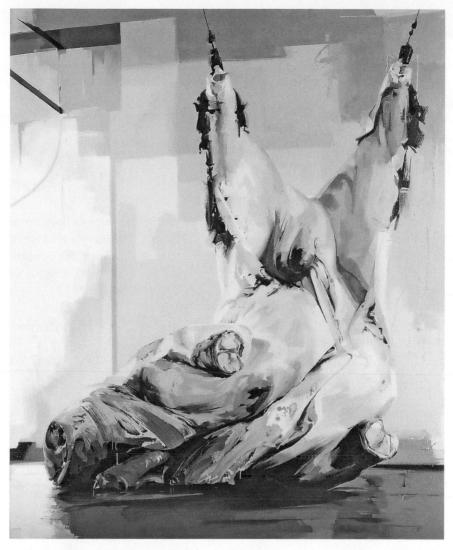

Jenny Saville, *Torso 2*, 2004, oil on canvas. © Jenny Saville. Courtesy Gagosian Gallery, New York.

them, but by the end of the painting, I know the eye sockets, the turn of their chin, better than I know my mother's. Working from photographs helps me have a model of an idea in my hand, it's like scaffolding. I paint out the photographic process itself, I don't want to exclude anything. I like that quote by Jean-Luc Godard, "Images are made with other images in mind." . . .

I like the spaces that a large scale offers. The different space of encountering a painting from a distance to being very close-up to a painting, the physical relationship of your body to that scale of object and mark-making. I've always loved encountering a Rothko up close. They really hum through your body. . . .

SIMON SCHAMA: Could you talk a bit more about the working and the practice of starting? You said you use bodies in order to embody an idea.

JS: With the transvestite I was searching for a body that was between genders. I had explored that idea a little in *Matrix*. The idea of floating gender that is not fixed. The transvestite I worked with has a natural penis and false silicone breasts. Thirty or forty years ago this body couldn't have existed and I was looking for a kind of contemporary architecture of the body. I wanted to paint a visual passage through gender—a sort of gender landscape. To scale from the penis, across a stomach to the breasts, and finally the head. I tried to make the lips and eyes be very seductive and use directional mark-making to move your eye around the flesh. . . .

SS: So you really do manipulate what's in front of you through the mark-making. It's very striking—I'm looking at a photograph of your transvestite painting *Passage* and that passage that moves from the penis and balls to the belly is really about the anatomy of paint as it constructs the body.

JS: I have to really work at the tension between getting the paint to have the sensory quality that I want and be constructive in terms of building the form of a stomach, for example, or creating the inner crevice of a thigh. The more I do it, the more the space between abstraction and figuration becomes interesting. I want a painting realism. I try to consider the pace of a painting, of active and quiet areas. Listening to music helps a lot, especially music where there's a hard sound and then soft breathable passages. In my earlier work my marks were less varied. I think of each mark or area as having the possibility of carrying a sensation. . . .

SS: You are yourself in a kind of exchange transaction between flesh and paint that nobody does in the same way that you do.

JS: I keep talking about the transvestite because the mark-making for that painting is fresh in my memory. When I was painting the genital area, I was trying to think about ways to use intense color and make marks that heightened a feeling of sex. Then when I painted the thigh, I had this area at the topside of the thigh and had four or five tones mixed up that I knew I wanted to run into each other. I got them all really oily. It was a one shot, to keep the color clean but slide them together and create the thrusting dynamic of this leg lifting up. The white dripped right across the thigh on towards the genitals. It was this incredible, orgasmic. . . .

In that thigh I had more about sex than the whole penis put together. Five years ago I would never have left that on the painting. But without the genitals there as a playoff, I don't think I'd have the same tension.

SS: What is your aim actually?

JS: I want it to be acute. . . . When I'm in the process of working an area of the painting, in my head I have an idea of a sequence of marks I'd like to try. Usually it doesn't work out like I planned—sometimes it's better and more suggestive than I'd imagined, but often it feels like a potential disaster and I panic. Adrenaline sets in, there's a kind of rush where you're pulling all these paint strings to articulate something and you have to hold your nerve. Just one mark can start to pull together something that has no structure. It's a weird game of control—trying to get to it—to suck it out of yourself and out of the painting. There's a moment when the painting starts to breathe, it gets a kind of presence.

CATHERINE OPIE *Self-Portrait* (2005)

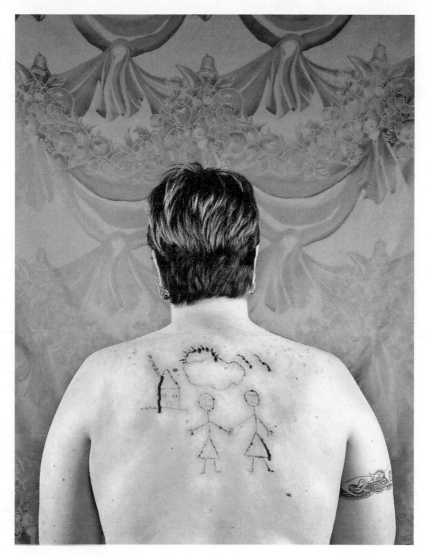

Catherine Opie, *Self-Portrait,* 1993, C-print. © Catherine Opie. Courtesy Regen
Projects, Los Angeles.

I wasn't really thinking about the art world or the impact this work would have on people.
It was a photograph that I had in my head for over a year before actually making it. I had a
good friend, fellow artist Judie Bamber, do the cutting. She hadn't ever done a cutting before.
I wanted to be apprehensive about the style of the cutting, as opposed to the piece I did the
following year *Pervert,* which was perfect. The image is about hope and being queer.

 * Catherine Opie, statement on *Self-Portrait* (1993), in Francesca Richer and Matthew Rosenzweig, eds., *No. 1:
First Works by 362 Artists* (New York: D.A.P./Distributed Art Publishers, 2005), 272. By permission of the artist
and the publisher.

Statement (2004)

In high school I had a crush on this beautiful woman named Cere, I would go to church with her and listen to her love of god and think, But I just love *you*. Years passed and I became a queer activist, coming out in San Francisco at the beginning of the AIDS epidemic. I saw people who loved god and hated us, and I continue to see people love god and hate us twenty years later. My faith is in myself and my family, making art, trying every day to talk about what is important, funny, and interesting.

WANGECHI MUTU Magnificent Monkey Ass Lies (2004)

See long ago around when stories were invented the Earth spoke

mournfully about the age of the monkey and his fuck ma. . . . I mean

DEATH machine . . . you know how we play Marco Polo with his eyes shut
That's it! That's our social contract . . . this mutha fuckin mess is us So I was
thinking if you were on the auction block would I even bid for your white
ass This cold has made you thin and bitter but my heart still aches with love
and I remember when animals devoured us and we tasted good to them,
everything I am saying is dedicated to all you magnificent monkey asses
yeah you. Your greatest invention is the desire to own
and now every demon on earth

My Darling Little Mother (2006)

My darling little mother,
I ought to have written long ago. See in the beginning I thought it was Love I was seeking. By night I sought her, when my soul loveth, but found her not. While Livingstone was in Africa, ether and chloroform anesthesia had been introduced in 1846 and 1847 respectively. Surgical intervention had become amazingly ambitious and intricate. He died in 1873 in the swamp around Lake Bangwelwee. Although modesty still surrounded its use, the vaginal speculum was deemed necessary. For examination in women's diseases. Turn away thine eye from me, for they has overcome me. Here in England levels were made to an inch. One degree in temperature corresponded to five hundred feet in height, said Speke. In 1840 some still thought of the stethoscope invented in 1816 as a toy. By 1863 its use was Mandatory. Modern germ theory was not established until after Livingstone's death.
I would cause thee to drink of spiced wine
of the juice of my pomegranate
With fondest Love and Curse

 * Catherine Opie, "Statement," in *100 Artists See God* (New York: Independent Curators International, 2004), n.p. By permission of the artist and the publisher.
 ** Wangechi Mutu, "Magnificent Monkey Ass Lies," written as a wall text for Mutu's "Artist in Residency" exhibition at the Studio Museum in Harlem, 2004. By permission of the artist.
 *** Wangechi Mutu, "My Darling Little Mother," written for the installation *Magic* at SITE: Santa Fe Biennial, June 2006. By permission of the artist.

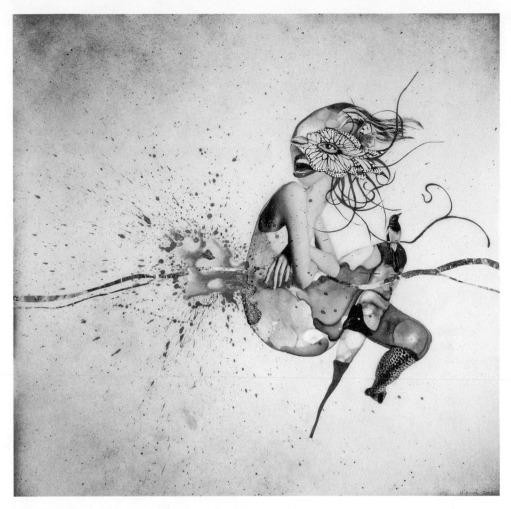

Wangechi Mutu, *Untitled,* 2005, mixed media. © Wangechi Mutu.

TAKASHI MURAKAMI The Super Flat Manifesto (2000)

The world of the future might be like Japan is today—super flat.

Society, customs, art, culture: all are extremely two-dimensional. It is particularly apparent in the arts that this sensibility has been flowing steadily beneath the surface of Japanese history. Today, the sensibility is most present in Japanese games and anime, which have beome powerful parts of world culture. One way to imagine super flatness is to think of the moment when, in creating a desktop graphic for your computer, you merge a number of distinct layers into one. Though it is not a terribly clear example, the feeling I get is a sense of reality that is very nearly a physical sensation. The reason that I have lined up both the high and the

* Takashi Murakami, excerpt from "The Super Flat Manifesto," in Takashi Murakami, *Super Flat* (Tokyo: MADRA Publishing Co., Ltd., 2000), 5. By permission of the author and the publisher.

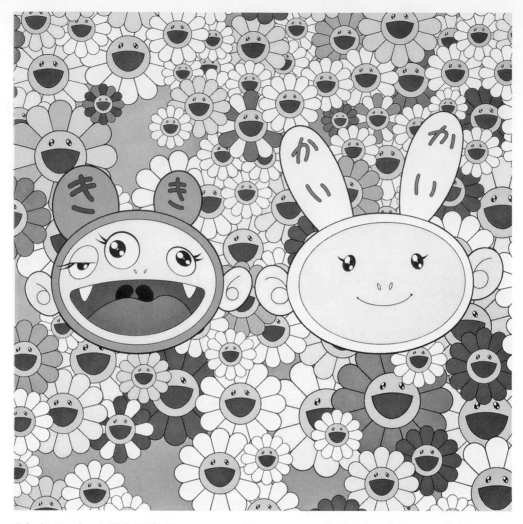

Takashi Murakami, *Kaikai Kiki News,* 2002, acrylic on canvas mounted on board. Courtesy Galerie Emmanuel Perrotin, Paris and Miami. © 2002 Takashi Murakami/Kaikai Kiki Co., Ltd. All Rights Reserved.

low of Japanese art . . . is to convey this feeling. I would like you . . . to experience the moment when the layers of Japanese culture, such as pop, erotic pop, otaku, and h.i.s.-ism, fuse into one.[1]

Where is our reality?

[R]econsider "super flatness," the sensibility that has contributed to and continues to contribute to the construction of Japanese culture, as a worldview. . . . "Super flatness" is an original concept of Japanese who have been completely Westernized.

Within this concept seeds for the future have been sown. Let's search the future to find them. "Super flatness" is the stage to the future.

1. h.i.s. is a discount ticket agency in Japan. By lowering the price of travel abroad, the company . . . had a profound effect on the relationship between Japanese and the West.

Earth in My Window (2005)

On August 6, 1945, for the first time in actual warfare, an atomic bomb, nicknamed "Little Boy," exploded over the city of Hiroshima. Three days later, on August 9, a second atomic bomb, nicknamed "Fat Man," hit Nagasaki. Together, the two bombs killed more than 210 thousand people; when survivors afflicted by the after-effects of the bombs are included, the figure rises to some 370 thousand. After the tragic explosive-destructive-Whiteout! of the bombs, only burned-out rubble remained: wasteland upon wasteland, utterly vacant land. After the blinding white light, a conflagration of orange . . . and then, instantaneously, a torrent of pitch-black rubble and mangled body parts actually rained on the people on the ground.

Shortly thereafter, Japan surrendered unconditionally, bringing the fifteen-year Pacific War to an end.

2005. Sixty years after the war. Contemporary Japan is at peace.

But everyone who lives in Japan knows—something is wrong. Still, it's not worth a second thought. Young girls butchered; piles of cash donations, scattered recklessly on foreign soil; the quest for catharsis through volunteerism; a brazen media prepared to swallow press restrictions in support of economic growth. The doorways of passably comfortable one-room apartments, adorned meaninglessly with amulet stickers from SECOM, a private security company. Safe and sound, hysteria.

Japan may be the future of the world. And now, Japan is Superflat.

From social mores to art and culture, everything is super two-dimensional.

Kawaii (cute) culture has become a living entity that pervades everything. With a population heedless of the cost of embracing immaturity, the nation is in the throes of a dilemma: a preoccupation with anti-aging may conquer not only the human heart, but also the body.

It is a utopian society as fully regulated as the science-fiction world George Orwell envisioned in *1984:* comfortable, happy, fashionable—a world nearly devoid of discriminatory impulses. A place for people unable to comprehend the moral coordinates of right and wrong as anything other than a rebus for "I feel good."

These monotonous ruins of a nation-state, which arrived on the heels of an American puppet government, have been perfectly realized in the name of capitalism. Those who inhabit this vacant crucible spin in endless, inarticulate circles. In order to solve the puzzle of Japanese culture today, let us view it through individual windows, whether images, songs, or some expression or behavior, as though screening them on a computer. Guided by the fragment of a soul visible at the instant those windows coalesce as one, we will draw the future a little closer.

When *kawaii, hetare* (loser), and *yurui* (loose or lethargic) characters smile wanly or stare vacantly, people around the world should recognize a gradually fusing, happy heart. It should be possible to find the kernels of our future by examining how indigenous Japanese imagery and aesthetics changed and accelerated after the war, solidifying into their current forms.

We Japanese still embody "Little Boy," nicknamed, like the atomic bomb itself, after a nasty childhood taunt.

* Takashi Murakami, "Earth in My Window," in Takashi Murakami, ed., *Little Boy: The Arts of Japan's Exploding Subculture* (New York and New Haven: Japan Society and Yale University Press, 2005), 98–149. © 2005 Japan Society, Inc. © 2005 Takashi Murakami/Kaikai Kiki Co., Ltd. All rights reserved.

M. F. HUSAIN *Portrait of the 20th Century* (1993)

Inside a rotunda, the traditional "PICHHWAEE" like backdrop, spreads around the wall 40 feet in circumference. You may begin from left or right as there is no beginning, no end. No matter "Das Kapital" appeared first or "Glasnost." Picasso's cubism first or "Hanuman the Grammarian" of Octavio Paz.[1] Tagore's "Geetanjali" or poet Iqbal's "Jawed Nama."[2]

Somewhere in the circumference you notice the vast stretch of Mother Teresa's lap, above, through the concrete column a tender float of white Saree fondles an African boy. Dinner time perhaps. Yes in Chaplin's "Gold Rush," he is seen eating his own shoe well boiled. Next to his wilderness a book of Sigmund Freud and "THOU" beside (the epitome of love and passion . . . that is Marilyn Monroe). Behind her, far in the distance is seen the first move of corporate wheels, multiple Monroe images on Andy Warhol.

As Martha Graham's dancing toes are airborne, the great "Pelé's" footwork moves like a ballet on world soccer field. Next to enter the world arena of Art with a thrust of Spanish Bull is Pablo Picasso on the floor. There Mao Tse-Tung is about to pick up his bowl of rice, three shots are heard and Mahatma Gandhi's peace march comes to an abrupt end. Fascist forces erupt here and there, though Hitler is dead yet his naked death keeps dancing skull in hand. On the backyard of Hitler the earth is razed to its pit level.

On the part two of our time . . . you face Vivekananda in whose light all shades of colour vibrate upward to the highest spiritual aspiration and then listen to the words in Octavio Paz's book "Hanuman the Grammarian," sending into flight the Superman. Below Kurosawa "Rashomon" Rape being committed or enacted. The truth may be in Alberto Giacometti's thin fragile man. The sculptor walks along with his own creation.

The boisterous beat of four boys from Liverpool render the deeper chord of universal rhythm echoing the sound of Saraswati Sitar.

Silence . . . listen to the power of Churchill's oratory from the ramparts of Parliament and de Gaulle's declaration, "France est de Gaulle, de Gaulle est France." Down below a roasted turkey on platter. Martin Luther King and Yasser Arafat too are among the list of invitees. In the course of dinner debate, Gorbachev excuses himself to return soon to join for coffee. With coffee spoon our civilization is going to be measured by thinkers like Bertrand Russell and Jean-Paul Sartre. No exit.

Up in the sky J.F.K. headline is unfurled by three gun salute. Amen.

* M. F. Husain, *"Portrait of the 20th Century,"* in *Let History Cut Across Me without Me* (New Delhi: Vadehra Art Gallery, 1993), n.p. By permission of the author. In this excerpt, Husain describes the characters in the sweeping epic of his forty-foot-high mural painting *Portrait of the 20th Century* (1992), which depicts major personalities in the arts, science, dance, literature, and politics.

1. *Editor's Note:* In his novel *The Monkey Grammarian* (1979), Octavio Paz drew on the Hindu myth of Hanuman, a celebrated monkey chief who was able to fly and was a conspicuous figure in the *Rāmāyana,* credited with being the ninth author of grammar. This account is given by John Dowson, M.R.A.SD., in his book *A Classical Dictionary of Hindu Mythology and Religion, Geography, History, and Literature* (1891), which Paz quoted at the beginning of his novel.

2. *Editor's Note:* Rabindranath Tagore (Bengal, 1861–1941) was a poet, musician, painter, and playwright, and the first Asian to win the Nobel Prize for Literature (in 1913), especially for his book of poetry *Gitanjali* (1910). The *Javid Nama* (1932), or "Book of Eternity," is a book of poetry considered to be the masterpiece of Allama Muhammad Iqbal (India, 1877–1938).

4 MATERIAL CULTURE AND EVERYDAY LIFE

Kristine Stiles

In 1958 the art critic Lawrence Alloway remarked: "The new role for the academic is keeper of the flame; the new role of the fine arts is to be one of the possible forms of communication in an expanding framework that also includes the mass arts."[1] This comment echoed Alloway's participation in discussions by the London-based Independent Group, founded in 1952, which focused on the impact of technology, mass media, and modern design on arts and culture. Meeting at the Institute of Contemporary Arts until 1955, Alloway, the architectural historian Peter Reyner Banham, and the artists John McHale, Eduardo Paolozzi, and Richard Hamilton, among others, studied designs and ideas ranging from toilet paper, helicopters, the U.S. car industry, and commercial advertising to sexual symbolism and Hollywood glamour. They also examined science fiction, pulp magazines, comics, television, and theories of cybernetics, as well as artificial intelligence, computers, and robotics, and criticized taste as a marker of class in determining and dividing fine (or high) art from popular (or low) culture.[2]

The Independent Group's discussions paralleled the ways artists throughout the world had begun to incorporate objects and images of everyday life into their work. Already by 1949, Willem de Kooning (see chap. 3) had pasted the smiling red-lipstick mouth of a cigarette-ad model onto the mouth of a woman in one of his works. The 1950s witnessed urban debris and everyday life as inspiration not only in Pop, junk, and funk art but also in assemblage, environments, happenings, Fluxus works, artists' books, and mail and stamp art (the latter using commercial systems and technologies to communicate internationally).[3] As print media exploded in a plethora of publications, photography increasingly shaped art, becoming a staple of conceptual and performance art from the 1960s into the twenty-first century. The Independent Group's celebration and critique of the use of photography in advertising transformed into postmodern ironic commentary on the market in the 1980s and 1990s. By 2003 the virtual space of the Internet would enable artists to work in cyber places like Second Life, where millions of users create avatar identities and live a parallel existence to their ordinary, or "first," life.

Architecture, too, shifted to embrace the everyday with repercussions in the fine arts, through the merging of vernacular and classical traditions that Robert Venturi,

Denise Scott Brown, and Steven Izenour described in their book *Learning from Las Vegas* (1972). In the 1980s graffiti art—once the sign of a marginal street culture—began to enter the gallery system, not only in New York's East Village but internationally as well. During the same period, university scholars embraced the issues raised by artists about the centrality of everyday life in popular culture by promoting multicultural pluralism in cultural, visual, and postcolonial studies. Increasing globalization followed the fall of the Berlin Wall in 1989, the end of apartheid and the demise of the Soviet Union in 1991, and the gradual opening of China in the 1990s. In the twenty-first century digital media and new delivery systems have increasingly entered the realm of art, from e-mail, streaming video, video and computer games, and Wikis to digital music players and cell phones. Indeed, as the British cultural critic Dick Hebdige wrote in 1989, drawing on Henri Lefebvre's 1947 book *The Critique of Everyday Life,* art that incorporates material culture and everyday life creates an interface between "culture as a standard of excellence, and culture as a descriptive category."[4] John McHale anticipated this direction in 1959 when he rejected concepts of "'eternal Beauty' and 'universal truth' [as] accreted into the classical canons by which the arts were judged" and insisted that "the transmission, employment and transformation [of the fine arts] . . . is merely part of the live process of cultural diffusion which, like many other aspects of societal interaction in our period, now occurs in a variety of unprecedented ways."[5] McHale's analysis is as accurate now as it was in 1959, for throughout the world since World War II, every decade has witnessed artistic investigation into the relationship between popular culture and the fine arts.

At the same time, a critique of such art has emerged from the negative social and cultural impact of capitalism. As early as 1963, in a symposium on Pop art at the Museum of Modern Art in New York, organized by Peter Selz, then a curator there, participants were split on the value of popular imagery and style in the fine arts. The art historian Leo Steinberg and Henry Geldzahler, then an assistant curator at the Metropolitan Museum of Art, defended Pop art, with Geldzahler stating, "It is the artist who defines the limit of art, not the critic or the curator."[6] Other critics and art historians, such as Hilton Kramer, Dore Ashton, Stanley Kunitz, and Selz, disagreed. Selz expressed their doubts when he later wrote: "We are dealing with . . . an art that is easy to assimilate—much too easy; that requires neither sensibility nor intellectual effort . . . for this is not folk art, grown from below, but 'kitsch' manufactured from above and given all the publicity Madison Avenue dealers have at their disposal."[7] After forty years of art that blurred the boundaries between popular culture and fine art, the critic Brian Wallis noted in 1992 that the "fundamental issue for artists . . . has been how to foster critical dialogue while operating in a system that everyone acknowledges as fully commodified."[8]

Richard Hamilton (b. U.K., 1922–2011) was one of the first artists to comment on the central role of popular culture and new technologies, in his small collage *Just What Is It That Makes Today's Homes So Different, So Appealing?* (1956), created for the exhibition *This Is Tomorrow,* organized by the Independent Group at Whitechapel Gallery in London in 1956. The inventory of images in Hamilton's collage visualized the aesthetic guidelines for Pop art that Hamilton, the principal theorist of Pop, laid out in a letter to the architects Peter and Alison Smithson in 1957. Ten years earlier, as a student, Hamilton had been expelled from the Royal Academy Schools for "not profiting by

instruction." He went on to organize exhibitions addressing the intersection of art, technology, and mass culture and became a specialist on Marcel Duchamp, reconstructing *The Bride Stripped Bare by Her Bachelors, Even* (1915–23), or *The Large Glass,* for a Duchamp exhibition that he organized at the Tate Gallery. Hamilton also published (at his own expense) a version of Duchamp's *The Green Box* (1934) and wrote extensively on numerous subjects, including the artist's social responsibility, censorship, and other artists' work such as that of the German-born Swiss artist Dieter Roth (aka Diter Rot and Dieter Rot, 1930–98).

Although Roth worked in a variety of media, from painting and sculpture (including food sculpture) to woodcut, film, graphic design, and poetry, he was best known for his eccentric artist's books. Roth's *Bilderbuch* (1956) and *Bok* (1956–59) were the first of more than one hundred idiosyncratic book objects that he made by combining texts and images with objects and materials, including even foodstuff: he constructed each of his *Literaturwurst* series (1961–74) by mixing a shredded periodical or book with lard and spices and stuffing the resulting mixture into sausage casing. Treating books as plastic entities without limitation, Roth experimented with elaborate, unusual bindings and contents ranging from rubber-stamp pictures, graphics, and poems to notes and aphorisms. Titles like *the collected shit and its branches* (1968) and *the seas of tears and their relatives* (1973) conveyed Roth's expansive humor, poetry, and humanity. Roth joined the Darmstadt Circle, a group of concrete poets including Emmett Williams, Daniel Spoerri, and Claus Bremer, in 1958. He coedited the poetry review *Spirale* (1953–64) with Eugen Gomringer and Marcel Wyss; cofounded his own press, forlag ed, with Einar Bragi in Iceland in 1957; and often published with the German poet Hansjörg Mayer's press, Edition Hansjörg Mayer (1968–81).

Öyvind Fahlström (b. Brazil, 1928–76), a Swedish theater critic, journalist, documentary filmmaker, poet, and painter who studied art history at the University of Stockholm, coauthored one of the first texts on concrete poetry, his "Concrete Poetry Manifesto," in 1953. His dense, fragmented collage paintings—influenced by the "cut-up," a compositional technique introduced by the novelist William Burroughs in *Naked Lunch* (1959)—mix images and texts drawn from a wide range of sources, including depictions of comic book personalities (Little Orphan Annie, Krazy Kat, and Beetle), political figures (Malcolm X, Mao Zedong, Richard Nixon, and Angela Davis), and celebrities (Bob Hope). Fahlström's interest in Aztec and Mayan hieroglyphic systems informed the "character-forms," or visual units, of what he called his "variable paintings," invented in 1962. An outgrowth of his interest in game theory, these works consist of metal game boards with movable magnetized parts that can be rearranged by the viewer. Fahlström's works also address such politically charged subjects as war and war games, racism, colonialism, militarism, capitalism, the World Bank, the Central Intelligence Agency, and other topics related to the Cold War. Fahlström described himself as a "witness," presenting the fragmented images, narratives, and ethical dilemmas of his period.

On October 27, 1960, in the French artist Yves Klein's Paris apartment, Nouveau Réalisme (New Realism) was officially founded when a group of artists signed a manifesto penned by the French critic Pierre Restany (1930–2003). Restany, who would author the group's two additional manifestos, later categorized three groups of artists associated with Nouveau Réalisme:

The first [Klein, Arman, César, Christo] tends to lay down a method of perception, to structure a language of sensitivity, the language of quantity driven from its threshold. . . . [The second are] stage-setters of modern nature around [Jean] Tinguely and his seemingly useless machines. Niki de Saint-Phalle and her target panels, [Daniel] Spoerri and his trap-paintings, are the bricoleurs of permanent metamorphosis. . . . [The third are] poet-voyeurs for whom the world of the street is a perpetually developing picture: [Raymond] Hains, [Jacques de La] Villeglé, [François] Dufrêne, [Gérard] Deschamps, [Mimmo] Rotella.[9]

Many have described the Swiss artist Daniel Spoerri (Daniel Isaac Feinstein; b. Romania, 1930), along with Restany, as the "brains" behind Nouveau Réalisme. Spoerri began making "trap" or "snare" paintings (*tableaux pièges*) in 1958, fixing to the table the accumulated residue of a meal he had cooked for friends and fellow artists, then mounting the assemblage—table, glasses, plates, utensils, cigarette butts, papers, and leftover food—on the wall. His text "Spoerri's Autotheater" considers the performative dimension of such works. Spoerri began creating food events in Copenhagen in 1961 and opened his *Restaurant de la Galerie J.* in Restany's Paris gallery in 1963. Emphasizing his culinary skills and consequent gastronomical art, Spoerri also cooked for patrons and artists in his Düsseldorf *Eat-Art Restaurant* (1968–71) and *Eat-Art Gallery* (1970–71). Spoerri collaborated with poets Dieter Roth, Emmett Williams, Pol Bury, and others on *Material* (1957–59), a review of European concrete and ideogrammatic poetry, and in 1959 founded Éditions MAT (Multiplication d'Art Transformable), one of the first efforts to make and distribute inexpensive artists' multiples. In 1962 Spoerri met artists associated with Fluxus, when he and the French poet and artist Robert Filliou (chap. 8) organized the Festival of Misfits in London. Spoerri conveyed his myriad activities in books such as *Topographie anecdotée du hasard* (1962), "re-annecdoted" with Filliou, translated by Emmett Williams as *An Anecdoted Topography of Chance (Re-Anecdoted Version),* and published by Dick Higgins (chap. 8) in his Something Else Press in 1966. In the early 1990s Spoerri moved to the Tuscan hill town of Seggiano, opening Il Giardino di Daniel Spoerri in 1997, a sculpture garden containing eighty-seven works by forty-two artists.

Almost twenty years earlier, in 1978, inspired by Antoni Gaudí's Parc Güell in Barcelona, Niki de Saint Phalle (Catherine-Marie-Agnès Fal de Saint Phalle; b. France, 1930–2002) began creating *Il Giardino dei Tarocchi* (The Tarot Garden) in the Tuscan village of Garavicchio. Its twenty-two sculptures, representing the twenty-two cards of the Major Arcana, are constructed from cement and polyester, and covered in local ceramic mosaics, glass, and mirrors. Saint Phalle, who began assembling objects in 1956, had joined the Nouveaux Réalistes by 1961. That year she made her first "shoot paintings," firing a .22-caliber rifle at assemblages that contained aerosol paint cans or balloons filled with colored pigments, which exploded and dripped paint. The act sardonically commented on the culture of war and the machismo of the Abstract Expressionist and *art informel* movements. Saint Phalle noted: "I shot because it was fun and made me feel great. I shot because I was fascinated watching the painting bleed and die. I shot for that moment of magic. It was a moment of scorpionic truth. White purity. Sacrifice. Ready. Aim. Fire. Red, yellow, blue—the painting is crying, the painting is

dead. I have killed the painting. It is reborn. War with no victims."[10] In 1966, working with her companion, the Swiss sculptor Jean Tinguely, and the Finnish-born Swedish sculptor Per Olof Ultvedt, Saint Phalle constructed *Hon* ("she" in Swedish), a giant sculptural walk-in environment at the Moderna Museet in Stockholm. Over seventy thousand visitors entered the reclining female figure (82 feet long, 20 feet high, and 30 feet wide) through her vagina and passed into internal rooms, including a cinema for showing Greta Garbo movies, an aquarium, a planetarium, and restaurants such as a milk bar situated inside one breast. *Hon* unabashedly displayed the sexuality with which Saint Phalle imbued her *Nana* sculptures, brightly painted figures, made of papier-mâché or plaster over chicken wire, which anticipated feminist celebrations of the female body.

Similarly concerned with war, in January 1966 Pino Pascali (b. Italy, 1935–68) installed military cannons and antiaircraft artillery collected from military surplus depots in Galleria Sperone in Turin. Shifting attention from the appropriation of objects from vernacular culture to those of military culture, Pascali expanded the meaning of Pop art to include the pervasive threat of the Cold War and the nuclear age. Like Saint Phalle, Pascali emphasized the moral dimension of everyday life and the social responsibility of the artist. With his participation in Arte Povera in the late 1960s, Pascali used industrial products (acrylic brushes and other synthetic materials), along with natural materials such as feathers, to create curious anthropomorphic objects.

Gerhard Richter (b. Germany, 1932) was trained in East Germany under the aesthetic dominant canon of Soviet Socialist Realism and worked as a commercial artist and scenery painter there before immigrating to West Germany in 1961. His contact with the European avant-garde, especially Fluxus, led to his collaboration with the artist Konrad Lueg (also known as Konrad Fischer) on the ironical Happening *Demonstration for Capitalist Realism* in a Düsseldorf furniture store in 1963. Avoiding the conventions of painting required of artists in East Germany, Richter turned to photography, conflating painting with the technologies of mass media. Resisting identification with any one style, he has painted in every manner, from realism to abstraction (both geometric and gestural), with subject matter ranging from history and portraiture to landscape and genre images. His varied and numerous series sustain a systematic critique of popular cultural idioms and fine art categories, revealing the arbitrary and hierarchical values of art history and its collusion with the market for art.

Born and raised under Eastern European socialism, Ion Grigorescu (b. Romania, 1945) also shifted between styles and media, from sculpture, painting, and artist's books to photography and film. He criticized Socialist Realism, which he considered to be kitsch, while making a subversive parallel criticism of the repressive demands and severe censorship imposed under Nicolae Ceauşescu's totalitarian presidency (1965–89). Grigorescu was one of the earliest Romanian artists to use photography and film extensively as both a medium in and a way of documenting his body actions, which he realized in private from the mid-1970s until after the Romanian revolution in December 1989. He also sometimes painted in delicate colors over his own and found photographs to augment photographic documents of his performances, images of popular Romanian folk life, and subjects related to Ceauşescu's razing of historic buildings in Bucharest to construct the "House of the People," one of the largest buildings in the world. The images of the destruction of Romanian life doubled, for the artist, as signs of the repres-

sion of Christianity under socialism. Since the 1990s, Grigorescu has painted religious icons while continuing his conceptual practices.

The social critique implicit in Richter's "capitalist realism" and Grigorescu's oeuvre is pronounced in *People's Choice* (1994–97) by the Russian collaborators Komar and Melamid. Mirroring, but also sardonically commenting on, democratic versus dictatorial processes, Komar and Melamid put into question the relationship between human agency and authoritarianism by creating a series of paintings based on responses to polls conducted in eleven countries, in which the public was asked to identify both their "most wanted" and their "least wanted" elements in a picture. As Komar and Melamid's paintings demonstrate, people throughout the world want to see similar things: a landscape with figures, animals, and water, and the color blue. Yet the visual results also pose a philosophical conundrum: their experimental conceptualism, aesthetic sophistication, and artistic authority threatened to trump the democratic notions of taste represented in the banal paintings of public choice that they created.

Born Vitaly Komar (1943) and Alexander Melamid (1945), the artists began working together in 1965, while attending the Stroganov Institute of Art and Design in Moscow. In the late 1960s they created "sots" art, a wry synthesis of Pop and conceptual art with Soviet Socialist Realism; and in 1973 they were expelled from the Soviet Artists' Union for "distortion of Soviet reality." Komar and Melamid immigrated to Israel in 1977 and New York in 1978. They continued to make quixotic series such as *Nostalgic Socialist Realism* (1982–83), *Monumental Propaganda* (1993), *American Dreams* (1994–99), and *Symbols of the Big Bang* (2001–3), in which they commented on similarities and differences in Russian and U.S. aesthetic politics. In their *Asian Elephant Art and Conservation Project* (1997–), the artists taught Thai elephants to make paintings, which were sold, at Christie's auction house and elsewhere, to raise funds for the endangered elephants and their keepers.

In the early 1970s the feminist artist Annette Messager (b. France, 1943) collected dead sparrows from Parisian streets, had a taxidermist stuff them, knitted wool sweaters in pastel colors, and then dressed the birds' corpses and laid them in rows in a glass vitrine. The resulting installation, *Boarders at Rest* (1971–72), was an oblique reference to French pensioners living in abject poverty at the end of their lives.[11] Throughout her oeuvre, Messager has used such materials as dead animals, stuffed toy animals, and fragments of photographs of women's bodies to comment on the forgotten and the oppressed in patriarchal society. In her well-known photographic installations, such as *My Vows* (1988–91), hundreds of photographs of body parts hang on strings in shaped patterns inspired by ex-voto offerings in Catholic churches. Messager has noted: "[Art] is literally cut out of life. . . . Art is a secret shared between the individual and the collective."[12]

A composer as well as a performance and video artist, Charlemagne Palestine (Charles Martin or Chaim Moshe Tzadik Palestine; b. U.S., 1947) introduced stuffed animals into his performances, beginning in 1970 at the California Institute of the Arts and the Pasadena Art Museum in Southern California. Classically trained as a musician and cantor, Palestine created intensely visceral solo performances and compositions that drew on the repetition of sounds and on chanting. His sensual, trancelike body actions and musical concerts aimed to evoke a hybrid ritual religiosity that he found missing in minimal art and music (with which his work has erroneously been compared). His

use of stuffed animals furthered his critique of minimalism as "lacking soul." For Palestine, stuffed animals became "spirits working with me," a carryover from childhood, where they represent "trust and contact" and "security and power" and function as "presences . . . like sound can be a presence."[13] Although long respected in Europe as both an artist and a musician, Palestine has been neglected in the United States precisely for his passionate externalization of psychological and emotional states, despite his highly disciplined means of expression.

Characterized as "high school/hell house/Lawrence Welk extravaganza" and "clusterfuck aesthetics" by the art critic Jerry Saltz,[14] the work of Mike Kelley (b. U.S., 1954–2012) sprawls eclectically over an array of intellectual and cultural ideas, taking on questions of class, sex, gender, and social and ideological taboos, among other subjects, in a broad range of media. Kelley earned an MFA from the California Institute of the Arts in 1978, after studying with Laurie Anderson, David Askevold, John Baldessari, and Douglas Huebler, among others. He first came to attention in the late 1980s with installations that included stuffed animals in vulgar positions suggestive of childhood abuse, trauma, and perversion. This work, along with that of such artists as Robert Gober, Jake and Dinos Chapman, and Paul McCarthy (with whom Kelley frequently collaborated [see chap. 8]), was seen as part of a tendency explored in the 1993 exhibition *Abject Art: Repulsion and Desire in American Art* at the Whitney Museum of American Art. In a simultaneously humorous, frustrated, and defensive response to having his work characterized as derived from trauma, Kelley produced *Educational Complex* (1995–2008), an architectural model of every school he had ever attended and his childhood home, in which he left blank the parts of the buildings he could not remember, a satirical nod to the repressed memory syndrome related to post-traumatic stress disorder (PTSD) and at the same time a tacit admission of its truth.

In 1959, more than a decade before Charlemagne Palestine used stuffed animals to animate his performances, Robert Rauschenberg (b. U.S., 1925–2008) mounted a stuffed goat in the middle of a painting placed on a platform on the floor, titled it *Monogram,* signifying its relationship to his identity, and described it as a "combine" (the term he coined for hybrid painting/sculptures that included ordinary objects). Rauschenberg studied art for a short time at the Kansas City Art Institute in 1947 and then at Black Mountain College, where he worked with Josef Albers and met the composer John Cage. For Cage's proto-Happening event of 1952 at Black Mountain, Rauschenberg hung his *White Paintings* (1951) on the ceiling. Impressed by the way they reflected light and shadow, Cage later commented that these paintings were an influence on his famous composition *4'33"* (1952) for how they also evoked silence. In the early 1950s, while traveling with the painter Cy Twombly in Europe and North Africa, both artists made constructions, Rauschenberg using sticks, bones, hair, rocks, and feathers. In 1953, at the Stable Gallery in New York, Rauschenberg exhibited a "grass painting" composed of boxes of soil planted with birdseed that he watered to grow. Stating his intent to "act in the gap" between art and life, he worked in every visual art medium from painting to performance, including inventing a chemical means to transfer photographic reproductions appropriated from popular magazines and newspapers onto his own drawings, prints, and paintings. He collaborated widely, working, for example, with Cage, the choreographers Merce Cunningham and Trisha Brown, and the engineer Billy Klüver (with whom he cofounded

Experiments in Art and Technology, or EAT [see chap. 5]). In 1982 Rauschenberg worked with Chinese artists at one of the oldest paper mills in the world in Jinjiang, China. This and other international collaborative experiences led in 1985 to ROCI (Rauschenberg Overseas Culture Interchange), an ambitious six-year project encompassing a traveling exhibition and residencies in different countries, among them China, Sri Lanka, Mexico, USSR, Cuba, Japan, and Chile. In 2002 he produced his *Short Stories* series, integrating mass media, painting, photography, and assemblage in enigmatic narrative works.

Jasper Johns (b. U.S., 1930) studied art briefly in 1949 before serving in the U.S. Army during the Korean War, stationed in Japan. After returning to New York in 1952, he struggled to make art, destroying it all upon meeting Rauschenberg in 1954. That same year, Johns painted the first of his many *Flag* paintings. Leo Castelli gave Rauschenberg and Johns their first one-person exhibitions in 1958 and 1959, respectively. Johns's use of common objects, as in his trompe l'oeil painted-bronze sculpture *Ballantine Ale* (1960), led critics to associate him with Pop art. But when G. R. Swenson included him among the artists he interviewed in his two-part *Art News* article "What Is Pop Art?" (1963–64), Johns emphatically denied an association with pop, later explaining that he explored the ambiguous messages of "preformed, conventional, depersonalized, factual, exterior elements" drawn from everyday life, and that his work related to "the world rather than . . . the personality." In his sketchbook notes to the painting *Watchman* (1964), Johns focused on the conceptual and behavioral similarities and differences between "spying" and "looking." Recalling Cold War rhetoric, Johns seems to suggest that the artist-watchman is a spy who gathers visual evidence. Johns once noted, "In my early work I tried to hide my personality, my psychological state, my emotions."[15] But his work in the 1980s and 1990s often referred directly to his home and studio, as well as nostalgia for and memories of childhood. The complex paintings of the 1990s also incorporate visual references to other artists, from Grünewald to Picasso.

Bruce Conner (b. U.S., 1933–2008) was a central force behind West Coast collage and assemblage movements and a pioneer of independent filmmaking. Born in Kansas and educated at Wichita University, the University of Nebraska, the Kansas City Art Institute, and the Brooklyn Museum Art School, Conner moved to San Francisco in 1957. There, he joined a circle that included the artists Jay DeFeo, Wallace Berman, Manuel Neri, Fred Martin, Carlos Villa, Wally Hedrick, Joan Brown, and George Herms, the filmmaker Larry Jordan, the poets Philip Lamantia and Michael McClure, and the actor Dennis Hopper, among others. Conner made his assemblages and relief sculptures from partially destroyed materials evoking decay, destruction, militarism, and sexuality. In 1958 he adapted his collage technique as montage in his first film, *A Movie*, in which he edited a wide range of images to the beat of music (mostly rock 'n' roll), creating the precursor for music videos. Twenty years later, Conner remained a pivotal figure in the San Francisco punk scene, making *Mongoloid* (1978), a montage film using found footage, cut to the beat of Devo's song of the same name. Conner worked for more than twenty years on a film about the African American gospel group The Soul Stirrers, a work that remained unfinished at the time of his death. One of the most original, irascible, iconoclastic, and intellectual artists of his generation, Conner produced unclassifiable art across many media.

George Brecht (George MacDiarmid; b. U.S., 1926–2008) studied at the Philadelphia College of Pharmacy and Science from 1946 to 1950. While working as a chemist on industrial patents in the early 1950s, he began to consider the role of indeterminacy and chance in art, science, and Eastern philosophy. First drawn to the Surrealists' and Jackson Pollock's use of chance, Brecht later found John Cage's work more compelling and enrolled in his class on musical composition at the New School for Social Research in New York in 1958. During this period, Brecht began composing "event scores," simple textual notations to be realized as actions or mental images. These texts for events became a featured aspect of scoring for Fluxus performances. He also presented ordinary objects like *Chair with a History* (1966) to display the performative relationship between thought, behavior, objects, and the accumulated history of their use over time. In his 1966 essay "Chance-Imagery," Brecht examined chance as a process underlying the operations of paradox, a topic that he later took up with Patrick Hughes in their book *Vicious Circles and Infinity* (1976). Between 1965 and 1968, Brecht and Robert Filliou operated La Cédille qui Sourit (The Smiling Cedilla), a curio store or "international center of permanent creation" on the French Riviera, to make "possible the eventual transition between socialism and communism, and finally, communism and anarchism."[16] Brecht explained that their philosophical aim was to chart a new "history of mind," providing "a new synthesis . . . that can be nourishing for all of us."[17]

Claes Oldenburg (b. Sweden, 1929) studied English literature and art at Yale University and worked as a journalist before moving to New York in 1956. Inspired by Jean Dubuffet's *art brut,* he began to make crude sculptures reproducing the culture of the street. His papier-mâché replicas of ordinary objects and foodstuffs, painted in a sloppy, brightly colored gesture to Abstract Expressionism, followed. In 1961 Oldenburg opened *The Store,* a display in his studio, where his humorous and exaggerated pastiches of everyday objects were on sale, and where, in 1962, he performed ten happenings as part of his "Ray Gun Theater," titled after his phallic alter ego, Ray Gun. Also in 1962 Oldenburg made his first soft sculptures in vinyl, cloth, and kapok, in collaboration with his first wife, Pat Muschinski, who did the stitching. He stopped performing in 1965 in order to distance himself from what he called "the formulaic evolution of Happenings into mass entertainment," which he said only reinforced "bourgeois values." His books *Store Days* (1967) and *Raw Notes* (1973) vividly portray this period and demonstrate his humorous, stream-of-consciousness transformation of the commonplace into the surrealistic. From the mid-1970s on, Oldenburg worked with his second wife, Coosje van Bruggen, on large-scale public monuments that expanded on his earlier concepts, such as *Clothespin* (1976) in downtown Philadelphia, *Spoonbridge and Cherry* (1988) at the Walker Art Center in Minneapolis, and *Shuttlecocks* (1994) at the Nelson-Atkins Museum in Kansas City.

Roy Lichtenstein (b. U.S., 1923–97) studied at the Art Students League in New York with Reginald Marsh and at Ohio State University before supporting himself as a teacher and freelance designer. He met Allan Kaprow when he joined the faculty at Douglass College at Rutgers University in 1960, and soon after met Rauschenberg, Johns, and Oldenburg. In late 1960 Lichtenstein began to paint images of ordinary objects and sections of cropped comic strips. His selections especially emphasized the simultaneously sentimental and violent aspects of American culture. Lichtenstein appropriated the benday dot from commercial printing as a reaction to the personalized mark of the New

York School, calling attention to the mechanized, depersonalized quality of his process and choice of subject matter. But his technique exposed the similarities between the processes of low-cost popular printed forms and those of abstract painting, which both display the means of their production: one in the technological dot matrix and the other in the gestural mark. Lichtenstein increasingly turned his attention to the relationship between painting and photographic reproduction, copying twentieth-century master-works and creating both painted and sculptural pastiches of the formulaic aspects of modernist movements.

Andy Warhol (b. U.S., 1928–87) studied art at the Carnegie Institute of Technology from 1945 to 1949. In 1952 he moved to New York, where he worked as a commercial artist and graphic designer for the department store Bonwit Teller, as well as for *Glamour* magazine. He began painting details of comic book characters in the early 1960s. His images of Campbell's soup cans and Hollywood celebrities, begun soon after, would become popular cultural icons. In a straightforward portrayal of American culture, Warhol refrained from direct moral or social commentary. But like the American photographer Weegee before him, he presented images of glamour and disaster as the substantive subjects of commodity culture. Warhol's interest in mass production led him to transform his studio into what he called "the Factory," where he created silkscreen paintings, sculptures, and films on a production line and eventually published *Interview,* a magazine reporting on celebrity gossip and events. Warhol functioned like the machine he claimed he wanted to become. Attempting to extract all semblance of individual personality from his art, he paradoxically managed to produce iconic images linked to both his personal aura and his historical period.

In 1952 James Rosenquist (b. U.S., 1933) began working as an outdoor sign painter, and in 1955 he won a scholarship to the Art Students League. In 1957 he met Johns, Rauschenberg, Robert Indiana, Ellsworth Kelly, Jack Youngerman, and other artists associated with Pop art and abstract painting. During this period, he started applying the commercial techniques of sign painting to images of American product culture. In 1964 he began *F-111,* an installation-size painting comprising fifty-one interlocking canvas and aluminum panels. The title refers to the U.S. military's most advanced fighter jet of the period, and thereby to the sociology of a culture Rosenquist described as "an inflated, warring society." He exhibited the work at Leo Castelli Gallery in New York in 1965, after which it was shown throughout Europe, in Leningrad, and, in 1967, at the São Paulo Biennial. Rosenquist's frequent comments on American social issues (including race, technology, sex, and the military), and his technique of presenting heterogeneous sets of fragmented images, anticipated postmodern theory and artistic practices. In 2009 Rosenquist published a memoir, *Painting Below Zero: Notes on a Life in Art,* which opened with the statement: "Painting has everything to do with memory."[18]

Lucas Samaras (b. Greece, 1936) met Allan Kaprow and George Segal at Rutgers University, where he was studying on a scholarship. He subsequently participated in happenings by Kaprow, Oldenburg, Robert Whitman, and others, and posed for Segal's plaster figures. During this same period, Samaras worked on a variety of boxes composed of accumulations of objects such as straight pins, razor blades, twine, glitter, and nails, the psychological character of which suggested personal fetishes. By 1964 Samaras began making room environments containing elements of his own personal history. He

increased the narcissistic element in these installations in *Mirrored Room* (1966), which required spectators to become self-viewing performers. Beginning in 1969, Samaras treated his body as an object in his Polaroid *Auto-Portraits,* images of himself performing body actions in the privacy of his apartment, and in his "Auto-Interviews," textual self-investigations. In the 2000s Samaras continued this practice in his *Mutations,* a body of surrealistic, psychedelic digital self-portraits.

Ray Johnson (b. U.S., 1927–95) began making collages in the mid-1950s after studying at the Art Students League (1944–45) and Black Mountain College (1945–48). These collages, which he called "moticos" (an anagram of the word "osmotic"), drew on mass-produced photographic images of celebrities, as in *Elvis Presley* (1955). They represented a model for the effortless assimilation of popular culture into the fine arts. They also reflected his interest in Kurt Schwitters's *Merz* (see chap. 6). In an effort to bypass commercial art institutions, Johnson began to communicate with other artists through letter writing, using the postal system as an alternative medium for both the exhibition and the distribution of art. He sent eccentric handmade postcards and stamps, decorated and collaged letters, artist's books, and other curious wrapped or unwrapped stamped objects (including socks, ties, and even bricks) through the international mail. In 1962 he founded the "New York Correspondance School" (NYCS), a humorous reference to the New York School painters. But in a 1973 letter published in the obituary section of the *New York Times,* he simultaneously dissolved NYCS and announced its transformation into Buddha University. Johnson exploited the democratic potential of public services and technologies like the photocopier and the fax machine in guerrilla artworks that anticipated certain marginal aspects of conceptual art. He inexplicably committed suicide in 1995.

While Johnson has been called the "father" of mail art, the painter Edward (Ed) Ruscha (b. U.S., 1937) has been identified as the father of artist's books in the United States (as Dieter Roth was before him in Europe). In his books Ruscha adopted techniques of advertising and commercial design that he had used in his paintings. These inexpensive, unnumbered books, manufactured en masse using offset printing, featured his unadorned, serial photographs of undifferentiated commercial buildings or common objects. Ruscha's first book, *Twentysix Gasoline Stations* (1963), was followed by *Some Los Angeles Apartments* (1965), *Every Building on the Sunset Strip* (1966), and *Real Estate Opportunities* (1970), among others. While the subject matter, drawn from Los Angeles mass culture, paralleled that of his paintings, with his books Ruscha abdicated production of unique handcrafted objects in favor of an inexpensive, portable medium. As a painter he continued to produce enigmatic paintings such as his "palindrome" series of the late 1990s and early 2000s, featuring mirrored images of mountains stenciled over with a palindromic phrase.

Just as Johnson and Ruscha introduced new media into the vocabularies of art, Judy Chicago (Judy Gerowitz; b. U.S., 1939) brought china painting, embroidery, and quilting—practices historically categorized as women's crafts—into the domain of fine art. A painter, sculptor, educator, organizer, writer, and pioneering feminist artist, Chicago received an MFA in 1964. Five years later she started the first women's art program at California State University at Fresno. Next, she cofounded the Feminist Art Program at the California Institute of the Arts (1971), Womanspace Gallery (1973),

the Feminist Studio Workshop (1973), and the Woman's Building (1973), and co-organized the exhibition *Womanhouse* (1972), all in Los Angeles. She began work on her ambitious large-scale installation *The Dinner Party* in 1974. This multimedia project involved collaboration with dozens of ceramicists and needleworkers, who helped to visualize the symbolic history of over 1,000 women of achievement, including mythical characters and historical figures, with 999 names appearing in the floor tiles and 39 in the place settings. *The Dinner Party* was followed by a series of large-scale visionary collaborative efforts, among them *Birth Project* (1980–85) and *Holocaust Project* (1985–93). Chicago recounted her maturation as a feminist activist in her autobiographies *Through the Flower: My Struggle as a Woman Artist* (1975) and *Beyond the Flower: The Autobiography of a Feminist Artist* (1996). With her husband, photographer Donald Woodman, she facilitated work on the mural *Pomona Envisions the Future* (2002–4), a community-based project (involving more than eighty Pomona, California, artists) that surveys the city's history from its Native American and Hispanic past to the present.

On May 14, 1971, Faith Ringgold (b. U.S., 1930) was found guilty of desecrating the American flag. Ringgold had participated in *The Flag Show* (1970) at the Judson Memorial Church in New York with the artists Jon Hendricks and Jean Toche, founders of the Guerrilla Art Action Group (GAAG). Together with other artists, they had sought to create a "meaningful confrontation and challenge to all laws governing the use and display of the American flag."[19] Unlike Johns, whose flag paintings remain ambiguous in their meaning, these artists summoned the flag to challenge everything from the Vietnam War to the racism Ringgold protested in her painting *Flag for the Moon: Die Nigger* (1969). Born in Harlem and educated at the City College of New York, Ringgold drew on a dense heritage of African American symbols in her work. By telling stories of black America, she hoped to effect change with her art. In 1972 Ringgold helped to organize Women Students and Artists for Black Liberation to struggle for representation of black women artists in exhibitions of African American art, acknowledging the double discrimination experienced by black women. Together with her daughter Michele Wallace, the controversial author of such books as *Black Macho and the Myth of the Superwoman* (1979), Ringgold was one of the founders of the National Black Feminist Organization in 1973. In 1980 Ringgold collaborated with her mother, Willi Posey, a fashion designer, on her first quilt and went on to create "story quilts"—artworks incorporating quilting, painting, collage, and narrative texts about African American history and life—such as *Who's Afraid of Aunt Jemima?* (1983), *The Flag Story* (1985), about a paralyzed Vietnam veteran, Memphis Cooley, and the powerful *Slave Rape Story Quilt* (1985), which opens with the words: "Mama was 8 months gone when he raped her. When she fought back he whipped her so bad she just lay there on the deck. . . . [Then] she crawled over to the side of the vessel and squatted down on her haunches. She give out a grunt like a roar of a lion and I was born right there on the slaveship Carriolle en route to South Carolina to be a slave in America." In 1991 Ringgold published her first children's book, *Tar Beach,* followed by other books educating children on African American history such as *If a Bus Could Talk: The Story of Rosa Parks* (1999) and the CD *How the People Became Color Blind* (2006).

In 1967 Jeff Donaldson (b. U.S., 1932–2004) was one of the artists who created Chicago's *Wall of Respect* on the South Side. This guerrilla mural symbolizing black national-

ism and liberation became a crucial antecedent for the mural movement of the 1970s (see chap. 3) and anticipated aspects of graffiti art. In 1968 Donaldson cofounded the Coalition of Black Revolutionary Artists (COBRA) with Gerald Williams, Wadsworth Jarrell, Jae Jarrell, and Barbara Jones-Hogu. In addition to painters, printmakers, photographers, and designers, members of COBRA included poets, writers, and musicians. The visual artists soon took the name AfriCOBRA (African Commune of Bad Relevant Artists). Emerging from the civil rights and black power revolutions of the 1950s and 1960s, these artists sought to create a "black aesthetic," integrating bright colors, harmony, musical rhythms, tones, patterns, lettering, and other iconic modalities in what Donaldson called a "Trans-African Art" derived from Africa and the Pan-African movement of the early twentieth century.[20] They established positive representations of blacks as common themes (e.g., the black family), a philosophy of "atavistic aesthetic, technical excellence, and social responsibility," and met regularly to critique each other's work. AfriCOBRA grew rapidly, joined by artists Carolyn Lawrence, Napoleon Jones-Henderson, Elliot Hunter, Nelson Stevens, Akili Ron Anderson, Adger W. Cowans, Murry N. DePillars, Michael D. Harris, James Phillips, and Frank Smith. Many of the artists had belonged to the visual art workshop of the Organization of Black American Culture, which aimed to reintegrate the arts into the community. AfriCOBRA drew its material and aesthetic from everyday life, producing posters, paintings, textiles, and inexpensive works located in or accessible to the African American community.

Also dedicated to the representation of African American culture are the eccentric paintings, prints, sculptures, performances, and installations of David Hammons (b. U.S., 1943). With his "body prints" from the 1970s, Hammons left imprints of his own body in black pigment on paper, and with later sculptures, such as *Rock Head* (2004), he glued on hair collected from black barbershops. Hammons has used materials like chicken bones and bottles, and even once, in 1983, undertook the act of selling different sizes of snowballs after a blizzard on New York City streets. In his *African American Flag* (1990) he left the U.S. flag's red stripes but replaced its blue field with green and its white stripes and stars with black ones, evoking the tricolor Black Liberation flag associated with the Pan-Africanist Marcus Garvey. "I really love to watch the way black people make things," Hammons has said. "Nothing fits, but everything works."[21] This ethical aesthetic informs how Hammons visualizes the simultaneously skewed experience of African Americans and Africans of the diaspora, who, despite racism, poor education, and poverty, have produced some of the most compelling art, music, and literature in the world. Although Hammons studied art at the Chouinard and Otis Art Institutes in Los Angeles, he has remained somewhat of a recluse, avoiding, yet participating in, the art market. "The art audience is the worst audience in the world," he has commented.

Kara Walker (b. U.S., 1969), who is a generation younger than Hammons, created confrontational installations that feature tableaux of cut-paper silhouettes representing the sexual violence of the antebellum South and slavery. Responding to charges of her using African American stereotypes in her work, Walker argued that she has the right "to misrepresent the misrepresentations of the black image" and that in doing so she is "investigating her own identity, as well as all imagery that has accumulated about black people." Her statement that she was "shocked to encounter in the dark alleys of my

imagination" her own images proves, as she noted, "the continued currency of an exaggerated black body in American culture that refuses to be buried and is clearly intact enough to warrant further investigation."[22] After the election of Barack Hussein Obama, the first African American president of the United States, Walker related her imagery to this historic moment.

As the civil rights movement reached a fever pitch in the late 1960s, Kim Jones (b. U.S., 1944) shipped out for Vietnam, where he served with the marines for a little over a year. After his return, he received a BFA from the California Institute of the Arts (1971) and an MFA from the Otis Art Institute (1973). Nine years after he went to Vietnam, Jones performed *Rat Piece* (1976), transforming himself into the walking sculpture "Mudman" by stripping, covering his body in mud and his head in pantyhose, and strapping a macabre tower of twigs, foam rubber, and mud lashed together with electrical tape onto his back; he then doused three rats in a cage with lighter fluid and burned them alive. Before carrying out this horrific and tragic action, Jones read a text about his "nakedness; the structure on his back [as] part of his physical being; feeling like a mad thing caught in the wind; trying to escape and to identify his feelings."[23] Jones's performance pictured the material reality and traumatic residue of the senseless brutality of his wartime experience, when soldiers often burned the rats that plagued their camps. In his drawings, sculptures, installations, books, and wearable marine-issue clothing (as in *Khaki Marine Shirt,* 2005), Jones has continued to depict battle scenes for a "war that never ends . . . an X-man, dot-man war game," creating a body of work that represents explicit expressions of post-traumatic stress disorder (PTSD).[24] His installation for the Venice Biennale in 2007 included two war jackets with drawings and a large-scale war drawing on the walls and on canvas.

In 1968, the year that Jones left Vietnam, Dinh Q. Lê was born in Hà Tiên, a Vietnamese town near the Cambodian border. Lê was ten years old when Communist Vietnam invaded Cambodia in an effort to end the genocide perpetrated by the Khmer Rouge. Lê's family immigrated to the United States in 1979. He received a BFA in photography from the University of California, Santa Barbara, and an MFA from the School of Visual Arts in New York. Lê has created large photomontages of the Cambodian genocide and the Vietnam War, weaving together strips of linen tape and C-prints containing imagery from Hollywood and documentary films, family and "found" photographs, or other sources, including candy wrappers and commercial packaging. In this way he joins the technique of traditional Vietnamese grass-mat weaving with allusions to the experience of PTSD, in which memories of trauma occur primarily in fragments and flashbacks. Having experienced the war as a child, as the son of survivors, and later in photographs and films, Lê depicts multiple aspects of trauma, from trans- to multigenerational trauma, in which memory is secondary, acquired through the family and cultural memory.[25] Now living in Ho Chi Minh City, Lê has also created installations, videos, and sculptures addressing the social conditions left by the war, such as the high incidence of conjoined twins resulting from chromosome damage traceable to the use of the chemical Agent Orange by U.S. forces. In 2006 he collaborated with Tran Quoc Hai, Le Van Danh, Tuan Andrew Nguyen, and Phu-Nam Thac Ha in a three-channel video, *The Farmers and the Helicopters,* which became part of an installation with a helicopter constructed from scrap parts.

The work of Enrique Chagoya, born in Mexico City in 1953, also addresses social and political issues. Chagoya studied economics in Mexico before immigrating in 1977 to the United States, where he worked as a community activist, producing graphic illustrations in support of Mexican farm laborers in Texas. Chagoya earned his BFA at the San Francisco Art Institute in 1984, the same year that he began to parody political figures in large charcoal drawings such as *Their Freedom of Expression . . . The Recovery of the Economy,* in which Ronald Reagan and Henry Kissinger appear as Mickey Mouse–clad artists. In this drawing Chagoya puns on the term "Mickey Mouse" as jargon for something trivial, while also criticizing U.S. intervention in Central America and asserting artists' right to speak out on political issues. By 1987 Chagoya had earned an MFA at the University of California at Berkeley. He has continued to offer acerbic and insightful caricatures, lampooning such figures as President George W. Bush and Governor Arnold Schwarzenegger of California, while also introducing into his work Aztec characters and codices that refer to his Mesoamerican roots.

A world away from Chagoya, Chéri Samba (Samba wa Mbimba N'zingo Nuni Masi Ndo Mbasi; b. 1956) has created brightly colored acrylic paintings depicting contemporary life in his native Democratic Republic of Congo (formerly Zaire). Using figurative representation and humor as vehicles for potent social commentary, Samba began selling his sketches while he was still a child in primary school. At the age of sixteen, he left his village for Kinshasa, where he worked as a sign painter before opening his own studio in 1975. In creating illustrations for his popular entertainment magazine, *Bilenge Info,* he developed his signature style of writing in French and Lingala, which he used in his paintings. Commenting ironically on the sexual mores, living conditions, and paradoxes of culture and politics in a society undergoing rapid change, Samba has often represented himself in his art, satirizing his role as a social commentator. His work gained international attention with its appearance in *Magiciens de la terre* at the Centre Georges Pompidou in Paris in 1989, an exhibition that sought to counteract colonialism by featuring artists from both the center of the global art market (the United States and Western Europe) and the so-called margins (Africa, Latin America, Asia, and Australia).

During the same period that Samba was developing his mature style, some artists in New York were exploring street culture. Jean-Michel Basquiat (see chap. 3), Keith Haring (b. U.S., 1958–90), and Kenny Scharf (b. U.S., 1958) created their own "tags," the markers used by graffitists to identify their own work amid otherwise anonymous markings of the urban environment. Haring's tag, the "Radiant Child," appeared on subway walls, on trains, and in abandoned buildings on the Lower East Side. After meeting the graffiti artist Fred Braithwaite, Haring developed a hybrid graffiti style that combined elements from *art brut,* Surrealism, Pop art, comic books, and television. Scharf created a type of Pop Surrealism, integrating cartoon characters with biomorphic, Day-Glo-colored, fantastic worlds characterized by a baroque horror vacui, suggesting scenes from *The War of the Worlds* and the effects of hallucinatory drugs. These artists contributed to the vibrant hip-hop scene in New York's East Village in the 1980s, when alternative venues like ABC No Rio (an offshoot of the artists' group Colab, or Collaborative Projects), Fashion Moda, Fun Gallery, Club 57, and the Mudd Club (founded by Diego Cortez, Steve Mass, and Anya Philips) flourished. Graffiti art moved quickly from the streets to SoHo galleries, where Warhol befriended and later collaborated with

artists like Basquiat and Haring. Haring opened the Pop Shop, a retail space in downtown Manhattan where he sold items produced in multiple, like the work being made in Warhol's Factory. But whereas Warhol appropriated representations from popular culture, Haring created his own imagery, which he reproduced on inexpensive popular cultural objects like refrigerator magnets and T-shirts to raise money to fight drugs, the proliferation of nuclear weapons, and AIDS (of which he eventually died).

Distinctly different from New York graffiti artists, Blek le Rat (Xavier Prou; b. France, 1952) and Banksy (identity unknown; b. U.K., 1974?) are identified with urban street art and use parody to comment on everyday social, cultural, and political conditions. Blek introduced sophisticated stencil imagery in 1981 to distinguish his work from American graffiti by artists such as Richard Hambleton. His first stencils were of rats on Paris streets, "because . . . only rats will survive when the human race will have disappeared and died out."[26] Blek's emphasis on rats recalls Christy Rupp's *Rat Patrol,* life-size drawings of rats she put up anonymously on New York City streets in 1979 during a three-week garbage strike to suggest how humans create a habitat for these animals. Blek's later images include "an old Irish man yelling against English soldiers" shooting at the IRA in Belfast, a sheep, an astronaut, tributes to various artists (Tom Waits, Joseph Beuys, Andy Warhol), and "the man who goes through the wall in our wonderful world." Banksy, who emerged in the mid-1990s in England, also used stencils, but he shifted from Blek's existential presentation of a figure in space toward audacious social commentary, as he discussed in his first book, *Banging Your Head Against a Brick Wall* (2001). Banksy is also known for his pranks against museums, such as hanging a mock cave painting on rock in the British Museum, complete with a text parodying the museum's informational wall texts and viewers' superficial readings of them.[27] In Banksy's work, as in Blek's, images, not words, dominate and relate to the site where they appear.

The art of David Wojnarowicz (b. U.S., 1954–92) drew on his own experience living on the streets as a young gay man and eventually dying of AIDS. His paintings, drawings, installations, videos, performances, and compelling writings all addressed the questions raised, at both an individual and a collective level, by homophobia, the HIV virus, and the AIDS epidemic. A self-identified social outsider, Wojnarowicz attempted to speak for and represent the "excluded, repressed, repulsive, despised, and phobically stigmatized" members of society. In the face of censorship and prejudice, his art signified the "taboo, unpredictable, dangerous, anarchistic, deviant, unexplained, criminal, insane, ethnic, low class, filthy, diseased, savage or grotesque" aspects of life he identified in the "heart of darkness."[28] In such texts as "Being Queer in America: A Journal of Disintegration," "Living Close to the Knives," and "Post Cards from America: X-Rays from Hell," Wojnarowicz courageously tore away the veil of secrecy and myth shrouding the pain of neglect, fear, and hatred experienced by homosexuals.[29]

Barbara Kruger (b. U.S., 1945) studied under Diane Arbus and Marvin Israel at Parsons School of Design in 1966 before becoming chief ad designer for the magazine *Mademoiselle*. In 1981, with black-and-white photomontages overlaid with red texts that recalled the classic design of *Look* magazine, Kruger began applying her knowledge of photography, television, and film to intervene in, critique, and oppose the subliminal power of the media. She especially concentrated on exposing gender stereotypes maintained by the media, depicting aspects of what the filmmaker Laura Mulvey has theorized as the "male

gaze" and showing how gender difference is coded by the psychological conditions of patriarchal desire.[30] Kruger's style, technique of representation, and theoretical intent became paradigmatic of postmodern feminists' social critique. Since the 1990s Kruger has continued her critique of American culture in video and film installations.

Sherrie Levine (b. U.S., 1947) first gained critical attention in the early 1980s when she began to photograph reproductions of photographs by Edward Weston, Eliot Porter, Walker Evans, and others. Appropriating mass-produced reproductions, she later re-presented works by late-nineteenth- and early-twentieth-century artists like Henri Matisse, Kasimir Malevich, Piet Mondrian, Vincent van Gogh, Joan Miró, Fernand Léger, and Alexander Rodchenko. In this way Levine has systematically investigated the theoretical critiques of originality and authorship put forth by cultural critics like Michel Foucault, Roland Barthes, and Jean Baudrillard. Her work questions the place of artistic authenticity in late capitalism and explores the problem of the "simulacrum," the reduplication of the real that, Baudrillard wrote, "becomes *reality for its own sake.*"[31] Ironically, Levine's copies transform the "copy" into an original, confounding received cultural categories and provoking consideration of the "hyperreality" of postmodern culture.

Such appropriation can have legal ramifications. Jeff Koons (b. U.S., 1955) commissioned an Italian factory to fabricate an edition of five life-size wooden sculptures of a man and a woman holding eight puppies. Koons had based this 1988 sculpture, titled *String of Puppies,* on a greeting-card image by the photographer Art Rogers entitled *Puppies* (1980). Rogers sued, and Koons was adjudged in violation of Rogers's copyright. Koons had become known in the 1980s for his industrially produced sculptures of banal objects such as inflatable plastic flowers, children's toys, household appliances, life-size porcelain figurines, and accessories for the consumption of alcohol. He explored the commodification of desire in the 1990s by creating a series of explicit silkscreen images and sculptures of himself and his then-wife, Ilona Staller (a Hungarian-born Italian singer, porn star, and politician known professionally as "Cicciolina"), having sex in various positions. These works parodied the highly charged emotional content constructed by the pornography industry in the same manner that his earlier works had satirized popular cultural consumption.

Similarly, the self-taught Italian artist Maurizio Cattelan (b. 1960) has used satire and parody to create controversial works, such as *The Ninth Hour* (1999), a sculpture depicting Pope John Paul II, holding his pontiff's staff and lying on the ground amid shattered glass after being struck down by a meteorite. In 1993, for his first participation in the Venice Biennale, Cattelan rented the space assigned to him to an advertising agency and wrote a critical and humorous text on the risky connections between art, the media, and mass communication. Similarly, for the 2001 Biennale he created an homage to, and parody of, Hollywood in the hills of Sicily, installing a giant sign (nearly 600 feet long and 75 feet tall) replicating the famous Hollywood sign in Los Angeles. Cattelan is a coeditor of *Charley,* a magazine that bills itself as "a machine for redistribution, a mechanism for spreading and exploiting information, rumors, and communication. Like most information, it is partial, unstable, and untrustworthy. There are no hierarchies and no favorites in *Charley:* it flirts equally with celebrity and failure."[32]

A different kind of irony and playfulness is found in the work of Tony Cragg (b. U.K., 1949), who won the prestigious Turner Prize in 1988. Interested in socioeconomic

and environmental issues and the excesses of disposable culture, in the 1970s Cragg began to assemble large floor and wall installations with mosaic-like figurative silhouettes made of fragmented plastic shards recovered from urban debris. He turned to found wood, metal, stone, and glass for his constructions in the 1980s. In the 1990s he began using more traditional sculptural materials (wood, marble, stone, and bronze) to create freestanding objects, some of which resemble test tubes and other scientific paraphernalia and hark back to his early training as a biologist before he studied art.

The 1990s marked the emergence of the Young British Artists (YBAs), led by Damien Hirst (b. 1965), who, in his second year at Goldsmiths College, in 1988, organized the exhibition *Freeze,* featuring work by such artists as Sarah Lucas and Fiona Rae and held in an abandoned building in London's Docklands. The success of the exhibition inspired a second show, *Freeze 2,* as well as the art journal *Frieze,* founded in London in 1991. Hirst's sculptures, paintings, and installations operate at the interface of art and popular culture, taking love and death as their central themes. For example, in his early *Natural History* works, the artist presented dead animals preserved in formaldehyde. Iconic works in this series include *The Physical Impossibility of Death in the Mind of Someone Living* (1991), featuring a 14-foot-long tiger shark, and *Mother and Child Divided* (1993), with a bisected cow and calf, which raised questions regarding biological existence in a period of genetic engineering and won Hirst the Turner Prize in 1995. Among Hirst's paintings are *Amazing Revelations* (2003), in which he arranged butterfly wings on canvas in mandala-like patterns that recall the butterfly collage paintings of Dubuffet in the 1950s, and the *Spin* series (2000–), made by using centrifugal force to apply paint to a spinning canvas, with the result resembling Op art and other styles from the 1960s. All of Hirst's work carries within it this art historical legacy, engaging material popular culture and its intersection with science. In addition to creating art, curating, and writing, Hirst has owned several restaurants, the most renowned being Pharmacy (1997–2003), in Notting Hill, London, an extension of his earlier *Pharmacy* (1992), a room-size installation replicating a real pharmacy, complete with prescription drugs. Hirst has been compared to Andy Warhol for his prescient and pointed commentary on contemporary society.

Other YBAs, such as Douglas Gordon, Gillian Wearing (chap. 5), and Rachel Whiteread (chap. 6), continued the use of industrially produced objects and mass media by the Independent Group generation, but turned their attention to new technologies, especially those of surveillance, as well as questions of gender, race, and class and the role of popular culture in the sociopolitical production of spectacle and the global art market. Many of these artists had attended Goldsmiths College and were promoted by the advertising mogul, collector, patron, and art dealer Charles Saatchi. The exhibition *Sensation: Young British Artists from the Saatchi Collection* (1997–2000) brought the YBAs to international attention, heightened by controversy surrounding certain works in the exhibition that were seen to be blasphemous (Chris Ofili's *The Holy Virgin Mary,* 1996), immoral (Tracey Emin's *Everyone I Have Ever Slept With, 1963–1995,* 1995), or unethical (Marcus Harvey's *Myra,* 1995). The YBAs' influence has been felt in experimental art throughout the world well into the twenty-first century, authorizing a plethora of styles and approaches to everyday life.[33]

Sir Eduardo Paolozzi, *Real Gold,* 1950, collage. By permission of the artist. Photo courtesy Tate, London.

RICHARD HAMILTON Letter to Peter and Alison Smithson (1957)

16th January 1957

Dear Peter and Alison

I have been thinking about our conversation of the other evening and thought that it might be a good idea to get something on paper, as much to sort it out for myself as to put a point of view to you.

There have been a number of manifestations in the post-war years in London which I would select as important and which have a bearing on what I take to be an objective:

Parallel of Life and Art
(investigation into an imagery of general value)

Man, Machine and Motion
(investigation into a particular technological imagery)

Reyner Banham's research on automobile styling

Ad image research (Paolozzi, Smithson, McHale)

Independent Group discussion on Pop Art–Fine Art relationship

House of the Future
(conversion of Pop Art attitudes in industrial design to scale of domestic architecture)

* Richard Hamilton, "Letter to Peter and Alison Smithson" (16 January 1957), in Hamilton, *Richard Hamilton Collected Words* (London: Thames and Hudson, 1983), 28. By permission of the author and the publisher.

This is Tomorrow
Group 2 presentation of Pop Art and perception material attempted impersonal treatment. Group 6 presentation of human needs in terms of a strong personal idiom

Looking at this list it is clear that the Pop Art/Technology background emerges as the important feature.

The disadvantage (as well as the great virtue) of the TIT show was its incoherence and obscurity of language.

My view is that another show should be as highly disciplined and unified in conception as this one was chaotic. Is it possible that the participants could relinquish their existing personal solutions and try to bring about some new formal conception complying with a strict, mutually agreed programme?

Suppose we were to start with the objective of providing a unique solution to the specific requirements of a domestic environment e.g. some kind of shelter, some kind of equipment, some kind of art. This solution could then be formulated and rated on the basis of compliance with a table of characteristics of Pop Art.

Pop Art is:
Popular (designed for a mass audience)
Transient (short-term solution)
Expendable (easily forgotten)
Low cost
Mass produced
Young (aimed at youth)
Witty
Sexy
Gimmicky
Glamorous
Big business

This is just a beginning. Perhaps the first part of our task is the analysis of Pop Art and the production of a table. I find I am not yet sure about the "sincerity" of Pop Art. It is not a characteristic of all but it is of some—at least, a pseudo—sincerity is. Maybe we have to subdivide Pop Art into its various categories and decide into which category each of the subdivisions of our project fits. What do you think?

Popular Culture and Personal Responsibility (1960)

It seems to me that the artist, the intellectual, is not the alien that he was and his consumption of popular culture is due, in some measure, to his new role as a creator of popular culture. Popular art, as distinct from fine art, art created by the people, anonymously, crudely and with a healthy vigor, does not exist today. Its present-day equivalent, pop art, is now a consumer product absorbed by the total population but created for it by the mass entertainment

* Richard Hamilton, excerpts from a lecture titled "Art and Design" at the National Union of Teachers conference "Popular Culture and Personal Responsibility" (26–28 October 1960); reprinted in Hamilton, *Richard Hamilton Collected Words* (London: Thames and Hudson, 1983), 151–56. By permission of the author and the publisher.

machine, which uses the intellectual as an essential part of its technique. The results are highly personalized and sophisticated, but also have a healthy vigor.

Although the intellectual participates in the production and consumption of popular culture he is apart from it in one important sense; he is more aware of the entire circumstances of the phenomenon as a social situation than is the normal consumer. This awareness is most important in that he understands that he is adopting standards oriented to mass tastes and it is this new catholicism which has caused alarm among the critics of popular culture. They feel that he has sold his soul to the devil.

My own view is that there is less to regret than one might suppose. An ideal culture, in my terms, is one in which awareness of its condition is universal. A culture in which each of its members accepts the convenience of different values for different groups and different occasions, one in which the artist holds tight to his own standards for himself and gives the best he can to whom he can without priggishness and with good humor, whilst facing his historical situation with honesty.

It is usual to include within the scope of the term "mass media" such modes of communication as the cinema, TV, magazines, newspapers, radio, advertising and so on. Other fields, less obviously concerned with transmitting a message, are addressing their audience in the same language and I was glad to find that art and design were included in the terms of reference for this conference. Marketing techniques do not stop at presenting a product; a product can be molded to a market and sometimes vice versa. Product design itself can even start in the advertising agency. In the case of a commodity like toothpaste or cosmetics the package is of greater importance than its contents in influencing the purchaser. Many products, in which efficiency of operation is the only real essential, are dependent on the design of the shell as the factor ultimately determining sales. In its efforts to gain and hold the affection of the mass audience a product must aim to project an image of desirability as strong as that of any Hollywood star. It must have gloss and glamor, and evoke a yearning for possession. . . .

The techniques of the mass media are powerful and it is fortunate for society that the mechanics of the mass media do breed people with visual taste and discrimination. It is important, too, that they should be of open mind and also that they should respect the audience they feed for what it is: an inquisitive, acquisitive, basically good-natured and essentially receptive swarm. The mass media afford advantages to society when they are most tolerant, cordial and self-respecting, conscious of their own high standards and the need to uphold them.

The mass media have to work within the sphere of play and are constantly widening the boundaries of this sphere. The machine, in its closest contacts with the mass audience, falls also within that area of human activity and often affords the kind gratification that we associate with toys: typewriters, telephones, kitchen gadgets, washing-machines, cars, garden tools all have their serious value, but the sensual and visual functioning that is increasingly the designer's main concern provides the pleasure of games. This is not suggesting that the activity is of a lower order; the classification has its uses, for this is the way that the mass media are playing the game and playing it well. If, as seems the case, the only alternatives for maintaining high productive potential are war or totalitarianism I would say that the mass media are reasonably harmless and inherently beneficial. The danger in the efficiency of the mass media seems to me to be in their ability to influence public opinion in spheres other than play, for instance in political affairs. The showmanship of [Joseph] McCarthy, who ruthlessly employed the techniques of the mass media, was good business for newspapers, for the

glossies and for TV regulated by audience statistics. It is for us as teachers to promote in the youth we teach a healthy suspicion of all dogma, whether it is politically oriented or aimed at fixing the pattern of our culture. What is needed for the youth of today is that they should be educated in a positive sense towards a complete understanding of the techniques of the mass media, whose products they already know and appreciate. Freedom of choice for the individual is the most precious of his democratic rights and it can only be properly exercised if he or she is in possession of all of the facts; his or her freedom should allow everyone to be what they want to be, but with cognizance.

Natural selection operates as effectively in the domain of man's mechanical extensions as in his biological processes; survival of those elements best fitted for survival occurs within the great mutation rates of our mechanical productions. If we were to try, and I think we should, to work consciously with the system and not against it, then our efforts should be directed at finding synthetic aids to this process of natural selection and this is our problem now. . . .

The mistake that critics of the mass media are making is to complain that pop art, as fed by the mass media to the mass audience, is not like fine art. But of course it is not. Fine art is assessable in terms of value judgments and its qualities are not transient, whereas pop art's values establish themselves by virtue of mass acceptance and will be expendable. What we might begin to worry about today is why current fine art is coming to assume all of the characteristics of pop art. If we were to list the essentials of pop art we might include these characteristics as fundamental to it: glamor, overt sincerity, wit, direct appeal, professionalism, novelty, an ability to co-exist within an existing pattern of style, and lastly, expendability. Only one of these properties, expendability, seems to be incompatible with the concept of fine art. Glamor, the lush emanation that the Hollywood star system employs, is something we are quite familiar with in art; French court painting and even Italian religious art exude the same magic for the populace. Is Dickens much the worse for a sincerity that outdoes Liberace's? Wit is common to Sterne, Erik Satie and Paul Klee. Much painting has direct appeal, every work of Michelangelo was acclaimed from the moment of unveiling. Professionalism—look at Rubens. Novelty—the essential newness of his preoccupation is an almost basic criterion for the artist. Artists working within the framework of an overall style produced the Gothic cathedrals. But expendability and fine art are not concomitant. A work of fine art emerges only from a consciousness of personal satisfaction which must be shattered if the conception included the knowledge that its value would be transitory. Yet, today, there is increasingly a tendency for fine art to bear the stamp of an expendable product. Art currently sanctioned by American museums and Government Information Services is more and more expendable (the American situation is beginning to apply in Britain also). Art is replaced from year to year with as little regret for the loss of last year's star as there is for the inevitable demotion of last month's pop record from the Top Ten. The fine artist, the intellectual, can and should work within the dual terms of the title of this conference: when contributing to popular culture through the mass media he must feel a sense of personal responsibility as part of that culture and recognise that his act is directed towards an audience and their needs. The responsibility that he owes to himself is to ensure that he also produces art objects which give him maximum private gratification—unless the artist feels that he can create values only for himself and regards the joy of others only as a gratuitous intensification of his own satisfactions he is less than an artist. This is his personal responsibility and I suggest that it is something that must be preserved as outside the province of the mass media. I said earlier that the artist must hold on to his own, and this sense of personal, yet impersonally timeless, value is what I feel to be his.

Propositions (1971)

A work of art is a vehicle for the transmission of information concerning the mental, or physical, activity of an artist.

The vehicle, or *medium, need not transmit* information (*a message*)—*it can stand as a symbol* for a message.

The work of art *may be structured* or not—it can be a *concept.*

An artist can *propose that his* work of art *shall* be structured by someone other than the artist—or it can be structured by *chance.*

Structures (*and non-structures*) may be *characterized* by *a style* (or *non-style*).

The style of a structured (or *unstructured*) message (or *symbolic non-message*) can *serve to identify* the *individuality* of an artist.

Art can be structured *in* the style of *another* artist, *either* in *sincere emulation* or as *ironic parody.*

A work of art is *evidence* that an artist *has proposed* a work of art.

An *eye witness account* is evidence that an artist has proposed a work of art. *But documentary* evidence (*i.e.* a *photograph*) is *more conclusive.*

A *painting* is documentary evidence that an artist has proposed a work of art.

DIETER ROTH Statement (1976)

D. Roth was born 46 years ago among the butchering Germans at that horrible stretch of time, when that cannibal, awful Hitler, Adolf, was just getting the Germans going at their best hit; butchering war. Hell was loose, but Roth survived, beatings and scoldings he survived, shitting and pissing in his timid pants, poor shaking little turd, he even managed to live through that rainstorm of bombs and grenades awful smashing horror, brought about on all, the living and the dead, by the horridly cruel cool English and the annihilatingly maneating cannibals, those fantastically cruel citizens of the so-called United States of Northamerica, horrible mankillers. Roth got out of that place (described) by chance of being one of the citizens of his horrible home country, namely, selfrighteously, murderously Christian Switzerland. He survived, pantpissing there for 12 years. Then one of the friendly Danes helped him out of it, getting to wonderful, wonderful Copenhagen. Having managed to happily survive there for a year matrimony got him, catching up with him. An awfully, dreadfully fearful drain he fell down into, wriggling there, at the bottom, pissing in his wet pants, shitting and drinking terrible, awfully pissing lots, screaming for mercy. Again he managed to escape, this time to a place that soon proved to him to be full of his like, butchering bastards, dwellers in shit, pissing in their pissing wet pants, eating each other's awful bodies and souls, dwellers of Hell. He did escape though, to another place, thoughtful eyes watching him (the eyes of his second parents, his children), doubling his raging shame. Steamer of the dampsteamingwets, shitpissing pants, stumbling around the corners of the all encompassing butcher's shop. Turdknickering awful bastard of fear, complaining.

* Richard Hamilton, "Propositions," in *Catalyst* (May 1971); reprinted in Hamilton, *Richard Hamilton Collected Words* (London: Thames and Hudson, 1983), 266. By permission of the author and the publisher.

** Dieter Roth, untitled statement (Barcelona, July 1976), in Richard Hamilton and Dieter Roth, *Collaborations of Ch. Rotham* (Stuttgart: Edition Hansjörg Mayer with Galeria Cadaqués, 1977), 121. By permission of the artist and the publishers.

I Only Extract the Square Root: Interview with Ingolfur Margeirsson (1978)

I discovered the potential of sour milk by accident. It was at a special period in my life, when I was married in Iceland,—that I sneaked out at night to draw what you might call "dirty pictures." I was very ashamed of this bent and to destroy these pictures I once poured sour milk over them. Then I noticed that they became very beautiful. Subsequently I always pour sour milk over pictures that weren't beautiful or didn't work out. Sour milk is like landscape, ever changing. Works of art should be like that—they should change like man himself, grow old and die.

.

I don't work very hard at making perfect works of art. I'm not very keen on being the best or making perfect things. I often wait until I'm under the weather, ill, tired or hung over to make things. Making art is like making other things in life, it depends on your mood, your state of mind. You make good things and everything in between. But even then, when I try to create in this state of mind, my upbringing makes itself felt and I end up writing or painting well. It shows that I haven't managed to break loose from my youth. I'm afraid of showing the truth. I'm still a slave to something. We are all slaves to something.

.

There's a saying in German that goes: "Who's left this suitcase here?" and is used when people break wind. I decided to create works of art about this saying.

I had a show of 40 suitcases, large, small, old and new, and all of them were full of cheese. There were two tons of cheese in that show. It was like a train terminal, suitcases everywhere. The people in Los Angeles didn't know the German saying but they noticed the smell. There was a heatwave on the West Coast at the time. In a few days the suitcases had begun to leak, there were pools on the floor and the smell indescribable. A cloud formed over the city. Soon flies and insects started to arrive and the gallery was covered with flies. The lady who owned the gallery sat there for six hours every day and couldn't see anything because of the flies, although both the walls and the floor were originally painted white. Eventually there were so many flies about that you couldn't get through the gallery. They were so dazed by the smell of the cheese that they covered the walls like thick paint. Then the police came, investigated this fly-business and said: Close the gallery. The gallery-owner's husband was a lawyer and he said: We stay open. There was a lot of fuss. Sanitary inspectors were brought in and they found that the cheese had formed vapours akin to laughing gas, which could be dangerous. Then the gallery lady, who'd sat in the place for six hours every day, said: I was wondering why I felt so merry the whole time.

.

It's important to exhibit your mistakes. Man is not perfect. Neither are his creations. I've given up using sour milk. Instead I use music. I sometimes fasten a tape recorder onto paintings or objects and have the music pour over the spectator/listener. This creates a certain effect: Those who look at the art don't realize how bad it is when they hear the music. For the music is even worse. Two bad things make one good thing.

* Dieter Roth, excerpts from "I Only Extract the Square Root," an interview with Ingolfur Margeirsson, in *Pjooviljinn* (3 September 1978); reprinted in *Dieter Roth* (Reykjavik: Nylistasafnid—The Living Art Museum, 1982), 8; and in *Dieter Roth* (Chicago: Museum of Contemporary Art, 1984), 8, 9, 20–21. By permission of the artist.

Offhand Design (1975)

take design as: shaping the readable part of a message the designer agrees with
then: if you don't like the message don't design it
 if you like the message design it
(reversed offhand design:
 if you don't like the message design it
 if you like the message don't design it)
put the message down: quickly cheaply simply easily shortly
give the work away if you can afford it
if not: sell it

experiment in offhand design
make an offhand book for instance:
go to a place (be invited for instance)
have impressions there
take things from the places where you have impressions (take really or mentally) bulbs from
 lamps, candy from stores, symbols from visions in dreams, symbols from visions in
 places, colors from clothes, colors from faces, colors from memory, colors from hope,
 colors from disgust
make (as many as time allows, invitation allows, health allows, walls want, you want, peo-
 ple want) flat things (pictures) out of the taken things
copy them photographically, make portraits of them, describe them, make remarks about
 them, divide them, alter them, keep them, give them
have machines doing the same for you, more for you, more for somebody else, more for
 themselves make pictures out of things, feelings, visions, remarks, accidents which
 come from those pictures
make (at any time) a pile from the pictures you like, somebody likes, certain people like,
 nobody likes
and bind them as a book

if you don't like this ↑
this please ↓

ask an intelligent designer: how must design be?
he will say: it should be: nice, beautiful, intelligent, colorful, witty, optimistic, inventive,
 etc.
ask any man: what should your work be like?
you will get this answer: it has to be nice, beautiful, intelligent, colorful, witty, optimistic,
 inventive, etc.
then:
ask the man how to arrive at this goal
he will say: love of the job, intelligence, craftsmanship, talent, hard work, patience, inven-
 tiveness, using good material, etc.
ask what his work has to do
he will answer: help selling, make things look good, make things enjoyable, etc.

* Dieter Roth, "Offhand Design," in *Dieter Roth: Frühe Schriften und typische Scheisse,* introduction by Oswald Wiener (Stuttgart: Edition Hansjörg Mayer, 1975), n.p. By permission of the author and the publisher.

so design is: making enjoyable, good looking, inventive, selling, intelligent gadgets
these gadgets are (as we know) supposed to keep people at, push people to loving, liking,
 enjoying, buying, thinking of, working for gadgets
design is then: much ado about gadgets
learn how to make, show, draw, push, picture, imagine, talk about, have, keep, work for,
 stand by, feel, eat, praise gadgets
this keeps people busy, the money rolling, the good designers famous

ÖYVIND FAHLSTRÖM Take Care of the World (1966)

1 ART: Consider art as a way of experiencing a fusion of "pleasure" and "insight."
Reach this by impurity, or multiplicity of levels, rather than by reduction. (The fallacy of
some painting, music, etc.; *satori* by mere reduction. The fewer the factors, the more they
have to be "right," "ultimate.")

The importance of bisociation (Koestler). In painting, factual images of erotic or
political character, for example, bisociated, within a game-framework, with each other and/
or with "abstract" elements (character-forms) will not exclude but may incite to "meditational"
experiences. These, in turn, do not exclude probing on everyday moral, social levels. . . .

2 GAMES: Seen either as realistic models (not descriptions) of a life-span, of the Cold
War balance, of the double-code mechanism to push the bomb button—or as freely invented
rule-structures. Thus it becomes important to stress relations (as opposed to "free form" where
everything can be related to anything so that in principle nothing is related). The necessity
of repetition to show that a rule functions—thus the value of space-temporal form and of
variable form. The thrill of tension and resolution, of having both conflict and nonconflict
(as opposed to "free form" where in principle everything is equal). . . .

3 MULTIPLES: Painting, sculpture, etc., today represent the most archaic art medium,
depending on feudal patrons who pay exorbitantly for uniqueness and fetish magic: the "spirit"
of the artist as manifested in the traces of his brushwork or at least in his signature (Yves Klein
selling air against a signed receipt in 1958).

It is time to incorporate advances in technology to create mass-produced works of
art, obtainable by rich or not rich. Works where the artist puts as much quality into the con-
ception and the manufacturer as much quality into the production, as found in the best
handmade works of art. The value of variable form: you will never have exactly the same
piece as your neighbor. . . .

4 STYLE: If bisociation and games are essential, style is not. Whether a painting is made
in a painterly, in a hard-edge graphic or in a soft photographic manner is of secondary inter-
est, just as documentary, melodramatic and dancelike dimensions can interweave in a play. I
am not much involved in formal balance, "composition" or, in general, art that results in mere
decorative coolness (art that functions primarily as rugs, upholstery, wallpaper). Nor am I
concerned with any local cute Pop or camp qualities *per se,* be they the thirties, comics, Hol-
lywood, Americana, Parisiana, Scandinavianisms.

5 ESSENTIALS: In order to seem essential to me, a material, content or principle does
not only have to attract me "emotionally," but should concern matters that are common and

* Öyvind Fahlström, excerpts from "Take Care of the World," in *Manifestos,* Great Bear Pamphlets (New York:
Something Else Press, 1966), 9–13. By permission of Sharon Avery-Fahlström.

fundamental to people in our time, and yet be as "fresh," as untainted by symbolism, as possible. I deplore my incapacity to find out what is going on. To find out what life, the world, is about, in the confusion of propaganda, communications, language, time, etc. . . .

6 RISK REFORMS: Attitude to society: not to take any of the existing systems for granted (capitalist, moderately socialized or thoroughly socialized). Refuse to presume that "sharpness" of the opposite systems will mellow into a worthwhile in-between. Discuss and otherwise influence the authorities towards trying out certain new concepts.

7 ARMS: Complete and unilateral disarmament (apart from a small permanent force submitted to the United Nations). Small countries will soon have to make the choice between this and acquiring nuclear weaponry anyway. The risk of disarming is minimal, as only other small countries now (or even later with nuclear arms) can be deterred. This step would, among other things, release tax-income, man- and brainpower for other reforms.

8 TERROR: Instead of prisons, create forcibly secluded, but large very complete (both sexes) and very "good" communities (everyday Clubs Méditerranés) where offenders could gradually find satisfying ways of living without offending society. The risk would of course be the suffering of victims, with potential offenders no longer deterred (a "10th Victim" situation?).

Value is having to find out what makes a "good" community; corralling the discontented part of the population; finding out if punishment deters; finding out if a major part of the population will turn criminal in order to be taken care of in a closed community rather than live in the open one.

9 UTILITIES: Free basic food, transportation and housing paid through taxes. Risk: "No one will care to work." Value: true equality—everyone paying taxes according to what he or she earns. As opposed to the present token equality, where an apple costs differently to each buyer.

10 PROFITS: Steer away from redundant, self-revolving production (five to ten different companies producing the same detergent—competition mainly on the level of marketing gimmicks) by letting government agencies assign projects to the two or three most qualified bidders (like military contracts plus limited competition). What to be produced thus will be decided centrally by the country; how to produce, by the manufacturer; and how to divide the profits, by manufacturers and workers. An attempt to combine planning and incentive. The risk of less variety and lack of incentive outweighed by the chance to diminish the alienation in ordinary blindfolded work; of replacing publicity with information; and primarily to divert brain- and manpower to neglected fields like housing, pleasure, education, etc.

11 POLITICS: Government by experts and administrators. Delegate the shaping of policies and the control of experts to a body of "jurors" replaced automatically at given intervals, chosen from outstanding persons in all fields. Abolish politicians, parties, voting. Perhaps have referendums. Voting and active participation on regional, labor and such levels where participation is concrete and comprehensible.

Find and channel some geniuses into creative administrative and diplomatic work, instead of excluding them from such leadership. Risk: nothing can be worse than the power games on local and global levels between smalltime politicians whose sole expertise lies in acquiring and keeping power.

12 PLEASURE: "The ecstatic society." Research and planning in order to develop and mass produce "art" as well as "entertainment" and drugs for greater sensory experiences and ego-insight. New concepts for concert, theater and exhibition buildings; but first of all pleasure houses for meditation, dance, fun, games and sexual relations (cf. the "psychedelic dis-

cothèque" on the West Coast, and the multiscreen discothèques of Murray the K and Andy Warhol). Utilize teleprinter, closed-circuit TV, computers, etc., to arrange contacts, sexual and other.

Incite to creative living, but also approve "passive" pleasures by means of new drugs—good drugs, i.e. strong and harmless, instead of perpetuating the use of our clumsy, inherited drugs, liquors, stimulants. Refine the activating (consciousness-expanding) new drugs. And develop euthanasia drugs to make dying easy, fast and irrevocable for terminal cases and prospective suiciders.

The risk of people not caring to work any more would be eliminated by the fact that people would have superficial benefits attractive enough to make it worthwhile to work in order to obtain them.

PIERRE RESTANY The Nouveaux Réalistes' Declaration of Intention (1960)

In vain do wise academicians or honest people, scared by the acceleration of art history and the extraordinary toll of our modern age, try to stop the sun or to suspend time's flight by running counter to the hands on a watch.

We are witnessing today the depletion and sclerosis of all established vocabularies, of all languages, of all styles. Individual adventures which are still scarce in Europe and America confront this deficiency—by exhaustion—of traditional means, and regardless of their scope, they tend to define the normative bases of a new expressivity.

It is not about an additional formula for oil or enamel media. Easel painting (like no other means of classical expression in painting or sculpture) served its time. It now lives out the last seconds, still occasionally sublime, of a long monopoly.

What else is proposed? The thrilling adventure of the real perceived in itself and not through the prism of conceptual or imaginative transcription. What distinguishes it? The introduction of a sociological relay to the essential stage of communication. Sociology comes to the rescue of consciousness and chance, whether with a choice of poster defacement, the look of an object, household garbage or salon scraps, the unleashing of mechanical affectivity, the diffusion of sensitivity beyond the limits of its perception.

All these adventures (both present and future) abolish the abusive distance created between general objective contingency and individual expressive urgency. The whole of sociological reality, the common good of human activity, the large republic of our social exchanges, of our commerce in society, is summoned to appear. There should be no doubts about its artistic vocation, if there were not still as many people who believed in the eternal immanence of pseudo-noble genres and painting in particular.

At the more essential stage of total affective expression and the exteriorization of the individual creator, and through the naturally baroque appearances of certain experiences, we make our way towards a neo-realism of pure sensitivity. Therein lies at the least one of the paths for the future. With Yves Klein and Tinguely, Hains and Arman, Dufrêne and Villeglé, some very diverse premises have been stated in Paris. The ferment is fertile, as yet unpredictable in its total consequences, and certainly iconoclastic (due to the icons themselves and the stupidity of their worshippers).

* Pierre Restany, "Les nouveaux réalistes, 16 avril 1960, Milan (1er manifeste)," in Restany, *Le nouveau réalisme* (Paris: Union Générale d'Éditions, 1978), 281–85. Translation by Martha Nichols. By permission of the author.

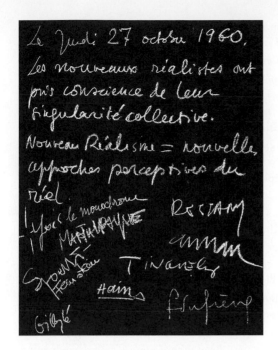

The signatures on the first manifesto of the
Nouveaux Réalistes, 1980. By permission
of Pierre Restany.

Here we are up to our necks in the bath of direct expressivity and at forty degrees above
dada zero, without any aggression complex, without typical polemic desire, without other
justifying urges except for our realism. And that works, positively. If man succeeds in rein-
tegrating himself into the real, he identifies the real with his own transcendence, which is
emotion, sentiment, and finally, poetry.

Forty Degrees above Dada (1961)

Dada is a farce, a legend, a state of mind, a myth. An ill-bred myth whose underground sur-
vival and capricious demonstrations upset everyone. André Breton had thought at first to
dispose of Dada by attaching it to Surrealism. But the anti-art explosive was short lived. The
myth of the entire *no* lived clandestinely between the wars in order to become, as of 1945,
with Michel Tapié the guarantee of an "art autre." Thanks to the change of absolute aesthetic
negativity into a methodological doubt, it was finally possible to incarnate new signs. A nec-
essary and sufficient blank slate, the dada *zero* constituted the phenomenological reference of
abstract lyricism: it was the big break with tradition, whereby broke the muddy wave of for-
mulas and styles, from the "informel" to "nuagisme." Contrary to general expectations, the
dada myth survived Tachism's excesses very well; easel painting marked the occasion, causing
the last remaining illusions regarding the monopoly of traditional means of expression to
disappear, in painting as in sculpture. . . .

* Pierre Restany, excerpts from "À quarante degrés au-dessus de dada, mai 1961, Paris (2e manifeste)," in
Restany, *Le nouveau réalisme* (Paris: Union Générale d'Éditions, 1978), 281–85. Translation by Martha Nichols. By
permission of the author.

We are witnessing today a general phenomenon of depletion and sclerosis of all established vocabularies: uselessly repeated stylistics and redhibitory [i.e., latent academisms (Fr. *redhibitories*)] with increasingly rare exceptions. Certain individual approaches confront—fortunately—this vital deficiency of classical methods and tend, regardless of their scope, to define the normative bases of a new expressivity. . . .

The Neo-Realists consider the world a painting, the large, fundamental work from which they appropriate fragments of universal significance. They allow us to see the real in diverse aspects of its expressive totality. And through these specific images the entire sociological reality, the common good of human activity, the large republic of our social exchanges, of our commerce in society is summoned to appear.

In the current context, Marcel Duchamp's ready-made (and also Camille Bryen's functioning objects) take on new meaning. They translate the right of direct expression belonging to an entire organic sector of modern activity, that of the city, the street, the factory, mass production. This artistic baptism of the ordinary object nevertheless constitutes par excellence the "dada act." After the *no* and the *zero,* here is a third position of the myth: Marcel Duchamp's anti-art gesture assumes positivity. The dada mind identifies with a mode of appropriation of the modern world's exterior reality. The ready-made is no longer the climax of negativity or of polemics, but the basic element of a new expressive repertory.

Such is Neo-Realism: a rather direct fashion of getting our feet back on the ground, but at forty degrees above the dada zero, and on the very level where man, if he succeeds in reintegrating himself with the real, identifies the real with his own transcendence which is emotion, sentiment, and finally, poetry.

DANIEL SPOERRI Trap Pictures (1960)

what am i doing? gluing together situations that have happened accidentally so that they stay together permanently. hopefully making the observer uneasy. i will come back to this later.

i must confess i put no value on individual creative accomplishments. perhaps that is a kind of snobbism, but in any case i was convinced of it long before i made trap pictures. for me, trap pictures are simply a new way of demonstrating this belief. i have nothing against the creative works of others, or, i should say, nothing against most of them. art interests me only insofar as it presents an optical lesson, regardless of whether it is individually or more or less objectively appreciated. in any case the border is difficult to fix, the observer, is always entitled, in my opinion, to individual reactions, or at least should be. in my case the optical lesson is based on focusing attention on situations and areas of daily life that are little noticed, if at all. unconscious points of intersection, so to speak, of human activity, or, in other words, the formal and expressive precision of chance at any given moment. and i can afford to take pride in the accidental since i am only its conceited and at the same time modest "attendant." conceited, because i sign my name to its achievements, for which i am not responsible. modest, because i am content to be its attendant (and a bad one at that, yes, that is how far my modesty goes). attendant to the accidental—that could be my professional title. but i must admit that i am not the first. that's fine with me—i don't consider even originality as absolutely necessary.

* Daniel Spoerri, "Zu den Fallenbildern" (December 1960), *ZERO* 3 (1961); reprinted as "Trap Pictures," in Otto Piene and Heinz Mack, eds., *ZERO,* trans. Howard Beckman (Cambridge, Mass.: MIT Press, 1973), 217. By permission of the author.

RESTAURANT
DE LA
GALERIE J.
8, Rue de Montfaucon
PARIS (6ᵉ) DAN. 30-65

A l'occasion de l'Exposition de Daniel SPOERRI
" 723 USTENSILES DE CUISINE "

la Galerie J. annonce l'ouverture d'un Service de Restaurant
du 2 au 13 Mars 1963
8. RUE DE MONTFAUCON — PARIS (6ᵉ)

La Galerie fermant ses portes sur l'Exposition chaque jour à 19 heures,
le Restaurant ouvrira à 20 heures (fermeture hebdomadaire le Dimanche).

Aux Fourneaux le Chef SPOERRI "DANIEL"
Les Critiques d'Art assurent le Service

Attention : Le nombre des couverts étant limité à 10 par
soirée (sauf le buffet exotique qui sera de 20 couverts) les
amateurs éventuels sont priés d'indiquer le menu de leur
choix, soit en téléphonant à DANton 30-65, soit en faisant
parvenir le bon ci-joint sans délai au Service Restaurant de
la Galerie J., le cachet de la poste faisant foi pour les
priorités. (Les places retenues et non occupées demeure-
ront à la charge de la personne ayant fait la réservation)

L'activité gastronomique du Chef SPOERRI "DANIEL" entraînant
d'immédiates conséquences esthétiques (dans la plus pure orthodoxie du
Nouveau Réalisme), le public est prié de venir juger sur pièces, le lendomain
du jour de clôture du Restaurant : **le 14 Mars à partir de 17 h.**

VERNISSAGE DES MENUS-PIÈGES
COCKTAIL

Daniel Spoerri, menu for Restaurant de la Galerie J., 1963. By permission of the artist.

my trap pictures should create discomfort, because i hate stagnations. i hate fixations. i like the contrast provoked by fixating objects, to extract objects from the flow of constant changes and from their perennial possibilities of movement; and this despite my love for change and movement. movement will lead to stagnation. stagnation, fixation, death should provoke change and life, or so i like to believe.

and one last thing. please don't think of the trap pictures as art. a kind of information, a provocation, directing the eye toward regions that it does not generally notice, that is all.

and art, what is that? is it perhaps a form of life? perhaps in this case?

Spoerri's Autotheater (1961)

1. a room or rooms.

2. these rooms are separated by solid or flexible walls (cloth, smoke, liquids, elastic materials, for instance a rubber wall, into which the audience throws itself from one side; this movement becomes a spectacle when observed from the other side).

3. to go from one room to another one must not walk through doors; holes placed either high or low must be used. we must make these holes ourselves if, for instance, the wall is made of paper.

4. the audience will consciously or unconsciously control the light in these rooms. consciously, in that the light should be worked and adjusted manually. unconsciously, in that the audience would set off lights by tripping light contacts.

5. most important for the completely unconscious participation of the audience is the principle of "contacts," which can trigger noises or various mechanisms as well as lights.

6. music noises: also intentionally or unintentionally produced by the audience. either they trip certain contacts or consciously select sounds or tones. in general, the music or noise used as background should be kept low. a crescendo of sounds should occur only periodically. the greatest care should be given to volume, so that extremes of light-dark, unconscious-conscious, can be correlated with loud-soft.

7. whether the audience ought to have masks, as in primitive theater, should be considered, in order to emphasize anonymity, which makes for a more objective event. (anything can be used as a mask: a cloth, a real gas mask, a bedpan.)

masking need not be a general rule. a minority could be without masks and therefore receive unusual attention. selection could be random, for example every tenth person would not receive a mask.

8. the arrangement of rooms could be like a labyrinth. dead ends would ensure a repetition of experiences. thus, the length of the visit paid by each individual would be different. that means the possibility that not everyone would experience everything. deceptive signs would increase confusion.

9. particular "gags" would provide entertainment in each room, e.g., tables and chairs in one room would have to be sawed apart by the audience as well as nailed together, all at the same time.

10. not allowed are objets d'art, or anything that by its aesthetic appearance could be valued as such.

11. props: at the entrance everyone receives some object, which he must carry throughout the entire exhibit, and which he can give up at the end e.g., large balloons, chairs, bicycles, typewriters, umbrellas, etc.

12. text: text rolls could be used, which keep the texts in constant motion at all times. in one room people must recite a text into a microphone. that way a steady stream of words would be guaranteed. this principle could be modified so that questions could be intermittently sent from one room and answers could come from another. answers would never correspond to questions, since those answering do not know the questions.

13. optically dynamic phenomena, like projections through prisms or stencils, would bring dark cells to life.

* Daniel Spoerri, "Spoerri's Autotheater," *ZERO* 3 (1961); reprinted in Otto Piene and Heinz Mack, eds., *ZERO,* trans. Howard Beckman (Cambridge, Mass.: MIT Press, 1973), 219. By permission of the author.

14. mirror rooms containing endlessly repeated optical vibrations.

15. additional extremes would be: hot–cold, straight–crooked, hard–soft, multicolored–monochromatic, dry–wet, etc.

16. individual artists should be in charge of organizing the individual rooms.

these notes are a rough outline which needs to be elaborated, and which can be changed at will in the course of realization.

NIKI DE SAINT PHALLE Dear Mr. Iolas (1961)

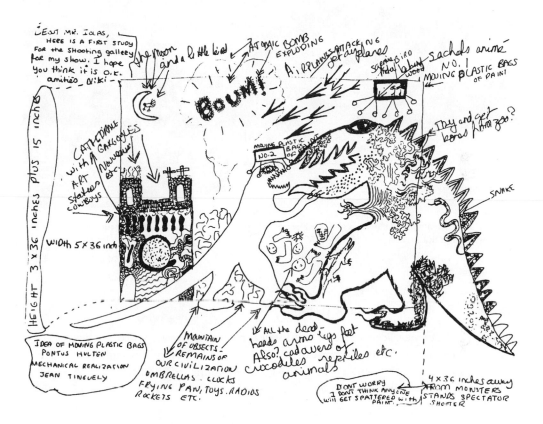

Pino Pascali, *Exhibition of Cannons* at Galerie Sperone, Turin, 1965, with actual Italian military cannons. By permission of Sperone Westwater, New York.

PINO PASCALI Statement (1966)

Europe is a different space from that of America: rather than being a place of action, it is a place or reflection on action. Americans can afford the luxury of nailing something to a painting, and the painting will work. They can take a comic strip and redo it, and the result is a painting because their gesture historically sums up their civilization, which is technologically the most advanced.

Our civilization, on the other hand, is technologically behind America, where a direct action between man and material is crazy. There is also a terrible time gap in America. For instance, if you go to a chemical lab, you will find incredible materials, that the American artist hasn't even discovered. Yet, artists now have to use the same materials as scientists because nature is exhausted; a new nature has been born.

Italy, you must realize, is a different space, it is selective, it refuses to get involved. The European's problem is that he is a self-sufficient loner, creating an autonomous civilization for himself. But this is not true in America. Even if Americans are highly individualistic, and even if they don't look one another in the eye, they are "inside" that American space, that

* Pino Pascali, untitled statement (1966), in Germano Celant, *The Knot: Arte Povera at P.S.1* (Turin: Umberto Allemandi, with P.S.1, Institute for Art and Urban Resources, New York, 1985), 162. By permission of Germano Celant and Umberto Allemandi and Company.

American civilization. Even if they don't look one another in the eye, they are bound together. A comic strip is their palate. I don't belong to either world.

Statement (1967)

I believe that a person who paints must use his medium politically, in order to resist in the void. When I spoke these words, in the void, I was not speaking. I, alone in my home, I spoke. I, and, all around the void was my city. No: I, isolated in the ivory tower, do you understand? It was really the city.

Then, that soap bubble came—I don't know how—into the gallery, or else the gallery became a soap bubble. . . . However, I say as a means for moral pretense. . . . The painter should almost be a moralist. He is a moralist because he has his moral idea of life—negative, positive, invented. However, if it is conscious, then he has his own moral identity.

In this sense, he is exemplary. This is really his only action. . . . If you try to create societies, then, you should start with these soap bubbles which produce foam and can create a whole invention. However, an invented thing can also be lighter than air; it can also fly. On the other hand, it can create cement fortifications that no one can enter but that resist time, where people suffocate and die. Do you understand?

In this sense, I think a person is a moralist if he deals with new facts, new phenomena. Look, the sculptor, the painter, anyone else, the musician, and all writers—they are people who stimulate phenomena. If you choose a phenomenon and identify with a phenomenon, then you negate the progress that originally existed, unless the phenomenon is a chain reaction that produces other facts. Basically, a phenomenon must always be stimulated. Phenomenon must stimulate phenomenon. The only limit to this chain reaction is death. There are no other limits which is why one rationally rejects death at a certain point. Not even rejects it, one fails to understand it. Death is really one of the most horrible things in existence.

GERHARD RICHTER Interview with Rolf-Gunter Dienst (1970)

ROLF-GUNTER DIENST: It was in 1962/63 that you copied a photograph for the first time—as you wrote—"to do something that has nothing to do with art, composition, color, creation, etc." But wasn't there color, all the same, even if reduced to black-gray-white tone?

GERHARD RICHTER: This is a statement which had to do with the state I found myself in. Apart from that, it indicated a method to realize my changed way of thinking. As to color, black and white really is no color in that sense as I wanted to avoid. That in the end this changed into color, has been an unintentional result. This was due to surroundings: if I place a gray tone next to a red or green one, it turns out to be a different gray, each time. On the other hand—and again this refers to color—the paintings turned out aesthetic, or anyhow,

 * Pino Pascali, untitled statement (1967), in Germano Celant, *The Knot: Arte Povera at P.S.1* (Turin: Umberto Allemandi, with P.S.1, Institute for Art and Urban Resources, New York, 1985), 219. By permission of Germano Celant and Umberto Allemandi and Company.

 ** Rolf-Gunter Dienst, excerpts from "Interview mit Gerhard Richter," in *Noch Kunst* (Düsseldorf: Editions Droste, 1970); reprinted in Richter, *Gerhard Richter* (Essen: Museum Folkwang, 1972), 19–21. By permission of the artist.

different to what was intended. Of course, this is always like that. The reason for building a pyramid was one thing. As we see it today is quite a different matter, altogether.

RGD: I thought that in depriving an object of its "natural" color, you make an artificial alteration in order to obtain a certain distance to the object.

GR: This is quite possible, but there have been others who had already done so before me. I take this "non-color" from photography. To make a photo is already the first artificial act.

RGD: You emphasize the smooth surface, the photographic likeness, the distance, and the impediment to all personal interpretation concerning the family pictures, paintings of planes, motor cars, or portraits you made in 1963/64. Does this help you to obtain a higher degree of objectivity?

GR: I feel that this is true; but there are other methods, too, and one can also leave this aside. Today, I no longer attach any special importance to whether I am objective, because everyone is objective.

RGD: Over and over again, you have reduced your color chart to gray shades. Was this done to make stand out artificially everything colored?

GR: I did not reduce any color chart to grays, on the contrary: gray tones became color chart themselves, unintentionally. Therefore, I was compelled, later, to do something else, as I do not want to get involved with this problem.

RGD: You work according to photographs. Are there any decisive aspects when you choose your subject matters?

GR: Perhaps this is done by negative selection, insofar as I have tried to avoid everything that touches known problems or any problem, for that matter: painterly, social, or aesthetic ones. I tried not to find anything concrete. Therefore, there were so many trivial themes; and again I had to be careful not to let triviality become my problem and my emblem. You may call that flight. . . .

RGD: If one starts from your way of painting, especially from your photographic painting, one might get the impression that your occupation concerning photography and publicity has perhaps determined your style.

GR: Publicity painting can be cancelled out, because I have done too little of it. And photography is rather a consequence than a cause. I have taken interest in photography because it illustrates reality so well.

RGD: Your style of painting has developed from socialist to "capitalist" realism. Anyhow, it remained mostly realistic. Does criticism of your surrounding reality interest you at all, or would you rather [not] comment on it?

GR: By the way, I have never painted socialist nor capitalist realism. I criticize as everyone does, constantly and a thousand things, except when I am painting. This would be just as impossible as commenting on anything.

RGD: May I come back once more to the cue word "capitalist realism." Heinz Ohff has reported that you adhere to socialist realism.

GR: Lueg and I have utilized "capitalist realism" for a happening. Therefore, this term has been memorialized. However, it did not concern so much our work as this one specific happening.

RGD: You once wrote: "Since there are no longer any priests and philosophers in this world, artists have become the most important people." This is a hopeful statement, as far as artists are concerned. How would you specify this extraordinary importance of an artist?

GR: This has to do with emancipation and with the fact that we no longer need Church or philosophers. The Church now has a different competency and other duties than before. Art no longer serves any institutions; it has become autonomous. I cannot describe the new situation, since art cannot be described. It proves itself only in its performance. First of all, I can feel that something is expected of art and of me, some sort of hope.

RGD: How would you interpret your role as a painter in our society?

GR: As a role that everyone has. I want to understand, what is. We know so little, and I try by forming an analogy. In fact, nearly every piece of art is an analogy. If Uecker nails, this is not a copy of something: he creates an analogy to something that exists. If I paint something, again this is an analogy of what exists, and I endeavor simply to get, possess, and seize it by painting it. I want to avoid all aesthetics, in order not to have obstacles in my way and not to have the problem of people saying: "well, this is how he sees the world," this is an interpretation.

RGD: You have made pictures, repeating ironically informalism, where an artistic hand-writing full of gestures is opposed to the perfect realization of the picture. What did you want to express with this work?

GR: It was not my intention to treat informalism with irony, at all. I cannot explain what I wanted to express. (I do not know whether I shall try to find some sort of justification for these pictures, but this is a question of principle.) These paintings do not differ from the others, or only superficially, which is not important. I believe that it is a matter of success to have a personal style. You know how easy it is to stylize, to catalogue, and to build up a development of art for some, or for whole epochs, and we can do without that. Therefore, this indiscrimination exists.

RGD: Color has resumed its importance as regards your latest pictures of the Eifel region or holiday landscapes. It appears romantic and emotional. Which functions do you want to attribute to color, in this case?

GR: If black and white turn into color, why not take real color, straight away?

RGD: The color of your new pictures provokes quite a distinct sentiment coming from the landscape and gives it a romantic appeal.

GR: This is much more difficult to achieve in black and white, for two reasons: first, black and white have become too aesthetic; secondly, I can express my intention of what I want to make or show, and why the landscape appeals so much to me, quite a lot better in color.

RGD: Why do you like this so much, then?

GR: Because the landscape simply is beautiful. Most probably it is the most terrific of what exists, at all.

RGD: You prefer a comparatively coarse hand-writing for your alpine views, which were painted in 1968, and thus you make cruder a seemingly impressionistic mood. Why did you do that?

GR: I was fed-up with painting those smooth photographic pictures. Perhaps I also wanted to correct a false impression, that of an aesthetic point of view. I refuse to see the world in a personal way. I have no aesthetic problem, and the way of painting is irrelevant. The paintings do not differ from each other, and I want to change my method of approach wherever I think it appropriate.

Interview with Rolf Schön (1972)

ROLF SCHÖN: Do you feel that the term "realism" can be used once more, today?

GERHARD RICHTER: It *is* being used, whether I find this right or wrong; but this is a different problem. For several thousand years without interruption, there has been realistic painting—to use the word in its usual meaning—and all of a sudden they try to make a hit out of that. This is more of a hindrance to art than a help. I do not speak for or against the other tendency (a few color stripes can be just as stupid as the representation of a car bumper), I have something against tendencies and terms, in general.

RS: Would you call yourself a realist?

GR: No, especially not in the sense as realism is used in art, that is in a very limited way. This does not change either, if one invents a great number of subdivisions of realism, this does not clarify anything. Basically, all these classifications are just restrictions—thus one tries to domesticate art, to make it available. And, in fact, art can only be available *without* restrictions of this kind.

RS: What made you adopt this realistic approach to painting?

GR: I suppose that everyone starts off like that: at some time or another he sees works of art and has the desire to make something similar. You wish to understand what you see and what exists, and you try to paint it. Later, you realize that nobody can demonstrate reality; the things we make only demonstrate themselves, and therefore they are reality in themselves.

RS: Why is it photography that plays such an important role for you?

GR: Because the photograph which we all use so frequently, each day, surprised me. All of a sudden, I was able to see it differently, as a picture which conveyed a different aspect to me, without all those conventional criteria which I formerly attached to art. There was no style, no composition, no judgement. It liberated me from personal experience. There was nothing but a pure picture. Therefore, I wanted to possess it and show it—not to use it as a means for painting but to use painting as a means for the photograph.

RS: Was it you who first made photography a legitimate partner of painting, in Germany?

GR: I don't know.

RS: What is your relation to illusion? Does the imitation of photos make for distance or does it rather bring about an impression of reality?

GR: Illusion with the aim to delude the eye is not for me, and my pictures do not have an illusive effect, either. Apart from that, I do not wish to imitate a photograph; I want to *make* one. And if I ignore deliberately that photography is generally understood to be a piece of exposed paper; I am making photos with different means and not pictures which resemble a photograph. And seen from this angle, even pictures which have been painted with a model (abstract ones, etc.) are photographs.

RS: How objective is your photographic painting in the sense of documentary description?

GR: Not at all. First of all, only the photographs can be objective because they are related to an object without being an object themselves. However, I can see them as an object, as well, and furthermore make them one in painting them, for example. After that, they can no longer be and are no longer meant to be objective; and they are not to document anything,

* Rolf Schön, excerpts from "Unser Mann in Venedig," *Deutsche Zeitung* (Stuttgart, 14 April 1972); reprinted as "Interview with Rolf Schön," in Richter, *Gerhard Richter* (Essen: Museum Folkwang, 1972), 23–25. By permission of the artist.

either, neither reality nor a mode of viewing. They are reality, perception, thus object, themselves and therefore can only be documented.

RS: Do you mistrust reality, since you start painting from photos?

GR: I do not mistrust reality, of which I know next to nothing, but I am suspicious regarding the image of reality which our senses convey to us and which is incomplete and limited. Our eyes have developed such as to survive. It is merely a coincidence that we can see stars with them, as well. And because we cannot accept this, we do a lot of things, for instance we paint (and we also take pictures, however, we don't do this in the sense of a substitute to reality; we want to use them as a tool).

RS: What does the lack of sharpness in your pictures mean: inconsistency of their contents? Or do you want to draw special attention to the subject? Or is this kind of blurred movement typical for this mass media being operated non-professionally?

GR: This outward hazyness is probably due to our incapacity, as mentioned before. I cannot describe anything more clearly about reality than my own relation to reality. And this has always something to do with hazyness, insecurity, inconsistency, fragmentary performance, or what have you. But this does not explain the pictures—only perhaps the cause for painting them. Paintings are something different, they are never blurred. What we consider being indistinct is in fact inaccuracy and this means being different in comparison with the subject painted. But since paintings are not made in order to compare them with reality, they cannot be indistinct or inexact or different (different from what?). How can color not be sharp on a canvas, for example?

RS: Which painters have you learned from?

GR: From all I know.

RS: What is your relation to Pop Art which has been described as being pioneering for the return to reality?

GR: Warhol's work has impressed me and also some other pictures; however, I cannot consider Pop Art as being the forerunner of realism, for Pop Art is not any more realistic than any other form of art, not more than the so-called abstract way of painting. Pop Art is only a very small part of the entire art scene and has been placed in the foreground, for once. Of course, this is due to facts which do not only depend on the economic situation on the market, but I am not interested in that. In my opinion, art remains up-to-date, art is not a matter of time, it has nothing to do with time.

ION GRIGORESCU Politics, Religion and Art Facing Crime (1992)

Diary

1962 I do not have to make art because it exists a priori.

1969 I forget and I start again to search desperately for beauty in a field sown with ugliness. The former intuitions contain a magnificent malice. I went to the other camp too quickly, and forgetting, and I have double and triple reasons for rebukes. Besides, I try to pull politics behind the door and have its edge to the door's. The struggle is between a direct art devoid

* Ion Grigorescu, "Politics, Religion and Art Facing Crime," in *Grigorescu Ion,* trans. Mihaela Eftimiù (Bucharest: Galeriile Catacomba, Fundatia Anastasia, Muzeul National de Arta al Romaniei Muzeul Colectiilor, 1992), n.p. By permission of the author and Fundatia Anastasia.

of mysteries and an art of mysteries and inexplicit. Politics is sharp and cuts the hands which hold it.

The Values of the Securitate and of the Communist Party

"My conscience is telling me that I have done nothing wrong"—They were ethical models: well-dressed, always clean, iron-pressed clothed, short-haired.

They had a family (compulsorily) and were not allowed to divorce. They had an easy job, attended to their job and, apparently, they did not get involved with politics. They obtained easily a house, a car, a high salary and pension. They were also models of practice: lying is necessary. Let us support the utopia so they'll have no proof against us. Let us be the constructors of capitalism in case of change. Let us have influential friends, be initiated, and act under cover.

As respectable people they told us about the ways of the Romanians: they all lie. Each Romanian is a thief. Let them take him to the militia station and give him a good hiding, that will teach him a lesson!

The socialist regime has persecuted us with the idea of revolution, although it was the one to continue the Soviet model as well as the National Socialist one.

All these regimes taught us how man looks. "I give you four years," said Hitler to the decadent artists to bring them into line to the Nazi ideal.

For Romania, the legend of the meeting dedicated to aspects of the human type is very significant: while those sitting at the table were looking for an "original model," sculptor Baraschi got out and then came back with a bust of Lenin made in USSR. . . . The same with history, the dead, the heroes. There is an immediate connection with the iconography of the church, with the institution and tradition. Then there is confusion and confiscation of terms: realism or illusory, or ambiguous, alive and dead. So that can I say that I don't remember how man looks and what represents tradition? reality or the delusive appearance?

They considered those truly saintly as ordinary people and passed by them despising and considering them just rubbish. The silent one, careful with his words, was taken for a fool and dumb. He who has not known all these for himself must not deceive himself; he is still flesh and blood, that is covered with darkness.

What is presented as excessively alive runs the risk of showing life's wear and tear hence bearing a seal of death. But in exchange perception can be mortified, or let us look at real mummification which bears the seal of the living. Both reality and representation may bear traces of sin (sins cannot be detached or wiped away—the surface is bitten by death watches). I feel how my painting goes to pieces, my painting's support too, the very colors alter, there is a death parallel to that of the subject.

I paint as I see—it is a decision from 1968. Since then I don't follow all that I understand. Recently, for the *Sex of Mozart* exhibition, I wanted to confront such difficult images as that of the divine and of the human, of the friendship between Jesus and Martha, Mary and Lazarus, with the convulsions of resurrection day, Jesus Christ's inner turmoil, and Martha's repulsion: "Lord, he has started to smell!"

VITALY KOMAR AND ALEXANDER MELAMID
Blue Landscapes, Bewitching Numbers, and the
Double Life of Jokes: An Interview with JoAnn Wypijewski (1997)

JOANN WYPIJEWSKI: How did the idea for this poll start?

ALEXANDER MELAMID: It was a continuation of our work for the last number of years, which was to get in touch with the people of the United States of America: somehow to penetrate their brains, to understand their wishes—to be a real part of this society, of which we're partially part, partially not.

VITALY KOMAR: But, you know, I would say it goes back further. I remember our plan to create paintings for different segments of society in Moscow back in 1977. Then, our idea was not associated with poll, and emigration prevented us from completing it, but we were trying to show that Soviet society, in spite of government propaganda, had many contradictions; that there were different circles, even classes; that, in spite of revolution, everyone really was not more or less same socially. Here in America, before we got results of poll we thought we would have to paint different pictures by income, by race. Instead, we made surprising discovery: in society famous for freedom of expression, freedom of individual, our poll revealed sameness of majority. Having destroyed communism's utopian illusion, we collided with democracy's virtual reality.

JW: And then the Russian poll, like every other poll you subsequently commissioned, yielded results along the American model—an ideal landscape—so it seems you're also colliding with capitalism's looming crisis, the end of frontiers left to conquer.

VK: Here, though, is another reason behind our polls: the search for new co-authors. Everyone works collaboratively. That is why society exists. Even artist who imagines himself to be like God, a solitary creator, is working in collaboration with his teachers, his predecessors, craftsmen who created his canvas and paints, and so on—just as God created world with help of angels. Old romantic view of artist is a travesty of monotheism. Van Gogh suffered as if he were crucified; very few—maybe twelve people only believed in him. But after he died he achieved immortality. It is no accident, I believe, that early in life he was a preacher.

 And now, I would say, conscious co-authorship is only fundamentally new direction in art since discovery of the abstract. Our interpretation of polls is our collaboration with various peoples of the world. It is collaboration with new dictator—Majority. When we were working on a proposal to redesign Lenin's Mausoleum we collaborated with another dictator—Stalin, who supervised original architect. Recently we collaborated with an elephant, who, by the way, is abstract painter; and before that we worked with a realist dog. If modernism taps traditions of early civilization, why not go a step further and explore the prehuman (according to Darwin) animal past? We can enter co-authorship with cultures of elephants, bacteria, plants, with gravitational fields of planets and stars. . . .

JW: So what do you make of the fact that the people have spoken for the blue landscape?

VK: I believe it reflects people's nostalgia about freedom. It's a very simple metaphor, and very deep at the same time: closed space and open space. The concentration of idea of closed

* JoAnn Wypijewski, excerpts from "Blue Landscapes, Bewitching Numbers, and the Double Life of Jokes: An Interview with Komar and Melamid," in JoAnn Wypijewski, ed., *Painting by Numbers: Komar and Melamid's Scientific Guide to Art* (1997; Berkeley: University of California Press, 1999), 8–49. By permission of the interviewer and the artists.

America's Most Wanted
Dishwasher-size (67%)

Paintings that are "realistic-looking" (60%)

Brush strokes (53%)

Blue (44%)

Outdoor scenes (88%) featuring lakes, rivers, oceans, and seas (49%)

Colors blended (68%)

More vibrant shades (36%)

Soft curves (66%) and playful, whimsical designs (49%)

Wild animals (51%) in their natural setting (89%)

Fall scene (33%)

Ordinary people or famous—makes no difference (50%)

Persons in group (48%), fully clothed (68%), and at leisure (43%)

Vitaly Komar and Alexander Melamid, diagram of the painting *America's Most Wanted,* 1994. By permission of the artists/former Komar and Melamid Art Studio Archive. Courtesy Ronald Feldman Fine Arts, New York.

space, I believe, it's prison. And concentration of idea of open space is a landscape—air, no barriers, in other words, vacation, freedom.

You know, we are not free. We do not choose to be born. We do not choose to inhabit this world, this space, this giant room, or, in language of contemporary art, this installation. But if, initially, life was not act of free will, then freedom does not exist in principle, much less in day-to-day life. In search of freedom, of blue landscape, we can at any time open the big door that leads out of this room, out of this time and space, out of this world and this life. But most of us are not capable of suicide; we are afraid to find out maybe behind this door there is another installation, another, different-colored landscape. So most of us do not choose to leave the room. Most of us wait for door to open by itself—another, maybe final, violation of our will. Meanwhile, we look for smaller freedoms, open smaller doors, which are so numerous in this installation they resemble some labyrinth of modern offices.

You know, life reminds me of office. Employees scribble abstract patterns in legal pads during meetings and leave office during lunch. Within greater enslavement we discover small freedom—so we think. But if we examine closer, this freedom turns out to be a new slavery, with its own smaller freedom/slavery, and so on: our choice of lunch, for example, its price, taste, nutrients, etc. . . .

JW: All that in a blue landscape.

AM: It might seem like something funny, but, you know, I'm thinking that this blue landscape is more serious than we first believed. Talking to people in the focus groups before we did the poll and at town hall meetings around the country after, I think people want to talk about art, for better or for worse, and they talk for hours and hours. It's hard to stop them;

nobody ever asks them about art. But almost everyone you talk to directly—and we've already talked to hundreds of people—they have this blue landscape in their head. It sits there, and it's not a joke. They can see it, down to smallest detail. So I'm wondering, maybe the blue landscape is genetically imprinted in us, that it's the paradise within, that we came from the blue landscape and we want it. Maybe paradise is not something which is awaiting us; it is already inside of us, and the point is how to figure it out, how to discover it, how to get it out.

We now completed polls in many countries—China, Kenya, Iceland, and so on—and the results are strikingly similar. Can you believe it? Kenya and Iceland—what can be more different in the whole fucking world?—and they both want blue landscapes. So we think that we hit on something here. A dream of modernism, you know, is to find a universal art. People believed that the square was what could unite people, that it is really, truly universal. But they were wrong. The blue landscape is what is really universal, maybe to all humankind.

JW: And how do you respond to people who say that's all very well but the broad public just doesn't know enough about art to be an adequate judge?

AM: I think it's the wrong premise—which is still in fine arts and the visual arts, and not in almost any other art form—that we need some special historical knowledge in order to appreciate art and make art. Just look at music, all this great American music. People don't know notation and still they create fantastic music. But we ask the people who create art to know a lot about art. I don't think it's necessary; everyone knows enough about art, because we're surrounded. The decoration over here on the wall, all the architecture, reproductions in magazines—it's all over. Everyone knows enough about art now to use their own judgment. Even if we want to know more, it's the wrong premise. In the poll we have this question, "How often do you go to museums?" Maybe it's interesting, but as a measurement—if you go to museums or don't go to museums—it has nothing to do with our work here. A museum is an institution. You can believe in God without visiting churches. And that's very important: you don't know about religion, you don't know about how many times you go to church, but still you believe. In the poll we use the word "art" as little as possible, because this word rings the wrong bell. It scares people who think they don't know. . . .

VK: You know, many followers of our work have expressed disappointment in the paintings we based on results of poll. Same thing happened to the Russian President: for first time ever, head of Russian government was elected democratically—and everyone is disappointed. The ideal is by definition a dream, but when a dream becomes reality it ceases to be ideal. Our poll results indicate that most people are dissatisfied with 90 percent of paintings currently hanging in museums, reproduced on posters, and sent on postcards. After all, majority of these images are not blue landscapes. Still, it is my hope that people who come to see our *Most Wanted* paintings will become so horrified that their tastes will gradually change, and another poll would gather different results for creation of paintings that do not resemble blue landscapes. . . .

AM: You know, the point is maybe the poll is not the best way. Maybe we could try some different approach. Maybe we have to buy a van and go around the country working on art among people—van art. From Vanguard to Van Art. But society now depends on polls, so we just pick the tool which is here. . . . So we have this truth—science, medicine, polls—and we say, Okay, that's truth. We trust it. If we won't trust in polls, the whole world will collapse. So what to believe? We don't believe in God, and we don't believe in science, so what is left? . . .

JW: In the same way that when you were in the Soviet Union you were painting pictures

that countered the official art, do you think that the poll and the pictures that came out of it are a kind of parallel to that in the United States?

AM: Definitely. This is a totally dissident art. Mostly, of course, because of the question, Who are the viewers? Who is the audience? Nobody asks this question.

ANNETTE MESSAGER *Le Repos des Pensionnaires* (2005)

Annette Messager, *Le Repos des pensionnaires* (detail), 1971–72, wool, feathers. Collection Centre Georges Pompidou, Paris. © 2012 Artists Rights Society (ARS), New York/ ADAGP, Paris. Courtesy Marian Goodman Gallery, New York/Paris. Photo: Mnam, André Morin.

One day, during summer, I stepped on a dead sparrow in a street in Paris. This contact with the presence of death, both familiar and strange, touched me profoundly.

* Annette Messager, "*Le Repos des Pensionnaires*," in Francesca Richer and Matthew Rosenzweig, eds., *No. 1: First Works by 362 Artists* (New York: D.A.P./Distributed Art Publishers, 2005), 239. By permission of the artist and the publisher. © 2012 Artist Rights Society (ARS), New York/ADAGP, Paris.

CHARLEMAGNE PALESTINE

SELF-DEFENDING THE TOYBOYMAN PIANIST PALESTINE (2006)

there are many issues between censorship, probity, work that touch many many wounds in the evaluation of my contribution all these 35+ years ago starting in California and Nyc my being considered a pianist not an artist also dates during the early seventies when i had already created unique videos and body performances and installations and probity monologues putting my foot into what avant-garde was and meant for me being difficult or bad as a gut instinct of what it meant to continue to be avant-garde

in 1975 for example i was invited by John Cage who from '74 on was frequenting my loft concerts for Bosendorfer piano on Reade Street which was connected to the then Idea Warehouse that Mabou Mines and Ken Jacobs and Phil Glass we all shared

Cage began to come regularly and bring friends at the time i was very flattered until soon after i was invited to a festival in Milano Italy and people there spoke of how Cage liked very much my work and then presented me as "his favorite disciple" i was furious not long after he invited me to participate with Merce and his troupe at Westbeth for a series of Dance/Music evenings events # 175 & 176 as Merce liked to present very neutrally, his philosophy: you do what you do and we'll do what we do and won't show the other until the performance (a great formula !! i often prefer working like that even now fuck chance art nothing to do with that just different energies and perceptions meeting clashing crashing embracing in space without safeguards) so i went to Merce's studio at Westbeth the week before to smell the atmosphere of his troupe and the people around him even with all the surface allispossibleness i felt that Cage wanted me expected me to be "Pianist Palestine" but in Cage/Cunningham land there were no absolute rules though when i entered the dance studio the first time i was impressed by the sign that said "no smoking and no shoes permitted" then i sat around rather invisibly listening to the gossip of the people who sat around the rehearsals blah blahing and was taken by how they were mostly your dancey smancey group of upidy snobs

as i had grown up in the sixties going to Cage/Cunningham radical events at the Armory or at the French/American Festival at Lincoln Center I was quite thrown by all the cutesy fruitsyness of that rehearsal and how i felt the heavyness of a conservative bourgeois lahdeedahness that made me horribly uncomfortable so i went home and decided to create a monologue which would be the background drone of the evenings events and recorded a "probing something else monologue" (if i may now re-evaluate those feelings and instincts way back then) while taking a long shower about the state of the Avant-Garde at that moment versus Cage & Cunningham of 1975

then i arrived for the performance with my tribe of animals on the piano dressed in a long full length rabbit coat and big crumpled cowboy hat and big heavy Fry work boots and smoking a Javanese Kretek cigarette the monologue tape began i played 4 minutes on the piano like good boy disciple (my ass) Pianist Palestine and begin to do a body art dovening girating falling banging myself against walls and the enormous studio mirror while chanting a sort of St Vitas Dance from the left side of the stage slowly accelerating my ecstatic trance dance while thin cute mostly tall Cunningham dancers (male & female) did cute stepsy whepsys and gradually i started to more and more position myself like some sort of wild animal carrying some of my own ToyTribebeasts in my hands who danced with me in the midst of

* Charlemagne Palestine, "SELF-DEFENDING THE TOYBOYMAN PIANIST PALESTINE," statement e-mailed to Kristine Stiles in response to a request for early writings on his work, 14 July 2006. © Charlemagne Palestine.

Charlemagne Palestine in concert, New York, 1973. Photo © 1973 Les Levine. All rights reserved.

Merce's dancers like Lilly Lollies Merce dancing with them (those performances they were going around shaking their arms as though each had some flypaper stuck to their hands that they were trying to finally get off their hands) at the end of the performance everyone was very cautious as to how to react to my unexpected onslaught

 i remember Joan Jonas was there Simone Forti Bill Hellerman Fabio Sargentini from Rome John Cage of course who came up to me and in front of everyone in March 1975 finally said that probably unconsciously i was baiting him to say (probity and that something else instinct)[1] because until that moment in Cage's world ALLL was Possible in Chance-

 1. *Editor's Note:* Here Palestine is referring to Kristine Stiles, "Never Enough Is *Something Else:* Feminist Performance Art, Avant-Gardes, and Probity," in James M. Harding, ed., *Contours of the Theatrical Avant-Garde: Performance and Textuality* (Ann Arbor: University of Michigan Press, 2000), 239–89.

Land !!! (later he would begin to re-evaluate that part of his alls possible even later condemning Glen Branca as making "Fascist Music") he said to me

" " " "Charlemagne" " " "

"YOU SHOULD NOT HAVE DONE THIS PIECE!!"

later i would be reproached by most of our artist community for this performance and the New York Times dance critic at the time (forgot his name) heavily criticised me as a Plumber not Artist (reference to the shower water monologue that went on all the evening behind the drama unfolding on stage) the critic took all my criticisms and made them his own and denounced the lack of avant-gardeness in Merce's company at that moment in time (which was exactly my point was the avant-garde dying? dead? or just changing garde or generation??) and everyone blamed me for having targeted Cage/Cunningham in such an insensitive way

and young and daring and reckless and stupid and passionate and inspired or delirious over responsibility of Being Avant-Garde i thought i had done a "terriffic piece"

and i said to myself at the time don't worry you are with a community of artists radicals etc and all will right itself in the end 31 years later i'm writing to you describing this piece that disappeared from the face of my career (censored) along with many others like it (censored) and was demoted to the rank of : TOYBOYMAN !!!

JUSTPIANISTPALESTINE !!!

MIKE KELLEY Dirty Toys: Interview with Ralph Rugoff (1991)

RALPH RUGOFF: The dolls and stuffed animals in your work often evoke objects left at the scene of a child abduction.

MIKE KELLEY: Because dolls represent such an idealized notion of the child, when you see a dirty one, you think of a fouled child. And so you think of a dysfunctional family. In actuality, that's a misreading, because the doll itself is a dysfunctional picture of a child. It's a picture of a dead child, an impossible ideal produced by a corporate notion of the family. To parents, the doll represents a perfect picture of the child—it's clean, it's cuddly, it's sexless, but as soon as the object is worn at all, it's dysfunctional. It begins to take on characteristics of the child itself—it smells like the child and becomes torn and dirty like real things do. It then becomes a frightening object because it starts to represent the human in a real way and that's when it's taken from the child and thrown away.

In our culture, a stuffed animal is really the most obvious thing that portrays the image of idealization. All commodities are such images, but the doll pictures the person as a commodity more than most. By virtue of that, it's also the most loaded in regard to the politics of wear and tear.

RR: Does this prejudice against dirtiness strike you as something peculiarly American?

MK: I'm sure all cultures have something that takes the place of dirt in ours—of the repressed thing. That's part of the machinery of culture. But in America, there also seems to be an intense fear of death and anything that shows the body as a machine that has waste products or that wears down. . . .

* Ralph Rugoff, excerpts from "Dirty Toys: Mike Kelley Interviewed by Ralph Rugoff," *21st Century* (Winter 1991–92): 4–11; reprinted in Thomas Kellein and Mike Kelley, *Mike Kelley* (Basel: Edition Cantz with Kunsthalle Basel, 1992), 86–90. By permission of the interviewer.

The funny thing about dolls is that you don't notice their scale because you project into them. Your relationship is sort of an interior one, a mental one. No matter how fucked up it is, you look at the doll and you see this lump of material as human, totally ignoring its material nature. In some earlier pieces, I deliberately avoided using humanoid figures in order to have the material nature of the objects in the foreground. I wanted viewers to walk into the gallery, see this stuff on the floor, and at first start to project into it, then after getting closer and seeing how filthy these objects actually are, they would become aware of the objects' physical nature—that it's not a doggy they're looking at, but a lump of cloth that's as dirty as a rag.

RR: Children also seem to be treated like stuffed animals: adults ignore the reality of children's physical desires in order to project this idealized image.

MK: One thing I've found about this work is that people are so unwilling to think about it in terms of the politics of the adult—no matter how many clues you give them, they always see the work in relation to the child, as if these dolls had something to do with children's desires. But they don't. All this stuff is produced by adults for children, expressing adult ideas about the reality of children. The children are totally absent from the production process except as designated consumers.

RR: Just like the entertainment industry fabricates movie stars for adult consumers.

MK: It's a comparable situation, just a different market. Images of movie stars are more overtly geared toward adult desires. If the doll is the perfect notion of what the child should be, the movie star is the perfect notion of what the adult should be.

RR: And what about the social position of the artist, who in many ways is still commonly represented as a type of child, irresponsible and unfettered by cultural and economic restraints?

MK: The artist's social position may be one of irresponsibility, but that doesn't mean he actually is irresponsible. That's one of the complexities of art production. The surface meaning is often not its deep meaning. You can say art is useless, but then you have to ask, "What's the use of the useless person in society?" There is use for him. So then what does "irresponsible" mean?

As an artist, you actually live in a very public environment. That's your job. That's why the myth of the artist as somebody who lives alone in some garret is absolutely ridiculous. Artists are some of the most public people there are. They're like a small business or a cottage industry, but one that is hooked into surrounding institutions.

In terms of the alliance of the artist, I think more to the point is the whole modernist cult of the child, in which the child was seen as this innocent figure of pure, unsocialized creativity. Which is a crock of shit, and is part of the problem, not part of the solution. . . .

I'm of the generation of artists for whom there was an extreme reaction against the handmade and clichéd ideas of self-expression, including the notion that the handmade art object revealed a personal, expressive psychology. I still think there is every reason to rebel against that idea, but I also think that to fixate on corporate modes of image-making and on mass-produced imagery is wrongheaded, because it's really easy for that style to become overly classical, despite the rhetoric of populism surrounding it.

I think it's possible now to start to look at handmade things in a different way. It's no longer heroic, as it used to be—the handmade now is pitiful and it doesn't necessarily have anything to do with emotion or a personal psychology. With my doll works, the viewer isn't led to reflect on the psychology of the artist but on the psychology of the culture. In that way, it's not different from work that mimics advertising, but you escape the classical overtones of

advertising and mass production. We speak the same language, but I wanted to speak it in a way that reveals the economics of the situation. . . .

RR: Yet now that prices for your work are taking off, people are saying they can't see a Mike Kelley without thinking of the price tag.

MK: But with my work those economics are totally about the ritualized nature of the commodity, not about the expense of producing it. In a way, the fact that this doll I paid fifty cents for is now selling for forty thousand dollars makes the work even stronger—it shows the strange position that art plays within the culture and how worth is determined. You can say that's terrible, but that's the way everything operates. Worth in this culture is dependent upon money, and people won't talk about the issues involved in the work unless the thing that gives it value in the culture is applied to it.

RR: In presenting spotless commodities as art, the other commodity artists reinforce, rather than critique, the market mentality?

MK: Perhaps; though I refuse to speak of art ever reinforcing culture more than anything else does. It seems to me that art has to be ritually separated from life in order to be art, so to talk about it as anything more than a mirror seems problematic. Even the worst examples of commodity art still picture the system in a way that makes it conscious, so you can talk about it, and I think that's a good thing.

RR: If art is a mirror, do you see it as politically neutral?

MK: I always think about art in terms of visual communication and representation. For instance, in body art, where artists might use their physical body as a medium, you don't talk about them in terms of their fullness as a human being, you talk about them as some sort of notion of a human being. It's through talking about them in that removed way, realizing them as a structure or an ideogram, that you can then politicize them.

But you have to get to the political through this ritualized process. That process is short-circuited in a lot of agitprop work, which is very naïve in the way it oversimplifies psychological processes. When you reduce the notion of art to simplistic ways of thinking and one-to-one relationships, I find you get dangerously close to fascistic ideas. I prefer to keep all these distinctions messier.

ROBERT RAUSCHENBERG Statement (1959)

Any incentive to paint is as good as any other. There is no poor subject.

Painting is always strongest when in spite of composition, color, etc., it appears as a fact, or an inevitability, as opposed to a souvenir or arrangement.

Painting relates to both art and life. Neither can be made. (I try to act in that gap between the two.)

A pair of socks is no less suitable to make a painting with than wood, nails, turpentine, oil, and fabric.

A canvas is never empty.

* Robert Rauschenberg, untitled statement, in Dorothy C. Miller, ed., *Sixteen Americans,* with statements by artists and others (New York: The Museum of Modern Art, 1959), 58. Reprinted by permission of the artist and the publisher.

Jasper Johns and Robert Rauschenberg, c. 1955. Photographer unknown. From *Jasper Johns* (New York: Whitney Museum of American Art, 1978). By permission of Jasper Johns and the Estate of Robert Rauschenberg/ Licensed by VAGA, New York, NY.

Note on Painting (1963)

I find it nearly impossible free ice to write about Jeepaxle my work. The concept I planetarium struggle to deal with ketchup is opposed to the logical community lift tab inherent in language horses and communication. My fascination with images open 24 hrs. is based on the complex interlocking if disparate visual facts heated pool that have no respect for grammar. The form then Denver 39 is second hand to nothing. The work then has a chance to electric service become its own cliché. Luggage. This is the inevitable fate fair ground of any inanimate object freightways by this I mean anything that does not have inconsistency as a possibility built-in.

The outcome of a work is based icy ice on amount of intensity concentration and joy that is pursued roadcrossing in the act of work. The character of the artist has to be responsive and lucky. Personally I have never been interested in a defensible reason post card for working achievement functionally is a delusion to do a needed work short changes art. It seems to me that a great part Indian moccasins of urgency in working lies in the fact that one acts freely friends and associates may become more closely allied with you real soon. U.S. postage stamps—sanitarily packaged—save a trip to post office shapes . . . files . . . cleans with key chain forget to bring it with you . . . to make something the need of which can only fishing 7 springs be determined after its existence and that judgment subject to change at any moment. 15'18". It is extremely important that art be unjustifiable.

Interview with Barbaralee Diamonstein (1977)

BARBARALEE DIAMONSTEIN: How do you achieve the immediacy in your work?

ROBERT RAUSCHENBERG: By not making up your mind before you're going to do it. It has to be immediate if you don't know what you're doing. And you take that chance and it's very embarrassing. Sometimes you succeed. Sometimes you don't. You don't have security.

BD: Do you plan your pieces?

RR: No I have discipline. I work everyday and I never know what I'm doing. . . . If you

* Robert Rauschenberg, "Note on Painting" (31 October–2 November 1963), in John Russell and Suzi Gablik, *Pop Art Redefined* (New York: Praeger, 1969), 101–2. Reprinted by permission of the artist and Henry Holt and Co., Inc.

** Barbaralee Diamonstein, excerpts from a videotaped interview with Robert Rauschenberg, in Diamonstein, ed., *Inside New York's Art World: Robert Rauschenberg and Leo Castelli,* recorded in cooperation with the New School for Social Research, New York, 1977. By permission of the interviewer, the artist, and the New School for Social Research.

know something you have a responsibility. . . . I don't think any honest artist sets out to make art. You love art. You live art. You are art. You do art. But you're just doing something. You're doing what no one can stop you from doing. And so, it doesn't have to be art and that is your life. But you also can't make life and so there's something in between there because you flirt with the idea that it is art. The definition of art would have to be about how much use you can make of it. Because if you try to separate the two, art can be very self-conscious, a blinding fact. But life doesn't really need it so it's also another blinding fact.

JASPER JOHNS Statement (1959)

Sometimes I see it and then paint it. Other times I paint it and then see it. Both are impure situations, and I prefer neither.

At every point in nature there is something to see. My work contains similar possibilities for the changing focus of the eye.

Three academic ideas which have been of interest to me are what a teacher of mine (speaking of Cézanne and cubism) called "the rotating point of view." (Larry Rivers recently pointed to a black rectangle two or three feet away from where he had been painting and said " . . . like there's something happening over there too.") Marcel Duchamp's suggestion "to reach the impossibility of sufficient visual memory to transfer from one like object to another the memory imprint"; and Leonardo's idea ("Therefore, O painter, do not surround your bodies with lines . . . ") that the boundary of a body is neither a part of the enclosed body nor a part of the surrounding atmosphere. Generally, I am opposed to painting which is concerned with conceptions of simplicity. Everything looks busy to me.

Interview with G. R. Swenson (1964)

JASPER JOHNS: I'm not a Pop artist! Once a term is set, everybody tries to relate anybody they can to it because there are so few terms in the art world. Labeling is a popular way of dealing with things. . . .

G. R. SWENSON: It has been said that the new attitude toward painting is "cool." Is yours?

JJ: Cool or hot, one way seems just about as good as another. Whatever you're thinking or feeling, you're left with what you do; the painting is what you've done. Some painters, perhaps, rely on particular emotions. They attempt to establish certain emotional situations for themselves and that's the way they like to work.

I've taken different attitudes at different times. That allows different kinds of actions. In focusing your eye or your mind, if you focus in one way, your actions will tend to be of one nature; if you focus another way, they will be different. I prefer work that appears to come out of a changing focus—not just one relationship or even a number of them but constantly changing and shifting relationships to things in terms of focus. Often, however, one is very single-minded and pursues one particular point; often one is blind to the fact that there is another way to see what is there.

* Jasper Johns, untitled statement, in Dorothy C. Miller, ed., *Sixteen Americans,* with statements by artists and others (New York: The Museum of Modern Art, 1959), 22. Reprinted by permission of the artist and the publisher.

** G. R. Swenson, excerpts from an interview with Jasper Johns in "What Is Pop Art? Interviews with Eight Painters," pt. 2, *Art News* 62, no. 10 (February 1964): 40–43, 62–67. By permission of the artist and the publisher. © 1964 ARTnews, LLC, February.

GRS: Are you aspiring to objectivity?

JJ: My paintings are not simply expressive gestures. Some of them I have thought of as facts, or at any rate there has been some attempt to say that a thing has a certain nature. Saying that, one hopes to avoid saying I feel this way about this thing; one says this thing is this thing, and one responds to what one thinks is so.

I am concerned with a thing's not being what it was, with its becoming something other than what it is, with any moment in which one identifies a thing precisely and with the slipping away of that moment, with at any moment seeing or saying and letting it go at that.

GRS: What would you consider the difference between subject matter and content, between what is depicted and what it means?

JJ: Meaning implies that something is happening; you can say meaning is determined by the use of the thing, the way an audience uses a painting once it is put in public. When you speak of what is depicted, I tend to think in terms of an intention. But the intention is usually with the artist. "Subject matter"? Where would you focus to determine subject matter? . . .

GRS: If you cast a beer can, is that a comment?

JJ: On what?

GRS: On beer cans or society. When you deal with things in the world, social attitudes are connected with them—aren't they?

JJ: Basically, artists work out of rather stupid kinds of impulses and then the work is done. After that the work is used. In terms of comment, the work probably has it, some aspect which resembles language. Publicly a work becomes not just intention, but the way it is used. If an artist makes something—or if you make chewing gum and everybody ends up using it as glue, whoever made it is given the responsibility of making glue, even if what he really intends is chewing gum. You can't control that kind of thing. As far as beginning to make a work, one can do it for any reason.

GRS: If you cast a beer can, you don't have to have a social attitude to beer cans or art?

JJ: No. It occurs to me you're talking about *my* beer cans, which have a story behind them. I was doing at that time sculptures of small objects—flashlights and light bulbs. Then I heard a story about Willem de Kooning. He was annoyed with my dealer, Leo Castelli, for some reason, and said something like, "That son-of-a-bitch; you could give him two beer cans and he could sell them." I heard this and thought, "What a sculpture—two beer cans." It seemed to me to fit in perfectly with what I was doing, so I did them—and Leo sold them.

GRS: Should an artist accept suggestions—or his environment—so easily?

JJ: I think basically that's a false way of thinking. Accept or reject, where's the ease or the difficulty? I don't put any value on a kind of thinking that puts limits on things. I prefer that the artist does what he does than that, after he's done it, someone says he shouldn't have done it. I would encourage everybody to do more rather than less.

Sketchbook Notes (1965)

Make neg. of part of figure & chair. Fill with these layers—encaustic (flesh?), linen, Celastic. One thing made of another. One thing used as another. *An arrogant object*. Something to be

* Jasper Johns, "Sketchbook Notes," *Art and Literature* 4 (Spring 1965): 191–92; reprinted in John Russell and Suzi Gablik, *Pop Art Redefined* (New York: Praeger, 1969), 84–85. By permission of the artist.

folded or bent or stretched. (SKIN?) Beware of the body and the mind. Avoid a polar situation. Think of the edge of the city and the traffic there. Some clear souvenir—A photograph (A newspaper clipping caught in the frame of a mirror) or a fisherman's den or a dried corsage. Lead section? Bronze junk? Glove? Glass? Ruler? Brush? Title? Neg. female fig.? Dog? Make a newspaper of lead or Sculpmetal? Impressions? Metal paper bag? Profile? Duchamp (?) Distorted as a shadow. Perhaps on falling hinged section. Something which can be erased or shifted. (Magnetic area) In WHAT use a light and a mirror. The mirror will throw the light to some other part of the painting. Put a lot of paint & a wooden ball or other object on a board. Push to the other end of the board. Use this in a painting. Dish with photo & color names. Japanese phonetic "NO" (possessive, "of") stencilled behind plate?. Determine painting size from plate size—objects should be *loose* in space. Fill (?) the space loosely. RITZ (?) CRACKERS, "if the contents of this package have settled," etc. Space everywhere (objects, no objects), MOVEMENT. Take flashlight apart? Leave batteries exposed? Break orange area with 2 overlays of different colors. Orange will be "underneath" or "behind." Watch the imitation of the shape of the body.

The watchman falls "into" the "trap" of looking. The "spy" is a different person. "Looking" is and is not "eating" and "being eaten." (Cézanne?—each object reflecting the other.) That is, there is continuity of some sort among the watchman, the space, the objects. The spy must be ready to "move," must be aware of his entrances and exits. The watchman leaves his job & takes away no information. The spy must remember and must remember himself and his remembering. The spy designs himself to be overlooked. The watchman "serves" as a warning. Will the spy and the watchman ever meet? In a painting named spy, will he be present? The spy stations himself to observe the watchman. If the spy is a foreign object, why is the eye not irritated? Is he invisible? When the spy irritates, we try to remove him. "Not spying, just looking"—Watchman.

Color chart, rectangles or circles. (Circles on black to white rectangles.) Metal stencil attached and bent away. OCCUPATION—Take up space with "what you do." Cut into a canvas & use the canvas to reinforce a cast of a section of a figure. The figure will have one edge coming out of the canvas "plane" & the other edge will overlap cut or will show the wall behind. A chain of objects (with half negative?) Cast RED, YELLOW, BLUE or cut them from metal. Bend or crush them. String them up. (or) Hinge them as in field painting. Bend them. Measurements or objects or fields which have changed their "directions." Something which has a name. Something which has no name. Processes of which one "knows the results." Avoid them. City planning, etc.

One thing working one way
Another thing working another way.
One thing working different ways
at different times.

Take an object.
Do something to it.
Do something else to it.
" " " " "

Take a canvas.
Put a mark on it.
Put another mark on it.
" " " " "

Make something.

Find a use for it.

AND OR

Invent a function.

Find an object.

BRUCE CONNER Interview with Mia Culpa (1979)

MIA CULPA: What's your involvement with the [Punk, New Wave] scene? You made a characteristic appearance pogoing with a 16mm camera during the coal miners' benefit at the Mabuhay last year. . . .

BRUCE CONNER: I always wanted to become a combat photographer! There was Roz, whose very first gesture on the first night as the first chord was struck was to run full speed off stage, land on the tops of the front tables, grab drinks out of people's hands, throw 'em down on the floor and kick all the chairs over. Cleared the space out real fast. But Roz couldn't last too long doing that. . . . I always look for those people, if any of them are playing with a band. . . . I kept going over to the Mabuhay and catching the opening night for the Sleepers, the Trend, UXA, all of those guys. Most of the *Search & Destroy* staff was home asleep when those events took place. . . .

MC: What are your serious obsessions at this point?

BC: You see, I have a diminished capacity. . . . Shrinking brain pan. My mind runneth over. At least the last four years, I've been dedicating myself to destroying as many brain cells as I can. I made the mistake once of buying a lifetime supply of expanded consciousness. And I started developing all these sort of infant consciousnesses, little tiny ones. Some of them would have particular jobs and characteristics that would be endowed by the great HEAD of myself, pointing at them. At one time I was very much involved in all kinds of "creative" endeavors—dance, theater, music, sculpture, painting, collage, printmaking, drawing, events—and I would do them all simultaneously. One little pocket of endowed consciousness would take care of preparing materials for making sculpture, and another would take care of the music, etc. And then when I'd get tired of doing a sculpture, I'd start doing a drawing. When I'd get tired of that, I'd play harmonica for a while, get tired of that, go out and do a dance thing, or hang out. . . .

MC: They all carried equal weight?

BC: They weren't a problem to deal with, except they kept growing. And they got bigger and bigger, and you got a house full of twenty, thirty full consciousnesses. They'd keep me awake at night. The only way I can knock them out is to become an alcoholic. It's possible to destroy an enormous number of brain cells by drinking alcohol and taking important drugs and abusing yourself physically. . . .

MC: Your assemblages and "found" constructions were pioneering works and earned you a considerable reputation in the art world. Then you stopped doing them altogether and started making collage films. You favor working with "found" footage in your work films, too. Why is that?

* Bruce Conner, "Bruce Conner Interview with Mia Culpa," pt. 1, *Damage* (San Francisco) 3 (August–September 1979): 8–11; pt. 2, *Damage* 4 (January 1980): 6–8. By permission of the artist; courtesy Gallery Paule Anglim, San Francisco.

Bruce Conner, 1979. Photo by Richard Peterson. By permission of the photographer.

BC: The pseudo-criminality of stealing already-formed objects or events; I don't see that as being any different from going through a process which people consider to be very creative, like doing a painting. You're stealing all the past experiences that everyone has had doing paintings. You're building on this huge pyramid which has millions of dead bodies down at the bottom of it. That's why somebody can do a painting today that has the same techniques that were being used in Egypt three thousand years ago, or in Chinese painting, or in Paleolithic works. There isn't that much difference. How you look at them and how you reject certain things is how you choose what they are.

MC: How do you feel behind a camera? Because you're in a position where you can very easily be a thief.

BC: Cameras are thieves. They steal the soul. The Hopi Indians were exactly right. They won't allow cameras at their ceremonics. That superficial commentary by anthropologists that it's a primitive notion. . . . It does steal and co-opt their privacy, their personality, their environment. They have no control over it, and they're aware of it. And they are the only ones of practically all the American Indians who still continue to have their rituals function.

I've never really felt that I've been that much in control of what a work is. I don't see them as something *I* make. I see it as an event. I see it as a process, and somewhere in the midst of the process it becomes a movie, or it becomes a party at the Deaf Club, or a trip to the canyons of Arizona. It becomes a broken rib at the Mabuhay. . . .

MC: Do you see any relation between the beat poetry scene and the current music rebirth?

BC: In the 50's, all the original places where people hung out—the bars—were closed down by the police in no time at all. One of the few places in existence then that still exists is called the Coffee Gallery. But in 1957, it was two rooms. One side was a bar, the other room was just a bare store front. . . . Somewhere in the 60's, people were allowed to go up on stage and be totally inept at playing music, until they finally learned how or stopped, which is what happened to a lot of bands that have now turned into granola. For me, the Deaf Club

and the Mabuhay are much closer to the beatnik scene. It wasn't impossible for anybody to get on stage unless they'd spent four years rehearsing, so that they'd never make a mistake or say the wrong thing.

I was involved in music then. I worked with La Monte Young and Terry Riley and a number of other people here, in NYC, and Boston, in performances that would now be called "performance" or "conceptual art" events. However, in the 50's and early 60's the only venue where you could expect people to take it seriously or react against it was in a concert context. I found myself eminently qualified to perform with musicians who had studied for fifteen years when they came around to playing John Cage amplified music for toy pianos. But you had to lie about it. There were a lot of other things that we did and we'd call it music so we'd get people into a room.

I can hardly believe that I've stayed alive. I didn't expect to live to 30. I planned my whole life to do everything I wanted to do by the time I was 30. . . .

MC: And when you hit 31?

BC: Try to go faster. 31's a real crummy speed to be at. . . .

MC: Did you ever feel that making art was an activity separate from your daily life?

BC: Making art and creating those things were part of my daily life for such a long time. At one time I was going to make every activity of my life tax-deductible by turning it into art.

MC: Has everything you've touched become art?

BC: No. That's like turning it into gold, isn't it? You can't eat it. Making art is not a part of my life now. The last drawing I started was a year and a half ago, and it ended up just sitting on the drawing table.

MC: You never experienced that before? There weren't times when you just put it all down—just can't or just won't?

BC: I could not put it down. It wasn't anything like a matter of choice. I had to continue to make things. But in the last five or six years it became clear that I was making more things than there was any possible use for, for me or anybody else. It was only to take care of my momentary experiences and cope with them. I discovered that the devices I had didn't work any more. The assumption that communicating with people through some medium was going to change things, or the world, to the better in your own personal philosophy: that was a driving force for me for quite a bit of time. I infiltrated the art world at a time when it was extremely difficult and unlikely to do so. And it gained a certain amount of communication value because there was nothing else going on in that situation. But most of the assumptions I had about what changes I was going to make were pure illusion. I discovered three or four years ago that I was at the same place I was when I was twenty-six years old. Except now they were going to "give" me a major retrospective. They were going to publish a catalogue. They were going to travel a show all around the country. It was going to be a big deal. It was going to be Rauschenberg, Jasper Johns and Bruce Conner, representing that period of time, of transformation, of assemblage art and events and such.

MC: Do you feel it was a post-mortem?

BC: They practically informed me it was a post-mortem. They treated it as if I was already dead. Up until fifteen years ago no one had a retrospective unless they were dead. I went to talk to Henry Hopkins (then Director of the San Francisco Museum of Modern Art) about the content of the show and how we were going to cooperate and put it together. The show was going to include films, collage, assemblage, sculpture, printmaking, drawing, anecdotal events, photographs, all sorts of things about performances and so on. . . . We ran into two

problems. Everything was being run as if I did not exist, except they would have my free advice and energy to put into it. The first disagreement was that he would not allow me to touch my own work or to select the work that would go into the show. He would not allow me to *reject* anything. Henry Hopkins insisted on being the sole judge. Now, if I had died before the show it wouldn't have made a helluva lot of difference. But to live on beyond that and have this representation (which was supposed to be an extension of my personality) re-transformed into a Frankenstein monster—take a little bit of this arm and that leg and a little bit of somebody else's brain, and you put it all together. For a period of time I did assemblages and collages using found objects, and they would sooner or later coalesce into something I could *call* art. A sculpture or a wall piece. I was working under the spaghetti theory of art. If you want to know if the spaghetti's done, you throw it on the wall or the ceiling and if it sticks, it's done. You put something in an art environment, you call it art, and if it sticks, it's art.

MC: Truth in labeling.

BC: Uh huh, no problem whatsoever. They're all liars anyway. There's no way anyone could prove art one way or another. It's a totally fraudulent environment. So I made objects which incorporated time and events prior to the time I assembled them. I dealt with it as a process. When they were assembled in one place that was just one step of the process. I did not frame them or put them on a pedestal. I made them vulnerable. I made them so that people could touch and re-arrange things. They were designed with the idea that time, the elements, would change them. Just by stopping the change . . . like if you put something in a block of solid plastic; that would change the whole structure simply by altering the way the time change would occur. So, one part of my retrospective was based on those works which I stopped doing in 1964. And in the meantime they've been out, being used. Things have probably been taken off them and added to them. Just turning them upside down would alter them.

As far as the catalogue and the exhibition were concerned, this aesthetic or philosophical/conceptual attitude towards the work would be exploited. That would be a reason for having the show. It would take pages in the catalogue to talk about these time capsules. Almost everything would have to come from someone besides myself, because I only own about three or four of them. I gave a lot of them away. Some people bought them; some museums have them. Many of them were never photographed. Of the photographs that were taken, most have disappeared. When the pieces would arrive for the exhibition, I wanted to be able to say, "This does *not* represent my work, but it will if I make some changes in it." Henry Hopkins would not accept me as the authority on my own work.

He said everything had to be exhibited exactly the way it arrived. However, if it was determined that a piece was damaged—not that it was altered or part of a process—if it was damaged, the museum had a very efficient process to take care of it. First, the person who's loaned the piece has to be convinced that it's damaged. Then, that person has to contact the insurance company and convince *them* that it's damaged. Once the company assumes the cost of dealing with the damage, they can choose either to take the work into their own possession and do whatever they want with it, or "repair" it. They will repair it by sending out notices to conservators and restorers, who will then submit bids for restoring the work. The lowest bid gets the job. That person, who certainly has to be licensed for doing this, may or may not choose to use me in an advisory capacity.

I told Henry this was unreasonable. He told me that this exhibition would be a terrific boon to my career. It would make me famous and rich. I've been told that since I've been twenty-one years old. I must have had him up against the wall for him to use that chestnut.

It's one of the more fraudulent myths of the art business. Whereas, the only way you can make any money is to get a percentage of the gate. The concept that the museum and galleries have been working on for so long is a 19th century one, wherein you confront a robber baron . . . who smashed millions of tiny babies into the ground, tore their eyeballs out and disemboweled them; he's done this his whole life. . . . And he's built castles around the world. He feels very comfortable until he sees the sublime vision that an artist has performed for him. He is so disintegrated and threatened by this event that he has to buy the artist off. This is the concept behind the whole economics of the art world. Half a million dollars to Georges Rouault, Robert Motherwell, Andy Warhol, Judy Chicago, so that they can be bought off for saying just the right thing or the wrong thing at the right moment. This pot at the end of the rainbow is what they always sell to you. You talk to them about money; they say, "I didn't know you were in this for the money."

I wanted my show to be free. He said, "It's a very expensive retrospective show, we'll have to charge $2.00 admission." So I said, let's make a smaller show. He wouldn't do it. I said, let's do a show without the collages and assemblages that we disagree about how to handle. He wouldn't do it. I think that's probably where the end of my involvement in the art world really happened. There's nobody else that would put on that kind of exhibition. Nobody cares. They don't care who they exhibit in those museums. It's just like a store window. They change it every month and a half and lots of people go in. . . . I quit the art business in 1967 for about three years. The only defect in that was that I kept on producing lots and lots of drawings and paintings which piled up to a point where obviously they had to be taken care of. At that time, whenever I'd get any letters about art-related events, I'd send them back or throw them out. Sometimes, I'd write deceased on them. I was listed in *Who's Who in American Art* and I sent back all their correspondence with "Deceased." After three years, *Who's Who* believed me. They put me in *Who Was Who*, which has people in it who are deceased as well as people who are obsolete. Recently, though, I got another form from *Who's Who*, asking me to fill it out because I'd been recommended. They have a very short memory. I don't think they have any memory at all. So I filled it out. All of the history on the new biography is for myself as a filmmaker, all the history on the prior biography is for myself as an artist. So the artist is definitely dead.

I think if you're going to have any value at all, it has to be very immediate. The artist category determines that you're non-threatening. Art and the Church and the national parks are practically the same thing. You're defended because you're ineffectual. You don't mean anything. That goes for anything that's non-profit. Everyone should fight this crap about government subsidization of the arts and non-profit crap because it just degrades your immediacy—you can't mean anything immediately once you play that game.

MC: Why film?

BC: Film's more immediate. It's all firsthand, every time. A movie that I did twenty years ago shown today, still looks like a new movie. I mean, it looks like a new old movie. The style of the film is such that even when I made it originally it was like an antique, using footage out of films that were older and purposely making it that way, within the limitations of a $350 budget. That was a movie called *A Movie* [1959]. It was twelve minutes long. People are always seeing the films and relating to them as firsthand experiences, no matter what, and it continues all the time. The advantage is that there isn't an enormous history around it. Being an artist, you're a victim of history. Immediately, you're put into categorical relationships in a historical context. Anything you can get involved in which is outside that systemizing,

I think the more rewards you get out of it. Otherwise, you end up doing imitations of your-self forever. When I stopped doing sculptures and collages, and assemblages in 1964, I lost my galleries. I was doing beautiful drawings. They couldn't sell the drawings. People would go into the gallery and they wouldn't want to look at Bruce Conner's drawings. They wanted to look at collages and assemblages. But as far as film is concerned, you keep on *doing* films; they always run through a projector, there's a certain consistency. You have an audience at a disadvantage. They can't see or hear anything else. You have them under your control. You make them look and live an experience, go through a process, which is enormously difficult to do in other forms of activity. . . . I keep collecting a lot of film footage to play with. Black and white is what I've ended up with because it's abstract. You can make a change from one place to another, which you cannot do as easily in color film. Color character from one film to another is so drastic. In black and white you can make a change from one place to another and there's an implied connection. You might make the connection by movement. . . .

MC: When you first started, did you have a desire to reach a mass audience and make feature length movies?

BC: I've always wanted to make big movies that everybody goes to see. There's a whole critical bureaucracy built up around independent filmmaking, as if the choices that filmmak-ers have made are conscious responses: they "chose" to use non-synchronous sound because of its certain aesthetic qualities, they "chose" to use . . .

MC: Grainy, faded stock . . .

BC: They "chose" to emphasize the character of the film rather than sets and dramatic construction. All it means is that there's a bunch of people who can't afford to make feature films. I wanted to make a movie. I didn't own a movie camera. I didn't even have editing equipment. Ever since I'd seen a Marx Brothers movie, *Duck Soup,* when I was fourteen, I'd wanted to. . . . I had an enormous fantasy of combining all the scenes and soundtracks of all the movies that I saw after that time. I kept waiting for someone to make that movie. It ap-peared totally obvious that this movie had to be made and nobody made it, so finally, I decided to make that film and the first thing I discovered was how impossible it was to get the footage. So, I went to a local camera store and bought a bunch of 16mm films of *Hopalong Cassidy* and *Creatures from the Black Lagoon, Headlines of 1953, Thrills and Spills,* and I started assembling it. . . . The idea was to edit all this footage and incorporate it into a kind of rear projection machine in a room. An environment that would incorporate all kinds of moving objects, strobe lights, random sounds coming off of the radio, tape machines, television. And this movie would continue to go all the time. Not only would there be separate images from totally different movies, but the sound that would be accompanying it would be totally dif-ferent every time it went through. Then I found out how much it costs to buy a rear screen projection machine, and I decided to make it into a regular movie. . . . When I realized that I couldn't do the rear projection process, I edited the film with the idea that it would go with that music, but I didn't play the music with it. I edited the whole film and then I recorded the music and put it on top of it, and it fit perfectly. I'd been listening to the music for maybe six or seven years and I *knew* it, but it was so intuitive, the way the music and the picture worked. . . .

MC: Is making art a subversive activity?

BC: I don't think making art represents a subversive activity at all. Not at all. There's this media obsession, that somehow if you use a technical structure or you use a social structure involved in communications that it's going to follow that you are communicating by using

that structure. Doesn't happen. First of all, even if you go through a media that's designed to communicate to other people, it may be a very great problem for you to even put your words or your communication in order before anybody can hear it. The next problem is that although you put your communication in perfect order, immediately at least fifty percent of the people will not acknowledge that they even heard it. Next problem is that out of those remaining fifty percent, there's going to be a number of people who will totally misinterpret the communication, or disagree with it, or attack it, or use it as a substructure for their own progress to the point where they themselves will use a media structure to make a pronouncement. Right now I just see thousands and thousands of people standing around on soap boxes, all talking simultaneously and not substantially listening to anybody else.

Everyone's being programmed into segmented concepts. Take education. You're locked into education until a legal or semi-legal age of 18, and then it's expected that you go on from there. Now, any creature that goes through the same habit pattern for fifteen, twenty years with their life broken into totally separate confrontations every hour, and then it's all broken into larger structures, twice or three times a year, then the whole idea of going out and living in an environment where you have to find a basis or structure for a long-term organization is incomprehensible. I see all these people that are rebelling against it. They can't cope with it, first of all. *But* invariably they're going to have to cope with it, the dialogue they're using has nothing to do with their coping. Otherwise, we would see half a million dedicated Marxists out on the streets every year, ready to change the world. Well, there were half a million dedicated transformations in the 1960's now selling real estate, "doing things for people" and also pulling in $25–30 thousand a year.

MC: And then there are people still floating around looking to start a rock 'n' roll band. . . .

BC: Well, so am I. I've decided that it's easier for me to wait until the other people are ready for me to play in their band.

GEORGE BRECHT Project in Multiple Dimensions (1957–58)

The primary function of my art seems to be an expression of maximum meaning with a minimal image, that is, the achievement of an art of multiple implications, through simple, even austere, means. This is accomplished, it seems to me, by making use of all available conceptual and material resources. I conceive of the individual as part of an infinite space and time: in constant interaction with that continuum (nature), and giving order (physically or conceptually) to a part of the continuum with which he interacts.

Such interaction can be described in terms of two obvious aspects, matter-energy and structure, or, practically, material and method. The choice of materials, natural and fabricated, metals, foils, glass, plastics, cloth, etc., and electronic systems for creating light and sound structures which change in time, follows inherently from certain intuitively chosen organizational methods. These organizational methods stem largely from other parts of my experience: randomness and chance from statistics, multi-dimensionality from scientific method, continuity of nature from oriental thought, etc. This might be emphasized: the basic structure of my art comes primarily from aspects of experience unrelated to the history of art; only

* George Brecht, excerpt from "Project in Multiple Dimensions" (1957–58), in Henry Martin, ed., *An Introduction to George Brecht's Book of the Tumbler on Fire,* with interviews by Ben Vautier and Marcel Alocco, Henry Martin, Irmeline Lebeer, Gislind Nabakowski, Robin Page, and Michael Nyman, and with an anthology of texts by George Brecht (Milan: Multhipla Edizioni, 1978), 126–27. By permission of the artist.

George Brecht, *Drip Music (Drip Event),* 1959–62, score for an event. By permission of the artist.

secondarily, and through subsequent study, do I trace artistic precursors of some aspects of my present approach.

It seems reasonable to expect this expression, if it comes from a unitary personal experience, not to be inconsistent with other aspects of that experience, and this is the case. When this art, without conscious roots, is examined on a conscious level, in terms of basic concepts such as space-time, causality, etc., it is found to be consistent with the corresponding concepts in physical science, and this is true in general of the work of certain exploratory artists whose work seems to stem, individual as it is, from common conceptual roots (e.g. John Cage, Allan Kaprow, Paul Taylor). In this sense, it seems to me, it would be possible to show how this art reflects fundamental aspects of contemporary vision, by examining it in terms of space-time, inseparability of observer-observed, indeterminacy, physical and conceptual multi-dimensionality, relativity, and field theory, etc. This study may be left to critics and theorists.

To summarize, my work is a complex product of a personality continuous with all of nature, and one making progressively better-integrated efforts to structure experience on all levels. Thus, what can be made of nature through rational effort (such as scientific understanding), though it is never a conscious part of my work, being a part of the personality, becomes part of the work. In this way, all approaches to experience become consistent with each other, and my most exploratory and dimly-felt artistic awareness, insights based on the most recent findings of modern science, and the personally meaningful ancient insights of oriental thought, just now being found appropriate to our modern outlook, form a unified whole. The consistency of such an overall approach to experience serves to reinforce the validity of each of its component parts, much as scientific constructs gain validity through their mutual function in explaining experience. This consistency becomes apparent only after each aspect gains independent maturity, however, and is in no case a pre-condition, or requirement, for satisfaction with any aspect. My art is the result of a deeply personal, infinitely complex, and still essentially mysterious, exploration of experience. No words will ever touch it.

CLAES OLDENBURG I Am for an Art . . . (1961)

I am for an art that is political-erotical-mystical, that does something other than sit on its ass in a museum.

I am for an art that grows up not knowing it is art at all, an art given the chance of having a starting point of zero.

 * Claes Oldenburg, "I Am for an Art . . ." (May 1961), in *Environments, Situations, Spaces* (New York: Martha Jackson Gallery, 1961); reprinted in an expanded version in Oldenburg and Emmett Williams, eds., *Store Days: Documents from The Store (1961) and Ray Gun Theater (1962)* (New York: Something Else Press, 1967), 39–42. By permission of the author.

I am for an art that embroils itself with the everyday crap & still comes out on top.

I am for an art that imitates the human, that is comic, if necessary, or violent, or whatever is necessary.

I am for an art that takes its form from the lines of life itself, that twists and extends and accumulates and spits and drips, and is heavy and coarse and blunt and sweet and stupid as life itself.

I am for an artist who vanishes, turning up in a white cap painting signs or hallways.

I am for art that comes out of a chimney like black hair and scatters in the sky.

I am for art that spills out of an old man's purse when he is bounced off a passing fender.

I am for the art out of a doggy's mouth, falling five stories from the roof.

I am for the art that a kid licks, after peeling away the wrapper.

I am for an art that joggles like everyone's knees, when the bus traverses an excavation.

I am for art that is smoked, like a cigarette, smells, like a pair of shoes.

I am for art that flaps like a flag, or helps blow noses, like a handkerchief.

I am for art that is put on and taken off, like pants, which develops holes, like socks, which is eaten, like a piece of pie, or abandoned with great contempt, like a piece of shit.

I am for art covered with bandages. I am for art that limps and rolls and runs and jumps.

I am for art that comes in a can or washes up on the shore.

I am for art that coils and grunts like a wrestler. I am for art that sheds hair.

I am for art you can sit on. I am for art you can pick your nose with or stub your toes on.

I am for art from a pocket, from deep channels of the ear, from the edge of a knife, from the corners of the mouth, stuck in the eye or worn on the wrist.

I am for art under the skirts, and the art of pinching cockroaches.

I am for the art of conversation between the sidewalk and a blind man's metal stick.

I am for the art that grows in a pot, that comes down out of the skies at night, like lightning, that hides in the clouds and growls. I am for art that is flipped on and off with a switch.

I am for art that unfolds like a map, that you can squeeze, like your sweety's arm, or kiss, like a pet dog. Which expands and squeaks, like an accordion, which you can spill your dinner on, like an old tablecloth.

I am for an art that you can hammer with, stitch with, sew with, paste with, file with.

I am for an art that tells you the time of day, or where such and such a street is.

I am for an art that helps old ladies across the street.

I am for the art of the washing machine. I am for the art of a government check. I am for the art of last war's raincoat.

I am for the art that comes up in fogs from sewer-holes in winter. I am for the art that splits when you step on a frozen puddle. I am for the worm's art inside the apple. I am for the art of sweat that develops between crossed legs.

I am for the art of neck-hair and caked tea-cups, for the art between the tines of restaurant forks, for the odor of boiling dishwater.

I am for the art of sailing on Sunday, and the art of red and white gasoline pumps.

I am for the art of bright blue factory columns and blinking biscuit signs.

I am for the art of cheap plaster and enamel. I am for the art of worn marble and smashed slate. I am for the art of rolling cobblestones and sliding sand. I am for the art of slag and black coal. I am for the art of dead birds.

I am for the art of scratchings in the asphalt, daubing at the walls. I am for the art of bending and kicking metal and breaking glass, and pulling at things to make them fall down.

I am for the art of punching and skinned knees and sat-on bananas. I am for the art of kids' smells. I am for the art of mama-babble.

I am for the art of bar-babble, tooth-picking, beerdrinking, egg-salting, in-sulting. I am for the art of falling off a barstool.

I am for the art of underwear and the art of taxicabs. I am for the art of ice-cream cones dropped on concrete. I am for the majestic art of dog-turds, rising like cathedrals.

I am for the blinking arts, lighting up the night. I am for art falling, splashing, wiggling, jumping, going on and off.

I am for the art of fat truck-tires and black eyes.

I am for Kool-art, 7-UP art, Pepsi-art, Sunshine art, 39 cents art, 15 cents art, Vatronol art, Dro-bomb art, Vam art, Menthol art, L & M art, Ex-lax art, Venida art, Heaven Hill art, Pamryl art, San-o-med art, Rx art, 9.99 art, Now art, New art, How art, Fire sale art, Last Chance art, Only art, Diamond art, Tomorrow art, Franks art, Ducks art, Meat-o-rama art.

I am for the art of bread wet by rain. I am for the rats' dance between floors. I am for the art of flies walking on a slick pear in the electric light. I am for the art of soggy onions and firm green shoots. I am for the art of clicking among the nuts when the roaches come and go. I am for the brown sad art of rotting apples.

I am for the art of meowls and clatter of cats and for the art of their dumb electric eyes.

I am for the white art of refrigerators and their muscular openings and closings.

I am for the art of rust and mold. I am for the art of hearts, funeral hearts or sweetheart hearts, full of nougat. I am for the art of worn meathooks and singing barrels of red, white, blue and yellow meat.

I am for the art of things lost or thrown away, coming home from school. I am for the art of cock-and-ball trees and flying cows and the noise of rectangles and squares. I am for the art of crayons and weak gray pencil lead, and grainy wash and sticky oil paint, and the art of windshield wipers and the art of the finger on a cold window, on dusty steel or in the bubbles on the sides of a bathtub.

I am for the art of teddy-bears and guns and decapitated rabbits, exploded umbrellas, raped beds, chairs with their brown bones broken, burning trees, firecracker ends, chicken bones, pigeon bones and boxes with men sleeping in them.

I am for the art of slightly rotten funeral flowers, hung bloody rabbits and wrinkly yellow chickens, bass drums & tambourines, and plastic phonographs.

I am for the art of abandoned boxes, tied like pharaohs. I am for an art of watertanks and speeding clouds and flapping shades.

I am for U.S. Government Inspected Art, Grade A art, Regular Price art, Yellow Ripe art, Extra Fancy art, Ready-to-eat art, Best-for-less art, Ready-to-cook art, Fully cleaned art, Spend Less art, Eat Better art, Ham art, pork art, chicken art, tomato art, banana art, apple art, turkey art, cake art, cookie art.

add:

I am for an art that is combed down, that is hung from each ear, that is laid on the lips and under the eyes, that is shaved from the legs, that is brushed on the teeth, that is fixed on the thighs, that is slipped on the foot.

square which becomes blobby.

ROY LICHTENSTEIN Interview with G. R. Swenson (1963)

G. R. SWENSON: What is Pop Art?

ROY LICHTENSTEIN: I don't know—the use of commercial art as a subject matter in painting, I suppose. It was hard to get a painting that was despicable enough so that no one would hang it—everybody was hanging everything. It was almost acceptable to hang a dripping paint rag, everybody was accustomed to this. The one thing everyone hated was commercial art; apparently they didn't hate that enough either.

GRS: Is Pop Art despicable?

RL: That doesn't sound so good, does it? Well, it *is* an involvement with what I think to be the most brazen and threatening characteristics of our culture, things we hate, but which are also powerful in their impingement on us. I think art since Cézanne has become extremely romantic and unrealistic, feeding on art; it is utopian. It has had less and less to do with the world, it looks inward—neo-Zen and all that. This is not so much a criticism as an obvious observation. Outside is the world; it's there. Pop Art looks out into the world; it appears to accept its environment, which is not good or bad, but different—another state of mind.

"How can you like exploitation?" "How can you like the complete mechanization of work? How can you like bad art?" I have to answer that I accept it as being there, in the world.

GRS: Are you anti-experimental?

RL: I think so, and anti-contemplative, anti-nuance, anti-getting-away-from-the-tyranny- of-the-rectangle, anti-movement-and-light, anti-mystery, anti-paint-quality, anti-Zen, and anti all of those brilliant ideas of preceding movements which everyone understands so thoroughly.

We like to think of industrialization as being despicable. I don't really know what to make of it. There's something terribly brittle about it. I suppose I would still prefer to sit under a tree with a picnic basket rather than under a gas pump, but signs and comic strips are interesting as subject matter. There are certain things that are usable, forceful and vital about commercial art. We're using those things—but we're not really advocating stupidity, international teenagerism and terrorism.

GRS: Where did your ideas about art begin?

RL: The ideas of Professor Hoyt Sherman (at Ohio State University) on perception were my earliest important influence and still affect my ideas of visual unity.

GRS: Perception?

RL: Yes. Organized perception is what art is all about. . . . It is a process. It has nothing to do with any external form the painting takes, it has to do with a way of building a unified

* G. R. Swenson, excerpts from an interview with Roy Lichtenstein, in "What Is Pop Art? Interviews with Eight Painters," pt. 1, *Art News* 62, no. 7 (November 1963): 25–27, 60–64. By permission of the artist and the publisher. © 1963 ARTnews, LLC, November.

pattern of seeing. . . . In Abstract-Expressionism the paintings symbolize the idea of ground-directedness as opposed to object-directedness. You put something down, react to it, put something else down, and the painting itself becomes a symbol of this. The difference is that rather than symbolize this ground-directedness I do an object-directed appearing thing. There is humor here. The work is still ground-directed; the fact that it's an eyebrow or an almost direct copy of something is unimportant. The ground-directedness is in the painter's mind and not immediately apparent in the painting. Pop Art makes the statement that ground-directedness is not a quality that the painting has because of what it looks like. . . . this tension between apparent object-directed products and actual ground-directed processes is an important strength of Pop Art.

GRS: Antagonistic critics say that Pop Art does not transform its models. Does it?

RL: Transformation is a strange word to use. It implies that art transforms. It doesn't, it just plain forms. Artists have never worked with the model—just with the painting. What you're really saying is that an artist like Cézanne transforms what we think the painting ought to look like into something he thinks it ought to look like. He's working with paint, not nature; he's making a painting, he's forming. I think my work is different from comic strips—but I wouldn't call it transformation; I don't think that whatever is meant by it is important to art. What I do is form, whereas the comic strip is not formed in the sense I'm using the word; the comics have shapes but there has been no effort to make them intensely unified. The purpose is different, one intends to depict and I intend to unify. And my work is actually different from comic strips in that every mark is really in a different place, however slight the difference seems to some. The difference is often not great, but it is crucial. People also consider my work to be anti-art in the same way they consider it pure depiction, "not transformed." I don't feel it is anti-art.

There is no neat way of telling whether a work of art is composed or not; we're too comfortable with ideas that art is the battleground for interaction, that with more and more experience you become more able to compose. It's true, everybody accepts that; it's just that the idea no longer has any power. . . .

GRS: A curator at the Modern Museum has called Pop Art fascistic and militaristic.

RL: The heroes depicted in comic books are fascist types, but I don't take them seriously in these paintings—maybe there is a point in not taking them seriously, a political point. I use them for purely formal reasons, and that's not what those heroes were invented for. . . . Pop Art has very immediate and of-the-moment meanings which will vanish—that kind of thing is ephemeral—and Pop takes advantage of this "meaning," which is not supposed to last, to divert you from its formal content. I think the formal statement in my work will become clearer in time. Superficially, Pop seems to be all subject matter, whereas Abstract-Expressionism, for example, seems to be all aesthetic. . . .

I paint directly—then it's said to be an exact copy, and not art, probably because there's no perspective or shading. It doesn't look like a painting *of* something, it looks like the thing itself. Instead of looking like a painting *of a* billboard—the way a Reginald Marsh would look—Pop Art seems to be the actual thing. It is an intensification, a stylistic intensification of the excitement which the subject matter has for me; but the style is, as you said, cool. One of the things a cartoon does is to express violent emotion and passion in a completely mechanical and removed style. To express this thing in a painterly style would dilute it; the techniques I use are not commercial, they only appear to be commercial—and the ways of seeing and composing and unifying are different and have different ends.

GRS: Is Pop Art American?

RL: Everybody has called Pop Art "American" painting, but it's actually industrial painting. America was hit by industrialism and capitalism harder and sooner and its values seem more askew. . . . I think the meaning of my work is that it's industrial, it's what all the world will soon become. Europe will be the same way, soon, so it won't be American; it will be universal.

ANDY WARHOL
Warhol in His Own Words: Statements (1963–87)

If you want to know all about Andy Warhol, just look at the surface: of my paintings and films and me, and there I am. There's nothing behind it.[1]

.

I see everything that way, the surface of things, a kind of mental Braille. I just pass my hands over the surface of things.[2]

.

The reason I'm painting this way is that I want to be a machine, and I feel that whatever I do and do machine-like is what I want to do.[3]

.

I like boring things. I like things to be exactly the same over and over again.[4]

.

I've been quoted a lot as saying, "I like boring things." Well, I said it and I meant it. But that doesn't mean I'm not bored by them. Of course, what I think is boring must not be the same as what other people think is, since I could never stand to watch all the most popular action shows on TV, because they're essentially the same plots and the same shots and the same cuts over and over again. Apparently, most people love watching the same basic thing, as long as the details are different. But I'm just the opposite: if I'm going to sit and watch the same thing I saw the night before, I don't want it to be essentially the same—I want it to be exactly the same. Because the more you look at the same exact thing, the more the meaning goes away, and the better and emptier you feel.[5]

.

 * Andy Warhol, excerpts from "Warhol in His Own Words," untitled statements (1963–87) selected by Neil Printz and collected in Kynaston McShine, ed., *Andy Warhol: A Retrospective* (New York and Boston: Museum of Modern Art and Bullfinch Press/Little Brown, 1989), 457–67. By permission of Neil Printz, the Andy Warhol Foundation for the Visual Arts, and The Museum of Modern Art, New York. © 2012 Andy Warhol Foundation for the Visual Arts/Artists Rights Society (ARS), New York. Excerpts from *Exposures* by Andy Warhol, © 1979 Andy Warhol Books, and excerpts from *America* by Andy Warhol, © 1985 Andy Warhol, both used by permission of The Wylie Agency LLC.
 1. Gretchen Berg, "Andy: My True Story," *Los Angeles Free Press* (17 March 1967), 3. Reprinted from *East Village Other*.
 2. Ibid.
 3. G. R. Swenson, "What Is Pop Art? Answers from 8 Painters, Part I," *Art News* 62, no. 7 (November 1963): 26.
 4. Read by Nicholas Love at Memorial Mass for Andy Warhol, St. Patrick's Cathedral, New York, 1 April 1987.
 5. Andy Warhol and Pat Hackett, *POPism: The Warhol '60s* (New York: Harcourt Brace Jovanovich, 1980), 50.

Andy Warhol, *Invisible Sculpture* at Area, New York, 1985. Art © 2012 Andy Warhol Foundation for the Visual Arts/Artists Rights Society (ARS), New York. Photo © PATRICK MCMULLAN/PatrickMcMullan.com

I think of myself as an American artist: I like it here. I think it's so great. It's fantastic. I'd like to work in Europe but I wouldn't do the same things. I'd do different things. I feel I represent the U.S. in my art but I'm not a social critic. I just paint those objects in my paintings because those are the things I know best. I'm not trying to criticize the U.S. in any way, not trying to show up any ugliness at all. I'm just a pure artist, I guess. But I can't say if I take myself seriously as an artist. I just hadn't thought about it. I don't know how they consider me in print, though.[6]

.

I adore America and these are some comments on it. My image [*Storm Door, 1960*] is a statement of the symbols of the harsh, impersonal products and brash materialistic objects on which America is built today. It is a projection of everything that can be bought and sold, the practical but impermanent symbols that sustain us.[7]

.

What's great about this country is that America started the tradition where the richest consumers buy essentially the same things as the poorest. You can be watching TV and see Coca-Cola, and you can know that the President drinks Coke, Liz Taylor drinks Coke, and just think, you can drink Coke, too. A Coke is a Coke and no amount of money can get you a better Coke than the one the bum on the corner is drinking. All the Cokes are the same and all the Cokes are good. Liz Taylor knows it, the President knows it, the bum knows it, and you know it.[8]

.

6. Berg, "Andy: My True Story," 3.
7. "New Talent U.S.A.," *Art in America* 50, no. 1 (1960): 42.
8. Andy Warhol, *The Philosophy of Andy Warhol (From A to B and Back Again)* (New York: Harcourt Brace Jovanovich 1975), 100–101.

Someone said that Brecht wanted everybody to think alike. I want everybody to think alike. But Brecht wanted to do it through Communism, in a way. Russia is doing it under government. It's happening here all by itself without being under a strict government; so if it's working without trying, why can't it work without being Communist? Everybody looks alike and acts alike, and we're getting more and more that way.[9]

.

Business art is the step that comes after Art. I started as a commercial artist, and I want to finish as a business artist. After I did the thing called "art" or whatever it's called, I went into business art. I wanted to be an Art Businessman or a Business Artist. Being good in business is the most fascinating kind of art. During the hippie era people put down the idea of business— they'd say "Money is bad," and "Working is bad," but making money is art and working is art and good business is the best art.[10]

.

When I have to think about it, I know the picture is wrong. And sizing is a form of thinking, and coloring is too. My instinct about painting says, "If you don't think about it, it's right." As soon as you have to decide and choose, it's wrong. And the more you decide about, the more wrong it gets. Some people, they paint abstract, so they sit there thinking about it because their thinking makes them feel they're doing something. But my thinking never makes me feel I'm doing anything. Leonardo da Vinci used to convince his patrons that his thinking time was worth something—worth even more than his painting time—and that may have been true for him, but I know that my thinking time isn't worth anything. I only expect to get paid for my "doing" time.[11]

.

I still care about people but it would be so much easier not to care. I don't want to get too close: I don't like to touch things, that's why my work is so distant from myself.[12]

.

If everybody's not a beauty, then nobody is.[13]

.

In the future everybody will be world famous for fifteen minutes.[14]

.

I don't feel I'm representing the main sex symbols of our time in some of my pictures, such as Marilyn Monroe or Elizabeth Taylor. I just see Monroe as just another person. As for whether it's symbolical to paint Monroe in such violent colors: it's beauty, and she's beautiful and if something's beautiful it's pretty colors, that's all. Or something. The Monroe picture

9. Swenson, "What Is Pop Art?" 26.
10. *Philosophy of Andy Warhol,* 92.
11. Ibid., 149.
12. Read by Nicholas Love (1 April 1987).
13. *Philosophy of Andy Warhol,* 62.
14. Andy Warhol, Kasper König, K. G. Pontus Hulten, and Olle Granath, eds., *Andy Warhol* (Stockholm: Moderna Museet, 1968), n.p.

was part of a death series I was doing, of people who had died by different ways. There was no profound reason for doing a death series, no victims of their time; there was no reason for doing it all, just a surface reason.[15]

.

[On beginning the "death series":] I guess it was the big plane crash picture, the front page of a newspaper: 129 die. I was also painting the Marilyns. I realized that everything I was doing must have been Death. It was Christmas or Labor Day—a holiday—and every time you turned on the radio they said something like "4 million are going to die." That started it. But when you see a gruesome picture over and over again, it doesn't really have any effect.[16]

.

[On making Brillo boxes:] I did all the [Campbell's soup] cans in a row on a canvas, and then I got a box made to do them on a box, and then it looked funny because it didn't look real. I have one of the boxes here. I did the cans on the box, but it came out looking funny. I had the boxes already made up. They were brown and looked just like boxes, so I thought it would be great just to do an ordinary box.[17]

.

The farther west we drove [to California, fall 1963], the more Pop everything looked on the highways. Suddenly we all felt like insiders because even though Pop was everywhere—that was the thing about it, most people still took it for granted, whereas we were dazzled by it—to us, it was the new Art. Once you "got" Pop, you could never see a sign the same way again. And once you thought Pop, you could never see America the same way again. The moment you label something, you take a step—I mean, you can never go back again to seeing it unlabeled. We were seeing the future and we knew it for sure. We saw people walking around in it without knowing it, because they were still thinking in the past, in the references of the past. But all you had to do was know you were in the future, and that's what put you there. The mystery was gone, but the amazement was just starting.[18]

.

The Pop artists did images that anybody walking down Broadway could recognize in a split second—comics, picnic tables, men's trousers, celebrities, shower curtains, refrigerators, Coke bottles—all the great modern things that the Abstract Expressionists tried so hard not to notice at all.[19]

.

When you think about it, department stores are kind of like museums.[20]

.

15. Berg, "Andy: My True Story," 3.
16. Swenson, "What Is Pop Art?" 60.
17. Glenn O'Brien, "Interview: Andy Warhol," *High Times* 24 (August 1977): 34.
18. *POPism,* 39–40.
19. Ibid., 3.
20. Andy Warhol, *America* (New York: Harper and Row, 1985), 22.

The best atmosphere I can think of is film, because it's three-dimensional physically and two-dimensional emotionally.[21]

.

All my films are artificial, but then everything is sort of artificial. I don't know where the artificial stops and the real starts.[22]

.

What we'd had to offer—originally, I mean—was a new, freer content and a look at real people, and even though our films weren't technically polished, right up through '76 the underground was one of the only places people could hear about forbidden subjects and see realistic scenes of modern life.[23]

.

I think movies should appeal to prurient interests. I mean, the way things are going now—people are alienated from one another. Movies should—uh—arouse you. Hollywood films are just planned-out commercials. *Blue Movie* was real. But it wasn't done as pornography—it was an exercise, an experiment. But I really do think movies should arouse you, should get you excited about people, should be prurient.[24]

.

Before I was shot, I always thought that I was more half-there than all-there—I always suspected that I was watching TV instead of living life. People sometimes say the way things happen in movies is unreal, but actually it's the way things happen to you in life that's unreal. The movies make emotions look so strong and real, whereas when things really do happen to you, it's like watching television—you don't feel anything. Right when I was being shot and ever since, I knew that I was watching television. The channels switch, but it's all television. When you're really involved with something, you're usually thinking about something else. When something's happening, you fantasize about other things. When I woke up somewhere—I didn't know it was at the hospital and that Bobby Kennedy had been shot the day after I was—I heard fantasy words about thousands of people being in St. Patrick's Cathedral praying and carrying on, and then I heard the word "Kennedy" and that brought me back to the television world again because then I realized, well, here I was, in pain.[25]

.

The acquisition of my tape recorder really finished whatever emotional life I might have had, but I was glad to see it go. Nothing was ever a problem again, because a problem just meant a good tape, and when a problem transforms itself into a good tape it's not a problem any more. An interesting problem was an interesting tape. Everybody knew that and performed for the tape. You couldn't tell which problems were real and which problems were exaggerated for the tape. Better yet, the people telling you the problems couldn't decide any more if they were really having the problems or if they were just performing. During the 60s, I think,

21. *Philosophy of Andy Warhol,* 160.
22. Read by Nicholas Love (1 April 1987).
23. *POPism,* 280.
24. Letitia Kent, "Andy Warhol, Movieman: 'It's Hard to Be Your Own Script,'" *Vogue* 155 (March 1970): 204.
25. *Philosophy of Andy Warhol,* 91.

people forgot what emotions were supposed to be. And I don't think they've ever remembered. I think that once you see emotions from a certain angle you can never think of them as real again. That's what more or less has happened to me.[26]

.

Interviews are like sitting in those Ford machines at the World's Fair that toured around while someone spoke a commentary. I always feel that my words are coming from behind me, not from me. The interviewer should just tell me the words he wants me to say and I'll repeat them after him. I think that would be so great because I'm so empty I just can't think of anything to say.[27]

.

Now and then someone would accuse me of being evil—of letting people destroy themselves while I watched, just so I could film them and tape record them. But I don't think of myself as evil—just realistic. I learned when I was little that whenever I got aggressive and tried to tell someone what to do, nothing happened—I just couldn't carry it off. I learned that you actually have more power when you shut up, because at least that way people will start to maybe doubt themselves. When people are ready to, they change. They never do it before then, and sometimes they die before they get around to it. You can't make them change if they don't want to, just like when they do want to, you can't stop them.[28]

.

A lot of people thought it was me everyone at the Factory was hanging around, that I was some kind of big attraction that everyone came to see, but that's absolutely backward: it was me who was hanging around everyone else. I just paid the rent, and the crowds came simply because the door was open. People weren't particularly interested in seeing me, they were interested in seeing each other. They came to see who came.[29]

.

You really have Social Disease when you make all play work. The only reason to play hard is to work hard, not the other way around like most people think.[30]

.

I suppose I have a really loose interpretation of "work," because I think that just being alive is so much work at something you don't always want to do. Being born is like being kidnapped. And then sold into slavery. People are working every minute. The machinery is always going. Even when you sleep.[31]

.

When I die I don't want to leave any leftovers. I'd like to disappear. People wouldn't say he died today, they'd say he disappeared. But I do like the idea of people turning into dust or

26. Ibid., 26–27.
27. Berg, "Andy: My True Story," 3.
28. POPism, 108.
29. Ibid., 74.
30. Andy Warhol's Exposures (New York: Andy Warhol Books/Grosset and Dunlap, 1979), 19.
31. Philosophy of Andy Warhol, 96.

sand, and it would be very glamorous to be reincarnated as a big ring on Elizabeth Taylor's finger.[32]

.

I never understood why when you died, you didn't just vanish, and everything could just keep going the way it was only you just wouldn't be there. I always thought I'd like my own tombstone to be blank. No epitaph, and no name. Well, actually, I'd like it to say "figment."[33]

JAMES ROSENQUIST The F-111: An Interview with G. R. Swenson (1965)

G. R. SWENSON: What is the F-111?

JAMES ROSENQUIST: It is the newest, latest fighter-bomber at this time, 1965. This first of its type cost many million dollars. People are planning their lives through work on this bomber, in Texas or Long Island. A man has a contract from the company making the bomber, and he plans his third automobile and his fifth child because he is a technician and has work for the next couple of years. Then the original idea is expanded, another thing is invented; and the plane already seems obsolete. The prime force of this thing has been to keep people working, an economic tool; but behind it, this is a war machine.

GRS: What about the man who makes the F-111?

JR: He is just misguided. Masses of people are being snagged into a life and then continue that life, being enticed a little bit more and a little bit more in the wrong direction.

GRS: What have you tried to do in this painting?

JR: I think of it like a beam at the airport. A man in an airplane approaching a beam at the airport, he may fly twenty or thirty miles laterally, out of the exact way, but he continues to be on the beam. As he approaches closer to what he wants, or to the airport, he can be less divergent because the beam is a little narrower, maybe only one or two miles out of the way, and less and less until when he gets right on it; then he'll be there.

The ambience of the painting is involved with people who are all going toward a similar thing. All the ideas in the whole picture are very divergent, but I think they all seem to go toward some basic meaning. They're divergent so it's allowable to have orange spaghetti, cake, light bulbs, flowers. . . .

GRS: Going toward what?

JR: Some blinding light, like a bug hitting a light bulb.

I think of the picture as being shoveled into a boiler. The picture is my personal reaction as an individual to the heavy ideas of mass media and communication and to other ideas that affect artists. I gather myself up to do something in a specific time, to produce something that could be exposed as a human idea of the extreme acceleration of feelings. The way technology appears to me now is that to take a stance—in a painting, for example—on some human qualities seems to be taking a stance on a conveyor belt: the minute you take a position on a question or on an idea, then the acceleration of technology, plus other things,

32. Read by Nicholas Love (1 April 1987).
33. *America,* 128–29.
* G. R. Swenson, excerpts from "The F-111: An Interview with James Rosenquist," in *Partisan Review* 32, no. 4 (Autumn 1965): 589–601. By permission of James Rosenquist/Licensed by VAGA, New York, NY.

will in a short time already have moved you down the conveyor belt. The painting is like a sacrifice from my side of the idea to the other side of society.

I can only hope to grasp things with the aid of a companion like an IBM machine. I would try to inject the humanity into the IBM machine; and myself and it, this extreme tool, would go forward.

I hope to do things in spite of my own fallacies.

If a company or institution is using people like digits and massing them in schools of learning toward appreciating new ideas and new inventions, I react to that and try to pose a problem to think in terms of humanity again. So this picture is partial, incomplete maybe, but a fragment I am expending into the boiler. . . . The style I use was gained by doing outdoor commercial work as hard and as fast as I could. My techniques for me are still anti-style. I have an idea what I want to do, what it will look like when I want it finished—in between is just a hell of a lot of work.

When they say the Rosenquist style is very precise, maybe they just know that painting style as they know it is going out of style. Ways of accomplishing things are extended to different generations in oblique places. Billboard painting techniques are much like Mexican muralist techniques.

The "F-111" was enclosed—four walls of a room in a gallery. My idea was to make an extension of ways of showing art in a gallery, instead of showing single pictures with wall space that usually gives your eye a relief. In this picture, because it did seal up all the walls, I could set the dial and put in the stops and rests for the person's eye in the whole room instead of allowing the eye to wander and think in an empty space. You couldn't shut it out, so I could set the rests.

GRS: Put in relief?

JR: Such as a light sky-blue area, which I've always felt as a relief. Or the one empty wall space with the missing canvas.

At first the missing panel was just to expose nature, that is, the wall wherever it was hung; and from there of course would be extended the rest of the space wherever it was exhibited. In the gallery the painting was a cube or a box where the only area left on the walls was the "missing" panel. At one time I planned to hang a plexiglass panel over it: you would look through it and still be exposed to the wall. . . .

Originally the picture was an idea of fragments of vision being sold, incompleted fragments; there were about fifty-one panels in the picture. With one of them on your wall, you could feel something of a nostalgia, that it was incomplete and therefore romantic. That has to do with the idea of the man now collecting, a person buying a recording of the time or history. He could collect it like a fragment of architecture from a building on Sixth Avenue and Fifty-second Street; the fragment even now or at least in the near future may be just a vacant aluminum panel whereas in an earlier period it might have been a fancy cornice or something seemingly more human.

Years ago when a man watched traffic going up and down Sixth Avenue, the traffic would be horses and there would be a pulsing, muscular motion to the speed on the avenue. Now what he sees may be just a glimmer, a flash of static movement; and that idea of nature brings a strange, for me even now, a strange idea of what art may become, like a fragment of this painting which is just an aluminum panel. . . . I wanted to relate the idea of the new man, the new person who appreciates things, to this painting. It would be to give the idea to people of collecting fragments of vision. One piece of this painting would have been a frag-

ment of a machine the collector was already mixed up with, involved in whether he knew it or not. The person has already bought these airplanes by paying income taxes or being part of the community and the economy. Men participate in the world whether it's good or not and they may physically have bought parts of what this image represents many times.

Then anyone interested in buying part of this, knowingly or unknowingly—that's the joke—he would think he is buying art and, after all, he would just be buying a thing that paralleled part of the life he lives. Even though this picture was sold in one chunk, I think the original intention is still clear. The picture is in parts. . . .

GRS: You were quoted in the *Times* as saying that you wanted this painting to be an antidote to the new devices that affect the ethics of the human being. . . .

JR: Yes. I hope this picture is a quantity that will release the idea of the new devices; my idea is that a man will turn to subversion if he even hears a rumor that a lie detector will be used on him in the normal course of business. What would happen if a major corporation decided to use all the new devices available to them? I'm sure the hint of this is starting to change people's ethics.

I said this picture was an antidote. To accumulate an antidote is to shift gears, to get to an area where an artist can be an effect. To get to another strata—anti-style could be a lever. . . .

I see a closer tie with technology and art and a new curiosity about new methods of communication coming from all sides. The present position of an artist seems to be a person who offers up a gift, an antidote to something, a small relief to a heavy atmosphere. A person looking at it may say, "That's beautiful, amazing, fantastic, a nice thing." Artists seem to offer up their things with very much humility and graciousness while society now and the economy seem to be very rambunctious. The stance of the artists now, compared with the world and the ideas in society, does not seem to equate; they don't relate except as an artist offering up something as a small gift. So the idea of this picture was to do an extravagance, something that wouldn't simply be offered as a relief.

LUCAS SAMARAS Another Autointerview (1971)

Why are you conducting this interview?
Because interview is a frequently abused form and self is a seemingly virginal patch of fertile content.
Why are you conducting this interview?
So that I can find out what's been declassified.
Why is that necessary?
It's a way to keep alert, a kind of sanitation.
Why are you conducting this interview?
So that I can protect myself.
From what?
From people's imagination.
How can you protect yourself with words?

* Lucas Samaras, "Another Autointerview," in *Samaras Album: Autointerview, Autobiography, Autopolaroid* (New York: Whitney Museum of American Art and Pace Editions, 1971), 5–7. By permission of the author.

Words ward off oblivion.

Why are you conducting this interview?

It's a way of releasing guilt.

Why are you conducting this interview?

I want to crystalize the daily situation of talking to myself.

Why are you conducting this interview?

In order to relax my mind from daily obsessions.

Why are you conducting this interview?

In order to formalize and isolate myself.

Why are you conducting this interview?

In order to enter the consciousness of others.

What are you?

A hunger.

What are you?

A smiling hunger.

What are you?

Inwardly I am an erotic sadness, outwardly I am a home-made process for unraveling meanings.

What are you?

I am an intermittent escapee from a more traditional behavior.

What makes you go away?

Desire for understanding.

What makes you come back?

Ancient uncontrollable signals.

What are you?

In the sense that I am an active irrational artist I am an early stage of a mutation. Also I am a beneficial impediment.

A what?

A slightly sadistic entertainer.

What are you?

An intense superstitious lover and hater of people.

What are you doing?

I am trying to synthesize love.

What are you doing?

Trying to evaluate and use what I've got.

How old are you?

Nineteen hundred and seventy-one.

Say it differently.

I am as old as the things I know.

How old are you?

I panic when I think of it.

Why?

It's a bowel-control anxiety.

How old are you?

Thirty-five.

How old is that?

Old enough to often get a stench of death.

What frightens you?

The separation between me and the things I see.

What frightens you?

The possibility for evil.

Are you a very moral person?

Outwardly yes. Inwardly I get glimpses of the cannibal, the selfish autocrat, the destroyer of things, the suicide.

What frightens you?

The needs of other people.

What is art?

The physical look of humanity.

Of what value is art?

It protects my adult existence.

How?

I can be pretty abnormal without having to isolatedly receive society's contempt or punishments. My separation is institutionalized.

Of what value is art?

It is a necessary component of being human.

Of what value is art?

It allows me to be revolutionary in a constitutional democracy.

Are you political?

Only in terms of art.

Why?

Regular society is out of my line.

Do you like society as it is now?

No, but neither do I like the weather.

Tell me a problem.

How can I get to accept, tolerate, live with and enjoy myself?

How do you cope with your body?

Carefully.

Is there something supernatural, undernatural or other about your body?

I sometimes control portions of it. I speak to it, telling it not to let me down. It's like another person. That's why when people make comments about my body I feel peculiar. They can't see my separation from it.

What do you fear about your body?

Its biology.

What do you fear about your mind?

Its passions.

What do you like about your body?

It takes me into the lives of other people.

What do you like about your mind?

Its conversation.

What's the most frequent question you ask yourself?

What am I going to do now.

Aren't you an artist?

Not always, there are unfortunate pauses, periods when I am anything but an artist.

When did you become an artist?

I set out to become one about twenty years ago. I was told that I was one about ten years ago, and now I am beginning to feel unembarrassed by it.

What embarrassment?

The proximity to the great men of the past.

What embarrassment?

The jealousy of other people.

What embarrassment?

The formal exposure of my psyche.

Is it very embarrassing?

No. It used to be embarrassing. Now there is some satisfaction in not being embarrassed by it any more.

What are the first questions you ask others?

What do you want from me and what do you have that I may want.

Does it work?

No. I have to deduce their answer through their actions and it might take between a week and two years.

Do you like others?

Yes.

Why don't you live with others on a daily basis?

Because I haven't found a good servant-master.

How come other people manage?

It's a wonder to me.

What are you?

I am everything that everybody is only differently.

Isn't everybody like that?

Yes.

Tell me more.

The word artist says enough.

Are you an object maker?

I am a thing maker.

What's the difference?

A thing is less clear and more inclusive.

Do you like well made things?

Yes. Well made things including well made thoughts. I also like things that are not well made, but I like them less. Sometimes I like terrible things.

Are you accepted as an artist?

By some. Most of my work was done to prove to others including myself that I was an artist rather than because I was one. Or it was the opposite. One doesn't always know what one is.

Do you like to be called artist?

Sometimes I like it, sometimes I don't. I like antagonism and temporary anonymity.

If you were alone in the world would you be an artist?

I am alone in the world.

Are you alone in the world?

I am alone in a world full of nice and unnice people.

For whom are you making art?

For the adults in my past, for anyone who will look and wonder and let me live, and for the unnamables who will come in the future.

Why are you making art?

So that I can forget my separateness from everything else.

What are you running away from?

From people's evaluations.

Why are you sentimental?

Because I am unsatisfied.

What did one year of therapy do for you?

It was better than taking a course in psychology.

What is interesting about psychology?

The adults in my past talked about it with a mixture of respect and horror. They loved to tell me that if one read or thought too much or too long one became crazy. I was interested in this curious mind that could spoil under misuse.

Why didn't you become a psychologist?

The course I took in college was full of dull charts and statistics. I wasn't interested in math.

Are you nice to people?

No. I am accurate about my feelings.

Do you want to be wealthy?

Not any more.

Why?

Wealth is a profession.

Don't you want to have wealth?

I want just enough to live and do my work without feeling that I have to give something away out of guilt or generosity.

What's wrong with generosity?

It perpetuates a moneyed aristocracy.

Do you want your work to be preserved?

Either actually or photographically or descriptively.

What's the need for a tomb?

I want my spiritual and corporeal hunger to be remembered.

Why don't you keep your problems and your pleasures to yourself?

Because I'm universalizing them.

Isn't that a little pretentious?

No, it's a little fatherly.

Why is it easier to make art than to deal with people?

Making art is dealing with people on your own terms. The ideal way of using people is using them like clay, but that being out of the question, except for lunatics and leaders, art is a good alternative.

Why is art a profession?

Because it's hard work. Besides, all parts of awareness are categorized and professionalized.

Since when?

Ever since humanity.

Are you a professional artist?

Well, I find it weird being called professional. After I've done some art I'm pretty much where I started from even if I'm not. Art stops being what I made and it has to be something I haven't made. Tomorrow I may not be able to do art. There is no guarantee.

What has the acceptance of your work by others done to your character?

It has erased my ninety-five-pound weakling image.

Tell me a problem.

I have difficulty in understanding how the world began, if it did begin, how did I begin, if I did begin, and how does anything I do begin. I have a few minutes of intelligent perplexity whenever I bring up these enigmas and then I get drowsy and want to sleep in someone's protective amplitude.

Who is that someone?

A conglomerate of many people from my past, particularly those who knew more than I did.

What word describes your dealings with people?

In terms of feeling the word is eroticism, in terms of dealing the word is criticism.

How criticism?

I am question-oriented. I ask why to anything that is presented as fact. It puts people on the defensive and often they expose some privacies.

Why do you like to see their weapons?

It's a kind of knowledge, sniffing them out to see if they are like me or if they are different, how they are different from the people that they remind me of.

Are you superstitious?

In my conscious dealings I always leave a margin for the unexpected.

Are you an indoors person or an outdoors person?

Indoors. The outdoors is a luxury and a drug. Going out is like going on an expedition even if I'm going out to buy some bread.

Why do you dislike leaving your house?

Someone might call me.

Why do you dislike leaving your house?

I might get lost or lose all the people I've known.

Why do you like the indoors?

Because I'm domesticated.

What does that mean?

It's a contemplative situation.

Isn't contemplation possible outdoors?

There are too many distractions and dissatisfactions with the multiple presentations of beauty.

Why don't you drive?

I don't trust my killer instincts.

Do you kill the animals you eat?

I kill the containers in which the flesh of the animals is packed.

Do you have any animals?

Only those that come of their own suicidal accord like roaches, spiders, flies, moths and mosquitoes.

Do you have any things that move in your apartment?

The TV, gas flame and water.

What is your reflection to you?

A disembodied relative.

Does your apartment tend to be sparse or cluttered?

Cluttered. I like to have within visual and physical grasp the tools and materials that I work with.

Do you live where you work?

Yes. There is a mixing of the two.

Have you considered yourself as a work?

I have been working on that.

Are you Christifying yourself?

Everything is traceable to everything else.

Why do you want a megaphone, why reach millions?

I don't want to reach millions but the equivalent of myself among those millions.

What for?

For continuity.

RAY JOHNSON What Is a Moticos? (1954)

The next time a railroad train is seen going its way along the track, look quickly at the sides of the box cars because a moticos may be there. Whether the train is standing still or speeding past you, a moticos[1] Don't try to catch up with it. It wants to go its way. But have your camera ready to snap its picture. It likes those moments of being inside the box. When your film is printed and the moticos is finally seen, it will not be seen, unless you paste the photograph of the moticos on the side of a box car so someone can see the moticos or take its picture. It may appear in your daily newspaper. Someone may put it there. Cut it out. Save it. Treasure it. Make sure it is in a box or between the pages of a book for your grandchildren to find and enjoy.

The moticos is not only seen on railroad trains, but on It really isn't necessary to see the moticos or know where it is because I have seen them. Perhaps I might point them out to you. The best way is to go about your business not thinking about silly moticos because when you begin seeking them, describing what they are or where they are going is So just make sure you wake up from sleeping and go your way and go to sleep when you will. The moticos does that too and does not worry about you. Perhaps *you* are the moticos. Destroy this. Paste the ashes on the side of your automobile and if anyone asks you why you have ashes pasted on the side of your car, tell them.

Or write the word *moticos* on the top of your automobile. It loves moving and rain water. Not so many people will wonder what it means. There will be no questions, hence no need for answers. And if you have an automobile, drive to pleasant places because Have you seen a moticos lately? Perhaps you have. They are everywhere. As I write this I wish someone were here to point one out to me because I know they exist.

* Ray Johnson, "What Is a Moticos?" (1954), previously unpublished manifesto. By permission of the author.
1. *Editors' Note:* On November 3, 1994, Ray Johnson, in response to questions from Kristine Stiles about the blank spaces and unfinished sentences in this text, said, "I don't know." When pressed further, Johnson again responded, "I don't know." After a long silence, Johnson said, "Why don't you put in 'I don't know'?" Johnson's responses are particularly poignant in light of his suicide on January 13, 1995.

April 5, 1973

Deaths
New York Times
229 West 43 Street
New York City 10036

Dear Deaths:

The New York Correspondence School, described by critic
Thomas Albright in "Rolling Stone" as the ."oldest and most
influential" died this afternoon before sunset on a beach
where a large Candian goose had settled down on it's Happy
Hunting Ground, was sitting there obviously very tired and
ill and I said to it "Oh, you poor thing". It mustered up
whatever strength it had and waddled away from me, "How
beautiful!" I thought, "How like a bird - about to die and
yet having some courage to try to go on". And then it
lifted it's legs and wings and shit out some black shit
it was such a large heavy bird it flapped it's wings and I
studied the curve of the wings I thought Anne Wilson would
like to see them. It just wanted to be alone to die without
a human standing there talking to it. I felt so bad. So it
flew off and soon I was aware I couldn't see it anymore it
had gone. Maybe if I go back there tomorrow, the tide will
have washed up it's feathery body.

Ruth Ford died her black hair blonde.

I telephoned her, "Breeze From the Gulf".

The stars look very different today. Ground Control to
Major Tom. Time to leave the Capsule. I'm stepping through
the door. Tell my wife I love her very much.

Most sincerely yours,

Buddha University

Ray Johnson, *Deaths,* letter to the *New York Times,* 5 April 1973. By permission of the artist.

EDWARD RUSCHA Concerning *Various Small Fires* (1965)

I—when I am planning a book, I have a blind faith in what I am doing. I am not implying I don't have doubts, or that I haven't made mistakes. Nor am I really interested in books as such, but I am interested in unusual kinds of publications. The first book came out of a play with words. The title came before I even thought about the pictures. I like the word "gasoline"

* Edward Ruscha, excerpts from "Concerning *Various Small Fires:* Edward Ruscha Discusses His Perplexing Publications," *Artforum* 3, no. 5 (February 1965): 24–25; reprinted in Ursula Meyer, *Conceptual Art* (New York: E. P. Dutton, 1972), 206. By permission of the author and *Artforum.*

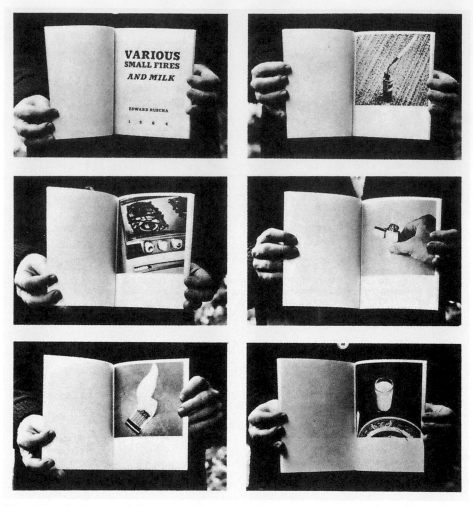

Edward Ruscha, *Various Small Fires and Milk,* 1964, self-published photographic book. By permission of the artist.

and I like the specific quality of "twenty-six." If you look at the book you will see how well the typography works—I worked on all that before I took the photographs. Not that I had an important message about photographs or gasoline, or anything like that—I merely wanted a cohesive thing. Above all, the photographs I use are not "arty" in any sense of the word. I think photography is dead as a fine art; its only place is in the commercial world, for technical or information purposes. I don't mean cinema photography, but still photography, that is, limited edition, individual, hand-processed photos. Mine are simply reproductions of photos. Thus, it is not a book to house a collection of art photographs—they are technical data like industrial photography. To me, they are nothing more than snapshots. . . .

Many people buy the books because they are curiosities. For example, one girl bought three copies, one for each of her boyfriends. She said it would be a great gift for them, since they had everything already. . . .

I have eliminated all text from my books—I want absolutely neutral material. My pictures

are not that interesting, nor the subject matter. They are simply a collection of "facts"; my book is more like a collection of Ready-mades. . . .

All my books are identical. They have none of the nuances of the hand-made and crafted limited edition book. It is almost worth the money to have the thrill of seeing 400 exactly identical books stacked in front of you. . . .

JUDY CHICAGO *The Dinner Party: A Symbol of Our Heritage* (1979)

During a trip up the northwest coast in the summer of 1971, I stumbled onto a small antique shop in Oregon and went in. There, in a locked cabinet, sitting on velvet, was a beautiful hand-painted plate. The shopkeeper took it out of the case, and I stared at the gentle color fades and soft hues of the roses, which seemed to be part of the porcelain on which they were painted. I became enormously curious as to how it had been done. The next year I went to Europe for the first time and found myself almost more interested in cases of painted porcelain than in the endless rows of paintings hanging on musty museum walls.

Classically trained as a fine artist, I felt somewhat uneasy with my interest in decorative arts. But I was sufficiently fascinated by the china-painting I had seen in Europe to enroll in a class given at a small shop in Los Angeles in the fall of 1972. The first class consisted of learning to mix pigments with what seemed like very exotic oils and then practicing to make dots, dashes, and commas, which, I was told, were the basic components of china-painting brushwork. We also learned how to thin down our paint so it would flow through a crow-quill pen point for line work. We then traced some forget-me-nots onto gleaming white porcelain plates and proceeded to do the pen work we had learned.

I soon realized that this hobbyist approach was not what I had in mind. I wanted to learn the basic components of the china-painting medium and use it for a new work—a series of painted plates that related to the series of paintings I had been doing, entitled "Great Ladies." These abstract portraits of women of the past were part of my personal search for a historical context for my art. After having worked on plexiglass for a number of years, I was now spraying paint on canvas. But I was dissatisfied with the way the color sat on top of the canvas surface instead of merging with it, as it had done on the plastic. I also wanted to use a brush again, thus allowing a contact with the paint surface that cannot be achieved by spraying.

The rose plate I had seen in Oregon suggested not only another painting technique, but also another format for my "Great Ladies." Since plates are associated with eating, I thought images on plates would convey the fact that the women I planned to represent had been swallowed up and obscured by history instead of being recognized and honored. I originally conceived of one hundred plates, which would hang on the wall as paintings normally do; the idea of setting the plates on a table came later.

Although the china-painting class left much to be desired, something else was beginning to unfold. I had been a "serious" art student from the time I was young, and later I became deeply involved in the art world. The women in this class were primarily housewives interested in filling their spare time. However, they also genuinely wanted to find a way to create some-

* Judy Chicago, excerpts from *The Dinner Party: A Symbol of Our Heritage* (Garden City, NY: Anchor Press/ Doubleday, 1979), 8–20, 52–56. © Judy Chicago. By permission of the author.

thing of value, and, as I learned more about the china-painting world, I realized that a number of these women were dedicated professionals as well. Shortly after I left the class, a sculptor friend of mine, Bruria, introduced me to Miriam Halpern, a china-painter who was sophisticated about art. Mim agreed to teach me, with the understanding that I didn't want to learn to paint forget-me-nots, but rather to develop an overall knowledge of china-painting techniques. . . .

During the year and a half I studied china-painting, I attended exhibitions, met painters, visited their houses, and asked questions about the history of china-painting. I learned that for the last thirty or forty years, china-painting had been entirely in the hands of these women and they had been responsible for preserving this historic technique. In the 1950's, a number of china-painters began to organize classes, shows, and publications. Before that, one could only learn the technique through one's mother or grandmother. Many women worked full-time in their home studios—painting, teaching, and showing. Despite the fact that some of them had been painting for as long as forty years, they didn't know how, nor did they have the resources, to present their work properly; it was poorly exhibited, improperly installed, and inadequately lighted, and it sold for outrageously low prices. Many china-painters had gone to art school when they were young and had soon married and had children. They later looked for a way to express themselves that did not require—as it did for so many professional artists—a choice between their family life and their work. . . .

The china-painting world, and the household objects the women painted, seemed to be a perfect metaphor for women's domesticated and trivialized circumstances. It was an excruciating experience to watch enormously gifted women squander their creative talents on teacups. I wanted to honor the women who had preserved this technique, and, by making china-painting visible through my work, I hoped to stimulate interest in theirs.

I finished my studies by 1974, and by that time my plan had changed. I had discarded the idea of painting a hundred abstract portraits on plates, each paying tribute to a different historic female figure. Instead, I was thinking about a series called "Twenty-five Women Who Were Eaten Alive." In my research I realized over and over again that women's achievements had been left out of history and the records of their lives had apparently disappeared. My new idea was to try to symbolize this. I had seen a traditional dinnerware set that had taken its creator, Ellie Stern, three years to paint. It made me think about putting the plates on a table with silver, glasses, napkins, and tablecloths, and over the next year and a half the concept of *The Dinner Party* slowly evolved. I began to think about the piece as a reinterpretation of the Last Supper from the point of view of women, who, throughout history, had prepared the meals and set the table. In my "Last Supper," however, the women would be the honored guests. Their representation in the form of plates set on the table would express the way women had been confined, and the piece would thus reflect both women's achievements and their oppression.

There were thirteen men present at the Last Supper. There were also thirteen members in a witches' coven, and witches were always associated with feminine evil. The fact that the same number had both a positive and a negative connotation seemed perfect for the dual meaning of the piece; the idea of twenty-five plates therefore gave way to thirteen. . . .

As long as women's achievements were excluded from our understanding of the past, we would continue to feel as if we had *never* done anything worthwhile. This absence of any sense of our tradition as women seemed to cripple us psychologically. I wanted to change that, and I wanted to do it through art.

My goal with *The Dinner Party* was consistent with all my efforts in the previous decade.

I had been trying to establish a respect for women and women's art; to forge a new kind of art expressing women's experience; and to find a way to make that art accessible to a large audience. I firmly believed that if art speaks clearly about something relevant to people's lives, it can change the way they perceive reality. In a similar way medieval art had been used to teach the Bible to illiterate people. Since most of the world is illiterate in terms of women's history and contributions to culture, it seemed appropriate to relate our history through art, particularly through techniques traditionally associated with women—china-painting and needlework. . . .

The women represented at the *Dinner Party* table are either historical or mythological figures. I chose them for their actual accomplishments and/or their spiritual or legendary powers. I have brought these women together—invited them to dinner, so to speak—in order that we might hear what they have to say and see the range and beauty of our heritage, a heritage we have not yet had an opportunity to know.

These guests, whether they are real women or goddess figures, have all been transformed in *The Dinner Party* into symbolic images—images that stand for the whole range of women's achievements and yet also embody women's containment. Each woman is herself, but through her can be seen the lives of thousands of other women—some famous, some anonymous, but all struggling, as the women on the table struggled, to have some sense of their own worth through five thousand years of a civilization dominated by men. The images on the plates are not literal, but rather a blending of historical facts, iconographical sources, symbolic meanings, and imagination. I fashioned them from my sense of the woman (or, if a goddess, what she represented); the artistic style of the time (when it interested me or seemed to have a potential to express something about the figure I was portraying); and my own imagery.

When I began working on the *Dinner Party* plates, I developed an iconography using the butterfly to symbolize liberation and the yearning to be free. The butterfly form undergoes various stages of metamorphosis as the piece unfolds. Sometimes she is pinned down; sometimes she is trying to move from a larva to an adult state; sometimes she is nearly unrecognizable as a butterfly; and sometimes she is almost transformed into an unconstrained being. . . .

There is a strong narrative aspect to the piece that grew out of the history uncovered in our research and underlying the entire conception of *The Dinner Party*. This historical narrative is divided into three parts, corresponding to the three wings of the table. The first table begins with pre-history and ends with the point in time when Greco-Roman culture was diminishing. The second wing stretches from the beginning of Christianity to the Reformation, and the third table includes the seventeenth to the twentieth centuries. Beginning with pre-patriarchal society, *The Dinner Party* demonstrates the development of goddess worship, which represents a time when women had social and political control (clearly reflected in the goddess imagery common to the early stages of almost every society in the world). The piece then suggests the gradual destruction of these female-oriented societies and the eventual domination of women by men, tracing the institutionalizing of that oppression and women's response to it.

During the Renaissance, the male-dominated Church—built in large part with the help of women—and the newly emerged, male-controlled State joined hands. They began to eliminate all who resisted their power—the heretics who held onto pre-Christian, generally female-oriented religions; the lay healers who continued to practice medicine in the face of increasing restrictions by the emerging medical profession; the political dissenters who chal-

lenged the corruption of the Church; the women who refused to submit to their husbands, to their fathers, and to the priests; those who insisted on administering the drug ergot to relieve the suffering of women in labor; those who helped women abort themselves; those who wished to practice sexual freedom; those who wanted to continue preaching or healing or leading social groups and religious groups; and all who resented and resisted the steady but inevitable destruction of what was left of female power. These women were harassed, intimidated, and—worst of all—burned, in a persecution whose real meaning has completely evaded the history taught to us today.

By the time of the Reformation, when the convents were dissolved, women's education—formerly available through the Church—was ended. Women were barred from the universities, the guilds, and the professions; women's property and inheritance rights, slowly eroded over centuries, were totally eliminated; and women's role was restricted to domestic duties. Opportunities were more severely limited than in pre-Renaissance society. The progress we have all been educated to associate with the Renaissance took place for men at the expense of women. By the time of the Industrial Revolution women's lives were so narrow, their options so few, there is little wonder that a new revolution began—a revolution that has remained hidden by a society that has not heard the voices raised in protest by women (as well as by some men) throughout the centuries.

The women represented in *The Dinner Party* tried to make themselves heard, fought to retain their influence, attempted to implement or extend the power that was theirs, and endeavored to do what they wanted. They wanted to exercise the rights to which they were entitled by virtue of their birth, their talent, their genius, and their desire, but they were prohibited from doing so—were ridiculed, ignored, and maligned by historians for attempting to do so—because they were women. . . .

Each plate is set on a sewn runner in a place setting that provides a context for the woman or goddess represented. The plate is aggrandized by and contained within that place setting, which includes a goblet, flatware, and a napkin. The runner in many instances incorporates the needlework of the time in which the woman lived and illuminates another level of women's heritage. The place settings are placed on three long tables—which form an equilateral triangle—covered with linen tablecloths. On the corners of the tables are embroidered altar cloths carrying the triangular sign of the Goddess. The tables rest on a porcelain floor composed of over 2,300 hand-cast tiles, upon which are written the names of 999 women. According to their achievements, their life situations, their places of origin, or their experiences, the women on the Heritage Floor are grouped around one of the women on the table. The plates are the symbols of the long tradition that is shared by all the women in *The Dinner Party*. The floor is the foundation of the piece, a re-creation of the fragmented parts of our heritage, and, like the place settings themselves, a statement about the condition of women. The women we have uncovered, however, still represent merely a part of the heritage we have been denied. If we have found so much information on women in Western civilization during the duration of this project, how much more is there still? Moreover, what about all the other civilizations on Earth?

The Dinner Party takes us on a tour of Western civilization, a tour that bypasses what we have been taught to think of as the main road. Yet it is not really an adequate representation of feminine history—for that we would require a new world-view, one that acknowledges the history of both the powerful and the powerless peoples of the world. As I worked on research for *The Dinner Party* and then on the piece itself, a nagging voice kept reminding me that the women whose plates I was painting, whose runners we were embroidering, whose

names we were firing onto the porcelain floor, were primarily women of the ruling classes. History has been written from the point of view of those who have been in power. It is not an objective record of the human race—we do not know the history of humankind. A true history would allow us to see the mingled efforts of peoples of all colors and sexes, all countries and races, all seeing the universe in their own diverse ways.

FAITH RINGGOLD Interview with Eleanor Munro (1977)

Mostly, I remember people. Faces of people. Everything about people. And then, early on, I got involved with the souls of people.

I was born in Harlem in 1930, in the deep Depression. But that Harlem was different. It was a highly protective place. Almost an extended family. My father drove a truck for the Sanitation Department, a good job in those days. Then as people began to lose their jobs, cousins and other relatives came up from the South. So there were relatives around, and these gave us a feeling of community.

My father taught my brother to protect my mother and us girls. He brought him up to understand that idea. That to him was being a man. Therefore though we've lived in Harlem all these years, the women in my family have no tales to tell of muggings or rapes. My mother too was consistently presenting a wholesome picture of life to us. She was what some would call a "good Christian woman." Today I'd shorten that to a "good woman." She was trained as a fashion designer and was always sewing. If I'd been left alone, I'd have done my own kind of thing earlier based on sewing. As it was, it wasn't until the Women's Movement that I got the go-ahead to do that kind of work.

When I was about two, I got asthma, and this affected my life in many ways. The days when I lay in bed were the foundation of my life as an artist. It was just me and my mother in a nice quiet place. She was industrious, always doing things, and there I was, making things in my bed: drawings, watercolors, all kinds of things. When I look today at how I manipulate cloth to make sculptural forms, I know for a fact that I am doing what I wanted to do from early childhood when I was sitting in bed with asthma. And as I consider how I have moved and developed, I get another feeling: that what I am doing now is the completion of something, the solution to problems that began way back there. I was spoiled and pampered. And I got the impression that life should adjust to me. That I ought to enjoy life. There should be more enjoyment than pain. Then, when I was very young, Mother and Father separated, and he would come on his days off and get me and take me here and there to show me off, sit me on a bar and show how I could read off the signs. The bartender would keep my milk ready for me. My father was probably the first to teach me to read, from the signs in the bars.

And Mother taught me at home; the teacher kept her informed. And all through school, though I never thought of art in a professional way, art was fun. It was something I could do alone, and I've always been a person who knows how to enjoy time spent alone.

I didn't think of art as a profession until I graduated from high school and the question of a career came up. In 1948 I went to City College. There I copied Greek busts and got a sound background in Western art. Greek sculpture. Compositions after Degas. Then I began to feel

* Eleanor Munro, excerpts from an interview (1977) with Faith Ringgold, in Munro, *Originals: American Women Artists* (New York: Simon and Schuster, 1979), 409–16. By permission of the author and the publisher.

that though I'd done the exercises fairly well, I wanted something more. But I didn't know how to get from Degas and the Greek busts . . . to Faith. That would take me considerable time. . . .

I had no background. No knowledge about the visual arts of black people. I appreciated the beauty of European art. The Rembrandts at the Uffizi anyone can appreciate. But I understood that that wasn't my heritage, the way you can enjoy a Chinese dinner and still not want to cook Chinese all the time.

Most black people who are artists have the same problem. Even if you want to adopt a culture that isn't yours, you can't. The only way you can make works of art in another person's style is to copy, but then you have to keep on copying and going back for reference to things someone did in the past. It hampers your own development. It's making art from art instead of art from life.

Here was a serious problem, for instance: what color are people supposed to be? I couldn't truthfully sit down and paint people without deciding what color they were. I was painting black people in the European, Impressionist way, with a thick palette knife. As a matter of fact, I thought it was coming along nicely. And so in 1962 I decided it was time to start showing. So I got some introductions to galleries and went on down.

I showed one painting with flat posterish figures of white men in a strong Hard-Edge pattern, with blue-gray shadows on their faces, to a woman at the Contemporary Arts Gallery. She just laughed and said, "What's this?"

Then I went to the Ruth White Gallery. I took that same painting and some others, of trees and flowers. I showed them to her and she said, "Do you know where you are?" I said yes. She said, "Are you sure?" And I said, "Yes. On East Fifty-seventh Street." And she looked at me and said, "You can't do this. *You can't do this!*" And she was being honest.

I looked at her, and then I noticed Birdie, my husband, looking at the exhibition in her gallery. I saw there was every style of painting in there. But the idea was: This is not something *you* can do. This does not come out of *your* experience. You have to make your own contribution. We left, and my husband said to me, "Now, don't get angry. But she said something very valuable in there. There's a lot of that kind of art in there already. But the point is, *you* can't do it." Therefore I tried to develop a style of painting related to what I imagined to be the African idiom. I still painted figures, but without the use of chiaroscuro—realistic but flat—to lend a high degree of visibility to the image of the American black person. And as a matter of fact, African art achieves something of the same result. By its decorative, flat appearance, it helps project the real look of black people. If you have a dark form, and you modulate it with shadows, you have nothing. But if you flatten it out and indicate the shadows in flat, contrasting colors, you have a strong pattern.

In 1967, I completed and exhibited a work in that genre titled *Die,* a twelve-foot-wide mural depicting a street riot. I carried the theme forward and three years later showed a group I called "American Black." One of these paintings was *Flag for the Moon, Die Nigger.* The Chase Manhattan Bank almost bought that one, until they noticed the words of the title worked into the design. Then they turned it down and bought another. Political art was taboo then as always. I was wasting my time trying to develop as an artist without an audience.

I made some stylistic changes. I decided to take the white pigment out of my painting. When you use oils, you use a lot of white. After a while, you may lose your sensitivity to other colors. The white gathers all the light. And I wanted to paint dark tones like Ad Reinhardt. To create *black light.* He was dead by then, so I couldn't ask him how he did it.

Finally I worked it out by using dry pigment with burnt umber and making my own oil base. Then, in 1971, I got a CAPS grant to do a mural for the Women's House of Detention on Rikers Island.

The inmates wanted me to show women of all ages and all races, a parable about rehabilitation. One of them asked me to paint "a long road leading out of here." Another asked for "all the children with God in the middle." All of them agreed they wanted to see no crime, no ghetto, no poverty. So I gave them a Feminist composition: a woman as President, a policewoman, a sportswoman, a mother giving a bride away, a woman priest, a woman doctor, a white woman with a mixed-race child, and women musicians.

That mural was well received, but I had had a terrible time walking it down fourteen flights of stairs. It was too large to fit into the elevator. So I decided, no more heavy pictures. There are enough roadblocks in front of a woman artist anyway. Thereafter, I made paintings matted upon lengths of cloth that could be rolled up—like Tibetan tankas. . . .

I became a Feminist in 1970. It happened the day I decided to launch a protest against an exhibit, to be held at the School of Visual Arts in New York, protesting the U.S. policy of war, repression, racism and sexism—an exhibit that itself was all male! I declared that if the organizers didn't include fifty percent women, there would be "war." Robert Morris, the organizer, agreed to open the show to women, and that was, so far as I'm concerned, the beginning of the Women's Movement in New York. Later there were demonstrations at the Whitney Museum and other places.

Two years after that, I went to Europe for the Documenta Exhibition in Kassel, Germany. The theme was a political one that year, and I thought it would be good to see and be included in it. So I took some posters I'd made, called *U.S. of Attica,* and copies of the *Feminist Art Journal* and *Women's World* and simply entered them in the show. It seemed to me I was the only black person in the city. I decided I couldn't possibly be inconspicuous, so I just walked around in my bright colors and put my posters everywhere, on the floor, on the walls and in the bookstores.

By '73, however, I was ready for a new focus on things. And now, some years later, my politics have changed a great deal. I'm into a new way of dealing with both art and life. . . .

It began back around '72. I was doing a lot of traveling. And I began to see, truthfully, that black women were not working for their own liberation. I saw that large groups of black women were not moving out together. I began to see that I would have to do my working-out on my own. And that it would be a very lonely life.

I looked around and saw that our black families are crumbling. Our families, like yours, are breaking up today, and there's nothing to take their place. The push among blacks today is to gain political power. But that's no use unless the families are maintained. Anyone who wants power has to be supported. There's no better support than the family.

In 1973, that year of change, I had a ten-year retrospective of my oil paintings at Rutgers University in New Brunswick, New Jersey. I'd been teaching African crafts at Bank Street College in New York, beadwork, appliqué, mask-making and so on. A student of mine saw the show and afterward wrote me that she was disappointed in it. "I didn't see any of the techniques you teach us," she wrote. "Beading. Tie-dying. Why aren't you using the techniques of African women?"

Around that time, too, there was a good deal of questioning whether there is such a thing as Feminist art. I concluded that there might be, but that we haven't been free to explore it. And so I decided to experiment. To stop denying the part of me that loves making things with cloth. But I still wanted my art to have a more human dimension than the flat tankas.

As I set to work, I began to remember how, back in the 1930s when I was a child, people were close to other people. How Harlem then was a friendly beautiful place. I remembered there was a Mrs. Brown, who was like another mother to me. So I did Mrs. Brown in cloth, and sat her in a chair. Then I did Catherine, her child, and put her in her arms.

Florence was a beautiful woman. When we were little we used to love to sit and watch her dress up for parties. I would kiss her, hug her, rub her hair. A beautiful black woman. I made a sculpture of her.

All these black women had a sense of themselves. No shyness. No holding back. Doing the best they could with what they had.

On a trip to Africa in '76, I would see the same qualities. I saw the black woman as she is in her own environment: unafraid. She can go anywhere. She can get into a crowded bus with her breasts uncovered to nurse her baby, and any man there will come to her aid if she needs it.

Later, I did Wilt Chamberlain, seven foot three inches tall, just a natural-born sculpture. Rope inside for legs, loose long legs and high-heel white shoes. He even had a ding-dong. My husband said, "Don't make him with nothing in his pants. If someone unzips him, they'll think you're trying to make some kind of statement." All my people have their sexual parts, the women and the men. . . .

Then I created an environment called *Windows of the Wedding,* with a series of abstract tankas hanging around the room where I displayed the couples. The tankas were based on designs of the Kuba tribe: eight triangles inside a rectangle. Originally those designs spelled out words. The language is lost now. What I was doing was trying to devise a language meaningful to me.

JEFF DONALDSON Ten in Search of a Nation (1969)

The whole thing started slow, real slow . . . suffering through an outdoor art fair in a wealthier Chicago suburb one hot July day in 1962, I asked Wadsworth Jarrell if he thought it would be possible to start a "negro" art movement based on a common aesthetic creed. And having little else to do—the wealthy anglos were not buying that day—we rapped about the hip aesthetic things that a "negro" group could do. When the sun went down, we packed up our jive, drove home to Chicago and the lake breeze cooled the idea from our minds. But that was cool, it was only a daydream balloon ethered by ennui and the hot sun—we let it float. They were buoyant times. The "negro" sky was pregnant with optimistic fantasy bubbles in those days. Education. Integration. Accommodation. Assimilation. Overcomation. Mainstreamation. THE PROMISE OF AMERICA. We would be freed.

But this was before the Washington picnic, its eloquent dream and its dynamite reality at the church in Birmingham. This was before the very real physical end of Malcolm. And the end of the "negro" in many of us. And it was before James Chaney. Afro-American. Before Lumumba. Before Jimmie Lee Jackson. Before Selma. Black. Before the Meredith March. Black Power. Before Luthuli. Sammy Young, Jr., and the others. Before Watts and Detroit, Chicago, Harlem and Newark. Black Nationalism. More Balloons. Separation. Self-determination. We would be free.

* Jeff Donaldson, "Ten in Search of a Nation" (1969), *Black World* 19, no. 12 (October 1970): 80–89; reprinted in *Afri-Cobra III* (Amherst: University of Massachusetts Art Gallery, 1973). By permission of the author.

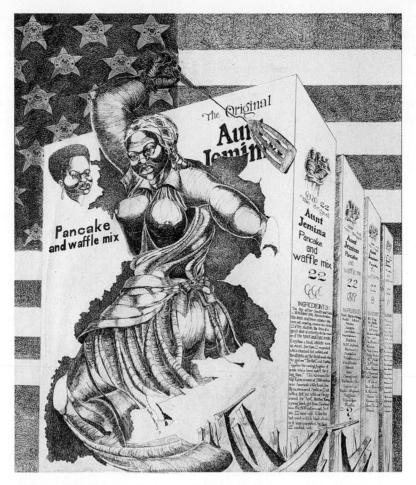

Murry N. DePillars, *Aunt Jemima,* 1968, pen and ink. By permission of the artist.

And the atmosphere of America became more electrically charged, the balloons jarringly shaken, many destroyed by the thunder and by the lightning of the real Amerika. And we (Jarrell, Barbara Jones, Carolyn Lawrence, me and other artists) bestirred ourselves, formed the OBAC (Organization of Black American Culture) artists' workshop and, following Bill Walker's lead, painted the Wall of Respect in Chicago. Black History. And thinking that we had done a revolutionary thing we rested and nodded anew, among the few remaining balloons.

And then the dreamer's dreamer had his balloon busted on a Memphis motel balcony. And that was the *last* balloon. And it was Chicago again and Harlem again, and San Francisco and D.C. and Cleveland and everywhere. And COBRA was born. And Law and Order. And off the pig. And we angrily realized that sleepers can die that way. Like Fred and Mark and very legally. And COBRA coiled angrily. Our coats were pulled. And the anger is gone. And yes, Imamu, it's Nation Time.

We are a family—COBRA, the Coalition of Black Revolutionary Artists, is now AFRICOBRA— African Commune of Bad Relevant Artists. It's nation time and we are searching. Our guidelines are our people—the whole family of African People, the African family tree. And in this

spirit of familyhood, we have carefully examined our roots and searched our branches for those visual qualities that are most expressive of our people/art. Our people are our standard for excellence. We strive for images inspired by African people/experience and images which African people can relate to directly without formal art training and/or experience. Art for people and not for critics whose peopleness is questionable. We try to create images that appeal to the senses—not to the intellect. The images you see here may be placed in three categories:

1. definition—images that deal with the past
2. identification—images that relate to the present
3. direction—images that look into the future.

It is our hope that intelligent definition of the past, and perceptive identification in the present will project nationfull direction in the future—look for us there, because that's where we're at.

This is "poster art"—images which deal with concepts that offer positive and feasible solutions to our individual, local, national, international, and cosmic problems. The images are designed with the idea of mass production. An image that is valuable because it is an original or unique is not art—it is economics, and we are not economists. We want everybody to have some.

Among our roots and branches we have selected these qualities to emphasize in our image-making—

(a) the *expressive awesomeness* that one experiences in African Art and life in the U.S.A. like the Holiness church (which is about as close to home as we are in this country) and the daemon that is the blues, Alcindor's dunk and Sayers's cut, the Hip walk and the Together talk.

(c) *symmetry* that is *free,* repetition with change, based on African music and African movement. The *rhythm* that is easy syncopation and very very human. Uncontracted. The rhythm the rhythm the rhythm rhythm rhythm

(f) images that mark the spot where the real and the overreal, the plus and the minus, the abstract and the concrete—the reet and the replete meet. *Mimesis.*

(g) *organic looking,* feeling forms. Machines are made for each other like we are made for each other. We want the work to look like the creator made it through us.

(B) This is a big one . . . *shine*—a major quality, a major quality. We want the things to shine, to have the rich lustre of a just-washed 'fro, of spit-shined shoes, of de-ashened elbows and knees and noses. The Shine who escaped the Titanic, the "li'l light of mine," patent leather. Dixie Peach. Bar BQ. fried fish, cars, ad shineum!

(z) *color* color Color color that shines, color that is free of rules and regulations. color that shines. color that is expressively awesome. color that defines, identifies and directs. Superreal color for Superreal images. The superreality that is our every day all day thang. color as bright and as real as the color dealing on the streets of Watts and the Southside and 4th street and in Roxbury and in Harlem, in Abidjan, in Port-au-Prince, Bahia and Ibadan, in Dakar and Johannesburg and everywhere we are. Coolade colors for coolade images for the superreal people. Superreal images for SUPERREAL people. Words can do no more with the laws—the form and content of our images. We are a family. Check the unity. All the rest must be sensed directly. Check out the image. The words are an attempt to posit where we are coming from and to introduce how we are going where we are going. Check out the image. Words do not define/describe relevant images. Relevant images define/describe themselves . . . dig on the

image. We are a family of image-makers and each member of the family is free to relate to and to express our laws in her/his individual way . . . dig the diversity in unity. We can be ourselves and be together, too. Check.

We hope you can dig it, it's about you and like Marvin Gaye says,

"You're what's happening in the world today, baby."

DAVID HAMMONS Interview with Kellie Jones (1986)

DAVID HAMMONS: I can't stand art actually. I've never, ever liked art, ever. I never took it in school.

KELLIE JONES: Then how come you do it if you can't stand it?

DH: I was born into it. That's why I didn't even take it in school, because I was born into it. All of these liberal arts schools kicked me out, they told me I had to go to a trade school. One day I said, "Well, I'm getting too old to run away from this gift," so I decided to go on and deal with it. But I've always been enraged with art because it was never that important to me. When I was in California, artists would work for years and never have a show. So showing has never been that important to me. We used to cuss people out: people who bought our work, dealers, etc., because that part of being an artist was always a joke to us.

But like someone told me, "Art is an old man's game, it's not a young man's profession." He said it was a very lonely, lonely, lonely profession. Most people can't deal with all the loneliness of it. That's what I loved about California though. These cats would be in their sixties, hadn't had a show in twenty years, didn't want a show, paint everyday, outrageous stamina. They were like poets, you know, hated everything walking, mad, evil; wouldn't talk to people because they didn't like the way they looked. Outrageously rude to anybody, they didn't care how much money that person had. Those are the kind of people I was influenced by as a young artist. Cats like Noah Purifoy and Roland Welton. When I came to New York, I didn't see any of that. Everybody was just groveling and tomming, anything to be in the room with somebody with some money. There were no bad guys here; so I said, "Let me be a bad guy," or attempt to be a bad guy, or play with the bad areas and see what happens. . . .

It was a totally different thing when I came here [to New York] in 1974. It was a painter's town exclusively. If you weren't painting you could forget it. And I was doing body prints then and was moving into conceptual art. I had to get out of the body prints because they were doing so well. I was making money hand-over-fist. But I had run out of ideas, and the pieces were just becoming very ordinary, and getting very boring. I tried my best to hold on to it. It took me about two years to find something else to do.

I came here with my art in a [mailing] tube. I had a whole exhibition in two tubes. I laid that on the people here and they couldn't handle it, nothing in it was for sale. This was after the body prints. This was after I had taken off for a couple of years and come up with an abstract art that wasn't salable. These things were brown paper bags with hair, barbecue

* Kellie Jones, excerpts from "David Hammons," REAL LIFE 16 (Autumn 1986): 2–9; reprinted in Russell Ferguson, William Olander, Marcia Tucker, and Karen Fiss, eds., *Discourses: Conversations in Postmodern Art and Culture* (New York and Cambridge, Mass.: New Museum of Contemporary Art and MIT Press, 1990), 209–19. By permission of the interviewer and the artist.

bones, and grease thrown on them. But nothing was for sale. Other Black artists here couldn't understand why you would do it if you couldn't sell it.

I was influenced in a way by Mel Edwards' work. He had a show at the Whitney in 1970 where he used a lot of chains and wires. That was the first abstract piece of art that I saw that had cultural value in it for Black people. I couldn't believe that piece when I saw it because I didn't think you could make abstract art with a message. I saw the symbols in Mel's work. Then I met Mel's brother and we talked all day about symbols, Egypt and stuff. How a symbol, a shape has a meaning. After that, I started using the symbol of the spade; that was before I did the grease bags. I was trying to figure out why Black people were called spades, as opposed to clubs. Because I remember being called a spade once, and I didn't know what it meant; nigger I knew but spade I still don't. So I just took the shape, and started painting it. I started dealing with the spade the way Jim Dine was using the heart. I sold some of them. Stevie Wonder bought one in fact. Then I started getting shovels (spades); I got all of these shovels and made masks out of them. It was just like a chain reaction. A lot of magical things happen in art. Outrageously magical things happen when you mess around with a symbol. I was running my car over these spades and then photographing them. I was hanging them from trees. Some were made out of leather (they were skins). I would take that symbol and just do dumb stuff with it, tons of dumb, ignorant, corny things. But you do them, and after you do all the corny things, and all the ignorant things, then a little bit of brilliance starts happening. There's a process to get to brilliancy: you do all the corny things, and you might have to go through five hundred ideas. Any corny thought that comes into your head, do a sketch of it. You're constantly emptying the brain of the ignorant and the dumb and the silly things and there's nothing left but the brilliant ideas. The brilliant ideas are hatched through this process. Pretty soon you get ideas that no one else could have thought of because you didn't think of them, you went through this process to get them. These thoughts are the ones that are used, the last of the hundred or five hundred, however many it takes. Those last thoughts are the ones that are used to make the image and the rest of them are thrown away. Hopefully you ride on that last good thought and you start thinking like that and you don't have to go through all these silly things.

It was just like a chain reaction, I started doing body prints in the shape of spades. So when I moved into using just the spade image it flowed. Then I started painting watercolors of spades. After that, I stopped using the framed format entirely; I had chains hanging off the spades. I went to Chicago to a museum and saw this piece of African art with hair on it. I couldn't believe it. Then I started using hair. . . .

There's so much stuff that I want to do with the hair that I didn't get a chance to do, because I just can't stay with any one thing. Plus I got really bad lice. Everyone kept telling me I was going to get lice. I shrugged it off as just a possible occupational hazard. But I did get a really bad case of head lice. Hair's like the filthiest material. It's a filter. When the wind blows through it the dirt stays on the hair. You could wash your hair every single hour and it would still be dirty. But I have information on Black people's hair that no one else in the world has. It's the most unbelievable fiber I've ever run across.

I was actually going insane working with that hair so I had to stop. That's just how potent it is. You've got tons of people's spirits in your hands when you work with that stuff. The same with the wine bottles. A Black person's lips have touched each one of those bottles, so you have to be very, very careful. I've been working with bottles for three years and I've

only exhibited them a couple of times. Most of my things I can't exhibit because the situation isn't right. The reason for that is that no one is taking the shit seriously anymore. And the rooms are almost always wrong, too much plasterboard, overlit, too shiny and too neat. Painting these rooms doesn't really help, that takes the sheen off but there's no spirit, they're still gallery spaces. . . .

Everybody knows about *Higher Goals*—the telephone pole piece—up there in Harlem. If I'm on the street up there I say, "I'm the guy who put that pole up there." I'll be on 116th or 110th and Amsterdam and talk to anybody and they'll say, "You're the one who did that. Yeah, I know where that is, I know you. Brother, come here, this is the cat who did the pole, yeah." So sometimes I'll just say that to talk to somebody on the street, at three or four in the morning or something, it's like a calling card. I've been trying to put it in the Guinness book of records as the highest basketball pole in the world but I don't know who to call.

I like playing with any material and testing it out. After about a year, I understand the principles of the material. I try to be one step ahead of my audience. Some artists are predictable. You've seen their patterns over the last ten years. They're staying within these frameworks because it's financially successful. I look at these cats and this is what I never ever want to be or never ever want to do. Why should I stay safe? It takes a long time to analyze a form—whether it be metal, oil paint, whatever—it may take them their whole lifetime to analyze this material. But who gives a fuck? There are so many things to play with. And I question if what these artists are doing is art or not. I don't think it is. An artist should always be searching and searching for things. Never liking anything he finds, in a total rage with everything, never settling or sacrificing for anything. That's what I enjoy anyway.

KARA WALKER What Obama Means to Me (2008)

In the last few weeks, I've been trying to make work that responds to him as a person and the themes that he speaks about. I really think *he's* an artist. He uses words in such a visual way. What's kind of fascinating to me is how in his books, in his memoirs and in his speeches, he has moved the conversation about race from the margins and from academia into the national state in a way that *I've* always wanted to do. Our American image, the image we sort of go around with apple pie and the Founding Fathers—is shifting away from the male patriarchal vision to something much more reflective of the place we actually live in. Our place that's of immigrants, who either came here willingly or unwillingly. It's incredible to have that kind of a person, who *so much* represents immigration. Yet he moves back and forth from being kind of an icon, a representative of these different strands of Americanism, to being a really capable human being. As he says in one chapter in *Dreams from My Father,* there is a way that people of color always have to remind white folks of their blackness, of their ethnicity as being apart from whiteness, and at the same time prove it's not just about race. He's a thinking, breathing, contemplating, philosophizing, soul-searching person who's actually trying to get it right.

* Kara Walker, responding to the question "What Obama Means to Me," in the Commemorative Inaugural Edition of *Newsweek* (January 21, 2009), 123. By permission of the author.

KIM JONES *Rat Piece* (1976)

vietnam dong ha marines its summer time 125 degrees heat sweat like pigs
work like dogs live like rats red dust covered everything

celts druids or priests great festival once every five years colossal
images of wicker work or of wood and grass were constructed these were
filled with live men cattle and animals of other kinds fire was then
applied to the images and they were burned with their living contents

running with friends killing birds and putting the feathers in our hair

macarther park on a bench near the lake shot a pigeon with a sling shot
crippled was staggering around picked up panicked what to do had to finish
off held under water looked around no one was watching the bird struggled
could feel muscles eyes bulged wide one last time a powerful straining
beak wide open relaxed pulled out of water feeling guilty looking around
quickly hide in near garbage can

sunset on the oceanfront walk a black man standing near a burning garbage
can said your rats are in there and laughed

north viets would hit us with rockets artillery and mortars we would jump
in our rat holes we lived in a constant state of tension anger there were
no hamburgers or ice cream only occasional warm beer or coke

vegetation wars picking special leaves and flowers laying them on the dirt
and concrete attacking them with rocks and dirt clods some were killed some
wounded a strong leaf could survive many attacks until its stem was crushed
the smell of burning leaves

east indian island of bali the mice which ravage the rice fields are caught
in great numbers and burned in the same way that corpses are burned but
two of the captured mice are allowed to live and recieve a little packet
of white linen then the people bow down before them as before gods and
let them go

rats live on no evil star *A PALINDROME ON THE SIDE OF A BARN IN IRELAND*

vietnam dong ha marine corps our camp covered with rats they crawled over
us at night they got in our food we catch them in cages and burn them to
death i remember the smell

some enjoyed watching the terrified ball of flame run

vietnam dong ha marine corps feel sorry for one and let it go my comrades
attack me verbally

vietnam dong ha marine corps guard duty it was my turn to sleep a duck
was quacking bothered me thew a rock at the duck hit its head next
morning it was staggering around crippled i couldnt kill it a friend
crushed its head with his boot

crying very much afraid when my father accidently kills a squirrel with
a 22 rifle

shooting lizards for sport with a friend on his ranch

he told her on their first date how he use to throw cats out of a
speeding auto on the freeway she said she loved cats later they
were married

boardwalk venice california a woman is concerned about a crippled pigeon
it should be put out of its misery she said i crushed the pigeons head
with a hammer on the concrete a spectator laughed with delight

making faces in the wet sand crushing them with rocks and fists

going out to the swamp near my house catching frogs and snakes laying in
the tall green grass watching the sky

* Kim Jones, untitled text from the performance *Rat Piece*, 17 February 1976, in Kim Jones, ed., *Rat Piece* (self-published edition of 500, 1990), 7. Courtesy of the artist and Pierogi Gallery, Brooklyn.

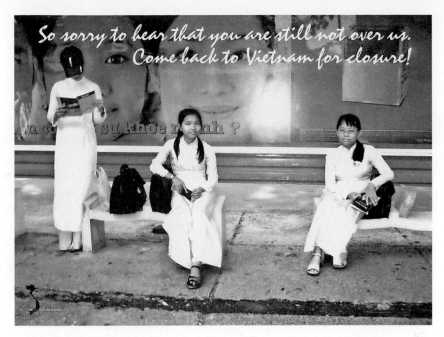

So sorry to hear that you are still not over us.
Come back to Vietnam for closure!

Dinh Q. Lê, *So Sorry,* from the series *Vietnam: Destination for the New Millennium,* 2005, photograph. Courtesy of the artist and Shoshana Wayne Gallery, Santa Monica.

DINH Q. LÊ

Cuoc Trao Doi Giua/Of Memory and History:
An Exchange with Moira Roth (1999–2001)

Dinh Q. Lê, Email, June 15, 1999, Ho Chi Minh City

. . . Every trip back to Vietnam I would bring a handful of American soil to Vietnam. I would mix the soil in the heavily silted water of the Mekong River as a way to spread this handful of soil throughout Vietnam. By doing this I hoped to help the wandering souls of all American MIAs lost in the jungle of Vietnam to have some sense of home. I hope this will help them rest in peace. I feel that in order for Vietnam to heal from the war, we need to help all the *oan hon* (lost souls) from the war find some peace. . . .

Dinh Q. Lê, Email, July 4, 1999, Ho Chi Minh City

It has been raining here almost every day. The rain cools everything down and softens the harsh city. It is great to be in the studio working while the rain pours loudly on the roof, on the pavement.

 * Moira Roth, excerpts from "Cuoc Trao Doi Giua/Of Memory and History: An Exchange between Dinh Q. Lê and Moira Roth" (June 1999–April 2003), in Christopher Miles, Dinh Q. Lê, and Moira Roth, *Dinh Q. Lê: From Vietnam to Hollywood* (Seattle: Marquand Books [for Emily Leach Gallery], 2003), 8–21; a section of this exchange appeared in a different form as "Obdurate History: Dinh Q. Lê, the Vietnam War, Photography, and Memory," in *Art Journal* 60, no. 3 (Summer 2001): 39–52. By permission of the author; the artist, courtesy Shoshana Wayne Gallery, Santa Monica; and Emily Leach Gallery, Portland, Oregon.

I am starting to get back to work on old and new projects. Thinking and rethinking about Tuol Sleng [Genocide Museum, Phnom Penh, Cambodia], the horror and the anger in the space; I am trying to incorporate that space into my new work. I need to go back to visit Tuol Sleng again—a trip I have been trying to avoid but cannot any longer. . . .

Dinh Q. Lê, Email, July 8, 1999, Ho Chi Minh City

I am currently working on/thinking about a couple of projects. The first project is a double video-projection installation. The video will focus on the rapidly changing cityscape of Ho Chi Minh City. . . . The video shoot will consist of two video cameras mounted on my moped, one in front, facing forward, and one in back, facing backward. I will be driving, weaving in and out of streets and alleys, recording the extreme contrasts in architecture and living conditions of the people in the city . . . as it is trying to move forward to the future. . . .

The second project . . . will deal with memory, specifically of the My Lai incident [U.S. Army massacre of Vietnamese civilians, March 16, 1968]. I am interested in the way nature actively erases both physical evidence and our memory of the event. We cannot keep all memories because not all memories are meant for us to keep. The question then becomes which memories to keep and which to let go of, as nature intended.

The last project is more vague: to go back to Tuol Sleng to photograph . . . the upstairs prison holdings and the torture chambers. I want to photograph just the empty interior architecture, no objects. I am not quite sure why at this point, but I think I need to create more of a context for my earlier Tuol Sleng portrait work. I will be headed for Cambodia in September or November. . . .

Dinh Q. Lê, Email, August 7, 1999, Ho Chi Minh City

I have never been to My Lai but I plan to do so on August 12. People here don't talk at all about My Lai. The older people remember but know very little about it. I think that nature definitely has a hand in the way we slowly forget things. Nature designed our brains to remember but also to forget. Nature never intended for us to remember everything.

In the My Lai case, as an artist and as a person, I feel that the victims are one of its most overlooked aspects. Our memory of the incident is only of the massacre. I do not want to remember the victims only at the most horrific moment of their lives. What were their lives like before they were taken from them, and what would they be like today if they had not died? What gives them hope, keeps their dreams and happiness? . . . Who were these people that have beome a symbol of guilt in America's conscience? These are the memories that have been completely forgotten, and these are the memories I want people to start remembering.

Dinh Q. Lê, Email, August 25, 1999, Ho Chi Minh City

I have just gotten back from My Lai. It was nothing like what I had expected or heard. It is an unpretentious little park, which from the outside looks like a little school with two little buildings on the property. The second is the exhibition hall where the photographs of the incident are on display—gruesome, but I felt they were necessary. There is a list of

all the victims and their ages, and in a display case are household objects belonging to them, ranging from hats to pots. . . . I do not feel it was a "theme" park or full of propaganda—which makes me quite curious about the reactions of American friends and some American Vietnam vets who see the place as full of propaganda. To tell you the truth, I don't have a clue as to how to approach this project at this point. It will take some time for me to work out all the issues. . . .

Dinh Q. Lê, Email, November 13, 1999, Bangkok

I am currently sitting in the Bangkok airport waiting for my connection to London. This is my first time going to Europe. I have been focusing all my resources and energies on two continents, Asia and North America, all these years, and now I am going to step foot on the third one. It feels like a big event in my life—I am going to London to put up my installations *Lotus Land* and *Damaged Gene Project*. The show opens on the 25th, Thanksgiving. I guess there is no Thanksgiving Day in England. . . .

[In later email, from December 13:]

The installation [*Lotus Land*] is based on the idea of a lotus pond—the idea of purity growing out of these muddy and contaminated soils. Sitting on nine lotus flowers and nine leaves are seven Siamese twins in various positions mimicking religious poses. The piece is about the birth defects in Vietnam as a result of the chemical defoliant Agent Orange used by the U.S. Army during the Vietnam War. One of the effects has been a tremendous increase in Siamese twins born in Vietnam. . . . Most of the twins do not survive due to limited expertise and facilities here. I have found that in some villages where the children are born, they are starting to worship them. The villagers believe that the children are special spirits. . . . What is fascinating to me is that some Vietnamese deities also have multiple arms, legs, and heads. The piece grows out of my fascination with the idea of collapsing distance between mythology and reality. . . .

Dinh Q. Lê, Email, February 20, 2000, Ho Chi Minh City

I just finished a giant piece of work. It measures 3 meters high by 6 meters wide. The piece consists of about 1,500 black-and-white photographs that I bought here [in Vietnam] at second-hand stores. Initially, I was interested in finding my family's photographs that we were forced to leave behind when we escaped from Vietnam. Sifting through these old photographs, I was hoping that one day I would find some of ours. Along the way, I realized these photographs are in a way my family's photographs. These people also were probably forced to abandon memories of their lives, because either they did not survive the war or they had escaped from Vietnam. . . .

Dinh Q. Lê, Email, February 6, 2001, Ho Chi Minh City

. . . It has been interesting for me to see the progression of my work over the years, from the angry political posters to *The Texture of Memory*. Gone is the raw voice of anger.

I realize that, in a way, I have learned to write poetry and to answer for myself Adorno's observation that "To write poetry after Auschwitz is barbaric. And this corrodes even the knowledge of why it has become impossible to write poetry today."

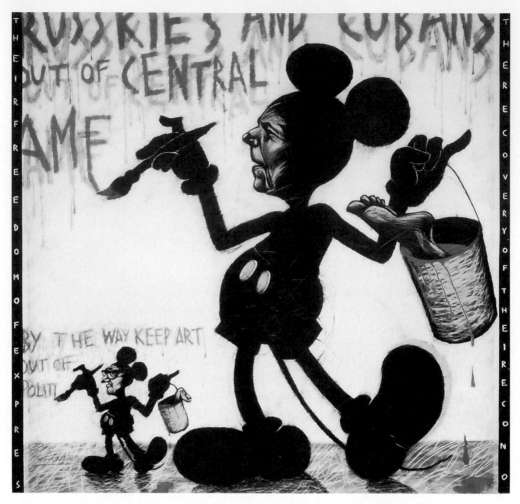

Enrique Chagoya, *Their Freedom of Expression . . . The Recovery of Their Economy,* 1984, charcoal and pastel on paper. By permission of the artist, courtesy Gallery Paule Anglim, San Francisco.

ENRIQUE CHAGOYA

> *Their Freedom of Expression. . . . The Recovery*
> *of Their Economy* (2005)

This was the first large-format charcoal drawing I ever did. It was done for a local exhibition that was part of a national campaign against intervention in Central America organized in New York City by Lucy Lippard and a group of Salvadoran poets in 1983–84.

I thought the drawing would go into the closet after the show, since supporters of Reagan and Kissinger would not like the way I portrayed them, and people who didn't like them would not want to see much of their faces anywhere. So I didn't want to make "art"; I just

* Enrique Chagoya, *"Their Freedom of Expression . . . The Recovery of Their Economy,"* in Francesca Richer and Matthew Rosenzweig, eds., *No. 1: First Works by 362 Artists* (New York: D.A.P./Distributed Art Publishers, 2005), 77. By permission of the artist, courtesy Gallery Paule Anglim, San Francisco, and the publisher.

wanted to do some kind of inexpensive charcoal-and-paper editorial cartoon to be seen as a billboard. To my surprise, I got a new way of looking at my own work, and also people reacted very favorably to the style and content. This evolved into a series of drawings in the same format that lasted through the mid '90s.

I had stopped drawing for almost ten years, and began to do artist books, prints, and paintings, but for the last couple of years I revisited my large charcoal drawings again thanks to the current political climate, and got a second wind with a new series. Drawing has become my favorite medium now, and I can't say enough about how much I owe to *Their Freedom of Expression . . .* and how much it has helped me to develop a lot of freedom in my own work.

CHÉRI SAMBA Statements (1989–95)

There is nothing complicated about cartoon drawings, since anyone can produce them, but they are rich in meaning because they carry a message, particularly if there are balloons (phylactery). In my case, I use two techniques, caricature (humor) and portrait. This is to teach a lesson to those who only deal in humor. Yet, I am a self-taught artist.[1]

.

I like to put the finishing touches on my paintings, even if the exact quality I am looking for isn't there, but in any case, my desire is to make very beautiful things and to have the message come through. . . . Before I was drawing directly with paint, but I saw that this technique didn't give me the images that I wanted; sometimes it did, but after some time, I found that this was too much work. I see that my new technique, first using pencils and then adding paint, helps me with the task of not losing sight of details.[2]

.

I really like showing what shocks people. I know that people don't like to tell the truth all the time, but what people don't like to say is exactly what drives me to paint.[3]

.

What I had wanted to paint was nudity. What is more, I know that here, in my home area, nudity is a very touchy issue. What I wanted to show at that particular moment was something very sensitive. I thought that maybe they would close their eyes, that they would not look at it since it had nudity. On the contrary, everyone came, especially those who knew how to read the comment [he means the intellectuals and the urban bourgeois].[4]

.

* Chéri Samba, statements quoted in Bogumil Jewsiewicki, *Chéri Samba: The Hybridity of Art,* Contemporary African Artists Series, no. 1 (Westmont, Québec: Galerie Amrad African Art Publications, 1995), 28, 42, 46, 90, 92, 94.

1. Chéri Samba, quoted in Jewsiewicki, *Chéri Samba,* 92.
2. Samba, quoted in "Chéri Samba," *Kanal Magazine* (October 1989): 70; in Jewsiewicki, *Chéri Samba,* 46.
3. Ibid.
4. Samba, quoted in Jewsiewicki, *Chéri Samba,* 42.

In Africa, nudity is very shocking. If an African, let's say a Zairian, can see the thighs of a woman up to her underwear, it is considered scandalous. . . . In the same vein, kissing in the street is also deemed obscene. . . . When I paint these types of scenes, I cross the boundary into the forbidden. . . . The solution, I found, is to turn the text which accompanies these images into a critique of these scenes or of these reportedly scandalous behaviors.[5]

.

It is true that I really like paradoxes. . . . What we can see in the painting isn't always of the same nature as, and can even sometimes contradict, what is said and written.[6]

.

The texts that I introduce on my canvases translate the thoughts of the people I depict in a given situation. It is a way of not allowing freedom of interpretation to the person who looks at my painting. For me, my work is incomplete if there aren't any texts, they symbolize the fantasy.[7]

.

I would say that my painting can also be political, why not? I am not a protestor: I tell the truth and if I criticize a little bit, it is to help the leaders.[8]

.

I like making self-portraits to show myself off since I am not a TV star. I want people to know who the artist is. If members of the mass media will not come to me, I'll be the first to promote myself.[9]

.

I paint for humanity, I paint for everyone. Obviously, I can't put all the languages of the world in my paintings. Otherwise, I would put them all in, if I knew them. . . . I don't always paint for Africans only. But I can inspire myself from Africa when the same story can concern Europeans.[10]

KEITH HARING Statement (1984)

Often when I am drawing in the subway in New York City an observer will patiently stand by and watch until I have finished drawing and then, quickly, as I attempt to walk away, will shout out, "But what does it mean?" I usually answer: "That's your part, I only do the drawings."

5. "Chéri Samba in Conversation with Bernard Mercadé," *Galeries Magazine* (1991), 86; in Jewsiewicki, *Chéri Samba*, 90.

6. "Samba with Mercadé," 85; in Jewsiewicki, *Chéri Samba*, 42.

7. Samba in conversation with Fatouma Saïd, "Un peintre chroniqueur," in *Le Nouvel Afrique-Asie* (1990): 42; in Jewsiewicki, *Chéri Samba*, 42.

8. Samba in *Kanal*, 70; in Jewsiewicki, *Chéri Samba*, 42.

9. "Samba with Mercadé," 10; in Jewsiewicki, *Chéri Samba*, 94.

10. Samba in *Kanal*, 70; in Jewsiewicki, *Chéri Samba*, 28.

* Keith Haring, untitled statement, *Flash Art* 116 (March 1984): 20–28. By permission of the Estate of Keith Haring and the publisher.

So, when I was asked to write something for *Flash Art,* I found myself in a similar situation. I still maintain that an artist is not the best spokesman for his work. For myself, I find that my attitude towards, and understanding of my work is in a constant state of flux. I am continually learning more of what my work is about from other people and other sources. An actively working artist is usually (hopefully) so involved in what he is doing that there isn't a chance to get outside of the work and look at it with any real perspective. A real artist is only a vehicle for those things that are passing through him. Sometimes the sources of information can be revealed and sometimes the effects can be located, but the desired state is one of total commitment and abandon that requires only confidence and not definition. The explanation is left to the observer (and supposedly the critics). However, in the past two years I have done dozens of interviews and frequently talk about what I think I am doing. Still, I have read very little real critical inquiry into my work, besides the on-going obsession with the phenomena of money and success. For this reason I decided to note a few of the things that nobody ever talks about, but which are central (I feel) to my work.

One of the things I have been most interested in is the role of chance in situations—letting things happen by themselves. My drawings are never preplanned. I never sketch a plan for a drawing, even for huge wall murals. My early drawings, which were always abstract, were filled with references to images, but never had specific images. They are more like automatic writing or gestural abstraction. This was my prime attraction to the CoBrA group (primarily Pierre Alechinsky) and Eastern calligraphy. Total control with no control at all. The work of William Burroughs and Brion Gysin (*The Third Mind*) came the closest in literature to what I saw as the artistic vision in painting. The artist becomes a vessel to let the world pour through him. We only get glimpses of this art spirit in the physical results laid down in paint.

This openness to "chance" situations necessitates a level of performance in the artist. The artist, if he is a vessel, is also a performer. I find the most interesting situation for me is when there is no turning back. Many times I put myself in situations where I am drawing in public. Whatever marks I make are immediately recorded and immediately on view. There are no "mistakes" because nothing can be erased. Similar to the graffiti "tags" on the insides of subway cars and the brush paintings of Japanese masters, the image comes directly from the mind to the hand. The expression exists only in that moment. The artist's performance is supreme.

This attitude toward working seems particularly relevant in a world increasingly dominated by purely rational thought and money-motivated action. The rise of technology has necessitated a return to ritual. Computers and word processors operate only in the world of numbers and rationality. The human experience is basically irrational.

In 1978 I came to New York City and attended the School of Visual Arts. I was keeping a diary when I first got to New York and was surprised when, rereading it recently, I came across various notations about a conflict I was having over the role of the contemporary artist. It seemed to me that with minimal and conceptual art the role of the artist was increasingly helping to usher in the acceptance of the cooly-calculated, verifiable, computer-dominated, plastic "reality." A comparison between a human worker and a computer would inevitably prove that (from an efficiency standpoint) the human was being surpassed and maybe even replaced by the capabilities of the microchip. The possibility of evolution evolving beyond the human level was a frightening realization. Artists making art that consisted solely of information and concepts were supported by corporations and museums.

It appeared to be right in line with the ideologies of corporations motivated by profit instead of human needs.

Although this is exaggerated, I think the contemporary artist has a responsibility to humanity to continue celebrating humanity and opposing the dehumanization of our culture. This doesn't mean that technology shouldn't be utilized by the artist, only that it should be at the service of humanity and not vice versa.

I think any artist working now has to take advantage of the technological advances of the past hundred years and use them creatively. Andy Warhol said he wanted to be a machine, but what kind of machine?

Living in 1984, the role of the artist has to be different from what it was fifty, or even twenty years ago. I am continually amazed at the number of artists who continue working as if the camera were never invented, as if Andy Warhol never existed, as if airplanes and computers and videotape were never heard of.

Think of the responsibility of an artist now who is thrust into an international culture and expected to have exhibitions in every country in the world. It is impossible to go backwards. It is imperative that an artist now, if he wants to communicate to the world, be capable of being interviewed, photographed, and videotaped at ease. The graphic arts of reproduction have to be utilized. It is physically impossible to be in more than one place at one time (at least for the moment). The artist has his own image as well as the image he creates. It is important that through all these permutations the artist retains a vision which is true to the world he lives in, as well as to the world his imagination lives in.

This delicate balance between ritual and technology is applied to every aspect of my work. Whether I draw with a stick in the sand or use animated computer graphics, the same level of concentration exists. There is no difference for me between a drawing I do in the subway and a piece to be sold for thousands of dollars. There are obvious differences in context and medium, but the intention remains the same. The structure of the art "market" was established long before I was involved in it. It is my least favorite aspect of the role of the contemporary artist; however, it cannot be ignored. The use of galleries and commercial projects has enabled me to reach millions of people whom I would not have reached by remaining an unknown artist. I assumed, after all, that the point of making art was to communicate and contribute to a culture.

Art lives through the imaginations of the people who are seeing it. Without that contact, there is no art. I have made myself a role as an image-maker of the twentieth century and I daily try to understand the responsibilities and implications of that position. It has become increasingly clear to me that art is not an elitist activity reserved for the appreciation of a few, but for everyone, and that is the end toward which I will continue to work.

Mushrooms + television childhood = Pop Surrealism.

Religion is strong . Mandalas are used in all religions.

they all have a center. They can hypnotically bring you to a
higher level. Early Mandalas were simple. Simple symbolic shapes.

The spiral is easily understood as a means to other levels (worlds).
F or example: the tornado, the bathtub drain spiral where entering
can take place (air through water).Galaxies are spirals. Suction-
black holes? Spirals are universal in space, in nature and
in culture. second degree religions include mandalas with icons.

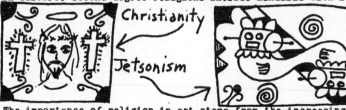

Christianity

Jetsonism

The importance of religion in art stems from the increasingly
threatening situation of nuclear catastrophe. Will I be alright
when I'm dead? Well, hopefully. If you believe in being good
you will lift your arms up the mushroom cloud, through a spiral
to "heaven".

Heaven being the universal oneness with time equals nature equals
god. God equals hydrogen atoms because they are the only things
created from nothing. Hydrogen God is the creator: sun, planets,
earth, man.The sun being hydrogen, fusing to helium as an after
product. Man plays god by using atoms,destroying himself in the
process-nuclear catastrophe. *Kenny Scharf*

Jetsonism is Nirvana.

* Kenny Scharf, "Jetsonism," in Steven Hagar, *Art After Midnight* (New York: St. Martin's Press, 1986), 104.
By permission of the artist.

BLEK LE RAT

A Graffiti Icon on His First Solo Show in America:
Interview with Samantha Gilewicz (2008)

SAMANTHA GILEWICZ: You pioneered street art in Paris, so from where did you draw inspiration?

BLEK LE RAT: The first time I was introduced to graffiti was in New York in 1971; I was very impressed by what I saw in the subway and around the city. It took me ten years to decide to make my own graffiti. I was influenced by an American artist, Richard Hamilton. He started painting these big human figures and their shadows in New York in the '80s. He was the first guy to export his work abroad, to Paris, London, Belgium, Italy. . . This guy was so important but he never got really famous. I decided to make stencils (it's a very old technique used by Italians during the Renaissance period) because I didn't want to imitate American graffiti.

SG: How did you come up with the name Blek le Rat, and why did you stencil rats?

BLR: There was a comic I used to have as a kid in France called Blek le Roc, so I transformed the name to Blek le Rat because 'rat' is an anagram for 'art.' I put tens of thousands, maybe a hundred thousand, shadows of small rats running along the streets in Paris. As a teenager even, my aim was to push the people to make graffiti art like me. Making a stencil is very easy; you don't have to be an art student. So, I thought that if I did those stencils in the street, other artists would have the strength to do it also. People all over the world do stencils now. It's very surprising.

SG: What inspired *Art Is Not Peace But War*?

BLR: An artist's life is a very difficult life. I took the phrase, "Art is not peace but war," from Norman Mailer's first article about graffiti for *The New York Times* in 1972. For me, I don't see art in peace, you have to fight a lot to be an artist, your life is like a war.

SG: What is it like working with your wife [Sybille Prou]?

BLR: My wife and I have been married for ten years now. I think as an artist it is very difficult to get some work done alone. She is a big part of the work; she gives me all sorts of ideas. The only thing we talk about is the work—It's terrible for my children (laughing)! It's Blek le Rat and Sybille, Sybille and Blek le Rat. . . .

SG: What artists do you admire these days?

BLR: Of course Bansky. I think he's the only true artist on the streets in England now. I also really like American graffiti; I'm very impressed by the work of Swoon. . . . And she's so young! I really respect Shepard [Fairey] for his work. I prefer to exhibit in Shepard's gallery [in Los Angeles] rather than a museum. I think he's the most important artist of his generation. He is important as Andy Warhol was important.

* Excerpt from Samantha Gilewicz, "The Insider: Blek Le Rat: A Graffiti Icon on His First Solo Show in America," *Nylon* (April 4, 2008): http://www.nylonmag.com/?section=article&parid=1212. By permission of the artist and the publisher.

Banging Your Head Against a Brick Wall: You could say that graffiti is ugly, selfish and that it's just the action of people who want some pathetic kind of fame. But if that's true it's only because graffiti writers are just like everyone else in this fucking country.

There is this idea that people who write Graffiti are just frustrated scribblers who couldn't make it in the art world, but that's not really the point. It's better being outside anyway. Bus stops are far more interesting and useful places to have art than in museums. Graffiti has more chance of meaning something or changing stuff than anything indoors. Graffiti has been used to start revolutions, stop wars and generally is the voice of people who aren't listened to. Graffiti is one of the few tools you have if you have almost nothing. And even if you don't come up with a picture to cure world poverty you can make someone smile while they're having a piss.

Graffiti ultimately wins out over proper art because it becomes part of your city, it's a tool; "I'll meet you in that pub, you know, the one opposite that wall with a picture of a monkey holding a chainsaw." I mean, how much more useful can a painting be than that?

Secrets, Lies and Beady Little Eyes: They say big brother is watching you. But maybe big brother is watching dutch girly videos on the next screen along.

Getting paranoid is an occupational hazard of illicit street painting, which is good. Your mind is working at its best when you're being paranoid. You explore every avenue and possibility of your situation at high speed with total clarity. I'm not interested in looking at things made by people who aren't paranoid, they're not working to their full capacity.

We can't do anything to change the world until capitalism crumbles. In the meantime we should all go shopping to console ourselves. . . .

Simple Intelligent Testing in Dumb Animals: A lot of people never use their initiative, because no-one told them to.

Weapons of Mass Distraction: People are fond of using military terms to describe what they do. We call it bombing when we go out painting, when of course it's more like entertaining the troops in a neutral zone, during peacetime in a country without an army.

It's healthy to think about bombs all the time, because it's difficult to get your head round the fact that humans have the hardware available to make their entire species extinct. Nobody talks about it anymore but they say this is why we've all become so into money, because at the back of our minds we all know that atomic bombs have taken our future away from us.

A wall is a very big weapon, it's one of the nastiest things you can hit someone with.

Doing what you're told is generally overrated. More crimes are committed in the name of obedience than disobedience. It's those who follow any authority blindly who are the real danger.

Zen and the Art of Mindless Vandalism: We came out of a pub one night arguing about how easy it would be to hold an exhibition in London without asking for any one's permission. As we walked through a tunnel in shoreditch[1] someone said: "You're wasting your time, why would you want to paint pictures in a dump like this?"

A week later we came back to the same tunnel with two buckets of paint and a letter. The letter was a forged invoice from a mickey mouse Arts organization wishing us luck with the "Tunnel Vision mural project." We hung up some decorators signs nicked off a building site

* Banksy, excerpts from *Banging Your Head Against a Brick Wall* (London: Weapons of Mass Distraction, 2001). By permission of the author.

1. *Editor's Note:* Shoreditch is an area within the London Borough of Hackney.

and painted the walls white wearing overalls. We got the artwork up in twenty five minutes and held an opening party later that week with beers and some hip hop pumping out the back of a transit van. Six months later someone knocked a hole in the wall and built a superclub in the middle of the piece. If I had a pound for every time that happened. . . .

I Love the Smell of Vandalism Early in the Morning: A beginners guide to painting with stencils

- Draw or copy your image on a piece of paper.

- Glue the paper onto a bit of card using good glue.

- Cut straight through drawing and card at the same time using a very sharp knife. Snap off blades are best. The sharper your knife the better the stencil looks. As the Grim Reaper said to his new apprentice: "You must learn the compassion suitable to your trade—a fucking sharp edge."

- Ideal card should be about 1.5 mm thick—much fatter and it's took difficult and boring to cut through. Any thinner and it gets sloppy too quick.

- Find an unassuming piece of card as a folder to hold your stencil in and leave the house before you think of something more comfortable you could be doing.

- Get a small roll of gaffa tape and pre-tear small strips ready to attach stencil to the wall.

- Shake and test can of paint before you leave. Cheap British paint is fine but some brands bleed more than others. Matt finish comes out better and dries quicker.

- Apply paint sparingly.

- Wear a hat.

- Move around the city quickly. Acting like a sad old drunk if you attract attention.

- Pace yourself and repeat as often as you feel inadequate and no-one listens to a word you say. . . .

Deride and Conquer: Who sacked all the clowns?

DAVID WOJNAROWICZ Post Cards from America: X-Rays from Hell (1988)

Late yesterday afternoon a friend came over unexpectedly to sit at my kitchen table and try and find some measure of language for his state of mind. "What's left of living?" He's been on AZT for six to eight months and his T-cells have dropped from 100 plus to 30. His doctor says: "What the hell do you want from me?" Now he's asking himself: "What the hell do I want?" He's trying to answer this while in the throes of agitating fear.

I know what he's talking about as each tense description of his state of mind slips out across the table. The table is filled with piles of papers and objects; a boom-box, a bottle of AZT, a jar of Advil (remember, you can't take aspirin or Tylenol while on AZT). There's an old

* David Wojnarowicz, excerpts from "Post Cards from America: X-Rays from Hell," in *Witnesses: Against Our Vanishing* (New York: Artists Space, 1988); reprinted in Barry Blinderman, ed., *David Wojnarowicz: Tongues of Flame* (Normal, Ill., and New York: University Galleries, Illinois State University, and Art Publishers, 1989), 105–12. By permission of the Estate of David Wojnarowicz.

smiley mug with pens and scissors and a bottle of Xanax for when the brain goes loopy; there's a Sony tape-recorder that contains a half-used cassette of late night sex talk, fears of gradual dying, anger, dreams and someone speaking Cantonese. In this foreign language it says: *My mind cannot contain all that I see. I keep experiencing this sensation that my skin is too tight; civilization is expanding inside of me. Do you have a room with a better view? I am experiencing the X-ray of civilization. The minimum speed required to break through the earth's gravitational pull is seven miles a second. Since economic conditions prevent us from gaining access to rockets or spaceships we would have to learn to run awful fast to achieve escape from where we are all heading . . .*

My friend across the table says, "There are no more people in their 30's. We're all dying out. One of my four best friends just went into the hospital yesterday and he underwent a blood transfusion and is now suddenly blind in one eye. The doctors don't know what it is . . . " My eyes are still scanning the table; I know a hug or a pat on the shoulder won't answer the question mark in his voice. The AZT is kicking in with one of its little side-effects: increased mental activity which in translation means I wake up these mornings with an intense claustrophobic feeling of fucking doom. It also means that one word too many can send me to the window kicking out panes of glass, or at least that's my impulse (the fact that winter is coming holds me in check). My eyes scan the surfaces of walls and tables to provide balance to the weight of words. A 35mm camera containing the unprocessed images of red and blue and green faces in close-up profile screaming, a large postcard of a stuffed gorilla pounding its dusty chest in a museum diorama, a small bottle of hydrocortisone to keep my face from turning into a mass of peeling red and yellow flaking skin, an airline ticket to Normal, Illinois, to work on a print, a small plaster model of a generic Mexican pyramid looking like it was made in Aztec kindergarten, a tiny motor-car with a tiny Goofy driving at the wheel . . .

My friend across the table says, "The other three of my four best friends are dead and I'm afraid that I won't see this friend again." My eyes settle on a six-inch-tall rubber model of Frankenstein from the Universal Pictures Tour gift shop, ™ 1931: his hands are enormous and my head fills up with replaceable body parts; with seeing the guy in the hospital; seeing myself and my friend across the table in line for replaceable body parts; my wandering eyes aren't staving off the anxiety of his words; behind his words, so I say, "You know . . . he can still rally back . . . maybe . . . I mean people do come back from the edge of death . . . "

"Well," he says, "he lost thirty pounds in a few weeks . . . "

A boxed cassette of someone's interview with me in which I talk about diagnosis and how it simply underlined what I knew existed anyway. Not just the disease but the sense of death in the American landscape. How when I was out west this summer standing in the mountains of a small city in New Mexico I got a sudden and intense feeling of rage looking at those postcard perfect slopes and clouds. For all I knew I was the only person for miles and all alone and I didn't trust that fucking mountain's serenity. I mean it was just bullshit. I couldn't buy the con of nature's beauty; all I could see was death. The rest of my life is being unwound and seen through a frame of death. My anger is more about this culture's refusal to deal with mortality. My rage is really about the fact that WHEN I WAS TOLD THAT I'D CONTRACTED THIS VIRUS IT DIDN'T TAKE ME LONG TO REALIZE THAT I'D CONTRACTED A DISEASED SOCIETY AS WELL.

On the table is today's newspaper with a picture of cardinal O'Connor saying he'd like to take part in operation rescue's blocking of abortion clinics but his lawyers are advising against it. This fat cannibal from that house of walking swastikas up on fifth avenue should lose his church tax-exempt status and pay retroactive taxes from the last couple centuries. Shut down our clinics and we will shut down your "church." I believe in the death penalty for people in positions of power who commit crimes against humanity, i.e., fascism. This creep in black

skirts has kept safer-sex information off the local television stations and mass transit advertising spaces for the last eight years of the AIDS epidemic thereby helping thousands and thousands to their unnecessary deaths.

My friend across the table is talking again. "I just feel so fucking sick . . . I have never felt this bad in my whole life . . . I woke up this morning with such intense horror; sat upright in bed and pulled on my clothes and shoes and left the house and ran and ran and ran . . . " I'm thinking maybe he got up to the speed of no more than ten miles an hour. There are times I wish we could fly; knowing that this is impossible I wish I could get a selective lobotomy and rearrange my senses so that all I could see is the color blue; no images or forms, no sounds or sensations. There are times I wish this were so. There are times that I feel so tired, so exhausted. I may have been born centuries too late. A couple of centuries ago I might have been able to be a hermit but the psychic and physical landscape today is just too fucking crowded and bought up. Last night I was invited to dinner upstairs at a neighbor's house. We got together to figure out how to stop the landlord from illegally tearing the roofs off our apartments. The buildings dept. had already shut the construction crew down twice and yet they have started work again. The recent rains have been slowly destroying my western wall. This landlord some time ago allowed me to stay in my apartment without a lease only after signing an agreement that if there were a cure for AIDS I would have to leave within 30 days. A guy visiting the upstairs neighbor learned that I had this virus and said he believed that although the government probably introduced the virus in the homosexual community, that homosexuals were dying en masse as a reaction to centuries of society's hatred and repression of homosexuality. All I could think of when he said this was an image of hundreds of whales that beach themselves on the coastlines in supposed protest of the ocean's being polluted. He continued: "People don't die—they choose death. Homosexuals are dying of this disease because they have internalized society's hate . . . " I felt like smacking him in the head, but held off momentarily, saying, "As far as your theory of homosexuals dying of AIDS as a protest against society's hatred, what about the statistics that those people contracting the disease are intravenous drug users or heterosexually inclined, and that this seems to be increasingly the case. Just look at the statistics for this area of the lower east side." "Oh," he said, "they're hated too . . . " "Look," I said, "after witnessing the deaths of dozens of friends and a handful of lovers, among them some of the most authentically spiritual people I have ever known, I simply can't accept mystical answers or excuses for why so many people are dying from this disease—really it's on the shoulders of a bunch of bigoted creeps who at this point in time are in the positions of power that determine where and when and for whom government funds are spent for research and medical care."

I found that, after witnessing Peter Hujar's death on November 26, 1987, and after my recent diagnosis, I tend to dismantle and discard any and all kinds of spiritual and psychic and physical words or concepts designed to make sense of the external world or designed to give momentary comfort. It's like stripping the body of flesh in order to see the skeleton, the structure. I want to know what the structure of all this is in the way only I can know it. All my notions of the machinations of the world have been built throughout my life on odd cannibalizations of different lost cultures and on intuitive mythologies. I gained comfort from the idea that people could spontaneously self-combust and from surreal excursions into nightly dream landscapes. But all that is breaking down or being severely eroded by my own brain; it's like tipping a bottle over on its side and watching the liquid contents drain out in slow motion. I suddenly resist comfort, from myself and especially from others. There is something I want to see clearly, something I want to witness in its raw state. And this need comes from my sense of mortality. There is a relief in having this sense of mortality. At least I won't arrive one day at my 80th birthday and at the eve of my possible death and only then realize my whole life was supposed

to be somewhat a preparation for the event of death and suddenly fill up with rage because instead of preparation all I had was a lifetime of adaptation to the pre-invented world—do you understand what I'm saying here? I am busying myself with a process of distancing myself from you and others and my environment in order to know what I feel and what I can find. I'm trying to lift off the weight of the pre-invented world so I can see what's underneath it all. I'm hungry and the pre-invented world won't satisfy my hunger. I'm a prisoner of language that doesn't have a letter or a sign or gesture that approximates what I'm sensing. Rage may be one of the few things that binds or connects me to you, to our pre-invented world.

My friend across the table says, "I don't know how much longer I can go on . . . Maybe I should just kill myself." I looked up from the Frankenstein doll, stopped trying to twist its yellow head off and looked at him. He was looking out the window at a sexy Puerto Rican guy standing on the street below. I asked him, "If tomorrow you could take a pill that would let you die quickly and quietly, would you do it?"

"No," he said, "not yet."

"There's too much work to do," I said.

"That's right," he said. "There's still a lot of work to do . . . "

BARBARA KRUGER Pictures and Words: Interview with Jeanne Siegel (1987)

JEANNE SIEGEL: You had your first solo show in 1974 at Artists Space. But it seems that you didn't get any serious critical attention until 1982—the kind of critical attention that raised issues that we're still discussing today. Why do you think there was that time gap and why do you think it happened in 1982?

BARBARA KRUGER: Why things "happen" as you say, in the art world as they do, does not differ greatly from the mechanisms of other "professional" groupings. Why certain productions emerge and are celebrated is usually due to a confluence of effective work and fortuitous social relations, all enveloped by a powerful market structure. Of course, just what the effectiveness of work is becomes pivotal and it is this area which is of interest to me. I see my production as being procedural, that is, a constant series of attempts to make certain visual and grammatical displacements. I didn't pop into the world with a beret on clutching a pair of scissors and a stack of old magazines. I don't think that an artist instantly materializes chock full of dizzying inspirations and masterpieces waiting to be hatched. I think the work that people do can be determined to some degree by where and when they've been born, how they've been touched, the color of their skin, their gender, and what's been lavished upon or withheld from them. I think it took me a while to determine what it could mean to call myself an artist and how I could do work that was questioning, yet pleasurable, for both myself and others. . . .

I find the labeling of my more recent work as *political,* to the exclusion of my early activity, to be problematic. First, I am wary of the categorization of so-called political and feminist work, as this mania for categorization tends to ghettoize certain practices, keeping them out of the discourse of contemporary picture-making. My early work was relegated to the category of the decorative, long before the short-lived celebration of "decorative art." Turning to craftlike procedures was a conventional, historically grounded way for women to define themselves through visual work. However, I don't subscribe to the uncritical celebra-

* Jeanne Siegel, excerpts from "Barbara Kruger: Pictures and Words," *Arts Magazine* 61, no. 10 (June 1987): 17–21; reprinted in Jeanne Siegel, ed., *Artwords 2: Discourse on the Early 80s* (Ann Arbor: UMI Research Press, 1988), 299–311. By permission of the author, the artist, and *Arts Magazine.*

tion of this work, which might suggest that women have a genetic proclivity toward the decorative arts. Women were allowed to develop certain virtuoso visual effects within the interiorized, domestic space of the home. I had the pleasures and problems of indulging in this type of artistic activity for a while, and I think that the relations which produced the sanctioning of this work certainly do constitute a politic. . . .

I think there are precedents for working with pictures excised from the media which go back a long way. But of course, I had friendships with many of the artists who were developing a vernacular sort of signage. However, the use of words lent my work a kind of uncool explicitness. I have to say that the biggest influence on my work, on a visual and formal level, was my experience as a graphic designer—the years spent performing serialized exercises with pictures and words. So, in a sort of circular fashion, my "labor" as a designer became, with a few adjustments, my "work" as an artist. . . .

JS: How does the image and the text work in advertising?

BK: It's difficult for me to engage in an analysis of advertising. Like TV, it promiscuously solicits me and every other viewer. In the face of these global come-ons I claim no expertise. I become as fascinated as the next person, but every now and then I feel the need to come up for air. In these forays above the watermark, I try to figure out certain procedures and manage some swift reversals. But there is no single methodology which can explain advertising. Its choreographies change from medium to medium: from print, to billboards, to radio, to TV. Each medium, according to its own technological capabilities, stages its own brand of exhortation and entrapment. . . .

I have frequently said, and I will repeat again, in the manner of any well-meaning seriality, that I'm interested in mixing the ingratiation of wishful thinking with the criticality of knowing better. Or what I say is I'm interested in *coupling* the ingratiation of wishful thinking with the criticality of knowing better. To use the device to get people to look at the picture, and then to displace the conventional meaning that that image usually carries with perhaps a number of different readings. . . .

I think that social relations on a neighborhood and global level are contained by a market structure, a calculator of capital that fuels a circulatory system of signs. We sell our labor for wages. Just because something doesn't sell doesn't mean it's not a commodity. None of us are located in a position where we can say "I am untainted and I'm pure." I think it would tend to be deluded if one thought that way. . . .

I work circularly, that is around certain ideational bases, motifs and representations. To fix myself, by declaring a singular methodology or recipe, would really undermine a production that prefers to play around with answers, assumptions and categorizations. . . . I think that sometimes there is an openness in terms of the possible readings of my work. But I'm also a body working within a particular space who is making work to further her own pleasure. And that pleasure means a certain investment in tolerances, in differences, in plenitudes, in sexualities and in pleasure rather than desire. Because desire only exists where pleasure is absent. And one could say that the wish for desire is the motor of a progress that can only efface the body.

It was Roland Barthes who suggested that the stereotype exists where the body is absent. He had a knack for being so economically eloquent. One of the possible meanings of his comment could be that the repetition of stereotype results in a figure which is not embodied. Not an empty signifier, but a perpetual ghost with a perpetual presence. . . .

My work was not informed by the history of poster design nor Surrealist photography because I simply wasn't aware of it. I think people who are basically very situated within art

historical practices and don't know anything about the world of magazine work and advertising, who are very naive about the repertory and choreography of type and photography, look at my work and say "Heartfield." And I was not even aware of [John] Heartfield till '80 or '81.

There are also people who come from, say a left art historical place, and who look at my work and say "Heartfield," because there are certain other things in the work that, especially if they're not American, are too difficult for them to really welcome into the discursive practices of art and art history. For instance, I was speaking to a curator from Europe a few weeks ago, and he said to me, there is much history in terms of your work in Europe, especially in Germany there's a historical grounding. And I said, well what's that? And he said Heartfield and Moholy-Nagy and I said I didn't know that Moholy-Nagy was doing work on gender and representation. . . .

My work tends to be rangy, but it tries to critically engage issues frequently not dealt with in much so-called *political* work: that is, the terrain of gender and representation. If one believes that there's a politic in every conversation we have, every deal we close, every face we kiss, then certainly the discourses and intercourses of sexuality have a place around or even on top of the conference tables of international diplomacy.

JS: In locating contemporary myths, Barthes makes a point that essentially he's talking about the French. Would you say yours are more about Americans?

BK: Not exclusively. No doubt there are site-specific discourses which have their meanings fixed within locations: indigenous struggles, community issues, labor relations, various national identities. I will foreground frequently, when I'm speaking, that every sort of address has some place. But I think that one should be very critical and very thoughtful when one tries to speak for others, which is a very problematic thing to do. . . .

I think that the exactitude of the photograph has a sort of compelling nature based in its power to duplicate life. But to me the real power of photography is based in death: the fact that somehow it can enliven that which is not there in a kind of stultifyingly frightened way, because it seems to me that part of one's life is made up of a constant confrontation with one's own death. And I think that photography has really met its viewers with that reminder. And also the thing that's happening with photography today vis-à-vis computer imaging, vis-à-vis alteration, is that it no longer needs to be based on the real at all. I don't want to get into jargon— let's just say that photography to me no longer pertains to the rhetoric of realism; it pertains more perhaps to the rhetoric of the unreal rather than the real or of course the hyperreal.

JS: One critic said that your use of "you" and "we" was so compelling that one can't escape into aesthetics. Would you discuss this strategy?

BK: I think that the use of the pronoun really cuts through the grease on a certain level. It's a very economic and forthright invitation to a spectator to enter the discursive and pictorial space of that object.

SHERRIE LEVINE Five Comments (1980–85)

Since the door was only half closed, I got a jumbled view of my mother and father on the bed, one on top of the other. Mortified, hurt, horror struck, I had the hateful sensation of

* Sherrie Levine, "Five Comments" (1980–85), in Brian Wallis, ed., *Blasted Allegories: An Anthology of Writings by Contemporary Artists,* with a foreword by Marcia Tucker (New York and Cambridge, Mass.: New Museum of Contemporary Art and MIT Press, 1987), 92–93. By permission of MIT Press.

having placed myself blindly and completely in unworthy hands. Instinctively and without effort, I divided myself, so to speak, into two persons, of whom one, the real, the genuine one, continued on her own account, while the other, a successful imitation of the first, was delegated to have relations with the world. My first self remains at a distance, impassive, ironical, and watching. [1980]

.

The world is filled to suffocating. Man has placed his token on every stone. Every word, every image, is leased and mortgaged. We know that a picture is but a space in which a variety of images, none of them original, blend and clash. A picture is a tissue of quotations drawn from the innumerable centers of culture. Similar to those eternal copyists Bouvard and Pécuchet, we indicate the profound ridiculousness that is precisely the truth of painting. We can only imitate a gesture that is always interior, never original. Succeeding the painter, the plagiarist no longer bears within him passions, humors, feelings, impressions, but rather this immense encyclopedia from which he draws. The viewer is the tablet on which all the quotations that make up a painting are inscribed without any of them being lost. A painting's meaning lies not in its origin, but in its destination. The birth of the viewer must be at the cost of the painter. [1981]

.

In the seventeenth century, Miguel de Cervantes published *Don Quixote*. In 1962, Jorge Luis Borges published "Pierre Menard, Author of the Quixote," the story of a man who rewrites the ninth and thirty-eighth chapters of *Don Quixote*. His aim was never to produce a mechanical transcription of the original, he did not want to copy it. His ambition was to propose pages which would coincide with those of Cervantes, to continue being Pierre Menard and to arrive at *Don Quixote* through the experience of Pierre Menard. Like Menard, I have allowed myself variants of a formal and psychological nature. [1983]

.

We like to imagine the future as a place where people loved abstraction before they encountered sentimentality. [1984]

.

I like to think of my paintings as membranes permeable from both sides so there is an easy flow between the past and the future, between my history and yours. [1985]

JEFF KOONS From Full Fathom Five (1988)

THE FOLLOWING QUOTES ARE EXCERPTED FROM A CONVERSATION HELD BY BURKE & HARE WITH JEFF KOONS IN NEW YORK THIS PAST DECEMBER.

> What is beautiful has a fly in its ointment; we know that. Why, then, have beauty? Why not rather that which is great, sublime, gigantic—that which moves masses?—Once more: it is easier to be gigantic than to be beautiful; we know that.
>
> Friedrich Nietzsche, *The Case of Wagner*

* Burke & Hare in conversation with Jeff Koons, "From Full Fathom Five," *Parkett,* no. 19 (collaboration Martin Kippenberger and Jeff Koons; 1989): 44–47. By permission of the publisher. Burke and Hare are pseudonyms for the New York critics Brooks Adams and Karen Marta, respectively.

Note: You need to know how Jeff Koons sounds. Not baritone or tenor—that's not what is meant. What is meant has more to do with tone than pitch. In movies, it's the tone most often assigned to the character who has to talk a potential suicide off the ledge. It's like margarine sliding over a spongy piece of Wonderbread—absolutely uninflected and very, very soft. It covers everything; hills and valleys are leveled in its creamy, inexorable progress. It lulls the listener and ubiquitizes the topic so that conversation is metamorphosed into an enormously heavy rock slowly plummeting fathom after fathom to the ocean floor where it lands in a whisper of stirred sand.

> . . . we are no longer surprised by Saint John's strange likeness to the Bacchus which hangs near it, which set Théophile Gautier thinking of Heine's notion of decayed gods who, to maintain themselves, after the fall of paganism, took employment in the new religion. We recognize one of those symbolical inventions in which the ostensible subject is used, not as a matter for definite pictorial realization, but as the starting point of a train of sentiment, as subtle and vague as a piece of music.
>
> Walter Pater, *The Renaissance*

Note: To Koons, one of the most significant of his recent works is a porcelain sculpture of St. John the Baptist. The piece was evolved from Leonardo Da Vinci's St. John the Baptist *in the collection of the Louvre. In Koons's 3-D variation, St. John has a suckling pig draped over one arm and holds a penguin in the other. It serves as our point of departure.*

JEFF KOONS: So, my St. John the Baptist is taken from Leonardo's, and what I like about it, in addition to the androgyny, is that he is embracing a pig and a penguin as well as a gold cross. For me, this is a symbol of being baptized in the mainstream—to be baptized in banality. The bourgeoisie right now can feel relieved of their sense of guilt and shame, from their own moral crisis and the things they respond to. The bourgeoisie respond to really dislocated imagery, and this is their rallying call; it's all right to have a sense of openness and emptiness in your life. Don't try to strive for some ideal other than where you are at this moment; embrace this moment and just move forward. I try to leave room for everyone to create their own reality, their own life. My work tries to leave the door open. It tries to have an individual participate in mobility, but it never shoots for any type of elitist position which wouldn't leave them room to create their own mobility. It's only to people in equilibrium with themselves that the work is dangerous because they have no desire, and there is no place for mobility in that. You see, I do not start with an ideal that is elevated above everybody. I start with an ideal down below and give everybody the opportunity to participate and move together. I think that's important.

My work will use everything that it can to communicate. It will use any trick; it'll do anything—absolutely anything—to communicate and to win the viewer over. Even the most unsophisticated people are not threatened by it; they aren't threatened that this is something they have no understanding of. They can look at it and they can participate with it. And also somebody who has been very highly educated in art and deals with more esoteric areas can also view it and find that the work is open as far as being something that wants to add more to our culture. The work wants to meet the needs of the people. It tries to bring down all the barriers that block people from their culture, that shield and hide them. It tells them to embrace the moment instead of always feeling that they're being indulged by things that they do not participate in. It tells them to believe in something and to eject their will. The idea of St. John and baptism right now is that there are greater things to come. And it's about embracing guilt and shame and moving forward instead of letting this negative society always thwart us—always a more negative society, always more negative.

Tod didn't laugh at the man's rhetoric. He knew it was unimportant. What mattered were his messianic rage and the emotional response of his hearers. They sprang to their feet, shaking their fists and shouting. On the altar someone began to beat a bass drum and soon the entire congregation was singing "Onward Christian Soldiers."

<div align="right">Nathanael West, The Day of the Locust</div>

I try to be effective as a leader. I'm very interested in leadership. I think that my own work has been helping to direct a dialogue, and it's been participating in it for quite some time. I'm anteing up the pressure and trying to increase the stakes continually. I've found that collectors are my power base. You know, I'm able to work as a function of their support of my work. I think that they have to have some interest in debasement and its political possibilities, even for their own use. I mean, it really has to be for their own use. I think that I give them a sense of freedom. I don't think that I'm debasing them and not leaving them a place to go. I'm creating a whole new area for them once they're feeling free. I see it as my job to keep the bourgeoisie out of equilibrium letting them form a new aristocracy.

I think it's necessary that the work be bought, that I have the political power to operate. I enjoy the seduction of the sale. I enjoy the idea that my objectives are being met. I like the idea of the political power base of art, but it's not just a money thing. It has to be a total coordination of everything, and money is a certain percent of it, maybe 20% of it. Look, abstraction and luxury are the guard dogs of the upper class. The upper class wants people to have ambition and gumption because, if you do, you will participate and you'll move through society into a different class structure. But eventually, through the tools of abstraction and luxury, they will debase you, and they will get your chips away from you.

And with a great musical roll of his voice he went swinging off into the darkness again, as if his thoughts had lent him wings. He was dreaming of the inspiration of foreign lands—of castled crags and historic landscapes. What a pity after all, thought Rowland, as he went his own way, that he shouldn't have a taste of it!

<div align="right">Henry James, Roderick Hudson</div>

Note: In 1987, Koons was invited to participate in the Münster Sculpture Project. He chose to make a stainless steel simulacrum of a popular sculpture (the Kiepenkerl) which occupies a position of both literal and legendary prominence in the city of Münster.

When I originally saw the piece, I chose it for what the image was and for its location. I wanted a luna piece. I always thought that stainless steel had a luna aspect about it, and here I was able to have it outdoors. The original was a bronze and it was of a Kiepenkerl coming to market with his kip. So it was an example of self-sufficiency to the community and I was trying to show that this self-sufficiency doesn't really exist anymore, that things had changed. And I was trying to meet the needs of the people through this false luxury, etcetera. The Münster piece was very important to my current body of work because it was a disaster. The casting was done by an industrial foundry, and when they pulled the stainless steel sculpture out of the oven, instead of letting it cool, they immediately banged the pieces up against the wall to knock off the ceramic shell. This was a disaster; everything was totally deformed. Really bad! When the pieces arrived at the finishing foundry, nothing fit together. I had a choice of not participating or doing radical cosmetic surgery to the piece. I decided it was important at this point to participate, so I gave the piece surgery on the understanding that

this would not count as a piece but as something that could be shown and eventually replaced with another one. As a result, I started to see how allegory and the hand really go together, because we had to totally manipulate the sculpture. We had to cut the rabbit's ears off to bend them down, we had to cut the guy's neck, we had to bend this out six inches, lengthen this so many inches. Now, even though the sculpture still has to be redone, it freed me. It let me start to work with the hands.

> The actor is both an element of first importance, since it is upon the effectiveness of his work that the success of the spectacle depends, and a kind of passive and neutral element, since he is rigorously denied all personal initiative. It is a domain in which there is no precise rule; and between the actor of whom is required the mere quality of a sob and the actor who must deliver an oration with all his personal qualities of persuasiveness, there is the whole margin which separates a man from an instrument.
>
> Antonin Artaud, *The Theater and Its Double*

Note: Koons's porcelain and polychromed wood sculptures are produced by workers in German and Italian factories primarily devoted to the production of decorative ornaments.

How did the production network come about? First, I went to Germany. I started seeing German companies, but they are not courageous; they will not disrupt their normal line. Their workers are educated to perform a certain task and that's what they perform. Then I went to Italy thinking that some of the smaller guilds could recommend people and that the Italian mentality is much more courageous. And at first, they would all say "No, we can't do this" and I would go back and say "Please, I really think you can do this," and then they would say "Okay, we'll do it." In the end, my Michael Jackson piece will be the largest porcelain ever produced in the world. So, what I was doing was financing their experimentation, for developing the technical facilities to make large porcelains.

The way it works is that one of the factory artists makes the model and signs it. I sign underneath the piece with the date and number of the edition. I have them sign it because I want them to give me 100%, to exploit themselves. I also like not being physically involved because I feel that, if I am, I become lost in my own physicality. I get misdirected toward my true initiative so that it becomes masturbative. Originally, I just wanted to find great artists that I could choose for their greatness and say, "Okay, do The Fall of Man" or whatever, an allegory, then it's a finished product. Boom, that's it, A Jeff Koons! And then I realized that there were no great artists around and I could not give these people that freedom. I mean, how can I let them do it; these people aren't artists. So, I had to do the creating. I did everything. I directed every color; I made color charts. This has to be pink, this has to be blue. Everything! Every leaf, every flower, every stripe, every aspect. You know, they're my paintings as much as they're my sculptures.

> You can watch people align themselves when trouble is in the air. Some prefer to be close to those at the top, and others want to be close to those at the bottom. It's a question of who frightens them more and who they want to be like.
>
> Jenny Holzer, *The Living Series*

Artists somehow develop this moral crisis where we are fearful of being effective in the world. We set up these inside games; we develop all these esthetics and all this formalism.

It's a totally ineffective structure which participates not at all in the outside world. We were the great seducers, we were the great manipulators, and we have given up these intrinsic powers of art—its effectiveness. The entertainment industry, the advertising industry have taken these tools from the art world and made themselves much more politically potent. We are really devastated and very impotent right now. A photographer just working for an advertising company has a platform to be much more politically effective in the world than an artist.

Right now the economic value of art continues to go up and up. However, it's totally valueless that we're being consumed, since one of the reasons that we're being consumed is because what we're doing is politically ineffective. Therefore, this person or that corporation can purchase the art because it won't cause any turmoil. What you have to do is exploit yourself and take the responsibility to victimize others. It's time that we regain everything that we had—all our powers—and exploit that.

> Her invitation wasn't to pleasure, but to struggle, hard and sharp, closer to murder than to love. If you threw yourself on her, it would be like throwing yourself from the parapet of a skyscraper. You would do it with a scream. You couldn't expect to rise again. Your teeth would be driven into your skull like nails into a pine board and your back would be broken. You wouldn't even have time to sweat or close your eyes . . . If she would only let him, he would be glad to throw himself, no matter what the cost. But she wouldn't have him. She didn't love him and he couldn't further her career. She wasn't sentimental and she had no need for tenderness, even if he were capable of it.
>
> Nathanael West, *The Day of the Locust*

MAURIZIO CATTELAN Interview with Michele Robecchi (2009)

MICHELE ROBECCHI: It seems like we're living in a time where it's essential to develop a strategy for survival. What's yours?

MAURIZIO CATTELAN: I don't think that the big crunch should be seen as a menace, but rather as an opportunity. It's one of these times in history—and we have plenty of examples from the past—where it's possible to really make a difference. And if art is serious about claiming a central role in today's society and culture, this is the best chance it's had in ages. The current climate doesn't represent a threat to the production of art but to the market. I think it's time for artists to get over auction houses, galleries, and high-production-value exhibitions and start using our voices again.

MR: Now, when you say exhibitions and galleries . . .

MC: I'm not talking about the intrinsic value of exhibitions. I'm criticizing the way they are perceived. I was going through a book of Marina Abramovic and Ulay's 1970s performance work the other day. These people did two, even three Documentas or Venice Biennales over the course of a decade without any fuss. They would just treat it as any of their other engagements, with the same level of dignity and commitment they'd reserve for a one-day event in a small gallery on the Austrian mountains. Today, large-scale exhibitions are overrated. I'm not saying the 1970s was a golden age—I don't believe such a thing ex-

* Michele Robecchi, excerpts from "Maurizio Cattelan," originally published in *INTERVIEW Magazine,* June 8, 2009. Courtesy of Brant Publications, Inc. Also with permission of the interviewer and the artist, courtesy Marian Goodman Gallery.

ists in art . . . It would be like talking about a golden age of science. But it's true that those were slightly more ideological times, and the relevance of artists wasn't established by their CVs but by their work.

MR: I agree about the market becoming too predominant, but at the same time, don't you think artists could be partially responsible for this? After all, it takes two to tango. If the system was so rotten, you could have refused to play the game a long time ago.

MC: Part of the blame can be put at the artists' door, too—no question. But I see our involvement more as a consequence. When there is too much money at stake, the whole system gets corrupted. Artists can be very vulnerable to these mechanisms.

MR: Why?

MC: It's in our nature. If you are a plumber, there is an objective way to establish whether you put together a great piping system or not. Art is a bit more slippery than that. So, when you fill a gallery with dirt and someone comes along waving wads of bills, it's difficult not to take them because they become a tangible acknowledgement that what you've been doing actually makes sense.

MR: Do you see this vulnerability as a relatively recent phenomenon? Or is it something in artists' DNA?

MC: I think it's genetic. Even during the Renaissance, it was all about where artists were hanging out, who they were associated with, who would get the biggest commission. There are no exceptions. It's pretty much the same with everything else, from architecture to sports. The only difference is that art, unlike sports or architecture, is not about supremacy or practical living. Art should be able to be innovative without compromising itself. That's why I believe artists should have bigger preoccupations than checking the price tags on their work or becoming curators' darlings.

MR: How about curators? The way the art system is structured today, many people think that they're the ones in a position to truly generate a change.

MC: Undoubtedly, artists have let curators take part of the burden off their shoulders over the years, but it's a bet that doesn't seem to have paid off. Because of their position, which is to act like some sort of catalyst between an institutional and a visionary world, curators cannot bring themselves to do the job. There are a few exceptions, of course, but in general, the vast majority of curators are more focused on the definition of their role and what this entails than anything else. Ninety percent of the panel discussions or round-tables these days are all about formats. Have you noticed that? What's the meaning of curating in the new millennium, what's the role of a collector, how art fairs or biennials should be . . . They only talk about structure—almost nobody is talking about theory. And since nobody else is doing it, I think artists should. Who knows, maybe it's time to write a new manifesto.

MR: You sound very passionate, which is sort of a new color for you. How do you think that an experience like co-curating the Berlin Biennale in 2006 helped in shaping these ideas?

MC: Curating the Berlin Biennale with Massimiliano [Gioni] and Ali [Subotnick] was an eye-opener but not necessarily for the reasons you are suggesting. It was something completely new because of the level of organization and bureaucracy involved and because it allowed us to explore areas where we've never been before. But stepping out of the so-called limitations dictated by being an artist or a curator wasn't a novelty for us. From The Wrong Gallery [a mini-gallery in Chelsea that Cattelan co-founded] to *Charley* [Cattelan's art periodical], we always tried to do something different.

MR: You just said the current economic situation should be seen as something liberating. When you started as an artist, at the end of the 1980s, a similar scenario presented itself with the art market suddenly going down the drain. How did you see it at the time?

MC: Looking back, it was a sobering moment as much as a missed opportunity. But I wasn't so involved as I am now. I was too busy dealing with personal issues to focus on those themes. Here I was, in my late twenties, with no art education or anything like that, desperately trying to come up with something clever without making a complete fool of myself. I was so afraid of doing something wrong that I ended up spending a lot of time on my own. It was a character-building experience. I didn't even consider myself an artist. To a certain extent, I still don't. And I'm sure I'm in good company!

MR: What makes you see it as a missed opportunity?

MC: The fact that, what we were going through in the '90s was mainly a generational change, which was exactly what happened when Arte Povera tried to take over 20 years earlier, at the end of the '60s. There was a group of new artists and new languages emerging, and the old guard was not very welcoming because of the threat they represented to their world. The difference in terms of economy and style was a big contributing factor in accentuating it, but, at the end of the day, what was happening was nothing new. It was just another generational turnover.

MR: Well, there are some differences. In the 1960s, the generational turnover you are talking about wasn't confined to art. Society, too, was deeply affected by this alternation. The 1980s were a relatively quiet time in comparison. Maybe the '80s artists were rebelling without a cause.

MC: Opulence alone was clearly not a good enough reason to start a revolution. The art world was quite marginalized before the 1980s. Suddenly everything was going great, and I'm sure the last thing people wanted was to hail a Robin Hood free-for-all kind of character criminalizing success and fortune. It's an awfully simplistic position to hold, too, unless you do it with intelligence or humor or some aplomb. Why would you want to be a party-wrecker? It's more fun to try to hijack the party than to spoil it. And I found out very early in life that people tend to prefer the class clown to the class nerd.

MR: Not to mention that sometimes the line between being a soldier and a revolutionary can be very thin.

MC: Yes. What I realized at the time was that there are three different kinds of revolutionaries: those who want to change things; those who are into the fight but couldn't care less if things change or not; and those who work following their instinct, responding to a situation in a personal way that can end up having collective results—and that can affect the world a lot more. That last model is possibly the one I'm interested in most. Look at Gerhard Richter. Or Andy Warhol. Warhol was proof that you can be revolutionary without being militant.

MR: Warhol certainly wasn't an apolitical artist, as a lot of people would love to believe. Yet I'm not sure if his acceptance of certain values, like celebrity, was revolutionary in the way that you mean.

MC: In the long run, he was more revolutionary than a lot of artists who were openly championing the very same values that he was incorporating into his work. In Warhol's work, serial repetition acts as a depowering or destabilizing force. He knew that believing in art as a society-changing weapon can be detrimental. There must be more to it than that. It has to be sensual, or witty, or visually appealing. The worst possible thing is when ideological art

becomes didactic. What you get as a result is little more than propaganda—and then it doesn't matter which side of the barricade you're on. . . .

MR: This year is the 100th anniversary of the *Futurist Manifesto*. Many people consider futurism and surrealism as the ultimate art movements that made a genuine attempt to change society. Both movements were masters at provocation. Where do you think they failed?

MC: Did they really fail? I think they are still very relevant today. Surrealism, and also dadaism, were pure gold. Maybe they got a bit carried away. Futurists were fundamentally fanatics, but I acknowledge that, in their madness, they anticipated a lot of what is going on today. Their blind faith in progress presents a lot of resemblances to all those people who are advocating a change through extreme ideology. What I find really funny is that futurists would be allergic to all these commemorative exhibitions that museums and curators are throwing for them. It is precisely what they were fighting against. The best way to honor their heritage would be to do something a little more outrageous and out of control than caging their art in a museum.

MR: Many think that their supporting the war was their epitaph.

MC: Yes, but their concept of war was different from the one we have today. If you think about it, World War II was the first time in history where civilian casualties were more numerous than the military's. Historically it was a massive turning point. It possibly set the model for all the wars we are witnessing today. The futurists were fantasizing about airplanes and missiles, but I don't think they were fully aware of the implications. Their actual idea of war was very naïve and old-fashioned.

MR: Right—horses and steel.

MC: Exactly. The people who were running it were total Evelyn Waugh characters. Nothing like what you would see today. War, like everything else, has become much more professional.

MR: So you don't think we are about to witness something similar to what happened in the 1930s?

MC: I don't think the two decades are comparable. I don't see the current crisis degenerating into a proliferation of totalitarian regimes. The crash of 1929 was a first. Unlike the current crisis, which was a long time coming, it was totally unpredictable. Nobody knew what was going to happen. Today we know that there's light at the end of the tunnel, no matter how long it takes to walk through. All we need are exceptionally inspired people to set an example and guide us through the dark.

MR: How do you perceive the wave of optimism following Barack Obama's election running parallel to this fear of the crisis?

MC: It's certainly an event of historical proportions, although a part of me can't help thinking that we've all been mesmerized, that what is happening is the result of a mass hallucinatory phenomenon, and that, sooner or later, something dramatic is going to happen. I suppose it's the pessimist in me. But if I should make an effort and be an optimist, I see Obama's win as proof of what we were just talking about. It's a return to more ideological values.

MR: There are massive expectations.

MC: Yes. It seems like the whole world is lining up outside the White House holding bread and fish, waiting for him to perform a miracle. In a way, it's a bit scary. But, at the same time, it's kind of exciting, too. It makes you look forward to the future. You don't get the opportunity to do that very often these days!

TONY CRAGG Statement (c. 1982)

The interests • Man's relationship to his environment and the objects, materials and images in that environment • The relationships between objects, materials and images • Obvious and immense areas; but apparently difficult areas for artists to work in without resorting to magic, alchemy or mystification • That could infer an objective approach, or, as I prefer to see it, a refusal to equate subjectivity with certain kinds of heavyhanded dramatics.

The objects • I am not interested in romanticizing an epoch in the distant past when technology permitted men to make only few objects, tools etc. • But, in contrast to today I assume a materialistically simpler situation and a deeper understanding for the making processes, function and even metaphysical qualities of the objects they produced • The social organizations which have proved to be most successful are productive systems • The rate at which objects are produced increases; complementary to production is consumption • We consume, populating our environment with more and more objects • With no chance of understanding the making processes because we specialize, specialize in the production, but not in the consumption.

The materials • The use of various materials, stone, bronze, iron etc. has been used as indications of technological development • Our use of materials goes as far as radioactive elements and biochemical substances of the most complex nature • Particularly exploitable have proved to be the chemically stable polymers—plastics • Due to the long relationship between man and such materials as earth, water, wood, stone and certain metals they evoke a rich variety of emotional responses and images • The experience of these materials alters, however, as they appear increasingly in synthetic, industrial forms • What does it mean to us on a conscious, or, perhaps more important, unconscious level to live amongst these and many other completely new materials? Many materials/objects because of their function or chemical instability need a protective coating • It is often possible and then usually desirable to give materials/objects a color.

The colors • It has not always been easy to produce colors and then they were frequently impermanent and limited • The colors of plants and animals are also limited and related to function • The possibilities for making the colors are unlimited and the choice should be too • But, many decisions about the colors of objects in our environment are industrial, commercial or even administrative • A response to demand? A demand often created by the supplier • The choice is between a range of offers which already represent some kind of lowest common denominator • These colors only become interesting after they have led a life reacting to the atmosphere and light, touched by other materials.

The images • Celluloid wildlife, video landscapes, photographic wars, Polaroid families, offset politics • Quick change, something new on all channels • Always a choice of second-hand images • Reality can hardly keep up with its marketing image • The need to know both objectively and subjectively more about the subtle fragile relationships between us, objects, images and essential natural processes and conditions is becoming critical • It is very important to have first order experiences—seeing, touching, smelling, hearing—with objects/images and to let that experience register • Art is good for that.

* Tony Cragg, untitled statement, in *Documenta 7,* 1 (Kassel: Documenta, 1982), 340. By permission of the author.

DAMIEN HIRST *On the Way to Work:* Discussion with Gordon Burn (2002)

GORDON BURN: An interest you seem to share with many of the artists of your generation is in taking something from life and changing it as little as possible. In other words, to make the artist's intervention as unobtrusive or undistorting as possible.

DAMIEN HIRST: I think it's probably right. To me, that sort of implies that it's to do with a communication of ideas rather than a communication of personality. I mean, the more I change it, the more I'm talking about myself. Whereas the less I change it, the more I'm talking about a kind of universal idea. It's, like, everyone knows what a settee is.

But I *sneak* myself into my work, definitely. Because I believe in those kind of very human, abstract-expressionist paint-how-you-feel ideas. I can't get rid of those ideas. I've tried. And the more I try, the more they come out in ways I don't expect.

GB: You talked about making a piece on instinct, without really knowing what it was about.

DH: But that instinct can probably be broken down to a little bit of what people want, a little bit of what they don't want, a little bit of the way the world is today, a little bit of how I feel in my life at the moment, and a little bit of TV, advertising creeping in. . . .

I don't think you can change people's minds without getting them listening to you. You can't tell people what to think, or what you think they should think, or what you think, unless they're listening to you. I mean, it's too easy for me to be dismissed by people going: 'Oh yeh, he just works on the sensational and animals.' If I can make some sculptures that are about the same kind of thing but don't actually have that in it, there must be a cultural reason for me to actually use dead heads, a social reason why people react to it. I mean, I think sensationalism is only an element in a composition, and I don't think if you're making a composition you should overlook it. . . .

GB: What is a celebrity? What would you say celebrity is?

DH: It's a fucking lie. It's something to make rich people rich and poor people poor.

GB: So doesn't that make for a certain tension? If celebrity is a lie, and being an artist, by definition, is being somebody who tells or reveals a truth.

DH: Being an artist is an idea, for a start. And art is about life. Being a celebrity is a part of life. So art should be able to deal with that. And if it can't, then it doesn't exist. . . .

GB: Where did it come from, your desire to be famous?

DH: It came from when you wanted to be the best drawer in the class. It came from when your parents said, 'I don't mind if you don't get a hundred out of a hundred, but do your best.' It wasn't being famous then, 'cause famous was something else. But it's the same thing, being best in the class. It means that you don't want to die. It boils down to immortality. I want to live for ever. And the best way to live for ever is to be better than everyone else. But it's fucking impossible. There's beautiful artists die every day, and never get recognized. The class just gets bigger, that's all. . . .

You've got to admit that you're a boring cunt at some point. D'you know what I mean? You're supposed to be a radical, top-notch, I'm-going-to-change-the-world fucking artist. And you're just a lad from Leeds with childish ambitions . . . I dunno. You've got to admit you're a star-fucker at the start, and that you want to be famous. Then you can move forward. You get to a point when you run out of people to be more famous than. Then what happens? . . .

* Damien Hirst and Gordon Burn, excerpts from *On the Way to Work* (New York: Universe, Rizzoli International, 2002). Used with permission from Rizzoli International Publications, Inc.

You buy a house in Devon and realize what you *really* want. For me, after Gagosian, there's nowhere to go, in terms of the art world. . . .

GB: What is art?

DH: It's a fucking poor excuse for life, innit, eh?! Art-schmart, God-schmod, Jesus-schmeesus . . . I have proved it to myself that art is about life and the art world's about money. And I'm the only one who fucking knows that. Everyone lies to themselves to make it *seem* like it's the other way. But it isn't.

You've got to fucking enjoy yourself, Gordon, haven't you? Don't I look like I'm enjoying myself? . . . It gets close sometimes. . . .

GB: Talk about Francis Bacon. Why you think he's good.

DH: He's the best. There's these two different things, painters and sculptors. And Bacon is a painter. He doesn't . . . It's not about your ability; it's about your guts, on some level. And Bacon's got the guts to fuck in hell. . . .

Fuck Auerbach. They're shit. Bacon's not that. Bacon's like: it's a doorway, it's a window; it's two-dimensional, it's three-dimensional; he's thinking about the glass reflecting . . . It's his guts. Absolutely. It's, like, he can't paint, and he admits it. And it's the most powerful position you can ever have. . . .

It's like, there's a painting he's done of a guy cross-legged, and he can't paint fucking baseball boots. But he doesn't pretend he can. That's why he's brilliant. He paints a baseball boot to the best of his ability, and it's totally fucking naked and clean, and it's right there in your face, and you go, 'This is a painting by a geezer who totally believes, and it's everything he says it is, and whatever his aim is, he's achieving much more than that.' It's totally laid out in front of you: no lies, no doubt, nothing. . . .

I grew up in a situation where painting was considered dead. But I had a massive desire to be a painter. Not an artist. Not a sculptor. I wanted to be a *painter*. Not a collagist. The idea of a painter is so much greater than the idea of a sculptor or an artist. You know: 'I'm a painter.' It's one on one, *mano a mano,* you on yourself. But the thing is painting is dead. It didn't work. For me, Bacon is the last result of the great painters. He's the last painter. It's all sculpture after that.

GB: Do you still look at art?

DH: Yeh. Less. I stopped for a long time. But now I look at it. I look at the world.

I tell you what: art is fucking unusual. It's just fucking unusual. But it's like . . . I know the rules. And the rules aren't so fucking mad. The rules of art aren't so mad. I'm torn at the moment between . . . You know, if there's anything wrong with the art world, I blame the artists, I don't blame anyone else. There are no rules. . . .

GB: What is great art?

DH: Great art is when you just walk round a corner and go, 'Fucking hell! What's *that!*' Great art is when you come across an object and you have a fundamental, personal, one-on-one relationship with it, and you understand something you didn't already understand about what it means to be alive. That's why people with loads of money want to possess it. That's why it's worth so much fucking money. But it isn't. They want to possess it. But they can't. Throw money at art, you get *nothing* back. You die. Then where does it go? Fantastic! Henry Moore. . . .

I've got a belief in art, right. And I don't know—in fact I don't care—whether it's right or not. I've got a really hard-to-beat, hard-to-believe, really hard idea about what I think art is. It's very romantic; it's very fucking childish, and it's really weird. But it's, like, without that, I've got nothing.

And I've definitely always treated it, and I always will treat it, as an all-or-nothing situation. There's no way I'm going to settle for half. So I asked a really big question, and I asked a really dumb question, and I've been into all sorts of areas that I don't really understand. And I've always been faced with the situation where, if I take a half, and shut the fuck up, I'm going to be fine. But it's definitely an all-or-nothing situation. Because that's the nature of the thing that I believe in. . . .

GB: Why are you an artist and not a scientist?

DH: Because I'm theatrical. I'm into beauty for the sake of beauty. I love the way that art doesn't really affect the world. Science affects the world much more directly. I don't want to affect the world that directly. I want to affect the world obliquely. I want to be on the wall for two hundred years rather than in your face for five minutes.

5 ART AND TECHNOLOGY

Kristine Stiles

The imagination that pictures, researches, and seeks transformation belongs to the alchemical mind of the scientist and the artist, both of whom approach the philosopher's stone. Scientific formulas and equations have been described as being elegant and beautiful, just as an artist's works may be scientifically informed and technologically constructed. Artists and scientists create at the interstice of the natural and the constructed. Like law, art and science attend to the definition and redefinition of form, charting conditions of justice, truth, and value.

In the two centuries before the advent of the digital age, the pairing of art with science was aimed at the manipulation and augmentation of light, movement, and sound using new materials and technologies, but never more so than in the period immediately after World War II.[1] To cite just a few examples, such themes appeared in the Slovakian-born Argentinean artist Gyula Košice's work (see chap. 2) as early as 1945; in the Argentinean group Arte Concreto Invención, with whom Košice was associated; in Lucio Fontana's *Black Light Environment* (1949), installed in Milan; and in László Moholy-Nagy's discussions in his book *Vision in Motion* (1947). Over the next two decades, art employing technology increasingly engaged viewer participation, with a marked amplification of the spectator's role in the 1960s. Frank Popper, a historian of art and technology, emphasized how participation, in the art of the 1960s, "refer[red] to a relationship between a spectator and an already existing open-ended art work, whereas the term 'interaction' implie[d] a two-way interplay between an individual and an artificial intelligence system."[2] The latter direction in art represents, in no small measure, the impact of cybernetics on aesthetics and the advent first of video and later of digital media, including virtual reality.

The field of cybernetics dates from the early 1940s and was defined by the mathematician Norbert Wiener in the title of his book *Cybernetics, or Control and Communication in the Animal and the Machine* (1948). A transdisciplinary information-communication theory linking the organizational principles and structures of all fields of knowledge, cybernetics is a mechanism for gathering feedback and a tool for an integrated systems approach to information. Cybernetics, which developed concurrently with general systems theory, provided a model for processual, intrasystemic organizational growth.

Cybernetic theory prognosticated the complete transformation of the social and biological environments, within which hybrid cybernetic entities, "cyborgs," would represent the postindustrial interchange between "organically human and cyberpsychically digital life forms as reconfigured through computer software systems."[3] Perhaps the defining concept of the post–World War II electronic age, cybernetics marked the transit from the simpler kinetic works of modernism to the postmodern interactive, telematic spaces of computer-generated reality, virtual environments, and cybernetic space.

Nicolas Schöffer (b. Hungary, 1912–92) began to apply cybernetics to the production of his "spatio-dynamique" sculptures in 1948. Initially trained in the Constructivist and Bauhaus traditions at the Budapest School of Fine Arts, Schöffer immigrated to France in 1935, where he resumed his studies of art and technology until they were interrupted by World War II. In 1955 he installed a 164-foot-high "spatio-dynamique" tower in Paris. Its autonomous and eccentric axial rotation was regulated by an electronic brain, which also broadcast electronic music from twelve tape-recorded cassettes by the French composer Pierre Henry, a specialist in *musique concrète*. A year later, in collaboration with François Terny, an engineer with the Philips Company, Schöffer introduced a more technologically sophisticated tower, *Cysp I,* its title derived from the first two letters of the words "cybernetic" and "spatio-dynamique." Schöffer coined numerous terms to describe various aspects of his work, among them "lumino-dynamique" (1957) for reflective surfaces, "chronodynamique" (1959) for dynamic temporal structures, and "teleluminoscope" (1961) for a broadcasting system that transmitted rhythmic visual movements on television and film. Schöffer applied advanced technology to interactive works incorporating art, music, architecture, television, theater, and aspects of psychotherapeutic medicine.

While Schöffer focused on the socially useful aspects of technology, the painter Gustav Metzger (b. Germany, 1926) addressed its destructive side. In 1959, twenty years after most of his family perished in the Holocaust and fourteen months before President Dwight D. Eisenhower cautioned about the "military-industrial-congressional complex,"[4] Metzger published "Auto-Destructive Art," the first of several manifestos on the interrelation of destruction and creation in art. He conceived "auto-destructive" artworks as civic monuments that would implode and self-destruct with the aid of technologically sophisticated internal computerized devices. Site-specific and requiring collaboration between scientists and artists, these sculptures were to visualize aspects of decay and disaster related to the culture of crisis within which they were imagined. A pacifist and political activist, Metzger condensed the vast experiential and technological territory of destruction into a manageable representation of the Cold War. His theoretical "demonstration-lectures" on "auto-destructive" and "auto-creative art" had a subversive impact on popular culture.[5] Metzger attended to the sociological function of art; wrote on cybernetics, automata, and computers; and in 1966 organized the Destruction in Art Symposium (DIAS), an international three-day symposium and month of events in London. By the mid-1970s Metzger had become even more critical of the cultural situation and called for a three-year art strike (1977–80). But he returned to art and by the 1990s produced evocative and interactive installations featuring blown-up photographs of various aspects of Nazi humiliation of Jews and the Holocaust. An exhibition of much of his work was held in 2009 at the Serpentine Gallery in London.

Although Metzger never built his visionary monuments, Jean Tinguely (b. Switzerland, 1925–91) captured the imagination of an international public in March 1960 when he created *Homage to New York*. Commissioned by Peter Selz, then curator of painting and sculpture at the Museum of Modern Art (MoMA) in New York, Tinguely constructed a kinetic assemblage of junk and found objects meant to destroy itself in an event held in MoMA's sculpture garden; however, the fire department extinguished an unanticipated fire that broke out in the sculpture before the work completely destroyed itself. In 1962 the National Broadcasting Company (NBC) commissioned and televised Tinguely's *Study for an End of the World, No. 2*, a similar spectacle of mayhem and destruction realized near a U.S. atomic-weapons test site in the Nevada desert outside Las Vegas. By 1964 Tinguely had abandoned these destructive assemblages and returned to creating "poetic metamatics" (his term), kinetic works representing the aim stated in his manifesto "Static" to use motion—the sign of life—to defeat death. With K. G. Pontus Hultén, W. J. H. B. Sandberg, and Daniel Spoerri, Tinguely organized *Bewogen Beweging* (Moving Movement, 1961), an ambitious exhibition of kinetic art at the Stedelijk Museum in Amsterdam that anticipated a spate of similar international exhibitions. The Venice Biennale and Documenta both featured kinetic art in 1964, and over a dozen such exhibitions took place the following year in the United States and Europe.

Work by the self-taught sculptor Takis (Panayotis Vassilakis; b. Greece, 1925) was included in most of these exhibitions. In 1955 Takis made his first kinetic sculptures, called *Signals,* consisting of thin, pliable, moving steel rods inspired by public-transportation signaling systems. He performed with these sculptures, which were augmented by explosives, noise, and multicolored lights, in the streets of Paris in 1957. The following year he began making telemagnetic sculptures related to his interest in radar scanners and invisible magnetic and electrical forces. These were succeeded by interactive "antigravity" sculptures controlled by spectators manipulating the magnetic environment. In 1960 the French Ministry of Industry awarded Takis a patent for his *Télésculpture* and *Télésculpture électromagnétique,* electromagnetic works incorporating music and light. Takis exhibited in the international exhibition *Light and Motion* at the Musée d'Art Moderne de la Ville de Paris in 1967, the same year that the American painter Alice Hutchins, then living in Paris, began making *Play-things,* small, tabletop-size magnetic sculptures that invited viewer interaction. Fluxus artists embraced her ludic works. Meanwhile, Takis continued to work at the intersection of art and science. Describing himself as an "intuitive scientist," he noted: "Socrates said that for him the person who discovers and who makes a thing which is invisible evident, is an artist."[6]

Takis's kinetic works coincided with the Cold War space race, as the Soviet Union launched its first satellite in 1957, followed by the United States in 1958. On November 29, 1960, as part of his exhibition *The Impossible: Man within Space* at the Galerie Iris Clert in Paris, Takis created an event featuring the poet Sinclair Beiles, who read from his "magnetic manifesto": "I am a sculpture. . . . I would like to see all nuclear bombs on Earth turned into sculptures."[7] The poet then leapt into the air and was momentarily suspended by a magnetic field created by a magnetized belt designed by Takis. Five months later, in April 1961, the Soviets put Yuri Gagarin in space; John Glenn became the first U.S. astronaut in space in 1962. *Early Bird,* the first U.S. commercial satellite, went into orbit in 1965, and Neil Armstrong and Buzz Aldrin landed on the Moon on

July 20, 1969. These events profoundly reshaped art practice, as artists increasingly recognized the need to collaborate with scientists and to form collectives for realizing projects with new technologies.

In 1957 Otto Piene (b. Germany, 1928) and Heinz Mack (b. Germany, 1931) founded the group ZERO in Düsseldorf; Günther Uecker joined them in 1961. Piene defined "zero" as "a zone of silence and of pure possibilities for a new beginning like at the count-down when rockets are started—zero is the incommensurable zone where the old state turns into the new."[8] Their publication *ZERO* (1958–61) revitalized art in Germany by bringing the German avant-garde in close contact with other European artists theorizing their work. ZERO's events included public light projections and other environmental displays incorporating smoke, fire, reflections, shadows, vibrations, or phenomena of motion exhibited sometimes in outdoor spectacles.[9] Piene immigrated to the United States in 1964 and became the director of the Center for Advanced Visual Studies at the Massachusetts Institute of Technology, following the retirement of its founder, the Hungarian artist György Kepes. As director, Piene urged the cessation of the "petty, perspectival, Renaissance viewer-object relationship," encouraging art of "cybernetic exchange."[10]

Many groups emerged during the same period as ZERO. Groupe de Recherche d'Art Visuel (GRAV) was founded in Paris in July 1960. Before it disbanded in 1968, GRAV established a communal studio for team research, issued several manifestos, constructed polysensorial environments and street actions with spectator participation, and exhibited in international shows. The collective included Hugo Rodolfo Demarco, Julio Le Parc, Horacio Garcia-Rossi, Francisco García Miranda, François Morellet, François and Vera Molnar, Sergio Moyano Servanes, Francisco Sobrino, Joel Stein, and Yvaral (Jean-Pierre Vasarely). Le Parc, who was among the most influential of GRAV's members, studied with Lucio Fontana (chap. 1) in Buenos Aires in the 1940s and was associated with the group Arte Concreto Invención before moving to Paris in 1958. His focus on the creation and manipulation of perception involved spectators in "game aesthetics," giving GRAV a political dimension associated with some happenings and other social actions by artists of the period. The French-born Morellet, whose circle also included Fontana, as well as Ellsworth Kelly (chap. 2), Jack Youngerman, Max Bill (chap. 2), Piero Manzoni (chap. 2), and Enrico Castellani, applied juxtaposition, superimposition, fragmentation, interference, randomization, and destabilization to his kinetic work. In 1961 GRAV formed Nouvelle Tendance (New Tendency) with the Zagreb collective Matko Mestrovic, a group studying psychological and physiological spectator responses to movement.[11] Nouvelle Tendance launched numerous international exhibitions of kinetic art and represented an association of European collectives that stressed anonymity and technological research. Its members included the Spanish group Equipe 57, as well as the Italian collectives Gruppo N from Padua (1959–67) and Gruppo T from Milan (1959–62).[12]

In October 1966 Robert Rauschenberg and Billy Klüver (b. Germany, 1927–2004), an artist and scientist working on laser research at Bell Laboratories, launched *9 Evenings: Theater and Engineering* at the 69th Regiment Armory in New York, a series of performance events integrating new technologies and derived from collaborations among ten artists and forty engineers. With Robert Whitman and Fred Waldhauer, they then cofounded the nonprofit organization Experiments in Art and Technology (EAT), with

Klüver serving as its first president, Rauschenberg as chair of the board of directors, Whitman as treasurer, and Waldhauer as secretary. They organized EAT to expand the role of artists in contemporary society and to eliminate their resistance to technological change.[13] EAT provided artists with access to new technologies and opportunities for collaboration with engineers. EAT later collaborated with Japanese companies in designing, building, and programming the Pepsi-Cola Pavilion at Expo '70 in Osaka; researched closed greenhouse environments (1971); proposed a single-channel satellite television system, entitled *U.S.A. Presents,* to be "programmed by the American people" (1971); and authored a study of mass-communication delivery systems in rural Guatemala (1973).

Expanding on the exchange between artists and scientists, Maurice Tuchman, then a senior curator at the Los Angeles County Museum of Art, organized the Art and Technology Program (1967–71), which involved more than seventy-five artists, twenty-three of whom collaborated with research scientists at leading technological and industrial corporations, particularly in the West Coast aerospace industry.[14] For example, Rockne Krebs, an artist from Washington, D.C., collaborated with the Hewlett-Packard Company on a sophisticated laser-projection project (and in 1969 participated in *Laser Light: A New Visual Art* at the Cincinnati Art Museum, the first exhibition of laser art). Robert Irwin (chap. 6) and James Turrell (chap. 6) explored the psychology of perception and experience in anechoic chambers with Dr. Ed Wortz, an experimental psychologist and then head of the life sciences department at Garrett Corporation; and Claes Oldenburg realized his undulating *Giant Ice Bag* (1969–70) with Walt Disney's WED Enterprises and other companies.

A very different kind of collective, Survival Research Laboratories (SRL) emerged in the late 1970s when mounting anger over corporate/government collusion in the nuclear weapons industry gave rise to public anxiety about nuclear annihilation, vividly expressed in the punk movement. Mark Pauline (b. U.S., 1953) founded SRL in 1978, its title a parody of corporate identity. Pauline worked with artists Matthew Heckert and Eric Werner to create frenzied spectacles of mechanical destruction that featured automated anthropomorphic robots. SRL's mock war games included huge flamethrowers, dynamite detonations, sirens, floodlights, catapults that hurled spiked balls, elements suggestive of torture, terror, and mayhem, and animal carcasses (or roadkill) attached to the mechanized works. Initially, SRL presented these performances in guerrilla actions, word-of-mouth events that took place under San Francisco freeway overpasses or in abandoned industrial-center parking lots. The first articles on SRL appeared in San Francisco New Wave and counterculture magazines like *Search & Destroy* (1977–79) and *RE/Search* (1978–), edited by V. Vale, later joined by Andrea Juno.[15] SRL soon performed before huge crowds at New York's Shea Stadium and other international venues, carrying out ideas related to Pauline's interest in Charles Mackay's discussion of "popular delusions" in his book *Extraordinary Popular Delusion and the Madness of Crowds* (1841). In their performances SRL satirized the violence anticipated by the Reagan-era proposed Strategic Defense Initiative (or Star Wars) and fundamentalist Christian censorship of the arts in the culture wars of the 1980s and 1990s.

The science fiction writer J. G. Ballard and the novelist William Burroughs were philosophical mentors for both SRL and Laurie Anderson (b. U.S., 1947). A composer,

musician, writer, and artist, Anderson graduated magna cum laude and Phi Beta Kappa in art history from Barnard College in 1969; studied art with Sol LeWitt and Carl Andre at the School of Visual Arts in New York; and received an MFA from Columbia University in 1972. Narrative performances by Vito Acconci (chap. 8) influenced Anderson's own storytelling genre of performance art. In 1975 she invented the "viophonograph," a violin with a built-in turntable and needle mounted mid-bow, which became a regular feature of her performances. After seeing Robert Wilson's multimedia production of Philip Glass's opera *Einstein on the Beach* (1976), Anderson increasingly integrated electronic technology with still photography, film, video, light, and shadow projections in her work, mixing music and images with storytelling, popular jargon, vernacular culture, and postmodern theory to explore identity, sexuality, nationality, and the media. Anderson's 1981 song "O Superman" (from her opera *United States,* first performed in 1983) made international pop-music record charts, and she has continued to hone her philosophical and humorous performances into the twenty-first century.

Using a xenon slide projector to greatly enlarge visual representations, Krzysztof Wodiczko (b. Poland, 1943) began doing projection works in 1981, projecting images onto the façades of public buildings and monuments in site-specific works visualizing the relations among ideology, power, and control inherent in the representational signification of public edifices. Technology has facilitated his exploration of the psychology of what he calls "social culture," the mechanics of censorship, and the propagandistic manipulation of symbols. For example, in 1985, while engaged in an authorized projection of the image of a tank on Nelson's Column in Trafalgar Square in London, Wodiczko surreptitiously turned the projector toward the façade of the South African embassy and projected the image of a swastika. Wodiczko earned an MFA from the Warsaw Academy of Fine Arts in 1968 and taught at the Warsaw Polytechnic from 1969 until his move to North America in 1977. Part of an elite corps of industrial designers at the academy, he studied under Jerzy Soltan, who had been a student at the Hochschule für Gestaltung in Ulm under Max Bill (chap. 2) and an assistant to Le Corbusier. Soltan taught Bauhaus and Constructivist principles on the unity of art, technology, and politics, which strongly informed Wodiczko's work. Increasingly concerned with the interrelationship of urban development, real-estate values, the homeless, and failures of the market economy, Wodiczko designed homeless vehicles for disenfranchised citizens in 1988. He considers such works "instruments" of survival and "prosthetics" for emotional trauma. He became director of the Center for Art, Culture, and Technology (formerly the Center for Advanced Visual Studies) at MIT in 1994.

Before computers and the Internet, no technology changed art as much as photography, television, and video. In 1959, Wolf Vostell (chap. 8) was the first artist to use televisions as a sculptural medium. Seven years later, Vostell, Allan Kaprow (chap. 8), and the Argentinian artist Marta Minujín planned a global collaboration to create a satellite broadcast of simultaneous happenings. Vostell and Kaprow dropped out of the project, and Minujín produced *Simultaneity in Simultaneity* in Buenos Aires on October 24, 1966. Her international media event was the first closed-circuit television broadcast of art.[16]

The composer and artist Nam June Paik (b. Korea, 1932–2006) exhibited altered television sets in *Exposition of Music—Electronic Television* at Galerie Parnass in Wuppertal, Germany, in 1963. Generally considered the "father" of video art, Paik, a student

of electronic music, earned a degree in aesthetics from the University of Tokyo and studied music in Germany, attending the International Summer Courses for New Music in Darmstadt, where he met Vostell and the composers John Cage and Karlheinz Stockhausen. Performing in the first Fluxus festival in 1962, Paik introduced spontaneity, unpredictability, danger, and eroticism into these events. In 1964 he moved to New York and began collaborating with the cellist Charlotte Moorman (U.S., 1933–1991), who appeared in such works as *TV Bra for Living Sculpture* (1969), *TV Glasses* (1971), and *TV Cello* (1971), which combined TV sets as objects or instruments with video and live performance. Moorman embodied Paik's desire to "eroticize" and "humanize" technology and to "renew the ontological form of music."

Paik also worked with the Japanese engineer Shuya Abe, constructing *Robot K-456*, a twenty-channel radio-controlled robot, in 1964. In 1965 Paik purchased one of the first Sony Portapak half-inch black-and-white video recorders, recorded Pope Paul VI's historic visit to New York, documented Fluxus performances at the Café au Go Go, and exhibited his first video sculptures at Galeria Bonino in New York. In 1970–71 Paik and Abe produced one of the first video synthesizers, and in the same year Sony brought out the portable color video recorder. (Sony standardized the system with three-quarter-inch videotape cassettes in 1972.) Paik realized his ambition to subvert and manipulate electronic media on a broad scale with his live interactive satellite transmission *Good Morning, Mr. Orwell,* broadcast by WNET-TV New York and WDR-TV Paris from the Centre Georges Pompidou on New Year's Day 1984. Viewed globally, the broadcast featured works by artists, poets, and composers, including Paik, Moorman, Joseph Beuys (chap. 7), Allen Ginsberg, William Burroughs, Douglas Davis, and Laurie Anderson.

A versatile representational medium that enfranchised both artists and the public, video enabled artists to record performances, conduct interviews, survey surveillance systems, transform installation spaces by introducing live image feeds, and create for and respond to a potentially unlimited viewing audience while subverting the codes of commercial television networks and conventional communication and distribution systems. In the autumn of 1968 the filmmaker Gerry Schum (b. Germany, 1938–73) conceived of a television gallery and proceeded to screen one or two video exhibitions a year on German national television. These TV exhibitions featured conceptual art, performance pieces, and site-specific earthworks. Concentrating on the technological reproduction of such ephemeral art forms, Schum established the Fernsehgalerie Schum (later Videogalerie Schum) in Essen, Germany, and broadcast the first television exhibition, *Land Art,* in 1968. Schum followed this broadcast with *Identifications,* a 1970 video exhibition of conceptual works by twenty European and American artists. During this same period Piene and Aldo Tambellini created *Black Gate Cologne,* a one-hour-long program broadcast in color on WDR-TV Cologne on January 26, 1969.

That same year Frank Gillette (b. U.S., 1941) and Ira Schneider (b. U.S., 1939) pioneered the use of the self-reflexive and self-reproducing aspects of video in their video sculpture *Wipe Cycle* (1969). They examined the technological aspects of feedback by utilizing playback video monitors on which they screened prerecorded images mixed with spectator action recorded in real time. Similarly, Shigeko Kubota (b. Japan, 1937), who moved to New York in the 1960s, explored electronic feedback by fusing prerecorded performances with color synthesized images in multiple-monitor installations. In 1972 she

produced the first of a series of works on Marcel Duchamp, in which "she transformed the monitor into a womb for the reinvention of female-originated and oriented art."[17]

Woody Vasulka (Bohuslav Peter Vasulka; b. Czechoslovakia, 1937) and Steina Vasulka (Steinunn Briem Bjarnadottir; b. Iceland, 1940) were among the first artists to examine video as an electronic audiovisual medium, inventing and modifying video production instruments and exploring the relationship between the electronic image and the sound signal, an interrelationship that became the form, content, and aesthetic of their works. After earning a degree in industrial engineering in Prague in 1956, Woody turned to television and film production at the Academy of Performing Arts in Prague, where, in the early 1960s, he met Steina, a classical musician studying at the Prague Conservatory. The couple married and in 1965 immigrated to the United States. In 1971, with Andreas Mannik, they founded the Kitchen, an interdisciplinary arts center in New York where they initiated the first annual video festival.[18] The same year, they organized *A Special Videotape Show* at the Whitney Museum of American Art. Between 1973 and 1974 the Vasulkas explored the Rutt/Etra Scan Processor, an electronic instrument for manipulating a monitor's raster. Creating unusual visual effects on the screen, their video *Noisefields* (1974) materialized the formal elements of the electronic signal, alternately filling the screen with "snow" (visual noise) and with rhythmic pulsating patterns and textures accompanied by static sound. In 1976, first with the physicist Don MacArthur and later with the design engineer Jeffrey Schier, Woody built the Digital Image Articulator, "a hybrid device that processes video signals and combines analog functions with digital components for programming."[19] In 1992 the Vasulkas organized the exhibition *Eigenwelt der Apparate-Welt: Pioneers of Electronic Art* (with an interactive catalogue on laserdisc) for Ars Electronica, an organization founded in 1979 and based in Linz, Austria, that sponsors exhibitions and symposiums on art, technology, and society.

In 1974 the artist and writer Douglas Davis (b. U.S., 1933) produced his interactive video series *The Austrian Tapes: Handing, Facing, Backing,* and in 1977 he used satellite telecasts to give a live international broadcast of his performance *The Last Nine Minutes* from Documenta 6 in Kassel, Germany. In 1982 the Museum of Modern Art in New York launched *Video and Satellite,* an exhibition of satellite transmission in the arts, featuring work by Davis, Liza Bear, Willoughby Sharp, Keith Sonnier, and others. Davis began to create video performances while working as a freelance editor and writer for such publications as the *National Observer, Newsweek,* and *Art in America,* and was influenced by Marshall McLuhan, the Canadian professor of literature who theorized that technology extended the body, electronic media united the world into a "global village," and, most famously, "the medium is the message."

In his 1978 *Proposal for QUBE,* Peter d'Agostino (b. U.S., 1945) challenged McLuhan's theory that by its very nature television (or video) is interactive, exposing as false the participatory claims of QUBE, a cable television channel in Columbus, Ohio, and questioning the efficacy and quality of the putative interaction. D'Agostino, who received a BFA from the School of Visual Arts in New York in 1968, began making slide, film, and multichannel video installations before earning his MA from San Francisco State University in 1975. Investigating the problems and potential of commercial television, by 1981 he had made his first interactive videodisc, followed by CD-ROMs (1989–), and what he called "critical virtual reality" (1993–). Exploring how television

encodes, transmits, and constructs ideology and knowledge, d'Agostino has edited anthologies offering a broad framework for the study of television and new-media theory, from *Transmission: Theory and Practice for a New Television Aesthetics* (1985) to *Transmission: Toward a Post-Television Culture* (1995).

Martha Rosler (b. U.S., 1943) earned an MFA in 1974 from the University of California, San Diego, where she studied with Allan Kaprow and David and Eleanor Antin (chap. 8), among others. Involved in the women's movement in Southern California in the early 1970s, Rosler produced her first feminist video performances in 1973. A persuasive theorist, she incorporated semiotics, psychoanalysis, feminism, and postmodern media theory into her writing and social activism, writing extensively and critically on the political dimensions of photography, video, and the ideological practices of art and social institutions. Rosler published widely in such journals as *Heresies, The Socialist Review,* and *Alternative Media.* Collaborating with Paper Tiger Television (PTTV), a collective founded in 1981 to produce alternative television programming, Rosler made *Born to Be Sold: Martha Rosler Reads the Strange Case of Baby $/M* (1988), in which she examined the political and legal effects of surrogate mothering and new reproductive technologies. She also collaborated in the late 1980s with Group Material (chap. 9) in town meetings and other projects on questions of community housing, homelessness, and urban planning.[20] In 2005 she made her library of more than 7,500 volumes available to the public as part of a five-month installation project, *Martha Rosler Library.*

Language is also critical to Gary Hill (b. U.S., 1951), whose single-channel projective and multiscreen video installations consider the phenomenological interrelationship among text, image, identity, and the body, transforming philosophical subjects into visual experiences. Hill began using video in 1973 and from 1974 to 1976 worked with Woodstock Community Video (WCV) in Woodstock, New York, founded by Ken Marsh and dedicated to providing alternative programming for cable television. Throughout the 1980s Hill created videos on subjects ranging from ecology to politics, gradually becoming interested in how video mediates between viewer and artwork and exploring visual and conceptual illusion. In his computer-generated video installation *Tall Ships* (1992), viewers walk down a long corridor, automatically activating video projections of twelve or sixteen life-size phantom figures, which appear to approach, lock eyes, and then turn and walk away. Hill later turned his attention to the U.S. military presence in the Middle East in two videos, *Guilt* and *Frustrum* (both 2006).

The work of Bill Viola (b. U.S., 1951) is equally haunting and visually arresting. Viola received a BFA from Syracuse University's Department of Experimental Studios in 1973 and began making films in the minimalist tradition of Stan Brakhage, Hollis Frampton, and Michael Snow. After graduating, he worked at art/tapes/22 in Florence, one of the first video art studios in Europe. Viola, who has traveled extensively, especially in Asia, lived for a year in 1980 in Japan, where he studied Buddhism with the Zen master Daien Tanaka and was the first artist-in-residence at Sony Corporation's Atsugi research laboratories. In *The Quintet of Remembrance* (2000) Viola focused on a group of five individuals who react to an unidentified event offscreen. He recorded the minute details of their facial expressions with a high-speed 35 mm film camera, shooting at 140 frames per second, and then slowed down the sixty-second sequence to sixteen minutes and nineteen seconds on video, running it in a continuous loop. This

was the first video installation to enter the collection of the Metropolitan Museum of Art in New York. Viola's multimedia installations use video to examine the interplay among the physical, mental, emotional, and psychological aspects of perception. He employs the camera as an extension of the body and as a tool for recording sense perceptions and for self-knowledge. His extensive familiarity with philosophy and mythology, as well as religious practices from Zen and Tibetan Buddhism to Judeo-Christian mysticism and Sufism, particularly inform his interest in visualizing "interacting opposites—light and dark, spiritual and physical, life and death."[21]

William Wegman (b. U.S., 1943) has matched Viola's attention to spirituality with a visualization of the psychology of humor. He is best known for video performances and photographic portraits featuring his Weimaraners—first Man Ray (named after the Dada/Surrealist photographer Man Ray) and later Fay Ray (named after the actress Fay Wray) and her puppies. Astutely analyzing the paradoxical relationship between humans and animals, as well as animals' interaction with everyday objects and behavior in ordinary situations, Wegman has featured his dogs in staged surrealistic permutations and comic parodies of the quotidian. In self-consciously ironical psychoanalytic monologues, he satirized the idea that video performance is essentially a narcissistic medium, a theory propounded in the mid-1970s.[22] Wegman's shrewd grasp of the transformative character of humor distinguishes his work from the formal restraint of minimal and conceptual art, which, nonetheless, informs the aesthetics of his videos and photographs.

Lynn Hershman (b. U.S., 1941) has worked across numerous media, frequently adopting new technologies to expand her visualization of questions of identity. She produced her first interactive laserdisc, *Lorna,* in 1983–84, in which viewers were invited to participate in the construction of the persona Lorna. This character grew out of Hershman's interest in alternative personas, first seen in *Roberta Breitmore* (1974–78), a five-year project during which the artist intermittently assumed the persona of her fictional character (Roberta Breitmore) to explore fragmented identity. She revisited this theme in *The Electronic Diaries* (1986–), a series of autobiographical videos in which she concentrated on the psychosomatic effects of childhood traumas such as incest and physical abuse.[23] Hershman has also made films under the name Leeson using virtual sets (*Conceiving Ada* [1997]) and exploring cyber-identity, cloning, hybrid replicants, and artificial life (*Teknolust* [2002]). Her "Agent Ruby," one of three self-replicating automatons in *Teknolust,* gained a virtual presence on the Web; another artificial intelligence character, "DiNA," began answering questions about her presidential candidacy in 2004.

Tony Oursler (b. U.S., 1957) has also examined mental disorders and multiple personalities, as well as spirit possession, in video projections that ranged in the late 1990s from depictions of a surrealistic disembodied eyeball and a sheep's brain to one of bantering puppets. In his *Come to Me* (1996) Oursler projected, onto a distorted fiberglass head, the image of a figure who taunted the viewer. In *Studio: Seven Months of My Aesthetic Education (Plus Some)* (2005), based on Gustave Courbet's *The Artist's Studio: A real allegory summing up seven years of my artistic and moral life* (1854–55), Oursler created a room-size installation featuring numerous videos and objects summarizing his art and its influences. Oursler turned from a meditation on the relationship between artists' biographies and aesthetics in the nineteenth and twentieth centuries to the relationship

between new technologies and obsessions and addictions in *Cell Phones Diagrams Cigarettes Searches and Scratch Cards* (2009).

Normalcy and its boundaries is a central topic of the large-scale, multiscreen video installations of Eija-Liisa Ahtila (b. Finland, 1959), who studied law at the University of Helsinki (1980–85) before studying film and video in London (1990–91) and multimedia and film in Los Angeles (1994–95). Her works often feature women battling mental breakdown and struggling for stability in stories that focus on separation, reconciliation, and detachment. Ahtila has studied the formation and disintegration of relationships and interpersonal communication from a feminist perspective, including real and fictive events in the lives of strangers as well as in fragments of her own experiences and memories. Inspired by conceptual art and its critique of institutions and its investigation of forms of knowledge, Ahtila's work self-consciously attends to revealing filmic illusion.

Pipilotti Rist (Elisabeth Charlotte Rist; b. Switzerland, 1962) studied commercial art, illustration, and photography at the Institute of Applied Arts in Vienna (1982–86) and video at the Basel School of Design (1986–88). She sang with the cabaret band Les Reines Prochaines from 1988 to 1994. In the mid-1980s she began making short Super 8 films, such as *I'm Not the Girl Who Misses Much* (1986), in which she dances before an unfocused camera in a black dress with her breasts exposed, repeatedly singing the first line of the Beatles' song "Happiness Is a Warm Gun." Rist's postpunk aesthetic is vivid in her videos *Pickelporno* (1992), in which a camera with a fish-eye lens examines the bodies of a couple, and *Ever Is Over All* (1997), in which Rist, wearing a beautiful blue gossamer cocktail dress, walks merrily along a city street, intermittently smashing the windows of parked cars with a large hammer, the end of which is shaped like a tropical flower. A feminist interested in technology, documentary and feature films, advertising, and popular culture, Rist creates surrealistic incongruities through juxtapositions of unrelated images and actions—fragments that suggest the border between normalcy and madness and disrupt stereotypes with humor.

Gillian Wearing (b. U.K., 1963) came to wide public attention with her photographic series *Signs that say what you want them to say and not signs that say what someone else wants you to say* (1992–93). Unseating cultural stereotypes about the difference between how people look and how they feel, Wearing asked six hundred passersby on the street to write a message on a piece of paper and then photographed her subjects holding up their signs. For *Confess All on Video. Don't Worry You Will Be in Disguise. Intrigued? Call Gillian* (1994), Wearing videotaped anonymous, masked individuals confessing stories (real and imagined) about their lives after responding to an ad she posted in a popular London entertainment magazine. Again referring to the era of the talk-show confessional and reality television, Wearing created *Family History* (2006), a film based on the BBC series *The Family,* probing how, in cooperation with the mass media and before the public, individuals willingly enact their fantasies in the interstice of truth and fiction.

Family and history are the themes of the video *Intervista—Finding the Words* (1998) by Anri Sala (b. Albania, 1974), who based the work on a 16 mm newsreel from the 1970s that he found in his family home. His mother, Valdet, is featured in the footage, giving a rousing speech at an Albanian Communist Party congress, being interviewed, and enthusiastically meeting Enver Hoxha, the Communist leader of Albania from 1944 to 1985. As the sound from the newsreel had been lost, Sala attempted to recover it, eventu-

ally succeeding by using lip readers from a school for the deaf in Tirana, the Albanian capital. He then (as shown in the video) confronted his mother with the reconstructed work, her words, and her past, forcing her to reflect upon her youthful Communist ideals and Albania's post-Communist history after 1989. Sala took up Albanian themes again in *Give Me the Colors* (2003). This semidocumentary centered on the artist Edi Rama (who studied in Paris with Sala and was later elected mayor of Tirana) and his effort to rehabilitate the drab, riot-torn, post-Communist capital. Sala's intimate portrait follows Rama's dialogue with the city's residents about painting its buildings bright colors. Sala trained as a fresco painter at the Albanian National Academy of Arts (1992–96) but left Albania in 1996 to study video and film directing in France and later moved to Germany.

Shirin Neshat (b. 1957) grew up in a partially secular Iran and moved to the United States just prior to the 1979 Iranian Revolution. She earned a BA, an MA, and an MFA from the University of California, Berkeley, before moving to New York. In 1990 she returned to Iran for the first time and witnessed the radically altered cultural and social conditions of this now-fundamentalist Islamic nation. Her trip resulted in the photographic series *Women of Allah* (1993–97), inspired by feminist poetry and newspaper images of women during the Iran-Iraq War (1980–88). Neshat borrowed many of the poetic verses that she wrote in Persian calligraphy over parts of the women's bodies in these photographs from Forugh Farrokhzad (1935–67), one of the most important Persian poets of the twentieth century. Farrokhzad was a popular secular intellectual, noted for her knowledge of Iranian history, including the 1953 CIA-organized coup that replaced the nationalist regime of Mohammad Mossadeq with the constitutional monarchy of Shah Mohammad Reza Pahlavi (overthrown in the 1979 revolution). Next Neshat created black-and-white films and videos, like *Turbulent* (1998) and *Rapture* (1999), based on religious codes and gender relationships in Muslim societies. In *Women without Men* (2004–8)—which began as a five-part, multichannel, large-scale video installation and became a feature-length film—Neshat worked with the open narrative structure of the 1989 novel of the same title by the feminist Iranian writer Shahrnush Parsipur. Parsipur, who was jailed for five years after the 1979 revolution, was imprisoned again for her secular and political references in *Women without Men,* which is set in 1953, during the Iranian revolution. Neshat's film follows four women as these events transform their lives.

Like Neshat and Sala, Stan Douglas (b. Canada, 1960) grapples with the inconsistencies and elisions of history and the invisible forces that shape the present. In his three-screen video installation *Evening* (1994), Douglas juxtaposed three different 1969 clips from Chicago television stations presenting "happy talk," a convention pioneered by television news executive William C. Fyffe to "humanize," as he said, the evening news. *Evening* underscores the disjuncture between "happy talk" and the dire cultural situation of the time, marked by the Vietnam War, student and social unrest, and the civil rights and feminist movements. In *Nu•tka•* (1996) Douglas turned to the history of Vancouver Island, overlaying images of its landscape with different eighteenth-century narratives describing battles between the English and the Spanish in the colonization of that land. Douglas has also staged historical events in a cinematic way to explore the posthumous residue of past events in the present, as he did for *Abbott & Cordova, 7 August 1971* (2008), a series of digital photographs that depict a 1971 clash between hippies protesting drug arrests and the Vancouver police.

Memory and emotion are frequent subjects in the interactive installations that Maurice Benayoun (b. Algeria, 1957) has created since 1994. *So.So.So. (Somebody, Somewhere, Some Time)* (2002), for example, activates retinal memory when viewers experience the reappearance of fragments of images that they have previously viewed and that intermittently overlay and interrupt their vision. In his fifteen-part multimedia work *The Mechanics of Emotions* (2008)—comprising such individual works as *World Emotional Mapping* (2005), *Frozen Feelings* (2005), *Emotional Stock Exchange* (2005), and *Emotional Vending Machine* (2006)—Benayoun turned to an examination of the status of human emotion in a mass-mediated world, presenting global communication networks as a "virtual nervous system." As he explains on his website: "From anywhere in the world one can feel what's happening anywhere else in real time as long as it is connected to the Net and is English speaking."[24] Benayoun has worked in a variety of media, from photography, video, digital media, and virtual reality to performance. He cofounded the award-winning computer graphics and virtual reality lab *Z–A* in 1987. Dedicated to computer animation, interactivity, and real-time graphics, Z–A produced *Quarxs* (1990–93), one of the earliest computer-animated graphics series, directed and conceived by Benayoun in collaboration with the Belgian graphic novelist François Schuiten. Benayoun's virtual reality installation *World Skin, a Photo Safari in the Land of War* (1997) won the Golden Nica in Interactive Art at Ars Electronica in 1998 for its 3D scenes of war landscapes. Viewers are invited to "photograph" these landscapes, causing the very images they take to disappear from the screen and leaving fragments of empty silhouettes, in "a tragedy without end," Benayoun comments.

The artist and media theorist Jordan Crandall (b. U.S., 1960) has created works that incorporate and theorize new technologies tied to global economics, the military, and communication networks, particularly those related to strategies of identifying, tracking, and targeting. Considering the impact of such technologies on the "body-image-machine complex," as well as the militarized condition of "strategic seeing," Crandall created his multimedia installation *Drive* (1998–2000), which incorporates Super 8 and 16 mm film, computer animation, motion-tracking software, satellite-derived photography, and infrared thermal imaging. *Drive* also incorporates digital video from a wearable camera using a monocular night vision attachment, both military and commercial film and video footage, and processed digital video from smart bombs, aircraft, and military targeting systems, among other imaging sources. With the vehicle as its central metaphor, *Drive* positioned Crandall's examination of embodiment within the pervasive context of surveillance and at the interface of theories (drawn from psychoanalysis, semiotics, cinema, and new media) of the construction and manipulation of consciousness. As the theorist Keller Easterling has written, digital devices for Crandall represent "a new set of interfaces and switches . . . [that] are about the material within which they are embedded—our bodies, our larger marketplaces and networks, and our daily theaters of operation. . . . they both ventriloquize and receive life beyond their own boundaries and capabilities."[25]

Easterling's comment points to the incomparable effect the computer has had on contemporary art. As early as 1950 Ben F. Laposky used a cathode-ray oscilloscope to compose what he called "electronic abstractions," and by 1960 William A. Fetter, a designer working for Boeing, would coin the term *computer graphics*. In 1961, at MIT,

Ivan Sutherland created Sketchpad, a computer drawing program, and Steve Russell developed *Spacewar!,* the first computer game. A year later the artist/engineer Michael Noll, at Bell Labs, began creating computer-generated artworks. The earliest computer-generated film appeared in 1963, the same year that the computer mouse was invented.

In 1965 the first exhibition of computer art was held at the Technical College of Stuttgart, Germany, and a second took place later that year at the Howard Wise Gallery in New York. In 1968 in Paris, Frank Malina, a pioneer of kinetic art and a scientist who contributed to the development of rocket technology, founded the journal *Leonardo,* focusing on artists using science and technology. Also in 1968 the British art critic Jasia Reichardt organized the first exhibition of cybernetic art, *Cybernetic Serendipity,* at the Institute of Contemporary Arts in London, and in 1970 the sculptor, curator, and art critic Jack Burnham mounted *Software: Information Technology: Its New Meaning for Art* at the Jewish Museum in New York.[26] The *Software* show included graphics, films, music, animated poems and other texts, painting machines, and robots, all computer-generated or computer-operated.

These are only some of the foundational events in the history of computers in art. Yet by 1971 no art department in the United States had its own computer, and computer scientist-artists—like Myron W. Krueger (b. U.S., 1942), often called the "father" of virtual reality—were all but ignored in the visual arts. Krueger completed his doctoral dissertation, "Artificial Realities," at the University of Wisconsin in 1974. Beginning with *Metaplay* (1970), the first interactive computer environment, Krueger explored and developed the computer's ability to respond in real time and to include viewer participation in multisensory events "in which the user moved without [the] encumbering gear" usually associated with the virtual reality environment.[27] His interactive installations became the prototypes for computerized simulations and virtual reality.

As art museums were slow to exhibit computer-related developments in visual art, a need emerged for alternative venues like Ars Electronica and the International Symposium on Electronic Art, started in 1988 as a place for critical discussion and exhibition of new technologies in interactive and digital media. In 1990 the symposium became part of ISEA (the Inter-Society for the Electronic Arts), which published the *International Journal on Electronic Art*. In response to these developments, cultural institutions devoted to new-media art began to spring up in the 1980s. The Center for Art and Media (ZKM) in Karlsruhe, Germany, for example, was first conceived in 1980, incorporated in 1988, and opened in a new building in 1997.

In 1999 the Austrian artist Peter Weibel (b. Ukraine [then USSR], 1944) became the director of ZKM, contributing to its international acclaim as a center for the practice, exhibition, and theorizing of new-media art. As artistic advisor and then director of Ars Electronica from 1986 to 1995, Weibel had been instrumental in selecting such visionary exhibition themes as *Digital Dreams—Virtual Worlds* (1990), on the interface between art and computer-generated virtual reality; *Out of Control* (1991), on art and destructive technology in the nuclear age; *Endo and Nano: The World from Within* (1992), on art and endophysics, nanotechnology, and other microtechnologies; and *Genetic Art* (1993), on art and artificial life. As a young artist, Weibel wrote concrete poetry, made films, and collaborated with Valie Export (see chap. 8) to create expanded cinema. In 1970 Weibel and Export published *Bildkompendium Wiener Aktionismus und Film,* an

unprecedented collection of documentation on the history, theory, practice, and imagery of Viennese Actionism (with which Weibel had been associated since his late teens). In his own artwork Weibel has applied his erudition and extensive knowledge of philosophy, mathematics, science, and semiotics to video performances and interactive computer installations, as well as to research into artificial intelligence and artificial life.

Jeffrey Shaw (b. Australia, 1944), the founding director of the Institute for Visual Media at ZKM (1991–2003), became the founder and codirector of the iCinema: Centre for Interactive Cinema Research at the University of New South Wales in Sydney in 2003. Shaw, who studied sculpture at the Brera Academy in Milan and St. Martins School of Art in London, was a pioneer of interactivity in installations beginning in the 1960s. In the late 1960s he cofounded the Eventstructure Research Group in Amsterdam, for art at the intersection of performance, installation, and technology. Shaw increasingly turned his attention to computer-based projects in the 1980s and 1990s, including the development of videodiscs, laserdiscs, and computer-simulated virtual reality. In collaboration with Dirk Groeneveld, Shaw created the interactive computer and video installation *The Legible City* (1989–90), a multisensorial environment aimed at extending the visual field into "psycho-geographic spaces," recalling Shaw's early studies in architecture at the University of Melbourne. In the 2000s he became a key figure in interactive digital cinema.

Work such as Shaw's is indebted to Roy Ascott (b. U.K., 1934), who began to introduce cybernetics into his work around 1960 and was an early advocate for computers in studio art classes. He had studied at the University of Durham in England (1955–59) and rapidly became known as a radical educator and director of experimental art programs in the United Kingdom, Canada, and the United States. In the early 1960s Ascott introduced "field theory" to his art classes at the Ealing School of Art, emphasizing process over product and system over structure in his "Groundcourse," a two-year experimental curriculum integrating art, science, and behaviorism. In 1980 Ascott organized *Terminal Art,* the first international computer-networking project involving U.S. and U.K. artists. One of the leading practitioners of telematic art—art created by geographically dispersed individuals collaborating via computer-mediated telecommunications networks—Ascott has written extensively on the aesthetic, educational, and social implications of cybernetic art.[28] In 1994 Ascott founded the Centre for Advanced Inquiry in the Interactive Arts (CAiiA) at the University of Wales in Newport, creating a program that awarded PhDs to some of the most innovative artists working in art and technology. In 2003 Ascott renamed CAiiA as the Planetary Collegium, relocated it to the University of Plymouth, and expanded its international network, especially to those working on telematics, technoetics, and consciousness. Ascott's prescience is apparent in a 1993 observation, made a decade before the start of Second Life, MySpace, and Facebook:

> Art in the cybersphere is emerging out of the fusion of communications and computers, virtual space and real space, nature and artificial life, which constitutes a new universe of space and time. This new network environment is extending our sensorium and providing new metaphysical dimensions to human consciousness and culture. Along the way, new modalities of knowledge and the means of their distribution are being tested and extended. Cyberspace cannot remain innocent, it is a matrix of human values, it

carries a psychic charge. In the cyberculture, to construct art is to construct reality, the networks of cyberspace underpinning our desire to amplify human cooperation and interaction in the constructive process.[29]

One of the first artists to earn his doctorate from Ascott's program at CAiiA in 1999 was Bill Seaman, whose "recombinant poetics" uses computer technology to combine poetry, visual imagery, and music in new ways, as seen in *The World Generator/The Engine of Desire* (1996–97), which he created with the programmer Gideon May.[30] Seaman collaborated with the German theoretical biologist and physicist Otto Rössler on "neosentience," or how the world comes to be known through the senses, how the body acquires pattern flows through time-based perturbations, and how to instantiate such processes in a computer. In their book *Neosentience: The Benevolent Engine* (2011), Seaman and Rössler envision an intelligent, embodied robotic system with the capacity for multimodal sensing. Using biomimetics, they posit a new paradigm of consciousness derived from artificial intelligence.[31]

Already in the 1970s, STELARC (Stelios Arcadiou; Cyprus, b. 1946) anticipated such research, arguing that the technological environment had rendered the human body's structure obsolete, especially in the compressed and computerized environment of outer space.[32] In his effort to redesign the human body, first in suspension performances then with robotics, STELARC performed with his *Third Hand* (1976–81). This artificial hand could be attached to his right arm and used to augment corporeal movement. In the 1980s, when STELARC undertook research on the amplification of internal body functions, he theorized that the resulting works would function as prototypes for the eventual implantation of electronic devices in the body and that artists of the future would be "evolutionary guides." In 1995 STELARC began a series of "Ping Body" performances, electronically linking his body to the Internet and permitting remote viewers to view and manipulate his movements via a computer-interfaced muscle-stimulation system. "Ever since we evolved as hominids . . . ," he wrote, "we constructed artifacts, instruments and machines. In other words we have always been coupled with technology. We have always been prosthetic bodies. We fear the involuntary and we are becoming increasingly automated and extended."[33] With this aim, in 2003 STELARC created *Partial Head,* a construction of living cells, and *The Walking Head,* a six-legged autonomous walking robot. In collaboration with the artist Nina Sellars, STELARC made *Blender* (2005), in which fat, nerve tissue, adrenalin, and O+ blood extracted from their bodies circulate through a huge blender, creating an "alternative corporeal architecture" for augmenting and changing the body.[34] *Blender*—an example of bioart, art based on living organisms—comments on hybridity, cloning, and other posthuman technologies.

Since the mid-1990s Eduardo Kac (Brazil, b. 1962) has practiced bioart and "transgenic art," which he defines as "genetic engineering techniques to transfer synthetic genes to an organism or to transfer natural genetic material from one species into another, to create unique living beings."[35] Kac also works with "biotopes," living beings whose internal metabolism changes related to continuously altered environmental conditions. In *Time Capsule* (1997), a performance broadcast simultaneously on television and the Internet, Kac had a microchip implanted in his ankle with a programmed identification number for tracking his movements. The performance, which addressed

the relationship between history, memory, and information, also included seven photographs from the 1930s of Kac's grandmother, a victim of the Holocaust, as critical reminders of the negative potential of technology and surveillance. Kac further investigated ethical questions in *Genesis* (1999), for which he created a synthetic "artist's gene" that translated into Morse code and converted into DNA base pairs a sentence from the Book of Genesis: "Let man have dominion over the fish of the sea, and over the fowl of the air, and over every living thing that moves upon the earth." Commenting on the divine sanction of human supremacy over nature in the Judeo-Christian tradition, Kac questioned the role of belief in the determination of human, animal, and natural biological systems and their uses. In an experiment to study the socialization of transgenic animals, Kac created *GFP Bunny* (2000) in collaboration with a French laboratory that altered a fertilized rabbit egg with the fluorescent genes found in the jellyfish *Aequorea victoria,* so that the resulting animal, a white rabbit that Kac named "Alba," would glow green under a specialized blue light. For Kac, *GFP Bunny* raised questions about genetic engineering, biodiversity, interspecies communication, religious and cultural practices and beliefs concerned with "normalcy, heterogeneity, purity, hybridity, and otherness," as well as the "expansion of the . . . conceptual boundaries of artmaking to incorporate life invention."[36]

From the late 1960s until the early 1990s, ORLAN (France, b. 1947) used her body as a sculptural medium in performances, photographs, and videos. Her nine cosmetic-surgery performances (1990–93) brought the artist to world renown. Gradually reconstructing her face and modifying her body in material enactments of self-portraiture, and ironically summoning Duchamp's notion of the readymade, ORLAN described herself a "modified readymade." In 1993 she exhibited *Omniprésence No. 2,* a photographic installation featuring two horizontal rows, each with forty-one images of self-transformation: on top, daily photographic portraits of her face healing from her seventh plastic surgery; below, digitally altered images of her features morphed with composites of what she considered to be the most beautiful women in the canon of Western painting (e.g., Leonardo da Vinci's Mona Lisa and Botticelli's Venus). A text between the two images reads "Entre-Deux" (Between the Two), suggesting that reality resides between the body-as-machine and the machine-as-computer. ORLAN has continued her transformations with *Self-Hybridizations,* begun in 1998. Using digital photography, she merges her features with images representing different cultural standards of beauty, from pre-Columbian and African to Native American and Chinese. Her *Harlequin Coat* (2007) is a multimedia installation created with her own skin cells and those from other races and species, cultivated together in vitro in a custom-made bioreactor. ORLAN, a feminist, calls her work "carnal art," which she defines as entailing the refusal to conform to Judeo-Christian laws regarding the sanctity of the body, denying DNA as the sole progenitor of corporeal formation, and embracing technology and science in the creation of a self-determined identity. Petitioning the French government in the early 2000s for control over her body and identity, ORLAN sought to reinvent herself as "reincarnated" through technology and artistry.

NICOLAS SCHÖFFER The Three Stages of Dynamic Sculpture (1963)

Spatiodynamism, Luminodynamism and Chronodynamism

Spatiodynamism appears at the opportune moment and leads to a new plastic adventure in which the three dimensions reassume their dominant role. The essential aim of spatiodynamism is the constructive and dynamic integration of space in the plastic work. A tiny fraction of space contains very powerful energy possibilities. Its exclusion by hermetically sealed volumes deprived sculpture for a long time of possibilities of development both in the field of formal solutions and on the level of the dynamic and energy enhancement of the work.

Spatiodynamic sculpture is first of all created by a skeleton. Its function is to circumscribe and take possession of a fraction of space and to determine the rhythm of the work. On this skeleton is built another rhythm of elements, planes or volumes, elongated or transparent, serving as counterweights and giving to the marked-out space all its possibilities of energy and dynamics. Thus sculpture becomes an airy, transparent work, penetrable from all sides, achieving a pure rhythm of proportions with the logical clarity of a rational structure encompassing and amplifying the aesthetic and dynamic possibilities of the latter.

Its impact has no limit, it has no privileged face, it affords from every angle of vision a varied and different aspect even from within and from above. The vertical, diagonal or horizontal succession of the rhythms composed exclusively with right angles makes it possible to visualize in the space the most varied, because suggested, sinusoids.

The complex of straight angles becomes a mine rich in acute angles varying with the position of the viewer and excluding any possible repetition. The use of acute angles would be a pleonasm in spatiodynamics and would inevitably lead to monotony. Whereas on a two-dimensional surface and the surface of a three-dimensional volume, the angles and the curves do not vary, having no relations in depth, when the structure is open there is a constant change of relation in depth according to the position of the viewer. Moreover, this constant displacement of the spectator's angle of vision on the one hand, and the transparency engendering proportional changes in relationships on the other, contribute powerfully to accentuate the dynamic effect of the work by giving it a life of its own even though it is inanimate. But this life is precisely the counterpoint of the animated life of the city that surrounds it. Naturally, spatiodynamic sculpture can be animated in its own way. Rotating axial movements on the vertical plane and on the multiple horizontal planes may be effected with rhythms carefully studied in relation to the plastic rhythm.

Spatiodynamics, which was the first stage in the research marking a break even with the immediate past, aimed at modeling space into an absolute. It constitutes a definitive break with traditional or even modern conceptions of the volumes of solids and voids. Opaque and palpable materials play only a secondary role. This conception of sculpture represented in itself, in relation to the past, such an innovation that no link could attach it to the latter, except the fundamental continuity which constitutes the characteristic activity of the creative artist, his will to go beyond.

Whereas in traditional art the material, colors, light and their combination represented an

* Nicolas Schöffer, excerpts from "The Three Stages of Dynamic Sculpture," in Guy Habasque and Jacques Ménétrier, *Nicolas Schöffer [Space, Light, Time]*, trans. Haakon Chevalier, with an introduction by Jean Cassou (Neuchâtel, Switzerland: Editions du Griffon, 1963), 132–42. By permission of the estate of Nicolas Schöffer and the publisher.

aim in itself, spatiodynamism considers them as means which serve to produce, to determine and to dynamize a spatial fact. Here the aim is essentially one of energy, not a material one.

Nevertheless, the element of plastic revolution, that is to say the passage from matter to absolute space, is not totally realized by the processes enumerated. It is possible to foresee delimitations of space with well-nigh invisible and totally transparent materials, or with stroboscopic optical effects which will in fact make it possible to render the materials occupying the marked-out space invisible, or to immaterialize them.

In order to obtain these effects, technical means which likewise represent a new departure must be resorted to. The essential plastic aim of spatiodynamism is to transcend matter, as is done today in physics. If the plastic aim to be attained is one which relates to energy, it is logical that elements already possessing a certain energy substance should be used to this end. These reactors, so to speak, are mechanisms adapted to purely plastic and aesthetic ends, and designed with this in view. More precisely, in the case of *Cysp I.,* for example, the energy-supplying element is electronic controls running on batteries, which also activate electric motors, while these in turn supply the driving power for locomotion, steering and animation. For the operation of this complex whole, electrical energy stored in these batteries is needed. The whole in operation can thus give rise to energetico-aesthetic phenomena on a very large scale. What we have, in short, is a transmutation of real energy into creative energy.

In respect to optical and stroboscopic problems, it is necessary to refer also to the use of rotating elements, having variable speeds, with a reflecting surface which is colorless on one side and polychrome on the other. When these turn, the stroboscopic effect is produced, communicating a sensation of immaterialization.

An interesting effect is obtained by reflecting surfaces in rotation which capture luminous and colored emissions, and reflect them in a great radius of action, thus considerably enlarging the spatial field of the work. The rapid displacement of the whole in movement is likewise a means of conquering adjacent spaces, and of enhancing its energetico-aesthetic power by the constant addition of elements.

The adding of sound represents another means of increasing the spatial power. Sounds derived from the work and processed electronically can be broadcast stereophonically, over considerable areas, by means of loud-speakers in a staggered series, and harmonizing completely with the sculpture. The sounds broadcast and recomposed by the electronic brain contribute to developing the energy possibilities of the spaces surrounding the sculpture in a great radius of action. Sound, light, color, movement, electrical energy, electric motors, electronics and cybernetics represent a new technical arsenal with infinite possibilities full of unknowns. Thus on the basis of spatiodynamic investigations, a new departure has been given leading to novel developments. After the use of space, light appeared with luminodynamism, the definition of which is simple: any space or surface delimited and differentiated into a number of *lumens,* that is to say charged with luminousness, possesses an attractive force which emphasizes the rhythm of structures. Light, whether colored or not, penetrates through the spatio-dynamic work, and in lighting up the structures, the opaque or translucent surfaces, gives rise to plastic developments which liberate an immense potential of aesthetic values having a considerable energy and a great power of sensorial penetration. The light-sources may be static, mobile or intermittent, and the conveyed shadows, the colored projections, captured in their entirety or fragmentarily on appropriate screens.

Luminodynamism is thus the handling of a surface or of a fraction of space of whatever size, in which are developed plastic and dynamic elements, colored or not by real or factitious movements (optical illusions). This development, if it is reflected on the surface, is accompanied by a luminous increase in relation to its surroundings, producing a differentiation mea-

surable in a number of *lumens*. If it occurs in space, the light penetrates and passes through the spatiodynamic sculpture, increasing its luminousness, and produces on any opaque or translucent surface placed before the sculpture a supplementary luminous plastic development, thus coupling two visions which are different, but each condensed to varying degrees.

To bring about this luminous condensation and effect, a differentiation between the surface or the space singled out and its surroundings, it is necessary, of course, to have a source of light more or less strong according to the dimensions of this surface or this space, and according to the degree of illumination of the surroundings. The use of captured and directed natural (solar) light can also be envisaged.

Luminodynamism includes all investigations and all artistic (plastic) techniques which use light condensed and projected on an opaque or translucent surface, or in a space made sufficiently opaque to give rise to a plastic visual unfolding having an aesthetic content. These projections can be cinematic or free. Cinematic projections concern cinematographic technique, and are predetermined on the visual as well as on the temporal plane. Free luminodynamic projections derive from a totally different technique without predetermination and without temporal limit. These techniques are based on the use of filters and reflectors which may be static or mobile, or both at once. The filters may be transparent, wholly or partially, colored or not, opaque or translucent with various perforations. The surfaces receiving the projections may be opaque or translucent, fragmented or whole, perforated or continuous, smooth or having varied textures, monochrome or polychrome, fixed or mobile, artificial or natural. The objects used in the case of double development (surface or space) must be spatiodynamic, that is to say composed of structures and planes in dynamic development in space and, like the surfaces which capture the projections, integrally or partially opaque, translucent or transparent, reflecting or not, colored or not, immobile or mobile.

By integrating, in addition to color, sources of artificial light and projections which add to the three-dimensional effects supplementary two-dimensional effects of equal importance, luminodynamism, the outgrowth of spatiodynamism, consummates the break with the past on the technical and conceptual plane, and, without sacrificing movement, achieves a real synthesis between sculpture, painting, cinematics and music. The ease with which luminodynamic works can be integrated into architecture makes it possible to add music to the components of the synthesis enumerated above.

Luminodynamic works have no place in the narrow and superannuated circuit of museums, collections, antiquities, etc., but become objects of daily use within reach of all, an article of mass consumption, a spectacle. It satisfies collectively the aesthetic needs of each, and at the same time eliminates all the harmful residues of sensorial and intellectual saturations.

The aim of luminodynamism is not to create a single, isolated object, reserved for a limited number of privileged individuals, but to create an element capable of affording spectacles on a grand scale, visible at great distances: large sculptures and their projections over thousands of square meters, whether in an urban setting or in nature. On a smaller scale, luminodynamic works can be manufactured on a mass production basis and distributed like radios, television sets, etc., thus bringing art within the reach of everyone. Luminodynamism in itself represents a synthesis fated to become integrated in the immense mosaic of partial syntheses; it situates art in its purely human and social context, while maintaining continuity in quality and in aesthetic content.

We have now reached the last foreseeable stage of present-day evolution, in which time becomes the new raw material to be molded. Temporal architecture, or rather, the intemporalization of time, constitutes the great problem in which space, movement and light will be integrated as constructive elements. . . .

In discovering a new chapter of creation, we grasp its intimate mechanism, we forge the process of creation itself, without taking account of the work (the result), which will necessarily be an open work with multiple facets, appearing at the whim of choice and anamorphoses, and at the same time being aesthetically determined. The nature of these relations of proportions, the conscious or instinctive means that govern it, will be immutable. Here we do not create a work, but a quality in constant fluctuation in time, possessing a rhythmic or modular specificity altogether its own. The predetermined, fixed, atemporal work is a thing of the past; the artist transposes the act of creation, and situates it in himself[;] essentially, he detaches himself from the result of the work. What interests him is to create a quality in an open form, with a solid hold on time. He juggles with indeterminisms, with anamorphoses, he chooses and eliminates while combining and switching. He sets his work into motion in time, and the work in turn sets the creation into motion, and the creator, as well as other creators, who can find inspiration in the original work.

The work assumes multiple phases, or discards them, discovers its riches, in complex combinations or by isolated but ever significant particles; unceasingly it brings out the worth of the conceptual initiative. *The artist no longer creates one of several works. He creates creation.*

GUSTAV METZGER Auto-Destructive Art (1959)

Auto-destructive art is primarily a form of public art for industrial societies.

Self-destructive painting, sculpture and construction is a total unity of idea, site, form, colour, method and timing of the disintegrative process.

Auto-destructive art can be created with natural forces, traditional art techniques and technological techniques.

The amplified sound of the auto-destructive process can be an element of the total conception.

The artist may collaborate with scientists, engineers.

Self-destructive art can be machine produced and factory assembled.

Auto-destructive paintings, sculptures and constructions have a life time varying from a few moments to twenty years. When the disintegrative process is complete the work is to be removed from the site and scrapped.

Manifesto Auto-Destructive Art (1960)

Man in Regent Street is auto-destructive.

Rockets, nuclear weapons, are auto-destructive.

Auto-destructive art.

The drop drop dropping of HH bombs.

Not interested in ruins, (the picturesque).

Auto-destructive art re-enacts the obsession with destruction, the pummelling to which individuals and masses are subjected.

Auto-destructive art demonstrates man's power to accelerate disintegrative processes of nature and to order them.

* Gustav Metzger, "Auto-Destructive Art" (London, 4 November 1959), in *Metzger at AA* (London: Destruction/Creation, 1965). By permission of the author.
** Gustav Metzger, "Manifesto Auto-Destructive Art" (London, 10 March 1960), in *Metzger at AA* (London: Destruction/Creation, 1965). By permission of the author.

Gustav Metzger, illustration of a computerized *Auto-Destructive Monument,* 1965, showing elements spilling out from four screens at different speeds and in different directions. The entire activity is computer-controlled. By permission of the artist.

Auto-destructive art mirrors the compulsive perfectionism of arms manufacture—polishing to destruction point.

Auto-destructive art is the transformation of technology into public art.

The immense productive capacity, the chaos of capitalism and of Soviet communism, the co-existence of surplus and starvation; the increasing stockpiling of nuclear weapons—more than enough to destroy technological societies; the disintegrative effects of machinery and of life in vast built-up areas on the person . . .

Auto-destructive art is art which contains within itself an agent which automatically leads to its destruction within a period of time not to exceed twenty years. Other forms of auto-destructive art involve manual manipulation. There are forms of auto-destructive art where the artist has a tight control over the nature and timing of the disintegrative process, and there are other forms where the artist's control is slight.

Materials and techniques used in creating auto-destructive art include: Acid, Adhesives, Ballistics, Canvas, Clay, Combustion, Compression, Concrete, Corrosion, Cybernetics, Drop, Elasticity, Electricity, Electrolysis, Electronics, Explosives, Feedback, Glass, Heat, Human energy, Ice, Jet, Light, Load, Mass-production, Metal, Motion picture, Natural forces, Nuclear energy, Paint, Paper, Photography, Plaster, Plastics, Pressure, Radiation, Sand, Solar energy, Sound, Steam, Stress, Terra-cotta, Vibration, Water, Welding, Wire, Wood.

Auto-Destructive Art, Machine Art, Auto-Creative Art (1961)

Each visible fact absolutely expresses its reality.

Certain machine produced forms are the most perfect forms of our period.

In the evenings some of the finest works of art produced now are dumped on the streets of Soho.

Auto-creative art is art of change, movement, growth.

Auto-destructive art and auto-creative art aim at the integration of art with the advances of

* Gustav Metzger, "Auto-Destructive Art, Machine Art, Auto-Creative Art" (23 June 1961), in *Metzger at AA* (London: Destruction/Creation, 1965). By permission of the author.

science and technology. The immediate objective is the creation, with the aid of computers, of works of art whose movements are programmed and include "self-regulation." The spectator, by means of electronic devices can have a direct bearing on the action of these works.

Auto-destructive art is an attack on capitalist values and the drive to nuclear annihilation.

MANIFESTO WORLD (1962)

everything everything everything everything

A world on edge of destruction. Objects become precious, matter becomes subject to feeling of reverence. This is an art form for artists. The mass of people appreciate Modern art 50 years after its practice. This art form will not be subject to this time lag since it is unlikely that in 50 years' time there will be a world in which to practice it.

An art of extreme sensibility and consciousness.

We take art out of art galleries and museums. The artist must destroy art galleries. Capitalist institutions.

Boxes of deceit.

Events happenings. Artist can not compete with reality.

The increasing quantity of events, happenings. Artist cannot integrate within himself all the experience of the present. He cannot render it in painting and sculpture.

New realism. The most vital movement now. However inevitably its course now is one of increasing commercialisation.

Nature imitates art.

New realism was a necessary step toward the next development of art. The world in its totality as work of art. Including sound. Newspapers.

New realism shows the importance of one object or relationship between a number of objects. This obviously is the first step to a large ensemble, the total relationship of objects including the human figure.

You stinking fucking cigar smoking bastards and you scented fashionable cows who deal in works of art.

There was a time when there were men and animals.

And men painted men and animals.

Then gods and kings came and men painted gods and kings.

Then men sat in carriages that moved over the earth and men painted carriages.

And now men fly to the stars. And men paint flying to the stars.

At this moment in London millions of men millions of objects millions of machines. Millions of interactions each fraction of a second between men objects and machines.

Day and night inventors create new machines objects that will be produced day and night.

The artist's entire visual field becomes the work of art. It is a question of a new artistic sensibility. The artist does not want his work to be in the possession of stinking people. He does not want to be indirectly polluted through his work being stared at by people he detests.

* Gustav Metzger, "MANIFESTO WORLD" (10 July 1962), in *Metzger at AA* (London: Destruction/Creation, 1965). By permission of the author.

The appropriation by the artist of an object is in many ways a bourgeois activity.

An element of condescension, superiority to workman.

Profit motive—this is now worth xxxx franc because I have chosen.

The artist acts in a political framework whether he knows it or not. Whether he wants to or not.

The quantity of experience the artist has to pack into a work is so vast now, it is not possible to compress it all into the space of an object.

The acceptance, substitution of World is thus not an escape from production.

The Door by Robin Page is the catalyst of the new aesthetic.

On Random Activity in Material/Transforming Works of Art (1964)

Certain major forms of art can be described as the drawing of belief.

A belief in molecular theory and related definable and undefinable beliefs, intuitions, shared with scientists and others, can best be stated by material/transforming works of art. Auto-destructive art, auto-creative art are forms of material/transforming works of art.

To "draw" in any other manner would be to kill the spirit and capture a mere fragment of the reality.

Random activity, and tangential problems of quality, are now critical and productive problems in art.

Random activity of the work of art escalates an extension of accepted (unproductive) concepts of art, nature and society.

If all factors of a work are understood, each moment is predictable. A great deal of "random" equates with ignorance. The presentation of activity with the minimum of ordering by the artist is belief at its maximum.

The artist desires and achieves a certain form, rhythm, scale: intends, and identifies with, all the transformations, predictable and unpredictable, that the work is capable of.

At a certain point, the work takes over, is in activity beyond the detailed control of the artist, reaches a power, grace, momentum, transcendence . . . *which the artist could not achieve except through random activity.*

JEAN TINGUELY Statement (1961)

Static, static, static! Be static! Movement is static! Movement is static because it is the only immutable thing—the only certainty, the only thing that is unchangeable. The only certainty is that movement, change, and metamorphosis exist. That is why movement is static. So-called immobile objects exist only in movement. Immobile, certain, and permanent things, ideas, works and beliefs change, transform, and disintegrate. Immobile objects are snapshots of a movement whose existence we refuse to accept, because we ourselves are only an instant in the great movement. Movement is the only static, final, permanent, and certain thing. Static

* Gustav Metzger, "On Random Activity in Material/Transforming Works of Art" (30 July 1964), in *Metzger at AA* (London: Destruction/Creation, 1965). By permission of the author.

** Jean Tinguely, untitled statement, in *ZERO* 3 (1961); reprinted in Otto Piene and Heinz Mack, eds., *ZERO*, trans. Howard Beckman (Cambridge, Mass.: MIT Press, 1973), 119. © 1973 Massachusetts Institute of Technology, by permission of The MIT Press. © 2012 Artists Rights Society (ARS), New York/ADAGP, Paris.

means transformation. Let us be static together with movement. Move statically! Be static! Be movement! Believe in movement's static quality. Believe in change. Do not hold onto anything. Change! Do not pinpoint anything! Everything about us is movement. Everything around us changes. Believe in movement's static quality. Be static!

The constant of movement, of disintegration, of change, and of construction is static. Be constant! Get used to seeing things, ideas, and works in their state of ceaseless change. You will live longer. Be permanent by being static! Be part of movement! Only in movement do we find the true essence of things. Today we can no longer believe in permanent laws, defined religions, durable architecture, or eternal kingdoms. Immutability does not exist. All is movement. All is static. We are afraid of movement because it stands for decomposition—because we see our disintegration in movement. Continuous static movement marches on! It cannot be stopped. We are fooling ourselves if we close our eyes and refuse to recognize the change. Actually, decomposition begins only when we try to prevent it. Decomposition does not exist! Decomposition does not exist! Decomposition is a state envisaged only by us, because we do not want it to exist, and because we dread it.

There is no death! Death exists only for those who cannot accept evolution. Everything changes. Death is a transition from movement to movement. Death is static. Death is movement. Death is static. Death is movement.

Be yourself by growing above yourself. Don't stand in your own way. Let us change with, and not against, movement. Then we shall be static and shall not decompose. Then there will be neither good nor evil, neither beauty nor unsightliness, neither truth nor falsehood. Conceptions are fixations. If we stand still, we block our own path, and we are confronted with our own controversies.

Let us contradict ourselves because we change. Let us be good and evil, true and false, beautiful and loathsome. We are all of these anyway. Let us admit it by accepting movement. Let us be static! Be static!

We are still very much annoyed by out-of-date notions of time. Please, would you throw away your watches! At least toss aside the minutes and hours.

Obviously we all realize that we are not everlasting. Our fear of death has inspired the creation of beautiful works of art. And this was a fine thing, too. We would so much like to own, think, or be something static, eternal, and permanent. However, our only eternal possession will be change.

To attempt to hold fast an instant is doubtful.

To bind an emotion is unthinkable.

To petrify love is impossible.

It is beautiful to be transitory.

How lovely it is not to have to live forever.

Luckily, there is nothing good and nothing evil.

Live in time, with time—and as soon as time has dribbled away, against it. Do not try to retain it. Do not build dams to restrain it. Water can be stored. It flows through your fingers. But time you cannot hold back. Time is movement and cannot be checked.

Time passes us and rushes on, and we remain behind, old and crumbled. But we are rejuvenated again and again by static and continuous movement. Let us be transformed! Let us be static! Let us be against stagnation and for static!

TAKIS Statement (1983)

I will try to put down on paper something about magnets. I have been intrigued by radar systems, and tried to find out how they function. I was told that they depend on a magnet which swings around through the full 360 degrees of the compass. The signal reported to the observer tells him of the presence of some other metallic object in space. I bought my first magnet and dreamt of using it in some way to bring about a perpetual movement by using the force of the magnet. I hoped to make some metallic object move forever. And I saw that the magnet gave me the use of a new fantastic element which I could apply to the iron-work which I had done before. (The "tiges" which I had been making were antennae to capture the force of nature in the clouds . . . electricity. In other works they had been receivers all along. This struck me as being incomplete.) Magnets, however, are not "receivers" but "senders." Yet, like radar itself a magnet "feels" out towards any passing metallic object facing the magnet. What I had been doing up until the moment I started with the magnets was making signals which merely received the electricity from the sky. Even though they moved, my sculptures seemed to me to still be static.

Up until now those who made metal sculptures had been trying to create tension by twisting iron bars. Many sculptors had been making twisted and pointed forms which were intended to create a sort of vibration between two points; the unreal made to seem real through the talent of the sculptor himself, if you like. What I wanted was to make what I felt to be really real. A magnet is not an idea—it is something so real that I was led to dream of making a Perpetual Motion machine with magnets. Very soon I realised that this was not really my intention. What interested me was, rather, the way in which magnetism creates a connection between two metallic objects through the magnetic waves which are a communication. When González twisted iron objects he produced only a graphic achievement such as the painters had been interested in. Many painters like Matta and Lam have worked along that line as have others who were more interested in creating an illusion of space rather than an action in space which I feel is the role of the sculpture.

When I wished to express the space-communication between an object and a magnet I was obliged to tie up the object. When I did this in order to keep an object at a distance from a magnet, I realized that I had "floated" the object. My metallic object floated in the air and vibrated. This was even further from my original intention. I had wished to communicate the two metals only symbolically but, now, they communicated realistically through the magnetic field. Immediately they gave the sensation of being alive. A new and very real force was working between the two objects which I had approached one to the other. When I attached an object by a string and floated it towards the magnet, even a breath of air started a visible vibration. In actual fact the vibration is continuous whether one sees it or not through the wave-motion of the magnetic field, working alternatively but continuously. The vibration is perpetual. What interested me was to put into iron sculpture a new, continuous, and live force. The result was in no way a graphic representation of a force but the force itself which had to be handled as one would handle any other force in nature—even an animal force. The perpetual movement aspect of it became obviously of secondary interest and I put myself to treating, guiding and dominating magnetic force itself in its aspects of real communication . . . the space communication of objects on this planet. More than that, I have wanted to bring

* Takis, untitled statement, in Muriel Emanuel et al., eds., *Contemporary Artists* (London: St. Martin's Press, 1983), 921. By permission of the artist.

Takis with his *Signals*, 1966. © 2012 Takis/Artists Rights Society (ARS), New York/ADAGP, Paris.

off what the Egyptians tried to communicate through the human form in which muscles were represented in a state of tension or slack. The ancient Cycladic sculptors, too, tried to represent these forces through the action of the muscles and forms. In what I do I intend that the tension of forces shall be as visible as the nylon cord which floats an object in front of the magnet whose live force and vibration gives life to what has seemed to be dead material.

OTTO PIENE Paths to Paradise (1961)

Yes, I dream of a better world.

Should I dream of a worse?

Yes, I desire a wider world.

Should I desire a narrower?

My dreams are different from songs and sagas. I am working toward their being festive and visible from far off. I am not pining away from longing and resignation because no patron will give me smoke and light. I already have my 12 searchlights, they belong to me. But they are just the beginning, for I would like 12 times 12, and then more, and they must be strong enough to light up the moon.

The pictures of the old world were equipped with heavy frames, the viewer was forced into the picture, pressed as though through a tube, he had to make himself small to see into this channel; he was brought low to experience the realm of art. Man stood in chains in front

* Otto Piene, "Paths to Paradise," *ZERO* 3 (1961); reprinted in Otto Piene and Heinz Mack, eds., *ZERO*, trans. Howard Beckman (Cambridge, Mass.: MIT Press, 1973), 148–49. By permission of the author. © 1973 Massachusetts Institute of Technology, by permission of The MIT Press.

of the old pictures and palaces; we needed 5000 years to outdo the Egyptians in building high, we needed 5000 years before we were in a position to build a tower as high as two pyramids—and then we learned to fly. What painting was able to bring as homage to the new state of things was the removal of the obstacle that pictures as well as statuary had formed up till then—for the eye—but it was still in Stygian blackness, bowed down under the ulcers of memory, the superfluities of time past, and the suppurations of the psyche. The portraying of masses turned to the destruction of masses, but mass remained mass as long as man tried to throw light on the world inside him.

One glance at the sky, at the sun, at the sea is enough to show that the world outside man is bigger than that inside him, that it is so immense that man needs a medium to transform the power of the sun into an illumination that is suitable to him, into a stream whose waves are like the beating of his heart. Pictures are no longer dungeons, where mind and body are shackled together, but mirrors whose powers affect man, streams freely pouring forth into space, not ebbing but flooding.

Mind, which is really body, and body, which really exists in mind, do not wish to allow us to treat them as separate entities. I believe that painting elevates man when it corresponds to his physical nature. I believe that there are opposites in the human organism which "cause his heart to beat higher," that there are painted volumes that are so real that they make the lungs fill more deeply and that start up a pulsebeat that brings power and rest, contentment and wings to mankind. And my pictures must be brighter than the world around them, un-realistic in the sense that politicians have given to the word. Why must we paint darkness? We have the most complete darkness when we shut our eyes, we do not need to wait for night; night is only relative, we can run before it, and stay always in brightness. The dynamic that man has achieved enables him to overcome the apparently natural basic contrasts. But to praise brightness alone seems to me to be insufficient. I go to darkness itself, I pierce it with light, I make it transparent, I take its terror from it, I turn it into a volume of power with the breath of life like my own body, and I take smoke so that it can fly.

A picture is a skirmish, in which man is directly involved. We treat pictures as neighbors or friends, we have them as sharers of intimacy, and with them we undergo all our experiences, whether pleasant or painful. Even the biggest, broadest, most expansive picture forces us into close touch with it, draws us to it. A picture is pleasing to a man who has roots, who has a resting place, but is not so pleasing to a wanderer forging through new spaces. What remains of art, of the constructive ability of man, if we look down on the world from above? The pyramids and Cologne Cathedral and all the skyscrapers of America are harmless algae in the sea of the transitory if we put distance between us and them. Centuries shrivel to moments when we think that they will roll on for ever. Is not that moment the greater, when man is distance himself, is himself space, that moment when he experiences eternity? The man who uses his body to enclose his mind and his mind to lift up his body, who lives this timeless moment, this heavenly reality, in order to stride freely through space, this man has paradise in him. He follows the beams of light that he creates, they envelop him and the universe, the light passes through him, and he through it.

I have arrived at the light ballet through painting and many other things, through my own methods and instruments. I only heard later that I was the son of half a dozen fathers, whom I did not know as such. Creative work always follows a course different from that in most books. The first steps were like those of a child learning to walk, they were made with full knowledge of this circumstance, it was a controlled archaic; the way in which light reacts to holes through which it is shone is such a complicated business that all those who are working on it at the mo-

ment, and those who will occupy themselves with it in the future, will have their work cut out. I experience with the light ballet similar degrees of sensation to what I feel while painting or looking at finished pictures. By this I do not mean to say that my acquaintance with projections and similar methods is like that with painting, but that it is not so important whether one paints or projects, the subject is not affected so very much—the difference is rather objective: I reach large spaces with articulated lights as media. I am sure that in my lifetime I will not get beyond the real beginnings, that is, assuming that I reach the real beginnings. Thus one will understand that I speak of the present state of the light ballet as archaic. In my imagination, the classical light ballet takes place in a large, perfectly hollow sphere, everyone can see it, can watch it or not, but I need a lot of time to get the searchlights.

My greatest dream is the projection of light into the vast night sky, the probing of the universe as it meets the light, untouched, without obstacles—the world of space is the only one to offer man practically unlimited freedom. (Why is there no art in space, why do we have no exhibitions in the sky? Are a few pilots perhaps artists weaving their perfect patterns in the sky? In the sky there are such enormous possibilities, and we amble along the rows of a museum while our old-fashioned pictures carry out an imaginary march-past!) Up to now we have left it to war to dream up a naïve light ballet for the night skies, we have left it up to war to light up the sky with colored signs and artificial and induced conflagrations. Imprisoned mankind achieves wonders defending itself. When will our freedom be so great that we conquer the sky for the fun of it, glide through the universe, live the great play in light and space, without being driven by fear and mistrust? Why do we not pool all human intelligence with the same security that accompanies its efforts in time of war and explode all the atom bombs in the world for the pleasure of the thing, a great display of human inventiveness in praise of human freedom? As a spectator of this astronautic theater, man would not have to take cover, he would be without fear, free, not bound by purpose.

Utopias have a largely literary worth. Utopias with a real basis are not Utopias. My Utopia has a solid foundation: light, smoke, and 12 searchlights!

I have something real to offer. Instead of narrowing the field of vision, instead of absorption, a view of something giving, flowing, pulsating. Not the shrinking of the world in the cells of human imagination, but expansion on every side, the shooting of the viewer into space, where he can breathe deeply of fresh air. In this heaven is paradise on earth.

HEINZ MACK Resting Restlessness (1958)

Painting engages the eye—this confrontation occurs dynamically—our eyes enjoy resting in restlessness.

The restlessness of rest, however, is scarcely perceptible, a contrast to the rhythm of the heart; it is movement that destroys itself; it does not give us the kind of vision that is alert, clear, and a measure of the immeasurable. Our painterly sensibility is a sensibility of sight. The motionless and the finite limit our vision and tire our eyes, and in the end deny them.

Among all the possible conditions derived from the concept of movement, only one is aesthetic: resting restlessness—it is the expression of continuous movement, which we call

* Heinz Mack, "Resting Restlessness," ZERO 2 (1958); reprinted in Otto Piene and Heinz Mack, eds., ZERO, trans. Howard Beckman (Cambridge, Mass.: MIT Press, 1973), 40–41. By permission of the author. © 1973 Massachusetts Institute of Technology, by permission of The MIT Press.

"vibration," and which our eyes experience aesthetically. Its harmony stirs our souls, as the life and breath of the work.

Just as a strong wind gives form to a thousand clouds, so creative movement can give spatial organization to color and formal components; in movement color finds resting restlessness, its form. To me, movement is the true form of a work.

Every dynamic component of form (no matter how minuscule and how limited its energy) has within itself the restlessness to exceed itself, to remain open to its surroundings even though it faces powers of equal strength that offer a continuous boundary.

The restlessness of a line: it wants to be a plane. The restlessness of a plane: it wants to be space.

This restlessness conforms to our painterly sensibility. Lines, surfaces, and space must continually merge with one another, "cancel out" one another (in the dialectical sense). If this integration is visible, a work vibrates, and our eyes meet with resting restlessness.

Much gets decided at the borderlines of the various components; no less critical, however, is the reaction of color, whose quantity and light intensity are as consequential as the degree of distribution of units of form and their overall relation to the format of the work.

Large parcels of form are to be dispensed with—they cannot become the force of continuous motion. Motion disappears once its momentum disappears.

This way I paint only a profusion of little forms. What about the larger, monumental form? It reappears in the "overall form" of the work, which is also a momentum of the small form; it is a principle of harmony, the complete integration of color and motion, whose continuous effects overcome the "sadness of finality."

An unexpected possibility of making aesthetic motion perceivable arose when I accidentally stepped on a thin piece of metal foil that was lying on a sisal mat. As I picked up the metal foil the light was set to vibrating. Since the rug was made by machine, the imprint was, of course, repetitive and merely decorative. The movement created by the reflected light was insignificant and dull. My metal reliefs, which I would rather call light reliefs, and which are formed by hand, only require light instead of color in order to come alive. Highly polished, a modest relief is sufficient to stir the repose of light and cause it to vibrate. The potential beauty of such a work is a pure expression of the beauty of light.

GROUPE DE RECHERCHE D'ART VISUEL (GRAV) Manifesto (1966)

We are particularly interested in the proliferation of works which permit of varied situations, whether they engender a strong visual excitement, or demand a move on the part of the spectator, or contain in themselves a principle of transformation, or whether they call for active participation from the spectator. To the extent that this proliferation allows the calling in question—even diffidently—of the normal relations between art and the spectator, we are its supporters. But this is only a first stage. The second might be, for example, to produce, no longer only the works, but ensembles which would play the part of social incitement, at the same time as liberating the spectator from the obsession with possession. These "multipliable" ensembles could take the form of centres of activation, games rooms, which would be set up and used according to the place and the character of the spectators. From then on, participa-

* Excerpt from "Manifeste du Groupe de Recherche d'Art Visuel (GRAV)," in Le Parc (Paris: Galerie Denise René, 1966); reprinted in Art Since Mid-Century: The New Internationalism, vol. 2 (Greenwich, Conn.: New York Graphic Society, 1971), 296. By permission of Yvaral.

tion would become collective and temporary. The public could express its needs otherwise than through possession and individual enjoyment.

Manifesto (1967)

For this Group, the introduction of light is neither an advance nor an end in itself. Its use varies according to the situations presented: variations, progressions, reflections, transformations of structures, projections, revolving lights, neons, all have been used separately in isolated situations (luminous boxes, grids, or neons, for example) or integrated in mazes or halls.

This Group is not concerned to create a work having light as its subject, nor to produce a super stage-performance, but, through provocation, through the modification of the conditions of environment, by visual aggression, by a direct appeal to active participation, by playing a game, or by creating an unexpected situation, to exert a direct influence on the public's behaviour and to replace the work of art or the theatrical performance with a situation in evolution inviting the spectator's participation.

BILLY KLÜVER
Theater and Engineering—An Experiment:
Notes by an Engineer (1967)

It is not a question of what the artist *should* do, but what he *will* do with technology. Whether technology is good or bad, threatening or friendly, beautiful or ugly is irrelevant. The qualities and shapes of technology are not the proper concern of the artist.

Claes Oldenburg suggests an enormous teddy bear monument in Central Park while György Kepes discusses the limited interest of the artists in the large scale environment.

We have to learn to listen to the artist.

If you ask what he wants he will not tell you. If you hang around long enough he will. Are you really there to listen?

Science and art are inevitably separated. Any attempt to "bring the two together" should be looked at with suspicion. Science deals with reality in rational, single-valued terms which are constantly related to a language that is uniquely understood. Art deals with the reality in irrational and poetic terms. Art allows for discontinuities that science cannot tolerate. History must have provided us with the separateness of art and science for a reason.

At the time of Aristotle, the Greeks cut the orange the other way. Agnos: mathematics, lawsuits, poetry and rhetoric. Techné: sculpture, painting, physics, medicine and crafts. Today the scientist and the artist share both Techné and Agnos.

A scientist could not work with an artist. What would they talk about? ESP? The beauty of the stars?

Would a scientist be able to work creatively if he had to live in the social situation of the

* Excerpt from "Manifeste du Groupe de Recherche d'Art Visuel (GRAV)," in *Lumière et mouvement* (Paris: Musée d'Art Moderne de la Ville de Paris, 1967); reprinted in *Art Since Mid-Century: The New Internationalism,* vol. 2 (Greenwich, Conn.: New York Graphic Society, 1971), 296. By permission of Yvaral and the Musée d'Art Moderne de la Ville de Paris.

** Billy Klüver, "Theater and Engineering—An Experiment: 2. Notes by an Engineer," *Artforum* 5, no. 6 (February 1967): 31–33. By permission of the author and the publisher. This is the second part of a two-part article beginning with Simone Whitman, "Theater and Engineering—An Experiment: 1. Notes by a Participant," *Artforum* 5, no. 6 (February 1967): 26–30.

artist? No other profession has as many guardians as that of the artist. If we tried to make the artist's situation as secure and free as that of the scientist we would probably be doing something wrong. But food, space, and material help.

Have you ever met a normal, healthy and working engineer who gives a damn about contemporary art? Why should the contemporary artist want to use technology and engineering as material? Only when a working relationship has been established between artists and engineers can we give answers. The 9 Evenings was a deliberate attempt by ten artists to find out if it was possible to work with engineers. Their investment in terms of putting-yourself-on-a-limb was considerable. For ten months they worked with thirty engineers and were able to make a series of beautiful performances out of the collaboration. I believe it was John Cage who remarked that the 9 Evenings "was like the early movies" where the camera, the stage, the literary content, and the acting were all separate and easily identifiable elements. An unmixed media. The horseless carriage—the wireless microphone—theater and engineering.

All decisions concerning 9 *Evenings* were made by the artists and myself during innumerable meetings. Because of Bob Rauschenberg's remarkably positive attitude and sensitivity, his contributions to these meetings were significant in terms of shaping the 9 *Evenings*. He reduced fear and limitation with a few words. He also took on a large part of the responsibility for raising the necessary money, a task which led him into many difficult and ungrateful situations. 9 *Evenings* was, however, above all, a cooperative effort where everyone took on the responsibility he could and wanted to handle. Whenever possible, decisions were first considered from the artists' point of view.

The name of the performances at the Armory came out of long arguments about what we were doing. The day "Art and Technology" was left behind was a day of relief for everyone.

It was decided early that no special emphasis should be placed on the technical elements in each performance. The obvious reason for this decision was to prevent situations from becoming technically "interesting." Engineers were given credit in their biographies, and not in the program notes. No excuses for technical failures were to be given. Each artist was given as much freedom to develop his work as possible. Restrictions in terms of props and stage equipment were eliminated.

We decided to reach for a large audience. It appeared logical to do this because of the large investment of the artists and of their commitment to technology as a material. But it seemed also necessary to make an attempt to break the Judson Church barrier of 500 faithful spectators and to confront a larger and unfamiliar audience with the works of contemporary artists. It was strongly felt that the presentation of the performances should be as conservative and as traditional as possible, to avoid the "fun" and "happening" atmosphere. Randomness, errors, and failure were never elements in the performances. Every effort was made to make everything run as smoothly as possible without compromising the artists' wishes. From the technical side the artists were assured that everything would work until we knew otherwise.

Much has been said about the inadequacy of our sound system for speech reproduction. The acoustical problems of the Armory were well-known before we moved in. A plan was set up for an alternate speaker system to handle speech. This plan was, however, rejected by the artists.

Over the nine-day period every artist performed his work twice. Each evening was dealt with as a separate and independent event. By distributing the performances randomly it was hoped that at least some of the performances would be seen twice. The over-emphasis on opening night by the audience proved, however, almost impossible to fight and the rough nature of our first two nights became the primary topic of most of the reviews. (I have since heard that almost every Broadway show has a rough beginning.)

The delays have interested the critics more than anything else. On the first night we started

40 minutes late due to difficulties with the general complexity of the situation at the Armory. The second night there was a 30-minute delay due to technical difficulties. From then on we decided to start on time no matter what the problems were. Our half-hour intermissions proved impossible to shorten.

There were over 8500 engineering hours of work that went into the 9 Evenings. This makes a total of more than four man-years of work for the 30 engineers involved. A low estimate of the value of the engineering time is 150,000 dollars. During the 16 days in the Armory 19 engineers worked more than 2500 hours and three of them worked more than 250 hours each. The audience was a little over 10,000.

The equipment that was built for 9 Evenings was in many respects remarkable. Each artist had his own specific project: Lucinda's Doppler sonar and ground effect machine, Debbie's remote control platforms, Steve's loops, Rauschenberg's IR TV and transmitters in the handles of the tennis rackets, Oyvind's chemical reactions, antimissile-missile, snowflakes and transmission systems, Yvonne's walkietalkies and programmed events, Whitman's TV and mixing panel facilities, Alex's differential amplifiers, Cage's photocells and telephone pickup of sounds, Tudor's use of Kieronski's vochrome and the rest, in particular the SCR circuits. In addition to these special projects we built an electronic system which we called TEEM. This included amplifiers, transmitters, receivers, tone decoders, tone encoders, SCR circuits, relays, etc. It also included a proportional control system which was used successfully by Cage, Tudor and Debbie. TEEM had the following general design criteria: each unit was to be as small as possible and battery-powered. A sufficient amount of units was to be available for quick replacement. All units were to be portable. TEEM was designed to fulfill the function of an on-stage environmental electronic system.

The growth of contact between the artists and the engineers was the most fascinating aspect of the *9 Evenings,* one which I can only briefly touch on here. From the engineer's point of view, *9 Evenings* presented complex technical problems. The engineers had never seen any of the artists' performances before moving into the Armory, and most of the artists had never spoken to the engineers. Most of the engineers, in fact, were without any previous contact with contemporary art. They worked hard in their spare time, and tried to communicate with the artists who lived in New York. It was not until the second night of the performances that the engineers, enclosed in the control booth, really understood the position of the artist and what he was trying to accomplish. The artist was on stage, completely exposed to a large audience, and demonstrating his faith in the engineers. After that second night, everything began to clear up. The vagueness about what the artist was up to had disappeared; the engineer could now evaluate his own contribution to the artists' work and step some distance from his natural commitment to his gear.

It is inevitable that the engineer's work has to precede that of the artist. This makes any collaboration highly imbalanced, but when all is fused together there are great possibilities for give and take. It was on the simple, practical level that the best results of the artist–engineer relationship were achieved; our best experiences came from the projects where the artists had worked with the same engineers from the first idea to its realization.

Critics and public had a field day at the engineers' expense. Because of our decision not to discuss the technical aspects of the performances, the engineers found themselves in a paradoxical position. Anything that was assumed to have gone wrong (whether it actually did or not) was attributed to technical malfunctions. This reaction by the critics and the audience reveals both an unfamiliarity with technology and a rather infantile expectation about technology as "performer." Much was said in the press about technical equipment that failed, but no one got very specific. Mr. Barnes, Miss Genauer, Miss Adler and others had a merry time declaring the engineers to be amateurs, incompetent, fooled by the artists, etc. Are they really serious?

The engineers, of course, have a very accurate record about what failed, where and why, and what we interpreted as wrong engineering decisions. From the technical point of view (one from which none of the critics seemed able to observe with competence) the engineers did a fantastic job—by any standards. Half

of the performances were more or less completely successful; others suffered from a few failures which were by no means as catastrophic as the critics implied.

The answer to the reaction of the critics must lie in the fact that they never considered what was going on. They had never thought about the relationship between an engineer and an artist, and confused the engineers' contribution with the artists', and vice versa. This, combined with the remarkable unfamiliarity with professional engineering (which achieved a high-point in Mr. Clive Barnes's explanation in the N.Y. Times, of Lucinda Childs' ground-effect machine, and in his later comments on a TV program that the machine was held up by "high frequencies") leads one to wonder about just what the function of the critic really is.

We had our best reviews in *Electronic News* and *The Wall Street Journal.*

If professional engineering is not made available to artists on a large scale, the technical elements that do appear in works of art run the risk of becoming precious, if not ridiculous. We have established a foundation called Experiments in Art and Technology *which will attempt to provide a link between the engineering world and interested artists. It is apparent to us that ultimately the problems of the artists must be handled by industrial laboratories and that the development of the problems must be paid for by industry itself. It is the purpose of EAT to convince industry to accept problems posed by artists. Simultaneously, a file of interested consulting engineers will be established who can take care of simple problems directly. It is hoped that EAT will become an efficient service organization that will deal only with the technical aspects of the artists' problems.*

MARK PAULINE/SURVIVAL RESEARCH LABORATORIES
Letter to Dennis Oppenheim (1982)

December 10, 1982

Dear Dennis Oppenheim,

As the originator and most active proponent of the concept of mechanical performance, I have, for some time now, been aware of your feeble and uninspired attempts to employ instruments of force. Initially this information seemed a fluke, merely indicating another instance of an older New York artist struggling to get back to where the money was. Consequently it was of no real concern to myself or to my assistants at SRL. Increasingly, however, we have found ourselves in the undesirable position of being compared to you. Add to this our disgust at the exaggerated publicity generated by your insignificant mechanical events. Furthermore, there have been suggestions from acquaintances of mine in NYC that any similarities between our activities might be due to more than mere coincidence. After considering several possible options, I have concluded that this affront to the honor of my organization can be settled only through a direct confrontation. Specifically, a duel, to be staged with machines of our choice, at a public location determined by yourself in or around NYC; to be judged by a panel of seven individuals acceptable to us both; to take place before the end of August 1983. If after a reasonable length of time no response to this letter is forthcoming, we at SRL will rest assured that your activities are indeed a gutless sham, propped up by clever publicity schemes and financed by a wealthy, bored social elite.

> Sincerely yours,
> Mark Pauline,
> Director, SRL

* Mark Pauline, "Letter to Dennis Oppenheim" (1982), in Fritz Balthaus, ed., *Survival Research Laboratories* (Berlin: Vogelsang, 1988), 38. By permission of the author.

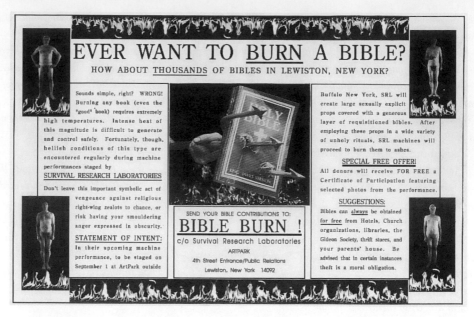

Mark Pauline/Survival Research Laboratories, poster for *Bible-Burn,* 1990. Poster photos of nude men by Anthony Aziz. By permission of Mark Pauline.

More Dead Animal Jokes: Interview with Bill Edmondson (1985)

If media-created labels like "post-industrial movement" are to be taken seriously, then Survival Research Laboratories is the chief innovator of that movement. Under the leadership of Mark Pauline, the three-man operation—which took its name from an ad in *Soldier of Fortune* magazine—have been staging grisly, maniacal spectacles in San Francisco for the past six-and-a half years.

Their work seldom features human performers, but is centered around the violent interactions of perversely reconstructed industrial equipment, some of which includes a radio-controlled car equipped with missiles and special launchers, a remote-control helicopter with an extending mechanical hand, a 16 ft. human-driven "crash car" (whose front-end possesses a six-foot ejecting stiletto blade), radio-controlled assault tanks, and a three-ton blowing machine that blows balls of fire over the audience. In each show, a group of these machines are activated through a central control panel by Pauline and SRL co-members Matthew Heckert and Eric Werner, then let loose upon the audience, creating a theatre of dark, apocalyptic war and destruction.

On May 10th, New Yorkers got their first glimpse of Survival Research Laboratories at a small-scale show staged at Area. Those who attended will know what I'm talking about. Those who didn't will know what to expect next time.

The following piece was constructed from portions of interviews conducted with Survival Research Laboratories over a four-year period.

* Bill Edmondson, "Survival Research Laboratories: More Dead Animal Jokes: An Interview with Mark Pauline," *East Village Eye* 6, no. 55 (June 1985): 35. By permission of Mark Pauline/Survival Research Laboratories. Portions of this interview appeared in *BOMB* 6 (1983) and aired on "Antidote" radio, WVVX, Highland Park, Illinois, 1984.

BILL EDMONDSON: To those unfamiliar with your work, how would you best describe it?

MARK PAULINE: It is a combination of conventional and unconventional industrial manufacturing and/or remanufacturing. We have a standard machine shop and use tools to make machines with parts and components that any other manufacturing operation would use. We're conventional in that sense. The main difference is the extreme and perverted tilt our whole operation is colored by. A good example is how we acquire our equipment and supplies—we seldom buy anything—we break into abandoned factories and rip them off. And our machines differ in that they're strictly inventions of our own fantasies and are used for theatrical presentation. We stage shows around them that play with various themes and express certain ideas through violent and destructive interaction.

BE: More often than not, you've been labeled as "performance artists." Is this a label you reject or embrace?

MP: Neither. Actually, I personally think of ourselves as commentators or researchers. We research, make our machines, experiment with them, then make public comments on our experiments.

It's not strictly a performance thing—that's only one aspect of our work. Each time we do a show, we research, then attack a new and different principle, flush it out and present a conclusion in the form of entertainment. So call it what you will.

BE: Mark, during the late '70s, prior to the formation of Survival Research Laboratories, you became known in San Francisco through a series of violent and pornographic billboard alterations. How and when did you get the idea for making machines?

MP: I've always liked machines; when I was a teenager I had a bunch of motorcycles and I've worked as a mechanic. When the billboard thing exhausted itself, I just decided to do it. I had many ideas—violent fantasies I've had all my life that could best be worked out in that way.

My idea was to take the same ideas that I'd been working on with billboards—violence, sex, and politics—and amplify them even more. You see, a machine is much more dangerous and powerful than any human, and when they interact violently, it creates something too powerful to forget.

BE: When you first started making machines, did you see them as a form of kinetic sculpture as well as an element to be incorporated into performance?

MP: No, they always intended to be used as tools in performance; the idea of them as sculpture never even occurred to me.

BE: Describe *Machine Sex,* the first machine show you did in February of 1979.

MP: *Machine Sex* was staged at a gas station in North Beach shortly after an OPEC price rise. I had built this de-manufacturing machine that was like a giant food processor, called "The Shredder." It was made out of a triangular-shaped drum, with a clear Plexiglas dome over it, with a conveyor belt you could tie objects to, leading into it. So, I tied on a bunch of dead pigeons and dressed them up in little paper Arab doll costumes. Then I activated the machine, and fed the pigeons through, where they were chopped up by a succession of very sharp blades. After that, their remains were ejected out the sides—blown about ten feet— so the audience got hit with gobs of feather, blood, guts, and bone. And for the soundtrack, I used that song based on *The Stranger* by Albert Camus, you know, "I am the stranger, killing an Arab . . . "

BE: Have you ever considered incorporating human elements in your work?

MP: We have, actually, but only to a very minimal, yet extreme degree. For instance, we used human performers in a show called *A Fiery Presentation of Dangerous and Disturbing Stunt Phenomena,* but only in a very cruel and destructive way. In that one, we all had bombs and

rockets attached to our backs—with protective metal plates worn underneath—which would detonate intermittently, knocking us down; one guy even had a rocket wired to his leg, that shot off. And then Matthew drove this weird looking go-cart through flaming and exploding troughs of gasoline . . . In that show, we also used the audience; not so much as performers but as targets! Matthew had this flame-thrower he kept on shooting toward the audience, and I had my radio control car (a 700 lb. life-size car, run by radio control) go completely berserk, careen out of control, break through this Plexiglas protection barrier, and run right out into the audience, knocking people over.

MATTHEW HECKERT: We also did it in another show called *Survival Research Laboratories Views With Regret the Unrestrained Use of Excessive Force,* where our other member, Eric Werner, used his "crash car," which is this huge three-wheeled car that looks like a giant torpedo, powered by a 327 Chevy V-8 engine, with very long, spiked, hydraulically powered arms mounted on the sides, that can top out at over 85 mph, to purposely crash into some very large and heavy structures.

MP: That show also featured a machine called "The Stairway to Hell," which was a 30 ft. high, 20 ft. long stairway, with a conveyor belt which ran from top to bottom. It was a moving, mobile unit driven around the performance area by remote control. At a certain point in the show, it was directed over to the audience, where piles of plaster skulls were purposely deposited off the conveyor belt and hurled at the crowd, hitting some of them.

BE: I think the most interesting element you work with is the "Organic Robot" (parts of dead animals grafted onto machines). How did you arrive at this particular concept?

MP: Well, I've always liked the whole concept of raising the dead, and the idea of raising the dead by reanimating their flesh and making them into machines really appealed to me and I realized it wouldn't be that hard.

The first one we made was done for a show by Monte Cazazza called *The Night of the Succubus.* Monte and I made him out of a pig's carcass and a cow's head we'd cut off. On the inside, it had a motor that would make him vibrate, so his head would shake back and forth violently. We named him "Piggley Wiggley" and since then I've made them out of dogs, rabbits, cows, and several other types of animals.

BE: Several years ago, your whole operation was drawn to a temporary halt, due to an accident you had. What exactly happened?

MP: I blew my hand off! I was working on this rocket I'd built that was propelled by a highly combustible fuel. I was taking the engine out, when I accidentally bumped it on its side. After that, all I remember is waking up on the ground, looking at my hand, and seeing this stump with these white bones sticking through.

BE: I imagine this has affected your ability to work quite a bit.

MP: It's affected my work in that I've lost a lot of valuable time by continually having to go back into the hospital for reconstructive surgery. But on the technical side, it hasn't been that hard because I'm left-handed and it was my right one I injured. I've adjusted to it because I've had to.

MH: But despite all the pain and trouble, there's been a positive side to this as well in the form of some of the people we've come in contact with. Surprisingly enough, a lot of doctors are very sympathetic to some of our ideas regarding organic robots.

MP: Yeah, there's one microsurgeon in particular who's agreed to help us do some brain implant work, where we could take various animals and implant electrodes in different parts of their brains, then activate them by radio control, enabling them to do five or six different

things. We would have groups of different animals set up, so we could coordinate their movements to follow our instructions, thus creating an animal-robot ballet.

BE: How soon do you see yourself doing the same thing with humans?

MP: I'd be perfectly willing and capable of doing it now except for one tiny detail—it's illegal. I don't want to go to jail. However, I'll tell you something, you don't do animal experiments just to do animal experiments—you do them to prepare for what you plan to do with humans some day.

Technology and the Irrational (1990)

While the designers and operators of complex experimental machine systems are the least likely to maintain or express a detached viewpoint on their activities, there is an inadvertent residue associated with the use of technology, akin to the aging rings of trees. A residue that taken at face value, as a factual record of an event, acts to reinforce the least interesting viewpoints and is the basic tool employed to justify the Science of the State, the one that produces defense industries, nuclear power, space telescopes/shuttles, super colliders etc. That is, of course, until things go awry, at which point the factual record is exposed to a more determined analysis or is grotesquely manipulated. This inability of the state to admit error reveals and often provokes the more interesting and irrational aspects of high technology (the absurdities of defense industry production as revealed by the end of the "cold war," a case in point being the stylized media campaign to promote stealth bombers and fighters modeled after car manufacturers' yearly introductory practices).

In the machine performances of SRL the non-rational and the absurd act as the baseline of all activity. The contention being that excess production can have only one responsible goal, to serve the unspoken needs that remain after the basic means to survive are achieved.

LAURIE ANDERSON Interview with Charles Amirkhanian (1984)

LAURIE ANDERSON: I want to cover a few things [this evening] particularly some ideas about talking and performance and a little bit about TV and some things about artificial intelligence. To begin with I'd like to talk about the song "KoKoKu," which is a song from the *Mister Heartbreak* record. Sometimes I find it hard to talk about music. Steve Martin once said, "Talking about music is like dancing about architecture." But you *can* do that. Recently, I saw an Oscar Schlemmer revival of some Bauhaus dance work, and you actually can dance about architecture—volume, space, and construction. I wrote "KoKoKu" because I was invited to a Bean Festival that was going to happen in the Southwest last year about this time. It was an Indian Festival, and the idea was basically to try to come to terms with some of the Earth's wobble. The leaders of this particular group of Indians felt that they had been getting some signals from out there, and basically the message that they had received was, "You have such a beautiful planet, please be very careful." I never made it to that festival, although this Sat-

* Mark Pauline, "Technology and the Irrational," in Gottfried Hattinger, Morgan Russel, Christine Schopf, and Peter Weibel, eds., *Virtuelle Welten,* vol. 2 (Linz: Ars Electronica, 1990), 232. By permission of the author.

** Laurie Anderson and Charles Amirkhanian, excerpts from "Laurie Anderson Interview with Charles Amirkhanian," Speaking of Music Series, San Francisco Exploratorium, 6 November 1984; published in Melody Sumner, Kathleen Burch, and Michael Sumner, eds., *The Guests Go in to Supper: John Cage, Robert Ashley, Yoko Ono, Laurie Anderson, Charles Amirkhanian, Michael Peppe, K. Atchley* (San Francisco: Burning Books, 1990), 147–57. By permission of the authors.

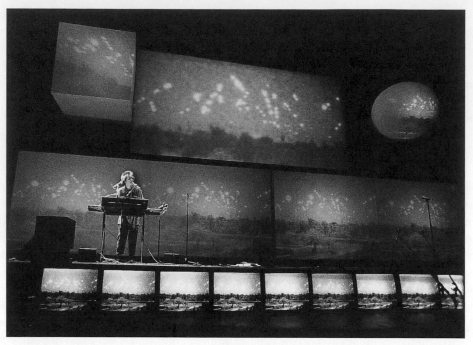

Laurie Anderson, from *Stories from the Nerve Bible,* 1992, multimedia performance. Photo by Mark Garvin.

urday I am going to a full moon Zuni Festival. It's an all-night drum festival out in the desert presided over by some characters called *The Mudheads* who have been rehearsing for a year, learning the creation myth backwards. So I don't know if they start with everything and go back to zero or if they talk backwards or what. . . .

In the song "KoKoku," there's motion on several levels. It begins with a percussion track, the word *shake,* which is done on a harmonizer, put into the repeat mode. The harmonizer has a very short memory, pathetically short—point five seconds, that's it—but once you register it in the machine it will continue indefinitely until it's unplugged or until it explodes. So the word *shake* is then put into a random mode which turns it into a Möbius Strip. This is a rhythm which is very precise over about a 17-second pattern. So, that's the bottom motion, a very small shaking. Above that on the next layer are various kinds of vibrato. Phoebe Snow's vibrato, which is already very slow, I slowed down further using a Synclavier. Then there's the kayagum, which is a Korean zither, played by several motions—you damp a string, you pull it, and you also pull long threads—so it's a beautiful action, and it also has a very very wide, slow vibrato. So there are those motions that happen over the others. And then the lyrics themselves are about a wider, broader motion: people looking up and people looking back down. The words in Japanese are fake haikus that I made up—which are more or less grammatically correct in Japanese. They are place words, still images.

Mountain with clouds. I am here. A voice.

Another verse is—

Birds are there.
A cry, my voice.
Mountain with clouds.

The English turns and moves around these Japanese freeze frames. . . .

CHARLES AMIRKHANIAN: What do you think about improvised music? You don't seem to use it very much.

LA: I never really understood what improvised music really is. When does the happy accident become a plan? When it can be repeated? When I start working on a piece *everything* is improvised, and because I work with tape, a lot of those chance events, those happy accidents, end up being saved as is. So in a sense, this is improvisation. Also, I've tried to leave room for improvised solo. In "KoKoKu," the kayagum player is basically improvising around the bass line. Through repetition, improvised lines become parts.

CA: Do you feel that the ambiguities in your work that resonate and then aren't resolved are a way to make people think?

LA: Well, it's true that very few of these ideas are spelled out in no uncertain terms. I really try to leave a lot of room and a lot of air so that people can draw their own conclusions. It's not that I don't have my own conclusions, but it's the *process* I'm interested in. For example, a lot of the rhythms are created visually. The music is going, and the pictures are going . . . and that creates a kind of counterpoint between what you're seeing and what you're hearing, a kind of polyrhythmic situation that you put together yourself. It's the same way with some of the ideas and issues that are raised in the work. My greatest fear is to be didactic, and even if I had "answers" I would never try to foist them on people. I think I've gradually learned to respect other people a little bit more and let them, in a sense, let them make connections themselves.

CA: Do you feel you have to seduce the machine in order to get it to do what you want?

LA: I have a real personal relationship with machines. It's true that even though I've been very very critical of technology in terms of what I say, I find that I make those criticisms through 15,000 watts of power and lots of electronics. And that says a couple of things at least, that I hate it and love it.

CA: I remember you said something to me once. You said, "Get the machine and work with it a lot before you go out and try to use it in your pieces."

LA: It's true, you have the thing and you have to fully understand it before you use it. The machine is an instrument. Occasionally, I talk to people in art schools who have problems with this. For example, let's say you're a painter and you want to use video tape, which is a very expensive medium. Not a lot of art students can afford it. So you're in a funny situation of trying to plan something without actually working with your material. You have to think the whole thing out and *then* get the equipment to accomplish it. It's as if you were a painter, and you had to just *think* of this amazing painting and then one day go out and rent a brush and come back and paint the thing real fast, and return it to the rental place clean the next day. It's very difficult to work like that. Anyone who uses any kind of material—words, or stone, or notes—knows you have to work with your material. It will teach you things. When I get really stuck—when I think, "This is it! This is the last idea I'm ever going to get," I try to shake it by just playing with things. I try to let the material suggest the shape. Otherwise, it feels forced . . . jammed together. So, I suppose I'm just saying something about having a kind of respect for the material or the equipment that you're working with, and taking the time to learn about it. . . .

CA: Do you get into a trance during performances and if so, what kind of experiences do you have?

LA: I think that I probably do, in a way, but also I'm so aware of what could possibly go

wrong. And things always do. Things always break down, little red lights on the harmonizer go dead, and I usually have a small screwdriver so that I can surreptitiously try to do something else while I'm talking, and be trying to fix whatever's going wrong. I actually like that probability because I find it very exciting to have to improvise. When something breaks down, you really can't say, "Can we turn the houselights on, please, we have some problems here." So, I probably am thinking about a couple of things, and that probably is a trance-like state. . . .

CA: In the performances, how do you put them together technically, what's live and what isn't?

LA: This is a giant sort of puzzle and the scores for these things are done in huge columns and it shows you what exact image is being used at that second. A lot of the basic tracks are on tape and I try to record those things so that they have as much to do with the live sound as possible. So I do several mixes and if the hall is a certain size, I use one mix that has a little bit of reverb on it. If the hall is very large I use something that has no reverb on it. I really try to tune the tape to the room and mix with the live instruments so that it doesn't sound like live musicians playing with tape. If you listen real hard, it does, and those of you who work with that sort of thing, I'm sure, know what's going on. . . . Now, when things break down, everybody starts looking over at everyone else, and we try to get out of it. That is, as I said, the most exciting part, it's a lot of fun to try to do that. . . .

CA: Did you pick up a background in analog and digital electronics?

LA: At one point I thought, well, I could stop working for three years and really try to learn some things about electronics. But I was afraid to do that really, because I thought, what if after three years I couldn't remember why I was learning this stuff? So, I try to learn only what I need to know at the time, and I also work with an electronic designer, Bob Bielecki, who can do a lot of rather elaborate designs. I'm pretty good on emergency maintenance, that's my specialty. . . .

CA: Could you talk about how your storytelling works into music, and how long it takes to get there.

LA: I think often the case is that words are just hanging around and I don't really know what to do with them, I can't quite throw them away yet. I always try to start things differently, sometimes with music, sometimes with an image. But I'd say the main focus of it is really words. I try to establish a very simple rhythm and then on top of that language drifts around with its own rhythms. I rarely write in stanzas or things that rhyme or things that scan or things that count out in a certain number of syllables. I think I like talking rhythms more than musical rhythms. . . .

And in terms of your question, about my spiritual reaction to it, I think of electronics as being, in fact, in a sense closer to that side. It doesn't go through the hands the way an instrument does. I love the violin because it's a hand held instrument, it's a very nineteenth century instrument, something that you hold as opposed to a keyboard which reminds me of driving a car. But electronics is very connected, of course, in terms of speed, to your brain. It's very very fast. So there's a kind of immediate freedom that you have. . . .

The point I'm trying to make is that, in a sense, as these two life forms—human and machine—begin to merge a little bit, we're talking about technology really as a kind of new nature, something to measure ourselves against, and to make rules from, and to also investigate. One of the things that is most encouraging about this is that kids who begin to work with computer systems when they're real little aren't intimidated by them as opposed to adults who actually become more dogmatic if they work with computers. Instead of having a phone conversation or a meeting, they talk to each other through their terminals, and one of the

things that happens is that people use a lot more foul language. Because you can't do that really very easily on the phone, but when you abstract it like that, it's a little bit easier. Also people become, strangely, more sure of themselves. They reach a decision more quickly and they become more sure that they're right, and less willing to give and take, when it's done through a terminal. Which I think has something to do with when you write something down and try to work it out, and then type it, it has real and sudden distance. It's almost as if somebody else did it when you see it typed out, you have a kind of distance from it. It's a little bit like that working with a terminal. . . .

I think there's a strange longing to talk to machines. There's a parking lot in Zurich. You drive up to this booth, and you hear this voice that says, "It's going to be so and so many francs to park here," in this kind of mechanical voice, and it shoots this ticket out. But, there's something a little bit too odd about the voice. There's a cable running out the door, and you can see this guy in the adjoining room doing the voice, you know, kind of mechanically, making the parking lot seem a little more high tech.

CA: Assuming that you would like an effect on mankind as a whole right now, what effect would you like your music to have?

LA: I can never predict what other people will like. I can't even predict what I will like. I suppose that the effect that I want from myself from music is, in a way, to scare myself a little bit, to surprise myself, to wake up.

About continuity. I don't know how many of you have spent time in New York but you can really lose track of that there because it really is, "Hey, what's hot this week?" That can become very deadening after a while. I'm thinking particularly of an evening that I mentioned before, the work of Oscar Schlemmer, the Bauhaus designer/choreographer. In this reconstruction of his work, Andreas Weininger, who used to play trumpet in the Bauhaus band, showed up at the Guggenheim to talk. This guy was 85 years old, and it was a Saturday night, and he came out and he said, "Hi, I'm from the nineteenth century." And we go, "Whoa." He said, "You know, we had Saturdays in the nineteenth century too, and what we did was . . . " and he proceeded to describe these insane long-ago evenings. It really seemed so alive and exciting. So wonderful. It was a kind of real continuity, and you really felt that, yes, there have been artists, and there is a long line, and we can learn from each other, and we can go forward, and try to be as generous as possible with each other.

KRZYSZTOF WODICZKO Memorial Projection (1986)

The aim of the memorial projection is not to "bring life to" or "enliven" the memorial nor to support the happy, uncritical, bureaucratic "socialization" of its site, but to reveal and expose to the public the contemporary deadly life of the memorial. The strategy of the memorial projection is to attack the memorial by surprise, using slide warfare, or to take part in and infiltrate the official cultural programs taking place on its site.

In the latter instance, the memorial projection will become a double intervention: against the imaginary life of the memorial itself, and against the idea of social-life-with-memorial as uncritical relaxation. In this case, where the monumental character of the projection is bureaucratically desired, the aim of the memorial projection is to *pervert this desire* monumentally.

* Krzysztof Wodiczko, excerpt from "Memorial Projection," in "Public Projections," *October* 38 (Fall 1986): 3–22. Courtesy Galerie Lelong, New York, and the publisher.

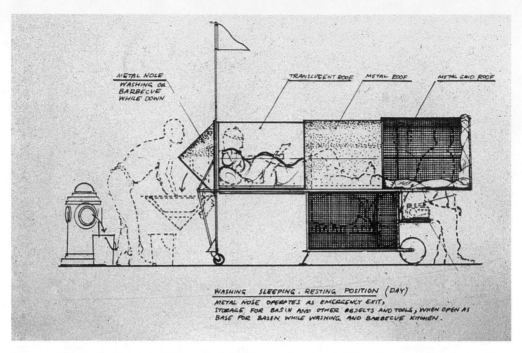

Krzysztof Wodiczko, *Homeless Vehicle,* 1988, ink on paper, showing washing, sleeping, and resting positions (day). Courtesy of the artist and Galerie Lelong, New York.

The Homeless Projection: A Proposal for the City of New York (1986)

"Architecture"

What has been called architecture is no longer merely a collection of buildings with "stable forms" and "permanent structures." Architecture must be recognized today as a social system: a new economic condition and a psycho-political experience. The new meanings ascribed to architecture through their interplay with changing circumstances and events are *not* new meanings but exist only as concepts in semiotic texts (Umberto Eco) and slogans in real estate advertisements for the gentry (Zeckendorf Towers). If architecture does on occasion preserve its traditional and sentimental appearance in an attempt to "interplay" with new events, this serves only to create, impose, and ultimately reject or appropriate these new social circumstances. In this way, "architecture" demolishes, relocates, rebuilds, renovates, rezones, gentrifies, and develops itself continuously. Mimicking and embodying a corporate moral detachment, today's "architecture" reveals its inherent cynicism through its ruthless expansionism. What has been defined as architecture is really, then, a merciless real estate system embodied in a continuous and frightening mass-scale event, the most disturbingly public and central operations of which are economic terror, physical eviction, and the exodus of the poorest groups of city inhabitants from the buildings' interiors to the outdoors.

 * Krzysztof Wodiczko, "The Homeless Projection: A Proposal for the City of New York," in "Public Projections," *October* 38 (Fall 1986): 3–22. Courtesy Galerie Lelong, New York, and the publisher.

The New Monument

Such forced exteriorization of their estranged bodies transforms the homeless into permanently displayed outdoor "structures," symbolic architectural forms, new types of city monuments: THE HOMELESS.

The surfaces of THE HOMELESS—over- or underdressed, unwashed, cracked from permanent outdoor exposure, and posing in their frozen, "classic" gestures—weather and resemble the official monuments of the city. THE HOMELESS appear more dramatic than even the most colossal and expressive urban sculptures, memorials, or public buildings, however, for there is nothing more disruptive and astonishing in a monument than a sign of life. To the observer the slightest sign of life in THE HOMELESS is a living sign of the possibility of the death of the homeless from homelessness.

The homeless must display themselves in symbolically strategic and popular city "accents." To secure their starvation wages (donations), the homeless must appear as the "real homeless" (their "performance" must conform to the popular MYTH OF THE HOMELESS): the homeless must become THE HOMELESS.

Adorned with the "refuse" of city "architecture" and with the physical fragments of the cycles of change, the homeless *become* the nomadic "buildings," the mobile "monuments" of the city. However, fixed in the absolute lowest economic and social positions and bound to their physical environment, the homeless achieve a *symbolic stability,* while the official city buildings and monuments lose their stable character as they continuously undergo their *real estate change.*

Unable to live without the dramatic presence of THE HOMELESS (since their contrast helps produce "value"—social, economic, cultural) and denying the homeless as its own social consequence, "architecture" must continuously repress the monumental condition of the homeless deeper into its (political) unconscious.

Projection

If the homeless must "wear" the building (become a new, mobile building) and are forced to live through the monumental problem of Architecture, the aim of the homeless projection is to impose this condition back upon the Architecture and to force its surfaces to reveal what they deny.

—To magnify the scale of the homeless to the scale of the building!

—To astonish the street public with the familiarity of the image and to make the homeless laugh!

—To employ the slide psychodrama method to teach the BUILDING to play the role of THE HOMELESS!

—To liberate the problem of the homeless from the unconscious of the "architecture"!

—To juxtapose the fake architectural real estate theater with the real survival theater of the homeless!

NAM JUNE PAIK
Afterlude to the Exposition of Experimental Television (1964)

(1)

My experimental TV is
> not always interesting
> but
> not always uninteresting
like nature, which is beautiful,
> not because it changes beautifully,
> but simply because it changes.
The core of the beauty of nature is that the limitless QUANTITY of nature disarmed the category
> of QUALITY, which is used unconsciously mixed and confused with double meanings.
> 1) character
> 2) value.
In my experimental TV, the word *QUALITY* means only the CHARACTER, but not the VALUE.
> A is different from B,
> but not that
> A is better than B.

> Sometimes I need red apple
> Sometimes I need red lips.

(2)))

2 My experimental TV is the first ART (?), in which the "perfect crime" is possible. . . . I had put just a diode into opposite direction, and got a "waving" negative television. If my epigons do the same trick, the result will be completely the same (unlike Webern and Webern-epigons) . . . that is . . .
> My TV is *NOT* the expression of my personality, but merely
> a "PHYSICAL MUSIC"

like my "FLUXUS champion contest," in which the longest-pissing-time record holder is honored with his national hymn (the first champion: F. Trowbridge. U.S.A. 59.7 seconds).
> My TV is more (?) than the art,
> or
> less (?) than the art.

> I can compose something, which lies
> higher (?) than my personality
> or
> lower (?) than my personality.

>

* Nam June Paik, excerpts from "Afterlude to the Exposition of Experimental Television," *V TRE* 5 Fluxus-newspaper 5 (1964); reprinted as Nam June Paik with Charlotte Moorman, "Videa, Vidiot, Videology," in Gregory Battcock, ed., *New Artists Video: A Critical Anthology* (New York: E. P. Dutton, 1978). By permission of the author.

Nam June Paik and Charlotte Moorman, *TV Bra for Living Sculpture,* May 1969, video performance. Photo by Peter Moore. © Estate of Peter Moore/VAGA, NYC.

3

Therefore (?), perhaps therefore, the working process and the final result has little to do and therefore . . . by no previous work was I so happy working as in these TV experiments.

In usual compositions, we have first the approximate vision of the completed work (the pre-imaged ideal, or "IDEA," in the sense of Plato). Then, the working process means the torturing endeavor to approach to this ideal "IDEA." But in the experimental TV, the thing is completely revised. Usually I don't, or *cannot* have any pre-imaged vision before working. First I seek the "WAY," of which I cannot foresee where it leads to. The "WAY," . . . that means, to study the circuit, to try various "FEEDBACKS," to cut some places and feed the different waves there, to change the phase of waves, etc., . . . whose technical details I will publish in the next essay. . . . Anyway, what I need is approximately the same kind of "IDEA" that American ad agency used to use, . . . just a way or a key to something NEW. This "modern" (?) usage of "IDEA" has not much to do with "TRUTH," "ETERNITY," "CONSUMMATION," "ideal IDEA," which Plato–Hegel ascribed to this celebrated classical terminology. (IDEA) = f.i.

"KUNST IST DIE ERSCHEINUNG DER IDEE."
 "Art is the appearance of the idea."
 (Hegel–Schiller.)

This difference should be underlined, because the *"Fetishism of Idea"* seems to me the main critical criterion in . . . contemporary art, like "Nobility and Simplicity" in the Greek art (Winckelmann), or famous five pairs of categories of Wölfflin in Renaissance and Baroque art.

4

INDETERMINISM and VARIABILITY is the very UNDERDEVELOPED parameter in the optical art, although this has been the central problem in music for the last ten years (just as parameter sex is very underdeveloped in music, as opposed to literature and optical art).

a) I utilized intensely the live-transmission of normal program, which is the most variable optical and semantical event in 1960s. The beauty of distorted Kennedy is different from the beauty of football hero, or not always pretty but always stupid female announcer.

b) *Second dimension of variability.*

Thirteen sets suffered thirteen sorts of variation in their VIDEO-HORIZONTAL-VERTICAL units. I am proud to be able to say that all thirteen sets actually changed their inner circuits. No two sets had the same kind of technical operation. Not one is the simple blur, which occurs when you turn the vertical- and horizontal-control buttons at home. I enjoyed very much the study of electronics, which I began in 1961, and some life danger I met while working with fifteen kilovolts. I had the luck to meet nice collaborators: HIDEO UCHIDA (president of Uchida Radio Research Institute), a genial avant-garde electronician, who discovered the principle of transistor two years earlier than the Americans, and SHUYA ABE, all-mighty politechnician, who knows that the science is more a beauty than the logic. UCHIDA is now trying to prove the telepathy and prophecy electromagnetically.

c) As the third dimension of variability, the waves from various generators, tape recorders, and radios are fed to various points to give different rhythms to each other. This rather old-typed beauty, which is not essentially combined with high-frequency technique, was easier to understand to the normal audience, maybe because it had some humanistic aspects.

d) There are as many sorts of TV circuits as French cheese sorts. F.i. some old models of 1952 do certain kind of variation, which new models with automatic frequency control cannot do.

Cybernated Art (1966)

℞ Cybernated art is very important, but art for cybernated life is more important, and the latter need not be cybernated.

(Maybe George Brecht's simplissimo is the most adequate.)

☠ But if Pasteur and Robespierre are right that we can resist poison only through certain built-in poison, then some specific frustrations, caused by cybernated life, require accordingly cybernated shock and catharsis. My everyday work with video tape and the cathode-ray tube convinces me of this.

✳ Cybernetics, the science of pure relations, or relationship itself, has its origin in karma. Marshall McLuhan's famous phrase "Media is message" was formulated by Norbert Wiener in 1948 as "The signal, where the message is sent, plays equally important role as the signal, where message is not sent."

✳ As the Happening is the fusion of various arts, so cybernetics is the exploitation of boundary regions between and across various existing sciences.

◈ Newton's physics is the mechanics of power and the unconciliatory two-party system, in which the strong win over the weak. But in the 1920's a German genius put a tiny third-party (grid) between these two mighty poles (cathode and anode) in a vacuum tube, thus enabling the weak to win over the strong for the first time in human history. It might be a Buddhistic "third way," but anyway this German invention led

* Nam June Paik, "Cybernated Art," in *Manifestos,* Great Bear Pamphlets (New York: Something Else Press, 1966), 24. By permission of the author.

to cybernetics, which came to the world in the last war to shoot down German planes from the English sky.

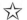 The Buddhists also say

Karma is samsara

Relationship is metempsychosis

We are in open circuits

Art and Satellite (1984)

At the turn of our century, the French mathematician Henri Poincaré said the following thing. . . . (Yes, it was in the midst of so-called material progress and the discovery of new Things. . . .) Poincaré pointed out that what was being discovered was not new THINGS but merely the new RELATIONSHIPS between things already existing.

We are again in the fin de siècle . . . this time we are discovering much new software . . . which are not new things but new thinks . . . and again we are discovering and even weaving new relationships between many thinks and minds . . . we are already knee-deep in the post industrial age. The satellite, especially the live two-way satellite is a very powerful tool for this human Videosphere. . . .

It is said that all the sciences can trace their roots to Aristotle: but the science of cosmic aesthetics started with Sarutobi Sasuke, a famous *ninja* (a samurai who mastered many fantastic arts, including that of making himself invisible, chiefly to spy upon an enemy). The first step for a *ninja* is learning how to shorten distances by shrinking the earth, that is, how to transcend the law of gravity. For the satellite, this is a piece of cake. So, just as Mozart mastered the newly-invented clarinet, the satellite artist must compose his art from the beginning suitable to physical conditions and grammar. Satellite art in the superior sense does not merely transmit existing symphonies and operas to other lands. It must consider how to achieve a two-way connection between opposite sides of the earth; how to give a conversational structure to the art; how to master differences in time; how to play with improvisation, in-determinism, echos, feedbacks, and empty spaces in the Cagean sense; and how to instantaneously manage the differences in culture, preconceptions, and common sense that exist between various nations. Satellite art must make the most of these elements (for they can become strengths or weaknesses), creating a multitemporal, multi-spatial symphony. . . .

There is no rewind button on the BETAMAX of life. An important event takes place only once. The free deaths (of Socrates, Christ, Bo Yi and Shu Qi) that became the foundations for the morality of three civilizations occurred only once. The meetings of person and person, of person and specific era are often said to take place "one meeting-one life," but the *bundle* of *segments* of this existence (if *segments* can come in *bundles*) has grown much thicker because of the satellite. The thinking process is the jumping of electrical sparks across the synapses between brain cells arranged in multilayered matrices. Inspiration is a spark shooting off in an unexpected direction and landing on a point in some corner of the matrix. The satellite will accidentally and inevitably produce unexpected meetings of person and person and will

* Nam June Paik, "Art & Satellite," in *Nam June Paik: Art for 25 Million People: Bon Jour, Monsieur Orwell: Kunst und Satelliten in der Zukunft* (Berlin: DAAD Galerie, 1984), n.p. By permission of the author and DAAD (Deutscher Akademischer Austauschdienst).

enrich the synapses between the brain cells of mankind. Thoreau, the author of *Walden, Life in the Woods,* and a nineteenth-century forerunner of the hippies, wrote, "The telephone company is trying to connect Maine and Tennessee by telephone. Even if it were to succeed, though, what would the people say to each other? What could they possibly find to talk about?" Of course, history eventually answered Thoreau's questions (silly ones, at that). There developed a feedback (or, to use an older term, dialectic) of new contacts breeding new contents and new contents breeding new contacts. . . .

Thanks to the satellite, the mysteries of encounters with others (chance meetings) will accumulate in geometric progression and should become the main nonmaterial product of post-industrial society. God created love to propagate the human race, but, unawares, man began to love simply to love. By the same logic, although man talks to accomplish something, unawares, he soon begins to talk simply to talk.

It is a small step from *love* to *freedom.* To predefine freedom is a paradox in itself. Therefore, we must retrace the development of freedom historically in order to understand it. The progressive American journalist Theodore White once wrote how impossible it was to explain the difference between *liberty* and *greed* to the leaders of the Chinese Communist Party at Yánān during the Second World War. There are 2,500,000,000 two-character permutations and combinations of the 50,000 Chinese characters. *Zìyóu,* the two-character word for *freedom,* however, did not come into being until the nineteenth century. Just as it is harder to translate *rén* (benevolence, humanity) and *li* (ceremony, etiquette) into English than *dào* (the way [of life, etc.]), it is extremely difficult to translate *liberty* and *freedom* into Chinese. It seems that *gòngchan,* the word *communist* as in the Chinese Communist Party, is a loanword from Japan; perhaps *zìyóu* originated in a similar fashion. Even in bright and free ancient Greece, there was the term *free man,* referring to a social class, but there was no philosophical concept of freedom. The passionate idea of freedom is said to have been born under the most unfree, dark domination, of medieval Christianity. Moreover, it was amidst the rise of fascism and the decadence of the Russian Revolution and after the loss of bourgeois freedom before and after the Second World War that man was most strongly and keenly aware of this passionate idea. The existentialism of Camus, Sartre, and Berdyayev was once again forgotten by West European society from the 1960s on, when it experienced a return of freedom and prosperity. In any case, freedom is not a concept inherent in man (it is found neither in the *Koran* nor in the *Analects* of Confucius) but is an artificial creation like chocolate or chewing gum.

The "increase in freedom" brought about by the satellite (from a purely existentialist point of view, an "increase in freedom" is paradoxical; freedom is a qualitative idea, not a quantitative one) may, contrary to expectation, lead to the "winning of the strong." (Although the imported concepts of freedom and equality may appear to be close brothers, they are in fact antagonistic strangers.)

Recently, an Eskimo village in the Arctic region of Canada started establishing contact with civilization. So far they only have four stores. The first is a general store. The second is a candy shop. (They had not even tasted sugar until quite recently.) The third is, of all things, a video cassette rental shop!!!

Video must have immeasurable magical powers. This means that the Eskimos' ancient traditional culture is in danger of being rapidly crushed by the bulldozers of Hollywood. The satellite's amplification of the freedom of the strong must be accompanied by the protection of the culture of the weak or by the creation of a diverse software skillfully bringing to life the qualitative differences in various cultures. As the poets of the beat generation learned from

Zen, Philip Glass obtained hints from the music of India, and Steve Reich looked to the music of Ghana in their creation of original forms of late twentieth-century high art, it is not an impossible task.

As long as the absorption of a different culture makes up the greater part of the pleasure of tourism, the satellite may be able to make every day a sight-seeing trip. So, Sarutobi Sasuke not only embodies the origins of cosmic aesthetics but also the ethnic romanticism that must always be the companion of satellite art.

GERRY SCHUM Introduction to TV Exhibition II: Identifications (1969)

"More and more artists are exploring the possibilities of the relatively new media of film, television and photography." That was the first sentence of my introduction to the Land Art broadcast in April 1969. We are now in a position to illustrate this statement with facts, and if necessary to make corrections. A video exhibition of the work of six American artists is at present traveling in the United States from coast to coast. The exhibits owe their existence to television recording. The summer exhibition "information" at the Museum of Modern Art in New York presented more than one hundred hours of film by artists from all the world. Now also several museums and collectors in Europe are beginning to buy video recorders with which to present art objects in the form of magnetic tapes.

The video recorders of today make it possible to show art on every kind of domestic television set. And it is also possible nowadays to watch art on one's own television set at any time, besides watching art transmissions. The video tape offered museums and collectors a way of showing art without all the difficulties involved in the use of 16 mm film.

The hopes which we expressed six months ago during the television exhibition Land Art have been strengthened by new technical possibilities. Nevertheless artists have not fallen for the new medium en masse. An "art of twentieth-century technology" did not emerge. Neither Hollywood nor the Italian Western is at all interested in video. Nor has a "television art" evolved, as opposed to the blossoming of art in the urban environment: objects adapted to the parks and suburbs they adorn.

The video recorder and television have created an entirely new medium of communication. It is now possible for contemporary tendencies in art to reach a broad public fairly directly, without having to wait for those obligatory five to ten years.

Communication is acquiring dimensions that were unknown until today. In spite of all this, however, the trend seems to be in the opposite direction. The television exhibition Land Art showed situations created by artists in more or less imposing landscapes. Landscapes which were much less exotic for the artists themselves than for the unprepared spectator. These artists have all, in fact, lived or at any rate spent a considerable length of time in the areas that figure in their respective works. What all the projects had in common were the greatly magnified proportions of the pictorial plane: spacious landscapes replaced the painter's canvas. De Maria and Heizer worked with the smooth sandy bed of a dried-up lake. Heavy machines were used: Jan Dibbets, for instance, used a bulldozer to realize his perspective corrections on a beach. I think the almost irritatingly flattering reviews of the Land Art exhibitions are

* Gerry Schum, introduction to "TV Exhibition II: Identifications," broadcast by Südwestfunk Baden-Baden, 30 November 1970; published in *Gerry Schum,* foreword by Dorine Mignot in collaboration with Ursula Wevers (Amsterdam: Stedelijk Museum, 1979). Courtesy Ursula Wevers, for the estate of Gerry Schum.

to some extent due to those impressive landscapes, but they were merely the starting point for a further-reaching process of formal change.

The ideas which had been reduced to a minimum, just as the gestures of the artists were wrapped up in the landscape. In this way even the most radical idea became reconcilable.

Identifications will not suffer from this problem.

The twenty works that you will see at this television exhibition were conceived and realized for this occasion by twenty artists of the international avant-garde, from Germany, the United States, England, France, Italy and the Netherlands.

Instead of large-scale art objects in snowy landscapes or deserts, we are now shown pure gesture, an attitude, or simply a statement by an artist. There has been a development away from the autonomous "large-scale object," in which the idea and concept are subservient to sheer scale or aesthetics. The film was reduced in favor of the essence of the object, the idea. The work of art loses its autonomy and can no longer be separated from the producer, i.e. the artist. Lawrence Weiner consistently refers to his video tapes as "visualizations," as something made visible. He demonstrates this idea in his work.

Jean Leering, the museum director, refers to Process Art—art that no longer finds a workable and hence integratable finality in the object per se. Art that wants to shock. The term Arte Povera, "poor art," was coined in Italy. It means that material and form are reduced to a sort of aggregate, just as much as is needed for the communication of the idea, without unnecessary embellishments. American artist critics duly came up with the term Conceptual Art. The idea as work of art, manifested as through many possibilities of communication. Giving the idea permanence, making it fixed in a material end-product, was avoided as much as possible. Identifications—the title of this television exhibition points to the correlation between the work of art and the artist in the artistic process. They have tried to overcome the separation between the artist and the work of art.

This essential separation is rooted in the demands of the traditional art market. The artist as a craftsman: it is due to this alone that art can be bought and sold.

Film and especially television offer the artist the possibility of avoiding the materialization of his ideas to some extent. Television broadcasting and video recording make direct contact between the artist and the public possible. The translation of the idea in terms of communicability or, to use Weiner's term, into a "visualization" benefits the idea.

We no longer experience the work of art as a painting or a sculpture, without contact with the artist. By using television as his medium the artist can reduce his work to an attitude, a simple gesture, which refers to his concept. The work of art then comes to the fore as the union of idea, visualization and the artist who invents the idea.

It is not my intention to comment upon each work in Identifications separately. The works are shown as conceived by the artists. None of them are accompanied by explanatory comments.

I would like to quote what Richard Long said in Land Art: "My work should be shown the way I made it. If explanations are necessary, then the work is no good."

The transmission of the television gallery is not an art-critical broadcast. It is first and foremost a disinterested presentation of art, not a comprehensive report, not an evaluation nor an explanation.

The artists in this exhibition want to provoke, to trigger thought processes. It is not my intention to level or smooth over oppositions that may arise, not to defend provocative objects.

FRANK GILLETTE Masque in Real Time (1974)

Occidental industrial man has defined himself into a shrinking niche of separateness, isolation, and condescension vis-à-vis the natural world while believing he has conquered it. This belief, with its accompanying myths and rationalizations, culminates in an unlimited exercise of private judgment linked with an "advanced" technology positing itself against the "external" environment. Ecocide and extinction are now authentic possibilities.

A nascent function (or role) of art, the artist, and aesthetic agencies lies in countering and reversing this belief, these myths and rationalizations. Through the *sensual* embodiment of a select perceptual range, art, indirectly and directly, generates strategems of purification and ecological world models. From the image of a stag painted on the walls of Lascaux some 15,000 years ago to the most recent electronic articulation in light, the unique value of artistic form derives from its "capacity to convey information that cannot be coded in any other way."[1]

1. Any substantial body of work in art is an evolution of a private (emotive, subjective) yet somehow shared and accessible epistemology, or *way of knowing*. The artist's task, his stock in trade, is sustaining a coherent and dynamic equilibrium while creating an evolving variety of forms. Art is the *sine qua non* for developing informational contexts, or realms of discourse, through which discontinuous and novel synthesis integrates the heretofore unlinked. By breaking in fresh psychological or psychic space the artist, therefore, informs survival, which requires a constant "supply of uncommitted potentiality for change, i.e., flexibility."[2]

1.1 Although any specific aesthetic process involves its embodiment in a medium, art is not restricted to any limited range of media and behaviors. The identification of art with certain historically sanctified media supports the same prevailing myth that characterizes art as essentially antienvironmental, and the aesthetic process as one that is exclusively isolative. Communication technologies provide a new continuum of media categorically different from and independent of the historicity of *prime objects*.[3]

1.2 "Mind is eternal, insofar as it apprehends an object under the species of eternity."[4] Thus art is here defined as (a) the production of "objects (or contexts) under the species of eternity," (b) as the medium for the transmission (or programming) of increasing degrees of discontinuous variance, (c) synergistically, as the best (optimum) possible combination of materials, events, systems, ideas, (d) functionally, as the trace (mapping, recapitulation, metaphorization) of the flow of essences (processes) through their course of (probable, anticipated, potential) changes-in-direction (differences-in-pattern, rate, paradigm) as experienced (perceived, intercepted) by the artist.

1.3 A deliberate deviation from a given body of rules which determine formal concerns governs germane aesthetic activity. Each case involves individual human beings behaving in eccentric characterological ways. Communications technology, on the other hand, has been programmed and deployed overwhelmingly by contrary means, i.e., with great emphasis on

* Frank Gillette, "Masque in Real Time" (1974), in Ira Schneider and Beryl Korot, eds., *Video Art: An Anthology* (New York: Harcourt Brace Jovanovich, 1976), 218–19. By permission of the author. This selection is a version of a presentation given at the World Man conference in Moltrasio, Italy, September 1974. It has been edited with the assistance of Marco Vassi.
1. E.H . Gombrich, "The Visual Image," *Scientific American* (September 1972).
2. Gregory Bateson, *Steps to an Ecology of Mind* (New York: 1972).
3. The term "prime object" is from George Kubler, *The Shape of Time* (London: 1962).
4. Spinoza, *Ethics* (V. prop. 31), "Mens aeterna est, quatenus res sub aeternitatis specie concipit."

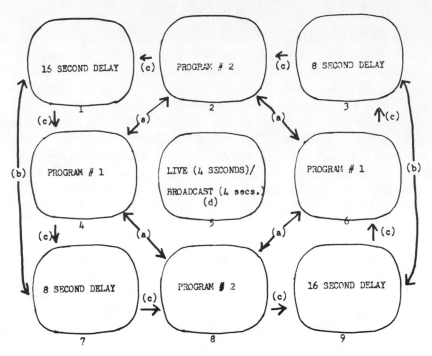

CYCLE (a) Monitors 2, 4, 6 and 8: Programmed change cycle, Program No. 1 alternating
every eight seconds with Program No. 2.

CYCLE (b) Monitors 1, 3, 7 and 9: Delay change cycle, Nos. 1 and 7 and 3 and 9 alternat-
ing (exchanging) every four seconds.

CYCLE (c) Monitors 1, 2, 3, 4, 6, 7, 8 and 9: Wipe cycle, grey "light" pulse, moving
counterclockwise every two seconds.

CYCLE (d) Monitor 5: Live cycle, four seconds of live feedback alternating with four seconds
of broadcast television.

Frank Gillette and Ira Schneider, diagram for *Wipe Cycle,* 1969, television camera, nine
television monitors, and videotape. As the viewer watches, she sees herself "live" together
with tapes of previous viewers and prerecorded programming. By permission of Ira
Schneider.

low variety, conformity, and repetition. Since art provides the incentive to experience the
unfamiliar, any event/object/concept utilizing contemporary communications technology as
its medium is a priori a declarative statement, heuristic in spirit. This confluence of attitude-
of-mind and technology represents an alternative course to the automatic, conforming influ-
ence of technological application.

2. Video systems are the most accessible and viable means to this conjunction of aesthetic
process and technical sophistication. They materialize the potential link between the artist
and the planetary exoskeleton of communications systems, television, holography, protean
computer networks, satellites, etc. Inasmuch as video is the first full materialization of this
linkage principle, it exemplifies the proposition that art is environmental. This primacy will
obtain until the subsequent displacement shift in communications technology.

2.1 Since video does not redefine established relations between viewer and *prime object,*
but opens and develops new relations, its aesthetic capacities cannot be understood in the
wake of prior models of interaction. Video is in itself an unprecedented channel of relation

through which the artist evokes and transmits states of awareness, sensations, perceptions, compulsions, affects, and thoughts. Paradoxically, as the artist gives shape to this set of relationships, his role returns to revive the primordial functions of the shaman and the alchemist, since art becomes a *record* of a process and not the manipulation of passive materials. Within this view, the artist's subjective-emotional state, i.e., his hybrid forms of introspection, and the technology which conveys them constitute parallel continuums.

2.2 Artistic media can be understood as extensions of the body. The video *network,* in this sense, is the extension of a neurophysiological channel, the connection between the world and the visual-perceptual system terminating in the prefrontal neocortex. Video can thus become a record of the resonance between that channel—eye/ear/prefrontal neocortex—and natural processes in time. The first criterion for a video aesthetic, then, is the economy of movement in the use of the camera as a record of mediation between the "eye-body," taken as the symbol and substance of the entire viscero-somatic system in video art, and the processes being recorded. Through a kinaesthetic *signature* which individuates the "loop"—eye-body, the technology itself, and the processes being recorded—the artist transmutes random information into an aesthetic pattern.

2.3 In the longer arcs of biological/genetic activity, continuity is the rule, while in the interstices of history—epochs, eras, generations, and individuals—continuity is the exception. The imposition of values derived from a perception of continuity, as history, upon the high variety and discontinuity of day-to-day living results in a distortion of our expenditure of flexibility and capacity to adapt. A corollary effect of the increasing use of video systems is the alteration of our apprehension of both the historical record and daily existence. Since video is a medium of real time, i.e., it transmits the temporal quality of the process being recorded, it alters our experience of our own memory, of history, and of daily life. This alteration is always idiosyncratic to the artist's attitude, or orientation, toward his center of gravity as he steers the camera. The body sense in relation to its environment through technology is the impacted perception which that complex of eye-body/technology/environment is itself recording. Thus video is a primary ecological medium.

3. "The proliferation of resemblances extends an object."[5] Orthodox aesthetic hierarchies are rooted in systems in which value, in general, is measured by the rarity of *prime objects.* Within the context of the video medium, however, it is possible to produce masters which can be replicated indefinitely, each copy equal in fidelity to the other and all to the original. Since video is purely informational (conceptual) and provides one example of the dematerialization of art, it requires new criteria for choice of content—an original *axiom of choice.* The nature of recording in videotape, in this perspective, involves bringing previously undetected patterns above the threshold of perception. These include configurations of meaning and metaphysical relationships that are subject to exposure in real time as well as purely visual patterns and aural textures. Choice of subject/content/process in videotape presupposes an awareness of the distributive nature of the medium. Hence, the place of *prime objects* in hierarchical aesthetic systems is filled, in the electronic media, by the concept of *network.*

3.1 Change is commonly associated with the overthrow of hierarchies. Things change for the better or for the worse; they never merely change. The central obstruction to the full acceptance of the video network as an artistic medium in its own right is the fear that some-

5. Wallace Stevens, *The Necessary Angel* (New York: 1951).

how or other *prime objects* will be devalued and traditional hierarchies, some of which have been accorded the status of guiding myth, will be replaced. In reality the issue is one of expanding our expectations of the potential of art to move and affect the world. It requires an integrative, as opposed to a reductionist, attitude of mind that favors diversity, variety, and novelty as evolutionary ends in themselves. For "human consciousness is in perpetual pursuit of a language and style. To assume consciousness is at once to assume form. Even at levels far below the zone of definition and clarity, forms, measures and relationships exist. The chief characteristic of the mind is to be constantly describing *itself*."[6]

SHIGEKO KUBOTA Video Poem (1968–76)

Behind the Video Door
I travel alone with my portapak on my back, as Vietnamese women do with their baby.
I like Video, because it's heavy.
Portapak and I traveled all over Europe, Navajo land and Japan without male accompany.
Portapak tears down my shoulder, backbone and waist. I felt like a Soviet woman, working at the Siberian Railway. I made a videotape called, "Europe on a half-inch a Day," instead of a popular travel book, "Europe on 5 dollars a Day." I had one summer with Navajo family in Chinle, Arizona, I made a videotape called, "An American Family."

Behind the Video Life
Man thinks, "I think, therefore I am."
I, a woman, feel, "I Bleed, therefore I am."
Recently I bled in half-inch . . . 3M or SONY . . . ten thousand feet every month. Man shoots me every night . . . I can't resist. I shoot him back at broad daylight with vidicon or tivicon flaming in overexposure.
Video is Vengeance of Vagina.
Video is Victory of Vagina.
Video is Venereal Disease of Intellectuals.
Video is Vacant Apartment.
Video is Vacation of Art.
Viva Video . . .

Notes for *Three Mountains* (1976–79)

I want to create a fusion of art and life, Asia and America, Duchampiana modernism and Levi-Straussian savagism, cool form and hot video, dealing with all of those complex problems, spanning the tribal memory of the Nomadic Asians who crossed over the Bering Strait over 10,000 years ago. Then, I came, flying in a Boeing 707, on July 4th in 1964, drawn to the glittering Pop Art world of New York.

6. Henri Focillon, *The Life of Forms in Art* (New York: 1955).
* Shigeko Kubota, "Video Poem" (1968–76), in Ira Schneider and Beryl Korot, eds., *Video Art: An Anthology* (New York: Harcourt Brace Jovanovich, 1976); reprinted in Mary Jane Jacob, ed., *Shigeko Kubota: Video Sculpture* (New York: American Museum of the Moving Image, 1991), 18. By permission of the author.
** Shigeko Kubota, "Notes for *Three Mountains*" (1976–79), in Mary Jane Jacob, ed., *Shigeko Kubota: Video Sculpture* (New York: American Museum of the Moving Image, 1991), 35–36. By permission of the author.

Although the descendants of the great Mohawk Nation did much of the high steel work on New York's skyscrapers, my reunion with my ancient cousin came in a dry desert amidst lonely sandstone spires, with the Navajo people. My friendship with the Mitchell-Sandovar family started with Doggie Mitchell, an outstanding American Indian musician, at Wesleyan University in 1968. Doggie, there as a teaching fellow in ethno-musicology, had an ebullient, partially nihilistic lifestyle.

We used to converse in Japanese, his broken Navajo-Japanese. He met a mysterious death at the age of twenty-five. The mourning of his untimely departure led to the formation and presentation of a multiracial group of four women artists, "White, Black, Red and Yellow," including Mary Lucier, Charlotte Warren, Cecilia Sandovar (Doggie's cousin), and myself. In 1973 Mary Lucier and I followed Cecilia to her hometown in Chinle, Arizona. We stayed with their matriarchal family, lived their lives, experienced some of their rites and festivals. Generally speaking, I was treated with exceptional warmth. An elder man told me, "Oh, poor Japanese, you traveled so long to such a small island, you should have stayed here in America." I laughed. This old man thinks that the Native Americans immigrated to China and founded Chinese civilization in 4000 B.C. Another person told me that my name, Shigeko, means "my daughter-in-law" in the Navajo language. The Navajo word for hello, pronounced "Ya-tu-hey, ya-tu-hey," means "Love me, love me" in Japanese.

———————

The landscape of the Navajo enchanted me: the incredible colors of Arizona, the skies of the high desert. When I finally had to leave, I resolved to return. In 1976 I traveled throughout western America, recording the landscape in color video in the mountains of Washington, Idaho, Montana, Wyoming, and the deserts and canyons of Utah, Arizona, and New Mexico.

Many great ancient sculptural works—Stonehenge, the Pyramids, Peru's Nazca Lines—bear within their grand scale and precisely composed form another, religious and reflexive, dimension. Sculpture mirrors nature while containing the imprint, the consciousness, of its maker.

Mountain—womb

My womb is a volcano.

Five-inch and eleven-inch images are dancing inside of it.

They sing of my history.

Herbert Read wrote in 1964 that, "From its inception in pre-historic times down through the ages, and until comparatively recently, sculpture was conceived as an art of solid form, of mass, and its virtues were related to spatial occupancy." Video's incursion into sculptural territory will negate the long-held prejudices concerning video that suggest that video is "fragile," "superficial," "temporal," and "instant."

People wonder why I am making mountains.

"Why do I climb the mountain?" Not, "Because it is there," a colonialist/imperialist notion, but to perceive, to see.

The mountains provide a visual storm of perceptual complexity in a setting of almost incomprehensible mass and volume.

. . . drove as fast as possible, faster than body speed, drove on the highway in Arizona called the Echo Cliff, from the north canyon to the south Grand Canyon through Navajo reservation, grabbed my camera with both hands, the wind was hitting the microphone out of the window of the car . . . the sound echoes faster than mental speed, it sounds like the Indian kids are riding the horse, drumming for the raindance ceremony.

"O ji Ya," a small valley of a thousand rocks is the name of my ancestor's village. I was born in the snow country, in a mountain village in Japan. My grandfather was a *sumi-e* painter. He spent his entire life painting only mountains. As a student, I climbed in the Japanese "alps." I camped for weeks on the slope of Mt. Fuji during the winter snows. Snow in the mountains is like video and sculpture. Lightness, speed, the ephemeral quality of the electron set against an unmoving, timeless mass.

My mountains exist in fractured and distended time and space. My vanishing point is reversed, located behind your brain. Then, distorted by mirrors and angles, it vanishes in many points at once. Lines of perspective stretch on and on, crossing at steep angles, sharp like cold, thin mountain air. Time flies and sits still, no contradiction.

Buckminster Fuller . . . explains that men leaving Asia to go to Europe went against the wind and developed machines, ideas and occidental philosophies in accord with a struggle against nature: that, on the other hand, men leaving Asia to go to America went with the wind, put up a sail, and developed ideas and oriental philosophies in accord with an acceptance of nature. These two tendencies met in America, producing a movement into the air, not bound to the past, traditions, or whatever. John Cage, *Silence,* 1958

WOODY VASULKA Notes on Installations (1996)

Initially I looked at video installations with a great deal of suspicion. I was a man of Printed Matter. I used to believe strongly in the powers of the immaterial image, in those cognitive units of energy organized in time. I believed that the time had come to do away with the gallery, as the last of the oppressive control of art. And I certainly belonged to the group that Jonas Mekas at the end of the 1960s called the "tribe that worships electricity." So, what is this current obsession of mine with making "TV furniture" in museums and galleries?

It may seem ironic that in constructing my new installations . . . I am filling the space with objects of a menacing character. My backyard junk pile contains some remarkable pieces. The device at the heart of *Theater of Hybrid Automata* was once a celestial navigator, a double cylinder with optics and sensors to keep the instrument locked to the polar star. Obviously this was a piece of military hardware, designed to drop its deadly cargo some-where in terrestrial space. The questions Where am I? Where am I going? and How am I getting there? are encoded in intercept plotting tables, gyro-heads of missiles, tracking devices, and other opto-mechanical junk. Now these devices idle in the junk fields of the Southwest, their electronic nervous systems, their hydraulic and pneumatic networks, ripped apart, bleeding.

When I reached an impasse in my work with the cinematic-electronic frame, I turned my attention to this sinister arsenal, giving it a chance to manifest a different final destiny. I had neither the tools nor the knowledge to continue my narrative quest in three-dimensional graphics. I had battled the software and the machine until I realized that it was my head that needed realignment. This may, at least in part, explain the depth of my betrayal of immate-riality and, therefore, the sudden appearance of installations in my recent work.

Of the attempts made to influence the early formation of my ethical code, the one that left

* Woody Vasulka, excerpt from "Notes on Installations: From Printed Matter to Noncentric Space," in *Steina and Woody Vasulka: Machine Media* (San Francisco: San Francisco Museum of Modern Art, 1996), 65–72. By permis-sion of the author and the publisher. Copyright © 1996 by the San Francisco Museum of Modern Art. All rights reserved.

the most permanent impression had to do with money. As Catholic boys in the suburbs of a Moravian town, we were constantly reminded by the chaplain, and later by the priest himself, of the dangers of even thinking about money. Later in school, the socialist doctrine was no less compelling. It was inconceivable to lust after money in public or within my circle of friends. We looked down on our fathers' attempts to pocket cash with their petty schemes of smuggling food from the countryside to the city right after the war, when food was scarce. In our youthful utopia, we talked of poetry, modern art, and jazz.

Fortunately, I could not draw. None of my lines or strokes would ever resemble a divine connection with the Ultimate. What remained was writing, poetry, music, and photography. So it was out of my ineptitude that I formed an ethical bond with the concept of Printed Matter. I was committed to the universality of the replicable template, to all codes conceived in an immaterial context, in a total privacy of time and space, to everything that had to do with facilitating the metaphysical flow of ideas, the most powerful tool of utopia. All of this without the charade of a museum or gallery, without the seduction of the bourgeois, to whom or to what even the most incorruptible sooner or later fall prey. And video? This is Printed Matter par excellence! It was a simple technicality to embrace this ideal, the abstract template of electronic media, duplicable, self-publishable. Without any social status, without having to play the entertainer, clown, or fool, an author, well-hidden in the labyrinth of his mind or in his studio, could suddenly reach out to the world.

In making films, I dreaded the bombastic, public phase. As a shy, young man I found everything associated with public rituals intimidating. My pleasure was to edit film. This intimate protocol of joining two parts to build a far higher meaning suited the temperament of the practicing poet I considered myself to be.

With video, I became an instant voyeur. When I made video feedback for the first time, I would step back, watch, and then quietly slip out of the room, knowing that the feedback was still there, that it was alive and improving itself each moment, and that it was getting more and more complex and robust. I understood the consequences this could have on the rest of my life. Even now, when I seed a bunch of dubious numbers into my computer, I watch the chaos unveil with the same fascination.

Video came so fast; it was so new. We all plunged into a frenzy of handling this hot new stuff called video. There were so many things to learn in a short time: this new picture material, so mysterious and seemingly untouchable, these frames, "drawn" and suspended by a magnetic force on the face of the cathode-ray tube. But there was much more to know: the nature of image elements; the waveforms, their unity and exchangeability with sound, their mutual affinities and interactions; the craft of creating waveforms into primitive aesthetic units, which would survive the critical scrutiny of art.

Analog video was just the beginning. By the mid-1970s, with the aid of the Digital Image Articulator (built with Jeffrey Schier), I was peering into an entirely different, completely unfamiliar—but even more intriguing—window. The process of constructing a digitally organized screen is one of the most exciting experiences I can remember. I watched as a linear array of numbers hidden somewhere in a computer came out orderly, constructing point by point a visual, cognitive, perceptual unit—a frame. This point-by-point progression of frame construction is accomplished by the mere addition of the number one. To start constructing the next line, the binary counter steps into the next numerical scheme. This goes forward again and again with the same assurance as the sun rising each morning.

Even more dramatic was the realization of the intrinsic duality of the code that creates the electronic frame. Not only do the counters transform computer memory into the territory

of the screen, each carries an actual image property: the expression of point/image, the number representing brightness or color—a tiny part of the image itself. And that's not all. Deep in the heart of every computer there is the "legendary" Central Processing Unit (CPU). Through it, everything could be reorganized with infinitely changing strategies. The drama comes from watching each line being drawn, each frame as a narrative assembly. No wonder I was transfixed by this kind of television.

Paradoxically, that experiencing of the code became instrumental in terminating my interest in the image as frame. Although the convenience of a frame is used to pass on an iconic shorthand, I finally realized that the radically *new* is not in the invention of a new image or even in a new set of syntactic devices as I had expected, but in the form of a gift offered to us by the machine: a new and undefined representation of space. . . .

There is no convincing or practical method to transpose the filmic world of light and shadow into the world of the computer. It is indeed this generic incompatibility, this artificial condition, that is the subject of my interest. I see film becoming a dysfunctional and alien element in the new digital space. The primary concept of the new space is expressed by the continuity necessary to represent multidimensional image/objects. Once constructed, the scene becomes a subject of recall, held indefinitely in the computer memory with all its previous conditions intact, including the continuity of all surfaces, equally significant and accessible from all directions. This is unlike film, where once the frame has been constructed and shot, space continuity is routinely discarded.

Furthermore, digital space has no generic method for looking at the world in the way that a camera does through its pinhole/lens apparatus. Digital space is constructed space, in which each component, aspect, concept, and surface must be defined mathematically. At the same time, the world inside a computer is but a model of reality as if seen through the eye of a synthetic camera, inseparable from the tradition of film. Yet, in this context, no viewpoint is ever discarded, the internal space is open to a continuous rearrangement, and access to a selection of views and narrative vectors is infinite, not only to the author, but also, with the use of certain strategies, to the viewer. Once the author constructs and organizes a digital space, the viewer can enter into a narrative relationship with it. A shot in film indicates a discrete viewpoint. Its narrative purpose is to eliminate other possible views. In contrast, the world in the computer contains the infinity of undivided space, undissected by the viewpoints of narrative progression. In the world of the machine, all sets of narrative vectors are offered in an equal, non-hierarchical way. The machine is indifferent to the psychological conditioning of a viewpoint. All coordinates of space are always present and available to the principles of selected observation.

The new space offered by the computer is a "noncentric" space with no coordinates. One must cross the threshold of the filmic or the electronic frame and fully enter this new space. As in the primordial forest, all directions are equally new, equally important and challenging. And in this forest, the event becomes the narrative drive. Is it the sign of danger that might have caught our attention? Is it the clue left by the predecessor on the forest floor? Is it the sound of the falling tree? Not all the events appeal just to our instincts. Inevitably we bring to the new space our cultural knowledge, our intellectual curiosity. Although the author will prescribe the event, more than ever we become partners in his play.

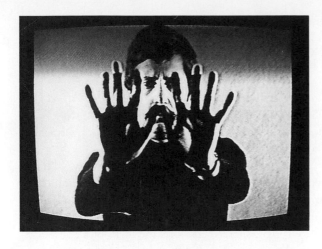

Douglas Davis, *Handing (The Austrian Tapes)*, 1974, live televised performance. By permission of the artist.

DOUGLAS DAVIS Manifesto (1974)

for mind
TO
against physical
 FORGET
against physical
 VIDEO
against physical
 IS
against against art
 TO
against keeping minds down
 MAKE
against counting measuring calculating edit *burn the manuals*
for living
 MIND AND BODY
for ascending thin subtle awful mysteri
 DISCARDING NAMES
looking fresh immediate
direct to mind to direct
STOP THE NAMES
The Camera is a Pencil
 a hand hold here

* Douglas Davis, "Manifesto," in *Douglas Davis: Events, Drawings, Objects, Videotapes, 1967–1972*, with essays by James Harithas, Nam June Paik, and David Ross (Syracuse, NY: Everson Museum of Art, 1974), n.p. By permission of the author and the publisher.

PETER D'AGOSTINO Proposal for QUBE (1980)

It's those blank TV and movie screens that interest me most. When they're turned off, there's never a trace—no evidence of what has transpired. Their effect on consciousness is only a matter of literary speculation.

Proposal for QUBE was presented as part of a series of one-person exhibitions, titled "Six in Ohio," at Ohio State University's Sullivant Gallery, October 20–November 11, 1978.

Designed as a video installation piece, the videotape incorporated in the work was scheduled to be cablecast on QUBE prior to the exhibition.

QUBE, as you may know by now, is the first commercial application of two-way "interactive" cable-TV technology. Located in Columbus, Ohio, home of the college football's Buckeyes and Woody Hayes, the team's former controversial coach, this city is also a major consumer test-market for products and surveys.

The "interactive" system available to QUBE subscribers takes the form of a console attached to the television set that enables the home viewer to "participate" in selected programs by pushing one of five "response" buttons. (In a recent program titled "How Do You Like Your Eggs?" the five buttons stood for scrambled, poached, sunny-side up, soft-boiled, and hard-boiled.) Once activated, the console feeds a central computer and the results of the home response are flashed on the screen. (Here forty-eight percent of the homes had pressed the scrambled button.) This is how viewers are "talking back to their television sets."

For my gallery exhibition, two cubicles were built: one, a viewing space for the continuous video playback. Adjacent to it was an exhibition space for two sets of panels displaying "Quotes to" and "Quotes from" QUBE.

The quotations "from QUBE" had appeared in the national press and were primarily responsible for generating a highly utopian attitude concerning "two-way" cable in Columbus; the quotations "to QUBE" were an attempt on my part to create a dialogue raising some of the obvious questions concerning this kind of system and its possible application.

Proposal for QUBE was conceived as a theoretical model of two-way communication based on a dialogue. The response mechanism in the form of the dialectic employed in "Quotes to" and "from" QUBE was extended into the content of the videotape and the method in which it was to be cablecast.

The tape contains five segments ranging from theoretical concerns to everyday events in the form of: *a text, a newspaper, a photograph, a film,* and *a video performance.* After sampling a portion of each of the five segments, the home audience would, by the consensus of their response, determine the sequencing of the tape and see the results of this process. (Five segments—1 through 5—would yield 120 possible variations for editing the final tape.) Aside from the apparent novelty of producing a videotape edited by a public opinion poll, I wanted to confront two central issues relative to communication and information systems—namely, feedback and ideology.

"Feedback," using Norbert Wiener's definition, is "a method of controlling a system by reinserting into it the results of its past performance," a learning process with the ability "to change the general method and pattern of performance." The present methods employed by QUBE limit feedback to the mere illusion of participation. As in McLuhan's *The Medium is the Message,* participation is defined solely by the formal properties of the medium—rather

* Peter d'Agostino, "Proposal for QUBE," *Video 80* 1, no. 1 (1980): 17; also in d'Agostino, *TeleGuide—Including Proposal for QUBE* (Dayton, 1980), 14, 15, 18. © 1980 Peter d'Agostino.

than its content: "The mosaic form of the TV image demands participation and involvement," while "Literacy in contrast conferred the power of detachment and non-involvement." Applying McLuhanesque jargon in statements such as "We are entering the era of participatory as opposed to passive television," QUBE seems to be presenting its unique apparatus—the computerized console—as its content. "What we have here is an electronic superhighway. You name it—we can do it."

A problem relative to this attitude is expressed in QUBE's policy towards public access: "Our local show in effect is public access, but we organize it." Redefining access in these terms, in fact, limits public participation.

This pre-packaging of media access provided by QUBE with its "newspeak" terminology such as "Qubit" and "Qubsumer" reminds me of a scenario from Ray Bradbury's novel *Fahrenheit 45* which concerns a futuristic two-way TV system:

"They mailed me my part this morning. I sent in some box-tops. They write the script with one part missing. It's a new idea."

"And then they go on with the play until he says, 'Do you agree to that, Helen?' and I say, 'I sure do!' Isn't that fun, Guy."

Don't send in any box-tops. Active participation is essential. However, each media or method has its own ideological implications. The apparatus itself creates the first level of meaning. Additional information like "Helen's response" can be virtually meaningless. Demystification is the first step. What is two-way cable TV? How is it being programmed? Although Proposal for QUBE was scheduled for cablecasting on October 13, 1978, it was canceled, I was told, due to "special programming" on the station. On November 22, after waiting a month, I sent a letter to QUBE requesting a new date for my program. As we approach the beginning of March, 1979, I'm still waiting for a "response."

Quotes from QUBE

" . . . the name QUBE doesn't stand for anything, but was chosen because it rhymes with 'tube' and because it suggests 'something that is distinctive and futuristic without being scary' "[†]

"We're bambambam. You jump around. You bounce. You play QUBE."[††]

Quotes to QUBE

"It is generally believed that modern communication systems must inevitably destroy all local cultures. This is because these systems have largely been used for the benefit of the center and not as two-way streets. Today, unchecked mass communication bullies and shouts humanity into silence and passivity. Artists everywhere are losing their local audiences, put out of countenance by the tireless electronic systems manipulated by the center."[†††]

[†] From a statement by QUBE president Lawrence B. Hilford in "Can't Stand the Show? TV Gadget Lets Viewers Rule," *Detroit Free Press,* December 1, 1977.

[††] From a statement by QUBE programming vice-president Harlan Kleiman in "Brave New World of Television," *New Times,* July 24, 1978.

[†††] Alan Lomax, "Appeal for Cultural Equity," *Journal of Communication* (Spring 1977).

Postscript

It's January, 1980. I'm sitting here in my studio in Yellow Springs, Ohio, looking into a gray winter sky and reflecting on my past experience with QUBE. Some things have changed since the preceding comments. QUBE has undergone some personnel changes, including a new program director. I also read of a recent collaborative project with WGBH, Boston, and of SoHo Television's four-week series of artists' programming on QUBE.

On the other hand, my "theoretical model" for two-way cable was expanded and later shown at the Long Beach Museum. My present concerns have shifted somewhat to certain practical aspects of two-way cable transmission. Additional research into the development of a "practical model" has led me to the following information regarding a community-based two-way cable system. The project was undertaken by New York University and three neighborhood communication centers (NCC) in Reading, Pennsylvania, with a grant from the National Science Foundation. Its premise was to "demonstrate the potential for communication technology to reinforce community consciousness." Components of the project included: two-way interactive capability, public initiated programs from neighborhood facilities, and an emphasis on serving distinct sub-groups within the population—in this case, senior citizens. After the initial experimental period, a non-profit corporation, Berks Community TV (BCTV), was formed to assume responsibility for the system. Reports indicate it is still operational and growing.

The Reading experiment is clearly a model for serving some important community needs. While at QUBE, can the recent attempts in experimental arts programming lead the way for more community involvement? Some serious questions remain.

> "We can be precise. The factors are
> in the animal and/or the machine the factors are
> communication and/or control both involve
> the message. And what is the message?"[1]

Stay tuned?

MARTHA ROSLER Video: Shedding the Utopian Moment (1985–86)

What we have come to know as *video art* experienced a utopian moment in its early period of development, encouraged by the events of the 1960s. Attention to the conduct of social life, including a questioning of its ultimate aims, had inevitable effects on intellectual and artistic pursuits. Communications and systems theories of art making, based partly on the visionary theories of Marshall McLuhan and Buckminster Fuller, as well as on the structuralism of Claude Lévi-Strauss—to mention only a few representative figures—displaced the expressive models of art that had held sway in the West since the early postwar period. Artists looked to a new shaping and interventionist self-image (if not a shamanistic-magical one), seeking yet

1. Charles Olson, "The Kingfishers."
* Martha Rosler, excerpts from "Video: Shedding the Utopian Moment," *Block* (Middlesex University) 11 (Winter 1985–86): 27–39; reprinted in Doug Hall and Sally Jo Fifer, eds., *Reading Video* (New York: Aperture, 1991), 30–58. By permission of the author and *Block*. An abbreviated version of this paper was first delivered at the Association of Art Historians Conference, City University, London, 1985.

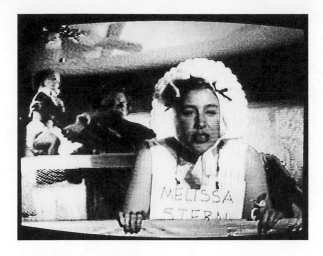

Martha Rosler, still from *Born to Be Sold: Martha Rosler Reads the Strange Case of Baby $/M,* 1988, color videotape produced by Martha Rosler and Paper Tiger Television. By permission of the artist.

another route to power for art, in counterpoint—whether discordant or harmonious—to the shaping power of the mass media over Western culture.

Regardless of the intentions (which were heterogeneous) of artists who turned to television technologies, especially the portable equipment introduced into North America in the late 1960s, these artists' use of the media necessarily occurred in relation to the parent technology: broadcast television and the structures of celebrity it locked into place. Many of these early users saw themselves as carrying out an act of profound social criticism, criticism specifically directed at the domination of groups and individuals epitomized by broadcast television and perhaps all of mainstream Western industrial and technological culture. This act of criticism was carried out itself through a technological medium, one whose potential for interactive and multi-sided communication ironically appeared boundless. Artists were responding not only to the positioning of the mass audience but also to the particular silencing or muting of *artists* as producers of living culture in the face of the vast mass-media industries: the culture industry versus the consciousness industry.

As a reflection of this second, perhaps more immediate motivation, the early uses of portable video technology represented a critique of the institutions of art in Western culture, regarded as another structure of domination. Thus, video posed a challenge to the sites of art production in society, to the forms and "channels" of delivery, and to the passivity of reception built into them. Not only a systemic but also a utopian critique was implicit in video's early use, for the effort was not to enter the system but to transform every aspect of it and— legacy of the revolutionary avant-garde project—to redefine the system out of existence by merging art with social life and making audience and producer interchangeable.

The attempt to use the premier vernacular and popular medium had several streams. The surrealist-inspired or -influenced effort meant to develop a new poetry from this everyday "language" of television, to insert aesthetic pleasure into a mass form and to provide the utopic glimpse afforded by "liberated" sensibilities. This was meant not merely as a hedonic-aesthetic respite from instrumental reality but as a liberatory maneuver. Another stream was more interested in information than in poetry, less interested in spiritual transcendence but equally or more interested in social transformation. Its political dimension was arguably more collective, less visionary, in its effort to open up a space in which the voices of the voiceless might be articulated.

That the first of these "streams" rested on the sensibility and positioning of the individual meant, of course, that the possibilities for the use of video as a theater of the self, as a narcissistic and *self*-referential medium, constantly presented themselves. And, indeed, the positioning of the individual and the world of the "private" over and against the "public" space of the mass is constantly in question in modern culture. Yet this emphasis on the experience and sensibilities of the individual, and therefore upon "expression" as emblematic of personal freedom and this as an end in itself, provided an opening for the assimilation of video—as "video art"—into existing art-world structures.

A main effort of the institutionalized art-delivery structures (museums, galleries, and so on) has been to tame video, ignoring or excising the element of implicit critique. As with earlier modern movements, video art has had to position itself in relation to "the machine"—to the apparatuses of technological society, in this case, electronic broadcasting. Yet the "museumization" of video has meant the consistent neglect by art-world writers and supporters of the relation between "video art" and broadcasting, in favor of a concentration on a distinctly modernist concern with the "essentials of the medium." This paper, in Part I, attempts to trace some basic threads of artists' reactions to nascent technological society and marketplace values in the nineteenth century using photography as the main example. The discussion invokes the dialectic of science and technology, on one side, and myth and magic, on the other. In considering the strategies of early twentieth-century avant-gardes with respect to the now well-entrenched technological-consumerist society, it asks the question: movement toward liberation or toward accommodation? Part II considers historiography and the interests of the sponsoring institutions, with video history in mind. Part III considers the role of myth in relation to technology, with a look at the shaping effects of the postwar U.S. avant-garde and Marshall McLuhan on the formation and reception of "video art" practices.

Part I: Prehistory

Video is new, a practice that depends on technologies of reproduction late on the scene. Still, "video art" has been, is being, forced into patterns laid down in the last century. In that century, science and the machine—that is, technology—began to appear as a means to the education of the new classes as well as to the rationalization of industrial and agricultural production, which had given impetus to their development. Although the engineering wonders of the age were proudly displayed in great exhibitions and fairs for all to admire, the consensus on the shaping effects that these forces, and their attendant values, had on society was by no means clear. Commentators of both Left and Right looked on the centrality of the machine as meaning the decline of cultural values in the West. Industrialization, technology's master, seemed to many to rend the social fabric, destroying rural life and traditional values of social cohesiveness and hard work that had heretofore given life meaning.

Central to the growing hegemony of the newly ascendant middle classes, bearers of materialist values and beneficiaries of these new social dislocations, were the media of communication—not excluding those physical means, such as the railroads, which welded communities together with bands of steel—and incidentally added to the repertoire of perceptual effects. Although the new mass press aided communication among classes and factions vying for social power, its overweening function was the continuous propagation of bourgeois ideology among members of the still-developing middle classes and, beyond them, to the rest of society. And it was this ideology that accorded science a central position. . . . This focus

on science and technology incorporated the implicit goals of conquest, mastery, and instrumentalism responsible for the degradation of work and the destruction of community.

The new technologies of reproduction, from the early nineteenth century on, were not segregated for the use or consumption of ruling elites but soon became embedded in cultural life. Perhaps the most public examples are the growth of the mass press, as previously noted, and the invention of photography, both before mid-century. The birth of the press in the previous century has been identified with the tremendous expansion of the public sphere, inhabited by the cultured, including the cultured bourgeois tradesman alongside the literate aristocrat. The growth of the mass press coincided with the pressure for broader democratic participation, to include the uncultured and unpropertied as well. The erosion of traditional authority, which had emanated from the aristocracy, helped bring the previous ruling ideologies into crisis.

Thus, conflict over cultural values and the machine stemmed from the aristocracy and from the newly proletarianized "masses" as well as from traditional craftspeople, tradespeople, and artists. Artists' revolts against the technologization and commodification of "culture" and its ghettoization as a private preserve of the ebullient middle classes took place in the context of the artists' own immersion in the same "free-market system" that characterized those classes. Thus, opposition to technological optimism was located in diverse social sectors, and for diverse reasons. Both cultural conservatives, such as John Ruskin, and political progressives, such as his former student William Morris, sought to find a synthesis of modern conditions and earlier social values. It might not be stretching a point too far to remark that the centrality of instrumental reason over intellectual (and spiritual) life is what motivated the search of these figures and others for countervailing values. The romantic movement, in both its backward-looking and forward-looking aspects, incorporates this perspective. . . . To some the political struggles of the day, the growth of turbulent metropolises housing the ever-burgeoning working classes, and the attendant depletion of rural life were the worst aspects of nineteenth century society. To others, like Morris, the worst aspect was the situation of those new classes, their immiseration of material and cultural life, and its deleterious effect on all of society, which he came to see as a matter of political power. Technological pessimism and an attempt to create a new "humanist" anti-technological culture marked the efforts of these latter critics.

The American history of responses to technology differs, if only at first. Initially mistrustful of technology, American thinkers by mid-century looked to technological innovation to improve the labor process and develop American industry, while safeguarding the moral development of women and children. The American transcendentalist poet and minister Ralph Waldo Emerson was initially one of the supreme optimists, but even he had turned pessimist by the 1860s.

Despite the doubts, stresses, and strains, there was, of course, no turning back. In cultural circles even those most suspicious of technological optimism and machine-age values incorporated a response to—and often some acceptance of—science and the technologies of mass reproduction in their work. The impressionist painters, for example, placed optical theories drawn from scientific and technical endeavors (such as the weaving of tapestries) at the center of their work, while keeping photography at bay by emphasizing color. They also turned away from the visible traces of industrialism on the landscape, in a nostalgic pastoralism. Photography itself quickly forced the other visual (and poetic!) practices to take account of it, but strove in its aesthetic practices to ape the traditional arts. . . .

It is worth noting that the person who introduced photography to America not only was

a painter but also was the inventor of the telegraph, Samuel F. B. Morse, who received the photographic processes from Daguerre himself. While they chatted in Morse's Paris lodgings, Daguerre's diorama theater, based on the protofilmic illusions of backdrops, scrims, and variable lighting, burned to the ground. This is the stuff of myth. Despite their conjuncture in Morse's person, it took close to one hundred years to get the technologies of sound and image reproduction together.

The subsequent history of Western high culture, which eventually included American high culture as well, included efforts to adapt to, subsume, and resist the new technologies. Although artists had had a history of alliance with science since the Enlightenment (and despite their market positioning vis-à-vis the middle classes, as previously described), even such technologically invested artists as the impressionists, and even photographers, were likely to challenge the authority of scientists often by stressing magic, poetry, incommensurability. . . .

So far I have cast photography in the role of rational and rationalizing handmaiden of bourgeois technological domination. There is another side to it. By the turn of the twentieth century, photography was well established as a rational and representational form, not only of private life and public spectacle of every type, but as implicated in official and unofficial technologies of social control: police photography, anthropometry, urban documentation, and time-and-motion study, for example. Photographs were commodities available to the millions by the millions. But, as previously noted, aesthetic practice in photography was interested in the model provided by the other arts. European aesthetic photography after the middle of the nineteenth century was associated both with the self-image of the intellectual and social elite (through the work of Julia Margaret Cameron) and with an appreciation of the premises of painterly Realism, though in coolly distanced form (P. H. Emerson). . . .

The photographic example provides an insight into the choices and silences of aestheticism with respect to technology. In addition to the use of a camera—a still-confusing mechanical intrusion—this new art photography depended for its influence on the latest technologies of mass reproduction. In Stieglitz's publication *Camera Work,* which helped create a nationwide, or worldwide, art-photography canon, current and historical photographs appeared as gravures and halftones, the products of processes only recently developed for the mass press. Thus, an art apparently hostile and antithetical to mass culture, preserving craft values and arguing against "labor consciousness," in fact depended on its technologies: a seeming paradox worth keeping in mind. The camera and print technologies were perceived as neutral, tool-like machines to be subsumed under the superior understandings of an aesthetic elite. The aesthetic sensibility was an alchemical crucible that effected a magical transformation.

Still, by 1916 Stieglitz had so thoroughly acceded to the photographic modernism of Paul Strand that he devoted the last two issues of the moribund *Camera Work,* specially resurrected for this purpose, to his work. . . . Photography was, for [Strand and others,] mediation *toward,* not away from, social meaning. For others, of course, photographic modernism meant a new abstract formalism or, through the rapid growth of product photography, a corporate symbolism of commodities.

Thus, photographic modernism accepted science and rationality but also allowed for an updated symbolism of the object in a commodified world, a transformation that advertising made into its credo. Whereas photographic pictorialism had suggested a predictable alliance of aestheticism and elitism as a noble bulwark against the monetary measure of the marketplace and sold proletarian labor, formalist modernism united the high arts with the mass culture of modern entertainment forms and commodity culture. Modernism, in Kantian fashion, favored

the material artwork while remaining vague about the meaning it was supposed to produce. Formalist ideologies were furthered by such Bauhaus figures as László Moholy-Nagy, who propagated a scientific vocabulary of research and development, therapeutic pedagogy, and experimentation. In art and architecture, formalist modernism promised a healthier, more efficient and adaptive—and liberatory—way of life, for all classes. The possibly revolutionary intent, to pave the way for democratic participation, could quickly turn into accommodation to new—technocratic—elites.

It has been observed that postwar American modernism, despite its strict separation of the arts from each other as well as from the social world, and with its fetishization of materials, nevertheless institutionalized the avant-garde. . . .

Art discourse made updated use of the dialectic of scientific experimentation on technique and magical transformation through aestheticism and primitivism, veering toward an avant-garde of technical expertise.

This hegemonic condition lasted about as long as "the American century" it seemed to accompany—that is, until the new decade of the 1960s. The rapid growth of television and the cybernetic technologies, which had gotten a big boost from the war and American militarization, hastened the crisis. Television had no difficulty building on the structure and format of radio, with pictures added. Radio had established itself in a manner like that of the mass press and photography in the previous century and had played a vital role in disseminating the new ideologies of consumerism, Americanism, and the State. Like photography, radio depended on action at a distance, but with the added fact of simultaneity. It appeared to be a gift, free as air. The only direct sales came through hardware—which took on the fanciful forms of furniture, skyscraping architecture, cathedrals, and the hearth, the mantelpiece, and the piano, all in one, with echoes of the steamship. Bought time appeared as free time, and absence appeared as presence. Radio had the legitimacy of science (and nature) and the fascination of magic.

Television was able to incorporate into this all the accommodations of photography and film, though in degraded form. As with advertising, the all-important text was held together with images of the object world, plus the spectacle of the State and the chaos of the street, and voyeuristic intrusions into the private lives of the high and the low, the celebrity and the anonymous. Television was like an animated mass magazine and more. As commentators from Dwight Macdonald and Marshall McLuhan to Guy Debord and Jean Baudrillard have observed, the totalizing, ever-whirling and -spinning microcosm of television supplanted the more ambiguous experience of the real world. . . .

The "antihegemonic" 1960s also brought a different relation to issues of power and freedom, more populist than avant-gardist, more political than aestheticist. Students rebelled against the construction of what Marcuse termed one-dimensional culture and its mass subject, while the politically excluded struggled against the conditions and groups enforcing their powerlessness. The iron hand of science and technology became a focus of agitation, particularly in relation to militarism and the threat of total war. The twin critique of technological and political domination helped beget a communitarian, utopic, populist, irrationalist, anti-urban, anti-industrial, anti-elitist, anti-intellectual, antimilitarist, communitarian counterculture, centered on youth. Hedonic, progressive, rationalist, antisexist, anti-racist, anti-imperialist, and ecological strains also appeared. The severe stress on the reigning ideologies also put models of high culture in doubt, not least among its own younger practitioners.

Artists looked to science, social science, and cultural theory—anywhere but to dealers, critics, or aesthetics—for leads. New forms attacked head-on the commodity status of art.

"Objecthood" was an issue not only because art objects were commodities but because they seemed insignificant and inert next to the electronic and mass-produced offerings of the mass media.

Part II: History

At last, video. This is well-worked territory. In fact, video's past is the ground not so much of history as of myth. We could all recite together like a litany the "facts" underlying the development of video art. Some look to the substantive use of a television set or sets in altered or damaged form in art settings in the late 1950s or early 1960s. Others prefer the sudden availability of the Sony Portapak in the mid-1960s, or the push supplied by Rockefeller capital to artists' use of this new scaled-down technology. But the consensus appears to be that there is a history of video to be written—and soon. I would like to consider the nature of such histories, and their possible significance for us.

Historical accounts are intent on establishing the legitimacy of a claim to public history. Such a history would follow a pattern of a quasi-interpretive account of a broad trend activated by significant occurrences, which, on the one side, are brought about by powerful figures and, on the other side, determine or affect what follows. Video's history is not to be a *social* history but an *art* history, one related to, but separate from, that of the other forms of art. Video, in addition, wants to be a major, not a minor, art.

Why histories now? Is it just time, or are the guardians of video reading the graffiti on the gallery wall, which proclaim the death or demotion of photographic media? (Like those of color photos, video's keeping, archival, qualities seem dismal, and the two are liable to vanish together without a trace.) If video loses credibility, it might collapse as a curated field. Or perhaps the growth of home video and music television has made the construction of a codified chain of *art*-video causation and influence interesting and imperative.

Some fear that if histories are written by others, important issues and events will be left out. Others realize the importance of a history in keeping money flowing in. The naturalization of video in mass culture puts the pressure on to produce a history of "art video," or "video art," that belongs in the art world and that was authored by people with definable styles and intentions, all recognizable in relation to the principles of construction of the other modern art histories. . . .

It is the self-imposed mission of the art world to tie video into its boundaries and cut out more than passing reference to film, photography, and broadcast television, as the art world's competition, and to quash questions of reception, praxis, and meaning in favor of the ordinary questions of originality and "touch." . . .

Video histories are now produced not by or for scholars but for potential funders, for the museum-going public, and for others professionally involved in the field, as well as to form the basis for collections and shows. The history of video becomes a pop history, a pantheon, a chronicle. Most important, the history becomes an *incorporative* rather than a transgressive one. And the names populating the slots for the early years are likely to be those of artists known for earlier work not in video or those of people who remained in the system, producing museumable work over a period of years or at the present. And, of course, they are likely to be New Yorkers, not Detroiters, or even Angelenos or San Franciscans, not to mention San Diegans. Some histories do recognize the contribution of Europeans—perhaps mostly those histories produced in Europe—or Canadians or even Japanese, always assuming they have entered the Western art world. Finally, the genres of production are likely to fit those

of film and sculpture. Codification belies open-endedness and experimentation, creating reified forms where they were not, perhaps, intended. This even happens when the intent of the history is to preserve the record of open-endedness. And so forth.

Thus, museumization—which some might point to as the best hope of video at present for it to retain its relative autonomy from the marketplace—contains and minimizes the *social negativity* that was the matrix for the early uses of video.

Part III: Myth

At the head of virtually every video history is the name Nam June Paik. . . . The myths of Paik suggest that he had laid all the groundwork, touched every base, in freeing *video* from the domination of corporate TV, and *video* can now go on to other things. Paik also frees video history from boring complexity but allows for a less ordered present. By putting the prophet at the front, we need not squabble over doctrine now, nor anoint another towering figure, since the video-art industry still needs lots and lots of new and different production. . . .

The elements of the myth . . . include an Eastern visitor from a country ravaged by war (our war) who was inoculated by the leading U.S. avant-garde master while in technology heaven (Germany), who once in the States repeatedly violated the central shrine, TV, and then went to face the representative of God on earth, capturing his image to bring to the avant-garde, and who then went out from it to pull together the two ends of the American cultural spectrum by symbolically incorporating the consciousness industry into the methods and ideas of the cultural apparatus—always with foundation, government, museum, broadcast, and other institutional support.

And—oh yes!—he is a man. The hero stands up for masculine mastery and bows to patriarchy, if only in representation. The thread of his work includes the fetishization of a female body as an instrument that plays itself, and the complementary thread of homage to other famous male artist-magicians or seers (quintessentially, Cage).

The mythic figure Paik has done all the bad and disrespectful things to television that the art world's collective imaginary might wish to do. He has mutilated, defiled, and fetishized the TV set, reduplicated it, symbolically defecated on it by filling it with dirt, confronted its time boundedness and thoughtlessness by putting it in proximity with eternal Mind in the form of the Buddha, in proximity with natural time by growing plants in it, and in proximity with architecture and interior design by making it an element of furniture, and finally turned its signal into colorful and musical noise.

Paik's interference with TV's inviolability, its air of nonmateriality, overwhelmed its single-minded instrumentality with an antic "creativity." Paik imported TV into art-world culture, identifying it as an element of daily life susceptible to symbolic, anti-aesthetic aestheticism, what Allan Kaprow called "anti-art art." . . . Paik's works formalize the TV signal and replicate viewer passivity, replacing messages of the State and the marketplace with aestheticized entertainment. . . . He neither analyzed TV messages, nor provided a counterdiscourse based on rational exchange, nor made its technology available to others. He gave us an upscale symphony of the most pervasive cultural entity of everyday life, without giving us any conceptual or other means of coming to grips with it in anything other than a symbolically displaced form. Paik's playful poetry pins the person in place.

The *figure* of Paik in these mythic histories combines the now-familiar antinomies, magic and science, that help reinforce and perpetuate rather than effectively challenge the dominant social discourse. Why is this important? The historical avant-garde has shown a deep am-

bivalence toward the social power of science and technology. Surrealism and dada attempted to counter and destroy the institutionalization of art in machine society, to merge it with everyday life and transform both through liberation of the senses, unfreezing the power of dissent and revolt. Although this attempt certainly failed, subsequent avant-gardes, including those that begin to use or address television technology, had similar aims.

Herbert Marcuse spelled this out back in 1937 in his essay "The Affirmative Character of Culture." Marcuse traces the use of "culture" by dominant elites to divert people's attention from collective struggles to change human life and toward individualized effort to cultivate the soul like a garden, with the reward being pie in the sky by and by—or, more contemporaneously, "personal growth." Succinctly put, Marcuse shows the idea of culture in the West to be the defusing of social activity and the enforcement of passive acceptance. In the Western tradition, form was identified as the means to actually affect an audience.

I would like to take a brief look at a sector of the U.S. avant-garde and the attempt to contain the damage perceived to have been wrought on the cultural apparatuses by the mass media. Consider the notable influence of John Cage and the Black Mountaineers, which has deeply marked all the arts. Cage and company taught a quietist attention to the vernacular of everyday life, an attention to perception and sensibility that was inclusive rather than exclusive but that made a radical closure when it came to divining the causes of what entered the perceptual field. This outlook bears some resemblance to American turn-of-the-century antimodernism, such as the U.S. version of the arts and crafts movement, which stressed the therapeutic and spiritual importance of aesthetic experience.

Cage's mid-1950s version, like Minor White's in photography, was marked by Eastern-derived mysticism; in Cage's case the antirational, anticausative Zen Buddhism, which relied on sudden epiphany to provide instantaneous transcendence; transport from the stubbornly mundane to the Sublime. Such an experience could be prepared for through the creation of a sensory ground, to be met with a meditative receptiveness, but could not be translated into symbolic discourse. Cagean tactics relied on avant-garde shock, in always operating counter to received procedures or outside the bounds of a normative closure. Like playing the strings of the piano rather than the keys or concentrating on the tuning before a concert—or making a TV set into a musical instrument. As Kaprow complained, this idea was so powerful that soon "non-art was more Art than Art-art." Meaning that this supposedly challenging counterartistic practice, this anti-aesthetic, this noninstitutionalizable form of "perceptual consciousness," was quickly and oppressively institutionalized, gobbled up by the ravenous institutions of official art (Art).

Many of the early users of video had similar strategies and similar outlooks. A number (Paik among them) have referred to the use of video as being against television. It was a counterpractice, making gestures and inroads against Big Brother. They decried the idea of making art—Douglas Davis called *video art* "that loathsome term." The scientist modernist term *experimentation* was to be understood in the context of the 1960s as an angry and political response. For others, the currency of theories of information in the art world and in cultural criticism made the rethinking of the video apparatus as a means for the multiple transmission of useful, socially empowering information rather than the individualized reception of disempowering ideology or subideology a vital necessity.

Enter McLuhan. McLuhan began with a decided bias in favor of traditional literacy—reading—but shifted his approval to television. With a peremptory aphoristic style McLuhan simplified history to a succession of Technological First Causes. Many artists liked this because it was simple, and because it was formal. They loved the phrase "The medium is the message"

and loved McLuhan's identification of the artist as "the antenna of the race." McLuhan offered the counterculture the imaginary power of overcoming through understanding. Communitarians, both countercultural and leftist, were taken with another epithet, "the global village," and the valorization of preliterate culture. The idea of simultaneity and a return to an Eden of sensory immediacy gave hippies and critics of the alienated and repressed one-dimensionality of industrial society a rosy psychedelic wet dream. . . .

McLuhan wrote that art's function is "to make tangible and to subject to scrutiny the nameless psychic dimensions of new experience" and noted that, as much as science, art is "a laboratory means of investigation." He called art "an early warning system" and "radar feedback" meant not to enable us to change but rather to maintain an even course. Note the military talk. Art is to assist in our accommodation to the effects of a technology whose very appearance in world history creates it as a force above the humans who brought it into being.

McLuhan gave artists a mythic power in relation to form that fulfilled their impotent fantasies of conquering or neutralizing the mass media. By accepting rather than analyzing their power, by tracing their effects to physiology and biology rather than to social forces, artists could apply an old and familiar formula in new and exciting ways. The old formula involved the relation of the formalist avant-garde to the phenomena of everyday life and culture.

I do not intend to trace the actual effects of McLuhanism on video art, for I believe that artists, like other people, take what they need from the discourse around them and make of it what they can. Many progressive and anti-accommodationist producers were spurred by the catch phrases and rumors of McLuhanism to try new ways to work with media, especially outside the gallery. Clearly, though, McLuhanism, like other familiar theories, offered artists a chance to shine in the reflected glory of the prepotent media and cash in on their power over others through formalized mimetic aestheticization.

Conclusion

Some new histories of video have taken up this formalized approach and have portrayed artists in the act of objectifying their element, as though tinkering could provide a way out of the power relations structured into the apparatus. Reinforcing the formalist approach has brought them—inadvertently—to bow, as McLuhan had done, to the power of these media over everyday life. In separating out something called video art from the other ways that people, including artists, are attempting to work with video technologies, they have tacitly accepted the idea that the transformations of art are formal, cognitive, and perceptual. At the very least, this promotes a mystified relation to the question of how the means of production are structured, organized, legitimated, and controlled, for the domestic market and the international one as well.

Video, it has been noted, is an art in which it is harder than usual to make money. Museums and granting agencies protect video from the marketplace, as I remarked earlier, but they exact a stiff price. Arts that are marginally salable have shrunken or absent critical apparatuses, and video is not an exception. Video reviewing has been sparse and lackluster in major publications. This leaves the theorizing to people with other vested interests. In the absence of such critical supports, museumization must involve the truncation of both practice and discourse to the pattern most familiar and most palatable to those notoriously conservative museum boards and funders—even when the institutions actually show work that goes beyond such a narrow compass.

To recapitulate, these histories seem to rely on *encompassable* (pseudo-) transgressions of the institutions of both television and the museum, formalist rearrangements of what are uncritically called the "capabilities" of the medium, as though these were God-given, a technocratic scientism that replaces considerations of human use and social reception with highly abstracted discussions of time, space, cybernetic circuitry, and physiology; that is, a vocabulary straight out of old-fashioned discredited formalist modernism.

Museumization has heightened the importance of installations that make video into sculpture, painting, or still life, because installations can live only in museums—which display a modern high-tech expansiveness in their acceptance of mountains of obedient and glamorous hardware. Curatorial frameworks also like to differentiate genres, so that video has been forced into those old familiar forms: documentary, personal, travelogue, abstract-formal, image-processed—and now those horrors, dance and landscape (and music) video. And, of these, only the brave curator will show documentary regularly. Even interactive systems, a regular transgressive form of the early 1970s, appear far less often now.

Perhaps the hardest consequence of museumization is the "professionalization" of the field, with its inevitable worship of what are called "production values." These are nothing more than a set of stylistic changes rung on the givens of commercial broadcast television, at best the objective correlatives of the electronic universe. Nothing could better suit the consciousness industry than to have artists playing about its edges embroidering its forms and quite literally developing new strategies for ads and graphics. The trouble is, "production values" mean the expenditure of huge amounts of money on production and postproduction. And the costs of computerized video editing, quickly becoming the standard in video-art circles, surpass those of (personal) film editing in factors of ten.

Some of the most earnest producers of art videotapes imagine that condensation of the formal effects of this kindly technology will expose the manipulative intent of television. The history of the avant-gardes and their failure to make inroads into the power of either art institutions or the advancing technologies through these means suggests that these efforts cannot succeed. . . .

As Alvin Gouldner has suggested in *The Dialectic of Ideology and Technology* (New York: Oxford University Press, 1976, p. 7), "The very political impotence and isolation of the cadres of the cultural apparatus grounds their pessimism in their own everyday life, while the technicians of the consciousness industry are surrounded by and have use of the most powerful, advanced, and expensive communications hardware, which is the everyday grounding of their own technological optimism."

We may infer that American video artists' current craze for super high-tech production is a matter of envy. It would be a pity if the institutionalization of video art gave unwarranted impetus to artists' desires to conquer their pessimism by decking themselves out in these powerful and positivist technologies.

On the other hand, as the examination of the Paik myth suggests, it would be equally mistaken to think that the best path of transgression is the destruction of the TV as a material object, the deflection of its signal, or other acts of the holy fool. The power of television relies on its ability to corner the market on messages, interesting messages, boring messages, instantly and endlessly repeating images. Surely we can offer an array of more socially invested, socially productive counterpractices, ones making a virtue of their person-centeredness, origination with persons—rather than from industries or institutions. These, of course, will have to live more outside museums than in them. But it would be foolish to yield the territory of the museum, the easiest place to reach other producers and to challenge the impotence imposed

by art's central institutions. Obviously the issue at hand as always is who controls the means of communication in the modern world and what are to be the forms of discourse countenanced and created.

GARY HILL Inter-View (1992)

I first used video in 1973. At the time I was doing a lot of sound work with sculpture. I worked almost exclusively with steel welding rods which by chance had rich sonic possibilities. This got me into tape recorders and tape loops, feedback, and ultimately electronically generated sound. I did some recording with a portapak and the fluidity of videotape freed up my thinking in a very radical way. Suddenly, the sculpture I had been doing for several years seemed overwhelmingly tedious and distant from this present-tense process. Video allowed a kind of real-time play, the possibility to "think out loud." Here was a process immediately accessible and seemingly a much closer parallel to thinking.

Within contemporary art what would you say is the primary difference between video and other mediums, particularly in the context of conceptual art and related practices?

Time, this is what is central to video, it is not seeing as its etymological roots imply. Video's intrinsic principle is feedback. So it's not linear time but a movement that is bound up in thinking—a topology of time that is accessible. This experience of time exists within specific electronic parameters that, to the eye, is a rectangular screen but which is very distant from a cybernetic process that includes oneself. I think this paradox of being intimate with time and estranged from it is what brought me to speech and specifically speech rather than some form of written text on the screen. Vocalization was a way to physically mark the time with the body through utterance—the speaking voice acting as a kind of motor generating images. This really puts one inside the time of speaking. Every syllable is tied to an image; suddenly words seemed quite spatial and the viewer becomes conscious of a single word's time. . . .

. . . Comparably speaking, your work, at least from the outside, changes fairly dramatically over short periods of time. Is there an identifiable thread here?

I would say that the commonality is linked to getting at the physicality of language and in breaking those categories down. I suppose I share some concerns with the language poets, but on the other hand I generally start a little closer to the norms of "meaning" and proceed to look for the cracks. I want to suspend the either/or relation of sense and nonsense; see what happens inside the experience of language, as meaning is taking root or being uprooted, as the case may be. My questioning lies more in what the nature of language is as it moves among sound, linguistics, and literature. The composer La Monte Young speaks of getting inside the sound; that tuning is ultimately a function of time (very long times). He seems to be saying that music/sound is not a dead object in the air but rather vibrations moving through the air and that one must continually listen and tune. It's interesting to think about an analogous relationship with language; as a processual continuum that "tunes" the world. . . .

Except for perhaps *Incidence of Catastrophe,* where even the flirtation with traditional narrative is highly self-conscious, I am working within a different domain of narrative having

* Gary Hill, excerpts from "Inter-View" (interviews with the Centre Georges Pompidou, Paris, 1992, rewritten by Gary Hill), in Robert C. Morgan, ed., *Gary Hill* (Baltimore: Johns Hopkins University Press, 2000), 290–98. By permission of the author and Carol Mann Literary Agency.

more to do with a kind of meta narrative; the works evolve from a self-reflexive practice that includes me as author/performer in the mise-en-scène. Rather than characters and locations, whether or not they exist literally, my subjects are more akin to entropy, memory, consciousness, and death. This other narrative brings about a web of interrelated questions which again I feel are strongly embedded in time. Once a word is spoken or a word is read (or an image is "read") time becomes an element in which the viewer "narrates" experience. Even cognition becomes part of the narrative scheme. . . .

. . . *What about installations? Both* DISTURBANCE *and* Between Cinema *seem intrinsically narrative.* . . .

Obviously these works are very much embedded in narrative space but it is always in relationship to a specific self-referential structure. Once again time and metaphorical spaces for texts to unfold are the parameters I begin with. In DISTURBANCE people are moving through a kind of broken sentence seen as seven monitors as they recite fragments of texts. There's a continuous weave and unraveling of different languages, people, questions, and inquiry; it is layered almost like a stratum; the point of view is constantly shifting. *Between Cinema and a Hard Place* plays with the construct of frames as it relates to photography and cinema. Images from single sources are distributed by computer-controlled electronic switching to several monitors. There are certain sections where scenes divide into two scenes, three scenes, and so on. With each division all the scenes slow down—half speed, third speed, quarter speed, etc. It is a kind telescopic time that makes the viewer aware of the process of seeing—of beholding the world through sight that exists in the folds of time. Images of the landscape and domesticity are precisely structured spatially and temporally juxtaposing with Heidegger's text, which speaks about a neighboring nearness between thought and poetry and differentiates this from parametric notions of time and space, using nature as a metaphorical referent for the place of thought. . . .

I think the most difficult aspect of using video in an installation is decentralizing the focus on the television object itself and its never-ending image. How does one get away from that everyday seduction of the continuous flow of images couched as information? I tried to do this in different ways. For instance, in BEACON the television object disappears completely and is seen as the dual beacon of a lighthouse. Light as source and image as source become interchangeable. Not only has the television been physically removed from its frame of reference, but the object producing the image is a metaphor turned on itself conversing with its own image. In *And Sat Down Beside Her,* the television is seen as a spider and in *I Believe It Is an Image in Light of the Other* the display has been incorporated into a canister—something like an oxygen bottle perhaps. We only see projected images in which the borders are defined by open books. . . .

Your recent installations differ radically in their outward appearance and yet one is aware of a conceptual thread, or at least an interconnectedness of divergent ideas and, cautiously I might add, systems that embody your thinking.

For the most part my recent work has developed around two strategies. *And Sat Down Beside Her,* BEACON, *I Believe,* and most recently, *Tall Ships* came about in varying ways from the notion of this diffused image I spoke of earlier. It has to do with making something that is already immaterial lose its identity even further; watch it sprawl over things and dissipate into the space. In *Tall Ships* this is brought to the extreme where, in a darkened 90-foot corridor the only things seen are "projected" figures that at once are images of reality (people) and the only source of illumination for the passer-by. Light, image, and representation become

a singular ontological presence that confronts the viewer. This is all the more amplified since the figures' movements are interactive with the presence or absence of viewers. . . .

The title comes from seeing an old photograph taken in Seattle around 1930. The last tall ship is being moved out of Lake Union before the final section of the Aurora Bridge is put into place. I imagined a sailing ship on the high seas—that frontal view of extreme verticality coming toward you. It has a kind of majestic buoyancy of something very sure of itself—something that will come forth with a kind of terrifying grace no matter what. It's dark, it's very dark but you can see clearly this beautiful thing cutting through the night—a night that isn't referenced by day. To think of a person like this—the human approaching—the notion of ships passing in the night took on a certain poetic space that felt very open. I don't think I was really clear about the piece until I had this title. I wanted the whole situation to be as unassuming as possible. All the people are family or friends or family and friends of friends. From the time of conceiving the piece to actual production, I simplified the movement of the people to only coming forward and then returning to a particular place and position of either standing or sitting. There are a few interruptions to that, for instance, after coming half way forward they would pause and go back or they would come back a second time after beginning to return. I gave very little instruction during the recordings. I only wanted their time up front but I wanted the time spent there to really open up. I left them kind of hanging there considerably longer than I told them it might be. I didn't want any theater or aesthetic. And in terms of the piece as a whole I wanted to avoid it being an experience with technology or anything having to do with a multicultural agenda. It's simply the idea of a person coming up to you and asking, "Who are you?" by kind of mirroring you and at the same time illuminating a space of possibility for that very question to arise. Basically, I wanted to create an open experience that was deliberate and at the same time would disarm whatever particular constructs one might arrive with, especially in a museum.

BILL VIOLA Video Black—The Mortality of the Image (1990)

Somewhere there is a video camera that has not been shut off for the last twenty years. Its rigid, unblinking eye has tirelessly been scanning a parking lot someplace, silent witness to all the comings and goings of the past two decades. It has seen the same man get out of his car each morning, his body gradually sagging, less resistant to gravity, as his gait imperceptibly slows over the intervening time. It has seen the unbroken procession of days and nights, the cyclic changes in the sun and moon, the growth of trees, and the perpetual variations of weather with the accumulation of its harsh marks. It has seen the parade of fashion in car design and clothing, and witnessed the evidences of human intentions and impulses in the sudden material alterations of the physical landscape.

However, this perpetual observer has no stories to tell, no store of wisdom, no knowledge of the grand patterns. Locked within a great immutable Now, it has no sense of past or future. Without a memory to give it a life, events flicker across its image surface with only a split second to linger as afterimages, disappearing forever without a trace. Today it will be shut off, the world abruptly ending in an arbitrary cutoff point as all endings are, and a new model

* Bill Viola, excerpts from "Video Black—The Mortality of the Image," in Doug Hall and Sally Jo Fifer, eds., *Illuminating Video: An Essential Guide to Video Art* (New York: Aperture with Bay Area Video Coalition, 1990), 477–86. © Bill Viola.

camera installed. In another society, this camera, with its accumulated existence, would be graduated to an object of power to be venerated and reciprocated. In the least, the tubes of old cameras such as this should be installed in a shrine with the hope that someday some future technology could coax from their surface the subtle residue of a lifetime's experience. Today's event will pass with barely a notice.

The concept that objects can acquire power, that a human being's inner thoughts and impulses can have a residual effect on the outer physical world, is of archaic origin. Reflecting a time when the material elements of nature were effused with Mind or spirit, this timeless world view is confined today to vague subjective sensations, often described as emotional, of empathy and the awareness of a "larger-than-me" order that often mark encounters with the remnants of the natural landscape. The evolution in cultural memory (history) of the assumed location of the artificial image describes a progressive emergence from within the heart and mind of the individual outward to its current residence as a depiction of the external world.

Sacred art in the Western tradition evokes images of the gold-leafed painted panels of the Middle Ages, a time when Asian and European art shared a common ground. One of the most striking things about medieval religious art is that the landscape (for us the *materia prima;* the physical, hard, "real" stuff of the world) appears as an insignificant element, a backdrop subordinate to the religious vision or epiphany. Space is a radiant gold and is substantially less real than the spiritual reality (scene or events) depicted. From our point of view, the inner and outer worlds have reversed their roles.

Paramount to the notion of the image as sacred object is the icon, a form found in both oriental and occidental traditions. The term *icon* (ancient Greek for "image") as it is usually understood refers more to a process or a condition rather than to any physical characteristics of an object. An icon can be any image that has acquired power through its use as an object of worship. In fact, the status of icon was the goal and even the measure of success of the majority of visual artworks created in the great religious traditions of ancient Christianity, Buddhism, and Hinduism. The presence of art critics was not required since devotees knew immediately at first glance whether the work in question qualified. The artists created their works for God, not for the art world, and therefore the work had to be exceptional and as close to perfect as possible, their personal devotion and insight being the main criterion and primary evidence of quality in the finished work.

Icons are timeless images, and in the West even though they often do depict a temporal event (the Annunciation, the Flight Out of Egypt, etc.) the mythic/religious existence of those events (i.e., their present tense) is far more important. Icons maintain their currency by being continually updated to the present, by sustaining a constant relevance to Now. They are necessarily functional objects, their function fulfilling a most basic primary and private need within the individual.

Images become icons either through content alone, i.e., images that were commissioned to perform such roles or, more importantly, through the cumulative power of use, itself a reaffirmation of an image's intrinsic power. It is as if the continuous act of worship/veneration leaves a residue that builds up over the years. This aspect of the Christian icon is an echo of the animistic world view of older tribal, "pagan" societies. No wonder such a strong backlash was unleashed in the home of the classical Christian icon, the Eastern church of the Byzantine empire. There in the eighth century, the so-called iconoclasts declared such practices pagan, initiating a conflict lasting more than a hundred years. Icon worship was finally restored by imperial decree.

Unlike the consumption-oriented mass media images of contemporary culture, icons maintain their relevance by remaining the same for centuries. Giving form to eternal realities, their affinity is toward the eternal themselves. . . .

One day in 1425, Filippo Brunelleschi walked out onto the Piazza del Duomo in Florence, and standing at the main doors to the cathedral, facing the baptistry across the piazza, he set up a small wooden box on a stand. He had invited various influential friends and *cognoscenti* to witness his experiment. One by one they stepped up to this curious device and closed one eye to stare through a small hole in one side.

To a twentieth-century observer, the only interpretation of this scene could be that of a photographer demonstrating a new camera, and by expanding the definition of photography perhaps more than is acceptable, Brunelleschi's box could be considered a crude camera. For a citizen of fifteenth-century Florence, the effects of looking into this device were as mind-boggling and astounding as if seeing an actual camera for the first time. Peering into the small hole, they first saw the direct monocular view of the baptistry across the way. Then, by the flip of a lever, a mirror was moved into position and a small painting of the baptistry appeared, exactly in line and proportional to the direct view. In fact, in regards to geometry and form, the two were barely distinguishable. Brunelleschi had made a sharp right-hand turn out of the Middle Ages. . . . What Brunelleschi achieved was the personification of the image, the creation of a "point of view" and its identification with a place in real space. In doing so, he elevated the position of the individual viewer to an integral part of the picture by encoding this presence as the inverse, *in absentia,* source of the converging perspectival lines. The picture became an opaque mirror for the viewer, and the viewer, in turn, became the embodiment of the painter, "completing the picture" as art historians like to say, with the two points of view merging in a single physical spot. The painter now says when he or she paints, "See things as I see them. . . . Stand in my shoes. . . . " Consequently, the picture plane and the retina became the same surface. Of course, Whose retina? was the key question as the manipulation of the viewer, an early form of behaviorism, was added to the list of artistic techniques.

In the dialogue between viewer and image, there were now three entities created, where formerly there were two, or possibly even one. Since previously most images were diagrammatic and/or emblematic representations (i.e., thoroughly two-dimensional), their use as a sacred vehicle was to achieve a sense of union between the viewer and the divinity. The image was to be taken to heart within the individual, with the concurrent loss of self- identity, so common to religious experience, forming the single image of "self/diety." It was an evocation rather than a description (the picture evoked the god or goddess within, not described him or her without).

With the new identification of the viewer with the painter rather than the sacred object, however, came the placement of both of them relative to a third entity, the nearby physical object(s), or subject of the painting, and along with it possibly the inauguration of the process of encroachment of the individual ego (i.e., the artist's) onto the image in the visual arts.

In the Brunelleschian world, the mechanism is perception, the image retinal. When the emphasis is on the act of seeing at a physical place, then time enters the picture as well ("if it's here, it's not there—if it's now, it's not then"). Images become "frozen moments." They become artifacts of the past. In securing a place on earth, they have accepted their own mortality. . . .

The inevitable mechanization of the image made possible two things that led to its liberation from the prison of frozen time: machine nature introduced automated sequential repeatability, and advances in the material sciences made possible the fixing of light impres-

sions on a durable surface, both necessary for the advent of the first moving pictures. It is important to note that the invention of photography was not the invention of the camera, but that of the process of fixing an image onto a plate. . . .

In this sense, moving images had been around for a long time. Technically, however, the first imparting of movement to artificial images (in this case drawings) occurred in 1832 with the simultaneous inventions of Joseph A. F. Plateau's Phenakistiscope and Simon R. von Stampfer's Stroboscope, soon followed by others, and leading up to the eventual integration of the photographic image into the process at the Edison laboratory during 1888–89 and the birth of true cinema. The emphasis of the term *moving image* is somewhat misleading, since the images themselves aren't really moving and the art of cinema lies more in the combination of image sequences in time (montage) than it does in making the images move.

Still, the question remains, exactly what is this movement in the moving image? Clearly it is more than the frenetic animation of bodies. Hollis Frampton, the great American avant-garde filmmaker, described it as "the mimesis, incarnation, and bodying forth of the movement of human consciousness itself." The root of the cinematic process remained the still picture, but images now had behavior, and the entire phenomenon began to resemble less the material objects depicted and more the process of the mind that was moving them.

A thought is a function of time, a pattern of growth, and not the "thing" that the lens of the printed word seems to objectify. It is more like a cloud than a rock, although its effects can be just as long lasting as a block of stone, and its aging subject to the similar processes of destructive erosion and constructive edification. Duration is the medium that makes thought possible, therefore duration is to consciousness as light is to the eye. . . . If from the medieval vantage point, the post-Brunelleschi optical painting seemed not to be all here (the illusion of someplace else compared to the concrete, nondescriptive existence of the icon image), then cinema was "really" not here. The physical apparatus of the moving image necessitates its existence as a primarily mental phenomenon. The viewer sees only one image at a time in the case of film and, more extreme, only the decay trace of a single moving point of light in video. In either case, the whole does not exist (except in a dormant state coiled up in the can or tape box), and therefore can only reside in the mind of the person who has seen it, to be periodically revived through their memory. Conceptual and physical movement become equal, experience becomes a language, and an odd sort of concreteness emerges from the highly abstract, metaphysical nature of the medium. It is the concreteness of individual experience, the original impetus for the story—"I went here and this happened. . . . " Sitting in the dark room, we sense a strange familiarity—an image is born, flashes before our eyes, and dies in blackness. . . .

In many countries throughout the world, black is the color of mourning. Echoing this ineffable finality, in European culture black is considered to be outside color, the condition of the "absence of light." The focal point for black in our lives is the pupil of the eye, portal to the tiny chamber in the center of the eyeball where darkness is necessary to resolve the original parent of the artificial image.

When the means of the artistic creation of images are the laws of optics and the properties of light, and the focus is the human eye, it was only a matter of time before someone thought to hold up a mirror. The ideal mirror, around since the beginning of humankind, is the black background of the pupil of the eye. There is a natural human propensity to want to stare into the eye of another or, by extension of oneself, a desire to see seeing itself, as if the straining to see inside the little black center of the eye will reveal not only the secrets of the other, but of the totality of human vision. After all, the pupil is the boundary, and veil, to both internal and external vision.

Looking closely into the eye, the first thing to be seen, indeed the only thing to be seen, is one's own self-image. This leads to the awareness of two curious properties of pupil gazing. The first is the condition of infinite reflection, the first visual feedback. The tiny person I see on the black field of the pupil also has an eye within which is reflected the tiny image of a person . . . and so on. The second is the physical fact that the closer I get to have a better view into the eye, the larger my own image becomes thus blocking my view within. These two phenomena have each inspired ancient avenues of philosophical investigation and, in addition to the palpable ontological power of looking directly into the organs of sight, were considered proof of the uniqueness and special power of the eyes and the sense of sight.

Staring into the eye is an ancient form of autohypnosis and meditation. In the Alcibiades of Plato, Socrates describes the process of acquiring self-knowledge from the contemplation of the self in the pupil of another eye, or in the reflection of one's own. . . .

The medieval Neoplatonists practiced meditating on the pupil of the eye, or *speculation,* a word that literally means "mirror gazing." The word *contemplation* is derived from the ancient practice of divination where a *templum* is marked off in the sky by the crook of an auger to observe the passage of crows through the square. *Medi*tation and *concen*tration both refer to the centering process of focusing on the self.

The black pupil also represents the ground of nothingness, the place before and after the image, the basis of the "void" described in all systems of spiritual training. It is what Meister Eckhart described as "the stripping away of everything, not only that which is other, but even one's own being."

In ancient Persian cosmology, black exists as a color and is considered to be "higher" than white in the universal color scheme. This idea is derived in part as well from the color of the pupil. The black disc of the pupil is the inverse of the white circle of the sun. The tiny image in "the apple of the eye" was traditionally believed to be a person's self, his or her soul, existing in complimentary relationship to the sun, the world-eye. . . .

So, black becomes a bright light on a dark day, the intense light bringing on the protective darkness of the closed eye; the black of the annihilation of the self.

Fade to black . . .

In two minutes, the tape runs out and the screen is plunged into snow. The hissing sound jars the viewer from sleep. A hand slowly comes in and fumbles for the power button. There is a click, silence, and the snow on the screen abruptly collapses into a momentary point of light, which gradually fades while the glass screen quietly crackles, dissipating its static charge, and the internal circuits begin to lose their heat to the cold night.

WILLIAM WEGMAN Interview with David Ross (1990)

DAVID ROSS: You're originally from California?

WILLIAM WEGMAN: I was born on a tiny cot in southwestern Massachusetts during World War II. A sickly child, I turned to photography to overcome my loneliness and isolation.

DR: I knew that. There is a sense of pathos in your work, of being an artist dealing with inevitable failure and having to overcome incredible adversity. There is something Horatio

* David Ross, "Interview with William Wegman by David Ross," in Martin Kunz, ed., *William Wegman: Paintings, Drawings, Photographs, Videotapes* (New York: Harry N. Abrams, 1990), 13–23. By permission of the interviewer and the artist.

Algeresque about it all. You as the American artist using your art against all the torments and assaults of modern life.

WW: Really, that's ironic.

DR: I guess irony is the right word for it.

WW: Pathetic irony.

DR: What I mean is that there is an inherent tension in the humor that comes from what you missed while the ostensible event was taking place.

WW: Sometimes it's a reaction against my own posturing. As a student I was a "blender" artist.

DR: Blender?

WW: My big idea was to combine the hard edge of Suprematism and De Stijl with the drips of Abstract Expressionism.

DR: Sort of like the "edge" of earlier abstraction meets the gutsy immediacy of Abstract Expressionism.

WW: The best of both. A bouquet. I eventually purged the personal and the sentimental to arrive at pure and simple geometric abstraction. Later in three dimensions. My little twist was that it glowed in the dark.

DR: Sounds scary.

WW: My last painting during this period in my life was in 1966 as a grad student at the University of Illinois at Champaign. A 4' × 8' Donald Judd–like construction. Sadly, I gave it up.

DR: Sad because you realized it had been done before or sad because you thought you couldn't do it?

WW: More because I felt it didn't belong to me and that I could become an average good painter following that direction, but not an average great painter. I guess I felt that painting didn't belong to me.

DR: But this was all part of a larger generational shift as well. Your friends, your artist peers were also making a similar somewhat depressing realization about their own potential in regard to the weighty accomplishments of the older generation.

WW: Of Modernism?

DR: Yes, of Modernism and what was left for them in terms of a slice of this heroic pie. The idea of being an artist-hero was a romantic fiction in the late '60s. In the late '60s all we needed to be was . . .

WW: Part of the solution. Not part of the problem. Well, . . . I knew it was my problem. I didn't think it was anyone else's though.

DR: Does it seem strange to be painting again?

WW: Funny, strange, and eerie.

DR: What made you start again?

WW: I had the urge to. . . . An increasingly uncontrollable urge. Is that wrong?

DR: No. Do you feel guilty about it?

WW: I had deep reservations.

DR: Were you afraid of what they might say?

WW: Painting is dead, after all. It's a little anticlimactic.

DR: Do you mean, following the line of your other work, it doesn't follow?

WW: At night, before going to sleep, I would have these visions. In this dreamy state, the Lord told me to start using my God-given talents. I interpreted this to mean painting.

DR: Very well. But does this mean God isn't interested in photography?

WW: God knows I'm still involved. When I first started making photo pieces it wasn't with the idea of a commitment to the medium. I didn't think I would have to become a photographer to make my photographs. I recall that anything could be used as material for art in that era. Photography was just one more thing.

DR: Talk a little about that time. Did you have a sense of disengagement with what you saw around you as a young artist? Did you have a sense of an audience for your work?

WW: I was in Wisconsin teaching sculpture—which was for me anything done in space and time. For instance, I was throwing radios off of buildings and photographing them . . . just to have a record of it. So I could show someone else.

DR: Who?

WW: Important people. This was the era of the piece movement . . . outdoor pieces and indoor pieces—floor pieces. I was working on a wall piece. I remember John Chamberlain came into my studio. He was a visiting artist. Some stuff I had stuck to the wall had fallen down. I was working with mud and photographs and thread, eyelashes, carrots, and acetone.

DR: Yum.

WW: He thought it looked great. It was a big mess. I knew what he meant though, but for me I needed some more clarity of intent. A way to start and finish a work and this was all middle.

DR: To enclose it.

WW: Yes. I needed that in order to proceed from one piece to the next. I had to get it myself. I felt lost. Then I had a "Eureka" type experience. Both video and photography contributed to that moment. I remember one photo in particular—*Cotto* [1970]. I had drawn little rings—little circles on my left hand on my fingers with my ring on my index finger and I went to a party.

DR: Very '60s.

WW: Well, a plate of salami was on the table and reaching in I was struck by the peculiar relationship of these little rings with the little rings in the salami—the peppercorns. Anyway I rushed home with the salami, set up my camera and photographed it with my own hand reaching in. I developed the negative and printed it and . . . "Eureka."

DR: And?

WW: Meaning I could construct a picture and that way directly produce a work—not a secondary record of it. The "construction" existed only for that purpose.

DR: Could you elaborate?

WW: Well . . . previously, my use of photography was to document an installation or event. The problem was to find a vantage point to make the piece look good. I remember floating Styrofoam commas down the Milwaukee river. I had to rush up the bank and quickly set up the camera on the bridge to catch them floating by. This new realization allowed me to set up things just for the camera in the comfort of my own studio.

DR: You then started producing these contained moments for the video camera? Did you feel your work fit into the whole video revolution you found taking place around you, or was it more of an extension of your "fabricate to photograph" attitude towards photography?

WW: I wasn't really around during this revolution. I later met Nam June Paik and Bruce Nauman, who I think of reverently. Actually, I thought my work was about as different from other video makers as you can get. The only common denominator was the medium.

DR: You seemed to be working yourself out of a corner, and yet you introduced an im-

portant element into the fledgling video community. Your works were short and, because they were often absurd, they were accessible. They seemed to use conventions from real TV—the blackout sketch of Sid Caesar—yet subvert them by insisting upon a rather hermetic "insider" anti-humor. You know, like "no soap radio" kind of jokes.

ww: They were linear in opposition to the "field" approach that was in at the time. For me I needed an entrance and an exit. Some artists just used the whole reel. For me they were a solution to a unique communication problem. How to reach an audience. They could be broadcast or shown closed circuit.

dr: You have often described your whole career in terms of technical milestones and hardware achievements.

ww: My first deck. The first that I owned was a CV Sony with a surveillance type camera which was very wide angle. Within these strict limitations I produced Reel 1. By Reel 2, I owned a Sony AV 3400—another table model. I never liked porta-paks. I increased my space by 12' with the RE15 electronic microphone, sound was more understandable and I began speaking more. By 1975, I owned a color VHS recorder and camera. With each replacement new possibilities were opened but others were shut down. I think I'm a very tech sensitive artist in that I don't overreach the media. In fact, I revel in the limits. With color and higher resolution I found it hard not to look like low-budget imitation Saturday Night Live stuff. You know, bad network television.

dr: Yeah, I think I follow you. But it is far more important that you were among the first to recognize that video was more a function of drawing rather than of cinema or television.

ww: I am attentive to the closed mirrorlike nature of video . . . the almost mesmerizing effect of the image in the monitor in relation to the subject which . . .

dr: Which was you . . .

ww: . . . and Man Ray. . . .

dr: There seems to be a struggle in your work—in all of your work, but it's most obvious in the video and the drawings—you seem to be trying to come to grips with a world that doesn't work. It disturbs me that critics have often seen your work as simply humorous and benign. I don't think your art is all that genteel. It's occurred to me that you are dealing with a deep sense of loss and anxiety . . . concern about the end of world. I see it as very troubled art. In fact I have often found something deeply ominous about your art. By the way, is Wegman a Jewish name?

ww: I once knew a young boy who had a gravel driveway. The little boy loved the driveway. He liked to play with the little pebbles. He had to go to the hospital for an operation. When he came back home he found the driveway had been paved.

dr: Is that true? [pause] The formal devices you were exploring in video have an analogue in literary criticism and in literature itself. What authors have influenced you?

ww: Besides Borges and Tolstoy? Proust.

dr: What about Buster Keaton?

ww: In California I liked the late night lumberyard ads and used car ads that spun off from Bob and Ray. I love Bob and Ray.

dr: And Man Ray. Having been a self-conscious student and then a somewhat reluctant teacher/grad student seems to have made a strong impression on you. . . . You seem to have remained obsessed with the role of the academic, the explainer . . . that comes across for me in one particular video with Man Ray.

ww': Well, yes, in Spelling Lesson [1973–74] and in many of the black-and-white photos

of the early 1970s as well. Education is the subject of countless drawings. Grad school was torture for me. I don't know why. Video is great for teaching, however. You can improve your golf swing or practice your bedside manner. You are going to die a slow and painful death. When I was teaching at Cal State Long Beach in 1970, I borrowed equipment from Physical Education and Psychiatry.

DR: Is that how you overcame your "rage and depression"?

WW: I believe that was through speed reading and the megadose prescription of deodorant. Having a dog helped.

DR: What about Man Ray? Your work with him is extraordinarily sought after, perhaps eclipsing your other work in terms of popular recognition.

WW: Again, I was incredibly lucky (not apparently lucky) in getting Ray and I think this is significant.[1] Getting him at just the right time—just when my video and photo work was still new and exciting to me. Ray fit right in. He was really curious about it and became very serious about our work.

DR: But does it bother you that in many circles you are known as the guy with the dog?

WW: First tell me what you think of my drawings. But seriously, I'm grateful for the recognition. It's frightening to think of what I would have done without him.

DR: It clearly has made you and that work of yours a household word,—at least in the houses of dog lovers.

WW: Especially those without yards.

DR: Pathetic!

WW: For me, Ray started as a space modulator, then became a kind of narrative device, then a character actor and ultimately a Roman coin.

DR: Julius Caesar?

WW: Or JFK.

DR: To me, your use of a contained vocabulary of formal elements (even though they didn't behave formally) has always been central to your work. This is especially evident in the drawings, which continue to serve as the core of your work. I mean, the drawings most elegantly represent your desire to present "contained" ideas as objects . . . to question the role of language (visual and verbal).

WW: ?

DR: Also, the drawings were so spare, not really minimal, but definitely associated with a reductive approach to the notion of presentation.

WW: For one thing, I really was relieved not to have to drag something in front of the camera. I could use a pencil and paper. A regular pencil and typing paper. That appealed to me.

DR: I remember the first time I saw them exhibited, the room looked so beautiful and formal. . . . What you saw were simply rows of small white rectangles tacked to the wall.

WW: Tacked but not brutally tacked.

DR: Just elegantly.

WW: Not even elegantly.

1. Man Ray was born in Long Beach, California, in July 1970. My wife Gayle and I bought him for $35. I wish I could remember the name of the family because I would like to thank them and perhaps give them more money (not really). He loved games and he absolutely knew about the camera. It is interesting to note that although I used him in only about 10 percent of the photographs and videotapes, most people think of him as omnipresent in my work. It irked me sometimes to be known only as the guy with the dog, but on the other hand it was a thrill to have a famous dog.—W. W.

DR: Just . . .

WW: . . . routinely.

DR: But not industrially.

WW: No.

DR: But the drawings themselves were filled with pathos. You were observing the pathetic failure of language, the condition of Postmodernism. They projected that pathos. They were never really cartoons, yet they often were seen as funny because of their primary ambiguity.

WW: The theme in my drawings keeps changing in the way that I do. Those first drawings were more about form—lists and statistical info. How to dot i's. Then later how to gouge them out with a bird beak.

DR: Not to change the subject, but in your photographs you tend to be more cleancut.

WW: Well, yes. In those that play off convention.

DR: The family unit, for instance, with Gayle [Wegman] and Man Ray.

WW: I liked to keep a matter-of-fact directness in those pictures.

DR: In order to . . .

WW: Invert it.

DR: Subvert?

WW: Not in the way you are implying.

DR: There was a time when your work would have been categorized in those Conceptual, essentially anti-photography shows using photographs which were all about undermining the photographic image, its history and its veracity.

WW: Right.

DR: But then in fact the work grew past that to the point where it established itself as real photography.

WW: In the Polaroids.

DR: Yes. Before that they were clearly not to be shown as fine art photographs matted and framed.

WW: Just tacked to the wall.

DR: But not brutally tacked.

WW: Just routinely. They are fine art photographs, not fine photography photographs.

DR: The Polaroids are slick in comparison. They are similar to the spirit of the early videos in the way they play off advertising conventions.

WW: The slickness is a given. It's just the way they come out of the camera which is what I really like about Polaroid. It has its own highly unique quirks. To me it's very much like video. At least in process.

DR: You mean with the instant feedback potential.

WW: Yes, and what that process opens up.

DR: The spontaneity.

WW: And zeroing in or honing in on something. Really getting to it. I should thank John Reuter who has operated the camera for the last ten years, and those before him—Roger Greguire and Joanne Verberg who introduced me to the camera in Boston. I really resisted at first. I had never used color before. In fact the first few days I used it I made black on black. Ray under a beach cloth against a black background. It was an act of faith for those that wanted a dog picture.

DR: And your beautiful models.

WW: Hester Laddey and Eve Darcy.

DR: and . . .

WW: Lindsay Ross.

DR: Whose misfortune it was to be in those photographs without the dog.

WW: Nevertheless, while we are giving credit, she really made those pictures. They are among my personal favorites.

DR: And what about the return to painting. Who can we thank for those?

WW: Well, we could start with David Davis. The New York City art store where I buy my painting supplies.

DR: What kind of canvas do you use?

WW: The finest cotton.

DR: And paints? Do you grind your own?

WW: No, but my assistants do. All I have to do is paint in the little leaves and hairs. My assistants do all the rest.

LYNN HERSHMAN
Video 1980–Present: Videotape as Alternative Space (1992)

Introduction

In 1980 I made a short videotape titled *Test Patterns*. The fluid and plastic possibilities, the painterly qualities of electronic colors and effects, the sculptural qualities of time, and the fracturing potential of narratives seemed natural to this medium.

When I was making temporary rooms, I designed video commercials, intended for broadcast. They were an electronic haiku that could, in less than a minute, impart the essence of an event and stand alone as an independent art work. To me, video is like an alternative space. The language is still being invented. Pushing the boundaries of television (which is what I think video should do) means penetrating screens that are often protected from truth. Audiences seem to be uncomfortable when television trespasses into realms of truth, because the format of television confuses fact and fiction.

When around electronics I have a physical response that may be similar to how some journalists feel about type and ink. My body becomes energized, as if I am an organic transponder.

Using the camera itself as a hypnotic, cycloptic eye for the person who is eventually seen on screen can have a transformative effect, as if the character transmogrifies through the process of passing time in front of the camera. Since 1983, I have made 49 videotapes.

Background

The diary has long been a way for women to record their private thoughts and feelings. In 1985, I began a life/art video project titled *The Electronic Diary*. A confessional told in first person, it records the transformation/transcendence of a middle-aged woman. I perform as, and am in real life, the central character of these segments which, in fact, actually occurred

* Lynn Hershman, excerpt from "Video 1980–Present: Videotape as Alternative Space," in *Lynn Hershman,* special edition, *Chimaera Monographie* 4 (Montbéliard, Belfort, France: Centre International de Création Vidéo, 1992), 88–91. By permission of the author.

during the year in which they were made. The themes transcend the personal to reveal the story of an individual participating, analyzing and reacting to her cultural environment by mirroring the obsessions, intrigues, pain, fracturing, alienation and hope of contemporary society. As the private becomes public, the monologue becomes an acute and sometimes piercing analysis of America.

As each story unfolds, the audience witnesses the medium turn on itself. The all-seeing, electronically biased camera lens becomes a myopic, cycloptic eye, a silent omniscient analyst, a literal camera obscura.

Inspired by the act of talking to the camera, the protagonist reveals deep, heretofore untold secrets, transgressing her silence and, most importantly, becoming empowered through the process. Unnerving self-revelations become apparent when both physical and psychological shifts occur. For example, the narrator gains and loses weight, ages, becomes ill, recovers and marries. Insights and perceptions that could not have been possible without the process of taping become clear and lucid.

The Electronic Diary derives from feminist performances of the 1970s. Both are concerned with documentation and articulation of identity. *The Electronic Diary,* however, is designed to be electronically distributed to a mass audience. Each video is produced privately, using no camera operator or technicians. Paradoxically, the completed works have been widely distributed and broadcast internationally.

Description

To date, six parts have been completed, one per year. In each segment, computer-based possibilities of videos are used to visually split, rupture or fragment the narrator. This technique underscores, through visual impact, the content of each message. Occasionally the narrator simulates schizophrenic psychosis to portray the pressures required to function in a wounded world.

Each diary directly confronts viewers by employing close-up head-shots as the primary means for telling each story. The cathartic nature of speech and revelation brings a balance, assurance and occasional wholeness to the duplicitous subcurrents of the text. This series is based on fact, on reality. However, close-up shots on video make even the most honest and despairing episodes hint at fictitiousness. Discrepancies emerge between what is being said and what the viewer wants to believe, creating a dramatic tension.

Individual traumas suffered by the narrator move to a more meaningful level when it becomes clear that the fracture and internal loss also apply to the audience, indeed, to the culture. As viewers witness the narrator reclaim personal history, displaced memory and finally an empowered identity, they also identify with and participate in the recovery.

Each segment ends with an unhinging or opening that leads into the next episode. Continuing sections delve deeper into both personal and international history. Innuendos and subtle references in early segments eventually come into focus later on, suggesting that all actions have ramifications that sometimes take decades to understand and articulate. The goal is to emphasize how destructive patterns can be reversed to allow new opportunities for a vital and positive future. That we are all survivors becomes the basis for the diary's communal language.

TONY OURSLER SKETCHES AT TWILIGHT (1997)

PAINTING IS A SENSUAL ART.

 SALVADOR DALÍ

THE ULTIMATE CONFLICT BETWEEN SIGHT AND SOUND, BETWEEN WRITTEN AND ORAL KINDS
OF PERCEPTIONS AND ORGANIZATION IS UPON US.

 MARSHALL MCLUHAN

SUMMER 1976

I ATTENDED CALIFORNIA INSTITUTE FOR THE ARTS WITH THE INTENT OF LEARNING TO PAINT
LIKE MICHELANGELO BEFORE I COULD PAINT ABSTRACTLY, PERHAPS IN THE MANNER OF KAN-
DINSKY. THERE I WAS INTRODUCED TO THE PRACTICES OF CONCEPTUAL ART AND THE REVO-
LUTIONARY SONY VIDEO PORTA–PAC. THE ONLY PORTABLE VIDEO RECORDING SYSTEM WAS MORE
THAN TEN YEARS OLD AT THAT TIME AND WAS NOT WIDELY AVAILABLE TO THE PUBLIC. I WAS
IMMEDIATELY ATTRACTED TO THE DEVICE AND SET ABOUT MAKING ART WITH IT. REAL TIME
IMAGE CREATION WAS A MATCH FOR MY HYPERACTIVE ATTENTION AND PACE. THE TUBE CAM-
ERAS OF THE DAY WERE EXTREMELY LOW RESOLUTION, WHICH CREATED A MAGICAL BLACK
AND WHITE, BUT MOSTLY GRAY IMAGE ON THE TV MONITOR. THERE ONE WATCHED A FUZZY,
SPOTTY, FUSION OF 2 AND 3 DIMENSIONAL SPACE. MY INTEREST IN THAT SPACE AND HOW IT
RELATES TO PHYSICAL SPACE HAS CONTINUED TO THIS DAY.

IMAGINE THE CAMERA VIEWFINDER SCISSOR–LIKE, EXCISING WHAT THE MIND'S EYE REJECTS
AND RETAINING WHAT IT SELECTS.

 JOHN BALDESSARI

SUMMER 1996

STORAGE SPACES ARE AUTOBIOGRAPHICAL. THE OBJECTS THEY HOLD BECOME A PERSONAL AR-
CHEOLOGICAL SITE. A MEMORY BANK MADE PHYSICAL. THIS IS WHY THEY ARE SO HORRIFYING,
THEY ARE A CONSTANT REMINDER OF THE PAST. STANDING IN YOUR STORAGE SPACE PUTS YOU
IN DIRECT CONFLICT WITH THE NATURAL LAWS WHICH GOVERN THE PASSAGE OF TIME. CLEAN-
ING OUT THIS SPACE IS, BY DEFAULT, A FORM OF EDITING OUR PERSONAL HISTORY. THE PROCESS
BECOMES INTROSPECTIVE, TO A SICKENING DEGREE, AS EACH INDIVIDUAL OBJECT, GREAT OR
SMALL, DEMANDS ATTENTION AND JUDGMENT AS TO ITS CURRENT VALUE. SOMETIMES AN OLD
BOOK FALLS OPEN TO THE FOLLOWING PASSAGE:

ALL THAT IS SOLID MELTS INTO AIR, ALL THAT IS HOLY IS PROFANED, AND MEN AT LAST ARE
FORCED TO FACE WITH SOBER SENSES THE REAL CONDITIONS OF THEIR LIVES AND THEIR RELA-
TIONS WITH THEIR FELLOW MEN.

 KARL MARX

* Tony Oursler, excerpt from "SKETCHES AT TWILIGHT," in Oursler, *My Drawings, 1976–1996* (Cologne: Ok-
tagon, 1997); reprinted in Elizabeth Janus and Gloria Moure, eds., *Tony Oursler* (Barcelona: Ediciones Polígrafa,
2001), 176–79. By permission of the author and the publisher.

THE POSSIBILITY OF ENTERING A VIDEO SPACE WAS RADICAL AND ULTIMATELY DESIRABLE FOR ME, A MEMBER OF THE FIRST GENERATION OF TELEVISION YOUTH. MY EXPERIMENTS IN PAINT-ING ENDED UP IN FRONT OF THE CAMERA AND I OFTEN PAINTED WHILE LOOKING THROUGH THE CAMERA. THROUGH THE LENS CONSTRUCTED, OR COLLAGE IMAGES WERE FREE TO BECOME ALMOST ANYTHING. THROUGH THE LENS MY PICTURES COULD BE ELECTRIFIED WITH ALL THE ATTRIBUTES OF LIFE; IF THEY NEEDED A HAND OR MOUTH I WOULD JUST CUT A HOLE AND STICK THE BODY PART THROUGH IT. IF SCENES NEEDED SOUNDS OR WORDS THEY COULD BE SPOKEN OR WRITTEN INTO THE TAPE; MUSIC COULD BE MADE TO ADD COLOR. I WAS STRUCK BY THE ABILITY OF THE CAMERA TO ALTER THE LAWS OF PHYSICS; TO TRANSFORM MATTER, SPACE AND TIME, INANIMATE TO ANIMATE: WORLDS UNTO THEMSELVES.

THE PAINTER IS THE EYES OF THE WORLD.
 OTTO DIX

FAILED PAINTER, LAPSED PAINTER, CLOSET PAINTER, PAINTING SUCKS, PAINTING FAILED ME. (A DRAMA FOR 2 PERFORMERS)

[SET IN A LARGE WHITE SPACE WITH HUMMING FLUORESCENT LIGHTS ABOVE]

1: I SHOULD EXPLAIN THAT I STARTED STUDYING PAINTING AS A CHILD AND HAVE ALWAYS EQUATED IT WITH INFANTILISM.
2: WHAT ABOUT WHEN YOU WERE PAINTING HOUSES FOR A LIVING, WAS THAT ART?
1: YEAH, I THOUGHT THAT THE SURFACES OF THE WALLS WERE MOST BEAUTIFUL.
2: YOU THOUGHT THAT BEING OBSESSED WITH SURFACES WAS A SYMPTOM OF SOME FORM OF MENTAL ILLNESS.
1: AND IN 1969 WHEN I WOKE TO DISCOVER MY LITTLE BROTHER HAD SMEARED THE WALL NEAR HIS CRIB WITH HIS OWN EXCREMENT, THE BROWN MASS SEEMED TO SAY IT ALL.
2: LOOK WHAT I MADE!
1: YOU GET BROWN BY MIXING ALL THE COLORS TOGETHER.
2: SO, SOME THINGS ARE BETTER DONE BY HAND.
1: TRUE.

DUST, MINUTE PARTICLES DERIVED FROM ALL FORM OF MATTER, COVERS THE GROUND, COVERS THE BOXES AND IS SUSPENDED IN THE ATMOSPHERE. DUST IS INHALED. ARE THE MEMORIES IT EVOKES WORTH PRESERVING? LET THE DUST SETTLE BEFORE YOU BRING UP THE SUBJECT AGAIN.

COLOR TV IS THE MOST RESOUNDING INDUSTRIAL FLOP OF 1956.
 TIME MAGAZINE

VIDEO DISPLACED FILM, WHICH DISPLACED PHOTOGRAPHY, WHICH DISPLACED PAINTING AS A PURVEYOR OF THE IMAGE IN OUR CULTURE. SINCE THERE IS VERY LITTLE HISTORY BEHIND VIDEO ART, WORKING IN THE MEDIUM HAS A FRESHNESS, A FREEDOM. IT FORCED ME TO FORGET THE FORMAL CONSTRAINTS AND OVERWHELMING HISTORY OF STATIC IMAGE MAKING. INSTEAD I COULD PLAYFULLY TAKE FROM THAT HISTORY, AND EMPLOY VARIOUS STYLES FOR THEIR SEMI-OTIC, REFERENTIAL VALUES. VIDEO CONTAINS THE HISTORY OF IMAGE MAKING, EVERYTHING

FROM POP TELEVISION, 16TH CENTURY STAGE DESIGN, GEORGES MÉLIÈS, GERMAN EXPRESSION-
IST FILM AND CONCEPTUAL ART WERE MIXED INTO MY TAPES AND INSTALLATION.

> REMEMBER, ANYTHING THAT CAN BE DONE CHEMICALLY CAN BE DONE IN OTHER WAYS.
> *WILLIAM BURROUGHS*

EACH OBJECT I TOUCH HAS A TEXT. LIKE IT OR NOT, I HEAR IT, SEE IT. EACH TOUCH THROWS
ME HOPELESSLY OUT OF MY TIME, OUT OF MY MIND. IN THIS FRACTURED PSYCHOLOGICAL STATE
I'M AMAZED THAT THIS FRAGILE SCRIBBLING ON PAPER SURVIVED, CAME TO REST AT ONE SPOT.
THE HAND MOVES FROM ONE POINT TO THE NEXT, A LINE. I MOVED ON THE AVERAGE OF ONCE
A YEAR FROM 1975 TO 1989. NOW, I SHUTTLED THIS CHAOTIC MASS TO YET ANOTHER STORAGE
UNIT, THIS TIME IN BROOKLYN, NEW YORK. I HATE BROOKLYN. BUT IT'S A GOOD PLACE TO PUT
YOUR OLD THINGS. ORDER CAN BE FOUND THERE. IN BROOKLYN, THE MATERIALS IN THE STOR-
AGE SPACE SEEM MORE STREAMLINED, AS IF THEY MIGHT TURN INTO SOMETHING GREATER THAN
THEIR SUM. ALMOST ANYTHING OF QUESTIONABLE VALUE HAS BEEN BRUTALLY EXCISED. THE
ESSENTIAL BOXES, TUBES AND PANELS REMAIN. JUMBLED BLOCKS OF TIME—NOW THE STORAGE
ROOM IS MY MODEL OF TIME.

I CONTINUE TO DRAW CONSTANTLY AS A WAY OF WORKING OUT IDEAS. MY PRODUCTIONS WERE
EXECUTED WITH THE MEAGER RESOURCES AVAILABLE WITHIN A STUDIO CONTEXT: THE ARTIST'S
BODY, PAPER, PAINTS, CLAY, WOOD, THE UBIQUITOUS CARDBOARD BOX, AND VARIOUS FOUND
OBJECTS FROM THE LOCAL THRIFT STORE. I HAD TRICKED MYSELF INTO MAKING THINGS BY
HAND, A PROCESS WHICH I LOVE, IN THE SERVICE OF A LARGER CONCEPTUAL FRAMEWORK.

> THE HUMAN MIND IS A MALLEABLE TOOL.
> *ALLEN DULLES, DIRECTOR CIA*

VIDEO IS A META-MEDIUM—SOMETHING THAT COULD APPROACH THE POETRY OF THOUGHT . . .

EIJA-LIISA AHTILA Interview with Doug Aitken (2006)

DOUG AITKEN: I have this vision of you working in Helsinki, with its long Finnish nights
and endless summer days, directing your films on the outer edges of the film community.
Your film installations tell stories that are deeply introspective. They live beyond the confines
of the film world in how personal they are. You distribute your films in both the art and film
communities. What challenges do you face having one foot in each of these worlds?

EIJA-LIISA AHTILA: Your description of me working here is quite correct, but I don't
think it has to do with living in Helsinki. In my case I could say I'm both a filmmaker and
an artist. When I make a work with moving images, I usually do both a film version and an
installation version. The film version is distributed through festivals and on television, and
the installation through galleries and museums. But if I think about my approach to the me-

* Doug Aitken, excerpts from "Interview with Eija-Liisa Ahtila," in Aitken, *Broken Screen: 26 Conversations
with Doug Aitken: Expanding the Image, Breaking the Narrative,* ed. Noel Daniel (New York: D.A.P./Distributed Art
Publishers, 2006), 18–24. By permission of the interviewer, the publisher, and the artist, courtesy Artists Rights
Society (ARS), New York/KUVASO, Helsinki.

dium of the moving image itself, it's more as an artist. The important thing for me is to express myself through the medium. Only when I have to, do I think about the differences between the two fields, like when I try to get financing from the film world. It's then that I often realize how different my approach is. It's not always easy to find a common language. But fortunately there are people out there who are interested in the new developments going on in film narration.

DA: What led you to start using multiple screens in your installations?

ELA: In 1994 I got an invitation to take part in an exhibition at Index Gallery in Stockholm. I wanted to depict the lives of teenage girls, a subject that was not very common back then. I was living in Los Angeles at the time and there were these black-and-white Calvin Klein billboards made up of several images put together. Do you remember them? I liked the idea of that kind of broken space and thought I'd like to do a similar thing with the moving image to reflect the experiences that teenage girls go through as their bodies transform from those of girls to those of women. . . .

I've done two works that were intended to be shown in advertising slots, *Me/We, Okay, Gray* in 1993 and *The Present* in 2001. It would be great to see more works by artists and filmmakers in among the advertisements on television. It's a format that has been completely abandoned and given over to advertisers. It would be great to be surprised once in a while.

DA: Your work tells stories that are laden with subtexts. You draw the viewer into dark, disjointed worlds where there are surreal encounters and sudden outbursts of violence. These worlds attest to the parallel realities inside your characters' minds and are often shown against the backdrop of domestic settings and other personal locations.

ELA: I want every subject matter to carry a particular rhythm. The size and running time of the images and the nature of the sound and lighting all need to serve this rhythm.

DA: Extreme editing techniques seem to be an important part of your work. Is there a specific idea about the moving image that you want to communicate through your editing?

ELA: I try to break the old rules of editing. During the editing process, there is so much going on that I need to have a certain distance from it in order to see how the story is taking shape in the material. This is why I never edit the works myself. I always work together with an editor during the whole process. There are a lot of traditional ways of editing that affect the nature of the narration, like cutting from one image size to another, editing around movement, breaking the line, and many other more subtle ones. But when you're working with three images that will ultimately unfold all at the same time on multiple screens in one installation, it is very different. Some of the rules apply, but they don't tell you how to deal with things like simultaneity or how to move a character from one screen to another.

DA: How do you go about doing this?

ELA: It's a lot of trial and error, and it's a lot of intuition. Every work has a rhythm of its own with demands of its own. There's so much you can experiment with, like showing action and reaction simultaneously, showing a detail shot along with a wide-angle shot, using images of different sizes at the same time, making time overlap by showing different parts of an action on separate screens. But for me, the choices always have to do with the subject matter and the atmosphere on-screen.

DA: How do you usually get started on a project?

ELA: Working is an ongoing thing for me, meaning that the long periods when I'm doing "nothing" are as essential as when I'm writing or editing. That's when I'm rearranging

myself or changing my rhythm, so I can't really say exactly when a project starts. Each project is different depending on the idea or the subject matter, but at a certain point enough things have taken place around me that I start writing.

DA: So you script your films first?

ELA: Yes, and I work out what kind of form would best correspond to the subject matter, how many screens I want and in what kind of structure, and the overall shape of the space. . . .

DA: Besides your personal experiences, what other areas in the arts do you look to as reference points?

ELA: I've seen a lot of films that I admire, but I don't feel I have such a strong connection to any of them. For me, it's easier to have a conversation with text. Maybe this has to do with the form most films have. They are so closed. I just finished the second draft of a script I'm working on, and before I started writing it, I read some poetry. Maybe I could say that the works of the poets T. S. Eliot and Arthur Rimbaud have influenced me. But I'm not being fair. What could be anything like Eliot's *Four Quartets?*

DA: What then does the moving image do for you that poetry cannot?

ELA: You can make the inner experience you have with the written word more accessible to others. You can create a fictional world that can be accessed through the senses. For example, you can explore how to communicate what a winter night's light is like by thinking about what response a particular sound might provoke. Or by thinking about how many things can take place in one frame while still allowing the viewer to take in the dialogue. With the moving image, you can take it a step further.

PIPILOTTI RIST Interview with Rochelle Steiner (2000)

ROCHELLE STEINER: *Ever Is Over All* includes two video projections. One is an image of a girl walking in an urban setting, and the other is a floral scene. They contrast with one another, but they also overlap and inform each other. What was your motivation for this piece and for the combination of these distinct images?

PIPILOTTI RIST: As you said, the two scenes overlap. The girl walks with a Red Hot Poker flower in her hands. To her right you see the same flowers in a garden. Then she casually destroys a series of car windows with the flower. I'm honoring nature by exaggerating the power of a tender, fibrous plant, and I juxtapose this with an extreme close-up that travels around the plants. The camera work makes the plants seem hundreds of feet tall. The blossoms remind me of a futuristic city. By watching the garden projection I imagine you could live in the blossoms. The concept of the camera movement is meant to imitate the flight of an insect, flying around and into the blossoms like a helicopter would fly around a landing pad on a rooftop. What interests me are the different perspectives or focal points. What's big and what's small, as well as what's weak and what's strong, are extremely relative. The obstacles we imagine are often bigger than they are in reality.

RS: When I watch this piece I feel like I'm in a dream. Some people have compared it to a fairy tale.

PR: It is a fantasy. When I created it, I wasn't thinking about fairy tales. It's true that it

* Rochelle Steiner, excerpt from "Interview with Pipilotti Rist," in *Wonderland* (St. Louis: Saint Louis Art Museum, 2000), 91–94. By permission of the interviewer, the artist, and the publisher.

has some similarities, but maybe that's because it depicts a delicate, feminine girl doing something very aggressive. This is a familiar aspect of fairy tales: the small child wins against the monster. There's always a balance of power to comfort the weak, the poor, and the children. Fairy tales always prove that the key to winning a struggle depends on our mental force and not on power or physical force. That interests me a lot. I'm very interested in the power of weakness and the beauty of the non-elegant. In that way, you can say that I refer to fairy tales. You know, if you glorify or empower a seemingly fragile woman, it can suggest mental strength. I'm fighting against clichés by exaggerating the person and giving her an unusual physical presence on screen. This suggests to me mental power or the strength of self-hypnosis.

RS: You mean a sense of self-confidence?

PR: Yes. You can do it, you can do it, you can do it. Things like this. Who the hell gave us all the illogical rules? In my work I want to encourage people to ignore unnecessary and hurtful limitations.

RS: Let's talk about the comparison you've made between the camera and a bee flying through your garden image. I notice that the ideas of journey and movement are very strong in your work. There are always people in motion in your videos—and the camera is in motion, too.

PR: I'm definitely aware of the movement of the camera. I only use a handheld camera, which means that things are moving all the time. I think of it as a type of journey. I am very much interested in movements that have a really clear aim or path. The way that you move is a language itself, just like the framing of photographs is a language. How you move, with which focus, and in which direction is a language or expression without words. My sense of movement comes across very emotionally. Camera movement is something I take great pride in. . . .

I use the camera to guide the viewer. I guide myself and I guide you as well. But I think that's what every artist is doing. If I were to give you a camera and you were to shoot a sequence, I would be able to tell some things about you: how you moved, what you looked at, for how long.

RS: Do you consider your video to be almost autobiographical? We see what you're looking at by where and how you move.

PR: Do you use the word "autobiographical" to mean "personal"? That's one of the classical aims of cultural expression—to try to uncover and show something to each other, to understand the other, or to see how someone is perceiving the world because we are so extremely alone. And then, if we watch something together, it might bring us closer to understanding each other. Or we might find ourselves in the way the other is watching.

I also use the camera to pay homage. I honor the thing I'm filming. In German we say *"huldigen."* I feel a bit like I'm a priest. The act of shooting is almost like a prayer. No one has ever asked me to talk about my camera movement. Most people want to talk about MTV.

RS: How do you compare your work to music videos?

PR: Some music videos utilize interesting camera work. Maybe this is part of the connection people see between MTV and my work. Music videos are different from most video art pieces where the camera work is often very rigid and strict.

RS: Are there certain films that have been influential on your work?

PR: Like most people today, I've seen many films, especially on TV. I don't even know the titles or directors' names, but they have still influenced me. After having done drawings and Super 8 animation films early in my career, I started to work with video and music. This was about the same time that MTV was developed in England. Later on, people saw a con-

nection. However, at that time I was more influenced by experimental films and by feature films.

There is a long history of music films that predates MTV. People saw my first video, *I'm Not the Girl Who Misses Much*, as a critical response to MTV. I hadn't even seen MTV at that point, but of course it's a reflection of pop culture. I would not want to distance myself from certain clips shown by MTV because I have a lot of respect for those colleagues. The only difference is I do not have to sell someone's product with my video works. I don't have to sell a band. I use the same media, but I'm privileged to convey purely poetical, philosophical, and political content.

RS: Are you still playing in your band, Les Reines Prochaines?

PR: No, it was too difficult to combine live tours with an art production and exhibition schedule. And, I have to admit, I never liked to go on stage during the entire six years. I suffered from the first to the last concert. But it was a good way to conquer my fears, and I learned a lot by doing it. For example, it's not necessary to worry about what people think of you, because you will never be able to even imagine what they think of you. This is as true in life as it was on stage.

GILLIAN WEARING Interview with Grady Turner (1998)

GRADY TURNER: People talk about your work in the context of confessional television programs, like Oprah Winfrey. I guess one could look at the content of your work and say that it's not alien to the interests of tabloids.

GILLIAN WEARING: Yeah, but the tabloids don't go to the art shows. When I was nominated for the Turner [Prize] a lot of people hadn't seen my work. They read that I did confessional work. And when they heard that people wear masks in the *Confessions* tape, the tabloids insinuated that I was getting people to make smutty comments under cover of the masks. That sounds as if eliciting smutty remarks had been my intention. It's all very twisted. I elicited people's confessions but I didn't know what they were going to say. I didn't know their remarks would be so sexually orientated. . . .

The tabloids are always about misrepresentation and ambiguous headlines. That's the way they're used to conducting business. . . .

GT: Let's talk about the video *10–16*. . . . You recorded interviews with seven children between the ages of ten and sixteen, then taped middle-aged actors lip synching the children's voices. The children's faces were not seen. The voice of a ten-year-old boy describing his treehouse came from the mouth of a man reclining on a couch. A woman sitting primly on a bed mimics a twelve-year-old girl who has "no worries, really"—except abortion. A thirteen-year-old boy plotting the demise of his lesbian mother and her lover is portrayed by a naked dwarf in a bathtub . . . The final interview comes from a businessman who painfully relates a sixteen-year-old's sexual confusion and self-loathing.

How did you find children to interview? How were the interviews conducted? In your relationship with the subject you're filming, there's clearly some measure of trust; these children confide things to you that perhaps they don't tell other people. . . .

GW: It took me quite a few months to get the right age ranges. It's very hard to interview young children, because they've got a lot of peer pressure. They want to make sure they've said the same things as their friends, or believe the same things as their friends. They're scared of being different. They're all at school and they've all been processed through the same system. I was trying to find lots of individual voices that came from a child's point of view, but at the same time had very particular things going on in their lives. I wandered around the streets asking children, or asking their parents, if I could talk to them. I had found it quite hard to get a sixteen-year-old, and then this boy came along and made the piece. Really, it was about him. At sixteen, he's just realizing that he's an adult and his body has become this mask. He's also realized that he's innocent. You still get captured innocence throughout *10–16*. You can feel adolescence creeping through those years. It reaches its pinnacle at sixteen, at that point you first feel the adult. When people first saw the piece, they didn't realize that adult actors were lip synching children's voices. They thought there was a problem with the audio. They were saying, "Why is that man saying those things about his sexuality?"

GT: You talked to kids you encountered on the street. Did you also work through schools?

GW: People get a bit wary of you when you approach children, and I understand why. I was going through one school, and then all of a sudden, the teachers said, "No, you can't." If the children were young, I'd ask the parents if I could interview them. With the older ones, sometimes the parents didn't know because I thought they were mature enough not to have to ask. It's a great responsibility when you're asking children about themselves. You feel the weight of your power as an adult. Their identities are protected by the fact that you don't see their faces in the video itself. And so they become anonymous. Obviously, I've had a lot of press on me, and the children realize that people have been talking about them within the art gallery context, which they've all accepted. But they fear being on television, given the way television exposes people. I always reassure my subjects that I never give anything away. I don't even know the sixteen-year-old's telephone number or his real name, he gave me a pseudonym. I had to reassure him that in the future I wouldn't recognize him on the street.

GT: So he created his own mask to protect himself from you. But you have taken on a certain responsibility as his confessor. You know things about him that he felt a need to tell. You now hold his secrets.

GW: Yes, but I don't have any access to him. As the years go by that voice remains in the piece, but the person goes on. We all have secrets, we all have things that we contain within our lives. He'll be a very different person in the years to come. The one thing I found with the work I've done is that when problems start young, they do affect you for the rest of your life. That was the point I was trying to make in *10–16:* Childhood is where the biggest problems happen.

In one of my other tapes, *Confessions,* I actually advertised in *Time Out:* "Confess all on video. Interested?" I put those who came forward in masks, to protect their anonymity. One of my confessors' foremost memories as a sixteen-year-old was watching his sister and brother kissing. His whole sexual life has revolved around this memory. Now he's a 36-year-old virgin. He visualizes his sister when he wants to kiss someone. It's very difficult for him. He confessed this on the video because he wanted someone to say he was absolutely normal, and he didn't have to worry, that everyone does that. . . .

GT: It sounds like you think more about documentary television and film than documentary photography.

GW: Yeah, I've never really had any direct influence from photography, although I do

like looking at documentary photography. People said to me, "You should look at August Sander and Diane Arbus." And so I did, and I found their work amazing. But I was influenced subconsciously by the documentaries on English television. They hung around in my memory. I had an emotional response to them and I'm still trying to grapple with that. Those documentaries were quite intimate family sketches. Maybe I saw things that would not be allowed on television under other circumstances. Today everyone has a go at it, they all own camcorders and cameras, people are more aware of their behavior and more self-conscious. It would be much harder to catch that intimacy today. . . .

I started the documentary-type work because I wanted to get to know people. I wanted to get into their heads. The chance encounter was the first way of talking to strangers, having that brief moment. I wanted to see if I would make something that could stretch that—which becomes more difficult because trust becomes important. On both sides, you have to establish a trust. And you have to meet people who are open to that, and that becomes harder. . . .

I'm deeply interested in people, that's the crux of all my work. And I'm interested in documentary, and other, more subliminal threads that do keep on popping up in other guises. A lot of my ideas mull around for years, I think about things for two or three years before I even get to them as art pieces.

ANRI SALA

Unfinished Histories: Interview with Massimiliano Gioni and Michele Robecchi (2001)

MASSIMILIANO GIONI AND MICHELE ROBECCHI: The first time we saw your work, it was . . . a video titled *Intervista,* in which you forced your mother to face today what she had said in the past, by restoring the audio of an old video that portrayed her during a communist rally. A quite direct, straightforward story, built on a simple narrative, with a beginning and an end, and nothing to do with the more flashy video loops that are fashionable in the art world today. Your video was somehow more cinematic, and yet more real. . . .

ANRI SALA: It was my first video. I learned a lot through filming and editing it. Above all, I experienced and learned how far one could go touching where it could hurt, but still respecting the other while implying oneself. It is not easy to give out your personal history or that of your dearest people, especially when it has been embroidered with disillusion, pain, loss, responsibility and failure. . . .

I'm very often working with problems that are or could be mine; therefore, I deal with them in a personal way. There are times when I'm dealing with somebody else's problem, appropriating it, because I believe that there is a very small step that could bring each of us into everybody else's situation. When this gets in your head, then you understand that when our common past is still fresh, it's unfair to speak about it in the third person. But it would sound like an interrogation if you do it in the second person, without being personally implied. In the Albanian communist society most of the people were accidentally and not consciously implied in the system. Or then again, they were mainly consciously implied in their ideals

* Massimiliano Gioni and Michele Robecchi, excerpts from "Anri Sala: Unfinished Histories," *Flash Art International* 214 (July–September 2001): 104–7. By permission of the interviewers; the artist, courtesy Marian Goodman Gallery, New York; and the publisher.

and accidentally implied in their results. There was no choice; the decisions were taken in the name of the people: reflection meant prison or a death sentence in the name of the people, the same people who had no more choice than you, the same people that were simply happy to survive. What makes the situation complex today is finding personal responsibility in the collective one. I don't have a solution; I just try to scratch things when I feel that I'm succumbing to the immoral collective mentality and passively accepting reality. . . .

My mother subscribed to a bigger ideal than personal freedom, things like the "people's struggle against imperialism, working class freedom . . . " And she ended up being part of a system that took away every single freedom from its own people. . . .

My responsibility should not simply be a commentary on what's happening in my country: it should be about participating in it, first of all because I consider myself part of a community there. Unfortunately, the way things are now, commentaries are tolerated but participation is not yet welcome. Yet the tolerance is growing, and I hope that gradually more people and ideas will find their place in society.

MG&MR: In your videos, the absurdity of violence and history comes across through the simple means of juxtaposition. You alternate past and present . . . or you present two characters, who apparently have nothing to do with each other . . . : it's as though your work were merely a matter of editing.

AS: The juxtaposition of different stories is extremely important: alternating past and present, moving to different places, from here to there, overlapping narratives. This alchemy of images and sounds helps to create a simulacrum of reality, an alternative present time, which is the time of a projection, and which could actually be more real than what we think reality is.

MG&MR: There is a strange mistrust towards reality in your work, even though everything you do seems informed by the language of television and documentary films.

AS: Maybe, I don't know. I think there are no such direct influences. Television and cinema were never really part of my everyday life. In Albania, the only TV program we had started at 18.00 and ended at 22.00, mainly airing the same news program and fiction film three times a day. Everything was so unreal that I remember the only realistic thing was the weather forecast.

At the end of the film *Intervista* my mother says: "I think we passed to you the ability to doubt, in the sense that you always have to question the truth." This is part of the mistrust towards reality that we inherited: people had to believe in a reality that didn't exist, and they had to act as if they saw it every day. It was like *The Matrix,* the film, have you seen it? You didn't have the choice to believe or not, and lots of the people probably didn't want to have one either. Actually in *The Matrix* there is this great scene I absolutely love. In this scene they ask Neo, the One, if he wants to go "Our way or the highway?" And Neo opens the door of the car he's sitting in and tries to leave. Trinity stops him and says: "Neo, please, you have to trust me." Neo answers: "Why?" Trinity: "Because you've already been down there, Neo. You already know that road. You know exactly where it ends. And I know that's not where you want to be." Neo closes the door. When I saw the film, I thought this road could be every street in Tirana and I couldn't stop thinking of all the people there trying to find a way out. . . . Since my first steps with painting, since the time I was studying in Albania, and later in France, I got in touch with new people and different situations: all that generated new doubts that sometimes proved to be hurtful, because they were triggering my insecurity, creating a feeling of uncertainty. And yet those doubts help me in my work.

MG&MR: How do they help you?

AS: The sense of beauty changed. The way the world was presented to me changed. What was given to see changed. The flux of the changes and the images they generated were of course important to my evolution, and for a while it was impossible for me to deal with certain problems through painting, photography, or still images. That's why I started working with video. I found that the ambiguity of moving images was more interesting and meaningful than the ambiguity of still images. Maybe it was just a personal problem, something that was simply related to the social and political changes in the world I was living in. Now I'm also working with photography, it feels as if I could have that gift back again, I mean this possibility of negotiating meanings all through one image. . . . Some borders are transparent, forgettable. Some others are not. The idea of an international, global, borderless world is an invention of the occidental culture, so it becomes its reality. Thus, the white cube becomes a place for global, international, borderless art, which is witness at the same time to a fragmentary world, made of prejudices, intolerance and separatism.

SHIRIN NESHAT Interview with Arthur C. Danto (2000)

ARTHUR C. DANTO: The last three years have been extremely productive for you, you've done four films. What were you doing before the films?

SHIRIN NESHAT: I graduated from UC-Berkeley in 1983 and moved soon after to New York City where I quickly came to the conclusion that art making wasn't going to be my profession. I felt what I was making was not substantial enough—and I was intimidated by the New York art scene. So I worked to earn money and took courses in various subjects. Soon after I met my future husband, who ran the Storefront for Art and Architecture, an alternative space in Manhattan. I dedicated the next ten years intensely to working with him at the Storefront, and that became my true education. Storefront functioned like a cultural laboratory, the program was quite cross disciplinary; I was constantly working with artists, architects, cultural critics, writers and philosophers. This exposure eventually led me to think about myself as an artist and I wanted to make artwork again. During those ten years I made practically no art and what I did make I was quite dissatisfied with and eventually destroyed. So it was only in 1993 that I began to seriously make artwork again.

AD: And those were photographs?

SN: Yes, I thought photography was the most appropriate medium for my subject as it had the realism that I needed. In the 1990s I finally began going back to Iran. I had been away for over ten years—since the Islamic Revolution. As I traveled back and forth a lot of things started to go through my mind, which eventually led me to develop the work that I have. My focus from the beginning was the subject of women in relation to the Iranian society and the revolution, so I produced a series of photographic images that explored that topic. . . .

I am very inspired by the new trend in Iranian cinema. In my opinion, it has been one positive aspect of the revolution, as it has in a way purified Iranian culture artistically by eliminating Western influences that had deeply infiltrated our culture. Before the revolution, Iranian film followed similar standards as in any commercial Western film, much of it was filled with superficiality, violence and sex. After the revolution, the government imposed

* Excerpted from the interview "Shirin Neshat by Arthur C. Danto," *BOMB* 73 (Fall 2000): 60–67. © Bomb Magazine, New Art Publications, and its Contributors. All rights reserved. The BOMB Digital Archive can be viewed at www.bombsite.com. Also by permission of the artist and Georges Borchardt, Inc., for Arthur C. Danto.

severe codes; filmmakers had to reformulate their ideas, and as a result a new form of cinema was born that thrived in the midst of all the governmental censorship. These films have been successful for their humanistic, simple and universal approach. They reveal so much about Iranian culture without being overly critical. . . .

 Turbulent was my first cinematic film. Prior to that, I had made a few videos which I consider very different; they were video installations, very sculptural, with no specific narrative, beginning or end. . . .

AD: There must have been a moment when the ideas that began to be expressed in *Turbulent* came to consciousness. You took a shift, a change in direction; did you feel yourself on the threshold of something quite different? . . .

SN: The first group of photographic work I produced in 1993 certainly reflected the point of view of an Iranian living abroad, looking back in time and trying to analyze and comprehend the changes that had taken place in Iran since the revolution. It was the approach of an artist who had been away for a long time, and it was an important turning point for me artistically and personally, as it became more than art making but a type of journey back to my native country. I was deeply invested in understanding the ideological and philosophical ideas behind contemporary Islam, most of all the origin of the revolution and how it had transformed my country. I knew the subject was very complex and broad so I minimized my focus to something tangible and specific. I chose to concentrate on the meanings behind "martyrdom," a concept which became the heart of the Islamic government's mission at the time, particularly during the Iran/Iraq War. It promoted faith, self-sacrifice, rejection of the material world, and ultimately, life after death. Mostly, I was interested in how their ideas of spirituality, politics and violence were and still are so interconnected and inseparable from one another. But after a few years, I felt that I had exhausted the subject and needed to move on. I no longer wanted to make work that dealt so directly with issues of politics. I wanted to make work that was more lyrical, philosophical and poetic. . . .

 When I first arrived in Iran, I was really taken by everything and desperately wanted to belong to the Iranian community again. It was almost a romantic return to Iran. *Turbulent* was the first work that no longer had the perspective of an artist distanced from her culture; it dealt with an issue that belonged to the present and revealed a new sense of intimacy and familiarity between myself and the subject. By this time, I had a pretty good understanding of the way in which Iranian society functioned. I had been traveling to Iran frequently and was working with an almost entirely Iranian crew.

AD: When you began to work on *Turbulent,* were you thinking of it as part of a trilogy— which is what, evidently, the three films constitute—or were you thinking of it as a single statement, which, as it turned out, led to two other films?

SN: I didn't think of it as a trilogy at first. It is just that one subject—one project led to the other. The topic of masculine and feminine in relation to the social structure of Iran started with *Turbulent.* As I finished it, I immediately moved on to making *Rapture,* which although very different, raised similar issues. Finally *Fervor* was made, which in my opinion closed the chapter on this series. What inspired me to make *Turbulent* was a strange experience I had on the streets of Istanbul, seeing a young, blind woman singing to make a little money; her music was extraordinary and the public gathered uncontrollably around her. I fell in love with her music, bought a cassette. Later I had her songs translated and became obsessed with how much her blindness—not having a visible audience—affected her music. . . .

 Turbulent is similar to *Rapture* in that both films are based on the idea of opposites,

visually and conceptually. The male singer represents the society's ideal man in that he sticks to the rules in his way of dressing and in his performance of a passionate love song written by the 13th-century Sufi poet Rumi. Opposite to him, the female singer is quite rebellious. She is not supposed to be in the theater, and the music she performs breaks all the rules of traditional Islamic music. Her music is free-form, improvised, not tied to language, and unpredictable, almost primal. . . .

An important aspect of *Turbulent* is that women in Iran are prohibited from singing in public, and there are no recordings by female musicians. The piece took off in various directions and brought about other important questions about the male and female contrast in relation to the social structure. The ultimate question was how each would go about reaching a level of mystical expression inherent in the Sufi music. . . .

Rapture followed the same framework. Once again, the women are the unpredictable force, they are the ones who break free. The men, from the beginning to the end, stay within the confinement of the fortress. This all ties back to what I believe is a type of feminism that comes from such a culture; on a daily basis the resistance you sense from the women is far higher than that of the men. Why? Because the women are the ones who are under extreme pressure; they are repressed and therefore they are more likely to resist and ultimately to break free. . . .

From my understanding, Western feminism is about reaching a certain level of equality between men and women. . . .

Iranian women, for example, feel that men and women have their own distinct roles and places, they are not competitive. . . . I believe their struggle is to reach an equilibrium necessary in a just and healthy society. They want the domestic responsibility—which actually gives them a lot of power. Where they suffer is in their inability to maintain their rights as women, for example in the areas of divorce, child custody, voting, etcetera.

AD: . . . Feminist theorists have said that the liberation of women also means the liberation of men. . . . There's a mutual liberation in that the future and destiny of male and female is quite open.

SN: It would be a generalization to speak about Islam as a whole, but I know in Iran women are quite powerful, unlike their clichéd image. What I try to convey through my work is that power, which is quite candid. In *Rapture,* the heart of the story is the women's journey from the desert to the sea; eventually a few leave on a small boat. This journey, the attempt to break free, for me symbolizes bravery, whether this leaving is for the purpose of committing suicide or reaching freedom, it does not matter. Those women remaining behind symbolize for me the idea of sacrifice. The film questions women's nature as opposed to men's, and shows how often women surprise us with their strength of purpose, particularly in moments of crisis.

AD: . . . I wanted to ask one thing about the titles. You've employed an extremely romantic vocabulary: turbulent, rapture, fervor—all psychological terms referring to states of extreme excitement. . . .

SN: What I look for in a title is suggestiveness, references that allow the viewers to draw their own interpretations. I thought *Turbulent,* for example, was about the woman's state of mind, she was clearly the one not at rest. In *Rapture,* I saw the meaning as a state of ecstasy.

AD: . . . It's just that American culture is not a particularly mystical one; ecstasy here means something like erotic rapture. There are analogies between mystical and erotic transport, and certainly the Persian poets were aware of that connotation. They tend, characteristically, in my recollection, to speak of religious ecstasy in terms of erotic metaphors.

SN: It's the same with *Fervor,* because it has its religious connotations but at the same time it could be sexual. Again, I was pointing toward the clash between sexual and carnal desire versus social control. . . .

The type of forbidden seduction that one experiences in that part of the world is of course very different from what one experiences here in the West. You're not supposed to make eye contact with the opposite sex. Every Iranian man and woman understands the dilemma, the problematics, and yet there is the joy of a simple exchange in a gaze. This type of social and religious control tends to heighten desire and the sexual atmosphere. Therefore, when there is a modest exchange it is the most magical, sexual experience. . . .

And the veil is an incredibly powerful icon in the way it empowers a woman sexually. It's supposed to be doing the opposite, but as you can tell, through a mere gaze the woman can excite men. These are the issues this project explored. I'm not sure it was understood in the West.

AD: I thought it was quite universal. It's a story that is told over and over again. How do men and women overcome the distances that are imposed between the genders?

SN: I approached *Fervor* as a way to close the chapter on this kind of gender curiosity that I've had. Finally, in *Fervor,* the issues are not about opposites, but about the commonality between the man and woman. The taboo surrounding sexuality concerns both men and women, but of course it is the woman who takes most of the heat. . . .

AD: Do you have any plans to work in Iran?

SN: It has been a dream for me to finally work in my own country. Slowly, I am advancing in that direction although the country is still in a state of flux so one never really knows if it is completely safe to work there or not. . . . In all my work, I am dealing with issues that address historical, cultural, sociopolitical ideas; but in the end, I want my work to transcend that and function on the most primal and emotional level. I think the music intensifies the emotional quality. Music becomes the soul, the personal, the intuitive and neutralizes the sociopolitical aspects of the work. This combination of image and music is meant to create an experience that moves the audience. It is an expectation that I have as an artist and I want that intensity from any work of art; I want to be deeply affected, almost like asking to have a religious experience. Beauty is important in relation to my work. It is a concept that is most universal, it goes beyond our cultural differences. . . .

It is particularly important in relation to my subject since in Islam, beauty is critical, as it directly ties to ideas of spirituality and love of God.

STAN DOUGLAS Evening (1994)

Historical Background

In the late 1960s there was a major paradigm shift in U.S. television journalism. There were, to be sure, many technical elaborations (the portable video recorder; live remote broadcasts; the transition to all-color regional broadcasting), but equally significant changes to news stagecraft were implemented, when that curious synthesis of journalism and entertainment

* Stan Douglas, "Evening" (1994); reprinted in *Stan Douglas* (London: Phaidon, 1998), 122–23. By permission of the author.

called "Happy Talk News" was introduced: no matter how bad the news is, present it with a happy face. This is what the format suggests on the most simple level, but it also meant the inclusion of "human interest stories," banter between co-anchors, and new techniques of vocal delivery (narcotic rhythms and peculiar descending inflections) that were a radical departure from the bone-dry styles of recitation passed on from radio announcing. Just as television news had the technical means to present social life in the U.S. with greater immediacy, it became more removed from that realm and increasingly obsessed with its own internal logic.

The chronically low-rated ABC-owned Chicago-area station WLS was the first to employ Happy Talk, and its huge ratings success led to the news format being imitated, almost instantaneously, across the United States. Then, as now, station managers justified their policies in terms of theorized audience approval and dollars earned but the introduction of Happy Talk may also be regarded as a hysterical response to the news of the late 1960s, and the conflicting demands of station owners, television advertisers, and audiences, because Happy Talk could be used to give closure to stories about the Vietnam War and civil dissent by theatrical rather than editorial means. As one might expect, older television journalists were not all that happy about being forced to research trivialities and then give them equal time with the frequently devastating news of the day, and the "Happy Talk" label was soon dropped and discredited, however the format itself remains the intrinsic structuring device of virtually all television news in North America.

Project Description

In *Evening* I have reconstructed through archival research of newspaper reports and television footage, two news days from January 1, 1969, and January 1, 1970 (roughly the epicenter of the adoption of Happy Talk by U.S. broadcasters). When the work is installed, three adjacent three-meter screens simultaneously present the differing approaches to the news peculiar to three fictionalized Chicago-area network affiliate stations, "WAMQ," "WBMB," and "WCSL." The sound system is arranged so that, in certain areas, a viewer may hear the polyphony of all three stations in concert or, when in front of a particular screen, is able to hear WAMQ undergo the transition to Happy Talk, WBMB maintain its paternal conventions, and WCSL perfect its Happy rhetoric. In addition to the United States' abiding war with Vietnam, the fulcrum stories reported are the Chicago Seven Trial and the first inquest into the assassination of Black Panther Deputy Chairman Fred Hampton. But none of these stories are reported in a way that reflects their complexity or irresolution. It should be remembered that *Evening* addresses the same medium that aided the U.S. Civil Rights Movement in the early 1960s by making local conflicts national and later, international issues, but which, within a decade, had begun to represent precipitates of the Movement as unreasoned or fragmented "special interests" lacking historical continuity. An analogue of this process of atomization is audible by way of the script, which I wrote to approximate a musical score. Polyphony is used to underline repetitions and differences in editorial treatment, certain stations solo when the others cut to commercial, and there are unisons of key words—such as when, at the beginning of each cycle, all of the news anchors simultaneously announce, "Good evening."

MAURICE BENAYOUN
So.So.So. (Somebody, Somewhere, Some Time) (2002–3)

So.So.So. is an interactive installation . . . that plunges the onlooker in the middle of the moment the one of photography which reveals a complex network of characteristic signs from our own experience of reality. What the visitor finds with the help of VR binoculars is a series of spherical panoramas which depict a moment, the same one, at 7.47 in the morning in different places involving different persons in different situations.

Somebody, Somewhere, Some Time.

Exploring these situations, the onlookers' eyes linger on specific details. They quickly glance at others desperately in quest of a meaning in the apparent banality of the scene. When they focus onto an element of the picture they slide from one scene to another. So doing, they conjure up the transitions, understanding the editing, now created, of which they are the involuntary cause. Thus sliding from one topic to another, from one thing to another, they do not at once understand that, what is actually displayed on the screen is their very own story that is being written.

As a matter of fact, on a wide screen—being discovered by the audience outside the action—is the trace of the onlooker's eyes painting the path of each visitor at their own pace. This is the 'Collective Retinal Memory,' a writing space, a dynamic palimpsest, in which, for some time, spreads out the story of the discovery, a particular reading that becomes a collective experience then. It is on the screen that can be seen the difference of the interpretations readable through the story of the moments of the individual attention.

From the Internet other readings are being developed simultaneously. The same pictures can be seen on line. The path of the Web users is written onto the Retinal Memory that becomes unique, displayed in real time in the exhibition and on demand on the Net. The shared writing space and the confronted looks make *So.So.So.* a thrilling experience in which the obscenity of the others' ongoing looks is unveiled by the CRM that, so doing, uncovers the intimate tropisms. This obscenity competes with the necessary complicity which reveals itself amid the fusion of the looks in a collective dynamic picture. In this nonlinear apparatus, the linearity of the narrative is built up by a chronology of individual experiences that erases an older trace, for a better transcription of a real time of the action.

Fiction blurs in a reality that it gradually pervades. Through their own paths, and in search of a meaning, the onlookers create explorations that are as many readings of the narrative. When their looks move from one clue to another, they then rearrange the chaos of information into an actual interpretation. That individual reading creates the new linearity which characterizes the fiction we know through a trace that is spread out at the surface of the Retinal Memory.

The literary narrative, like the movie narrative, is a written trace, intentional, organised as a discourse. The trace left by the user on the Collective Retinal Memory is [an] unintentional trace. Like the ephemeral print of our steps in the sand, it tells us where we have been and what we lingered over. But, like the footprint, it vanished, erased by time or by the new traces left by other people. This dynamic narrative inverts the narrative process. Facts exist before the text and even it results from their discovery. Reading becomes writing. Intentional or

* Maurice Benayoun, "*So.So.So. (Somebody, Somewhere, Some Time),*" text from artist's website (http://www .benayoun.com). Translation by Jean-Michel Benayoun. Also in Jeffrey Shaw and Peter Weibel, *Future Cinema: The Cinematic Imaginary After Film* (Cambridge, MA: MIT Press, 2003). By permission of the author.

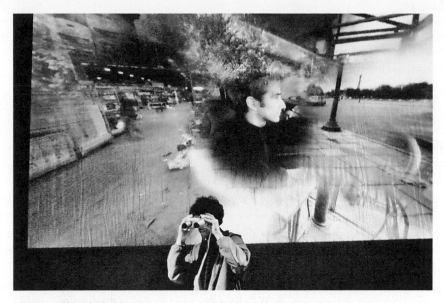

Maurice Benayoun, still from *So.So.So. (Somebody, Somewhere, Some Time)*, 2002–3, interactive installation including Internet, VR binoculars, and video projection, with music by Jean-Baptiste Barrière. By permission of the artist.

not, clues that fill each image/scene become anchors, letting in a story that everybody can tell himself and that the Retinal Memory bear[s] witness [to]. The synchronicity of the so presented events (7:47 am) contribute in telling a story that doesn't go on, all of it written at the present time. The virtual is not any more in the technology that defines it. It is in the apparently undefined number of paths. It is in the ghost highway where we would expect shortcuts and not too beaten paths. Our experience of the world is not so different and to live in the world is to interpret forever. That means to create links and connections between facts and things. To extract meaning from the surrounding chaos. Narrative is a peculiar intelligence of the world. The script is its transmission.

In the closed world of the fiction, there is a crime, necessarily. The accident justifies the attention. This is a hitch in the apparent daily life continuum. Sometime the crime might be the lack of hitch and moreover the fact to show the world as an organised dullness of its appearance. *So.So.So.* is the exhibit of a crime hidden by the anecdote and the banality. The tragedy is probably the fruit of the conjunction of the impossible achievement of the narration and the ineluctable finite of the duration of the show as well as the one of the duration of life.

Narrative fields are superimposed. Everything leads us to think that the story coming from the given scenes is in the frozen present of a unity of time which is, converted in space, the one of photography. As visitors, we are trying to find out how the characters are involved in a common story that sounds so common if we look at the surrounding environments. The sound work follows the same logic. In space, the interactive music composition by Jean-Baptiste Barrière mixes facts, superimposes clues. One can spot in the sound the obsessive presence of information, produced by the medias. Radio, the sound from TV that, like the leitmotiv coming from the press, reminds us that another story introduced as the one from the world, is going on, less intrusive but far away: a sniper in Washington, Chechens in Moscow, a front page with Saddam Hussein close to the one with G. W. Bush or Charlie Chaplin playing a Dictator for light opera. Two possible stories so far, the trivial story of our immedi-

ate experience of the world and the one of its media transcription. Where stays the real tragedy? Probably elsewhere, in the vanishing of author, ghost apparition in parking place, footprints left on the beach sand, far away from the world and from time, as if he wanted to escape from having to tell the story, to live, finally, its own story.

JORDAN CRANDALL Armed Vision (1999)

Today we witness the rise of an entirely new kind of image. It is the type of image that is streamed through a missile-mounted camera as it hurls toward its target: a speeding image propelled through space, at the window of a remotely-piloted vehicle, harnessed to a weapons system, its sights locked onto the object that it aims to obliterate. As in a videogame, we experience a rush of adrenaline, a strange combination of glee and dread as it explodes. We move from the machinic-camera point of view to the perspective that destroys all perspectives. Our line of vision fuses with the projectile. The militarized image hovers eerily in between.

Such an image may seem to have a short life span, but its apparatus endures. It is increasingly fueling changes in the visual field. We do not need to look to smartbomb-riding image streams to see these changes, for these new kinds of militarized formats appear everywhere today. They are components of powerful warfare complexes. They have joysticks attached to them. They are embedded in struggles among combative actors, bound up in escalating drives for the maintenance and manufacture of strategic advantage. They are part of new fitness regimes, new formats of adequacy and muscularity. They aim to both violate and shield. They are at work not only in government but increasingly in corporate sectors. In every case, they mark a renewed, compulsive militarization—joined to the relentless pace of technological innovation and the erotic charge of combat—that is everywhere a powerful force driving global societies.

I want to consider the forces that animate this kind of image, the power vectors that traverse it, and the militarized apparatus that it marks. I want to consider the kind of armed seeing that it registers and calls forth. In order to set the stage for this investigation, I want to consider another trajectory of representational development—a trajectory that runs alongside, and intertwines with, our familiar civilian narratives. These civilian narratives emphasize ground-level orientations—the advance or retreat of sightlines and perspectives along the terrestrial expanse of the earth; the arraying of montages or sequences along a horizontal axis or along the y-axis of spatial depth according to a civilian temporality (clocktime). In contrast, the orientation that I will consider could be regarded as that of the vertical or aerial: of looking downward rather than sideways.

This vertical orientation is but a figure—one that does not necessarily correspond to the kind of aerial images that we know. Accordingly, the distinctions between these figurative orientations of vertical and horizontal, or aerial and terrestrial, do not hold up for long. They bleed into one another. The aerial is simply figured in order to mark an orientation "extra" to groundlevel representational concerns. It is to mark another vector leading into the image, another perspective into the constitution of its assemblage. This "extra" orientation could

 * Jordan Crandall, excerpts from "Armed Vision" (1999), in Brian Holmes, ed., *Jordan Crandall: Drive,* with an introduction by Peter Weibel (Ostfildern, Germany: Hatje Cantz with Neue Galerie Graz am Landesmuseum Joanneum and ZKM Karlsruhe, 2000), 198–209. By permission of the author and the publishers.

mark a war machine in contrast to a work machine, or what, after Deleuze and Guattari, could be described as a speed-fluctuation-mobile system in contrast to a gravity-displacement, weight-height system. It indicates an apparatus of tracking movement, rather than simply representing movement. It is an orientation that is somehow ultimately not "for us." It is the perspective of a militarized, machinic surround, in which we are seen from a viewpoint not recognizably our own. Its gaze is not particular to the military but is shared by the nation-state, the corporate sector, and, increasingly, the social and subjective dimensions of individuals and groups. However I would like to primarily track its militarized aspects, while tapping in to its erotic dimension, especially in its capacity to relay across the public and private as part of a new process of identification.

We know, increasingly, that this atmospheric surround sees us, but we don't know how it sees or what its images of us look like. Are there even images in this situation? Machines don't necessarily need images to see. And just as images are increasingly eliminated in the context of vast flows of data that can be routed, sorted, and read by machines, human viewers or operators are not always necessary in emerging systems that advance ever more rapidly toward realtime activity. Sometimes the margin for strategic advantage is lost in the blink of an eyelid. And militarized perspectives require the maintenance of that strategic edge at all costs. This is why they exist, and why they cause distances to warp in their aftermath. But it is not really a matter of humans being eliminated so much as their functions being integrated into the circuits—as, concurrently, these circuits are incorporated into retooled bodies. Just as we know, to a certain extent, that humans are already cyborgs, we should also know that images are already machine-images. Images, as we have known them, are virtually ceasing to exist, as are the industrialized bodies that were necessary to see them. . . .

Armed vision is a vision upgraded and made safe against an unprocessed exteriority, a dangerous and unrealiable outside. Database society is driven by the threat of danger, a danger that militarized perspectives both counter and help to create. It relies on a sporadic state of emergency, a virtual panic sphere, around which the public rallies. Protective measures are installed in order to insure the public's safety—safety from bodily harm and from the possibility of its transmissions being assaulted (doctored, stolen, lost, rerouted). Under the possibility of danger, database and corporeality blend in a hybrid body—a statistical person—requiring new protections. Virtual prophylactics couch bodily, social, or territorial formations in a protective casing. This technology/image/movement cluster—a protective "vehicle"—helps to define an interior versus an exterior, and thus is embedded in a subjectivizing process. It helps to contour the physical parameter of the users that in/habit its confines. It is thus part of a process of incorporation. It helps to immerse its users into emerging systems and realities. It is thus part of a process of integration. It helps to protect against dangers while simultaneously helping to produce those dangers. It is thus part of an economy of security.

Computerization has brought massive changes in the development and coordination of databases, the speed and quality of communication with intelligence and tactical agencies, operations and combat teams. New technologies of tracking, identification, and networking have increased this infrastructure into a massive machinery of proactive supervision and tactical knowledge. Originally conceived for the defense and intelligence industries, these technologies have, after the cold war, rapidly spread into the law enforcement and private sectors. What would Benjamin have done with such apparatus as night vision technology, developed as result of the Vietnam war, which allows downlinked airborne cameras to track human signatures in total darkness? Militarized images no longer even need light. The axis of exposure has vanished. The form of seeing that these images call forth, conjoined with

data-flows and –bases, conspire to render them unnecessary. This new regime is not about presentation but about processing. The moving image has moved on. In the twenty-first century, we will no longer sit still.

MYRON W. KRUEGER Responsive Environments (1977)

Introduction

Man–machine interaction is usually limited to a seated man poking at a machine with his fingers or perhaps waving a wand over a data tablet. Seven years ago, I was dissatisfied with such a restricted dialogue and embarked on research exploring more interesting ways for men and machines to relate. The result was the concept of a responsive environment in which a computer perceives the actions of those who enter and responds intelligently through complex visual and auditory displays.

Over a period of time the computer's displays establish a context within which the interaction occurs. It is within this context that the participant chooses his next action and anticipates the environment's response. If the response is unexpected, the environment has changed the context and the participant must reexamine his expectations. The experience is controlled by a composition which anticipates the participant's actions and flirts with his expectations.

This paper describes the evolution of these concepts from their primitive beginnings to my current project, VIDEOPLACE, which provides a general tool for devising many interactions. Based on these examples an interactive art form is defined and its promise identified. While the environments described were presented with aesthetic intent, their implications go beyond art. In the final section, applications in education, psychology and psychotherapy are suggested.

GLOWFLOW

In 1969, I became involved in the development of GLOWFLOW, a computer art project conceived by Dan Sandin, Jerry Erdman and Richard Venezsky at the University of Wisconsin. It was designed in an atmosphere of encounter between art and technology. The viewer entered a darkened room in which glowing lines of light defined an illusory space. The display was accomplished by pumping phosphorescent particles through transparent tubes attached to the gallery walls. These tubes passed through opaque columns concealing lights which excited the phosphors. A pressure sensitive pad in front of each of the six columns enabled the computer to respond to footsteps by lighting different tubes or changing the sounds generated by a Moog synthesizer or the origin of these sounds. However, the artists' attitude toward the capacity for response was ambivalent. They felt that it was important that the environment respond, but not that the audience be aware of it. Delays were introduced between the detection of a participant and the computer's response so that the contemplative mood of the environment would not be destroyed by frantic attempts to elicit more responses.

While GLOWFLOW was quite successful visually, it succeeded more as a kinetic sculpture than as a responsive environment. However, the GLOWFLOW experience led me to a number of decisions:

* Myron W. Krueger, "Responsive Environments," in *Proceedings of American Federation of Information Processing Societies* 46 (June 13–16, 1977): 423–33. By permission of the author.

1. Interactive art is potentially a richly composable medium quite distinct from the concerns of sculpture, graphic art or music.

2. In order to respond intelligently the computer should perceive as much as possible about the participant's behavior.

3. In order to focus on the relationships between the environment and the participants, rather than among participants, only a small number of people should be involved at a time.

4. The participants should be aware of how the environment is responding to them.

5. The choice of sound and visual response systems should be dictated by their ability to convey a wide variety of conceptual relationships.

6. The visual responses should not be judged as art nor the sounds as music. The only aesthetic concern is the quality of the interaction.

METAPLAY

Following the GLOWFLOW experience, I conceived and directed METAPLAY which was exhibited in the Memorial Union Gallery of the University of Wisconsin for a month in 1970. It was supported by the National Science Foundation, the Computer Science Department, the Graduate School and the loan of a PDP-12 by Digital Equipment Corporation.

METAPLAY's focus reflected my reactions to GLOWFLOW. Interaction between the participants and the environment was emphasized; the computer was used to facilitate a unique real-time relationship between the artist and the participant. An 8' by 10' rear-projection video screen dominated the gallery. The live video image of the viewer and a computer graphic image drawn by an artist, who was in another building, were superimposed on this screen. Both the viewer and the artist could respond to the resulting image.

HARDWARE

The image communications started with an analogue data tablet which enabled the artist to draw or write on the computer screen. The person doing the drawing did not have to be an artist, but the term is used for convenience. One video camera, in the Computer Center, was aimed at the display screen of the Adage Graphic Display Computer. A second camera, a mile away in the gallery, picked up the live image of people in the room. A television cable transmitted the video computer image from the Computer Center to the gallery and the two signals were mixed so that the computer image overlaid the live image. The composite image was projected on the 8' × 10' screen in the gallery and was simultaneously transmitted back to the Computer Center where it was displayed on a video monitor providing feedback for the artist.

The artist could draw on the Adage screen using a data tablet. By using function switches, potentiometers and the teletype keyboard the pictures could be rapidly modified or the mode of drawing itself altered. In addition to the effects of simple drawings, the image could be moved around the screen, image size could be controlled and the picture could be repeated up to ten times on the screen displaced by variable X, Y and size increments. A tail of a fixed number of line segments could be drawn allowing the removal of a segment at one end while another was added at the opposite end. An image could be rotated in 3-space under control of the pen. Although this was not true rotation, the visual effect was similar. A simple set of transformations under potentiometer and tablet control yielded apparent animation of people's outlines. Finally, previously defined images could be recalled or exploded. While it might

seem that the drawing could be done without a computer, the ability to rapidly erase, recall and transform images required considerable processing and created a far more powerful means of expression than pencil and paper could provide.

INTERACTION

These facilities provided a rich repertoire for an unusual dialogue. The artist could draw pictures on the participants' images or communicate directly by writing words on the screen. He could induce people to play a game like Tic-Tac-Toe or play with the act of drawing, starting to draw one kind of picture only to have it transformed into another by interpolation.

LIVE GRAFFITI

One interaction derived from the artist's ability to draw on the image of the audience. He could add graffiti-like features or animate a drawn outline of a person so that it appeared to dance to the music in the gallery. The artist tried various approaches to involve people in the interaction. Failing to engage one person, he would seek someone more responsive. It was important to involve the participants in the act of drawing. However, the electronic wand designed for this purpose did not work reliably. What evolved was a serendipitous solution. One day as I was trying to draw on a student's hand, he became confused and moved it. When I erased my scribblings and started over, he moved his hand again. He did this repeatedly until it became a game. Finally, it degenerated to the point where I was simply tracking the image of his hand with the computer line. In effect, by moving his hand he could draw on the screen before him.

The relationship established with this participant was developed as one of the major themes of METAPLAY. It was repeated and varied until it became an aesthetic medium in itself. With each person we involved in this way, we tried to preserve the pleasure of the original discovery. After playing some graffiti games with each group that entered, we would focus on a single individual and draw around the image of his hand. After an initial reaction of blank bewilderment, the self-conscious person would make a nervous gesture. The computer line traced the gesture. A second gesture, followed by the line was the key to discovery. One could draw on the video screen with his finger! Others in the group, observing this phenomenon, would want to try it too. The line could be passed from one person's finger to another's. Literally hundreds of interactive vignettes developed within this simple communication channel.

Drawing by this method was a rough process. Pictures of any but the simplest shapes were unattainable. This was mainly because of the difficulty of tracking a person's finger. Happily, neither the artist nor the audience were concerned about the quality of the drawings. What was exciting was interacting in this novel way through a man–computer–video link spanning a mile.

PSYCHIC SPACE

The next step in the evolution of the responsive environment was PSYCHIC SPACE, which I designed and exhibited in the Memorial Union Gallery during May and June of 1971. It was implemented with the help of my students, the Computer Science Department and a National Science Foundation grant in Complex Information Processing.

PSYCHIC SPACE was both an instrument for musical expression and a richly composed,

interactive, visual experience. Participants could become involved in a softshoe duet with the environment, or they could attempt to match wits with the computer by walking an unpredictable maze projected on an 8' × 10' video screen.

HARDWARE

A PDP-11 had direct control of all sensing and sound in the gallery. In addition, it communicated with the Adage AGT-10 Graphic Display Computer at the Computer Center. The Adage image was transmitted over video cable to the gallery where it was rear-projected on the 8' × 10' screen. The participant's position on the floor was the basis for each of the interactions. The sensing was done by a 16' × 24' grid of pressure switches, constructed in 2' × 4' modules, each containing eight switches. Since they were electronically independent, the system was able to discriminate among individuals if several were present. This independence made it easy for the programming to ignore a faulty switch until its module was replaced or repaired. Since there were 16 bits in the input words of the PDP-11, it was natural to read the 16 switches in each row across the room in parallel. Digital circuitry was then used to scan the 24 rows under computer control.

INPUT AND INTERACTION

Since the goal was to encourage the participants to express themselves through the environment, the program automatically responded to the footsteps of people entering the room with electronic sound. We experimented with a number of different schemes for actually generating the sounds based on an analysis of people's footsteps. In sampling the floor 60 times per second we discovered that a single footstep consisted of as many as four discrete events: lifting the heel, lifting the toe, putting the heel down and putting the ball of the foot down. The first two were dubbed the "unfootstep." We could respond to each footstep or unfootstep as it occurred, or we could respond to the person's average position. A number of response schemes were tried, but the most pleasing was to start each tone only when a new switch was stepped on and then to terminate it on the next "unfootstep." Thus it was possible to get silence by jumping, or by lifting one foot, or by putting both feet on the same switch.

Typical reaction to the sounds was instant understanding, followed by a rapid-fire sequence of steps, jumps and rolls. This phase was followed by a slower more thoughtful exploration of the environment in which more subtle and interesting relationships could be developed. In the second phase, the participant would discover that the room was organized with high notes at one end and low notes at the other. After a while, the keyboard was abruptly rotated by 90 degrees.

After a longer period of time an additional feature came into play. If the computer discovered that a person's behavior was characterized by a short series of steps punctuated by relatively long pauses, it would use the pause to establish a new kind of relationship. The sequence of steps was responded to with a series of notes as before; however, during the pause the computer would repeat these notes again. If the person remained still during the pause, the computer assumed that the relationship was understood. The next sequence of steps was echoed at a noticeably higher pitch. Subsequent sequences were repeated several times with variations each time. This interaction was experimental and extremely difficult to introduce clearly with feedback alone, i.e., without explicit instructions. The desire was for a man-machine dialogue resembling the guitar duel in the film "Deliverance."

Maze—A Composed Environment

The maze program focused on the interaction between one individual and the environment. The participant was lured into attempting to navigate a projected maze. The intrigue derived from the maze's responses, a carefully composed sequence of relations designed to constitute a unique and coherent experience.

HARDWARE

The maze itself was not programmed on the PDP-11, but on the Adage located a mile away in the Computer Center. The PDP-11 transmitted the participant's floor coordinates across an audio cable to the Adage. The data was transmitted asynchronously as a serial bit stream of varying pulse widths. The Adage generated the maze image which was picked up by a TV camera and transmitted via a video cable back to the Union where it was rear-screen projected to a size of 8' × 10'.

INTERACTION

The first problem was simply to educate the person to the relationships between the floor and the screen. Initially, a diamond with a cross in it representing the person's position appeared on the screen. Physical movement in the room caused the symbol to move correspondingly on the screen. As the participant approached the screen, the symbol moved up. As he moved away, it moved down. The next step was to induce the person to move to the starting point of the maze, which had not yet appeared on the screen. To this end, another object was placed on the screen at the position which would be the starting point of the maze. The viewer unavoidably wondered what would happen if he walked his symbol to the object. The arrival of his symbol at the starting point caused the object to vanish and the maze to appear. Thus confronted with the maze, no one questioned the inevitability of walking it.

SOFTWARE BOUNDARIES

Since there were no physical constraints in the gallery, the boundaries of the maze had to be enforced by the computer. Each attempt to violate a boundary was foiled by one of many responses in the computer's repertoire. The computer could move the line, stretch it elastically, or move the whole maze. The line could disappear, seemingly removing the barrier, except that the rest of the maze would change simultaneously so no advantage was gained. In addition, the symbol representing the person could split in half at the violated boundary, with one half held stationary while the other half, the alter ego, continued to track movement. However, no progress could be made until the halves of the symbol were reunited at the violated boundary.

Even when the participant was moving legally, there were changes in the program contingent upon his position. Several times, as the goal was approached, the maze changed to thwart immediate success. Or, the relationship between the floor and the maze was altered so that movements that once resulted in vertical motion, now resulted in horizontal motion. Alternatively, the symbol representing the participant could remain stationary while the maze moved.

Ultimately, success was not allowed. When reaching the goal seemed imminent, additional

boundaries appeared in front of and behind the symbol, boxing it in. At this point, the maze slowly shrank to nothing. While the goal could not be reached, the composed frustration made the route interesting.

EXPERIENCE

The maze experience conveyed a unique set of feelings. The video display space created a sense of detachment enhanced by the displaced feedback; movement on the horizontal plane of the floor translated onto the vertical plane of the screen. The popular stereotype of dehumanizing technology seemed fulfilled. However, the maze idea was engaging and people became involved willingly. The lack of any other sensation focused attention completely on this interaction. As the experience progressed, their perception of the maze changed. From the initial impression that it was a problem to solve, they moved to the realization that the maze was a vehicle for whimsy, playing with the concept of a maze and poking fun at their compulsion to walk it.

VIDEOPLACE

For the past two years I have been working on a project called VIDEOPLACE, under the aegis of the Space Science and Engineering Center of the University of Wisconsin. This work is funded by the National Endowment for the Arts and the Wisconsin Arts Board. A preliminary version was exhibited at the Milwaukee Art Center for six weeks beginning in October 1975. The development of VIDEOPLACE is still under way and several more years will be required before its potential is fully realized both in terms of implementing the enabling hardware and exploring its compositional possibilities.

VIDEOPLACE is a conceptual environment with no physical existence. It unites people in separate locations in a common visual experience, allowing them to interact in unexpected ways through the video medium. The term VIDEOPLACE is based on the premise that the act of communication creates a place that consists of all the information that the participants share at that moment. When people are in the same room, the physical and communication places are the same. When the communicants are separated by distance, as in a telephone conversation, there is still a sense of being together although sight and touch are not possible. By using television instead of telephone, VIDEOPLACE seeks to augment this sense of place by including vision, physical dimension and a new interpretation of touch.

VIDEOPLACE consists of two or more identical environments which can be adjacent or hundreds of miles apart. In each environment, a single person walks into a darkened room where he finds himself confronted by an 8' × 10' rear-view projection screen. On the screen he sees his own life-size image and the image of one or more other people. This is surprising in itself, since he is alone in the room. The other images are of people in the other environments. They see the same composite image on their screens. The visual effect is of several people in the same room. By moving around their respective rooms, thus moving their images, the participants can interact within the limitations of the video medium.

It is these apparent limitations that I am currently working to overcome. When people are physically together, they can talk, move around the same space, manipulate the same objects and touch each other. All of these actions would appear to be impossible within the VIDEOPLACE. However, the opposite is true. The video medium has the potential of being more rich and variable in some ways than reality itself.

It would be easy to allow the participants to talk, although I usually preclude this, to force people to focus on the less familiar kinds of interaction that the video medium provides. A sense of dimension can be created with the help of computer graphics, which can define a room or another spatial context within which the participants appear to move around. Graphics can also furnish this space with artificial objects and inhabit it with imaginary organisms. The sense of touch would seem to be impossible to duplicate. However, since the cameras see each person's image in contrast to a neutral background, it is easy to digitize the outline and to determine its orientation on the screen. It is also easy to tell if one person's image touches another's, or if someone touches a computer graphic object. Given this information the computer can make the sense of touch effective. It can currently respond with sounds when two images touch and will ultimately allow a person's image to pick up a graphic object and move it about the screen.

While the participants' bodies are bound by physical laws such as gravity, their images could be moved around the screen, shrunk, rotated, colorized and keyed together in arbitrary ways. Thus, the full power of video processing could be used to mediate the interaction and the usual laws of cause and effect replaced with alternatives composed by the artist.

The impact of the experience will derive from the fact that each person has a very proprietary feeling towards his own image. What happens to his image happens to him. In fact, when one person's image overlaps another's, there is a psychological sensation akin to touch. In VIDEOPLACE, this sensation can be enhanced in a number of ways. One image can occlude the other. Both images can disappear where they intersect. Both images can disappear except where they intersect. The intersection of two images can be used to form a window into another scene so two participants have to cooperate to see a third.

VIDEOPLACE need not involve more than one participant. It is quite possible to create a compelling experience for one person by projecting him into this imaginary domain alone. In fact the hardware/software system underlying VIDEOPLACE is not conceived as a single work but as a general facility for exploring all the possibilities of the medium to be described next.

Response Is the Medium

The environments described suggest a new art medium based on a commitment to real-time interaction between men and machines. The medium is comprised of sensing, display and control systems. It accepts inputs from or about the participant and then outputs in a way he can recognize as corresponding to his behavior. The relationship between inputs and outputs is arbitrary and variable, allowing the artist to intervene between the participant's action and the results perceived. Thus, for example, the participant's physical movement can cause sounds or his voice can be used to navigate a computer defined visual space. It is the composition of these relationships between action and response that is important. The beauty of the visual and aural response is secondary. Response is the medium!

The distinguishing aspect of the medium is, of course, the fact that it responds to the viewer in an interesting way. In order to do this, it must know as much as possible about what the participant is doing. It cannot respond intelligently if it is unable to distinguish various kinds of behavior as they occur.

The environment might be able to respond to the participant's position, voice volume or pitch, position relative to prior position or the time elapsed since the last movement. It could also respond to every third movement, the rate of movement, posture, height, colors of clothing or time elapsed since the person entered the room. If there were several people in the

room, it might respond to the distance separating them, the average of their positions or the computer's ability to resolve them, i.e., respond differently when they are very close together.

In more complex interactions like the maze, the computer can create a context within which the interaction occurs. This context is an artificial reality within which the artist has complete control of the laws of cause and effect. Thus the actions perceived by the hardware sensors are tested for significance within the current context. The computer asks if the person has crossed the boundary in the maze or has touched the image of a particular object. At a higher level the machine can learn about the individual and judge from its past experience with similar individuals just which responses would be most effective.

Currently, these systems are constrained by the total inability of the computer to make certain very useful and for the human very simple perceptual judgments, such as whether a given individual is a man or a woman or is young or old. The perceptual system will define the limits of meaningful interaction, for the environment cannot respond to what it cannot perceive. To date the sensing systems have included pressure pads, ultrasonics and video digitizing.

As mentioned before, the actual means of output are not as important in this medium as they would be if the form were conceived as solely visual or auditory. In fact, it may be desirable that the output not qualify as beautiful in any sense, for that would distract from the central theme: the relationship established between the observer and the environment. Artists are fully capable of producing effective displays in a number of media. This fact is well known and to duplicate it produces nothing new. What is not known and remains to be tested is the validity of a responsive aesthetic.

It is necessary that the output media be capable of displaying intelligent, or at least composed reactions, so that the participant knows which of his actions provoked it and what the relationship of the response is to his action. The purpose of the displays is to communicate the relationships that the environment is trying to establish. They must be capable of great variation and fine control. The response can be expressed in light, sound mechanical movement, or through any means that can be perceived. So far computer graphics, video generators, light arrays and sound synthesizers have been used.

Control and Composition

The control system includes hardware and software control of all inputs and outputs as well as processing for decisions that are programmed by the artist. He must balance his desire for interesting relationships against the commitment to respond in real-time. The simplest responses are little more than direct feedback of the participant's behavior, allowing the environment to show off its perceptual system. But far more sophisticated results are possible. In fact, a given aggregation of hardware sensors, displays and processors can be viewed as an instrument which can be programmed by artists with differing sensitivities to create completely different experiences. The environment can be thought of in the following ways:

1. An entity which engages the participant in a dialogue. The environment expresses itself through light and sound while the participant communicates with physical motion. Since the experience is an encounter between individuals, it might legitimately include greetings, introductions and farewells—all in an abstract rather than literal way. The problem is to provide an interesting personality for the environment.

2. A personal amplifier. One individual uses the environment to enhance his ability to interact with those within it. To the participants the interaction might appear similar to that

described above. The result would be limited by the speed of the artist's response but improved by his sensitivity to the participants' moods. The live drawing interaction in METAPLAY could be considered an example of this approach.

3. An environment which has sub-environments with different response relationships. This space could be inhabited by artificial organisms defined either visually or with sound. These creatures can interact with the participants as they move about the room.

4. An amplifier of physical position in a real or artificially generated space. Movements around the environment would result in much larger apparent movements in the visually represented space. A graphic display computer can be used to generate a perspective view of a modelled space as it would appear if the participant were within it. Movements in the room would result in changes in the display, so that by moving only five feet within the environment, the participant would appear to have moved fifty feet in the display. The rules of the modelled space can be totally arbitrary and physically impossible, e.g. a space where objects recede when you approach them.

5. An instrument which the participants play by moving about the space. In PSYCHIC SPACE the floor was used as a keyboard for a simple musical instrument.

6. A means of turning the participant's body into an instrument. His physical posture would be determined from a digitized video image and the orientation of the limbs would be used to control lights and sounds.

7. A game between the computer and the participant. This variation is really a far more involving extension of the pinball machine, already the most commercially successful interactive environment.

8. An experimental parable where the theme is illustrated by the things that happen to the protagonist—the participant. Viewed from this perspective, the maze in PSYCHIC SPACE becomes pregnant with meaning. It was impossible to succeed, to solve the maze. This could be a frustrating experience if one were trying to reach the goal. If, on the other hand, the participant maintained an active curiosity about how the maze would thwart him next, the experience was entertaining. Such poetic composition of experience is one of the most promising lines of development to be pursued with the environments.

Implications of the Art Form

For the artist the environment augurs new relationships with his audience and his art. He operates at a metalevel. The participant provides the direct performance of the experience. The environmental hardware is the instrument. The computer acts much as an orchestra conductor controlling the broad relationships while the artist provides the score to which both performer and conductor are bound. This relationship may be a familiar one for the musical composer, although even he is accustomed to being able to recognize one of his pieces, no matter who is interpreting it. But the artist's responsibilities here become even broader than those of a composer who typically defines a detailed sequence of events. He is composing a sequence of possibilities, many of which will not be realized for any given participant who fails to take the particular path along which they lie.

Since the artist is not dedicated to the idea that his entire piece be experienced he can deal with contingencies. He can try different approaches, different ways of trying to elicit participation. He can take into account the differences among people. In the past, art has often been a one-shot, hit-or-miss proposition. A painting could accept any attention paid it, but could do little to maintain interest once it had started to wane. In an environment the loss of

attention can be sensed as a person walks away. The medium can try to regain attention and upon failure, try again. The piece has a second strike capability. In fact it can learn to improve its performance, responding not only to the moment but also to the entire history of its experience.

In the environment, the participant is confronted with a completely new kind of experience. He is stripped of his informed expectations and forced to deal with the moment in its own terms. He is actively involved, discovering that his limbs have been given new meaning and that he can express himself in new ways. He does not simply admire the work of the artist; he shares in its creation. The experience he achieves will be unique to his movements and may go beyond the intentions of the artist or his understanding of the possibilities of the piece.

Finally, in an exciting and frightening way, the environments dramatize the extent to which we are savages in a world of our own creation. The layman has extremely little ability to define the limits of what is possible with current technology and so will accept all sorts of cues as representing relationships which in fact do not exist. The constant birth of such superstitions indicates how much we have already accomplished in mastering our natural environment and how difficult the initial discoveries must have been.

Applications

The responsive environment is not limited to aesthetic expression. It is a potent tool with applications in many fields. VIDEOPLACE clearly generalizes the act of telecommunication. It creates a form of communication so powerful that two people might choose to meet visually, even if it were possible for them to meet physically. While it is not immediately obvious that VIDEOPLACE is the optimum means of telecommunication, it is reasonably fair to say that it provides an infinitely richer interaction than Picturephone allows. It broadens the range of possibilities beyond current efforts at teleconferencing. Even in its fetal stage, videoplace is far more flexible than the telephone is after one hundred years of development. At a time when the cost of transportation is increasing and fiber optics promise to reduce the cost of communication, it seems appropriate to research the act of communication in an intuitive sense as well as in the strictly scientific and problem-solving approaches that prevail today.

Education

Responsive environments have tremendous potential for education. Our entire educational system is based on the assumption that thirty children will sit still in the same room for six hours a day and learn. This phenomenon has never been observed in nature and it's the exception in the classroom, where teachers are pitted against children's natural desire to be active. The responsive environments offer a learning situation in which physical activity is encouraged. It is part of the process. An environment like VIDEOPLACE has an additional advantage. It gives the child a life-size physically identical alter ego who takes part in composed learning adventures on the video screen. In a fully developed VIDEOPLACE the size and position of the child's image on the screen would be independent of actual location in the room. In an interactive Sesame Street a child would be mesmerized as his own miniaturized image was picked up by a giant Big Bird. Conversely he would be delighted if the scales were reversed and he were able to pick up the image of a tiny adult teacher who spoke to him from his hand. The most overworked educational cliché, "experience is the best teacher," would

have new meaning in this context. The environments provide an experience which can be composed and condensed to demonstrate an educational point.

While it is easy to generate examples of how the environments can be used to teach traditional subjects, their significance does not lie only in their ability to automate traditional teaching. More important, they may revolutionize what we teach as well as how we teach. Since the environments can define interesting relationships and change them in complex ways, it should be possible to create interactions which enrich the child's conceptual experience. This would provide the child with more powerful intellectual structures within which to organize the specific information he will acquire later. The goal would be to sophisticate the child, not to feed him facts.

Psychology

Since the environments can monitor the participants' actions and respond with visual and auditory feedback, it is natural to consider their application to the study of human behavior. The use of the computer allows an experimenter to generate patterns and rhythms of stimuli and reinforcers. In addition, the ability to deal with gross physical behavior would suggest new experimental directions. For instance, perception could be studied as part of physical behavior and not as a sedentary activity distinct from it. Also, an environment like VIDEOPLACE is very general. The same aggregate of hardware and software could be programmed to control a broad range of experiments. The scheduling of different experiments could be interspersed because only the software would have to be changed.

Since the university students used as subjects in many experiments are quite sophisticated about the concerns of psychologists, what is often being studied is the self-conscious behavior of people who know they are in an experiment and are trying to second-guess it. On the other hand, environments open to the public offer a source of spontaneous behavior. It is quite easy for the computer to take statistics without interfering with the experience. Or, interactions can be composed to test specific experimental hypotheses.

Psychotherapy

It is also worth considering the application of responsive environments to psychotherapy. Perhaps most important for a psychotherapist is the ability of the environment to evoke and expand behavior. We have found in the past that people alone in a dark room often become very playful and flamboyant—far more so than they are in almost any other situation. Since the environment is kept dark, the patient has a sense of anonymity; he can do things that he might not do otherwise. The fact that he is alone in the dark serves to protect him both from his image of himself and from his fear of other people. The darkness also is a form of sensory deprivation which might prevent a patient from withdrawing. If he is to receive any stimulation at all, it must be from acting within the environment. Once he acts, he can be reinforced for continuing to act.

In the event that the subject refuses to act, the environment can focus on motions so small as to be unavoidable and respond to these and as time goes by encourage them, slowly expanding them into larger behavior, ultimately leading the patient to extreme or cathartic action.

In certain situations the therapist essentially programs himself to become mechanical and predictable, providing a structure that the patient can accept which can be expanded slowly beyond the original contract. It is possible that it would be easier to get a patient to trust a

mechanical environment and completely mechanized therapy. Once the patient was acting and trusting within the environment, it would be possible to slowly phase in some elements of change, to generalize his confidence. As time went by, human images and finally human beings might be added. At this point, the patient could venture from his responsive womb, returning to it as often as needed.

Conclusion

The responsive environment has been presented as the basis for a new aesthetic medium based on real-time interaction between men and machines. In the long range it augurs a new realm of human experience, artificial realities which seek not to simulate the physical world but to define arbitrary, abstract and otherwise impossible relationships between action and result. In addition, it has been suggested that the concepts and tools of the responsive environments can be fruitfully applied in a number of fields.

What perhaps has been obscured is that these concepts are the result of a personal need to understand and express the essence of the computer in humanistic terms. An earlier project to teach people how to use the computer was abandoned in favor of exhibits which taught people about the computer by letting them experience it. METAPLAY, PSYCHIC SPACE and VIDEOPLACE were designed to communicate an affirmative vision of technology to the lay public. This level of education is important, for our culture cannot continue if a large proportion of our population is hostile to the tools that define it.

We are incredibly attuned to the idea that the sole purpose of our technology is to solve problems. It also creates concepts and philosophy. We must more fully explore these aspects of our inventions, because the next generation of technology will speak to us, understand us, and perceive our behavior. It will enter every home and office and intercede between us and much of the information and experience we receive. The design of such intimate technology is an aesthetic issue as much as an engineering one. We must recognize this if we are to understand and choose what we become as a result of what we have made.

PETER WEIBEL Project and Film Concept (1967–68)

I think	about film projections through walls, to project on a nightly stroll horror and panic into the house of citizens, to facilitate prisoners' masturbation
I have	thought about a film in cinemascope which shows from the beginning, in natural size, how a spider reproduces, begins to spin her web, and lasts until the cobweb covers the entire screen
I think	about films as radiations, waves, corpuscles
I think	about films which can film my thoughts, so they become more illustrative to myself
I think	about projections on the ocean floor, to again be able to enjoy a landscape

 * Peter Weibel, excerpt from "Projekt und Konzeptfilme" (1967–68), in *Protokolle '82: Zeitschrift für Literatur und Kunst,* vol. 2, ed. Otto Breicha with Kulturamt der Stadt Wien (Vienna: Jugend und Volk, 1982): 72. Translation by Matthias Visser. By permission of the author.

I think	about chemically prepared screens which swell and explode from beams of light and warmth: a line with the beam over the screen, and a steaming scar remains
I think	about hundreds of spectators whose eyebrows I shave with laserbeams, with the laserknife
I think	about the projections of beams, which destroy or hyperactivate the braincells (brain-center nerves) of spectators: the mute stagger outside, in linguistic confusion salivating, the word love becomes incomprehensible, constant shifting and sighing
I think	about holographic projections: feasts of celebrities at which everyone is an intruder, an interchange of landscapes (Vienna woods for Eskimos and Taiga in Vienna)
I think	about magnetic communication so I can produce my body in every desired shape: a round ball while running down a hill, a string in front of locked doors, flat like a thousand in an emergency
I think	about an exactly calculated generation of ultrasound able to create an artificial earthquake: between every row gaps a crack of 10 cm
I think	about really funny, but not real films
I think	often of porno-films
	glasses with an incorporated radio, tv or . . .

JEFFREY SHAW *The Legible City* (1988–90)

The viewer uses a bicycle to simulate travelling in a virtual three dimensional urban space. The city's architecture is represented by solid letters and words that can be read while bicycling. Between reality and representation, between the city and its simulation, there is the psychogeography of the vicarious experience. . . .

The spectator is able to use a bicycle to simulate travelling in a virtual representation of a city. This city is constituted by solid three dimensional letters that form words and sentences along the sides of the streets. These words and sentences are placed so that they conform to the physical plan and scale of actual cities (Manhattan, Amsterdam), following their particular organisation of streets, intersections, parks, canals, etc. Thus in this work the city's original architecture of buildings is completely replaced by a new architecture of text.

Bicycling through this city of words is consequently a journey of reading. Choosing direction, choosing where to turn, is a choice of texts and their juxtaposition, and the identity of this city emerges in the conjunction of meanings these words generate as they emerge along the bicyclist's path.

The bicyclist is completely free to move anywhere in this three dimensional database—not just along the streets but also across and between and through the buildings of letters.

The image of this city is video projected onto a large video screen in front of the bicycle

* Jeffrey Shaw, excerpts from "*The Legible City*" (1988–90), in *The Legible City: An Interactive Installation by Jeffrey Shaw in Cooperation with Dirk Groeneveld and Gideon May* (Amsterdam: Colophon, 1990), n.p. By permission of the author.

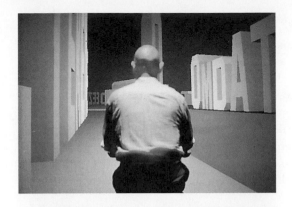

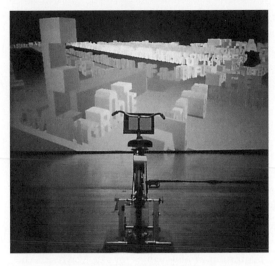

Jeffrey Shaw, *The Legible City,* 1988–90,
interactive computer graphic installation.
By permission of the artist.

which is fixed to the floor in a darkened room. The image itself is computer generated in real
time in response to data transmitted from the bicycle. The bicyclist controls his/her speed
and direction of movement by pedalling faster or slower and by turning the steering handle.
The result is a quite accurate simulation of the normal experience of bicycling. Just in front
of the bicycle there is a small liquid crystal video screen which shows a ground plan of the
city with a moving dot that represents the bicyclist's location there.

Manhattan Version 1988–89 (Text in English)

In this first realised version of this work, the virtual space in which the bicyclist can travel is
based on the ground plan of part of Manhattan—the area boundaried by 34th and 66th Streets,
and Park and 11th Avenues. The texts written by Dirk Groeneveld are eight separate fictional
storylines. They have a particular relationship to Manhattan, being monologues by ex-Mayor
Koch, Frank Lloyd Wright, Donald Trump, Noah Webster, a cab driver, a tour guide, a "con"
man and an ambassador. Each storyline has a specific location in the city, and each is visually
identified by the particular colour of its letters. Thus the bicyclist can choose to follow one
storyline by following its letter colour, and also recognise the transitions he/she makes from
one text to another because the colour changes.

The area represented is the old inner city and the canals as far as the 19th century boundary. Whereas in the Manhattan version all the letters were the same size, here the letters are individually scaled to conform to the size of the buildings they replace, creating a quite literal representation of the actual architectural forms and skyline of Amsterdam. Accordingly the colouring of the letters is a range of brick and stone tones. The texts are largely factual—they are edited by Dirk Groeneveld from archive documents concerning actual events that occurred in Amsterdam from the 15th to the 19th centuries, and they are located in those areas of the city to which they refer. The vocabulary and spelling of the old Dutch language as used in the sources is respected, which reflects the historicity of Amsterdam's architecture.

ROY ASCOTT Behaviourables and Futuribles (1967)

When art is a form of behaviour, software predominates over hardware in the creative sphere. Process replaces product in importance, just as system supersedes structure.

Consider the art object in its total process: a behaviourable in its history, a futurible in its structure, a trigger in its effect.

Ritual creates a unity of mood. We need a grand rite of passage to take us from this fag end of the machine age into the fresh new world of the cybernetic era.

Just as our environment is becoming more and more automatic, so our habitually automatic behaviour becomes less taken for granted and more conscious and examined.

Now that we see that the world is all process, constant change, we are less surprised to discover that our art is all about process too. We recognise process at the human level as behaviour, and we are beginning to understand art now as being essentially behaviourist.

Object-hustlers! Reduce your anxiety! Process culture and behaviourist art need not mean the end of the Object, as long as it means the beginning of new values for art. Maybe the behaviourist art object will come to be read like the palm of your hand. Instead of figuration— prefiguration: the delineation of futuribles. Pictomancy—the palmistry of paintings—divination of possible futures by structural analysis. Art as apparition? Parapsychology as a Courtauld [Institute] credit?

Cézanne's structuralism reflected a world flooded with physical data. Our world is flooded with behavioural data. How does that grab you?

Social inquisitiveness is a factor we would like to reinforce.

All in all we are still bound up with the search for myths. But the context will be biological and behavioural—zooming through the micro/macro levels. Get ready for the great *biomyths,* visceral legends.

Imagine this game. Groups of people with highly constrained artificial behaviours moving through zones with different functions (like: magic, camouflage, enlargement, reversal, disparity). Gives you: zone-shifts, time-shifts, identity-shifts. No light-pen needed to work out that potential.

Dare we talk about art and social modelling?

We are very much concerned with generating futuribles—maybe that's because the more we can dream up alternative futures the more changeable the present can become. And *change*

* Roy Ascott, "Behaviourables and Futuribles" (1967), *Control* 5 (1970): n.p. By permission of the author.

is what we are all about—change for its own sake. That is the essence of behaviourist art, and generating change is the aim of the behaviourist artist.

We could talk about the levels of resolution for examining two classes of art system—the discrete and the continuous. That's like classical and behaviourist art.

How about the notion of secret reciprocity?

Cybernetics will have come of age when we no longer notice the hardware, where the interface is minimal. Same goes for art?

The cybernetic age is an age of silences. Same goes for music?

Artist on the campus. We can create new rituals in the centres of learning. We can introduce art as visual matrix for the varied discourse of a university. To hell with commissioned monuments!

Is it useful to discuss the thermodynamics of an artwork? An artwork is *hot* when it is densely stacked with information bits, highly organised and rigidly determined. Hot artwork admits of very little feedback in the system artifact/observer. It's really a one way channel; pushing a message from the artist, out through the artwork into the spectator.

Call it *cool* when the information bits are loosely stacked, of uncertain order, not clearly connected, ambiguous, entropic. Then the system allows the observer to participate, projecting his own sense of order or significance into the work, or setting up resonances by quite unpredicted interaction with it. We must also consider the cut-out mechanism which operates when an artwork overheats; when it is too hot, too densely stacked with an overburdened accumulation of bits, a sort of infinitely inclusive field. Then the system switches to a *very cool* state and feedback of a high order is possible.

Behaviourist art has two principal aspects—the biological and the social. It will be more or less visceral, more or less groupy.

Great art sets up systems of attitudes which can bring about the necessary imbalance and dispersal in society whilst maintaining cultural cohesion. For a culture to survive it needs internal acrimony (irritation), reciprocity (feedbacks), and variety (change). Enter art.

With heart-swopping behind us, what about behaviour-transplants?

The process structuring of artworks must inevitably reflect the substructure of behaviours in our cybernated ecology. Gives you: video analogues of processes which may trigger new behaviours.

Art now comes out of a passionate affair with the future. Let's take into account ESP, astrology, divination by tarot, the whole psychic scene, and work out scenarios for the astral plane. Let the mediums give the message. Remember! Black and white magic is easily reproduced.

If we are to keep art schools let them be structured as homeostatic organisms, living, adaptive instruments for generating creative thought and action. But first—more artists and scholars—fewer clerks and boy scouts. No more phoney-liberal blind man's bluff. Within a behaviourist framework the creative interplay of reason, passion and chance can take place.

The CAM-concept is essentially a futurible—anticipatory and speculative, depending for its viability on an understanding of the past. As a projection of our behaviour-based culture it is intended to be a scenario which is neither surprise-free or definitive. It is an Alternative. The idea of the alternative or multifold alternatives is becoming the very core of art as it progresses. As in science and sociology, to which it aspires from time to time to relate, generating alternative futures seems to be essential to the internal development of art.

Art creates mythic futures. The mythology of change and uncertainty and the ritualisation of the will to form combine in behaviourist art. "Only through myth and the structures it

requires can we combine the necessary paradox of definition and ambiguity, of order and uncertainty, of the tangible and the infinite." Levi-Strauss.

In the post-industrial society it is not technology that will carry us through so much as psychotechnology. That may take us beyond Skinner's behavioural engineering into the shadow lands, the futuribles, the speculative, astrological, dreamed-up, out-of-body, *future behaviours*. We may not have reached the frontiers of parapsychology, but when we do—wham! Instant communication with *no* media. Total telepathy, waves of alternative behaviours surging on from creative impulses of the mind. A hardline software culture, always being rerouted, conditioned only to branch.

Art is now a form of behaviour.

Message ends.

Is There Love in the Telematic Embrace? (1990)

The past decade has seen the two powerful technologies of computing and telecommunications converge into one field of operations that has drawn into its embrace other electronic media, including video, sound synthesis, remote sensing, and a variety of cybernetic systems. These phenomena are exerting enormous influence upon society and on individual behavior: they seem increasingly to be calling into question the very nature of what it is to be human, to be creative, to think and to perceive, and indeed our relationship to each other and to the planet as a whole. The "telematic culture" that accompanies the new developments consists of a set of behaviors, ideas, media, values, and objectives that are significantly unlike those that have shaped society since the Enlightenment. New cultural and scientific metaphors and paradigms are being generated, new models and representations of reality are being invented, new expressive means are being manufactured.

Telematics is a term used to designate computer-mediated communications networking involving telephone, cable, and satellite links between geographically dispersed individuals and institutions that are interfaced to data-processing systems, remote sensing devices, and capacious data-storage banks. It involves the technology of interaction among human beings and between the human mind and artificial systems of intelligence and perception. The individual user of networks is always potentially involved in a global net, and the world is always potentially in a state of interaction with the individual. Thus, across the vast spread of telematic networks worldwide, the quantity of data processed and the density of information exchanged is incalculable. The ubiquitous efficacy of the telematic medium is not in doubt, but the question in human terms, from the point of view of culture and creativity, is: What is the content?

This question, which seems to be at the heart of many critiques of art involving computers and telecommunications, suggests deep-seated fears of the machine coming to dominate the human will and of a technological formalism erasing human content and values. Apart from all the particulars of personal histories, of dreams, desires, and anxieties that inform the content of art's rich repertoire, the question, in essence, is asking: Is there love in the telematic embrace?

In the attempt to extricate human content from technological form, the question is made more complicated by our increasing tendency as artists to bring together imaging, sound, and text systems into interactive environments that exploit state-of-the-art hypermedia and that

* Roy Ascott, excerpts from "Is There Love in the Telematic Embrace?" *Art Journal* 49, no. 3 (Fall 1990): 241–47. By permission of the author and the College Art Association, Inc.

engage the full sensorium, albeit by digital means. Out of this technological complexity, we can sense the emergence of a synthesis of the arts. The question of content must therefore be addressed to what might be called the *Gesamtdatenwerk*—the integrated data work—and to its capacity to engage the intellect, emotions, and sensibility of the observer. Here, however, more problems arise, since the observer in an interactive telematic system is by definition a participator. In a telematic art, meaning is not something created by the artist, distributed through the network, and *received* by the observer. Meaning is the product of interaction between the observer and the system, the content of which is in a state of flux, of endless change and transformation. In this condition of uncertainty and instability, not simply because of the crisscrossing interactions of users of the network but because content is embodied in data that is itself immaterial, it is pure electronic *difference,* until it has been reconstituted at the interface as image, text, or sound. The sensory *output* may be differentiated further as existing on screen, as articulated structure or material, as architecture, as environment, or in virtual space.

Such a view is in line with a more general approach to art as residing in a cultural communications system rather than in the art object as a fixed semantic configuration—a system in which the viewer actively negotiates for meaning. In this sense, telematic networking makes explicit in its technology and protocols what is implicit in all aesthetic experience where that experience is seen as being as much creative in the act of the viewer's perception as it is in the act of the artist's production. Classical communications theory holds, however, that communication is a one-way dispatch, from sender to receiver, in which only contingent "noise" in the channel can modify the message (often further confused as the meaning) initiated at the source of transmission. This is the model that has the artist as sender and therefore originator of meaning, the artist as creator and owner of images and ideas, the artist as controller of context and content. It is a model that requires, for its completion, the viewer as, at best, a skilled decoder or interpreter of the artist's "meaning" or, at worst, simply a passive receptacle of such meaning. It gives rise to the industry of criticism and exegesis in which those who "understand" this or that work of art explain it to those who are too stupid or uneducated to receive its meaning unaided. In this scenario, the artwork and its maker are viewed in the same way as the world and its creator. The beauty and truth of both art and the world are "out there" in the world and in the work of art. They are as fixed and immutable as the material universe appears to be. The canon of determinism decrees prefigured harmony and composition, regulated form and continuity of expression, with unity and clarity assured by a cultural consensus and a linguistic uniformity shared by artist and public alike.

The problem of content and meaning within a telematic culture gives added poignancy to the rubric "Issues of Content" under which this present writing on computers and art is developed: "issue" is open to a plurality of meanings, no one of which is satisfactory. The metaphor of a semantic sea endlessly ebbing and flowing, of meaning constantly in flux, of all words, utterances, gestures, and images in a state of undecidability, tossed to and fro into new collusions and conjunctions within a field of human interaction and negotiation, is found as much in new science—in quantum physics, second-order cybernetics, or chaology, for example—as in art employing telematic concepts or the new literary criticism that has absorbed philosophy and social theory into its practice. This sunrise of uncertainty, of a joyous dance of meaning between layers of genre and metaphoric systems, this unfolding tissue woven of a multiplicity of visual codes and cultural imaginations was also the initial promise of the postmodern project before it disappeared into the domain of social theory, leaving only its frail corpus of pessimism and despair.

In the case of the physicists, the radical shift in metaphors about the world and our par-

ticipation in its creation and redescription mean that science's picture window onto reality has been shattered by the very process of trying to measure it. . . . In the context of telematic systems and the issue of content and meaning, the parallel shift in art of the status of "observer" to that of "participator" is demonstrated clearly if in accounts of the quantum principle we substitute "data" for "quanta." Indeed, finding such analogies between art and physics is more than just a pleasant game; the web of connections between new models of theory and practice in the arts and the sciences, over a wide domain, is so pervasive as to suggest a paradigm shift in our world view, a redescription of reality and a recontextualization of ourselves. We begin to understand that chance and change, chaos and indeterminacy, transcendence and transformation, the immaterial and the numinous are terms at the center of our self-understanding and our new visions of reality. How then, could there be a content—sets of meanings—contained within telematic art when every aspect of networking in dataspace is in a state of transformation and of becoming? The very technology of computer telecommunications extends the gaze, transcends the body, amplifies the mind into unpredictable configurations of thought and creativity.

In the recent history of Western art, it was Marcel Duchamp who first took the metaphor of the glass, of the window onto the world, and turned it back on itself to reveal what is invisible. We see in the work known as *The Bride Stripped Bare by Her Bachelors, Even,* or *The Large Glass,* a field of vitreous reality in which energy and emotion are generated from the tension and interaction of male and female, natural and artificial, human and machine. Its subject is attraction in Charles Fourier's sense, or, we might even say, love. *The Large Glass,* in its transparent essence, always includes both its environment and the reflection of the observer. Love is contained in this total embrace; all that escapes is reason and certainty. By participating in the embrace, the viewer comes to be a progenitor of the semantic issue. The glass as "ground" has a function and status anticipating that of the computer monitor as a screen of operations—of transformations—and as the site of interaction and negotiation for meaning. But it is not only through the Glass that we can see Duchamp as prophetic of the telematic mode. The very metaphor of networking interaction in a field of uncertainty, in which the observer is creator and meaning is unstable, is implicit in all his work. Equally prophetic in the Glass is the horizontal bar that joins the upper and lower parts of the work and serves as a metaphor for the all-around viewing, the inclusive, all-embracing scope of its vision. This stands in opposition to the vertical, head-to-toe viewing of Renaissance space, embodied in the Western pictorial tradition, where the metaphor of verticality is employed insistently in its monuments and architecture—emblems often as not of aggression, competition, and dominance, always of a tunnel vision. The horizontal, on the other hand, is a metaphor for the bird's-eye view, the all-over, all-embracing, holistic systems view of structures, relationships, and events—viewing that can include the ironic, the fuzzy, and the ambiguous. This is precisely the condition of perception and insight to which telematic networking aspires.

Perhaps the most powerful metaphor of interconnectedness and the horizontal embrace in art before the advent of telematic media is to be found in the work of Jackson Pollock. Here the horizontal arena, a space marked out on the surface of the earth, is the "ground" for the action and transformation that become the painting itself. Pollock created his powerful metaphors of connectedness by generating fields of intertwining, interweaving, branching, joining, colliding, crossing, linking lines of energy. His space is inclusive and inviting, his imagery carries a sense of anonymity of authorship that embraces the viewer in the creation of meaning. Nothing in painting could be more emblematic or prophetic of the network consciousness emerging with the telematic culture. . . .

The emerging new order of art is that of interactivity, of "dispersed authorship"; the canon is one of contingency and uncertainty. Telematic art encompasses a wide array of media: hypermedia, videotex, telefacsimile, interactive video, computer animation and simulation, teleconferencing, text exchange, image transfer, sound synthesis, telemetry and remote sensing, virtual space, cybernetic structures, and intelligent architecture. These are simply broad categories of technologies and methodologies that are constantly evolving—bifurcating, joining, hybridizing—at an accelerated rate.

At the same time, the status of the art object changes. The culturally dominant objet d'art as the sole focus (the uncommon carrier of uncommon content) is replaced by the interface. Instead of the artwork as a window onto a composed, resolved, and ordered reality, we have at the interface a doorway to undecidability, a dataspace of semantic and material potentiality. The focus of the aesthetic shifts from the observed object to participating subject, from the analysis of observed systems to the (second-order) cybernetics of observing systems: the canon of the immaterial and participatory. Thus, at the interface to telematic systems, content is created rather than received. By the same token, content is disposed of at the interface by reinserting it, transformed by the process of interaction, back into the network for storage, distribution, and eventual transformation at the interface of other users, at other access nodes across the planet. . . .

Telematic culture means, in short, that we do not think, see, or feel in isolation. Creativity is shared, authorship is distributed, but not in a way that denies the individual her authenticity or power of self-creation, as rather crude models of collectivity might have done in the past. On the contrary, telematic culture amplifies the individual's capacity for creative thought and action, for more vivid and intense experience, for more informed perception, by enabling her to participate in the production of global vision through networked interaction with other minds, other sensibilities, other sensing and thinking systems across the planet—thought circulating in the medium of data through a multiplicity of different cultural, geographical, social, and personal layers. Networking supports endless redescription and recontextualization such that no language or visual code is final and no reality is ultimate. In the telematic culture, pluralism and relativism shape the configurations of ideas—of image, music, and text—that circulate in the system.

It is the computer that is at the heart of this circulation system, and, like the heart, it works best when least noticed—that is to say, when it becomes invisible. At present, the computer as a physical, material presence is too much with us; it dominates our inventory of tools, instruments, appliances, and apparatus as the ultimate machine. In our artistic and educational environments it is all too solidly there, a computational block to poetry and imagination. It is not transparent, nor is it yet fully understood as pure system, a universal transformative matrix. The computer is not primarily a thing, an object, but a set of behaviors, a system, actually a system of systems. Data constitute its lingua franca. It is the agent of the datafield, the constructor of dataspace. Where it is seen simply as a screen presenting the pages of an illuminated book, or as an internally lit painting, it is of no artistic value. Where its considerable speed of processing is used simply to simulate filmic or photographic representations, it becomes the agent of passive voyeurism. Where access to its transformative power is constrained by a typewriter keyboard, the user is forced into the posture of a clerk. The electronic palette, the light pen, and even the mouse bind us to past practices. The power of the computer's presence, particularly the power of the interface to shape language and thought, cannot be overestimated. It may not be an exaggeration to say that the "content" of a telematic art will depend in large measure on the nature of the interface; that is, the kind of configura-

tions and assemblies of image, sound, and text, the kind of restructuring and articulation of environment that telematic interactivity might yield, will be determined by the freedoms and fluidity available at the interface.

The essence of the interface is its potential flexibility; it can accept and deliver images both fixed and in movement, sounds constructed, synthesized, or sampled, texts written and spoken. It can be heat sensitive, body responsive, environmentally aware. It can respond to the tapping of the feet, the dancer's arabesque, the direction of a viewer's gaze. It not only articulates a physical environment with movement, sound, or light; it is an environment, an arena of dataspace in which a distributed art of the human/computer symbiosis can be acted out, the issue of its cybernetic content. Each individual computer interface is an aspect of a telematic unity such that to be in or at any one interface is to be in the virtual presence of all the other interfaces throughout the network of which it is a part. This might be defined as the "holomatic" principle in networking. It is so because all the data flowing through any access node of the network are equally and at the same time held in the memory of that network: they can be accessed, through cable or satellite links, from any part of the planet at any time of day or night, by users of the network (who, in order to communicate with each other, do not need to be in the same place at the same time). . . .

To the objection that such a global vision of an emerging planetary art is uncritically euphoric, or that the prospectus of a telematic culture with its *Gesamtdatenwerk* of hypermediated virtual realities is too grandiose, we should perhaps remind ourselves of the essentially political, economic, and social sensibilities of those who laid the conceptual foundations of the field of interactive systems. This cultural prospectus implies a telematic politic, embodying the features of feedback, self-determination, interaction, and collaborative creativity not unlike the "science of government" for which, over 150 years ago, André Marie Ampère coined the term "cybernetics"—a term reinvigorated and humanized by Norbert Wiener in this century. Contrary to the rather rigid determinism and positivism that have shaped society since the Enlightenment, however, these features will have to accommodate notions of uncertainty, chaos, autopoiesis, contingency, and the second-order cybernetics or fuzzy-systems view of a world in which the observer and observed, creator and viewer, are inextricably linked in the process of making reality—all our many separate realities interacting, colliding, re-forming, and resonating within the telematic noosphere of the planet.

Within these separate realities, the status of the "real" in the phenomenology of the artwork also changes. Virtual space, virtual image, virtual reality—these are categories of experience that can be shared through telematic networks, allowing for movement through "cyberspace" and engagement with the virtual presence of others who are in their corporeal materiality at a distance, physically inaccessible or otherwise remote. The adoption of a headset, DataGlove, or other data wear can make the personal connection to cyberspace—socialization in hyperreality—wherein interaction with others will undoubtedly be experienced as "real," and the feelings and perceptions so generated will also be "real." The passage from real to virtual will probably be seamless, just as social behavior derived from human-computer symbiosis is flowing unnoticed into our consciousness. But the very ease of transition from "reality" to "virtuality" will cause confusion in culture, in values, and in matters of personal identity. It will be the role of the artist, in collaboration with scientists, to establish not only new creative praxes but also new value systems, new ordinances of human interaction and social communicability. The issue of content in the planetary art of this emerging telematic culture is therefore the issue of values, expressed as transient hypotheses rather than finalities, tested within the immaterial, virtual, hyperrealities of dataspace. Integrity of the work will not be

judged by the old aesthetics; no antecedent criteria can be applied to network creativity since there is no previous canon to accommodate it. The telematic process, like the technology that embodies it, is the product of a profound human desire for transcendence: to be out of body, out of mind, beyond language. Virtual space and dataspace constitute the domain, previously provided by myth and religion, where imagination, desire, and will can reengage the forces of space, time, and matter in the battle for a new reality.

The digital matrix that brings all new electronic and optical media into its telematic embrace—being a connectionist model of hypermedia—calls for a "connective criticism." The personal computer yields to the interpersonal computer. Serial data processing becomes parallel distributed processing. Networks link memory bank to memory bank, intelligence to intelligence. Digital image and digital sound find their common ground, just as a synthesis of modes—visual, tactile, textual, acoustic, environment—can be expected to "hypermediate" the networked sensibilities of a constellation of global cultures. The digital camera—gathering still and moving images from remote sensors deep in space, or directed by human or artificial intelligence on earth, seeking out what is unseen, imaging what is invisible—meets at a point between our own eyes and the reticular retina of worldwide networks, stretching perception laterally away from the tunnel vision, from the Cartesian sight lines of the old deterministic era. Our sensory experience becomes extrasensory, as our vision is enhanced by the extrasensory devices of telematic perception. The computer deals invisibly with the invisible. It processes those connections, collusions, systems, forces and fields, transformations and transferences, chaotic assemblies, and higher orders of organization that lie outside our vision, outside the gross level of material perception afforded by our natural senses. Totally invisible to our everyday unaided perception, for example, is the underlying fluidity of matter, the indeterminate dance of electrons, the "snap, crackle, and pop" of quanta, the tunneling and transpositions, nonlocal and superluminal, that the new physics presents. It is these patterns of events, these new exhilarating metaphors of existence—nonlinear, uncertain, layered, and discontinuous—that the computer can redescribe. With the computer, and brought together in the telematic embrace, we can hope to glimpse the unseeable, to grasp the ineffable chaos of becoming, the secret order of disorder. And as we come to see more, we shall see the computer less and less. It will become invisible in its immanence, but its presence will be palpable to the artist engaged telematically in the world process of autopoiesis, planetary self-creation.

The technology of computerized media and telematic systems is no longer to be viewed simply as a set of rather complicated tools extending the range of painting and sculpture, performed music, or published literature. It can now be seen to support a whole new field of creative endeavor that is as radically unlike each of those established artistic genres as they are unlike each other. A new vehicle of consciousness, of creativity and expression, has entered our repertoire of being. While it is concerned with both technology and poetry, the virtual and the immaterial as well as the palpable and concrete, the telematic may be categorized as neither art nor science, while being allied in many ways to the discourses of both. The further development of this field will clearly mean an interdependence of artistic, scientific, and technological competencies and aspirations and, urgently, on the formulation of a transdisciplinary education.

So, to link the ancient image-making process of Navajo sand painting to the digital imaging of modern supercomputers through common silicon, which serves them both as pigment and processor chip, is more than ironic whimsy. The holistic ambition of Native American culture is paralleled by the holistic potentiality of telematic art. More than a technological

expedient for the interchange of information, networking provides the very infrastructure for spiritual interchange that could lead to the harmonization and creative development of the whole planet. With this prospectus, however naïvely optimistic and transcendental it may appear in our current fin-de-siècle gloom, the metaphor of love in the telematic embrace may not be entirely misplaced.

STELARC
Beyond the Body: Amplified Body, Laser Eyes, and Third Hand (1988)

THE INVASION OF TECHNOLOGY: MINIATURIZED AND BIOCOMPATIBLE, TECHNOLOGY IMPLODES BACK TO THE BODY, NOT ONLY LANDING ON THE SKIN BUT EMBEDDING ITSELF AS AN INTERNAL COMPONENT. IMPLANTED TECHNOLOGY ENERGIZES THE BODY, ACCELERATING IT TO ATTAIN PLANETARY ESCAPE VELOCITY. EVOLUTION ENDS WHEN TECHNOLOGY INVADES THE BODY. IT IS NO LONGER OF ANY ADVANTAGE EITHER TO REMAIN "HUMAN" OR TO EVOLVE AS A SPECIES. HUMAN THOUGHT RECEDES INTO THE HUMAN PAST. THE END OF PHILOSOPHY, THE END OF THE HUMAN FORM.

1. If the earlier events can be characterized as PROBING and PIERCING the body (the three films of the inside of the stomach, lungs and colon/the 25 suspensions), then the recent performances EXTEND and ENHANCE it. The amplified internal rhythms, laser eyes and mechanical hand acoustically and visually expand the body's parameters. They can no longer be seen as biofeedback situations (they never really were) but rather SCI-FI SCENARIOS for human-machine symbiosis—with sound as the medium that reshapes the human body, for redesigning an obsolete body. It may not yet be possible to physiologically modify the body, but it can resonate with modulated rhythms. The body does not simply acquire an acoustical aura—its humanoid form is stretched and restructured with sound. The amplified body is no longer the container of its rhythms. The humanoid form is transformed into the cuboid space. The body becomes hollow, resonating with its own echoes.

HOLLOW BODY: OFF THE PLANET, THE BODY'S COMPLEXITY, SOFTNESS AND WETNESS WOULD BE DIFFICULT TO SUSTAIN. THE STRATEGY SHOULD BE TO HOLLOW, HARDEN AND DEHYDRATE THE BODY. EXTRATERRESTRIAL ENVIRONMENTS AMPLIFY THE BODY'S OBSOLESCENCE, INTENSIFYING THE PRESSURES FOR ITS MODIFICATION. THE SOLUTION TO RADICALLY REDESIGNING THE BODY LIES NOT WITH ITS INTERNAL STRUCTURE BUT WITH A CHANGE OF SKIN.

2. The artificial hand, attached to the right arm as a third hand, is capable of *independent action,* being triggered by the EMG signals from the abdominal and thigh muscles. It has pinch-release, grasp-release, 290° wrist rotation (CW and CCW) and a tactile feedback system for a "sense of touch." But whilst the body activates its extra manipulater, the real left arm is REMOTE-CONTROLLED—jerked into action by a muscle stimulater with varying intensity of voltage and rate of frequency, both in *random* and *repetitive* modes. Of necessity, this remote-controlling is done intermittently (it is quite painful) and is used to "pace" the body's performance and to alter the body's general condition, thereby affecting its acoustical field. The stimulater signal is used as a sound source, whilst the motor mechanism of the Third Hand is picked up by a contact microphone.

ANAESTHETIZED BODY: THE BODY INSERTED INTO THE MOBILE MANIPULATER UNIT WILL

* STELARC, "Beyond the Body: Amplified Body, Laser Eyes & Third Hand," *NMA* 6 (1988): 27–30. By permission of the author and NMA Publications.

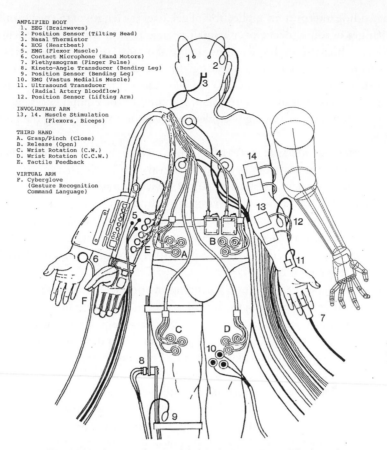

STELARC, drawing for *Amplified Body / Laser Eyes / Third Hand,* 1986.
By permission of the artist.

SPIN, GLIDE, CIRCLE AND HOVER. ITS MECHANICAL ARMS WILL BE OF PRIMATE PROPORTIONS, DOUBLE-JOINTED AND CAPABLE OF HIGH-SPEED MODES OF OPERATION. AS WELL AS EMG CONTROL IT WILL ALSO HAVE AUTOMATIC COMPUTER CONTROL AND A SOUND ACTIVATION INTERFACE. IT WILL NOT SIMPLY AUGMENT BUT RATHER REPLACE THE HUMAN LIMBS. THE BODY PLUGGED INTO MACHINE SYSTEMS NEEDS TO BE PACIFIED. IN FACT, TO FUNCTION IN THE FUTURE AND TO TRULY ACHIEVE A HYBRID SYMBIOSIS, THE BODY WILL NEED TO BE INCREASINGLY ANAESTHETIZED.

3. Body processes amplified include brainwaves (EEG), muscles (EMG), heartbeat (ECG), pulse (PLETHYSMOGRAM-finger clip-on photo-electric type) and bloodflow (DOPPLER FLOW METER), with a KINETO-ANGLE TRANSDUCER transforming bending motion into a sequence of sounds. A C-DUCER has also been used over the larynx to pick up vibration in the throat and stomach activity has been monitored by swallowing a transmitter (tethered so that it can be later extracted). With the heart, the opening and closing of the valves, the gurgling of the blood and the gushing of the blood thru the wrist can be amplified best by the Doppler ultrasonic sound transducers—the *pencil-type* probe for deep monitoring and the *flat-type* for the shallow wrist section. Although the pencil-type probe has several disadvantages in having to

be held and needing intermittent application of gel (over the length of the performance), quite dramatic changes of sound occur over a small change of skin scanned and by pointing the probe at slightly different angles. By constricting the radial artery of the wrist, the sound varies from the normal repetitive "whooshing" to a "clicking" as the blood is dammed with a flooding rush of sound as the wrist is relaxed. The use of a TELEMETRY UNIT minimizes the hand-wiring of the body (transmission distance is 30m) to the equipment, safely isolating it from the electrical system, removing possible hum and noise and allowing the body freedom of movement.

HUMAN–MACHINE SYMBIOSIS: REMOTE SYSTEMS AND SURROGATE ROBOTS PRESENT THE GREATEST POTENTIAL AND THE MOST INTRIGUING DILEMMA. TELECHIRIC SYSTEMS WOULD HAVE TO BE MORE THAN HAND-EYE MECHANISMS. THEY WOULD HAVE TO CREATE A KINESTHETIC SENSE I.E. PROVIDE THE SENSATION OF POSITION, MOVEMENT AND BODY TENSION. THIS PRESUP-POSES SOPHISTICATED HUMAN-LIKE AND INTELLIGENT ROBOTS CAPABLE OF SOME AUTONOMY EVEN WITH HUMAN PARTICIPATION IN THE LOOP. THE PROBLEM IS WHETHER SURROGATE ROBOTS CAN ADEQUATELY SENSE AND ACT—COLLAPSING THE TIME-SPACE BETWEEN THE BODY AND WHAT IS PERCEIVED AT A DISTANCE.

4. Actions such as flicking of the fingers, bending an arm, twitching the facial muscles, turn-ing the torso and lifting the leg bring forth a cascade of sound. Powerful acoustical effects can be generated both by discernible gesture and invisible internal contractions and control. The sound field is configured by buzzing, warbling, clicking, thumping, beeping and whooshing sounds. A combination of percussive-like and wind-like sounds; of triggered, random, repetitive and rhythmic sound. There is a general score or structure in the performance depending on the number and type of body frequencies amplified. Within these performance parameters the body improvises depending on the feedback it generates. *Orchestration* of the event involves selective tuning into/out of channels of sound (varying the *complexity*); increasing or decreasing the vol-ume of certain sounds (*contouring* the sound field); physical control of certain body functions and motions; activation of the mechanical hand and the use of digital delay (foot pedal) to loop and superimpose sequences of sound. The general dilemma of the process is to modulate the origi-nal signal in a way that best reflects the body function and maintains an identity with it. An interplay between physiological control and electronic manipulation.

THE HUM OF THE HYBRID (NO BIRTH/NO DEATH): DEATH DOES NOT "AUTHENTICATE" EXISTENCE. DEATH IS AN OUTMODED STRATEGY REQUIRED OF AN EVOLVING SPECIES. IT IS OF NO ADVANTAGE TO THE AWARE INDIVIDUAL! TECHNOLOGY EQUALIZES THE PHYSICAL POTENTIAL OF HUMAN BODIES AND STANDARDIZES HUMAN SEXUALITY. WITH THE POSSIBILITY OF NURTUR-ING THE FETUS OUTSIDE THE WOMB THERE TECHNICALLY WILL BE NO BIRTH. AND IF THE RE-PLACEMENT OF MALFUNCTIONING PARTS CAN BE FACILITATED THEN THERE WOULD BE NO REASON FOR DEATH. THE MODIFIED BODY WILL BE ASEXUAL AND IMMORTAL. THIS IS NO MERE FAUSTIAN DESIRE NOR SHOULD THERE BE ANY FRANKENSTEINIAN FEAR. REDESIGNING OUR BODY MEANS REDEFINING OUR ROLE.

5. In previous events, He/Ne (Helium-Neon) lasers were reflected off small optical mirrors stuck to the eyes. This was simple needing no other paraphernalia but it required the head to be almost totally rigid and always facing in one direction. It limited the laser sequences to short durations and to only a direct frontal effect. Now Ar (Argon) beams are propagated thru OPTICAL FIBRE CABLE and an input-output lens system—allowing more powerful lasers to be used safely, with the head and body being able to turn without losing the beams. The output lens[es] are positioned in front of the eyes by an aluminum-frame head structure to allow the eyes to track the beams. The laser eyes are *modulated by the heartbeat,* pulsing on and

off—the sounds of solenoid clicks amplified to synchronize with the ECG. By blinking, twitching facial muscles and oscillating the head it is possible to SCAN the space and SCRIBBLE images, seemingly with the eyes.

DETACHED BREATH/SPINNING RETINA: THE PSYCHO-SOCIAL FLOWERING OF THE HUMAN SPECIES HAS WITHERED. WE ARE IN THE TWILIGHT OF OUR CEREBRAL FANTASIES. HUMAN EXISTENCE CAN NO LONGER BE JUSTIFIED "IN ITSELF." THE TECHNOLOGICAL TERRAIN CONCEALS COUNTLESS BODY PACEMAKERS—VISUAL AND ACOUSTICAL CUES TO ALERT, ACTIVATE AND CONDITION THE BODY—DIRECTING IT IN PRESCRIBED DIRECTIONS AND VELOCITIES. COMPLEXITY GENERATES CONTROL. AND IN THE HIGH STIMULATION OF CONTEMPORARY SOCIETY THE REFLECTIVE MOMENT BETWEEN INTENTION AND ACTION IS ERASED. THE SINGULARITY OF COMPLEXITY DISINTEGRATES THE PERIMETER OF COHERENCE.

6. The installation, often of large rocks, suspended poles of wood and tensegrity constructions manifests mass, weight and gravity emphasizing the physicality of the body—providing the setting for its acoustical transformation. The installation is activated when the body is plugged into it. The body performs in a structured light environment, which flares and flickers, responding and reacting to the electrical discharges of the body—sometimes synchronizing, sometimes counterpointing. Light manifests and further amplifies the body's internal rhythms. It does not simply respond and illuminate but is understood as a physical phenomenon that can in turn directly affect certain body rhythms. For example strobe flicker triggering and driving brainwaves. The light installation not only extends the body but also helps to redefine its form.

OBSOLETE SKIN: SKIN HAS BECOME INADEQUATE IN INTERFACING WITH REALITY. TECHNOLOGY HAS BECOME THE BODY'S NEW MEMBRANE OF EXISTENCE.

7. In amplifying the body, the audience is *immersed* in its rhythms. The body does not merely acquire an acoustical aura but rather the audience finds itself *inside the body*. By externalizing internal rhythms the distance between performer and audience collapses. It is a postverbal communication where the audience identifies instantaneously with the synchronized sounds from posture and gesture.

TOWARDS HIGH-FIDELITY ILLUSION: THE SIGNIFICANCE OF TECHNOLOGY MAY BE THAT IT CULMINATES IN AN ALIEN CONSCIOUSNESS—ONE THAT IS POST-HISTORIC, TRANS-HUMAN AND EVEN EXTRATERRESTRIAL.

EDUARDO KAC *GFP Bunny* (2000)

My transgenic artwork *GFP Bunny* comprises the creation of a green fluorescent rabbit (named *Alba*), its social integration, and the ensuing public debate. GFP stands for green fluorescent protein. *GFP Bunny* was realized in 2000 and first presented publicly in Avignon, France. Transgenic art . . . is a new art form based on the use of genetic engineering to transfer natural or synthetic genes to an organism, to create unique living beings. This must be done with great care, with acknowledgment of the complex issues thus raised and, above all, with a commitment to respect, nurture, and love the life thus created. . . .

GFP Bunny is a transgenic artwork and not a breeding project. The differences between the two include the principles that guide the work, the procedures employed, and the main

* Eduardo Kac, excerpts from "*GFP Bunny*," in Peter Tomaž Dobrila and Aleksandra Kostić, eds., *Eduardo Kac: Telepresence, Biotelematics, Transgenic Art* (Maribor, Slovenia: KIBLA, 2000), 101–29. By permission of the author.

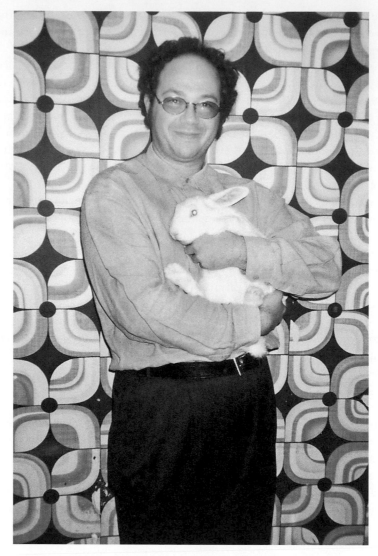

Eduardo Kac, *GFP Bunny,* 2000, transgenic work with Kac and Alba, the fluorescent bunny. Courtesy Fringe Exhibitions, Los Angeles.

objectives. Traditionally, animal breeding has been a multi-generational selection process that has sought to create pure breeds with standard form and structure, often to serve a specific performative function. As it moved from rural milieus to urban environments, breeding de-emphasized selection for behavioral attributes but continued to be driven by a notion of aesthetics anchored on visual traits and on morphological principles. Transgenic art, by contrast, offers a concept of aesthetics that emphasizes the social rather than the formal aspects of life and biodiversity, that challenges notions of genetic purity, that incorporates precise work at the genomic level, and that reveals the fluidity of the concept of species in an ever increasingly transgenic social context.

As a transgenic artist, I am not interested in the creation of genetic objects, but in the

invention of transgenic social subjects. In other words, what is important is the completely integrated process of creating the bunny, bringing her to society at large, and providing her with a loving, caring, and nurturing environment in which she can grow safe and healthy. This integrated process is important because it places genetic engineering in a social context in which the relationship between the private and the public spheres [is] negotiated. In other words, biotechnology, the private realm of family life, and the social domain of public opinion are discussed in relation to one another. Transgenic art is not about the crafting of genetic objets d'art, either inert or imbued with vitality. Such an approach would suggest a conflation of the operational sphere of life sciences with a traditional aesthetics that privileges formal concerns, material stability, and hermeneutical isolation. Integrating the lessons of dialogical philosophy and cognitive ethology, transgenic art must promote awareness of and respect for the spiritual (mental) life of the transgenic animal. The word "aesthetics" in the context of transgenic art must be understood to mean that creation, socialization, and domestic integration are a single process. The question is not to make the bunny meet specific requirements or whims, but to enjoy her company as an individual (all bunnies are different), appreciated for her own intrinsic virtues, in dialogical interaction.

One very important aspect of *GFP Bunny* is that Alba, like any other rabbit, is sociable and in need of interaction through communication signals, voice, and physical contact. As I see it, there is no reason to believe that the interactive art of the future will look and feel like anything we knew in the twentieth century. *GFP Bunny* shows an alternative path and makes clear that a profound concept of interaction is anchored on the notion of personal responsibility (as both care and possibility of response). *GFP Bunny* gives continuation to my focus on the creation, in art, of what Martin Buber called dialogical relationship, what Mikhail Bakhtin called dialogic sphere of existence, what Emile Benveniste called intersubjectivity, and what Humberto Maturana calls consensual domains: shared spheres of perception, cognition, and agency in which two or more sentient beings (human or otherwise) can negotiate their experience dialogically. The work is also informed by Emmanuel Levinas' philosophy of alterity, which states that our proximity to the other demands a response, and that the interpersonal contact with others is the unique relation of ethical responsibility. I create my works to accept and incorporate the reactions and decisions made by the participants, be they eukaryotes or prokaryotes. This is what I call the human-plant-bird-mammal-robot-insect-bacteria interface.

In order to be practicable, this aesthetic platform—which reconciles forms of social intervention with semantic openness and systemic complexity—must acknowledge that every situation, in art as in life, has its own specific parameters and limitations. So the question is not how to eliminate circumscription altogether (an impossibility), but how to keep it indeterminate enough so that what human and nonhuman participants think, perceive, and do when they experience the work matters in a significant way. My answer is to make a concerted effort to remain truly open to the participant's choices and behaviors, to give up a substantial portion of control over the experience of the work, to accept the experience as-it-happens as a transformative field of possibilities, to learn from it, to grow with it, to be transformed along the way. Alba is a participant in the *GFP Bunny* transgenic artwork; so is anyone who comes in contact with her, and anyone who gives any consideration to the project. A complex set of relationships between family life, social difference, scientific procedure, interspecies communication, public discussion, ethics, media interpretation, and art context is at work. . . .

The success of human genetic therapy suggests the benefits of altering the human genome

to heal or to improve the living conditions of ill humans. In this sense, the introduction of foreign genetic material in the human genome can be seen not only as welcome but as desirable. Developments in molecular biology, such as the above example, are at times used to raise the specter of eugenics and biological warfare, and with it the fear of banalization and abuse of genetic engineering. This fear is legitimate, historically grounded, and must be addressed. Contributing to the problem, companies often employ empty rhetorical strategies to persuade the public, thus failing to engage in a serious debate that acknowledges both the problems and benefits of the technology. There are indeed serious threats, such as the possible loss of privacy regarding one's own genetic information, and unacceptable practices already underway, such as biopiracy (the appropriation and patenting of genetic material from its owners without explicit permission). . . .

Since the domain of art is symbolic even when intervening directly in a given context, art can contribute to reveal the cultural implications of the revolution underway and offer different ways of thinking about and with biotechnology. Transgenic art is a mode of genetic inscription that is at once inside and outside of the operational realm of molecular biology, negotiating the terrain between science and culture. Transgenic art can help science to recognize the role of relational and communicational issues in the development of organisms. It can help culture by unmasking the popular belief that DNA is the "master molecule" through an emphasis on the whole organism and the environment (the context). At last, transgenic art can contribute to the field of aesthetics by opening up the new symbolic and pragmatic dimension of art as the literal creation of and responsibility for life.

ORLAN *This Is My Body . . . This Is My Software* (1996)

I am a multi-media, pluri-disciplinary and inter-disciplinary artist. I have always considered my woman's body, my woman-artist's body, privileged material for the construction of my work. My work has always interrogated the status of the feminine body, via social pressures, those of the present or in the past. I have indicated certain of their inscriptions in the history of art. The variety of possible images of my body has dealt with the problem of identity and variety. . . .

Art that interests me has much in common with—belongs to—resistance. It must challenge our preconceptions, disrupt our thoughts; it is outside the norms, outside the law, against bourgeois order; it is not there to cradle us, to reinforce our comfort, to serve up again what we already know. It must take risks, at the risk of not being immediately accepted or acceptable. It is deviant, and in itself a social project.

Art can, art *must* change the world, it's its only justification. . . .

My work emerged during the 'Seventies—I should specify that I was twenty-three—I was born 30 May, 1947—and my first street performances took place in 1965, when I was eighteen—when art was engaged with the social, the political, the ideological; a period when artists invested intellectually, conceptually and sometimes physically in their work.

At that time, I had already used surgery at a performance symposium organised in Lyons. I had to be operated on urgently: my body was a sick body that suddenly needed attention. I decided to make the most of this new adventure by turning the situation in on itself, by con-

* ORLAN, excerpts from "Conference," in *ORLAN: This Is My Body . . . This Is My Software* (London: Black Dog Publishing, 1996), 83–93. © 2012 Artists Rights Society (ARS), New York/ADAGP, Paris.

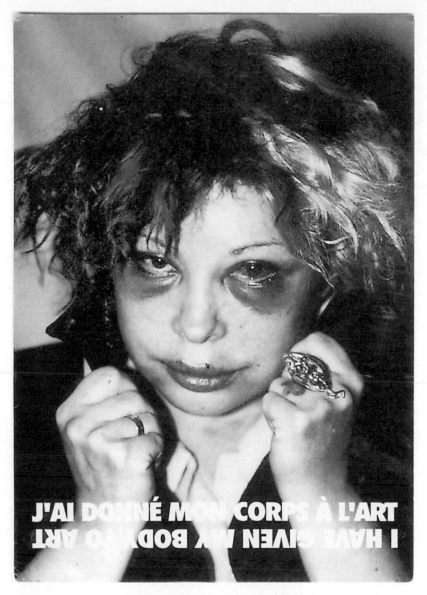

ORLAN, *I Have Given My Body to Art*, 1993, poster for the Sandra Gering Gallery, 1995, New York. © 2012 Artists Rights Society (ARS), New York/ADAGP, Paris. Photo courtesy Galerie Michel Rein, Paris.

sidering life an aesthetically recuperable phenomenon: I had a camera and video recorder brought into the operating room and the videos and the photographs were shown as if it had been a planned performance.

Being operated on is beyond the frivolous and this experience was very intense: I was certain that one day, somehow, I would work again with surgery. I wanted to take up these tropes and ingredients of my work again to elaborate a performance without being false to myself, a performance in continuity with previous steps and approaches. A performance fac-

ing the future, using up-to-date techniques. One of my favourite mottoes is, "Remember the Future." It should be a performance radical for myself and beyond myself . . .

It was on reading a text by Eugénie Lemoine-Luccioni, a Lacanian psychoanalyst, that the idea of putting this into action came to me (a move from reading to the carrying out of the act).

At the beginning of all my performance-operations, I read this excerpt from her book, *La Robe:* "Skin is deceiving . . . in life, one only has one's skin . . . there is a bad exchange in human relations because one never is what one has . . . I have the skin of an angel, but I am a jackal . . . the skin of a crocodile, but I am a puppy, the skin of a black person, but I am white, the skin of a woman, but I am a man; I never have the skin of what I am. There is no exception to the rule because I am never what I have."

Reading this text, I thought that in our time we have begun to have the means of closing this gap; in particular with the help of surgery . . . that it was thus becoming possible to match up the internal image with the external one.

I say that I am doing a woman-woman transsexualism by alluding to transsexuals: a man who feels himself to be a woman wants others to see: woman. We could summarise this by saying that it is a problem of communication.

One can consider my work as classical self-portraiture, even if initially it is conceived with the aid of computers. But what can one say when it comes to permanently inscribing this work in the flesh? I speak of a 'carnal art,' in part to differentiate myself from corporeal art, to which nevertheless it belongs.

My work, and its ideas incarnated in my flesh, pose questions about the status of the body in our society and its evolution in future generations via new technologies and up-coming genetic manipulations.

My body has become a site of public debate that poses crucial questions for our time. . . .

Each operation has its own style. This ranges from the carnivalesque—which, for me, is not a pejorative word: the word 'carnival' originally means 'carne vaut'—to high tech, passing through the baroque, etc.

For I think there are as many pressures on women's bodies as there are on the body—on the physicality—of works of art.

Our era hates the flesh; and works of art cannot enter networks and certain galleries except via pre-established moulds. Among others, the use of parody, the grotesque and the ironic are irritating, judged to be in bad taste and often scorned.

I read the texts for as long as possible during the operation, even when they are operating on my face, which during the last operations gave the impression of an autopsied corpse that continued to speak, as if detached from its body.

Each performance-operation is built on a philosophical, psychoanalytical, or literary text (e.g. from Eugénie Lemoine-Luccioni, Michel Serres, Sanskrit Hindu texts, Alphonse Allais, Antonin Artaud, Elisabeth Betuel Fiebig, Raphael Cuir, Julia Kristeva).

The operating room becomes my studio from which I am conscious of producing images, making a film, a video, photos, and objects that will later be exhibited. These works attempt, by varying degrees, to be autonomous. I try to inscribe again in substance the same ideas that presided in the elaboration of the performances—from which they issue—so that the quality of this materiality reveals the essence of these ideas.

In the plastic work, it is less a question of equalling the transition to action and the violence of the act, a bringing to light of the elements of construction of a thought, which affords itself the freedom of transgression of the taboo act. That is to say, like any artist, I have to take off from a certain position, from a social project and/or an artistic problem, and have to find a plastic solution and put it to work. . . .

I am the first artist to use surgery as a medium and to alter the purpose of cosmetic surgery: to look better, to look young. "I is an other" ("Je est un autre").[1] I am at the forefront of confrontation. . . .

My work is a struggle against the innate, the inexorable, the programmed, Nature, DNA (which is our direct rival as far as artists of representation are concerned), and God!

My work is blasphemous. It is an endeavour to move the bars of the cage, a radical and uncomfortable endeavour!

I based one of my operations on a text by Antonin Artaud who dreamed of a body without organs. This text mentions the names of poets of his time. Then it enumerates the times these poets must have defecated, urinated, how many hours were needed to sleep, to eat, to wash, and concludes that this is totally disproportionate to the fifty or so pages of magical production (as he calls the creative act).

A few words about pain. I try to make this work as unmasochistic as possible, but there is a price to pay: the anaesthetic shots are not pleasant. (I prefer to drink a good wine with friends than to be operated upon!) Nevertheless, everyone is familiar with this: it's like being at the dentist—you make a face for a few seconds. And as I have not paid my tribute to Nature, in experiencing the pains of childbirth, I consider myself happy. After the operations, it is sometimes uncomfortable, sometimes painful. I therefore take analgesics.

As my friend the French artist, Ben Vautier, would say, "Art is a dirty job but somebody's got to do it." In fact, it is really my audience that hurt when they watch me and these images on video.

I compare myself to a high-level athlete. There is the training, the moment of the performance where one must go beyond one's limits—which is not done without effort or pain—and then there is the recuperation.

Like a sportsman who makes a solitary crossing of the Atlantic, we often do crazy things without necessarily being crazy.

"I have given my body to Art." After my death it will not therefore be given to science, but to a museum. It will be the centrepiece of a video installation.

When the operations are finished, I will solicit an advertising agency to come up with a name, a first name, and an artist's name; next, I will contract a lawyer to petition the Republic to accept my new identities with my new face. It is a performance that inscribes itself into the social fabric, a performance that challenges the legislation, that moves towards a total change of identity. (Should this prove impossible, in any event, the attempt and the pleading of the case by the attorney will form part of the work.)

1. *Editor's note:* The phrase is that of French poet Arthur Rimbaud in a letter to Georges Izambard, May 13, 1871, reprinted in Rimbaud's *Correspondance* (Paris: Arthème Fayard, 2007), 64.

6 INSTALLATIONS, ENVIRONMENTS, AND SITES

Peter Selz and Kristine Stiles

From the early 1920s until he fled Nazi Germany in early 1937, Kurt Schwitters worked on his initial *Merzbau* (Merz building)—also called *The Cathedral of Erotic Misery*. This elaborate environment, created in his home in Hannover, included "caves" dedicated to his friends Jean Arp, Theo van Doesburg, Hannah Höch, and El Lissitzky, with such names as "Nibelungen Hoard," "Goethe Grotto," "Sex-Crime Cavern," and "Great Grotto of Love." Schwitters coined the term *Merz*—from the second syllable of the German word *Kommerz* (commerce), which appeared in one of his early collaged paintings—to refer to his way of incorporating found materials from industrial society into his work, whether his *Merzbau* or *Merzbilden* (Merz pictures). After having to abandon his Hannover *Merzbau* (later destroyed by wartime bombing), Schwitters began constructing another in Norway (1937–40), later lost to fire, and finally one in England (1945–48), which remained unfinished at the time of his death.

Schwitters was educated at the Dresden Academy of Art, but many examples exist of unschooled artists who made environments and installations. For instance, the French postman Ferdinand Cheval built the *Palais idéal* (1879–1912), a large environment in Hauterives, in southeastern France. It is an amalgam of architectural styles, from Buddhist, Hindu, and Muslim to baroque, medieval, and Swiss alpine. In Los Angeles Simon Rodia, an Italian immigrant and tile setter, built the *Watts Towers* (1921–54), seventeen interconnected structures, several soaring nearly 100 feet upward, made of steel rods, wire screening, and concrete, and decorated with brilliantly colored shards of tile and glass.

Some consider the small windowed boxes constructed by Joseph Cornell (b. U.S., 1903–72) over the course of almost five decades (beginning in the 1930s) to be miniature environments. These imaginary worlds contain an assortment of objects, from maps, butterflies, compasses, toys, mirrors, sand, and marbles, to images and symbols from art history, geography, and science. Although lacking artistic training, Cornell was knowledgeable about the history of European avant-garde movements and associated with many of the Surrealist artists exiled in New York during World War II. The visual poetry of his works inspired generations of artists and poets, including the Mexican Nobel laureate Octavio Paz.

In 1965, in an effort to classify such art, Peter Selz curated the landmark exhibition

The Art of Assemblage at the Museum of Modern Art in New York, and the following year Allan Kaprow brought out his book *Assemblage, Environments and Happenings.* Both described how diverse artists had been drawn to the "junk culture" of the heterogeneous city and the disposable economy, culling aspects of it to include in paintings, collages, sculptures, assemblages, and environments.

Frederick Kiesler (1890–1965) anticipated a culture in which materials, structures, and forms would combine in what he called the "City in Space," about which he wrote in his "Manifesto of Tensionism" (1925). A visionary architect, sculptor, painter, designer, writer, and theater director, Kiesler was born in what is today Ukraine and educated in Vienna. He joined the De Stijl group in 1923, before immigrating to the United States in 1926. In 1942 he designed the Surrealist interior of Peggy Guggenheim's New York gallery, Art of This Century, applying his theory of "endless space" to his design. This theory also informed his environmental sculptures, such as *Galaxies* (1952), created the same year that the Museum of Modern Art named him one of "the 15 leading artists at mid-century." Kiesler directed scene design at the Juilliard School of Music (1933–57) and in 1937 founded and served as director of the Laboratory for Design Correlation at Columbia University, until its closure in 1941. Based on his theory of "correalism," Kiesler stipulated that "the essence of reality is not in the 'thing' itself, but in the way it correlates and orders itself to its environment."[1] In 1959, with the architect Armand Bartos, Kiesler designed the Shrine of the Book, a wing of the Israel Museum in Jerusalem that serves as a sanctuary for the Dead Sea Scrolls.

Like Kiesler, Louise Nevelson (Leah Berliawsky; 1899–1988) was born in what is now Ukraine and was associated with the pivotal art movements of her time. Having immigrated to the United States as a child, she studied at the Art Students League in New York (1929–31) and then briefly at Hans Hofmann's school in Munich (1931), where she learned about Cubism and Hofmann's ideas on "push and pull." In 1933 she served as an apprentice to the Mexican muralist Diego Rivera and became acquainted with Surrealism. By the late 1950s Nevelson began placing discarded wood and wooden objects into wooden crates and eventually integrated these smaller assemblages into large wall constructions installed as room environments. She initially painted her constructions a uniform black, which conveyed an aura of mystery, but then turned to white and finally to gold, the latter suggestive of Byzantine churches and baroque chapels. Nevelson received numerous public commissions, including one from the World Trade Center for *Sky Gate—New York* (1978). It was destroyed on September 11, 2001.

In contrast to Nevelson, Isamu Noguchi (b. U.S., 1904–88) worked with time-honored sculptural materials like fine woods, stone, marble, and bronze. He created sculptures, environments, and gardens that related to places, historical events, and ancient traditions, and functioned as mediators between earth and sky. He also designed contoured playgrounds, sets and costumes for Martha Graham's and George Balanchine's dance performances, and commercial objects like furniture and lamps. Intellectually steeped in both Western and Eastern traditions, Noguchi did not fit into any one stylistic movement. Nevertheless, his work clearly reflects the influence of Constantin Brancusi, for whom Noguchi served as a studio assistant in 1927, especially the Romanian sculptor's 1937–38 installation commemorating World War I in Târgu Jiu, Romania, featuring *The Table of Silence, The Kiss Gate,* and *The Endless Column.*

Many other artists around the world in the late 1950s and throughout the 1960s experimented with sculpture as environment: Mathias Goeritz in Mexico City, Hélio Oiticica in Rio de Janeiro, Yves Klein in Paris, Herbert Ferber and Lucas Samaras in New York, Harold Paris in Berkeley, and Edward Kienholz in Los Angeles, to name a few. Born in a rural area of the state of Washington and untrained as an artist, Kienholz (1927–94) moved to Los Angeles in 1953, supported himself as a carpenter, and began assembling wooden objects from bits of junk with the bricoleur's facility for mechanical skill. In 1957, together with the curator Walter Hopps and the poet Bob Alexander, he founded the Ferus Gallery, which fostered the development of a vigorous new Los Angeles avant-garde. In 1962 he exhibited *Roxy's,* an environment replicating a brothel, based on his memory of one he had visited as a teenager in Idaho. Kienholz's tableaux are rich in social and political criticism and satire: *The Beanery* (1965) comments on the life of barflies; *The State Hospital* (1966) addresses the neglect of the mentally ill in state hospitals; others allude to teenage sex, abortion, aging, racism, fascism, the Vietnam War, and the art world. Beginning with *Middle Island No. 1,* exhibited in 1977 at the Venice Biennale, Kienholz and his wife, the artist Nancy Reddin Kienholz, collaborated on environments until his death.

Also in 1977 Eduardo Chillida (1924–2002) installed *Comb of the Wind* on the Bay of Biscay, near his native city of San Sebastián, in the Basque region of Spain. Consisting of three gigantic steel claws, set into the boulders of a cliff jutting into the sea, the site-specific installation appears to grasp the sky. The critic and curator James Johnson Sweeney declared it the "triumph of a sensitive, respectful man doing homage to both [humanity] and nature in the same sculpture."[2] Chillida realized his work in a variety of materials, from forged iron, oak, and Corten steel to burnt clay and alabaster. His early studies in architecture and consequent knowledge of the laws of architectonics supported his interest in the relationship between solid and void in his sculptures, as well as his metaphysical concern with matter and absence and time and space.

For Christian Boltanski (b. France, 1944), installation became the means for metaphysical reflections on memory, death, the human condition, and the tragedy of the Holocaust. A painter before adopting a variety of media, from film and video to performance and photography, Boltanski has installed walls of darkly lit photographs of children or piles of used clothing, creating fictive archives that serve as memorials for the anonymous dead and challenging truth in memory. His "cast-shadow pieces," such as his floor installations with tiny marionettes carefully lit in a tangle of electrical wires, evoke life as both sacred and a mere flicker in time. Boltanski's use of photographs in particular recalls the German critic Siegfried Kracauer's 1927 observation of how photographs transform living subjects into dead objects frozen in time and how they, paradoxically, attract fascination because of the near-ubiquitous fear of death.[3]

Christo (Christo Javacheff; b. Bulgaria, 1935) studied at the Fine Arts Academy in Sofia before arriving, by way of Prague and Vienna, in Paris, where in the late 1950s he joined the Nouveaux Réalistes. In 1958 he married the French-born artist Jeanne-Claude (Jeanne-Claude Denat de Guillebon; 1935–2009), who would become his constant collaborator. Both would be naturalized as U.S. citizens. In an early installation, *Iron Curtain* (1962), they blocked the rue Visconti in Paris with oil barrels. They then began wrapping objects, often on a large scale, creating mysterious presences while

at the same time calling attention to the capitalist preoccupation with packaging. Among the buildings and other structures they wrapped were the Kunsthalle Bern (1968), the Museum of Contemporary Art in Chicago (1969), the Pont Neuf in Paris (1985), and the Reichstag in Berlin (1995). Their temporary installations and interventions in natural environments have included *Wrapped Coast,* covering one and a half miles of coastline near Sydney (1969); *Valley Curtain* at Rifle Gap in Colorado (1972); *Running Fence* along twenty-four and a half miles of coastline in Northern California (1976); *Surrounded Islands* in Biscayne Bay, near Miami (1983); *The Umbrellas,* created simultaneously in Japan and the United States (1991); and *The Gates* in New York's Central Park (2005). For all of these projects, the artists initiated political, social, cultural, and environmental processes to obtain permission to create their work, which often traversed public and private domains. They also financed their own work, accepting no sponsorships and remaining independent from external professional and financial pressures. As environmentalists, they recycled all the materials used in their impermanent structures, which continue to exist only in memories, photographs, films, and documentary books.

Also site-specific are many of the projects of Maya Lin (b. U.S., 1959). She proposed her design for the *Vietnam Veterans Memorial* (1982) while still an undergraduate at Yale University. Situated on the National Mall in Washington, D.C., the memorial fuses architecture and sculpture in the manner of some funerary monuments. Its polished-granite walls serve as reflective surfaces, merging viewers with the engraved names of the nearly sixty thousand Americans who died in Vietnam. Cut into the ground in a V-shape, located between the Washington Monument and the Lincoln Memorial, the monument becomes a gash in the Mall, symbolizing the war's rupture of U.S. history and forging an austere place of personal and national mourning. Lin has also designed the *Civil Rights Memorial* (1989) in Montgomery, Alabama; created earthworks such as *Wave Field* (1995) at the University of Michigan and *Flutter* (2005) in Miami; and mapped specific environments in works like *Where the Land Meets the Sea* (2008), a drawing in space showing the topography of part of the San Francisco Bay. She served on the selection jury for the World Trade Center Site Memorial Competition in 2003.

Minimalist art and earthworks, in part, inspired Lin's designs. In the early 1960s, in response to the increasing commodification of art, some artists turned away from the gallery system to work on the land. The artist Michael Heizer summed up this movement when he noted: "The position of art as a malleable barter-exchange item falters as the cumulative economic structure gluts. The museums and collections are stuffed, the floors are sagging, but real space still exists."[4] Some artists who began to use the earth as their artistic material were inspired by the Austrian-born artist and designer Herbert Bayer. Photographs of his *Earth Mound* (1955)—a circular mound, 40 feet in diameter, set within a grassy plane in Aspen, Colorado—were exhibited at the pivotal exhibition *Earth Works* at Dwan Gallery in New York in 1968.

Three years before the *Earth Works* show, in 1965, Alan Sonfist (b. U.S., 1946) approached New York City government officials with the idea of "natural phenomena as public monuments." He eventually created *Time Landscape* (1965–) in Greenwich Village, planting an urban forest grown from seeds he had collected from plant species that had flourished in sixteenth-century Manhattan. Today this small ancient forest, inter-

spersed with volunteer plants that have taken root over nearly fifty years, thrives at the corner of La Guardia Place and Houston Street. The first urban earthwork, it was granted landmark status in 1999. Sonfist's idea of a "natural/cultural landscape" can be traced to his childhood, when he collected and displayed twigs, leaves, seeds, and rocks culled from a forest near the Bronx. A variation on this practice reappeared in his *Gene Bank* series of the 1970s, in which he photographed old-growth forests and then exhibited plant and soil specimens from them together with the images. His *Circles of Time* (1986–89)—an installation in the Fattoria di Celle, a sculpture garden in Pistoia, Italy—consists of a series of rings representing the land at different historical moments in Tuscan history.

Richard Long (b. U.K., 1945) also works with, rather than imposes upon, nature. His first work, *A Line Made by Walking* (1967), was an ephemeral installation made by repeatedly walking in a straight line across grass in a London park, imprinting his trace, and then leaving the grass to return to its unmarked condition. Photographs of the line were all that remained. Long later expanded his walks to sites throughout the world, including wilderness settings from the Himalayas, Alps, and Andes to the Arctic Circle. During his journeys, he arranged indigenous stones, driftwood, river mud, and other found materials in primary shapes common to ancient cultures (straight lines, circles, spirals, and squares), and then photographed these site-specific works. He has also installed these natural materials in art institutions, in formations similar to those he made on the land, exhibiting his structures alone or with topographical maps, paintings, and/or "word pieces," a minimalist kind of poetry.

A number of other British artists were pioneers in using the land as their art medium. In 1969 Hamish Fulton also began walking in the English countryside and, like Long, subsequently continued his walking projects throughout the world. Insisting that his activity is not land art, Fulton has photographed the places through which he moved and then exhibited these visual documents of his journeys. Similarly, the photographer and sculptor Andy Goldsworthy began working directly on the land in the late 1970s, taking color photographs of the fleeting constructions he makes using natural, often ephemeral materials such as icicles, leaves, mud, sticks, pebbles, and feathers. The German filmmaker Thomas Riedelsheimer's documentary *Rivers and Tides* (2001) visualizes the impact of time on Goldsworthy's work. In a more anthropocentric style, the concrete poet and sculptor Ian Hamilton Finlay constructed a garden installation, *Little Sparta* (1966–2006), on an abandoned farm in southern Scotland in the Pentland Hills near Edinburgh.[5] Carving a variety of poetic, historical, and philosophical texts onto stones, he then arrayed these throughout the garden environment, relating constructed knowledge to the processes of nature.

The apogee of land or earth art is often considered to have occurred in the United States, where artists began to make massive installations in remote sites during the late 1960s and early 1970s. For example, after making *Two Lines in the Desert* (1969), two parallel lines, both one mile long, drawn in chalk in the Mojave Desert, Walter De Maria (b. U.S., 1935) created *The Lightning Field* (1977) on a remote plateau in western New Mexico.[6] Four hundred polished stainless-steel poles, each 2 inches in diameter and an average of 20 feet high, are spaced 220 feet apart in a minimalist grid measuring one mile by one kilometer. The work is meant to be walked through and viewed at a

distance from a small cabin built in 1923 that faces the field. Visitors are required to stay overnight in the cabin in order to experience directly over 24 hours both the rational, abstract, industrial form of the installation and the unpredictable behavior of the earth, sky, light, fauna, and flora. Before he became associated with minimalism and earthworks, De Maria participated in proto-Fluxus activities, made films, and drummed for the rock group the Primitives, a forerunner of the Velvet Underground.

Robert Smithson (b. U.S., 1938–73) is also a central figure in the epic period of minimalism, conceptual art, and land art. His *Spiral Jetty* (1970), a spiraling walkway built up of stones and earth in the Great Salt Lake in Utah, evokes associations to growth and destruction: over time microorganisms turned the stones pink, and at one point the entire structure disappeared under rising water levels, only to reemerge years later. Addressed to life and entropy, *Spiral Jetty* is a metaphor for the coil of time and theories of the irreversibility of energy loss. Its location near an abandoned oil-drilling operation reflected Smithson's interest in the rehabilitation of the environment damaged by industry. Smithson was seminal in theorizing art's relationship to the environment, distinguishing between "site" (the original context in which a work of art appears) and "non-site" (the gallery or other space to which the work is moved). Smithson died in a plane crash while photographing his work *Amarillo Ramp* (1973) in a desolate area of Texas.

Other U.S. artists associated at times with land art include Carl Andre (see chap. 2), whose end-to-end *Log Piece* (1968) evinced his notion that horizontal sculpture represents "the engaged position," which "is to run along the earth."[7] Richard Serra (chap. 7) created the site-specific installation *Spin Out, for Robert Smithson* (1972–73) in a wooded glen at the Kröller-Müller Museum in Otterlo, the Netherlands. Robert Morris (chap. 7) erected large outdoor works throughout the United States and elsewhere. Michael Heizer (b. U.S., 1944) moved, in 1967, to a remote area of Nevada, where he created *Double Negative* (1969–70) by cutting two trenches, each 1,500 feet long, 50 feet deep, and 30 feet wide, into the desert, displacing 240,000 tons of rock. Earlier, in *Annual Rings* (1968), Dennis Oppenheim (b. U.S., 1938–2011) shoveled huge masses of snow to expose rings of water in the Saint Lawrence River on the U.S.-Canadian border. In the related *Directed Seeding* and *Canceled Crop* (both 1969), Oppenheim first seeded a field of grain in Holland and then harvested it in the form of an X. Nancy Holt (b. U.S., 1938), a photographer, filmmaker, poet, and sculptor who was married to Robert Smithson, created *Sun Tunnels* (1976), orienting tubular forms toward the summer and winter solstices to reflect astronomical configurations. Like many other artists associated with earthworks, Holt returned to an urban setting in the 1980s, creating public sculptures with lessons learned from the land.

Born in 1938 in Budapest, Agnes Denes grew up in Stockholm and moved to New York in 1954. A generalist in an era of specialization, Denes drew on mathematics, physics, geography, biology, history, and philosophy for her conceptual installations. In works like *Rice/Tree/Burial* (1968), in Sullivan County, New York, she considered re-generation and the life cycle, as she also did in *Wheatfield—A Confrontation* (1982), in which she planted, tended, and harvested a two-acre wheatfield in what was then the Battery Park Landfill. Today the visionary pathos of the work, which celebrated the earth's endurance, is its site, near New York's World Trade Center.

Robert Irwin (b. U.S., 1928) began as a painter, gradually reducing his picture surfaces to spare monochromes. His concentration on the visual perception of light and space, like that of other Los Angeles artists such as Maria Nordman and Douglas Wheeler, eventually led him to create installations where the threshold (or upper registry) of the visibility of light became his goal. Reading extensively in philosophy, from Plato and Wittgenstein to the present, and consulting psychophysics (the study of the relationship between stimulus and sensation), Irwin developed his own theory of aesthetic perception, classifying outdoor sculpture into four categories: site-dominant, site-adjusted, site-specific, and site-conditioned/determined. Advocating an unobtrusive approach to the land—an art "so ephemeral as to threaten to disappear altogether"—Irwin encouraged viewers to "discover and value the potential for expressive beauty in everything." A decade later he designed the 134,000-square-foot Central Garden for the Getty Center in Los Angeles (1997). The garden is constantly altered by the seasons and weather, bearing out Irwin's comment, carved into the garden's plaza floor, "Always changing, never twice the same."[8]

The interplay of light and space in perception informs the investigations undertaken by James Turrell (b. U.S., 1943) into sensory synaesthesia (perceiving sensory data of one sense with another) and anomalous encounters with light (as in lucid dreaming and near-death experiences). Turrell studied psychology and mathematics before earning an MFA from the Claremont Graduate School in 1973. The emanation of light in Mark Rothko's paintings and the French philosopher Maurice Merleau-Ponty's exploration of perception and illusion in *Phenomenology of Perception* (1945) both influenced Turrell's first indoor installations in which light could be perceived as a physical presence. Effects of light (like that of moonlight or seeing one's shadow cast from the light of the planet Venus) led to his *Roden Crater* (1972–), a project in which the artist continuously sculpts an extinct volcano on the western edge of the Painted Desert in Arizona into a natural observatory for viewing celestial phenomena like starlight from galaxies older than Earth's solar system. The installation also comprises tunnels leading to observation chambers, whose interconnections reveal geological and astronomical conditions of space and time. One of the most ambitious works of art ever undertaken by an individual artist, *Roden Crater* must be understood in relation to both the structure and the limits of natural perception and learned concepts. Similarly, Charles Ross conceived of his *Star Axis* in 1971, an ongoing, extensive architectonic land sculpture in an isolated area of New Mexico, that reveals images "drawn by light . . . manifesting elements of light's structure, solar power, the combined motions of the earth in space and the geometry of the stars."[9]

Embracing the concept of doing no more harm to the fragile earth, Helen Mayer Harrison (b. U.S., 1929) and Newton Harrison (b. U.S., 1932) have created aesthetic interpretations of the state of the ecology, addressing environmental challenges and developing metaphors for humans' dependence on and close relationship with nature. Helen's background was in the social sciences; Newton's, in the arts, including the intersection of art and technology. In the early 1970s the couple began collaborating on projects combining the social and artistic spheres. They worked in tandem with biologists, ecologists, environmentalists, urban planners, engineers, and landscape architects, as well as other artists, on such challenges as watershed restoration, urban re-

newal, and agricultural and forestry issues, undertaking research that ranged from sociological studies of a region to aerial photography of it. Their wide-ranging inquiries led to installations of large cartographic images, sometimes accompanied by performative readings on the precarious state of nature, as well as to proposals to planning agencies for helping to institute change. Peter Selz described their art as "survival instruction."[10] The artists note that their work begins when they "perceive an anomaly in the environment that is the result of opposing beliefs or contradictory metaphors."[11]

Also submitting art to a sociological interaction with the urban environment, Gordon Matta-Clark (b. U.S., 1943–78) began, in the early 1970s, to make site-specific installations in New York City by surreptitiously cutting into abandoned waterfront buildings, creating vertiginous angles and unexpected views. He then photographed these "cuts" and exhibited the photographs alongside sections removed from the buildings. In 1971 Matta-Clark opened a restaurant called Food with the artists Caroline Goodden, Tina Girouard, and others. There, cooking became a means for the creation of conceptual and performance art. Together with such artists as Laurie Anderson, Matta-Clark, who had studied architecture at Cornell University, developed the idea of "Anarchitecture," reflecting on the transitional and noninstrumental aspects of such things as "surplus land" (gutter and curb space) and on the rationalization and colonization of space in modernism. In *Splitting* (1974) Matta-Clark cut a suburban house in half to expose layers of life lived in the built environment and to recuperate what he called the "throwaway environment." Positioning installation in the context of New Left political ideals, he believed his "cuts" might "trigger people in . . . the neighborhood and the culture" to become more involved in the reconstruction of everyday life.[12]

Charles Simonds (b. U.S., 1945) shared a studio with Matta-Clark in the early 1970s and formed close friendships with Robert Smithson and the art critic Lucy Lippard. In 1971 Simonds began making miniature architectural complexes and landscapes out of brick and clay, which he placed as tiny installations in the cracks of urban buildings. The audience for most of his street works consisted primarily of passersby, especially children, whether in the slums of New York or on the communal farms along the Li River near Guilin, China. He also created hamlets in corners and odd architectural spaces in museums and galleries. Simonds's miniaturized environments bring to mind the archetypical "little people" who inhabit stories and myth, from Irish leprechauns and Jonathan Swift's Lilliputians to the hobbits of J. R. R. Tolkien's Middle-earth and the visions of Jules Verne. As such, his work provokes consideration of the hubris of humans, who, as the curator and art critic Jane Fudge has astutely observed, "crawl upon the skin of the planet, living in a conceit of human-sized time and space."[13]

Working in a much larger scale than Simonds, Alice Aycock (b. U.S., 1946) began in the early 1970s to create site-specific mazes, platforms, tunnels, and trenches in the Pennsylvania countryside that suggested primitive architectural edifices infused with myth. Her first outdoor installation, *Maze* (1972), a wooden structure 32 feet in diameter and 6 feet tall, recalled the labyrinths of ancient cultures, from the Minoan to the Mayan. In the late 1970s Aycock's structures became increasingly enigmatic, beginning with her gallery installation for Documenta 6, *The Beginnings of a Complex* (1977), which consisted of freestanding architectural façades with windows. *The Machine That Makes the World* (1979) initiated several decades of large-scale kinetic sculptures and public

installations in which she explored the aesthetic intersection of science, technology, anomalous phenomena (like ghosts), psychology, and philosophy, and especially metaphysical concepts like the soul. *Starsifter, Galaxy NGC 4314* (2005), at Ramapo College of New Jersey, is a 30-foot-long installation that pays homage to a spiral galaxy located 40 million light-years from Earth, in a ring of stars about 5 million years old. NGC 4314, which has been photographed by the Hubble space telescope, is one of the closest sites of new star formation.

Outer space became the subject of fantasy and escape in the installation *10 Characters* by Ilya Kabakov (b. Ukraine, 1933). In this series of rooms, imagined in 1982 and realized in 1988, each space addressed a different invented character, such as "The Man Who Collects the Opinions of Others" and "The Man Who Flew into Space from His Apartment." The latter room simulated a cramped and cluttered Moscow communal apartment, inside of which hung a crude human-size slingshot, apparently used by the absent protagonist to catapult himself through the hole in the ceiling into freedom, thus exiting his miserable existence. Kabakov's characters operated both as ventriloquists for his own inner life, or "field of consciousness,"[14] and as commentary on failed utopian communism, specifically the harsh reality that lay behind the Soviet vision of cosmonauts conquering the cosmos. Years before, in the early 1970s, Kabakov did a series of albums, also titled *10 Characters,* containing drawings and texts depicting life in the Soviet Union as hopeless and drab. A prolific artist, he completed more than fifty of these albums by 1976. Circulated privately, they inspired "unofficial" experimental practices, such as conceptual and performance art, by countless Soviet artists. Particularly renowned for such practices was the Collective Actions group of the mid-1970s, especially its leader the artist-poet Andrei Monastyrsky, who is credited with Kabakov as a founder of Moscow conceptualism. *Ten Characters* underpins Kabakov's concept of "total installation," his ideal form for immersing viewers in the "field of the painting" (painting being his metaphor for the foundational experience of art). Kabakov, who studied graphic art at the Surikov Art Institute in Moscow, graduating in 1957, for a time illustrated children's books for a living. He immigrated to the United States in 1993.

Dan Perjovschi (b. 1961) grew up in the Soviet bloc country of Romania under the dictatorship of Nicolae Ceaușescu. Both Perjovschi and his wife, the artist Lia Perjovschi (Amalia Parcurar), participated in the 1989 Romanian Revolution. In a 1993 performance in Timișoara, where the revolution began, Perjovschi had the word "Romania" tattooed on his bicep as a marker of his former subjugation. By 2003, when he had the tattoo removed in another performance, Perjovschi had become internationally renowned for installations with thousands of drawings and captions characterized by dark humor and biting cultural, social, and political commentary. *Anthropoteque* (1990–92), for example, allowed viewers to manipulate more than five thousand flip drawings on a wall, and *rEST* (1999), a grid of thousands of drawn images, covered the entire floor of the Romanian Pavilion at the 48th Venice Biennale, before the visiting public gradually scuffed off the drawings while viewing them. Combining performance with site-specific installation, Perjovschi often interacts with the public while making his works, as in his installation WHAT HAPPENED TO US? (2007), where for two weeks he created hundreds of small drawings directly on a wall at the Museum of Modern Art in New York. Perjovschi also disseminates his drawings via newspapers, fax, e-mail, tele-

phone, and Facebook. At times he has collaborated with Lia Perjovschi on public educational projects, such as a Romanian national television program, *Everything on View,* which covered international experimental art, dance, film, theater, architecture, and literature, as well as politics, in ten three-hour-long shows in 2000.

Alfredo Jaar, born in Chile in 1956, was seventeen years old in 1973 when Salvador Allende, then the elected president of Chile, was overthrown in a violent military coup by Augusto Pinochet, whose dictatorship lasted until 1990. Six years later, Jaar attended the Chilean–North American Institute of Culture and then the University of Chile in Santiago, before immigrating to the United States in 1981. In his subsequent installations and community-based projects, comprising photographs, films, and sometimes performance, he has confronted political corruption, the exploitation of laborers, war, genocide, migration, famine, environmental pollution and disasters, and human rights abuses, with the aim of producing an ethical aesthetic oeuvre that, in his words, elicits "empathy, solidarity, and intellectual involvement."[15] Jaar has often created works in series, such as *The Rwanda Project* (1994–2000), which included twenty-one individual works that attempted to visualize the overwhelming number of people killed—one million—in one hundred days during the Rwandan genocide of 1994. In 2004 Jaar turned to the question of how artists and intellectuals can have an impact on politics in a series of installations titled *The Gramsci Trilogy,* dedicated to the Italian philosopher Antonio Gramsci, who was imprisoned under the fascist dictatorship of Benito Mussolini. Jaar's work often circles back from world events to Chilean politics in order to address the injustices of his past as well as the continuing "criminal indifference" of the world.[16]

Doris Salcedo (b. 1958) is best known for sculptural installations using domestic furniture, textiles, bits of clothing, and other familiar materials that, while being everyday things, nonetheless symbolize political strife, social struggle, individual pain, and collective tragedy both in her native Colombia and internationally. Imbued with the sense of events charged with significance, Salcedo's art concerns memory, forgetting, victims, perpetrators, and those considered "other," especially immigrants, "outsiders," and "displaced" people, the term she uses to describe her own, as well as artists', situation in general. Among others, the Colombian artist and intellectual Beatriz González educated Salcedo as a painter, training that is vivid in the worked surfaces of Salcedo's sculpture. The artist was also strongly influenced by Joseph Beuys (chap. 7), especially his notion of "social sculpture," which deeply informed her approach to how materials can convey political and cultural meanings such as the "precariousness [of] thought: an inability to articulate history and therefore to form a community."[17] In the 2000s, Salcedo turned increasingly to large-scale installations, as at the 8th Istanbul Biennial in 2003, where she stacked 1,600 wooden chairs between two buildings. This dramatic work recalled the fifty-three hours during which she had chairs lowered over the façade of the new Palace of Justice in Bogotá in remembrance of the violent seizing of the previous Supreme Court building in 1985. Her *Shibboleth* (2007) at the Tate Modern ran a crack 548 feet through the huge Turbine Hall to symbolize the role of art and its institutions in the history of racism and displacement.

Yinka Shonibare, who was born in London in 1962 but grew up in Nigeria, has described himself as "a citizen of the world" who only began to grasp his "blackness . . . when [he] stepped off the plane at Heathrow."[18] After receiving an MFA from Gold-

smiths College in London in 1991, Shonibare quickly became associated with the Young British Artists, recognized for his daring installations of mannequins dressed in Victorian clothes made of kente cloth. Shonibare arrived at this signature aspect of his work after being advised by an art teacher to explore his "traditional African roots," only to find, ironically, that this fabric, commonly associated with Africa, was industrially produced in Indonesia, the Netherlands, and England and then exported to Africa in the nineteenth century. Shonibare used the material as "a metaphor for something which is multicultural and essentially hybrid, like my identity."[19] In 2002, for example, he incorporated Ankara fabric from Nigeria in various works to comment on the intersection of politics, race, and sex: *Space Walk* presents astronauts in flight suits made of the cloth; *Gallantry and Criminal Conversation* arrays headless figures, dressed in the fabric, in various sexual positions; and *Dreamscape* encases dildos in condoms made of the fabric. Shonibare has also created performative photographic installations, such as *Dorian Gray* (2001), in which he documented himself in the role of the notorious dandy.

Nicholas Hlobo (b. South Africa, 1975) explores gender, race, ethnicity, and sexual stereotypes in installations constructed from both found materials (like old wood and tires) and bright, new materials like feathers, ribbons, and gossamer fabrics. Born in Cape Town, Hlobo received a degree in fine art from Johannesburg's Technikon Witwatersrand in 2002. His work incorporates elements of South African culture that are grounded in metaphors, such as the Xhosa choral song about the courage and confidence of the dung beetle. *Intente* (2006) features a phallic form created from a rubber inner tube and, like a tent, held in place by ropes tied to rocks. This piece considers the paradoxical display of protection, destruction, and power in military camps, using the tent as a metaphor for masculinity and playing on the Xhosa phrase *umis' iintente* ("he's got his tents up"), slang for an erection. In addition, as Hlobo explains, "the thought of something pushing from below with great pressure can be related to the struggle for equal rights by homosexual men and women."[20]

In the 1980s Mona Hatoum, who was born in Lebanon in 1952, used performance and video to create visceral actions involving bodily fluids and violent situations metaphorically suggestive of her experience as a Palestinian living in Lebanon and as an exile in England after the Lebanese Civil War began in 1975. After abandoning performance as too politically direct, Hatoum turned to making large-scale installations, often using electricity as an "invisible force." *The Light at the End* (1989), an installation of six vertical lines of light at the end of a darkened room, assaulted viewers as they approached and recognized that the light came from unguarded electrical heating elements mounted on a metal structure with bars like a prison. Disturbing the idea of home as a place of safety and comfort, and representing it instead as somewhere from which one might be forced to flee, Hatoum also has objects manufactured in uncanny ways. In *Cage-à-deux* (2002) a human-size birdcage suggests incarceration and torture, a theme presented without moralizing, like other political topics in her work. In such installations as *Continental Drift* (2000) and *Homebound* (2000), Hatoum focused on geographic unsettlement, the resulting instability of identity, and the difficulty of belonging.

Gabriel Orozco (b. Mexico, 1962) approaches art with a philosophical attitude, using a wide variety of media, including painting, sculpture, photography, and video, to explore social, political, and cultural challenges in common situations and everyday

events. Educated at the National School of Plastic Arts in Mexico City (1981–84) and the Fine Arts Circle in Madrid (1986–87), Orozco epitomizes the global artist who lives a seminomadic existence, traveling the world to create site-specific works. His installations are characterized by a highly conceptual approach and minimalist aesthetic. In *Home Run* (1993), for example, he placed oranges in cups, vases, and other containers in the windows of apartment buildings adjacent to the Museum of Modern Art in New York, transforming the museum exhibition into public art and asking viewers to "confront reality" afresh. In a series of 2006 paintings, he considered "the phenomenology of structures, in which the symbol of the circle acts as a bridge between geometry and organic matter, and the sequencing of colour is based on the principles of movement within a game of chess."[21]

In *Mining the Museum* (1992), Fred Wilson (b. U.S., 1954) reinstalled the collection of the Maryland Historical Society in Baltimore, placing objects from white antebellum southern culture next to objects used to oppress black Americans, such as Ku Klux Klan hoods and slave shackles. By positioning cultural objects within a broader historical context, Wilson drew attention to how racism pervades society and its institutions, including art museums, a subject that informs all of his work. Sixteen years later Wilson installed *An Account of a Voyage to the Island Jamaica with the Un-Natural History of That Place* (2008) as part of the exhibition *Materialising Slavery: Art, Artefact, Memory and Identity* at the Institute of Jamaica in Kingston. Marking the bicentenary of the abolition of the transatlantic slave trade, the exhibition as a whole related to the artist's mixed African, American Indian, and European heritage. Wilson's installation, which considered the effect of colonization on people and nature, referred to the work of Sir Hans Sloane, a British physician, scientist, and collector (1660–1753) who made extensive notes on the local fauna and flora of Jamaica and amassed a large number of plants, animals, antiquities, coins, and other objects that would later enter the collections of the British Museum and the Natural History Museum in London. Wilson's title plays on the title of Sloane's two-volume work on his collection, replacing the "Natural" of the original with "Un-Natural."[22] Wilson received a BFA from the State University of New York at Purchase in 1976, where he was at the time the only black student in his program. His awareness of the negative effects of stereotyping has made Wilson "really want to know about things, to not take anything for granted."[23]

Rachel Whiteread (b. U.K., 1963), one of the Young British Artists who gained prominence the early 1990s, first garnered attention for *Ghost* (1990), a monumental sculptural cast of the interior space of a small room in a Victorian house. With *House* (1993–94), she cast the inside of a nineteenth-century terrace house in the East End of London scheduled for demolition. The work brought her international fame and drew attention to the issue of urban renewal. Whiteread has continued to cast odd, seldom-considered spaces—such as those under tables and chairs, around books arranged on shelves, in staircases, and under floorboards—in a variety of materials, including resin and plastics. In doing so, she creates an uncanny experience of absence that once felt seems present. In the late 1990s Whiteread was commissioned to design a memorial for Austrian victims of the Holocaust for the city of Vienna. Her Judenplatz *Holocaust Memorial* (2000), also known as the *Nameless Library,* is a concrete building, the walls of which have been cast from shelves of books with the spines facing in, like a huge ar-

chitectural sarcophagus that evokes Nazi book burning and the idea of Jews as "people of the book." In its traumatic implications Whiteread's work is uncannily reminiscent of Doris Salcedo's, which evokes places and furniture bereft of human presence.

Whereas Whiteread, with *House,* pictured the destruction of the past and reclaimed it in sculptural form, Andrea Zittel (b. U.S., 1965) creates works related to living in the present. Zittel received a BFA in painting and sculpture from San Diego State University in 1988 and an MFA in sculpture from the Rhode Island School of Design in 1990. She began making *Living Unit,* a compact, autonomous structure designed as a complete living environment, which grew out of the demands of her own small Brooklyn storefront apartment and her interest in self-sufficiency. In *Living Unit* she mockingly transformed "limitations into 'luxuries'" and provided a sense of "elegance and simplicity," from A to Z.[24] Zittel started her own corporation, A–Z Administrative Services, to market her unconventional objects. In 1999, for a commission from the Danish government, Zittel created *A–Z Pocket Property,* a 44-ton floating concrete island off Denmark's coast, where she lived for one month in isolation. The title of this work alludes to her larger project of combining "your three most important possessions: your plot of land, your home, and your vehicle into a hybrid prototype product."[25] By 2000 she had moved to A–Z West, a 25-acre parcel of land in the California desert. There Zittel has co-organized High Desert Test Sites, a series of experimental art sites, of which A–Z West is one. In 2007 she opened Smockshop to generate income for "artists whose work is either non-commercial, or not yet self sustaining."[26] Zittel designs the smocks, which are sewn by artists, who may reinterpret her original design according to their abilities and tastes. "Rules make us more creative," Zittel has observed.[27]

The expansive possibilities of installation art in the twenty-first century are reflected in the work of Pierre Huyghe (b. France, 1962), whose wide-ranging oeuvre includes filmic installations and public events. Beginning in the mid- to late 1990s, in a number of French cities from Paris to Dijon, Huyghe installed billboards that pictured the place in which the billboard itself was situated, thereby rendering uncanny the world in front of the viewer. Similarly commenting on the truth and fiction of everyday life and the ways in which cultural constructs become naturalized, in his film *Streamside Day* (2003) Huyghe juxtaposed a clip from the film *Bambi* with footage of a suburban housing development, in an attempt to unseat utopian ideas of wilderness. In a series of works for *No Ghost Just a Shell* (1999–2003), created in collaboration with the filmmaker Philippe Parreno, Huyghe purchased a *manga* (Japanese comic) character and invited such artists as Liam Gillick, Dominique Gonzalez-Foerster, and Rirkrit Tiravanija (chap. 7) to "fulfill this empty shell." Speaking "through the character in different ways," the artists created a "polyphony" that mirrored the collaborative nature of the project.[28]

Morphing from assemblage and environments in the 1960s to installation in the 1970s and 1980s, and from moving images to virtual reality in the 1990s and twenty-first century, site-oriented art has proved to be a versatile form, incorporating media as diverse as drawing, painting, sculpture, and architecture to the most advanced technology and the earth itself.

JOSEPH CORNELL Objects and Apparitions (1974)
by Octavio Paz

Hexagons of wood and glass,
scarcely bigger than a shoebox,
with room in them for night and all its lights.

Monuments to every moment,
refuse of every moment, used:
cages for infinity.

Marbles, buttons, thimbles, dice,
pins, stamps, and glass beads:
tales of the time.

Memory weaves, unweaves the echoes:
in the four corners of the box
shadowless ladies play at hide-and-seek.

Fire buried in the mirror,
water sleeping in the agate:
solos of Jenny Colonne and Jenny Lind.

"One has to commit a painting," said Degas,
"the way one commits a crime." But you constructed
boxes where things hurry away from their names.

Slot machine of visions,
condensation flask for conversations,
hotel of crickets and constellations.

Minimal, incoherent fragments:
the opposite of History, creator of ruins,
out of your ruins you have made creations.

Theater of the spirits:
objects putting the laws
of identity through hoops.

The "Grand Hotel de la Couronne": in a vial,
the three of clubs and, very surprised,
Thumbelina in gardens of reflection.

A comb is a harp strummed by the glance
of a little girl
born dumb.

The reflector of the inner eye
scatters the spectacle:
God all alone above an extinct world.

* Octavio Paz, "Objects and Apparitions—for Joseph Cornell," trans. Elizabeth Bishop, *New Yorker,* June 24, 1974; reprinted in Dore Ashton, *A Cornell Album* (New York: Viking, 1974; Da Capo Press, 1989), 115–18. © 1974 The New Yorker Magazine, Inc. By permission of the poet and The New Yorker Magazine, Inc.

The apparitions are manifest,
their bodies weigh less than light,
lasting as long as this phrase lasts.

Joseph Cornell: inside your boxes
my words became visible for a moment.

FREDERICK KIESLER Second Manifesto of Correalism (1965)

A New Era of the Plastic Arts has begun. It is now 1965.

Our western world has been over-run by masses of art objects. What we really need are not more and more objects, but an objective.

L'art pour l'art of seventy-five years ago and the period of art for the artist's sake of the last twenty-five years are over. Before we can go into new productions, a new objective must first be crystallized out of a world consciousness which is the concern of all of us, not of any particular stratum of society. The world events since the last war have grown in turbulence and have thrown us together. Estheticism as a sole criterion for the validity of a work of art is evaporating. The artist will not work any more for his glory in museums or galleries but for solidifying the meaning of his creations on a larger scale without falling into the pitfalls of social realism or anecdotal accounts of events. He will take active part through his work in forming a new world image.

The era of experimentations in materials and forms over half a century has run its gamut; a new era has begun, that is an era of correlating the plastic arts within their own realms but with the objective of integrating them with a life freed from self-imposed limitations.

The poet, the artist, the architect and the scientist are the four cornerstones of this new-rising edifice.

.

Just as we have been restricting our lives to this earth since homo sapiens became man, so have the plastic artists acted within the confines of the spirit of this planet. What we artists were doing was simply trading traditions with little forays into the unknown to flatter our fickle ego. To look up at the sky, at the stars, at the moon, at the sun was a romantic or fearful dream. Now the outer-space (as the super-galaxies are called) is coming closer and closer to us and is changing from an abstraction into the realism of our world.

The plastic arts must now expand their horizons, too, and widen the arena of their activities to unforeseen capacities. It is evident that the constantly expanding universe of our environment forces us more and more to give attention to time-space continuity.

The traditional art object, be it a painting, a sculpture, a piece of architecture, is no longer seen as an isolated entity but must be considered within the context of this expanding environment. The environment becomes equally as important as the object, if not more so, because the object breathes into the surrounding and also inhales the realities of the environment no matter in what space, close or wide apart, open air or indoor.

No object, of nature or of art, exists without environment. As a matter of fact, the object

* Frederick Kiesler, "Second Manifesto of Correalism," *Art International* 9, no. 2 (March 1965): 16–19. By permission of Lillian Kiesler and the publisher.

itself can expand to a degree where it becomes its own environment (see my wooden galaxy exhibited at the Museum of Modern Art in 1951).

Thus we have to shift our focus from the object to the environment and the only way we can bind them together is through an objective, a clarification of life's purpose—otherwise the whole composite picture in time and space will fall apart.

In my show at the Guggenheim Museum, I tried on a small scale to indicate the new relationship between object and environment, of course with moderate means but taking in the whole scale of architecture, painting, and sculpture, real and abstract—but non-objective. There are several galaxial co-ordinates in that large room, yet, without losing their individual identity, they are related to each other in a totality forming its own continuum. I hope that this first exhibition of environmental sculptures is successful, inspiring other artists, poets and scientists alike, to work together and bring the expanding universe of the plastic arts into an ever-growing reality.

LOUISE NEVELSON *Dawns and Dusks* (1976)

I began using found objects. I had all this wood lying around and I began to move it around, I began to compose. Anywhere I found wood, I took it home and started working with it. It might be on the streets, it might be from furniture factories. Friends might bring me wood. It really didn't matter.

Now, no one, to my knowledge, at that time was using old wood. Sculptors were using the torch. It somehow wasn't what I wanted. The noise and the masquerade offended me, and I didn't like the execution. It was too mechanical for me. Because I was creating every second, with this great intensity and great energy. And I just automatically went to wood. I wanted a medium that was immediate. Wood was the thing that I could communicate with almost spontaneously and get what I was looking for. For me, I think the textures and the livingness . . . when I'm working with wood, it's very alive. It has a life of its own. If this wood wasn't alive, it would be dust. It would disintegrate to nothing. The fact that it's wood means it has another life. . . .

To me, actually, some of the poorest and cheapest woods are really the most exciting—the Japanese boxes and crates have the most texture, and they have knots in them. It doesn't matter. During the war there was a shortage of materials, and I decided that creativity was the important thing and I would see things that I could use, everywhere. I always wanted to show the world that art is everywhere, except it has to pass through a creative mind. I had always, way back years ago, felt *that*. . . . In my environment as a child I was very aware of relationships. The injustices of relationships. And I suppose I transferred that awareness to material, what we call "inanimate." I began to see things, almost anything along the street, as art. I don't think you can touch a thing that cannot be rehabilitated into another life. And once I gave the whole world life in that sense, I could use anything.

I feel that what people call by the word *scavenger* is really a resurrection. You're taking a discarded, beat-up piece that was no use to anyone and you place it in a position where it goes to beautiful places: museums, libraries, universities, big private houses. . . . These pieces of old wood have a history and drama that to me is—well, it's like taking someone who has been

* Louise Nevelson, excerpts from Diana McKown, *Dawns and Dusks* (New York: Charles Scribner's Sons, 1976), 76, 111, 125, 128, 130. By permission of the author and the artist.

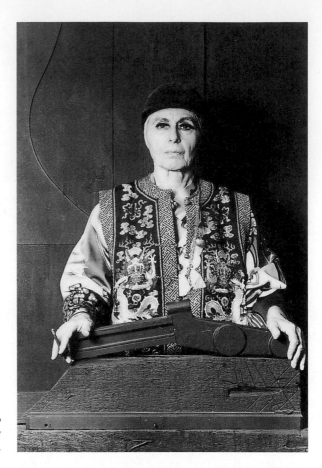

Louise Nevelson, 1976. Photo
© Lynn Gilbert. Courtesy
Pace Gallery, New York.

in the gutter on the Bowery for years, neglected and overlooked. And someone comes along who sees how to take these beings and transform them into total being. . . .

About what black . . . the illusion of black means to me: I don't think I chose it for black. I think it chose *me* for saying something. You see, it says more for me than anything else. In the academic world, they used to say black and white were no colors, but I'm twisting that to tell you that for me it is the total color. It means totality. It means: contains all. You know, this is one of the most interesting things to me, that people have identified with black all their lives and, for some reason, they identify black with death or finish. Well, it may be that in the third dimension black is considered so. It's a myth, really. But after painting, using color. . . . Now, I don't see colors, as I've often said, the way others do. I think color is magnificent. It's an illusion. It's a mirage. It's a rainbow. But why not? It's great. I was considered quite a colorist, and I can appreciate that artists in the past centuries used color—that it was right. And they were symphonies. Certainly I'm a great admirer of Bonnard or Matisse. I think Bonnard used color of that tone, we'll call it not a minor key but a major key—the treble clef. Well, he reached a symphony of color. Now if you can do that and you *want* that it almost becomes no color, because it's a mirage of light. There isn't a color that isn't of that intensity if you can get that essence and *not* think of it as color. Not only black and white and gold and silver, but you can also go to the rainbow and you can see in the sky the purples and the blues.

But when I fell in love with black, it contained all color. It wasn't a negation of color. It

was an acceptance. Because black encompasses all colors. Black is the most aristocratic color of all. The only aristocratic color. For me this is the ultimate. You can be quiet and it contains the whole thing. There is no color that will give you the feeling of totality. Of peace. Of greatness. Of quietness. Of excitement. I have *seen things* that were transformed into black, that took on just greatness. I don't want to use a lesser word. Now, if it does that for things I've handled, that means that the *essence* of it is just what you call—alchemy. . . .

The first stacked wall I did in the house on 30th Street. That big black wall that is in the Museum of Modern Art (*Sky Cathedral*). That went to the MoMA in 1956, so I must have done it in 1954–1955, but I changed it. I redesigned it for the space up in the museum. . . .

I attribute the walls to this. I had loads of energy. I mean, energy and energy and loads of creative energy. And no matter how much space—now it's different, but at that time if I'd had a city block it wouldn't have been enough, because I had this energy that was flowing like an ocean into creativity. Now I think a brook is beautiful, and a lake you can look at and it's just peaceful and glorious, but I identify with the ocean. So I did begin to stack them. It was a natural. It was a flowing of energy.

I think there is something in the consciousness of the creative person that adds up, and the multiple image that I give, say, in an enormous wall gives me so much satisfaction. There is great satisfaction in seeing a splendid, big, enormous work of art. I'm fully aware that the small object can be very precious and very important. But to me personally, I think there is something in size and scale. We have all heard of quantity, of quality. I want a lot of quality in a lot of quantity.

ISAMU NOGUCHI *A Sculptor's World* (1968)

My regard for stone as the basic element of sculpture is related to my involvement with gardens. My own work, I feel, is renewed each time I work in either—periodic activities that thread my life. With earth as with stone, it is the most physical involvement, to which I return with zest. . . .

Why do I continuously go back to Japan, except to renew my contact with the earth? There still remains unbroken the familiarity with earthly materials and the skill of Japanese hands. How exquisitely functional are their traditional tools. Soon these, too, will be displaced by the machine. In the meantime I go there like a beggar or a thief, seeking the last warmth of the earth.

How limited I find my own abilities, always seeming to become less than before. My schooling has been only that of long experience; learning from each new piece a fresh insight—discovery that leads me always to the next and the next, occasionally with a shock of recognition—an accident, perhaps, dragged out of some unconscious memory. What is the artist but the channel through which spirits descend—ghosts, visions, portents, the tinkling of bells.

I remember a conversation I once had with Suzuki Daisetsu, the great Zen expositor, on the train from Kyoto to Tokyo. I had said that in the West the ideal was to triumph over gravity, and that in doing a rock garden in America it would be logical to have the rocks themselves levitate (as I was then doing in the Chase Manhattan Garden). He replied, "Ah, that is why they will eventually have to come back to us." Did he include me in "us"?

* Isamu Noguchi, excerpts from *A Sculptor's World,* with a foreword by R. Buckminster Fuller (New York: Harper and Row, 1968), 38, 40, 159, 161, 170–71. Copyright © 1968 by Isamu Noguchi. Reprinted by permission of The Isamu Noguchi Foundation, Inc., and HarperCollins Publishers.

In Japan the rocks in a garden are so planted as to suggest a protuberance from the pri- mordial mass below. Every rock gains enormous weight, and that is why the whole garden may be said to be a sculpture, whose roots are joined way below. We are made aware of this "floating world" through consciousness of sheer invisible mass. At times I am deluded into thinking that the meaning of sculptures may be defined. Is it not the awareness of an inner reality, such as this, of which sculpture is a reflection and a sign? The heavenly bod- ies floating in the firmament are all connected, by gravitational forces that link them one to the other to attract and repel. Earthbound though we are, we are free to move about its surface, like filings on a magnet.

New concepts of the physical world and of psychology may give insights into knowledge, but the visible world, in human terms, is more than scientific truths. It enters our consciousness as emotion as well as knowledge; trees grow in vigor, flowers hang evanescent, and mountains lie somnolent—with meaning. The promise of sculpture is to project these inner presences into forms that can be recognized as important and meaningful in themselves. Our heritage is now the world. Art for the first time may be said to have a world consciousness.

My own contradictions, enhanced perhaps by my mixed parentage, are probably shared by most artists to some degree. We all look to the past and to the future to find ourselves. Here we find a hint that awakens us, there a path that someone like us once walked.

I have been fortunate in the people I met at critical junctures who inspired my choices. Were they chance? After each bout with the world I find myself returning chastened and contented enough to seek, within the limits of a single sculpture, the world. . . .

Invention

It is clear that I often craved to bring sculpture into a more direct involvement with the com- mon experience of living. At such times I felt there must be a more direct way of contact than the rather remote one of art. Initially this may have been no more than an attempt to move beyond the narrowing horizons of artistic sensibility. It bothered me that art so soon became a style with little creation added to its production. Why should the artistic imagination be so contained, or be unequal to the broadening scope of our world awareness? I thought of func- tion as a determinator of form, and invention of function as a possible opening to an art beyond the accepted categories. Not art? Invention is equally creation to me.

In the throw of chance, the free association and automatism of invention, the limits are those of the possible, not those of taste but of physical economy. Art might be an engineering, sculpture a structuring, functional in its purpose as art—or use, the lack of which I did not recognize as necessary to art.

I have described my very tentative attempts to design for industry, and my troubled efforts to find work through competitions or commissions, or to make work through invention as with light sculptures (*lunars*) which culminated in *akari*.

But beyond the reach of industrially realizable design or architecturally applied sculpture was, I felt, a larger, more fundamentally sculptural purpose for sculpture, a more direct ex- pression of Man's relation to the earth and his environment.

Architecture

Today we are familiar with the spaces within sculpture but, apart from this, the concept of sculptural space has hardly been touched. Sculptors think of space as just a receptacle for

sculpture and, in any case, that sculpture is enough of a job in itself—which it is. If a sculpture happens to suit the needs of an architect, it will be bought, or an enlargement made. A commission smacks of the academic past, and turns out as decoration. The free found sculpture at least avoids some compromise, although it is a question not of whether a work is made for the purpose, but whether it lives and gives life to its surrounding air.

Most sculpture, unfortunately, lives in its own space, with a purely fortuitous relation to wherever it is placed. This is different from true architectural space.

Brancusi could have become the perfect architectural sculptor. His work clearly has a deep awareness of architectural space. In all his capitals, doorways, columns, furniture and pedestals, he gives a wonderful view of what architectural sculpture might be. And yet he never worked with architects, and so far as I know, was never asked to. He set his own problems. (In the last years of his life I came to feel that his terrible bitterness may have been due partly to this lack of contact).

Is the solution of collaborative problems beneath the dignity of an artist? I have treated it as a test of my competence to be able to contribute something in spite of so-called collaboration which is so one-sided. It is said that true collaboration can only occur when the sculptor and the architect are the same person, but there must be exceptions.

I myself have tried to get around this difficulty by seeking commissions which are separate but in counterpoint to the architecture, with an equivalent scale and using the creation of space as an extension of sculpture. I am excited by the idea that sculpture creates space, that shapes intended for this purpose, properly scaled in a space, actually create a greater space. There is a difference between actual cubic feet of space and the additional space that the imagination supplies. One is measure, the other an awareness of the void—of our existence in this passing world. . . .

Gardens

I like to think of gardens as sculpturing of space: a beginning, and a groping to another level of sculptural experience and use: a total sculpture space experience beyond individual sculptures. A man may enter such a space: it is in scale with him; it is real. An empty space has no visual dimension or significance. Scale and meaning enter when some thoughtful object or line is introduced. This is why sculptures, or rather sculptural objects, create space. Their function is illusionist. The size and shape of each element is entirely relative to all the others and the given space. What may be incomplete as sculptural entities are of significance to the whole. . . .

Playgrounds

Brancusi said that when an artist stopped being a child, he would stop being an artist.

Children, I think, must view the world differently from adults, their awareness of its possibilities are more primary and attuned to their capacities. When the adult would imagine like a child he must project himself into seeing the world as a totally new experience. I like to think of playgrounds as a primer of shapes and functions; simple, mysterious, and evocative: thus educational. The child's world would be a beginning world, fresh and clear.

The sculptural elements here have the added significance of usage—in actual physical contact—much as is the experience of the sculptor in the making.

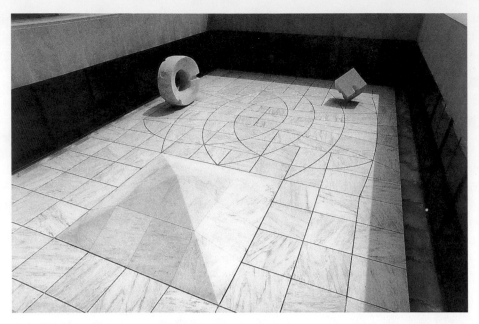

Isamu Noguchi, *Sunken Garden,* Beinecke Rare Book and Manuscript Library, Yale University, New Haven, Connecticut, 1960–64, white marble. Photo by Ezra Stoller, © Esto. All rights reserved. Courtesy of the Isamu Noguchi Foundation, Inc.

Marble Garden, Beinecke Rare Book Library, Yale University

ARCHITECTS: SKIDMORE, OWINGS & MERRILL

In view of the powerful, classic geometry of the Yale Library building, and since no planting was possible anyway, I proposed a garden in which everything would be of white marble. The whole project was executed in Rutland, Vermont.

The idea started from the sand mounds often found in Japanese temples. But soon the image of the astronomical gardens of India intruded, as did the more formal paving patterns of Italy. It became a dramatic landscape, one that is purely imaginary; it is nowhere, yet somehow familiar. Its size is fictive, of infinite space or cloistered containment.

As seen from the reading room, the illusory effect of space is cut by a pyramid (geometry of the earth or of the past), whose apex introduces another point of infinity. To the right beyond this, dominating the drama, is the circular disk of the sun almost ten feet high. A ring of energy, it barely touches the horizon. Its radiation, like lines of force in a magnetic field, transfixes it in a curvilinear perspective.

The symbolism of the sun may be interpreted in many ways; it is the coiled magnet, the circle of ever-accelerating force. As energy, it is the source of all life, the life of everyman—expended in so brief a time. How he does this, is the purpose of education. Looked at in other ways: the circle is zero, the decimal zero, or the zero of nothingness from which we come, to which we return. The hole is the abyss, the mirror, or the question mark. Or it may be the trumpet that calls youth to its challenge—from which a note has sounded (as the cube).

The cube signifies chance, like the rolling of dice. It is not original energy (sun) or matter (pyramid), but the human condition from whose shadow the rest is seen in light. If the "sun" is primordial energy, the cube is that man-made pile of carbon blocks by which he has learned to stimulate nature's processes. The cube on its point may be said to contain features of both earthly square and solar radiance.

Looked at from above, this garden is contained by the massive frame of granite that surrounds it. The drama is being silently enacted, inexorably.

The tactile evolution of sculpture is, of course, more complicated than words, and impossible to describe. There were at least ten variants of the sun, and the cube went through phases when it was not a cube at all, and was originally in a cupped well. Many of these elements were in themselves more interesting than those used. However, nothing could be allowed to detract from the whole. The sun being more plastic could not stand apart from the rest, the cube and the pyramid had each to relate to each other and to the topography as a whole.

EDWARD KIENHOLZ *The Beanery* (1965)

Barney's was an ongoing situation, and more of a social center than an art center. . . . I used to sit there in the back booth . . . and speculate how you'd ever duplicate that. It was just a technical problem: how would you make the Beanery? And then one night I drove up and saw that damn newspaper. It said, "Children Kill Children in Vietnam Riots." I went over and bought a paper and read the article. . . . Then I watched all the people walk into the bar, glancing at the headlines and just walking on. . . . They just wanted to get loose; they didn't want to cope with that—and I just decided at that point that I'd do it.

The State Hospital (1966)

This is a tableau about an old man who is a patient in a state mental hospital. He is in an arm restraint on a bed in a bare room. (The piece will have to include an actual room consisting of walls, ceiling, floor, barred door, etc.) There will be only a bedpan and a hospital table (just out of reach). The man is naked. He hurts. He has been beaten on the stomach with a bar of soap wrapped in a towel (to hide tell-tale bruises). His head is a lighted fish bowl with water that contains two live black fish. He lies very still on his side. There is no sound in the room.

Above the old man in the bed is his exact duplicate, including the bed (beds will be stacked like bunks). The upper figure will also have the fish bowl head, two black fish, etc. But, additionally, it will be encased in some kind of lucite or plastic bubble (perhaps similar to a cartoon balloon), representing the old man's thoughts.

His mind can't think for him past the present moment. He is committed there for the rest of his life.

* Edward Kienholz, on *The Beanery* (1965), from interview with Kienholz, conducted in 1977 by Lawrence Wechsler, Center for Oral History Research, Young Research Library, University of California, Los Angeles. By permission of Nancy Reddin Kienholz and the Center for Oral History Research, University of California, Los Angeles.

** Edward Kienholz, on *The State Hospital* (1966), concept statement; reprinted in *Edward Kienholz* (Stockholm: Moderna Museet, 1970), no. 10. By permission of Nancy Reddin Kienholz.

The Portable War Memorial (1968)

I would first of all never insult this country (America) as I love it perhaps even as well as you. I would, however, in my way presume to change it. My method, as is the method of most artists, is a system of focus and point of view.

Now, to the actual piece which reads as a book from left to right. On the left side are the propaganda devices. Uncle Sam of the First World War, Kate Smith singing "God Bless America," the Marines on Mount Suribachi . . .

The Marines stand in front of a blackboard tombstone that contains some 475 chalk written names of independent countries that have existed here on earth but are no longer. Places such as Akkad. Now, I don't know where Akkad was, probably you don't, but somebody once said to somebody else, "You stay the hell off Akkad or I'll get a gun/spear/rock/club and I'll do you in." The earth has always been pretty much the size it is now, but the boundaries that men place on it do change at great human cost, with questionable justification.

The next section is "business as usual," with tables to sit at and real Cokes to be bought from a real Coke dispenser. The clock is set at the current time and all is quite pleasant until you notice that the last tombstone which represents the future (and is necessarily blank) has a very small human man form crucified to it. His relationship is perhaps 2 inches to 9 feet. Upon closer investigation, hopefully with Coke in hand, the viewer notices that the figure has burned hands indicating mankind's nuclear predictability and responsibility.

One last point, the tombstone of names has an inverted cross which says "A Portable War Memorial Commemorating V— (here is a small blackboard square) Day, 19— (here is another small blackboard square)." This permits updating with the piece of chalk that is provided. The sculpture could be assembled, for instance, in Montreal with a "C" in the first square and the appropriate date in the second commemorating V.C. Day (victory in Canada), if we ever get into a serious conflict with our good neighbors to the North.

I think the fighting instinct is natural and even necessary, but I want to see it propagandized and channeled by thinking, responsible leadership. The wealthiest and most powerful nation in the world can never "win" in a one for one confrontation. ("Of course they won, they were the biggest.") Our moral/ethical posture is not so shining that we should weight other cultures with it. We should, perhaps, as a nation and as individuals, understand ourselves and our influences to a far greater degree.

I truly regret those men/all men who have died in the futility of war because in their deaths I must comprehend our future.

In peace,
Edward Kienholz
Los Angeles,
Calif.,
U.S.A.

* Edward Kienholz, on *The Portable War Memorial* (1968), from a letter to the editor, published in *Artforum* 7, no. 10 (Summer 1969); reprinted in *Edward Kienholz* (Stockholm: Moderna Museet, 1970), no. 12. By permission of Nancy Reddin Kienholz.

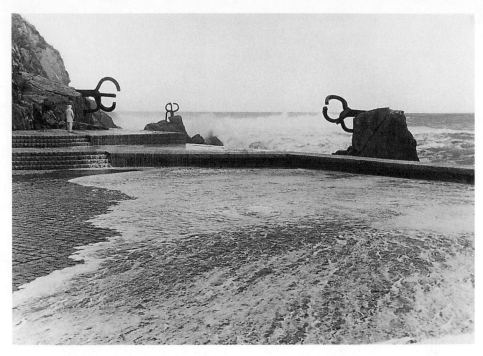

Eduardo Chillida with *The Comb of the Wind,* 1985, steel. Photo by F. Català Roca. Courtesy the photographer and Tasende Gallery, La Jolla.

EDUARDO CHILLIDA

The Comb of the Wind: Conversation with Luis Peña Ganchegui (1986)

This place is the origin of all. . . . It is the true author of these works. I discovered it and then paid an homage to it. . . . That place captured my imagination before I knew I was going to do something in it . . . much before I became a sculptor . . . much before I finished my High School. . . . I could be fourteen then wondering where the waves would come from. . . .

I understood I had to make a preamble to the sculptures in a place that is the beginning and the end of the city . . . as a symbol of the meeting of the city with nature. Of a city that ends in an absolute which is the ocean. . . .

The work demonstrates a way of intervention in the city which has much to do with the romantic Germans, specially with Novalis. These philosophers understood nature as something not to be exploited but to be understood and interpreted. The *Comb of the Wind* is then a metaphor of this attitude as regards the city. . . .

The plaza anterior to the sculptures is a "temenos" like in the space before the Parthenon. . . . It also contributes with a series of artifices to the geographic history of the place. . . .

When the practical possibility of making the work gets closer I reconsider all anew, something that is common in me. In all my first sketches the sculpture was in the free rock. I

* Eduardo Chillida, excerpts from "Conversation with Luis Peña Ganchegui," in Jesús Bazal, *Arquitecturas: The Comb of the Wind: Eduardo Chillida and Luis Peña Ganchegui,* trans. Moses Okonkwo and Maurice Fremont-Smith (Pamplona: Q Editions, 1986), 27–80. By permission of the artist. Luis Peña Ganchegui was the architect for *Comb of the Wind.*

discovered that many of the last things I had done were too notorious. In that place very elemental things occurred; the horizon at the background, the persistence of the sea with its struggle, men coming closer to watch the unknown from the beginning of time to the present that we continue to watch without knowing what is there behind.

Then I started to work with three pieces. At the beginning I did it with relatively differentiated pieces, but the time came when I saw that I could not allow myself, in no way, such eccentricities in that place. I had to make three pieces very similar but not equal, with a scale applicable to all. . . .

The reason for choosing the places for the three sculptures, at the end, is very elemental. The piece on the left to which the public has access is there because [it] is the end of the urban network of San Sebastian. That rock has an important role in the geology of the city. I discovered with time that the two places I had in mind as important for this election of place were going to determine the scale. I have not chosen the scale. I understood that these two places formed part of the same stratum, erosioned by centuries of waves that have broken it leaving the rock on the left as witness. Clear ideas of what I wanted began to get form. . . . Those strata are witnesses of the history of my people, they were there before our ancestors. This compelled me to set horizontally the two pieces, searching each for one another, wanting to join what once was united, that is, uniting us with the past, not forgetting the past.

A third element on the horizon . . . and with the three making the life of the ocean participate in the whole scene. . . . The piece on the background is an affirmation to the future. It seems to balance itself on the horizon . . . The *Comb of the Wind* is an interrogation to the future . . . an homage to the wind, which I admire much, and to my people. . . .

CHRISTIAN BOLTANSKI Interview with Démosthènes Davvetas (1985)

DÉMOSTHÈNES DAVVETAS: What role does cultural memory play in shaping your artistic language?

CHRISTIAN BOLTANSKI: It's very important. I remember the years just after the war, when anti-Semitism was still strong in France: "feeling one was different from the others." I fell into such a state of withdrawal that at age eleven I not only had no friends and felt useless, but I quit school, too. I spent my time at home, drawing. One day, my brother congratulated me on one of my drawings and that was enough to convince me that I too was good for something; then I started painting without respite.

DD: Your first works, then, grew out of this situation.

CB: Yes, indirectly. I wanted to tell a story. I chose religious or historical subjects (for instance, the Turkish massacre of the Armenians), with lots of figures in large formats and on plywood, wanting no doubt to deal indirectly with the massacre of the Jews. I also made a lot of puppets, like *marionettes de théatre*. I liked the results, and that spurred me on. In 1968 I rejected political art and its figurative conventions, because I considered painting not as something specific and narrow, but as a vast space, a "territory." At that time I made several experimental films, but I was mainly interested in photography.

* Démosthènes Davvetas, excerpts from an interview with Christian Boltanski, *Flash Art* 124 (October–November 1985): 82–87. By permission of the artist and the publisher.

DD: Why is that?

CB: I had a score to settle with my childhood. The refusal to die was identified with the refusal to grow up, to become an adult. I wanted to show that situation as clearly as possible. Don't forget my artistic sensibility derives from my personal mythology. What better medium could I have found, at the time, than photography, which seduced me as a "means" for capturing "truth." In 1969 I made my official artistic début by publishing a book of photos representing all the things that inhabited my childhood (sweaters, toys, etc.). That was a sort of search for a part of myself that had died away, an archaeological inquiry into the deepest reaches of my memory.

DD: Did the figure of C.B. grow out of this process?

CB: Yes, C.B. was everywhere. A collection of myth was created around him. But we had no way of knowing what would happen to him. He always played a part that escaped us. The more I talked about myself and my past, the more I felt myself become transparent. My self disappeared. Without wanting to, I resembled those missionaries who go around the world proclaiming the truth. And what is truth? How can one ignore that the photograph is only a trick-truth? Remorse of conscience cast me in the opposite direction: I wanted to kill C.B. Now, to go from thought to action is the hardest part of this process. It's difficult for a mother to kill her child. I needed time. . . .

DD: So, judging from what you've told us we may assume that the *Clowns* of 1973–74 were the first step in this direction.

CB: That's right. The *Clowns* mark the moment in which I declared that C.B. was a false priest, and as such, was doomed.

DD: The coup de grace was delivered in 1975–76, with the *Model Images.*

CB: C.B. was no more. Through these pieces (photos of friends and relatives), I wanted to keep a certain distance between myself and my work, and create, thanks to this distance, something inoffensive, accessible for the viewer, something that would seduce and charm by virtue of its beauty. I had such a desire to carry on in the same direction, that I began the following series, *Compositions,* in 1972, along the same lines: large photographs representing still lifes (a chocolate bar, for instance), that could readily affect the viewer. Suddenly (in 1978–80), while working on my *Japanese Compositions,* I noticed that I had rediscovered myself in the work without realizing it. People said that I had no choice [other] than to refuse to grow up.

DD: Your recent works, the *Shadow Pieces* (which you showed in the Paris Biennale) are somewhat lighter in comparison to the ponderous atmosphere of the *Compositions.*

CB: In effect, my work is similar to the pace of day-to-day life. At times one feels ill, at times well, and at times nervous. In my work it's the same way: I love to change, to touch on all the possibilities of expression. That's why I wanted to work in a lighter way, after the heaviness of the *Compositions.* The *Shadow Pieces* are little cardboard objects that I've made. These are projected on the wall by means of a slide projector, which of course enlarges their image. Here one finds the sequel to the problem that began with the *Compositions:* the reproduction of small objects in large formats.

DD: In this case, the photograph surpasses the limits of the medium.

CB: What counts most in my work is not the medium, but the emotions and the images. My shadows are related to death. It's something that comes from far away, the shadow of memory. On the wall, one sees not the object itself, but its reflection. Like truth. The shadow replaces the photograph and the small object becomes invisible.

DD: In another recent work, at Elisabeth Kaufmann in Zurich, you presented an installation of electric lights around childhood photographs of different people. These pieces had the effect of icons.

CB: They're atmosphere pieces. They are directly related to their environment. This work was intended to create an ambiance instead of a picture.

DD: Your materials are always simple and seemingly valueless.

CB: I've always wanted to take something simple, ugly, insignificant, or humble, and transform it, giving it a magical, mystical dimension. I think the beauty in art is the disproportion of the poverty of means. In this poverty, I search for and obtain a spiritual richness.

DD: You never cease to claim that you're a painter. What does this mean for you?

CB: I come from painting. I go to see exhibitions, I look at the paintings. Sure, I'm not a conventional painter, attached to a canvas. I work differently: I spend my most limpid moments lying on my bed, or sitting on the floor sculpting or molding simple, poor materials. This keeps my hands occupied: I always have to make something, even if I don't intend to show it. And a time comes when I feel it click, I know I'm on to something: that's the moment of the work of art. Each piece I make is directly related to the one before. I work doggedly on breaking down the old form, then I look like mad for a new one. It's a terrible situation.

DD: What role does the viewer play in your works?

CB: The viewer is part of the work. I try to communicate with him by stimulating his memory: the viewer has the right to interpret the picture as he likes, to make his own picture. For me it's enough simply to give him the signs, to communicate with him without trying to teach or direct him. I want to bring out the viewer's interior and invisible powers.

DD: How do you view new painting, as it appeared in the early eighties?

CB: Everyone has the right to use the means he wants to obtain the results he wants. I don't belong to any school or movement. I love sentimentals (and I don't mean this in a pejorative way). I feel respect for those who speak the truth, their truth, the one they've discovered. "Conceptuals" can interest me as much as "new painters."

DD: Do you consider yourself a French painter?

CB: I was born in France, and my family background is Russian. Recently a Polish artist invited me to show in an exhibition of Poles because she said she considered my work Polish. I belong to the young tradition of Central Europe, but my real country is painting.

CHRISTO Fact Sheet: *Running Fence* (1976)

THE PROJECT: Running Fence was a 24.5-mile-long art work that traversed rolling pasture land in parts of Marin and Sonoma counties in northern California during 14 days of September, 1976. The 18-foot-high white fabric fence undulated along a generally east-west axis. The Fence intersected 12 public roads, including U.S. Highway 101 and State Highway 1, and 11 private roads. It crossed the town of Valley Ford and passed near the communities of Bloomfield and Cotati. The east extremity of the Fence was situated on Meacham Hill, north of Petaluma. The west end of the Fence extended several hundred feet offshore in Bodega

* Christo, "Fact Sheet" (1976), in *Christo—Running Fence* (New York: Harry N. Abrams, 1978), 12–13. By permission of the author and the publisher.

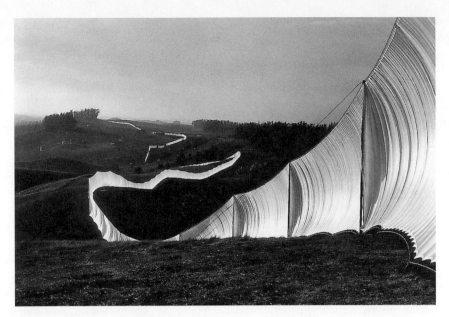

Christo and Jeanne-Claude, *Running Fence* (Sonoma and Marin counties, California), 1972–76, fabric sheet 18 feet high and 24.5 miles long. © Christo 1976. Photo by Jeanne-Claude. By permission of the artists.

Bay. The Fence consisted of 2,050 panels of woven nylon, supported by steel poles, which were usually 62 feet apart, and cables. The 558-foot-long ocean portion consisted of a single panel of fabric, tapering from a height of 48 feet on the beach to two feet at the anchored seaward tip. The project was completed on September 10, 1976, and remained on view for two weeks. The Fence was completely removed by October 23, 1976. The total cost of the project was more than $3 million. The bulk of the money went toward materials, labor, legal fees, specially designed vehicles, travel, permits, bonds, and insurance.

LEGAL BACKGROUND: The Fence crossed 55 parcels of privately owned land, for which 60 contracts (easement agreements) were obtained from owners and lessees. Both counties required building permits and removal bonds. Before it was completed, the Fence prompted 17 public hearings, several court sessions, and an Environmental Impact Report (EIR). Among the 15 governmental agencies that had a say in the construction of the Fence: the Marin County Planning Commission, the Marin County Board of Supervisors, the Sonoma County Board of Zoning Adjustments, the Sonoma County Board of Supervisors, the State Lands Commission, the California Highway Patrol Department, the State Forestry Division, the California Fish and Game Department, and the Water Quality Control Board. A regional division of the California Coastal Zone Conservation commission granted a Coastal Development Permit, but when this decision was appealed to the statewide Coastal Commission, the permit was automatically revoked. Therefore, the shore portion of the Fence was constructed without the required permit. Nine lawyers represented Running Fence in its legal hurdles.

THE MATERIALS: The 165,000 yards of fabric were woven by J. P. Stevens & Co., Inc., then sewn into 2,100 panels, each 18 × 68' with grommets on all four sides. The fabric panels were attached to horizontal cables at top and bottom by 312,000 steel hooks, and fastened to the 2,050 poles by lateral wire rings. The poles were 21 feet high—18 feet above

ground and three feet below ground. Each pole was supported by a pair of "shoe angles," 2.5-foot lengths of L-shaped steel beam, which prevented the poles from sinking into the ground, thereby eliminating the need for concrete. The poles were braced laterally by guy cables, secured by 13,000 steel anchors, submerged in the earth. Some 90 miles of steel cable were used in the project. At the end of the viewing period, the anchors were driven below plow level; all holes were backfilled with sand and reseeded with grass. The other building materials were removed, gathered, and presented to the ranchers whose land the Fence crossed.

THE EQUIPMENT: More than 20 vehicles, six of them specially designed, were used during the construction period. Flatbed, pickup, and ladder-boom trucks, anchor-drivers, and a power wagon distributed cable, drove anchors, and set poles, or functioned as mobile service stations, delivering fuel and water to other vehicles in the fields. Most of the vehicles were equipped with two-way radios for communication and flotation tires to prevent rutting the soil.

THE WORK TEAM: More than 60 employees worked 40 to 60 hours a week during the anchor-driving, cable-laying, and pole-erecting phase from April to September, 1976. During the last week of August and the first 10 days of September, approximately 360 employees were hired to install the fabric panels. After the Fence was completed, 80 of these workers stayed on during the two-week display period to serve as traffic monitors.

The chief engineer of the Fence was Dr. Ernest C. Harris, working in association with the URS/Ken R. White Company of Denver, Colorado. The URS head office in San Mateo, California, filed for all the permits. Bryan & Murphy Associates, Inc., of Walnut Creek, California, surveyed the land for Running Fence and prepared property sketches and maps. John Thomson of Boxford, Massachusetts, designed the fabric panels; he joined with James Fuller and Dimiter S. Zagoroff, also of Massachusetts, in designing the marine portion of the Fence. Robert E. Urie, technical manager of synthetic industrial fabric at J. P. Stevens & Company, Inc., in New York, advised in the selection of the woven nylon fabric. Rubber-Crafters of West Virginia sewed the yardage into 2,100 panels; the extra 50 panels were held in reserve for emergency use.

Peter Selz and Lynn Hershman served, respectively, as Running Fence project director and associate project director. Legal services were provided by Fred Altschuler, Edwin Anderson, William M. Bettinelli, Jerome B. Falk, Jr., Scott Hodes, Paul Kayfetz, Howard N. Nemerovski, Dennis Rice, and Stephen Tennis.

A & H Builders, Inc., of Broomfield, Colorado, was primary contractor under the direction of its president, Theodore Dougherty, and project superintendent Henry B. Leininger. The underground Construction Company of San Leandro, California, was the subcontractor, with Anello Angelo as head foreman. Foresight Industries, Inc., of Cheyenne, Wyoming, designed and developed the anchor-driver equipment and the triplex anchors. Roy Jameson & Son Trucking Company of Petaluma, California, made the "pigtail" cables and prepared the poles with holes and slots. Allied Wire Products, Inc., of Santa Rosa, California, fabricated the 29,000 wire connectors for tying the fabric to the poles, as well as the 312,000 top and bottom steel hooks.

FUNDING: Christo's three million two hundred and fifty thousand dollars temporary work of art was entirely financed by the artist through the Running Fence Corporation (Jeanne-Claude Christo-Javacheff, President). All projects by the artist have been financed through the sale of his studies, preparatory drawings, collages, scale models, early works and original lithographs. Christo does not accept any kind of sponsorship.

Wrapping Up Germany: Interview with Sylvère Lotringer (1982)

SYLVÈRE LOTRINGER: What induced you to undertake the apparently incongruous project of wrapping the Reichstag?

CHRISTO: Until now, all my projects have been situated in the Western world and within only one system. For the Reichstag project, we had to negotiate simultaneously, and for the first time, within two different systems. What I was mainly interested in, was to work in a place where the separation between both Berlins was obvious. I am fascinated by the physicality of this separation. Its demonstrative character. It is not a frontier border in the countryside, but a city, one of the biggest and the most remarkable in the world from an urban point of view, which is divided like that.

SL: What have been the consequences of this division, from an urban point of view?

C: On one side is East Berlin, which includes the former administrative headquarters of the city. The Eastern part has been entirely rebuilt according to a totalitarian urban plan, like in Bulgaria or Hungary, with spacious but empty avenues sort of Kafkaesque, obviously conceived for groups, never individuals. On the other side is West Berlin, which corresponds to the old residential neighborhoods. It has been rebuilt in the flamboyant style of capitalism, with neon lights, concrete, and glass walls.

SL: In a word, the window dressing of the West. What about the Reichstag?

C: Besides its enormous dimensions, there is nothing unusual about it. Its structure is completely trivial. It looks like a Nineteenth Century casino.

SL: What's important is obviously its symbolic value.

C: Its symbolism is, in fact, mostly inappropriate. Hitler hated the Reichstag, which symbolized German democracy. After the 1933 fire, he had his parliament installed in the big opera house. It was only in 1943–44 that Göring, who presided over the Reichstag, held the last Nazi parliamentary session there. Furthermore, in Albert Speer's project to planify Berlin, it is obvious that the Reichstag would have been one of the first buildings to disappear. Which did not keep the Russians, in a famous photograph taken a few days before the end of the war, from representing a . . . machine-gun next to a rocket on which was written: "Vo Reichstago" (for the Reichstag).

SL: Even when inappropriate, symbols can be deadly. There have been ferocious fights over the Reichstag.

C: The Reichstag was not important, from a military point of view, in the battle of Berlin. Of course, not far away were Hitler's bunker and Göring's Chancellery, the latter linked to the Reichstag by a tunnel which was supposedly used to set fire to the building in 1933. Two Nazi commandos defended the Reichstag like mad, step by step, floor by floor, with the same lack of purpose as the Russians who lost two thousand men in attempting to take hold of it. I have the feeling that they were sacrificed for a mere photograph, the famous photograph of the Russian soldier waving the Soviet flag on the roof of the Reichstag. I have a photograph of the inside of the building where one can see inscriptions in Cyrillic.

SL: Which shows that the Russian soldiers knew how to write. What happened to the Reichstag after the war?

* Sylvère Lotringer, "Wrapping Up Germany," an interview with Christo, trans. John Johnston and Marc Parent, in *The German Issue,* special issue, *Semiotext(e)* 4, no. 2 (1982): 8–26. By permission of the artist and the publisher.
 Editors' Note: The Reichstag would be wrapped by Christo and Jeanne-Claude in June 1995.

C: It remained in ruins until the end of the Fifties. In 1960, Bonn's government spent some sixty million dollars restoring it. They wanted to make a historic building out of it, a kind of meeting place for the future parliament.

SL: The Reichstag is no longer the seat of Federal Germany's parliament?

C: No. The Russians refuse to allow the structure to be used for political purposes. No minister of the Federal Republic is allowed to enter it, only members of the four allied countries. A year ago, Schmidt came with Andreotti, the Italian prime minister, to show him the Reichstag. The Soviet Jeeps kept him from coming close to it. To allow him to enter the Reichstag would have set a political precedent.

SL: So it isn't used at all.

C: It is used as a historical museum of the city of Berlin. Sometimes, scientific congresses are held there, but never political ones.

SL: As I understand it, there are no more reasons to set the Reichstag on fire. Wasn't it a Bulgarian who was accused of setting it on fire?

C: The accused was a Dutch anarchist, but Georgi Dimitrov, a Bulgarian communist leader and a very important figure of the Comintern, the Communist International, was also allegedly involved in the attempt. Dimitrov wasn't just anybody. He was a bright lawyer who spoke very good German. The Nazis wanted to use Dimitrov's trial for propaganda, but he undertook his own defense and turned the trial into an all-out attack against the Nazis. Dimitrov made a famous retort to Göring, who had accused him of being a Bulgarian savage: "When your King was still speaking German to his horses, the Bulgarians already had an alphabet and wrote poetry."

SL: Was Dimitrov accused of having inspired the attempt?

C: Not of inspiring it, but of having physically perpetrated it. The German regime at that time made it impossible to condemn the nationals of another country. The Bulgarian Tsar, who was of German descent, deprived Dimitrov of his Bulgarian citizenship; but Stalin, in a bold move, immediately conferred on him Soviet citizenship! Later, Dimitrov became the first president of the Democratic Bulgarian Republic. A monument was erected in his name.

SL: And you erect a monument to the Reichstag. Weren't the Germans shocked by the fact that you too are Bulgarian? A Bulgarian sets the Reichstag on fire, another comes to wrap it up . . .

C: I am not keeping my Bulgarian origins a secret. But the *Pravda* editorial that condemned the Reichstag project didn't even mention that I was a refugee from Eastern Europe.

SL: And what about the Bulgarians, did they think it was an oblique way to do homage to Dimitrov?

C: On the contrary. My brother was questioned by the authorities of the Bulgarian State Department of Culture about the Reichstag. Dimitrov, in Bulgaria, is a little like Washington.

SL: Are you interested in what the Bulgarians think of this project?

C: Yes, but I am much more concerned with the Soviet government's reaction, for they have a direct effect on the present negotiations.

SL: Why must you take the Soviet government's reactions into account?

C: Technically, the whole structure of the Reichstag falls within the British zone. But in fact, the facade, to a depth of 28 meters, is under Russian control.

SL: Is it guarded by the army?

C: By Vopos.

SL: The Reichstag therefore can't be wrapped.

c: This is why I want to wrap it. And to do so, I must negotiate with the Soviets. It is impossible for individuals to deal directly with the army. Hence, the three Western allies—the Americans, the French, and the English—are presenting my project to the Russians.

sl: What were the arguments stated by *Pravda* to condemn your project?

c: It is asserted that what I was doing offered nothing to the masses, to the workers; that it was the prototype of wanton, formalist and decadent art.

sl: Maybe *Pravda* is not entirely wrong. Wasn't that the reason for your leaving Bulgaria?

c: I participated, against my will, in the Agit-Prop. We were to spend every weekend in the kolkhoz and take a hand in "artistic" activities in the service of the party. I hated that. I left my country at the age of 22 (my son's age) on the spur of the moment because I was suffocating. I wanted to escape the terrible provincialism and to experience a freer professionalism. I didn't leave for the sake of love, but because the art world in Bulgaria meant academicism and socialist-realism.

sl: What would have happened to you if you had stayed in Bulgaria?

c: Since I was a very talented student, I would have most probably been sent to the Soviet Union to conclude my specialized training as a socialist-realist. To go to Leningrad or Moscow to study was the highest award.

sl: You might have ended up wrapping the Red Square . . .

c: There are no propitious circumstances, as far as work is concerned, in the East. Nevertheless, I grew up in a communist country and I feel very personally and emotionally concerned with the relations between the East and the West.

sl: Which brings us back to the Reichstag project. Is it to be as "wanton," as far as the relationships between the East and the West are concerned, as it is accused of being?

c: It is clear that by asking the Russians, the Germans, the French, the English, and the Americans for permission, we are led to a totally new interpretation of the project, which none of the others ever provoked. With the wrapping of the Reichstag, we will find ourselves in a remarkable situation in which it shall be possible for a work of art to be perceived simultaneously from East and West Germany. From a visual point of view, a communication will be established by means of these structures, and it will keep changing during the two weeks of the installation. Wrapping the Reichstag corresponds to a real event. That means a profound transformation of the space. All my projects, not only this one, maintain an intimate relationship with a space and its meaning, not unlike what happens in the works of urban-planning architects, with whom I am often compared. If you want to build a highway, a school, or a bridge somewhere, you have to take into account what the people will see there. You just ask yourself whether this can become an object of communication or not.

sl: Your projects, "Central Park" here, "Running Fence" in California, or "Iron Curtain" in Paris, are always a means of rendering space perceptible. The wrapping of the Reichstag will undoubtedly go much further. It has the capacity to crystallize the relationships between two worlds. To render the political space perceptible. This can also be very risky.

c: That is what all my opponents claim. According to them, Germany's division, artificial from the start, has ended up separating both sides, not only physically, but mentally. Günter Grass fears that the East Germans might see in this gesture a blasphemy against their sense of heritage, especially the older people, who are not accustomed to modern art and remain very attached to historical references.

sl: Do you think this objection is valid?

c: There is, in fact, a lot of information circulating between both Germanys, mainly

through the television network, which is hard to control. Consequently, the risk is an imaginary one. A senator opposed to my project even declared at the Bundestag that the Russians might call it an invasion of their territory and close the check points with West Berlin if the drapes that cover the Reichstag were to puff out in a gust of wind. These are not serious objections. In fact, no one wants to create any kind of tension. Anything that might favor the contacts between both sides is perceived by both sides as positive. Thus everybody will benefit from this project. Of course, there's always the possibility that something may go wrong. Chance has always been a factor in all of my projects. The international situation can tighten up and both sides can become hysterical. The Russians, however, are not the ones who are creating the problems, but a conservative group from West Germany.

SL: From West Germany or West Berlin? Within which jurisdiction is the Reichstag?

C: The Reichstag building is under a special regulation. It is under the jurisdiction of the Federal Republic of Bonn, which also insures its management. The Reichstag is a direct responsibility of the Bundestag's president, the second most important authority after the President. Both of them are now members of the party opposed to Chancellor Schmidt, which does not make things easier.

SL: You have received the support of Willy Brandt and the left wing of the Social Democrat party.

C: In 1976, when I started working on this project, the president of the Bundestag was a Socialist. Now the president, Dr. Schückler, is a member of the Bavarian party, an ultra-conservative, one of Strauss' men. Perhaps we made a tactical mistake in polarizing this project. We were seeking allies on both sides. We have some Christian Democrat supporters but not as many as in the Socialist party.

SL: What's the next step then?

C: To get permission to go ahead with the project. That's always the hardest thing to obtain. After the October 1980 elections, it looked as if we were going to win. By the end of May 1981, however, everything fell through. It was the second time they refused to grant permission.

SL: How many refusals before you abandon a project?

C: Each case is different. At present I'm working simultaneously on four projects. I'll simply put the Reichstag aside for a year or so.

SL: History will have to wait.

C: Not for long. I'm preparing a big scale model in three dimensions which will be exhibited at the Cologne museum. We'll take advantage of the show to renew our contacts with the senators.

SL: Why is Willy Brandt favorable to the project?

C: Because such a project, according to him, can only be realized in a nation which has reached maturity. Germans, he says, will be able to look at it as at a mirror. Even if the project carries historical references in a somewhat questionable situation of pride, it shall raise comments that will give the Reichstag a new currency in the future. The project will electrify the place, give it a new energy, and not just the energy of memory which it has now, since people go there like they visit an historical monument. This is the reason why we were supported by lawyers, bankers, journalists, professors, and "establishment" people who are not especially interested in art. Beyond its proper aesthetic dimensions, they saw in the project an exceptional public dimension. They felt that once the project was carried out, many ideas and effects which would otherwise remain unsuspected, could be realized.

SL: Is the present situation very different from the conditions in which the project was initiated?

C: Nine years ago, when we actually started the project, nobody was interested in the Reichstag. It had sunk into oblivion, like a wound not to be touched. In the Seventies, however, the Germans suddenly began to reinvent National Socialism. The Hitler period became an extraordinary creative resource for a whole generation of filmmakers and writers. As far as the terrorists were concerned, the Thirties became a fundamental reference. All of a sudden, because it was identified with that period, the Reichstag took on a great importance.

SL: Your project came right on time. In fact, it was ahead of it.

C: I wasn't aware of all that in the beginning. This aspect appeared later. The project really was bigger than my idea; it's because the situation is so fertile.

SL: With the digging up of the National-Socialist past, there has also been, as much on the Left as on the Right, in both the East and the West, a reappearance of the idea of the Prussian State. An exhibition on the subject, which raised quite a few controversies, was lately held right near the Reichstag. Did this have an effect upon your project?

C: What's new is the idea of seeking the origins of Prussia, which only remains in the spirit of discipline without which the paradoxical separation of both Germanys wouldn't have been possible. One must not forget that East Germany is a Prussian State. The masses couldn't have lived through such a situation without an incredible disposition to obey. Communism did not give birth to this police state; it was already running in the people's veins. If the division had occurred in a "softer" area, like Bavaria, the results would have been completely different. This paradox is inscribed in the German nation. Its effects on the project are also unpredictable. Once it is wrapped, the concrete object will develop its own autonomous relationships.

SL: In short, you started out with an art object, a project concerned with space, and you find yourself with a political litmus test, or a detonator. A time-bomb.

C: The Carter administration was pretty nervous about this project. I was told by Vice President Mondale at the time that they already had enough problems with Berlin without the ones I was going to add.

SL: Due allowance being made, your undertaking reminds me of the conceptual artist André Cadere's arriving uninvited with his "art stick" at galleries and museums and letting them decide whether it is art or not. Like him, you install a little artistic machine in the midst of the institutional gearwheels, but your device has taken a worldwide political dimension. Besides, it's more than the political aspect, it's the relationship you share with the financial powers which troubles people. Since your projects need considerable amounts of money, you are often accused of being a capitalist. How does that make you feel coming from a socialist country?

C: I am constantly accused of being a capitalist. Not only by the Russians, and because of the Reichstag, but because of all my big projects and by artists as well.

SL: Does one have to be educated in an Eastern country to really understand capitalism and to know how to mobilize economic forces for artistic ends?

C: My education in Bulgaria has certainly been very important for my present work. Since the art world there was ossified, I started to associate with other people, engineers, lawyers, workers, architects, so that even now I see very few artists. The world of galleries and museums is like a vacation for me. I go there for pleasure.

The misfortune of many American and Western artists is that they were taught to scorn economics. Economics is one of the most important inventions of the 20th century.

Since I studied Marxism closely, I am able to use the resources and structures of capitalist society. I am able to apply what I learned, to manipulate the system here, but in a very cynical way, aiming toward absurd ends which no one can appropriate.

SL: I have always thought your projects constitute a kind of simulation of the capitalist system, a mock-epic of Capital. "Running Fence" is the conquest of the West played out again, but for no purpose. The contracts are negotiated one at a time, but no land is bought; you are content to go once again through the forms which enabled capitalism to secure expansion on a continental scale.

C: I don't think that there is a capitalist or a socialist system. Technically, the way communism is practiced is not that different from what exists here. In both cases, it's really a matter of state capitalism. Marx discovered an extraordinary machinery.

SL: You think the difference between the two regimes is negligible?

C: There certainly are important differences; otherwise I wouldn't be here. Capitalist society offers a natural organic anarchy which it knows how to use for its own purposes. Communist society, on the contrary, is structured in a very rigid way: it has an almost tsarist rigidity, in any case it is very archaic. Even biologically speaking, because they are so old, the Soviet authorities are incapable of accepting movement.

SL: What strikes me is the singular relationship each project maintains, not only with location and space, but also with their history. It is never a question of manipulating a system in general, but of diverting, in a very specific way, the elements of a particular cultural situation.

C: A new element emerges from every place, every city, every space, and one has to start from scratch in order to discover how to get the project accepted. The essential thing is to remain humble, to listen to all advice, for you never know in advance what is the right approach. Furthermore, the people I talk to all know the locations better than I do. In fact, that's really the reward. The location is always richer than I can imagine.

SL: For my part, I am very sensitive to the humor such a humble attitude implies. For example, I find very appropriate the fact that your first "concrete" construction, a huge metallic "pyramid" (the Mastaba of Abu Dhabi), will be erected in the middle of the desert, in the United Arab Emirates. And that it will be made of thousands of oil barrels. You chose the cradle of nomadic civilization, which has become the pillar of the Western economy, as the place to build a huge tent—made not of cloth, but of stainless steel. Now this is a serious form of parody, a humorous inveigling of a location and of a culture. History's tragedy doesn't return as a farce, as Marx said, but as an ambiguous ritual, maybe the only one which we can still share. In a way, your wrappings always summon up the altar of history. Conquest of the West, but without the Indians: pyramid of solitude, but without the nomads; tribunal of the Reichstag, but without the Jews. When you showed me the photographs of your scale model, a huge and spectral Reichstag wrapped up in its grey shroud, I couldn't help thinking of the end of history. Not Hegel's: It is not humanity finally reaching its self-realization. It's a building which is no longer used.

C: I want to wrap the Reichstag in a very thick cloth, almost 50% thicker than the surface of the stone. The cloth will obviously efface all details and accentuate the proportions. The building will become much more organic. The symmetry, which is very banal, will be upset by the new forms created by the roof. The movement of the cloth, puffed out by the wind, will give a feeling of grandeur.

SL: The ritual of packaging in a society which has consumed everything, even its own symbolism. Collective symbols, shameful practices, defunct traditions are thus not only ex-

humed, but elevated in the open air into esthetic experiences, turned into ambiguous objects of conviviality. It means paying back society in its own coin and confronting history with the hallucination of its own existence. It would not be such a bad thing after all if the Germans could confront the ghosts of their past under the funeral mask, displaced and parodied, of their own grandeur.

MAYA LIN Interview with Elizabeth Hess (1983)

ELIZABETH HESS: Certain people are outraged by your memorial. They read it as a statement against the Vietnam war.

MAYA LIN: The worst thing in the world would have been indifference to my piece. The monument may lack an American flag, but you're surrounded by America, by the Washington Monument and the Lincoln Memorial. I don't design pure objects like those. I work with the landscape, and I hope that the object and the land are equal players.

EH: Is your piece political?

ML: The piece itself is apolitical in the sense that it doesn't comment directly on the war—only on the men that died. For some people—especially right-wing politicians—that's political enough. It's like the emperor's new clothes: What people see, or don't see, is their own projection. . . .

EH: Why did you choose black for the color of the stone?

ML: Classical Greek temples were never white. They were highly colored. At some point much later, someone decided that white signified classical architecture. Black for me is a lot more peaceful and gentle than white. White marble may be very beautiful, but you can't read anything on it. I wanted something that would be soft on the eyes, and turn into a mirror if you polished it. The point is to see yourself reflected in the names. Also the mirror image doubles and triples the space. I thought black was a beautiful color and appropriate for the design. . . .

Interview with Sarah J. Rogers (1993)

SARAH ROGERS: You just completed work on the *Women's Table* for Yale University. You are known to have consciously dealt with the dimension of time and history there and in other works such as the *Civil Rights Memorial* in Montgomery. Could you elaborate?

ML: I think in the *Women's Table* the use of time is quite literal. Its structure is a water table and its shape is an ellipse. On its top is a spiral of numbers that begin with zeros. The zeros slip out of a water font where the water's coming up, and then all of a sudden at a marker for "1870" you see numbers emerging alongside the spiral. It counts the number of women enrolled at Yale, both undergrad and grad, from when there were none to the present day. We installed the table October 1. There's one more date left to be carved, it's 1993's enrollment, which it turns out will be 5,225. We had to wait until this year's enrollment was in.

Time is something that has always been a part of the public works as chronologies. It brings you into a notion of real time and real experience so that anyone can read it and put

* Maya Lin, excerpt from Elizabeth Hess, "Interview with Maya Lin," *Art in America* 71, no. 4 (April 1983): 123. By permission of the artist.
** Maya Lin, from interview (1993) by Sarah J. Rogers in *Maya Lin: Public/Private* (Columbus: Wexner Center for the Arts, Ohio State University, 1994). By permission of the artist.

themselves back in that place or become part of the real time of the piece. The *Women's Table* graphically and truthfully tells of the growth and emergence of women at Yale, which, in a way, chronicles the emergence of women in modern times. The spiral itself was also chosen specifically to mark a beginning but leave the future completely open—unlike, say, the *Vietnam Veterans Memorial,* where the beginning and end of the war meet at the apex. The names start on the right-hand side, go around always clockwise, ending up back at the apex on the bottom of the left with '75. That one has a very finite time period, it's a closed circle.

The *Civil Rights Memorial* begins with the 1954 *Brown vs. Board of Education* case. Again you walk around clockwise to read the history so it very much is about time and the pace of time. It ends with Martin Luther King's assassination, but there's a gap between '54 and '68 signifying the time before and the time after. We are highlighting aspects of what we will call the main civil rights era, but the notion of working towards racial justice and equality is an ongoing pursuit, which is how that whole piece got started, with the quote "We are not satisfied, we shall not be satisfied, until justice rolls down like waters." So in that piece I had to incorporate the past, leaving it open and also referring to the future.

The Yale piece really is about a beginning without an end. Women, including me, were allowed to go to school there and now, hopefully, our numbers will increase. But one important thing is the inscription will end with one last data point, which is 1993's enrollment, signifying when I created the piece. Actually it gets engraved in the next week. . . .

Lecture (1995)

My work originates from a simple desire to make people aware of their surroundings—this can include not just the physical but the psychological world we live in.

This desire has led me at times to become involved in artworks that are as much politically motivated as they are aesthetically based.

I have tried in my work to respond to our current situations—communicating to an audience an idea of our time, an accounting of history—yet I would hesitate to call myself a "political artist." If anything I would prefer apolitical as a description of myself. I do not choose to overlay personal commentary upon historical facts. I am less interested in presenting my opinion than in presenting factual information—allowing the viewer the chance to come to his or her own conclusions. . . .

The *Vietnam Veterans Memorial* is not an object inserted into the earth but a work formed from the act of cutting open the earth and polishing the earth's surface—dematerializing the stone to pure surface, creating an interface between the world of the light and the quieter world beyond the names. I saw it as part of the earth—like a geode.

ALAN SONFIST Natural Phenomena as Public Monuments (1968)

Public monuments traditionally have celebrated events in human history—acts of heroism important to the human community. Increasingly, as we come to understand our dependence on nature, the concept of community expands to include non-human elements. Civic mon-

* Maya Lin, unpublished lecture (1995). By permission of the artist.
** Alan Sonfist, "Natural Phenomena as Public Monuments" (1968), presented at the Metropolitan Museum of Art, New York; published in *Alan Sonfist* (Purchase, NY: Neuberger Museum, 1978). By permission of the author and the Neuberger Museum of Art, Purchase College, State University of New York.

uments, then, should honor and celebrate the life and acts of the total community, the human ecosystem, including natural phenomena. Especially within the city, public monuments should recapture and revitalize the history of the natural environment at that location. As in war monuments that record the life and death of soldiers, the life and death of natural phenomena such as rivers, springs and natural outcroppings need to be remembered.

Historical documents preserve observations of New York City's natural past. When the first European settlers arrived they saw the natural paradise of the Native Americans:

> . . . The region in which they lived, which has now become the area of the greater City, was a paradise of nature, teeming with its products, and rich in natural beauty of woods and waters. Its varied climate, as one old time writer described it, was "of a Sweet and Wholesome Breath," its "uplands covered with berries, roots, chestnuts and walnuts, beech and oak masts." Birds sang in the branches, the deer and elk roamed the grassy meadows, the waters swarmed with fish, the woods were redolent with the scent of the wild grape and of many flowers. Oak trees grew seventy feet high.
>
> Reginald Bolton, *Indian [Life] of Long Ago*

In a city, public art can be a reminder that the city was once a forest or a marsh. Just as some streets are named after trees, street names could be extended to other plants, animals and birds. Areas of the city could be renamed after the predominant natural phenomena that existed there. For example, Manhattan's Lower East Side could be renamed by its previous marsh characteristics to create another symbolic identity and unification within the urban area. An educational force within the community, it would enable the community to get an overall view of the ecology that once existed.

I propose to create a "Time Landscape," a restoration of the natural environment before Colonial settlement, for the Metropolitan Museum in the northeast corner of the grounds. I have a broad plan that could affect the whole city, for which the sculpture at the Metropolitan would be a model: the museum would be a nexus for the art of historical ecology. Throughout the complex urban city I propose to create a series of historical "Time Landscapes." I plan to reintroduce a beech grove, oak and maple trees that no longer exist in the city. Each landscape will roll back the clock and show the layers of time before the concrete of the city. On Canal Street I propose to create a marshland and a stream; on Spring Street I propose to restore the natural spring; in front of City Hall I propose to restore the historical lake. There are a series of fifty proposals I have made for the City of New York.

The public art in urban centers throughout the world could include the history of their natural environment. Time Landscapes renew the city's natural environment just as architects renew its architecture. This is a pilot project for reconstruction and documentation that can coincide with new building in the city. Instead of planting trees in concrete boxes for public plazas, public landscaping can be given meaning by being planted with "Time Landscape" nature indigenous to that site. Obvious examples are marsh pools, grassland flowers, rock ledge moss and ferns. Thus as the city renews itself architecturally, it will re-identify its own unique characteristic natural origins and its own natural traditions.

Since the city is becoming more and more polluted, we could build monuments to the historic air. Museums could be built that would recapture the smells of earth, trees and vegetation in different seasons and at different historical times, so that people would be able to experience what has been lost. A museum of air sponsored by the U.N. can show different air of different countries.

Other projects can reveal the historical geology or terrain. Submerged outcroppings that still exist in the city can be exposed. Glacial rocks can be saved as monuments to a dramatic

natural past. If an area has been filled in or a hill leveled out to build buildings, an indicator can be placed to create an awareness of the original terrain. Earth cores that indicate the deep geology of the land can be displayed on the site or within the building.

Because of human development, the island of Manhattan has totally lost its natural contour. By creating markings throughout the streets, the natural outline could be observed again. Indian trails could also be followed with an explanation of why the trail went over certain terrain that no longer exists. The natural past can be monumentalized also by sounds. Continuous loops of natural sounds at the natural level of volume can be placed on historic sites. Streets named after birds can have sounds of those birds or animals played at occasions such as when animals come out of hibernation or at mating time. The sounds, controlled by the local community, change according to the natural pattern of the animals and the rhythmic sounds return to the city. Natural scents can evoke the past as well. At the awakening of a plant at its first blooming, the natural essence can be emitted into the street.

The sun is such a remote but essential part of our life. Its continual presence can be emphasized by building monuments. Sides of buildings in prime locations can be marked with various sun shadow marks at different hours. As the angle of the sun changes during the year, buildings marked in various parts of the city can indicate the time of year. Another example of public monuments to the sun allows people to see the reaction of natural substances to the sun.

Public monuments embody shared values. These values can emerge actively in our public life; there can be public celebrations of natural events. Our definition of what is news is due for a re-evaluation also to include notice of, and explanation of, the natural events that our lives depend on. The migrations of birds and animals should be reported as public events: this information should be broadcast internationally. Reoccurring natural events can be marked by public observational celebrations the longest day, the longest night, the day of equal night and day, the day of lowest tide and so on, not in primitive mythical worship but with the use of technology to predict exact time. Technology can visualize aspects of nature outside the range of the human eye, such as public outdoor projections of telescopic observations: public monuments of the sky. Many aspects of technology that now allow individuals to gain understanding of nature can be adjusted to a public scale. Public monuments can be monuments of observation—sites from which to best observe natural phenomena. The ocean floor at low tide affords reoccurring means of observation. Such monuments are created for certain times of the day of the year.

The concept of what is public monument, then, is subject to reevaluation and redefinition in the light of our greatly expanded perception of what constitutes the community. Natural phenomena, natural events and the living creatures on the planet should be honored and celebrated along with human beings and events.

RICHARD LONG
Five, Six, Pick Up Sticks / Seven, Eight, Lay Them Straight (1980)

I like simple, practical, emotional,
quiet, vigorous art.

I like the simplicity of walking,
the simplicity of stones.

* Richard Long, excerpt from *Five, Six, Pick Up Sticks / Seven, Eight, Lay Them Straight* (London: Anthony d'Offay Gallery, 1980); reprinted in R. H. Fuchs, *Richard Long* (New York and London: Solomon R. Guggenheim Museum and Thames and Hudson, 1986), 236. © Richard Long. By permission of Anthony d'Offay Gallery.

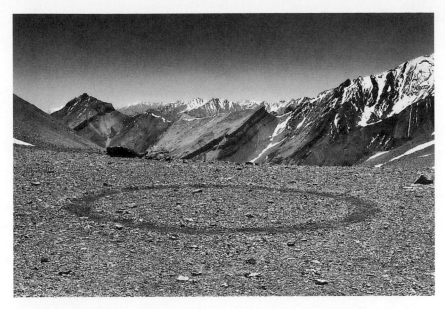

Richard Long, *Walking a Circle in Ladakh, 16,460 Ft., Pingdon La, Northern India, 1984,* detail from framed photographic work with text. By permission of the artist.

I like common materials, whatever is to hand,
but especially stones. I like the idea that stones
are what the world is made of.

I like common means given the
simple twist of art.

I like sensibility without technique.

I like the way the degree of visibility
and accessibility of my art is controlled
by circumstance, and also the degree to which
it can be either public or private,
possessed or not possessed.

I like to use the symmetry of patterns between time,
places and time, between distance and time,
between stones and distance, between time and stones.

I choose lines and circles because they do the job.

My art is about working in the wide
world, wherever, on the surface of the earth.

My art has the themes of materials, ideas,
movement, time. The beauty of objects, thoughts, places
and actions.

My work is about my senses, my instinct, my own scale
and my own physical commitment.

My work is real, not illusory or conceptual.
It is about real stones, real time, real actions.

My work is not urban, nor is it romantic.
It is the laying down of modern ideas in
the only practical places to take them.
The natural world sustains the industrial world.
I use the world as I find it.

My art can be remote or very public,
all the work and all the places being equal.

My work is visible or invisible. It can be an
object (to possess) or an idea carried out and equally
shared by anyone who knows about it.

My outdoor sculptures and walking locations
are not subject to possession and ownership. I like the fact
that roads and mountains are common, public land.

My outdoor sculptures are places.
The material and the idea are of the place;
sculpture and place are one and the same.
The place is as far as the eye can see from the
sculpture. The place for a sculpture is found
by walking. Some works are a succession
of particular places along a walk, e.g.
Milestones. In this work the walking,
the places and the stones all have equal importance.

My talent as an artist is to walk across
a moor, or place a stone on the ground.

My stones are like grains of sand in
the space of the landscape.

A walk expresses space and freedom
and the knowledge of it can live
in the imagination of anyone, and that
is another space too.

A walk is just one more layer, a mark, laid
upon the thousands of other layers of human
and geographic history on the surface of the
land. Maps help to show this.

A walk traces the surface of the land,
it follows an idea, it follows the day
and the night.

A road is the site of many journeys.
The place of a walk is there before the
walk and after it.

A pile of stones or a walk, both
have equal physical reality, though
the walk is invisible. Some of my
stone works can be seen, but not
recognised as art.

The creation in my art is not in the common
forms—circles, lines—I use, but the
places I choose to put them in.

A good work is the right thing in the right
place at the right time. A crossing place.

Fording a river. Have a good look, sit down, take off boots
and socks, tie socks on to rucksack, put on boots,
wade across, sit down, empty boots, put on socks and boots.
It's a new walk again.

© Richard Long

WALTER DE MARIA Meaningless Work (1960)

Meaningless work is obviously the most important and significant art form today. The aesthetic feeling given by meaningless work cannot be described exactly because it varies with each individual doing the work. Meaningless work is honest. Meaningless work will be enjoyed and hated by intellectuals—though they should understand it. Meaningless work cannot be sold in art galleries or win prizes in museums—though old fashion records of meaningless work (most all paintings) do partake in these indignities. Like ordinary work, meaningless work can make you sweat if you do it long enough. By meaningless work I simply mean work which does not make you money or accomplish a conventional purpose. For instance putting wooden blocks from one box to another, then putting the blocks back to the original box, back and forth, back and forth etc., is a fine example of meaningless work. Or digging a hole, then covering it is another example. Filing letters in a filing cabinet could be considered meaningless work, only if one were not a secretary, and if one scattered the file on the floor periodically so that one didn't get any feeling of accomplishment. Digging in the garden is not meaningless work. Weight lifting, though monotonous, is not meaningless work in its aesthetic sense because it will give you muscles and you know it. Caution should be taken that the work chosen should not be too pleasureable, lest pleasure becomes the purpose of the work. Hence sex, though rhythmic, cannot strictly be called meaningless—though I'm sure many people consider it so.

 Meaningless work is potentially the most abstract, concrete, individual, foolish, indeter-

 * Walter De Maria, "Meaningless Work" (March 1960), in La Monte Young, ed., *An Anthology* (New York: George Maciunas and Jackson Mac Low, c. 1962; reprint, New York: La Monte Young and Jackson Mac Low, 1963; reprint, Cologne: Heiner Friedrich, 1970). By permission of La Monte Young, dba Just Eternal Music, worldwide administration by Editions Farneth International. All rights reserved.

minate, exactly determined, varied, important art-action-experience one can undertake today. This concept is not a joke. Try some meaningless work in the privacy of your own room. In fact, to be fully understood, meaningless work should be done alone or else it becomes entertainment for others and the reaction or lack of reaction of the art lover to the meaningless work cannot honestly be felt.

Meaningless work can contain all of the best qualities of old art forms such as painting, writing etc. It can make you feel and think about yourself, the outside world, morality, reality, unconsciousness, nature, history, time, philosophy, nothing at all, politics, etc. without the limitations of the old art forms.

Meaningless work is individual in nature and it can be done in any form and over any span of time—from one second up to the limits of exhaustion. It can be done fast or slow or both. Rhythmically or not. It can be done anywhere in any weather conditions. Clothing if any, is left to the individual. Whether the meaningless work, as an art form, is meaningless, in the ordinary sense of that term, is of course up to the individual. Meaningless work is the new way to tell who is square.

Grunt

Get to work

On the Importance of Natural Disasters (1960)

I think natural disasters have been looked upon in the wrong way.
Newspapers always say they are bad. a shame.
I like natural disasters and I think that they may be the highest form of art possible
to experience.
For one thing they are impersonal.
I don't think art can stand up to nature.
Put the best object you know next to the grand canyon, niagara falls, the red woods.
The big things always win.
Now just think of a flood, forest fire, tornado, earthquake, Typhoon, sand storm.
Think of the breaking of the Ice jams. Crunch.
If all of the people who go to museums could just feel an earthquake.
Not to mention the sky and the ocean.
But it is in the unpredictable disasters that the highest forms are realized.
They are rare and we should be thankful for them.

The Lightning Field: Some Facts, Notes, Data, Information, Statistics, and Statements (1980)

The Lightning Field is a permanent work.

The land is not the setting for the work but a part of the work.

* Walter De Maria, "On the Importance of Natural Disasters" (May 1960), in La Monte Young, ed., *An Anthology* (New York: George Maciunas and Jackson Mac Low, c. 1962; reprint, New York: La Monte Young and Jackson Mac Low, 1963; reprint, Cologne: Heiner Friedrich, 1970). By permission of La Monte Young, dba Just Eternal Music, worldwide administration by Editions Farneth International. All rights reserved.

** Walter De Maria, "*The Lightning Field:* Some Facts, Notes, Data, Information, Statistics, and Statements," *Artforum* 18, no. 8 (April 1980): 58. By permission of the author and the publisher.

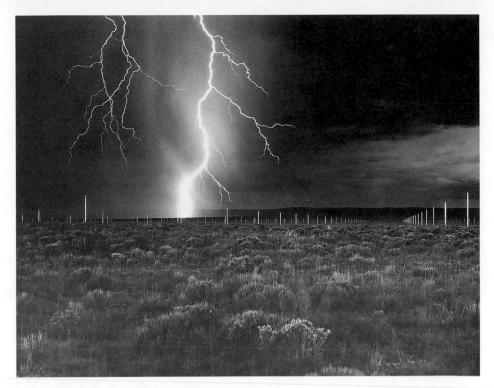

Walter De Maria, *The Lightning Field* (New Mexico), 1977, a permanent earth sculpture, 400 stainless steel poles arranged in a grid array measuring 1 mile by 1 kilometer, average pole height 20 feet 7 inches, pole tips from an even plane. Photo by John Cliett. © Dia Art Foundation.

The work is located in West Central New Mexico.

The states of California, Nevada, Utah, Arizona and Texas were searched by truck over a five-year period before the location in New Mexico was selected.

Desirable qualities of the location included flatness, high lightning activity and isolation.

The region is located 7,200 feet above sea level.

The Lightning Field is 11½ miles east of the Continental Divide.

The earliest manifestation of land art was represented in the drawings and plans for the *Mile Long Parallel Walls in the Desert,* 1961–1963.

The Lightning Field began in the form of a note following the completion of *The Bed of Spikes* in 1969.

The sculpture was completed in its physical form on November 1, 1977.

The work was commissioned and is maintained by the Dia Art Foundation, New York.

In July, 1974, a small *Lightning Field* was constructed. This served as the prototype for the 1977 *Lightning Field.* It had 35 stainless steel poles with pointed tips, each 18 feet tall and 200 feet apart, arranged in a five-row by seven-row grid. It was located in Northern Arizona. The land was loaned by Mr. and Mrs. Burton Tremaine. The work now is in the collection of Virginia Dwan. It remained in place from 1974 through 1976 and is presently dismantled, prior to an installation in a new location.

The sum of the facts does not constitute the work or determine its esthetics.

The Lightning Field measures one mile by one kilometer and six meters (5,280 feet by 3,300 feet).

There are 400 highly polished stainless steel poles with solid, pointed tips.

The poles are arranged in a rectangular grid array (16 to the width, 25 to the length) and are spaced 220 feet apart.

A simple walk around the perimeter of the poles takes approximately two hours.

The primary experience takes place within *The Lightning Field*.

Each mile-long row contains 25 poles and runs east-west.

Each kilometer-long row contains 16 poles and runs north-south.

Because the sky-ground relationship is central to the work, viewing *The Lightning Field* from the air is of no value.

Part of the essential content of the work is the ratio of people to the space: a small number of people to a large amount of space.

Installation was carried out from June through October, 1977.

The principal associates in construction, Robert Fosdick and Helen Winkler, have worked with the sculpture continuously for the last three years.

An aerial survey combined with computer analysis determined the positioning of the rectangular grid and the elevation of the terrain.

A land survey determined four elevation points surrounding each pole position to insure the perfect placement and exact height of each element.

It took five months to complete both the aerial and the land surveys.

Each measurement relevant to foundation position, installation procedure, and pole alignment was triple-checked for accuracy.

The poles' concrete foundations, set one foot below the surface of the land, are three feet deep and one foot in diameter.

Engineering studies indicated that these foundations will hold poles to a vertical position in winds of up to 110 miles per hour.

Heavy carbon steel pipes extend from the foundation cement and rise through the lightning poles to give extra strength.

The poles were constructed of type 304 stainless steel tubing with an outside diameter of two inches.

Each pole was cut, within an accuracy of $\frac{1}{100}$ of an inch, to its own individual length.

The average pole height is 20 feet $7\frac{1}{2}$ inches.

The shortest pole height is 15 feet.

The tallest pole height is 26 feet 9 inches.

The solid, stainless steel tips were turned to match an arc having a radius of six feet.

The tips were welded to the poles, then ground and polished, creating a continuous unit.

The total weight of the steel used is approximately 38,000 pounds.

All poles are parallel, and the spaces between them are accurate to within $\frac{1}{25}$ of an inch.

Diagonal distance between any two contiguous poles is 311 feet.

If laid end to end the poles would stretch over one and one-half miles (8,240 feet).

The plane of the tips would evenly support an imaginary sheet of glass.

During the mid-portion of the day 70 to 90 percent of the poles become virtually invisible due to the high angle of the sun.

It is intended that the work be viewed alone, or in the company of a very small number of people, over at least a 24-hour period.

The original log cabin located 200 yards beyond the mid-point of the northernmost row has been restored to accommodate visitors' needs.

A permanent caretaker and administrator will reside near the location for continuous maintenance, protection and assistance.

A visit may be reserved only through written correspondence.

The cabin serves as a shelter during extreme weather conditions or storms.

The climate is semiarid, eleven inches of rain is the yearly average.

Sometimes in winter *The Lightning Field* is seen in light snow.

Occasionally in spring 30- to 50-mile-an-hour winds blow steadily for days.

The light is as important as the lightning.

The period of primary lightning activity is from late May through early September.

There are approximately 60 days per year when thunder and lightning activity can be witnessed from *The Lightning Field.*

The invisible is real.

The observed ratio of lightning storms which pass over the sculpture has been approximately 3 per 30 days during the lightning season.

Only after a lightning strike has advanced to an area of about 200 feet above *The Lightning Field* can it sense the poles.

Several distinct thunderstorms can be observed at one time from *The Lightning Field.*

Traditional grounding cable and grounding rod protect the foundations by diverting lightning current into the earth.

Lightning strikes have not been observed to jump or arc from pole to pole.

Lightning strikes have done no perceptible damage to the poles.

On very rare occasions when there is a strong electrical current in the air, a glow known as "St. Elmo's Fire" may be emitted from the tips of the poles.

Photography of lightning in the daytime was made possible by the use of camera triggering devices newly developed by Dr. Richard Orville, Dr. Bernard Vonnegut and Robert Zeh, of the State University of New York at Albany.

Photography of *The Lightning Field* required the use of medium- and large-format cameras.

No photograph, group of photographs or other recorded images can completely represent *The Lightning Field.*

Isolation is the essence of Land Art.

ROBERT SMITHSON *The Spiral Jetty* (1972)

> *Red is the most joyful and dreadful thing in the physical universe; it is the fiercest note, it is the highest light, it is the place where the walls of this world of ours wear the thinnest and something beyond burns through.*
>
> G. K. Chesterton

My concern with salt lakes began with my work in 1968 on the Mono Lake Site-Nonsite in California. Later I read a book called *Vanishing Trails of Atacama* by William Rudolph which

* Robert Smithson, excerpts from "The Spiral Jetty," in Gyorgy Kepes, ed., *Arts of the Environment* (New York: George Braziller, 1972); reprinted in *The Writings of Robert Smithson: Essays with Illustrations,* ed. Nancy Holt (New York: New York University Press, 1979), 221. By permission of Nancy Holt and George Braziller, Inc.

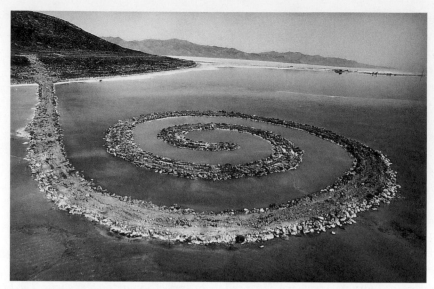

Robert Smithson, *Spiral Jetty* (Great Salt Lake, Utah), 1970, mud, precipitated salt crystals, rock, water coil 1500 feet long and 15 feet wide. Art © Estate of Robert Smithson/ Licensed by VAGA, New York, NY. Photo © Gianfranco Gorgoni.

described salt lakes (salars) in Bolivia in all stages of desiccation, and filled with micro bacteria that give the water surface a red color. The pink flamingos that live around the salars match the color of the water. In *The Useless Land,* John Aarons and Claudio Vita-Finzi describe Laguna Colorada: "The basalt (at the shores) is black, the volcanos purple, and their exposed interiors yellow and red. The beach is grey and the lake pink, topped with the icing of iceberg-like masses of salts." Because of the remoteness of Bolivia and because Mono Lake lacked a reddish color, I decided to investigate the Great Salt Lake in Utah.

From New York City I called the Utah Park Development and spoke to Ted Tuttle, who told me that water in the Great Salt Lake north of the Lucin Cutoff, which cuts the lake in two, was the color of tomato soup. That was enough of a reason to go out there and have a look. Tuttle told my wife, Nancy Holt, and myself of some people who knew the lake. First we visited Bill Holt who lived in Syracuse. He was instrumental in building a causeway that connected Syracuse with Antelope Island in the southern part of the Great Salt Lake. Although that site was interesting, the water lacked the red coloration I was looking for, so we continued our search. Next we went to see John Silver on Silver Sands Beach near Magna. His sons showed us the only boat that sailed the lake. Due to the high salt content of the water it was impractical for ordinary boats to use the lake, and no large boats at all could go beyond the Lucin Cutoff on which the transcontinental railroad crossed the lake. At that point I was still not sure what shape my work of art would take. I thought of making an island with the help of boats and barges, but in the end I would let the site determine what I would build. . . .

Driving West on Highway 83 late in the afternoon, we passed through Corinne, then went on to Promontory. Just beyond the Golden Spike Monument, which commemorates the meeting of the rails of the first transcontinental railroad, we went down a dirt road in a wide valley. As we traveled, the valley spread into an uncanny immensity unlike the other landscapes we had seen. The roads on the map became a net of dashes, while in the far distance the Salt Lake existed as an interrupted silver band. Hills took on the appearance of melting solids, and

glowed under amber light. We followed roads that glided away into dead ends. Sandy slopes turned into viscous masses of perception. Slowly, we drew near to the lake, which resembled an impassive faint violet sheet held captive in a stoney matrix, upon which the sun poured down its crushing light. An expanse of salt flats bordered the lake, and caught in its sediments were countless bits of wreckage. Old piers were left high and dry. The mere sight of the trapped fragments of junk and waste transported one into a world of modern prehistory. The products of a Devonian industry, the remains of a Silurian technology, all the machines of the Upper Carboniferous Period were lost in those expansive deposits of sand and mud.

Two dilapidated shacks looked over a tired group of oil rigs. A series of seeps of heavy black oil more like asphalt occur just south of Rozel Point. For forty or more years people have tried to get oil out of this natural tar pool. Pumps coated with black stickiness rusted in the corrosive salt air. A hut mounted on pilings could have been the habitation of "the missing link." A great pleasure arose from seeing all those incoherent structures. This site gave evidence of a succession of man-made systems mired in abandoned hopes.

About one mile north of the oil seeps I selected my site. Irregular beds of limestone dip gently eastward, massive deposits of black basalt are broken over the peninsula, giving the region a shattered appearance. It is one of few places on the lake where the water comes right up to the mainland. Under shallow pinkish water is a network of mud cracks supporting the jig-saw puzzle that composes the salt flats. As I looked at the site, it reverberated out to the horizons only to suggest an immobile cyclone while flickering light made the entire landscape appear to quake. A dormant earthquake spread into the fluttering stillness, into a spinning sensation without movement. This site was a rotary that enclosed itself in an immense roundness. From that gyrating space emerged the possibility of the Spiral Jetty. No ideas, no concepts, no systems, no structures, no abstractions could hold themselves together in the actuality of that evidence. My dialectics of site and nonsite whirled into an indeterminate state, where solid and liquid lost themselves in each other. It was as if the mainland oscillated with waves and pulsations, and the lake remained rock still. The shore of the lake became the edge of the sun, a boiling curve, an explosion rising into a fiery prominence. Matter collapsing into the lake mirrored in the shape of a spiral. No sense wondering about classifications and categories, there were none.

After securing a twenty year lease on the meandering zone, and finding a contractor in Ogden, I began building the jetty in April, 1970. Bob Phillips, the foreman, sent two dump trucks, a tractor, and a large front loader out to the site. The tail of the spiral began as a diagonal line of stakes that extended into the meandering zone. A string was then extended from a central stake in order to get the coils of the spiral. From the end of the diagonal to the center of the spiral, three curves coiled to the left. Basalt and earth was scooped up from the beach at the beginning of the jetty by the front loader, then deposited in the trucks, whereupon the trucks backed up to the outline of stakes and dumped the material. On the edge of the water, at the beginning of the tail, the wheels of the trucks sank into a quagmire of sticky gumbo mud. A whole afternoon was spent filling in this spot. Once the trucks passed that problem, there was always the chance that the salt crust resting on the mud flats would break through. The Spiral Jetty was staked out in such a way as to avoid the soft muds that broke up through the salt crust, nevertheless there were some mud fissures that could not be avoided. One could only hope that tension would hold the entire jetty together, and it did. A cameraman was sent by the Ace Gallery in Los Angeles to film the process.

The scale of the Spiral Jetty tends to fluctuate depending on where the viewer happens to be. Size determines an object, but scale determines art. A crack in the wall if viewed in terms

of scale, not size, could be called the Grand Canyon. A room could be made to take on the immensity of the solar system. Scale depends on one's capacity to be conscious of the actualities of perception. When one refuses to release scale from size, one is left with an object or language that *appears* to be certain. For me scale operates by uncertainty. To be in the scale of the Spiral Jetty is to be out of it. On eye level, the tail leads one into an undifferentiated state of matter. One's downward gaze pitches from side to side, picking out random depositions of salt crystals on the inner and outer edges, while the entire mass echoes the irregular horizons. And each cubic salt crystal echoes the Spiral Jetty in terms of the crystal's molecular lattice. Growth in a crystal advances around a dislocation point, in the manner of a screw. The Spiral Jetty could be considered one layer within the spiraling crystal lattice, magnified trillions of times. . . .

Chemically speaking, our blood is analogous in composition to the primordial seas. Following the spiral steps we return to our origins, back to some pulpy protoplasm, a floating eye adrift in an antediluvian ocean. On the slopes of Rozel Point I closed my eyes, and the sun burned crimson through the lids. I opened them and the Great Salt Lake was bleeding scarlet streaks. My sight was saturated by the color of red algae circulating in the heart of the lake, pumping into ruby currents, no they were veins and arteries sucking up the obscure sediments. My eyes became combustion chambers churning orbs of blood blazing by the light of the sun. All was enveloped in a flaming chromosphere; I thought of Jackson Pollock's *Eyes in the Heat* (1964; Peggy Guggenheim Collection). Swirling within the incandescence of solar energy were sprays of blood. My movie would end in sunstroke. Perception was heaving, the stomach turning, I was on a geologic fault that groaned within me. Between heat lightning and heat exhaustion the spiral curled into vaporization. I had the red heaves, while the sun vomited its corpuscular radiations. Rays of glare hit my eyes with the frequency of a Geiger counter. Surely, the storm clouds massing would turn into a rain of blood.

Once, when I was flying over the lake, its surface seemed to hold all the properties of an unbroken field of raw meat with gristle (foam); no doubt it was due to some freak wind action. Eyesight is often slaughtered by the other senses, and when that happens it becomes necessary to seek out dispassionate abstractions. The dizzying spiral yearns for the assurance of geometry. One wants to retreat into the cool rooms of reason. But no, there was Van Gogh with his easel on some sun-baked lagoon painting ferns of the Carboniferous Period. Then the mirage faded into the burning atmosphere.

MICHAEL HEIZER, DENNIS OPPENHEIM, AND ROBERT SMITHSON

Discussions with Willoughby Sharp and Liza Bear of *Avalanche* (1968–69)

AVALANCHE: Dennis, how did you first come to use earth as sculptural material?

DENNIS OPPENHEIM: Well, it didn't occur to me at first that this was what I was doing. Then gradually I found myself trying to get below ground level.

A: Why?

DO: Because I wasn't very excited about objects which protrude from the ground. I felt this implied an embellishment of external space. To me a piece of sculpture inside a room is

* Willoughby Sharp and Liza Bear, "Discussions with Michael Heizer, Dennis Oppenheim, and Robert Smithson, 1968, 1969," *Avalanche* 1 (Fall 1970): 48–59. By permission of the interviewers.

a disruption of interior space. It's a protrusion, an unnecessary addition to what could be a sufficient space in itself. My transition to earth materials took place in Oakland a few summers ago, when I cut a wedge from the side of a mountain. I was more concerned with the negative process of excavating that shape from the mountainside than with making an earthwork as such. It was just a coincidence that I did this with earth.

A: You didn't think of this as an earthwork?

DO: No, not then. But at that point I began to think very seriously about place, the physical terrain. And this led me to question the confines of the gallery space and to start working things like bleacher systems, mostly in an outdoor context but still referring back to the gallery site and taking some stimulus from that outside again. Some of what I learn outside I bring back to use in a gallery context.

A: Would you agree with Smithson that you, Dennis, and Mike are involved in a dialectic between the outdoors and the gallery?

DO: I think that the outdoor/indoor relationship in my work is more subtle. I don't really carry a gallery disturbance concept around with me; I leave that behind in the gallery. Occasionally I consider the gallery site as though it were some kind of hunting-ground.

A: Then for you the two activities are quite separate?

DO: Yes, on the whole. There are areas where they begin to fuse, but generally when I'm outside I'm completely outside.

ROBERT SMITHSON: I've thought in this way too, Dennis. I've designed works for the outdoors only. But what I want to emphasize is that if you want to concentrate exclusively on the exterior, that's fine, but you're probably always going to come back to the interior in some manner.

A: So what may really be the difference between you is the attitude you have to the site. Dennis, how would you describe your attitude to a specific site that you've worked with?

DO: A good deal of my preliminary thinking is done by viewing topographical maps and aerial maps and then collecting various data on weather information. Then I carry this with me to the terrestrial studio. For instance, my frozen lake project in Maine involves plotting an enlarged version of the International Date Line onto a frozen lake and truncating an island in the middle. I call this island a time-pocket because I'm stopping the IDL there. So this is an application of a theoretical framework to a physical situation—I'm actually cutting this strip out with chain saws. Some interesting things happen during this process: you tend to get grandiose ideas when you look at large areas on maps, then you find they're difficult to reach so you develop a strenuous relationship with the land. If I were asked by a gallery to show my Maine piece, obviously I wouldn't be able to. So I would make a model of it.

A: What about a photograph?

DO: Ok, or a photograph. I'm not really that attuned to photos to the extent to which Mike is. I don't really show photos as such. At the moment I'm quite lackadaisical about the presentation of my work; it's almost like a scientific convention. Now Bob's doing something very different. His non-site is an intrinsic part of his activity on the site, whereas my model is just an abstract of what happens outside and I just can't get that excited about it.

A: Could you say something, Bob, about the way in which you choose your sites?

RS: I very often travel to a particular area; that's the primary phase. I begin in a very primitive way by going from one point to another. I started taking trips to specific sites in 1965: certain sites would appeal to me more—sites that had been in some way disrupted or pulverized. I was really looking for a denaturalization rather than built up scenic beauty. And

Alice Aycock, *Maze* (Gibney Farm, New Kingston, Pennsylvania), 1972 (destroyed 1974), wood. Photo by Silver Springs Township Police Department. By permission of the artist.

substructure. From the center pit one moved through the labyrinth to the "dead end of the outer ring" underneath the temple. The name of the building recorded on an inscription is Thymela or Place of Sacrifice.

A fourteenth-century maze at Wing, Rutland, England, is located near an ancient tumulus. The maze was used as a form of penance.

Originally, I had hoped to create a moment of absolute panic—when the only thing that mattered was to get out. Externalize the terror I had felt the time we got lost on a jeep trail in the desert in Utah with a '66 Oldsmobile. I egged Mark [Segal] on because of the landscape, a pink and gray crusty soil streaked with mineral washouts and worn by erosion. And we expected to eventually join up with the main road. The trail wound up and around the hills, switchback fashion, periodically branching off in separate directions. Finally, the road ended at a dry riverbed. We could see no sign of people for miles. On the way back, I accused Mark of intentionally trying to kill me.

Hopi Indian myth states that before a permanent settlement could be made, each clan had to make four directional migrations, north, south, east, west to the farthest points of the landmass. Their paths formed a great cross whose center, located in the American Southwest, was considered by the Hopis to be the magnetic and spiritual center of the universe. When a clan reached the end of a directional line, they first turned right or left before retracing their steps. The motif formed by this turn was a swastika which rotated either clockwise or counterclockwise according to the movements of the sun or the earth. As the migrations came to an end, the Hopis moved in concentric circles which spiraled in towards the center.

When I realized the expense and difficulties involved in building so large a circular structure, I cut out the four exterior rings and reorganized the plan as an axial alignment along

the cardinal points of the compass. The outside entrance in the lower right section of the aerial view forms the end point along the east-west axis.

Rumors about the *maze* have been spread within a thirty-mile radius by word of mouth. From the Carlisle Pike to Locust Point Road over the road that runs along the railroad tracks, they cut off onto the dirt road which they wore into the field, circle around the *maze,* go inside through the barriers which they tore down to make it easier to get to the center, build a fire, drink, "smoke dope," and repeat the process in reverse.

In the essay "Pascal's Sphere," Borges traces the history of the concept of the sphere whose center is everywhere and circumference nowhere from the Greek philosophers to Pascal. The current form of this idea is the theory of the uniformly expanding universe: from any point in the universe one appears to be standing at the center.

Designing an entrance or barrier along a specific path had the effect of reorganizing the whole network structure.

Like the experience of the highway, I thought of the *maze* as a sequence of body/eye movements from position to position. The whole cannot be comprehended at once. It can only be remembered as a sequence.

I was asked if I thought a maze was a basic form like the circle and the square. No, not exactly. But it seems to be a recurrent need—an elaboration of the basic concept of the path. I certainly intended to tap into the tradition. And what about Borges's reference to that "one Greek labyrinth which is a single, straight line . . . invisible and unceasing"?

I took the relationship between my point of entry and the surrounding land for granted, but often lost my sense of direction when I came back out. From one time to the next, I forgot the interconnections between the pathways and kept rediscovering new sections.

ILYA KABAKOV Installations (1996)

During my entire working life, beginning in 1955 (it is from about that point on that I have been keeping track of my work "for myself"), a change in genres was always taking place. Genres would sort of burst forth from my imagination, not dictated by anything from the outside, but rather in a way whereby they would first completely "expose themselves" (just like photos appear under the influence of a developing agent) and then disappear completely. With rare exceptions I would not return to a genre that I thought had been exhausted. Thus, individual drawings were replaced by series of these drawings, and they led in 1970 to the appearance of the "album" genre, which also formed a few series: *10 Characters, On Gray and White Paper,* and others. The genre "small paintings" was replaced by the series of "painting-objects," and then came empty white board-objects; finally "anonymous," abandoned objects: crates, folders with collections of "someone's" papers, an enormous archive brought from who knows where. It is also unknown where "someone" got these boards with schedules, plans, and instructions that were apparently just lying about on the street. After that emerged from somewhere (all "from there," from our life surrounding us on all sides) "the person from the ZhEK"—an artist-personage who painted one painting after another in quick succession, in the style that resembles Sots realism, but with feeble execution.

 * Ilya Kabakov, "Installations," in Amei Wallach, *Ilya Kabakov: The Man Who Never Threw Anything Away,* introduction by Robert Storr and comments by Ilya Kabakov (New York: Harry N. Abrams, 1996), 178–79. © 1996 Amei Wallach. Published by Harry N. Abrams, Inc. All Rights Reserved. Artist © Artists Rights Society (ARS), New York/VG Bild-Kunst, Bonn.

None of these genres disappeared into nowhere, but rather each served as the basis and material for the next. This same thing happened with the appearance of the next genre, which still can't fully come to an end and "exhaust" itself—the installation.

It emerged, as it seems to me, in the following way. Virtually all of my works, beginning already with the drawings, were surrounded by a net of commentaries. These were not "my" commentaries, although of course I wrote them with my own hand. But mentally, internally, it was as though these originated from others; they were in the very precise sense others' "voices" which expressed themselves concerning my works, and which I "heard" clearly and would write down afterward. Internally the situation appeared "spatially" like this: a viewer stood before my paintings and said (thought) something about them, and I observed the situation. I depicted this situation a number of times and arranged it all on the same plane, on the same painting or drawing: the objects and the opinions about them. But this juxtaposition of text and object on the same surface didn't suit me—both parts didn't work "in the gap." Therefore, for me the installation was primarily the inserting of the viewer into the "field of maneuvering" between the objects. And, of course, I fully realize that the "real" visitor of the installation is not this same viewer constructed by me, through whose eyes I see and evaluate what I have constructed inside. In order to bring these two closer together, I invented a special type of closed installation in 1988 which I called "total." The first experiment with it was *10 Characters* in the Ronald Feldman Gallery in New York.

To facilitate the reader's orientation in this overview, I decided in hindsight to arrange the installations according to themes which now seem convenient, but, of course, when I made them there was nothing of the sort in their conception.

1. A few installations belong to the group called *The Communal Apartment*. Among them are those that depict it as a joint complex: the rooms of the residents, a corridor, etc.; but each of its parts is separate: the "toilet," the "corridor near the kitchen," the "rooms of the residents." The "communal kitchen" occupies the main place among them.

2. Installations with "little white people" were built in 1988–92 in various ICAs, museums, and galleries. In each of them, "little white people," always 1.5 cm in height, appear in the most unexpected places: on the paintings, in pots and pans, in clothing thrown on the floor, and even in a large glass crate in the middle of a large hall in which a meeting was supposed to have taken place.

3. To the "practical" installations belong those which represent places and objects saturated with ideological content, an atmosphere of the communist propaganda and agitation that still existed not all that long ago and which could serve as a unique sort of epitaph and memorial (herein was in fact their aim) of the Soviet Union. To this category belong other installations (see below).

4. Installations with garbage. These installations incorporate all kinds of scraps of garbage of everyday life: empty boxes, packages, scraps of paper, matchsticks, broken pencils, etc. The scraps are always "exhibited" along with texts written on small paper labels attached to them. This fragmentary text has a lot in common with the garbage itself—it is anonymous everyday speech, belonging to "each and every person."

5. Flies. The "fly" theme runs through all my works—drawings, paintings, albums— beginning in 1955, and I still can't explain what connects me so with this insect. Yet some of the most important installations for me are also connected with this theme. Each author has his own favorite insect: ants, bees, mosquitoes, spiders. I constantly "stumble across" the fly. It would be interesting to find out why.

6. Biography. An experiment of exhibiting my biography is the main theme running through a few installations, and various means and various techniques are used for this purpose.

I am always looking back, into the past, and as a rule all of this has a depressing, sad quality. But when it concerns someone "else," then everything is just the opposite: the past begins to shine from the depths similar to a radiant painting of paradise, sparkling and pure.

7. Musical installations. Here belong those in which music is heard or is present, visually, in the form of music stands, notes standing on them, or both of these at the same time. The composer Vladimir Tarasov participated in the installations with sound, as either the composer or musical arranger.

8. Installations that are built as images of Soviet institutions and establishments belong to the gloomiest and most depressing group, and these can be called "total" in the real sense of the word, not only in terms of genre, but in their common, repressive atmosphere which seizes any viewer, whether a Westerner or one who experienced the reality of these organizations in my Homeland.

9. To the group of installations of "personages" belong those that each consist of one room in which said personage resides. At the base of the concept of such an installation rests a given idea, the birth and development which this personage represents. Such a conception doesn't differ in any way from similar personages in literature, but here in the installation what speaks about this main idea are things, paintings, drawings of the "hero," or an explanatory story standing right there inside, on a shelf.

DAN PERJOVSCHI No Visa? Better Have American Express (2002)

One)

Once upon a time I had no passport whatsoever. It was "the golden age" of communist ideology and there was no use to travel if you already lived in the best of all human societies. Passports were kept safe and clean by Securitate, our version of the KGB. But I had a friend who did not believe that the lack of milk, freedom of speech, soup, and blue jeans meant pure happiness. His dream was of decadent West Germany and he kept trying to swim the Danube, cross the Hungarian border on foot, and high jump the electric fences protecting us from you. Every time he tried (by water, land or sky), our legendary peasants, embodiments of common sense and national pride, would catch him, tie him down, beat him and deliver him to local police for a more professional beating. The last time he tried he was brought home and publicly judged in front of the fellow workers of his socialist factory. At the climax of the theatre the communist leaders staged for the working class they asked him a basic question: why you wanna leave such a wonderful country? No need to answer because exactly at that very moment—due to the National Savings Plan—the electricity was cut in the city. Now he is in Germany living the dream of his youth. He is fat, lost his hair, and the last time I met him he was falling asleep while we drank some beers after his 10 hour a day job.

Two)

Once upon another time there was a revolution. 1000 dead people did not impress the world media who felt betrayed because there were not half a million, as it was said in the first moments of confusion. But what matters is that after some weeks I got my first passport and I

* Dan Perjovschi, "No Visa? Better Have American Express," July 2002, at http://subsol.c3.hu/subsol_2/ contributors2/perjovschitext.html. By permission of the author.

Dan Perjovschi, installation views of *White Chalk—Dark Issues,* 2003, chalk drawings at Kokerei Zollverein, Zeitgenössische Kunst und Kritik, Essen, Germany. Photos by Wolfgang Guenzel (overview) and Andreas Wiesen (detail). By permission of the artist.

started the ten year habit of queuing in front of Embassies. Three or four days in front of the Italians with hysterical mothers and new born kids. The impossible mission of getting through the crowd in front of France. If you get in, you sit and listen to a 40 minute love chat between two Romanian clerks at the front desk who are supposed to be processing your application. Or after a day and a night assaulting Belgium and miraculously finding yourself in front of the desk, you see it closing in front of your eyes . . . half an hour before schedule. Winter time in front of the Austrians is not a joke. Because of the ice on the walkway, you can easily slip and lose your position in the queue and then nobody will let you in again. The Romanian clerk at the Austrians accepts bribes in full view for letting some guys pass you and enter in front of the queue.

You have to have nerves and a suitcase full of papers: a proper invitation (food, bed and pocket money provided by your host, clearly mentioned), no fax or e-mail accepted; a copy and original of your working record; if you're an artist and have no working record, an official paper from the Union of Artists proving you are an artist; a financial record for past few years; to show you have reason to come back—proof of property (car, flat); a letter from your job agreeing to give you a legal holiday; valid health insurance; respectable references; copies of old passport etc. etc. etc. depending on the different tastes of each of the unified Schengen spaces.[1] And of course you have to have money. One on one with your western counterparts. US citizens pay 60 bucks to get a Romanian visa, you pay 60 too, for their J, E, I or whatever type . . . But once you pass the first border of the civilized world your heart grows huge and you feel the taste of victory. You have just achieved something important. It's called freedom.

Three)

One year after Bulgarians we don't need visa for Schengen states anymore (we don't care about Serbs or Albanians). New year's day 2002 was celebrated with banners: Europe here we come!!! Big joy, national pride restored, old humiliations forgotten, our 2000 years of history re-enforced. We deserve, we are recognized, we are Europeans. Now I only have to show at the border a proper invitation—no fax accepted, a translation in Romanian language authenticated by a legal office, a valid insurance, and 100 Euro in cash for each day I want to spend as a 21st century politically correct, human rights endowed European citizen.

ALFREDO JAAR Conversation with Anne-Marie Ninacs (1999)

I have great admiration for documentary photographers and their work has been of tremendous inspiration to me. I admire their extraordinary courage and commitment to document very difficult, desperate situations. I have always thought that their images, besides their absolute necessity to inform us, can also be read as modest signs of solidarity, lonely expressions of concern of an indifferent society.

Regarding the images themselves, they are, sometimes, extremely powerful and effective and many of them can be credited with influencing public opinion and affecting the course of events. But unfortunately, the power of these images has been decreasing inexorably for at

1. *Editor's Note:* Europe's borderless zone created by the Schengen Agreement in 1995.
* Anne-Marie Ninacs, "Alfredo Jaar in Conversation with Anne-Marie Ninacs," in Pierre Blache, Marie-Josée Jean, and Anne-Marie Ninacs, eds., *Le souci du document: Le mois de la photo à Montréal* (Montreal: VOX, Centre de diffusion de la photographie/Les Éditions Les 400 coups, 1999), 210–11. By permission of the interviewer, the artist, and the publisher.

least twenty years, and this is not so much because of their quality but because the context in which they are shown has changed dramatically. We are confronted today to too many images, and too fast, in the so-called information highway, a media landscape filled with thousands of images, all fighting to get our attention, and most of them asking us to consume, consume, consume. So the question is, how can an image of pain, lost in a sea of consumption, affect us?

Well, sadly, in most cases, it can't. And that is why I have felt the need to create a mise-en-scène for my images, an environment where they make sense and can affect the audience. As Jean-Luc Godard has said: "The definition of the human condition is in the mise-en-scène itself." I have felt that without this protected environment, my images cannot survive. I believe it is imperative to slow down, to contextualize and to frame properly each image so it makes sense, so it cannot be dismissed. And that is what I have tried to do within the context of my installations. It is not that presentation takes over representation; it is rather that representation today requires new strategies of representation. I see my recent installations as essays of representation, as exercises in a search for new strategies of representation. Let us always remember that reality cannot be represented, we can only create new realities. How do we do this today, so these new realities created by us make sense and help us to better understand the world?

To work "in situ" is a fundamental aspect of my work and most of my projects are based on documentation made on site. This contact with the "real world" is what triggers the work in the first place and more precisely it is the need to make sense of that experience that becomes the *raison d'être* of the project. In that first phase of the project my work is very similar to that of an investigative reporter and I accumulate all kinds of information, not only visual. For me, to go "there" means to be a privileged witness, to get as close as possible to a reality other than mine, but not only to gather evidence, which I do as thoroughly as possible, but also to express solidarity and to create bridges between different realities. That experience is invaluable and there is absolutely nothing I can do after, when I am back in my small privileged world—almost a world of fiction compared to these experiences—to match the intensity and the depth of feelings and emotions lived "there."

These "experiences" have basically changed my life and I am a product of them. It is through them that I learn about the world, it is through them that I understand the world, it is because I go through these experiences that I feel the need to be an artist. And what I try to do as an artist is to translate these experiences into a language to communicate them to an audience and to make sense for them. For me this act of translation is clearly an act of creation, but also an act of responsibility. But this act of translation is also an almost impossible task and that is why I refer to my installations as exercises, they are futile, utopian exercises that are necessary only for my own survival. Are these exercises "real"? Yes, they are. Do they bridge the gap, the void, between the reality they are based on and their representation? No, they don't. But that does not make them less real.

Each project follows a program created in response to a very specific issue I propose myself to address regarding the specifics of the situation I am focusing on. This program contains everything, from the objective of the project to its implementation. And the creation of this program is of course based on the analysis I have made of the situation I am working with and all the important elements that will determine its final outcome. Here, the notions of audience, space, and time are the three axes around which the creation process revolves. Most projects are designed specifically for an audience and a space, and by space I do not mean only physical space but also social space, a space filled with meaning much beyond its physical features.

Regarding the audience, my fundamental concern is to try to establish a dialogue. I measure the success of a project according to the audience's participation and involvement. Art is communication and there is communication only when the audience responds. No response, no communication, no art. It is the audience that completes the work that moves the work from the world of "theory" to the world of "practice," that makes it "real." The work is designed in order to trigger the audience's reaction. If the work is truly successful, these body movements and these mental reactions, in a way all the physical commitment that the work triggers, should lead later to another kind of involvement, an intellectual involvement, because each work must suggest and must try to create a new model, a paradigm of social participation.

Finally, time is also of utmost importance: the time of most projects is always here and now, the audience must realize it is a "real life" issue, whose final outcome could actually be affected by the audience's reaction and participation. I know it is a lot to demand of an artwork, and it is almost impossible to achieve this, but that is the direction the work tries to suggest. The work is definitely "anti-fiction" and is always pointing towards life. As James Baldwin said, life is more important than art, that's what makes art important.

Unlike Kundera, I have never considered art "a territory where moral judgment is suspended." As Godard said: "It might be true that you have to choose between ethics and aesthetics, but it is also no less true that, whichever one you choose, you will always find the other one at the end of the road." I firmly believe that with every esthetic decision we take, we are also taking an ethical one. And of course the audience too participates in this inescapable polarity and is confronted by the same equation. Even the most estheticized reading is full of ethical connotations that are impossible to ignore.

On the other hand, conscious of the limited audience we reach, and of the difficulty we have in communicating, I make great efforts to work outside the so-called "art-world." In fact, my installations in museums and galleries represent just one third of my work. Another third is dedicated to public interventions, projects in public spaces where I try to reach a different, larger audience. The last third of my time is spent in lecturing and conducting workshops and seminars. It is only by diversifying my activities and fields of action that I feel I can reach a sizable audience.

What makes the audience move from an esthetic experience to an ethical realization? And how does this ethical realization translate into action? The most successful works do exactly that: they offer you an esthetic experience, they inform you and they ask you to react. And the depth of your reaction will be determined by the capacity of the work to move you through your senses as well as through your reason, a very difficult combination that is almost impossible to reach. That is why I insist on the fact that I conceive all my works as exercises, most of them futile but still necessary. As Gramsci said: "pessimism of the intelligence, optimism of the will."

Doris Salcedo, *Shibboleth,* 2007, installation in Turbine Hall, Tate Modern,
London. © Doris Salcedo; courtesy Alexander and Bonin, New York.
Photo: Tate, London/Art Resource, NY.

The history of racism runs parallel to the history of modernity, and is its untold dark side. . . .
[Shibboleth] represents borders, the experience of immigrants, the experience of segregation,
the experience of racial hatred. The space which illegal immigrants occupy is a negative space.
And so this piece is a negative space. . . . It's bottomless. It's as deep as humanity.

 * Doris Salcedo, quoted by Tate Modern (www.tate.org.uk/modern/exhibitions/dorissalcedo) and in "Salcedo
Causes a Rift at Tate Modern," *Guardian,* 8 October 2007. © Doris Salcedo. By permission of the artist, courtesy
Alexander and Bonin, New York.

YINKA SHONIBARE Interview with Anthony Downey (2005)

YINKA SHONIBARE: My work has always used a theatrical language. The first time I did anything filmic was in photography: *The Picture of Dorian Gray* [2001] was actually a series of stills from a film in which I acted out the various parts in *Dorian Gray*. I've always wanted to do film, but I did photography, I did stills, because I just did not have the resources to make the kind of film I envisioned. My work comments on power, or the deconstruction of power, and I tend to use notions of excess as a way to represent that power—deconstructing things within that. . . .

The main preoccupation within my art education was the construction of signs as outlined in Roland Barthes's *Mythologies*. So the idea of the theatrical for me is actually about art as the construction of a fiction, art as the biggest lie. What I want to suggest is that there is no such thing as a natural signifier, that the signifier is always constructed—in other words, that what you represent things with is a form of mythology. Representation itself comes into question. I think that theater enables you to really emphasize that fiction. For example, in *The Picture of Dorian Gray,* a black man plays within an upper-class nineteenth-century setting, and also in *The Diary of a Victorian Dandy.* The theatrical is actually a way of *re*-presenting the sign.

ANTHONY DOWNEY: What you're saying is that the sign itself is unstable, which ties into the notion of the identitarian ambiguity that you bring out in the masquerade in *Un Ballo in Maschera.*

YS: It goes further than that. On the one hand, the masquerade is about ambiguity, but on the other hand—and you could take the masquerade festivals in Venice and Brazil as examples—it involves a moment when the working classes could play at being members of the aristocracy for a day, and vice versa. We're talking about power within society, relations of power. As a black person in this context, I can create fantasies of empowerment in relation to white society, even if historically that equilibrium or equality really hasn't arrived yet. It's like the carnival itself, where a working-class person can occupy the position of master for however long the Venice carnival goes on—and it goes on for ages—and members of the aristocracy could take on the role of the working classes and get as wild and as drunk as possible. So the carnival in this sense is a metaphor for the way that transformation can take place. This is something that art is able to do quite well, because it's a space of transformation, where you can go beyond the ordinary. . . .

To be an artist, you have to be a good liar. There's no question about that. If you're not, you can't be a good artist. Basically, you have to know how to fabricate, how to weave tales, how to tell lies, because you're taking your audience to a nonexistent space and telling them that it does exist. But you have to be utopian in your approach. You have to create visions that don't actually exist yet in the world—or that may actually someday exist as a result of life following art. It's natural for people to want to be sectarian or divisive. Different cultures want to group together, they want to stick to their own culture, but what I do is create a kind of mongrel. In reality most people's cultures have evolved out of this mongrelization, but people don't acknowledge that. British culture in reality is very mixed. There's a way in which people want to keep this notion of purity, and that ultimately leads to the gas chambers. What I am doing may be humorous so as to show the stupidity of things. But at the same time I

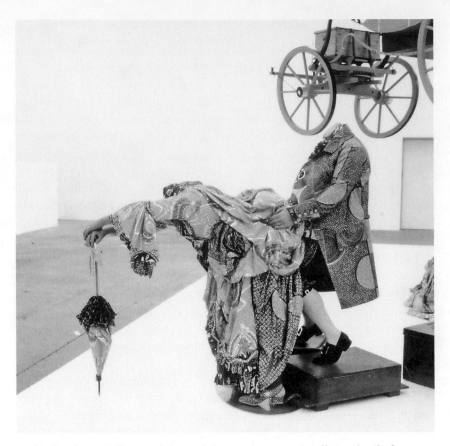

Yinka Shonibare, *Gallantry and Criminal Conversation,* 2002, installation detail of a "Grand Tour" outing with nobles wearing eighteenth-century English fashions tailored from what looks like African kente cloth but is actually Dutch wax-printed cotton purchased by the artist in Brixton Market in London. © Yinka Shonibare, MBE. Courtesy of the aritst; James Cohan Gallery, New York; and Stephen Friedman Gallery, London.

understand that the logical conclusion of sectarianism is Auschwitz, or the "logical" in its starkest manifestation. So even though these works are humorous, there's a very dark underlying motivation.

NICHOLAS HLOBO Interview with Sophie Perryer (2006)

In my work I explore Xhosa traditions or African traditions, and gender issues, with an emphasis on masculinity and rituals. When I thought of making an artwork that is particularly masculine, I decided to make a kraal—but also to challenge the purpose of the kraal.

The kraal is a space where, firstly, cows are kept, and secondly, certain rituals take place. When the boys come out of the bush and go to their final graduation, the celebration where

* Nicholas Hlobo, excerpted from interview with Sophie Perryer, in *Nicholas Hlobo: Izele* (Capetown: Michael Stevenson Gallery, 2006), 5. By permission of the artist, the interviewer, and the publisher.

they are introduced back to the family, they'd go to the kraal and get advice. They'd sit there and older men would advise them on how they should carry themselves as men now that they're grown up.

It's a space where women are not freely allowed to go. Only if you are a daughter of the family can you go into the kraal. If a woman has married into the family, she will be invited into the kraal to be introduced to the ancestors. That ceremony, *ukutyiswa amasi,* gives her the right to enter the kraal.

It's also a space that symbolizes wealth, where the spirits reside. The size of your kraal is like a show of how much wealth you have, as traditionally African wealth was portrayed through cows or sheep. This is more like a goat or sheep kraal. You'd only fit one or two cows in here, not more than that.

I wanted to make it similar to a kraal you'd find in KwaZulu-Natal. I talk about Xhosa traditions, but the shape of this kraal is very rare among Xhosa communities. The Xhosa people make rectangular kraals; it's only in Zululand that they make round kraals. I've used wooden stakes. The exotic and indigenous wood is symbolic in a sense. The reason for the indigenous wood is to be in touch with South Africa, where I come from, and the exotic wood, especially the blue gum, makes reference to the history and economic growth of South Africa. The blue gum came from Australia; it was brought here to be planted because it's fast-growing, and it grows straight. When gold was discovered in Johannesburg, they needed timber to support the mineshafts. There's also Pride of India, an ornamental tree. All these stakes have some spirituality, they make reference to other countries and cultures. In my works I talk about myself, my entire South African heritage. I'm not just Xhosa, in my genealogy there is diversity.

Another thing I've done is make this look like a plaything. It's a trampoline. A trampoline is very serious, used by gymnasts, but it's also used by kids. The reason I introduced play is to challenge the notion of what is respectable, and what is respected as a man's space.

The stakes extend over the trampoline part of the kraal. They have a rhythm that was influenced by the ground on which they were built. On one side they are almost upright, but on the other side they are leaning. They resemble people who are watching over what is happening here; they are like spectators of this game, keeping guard over everything inside the kraal.

Some of the stakes have knots that resemble wounds or genitalia. For example this could be an anus, or it could be a vagina. The treatment of the wood was not planned. I got it from Yeoville, near the water tower. We had to chop it, cut off all the branches and then throw each piece to the bottom of the hill. The wood was scarred by this process, which could be related to how hard the route is that men have to take when they go through the process of initiation. This is not only the case with Xhosa initiation into manhood, it happens in all cultures. If you're gay, you have to work your way up to being accepted by your family and the community; first you have to accept yourself. It's all about hardship, the hard road you have to take as a person. . . .

I wanted to play with the colours of . . . red and pink ribbons. Even though I use pink to suggest homosexuality, pink is also a very strong colour in the Xhosa tradition. There are pink beads, and the Bhaca people use pink pompoms in their headdresses. So, the colours relate to fashion—Xhosa traditional fashion. Red relates more to the red masks that people wear—the initiates would wear red masks when they are coming out—and it relates to AIDS, and to blood.

MONA HATOUM Interview with John Tusa (2006)

JOHN TUSA: You wanted to be an artist, your father wanted you to have a practical skill, was he really opposed to you becoming an artist?

MONA HATOUM: Yes very much so. When I was a teenager and we were discussing my future and I mentioned that I wanted to become an artist he categorically refused to send me to art school, because he said he wanted me to do something that will get me a real job, and that was the end of the conversation.

JT: But when you said to yourself that you always knew you wanted to be an artist what exactly did you have in mind?

MH: Since I was a child I was interested in drawing and made things all the time and I always wanted to become an artist. I suppose at the time I was thinking about becoming a painter, because women in that society would not be expected to be doing heavy work like sculpture or working with heavy machinery, so I was thinking that I'd like to be an artist as a painter. . . .

JT: This was in Beirut?

MH: Yes, in Beirut. So the only times we were able to draw, and it was completely optional, we had to do it at home, we couldn't do it at the school, was making illustrations to poems that we copied out in a notebook, so we were allowed to make illustrations on the opposite page where the poem was written, or making illustrations in the science class, "Sciences Naturelles," you know like making a drawing of an amoeba or all these kind of plants and things like that, and I remember that I used to spend a lot of time actually perfecting these drawings, and I felt extremely encouraged when on one occasion for instance the teacher showed one of my drawings to the whole class and said this is a masterpiece. So I mean that's all the encouragement I got as a child towards becoming an artist. And in fact what happened is my father actually saved all these notebooks. I actually found them in his filing cabinet after his death, so he must have recognised some kind of talent in these early drawings to keep hold of them all these years, yet when I mentioned that I wanted to go to art school he objected to it completely, which was quite surprising for me. . . .

JT: What were your terms of reference though? Did you think that art looked like Western art, or did you think it looked like Arabic calligraphy? I'm just trying to think what your terms of reference could have been.

MH: No, Arabic calligraphy never entered into my mind as . . . an art form, because that's a very traditional art form. I grew up in a very westernised cosmopolitan city. Beirut is very French in many ways. I went to French schools and most of the subjects we studied were in French. The idea of doing Arabic calligraphy was not something that came into my mind, I was making drawings from nature and figurative drawing. . . .

Well the funny thing, I mean the great masterpieces, the very early memory I have of seeing the great masterpieces was in the back of the French dictionary, Larousse French to French dictionary, there was a section on famous people in the cultural world and there were these tiny little black and white mostly reproductions of paintings, stamp size like, which I used to look at with a magnifying glass and marvel at the beauty of these paintings . . .

JT: But you did finally get to a graphic art school in Beirut didn't you?

* Excerpts from "John Tusa Interview with the Palestinian Artist Mona Hatoum," BBC Radio 3, broadcast 4 August 2006; transcript at http://www.bbc.co.uk/radio3/johntusainterview/hatoum_transcript.shtml. By permission of the interviewer, the artist, and the British Broadcasting Corporation.

MH: Well as a compromise to be able to go to university and study some kind of career related to art, but obviously it wasn't art. It was a way of doing something that would get me a job as soon as I left university, and it was only a two year course so it meant that I could get out of my father's grip or whatever within two years, so I did two years of graphic design. . . .

JT: Let's move forward to the art school in London. . . .

MH: Before I went to the Slade, when I went to the Byam Shaw, I was not really working with bodily fluids. This was something that came afterwards and it was more a kind of reaction to this kind of feeling that people were so disembodied around me, people were just like walking intellects and not really giving any attention to the body and the fact that this is part of one's existence, and that for instance the work that I wanted to make I wanted it to appeal to your senses first maybe or to somehow affect you in a bodily way and then the sort of connotations and concepts that are behind that work can come out of that original physical experience. This is what I was aiming at in the work. I wanted it to be experienced through the body. In other words I want work to be both experienced sensually and intellectually rather than just one dimensionally if you like. . . .

JT: You seem to have had a fascination for using electricity, creating metal constructions and putting electricity through them so the electricity actually crackled, so there was a sound, a physical nature and a sense of danger.

MH: Yeah I mean electricity and other kinds of invisible forces were things that I really enjoyed working with as a student, but electricity was one that, of course, has danger attached to it, and one of the earliest works was this kind of installation with metal objects, household objects, or even a metal ruler which I hung from the ceiling in a continuous line, and right at the bottom there was a light-bulb and the electricity was running through all these objects and lighting the light-bulb so obviously there was something very dangerous about it so those objects were electrified, and it's funny because very recently, in the last five years, I started using the same idea. This time creating like a home environment with an assemblage of sometimes furniture, metal furniture in a space and all the objects are connected together with electric wire and the electricity is running through those objects to light, light-bulbs which are hidden inside colanders or underneath beds or whatever. . . .

It becomes a sort of threat as opposed to comfort and then makes you think about all the possible unpleasant things to do with home whether it's like the housewife or the woman feeling entrapped by domesticity, or whether it's to do with a condemned environment where the inhabitants have to flee, or an environment that is to do with incarceration as in being under house arrest, or the notion of the home denied. I mean there could be so many different readings, but basically what I like to do with these works is to introduce a kind of disruptive element, physical or psychological element, that makes you question the whole environment. . . .

I was very lucky that I did not grow up in a Palestinian camp. My parents were fairly privileged because my father managed to be employed by the British Embassy in Lebanon and therefore we had a relatively comfortable home environment. . . .

I would say it's more to do with trying to expose a kind of undercurrent of malevolence or of contradictions in situations of maybe things that appear to be one way but are actually hiding something else underneath, and maybe it's the question of having lost that stable environment, longing for it at the same time dreading the idea of home becoming almost also like a prison. . . .

JT: Well the work like *The Light At The End,* i.e. light at the end of the tunnel, and after

all the idea of a light at the end of the tunnel is basically reassuring isn't it? . . . Is this a classical Hatoum image? There's the light, it's not a light, it could actually kill you.

MH: Well that's a very good example because that's one instance where I was exploring this idea of announcing the piece with a title that gives you an impression of something positive yet when you get close to the work you realise it's exactly the opposite, so your expectation about the work gets completely disrupted. The light at the end of the tunnel is not a light at all but it's electric heating elements that if you touched them, they could burn you through to the bone. . . .

It's a cruel image and also the structure itself looks like a prison gate where the bars have become electric heating elements, so there's the implication of torture, pain, incarceration, all those things, but at the same time it's a very minimal structure and it's very beautiful and it's very attractive and it induces in you this feeling of wanting to be playful or take risks and put your hands in between the bars. . . .

Associations with imprisonment, torture, pain, whatever, but without ever focusing on any specific place or any specific region or culture, and where you have the oppressed and the oppressor never defined so that when you look at this, when you're in front of that work you could be identifying yourself as the jailed or the jailor, you could be either. It's not moralising, it's not defining the source of conflict or the place or the culture. It's just presenting you with a situation which makes you almost experience that pain first hand.

JT: You see everything you've said, which is generally political and you've insisted, and I quite understand why, that you operate at a high level of generalism, I wonder what you felt when Edward Said said that he thought that you had expressed more vividly than anybody else the Palestinian condition. Now from what you've just said that's exactly what you're not doing, so when Said said that did you mind?

MH: People interpret these works depending on their own experience, so his experience of exile and displacement is that of the Palestinians so he read specifically the Palestinian issue in my work, but it's not so specifically to do with the Palestinian issue. It could be related to a number of people who are exiled, who are displaced, who suffer a kind of cultural or political oppression of any kind. Now sometimes people who are writers look for very literal meaning and, therefore, the content in the work is more important than the form. I actually like it when critics writing about my work give value to the form as well as the possible readings, or the possible meanings that come through that form, but that can be multiple, that is not necessarily fixed, because I think the language of art is very, very slippery. You can never say this work is about this. . . .

JT: And it should be slippery?

MH: The language of art is slippery and cannot speak in very direct terms, and in an artwork you can't say this equals that and that's it. The meanings are never fixed. It's like you can approach the same work of art from different angles and read different things into it . . .

JT: Let's talk about one of your most famous pieces and that is *Corps étranger (Foreign Body),* when micro cameras explored your own body through most of its, or all of its openings, its orifices, and what made you want to do that? I mean the first contradiction of course which we've been talking about is that it's called *Foreign Body* but the body is your own. So what is the contradiction between the title and the image?

MH: It's the body of a foreigner. . . .

We don't have access to our insides except when, you know, we go to hospital and discover we have a terrible disease, so the internal workings of our body are completely for-

eign to us most of the time. This is sort of a long story. The inspiration behind it goes very far back to a series of performances I was making when I was a student actually. It was a series of performances where I was pretending that I had a magic camera that could see through the clothes of the people in the audience. I was making performances where the audience was expecting me to be the performer, you know, baring myself if you like, and I turned the camera on to the audience instead and I was sort of scanning their body and . . . some of them hated it and experienced it as a complete kind of violent intrusion into their boundaries.

JT: So was that why you did it? . . .

MH: I became very aware of the existence of CCTV cameras, you know surveillance became very present in my work, 1984 and all that stuff, so that was part of it, and to make people aware of the fact that we are being observed all the time. I was sort of taking it a bit further and making it into a kind of humorous situation where I was using models behind a screen, and I was mixing images that were fed through with a live camera of the audience with images of the naked bodies of the two assistants who were, you know, directing the camera at themselves, or I would put in X-ray images so I was pretending that the camera had an X-ray vision, or sometimes I was doing very playful things like putting on a man's arm a tattoo saying 'mum' or something, you know, or playing with the gender, you know swapping the gender where the camera focused on a man's shirt and then when it disappears, on the screen you see a woman's naked torso behind it. . . .

[With *Corps étranger*] I had to go through it myself in order to make the work of course. So yeah I mean the funny thing is I wanted to do this work since I was a student as a result of all these performances I was making, but I couldn't get any doctor to agree to do the intervention on me . . .

JT: Did you learn anything about yourself as a result of being such a central part of one of your own works of art?

MH: You know when I'm making a work like that I'm really thinking in very abstract terms. I'm not thinking about myself specifically. I mean what I learnt is that everybody inside is exactly the same, because I looked at a lot of images of, you know, endoscopy, and the doctors agreed with me that everybody is so similar inside, you know, unless of course you have something medically wrong with you. But it was very much about really going into the body and turning it inside out and making it vulnerable at the same time making it threatening. . . .

Where the camera is going down the intestine for instance you're looking at a hole in the floor and it feels like you're on the edge of an abyss that can swallow you up, but also all the associations with woman's body as a dangerous kind of thing: the vagina dentata, the unconscious fear of women can be activated in those situations, or just the fact that you're inside this cylinder with the strong sounds of the body, heartbeat and all that, makes you kind of feel like you've re-entered the womb, it could have a cathartic kind of feeling . . .

JT: So is it also trying to de-mythologize our fear and our ignorance of body?

MH: To activate those fears and . . . To question them. . . .

In many ways I, I feel like this kind of living in a perpetual state of alienation has become a necessity, and it's like I sometimes think that I structure my life in such a way that I'm recreating that original state that I was in when I first left Lebanon, because it was both a very exciting time and at the same time very hard but also very challenging. So in many ways it's almost like there's a compulsion to repeat that moment, and therefore whenever I start feeling too comfortable in one place I take up a job teaching in Venice for two and a half months, which I just finished, and alienating myself both from London and Berlin which was

quite difficult but somehow, you know, I sometimes feel I do these things constantly to sort of destabilise the situation I am in.

GABRIEL OROZCO
The Power to Transform: Interview with Robert Storr (1997)

GABRIEL OROZCO: I don't have a studio and I work in the place where I am living and I am very curious about looking at what is happening and establishing contact with the situation. They are always general things that you are thinking about. But all these phenomena of culture that you confront are happening to you and it is very interesting to learn from them and deal with them. It has a lot to do with desire. Why you love the [Citroën] DS, has a lot to do with a sexual thing. That is why you feel attracted to something and you want something and you have a relation with it. . . .

ROBERT STORR: It strikes me that Mexico, generally speaking has not fostered very many conceptually oriented artists. . . . Was there a context for more conceptual work [in the 1960s and 1970s]?

GO: There were some groups, such as Osuma. There was a new generation doing work on the street. It was very political, related to the events of 1968. In some museums in the universities, you could see some of these shows. Helen Escobedo, the former wife of Mathias Goeritz, was showing some of these artists. It was a movement, but it was very much underground.

RS: I was in Guadalajara two years ago and there was quite a lot of conceptual work being done. But it seemed still that the conceptually-oriented artists were very embattled. They felt isolated in the culture as a whole.

GO: That's because of the generation called Ruptura, because they broke with the muralists in the 50s and 60s, and part of the 70s. After that in the 80s came a new wave of neo-Mexicanism, which was rather like the Transavanguardia. It was figurative painting, with Mexican symbols. Related to Frida Kahlo—ex-votos, hearts and things like that. The place was full of that in the 80s. All these groups disappeared in the 80s. I think that the people who were supporting this are still the directors of the museums in Mexico. They are still in charge of Mexican culture. . . .

RS: Latin American artists would look inward or they would look outward to the United States or Europe, but not to their neighbors. I wondered whether that was your perception. You've worked in Brazil.

GO: When I saw all that work in Brazil, it was a great discovery. I started to look for this kind of work but information was very very hard to find in Mexico. We were isolated and we are still kind of isolated. Brazil was very much in contact with European type of work. But I never knew about Hélio Oiticica or Lygia Clark, I found out about them in Europe. Then when I did my trip to Brazil, I immediately made friendships with Cildo Meireles and Tunga and Waltercio. Their perception of Mexico was pretty much like mine. We thought that the Mexicans were a bit too arrogant. It is a very culturally proud country. It was very problematic with other South American countries. Mexico was too much "Mexico." The

* Robert Storr, "Gabriel Orozco: The Power to Transform: Interview," *Art Press*, no. 225 (June 1997): 20–27. By permission of the interviewer; the artist, courtesy Marian Goodman Gallery, New York; and the publisher (www.artpress.com).

problem also has to do with the tendency of people in the North to generalize about the countries to the South, to always think in terms of the exotic, the tropical and to expect art that reflects that. North Americans see everything in Latin America through certain stereotypes based on the Caribbean or Mexico of many years ago. They think of palm trees and colorful costumes, and are not prepared for geometric abstraction or conceptual art. Felix Gonzalez-Torres felt it was necessary to go out of his way to defy those expectations but they persist. I think we all have that problem somehow.

RS: Some of your work seems to refer specifically to work by other artists. For example, the piece where you rode a bicycle around a manhole cover seems to me, anyway, to refer to Richard Serra, and some of the street pieces that he did. Similarly it is possible to see the chess piece you did as looking back to Duchamp and his use of chess as a model of art as a game. Is that a side aspect of what you are doing or are such references more fundamental?

GO: I think it is a side aspect. I was aware of these connections. When you are transforming and trying to generate your own experiences, you have all this information which is very influential in how you act. Also you have a particular phenomenon which is present right there at the time and it is not about history. I can tell you for every piece why I made that piece and it is not because of another artist. It's not that I was making a homage or because I was trying to connect with anything. Like that bicycle. I bought a bicycle because I need a bicycle. I was in the East River park with my camera and it had just rained and the light was very beautiful and it was full of reflections . . . then there were all these cycling guys going really fast and I was there with my $100 bicycle, and they were fast and avoiding all the puddles and I was thinking that they didn't need to avoid the puddles. They are accidents, it is the residue of something. I also have this photo of *An Island Into an Island*. I like puddles. What I did was just to cross them and instead of avoiding them, I made a personal situation absurd, connected it to the puddle. And it is an extension of the reflection because you see the reflection of the branches in the water and the extension of the lines. It was a very basic thing, very stupid. I didn't plan it at all. To the art world, chess is related to Duchamp, but chess is related with everything else. Duchamp is the least important thing about chess. Chess is a thing in itself. I was really just trying to make a new game because I was a chess player and pretty serious and then I left and I couldn't keep playing . . . so I wanted to make a game that nobody wins. . . .

RS: . . . One of the things that strikes me in some of the writing about you is that it seems that your work is not actually inside the game of postmodernist logic, but the writing about it often begins with a citation from Foucault, Lacan, or Barthes, or whoever it is, but also with citations from art history. So a work of yours can be put in the line of Sherrie Levine or the line of Duchamp or in the line of Fontana . . . it's almost as if the critical world wants to close in and take the work that you are doing and fit it neatly into a discourse of the 1980s, even if you don't particularly want that to happen.

GO: That can become a serious problem if it's limited to this approach. I would love to be related with other artists, but of course, this is something I cannot say. I cannot say, please connect me with this or connect me with that, because that is very pretentious, but they don't mention artists that I am very interested in. Like André Cadere. He was very important for me when I was doing my project in Belgium in 93, when I was thinking about his work all the time. And Manzoni. They rarely mention Hélio Oiticica or Lygia Clark from Brazil, and they are important. That there is this kind of line connecting whatever you want from Duchamp until now. The banality, the void, the emptiness, the nothing, the anarchy, the Dada-

ist, the readymade, the neutrality, the distance—whatever you want. There is a line there, and there are critics that are thinking about that. They have their eyes and their own information and they have their own interests. I respect that. I think my work has a lot to do with a kind of a present situation. It's a situation in which I am trying to put together things that I don't understand and trying to make some kind of sense. . . .

RS: If I can take it that you reject the idea that art can be pure under any terms, and that one kind of purity is art that is purely aesthetic and has no social and political dimension, I wonder if you felt that old definitions of how to be political also needed to be examined?

GO: Yes, absolutely. One of the most important things to consider and to think about is the 80s strategies in terms of politics and using the media and dealing with the institution inside the institution, criticizing the media from inside the media . . . How this worked and didn't work. I think we are dealing with this now. One of the things that I've always tried to deal with is that artists engaged in those issues were always thinking of the public as something completely big and abstract, as if they thought, "I have to get into the media to talk to these people." So there you are, and then what? Do you have something to tell them? Who gives you the authority to say something, to go up on the podium and say something? Why do you think that you are so important? I hope that never happens to me. The problem is the perception of the public as something abstract and amorphous, which I think is common ground between the strategies in the early 80s and in the early part of the [twentieth] century. This notion of the public as a mass, I think that is a little bit of a problem. At least I am trying to deal with it in a different way. It's a matter of how you deal with the particular and the general, the private and public.

So I try to avoid the personal specificities, because I think they become nostalgic and it is a kind of self-mythology and then I try to avoid the media and the public and the masses, whatever. I don't believe that it makes that much difference in the end. I'm trying to change the scale in terms of gesture. For me, the breath on the piano is as important as the DS, and I think if they are both important, good or whatever, then they have the same power to transform. One is a big important historical car, more expensive to make, and the other is just breath on a piano. The two have the same power to change something.

FRED WILSON *No Noa Noa: History of Tahiti* (2005)

No Noa Noa was not the seminal work where I realized that conceptual art was the path I would take as an artist. That earlier work is lost, but not forgotten. *No Noa Noa* was the work through which I think I learned the most about what I was interested in and continue to be interested in as an artist. I learned that a curiosity about hidden history, culture, and race were firmly a part of me and would always be by my side like a faithful dog, occasionally nipping at my heels. I learned that I was driven to research the subjects that interest me in order to invest my art with meaning. The gathering of information gave me the license and inspiration to go beyond my research, to delve into my own thoughts, desires, and demons sparked by the chosen topic.

* Fred Wilson, *"No Noa Noa: History of Tahiti,"* in Francesca Richer and Matthew Rosenzweig, eds., *No. 1: First Works by 362 Artists* (New York: D.A.P./Distributed Art Publishers, 2005). © Fred Wilson, courtesy PaceWilden-stein, New York. By permission of the artist and the publisher.

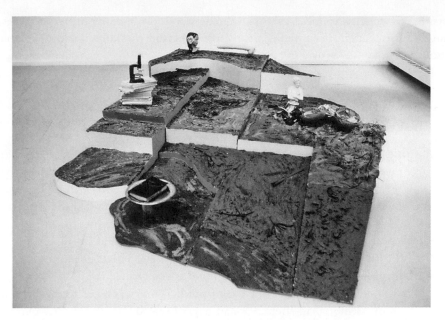

Fred Wilson, *No Noa Noa: History of Tahiti, Portrait of Paul Gauguin,* 1987, plaster, wood, bible, blood, mixed media. © Fred Wilson, courtesy PaceWildenstein, New York. Photo courtesy the artist and PaceWildenstein, New York.

For the creation of *No Noa Noa,* I had to chop up a wooden mask. It was the first time I broke a cultural artifact to release meaning. I remember it distinctly. The violent act was difficult for me to do as I am perhaps impossibly nonviolent in nature. I have the utmost respect for things in the world. Yet I knew that I had to do it, and that it was an act of abandon that was completely necessary to break through received notions. I remember apologizing to the mask before destroying it, and then feeling satisfied that it heard me and gave me its blessing. After I destroyed it, I knew *No Noa Noa* was to be a milestone for me. It was as if the mask passed on to me new abilities.

I learned that the power and politics of beauty would also play a part of my art-making and thinking. While I always knew I was interested in both high art and kitsch, *No Noa Noa* was the first time I juxtaposed disparate objects to create a new thought. This thrilled me immensely. It still does.

I also learned about my interests through the viewer's response to the work when it was first shown at Artists Space in the then-prestigious "Selections" exhibition. Mostly their offhand comments or actions inadvertently made clear to me what I was not interested in, as when a couple of viewers laughed upon seeing the huge, fleshy dildo, which I intended to be a sad commentary on a moment in history. From this I realized I had to dig deeper and work harder to get my feelings to emerge and to make my art mirror my emotions. In another instance, a curator told me that he would love to exhibit the juxtaposed objects in my work, if I ever wanted to show them without the multileveled, multicolored platform. I had never thought of doing this before because it was not my intention. His offer disturbed me for a long time, because I felt strongly that the context of objects was all-important. Context was king. The "white cube" was not the right context for me, because it presumed to be a non-context. It was this nagging realization that led me to search for a context for

objects that made sense to me. I eventually understood, through my life experiences, that the museum space itself, if viewed critically, could be and would be, the cogent context I was looking for.

RACHEL WHITEREAD
 If Walls Could Talk: Interview with Craig Houser (2001)

CRAIG HOUSER: In October 2000, after five years in the making, your *Holocaust Memorial* was finally unveiled in Vienna's Judenplatz, which is largely a residential square. For the project, you created a single room lined with rows and rows of books, all of it rendered in concrete. There is a set of closed double doors in front, and the names of the concentration camps where Austrian Jews died are listed on the platform surrounding the memorial. The piece is located near the Holocaust Museum in Misrachi Haus, and sits to one side of the Judenplatz, directly above the archeological site of a medieval synagogue. How did you get involved in the project, and what was on your mind as you created the piece?

RACHEL WHITEREAD: When I came back from Berlin, I was asked to make a proposal for the Holocaust Memorial in Vienna. I had never been to Austria, and I looked at this project and thought, very innocently, that Vienna would be an equivalent to Berlin, and it would be an interesting place to try to make a memorial to such atrocities.

In Berlin, I did a lot of reading. I also went outside the city and visited some concentration camps and thought long and hard about what had happened and how people have dealt with the Holocaust. I was very interested in the psychology of that experience, and the repercussions of it within the city.

When I went to Vienna, I didn't realize that the politics would be so different from the politics in Berlin. And I didn't think for a moment that my proposal would actually be chosen. . . .

There were twelve to fifteen international artists and architects who had been asked to submit proposals, and I was a baby compared to most of them. In the end, I was selected, which was a mixed blessing. It entailed five years of very, very difficult problems—with the city, the bureaucracy, and the politics. Luckily, I worked with some really great architects there; if it wasn't for them, I probably would have been crushed by the whole experience and might have just given up. I can't say I enjoyed making the piece at all, though I'm very proud that it's there.

CH: In making the casts of books for the memorial, you did it differently from most of your other book pieces. Instead of doing negative casts—showing the space around the books—you created positive casts. The leaves of the books protrude toward the viewer, and we end up seeing what appears to be a library from the outside. What is the significance of these positive casts?

RW: When I was making this piece, I was thinking about how it might be vandalized, how it could be used without being destroyed, and how it should be able to live with some dignity in the city . . . I knew my piece was going to be a memorial, and I wasn't quite sure

if it would be respected. So I made replaceable book pieces that are bolted from the inside, and a series of extra pieces to serve as replacements if necessary, in case there is some terrible graffiti. . . .

They are also much easier to read as a series of books, and I didn't want to make something completely obscure. I mean, some people already think it's an abstract block that they can't really understand; others think it's an anonymous library. It also looks quite like a concrete bunker. . . .

I wanted to make the piece in such a way that all the leaves of the books were facing outward and the spines were facing inward, so that you would have no idea what the actual books were.

CH: Why did you want to hide the names and titles of the books?

RW: I don't think that looking at memorials should be easy. You know, it's about looking: it's about challenging; it's about thinking. Unless it does that, it doesn't work.

CH: The library you've created seems institutional. The books are all the same size, placed in neat, even rows, and they fill the walls side to side. They look systematized.

RW: The original books for the cast were made from wood, so they are completely systematized.

CH: So nothing was ever really "documented."

RW: No. There's nothing real about that piece at all, in a way. The doors were constructed; I constructed the ceiling rose. It's all about the idea of a place. Rather than an actual room, it's based on the idea of a room in one of the surrounding buildings. It was about standing in a domestic square amidst very grand buildings, and thinking about what the scale of a room might be in one of those buildings. I didn't ever want to try to cast an existing building.

CH: Other art and architectural projects related to the Holocaust were created at the same time as yours. Does your piece relate to Micha Ullman's *Bibliothek* [1996], a memorial against Nazi book burnings in Berlin? Or Daniel Libeskind's Jewish Museum [1997] in Berlin?

RW: No. . . . In terms of other works, I actually think the memorial has far more in common with Maya Lin's *Vietnam Veterans Memorial* in Washington, D.C. When I was thinking about making the *Holocaust Memorial,* I spent a week there, and visited Lin's memorial twice. I wasn't interested in the politics related to the monument, but the way people who are alive today respond to it, reacting to something that may be within their history or within their own family's history. Lin's piece showed incredible sensitivity and maturity.

When I visited concentration camps, I was more interested in how people responded to the camps than in the actual places. I spent a lot of time just watching people. I watched kids picnicking on the ovens, and other people stricken with grief. I saw grandparents with their grandchildren, having the most appalling experiences, trying to somehow tell this younger generation about the past.

CH: So now that the memorial is completed, how has it been received?

RW: I'm very surprised. It's actually very moving how people have reacted to it. I had expected graffiti, but people have been leaving candles, stones, and flowers on the memorial. I think it's already become a "place of pilgrimage." People come into the city and go to Judenplatz specifically to see the memorial, the museum in Misrachi Haus, and the excavations of the medieval synagogue underneath the square. If I've in any way touched people, or affected a certain political force in Austria, I'm very proud to have done that.

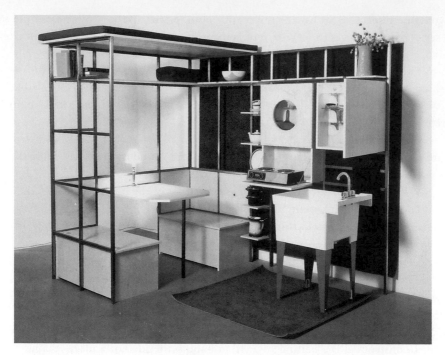

Andrea Zittel, *A–Z Management and Maintenance Unit: Model 003*, 1992, steel, wood, carpet, mirror, plastic sink, stovetop, glass. © Andrea Zittel; courtesy of Andrea Rosen Gallery.

ANDREA ZITTEL

A–Z Management and Maintenance Unit: Model 003 (2005)

In 1991 when I made my first Living Unit (titled *A–Z Management and Maintenance Unit*), I was actually breeding animals as my artwork. I lived and worked in a 200-square-foot store-front with flies, quail, and chickens, and my 80-pound pet Weimaraner named Jethro. The endeavor was to create a new breed of chicken as a designer pet. I was also designing Breeding Units for the birds to live in which resembled a cross between an apartment building and a piece of Ikea furniture. The Breeding Units were elegant and simple, and had room for everything that was needed to take care of the animal.

Even though I'm pretty well-organized, the interior of the storefront studio space was incredibly chaotic and dirty. I remember that there was a certain point when I started to look at my living conditions and thought to myself that the animals had it a lot better than I did. So around that time I started to build a unit for myself, which would reduce and compact my living functions into a 49-square-foot area. The Management and Maintenance Unit that I ultimately designed to contain all of these functions had a metal, "U-shaped" frame that reminded me of a Mondrian grid. It had cabinets and shelves to contain the necessities for things like cooking and grooming. The plastic slop sink doubled as a bathtub, and there was a loft bed that was supported by the framework.

* Andrea Zittel, *"A–Z Management and Maintenance Unit: Model 003,"* in Francesca Richer and Matthew Rosenzweig, eds., *No. 1: First Works by 362 Artists* (New York: D.A.P./Distributed Art Publishers, 2005), 420. © Andrea Zittel. By permission of the artist and the publisher.

I remember that when I first designed this Unit I actually wasn't very fond of "Modern design"—but I was interested in the way in which Modernism took qualities that had historically been associated with poverty, such as white paint, functionality, and simplicity, and by using an ethical or intellectual code translated these qualities into a design that was considered morally elite. Since I was struggling to make ends meet, and my own life was by necessity rather sparse and pared-down anyway, I thought that I could use the language of Modern design to glamorize my own situation. I often referred to this as "turning my limitations into liberations." I felt that since I couldn't afford to live the way that other people did, I would at least make them wish that they could live like me.

PIERRE HUYGHE Interview with George Baker (2004)

I wanted . . . in a certain way to register the manner in which there had been a shift . . . between the "Dia generation" and my own generation of artists. The earlier artists were mostly concerned with space and sculptural resolution, whereas temporal issues seem to be more important today. . . .

Think of Smithson's *Spiral Jetty* (1970). My interest was not in creating an object that escapes the exhibition frame only to merge with the landscape in its scale, but to do this more in a temporal sense. It would no longer be something in the middle of nowhere, no longer subject to this fascination of the Earth artists with the empty desert. My work would be precisely *in-between* the city and nature, *in-between* this place of meetings, signs, and corporations, which is the city, and nature. . . .

I simply wanted the work to be neither in nature nor in the city, and ultimately to base my action not on the production of a physical form but on an event. And yet, at the same time, this event would have a kind of permanence not unlike Smithson's production of a material object like the *Spiral Jetty*. The event would not be a performance exactly, because a performance arrives and it dies. Although, as in the theater, it can sometimes be replayed. The replay really is the most important thing. It is not the event anymore that is important, it is the replay. If artists in the 1960s and the '70s used to deal with this idea of event, performance, action—Kaprow, for instance—the representation of the event was not incorporated into the conception of the project. But now things have changed, and ultimately representation or images became more important than real events. We can see this with the current war, we can witness the way the media twists an event, the way representation is dictating the event. Today, an event, its image, and its commentary have become one object. There is an interchangeability in their occurrence and an anthropophagy. . . .

It is obviously difficult to define oneself after a postmodern period where we all became extremely self-conscious and aware about the consequences of our actions. This is why conclusions should be suspended but the tension should remain. There is a complexity that must be recognized and that produces a fragile object.

. . . It is a huge problem when the "political" becomes a subject for art. For me, Buren is a political artist. It is a practice that is political, not the subject or the content of art. Politics is not an apple that you paint in order to legitimate the fact that you paint. That is a moral issue.

* George Baker, excerpts from "An Interview with Pierre Huyghe," *October* 110 (Fall 2004): 80–106. © 2004 by October Magazine, Ltd. and the Massachusetts Institute of Technology. By permission of the interviewer; the artist, courtesy Marian Goodman Gallery, New York; and the publisher.

7 PROCESS

Kristine Stiles

Attention to the process of making art assumed an increasingly important role from the 1950s on. By exposing in the finished artwork how art comes into being—how materials behave and how procedures are undertaken—artists disclosed art's dependence on the conditions of its facture, the context of its making, and the ideological aspects of its production and reception. This emphasis constituted a significant repudiation of the formalist claims, predominant in the postwar period, that advanced art is autonomous, divorced from the public sphere, and apolitical. The understanding of process as a determining factor in art also led to the recognition that the modernist avant-garde had actually joined aesthetics to social aims. Piet Mondrian is a prime example. Though he is often presented as a quintessential modernist formalist, in his 1926 essay "Home-Street-City," Mondrian argued: "Neo-Plasticism views the home not as a place of separation, isolation or refuge, but *as part of the whole, as a structural element of the city.*"[1] In this light, Mondrian's paintings appear not as self-referential images of flatness, but as models of process aimed at demonstrating how balance or imbalance may be achieved in everyday life, moving from the home (or studio) to the street and the city (or world), where art interconnects with and alters social conditions.

The term "process" in the context of art is both precise and imprecise, an ahistorical referent and a specific marker of a period in the history of art. Artists making process art, an experimental genre that emerged in the late 1950s and that functioned as a point of intersection between painting and sculpture, attended to the inherent properties of materials, visualizing their intrinsic conduct and behavior in the act of making. In an attempt to grapple with this new approach to art making, which appeared to defy categorization, the critic Lucy Lippard organized the exhibition *Eccentric Abstraction* at the Fischbach Gallery in New York in 1966. She described process art as "idiosyncratic, perverse . . . sensuous [and] evocative."[2] A decade later she stressed that the aesthetic "order" of minimalism was also an "anti-order," a rejection of "Cartesian 'composed' order in favor of the 'disorder' or lack of order involved in matter-of-fact repetition and progressions."[3] "Postminimalism," a term coined by the critic Robert Pincus-Witten, designated the point at which the "rigorous external geometry" of minimalism gave way to visualization of the behavior of materials and processes in gestural action paint-

ing, happenings, body art, certain forms of conceptual art, performance, and installation.[4] In 1969 the curators Marcia Tucker and James Monte organized *Anti-Illusion: Procedures/Materials* at the Whitney Museum of American Art in New York, an exhibition emphasizing the boundary between formalism and "anti-form."

"Anti-form" is the term that the artist Robert Morris (b. U.S., 1931) used to describe unorthodox works of the late 1960s such as scatter installations, in which a variety of materials could be dispersed either carefully or randomly throughout a space. Morris's own systematic practice and theoretical engagement with the visual unfolding of process was among the most rigorous of its time. He had studied engineering and then art, moving from the University of Kansas City to the Kansas City Art Institute, the California School of Fine Arts in San Francisco, and Reed College. After returning to San Francisco in the mid-1950s, he attended workshops led by the dancer Anna Halprin (he was then married to the dancer Simone Forti). In 1961 Morris and Forti moved to New York, where they participated in the proto-Fluxus milieu, together with the composer La Monte Young and the artists Walter De Maria (chap. 6), Henry Flynt (chap. 9), and Yoko Ono (chap. 8). He earned a master's degree in art history from Hunter College in 1963. Morris broke with Fluxus in 1964, when he began to exhibit his proto-minimalist works, architectonic sculptures fabricated in plywood and painted a uniform gray.[5] In 1966 Morris began to examine the sculptural implications of process and the transition from conceptual to material states. That same year he published the first of a series of articles entitled "Notes on Sculpture." Part III of this series, "Notes and Non-sequiturs," summarized many ideas pertaining to the transition from formalism to anti-form.[6] Morris located the interconnection between art, linguistics, behavior, psychology, and phenomenology at this juncture, and referred to process as "reclamation," an act able to refocus attention on the energies that alter viewers' perceptions.[7] Morris was identified primarily with minimal, process, and conceptual art until the 1980s, when he began making paintings, sculptures, installations, and films.

A graduate of Yale University School of Art and Architecture in 1959, Eva Hesse (b. Germany, 1936–70) developed an eccentric ("absurd," in her words) visual vocabulary featuring balls with cords, hanging strings, circles of twine, containers (boxes, tubes, and vessels), and diaphanous hanging sheets of impermanent and disintegrative materials. Together with artists like Sol LeWitt (chap. 9), Carl Andre (chap. 2), Robert Ryman, Mel Bochner (chap. 9), and Dan Graham (chap. 9), Hesse investigated process and change in works organized in serial repetition; she called these works "sequels," "schemas," and "accretions." Wrapping and binding objects, Hesse drew attention to what the sculptor Jackie Winsor, in discussing her own artistic approach, described as "'making time' and 'perceiving time' so that the form grows out of process."[8] In juxtaposing binary categories (hard/soft, straight/round, etc.), Hesse attempted to visualize qualities of "soul, introspection, and inner feelings" related to the professional conflicts that she, as a female artist, felt and recorded in diaries and letters.

Martin Puryear (b. U.S., 1941) harnessed process as a technique for recuperating the ritual sources of art. After earning a BA from the Catholic University of America in Washington, D.C., in 1963, Puryear joined the Peace Corps in lieu of serving in Vietnam. Working in Sierra Leone (1964–66), he gained an appreciation for the craft of local sculptors and decided to study printmaking, sculpture, and woodworking. He

attended the Royal Swedish Academy of Fine Arts in Stockholm from 1966 to 1968, where, in addition to incorporating West African craft into his work, Puryear developed an affinity for the simplicity and spare qualities of Scandinavian design and woodworking. Next he enrolled at Yale University, earning an MFA in 1971. The unorthodox shapes of Puryear's sculptures unite non-Western handcraft traditions with the history of Western abstraction from biomorphism to minimalism. Combining numerous cultural references, Puryear nevertheless avoids fixed historical associations. He invites visual engagement in his processes of making by leaving visible the joints, staples, nails, and other structural elements of his sculptures.

Nancy Graves (b. U.S., 1939–95) used processes of association and field research as the intellectual foundation for works such as *Camels* (1967–69), a series of realistic, life-size constructions made of wood, steel, burlap, polyurethane, skin, wax, and oil. These sculptures drew on her extensive study of taxidermy, skeletons, bones, and fossils, as well as her interest in the intersection of art, the natural sciences, techniques of display in natural history museums, and the wax effigies made by the eighteenth-century anatomist Clemente Susini. Graves saw Susini's works in Italy while on a Fulbright-Hayes fellowship after earning an MFA from the Yale University School of Art and Architecture in 1964. Following the *Camels* series, she continued to juxtapose unorthodox materials in her *Camouflage* series (1971–74), in which she charted atmospheric and aquatic currents on maps and used aerial photography to connect art to geography, paleontology, and anthropology. She also created lithographs based on the geological maps of *Lunar Orbiter* and *Apollo* landing sites, and used stills of NASA's lunar photographs in her film montage *Reflections on the Moon* (1974). Graves had begun to make short films in 1970, continuing her interest in process by exploring color, light, form, and surface. Before her early death, Graves produced a series of polychrome bronze sculptures cast directly from natural objects in 1976 and designed sets and costumes for the choreographer and dancer Trisha Brown's *Lateral Pass* (1985).

Richard Serra (b. U.S., 1939) also received an MFA from Yale in 1964. Two years later, in a series of works that exemplify process art, he began to study the relation between the visual, physical, and tensile properties of materials and the unfolding of time, using various media from words to film and sculpture. In *Verb List Compilation* (1967–68), he listed action verbs as linguistic equivalents to tasks. In *Hand Catching Lead* (1968), a silent three-minute film, he recorded and performed the simple action of continually trying to catch and hold a piece of lead. For *Splashing* (1968), he repeatedly threw molten lead against the angle between the floor and the wall, allowing each layer to cool before pulling the shaped wedge away, over time creating a series of these sculptural forms. Other works by Serra visualized the material properties of weight, gravity, and balance, especially the precarious points of tension between them. In his site-specific public works, he expanded these concerns to an investigation of how sculpture intersects with social relations. Yet his *Tilted Arc* (1981), a commission for Federal Plaza in New York, met with prolonged public resistance after it was installed, resulting in a 1985 public hearing that determined it should be removed. Serra appealed this decision but lost, and *Tilted Arc* was taken down by the city in 1989, essentially destroying this site-specific work. A 2002 commission for Serra to create a similar sculpture on a green space at the California Institute of Technology was likewise reversed, when

students and faculty alike rejected the artist's proposal on the grounds that it would obscure light and negatively alter the space. In 2004 Serra himself participated in cultural politics with a drawing based on the infamous photograph of an Abu Ghraib prisoner with the words "STOP BUSH" above. Referring directly to the torture of Iraqi prisoners by U.S. military personnel in Baghdad, Serra's image—published on the back cover of *The Nation* the day after July Fourth—decried the betrayal of American democratic ideals.

Biting social commentary is also seen in the work of Bruce Nauman (b. U.S., 1941), especially in the charged phrases that have appeared in many of his neon sculptures that address social issues ranging from gender and sexuality to politics and art. Nauman's work also contains dry humor and witty puns, recalling the ironical ceramic sculptures of Robert Arneson and paintings of William T. Wiley, Nauman's teachers at the University of California, Davis, where he earned an MFA in 1966. In video performances from the late 1960s into the twenty-first century, Nauman has deployed his body as a physical object engaged in various processes and has created installations intended to alter viewers' psychological and perceptual experiences of time, space, and place. Like many artists of his generation, Nauman is familiar with structuralism, semiotics, information theory, phenomenology, and the psychology of perception. He has acknowledged the influence of the philosopher Ludwig Wittgenstein, the playwright Samuel Beckett, and the composer John Cage. Indeed, his clown video performances of the 1980s summon Beckett's "theater of the absurd," and his large-scale, multiprojection installation *Mapping the Studio I (Fat Chance John Cage)* (2002) is a wry rejoinder to Cage's notions of chance. The latter work, which records the artist's cat dispatching an infestation of mice in his studio, deploys the cat/mouse metaphor to visualize artists' attempts to entrap and realize their concepts, thus evincing the artist's relationship to process, as well as unfinished or discarded studio projects. Nauman reflects on what happens when the creative process fails in his 2005 film *Office edit II with color shift, flip, flop & flip/flop (Fat chance John Cage), Mapping the Studio 2001.*

Starting in the late 1960s, Robert Ryman (b. U.S., 1930), Richard Tuttle (b. U.S., 1941), and Barry Le Va (b. U.S., 1941) all experimented with process in works and installations that challenged conventional definitions of painting and sculpture. Ryman did not receive formal art training but studied art in the collection of the Museum of Modern Art in New York while employed there as a guard. Using white as a neutral pigment and the square as a uniform shape, Ryman stressed the process and structure of painting, stating: "It's not a question of what to paint, but how to paint."[9] Jo Baer, Robert Mangold, and Dorothea Rockburne (chap. 2) similarly studied the structure of painting, attending to edges, boundaries, shapes, fields, frames, supports, and the space around the work. Tuttle addressed process in small, eccentrically shaped, unstretched, wrinkled, sewn, and color-dyed canvases, called "floor pieces" or "wall pieces," depending on whether they were placed directly on the floor or pinned loosely to the wall. The more unobtrusive the work, the more the painting asserted its integrity as a sculptural object. In his installations, Le Va emphasized the impossibility of perceiving the difference between indeterminate and determinate placement, accident and intention, in sculptural situations that otherwise appeared visually similar. Le Va also used his body as a tool, performing and simultaneously exhibiting acts of making and doing.

Sam Gilliam (b. U.S., 1933) has visualized processes of making throughout his diverse oeuvre. Gilliam received an MFA in painting from the University of Louisville in 1961 and became associated with the Washington Color School after he moved to D.C. the following year. In 1968, in a manner reminiscent of Jackson Pollock's pouring technique, he began pouring, dripping, and spattering paint onto large unstretched canvases, which he then suspended in dramatic baroque installations of expressionistic swags and folds. Gilliam compared these works to landscape painting, with its atmospheric effects, shapes, and motifs. In the mid-1970s he began making geometric collage paintings, followed by paintings constructed in a patchwork-quilt-like form. These were succeeded by works incorporating metal pieces. By the 2000s Gilliam had begun to produce abstract, sometimes shaped, paintings that juxtaposed lush, gesturally applied color with hard-edge, minimalist elements.

Lynda Benglis (b. U.S., 1941) also took action painting as a starting point, making wax paintings and introducing Day-Glo fluorescent pigments into latex, foam, and polyurethane sculptures made by pouring the liquefied material directly onto the floor, where it congealed in thick, free-flowing sculptural masses, or what she called "frozen gestures." Extending the action of her body into materials, Benglis united the gestural vocabulary of action painting with garish colors that simultaneously satirized as they linked together New York School action painting, minimalist machismo, and pop art and culture. A strident feminist, Benglis produced videos such as *Female Sensibility* (1973), featuring two women kissing. When Robert Morris ran an advertisement in *Artforum* featuring himself nude from the waist up, wearing only a German World War II helmet, dark glasses, a spiked dog collar, and large chains around his neck, Benglis responded with her own *Artforum* advertisements, culminating in a photograph of herself nude, with her body heavily greased, wearing dark glasses and holding a gigantic dildo at her crotch. Thirty years later she created *Bikini Incandescent Column* (2004), a 14-foot-tall illuminated lanternlike sculpture that refers simultaneously to the phallic plume of an atomic bomb and to male aggression. The work's title calls to mind not only the 1946 atomic tests conducted by the United States at Bikini Atoll in the Pacific Ocean, but also the swimsuit named after the atoll, which caused an "explosion" in women's wear later the same year.

A feminist with an entirely different set of interests, Mierle Laderman Ukeles (b. U.S., 1939) wrote "Maintenance Art" in 1969, a manifesto decrying the consumption of women's time by service-related labor and domestic responsibilities. Broadening the focus of her activism, Ukeles began to address sanitation and environmental issues as well as the psychological and sociological conditions of workers' lives. Her site-specific installations, videos, and interactive collaborations often included the recycling of materials and a systems-oriented approach that involved her in long-range planning, analysis, and consultation projects devoted to global ecological survival. As the artist-in-residence for the New York City Department of Sanitation since 1978, Ukeles has worked with policymakers, ecologists, and city planners on intergovernmental, regulatory, and environmental projects, ranging from anti-pollution and anti-landfill initiatives to resource recovery and attention to waste management, wetlands, water and waste flow, and nature cycles. In 1989 Ukeles also began transforming an expired landfill in Cambridge, Massachusetts, into Danehy Park. Reclaiming the land for public use, she

planted native grasses and made a 24-foot-diameter dance floor from crushed, recycled rubber, as well as a winding, wheelchair-accessible path of glassphalt (asphalt mixed with recycled glass).[10]

Since the early 1970s Bonnie Sherk (b. U.S., 1945), a landscape architect, planner, educator, and performance and installation artist, has created utopian but pragmatic ecological and cultural projects. Her first visionary work, *Crossroads Community* (1974–80), also known as *The Farm,* was a self-sustaining, site-specific, participatory environment and ecological system, a working farm with plants and animals situated on seven acres of land under a freeway interchange in San Francisco. It later became a public park. In 2000 Sherk founded *A Living Library* (or *ALL*), which aims for sustainable environmental and educational change by transforming "sunken meadows and brownfields, urban sprawl and desolation, public parks and plazas, concrete and asphalt schoolyards, civic centers or undeveloped wastelands into vibrant and relevant community learning environments and highly visible public magnets offering innovative and practical community and economic development."[11] With projects coordinated with schools in San Francisco and New York, Sherk has described her living libraries as "a framework for making profound systemic changes in local communities."[12]

Ann Hamilton (b. U.S., 1956) graduated from the University of Kansas with a degree in textile design and earned an MFA from Yale University School of Art and Architecture in 1985. Chosen to represent the United States at the 1991 São Paulo Biennial and the 1999 Venice Biennale, she has worked in a variety of media, from sculpture and language pieces to video and photography. Often using natural, organic materials like flour and cotton, she emphasized change in installations characterized by austerity, muted colors, and sensory elements from sound to touch. She also sometimes introduced a performative aspect to her installations, heightening attention to process by performing concentrated simple actions over long durations. In 1991 Hamilton collaborated with Kathryn Clark (b. U.S., 1950), a photographer and book artist who had studied American history at the University of Kansas and earned an MFA from the University of California, Santa Barbara, in 1986. In their installation *View* (1991), they conversed on the idea of "work," discussing collaboration as a process and attending to the political, social, and institutional conditions determining their interchange and friendship, as well as the material construction of their piece, the museum as a site, and the surrounding city. Since the mid-1990s Hamilton has also collaborated on numerous public works, such as the design of Allegheny Riverfront Park (1994–2001) in Pittsburgh with the landscape architect Michael Van Valkenburgh and the artist Michael Mercil. The same team collaborated on the creation of Teardrop Park at Battery Park City in New York (2007), just two blocks from Ground Zero, where the World Trade Center stood before September 11, 2001.

Trained as a scientist and sculptor, Mark Thompson (b. U.S., 1950) has explored time, space, physics, and human communities in works related to his interactions with honeybees, a social insect shaping his "life and sensibility."[13] Presenting the honeybee in sculptural environments and performances, he incorporated materials such as beeswax, water, and sunlight in order to refer to the social, historical, and physical aspects of a particular site. Thompson's video *Immersion* (1974–76) opens with a visual sensation of great energy, suggestive of subatomic particles, the movement of which is eventually

seen to be that of the bees. Thompson's head and upper torso then emerge from the bottom of the frame and are gradually covered with the insects, which swarm to protect their queen, buried in a small box in the artist's hair. In the performance *Passage with Backpack Hive, Point Arena, California* (1977–79), Thompson wore a live honeybee hive in a wicker backpack and walked slowly, only eight or nine feet per hour, in an effort to facilitate the honeybees' foraging. Later, in a 1992 performance in Japan, Thompson connected his California walk to the poet Matsuo Bashō's 1689 walk to the backcountry described in the classic text *Oku no hosomichi (The Narrow Road to Oku)*. In Berlin in spring 1989 Thompson expressed the idea of political unity in an installation-performance in which he tracked his honeybees as they foraged between East and West Germany. Creating a physical and psychic path joining the artificially separated city through the free-flying natural habits of his bees, Thompson's action anticipated the fall of the Berlin Wall on November 9 of that year. He has commented: "The honeybee hive and the beekeeper offer a meaningful symbiotic guide towards nurturing interdependence . . . suggest[ing] a clear and powerful ecological model for human interaction in the natural environment."[14] Thompson has asserted that process alone is not enough to sustain the production of art; rather, the cycle of evolution, renewal, and resolution in process must be integrated into the formal structure of a work to make it complete.

Pinchas Cohen Gan, who was born in Morocco in 1942, immigrated to Israel in 1949, receiving a BFA from the Bezalel Academy of Arts and Design in Jerusalem in 1971. He also studied at the Central School of Art in London and received a BA in social science and art history from the Hebrew University of Jerusalem in 1973. In 1972 Cohen Gan held his first one-person exhibition, showing etchings in a cowshed on the kibbutz Nirim in the Negev. For the next four years he created ephemeral conceptual installations that anticipated the post-studio movement of the twenty-first century, carrying out what he called "activities" in the Israeli countryside that focused on social and political themes. In 1974, for example, he pitched a tent in Jericho and gave impromptu lectures to Palestinian guards on the subject of "Israel in the Year 2000," predicting peace at the turn of the millennium. Cohen Gan created similar installations in places where borders were in contention: India, South Africa, and the United States. Cohen Gan's interest in process reflects his view that a single work of art "is merely a fragment of the whole . . . a juncture through which social, political, ideological, textual, and scientific associations intersect; [and] a segment of a well-defined global sign system, which is complete with the ideational abstraction manifested by some super-formula."[15] Formulating a pictorial and intellectual strategy based on the relationships among "figure, form, formula," Cohen Gan also wrote theoretical texts drawing on cybernetics, computer theory, science, mathematics, logic, philosophy, and semiotics. His multilinguistic lexicographical signs attend to cultural, religious, scientific, and philosophical subjects.

Joseph Beuys (b. Germany, 1921–86) employed sculpture as a spatial metaphor for the interrelatedness of society, engaging in a comprehensive art practice that included traditional visual art media, performance, and installation as well as pedagogy, theory, and political activism. Referring to his practice as "social sculpture," Beuys argued that the plastic dimension of thought is connected to the social construction of lived reality and that "everyone is an artist." He used unorthodox materials (fat, felt, and other animal,

mineral, and vegetal substances) as metonyms for the transformative properties of matter and mind, constructing a personal, metaphysical cosmology of himself as a healer. Beuys rejected logical positivism, embraced Hegelian idealism and Germanic mysticism, and drew on esoteric traditions from Rosicrucianism and alchemy to theosophy and anthroposophy in his consideration of the "spiritual in the material." Beuys joined the Hitler Youth before it was compulsory, against his parents' wishes, and volunteered for military service immediately after Germany invaded Poland in 1939, serving the Third Reich throughout the war. After the war he attended the Düsseldorf Art Academy, and in 1961 was appointed professor of sculpture there. He then formed the German Student Party in 1967. Dismissed from his teaching position in 1972 for refusing to restrict enrollments, he sued and was reinstated in 1978. Beuys coauthored, with the writer Heinrich Böll, a manifesto for the Free International University for Creativity and Interdisciplinary Research (FIU) in 1972 and ran for public office in 1976.

During his student years at the Düsseldorf Art Academy, Franz Erhard Walther (b. Germany, 1939) began to theorize art as a formless phenomenon activated by viewer participation. His *First Work Series* (1963–69) consisted of a canvas apparatus, fabricated by his first wife, Johanna, that required active viewer participation in a variety of processes to realize the work. These actions included walking, lying down, standing, and other bodily movements involving the work in the revelation of its own structure. For *Process Book* (1963–69), Walther made a life-size canvas bookwork that included sixty-eight "pages" with which viewer-participants engaged in physical ways. Other works by Walther could be worn as clothing, and his "walking pieces" permitted participants extended motion. Walther acknowledged a debt to European *informel* painting and to the impetus of Piero Manzoni (chap. 2) and Lucio Fontana (chap. 1), "who, with their systems of cutting or molding the canvas, provided the catalyst for Walther's own tactile formulation of 'non-space' and destruction of the Albertian window."[16]

Rebecca Horn (b. Germany, 1944) also created and performed body sculptures, which she made from soft materials suggestive of bandages, after being hospitalized in 1968 with lung poisoning, the result of working with sculptural materials like fiberglass. She eventually turned to installation, producing works featuring automated electromechanical elements distinctly suggestive of erotic movement that reinforced what she described as a "consciousness electrically impassioned."[17] Horn, who studied art at the University of Fine Arts in Hamburg (1964–70), began teaching at the Berlin University of the Arts in 1989. She compared the multimedia classes there to her working process: "It all interlocks. . . . I always start with an idea, a story, which develops into a text, go from the text into sketches, then a film, and out of that come the sculptures and installations."[18]

Jan Dibbets (b. Netherlands, 1941) approached sculpture, performance, and kinetic installation from a base in conceptual art. Dibbets produced the first of his *Corrected Perspectives* in 1967. Using light-colored string, tape, or rope on ephemeral surfaces such as sand or grass, as well as on his studio floor, he laid out geometric forms, especially squares, so that they altered illusionistic perspective and served as "demonstrations" for different viewing experiences. He then documented these temporary installations in photographs that became the final iteration of the artwork. *Corrected Perspectives* required seeing the transient object from different points of reference in an attempt to correct habitual modes of viewing that had been codified in Renaissance perspective and then

reiterated in technologies such as the camera. Interested in the relationship between traditional artistic media, new photographic technologies, and mass communication, Dibbets also created *TV as a Fireplace* (1969), a video that transformed the television screen into an electronic illusion of a fireplace, simulating fire through technological means. The work was broadcast on German national television as part of Gerry Schum's "Fernsehgalerie" (Television Gallery) in 1969 (see chap. 5). In the 1980s Dibbets returned to his earlier practice of collaging photographs to expose the ambiguities of perception, creating evocative conceptual photographs of architectural forms and motifs.

Barry Flanagan (b. U.K., 1941–2009) also approached process through conceptual practices in the late 1960s. After attending Birmingham College of Arts and Crafts (1957–58), he studied at St. Martin's School of Art in London (1964–66), where the conceptual artist John Latham (chap. 9) was his mentor. In 1966, rebelling against the pervasive influence of the sculptor Anthony Caro, who also taught at St. Martin's, Flanagan helped Latham launch his infamous *Still and Chew* party, at which guests masticated Clement Greenberg's influential book *Art and Culture* (1961). During this period Flanagan made a series of works whose titles—*Heap, Pile, Bundle*—underscored his procedural attention to the behavior of unorthodox sculptural materials like sand, flax, sacking, wool, fabric, and rope. He went on to teach at St. Martin's and the Central School of Arts and Crafts (1967–71), later producing stone and bronze figurative sculptures of leaping hares that mocked monumental sculpture. Employing humor to resist entrenched European aesthetic traditions, Flanagan's hare sculptures also acknowledged ancient symbolism from Asia to Europe, by which hares have paradoxically been associated with witches, shape-shifting, and good luck, as well as serving as archetypal symbols of the moon goddess, fertility, the lunar cycle, and rebirth.

Flanagan was initially associated with Arte Povera, the movement identified by the art critic Germano Celant (b. Italy, 1940). Celant chose artists who used "poor" or everyday nonaesthetic materials like animals and plants for the exhibition *Arte povera—Im spazio* at Galleria La Bertesca in Genoa in 1967. Rooted in the *art informel* of Lucio Fontana and Alberto Burri (chap. 1), Arte Povera first named a collection of artists in Italy such as Giovanni Anselmo, Alighiero Boetti, Luciano Fabro, Jannis Kounellis, Mario Merz, Giulio Paolini, Michelangelo Pistoletto, Gilberto Zorio, and later Marisa Merz. Eventually, Arte Povera came to be associated with a wide spectrum of international artists who, rather than sharing a distinct stylistic similarity, held similar attitudes about how art might represent the processes and impact of industrialization, technology, and consumption on contemporary life. Despite, or perhaps because of, the success of Arte Povera, Celant renounced the term a few years after coining it, feeling that neither a politically charged art movement nor a discrete group of artists had emerged.

Jannis Kounellis (b. Greece, 1936), a central figure of Arte Povera, immigrated to Italy after the Greek Civil War, in 1956, and subsequently studied at the Academy of Fine Arts in Rome, where he began as a gestural painter. Later he declared: "I am a Greek person but an Italian artist." Like many of his generation, Kounellis responded to the unprecedented industrialization and consumerism rampant in Italy during the 1950s and 1960s by abandoning painting for performance and installation. His work is characterized by the inclusion of objects from everyday life, such as door and window frames and mattresses, musical and performative components, and earth, fire, water, and air as al-

chemical forms. At Galleria L'Attico in Rome in 1967, Kounellis exhibited a live parrot, rows of metal containers with earth, cacti, and other organic materials. Two years later he tethered twelve live horses to the same gallery walls as a meditation on nature and cultural systems. Kounellis also filled heavy metal cubes with light cotton, juxtaposing organic and industrial products as a commentary on Western binary systems and the separation of rational and intuitional epistemological systems.

Both Kounellis and Mario Merz (b. Italy, 1925–2003) grew up in families and a social milieu charged with leftist politics. During World War II Merz belonged to the antifascist group Giustizia e Libertà (Justice and Liberty) and was imprisoned for partisan activities. After the war he published drawings in the communist newspaper *L'Unità*. In 1963 Merz abandoned *informel* painting to construct assemblages, which eventually developed into multidimensional installations. He became interested in the thirteenth-century Italian mathematician Leonardo Fibonacci's system of numerical progression (1, 1, 2, 3, 5, 8, 13, 21, . . .), for which the spiral and other organic forms (the skin of reptiles and the form of seashells, for example) are visual equivalents. Synthesizing the rational and the organic, Merz compared the dynamic proliferation in the Fibonacci sequence and its biological equivalents to the political and economic multiplications of capitalism. He also compared nomadic and tribal existence to aspects of urban culture, introducing the igloo in 1968 as a symbol illustrating how "geography becomes past history." Simultaneously a "micro-organic city" and an image of shelter, the igloo functioned as a metaphor for nomadic survival. In his installations, Merz juxtaposed the igloo with modern technologies (motorcycles, newspapers, neon tubing spelling out words or in the form of numbers, etc.), as well as animals and organic materials (a crocodile, fruit, etc.), visualizing the tension and conflict between nature and the systems, institutions, and technologies of contemporary culture.

From 1966 to 1968 Giuseppe Penone (b. Italy, 1947) studied at the Academy of Fine Arts in Turin with Giovanni Anselmo and Michelangelo Pistoletto, both of whom were associated with Arte Povera. Penone initially cast molds of his ears, lips, nose, and other body parts, placing these casts over growing vegetables to cause them to conform to the shapes of his features. Joining the internal workings of nature with the ways in which society imprints nature, he compared human will to the generative growth, evolution, change, and energy of plants. In his series *Breaths* (1978), Penone blew on piles of leaves, using the depressions caused by his breathing as molds for terra-cotta amphoras, which he identified as metaphors for the "breath of the Gods." By revealing the shape of breath through the "transfusion of energies," Penone sought to depict the invisible matter that animates life. Beginning in the late 1960s and into the twenty-first century, Penone also hollowed out huge wooden beams, carving them until only a sapling-like core was left, creating a tree within a tree. In *Cedar of Versailles* (2002–3), for example, he cut the profile of a young cedar within the trunk of a five-ton cedar that had fallen in the Forest of Versailles in December 1999. Penone's monumental yet intimate visual and sculptural dialogues engage the processes by which natural forces and human action combine to alter the environment and the imagination.

Teresa Murak (b. Poland, 1949) has been acknowledged as a precursor of process and ecological art in Poland for her unique combination of biological elements with sculpture, installation, and performance. After studying art history at the Catholic University of

Lublin (1969–70), she attended the Academy of Fine Arts in Warsaw (1971–76). While still a student, she sowed watercress seeds onto women's garments, which she watered and wore, using the heat of her body to help sprout the seeds and transforming the surface of the gowns into a lush, grass-like field. Murak then wore her seeded smocks in public performances that were both distinctly political and religious in tone, comparing and contrasting nature, culture, and religion in terms of the ecological life cycle, the social and psychological conditions under Soviet bloc communism, and belief in life, death, and resurrection characteristic of the Catholic faith in which she was raised. In *Procession* (1974), for example, she wore a full-length cloak of grass to walk through the streets and main square of Warsaw, the site of major political events. That same year she created *Easter Carpet,* a 230-foot-long tapestry of seeds for the church of her village of Kielczewice (near Lublin). In the mid- to late 1980s Murak worked with such symbolic materials as leavened bread and dust mixed with water, before turning to full-scale earthworks, such as *The Sun Rises Out of the Earth* (1994–95), a small hill-like structure of basalt, earth, and grass in a courtyard at the Center for Polish Sculpture in Oronsko. Murak, who has studied Eastern philosophy, especially Zen and Taoism, described her meditative works as "manifesting the place of transfiguration, i.e. the process in which creation and cognition are identical, in which they form a whole." She said, "I keep aiming at going beyond the material to reveal the invisible. I always look for the spiritual."[19]

The site-specific sculptural installations of Patrick Dougherty (b. U.S., 1945) represent the essence of engagement in process. Dougherty earned a BA in English from the University of North Carolina, Chapel Hill, in 1967 and an MA in public health from the University of Iowa in 1969 before turning to sculpture. His interest in primitive building techniques, natural construction materials, and the changing states of nature inspire his temporary installations. Dougherty has constructed fanciful, large-scale webbed and nested structures entirely from twigs, branches, and saplings that are green and supple at first, but dry and fall apart over time, and most are eventually disassembled and carted away. Sometimes his ephemeral works resemble exotic buildings in the form of abstract undulating shapes, complete with door and window openings. For the site-specific structures and sculptures he has constructed throughout the Americas, Europe, and Asia, Dougherty would first visit a locale to identify and select the native flora for his materials and then make the structure with the help of local participants. Demonstrating respect for and connection to the particularities of place, his works enhance their surroundings with a physical and natural reminder of the interrelationship between nature and creativity, embodying sustainability, sculptural design, and community participation.

In his site-specific work *The weather project* (2003), installed in the gigantic Turbine Hall at Tate Modern in London, Olafur Eliasson (b. Denmark, 1967) created the impression of a huge radiating sun. He realized the work by using a semicircular disc comprising hundreds of mono-frequency lamps emitting yellow light, augmented by humidifiers that diffused mist to transform the space into a glowing environment seemingly bathed by the sun's rays. A mirror covered the ceiling, reflecting back viewers as tiny black forms. Eliasson, who studied at the Royal Danish Academy of Fine Arts in Copenhagen (1989–95), began collaborating in 1996 with the architect Einar Thorsteinn, who contributed both conceptual ideas and technical skills to some of Eliasson's pavilions, tunnels, and camera obscura projects. For some installations, Eliasson worked

with as many as forty assistants, many of them trained as architects. In his work he considers the consequences of natural and artificial phenomena on perception, as well as the relationship between environment (or space and place) and work. In *The New York City Waterfalls* (June–October 2008), Eliasson installed four artificial waterfalls, ranging in height from 90 to 120 feet, at various locations in New York Harbor, with the aim of showing how water, normally perceived as a surface, is also a volume of enormous physicality.

Cai Guo-Qiang (b. 1957) has produced visual spectacles comparable to, but very different from, those of Eliasson. Born and raised in China and trained in set design at the Shanghai Drama Institute from 1981 to 1985, Cai then lived in Japan until 1995, when he moved to New York. Before he left China, Cai began to use gunpowder in concert with oil paint to observe the processes of charring and burning, as in *Self-Portrait: A Subjugated Soul* (1985), which he reworked in Japan after the events of Tiananmen Square in 1989. Cai eventually expanded his gunpowder drawings into large-scale events including fireworks and other pyrotechnics, and he directed the visual special effects for the opening and closing ceremonies of the 2008 Olympic Games in Beijing. His spectacular displays are based on his research into Chinese philosophy, medicine, folklore, and mythology, and refer as well to the invention of gunpowder in China.[20] Cai's use of explosives as art refers metaphorically to the repressive, destructive decades brought on by Mao Zedong's Cultural Revolution, which began in 1966, when Cai was nine years old. Drawing on his memories and combining an ambiguous nationalism with a critique of China's recent history, Cai in 1999 famously produced *Rent Collection Courtyard* for the 48th Venice Biennale. This terracotta installation was an exact replica of a renowned Socialist Realist Chinese sculpture, a tableau with eighty-one figures that had been sculpted in the 1960s during the Chinese Cultural Revolution by members of the Sichuan Academy of Fine Arts (one of whom assisted Cai in Venice). Remaining unfired, Cai's work was left to crumble and was eventually destroyed, communicating—like his work with explosives—the transient conditions and processes of life.

The production of visual spectacle is also the province of Jeff Wall (b. Canada, 1946), whose large-scale photographic tableaux, often presented as transparencies mounted on light boxes, show his interest in the history of realist narrative in painting and film. Using various processes (from staging his works live to digitally combining different shots), Wall produces photographs that are characterized by drama and theatricality, augmented by dynamic action. His images may be categorized in two broad categories: documentary-like photographs and cinematographic ones that involve casts of actors posing on created sets, as well as crews to set up the scenes. The photographic tableaux capture not only a particular historical setting, but also mood and content, which are often conveyed in subtle visual exchanges among characters. Equally committed to depicting "the here-and-now," Wall was inspired by the Symbolist poet Charles Baudelaire's 1859 charge to modern artists to become "painter[s] of modern life."[21] Trained as an art historian at the University of British Columbia in Vancouver (1964–70) before doing postgraduate work at the Courtauld Institute of Art in London (1970–73), Wall has taught at several universities and art schools, authored numerous critical texts on contemporary artists, and contributed to defining the 1980s Vancouver School, a collection of artists following a conceptual approach to art-making.

Jolene Rickard (b. 1956), a member of the Turtle Clan of the Tuscarora nation, earned a BFA from the Rochester Institute of Technology, an MS from Buffalo State College, and a PhD from the State University of New York at Buffalo, before returning to her reservation in northern New York, "reintegrating herself in an ongoing spiritual education, and becoming embroiled in the intricacies of reservation politics."[22] In a 1989 radio broadcast, Rickard stated: "I'm not an American and neither will my children be. I'm a Tuscarora. I'm not a generic Indian either. We have separate political identities and separate relationships to our own tribes and specific understandings of our rituals. I'm not an advocate of taking a little bit of the pipe ceremony of the Lakotas and mixing it with a little bit of sand painting from the Navajos. I have my own religion."[23] An art historian expert in Native American art history and cultural theory, as well as an artist, Rickard approaches process though representations of time, using photographs, projections, and interactive elements in her installations to re-create and re-present Tuscarora and Iroquois experiences and environments. For the National Museum of the American Indian in Washington, D.C., which opened in 2004, she developed the "wall of gold," consisting of more than four hundred gold objects once owned and used by Native peoples, from 1490 to the present. Rickard writes polemically about the aesthetic practices of First Nations and indigenous peoples globally, warning of the dangers of Native cultures being appropriated and absorbed.

Anomalous forms of experience are subjects Susan Hiller (b. 1940) has addressed in her art. Born in the United States, Hiller moved to England in 1973 after deciding to become an artist and abandoning her career as an anthropologist (she earned a PhD in anthropology from Tulane University in 1965). Describing herself as a kind of archaeologist of culture, she explored subjects often trivialized by science and by society in general: dreams, psychic phenomena (clairvoyance, telepathy, etc.), automatism, UFOs, near-death experiences, and ghosts (what she has called "phantoms that haunt the inner worlds" of humans). She has also examined the conditions of the human mind through reference to psychoanalysis and Surrealist considerations of the illusive states of matter and energy. In her multimedia work *From the Freud Museum* (1991–97), she thought about how "we all live inside the Freud museum" as a result of the pervasiveness of Freudian notions of the unconscious and the ego/id. With her eclectic style Hiller, a staunch feminist, fuses her interests in pure experimentation and visionary, spiritual experience with Jackson Pollock's processes in action painting, Ad Reinhardt's interest in calligraphic "spontaneous expression," minimalist form, and a conceptualist approach. She has worked in a wide variety of media, from writing, drawing, photography, video, and film to performance and installation.

The Brazilian-born Thai artist Rirkrit Tiravanija (b. 1961) works at the intersection of social and aesthetic processes in post-studio activities. His first pieces were cooking exhibitions, in which he invited viewer/participants to watch him cook and to eat his food. Unlike Daniel Spoerri (chap. 4) in the 1960s and Gordon Matta-Clark (chap. 6) in the 1970s, who both cooked in their own restaurants for other artists and friends, Tiravanija used the international gallery system as a venue to attend to an ordinary, but essential, activity in a context where participants might contemplate everyday life in an aesthetic framework. In 1998, together with the artist Kamin Lertchaiprasert, Tiravanija created *The Land,* an artists' commune project in a rural setting about twelve and a half

miles from Chiang Mai, the unofficial capital of northern Thailand. They invited international artists and architects to work the land (growing rice and other foods), interact with the local population, and build alternative, environmentally sound structures for sleeping quarters, a kitchen, rooms for meditation, and a central hall for gatherings (the power for which is generated by the movement of elephants), with the aim of constructing a self-sustaining environment. Individuals and collectives with a wide range of experience and interests have participated in *The Land,* including the Thai artists Prachya Phintong and Angkrit Ajchariyasophon; the German artist Tobias Rehberger; the Algerian/French filmmaker Philippe Parreno; the French architect François Roche, designer of organic, experimental architectural projects; and SUPERFLEX, a Danish collaborative comprising three artists and an engineer whose work focuses on global environmentalism. Tiravanija's work fosters community and engages the public in art as an alternative form of thinking about the conduct and processes of life.

ROBERT MORRIS
Notes on Sculpture Part III: Notes and Nonsequiturs (1967)

Seeing an object in real space may not be a very immediate experience. Aspects are experienced; the whole is assumed or constructed. Yet it is the presumption that the constructed "thing" is more real than the illusory and changing aspects afforded by varying perspective views and illumination. We have no apprehension of the totality of an object other than what has been constructed from incidental views under various conditions. Yet this process of "building" the object from immediate sense data is homogeneous: there is no point in the process where any conditions of light or perspective indicate a realm of existence different from that indicated by other views under other conditions. The presumption of constancy and consistency makes it possible to speak of "illusionism" at all. It is considered the less than general condition. In fact, illusionism in the seeing of objects is suppressed to an incidental factor.

Structures. Such work is often related to other focuses but further, or more strongly, emphasizes its "reasons" for parts, inflections, or other variables. The didacticism of projected systems or added information beyond the physical existence of the work is either explicit or implicit. Sets, series, modules, permutations, or other simple systems are often made use of. Such work often transcends its didacticism to become rigorous. Sometimes there is a puritanical scepticism of the physical in it. The lesser work is often stark and austere, rationalistic and insecure.

While most advanced three-dimensional work shares certain premises, distinctions can be made between works. Certain ambitions and intentions vary and can be named. Terms indicating tendencies can be attempted on the basis of these different aims. While the terms arrived at do not constitute classes of objects which are exclusive of each other, they locate distinct focuses.

Objects. Generally small in scale, definitively object-like, potentially handleable, often intimate. Most have high finish and emphasize surface. Those which are monistic or structurally undivided set up internal relations through juxtapositions of materials or sometimes by high reflectiveness incorporating process part of the surroundings; sometimes by transparency doing the same thing more literally. Those which are structurally divided often make use of modules or units. Some of these—especially wall-hung works—maintain some pictorial sensibilities: besides making actual the sumptuous physicality which painting could only indicate, there is often a kind of pictorial figure-ground organization. But unlike painting, the shape becomes an actual object against the equally actual wall or ground. Deeply grounded in, and confident of the physical, these objects make great use

* Robert Morris, excerpts from "Notes on Sculpture Part III: Notes and Nonsequiturs," *Artforum* 5, no. 10 (Summer 1967): 24–29. By permission of the author and the publisher.

of the traditional range of plastic values: light, shadow, rhythms, pulses, negative spaces, positive forms, etc. The lesser works often read as a kind of candy box art—new containers for an industrial sensuality reminiscent of the Bauhaus sensibility for refined objects of clean order and high finish. . . .

The trouble with painting is not its inescapable illusionism *per se*. But this inherent illusionism brings with it a non-actual elusiveness or indeterminate allusiveness. The mode has become antique. Specifically, what is antique about it is the divisiveness of experience which marks on a flat surface elicit. There are obvious cultural and historical reasons why this happens. For a long while the duality of thing and allusion sustained itself under the force of profuse organizational innovations within the work itself. But it has worn thin and its premises cease to convince. Duality of experience is not direct enough. That which has ambiguity built into it is not acceptable to an empirical and pragmatic outlook. That the mode itself—rather than lagging quality—is in default seems to be shown by the fact that some of the best painting today does not bother to emphasize actuality or literalness through shaping of the support.

At the extreme end of the size range are works on a monumental scale. Often these have a quasi-architectural focus: they can be walked through or looked up at. Some are simple in form but most are baroque in feeling beneath a certain superficial somberness. They share a romantic attitude of domination and burdening impressiveness. They often seem to loom with a certain humanitarian sentimentality.

Sculpture. For want of a better term, that grouping of work which does not present obvious information content or singularity of focus. It is not dominated by the obviousness of looming scale, overly rich material, intimate size, didactic ordering. It neither impresses, dominates, nor seduces. Elements of various focuses are often in it, but in more integrated, relative, and more powerfully organized ways. Successful work in this direction differs from both previous sculpture (and from objects) in that its focus is not singularly inward and exclusive of the context of its spatial setting. It is less introverted in respect to its surroundings. Sometimes this is achieved by literally opening up the form in order that the surroundings must of necessity be seen with the piece. (Transparency and translucency of material function in a different way in this respect since they maintain an inner "core" which is seen through but is nevertheless closed off.) Other work makes this extroverted inclusiveness felt in other ways—sometimes through distributions of volumes, sometimes through blocking off, or so to speak "reserving" amounts of space which the work does not physically occupy. Such work which deals with more or less large chunks of space in these and other ways is misunderstood and misrepresented when it is termed "environmental" or "monumental."

It is not in the uses of new, exotic materials that the present work differs much from past work. It is not even in the non-hierarchic, non-compositional structuring, since this was

clearly worked out in painting. The difference lies in the kind of order which underlies the forming of this work. This order is not based on previous art orders, but is an order so basic to the culture that its obviousness makes it nearly invisible. The new three-dimensional work has grasped the cultural infrastructure of forming itself which has been in use, and developing, since Neolithic times and culminates in the technology of industrial production.

There is some justification for lumping together the various focuses and intentions of the new three-dimensional work. Morphologically there are common elements: symmetry, lack of traces of process, abstractness, non-hierarchic distribution of parts, non-anthropomorphic orientations, general wholeness. These constants probably provide the basis for a general imagery. The imagery involved is referential in a broad and special way: it does not refer to past sculptural form. Its referential connections are to manufactured objects and not to previous art. In this respect the work has affinities with Pop art. But the abstract work connects to a different level of the culture.

The ideas of industrial production have not, until quite recently, differed from the Neolithic notions of forming—the difference has been largely a matter of increased efficiency. The basic notions are repetition and division of labor: standardization and specialization. Probably the terms will become obsolete with a thoroughgoing automation of production involving a high degree of feedback adjustments.

Much work is made outside the studio. Specialized factories and shops are used—much the same as sculpture has always utilized special craftsmen and processes. The shop methods of forming generally used are simple if compared to the techniques of advanced industrial forming. At this point the relation to machine-type production lies more in the uses of materials than in methods of forming. That is, industrial and structural materials are often used in their more or less naked state, but the methods of forming employed are more related to assisted hand craftsmanship. Metalwork is usually bent, cut, welded. Plastic is just beginning to be explored for its structural possibilities; often it functions as surfacing over conventional supporting materials. Contact molding of reinforced plastics, while expensive, is becoming an available forming method which offers great range for direct structural uses of the material. Vacuum forming is the most accessible method for forming complex shapes from sheeting. It is still expensive. Thermoforming the better plastics—and the comparable method for metal, matched die stamping—is still beyond the means of most artists. Mostly the so-called industrial processes employed are at low levels of sophistication. This affects the image in that the most accessible types of forming lend themselves to the planar and the linear.

The most obvious unit, if not the paradigm, of forming up to this point is the cube or rectangular block. This, together with the right angle grid as method of distribution and

placement, offers a kind of "morpheme" and "syntax" which are central to the cultural premise of forming. There are many things which have come together to contribute to making rectangular objects and right angle placement the most useful means of forming. The mechanics of production is one factor: from the manufacture of mud bricks to metallurgical processes involving continuous flow of raw material which gets segmented, stacked, and shipped. The further uses of these "pieces" from continuous forms such as sheets to fabricate finished articles encourage maintenance of rectangularity to eliminate waste.

Tracing forming from continuous stock to units is one side of the picture. Building up larger wholes from initial bits is another. The unit with the fewest sides which inherently orients itself to both plumb and level and also close packs with its members is the cubic or brick form. There is good reason why it has survived to become the "morpheme" of so many manufactured things. It also presents perhaps the simplest ordering of part to whole. Rectangular groupings of any number imply potential extension; they do not seem to imply incompletion, no matter how few their number or whether they are distributed as discrete units in space or placed in physical contact with each other. In the latter case the larger whole which is formed tends to be morphologically the same as the units from which it is built up. From one to many the whole is preserved so long as a grid-type ordering is used. Besides these aspects of manipulation, there are a couple of constant conditions under which this type of forming and distributing exists: a rigid base land mass and gravity. Without these two terms stability and the clear orientation of horizontal and vertical might not be so relevant. Under different conditions other systems of physical ordering might occur. Further work in space, as well as deep ocean stations, may alter this most familiar approach to the shaping and placing of things as well as the orientation of oneself with respect to space and objects.

The forms used in present-day three-dimensional work can be found in much past art. Grid patterns show up in Magdalenian cave painting. Context, intention, and organization focus the differences. The similarity of specific forms is irrelevant.

Such work which has the feel and look of openness, extendibility, accessibility, publicness, repeatability, equanimity, directness, immediacy, and has been formed by clear decision rather than groping craft would seem to have a few social implications, none of which are negative. Such work would undoubtedly be boring to those who long for access to an exclusive specialness, the experience of which reassures their superior perception. . . .

Pointing out that the new work is not based upon previous art ordering but upon a cultural infrastructure is only to indicate its most general nature, as well as its intensely intransigent nature. The work "sticks" and "holds" by virtue of its relationship to this infrastructure. But the best as well as some of the worst art uses these premises. The range for particularization and specific quality within the general order of forms is enormous and varies from

the more or less specific intentions and focuses indicated above, down to the particular detail of a specific work. These particularities make concrete, tangible differences between works as well as focus the quality in any given work.

The rectangular unit and grid as a method of physical extension are also the most inert and least organic. For the structural forms now needed in architecture and demanded by high speed travel the form is obviously obsolete. The more efficient compression-tension principles generally involve the organic form of the compound curve. In some way this form indicates its high efficiency—i.e., the "work" involved in the design of stressed forms is somehow projected. The compound curve works, whereas planar surfaces—both flat and round—do not give an indication of special strength through design. Surfaces under tension are anthropomorphic: they are under the stresses of work much as the body is in standing. Objects which do not project tensions state most clearly their separateness from the human. They are more clearly objects. It is not the cube itself which exclusively fulfills this role of independent object—it is only the form that most obviously does it well. Other regular forms which invariably involve the right angle at some point function with equal independence. The way these forms are oriented in space is, of course, equally critical in the maintenance of their independence. The visibility of the principles of structural efficiency can be a factor which destroys the object's independence. This visibility impinges on the autonomous quality and alludes to performance of service beyond the existence of the object. What the new art has obviously not taken from industry is this teleological focus which makes tools and structures invariably simple. Neither does it wish to imitate an industrial "look." This is trivial. What has been grasped is the reasonableness of certain forms which have been in use for so long.

New conditions under which things must exist are already here. So are the vastly extended controls of energy and information and new materials for forming. The possibilities for future forming throw into sharp relief present forms and how they have functioned. In grasping and using the nature of made things the new three-dimensional art has broken the tedious ring of "artiness" circumscribing each new phase of art since the Renaissance. It is still art. Anything that is used as art must be defined as art. The new work continues the convention but refuses the heritage of still another art-based order of making things. The intentions are different, the results are different, so is the experience.

EVA HESSE Letter to Ethelyn Honig (1965)

I wonder if we are unique, I mean the minority we exemplify. The female struggle, not in generalities, but our specific struggles. To me insurmountable to achieve an ultimate expression, requires the complete dedication seemingly only man can attain. A singleness of purpose

* Eva Hesse, excerpt from "Letter to Ethelyn Honig" (early 1965), in Lucy Lippard, *Eva Hesse* (New York: New York University Press, 1976), 205. © The Estate of Eva Hesse, Hauser & Wirth, Zürich/London. Also by permission Lucy Lippard and New York University Press.

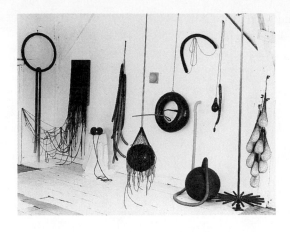

Eva Hesse, studio view, 1965–66.
© The Estate of Eva Hesse, Hauser & Wirth, Zürich/London. Photo: Gretchen Lambert.

no obstructions allowed seems a man's prerogative. His domain. A woman is sidetracked by all her feminine roles from menstrual periods to cleaning house to remaining pretty and "young" and having babies. If she refuses to stop there she yet must cope with them. She's at disadvantage from the beginning. . . . She also lacks conviction that she has the "right" to achievement. She also lacks the belief that her achievements are worthy. Therefore she has not the steadfastness necessary to carry ideas to the full developments. There are handfuls that succeeded, but less when one separates the women from the women that assumed the masculine role. A fantastic strength is necessary and courage. I dwell on this all the time. My determination and will is strong but I am lacking so in self esteem that I never seem to overcome. Also competing all the time with a man with self confidence in his work and who is successful also.

I feel you have similar problems which is also evident in your work. Are we worthy of this struggle and will we surmount the obstacles. We are more than dilettantes so we can't even have their satisfactions of accomplishment. The making of a "pretty dress" successful party pretty picture does not satisfy us. We want to achieve something meaningful and to feel our involvements make of us valuable thinking persons.

Read "The Second Sex."

I am finishing book now.

I've always suffered with these thoughts but now I've temporarily found a spokesman. But naturally I don't feel a native ability that she or others has that have succeeded.

Statement (1968)

I would like the work to be non-work. This means that it would find its way beyond my
 preconceptions.
What I want of my art I can eventually find. The work must go beyond this.
It is my main concern to go beyond what I know and what I can know.
The formal principles are understandable and understood.

* Eva Hesse, untitled statement, in *Eva Hesse* (New York: Fischbach Gallery, 1968); reprinted in Lucy Lippard, *Eva Hesse* (New York: New York University Press, 1976), 131. © The Estate of Eva Hesse, Hauser & Wirth, Zürich/London. The last line was to read: "In its simplistic stand, it achieves its own identity." The line was omitted in the final version (see Lippard, *Eva Hesse*, 216 n.21).

It is the unknown quantity from which and where I want to go.
As a thing, an object, it accedes to its non-logical self.
It is something, it is nothing.

Statement (1969)

Hanging.
Rubberized, loose, open cloth.
Fiberglass—reinforced plastic.

Began somewhere in November–December, 1968.
Worked.
Collapsed April 6, 1969. I have been very ill.
Statement.
Resuming work on piece,
have one complete from back then.
Statement, October 15, 1969, out of hospital,
short stay this time,
third time.
Same day, students and Douglas Johns began work.
MORATORIUM DAY
Piece is in many parts.
Each in itself is a complete statement,
together am not certain how it will be.
A fact. I cannot be certain yet.
Can be from illness, can be from honesty.
irregular, edges, six to seven feet long.
textures coarse, rough, changing.
see through, non see through, consistent, inconsistent.
enclosed tightly by glass like encasement just hanging there.
then more, others. will they hang there in the same way?
try a continuous flowing one.
try some random closely spaced.
try some distant far spaced.
they are tight and formal but very ethereal. sensitive. fragile.
see through mostly.
not painting, not sculpture. it's there though.
I remember I wanted to get to non art, non connotive,
non anthropomorphic, non geometric, non, nothing,
everything, but of another kind, vision, sort.
from a total other reference point. is it possible?
I have learned anything is possible. I know that.
that vision or concept will come through total risk,
freedom, discipline.
I will do it.

* Eva Hesse, untitled statement, in *Art in Process IV* (Finch College, 1969); reprinted in Lucy Lippard, *Eva Hesse* (New York: New York University Press, 1976), 165. © The Estate of Eva Hesse, Hauser & Wirth, Zürich/London.

today, another step. on two sheets we put on the glass.
did the two differently.
one was cast—poured over hard, irregular, thick plastic;
one with screening, crumpled. they will all be different.
both the rubber sheets and the fiberglass.
lengths and widths.
question how and why in putting it together?
can it be different each time? why not?
how to achieve by not achieving? how to make by not making?
it's all in that.
it's not the new. it is what is yet not known,
thought, seen. touched but really what is not.
and that is.

Statement (n.d.)

You asked me to write
Sol, closeness and not knowing enough.
Another's world.
I cannot know your world.
You write the systems,
You set up the grids
You note 1, 2, 3, 4.

I see them.
Your order their order.
Units, strength, cubes, columns—tough stances,
strong

but I see the fragile sensitivity,
the you which is and should be there.

Intuition, idea, concept followed through
no arbitrary choices,
no test
never arbitrary, never decoration.

the strength of vision and soul is there, it must.
we are left ultimately with a visual presence.
why deny that. can't deny that.
It's what we
are left with. A visual presence.
Depth: that too we must be left with.

Sol, there is depth and vision, a presence
art.

* Eva Hesse, untitled statement, Hesse Archives, Allen Memorial Art Museum, Oberlin College, n.d.; published in Linda Norden, "Getting to 'Ick': To Know What One Is Not," in *Eva Hesse: A Retrospective* (New Haven: Yale University Art Gallery and Yale University Press, 1992), 69. © The Estate of Eva Hesse, Hauser & Wirth, Zürich/London. Also by permission of Allen Memorial Art Museum and the publishers.

MARTIN PURYEAR

Conversations with Hugh M. Davies and Helaine Posner (1984)

Self and Bask

HUGH DAVIES: Dualities and tensions appear to be among the strongest characteristics of your work. For example, *Self* looks like it's solid, but it's really a very thin shell. And it appears to be carved, but in fact it's constructed.

MARTIN PURYEAR: The strongest work for me embodies contradiction, which allows for emotional tension and the ability to contain opposed ideas. So on the face of it *Self* is organic, almost as if carved out of a block, but in reality it was made over a form, built in layers. It was very important to me that the piece not be made by removal or by abrading away material, but rather that it be produced by a more rational process. It was put together piece by piece, though I finally arrived at a shape that existed *a priori* in my mind, and it was a carved kind of shape. It looks as though it might have been created by erosion, like a rock worn by sand and weather until the angles are all gone. *Self* is all curve except where it meets the floor at an abrupt angle. It's meant to be a visual notion of the self, rather than any particular self—the self as a secret entity, as a secret, hidden place.

HD: And how does *Bask* compare to *Self*?

MP: *Bask* is more calculated and more pure. The shape is a single arc floating above a straight line. It's meant to float above the floor and to stretch taut along the floor. While it reads as a dark silhouette, with an organic, slowly curving contour rising above the floor, the lower edge is sharp like a blade, dead straight, and fixed along the same ground plane as the observer. I wanted these different qualities to co-exist in a single work.

HD: What is meant by the title of *Bask*?

MP: It's the archetypal notion of basking, of lying extended in the sun like a seal or a whale.

Recent Work

HD: The circles you've been making in the last few years seem to involve concerns of both painting and sculpture.

MP: The circles are about line. From a few feet away they become lines drawn on a wall, yet they do have volume. I have to build things. Even when I returned to the impulse to work with line on the wall, it was not with paint, pencil or crayon but by building it. Each of the circles reads as a line, but it really is an object. In a sense I guess you could say it's drawing with wood. David Smith drew with iron and steel; this is drawing with wood. I felt this to be particularly true of *Some Tales* of 1977, which I assembled element by element, line by line, using spokeshaved wooden saplings instead of drawn lines.

HD: Does *Equation for Jim Beckwourth* of 1980 work in a way similar to *Some Tales?*

MP: *Beckwourth* also uses line, but in this installation the raw skin thongs were stretched horizontally to form straight lines in contrast to the twisted lines made of saplings. The two halves of the equation were different in their materials but alike in that both halves included

* Hugh M. Davies and Helaine Posner, excerpts from "Conversations with Martin Puryear," in *Martin Puryear,* ed. Karen Koehler (Amherst: University of Massachusetts Art Gallery, 1984), 23–40. Edited for the present volume by the artist. By permission of the artist and the publisher.

helical lines placed on the wall at eye level, like writing. Essentially the piece had two zones, one of skin and one of wood. The skin side was made up of tightly twisted rawhide thongs and a large rawhide cone serving as one polarity high up on the wall. The other half, the wood zone, was composed of twisted vines and saplings, making loose, looping irregular coils; and a timber and sod object resting on the floor. The object was a box or cabin shape with a fuzzy turf top, like a domed sod roof. An extremely long, slender sapling connected the rawhide cone and timber and sod box diagonally. . . .

HD: Is the rawhide cone comparable to the rawhide in *Cedar Lodge,* which you built at the Corcoran Gallery in 1977?

MP: The *Beckwourth* rawhide cone was probably more symbolic, whereas the rawhide in the Corcoran was used more like a light filter, kind of an amber skylight. . . .

HD: *Beckwourth* and *Some Tales,* then, are about drawing with wood, making lines with wood, both two- and three-dimensionally. What about the circles?

MP: Well, the circles are both line and object, but they're also a format for paint . . . normally I just start out with forms and shapes and colors. Making sculpture that you know you're going to paint is very different. I make the basic circle, which is usually not a true circle, and then confront certain choices; what should the scale and thickness be; should the circle be tapered or left parallel all the way around, undiminishing; should it be faceted, perfectly round, or flattened to become oval in certain sections; should things be added to it? Once you've begun with the form you start to think about color—the pieces usually get a color almost simultaneously. Usually when a piece starts to settle into a shape it begins to have its own color.

HD: So the shape will suggest a color?

MP: Almost always. That's the only way that I can consistently make peace with the notion of putting color on an object or a shaped thing. It changes the nature of the object so much once you put on just one thin film of color—it becomes a totally different thing. The form has to be made to carry the color from the outset. . . .

HD: I'm intrigued by the piece you built at the and/or Gallery in Seattle in 1981, *Where the Heart Is,* which was essentially a yurt containing a variety of elements: a chair, a stove, a kettle and a lamp. Do you think it is more literal in its allusions than most of your pieces?

MP: That piece was certainly a literal representation of something that already existed in the world. Though it's not of my own invention, the yurt was nonetheless heavily charged with poetry. It reflects a very subjective attitude toward something that already existed, and in that sense it was perhaps too private. My sister, who lives in Seattle, saw the work and thought it was a real self-portrait; but at least one critic there, who had seen earlier work I'd done, was really confounded by the piece because it seemed so literal. I suddenly realized how strong knowledge of your past work conditions the reaction to your subsequent work, especially if you're not interested in verbally defining the work yourself, at every turn. This came as something of a shock to me since I'd always taken pains to keep my options open, and to avoid type-casting myself. The Seattle critic felt it was peculiar for me to suddenly present something that he perceived as a bald anthropological display. As I told him later it was all about metaphor. It was a presentation of a number of things which subliminally, or indirectly, infuse my work. There is real nostalgia in the way our culture looks at the apparent simplicity and harmony of life in distant places. That's really what *Where the Heart Is* touches on. For me the yurt is a powerful symbol of mobility, and so beautiful, the structure of it is just visually beautiful. It was quite a personal work. The yurt was furnished with an African-type

chair, a carved wooden bird-of-prey effigy perched inside, and another outside on a ledge on the Gallery wall. The installation also consisted of some quotations from a Russian ornithologist who had written a book on a particular bird-of-prey that's fascinated me for a long time. The bird is called the gyrfalcon, and has a rather romantic history. It is the largest of all falcons, and appears only in Arctic regions of the globe: Lapland, Siberia, Alaska, Iceland and Northern Canada. The gyrfalcon is found in different color phases, from pure white in Greenland to nearly solid black in Labrador. There are various theories advanced about the color phases, regarding whether the plumage differences represent subspecies or racial differences and why they're distributed as they are geographically. This interested me as another kind of metaphor. The quotes from the Russian treatise dealt with this issue in a typically detached scientific fashion, of course. . . .

Art versus Craft

HD: How does the African craft tradition compare to the crafts in America?

MP: In more traditional, more slowly evolving societies, there is always a down playing of the craftsmen's ego. You spend time learning, in an almost menial way, initially, from an acknowledged authority, and you only earn the right to be an artist, with anything personal to invest in the work, through mastery. In our culture the ego is paramount from the beginning. As young children, we're told to pick up clay or paint and "express ourselves." In Western society we're conscious of our place in a much more expanded cultural cosmos. The making process itself can be crucial or it can be quite incidental, like an afterthought, really. For my part the physical act of making a work of art is essential. . . .

I think art can exist within any craft tradition. Craft is just another way of saying means. I think it's a question of conscious intention, finally, and personal gifts, or giftedness. It seems that in art there is a primacy of idea over both means or craft, and function. Idea has to transcend both. I think this is probably why it's so difficult for us to make art out of something functional, or in a realm where craft has been nurtured for its own sake. I would never insist that the *Pavilion-in-the-Trees* in Cliveden Park be called sculpture. It's a small enclosure set on tall poles that will be built in a wooded park in the Germantown area of Philadelphia. It has a domed grid roof of redwood and is reached by a sloping ramp from the ground. Given that categories are blurred these days I would still say that it's a public amenity, designed by a sculptor, which tries to invest a public facility with a bit more poetry than it otherwise might have. . . .

Outdoor Sculpture

MP: I get a lot out of knowing what my work means in the world. One of the problems associated with public sculpture is context, deciding what the function of sculpture is in society today. It's one of the most difficult things to settle. I feel more and more that gardens offer me a clue, a self-justifying kind of context, because gardens are by nature gratuitous places.

Being an Artist

HELAINE POSNER: What were your expectations of a life as an artist?

MP: I didn't approach the prospect of being an artist with the notion that anything was guaranteed, or that I had a right to anything, least of all success. It's the kind of life you go

into with a lot of hope, but you really take your chances. The reward has been the chance I've had to live a life that involves doing what I love more than anything else, and having that be at the center of my life rather than on the periphery.

NANCY GRAVES Conversation with Emily Wasserman (1970)

NANCY GRAVES: When I started working with the camel as a form, I saw that it had implications that would allow me to work *out* of it, however my work was directed. . . .

EMILY WASSERMAN: Could the starting point have been an elephant as well?

NG: No.

EW: Why?

NG: An elephant is not that possible, it's too massive: there's enough that's bizarre about the camel to allow for it as a sculpture problem. And then it leads into history also.

EW: What kind of history?

NG: The camel is a pre-historic form from North America. You have to start somewhere, so therefore, from an exterior form, the alternative was its opposite—the interior—and that's a much greater abstraction.

EW: It's as if you were exploring a whole archaic culture and its remains . . .

NG: . . . which went back fifty million years.

In order to make these pieces, I have to have some kind of specific relationship to them. I did go to Los Angeles to check out the Pleistocene forms from the tar pits adjacent to the L.A. County Museum. I try to be very specific about the visual history. I try to make a departure from that, within the area of abstraction.

One of the reasons I made the taxidermy form was that it was meaningful in terms of problems raised by earlier work: "Is it real, or could a taxidermist have done it, and therefore, why bother?" Here, I considered the *inside* of the taxidermy piece, which is the mold-for-the-process of-making-the-mold. I attempted to translate this form in as many ways as possible, into a sculpture situation. The base, which is no longer a problem, is attached to a pole at a fulcrum point. Each part is interdependent: that is, detachable, and moves interdependently. What is defined is the *rod as armature,* the function of a base, and the process of what it is to make a cast in terms of that specific form. This is then equated to the whole: "inside/outside," with the rod as support. The rod exists *in* the bones, and the rod lies *outside* the bones also; when it is in the bones, it is sculpture, when it is outside, it functions as armature. Outside, there is a relation to osteology. The process of dangling and/or bobbing here, is the beginning of that interest in "levity," which then allowed for the hanging pieces later. In *Vertebral Column with Skull and Pelvis* I also deal with the problem of casting as an allusion to another medium, and make something which, in its own right, is sculpture.

EW: The work seems to derive from itself somehow; did anything else lead you to those particular historical or formal concerns?

NG: The Museum of Natural History in Florence, Italy (where I lived and worked during 1966) contains the wax-works of an 18th-century anatomist, named Susini. What I saw there was a man whose total obsession was circumscribed within a very academic situation.

* Emily Wasserman, excerpts from "A Conversation with Nancy Graves," *Artforum* 9, no. 2 (October 1970): 42–47. By permission of the artist and the publisher.

That is, he was trying to define human anatomy in terms of drawings, and their reproduction in wax. The results *were* art, even in terms of that socio-historical period, although they were not recognized as such—they were not just copied cadavers. Visually, it's the most emphatic thing—the attempt to be rigorous about whatever the problem was, was much more thorough and complete than most artists usually are. I could relate the various anatomical forms to the work of Claes Oldenburg. The significance of this for me was that Susini had produced a complex body of work from a single point of origin.

EW: Did you have any inkling that those "soft form" camels which looked back to Susini's work (or sideways at Oldenburg's) would lead you to the abstract hanging pieces?

NG: Having done a lot of "art-making," I know what to avoid. This, to me, is not like what I see when I walk up and down Madison Avenue, and yet it couldn't have been made if I were not aware of all that. I have to keep an awareness of this in my own terms. Many artists work out of each other and gratefully acknowledge it. Once one acknowledges one's references, one tries to deny them, in another sense. It seems to me the only way to do that is to find another structure, another way of thinking, which doesn't allow for Western rationality. I really believe that that is the problem right now. One who keeps to that [Western] form is going to be trapped by it. So I would like to try to find another way.

EW: What about these floor pieces—how do they relate to that alternative way of thinking or working?

NG: Most floor pieces which I have made have to do with similar forms, in some way varied. The form itself is very simplistic, so that one can immediately find some access to the *gestalt*. In the first floor pieces I was concerned with the concept of "mirage"—which led me to the idea of reflections. How the mind receives visual material and observes it: this can never be read as a whole—but as an idea, a presence, and here, an extension in a certain direction relative to the floor. . . .

I'm interested now in the problem of "levity"; that is, a lot of these pieces move independently. They have a fulcrum, and yet it appears that they should weigh a great deal. Each part is free-moving. Even in the taxidermy piece, every point moves relative to a fulcrum.

EW: When I was last here at the studio, you were talking about those pieces *[Hanging Vertical Wire Piece* and *Skin Bisected; Shadow Reflection],* and you also mentioned mnemonic imagery. . . .

NG: There is an aluminum wire piece *[Hanging Mnemonic Wire Piece]* which I haven't completed, and don't know whether I can be successful about it. It is *an idea that is only known to one person,* therefore, to me it is a reflection piece. Every time there is a loop in the wire, that's a point of departure, but only for the "knower of the form." But the difficulty is that the problem must be visual, and it may not have achieved that clearly.

EW: Well, that is a quality of all symbols—mandalas, Tantric yantra diagrams, etc.—that they can only be understood if you happen to comprehend what that particular body of knowledge or religion is about.

NG: Yes, and that interests me also. *The Obviation of Similar Forms* is, again, an "inside/ outside" piece. And it's a positive/negative situation as well. The "pluses" support the "minuses." If a form is repeated in a static and close enough confined situation, it becomes impossible to see it. The result is the *gestalt;* having departed from there, I came back to it.

EW: Despite the *gestalt,* when you look at the piece, you do see all the different parts. . . .

NG: But the fact remains that the separate forms are varied, yet all are of a like species— leg bones. *Calipers* in a visual context should be related to the *Fossils Incorrectly Located*—if

you're talking about the bones—this is the "bones of the bones"! Because the ideas are more complex than the visual explication, it's unsatisfactory, however. Each caliper is the measurement of the spaces within the *Pleistocene Skeleton*. They measure both the negative and positive spaces, and when placed on the floor, each rod rusts to form its own shadow. When the corrosion *separates,* it is then a kind of residual cast, or a shadow.

EW: You mean that once the rods are on the floor, they measure only each other?

NG: Yes. When you remove a caliper from its source, what remains is the measurement; the rod becomes the "positive," while the spaces between them are "negative."

EW: Why is the measurement considered "negative"?

NG: It's another way of perceiving the physical fact of that situation. You're right back with the "bones of the bones" again!

Cast Shadow Reflecting Itself from Four Sides followed *Obviation of Similar Forms.* Each of these units is visually and spatially interdependent. The piece extends from floor to ceiling, and is another "inside/outside" situation.

EW: In that other shadow/reflection piece *[Shadow-Reflections with Sun-Disks]* the units are bone-like, but also feathery. They remind me of the war standards decorated with feathers on a long pole, carried along with battle shields and weapons by some American Indian tribes.

NG: Yes, that's in there; but I didn't consciously make that translation. The piece is made of 2 steel rings, each with eighteen hanging units formed with gauze and a wax adhesion. I did want to make something which was that *light,* each unit being interdependent. I was also interested in the circle—sun-disk—as it related to the American Indian.

EW: What is that group of animal skin strips hanging from the ceiling?

NG: That's a *Totem with Shadows.* The idea of a totem incorporates its own "shadow"— the man and his totem are one and the same (in name, in life context, in spirit). Additionally, there are shadows of the forms themselves, the animal skins and parts, in complementary colors (orange skins/blue shadows).

EW: It's certainly like a fetish, or other such talisman. . . .

NG: That's as far as it can go, it seems, in terms of the literalness. This is an additional way of dissecting the same forms.

EW: Traditionally, small fetishes were worn around the neck, or carried in a pouch, but here, suddenly it's giant, so it is scary.

NG: There's another similar piece where a spike penetrates a camel's head, which has a beatific expression on its face—it is impaled eight feet above the floor. It's very primitive, but it's also very pastoral.

RICHARD SERRA Rigging (1980)

When I started, we were hand-manipulating pieces. These pieces were not joined in any permanent manner. The only possible means to erect them was with the help of other people who were choreographed in relation to the material. We had to stand in certain relation to each other and in definite relationship to the construction, and lean the construction in. We did 6 or 7 pieces this way. It was the second lead series, conceived as weight, as counterbalance—

* Richard Serra, "Rigging," in Richard Serra and Clara Weyergraf, *Richard Serra: Interviews, Etc. 1970–1980* (New York: Hudson River Museum, 1980), 119–31; an earlier version was published in *Cover* (January 1980). The text is based on an interview between Gerard Hovagymyan and Richard Serra. By permission of the artist.

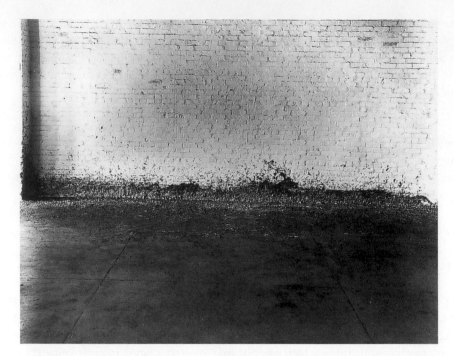

Richard Serra, *Splashing,* 1968, molten lead, at Castelli Warehouse, New York. Courtesy of the artist and Leo Castelli Gallery, New York. Photo by Peter Moore; © Estate of Peter Moore/VAGA, NYC.

the weight overhead compressed downward and held up what was underneath. We had to walk in with a bar and set it with linchpin accuracy. These pieces were shown at the Castelli Warehouse in 1969. There were several people involved . . . Phil Glass, Chuck Close, Spalding Gray, Dickie Landry and others. Together, we would map out what to do. Two people would be on each plate. There were four or five plates. And then Phil and I would fit in the overhead roll. The pieces were titled *1–1-1, 2–1-1, 2–1-2.*

In a sense, it was not what you call "rigging" in terms of using tools other than your hands, but I have always thought of rigging as a hand-extension. All technology is a hand extension— electricity is a central nervous system extension. I think that there is no model for rigging, no book from which you can learn. There is no prescribed way to go about doing it. There are three or four principles you can learn . . . they go between a nutcracker, a wheelbarrow and a pulley. Other than that, it is knowing where the fulcrum is. You must rely on your experience in handling materials, knowing weight loads and leverage principles, having a competent engineer. Usually in a rigging crew, there is someone who oversees the job, who can tell other people what and how to do whatever and wherever. That is the person I work with beforehand. The first piece I rigged with a "professional" crew was one of a series of steel pieces in 1970, titled *Strike.* It was a single steel plate into a corner. It was not a very difficult job to do. The strategies to get something into place are a matter of assessing the floor loads, figuring out dollying and openings. In this instance, an eight feet by twenty-four feet steel plate one inch thick was placed so that it bisected a 90° corner and was set to free stand, the wall and the floor solebearing the load.

In 1969, I made a statement about using no artificial building devices and using only nec-

to roll	to curve	to scatter	to modulate
to crease	to lift	to arrange	to distill
to fold	to inlay	to repair	of waves
to store	to impress	to discard	of electromagnetic
to bend	to fire	to pair	of inertia
to shorten	to flood	to distribute	of ionization
to twist	to smear	to surfeit	of polarization
to dapple	to rotate	to complement	of refraction
to crumple	to swirl	to enclose	of simultaneity
to shave	to support	to surround	of tides
to tear	to hook	to encircle	of reflection
to chip	to suspend	to hide	of equilibrium
to split	to spread	to cover	of symmetry
to cut	to hang	to wrap	of fluction
to sever	to collect	to dig	to stretch
to drop	of tension	to tie	to bounce
to remove	of gravity	to bind	to erase
to simplify	of entropy	to weave	to spray
to differ	of nature	to join	to systematize
to disarrange	of grouping	to match	to refer
to open	of layering	to laminate	to force
to mix	of felting	to bond	of mapping
to splash	of grasp	to hinge	of location
to knot	to tighten	to mark	of context
to spill	to bundle	to expand	of time
to droop	to heap	to dilute	of carbonization
to flow	to gather	to light	to continue

Richard Serra, *Verb List,* 1967–68. Courtesy of the artist.

essary and relevant tools. At that time, the pieces were predicated on how they were constructed. I have always been interested in the logic of how one structures. But when you are building a 100-ton piece, you have to meet codes. One of the codes that pieces like *Terminal* are testing is a tendency to overturn.

At a certain point, I was building pieces that were hand-manipulated. You could walk around and assess their axiomatic building principles. But you could not enter into them. You could not go through them. They did not involve any larger degree of ambulatory space or peripatetic vision. I have stopped doing these. I became interested in larger scale and larger masses. The discrete object dissolved into the sculptural field which is experienced in time. This occurred in 1970, after a trip to Japan, where I started doing circles flush to the ground. Then I built a thirteen-acre piece in King City in Toronto, after building a piece for the Pulitzers in St. Louis. All of the landscape pieces involved anticipation and reflection and walking and experiencing the time of the landscape. The pieces acted as barometers or viewing edges within the landscape. The landscape work reopened the more structural pieces and defined new omnidirectional axial radii so there were many ways of entering into, through, and around. At that point, the basic content changed from a discrete object in the round to walking in time, which has to do with anticipation and reflection. It is a different concept of organizing space.

The work has evolved to where I can't physically manipulate it, due to its mass. I need to employ technology. I have to deal with cranes and whatever processes will get the work into place . . . steel mills, ship yards, bridge companies, whatever. Nine-tenths of the work involves those extensions. There is nothing mysterious about it. All of it can be figured out with crews beforehand.

I was recently in Germany to place a 70-ton forged cube in Berlin. I didn't foresee any difficulties with it, but when you are swinging 70 tons in the air with a large boom on a thin deck, you must have a clear deference for the material. If someone miscalculates any given point of understanding, you can get into trouble.

The *Cube* (*Berlin Block for Charlie Chaplin*) is placed in the National Galerie of Berlin. The building was designed by Mies van der Rohe. It is the first important steel and glass structure, classical in every sense . . . a square glass box on the deck of a square stone platform, each supported by steel pylons or columns. I did not want to build a construction on top of this construction. I wanted to find a way of holding in place the gravitational load, a force, a mass, contrary to the center of the architecture, so that it would contradict the architecture. . . .

In not relying on an industrial module (buying a product from a warehouse, for example, which in a sense is very alienating, distancing from the material) I was able to work on a level of immediacy and direct the procedure of production. In effect, I was making and forming material from its molecular structure on up.

The *Cube* was installed in October. It was dropped into a slot, which is inclined into the deck two and three-quarter inches and its weight load is excessive of what the deck would hold. They had to build a cement column with reinforcing rods in the basement below it . . . more or less, a pillar in the museum. One extension of rigging is that we are reassembling the architecture to hold the piece.

I think that if a work is substantial, in terms of its context, then it does not embellish, decorate, or point to specific buildings, nor does it add on to a syntax that already exists. I think that sculpture, if it has any potential at all, has the potential to create its own place and space, and to work in contradiction to the spaces and places where it is created in this sense. I am interested in work where the artist is a maker of "anti-environment" which takes its own place or makes its own situation, or divides or declares its own area.

There seems to be in this country right now, especially in sculpture, a tendency to make work which attends to architecture. I am not interested in work which is structurally am-biguous, or in sculpture which satisfies urban design principles. I have always found that to be not only an aspect of mannerism but a need to reinforce a status quo of existing aesthetics. Most of the architecture that has been built is horrendous. I am interested in sculpture which is non-utilitarian, non-functional . . . any use is a misuse. I am not interested in sculpture that conventionalizes metaphors of content or assimilates architectonic spiritual structures, for there is no socially shared metaphysic.

When sculpture is placed in front of a corporate building, it runs the risk of being co-opted by the building, it is hard to avoid the morality of the context. I would rather stay within my own backyard of thinking. But every artist is always asked to betray himself, constantly.

I built a piece in 1977 for Documenta titled *Terminal* which was comprised of four trapezoids twelve feet by forty feet by two and three-quarter inches tilted in their axial radius. The work enclosed a forty foot shaft; there was one opening which you could enter into and look up at the sky through a nine foot by nine foot shaft. This work has subsequently been placed in front of a train depot (Bochum, Germany) in the confines of the intersection of the traffic. In effect, the streetcars pass within one and a half feet of it. The work is implicit and clear, awkward; it is articulated inside and out; it is continuous and defined; it is round and square, planar and volumetric. Various levels of meanings and tensions are explicit, in context. In effect, it is the largest structure (in terms of mass and weight) within a 2-mile radius. It reduces most of the architecture to its cardboard-model inventiveness.

The work has met with much disapproval. The resistance has been voiced by the Christian Democratic Union (CDU), the conservative right-wing party. The situation has become so

outrageous that they have plastered 100,000 posters in the Ruhr Valley denouncing the work. The same kind of repression was evident in the 30's and it is beginning again in Germany. It starts with the intellectuals, then the artists, then the homosexuals and lesbians, then the longhairs, and whomever they find suspect.

Art is being used as a political alibi. No one talks about how many starfighters they bury into the ground every year; no one talks about the fact that Germany has the largest and best surveillance electronics system in the world. Nor do they talk about the misuse of their tax-payers' money in terms of urban design. But everyone gets off on the sculpture. I found the fact that they are using the sculpture as a scapegoat incredible.

In Germany right now, my sculpture is being used by the neo-fascists to suppress art. In St. Louis, my piece was dismissed by the architect because it did not satisfy the needs of their urban design. In Washington, D.C., the work was defeated because it did not attend to the notion of elaborating on the democratic ideologies that this country thinks are necessary in terms of the decorative function of art, or the political function of art. I did not "serve the needs of the country." They wanted me to put flag poles on top of pylons. My retort to that was I couldn't imagine putting a swastika, a flag or a symbol on top of a Brancusi or a Rodin.

BRUCE NAUMAN Notes and Projects (1970)

It has been shown that at least part of the information received by the optical nerves is routed through and affected by the memory before it reaches the part of the brain that deals with visual impulses (input). Now René Dubos discusses the distortion of stimuli: we tend to symbolize stimuli and then react to the symbol rather than directly to the stimuli. Assume this to be true of other senses as well. . . .

French Piece (August, 1968)

1. Piece of steel plate or bar four inches by four inches by seven feet, to be gold plated, and stamped or engraved with the word "guilt" in a simple type face about one or two centimeters high. The weight will be about three hundred eighty pounds.

2. If the bar cannot be plated, the plain steel bar should be stamped or engraved "guilt bar," the letters running parallel to and close to a long edge.

3. Both pieces may be made.

> lighted steel channel twice
> leen lech Dante'l delight light leen snatches
> light leen lech Dante'l delight leen snatches
> leen leche'l delight Dantes light leen snatch
> light leen snatch'l delight Dantes leen leech
> light leen leech'l delight Dantes leen snatch
> snatch leen leen leeche'l delight light Dante

When I want to make a painting of something covered with dust or in fog should I paint the whole surface first with dust or fog and then pick out those parts of objects which can be seen or first paint in all the objects and then paint over them the dust or fog?

* Bruce Nauman, "Notes and Projects," *Artforum* 9, no. 4 (December 1970): 44. By permission of the author and the publisher.

Hire a dancer or dancers or other performers of some presence to perform the following exercises for one hour a day for about ten days or two weeks. The minimum will require one dancer to work on one exercise for ten to fourteen days. If more money is available two dancers may perform, one dancer performing each exercise at the same time and for the same period as the other. The whole may be repeated on ten or fourteen day intervals as often as desired.

(A) BODY AS A CYLINDER

Lie along the wall/floor junction of the room, face into the corner and hands at sides. Concentrate on straightening and lengthening the body along a line which passes through the center of the body parallel to the corner of the room in which you lie. At the same time attempt to draw the body in around the line. Then attempt to push that line into the corner of the room.

(B) BODY AS A SPHERE

Curl your body into the corner of a room. Imagine a point at the center of your curled body and concentrate on pulling your body in around that point. Then attempt to press that point down into the corner of the room. It should be clear that these are not intended as static positions which are to be held for an hour a day, but mental and physical activities or processes to be carried out. At the start, the performer may need to repeat the exercise several times in order to fill the hour, but at the end of ten days or so, he should be able to extend the execution to a full hour. The number of days required for an uninterrupted hour performance of course depends on the receptivity and training of the performer.

GOEDEL'S PROOF

1931: "On Formally Undecidable Propositions of Principia Mathematica and Related Systems." 1) If a system is consistent then it is incomplete. 2) (Goedel's incompleteness theorem) implies impossibility of construction of calculating machine equivalent to a human brain.

FILM SET A: SPINNING SPHERE

A steel ball placed on a glass plate in a white cube of space. The ball is set to spinning and filmed so that the image reflected on the surface of the ball has one wall of the cube centered. The ball is center frame and fills most of the frame. The camera is hidden as much as possible so that its reflection will be negligible. Four prints are necessary. The prints are projected onto the walls of a room (front or rear projection; should cover the walls edge to edge). The image reflected in the spinning sphere should not be that of the real room but of a more idealized room, of course empty, and not reflecting the image projected on the other room walls. There will be no scale references in the films.

FILM SET B: ROTATING GLASS WALLS

Film a piece of glass as follows: glass plate is pivoted on a horizontal center line and rotated slowly. Film is framed with the center line exactly at the top of the frame so that as the glass

rotates one edge will go off the top of the frame as the other edge comes on the top edge of the frame. The sides of the glass will not be in the frame of the film. Want two prints of the glass rotating bottom coming toward the camera and two prints of bottom of plate going away from camera. The plate and pivot are set up in a white cube as in Set A, camera hidden as well as possible to destroy any scale indications in the projected films. Projection: image is projected from edge to edge of all four walls of a room. If the image on one wall shows the bottom of the plate moving toward the camera, the opposite wall will show the image moving away from the camera.

Dance Piece

You must hire a dancer to perform the following exercise each day of the exhibition for 20 minutes or 40 minutes at about the same time each day. The dancer, dressed in simple street or exercise clothes, will enter a large room of the gallery. The guards will clear the room, only allowing people to observe through the doors. Dancer, eyes front, avoiding audience contact, hands clasped behind his neck, elbows forward, walks about the room in a slight crouch, as though the ceiling were 6 inches or a foot lower than his normal height, placing one foot in front of the other, heel touching toe, very slowly and deliberately.

It is necessary to have a dancer or person of some professional anonymous presence.

At the end of the time period, the dancer leaves and the guards again allow people into the room.

If it is not possible to finance a dancer for the whole of the exhibition period a week will be satisfactory, but no less.

My five pages of the book will be publicity photographs of the dancer hired to do my piece, with his name affixed.

Manipulation of information that has to do with how we perceive rather than what.

Manipulation of functional (functioning) mechanism of an (organism) (system) person.

Lack of information input (sensory deprivation) = breakdown of responsive systems. Do you hallucinate under these circumstances? If so, is it an attempt to complete a drive (or instinct) (or mechanism)?

Pieces of information which are in "skew" rather than clearly contradictory, i.e., kinds of information which come from and go to unrelated response mechanism. Skew lines can be very close or far apart. (Skew lines never meet and are never parallel). How close seems of more interest than how far apart. How far apart = Surrealism?

WITHDRAWAL AS AN ART FORM

activities
phenomena
Sensory Manipulation
 amplification
 deprivation
Sensory Overload (Fatigue)
Denial or confusion of a Gestalt invocation of physiological defense mechanism (voluntary or involuntary). Examination of physical and psychological response to simple or even over-

simplified situations which can yield clearly experienceable phenomena (phenomena and experience are the same or undifferentiable).

Recording Phenomena

Presentation of recordings of phenomena as opposed to stimulation of phenomena.

Manipulation or observation of self in extreme or controlled situations.

- Observation of manipulations.
- Manipulation of observations.
- Information gathering.
- Information dispersal (or display).

ROBERT RYMAN Statement (1971)

In the Fall of 1968 I did my first show at Konrad Fischer's Gallery in Düsseldorf. The exhibition consisted of six paintings on paper panels, nine panels to a painting. The panels were crated and shipped to Düsseldorf. In the process of getting them through customs (in order to avoid the duty that is to be paid on "Art" arriving in the country), Konrad had listed them as "paper" and not as paintings. But the customs official said, "But? It is expensive paper (handmade) so you will have to pay so much!" "Yes, it is expensive paper" Konrad said, "but it has been used." The customs official agreed that it had indeed been used. So the paintings arrived designated as "Used Paper." Since that time I have wondered about the possibility of paintings being defined as "Used Paint." Then there could be "Used Bronze," "Used Canvas," "Used Steel," "Used Lead." . . .

Statements (1983)

Pop art opened up artists' eyes to the fact that other things could be done with painting. Pop was certainly the dominant avant-garde movement in painting in the early '60s. All other approaches to painting were not considered. In fact painting was pronounced dead several times. A lot of the lesser-known Abstract-Expressionist painters, and there were a lot, did not know what to do. It was a shock thing. Many painters I know stopped painting and turned to sculpture because they felt they could not continue with the approach that they had been involved with. They felt sculpture offered more of a way to further the problems that they had been involved with. I felt very much alone in those years. . . .

Almost from the beginning I have approached painting intuitively. The use of white in my paintings came about when I realized that it doesn't interfere. It is a neutral color that allows for clarification of nuances in painting. It makes other aspects of painting visible that would not be so clear with the use of other colors. As to the square format, it always seemed to me to be a more suitable space to work on than the rectangle. I always had problems with rectangles. Altogether I only did four or five paintings at the most on rectangles.

I would say that Rothko had an important influence on me. There was also Matisse, particularly, and Cézanne. What interested me in Matisse was not so much what he was painting but how he was doing it. It was his sureness, the way he put the paint down. You could tell

* Robert Ryman, untitled statement, *Art Now* 3, no. 3 (1971): n.p. By permission of the author.

** Robert Ryman, untitled statements, in "The 60's in Abstract: 13 Statements and an Essay," *Art in America* 71, no. 9 (October 1983): 123–24. By permission of the author and the publisher.

that he didn't fool around with it, it just went down. He was so sure, it was so immediate. That's what I got from him. With Cézanne it was more the way he would work with the paint and you wouldn't know how he did it . . . the building up, the structure, the complicated composition. You would look at all that and you would say, "How did that happen?" . . .

Many artists today have a more commercial outlook. They feel they are entitled to make a living with their painting. I never felt that way at all in the '60s and I think that most of us didn't. It was never a matter of compromising your work to fit the taste. . . . I shied away from teaching for a long time because I was afraid it would take too much from my painting. I felt I would become too immersed in the education aspect so I would usually pick up jobs that left my mind free. Working in a library or a museum as a guard were the kind of jobs that seemed ideal.

I don't think it is any easier to be an abstract painter today than it was in the '60s. It was rough then, and it's rough now. Representational painting has always had a larger audience. . . .

I would say that the poetry of painting has to do with feeling. It should be a kind of revelation, even a reverent experience. You come away feeling delight. It's like seeing a movie or going to an opera. If you can tune in to the frequency of what you are experiencing, you come away feeling very good. You feel sustained, and it can last for several days or longer. It's a feeling of well-being. Poetry does it, music does it, painting does it. I think that's what art is, if it can convey that feeling.

RICHARD TUTTLE Work Is Justification for the Excuse (1972)

Just as we have no concern for other people, we have no concern for ourselves. We have a common concern for infinity which we can only think of as indefinite, real, and in absolute. To believe, as we do, that heaven exists for the chosen is a denial of everything and anything rational in the—small letter—universe. Therefore, I would say that our denial of any principle less than equal to denial of reality is in itself greater than equal to that denial. Absolute positivism suffers from Utopian ideals, but there is not and never has been a reality greater than the excruciation of its absolute realization. If this be the case, we are left with nothing other than this impulse to impede ourselves. In other words, to go on. That is justification enough and motivation enough to causally/casually inflict our will upon others for brief periods, which I gather is the express purpose of my invitation to participate in documenta.

I hardly understand anything, much less anything important, but my inclination must, or seems to, have some significance in the world in which I am living. There is seldom any excuse as good as the excuse to be, and the fact that anyone (anyone else) can be motivated in that same direction comes as somewhat of a surprise. That this surprise quality is not only valuable to me but is also an exercise in the "art of living" causes me to wonder whether the mind's viewpoint has anything to do with what is, after all, the exact viewpoint of its observation, or whether, in fact, that what we judge worth looking at is, in fact, even in our mind's eye (there). It is however an estimable fact that an artwork exists in its own reality and in *that* exists a certain cause and effect pattern which has baffled the ancients as well as myself. To make something which looks like itself is, therefore, the problem, the solution. To make something which is its own unraveling, its own justification, is something like the dream.

* Richard Tuttle, "Work Is Justification for the Excuse," in *Documenta 5* (Kassel: Documenta, 1972), 17.77. By permission of the author.

There is no paradox, for that is only a separation from reality. We have no mind, only its dream of being, a dream of substance, when there is none.

Work is justification for the excuse.

BARRY LE VA

" . . . a continuous flow of fairly aimless movement":
Interview with Liza Bear of *Avalanche* (1971)

AVALANCHE: *Velocity Piece #1,* which you presented at Ohio State University in Columbus in October 1969, is substantially different from the floor pieces in a number of materials—paper, canvas, felt, chalk, flour, and others—which had comprised the major body of your work since early 1966, or at least the part of it which is known. Do you see that piece as marking a significant departure from your previous concerns?

BARRY LE VA: Yes, in that it was a conscious effort to get away from the forms with which I had been working. I wanted to remove certain visual aspects of my work for a while, and to involve the audience in a more physical and time-consuming way. In terms of *Velocity,* what really interested me were the function of stereo, the acoustics of the space, and the location of the gallery relative to its immediate environment. I considered it to be experimental insofar as I was getting away from a visual format. The exhibition at Ohio State consisted of a taped stereo recording of me running hard into the gallery walls as long as I could; the sounds were of my footsteps and the impact of my body against the walls. While I was running two microphones were set up at either end of the rectangular space so that there wouldn't be any dead spots, then for the exhibition the speakers were placed in approximately the same positions. People would have an auditory experience of the footsteps going in a straight line from one end to the other, my body hitting the wall, bam, stop, and back again. What the sounds did was to articulate the changing location of the footsteps as they travelled across the floor, although they were in fact emanating from two speakers in fixed positions. I wanted people to visualize and experience the event from start to finish as they heard the tape.

A: So you were interested in setting up a situation in which one could locate something without having to see it. Was this your first piece using sound?

BLV: It was the first I had a chance to execute. I had done some research for others using tape recorders in my studio, but I didn't have the opportunity to present them in public until Frank Johnston invited me to do a one-man exhibition at Ohio State.

A: It was also the first piece that involved performance, wasn't it?

BLV: Yes, in a sense, but there are other things I should say before I go into that aspect of it. One of the most important points of the piece was the dialogue set up during the exhibition between the activity inside the gallery and the activity in the surrounding environment, basically the hallway which was parallel to the gallery. Students would constantly travel up and down that hallway on their way to classes. So in terms of direction, the gallery and hallway activities were parallel; in terms of intention, density, configuration, and duration of the movement, they were diametrically opposed. In the hallway, shifting groups of students were ambling along at different paces and forming different patterns. There was a continuous flow

* Excerpts from "Barry Le Va: '. . . a continuous flow of fairly aimless movement,'" an interview with Liza Bear, *Avalanche* 3 (Fall 1971): 64–75. By permission of the artist, the interviewer, and the publisher.

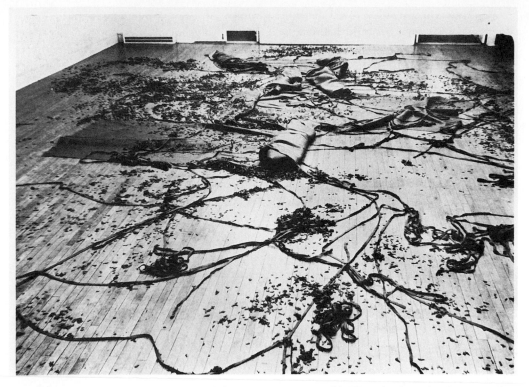

Barry Le Va, *Source (Sheets to Strips to Particles) No. 1,* 1967–68, gray felt. Photo by the artist. Courtesy of the artist and Sonnabend Gallery, New York.

of fairly aimless movement, the students were just in transit. The space was open-ended, there were no barriers. Inside the exhibition space, which was bounded on its other side by an exterior courtyard and separated from the hallway by a wall, the activity was very concentrated. The only sounds here were of me running at 30-second intervals and bashing into the walls. My activity had a specific purpose: to continue running until I had utterly exhausted myself. There *were* physical barriers—the walls; there was a finite duration—I ran for 1 hour and 43 minutes; and there was a single configuration—a straight line.

A: Then the whole piece was integrated very closely into the architectural and functional features of the locale and the human movement within it.

BLV: Definitely. There was also the fact that sounds from the gallery could be heard in the hallway, and vice versa—that was one form of interaction between the two spaces. And students had the option, when the door was open, of walking through the gallery and becoming part of the piece in a sense, in terms of traffic flow as a kind of substructure.

A: Could you say something about the subtitle of the piece, which is *Impact Run, Energy Drain?*

BLV: Okay. I think Impact Run is self-explanatory. The energy drain was one of the main purposes of the piece, and that of course increased with time until I was completely worn out and couldn't move at all. The distance between the far walls of the gallery was about fifty-five feet, enough to maintain quite a speed. I'd say the first few runs took about three seconds, then longer and longer up to about seven seconds. After a while I was in extreme physical pain, but I'd anticipated that because I'd made test runs in my studio beforehand.

A: How did that affect you? I mean the pain.

BLV: Well, what basically interested me was my psychological response to the sheer physical experiences of fatigue and pain. Of course it was a foregone conclusion that if I kept banging into the wall I would get tired and it would hurt. But what I couldn't tell in advance was how I would feel in between the runs. What in fact happened was that every time I hit the wall, I became more and more determined to continue and to keep up my initial velocity.

A: Did you hit the wall front on?

BLV: Yeah, with everything I could. Sometimes I would try to block, but every part of my body ended up being used. After a while my arms were bleeding. When I hit the wall, blood would fly onto the opposite wall. All these physical traces were left as part of the piece, skin from my elbows, sweat marks, blood. I wanted the record to be as complete and as clinical as possible.

A: How did your reactions change as time progressed?

BLV: After a while I fell into a kind of valley of fatigue, let's say, and I would be on another level. I could feel I wasn't running as fast as the first time. It was like taking one step forward and two back. By the last fifteen minutes or so, the rest periods were much worse than the running. My body had taken so much from the impacts that my arms and legs became incredibly cramped when I rested, to the point where I was physically like a cripple. The last five or six times I was running on one foot.

A: From what you've said so far, it sounds as though *Velocity* wasn't primarily concerned with performance—the performance element was a means of demonstrating certain concepts that interested you.

BLV: Yes, and that's why I did it privately, with no audience except the assistants. I had to do it at night to cut out extraneous noises. Since the only other visuals in the exhibition were the two speakers and a $2\frac{1}{2}$-foot taped path from wall to wall, I suppose you could call it a performance without the performer.

A: In terms of the limited visuals presented, did you see *Velocity* as going one stage beyond the felt pieces in eliminating what you call "eye intimacy"?

BLV: I thought my 1967–68 felt pieces succeeded in *reducing* eye intimacy. They utilized the full space and eventually spilled over into several rooms. In *Velocity,* the only function of the visuals was to preserve all the information as exactly as possible, so that together with the sounds they would act as traces from which the event could be reconstructed. The fact that *I* made the runs isn't significant either: I trusted myself to go to the limits.

A: Don't you think there is an element of self-destruction in the piece?

BLV: Well, it didn't seem brutal to me while I was doing it, although when I heard the recording afterwards I had mixed feelings about that. At certain stages I could remember running into the wall and how much that impact had really hurt. But really I was more conscious of the necessity to keep going than of the pain. What probably hurt most of all was the aching in my lungs and having to run before I'd got my breath back.

A: Did you have to stay in bed afterwards?

BLV: No, I just had to have a few beers. I've never been so exhausted except perhaps one year in Junior High when I was running laps. It became an athletic feat.

A: Is your own total bodily involvement an element that you want to continue in your work?

BLV: I can't answer that. All I can truthfully say is it depends on the specific issues I pursue. Anyway, the emphasis is very different. In 1968 I started to read Sherlock Holmes—

in fact, I've been reading him off and on ever since—and that eventually permeated my thinking. I became intrigued by the idea of visual clues, the way Sherlock Holmes managed to reconstruct a plot from obscure visual evidence. What I'm trying to do now is to set up situations in which audiences have to use their minds to piece elements back together.

A: That's very interesting. Do you see the direction of your work as having been influenced by any earlier sculpture?

BLV: When I was a student I became very affected by certain conceptual and perceptual aspects of Minimalism, independently of what was going on in school. I was impressed by the rigorous structure of Minimalist thinking, without necessarily wanting to emulate a minimalist gestalt. At this time, I was also becoming disgusted with the precious object, work primarily concerned with polished surfaces, color, plastic materials and small size—and the materialistic attitudes that supported it. And my student work developed partly as a strong reaction to that.

A: You actually started doing floor pieces with paper, canvas, puzzle parts, and wood in mid-1966. How did that come about?

BLV: At first I didn't consider myself to be making sculpture so much as just dealing with three-dimensional problems. For a while after I got bored with painting I was drawing strip cartoons—I'd already done a lot of comic strips in Junior High. The way I got into 3-D problems was when I decided to construct room-size, 3-D cartoons in simplified form, based on elements from the comic strips, out of masonite wood and painted canvas stuffed with newspaper. I remember one day, after I'd been constructing a piece for about three hours, I suddenly became aware of all the debris on the floor, bits of canvas and other stuff, and this residue seemed much more interesting and significant than what I was making. It had exactly what I was after. Not so much indications of a specific process, of what had been done to the material, as of marking off stages in time. And as a result I became involved in some problems of perception—how you perceive anything as ordered or disordered. Then the question became: when is a piece in a state of flux, or how do you describe what state a piece is in? For instance, folded felt could be about folding, but it could also be said to be about waiting to be used, or waiting to be kept, or waiting to be cut, or just waiting. When it's not folded, is it still about folding, or is it about something else that happened to it in the past, or is it in another phase still?

A: Then it's not so much that you expect someone looking at it to make a decision one way or the other as to raise these questions. Do you think that makes some of your work difficult to read?

BLV: Maybe some of the larger felt pieces and early flour pieces were hard to read because of the way I made them.

A: Why did you decide to use felt?

BLV: A girl I knew had suggested I use felt because it didn't unravel, it didn't have to be painted and it was cheap, so one day I went down to a yardage house in L.A. and bought some rolls of lightweight felt which I cut up into large quantities of sheets, strips and particles. From these units I made several pieces. The first few were colored, then I used black, black and grey, and in the end just grey.

A: You got rid of color.

BLV: Yes. If color comes into my work now it's completely incidental. I would construct the early pieces in layers, like a pizza, and put down quantities of different elements in various locations. I would have a specific program or recipe for a piece knowing that I could change

it around according to the requirements of the space. So the position of the elements could be altered after I had gone through the program. Sometimes I would have a room full of felt units which could be read as five pieces or as one, depending on how you organized what you saw. If I wasn't satisfied with the way it looked, I would kick the felt or shove it around. But gradually I became less and less concerned with the ordering of parts and more concerned with horizontal scale, vastness.

A: Can you explain why?

BLV: I wanted to rip out anything that in my eyes made traditional works of art, art, to get rid of any lingering object orientation by emphasizing horizontal scale. Formwise, to have no visible structure, no unification, no pattern—not to accentuate the form at all. In the later felt pieces and the first of the chalk pieces, I wanted to keep the piece in a suspended state of flux, with no trace of a beginning or end. They were not a statement about materials, or about a specific process. They were relative to time, place, and my physical activity. A lot of tension built up because of this unresolved state.

A: Did you see this work as having economic or political implications?

BLV: No, not at first. I was more concerned with the esthetic issues. Eventually they led me to question the commodity status of a work of art and I secretly enjoyed the fact that my pieces were impossible to own for any length of time.

A: So the flour and chalk pieces grew out of an increased concern with horizontal scale?

BLV: Yes, because powdered substances obviously provided a more efficient way of covering a large surface. But apart from the sculptural issues that had developed of their own accord, I had also found myself getting more involved in perceptual problems. The elements I was working with got smaller and became less structured and covered more of the floor. It was in this sense that they reduced eye intimacy—you had to walk around to see all the elements. In fact the last of the felt pieces had consisted of minute cut-up particles spread over an area of 50 to 70 feet, but felt still seemed to have too much physical presence. So I started using materials that were more ephemeral. Since chalk or flour was easily dispersed, I could work on a much larger scale, covering areas of 90 feet by 90 feet. I also liked their ambiguity— fine powders form a film of dust over a floor surface, fill up the cracks, so that the piece blends into the floor. My first pieces utilized mixtures of chalk or flour with other materials—paper toweling saturated in mineral oil, or mineral oil alone rolled across large areas of dust. Then I started doing experimental studio pieces with chalk or flour alone which involved residue drifts and removals.

A: Oh, what were they?

BLV: Well, I would stand by the wall and throw flour with two hands across the room. When it had hit the floor and dispersed, a fine layer of dust would usually cover the entire floor area. I would scrape away about half the dust in relation to some architectural feature of the space, say in a diagonal line from one corner to another, leaving half the surface bare.

A: Did you make use of that idea at the *Anti-Illusion: Procedures and Materials* show at the Whitney?

BLV: In a sense. What I liked about that piece was its fluctuating scale. Although the architectural boundaries of the room gave one an indication of its real size, when you looked at the piece scale tended to be lost, because it was pretty much an even surface. Basically all the pieces made with fine dust became barriers. They had a kind of ambivalence about them: on the one hand they seemed to invite you to walk across them, because they were spread over an area where you would normally walk, yet at the same time they denied you

that right because they were so fragile, they would disintegrate the moment you stepped on them.

A: You don't seem to make much use of the vertical dimension.

BLV: The vertical provides too much visual relief, and enables one to determine height—I'm not interested in that aspect of scale. Whereas I can use the horizontal plane to bring out the discrepancy between what one knows about a piece's scale in terms of extension, and how one perceives it. And it diminishes the material aspect. Anyway, this concern with scale and residue drift eventually led to a piece called *6 Blown Lines (Accumulation Drift),* which I did for a one-man show at Stout State University, Menominee, Wisconsin, in the fall of '69. The art gallery there was a rectangular room about 70 by 40. What I did was to lay down a line of flour about 2' high across the width of the room, about 8 feet to 10 feet from the far wall and parallel to it. Then I walked down the line holding an air compressor and blew parts of it away. I repeated the same process with five more lines, one at a time, laying it down and blowing it, until I reached the other end of the room. The final state of the piece consisted of a progressive accumulation of dust towards the far end of the space. I consider it an important piece.

SAM GILLIAM The Transformation of Nature through Nature (1986)

Graduates, Mr. President, teachers, proud parents, and other guests: Ever since I was asked by Bob to address this illustrious group, I have been filled with a certain sense of pride and anxiety. One, I have finally made it to Tennessee, and, secondly, there is nothing more responsible than speaking to a group of artists who are about to embark on their maiden voyage in a great occupation. I have sat in many audiences where one has bemoaned the artist. Thus, I have come to praise the role he plays as a transformer of nature. I have also come to challenge the process of that transformation to greater heights.

Robert Henri, in his book *The Art Spirit,* a collection of lessons and orations given to his students, encouraged them to "Keep your old work. You did it. There are virtues and there are faults in it. You can learn more from yourself than you can from anyone else." I have always used this quotation to my students and particularly to the group of students I have taught the past two years in a seminar course on survival. I like its meaning in that it proposes that the work that you have done is a treasure chest that should be savored. The work that you have done is much like a knapsack of your anticipated belongings. The work that you have done is also a crystal and when held up to the sun will radiate the aspirations of the whole of society whom it is your intention to serve.

Let's look at the artist in this way. They tell me that once upon a time in a very mythical land that was filled with small huts there existed a huge volcano. It had an amazing fire that came from within it. This was such a great fire that it kept the valley warm, lighted and always with pleasant weather. What was not known was that behind the volcano was a team of little people armed with bellows and logs fanning the fire and making it blaze higher. These little people formed a long lineage. I will name only a few: Rembrandt, Leonardo, Monet, Van Gogh, Eva Hesse, Cézanne, Pollock, Avery and many others. And now you have been called to join that team. For the illusions, the spaces, the forms that you create will keep your fellow persons warm, lighted and always in good weather.

* Sam Gilliam, excerpts from "The Transformation of Nature through Nature," commencement address, Memphis College of Art, May 1986. By permission of the author.

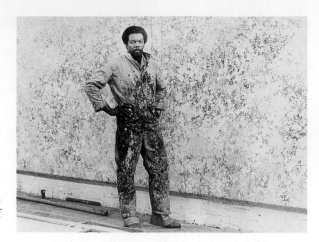

Sam Gilliam, c. 1978. Photo
© Paul Feinberg. Courtesy of
the artist and the photographer.

I am reminded of a statement that was made to my class when we graduated from the University of Louisville in the 1960s. We had been blessed by having a very great teacher who had taught at the Bavarian Academy in Germany. Unfortunately, he had been captured and placed in a concentration camp as an artist during WWII. He mentioned to us how he had run and hidden in order to keep his life. He also mentioned how in appreciation to whatever being that kept him alive, he drew every day while on the run. He said his reasons for drawing were to keep his memories of life alive. He pointed out that even when captured and placed in prison, he made art in his head to keep his sanity. And how upon repatriation, he afforded himself a trip around the world, mostly to check out if things were still the same and when he was assured that things were, he went back to making his art.

However, this time he resumed his art with things from Japan, India, Greece, etc., in a crazy quilt way. He also said that one of the things that entered his work was the figure of a Centaur and that this symbolized for him the mythical aspect of being the artist. Hence, among Greece, Italy, India there stands the mighty Centaur. The most special thing that I remember from this period of my life was that he suggested, "Keep on working. For in the work you not only see, but you also help others to see."

He said during this time he had one complaint. That in Munich where he had taught, he had taught many students who had great talent. However, when he visited them, many had gone on to become teachers of art. And, of course, they readily showed him the work of their students. And when he asked for their own work, they said they had stopped. This, young graduates, shocked the old man and hurt him. He said, "You, by stopping your art, have erased the Centaur from the work. You have allowed the fire to go out." An artist must stay an artist. For without the artist in him, he cannot see and others cannot see through him. . . .

It is said that at this time in 1986 there is a lull in art, that the thing that was sought in Post WWII years by many immigrants coming here has been lost. It is said that even the sense of this land as honored by the Hudson River School is lost from American art. What has come to replace this great inheritance is known as rampant commercialism and production. It is suggested that there is not a transcendence between the public and the art, that only a special group counts. It sounds like Sodom and Gomorrah reigns in this mythical land with the gigantic volcano.

Many of us have come to recognize the absence of the Centaur, the lowering of the light. But do we recognize, more specifically, the possibility of losing the nature of humanity in this way? Do we realize that there is a need for the artist to act as an artist? Where does this come from?

I guess the most immediate answer is contained in something I have already expressed earlier in this speech. That is of the professor who even though on the run, made drawings, who even though imprisoned, kept art alive in his head and who upon release went around the world to make sure that the world was still there, who created the mighty Centaur as a symbol of himself, as an artist to remind himself that the artist was still there.

Picasso in his series about the artist and the model keeps himself there. Rembrandt in his self-portrait keeps his presence in art. My teacher chided his students for not keeping themselves present as artists before their students. Now, I challenge you that the most important thing you must do is to keep the artist present in you, keep the artist present in your work, to use the artist in you to secure you on the nights when you have to run and hide, to keep the artist in your presence and mind in times when you are hostage to situations, difficulties, like bad grades, and keep the artist in you even though you cannot work as an artist. You are coming aboard the Grand Armada. You have first watch. The nature of nature is your quest. It is the only way that the valley can be warm. It is the only way that the valley can be lighted and it is the only way that the valley can have good weather.

I have not been around the world as my teacher had, but I have found a clever way to climb aboard the Grand Armada and to experience the world. It is something I figured out in 1962 when I first came to Washington. I realized that in any day I had four hours I could go to the National Gallery and walk the entire gallery which extends some two blocks and look at paintings, allowing trails of man's existence to criss-cross and interface in various beautiful rhythms. In four hours one can see all of the paintings in the National Gallery. I remember that one: "In order to see a painting, one must be a painting." Thus, having remembered this, I know that the nature of man as defined by art is in me. Secondly, in many hours alone in a studio I have often thought about such trips. . . .

Thus, I want to say to you, as the artist, you are nature. I must say that you as the artist must always make new work. You as the artist must keep the Centaur present. You as the artist must keep the fire blazing.

It is the hope of the world. More importantly, it is the hope of America; it is the hope of Tennessee. It is the hope of each individual that we are immediate to.

We are, as was Georgia O'Keeffe, or as are Louise Nevelson, Frank Stella, and many among you, avatars, all of whom, including you, have chosen to transform the sense of nature through yourselves for others.

Let me end as I have begun. "Keep your old work. You did it. There are virtues and there are faults in it for you to study. You can learn more from yourself than you can from anyone else."

Represent the Centaur. Stock the volcano. Good luck. God bless you all.

Hello and Good-bye to you all.

LYNDA BENGLIS Conversation with France Morin (1977)

LYNDA BENGLIS: I think art exists in a realm of idea, as well as of physical, visual reality objects. I don't say it can't exist in objects. I think there is a great deal of focus on people just making icons, I like to think of them as icons, fixed situations and space and I think there is just as much reason to focus on that as there is on anything else. I happen to think for myself

* France Morin, excerpts from "Lynda Benglis in Conversation with France Morin," *Parachute* 6 (Spring 1977): 7–11. By permission of the artist and the publisher.

and my interest, I like to do as much as I can in any area that interests me and I don't think I've really covered that much territory. I could get into performance. I don't seem to be interested in that aspect, that idea of performance I think maybe because I can make things tighter in performing on video and in other words, I can keep planning and editing and spearing down so performance as such interests me through a medium say like video. I have not thought about stage performance dancing, but when I was doing large polyurethane pieces, they were environmental. Presenting them, getting them together, the production of getting a large show together is very much to me as a performance is. Performing is essentially working in an isolated environment presenting something, a final product that exists in a limited time, so I think the prop piece exists in a way as a kind of performance. . . .

My feeling is that each artist does create an environment or feeling or an ambiance anyhow, and why not call the attention to that aspect as well as the aspect of the individual icon. Even those icons in an exhibition seem to have to adjust to an environment so it is a matter of arranging. I think those things are interchangeable essentially.

FRANCE MORIN: Transforming a place of exhibition into an environment involves a notion of theatricality. . . .

LB: Once I remember Pincus-Witten visited me in East Hampton and he said your work is theatrical. I said "What's wrong with that" (at that point he was talking about the polyurethane pieces). I said "theatricality is not particularly a bad adjective." I think that was thought over—that was meant to be a criticism—so much now is theatrical. I am involved with those icons since they are really involved with feelings or gestures that have to do with a physical presence that one can identify with, in other words. When one looks at them they take on an anthropomorphic gesture and most of my work has that kind of feeling of movement in physicality, in that it suggests the body or brings up bodily responses—whether we think of the wax pieces it could be oral because the wax is very sensuous and suggests taste or whether it's the knots which suggest limbs, the viscerals or the polyurethane pieces which suggest wave formations or again viscerals in some way. I think that all these are an effort on my part as a tridimensional artist to bring about feelings that are in some way known to the viewer, that are of nature, in other words . . . prehistoric in a way or things that people know about when they look at them, although the forms are not specifically recognizable, the feelings are. I'm interested in that. That in itself is a form of theater.

FM: Do you think it had anything to do with the fact that you are a woman? The way your work was looked at, or talked of. . . .

LB: I think because structurally they were not hard edged. . . . I really don't know. At that time, very few women were exhibited; there are a lot more now but then I was among the first ones. I had been picked up for an article in *Life* [February 1970]: two men, two women [Van Buren, Serra, Benglis and Hesse]. I was picked out because I was a woman, I was being looked at because I was doing interesting work but also connected to the fact I was a woman so I was one of . . .

FM: . . . the beginners . . .

LB: Yes beginning, in that sense. In that sense too I was lucky because it was among my first exhibited work and it was immediately recognized.

FM: It could be partly because of that but don't you think also because of the emergence around 1970 of a post minimalist stance—minimalism was really on its decline—and we started to talk, among other things, of sculpture in pictorial terms. . . .

LB: I think it was also having to do with the ideas that were being formed . . . but yes it

was because of that too. I think it was all reasons, one really didn't take precedence over the other. Perhaps, I got more attention, maybe faster, than somebody else, because I was a woman and because the work in terms of ideas was right for the time. . . .

FM: What about the very special attention you always gave your announcements for shows? One being a Hollywood style chromo of yourself for a show in 1974. Another one being a photograph of you as a child dressed for a party in Greek evzone costume.

LB: Then that was upon looking back recognizing the fact I was being given this attention for many reasons and if there is a movement now, I think the Feminist movement as such is one of the stronger recognizable ones—stronger that it is recognizable I would say and specifically recognizable. I felt I wanted to make statements in that particular category and I do think of art as being different kinds of statements about particular categories.

FM: What about the ad in *Artforum* in November 1974?

LB: I've been involved, in the very beginning say for about two or three years with notions of sexuality, also notions of the star system, isolating myself and mocking myself on the media whether it would be the video or photographs. I had taken, prior to that ad, a photograph of me in front of a car, I had my hair pushed back and a double-breasted suit on. I was looking very tough. It was not an unknown image being in front of a car. It was self-referential, I did have that car. I was very involved with that car in Los Angeles, a car is a very important symbol, say it's a kind of extension of the body. It was referential in that art world and Los Angeles had long been using kind of funny announcements in some ways more self-referential and punning the star system in Hollywood as well as their own situation there. It was very natural in that sense in terms of idea, but also it was warmer, it was easier to take off one's clothes at the beach so all these things just developed gradually out of a system I was experiencing there, as well as say being very aware of the feminist movement and wanting to make a sort of statement; I could make a pin-up out of myself: that would be fine. A lot of the feminists there who were really hard core feminists got very angry, they thought, well OK you have an OK body, so you can do that . . . that was the basic criticism, which is totally illogical. It was silly, because anybody can present themselves looking good, given the right make-up, given the right camera angles, it's all about illusion anyhow, art is about illusion essentially. That was a very bad criticism. I knew I had hit upon something with that particular ad and I call that the soft core ad.

The car essentially was the first thing. Prior to the car, however, I had done a photograph when I was eleven years old in a Greek soldier's outfit and I used it as an announcement; that again was referential to early experience, I had done the soft knots, the cloth sparkled knots, they were made out of the same kind of cloth as the Greek soldier's costuming. I used that photograph three times for three shows. Prior to that, I had done a video tape drawing a mustache on myself on a photograph and that was again a kind of reference to Duchamp and a self-reference. I had been using my face or myself in the video and this built up notions of female sensibility, it was another tape I did, I got tired of people asking me: "Is there such a thing as female sensibility" and I decided to really sock it to them, I said yes this is it. So mainly what I did was self-referential, self-mocking, mocking of sexuality to the extent that I said if all these things are out, then nobody will think about them anymore. If they can laugh at them, if they can feel less self-conscious about it, then it's all there; you know we have greater freedom if it's there and that's how I felt about all of those things. I must tell you about the ad in ARTFORUM that the timing was extremely important. It could have been at no other time, because the media were very sensitive at that time, it was the time of

Nixon's resignation. Everybody everywhere was very sensitive. I am glad I have witnessed that.

FM: The context may have been more difficult or different, but do you think there is such a thing as female art and male art?

LB: Yes. I do feel that there is. Because, as I said, it's one of the recognizable movements, woman artists have focused on femaleness as subject matter, so I think in that sense certainly it is recognizable, as to say something essentially abstract, looks more male or female, I think all that really depends on our culture, on our associations. How we are going to group it finally, we don't know enough about psychology to say of a body whether it is male or female in terms of physicality, or whether it is male or female in terms of psychology, maybe we will never know enough to say so. I think that's what art is about, describing those areas of feelings that have to do with bodily sensations, bodily feelings but it's also a total response, all art is about total responses. I get back to that sweetness and sourness; you can't measure essences nor can you measure femaleness or maleness; you can structurally identify it, but you can't measure it, so in that sense we will never know enough about it, we will only say someday that this was an era in terms of focus of femaleness so this was an era in terms of idea when the feminist movement was structurally in the society. It functioned in one way and the art world only mimics the society. I don't wish to separate myself from it, I don't wish necessarily to be a part of it, but I am a part of it whether I want it or not.

FM: How long did you do the soft knots before you did the metallized ones?

LB: I think about a year and a half but I had applied sparkling metal flakes to them, so it naturally moved me into thinking about a metallic finish and then in Portland, I met someone who had actually done metallizing on the surface of wood and said that there were metal guns that could actually spray the wood, so I decided to see if I could not find someone that had that kind of equipment and to try to metallize the cloth since he had mentioned you could even metallize a rose bud, I love the idea of something alive and organic being metallized. This was in '72 or '73. In Los Angeles I found someone who was metallizing. We rented the gun because they had never used one. Since then, I realized that these guns existed everywhere. They were used to reinforce machinery after it has been worn down. It was also used decoratively around 15 years ago.

FM: When you were doing your polyurethane and latex pieces people have talked about Pollock, when you did the soft knots people have talked about Oldenburg. How do you feel about that now?

LB: Well, I was very aware of the connections. There are always connections in art in order to explain one image and its relationship to the other so it did not bother me that much because Pollock was rooted in a different kind of tradition with subject matter and Oldenburg was also rooted in a different kind of tradition with subject matter. They were trying to do different things and their image came about in a certain way and my image came about in a certain way, it could be related in a certain way in terms of writing and criticism as such, people have to do that in order to have an understanding of the culture. . . .

FM: What do you feel about art and politics? You don't think art is political in its essence?

LB: I don't think art in its essence is political, it can be used for propaganda purposes, if it's geared that way, of course, but it can be political if it's directed that way. It is used for political purposes not only because one can make political statements (essence wise) but because it functions at that cultural economic level. It can function politically in two different ways: economically as well as subject matter wise.

FM: What about your collaboration with Robert Morris?

LB: We had done a video piece together, I think that was the beginning of the exchange. It was called *Exchange*. Perhaps we approached each other as individual artists with different interests, he has a tendency to try to get to know what each artist does. I think he is a great eclectic and he is very good. He had been involved with his theatre performances with some of the things I was interested in. You might say I saw him coming, he really interested me for his past work so it was with that in mind that I became involved with him in these exchanges so to speak, but we did a lot of talking about art and different things that were going on, fantasizing about things we could do, or would do. The ARTFORUM ad was in a way a kind of mocking of both sexes and I could have done it with a male. I started thinking about it and I did photograph myself in the nude with someone in Venice. Later Morris came with me to buy the dildo and we had different poses but he had been involved with playing with me, involved with taking photographs of himself in different poses in polaroid and I had him play with me with the dildo, so there was a question of maybe doing a large pin-up male and female in that way, mocking, then finally the dildo was a kind of double statement it was the ideal thing to use, it was both male and female so I didn't really need a male and it was a statement I really wanted to make finally by myself. I was encouraged to do it by Pincus-Witten and by Morris. They kind of gave me permission and I paid $3,000.00 for the space. I don't think you do anything in this world without say the permission.

FM: Do you feel like adding anything?

LB: I could say something about the metals, the ideas of the metals, that I was attracted to them because of notions of energy that the metals have and the quality like muskrat you are attracted by something that shines and also the fact of our resources, it was kind of a funny thing to be involved with, if I could have casted in gold or silver I would have and it just interested me to cast in things that were culturally important, in other words, they melted bronze as in times of war and till, somehow, these things are so useful to us, just as I was attracted to things that had no use say flimsy, decorative and then I began wanting to go from the sleazily decorative (the early sparkled knots) to something that appeared to be more frozen and solid in form and more permanent, but it's only a mock idea of permanence because bronze can be melted in times of war. So I am not really involved with notions of permanence only in form and content. I have been criticized for that notion of permanence or not, environments or not environments, artists are criticized for this. . . .

MIERLE LADERMAN UKELES Maintenance Art Manifesto (1969)

I. Ideas:

 A. The Death Instinct and the Life Instinct:

 The Death Instinct: separation, individuality, Avant-Garde par excellence; to follow one's own path to death—do your own thing, dynamic change.

 The Life Instinct: unification, the eternal return, the perpetuation and MAINTE-NANCE of the species, survival systems and operations, equilibrium.

* Mierle Laderman Ukeles, excerpt from "Maintenance Art Manifesto" (1969); published in Lucy R. Lippard, ed., *Six Years: The Dematerialization of the Art Object from 1966 to 1972* (1973; Berkeley: University of California Press, 1997), 220–21. © 1969 Mierle Laderman Ukeles, courtesy Ronald Feldman Fine Arts, New York.

(excerpts from a letter distributed to 300 maintenance workers)

Dear Friend Worker:

I want to invite you to join with me in creating a living Maintenance Art work. This art work will take place all throughout the 55 Water Street Building from September 16 to October 20, 1976. Your supervisors have already O.K.'d it. It is part of an exhibition during this time at the Whitney Museum on the 2nd floor of the building called "ART ⇄ WORLD".

I am a maintenance artist. My work is called Maintenance Art Works. I use my "artistic freedom" to call "maintenance" -- the work that you do, and the work that I do -- "art." Part of the time I do private maintenance at home taking care of my family; and part of the time I do public maintenance in museums and galleries to show people my ideas. Like this Maintenance Art work I'm writing you about now.

I want people to know about and to see the kinds of jobs you do. Because this whole huge building NEEDS your work. Your work keeps this building going. Without your work, the whole building would not work. Then all the people who do office work and bank work and business work etc. couldn't continue their jobs here. In a way, it is your daily support work that keeps this whole building up just as much as the steel and marble and glass.

Your part is very easy. It will not take one minute of extra time or effort. You will not have to do anything different from the way you always do. Really, it will take place inside your head -- in your imagination.

This is how it goes: It's like a game you play with me. I ask you to take my idea of art for yourself! Pick one hour each day, any working hour, during all the days from Sept. 16 to Oct. 20 (5 weeks) and think during that one hour that your same regular work is Art. You do not have to tell anyone about it while you do it, or you can if you want to -- that is your business. You continue to do your work as usual -- just imagine in your head that your regular work from, say for example, 9 to 10 is Art.

I am asking you to do that. Also, at the end of every day, when you punch your timecard OUT, I will leave a form paper for you to sign -- very simple -- you write your name and the hour when you chose to do maintenance art that day, what kind of job (for example, floor washing, window cleaning, elevator repair, dusting, security, etc.) and any comments you might want to share. I will pick these forms up every day and put them in the museum on the 2nd floor so visitors can look at them.

Two more things. 1) I have a button to give you to please wear everyday on your uniform, so people in the building and visitors to the museum will know you're doing this Maintenance Art work with me. 2) I will be in the building every day during these 5 weeks, going around and taking same photographs of all the different maintenance and security work. I will show these photographs in the museum so visitors can get an idea -- for their own imaginations -- of how much human labor is going on around them every day and night to keep this building going in the world: your work. I won't bother you; I won't disturb your work -- but you'll get used to seeing me around.

> Please help! Everybody is cooperating:
> 1. choose any one hour for imagining your regular work
> as Art .DAILY
> 2. wear your buttonDAILY
> 3. sign your formsDAILY
> 4. I'll take my picturesDAILY

Together, we'll make a true picture of 55 Water Street, New York City.

Thank you.

Mierle Laderman Ukeles

Mierle Laderman Ukeles

MAINTENANCE ART SAYING:

If you don't know who's keeping you up
You don't know what's flying.

Mierle Laderman Ukeles, *I Make Maintenance Art One Hour Every Day,* from a letter distributed to 300 maintenance workers, 1976. © Mierle Laderman Ukeles. Courtesy of the artist.

B. Two basic systems: Development and Maintenance. The sourball of every revolution: after the revolution, who's going to pick up the garbage on Monday morning?

Development: pure individual creation; the new change; progress, advance excitement, flight or fleeing.

Maintenance: keep the dust off the pure individual creation; preserve the new; sustain the change; protect progress; defend and prolong the advance; renew the excitement; repeat the flight.

> show your work—show it again
> keep the contemporaryartmuseum groovy
> keep the home fires burning

Development systems are partial feedback systems with major room for change.

Maintenance systems are direct feedback systems with little room for change.

C. Maintenance is a drag; it takes all the fucking time (lit.) The mind boggles and chafes at the boredom. The culture confers lousy status on maintenance jobs—minimum wages, housewives—no pay.

clean your desk, wash the dishes, clean the floor, wash your clothes, wash your toes, change the baby's diaper, finish the report, correct the typos, mend the fence, keep the customer happy, throw out the stinking garbage, watch out don't put things in your nose, what shall I wear, I have no sox, pay your bills, don't litter, save string, wash your hair, change the sheets, go to the store, I'm out of perfume, say it again—he doesn't understand, seal it again—it leaks, go to work, this art is dusty, clear the table, call him again, flush the toilet, stay young.

D. Art:

Everything I say is Art is Art. Everything I do is Art is Art. "We have no Art, we do everything well." (Balinese saying)

Avant-garde art, which claims utter development, is infected by strains of maintenance ideas, maintenance activities, and maintenance materials.

Conceptual & Process art especially claim pure development and change, yet employ almost purely maintenance modes and processes.

E. Exhibitions of Maintenance Art: zero in on pure maintenance, offer it as contemporary art, and yield CLARITY.

Sanitation Manifesto! (1984)

Sanitation is the working out of the human design to accept, confront, manage, control, even use DECAY in urban life.

Sanitation, face it, is the perfect model of the inherent restrictiveness imposed by living inside our corporeal bodies, via material "necessity," in urban civilization (and its discontents), in finite planetary "reality."

We are, all of us whether we desire it or not, *in relation to* Sanitation, implicated, dependent—if we want the City, and ourselves, to last more than a few days. I am—along with

* Mierle Laderman Ukeles, "Sanitation Manifesto!" (1984); published in *The Act* 2, no. 1 (Winter–Spring 1990): 84–85. © 1984 Mierle Laderman Ukeles, courtesy Ronald Feldman Fine Arts, New York.

every other citizen who lives, works, visits or passes through this space—a co-*producer* of Sanitation's work-product, as well as a *customer* of Sanitation's work. In addition, because this is a thoroughly *public* system, I—we—are all *co-owners*—we have a *right to a say* in all this. We are, each and all, bound to Sanitation, to restrictiveness.

Now, if that is true, how does that inextricable bond impinge on my commitment to Art in democracy as *the* primary system articulating the forms of (individual) *freedom?* What happens to the inherently "free" artist in a most mundane inherently restrictive public work system? Obversely, what happens to the notion of freedom and limitless value of a "public service" sanitation worker in this "free" society? How do these extremes relate? The contextual edges, boundaries and limits of each conflicting field-structure—free-art and social-necessity—shape, frame and ultimately define each other, in tension.

Sanitation is the principal symbol of Time's passage and the mutable value of materiality in organized urban life.

Sanitation, as an environmental energy system, is trapped in a miasma of essentially pre-democratic perceptions. The public generally doesn't "see" beyond the tip of its nose—or see where we put our waste, or see what we do or should do with it, or see what choices we have about managing our waste. Waste is our immediate unwanted past. Do we "conserve" its energy through transformation, or do we drown in it? We are facing an environmental crisis, because we are running out of space to put it "away." To begin to accept as "ours" the difficult social task of dealing with "our" waste at the highest, not the most mediocre, level of intelligence and creativity in reality, in all its effulgent scale here, people need to understand how they connect one to the other across our society, in all *its* scale. We need holistic interconnected perceptual models of how we connect and how we add up.

As a first step, we certainly need to peel away and separate ourselves from the ancient, transcultural alienating notion and aura of the caste-stigma of waste-worker, of "garbage-man," which has always translated, trickily, into "their" waste, not "ours"; they're "dirty," we're "clean."

Sanitation is the City's first *cultural* system, not its displaced-housekeeper caste-system. To do Sanitation is to husband the City as home. I think it can serve as a model for democratic imagination, as follows:

Sanitation serves *everyone;* it starts from that premise: it accepts that *everyone must be served in a democracy,* and the City must be maintained in working works *everywhere,* no matter what socioeconomic "culture." Sanitation works *all the time,* through all seasons, no matter what the weather conditions. *Sanitation is totally inter-dependent with its public: locked in—the server and the served.* Sanitation, in democracy, implies the possibility of a public-social-contract operating laterally, not upstairs-downstairs, but equally between the servers and the served. This is accomplished at totality of scale; yet it deals on an incremental basis (house to house, bag to bag), and it cuts across all differences. Out of these most humble circumstances, we can begin to erect a democratic symbol of commonality.

I believe we *do* share a common symbol system: we are all free citizens of this City. We all (should) have equal rights. We all share responsibility for keeping the City alive. We are inherently INTER-DEPENDENT: that is the essence of living IN a City. That is simply a basic commonality; it does not deny each citizen's individuality, nor diminish the inestimable value of each living being. Rather it sets each of us in a CONTEXT of inter-dependence. We're in this together. Just as by law, we can't ship our garbage OUT, but *have* to deal with it IN our common "home" manage it so it doesn't destroy us, *we too, all together, have to work our individual freedom out without destroying each other.*

Now, here is the intersection between Sanitation as the symbol of inter-dependent reality with free art:

WORKING FREEDOM—THAT'S AN ARTIST'S JOB.

BONNIE ORA SHERK *Crossroads Community (The Farm)* (1977)

It seems that some clues to our possible, positive survival as a species can be found by involving ourselves in the human creative process (art) and by re-examining our place as human creatures in relation to other life forms, and by understanding and communicating with those life systems and forms in a more sensitive and conscious way. Very generally, people of our civilization tend to be extremely presumptuous and naive about their relationship to the universe. Some symptoms of this adolescence are: racism and sexism; renovating much of the earth with concrete and basing our modern lives on confused computer categories and bureaucratic ballgames; insensitivities to native intelligences of plants, animals, and children; mass disregard and disrespect for the uniqueness of individuals; bias against feeling states; and the overwhelming greed, waste, and territorialism of huge numbers of people, corporations, and governments. If we are to continue on this planet and grow as conscious beings we must attain a more spiritual and ecological *balance* within ourselves and among larger groups and nations. How can we do this?

Each of us has the potential for discovery and may have solutions for these grave problems. If we can learn to trust and share, and relax and flow we will be able to receive the magic which surrounds us every moment and which we are.

In my own life I have strived to understand and act on these issues and qualities which to me are connected to the essence of being. I have experienced through art and the observation of natural processes the wholeness of life and the interconnectedness of different states of being/knowing/loving.

The creation of art is akin to the spirit and attitude of country in its logic of wholeness and process. Everything found in the country is implicit in the city. Urban environments today, however, due in part to technological excesses, fragment our spaces and lives so that we have difficulty experiencing whole systems. This fragmentation guides us towards the disintegration of our personalities and the loss of our identities.

As an artist, I have tried to expand the concept of art to include and even be life, and to make visible connections among different aesthetics, styles, and systems of knowledge. The most recent and devotional vehicle for this coming together is a multicultural, agricultural collaborative artwork called *Crossroads Community (The Farm),* or more simply, *The Farm.* This life-scale environmental, performance sculpture, which is also a non-profit public trust, and a collage of local, State, and Federal sources, exists on a multitude of levels including cartoon, metaphor, contradiction, and action.

Physically, *The Farm* is a series of simultaneous community gathering spaces: a farmhouse with earthy, funky, and elegant environments; a theatre and rehearsal space for different art forms; a school without walls; a library; a darkroom; unusual gardens; an indoor/outdoor environment for humans and other animals; and a future cafe, tearoom, and nutrition/heal-

* Bonnie Ora Sherk, "*Crossroads Community (The Farm),*" position paper for Center for Critical Inquiry, 1st International Symposium, San Francisco Art Institute, November 1977. © 1977 Bonnie Ora Sherk.

ing center. Within these places many people of different ages, backrounds, and colors come and go, participating in and creating a variety of programs which richly mix with the life processes of plants and animals. All of these life elements are integrated and relate holistically with fascinating interfaces. It is these interfaces which may indeed be the sources of emerging new art forms.

The Farm, as a life frame, is particularly unusual, however, because it juxtaposes, symbolically and actually, a technological monolith with an art/farm/life complex. Crossroads Community sits adjacent to a major freeway interchange on its southern side where four high-need neighborhoods and three creeks converge. On its northern boundaries, *The Farm* edges on a 5.5 acre open space of land which the City of San Francisco has just acquired for a neighborhood park. (*The Farm* was instrumental in calling attention to the availability of this land and convincing The City to buy it.)

Part of *The Farm*'s dream is to uncover the natural resources of the earth, like the water which flows underneath, and to recycle the concrete which currently covers the land to create rolling hillsides, meadows, gardens, windmills, ponds, play and performing spaces, etc. This lush, green environment would connect *The Farm* with the public elementary school that borders the future park on the north.

The potential for this project which involves the creative integrity of its surrounding neighbors and schoolchildren is astounding: as a model for other places; and as a possible series of solutions for the many urban errors specific to this site. Another aspect for the future is to blur the boundaries between land parcels and act on new possibilities for fluid interchange.

The most critical difficulty for *The Farm,* at present, is to make an unresponsive and frightened establishment receptive to A Gift that is a tribute to humanity and a celebration of magic.

ANN HAMILTON AND KATHRYN CLARK View (1991)

Collaboration

Our conversations form the basis of our friendship and are what allow us to work together. For us, the interest in collaboration extends from an emotional need to be part of a community. Because we don't always work together, our decision to collaborate on a specific project occurs when the challenge of a situation brings up issues we are already talking about. We share an interest in how meaning is exemplified by materials and in reexamining the ways we know things cerebrally versus the kind of knowledge that comes through the senses. Certain issues that circulate again and again in our discussions always come back to a shared concern for how the value of individual experience and voice is lost in institutional processes. Our conversations follow a loose associative pattern . . . sometimes painfully slow. Every thought gets turned over and scrutinized by two. But we are patient, pursuing a meandering thread that doesn't seem immediately related to the larger conversation. That patience follows from our interest in the interdependence of systems that somehow makes any idea relevant. Issues get more refined, and there is the benefit of being able to check your own impulses within a larger context.

* Ann Hamilton and Kathryn Clark, *View* (Washington, DC: Hirshhorn Museum and Sculpture Garden, Smithsonian Institution, 1991). By permission of the authors and the publisher.

Collaboration, in its diffusion of individual authorship, places the emphasis less on the who and more on the what. For us, working together makes public a commitment to a process of exchange that goes on whether it is an individual or group effort. Most important, collaborating is more satisfying than working alone.

Washington/Hirshhorn

Our earliest conversations focused on Washington as the nation's capital, and we discussed the difficulty of locating points of access if you want to engage or confront the governmental bureaucracy. Everyone has had the experience of trying to fit a description of private life into generic government forms, where everything with emotional value is reduced to a statistical list. Likewise, when you do participate in a public political demonstration you often come away feeling that, although it is a media event, no one in the government is home to listen. Although we have access to more and more information, it is difficult to perceive ways in which to act on that information, and the attempt can be like entering some Kafka-esque maze.

So, rather than a site of public involvement, Washington has become a site where one takes pictures and gathers souvenirs. That shift from active participation to passive looking involves a loss that became central to our discussions of the project and eventually led us in a direction very different from that of our original conversation. In *palimpsests,* the installation at the New Museum of Contemporary Art in New York, we drew upon published and private memoirs that, copied by hand, lined the walls with fragments of human memory. With the Hirshhorn WORKS project, we again had the opportunity to draw on printed material, taking advantage of the various archives of Washington. We thought our interest in re-evaluating historical information would lead to working in a more overtly political manner. Finally, though, in the face of our response to the Hirshhorn's architecture, that direction dropped from our conversation.

The circular form of the Hirshhorn Museum building presents the image of a vault or a militaristic fortress. It has a hard exterior that protects and isolates its own belly. But the core of the museum is windows—it looks in on itself. As we walked round and round the hallways, with no external points of reference, we experienced the museum as a system impervious to the outside. One is fixed in a repeating course circling the fountain that sits off-center in the interior court, echoing the elliptical path of the Earth around the Sun. A sense of timelessness and disorientation were our first and primary experiences. The fortresslike exterior and its facade of permanence in the face of the flux and change of time seemed to encapsulate two irreconcilable desires: the desire to collect, contain, and preserve and the desire to participate in the impermanence of the world outside the collection.

Collecting

The Hirshhorn cannot be considered apart from its relationship to the Smithsonian, a vast institution that is charged with collecting and classifying objects and disseminating knowledge. A museum acts as a framing device to sanction and display the accumulations of the various urges and motivations to collect. We are both avid collectors who take great pleasure in finding something special and housing it among other treasures. Yet our impulse to collect is in many ways childish, with a motivation somewhat akin to that of a pack rat whose attention is snared by the gleam of a silver thread. In the end, our collections are diverse and eclectic

rather than categorical and striving toward completeness. In contrast, when collections are built and institutionalized, what is collected and what is ignored become political issues. Whether contemporary Western art or artifacts in a natural history museum, those aspects of culture that are designated as valuable for collection are often at odds with what is actually valuable in daily life. A museum makes it possible for viewers to return to its collections again and again, but it also sets things apart from the continuum of life—takes them out of circulation and places them in the stasis of a perpetual past.

Making site-related work—work that is ephemeral and constituted of organic materials—is part of retracing the path back toward art that is among the living and therefore among the dying. Such materials as water, wax, and paprika, which can change form and mark or be marked by time, reflect our view of art as more an ongoing process than a product. Introducing living systems—the snails that devoured cabbage heads in *palimpsests* or the moths that lived, reproduced, and died in Ann's recent installation at the Wexner Center in Columbus, Ohio—is a way of extending the process of making into the public life of the work. It raises issues of tending and offers a more active relationship with the work on the part of the institution and the viewer. If collecting is about the removal of objects to a hermetic context, then art that exists in the seams can introduce and remind us of all that cannot be preserved.

Work

The challenge of the Hirshhorn WORKS project was to place work in or with a site that didn't isolate it but let it interact with the museum. Outside or tangential to our discussions about the site was a desire to create something that was emotional, as a contrast to our perception of the coldness in the building. The tactile warmth of our previous installation depended on completely surrounding and enveloping the viewer in the relationships of the work. Initially, it was difficult to see a way to create the experience we wanted by affecting a wall or portion of the Hirshhorn's architecture. When we explored what kind of emotion we wanted, we kept returning to a need to acknowledge a sense of loss . . . whether personal, cultural, or specifically the loss we have talked about when objects are collected. Not only objects collected within the context of art but all the myriad artifacts and data that are the remnants of the plants, animals, and cultures that are becoming extinct in giving way to the demands of the industrial world. With the acknowledgment of loss came the use of water, with not only its reference to tears but its ability to wear down and mark over time. Our discussions about the loss of active involvement in the shift from participant to viewer led to our masking the windows, an act that limited the view and amplified the interior, self-referential aspect of the museum. Ironically, the loss that we were exploring metaphorically parallels a very real sense of loss that we both feel when the process of making a piece is finished and it becomes public.

We both have established a history of working with a community of people to create art. The intensive labor of Ann's installations necessitates the efforts of many hands. A community forms out of working together, and the spirit of the continuing hive situation imbues the work with the felt presence of that collectivity. The accumulation of individual hand gestures visibly marks the work. In this, the work is both the labor and the thing. Over the past few years, Kathryn has worked as artist or artistic administrator on projects that linked artists with community activist groups. An important aspect of these collaborations has been that the work produced was only one part of a multiple agenda that included lobbying, education, and direct relief or services. *Naming Names,* an installation that included the names of 12,000 civilians killed in Guatemala and El Salvador, acknowledged the continuing labor of the human rights

groups that collect the names and the local community that commits to remembering the loss through the activity of transcribing the lists by hand. The work is part of the process of involvement, not the object.

Both of us were raised in the Midwest and with an ethic that placed a high value on all forms of work. Making art is a process of affirming work's pleasure.

MARK THOMPSON *A House Divided* (1989)

During May–June of 1989, I was involved in the project *A House Divided* in conjunction with the exhibition *Ressource Kunst*. The installation site was an early 1800s hospital, the Künstlerhaus Bethanien, bordering the Wall in West Berlin. In mid May, I began a three-week exploration of East and West Berlin to gather the raw materials/resources for the installation. Working with a 19th-century bee hunting box used to track and locate wild honeybees living in hollow trees in the forest; local honeybees were tracked to their hives within a 5-mile area of East and West Berlin. This tracking process involved catching honeybees, feeding and releasing them, then carefully sighting along the returning bee flight direction in a series of steps to locate the source of the honeybees. Through this process interactions occurred with a variety of people and beekeepers from both cities. Usually the children were the most curious and excited about catching the bees and following them throughout the city.

In West Berlin I met Herr Pickard, a beekeeper whose beehives were about one mile away from the Kunstlerhaus Bethanien. After an explanation of how I had found him, we spent the afternoon examining his bees and pulling honey off of his hives. I described my project and the need to gather beeswax for the windows from beekeepers in both cities. He gave me the seed crystal of wax for the windows—a small fragment of wax harvested before the Chernobyl nuclear meltdown, his most precious wax because it was non-radioactive. This meeting began a working relationship that continued throughout the exhibition. From other East and West German beekeepers beeswax was purchased as the raw material for covering the two windows and iron columns supporting the ceiling. After melting and blending, the wax was poured into translucent slabs for sealing the two, arched window openings and coating the columns in the former hospital ward. Glowing with a golden-yellow presence in the darkened room, sunlight passed through beeswax drawn from the East and the West—wax transmuted from nectar through the body of the honeybee. Within the installation near the windows was the Live-in Hive—a glass walled beehive designed as a shared living space between the honeybees and my head.

Before the opening of the exhibition, a swarm of honeybees (found during my earlier Berlin exploration) was transferred into the Live-in Hive from Herr Pickard's backyard hive. Passing freely through a wire mesh tube through the ceiling, the bees came and went gathering nectar and pollen from flowers on both sides of the Wall. Foraging in a five-mile circular area around the Wall, the honeybees transformed this raw nectar through their being, generating the wax architecture of their city-home. During this process my head was placed inside the hive in a series of private, sitting meditations bringing me closer to the beginnings of a new city. This city architecture of living walls of honeycomb fused together from the flowers of two Berlins—taking form in relation to a human being. The honeybees and the

* Mark Thompson, "*A House Divided*" (1989), special issue, "Art and Healing," ed. Kristine Stiles, *White Walls: A Journal of Language and Art* (Chicago) 25 (Spring 1990): 83–85. By permission of the author and the publisher.

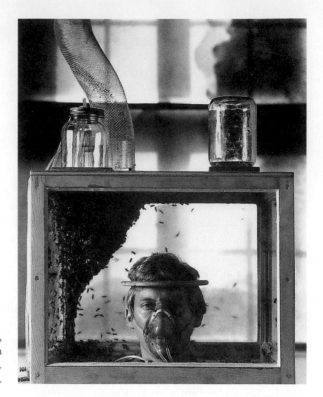

Mark Thompson, *A House Divided,* 1989,
honeybees, beeswax, and the artist in
West Berlin. Photo by Michael Harms.
Courtesy of the artist.

artist bound together through creative, natural processes form a living bridge between two cities, two worlds.

PINCHAS COHEN GAN

Introduction to *Dictionary of Semantic Painting and Sculpture* (1991)

A. General Background

The Dictionary contains 200 entries representing universal visual expressions pertaining to man in a cultural, scientific, religious, and philosophical context, as confronted with their literal meanings. The image is the cash value of the locutions. The routine observer may argue that this is an improper dictionary, since a word cannot be pictured in an unequivocal manner—let alone a concept or a phrase.

Theory Is Biography

According to Heidegger, science is the theory of reality. Plato holds that theory is looking outward. In either case, we are dealing with conventions to which this critical dictionary gives expression.

* Pinchas Cohen Gan, "Introduction," in *Dictionary of Semantic Painting and Sculpture* (Tel Aviv: Bezalel, 1991), 518–20. By permission of the author.

B. Fundamental Assumptions

1. Artistic creation is an autonomous notion which puts in doubt the very justification of criticism as a philosophical or scientific discipline.

2. The Dictionary proposes a new interpretation of concepts and their identification. The images represent themselves as well as their own absence.

3. The Dictionary is formed as a flexible, semantic construction calling into action theory and practice at the same time.

4. Theory is classical human language based on sound; practice is expressed by the pre-eminence of plastic art, cinema, television and video.

5. A principle of simulation operates in the Dictionary at the same time as dialectical freedom. The hieroglyphical motif and the alphabet are present as well as modern science (an example is Mendeleyev's periodic classification which enabled scientists to predict the existence of chemical elements before they were actually discovered).

6. The Dictionary provides a new possibility of quantification with a concentration at the same time on immediate and remote information. The reader may choose an entry and pass on to the following one.

7. The graphic conception of the Dictionary is three-dimensional—a spiral vertigo without a centre.

8. The Dictionary is "mute," as a painting or a written word is mute. There is no contour —merely selection and combination.

C. Attributes

1. The Dictionary relies on the reader's selective memory and his aptitude for translation.

2. There is no continuity between notions, rather a consistency of leaps and irrelevancies.

3. As in mathematics, the situation is physically catastrophic but biographically critical and, as I have argued, theory is biography.

4. The graphic expression of this biography is non-Euclidean geometry.

5. The Dictionary is therefore a theoretical biography.

6. The Dictionary is a lexicon of death since it is based on past creations, and its iconography is hermeneutic (pertaining to the science of interpretation).

7. The lexicon breaks with the myth of the solitary, unintegrated and passive artist. It is a work that blends in a critical manner with the study of contemporary art and philosophy.

8. The Dictionary is an avant-garde lexicon confronting art with its double mirror image; it is a systematic art form.

D. Methodology

1. Conception—the Dictionary is based on a confrontation of picture-notion-sound, or of image-language-sound.

2. Order—alphabetical.

3. Concepts—concepts are defined by combining mathematical terms with general expressions from the history of art and culture.

4. Visual representation—based on works of art through the history of their creation.

E. Procedure and characteristics

1. The Dictionary is, in a sense, an anthropology of the finality of man and his spiritual creation—art. The procedure is a transition from structural absolutism to translational relativity.

2. The Dictionary is a kind of cyclic "prayer book" providing in every picture a novel interpretation of nature.

3. An asymmetry exists between fiction (art) and history (culture). The variation in the form of concepts appearing in the Dictionary makes it possible to create a reality which is, as it were, stable and capable of a relatively constant interpretation.

4. The following types of statement will be found in the Dictionary:

a. Word—a primary value-related statement;

b. Sentence—completes a statement concerning culture;

c. Metaphor—interrupts the continuing relevance of a sentence;

d. Semantic invention—has a critical character;

e. Text—expression of the artistic and cultural history of mankind.

5. These five statements result in a historical situation for the artist-historian, the works of art becoming reality itself imbued with an inner illumination.

F. Conclusion

The study of the history of art and culture is connected with the perception of language. The Dictionary represents a translation of the artist's unconscious system of symbols into the language system of culture and society in general.

The artist is seen as an agent of pictorial systems moving, as in art, like a pendulum within the sphere of culture, and creating non-existent matter through desire and fear.

This Dictionary seeks to establish a connection with mankind and its culture, and to reinforce the iron rule laying down that the importance of one man's art is of no value.

G. Equation of Diagrammatic Representation for the Dictionary of Semantic Painting

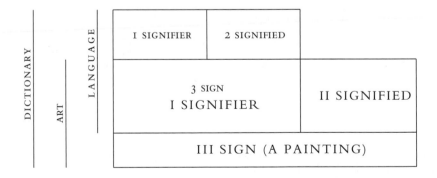

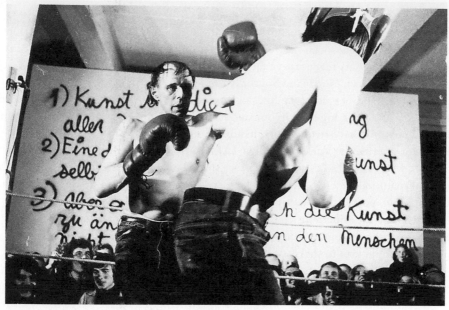

Joseph Beuys fighting Abraham David Christian in *Boxing Match for Direct Democracy*, at *documenta 5*, October 1972. Photo by Eric Puls. © 2012 Artists Rights Society (ARS), New York/VG Bild-Kunst, Bonn.

JOSEPH BEUYS Statement (c. 1973)

My objects are to be seen as stimulants for the transformation of the idea of sculpture, or of art in general. They should provoke thoughts about what sculpture *can* be and how the concept of sculpting can be extended to the invisible materials used by everyone:

Thinking Forms	how we mould our thoughts or
Spoken Forms—	how we shape our thoughts into words or
SOCIAL STRUCTURE—	how we mould and shape the world in which we live: *Sculpture as an evolutionary process;* everyone an artist.

That is why the nature of my sculpture is not fixed and finished. Processes continue in most of them: chemical reactions, fermentations, colour changes, decay, drying up. Everything is in a *state of change*.

* Joseph Beuys, untitled statement (c. 1973), in Caroline Tisdall, *Joseph Beuys* (New York: Solomon R. Guggenheim Foundation, 1979), 7. © 2012 Artists Rights Society (ARS), New York/VG Bild-Kunst, Bonn. By permission of the publisher.

Appeal for an Alternative (1978)

This appeal is directed to all people in the European sphere of culture and civilization. The breakthrough into a new social future can succeed if a movement develops in the European zones which, through its regenerative faculties, levels the walls between East and West, and bridges the gap between North and South. It would be a start if, let's say, the people of Central Europe decided to act along the lines of this appeal. If today in Central Europe we commenced to live and work together in our states and societies in accordance with the demands of our time, it would have strong repercussions in every other part of the world.

Before considering the question "WHAT CAN WE DO," we have to look into the question "HOW MUST WE THINK?," so that the lip service that all political parties today pay to the highest ideals of mankind becomes the real thing, and is no longer belied by the actual practices of our economic, political and cultural reality.

Be warned against impetuous change. Let us start with SELF-CONTEMPLATION. Let us ask ourselves what prompts us to reject the status quo. Let us seek the ideas that indicate to us the direction we should take to make a new start.

Let us examine the concepts on which we have based our regulation of the conditions in the East and West. Let us consider whether these concepts have furthered our social organism and its correlation with the natural order of things; whether they have led us to the establishment of a healthy existence, or whether they have harmed mankind, and now put even mankind's very survival on the line.

Through careful observation of our own needs, let us reflect whether the principles of western capitalism and eastern communism are receptive to that which, judging from recent developments, more and more clearly emerges as the central impulse in the soul of man, and expresses itself as the will to concrete self-responsibility: to be freed from a relationship founded on command and subjugation, power and privilege.

I have pursued this question patiently for some years. Without the help of many other people, whom I encountered in the course of this research and experience, I would hardly have come to the answers which I want to communicate in this appeal. Thus, these answers are not just "my opinion"; they have also been recognized by many other people.

At present, there are still too few to bring about the change right away. Their numbers must be increased. If what I am suggesting here can also be brought to bear in a political-organizational way, and can finally be applied in CONCERTED EXTRA-PARLIAMENTARY ACTION, the appeal has attained its goal. It is therefore a question of a NON-VIOLENT REVOLUTION, an alternative based on an openness towards the future.

The Symptoms of the Crisis

We may assume that the problems which motivate us to reject the status quo are common knowledge. A brief summary will suffice to point out the main factors in the total problem.

THE MILITARY THREAT

Even when the superpowers harbour no aggressive intentions, there is the danger of the atomic destruction of the world. War technology and weapon arsenals, stepped up to the point of ab-

* Joseph Beuys, "Appeal for an Alternative," trans. B. Kleer, in *Centerfold* (Toronto), August–September 1979. Originally published in German in *Frankfurter Rundschau,* 23 December 1978. © 2012 Artists Rights Society (ARS), New York/VG Bild-Kunst, Bonn. Translation by permission of B. Kleer and *Fuse* magazine.

surdity, no longer permit a secure control of the total operation, which has become extremely complex. Despite the accumulated potential of the hundred-fold destruction of earth, the embittered arms race accelerates from year to year behind the facade of the so-called disarmament talks.

This collective insanity results in an incredible waste of energy and raw materials, and a squandering of the creative abilities of millions of people.

THE ECOLOGICAL CRISIS

Our relationship to nature is characterized by the fact that it is a totally disturbed one. The complete destruction of the natural foundation on which we stand is imminent. We are well on the way to destroying it in that we maintain an economic system based on the unrestrained plundering of this foundation. It must be stated very clearly that, on this point, the economic systems of private capitalism in the West and state capitalism in the East do not fundamentally differ. The destruction is a worldwide phenomenon.

Between the mine and the garbage dump runs the one-way street of modern industrial civilization, whose expansive growth victimizes an ever increasing number of lifelines in the ecological system.

THE ECONOMIC CRISIS

It has many symptoms—the daily fare of newspapers and newscasts. There are strikes and lockouts; millions (speaking worldwide) are unemployed, and cannot put their abilities to work for the community. In order to avoid having to slaughter the sacred cow, the "law of the marketplace," vast quantities of the most valuable foodstuffs, accumulated through subsidized over-production, are destroyed without batting an eyelid, while at the same time, in other parts of the world, thousands are dying of starvation.

Here it is not a question of producing to satisfy the needs of consumers, but rather, a cleverly disguised waste of goods.

This kind of management delivers mankind ever more systematically into the power of a clique of multinationals who, along with the top functionaries of the communist state monopolies, make decisions at their conference tables about the destiny of us all.

Let's dispense with a further characterization of what is constantly being touted as the "monetary crisis," the "crisis of democracy," the "education crisis," the "energy crisis," the "crisis of the legitimacy of the state," etc. and conclude with a brief comment on the

CRISIS OF CONSCIOUSNESS AND MEANING

Most people feel that they are at the mercy of the circumstances in which they find themselves. This leads, in turn, to the destruction of the inner self. These people can no longer see the meaning of life within the destructive processes to which they are subject, in the complex tangle of state and economic power, in the diverting, distracting manoeuvres of a cheap entertainment industry.

Young people especially are lapsing into alcoholism and drug addiction, and are committing suicide in increasing numbers. Hundreds of thousands become victims of fanatics disguised as religious people. The opposite of this loss of identity of the personality is the motto: "After me the deluge"—the reckless 'living it up,' the pursuit of instant gratification, a glib conformation in order to take, at least for oneself, what there is to get from the total senselessness, as long as life lasts, without considering who has to pay the bill.

These are accounts which must be settled by our environment, our contemporaries and future generations. It is time to replace the systems of "organized irresponsibility" (Bahro) with an alternative based on equilibrium and solidarity.

The Causes of the Crisis

To get back to the heart of the matter: We may say that two structural elements of the social orders that have come to power in the 20th century represent the actual causes of the total mess: MONEY AND THE STATE, i.e. the roles that money and the state play within these systems. Both elements have become *the* decisive means to power. THE POWER IS IN THE HANDS OF THOSE WHO CONTROL THE MONEY AND/OR THE STATE. The monetary concept of capitalism forms the basis of this system in the same way as the concept of the totalitarian state is the basis of communism as we have come to know it.

Meanwhile, these two ideas have been reciprocally assimilated into the concrete manifestations of current conditions in East and West. In the West, the tendency towards an extension of the state function is gaining momentum, while in the East, aspects of the money mechanism developed by capitalism have been introduced. Although clear differences do exist between western and eastern capitalism, e.g. with regard to respect for human rights, it is nevertheless true that both systems are tending increasingly towards destructiveness, and that, through their opposing powers, they threaten the future of mankind in the extreme. For this reason, it is time that "both be replaced by a new principle," since both are "on their last legs" (Gruhl).

Among us, too, this can only be done by a change in the constitution.

The practically neurotic loyalty to the Basic Law which has developed in the interim makes us blind and incapable in face of the necessity of developing its rudiments further.

In a society that has attained a certain level of democratic development, why, in fact, should requisite further development not be openly discussed? Already, far too many are afraid that they may fall under the suspicion of being enemies of the constitution. They deny themselves even creative ideas on how to extend the concepts of justice once these have been formalized, if the progress of conscience demands it. And it does. The upshot: CAPITALISM AND COMMUNISM HAVE LED MANKIND INTO A DEAD-END STREET.

As incontestable as this is, and as widespread this insight, it is still little comfort, if no models for a solution have yet been formulated; that is, ideas for free, democratic perspectives, in solidarity with nature and one's fellow man, based on foresight and a feeling of responsibility for the future of the whole. But such models *have* been worked out. One in particular is discussed in the following:

The Solution

Wilhelm Schmundt demanded the "correction of concepts" as the central requirement of a sound alternative. Eugen Loebl, the economic theoretician of the Prague Spring, agrees with this when he speaks of the "REVOLUTION OF CONCEPTS" that cannot be postponed. Schmundt entitled one of his books "Revolution and Evolution"; with this, he means to say: "Only when we have effected a 'revolution of concepts,' by re-thinking the basic relationships within the social organism, will the way be open for an *evolution without force and arbitrariness.*"

Unfortunately, the attitude that concepts are 'not the point' still lives on, often precisely in those circles that think in political alternatives. This flippant preconception must be overcome if the new social movement is to be effective and become a political force. Concepts always involve

a far-reaching set of practices, and the way in which a situation is thought about is decisive for how it is handled—and before this, how and whether the situation is understood at all.

In working out the alternative, i.e. the THIRD WAY (of which the Italian Communist Party, as the first communistic party, now also speaks positively), we start with the human being. He creates the SOCIAL SCULPTURE and it is according to his measure and his will that the social organism must be arranged.

After feeling and recognition of human dignity, man today puts three basic needs in the forefront:

1. He wants to DEVELOP FREELY his abilities and his personality, and wants to apply his capabilities, in conjunction with the capabilities of his fellow man, FREELY for a purpose that is recognized as being MEANINGFUL.

2. He sees every kind of privilege as an intolerable violation of the democratic principle of equality. He needs to count as a responsible person with regard to all rights and duties—whether in an economic, social, political or cultural context—as an EQUAL AMONG EQUALS. He must have a voice in the democratic dealings on all levels and in all areas of society.

3. He wants to GIVE SOLIDARITY AND CLAIM SOLIDARITY. That this is a prime need of contemporary man may perhaps be questioned, because egoism is by and large the dominant motivator in the behaviour of the individual.

However, a conscientious investigation proves that this is not so. It is true that egoism may stand in the forefront and determine behaviour. But it is not a need, not an ideal to which people aspire. It is a drive that prevails and rules. What is desired, is MUTUAL ASSISTANCE, FREELY GIVEN.

If this impulse of solidarity is understood to be the human and humane ideal, the mechanisms in our present social structure which activate the egoistic drive must be re-cast in such a way that they no longer work against man's inner intentions:

THE "INTEGRAL SYSTEM" OF NEW CONCEPTS OF WORK AND INCOME.

In industrial society based on a division of labour, ECONOMIC LIFE has developed into an INTEGRAL SYSTEM, as Eugen Loebl put it. This means that when people work, they leave the private sphere, the households, and stream into the associated places of production. The products of their labour no longer reach the marketplace by a barter system through individuals or guilds; rather, they get there through a concurrence of complex processes. Each end product is the result of the joint activity of all within the framework of the WORLD ECONOMY.

All activities, including those of education, training, science, the banks, administration, parliaments, the media, etc. are integrated into the whole.

Two processes constitute the basic structure of this type of economy: the stream of capability values, which are applied at work, and the stream of intellectual or physical CONSUMER VALUES. The technical means of product must here be considered more highly developed resources.

All work is, on principle, WORK FOR OTHERS. That means that, at a certain point, every worker makes his contribution towards the creation of an item, which in the final analysis will be used up by his fellow men. A person's work is no longer related to *his* consumerism. It is equally significant that the integral system no longer permits the workers' income to be considered an index of the exchange value of their labour, since there is no longer an objective yardstick to determine an individual's contribution to the production of a particular consumer item. Similarly, the objective participation of a firm in the total product cannot be determined.

If we acknowledge these realities, and do not allow ourselves to ignore them because of these interests and those disinterests, then we have to recognize that, along with the transition from the barter economy (including a money trading economy) to the INTEGRAL ECONOMY, the relationship of work/income has changed fundamentally.

If we were to follow these realizations through to their logical conclusions, this alone would cause the current economic situation to change radically. The income that people need to maintain and develop their lives would no longer be a derived quantity, but rather a primary right, a human right that must be guaranteed in order to meet the prerequisites that will enable people to act among their coworkers in a responsible and committed way.

The democratic method of agreement, based on a point of view oriented to need, is the proper principle by which to establish income as an elementary human right. The extent and type of work must also be considered and regulated by democratic society in general and workers' collectives in particular, in accordance with their autonomous forms.

This invalidates all of today's pressures, injustices and frustrations, which derive from the anachronism: 'remuneration for work.' Unions and employers' associations become superfluous. If there are differences in income, they are transparent and democratically desired by all. The socio-psychological consequences of overcoming the dependence on remuneration are also positive. Nobody buys or sells abilities and work. With regard to their income, *all* workers belong to a democratic community of citizens with equal rights.

THE CHANGE IN THE FUNCTION OF MONEY

Just as the nature of work changed fundamentally during the transition to art integral economy, so, too, a metamorphosis has set in in the monetary processes. But in the same way as the concepts of the barter economy were retained to regulate the relationship of work/income, so too, these concepts remained decisive for the organization of the monetary system. For this reason, money could not be integrated as an ordering agent into the social organism.

This has prompted many analyses of money, based on psychological, sociological, economic-theoretical and other points of view. But they have all been of little use. The power of money remained unbroken. Why? Because we did not change our concept of money when historical development would have required it.

What has led to the change (so far still ignored) in the function of money? This change came about with the emergence of central banking in modern monetary development. Money was no longer part of the world of economic values, in which it had previously served as the universal medium of exchange.

The new method of issuing and managing money through the institution of central banking led to the development of a *circulation system* within the social organism. Thus, like the evolutionary step in the biosphere from a lower to a higher organism, the social whole acquired a more complex form of existence. Money constituted a new functionary system. It became the ARBITER OF THE RIGHTNESS of all creative and consumer processes.

On the production end, firms require money to operate. They get it from the banking system in the form of credit (interest, today linked with the idea of credit, derives from a misunderstanding of the nature of money!).

In the hands of business, money = PRODUCTION CAPITAL is a document of law. It OBLIGATES firms to channel the capabilities of their workers into work.

When money is put at the disposal of workers in the form of income, it changes its legal meaning. As CONSUMER CAPITAL it ENTITLES the user to acquire consumer items.

The money then flows back into the production sphere and changes its meaning one more time. Now it is MONEY UNRELATED TO ECONOMIC VALUE. As such, it entitles the firms who gain it—to nothing. With it, credits are paid off, companies' accounts are balanced at the credit banks. Since many concerns—e.g. schools and universities—do not charge for their services, the balance of accounts among the firms themselves, insofar as some have a profit and others, a deficit, must be undertaken in conjunction with association banks.

This concept of money, raised to the level of the successful social evolution, has sweeping repercussions. It solves the problem of power insofar as it is based on the monetary aspect. Because of the refusal to recognize that monetary regulations were no longer part of economic life, but had become an independent functionary system in the area of law, the old Roman concept of private ownership could survive without restriction. So also the categories of profit and loss could become operational. The unrestricted appropriation of everything involved with the production sites remained legitimate.

On the other hand, the recognition of the transformed monetary concept leads, without a single civic measure or fiscal exercise, towards the abolition of the ownership as well as the profit principle in the production sphere.

And what becomes of the stock exchange, land speculations, usury, inflation? They disappear, as do the hostages of unemployment. The world of stocks passes away overnight, without causing even one gear to grind. And the stockholders, the speculators, the big landowners? Will they present their holy riches to mankind on the sacrificial altar of the dawning new age? We shall see. In any case, everyone will find his place in society, where he can apply his abilities for the benefit of the whole in a free, productive and meaningful way.

With regard to consumerism, production will be in accordance with consumer need. No profit or ownership interests inhibit or divert this, the only proper economic goal. The fraternity that has already reached an elementary stage within the integral system—"Work is, on principle, work for others"—can evolve without hindrance.

A new light is cast on the ecological question as well. Economic ecology is self-evident, when a free science, liberal education and open information systems comprehensively research and disseminate the laws of life and illuminate their significance for man.

THE FORM OF FREEDOM OF THE SOCIOLOGICAL ORGANISM

We might consider entrusting the state with the management of social development, were it not for the fact that this stands in radical contradiction to the freedom impulse, to the demand for self-determination, self-responsibility and self-government (decentralization). For this reason, the last important question that arises in conjunction with the concept of the evolutionary alternative of the Third Way—"How can a society freed of constraints find its developmental direction, oriented to human needs and physical necessities?"—can only be answered with a description of the "form of freedom of the social organism" (Schmundt).

On the one hand, freedom is an individual impulse to act according to self-determined motives. On the other hand, self-determined action is free only if it occurs "with insight into the conditions of life of the whole" (Rudolf Steiner).

For the complex interrelationships within our production, which is based on a division of labour, this means that the individual, or the individual firm, can only with great difficulty discern, on its own, how the task—to produce something for the needs of others—can best

be accomplished. Thus it is necessary to incorporate into the body of society a new function-ary system: the SYSTEM OF ADVISORY TRUSTEES, an authentic counsellor-system as a constant source of inspiration.

Every worker's collective can best gain an insight into the conditions, relationships and effects of its actions if it appoints a board of trustees in which the democratically authorized management of the firm discusses the purposes, goals and development of the firm, from the most comprehensive viewpoint possible, with leading personalities of other companies, banks, scientific research institutions and also representatives of its consumer groups. Those respon-sible in each case must make the decisions. Through the assistance of the trustees, these deci-sions will be supported by an optimally objective perception of the situation.

What holds true for the associations of workers' collectives among themselves also plays a role in the basic structure of a single free concern. Once the antithesis of "employer" and "employee" is overcome, the field is open for a social structure in which processes of FREE CONSULTATION, DEMOCRATIC DEALING, and finally, a JOINT EFFORT for the social environment are interwoven.

Everyone has the right to free entreprenurial initiative, because man is an enterprising being. It is necessary that managers have the capacity to call upon their co-workers in ac-cordance with their professional competence and expertise. This function, however, will bring them neither material privileges nor any other form of power that is not democratically legitimate. Thus, within the framework of the Third Way, FREE ENTERPRISE in a self-admin-istrated economy and self-governed culture is the democratic base unit in a post-capitalistic and post-communistic NEW SOCIETY OF REAL SOCIALISM.

The law-giving, ruling and administrative activities of the state are limited to the function of determining the democratic rights and duties applicable to all, and of putting them into practice.

The state will shrink considerably. We shall see what remains.

WHAT CAN WE DO NOW TO BRING ABOUT THE ALTERNATIVE?

Whoever considers this image of the evolutionary alternative will have a clear fundamen-tal understanding of the SOCIAL SCULPTURE which is shaped by MAN AS ARTIST.

Whoever says that a change is necessary, but skips over the "revolution of concepts" and attacks only the external manifestations of the ideologies, will fail. He will either resign, content himself with reforming, or end up in the dead-end street of terrorism. All three are forms of the victory of the system's strategy.

If we ask in conclusion, therefore: WHAT CAN WE DO? in order to actually reach the goal of a new form from the ground up, we have to recognize that there is only *one* way to trans-form the status quo—but it requires a wide spectrum of measures.

The only way is the NON-VIOLENT TRANSFORMATION. Non-violent, but not, indeed, because violence does not appear promising at a given time or for particular reasons. No. Non-violence on principle, on human, intellectual, moral and socio-political grounds.

On the one hand, the dignity of man stands and falls with the inviolability of the person, and whoever disregards this steps down from the level of humanity. On the other hand, it is precisely those systems which must be transformed that are built on force of every thinkable kind. Thus the use of any kind of force constitutes an expression of behaviour that conforms to the system, i.e. that reinforces what it wants to dissolve.

This appeal is an encouragement and exhortation to go the way of the nonviolent trans-formation. Those who have been passive so far, although filled with uneasiness and dissatis-faction, are called upon to BECOME ACTIVE. Your activity is perhaps the only thing which can

lead those who are active, but are flirting with the tools of violence, or who already use violence, back to the route of non-violent action.

Although the "revolution of concepts" described above is the essential factor in the means to change that is outlined here, it is not necessarily the first step. Nor can it claim absoluteness. Whoever has the capability of thinking through the theories of Marxism, liberalism, the Christian social teaching, etc. will realize that these theories certainly come to the same conclusions as we do.

Today it is necessary to think the historical initiatives through to their conclusions. Where this has been done courageously, it is noticeable how the fronts shift. Then Bahro is closer to Karl-Hermann Flach and William Borm than these are to their party colleague Lambsdorff, and closer than he, in turn, was to his associates, who arrested and condemned him.

The process of conversion of inveterate abstract concepts is in full swing. It must lead to a GREAT DIALOGUE: to inter-factionary, interdisciplinary and international communication between the alternative theoretical solutions. The FREE INTERNATIONAL UNIVERSITY (free college for creativity and inter-disciplinary research) offers a constant opportunity to organize and develop this communication.

"Against the concentrated interests of the powerful, only a compelling idea, one at least as strong as the humanistic concepts of the last centuries and the Christian concepts of the first centuries of our time, stands a chance." (Gruhl) We need a constant and comprehensive dialogue to develop this "compelling idea" from the various beginnings spawned by the new social movement. The FREE INTERNATIONAL UNIVERSITY, as the organizational focus of this research, work and communication, therefore signifies all the groups and basic units in our society in which people have gathered to consider jointly the questions of our social future. The more people who involve themselves in this work, the more strongly and effectively the alternative ideas will be brought to bear. Therefore the appeal is sounded: FOUND WORK CENTRES OF THE FREE INTERNATIONAL UNIVERSITY, the university of the people.

But this alone is not yet enough. Wherever possible, we should decide to PRACTISE alternative life and work styles. Many have made a start, of limited scope and in special areas. The THIRD WAY CONSTRUCTION INITIATIVE ACTION [AUFBAUINITIATIVE AKTION DRITTER WEG] (business association, endowment, membership organization), is a *consolidation* of alternative economic and cultural enterprises. Individual groups or businesses that want to put their alternative ideas into practice are called upon to support this project.

A final, topical aspect, perhaps the most important and decisive for the way of non-violent transformation. How can the NEW SOCIAL MOVEMENT attain a POLITICAL DIMENSION?

This raises the question of the possibility of parliamentary action, at least within the western democracies. If we follow this path, we do right only if we develop a NEW STYLE of political work and political organizing. Only if we practise this new style will we overcome the obstacles—restrictive clauses and the like—that are erected in, the way of alternative developments.

In any case, it would be necessary that alternative models for a solution arise from the parliaments as well, to be perceptible to the public at large. But to do this, people who have worked out such models have to get into the parliaments. How will they do this? By concentrating their entire strength on a JOINT ELECTORAL INITIATIVE.

How the total alternative movement is understood is decisive for such an effort. After all, the movement comprises many streams, initiatives, organizations, institutions, etc. Only in solidarity do they all stand a chance.

Joint electoral initiative does not mean old-style party organization, party platform, party debate. The unity that is required can only be a UNITY IN THE MANIFOLD.

The citizens' initiative movement, the ecological, freedom, and women's movements, the movement of operational models, the movement for a democratic socialism, a humanistic liberalism, a Third Way, the anthroposophical movement and the Christian-denominational oriented streams, the civil rights movement and the Third World movement must recognize that they are indispensable components of the total alternative movement; parts that do not exclude or contradict one another, but are mutually complementary.

In reality, there are alternative concepts and initiatives that are Marxistic, Catholic, protestant, liberal, anthroposophical, ecological, etc. In many essential points they already *agree* to a large extent. This is the basis of *solidarity* in the unit. In other areas, there is *disagreement*. This is the basis of *freedom* within the unit.

A joint electoral initiative of the total alternative movement is only realistic in the form of an ALLIANCE of many autonomous groups, whose relationship among themselves and towards the public is defined by a spirit of ACTIVE TOLERANCE. Our parliaments need the liberating spirit and the life of such a union, the UNION FOR THE NEW DEMOCRACY.

The vehicles that will take the new route are ready to roll. They offer space and work for all.

Readers who are interested in information and collaboration on the projects "Free International University," "Third Way Construction Initiative Action," and "Union for the New Democracy" may contact the Free International University, 8991 Achberg, 4000 Düsseldorf 11, Drakeplatz 4, Federal Republic of Germany (Tel. 0 83 80/4 71).

FRANZ ERHARD WALTHER
Contrasting Pairs and Distinctions in the Work (1977)

As a result of the choice of a particular workpiece, place, treatment, time, persons and "instrumentarium" are bound by the following forms of conditions which influence the emergence of the work in question.

Interior—exterior:
The interior as a naturally incorporated / combinable boundary (intrinsic relationship to interiors in the vehicle) ↔ the exterior as natural field for expansion (the factual necessity of working in a free space).

Surveyable with the eye—not surveyable with the eye:
The development exceeds neither my spatial nor my temporal field of vision ↔ the situation is spatially (temporally) so extensive that I cannot survey it by eye.
The situation in the / with the vehicle limits my field of vision ↔ the vehicle permits a complete visual survey.

Small area—large area:
The development demands limitation to a small area / I require small spaces for the development ↔ large extensive areas are a precondition for development / I need large areas for development.

* Franz Erhard Walther, "Contrasting Pairs and Distinctions in the Work," in *Franz Erhard Walther: Arbeiten 1969–1976,* trans. Dennis S. Clarke and Maria Lino (São Paulo: XIV Bienal Internacional de São Paulo, República Federal da Alemanha, 1977), n.p. By permission of the author.

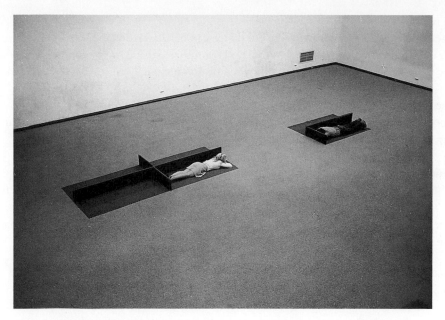

Franz Erhard Walther, *Exercise Piece, First Set No. 58,* 1969, performers with cotton and wood. Courtesy of the artist.

Fixed spot—change of position:
The element must be set up at a fixed spot ↔ the element can be transported—the element requires a continual change of position.

Single point reference—open field:
I set up a fixed point and concentrate on it ↔ I acquire and retain an open field for my activity.

No possibility of withdrawal—possibility of withdrawal:
I cannot withdraw as I find myself in association with other participants; if I withdraw, I upset the situation ↔ the situation is influenced if I withdraw; I cannot withdraw without upsetting the procedure.

Choice of spot choice of field:
I choose a spot at which I want to work. (I choose a spot which satisfies my needs) ↔ I choose a field for working. (I choose a field which allows expansion).

No reference to the surroundings—reference to the surroundings:
Work with the vehicle, the process develops without direct reference to the surroundings. / In the work I make no contact with the surroundings ↔ the work with the vehicle develops in reference to the surroundings and in the surroundings. In the work I refer to the surroundings.

Spatially limited—spatially not limited:
The possibility of expansion, my radius is restricted by the vehicle, I must limit myself ↔ spatially I can expand to an unlimited degree (I am, of course, bound by the inner cohesion of the process).

Inner world—outer world:
Inner concepts which remain with me but which can be outwardly manifested as actions (that which develops inside me) ↔ What I find and recognize outside my own mind and to which I react (what affects me and is accepted by me or remains vis à vis).

Landscape important—landscape unimportant:
The process with the vehicle can only be developed if a free landscape area is available ↔ during the development of the process there is no direct reference to the landscape.

Surroundings important—surroundings unimportant:
The surroundings are important because during the process I have a direct reference to them / the surroundings exert an influence ↔ the surroundings are not important because no direct reference occurs; I have simply a spot where I remain / the surroundings have no recognizable influence.

Object—space:
That which I work on in the process ↔ the spatial extension of the activity.

Spatially surveyable—spatially not surveyable:
The process takes place on a spatially limited field or has to take place on a spatially limited field ↔ the procedure is so extensive or self-expanding that it can not be spatially surveyed.

Rest situation—external movement:
In order to further developments, I have to produce a rest situation. The rest situation fosters the process / the vehicle requires the rest situation ↔ the external movement is a precondition for the development; without this movement the process cannot get started / the vehicle requires the external movement.

Moment of time—moment of space:
The development is borne essentially by the moment of time (emphasis on time) ↔ the development is based essentially on the moment of space (space as emphasis).

Walking—standing—lying—sitting:
External primary situations (engagement of the bodily posture in the process).

Isolation—association:
The work element contains the moment of isolation. I can strengthen or weaken this moment / the moment of isolation occurs during usage ↔ the work element has associative characteristics or is an association which I can specifically use / In the work occur conditions of an associative nature.

Self-determination—ectodetermination:
I determine the procedure and all relevant decisions connected with it (thereby I must concur with the process conditions) ↔ the procedure cannot be determined by myself alone because it is conducted by several persons (if I try to determine it in a particular way, I upset the process). My actions are necessarily influenced by the others. The procedure cannot take place without mutual influencing.

Involvement—non-involvement:
In the course of the process I am firmly involved in the structure through the type of the work element / I am firmly involved in the emerging / already emerged situation ↔ the work element is of such a type that I can involve myself in the structure / the work element rejects any involvement / the emerging situation requires no involvement.

Mutual reaction—co-operation:
Mutual reaction as element ↔ co-operation as basis for creation.

Possibility of transference—isolation:
The creations are transferable to other situations (transferability) / the experience can be transferred ↔ the creations cannot be transferred to other situations and remain an isolated experience (isolation form) / the experience cannot be transferred.

Responsible to the participants—not responsible to the participants:
The work demands responsibility towards the others / I have together with the other participants entered into a situation of joint responsibility (I have myself helped to create the situation); if I withdraw, the situation collapses ↔ the work demands no direct responsibility vis à vis the other participants / the circumstances are such that no direct responsibility vis à vis the others is demanded.

Order—chaos:
I try to introduce into the creation an order / arrangement (measurement, number) (structure) (form) ↔ I promote a free, uncontrolled, self-expanding development, in which creations are formed which do not emerge without that attitude which approves of the chaotic.

Structured—not structured:
Determination of the length of time and route, regulations concerning action, concepts—measure of time and activity with reference to the structure ↔ length of time and route emerge from the development, the action is intuitive—here there is no pre-structuring; there are no designs with reference to time and activity.

Objective—subjective:
The work element, the objectified process ↔ action procedure, action justification.

Physical movement—mental movement:
I move physically by proceeding from one point to another (change of location). I find myself at one spot, which I do not leave, and there I move my body (fixed spot) ↔ I find myself at one spot and execute mental movements (change of location). I find myself at one spot and concentrate my mental movement on a spot before me (fixed spot).

Passive / passive activity—Active / active activity:
Attitude of observation and acceptance of the process (passive conduct) ↔ urge to influence or shape the procedure (active conduct).

Inside—outside:
What is formulated inside me ↔ what is manifested outwardly as action.

Design—course of action:
I design an action possibility / the design is implemented in the course of the action ↔ in the course of the action incalculable moments occur / the design is changed or rejected in the course of action.

Activity—creation:
The action with the workpiece / physics ↔ the creation, development, formation during action / chemistry.

Physical—psychological:
Weight of bodily activity. Mass of the parts ↔ volume of formulation.

Creation recordable—creations not recordable:
Creations are by their very nature communicable and can be recorded ↔ the creations are not communicable and remain an individual experience (and as such have their effectivity). The attempt at communication destroys the creations.

Demonstration—practice—use:
Getting to know the measurable. Experiencing the preconditions ↔ process, operation, term, concept, procedure.

Discretionary powers of all participants—discretionary powers of one participant—discretionary powers of none of the participants:
The basic possibility is determined by the work element, the structure ↔ the working conditions can be determined by the structure, the work element.

The opposite number can change his position relative to me—my opposite number cannot change his position relative to me:
The workpiece permits the change of position and location ↔ the workpiece is tied to location and position.

Near—distant:
The vehicle is established, the use demands one's presence near the structure / the element is to be found in my immediate proximity ↔ the vehicle is established but allows a certain measure of distance / the vehicle is not established—I can measure distances.

Single / individual—group:
I develop and am responsible for the procedure. I survey the development as regards myself ↔ The process is developed by several persons and is their joint responsibility—I cannot survey the whole development by myself, for myself.

Intuition—planning:
The process as a work is developed intuitively ↔ with reference to theme and direction, the process is planned.

Body relaxed—body tensed:
The body is in a state of relaxation (the structure demands a temporary or permanent state of

relaxation for the body) / the body was tensed and is now relaxing ↔ the work with the structure demands continuous or temporary bodily exertion.

Method of use laid down—method of use to be determined:
The method of use in the workpiece is clearly laid down ↔ the method of use must be determined before work starts or is determined on its own account during work.

Action—non-action:
The vehicle demands action / I aim at justified action ↔ the vehicle does not necessarily demand action / I aim at non-action.

Nothing material is left over—some material is left over:
The process leaves behind nothing material ↔ in the course of the process materials are collected which indicate the genesis, or traces remain from which the action or the procedure can be determined.

Enclosed / wrapped up—open / not wrapped up:
The body is enclosed by or wrapped in the object ↔ the body is not wrapped up (the structure—an open segment).

Instrument stationary during use—instrument to be transported during use:
The instrument requires a fixed spot and is installed there for use (any change of location requires a new installation) ↔ the transport of the element is a precondition for the process.

Change in the element during use—no change in the element during use:
In the course of the process of use the element undergoes a change / it expands in area / something is added to it ↔ the element undergoes no intrinsic change / it can be transplanted.

Element fixed to the body—element not fixed to the body—gap between element and the body:
I am connected directly to the element—I am indirectly connected with the element—I can connect myself with the element—I need not connect myself with the element.

Temporally surveyable—temporally not surveyable:
I have set myself a time scale within which I complete the process / there is a time limit to operation in the structure ↔ a time scale cannot be set without destroying the creations / operation in the structure cannot be limited in time.

Culture—nature:
Constitutions in the process which are determined by cultural tradition ↔ formations / effects in the process determined by nature.

Limited in time—not limited in time:
The process is completed in a short time, which cannot be extended / the effectivity of the process is limited in time ↔ the process in no way requires a definite period of time to enable it to develop / in order to help make the process effective, I must allow myself unlimited time; the process cannot be limited, i.e. I cannot bring it to an end.

Organic—inorganic:
The process is organically connected with the object / the process develops organically in time ↔ the process develops arbitrarily with the object / I organize the process on a time basis, i.e. I set a time scale which, however, is in no way arbitrary.

Warming up—cooling off:
Warming up through activity / warming up through lying in the element ↔ minimal activity, relaxation—body temperature drops.

Movement at the vehicle / movement in the vehicle—movement with the vehicle:
I move in direct contact with the vehicle or at a little distance from it / movement in the vehicle at a fixed spot—I change only position or posture ↔ I move with the vehicle on the spot / I move with the vehicle—no fixed spot can be determined, or if a fixed spot can be determined, I can still move freely.

Eye—memory:
I can take in the momentary situation with my eyes ↔ the development up to date is recorded in the brain.

In one direction—in two directions—in several directions:
Movement in one direction only (alone-together)—movement in two directions (forwards-backwards) (alone-together)—movement in different / several directions (away from one another—together / towards one another)

Seeing—knowing:
That which can be visually grasped determines the process / vision structures the process ↔ the knowledge introduced establishes the process / knowledge structures the process.

Reality—conception:
The actual course / course of the process ↔ the subsequent reconstruction of the course of the process.

Sculptural—architectural:
The corporality of the human figure is stressed, body and action are plastically defined and presented ↔ the user moves in architectural-spatial conditions and in reference to them.

Space reference—person reference:
The elements and their composition are in immediate reference to the space provided. The action concerned follows these circumstances ↔ the action with the elements demands a direct reference to the other participants.

Present—future:
That which in any given moment I do, must do or can do ↔ in the process I lay down a field for future actions and move towards it.

Decreasing—increasing:
In the process I "use up," for instance, time, energy, routes that have been laid down—or:

energy decreases ↔ in the process, for instance, density of the work concept, intensity and experience increase—or also: energy increases.

Approach—withdrawal:
The piece requires the approach to the other person or persons ↔ the piece demands withdrawal from the other person or persons.

Direct—indirect:
The element demands reference to other participants or to the surroundings directly and immediately ↔ the element determines the reference to other participants or to the surroundings in such a way that this reference can only occur indirectly.

REBECCA HORN
The Concert in Reverse: Description of an Installation (1987)

You enter the damp, dark inner vault by the cellar door. Small, flickering oil lamps illuminate the path all the way to the outer courtyard. From afar, out of all directions in the round, you hear soft knocking. A large opening in the masonry leads back to the light, to an untouched garden, to a miniature wilderness.

You follow the cleared path, climb a flight of stairs, hold on to an elderberry bush. On the upper platform, still outside, the knocking sound swells in stair-step rhythm. Little steel hammers, attached to the walls and ceilings of the cells and corridors, invent their own, constantly changing rhythms; knocking signals from another world.

Through the second cell on the upper floor (a bomb has destroyed the inside wall) you can look into and down on the circular inner courtyard as if from an open loge. High up in the trees growing perpendicularly out of the walls, there hangs a large glass funnel filled with water. It releases a drop of water every twenty seconds that falls twelve meters (ca. 39 feet) into a pool below. The circular ripples smooth out to a black mirror until the next drop sets the rhythm for the concert in reverse. A pair of snakes, earth-bound—nourished daily by a mouse from Münster—watches and monitors the comings and goings month after month.

The Keep: History of a Building (1987)

From 1528 to 1536, the keep which had been built to replace the old northeastern tower was part of the city fortifications. With a diameter of 23.3 meters (76.4 feet) and an original height of almost 15 meters (49 feet), it is comparable to the huge defensive towers in Goslar. Old illustrations depict it with a conical roof and embrasures. Early in the 17th century there was talk of converting the tower into a prison. Since the idea was initially rejected, the keep was used to house one and later two horse-mills (the horses ran the treadwheels of the mill) and also to store gunpowder. The former tower was finally converted into a prison in 1732.

* Rebecca Horn, "The Countermoving Concert: Description of an Installation" (Odenwald, 20 April 1987), trans. Catherine Schelbert, *Parkett* 13 (1987): 46. By permission of the author, courtesy Marian Goodman Gallery and Sean Kelly Gallery, New York, and the publisher. "The Concert in Reverse" was mistranslated as "The Countermoving Concert" in *Parkett*.

** Rebecca Horn, "The Keep: History of a Building," trans. Catherine Schelbert, *Parkett* 13 (1987): 47. By permission of the author, courtesy Marian Goodman Gallery and Sean Kelly Gallery, New York, and the publisher.

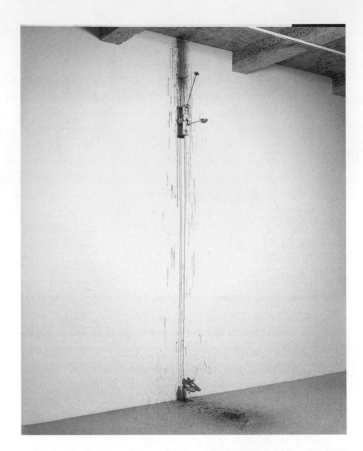

Rebecca Horn, *Lola—A New York Summer* (with detail), 1987, metal paint, and tap-dancing shoes. Photo by Jon Abbott. Courtesy of the artist, Marian Goodman Gallery, New York.

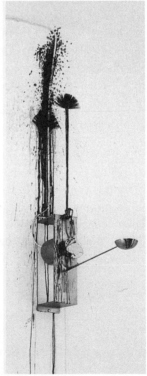

Johann Conrad Schlaun drew up the new plans for the building. The prison became part of a complex with two wings for a penitentiary. Six cells were built into each of the tower's three stories: those in the cellar were without light, the cells on the ground floor each had one small window looking out on the circular inner courtyard, those on the top floor not only had windows but could even be heated. The prison was dissolved at the end of the 17th century. In 1911 the city acquired the tower which had, in the meantime, been declared a historical monument. With a few structural changes, it was used for emergency housing after World War I. A painter was among those who took up residence there. In 1938 the keep was turned over in an official ceremony to the Hitler Youth who settled down in their newly renovated and furnished squadrooms and quarters for the German Young People. Towards the end of the war, the building was taken over by the Gestapo. Polish and Russian prisoners of war were executed in the light well, the technique being to hang four people at once. In the last year of the war bombs destroyed the roof and the inner courtyard. The city walled up and barricaded the windows and doors from outside to prohibit entry in an attempt to banish the atrocities of the preceding years. Cut off from the outside and yet exposed to wind and weather by a gaping wound from within, the keep gave in to the timid growth of new organic life. Trees reaching up to the skies took root in walls and windows. Ferns and moss grew rampant over stairs and corridors until a lush garden of paradise emerged, covering the naked masonry with plant growth.

JAN DIBBETS Statement (1969)

I thought that the lawn was really the most beautiful sculpture I could imagine. And so I started to use nature as visual material. My first projects were the *Grass Rhomboids,* rectangular sections of grass which I cut out and piled on top of each other. This was still related to the superposed painting: instead of paintings, I now piled up grass-sods. I realized that if you want to use nature, you have to derive the appropriate structure from nature too. This resulted in the *Grass-Roll,* actually the first proper grass sculpture.

Nature consists of a large number of ecological systems. For example: a tree needs a certain amount of space throughout its growth, and crowds out less healthy specimens of trees and plants. Natural selection takes place, which is why trees make a particular pattern in a wood. If the trunks of one kind of tree are painted white, this natural pattern becomes visible. The wood then becomes a big sculpture, and nature a work of art.

Statement (1969)

Institutes such as galleries and museums have come in our society to be promoters of new directions in fine arts. The museum and the gallery make known the art. This brings in its train the fact that lots of artists without knowing are searching for their conception from the point of view of the museum or with regard to the gallery.

* Jan Dibbets, untitled statement (1969), in *To Do with Nature* (Amsterdam: Visual Arts Office for Abroad, 1979); reprinted in Dore Ashton, ed., *Twentieth-Century Artists on Art* (New York: Pantheon, 1985), 174–75. By permission of the author.

** Jan Dibbets, untitled statement, in Germano Celant, ed., *Arte Povera* (Milan: Gabriele Mazzotta, 1969); translated as *Art Povera* (London: Studio Vista; New York: Praeger, 1969), 103. By permission of the author, the editor, and Macmillan Publishing Company for Studio Vista.

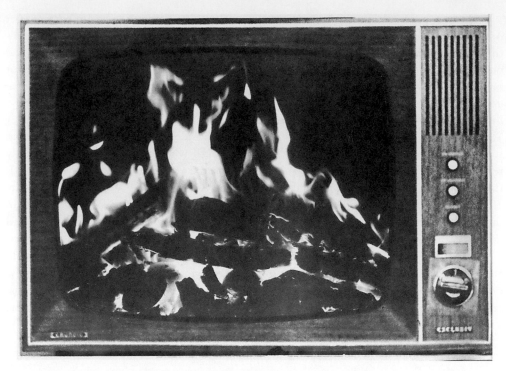

Jan Dibbets, *TV as a FIREPLACE,* 1969, video broadcast. Courtesy of the artist.

Moreover the gallery thrusts an extra aspect on the art: the possibility of selling. In spite of that you have to realize that the museum and the gallery in their present form are institutes which don't meet any longer the new demands that art is asking for. Besides it is a hindrance to creativity to fasten yourself to a norm of showing and selling.

Painting and the selling have become clichés of fine arts. I search consciously for a form of art which is not tied by tradition and in which an oeuvre is less important than the research. There are so many different situations in which to look at something, that standing right before the painting or walking around a sculpture could well be the most simple kind.

You can fly over something, you can walk along something, drive (by car or train), sail, etc. You can "disorientate" the spectator in space, integrate him, you can make him smaller and bigger, you can force upon him space and again deprive him of it.

I start by thinking I'm going to make use of all possibilities without troubling any longer about problems when something starts to be art. I don't make the eternal work of art, I only give visual information. I'm more involved with the process than the finished work of art. The part of my object is untranslated. I think objects are the most usual part of my work. I'm not really interested any longer to make an object.

Interview with Liza Bear and Willoughby Sharp of *Avalanche* (1970)

AVALANCHE: Can you describe in detail how you left painting and sculpture and went on to do earth things?

* Liza Bear and Willoughby Sharp, excerpts from "DIBBETS: Interview with Liza Bear and Willoughby Sharp," *Avalanche* 1 (Fall 1970): 34–39. By permission of the interviewers.

JAN DIBBETS: Yes. There are several points that I'd like to make. Every time I did a painting, I realized that you have to look at it from one viewpoint. This was still true even when I tried to escape from it by making a serial painting like "Three half-cubes, blue and orange." Then I tried to make work which would change when you walked around it. But I realized that the works would always depend on what you saw during those few moments that you were walking around them. The other important point that I realized was that stacking canvases and picture frames was the simplest way of making a painting, as near to zero as I could go.

A: Alright, what was your next work?

JD: The first thing I made after that was the *Grass Square.* That was the same as the *Last Painting,* in a way. And I also made some grass piles.

A: Why did you do that?

JD: It was something much larger than just a desire to work with grass, you know. I realized very well that what I saw around me impressed me much more than art ever could.

A: Your environment?

JD: Well, I would say life. When I went through the parks, I used to think that when people are taken out of the environment, what is left behind is there to be used. I felt it belonged to me, in a way. At first I couldn't find the form in which to use it. I wasn't satisfied with the *Grass Square.*

A: Because of the scale?

JD: That didn't interest me. The scale is unimportant when you're working with ideas. I can write down on a piece of paper plans for a work on such a large scale that it could never be realized, a road between two planets or something. Scale doesn't work for me.

A: So what you are really interested in are the ideas within this medium.

JD: Yes, much more than the scale. And the documentation about the work isn't of real importance to me either. I've done lots of works without taking photographs.

A: But some people say that the photograph becomes the work, in a sense, because the work gets destroyed, and the photograph is what people see.

JD: Well, I am trying to develop something, and I feel I'm not at the end of the development yet.

A: You're trying to develop the ideas rather than the material works themselves.

JD: Yes, but I also feel I have to try to correct what I did earlier.

A: Since your first grass work is so conceptual, you could make a drawing and anybody could do it. So you're not involved in carrying out the work specifically yourself. That leads to the project with the multiple. Could you explain that a little?

JD: You know, I'm trying to do two kinds of things. One is that I like the idea of trying to break down the attitude to art in Holland. I did a multiple show in 1966, of multiple paintings—anyone could have made them—to demonstrate to people how they could do it themselves. Then everyone started to make multiples, and now there are multiple shops in Amsterdam. An artist who makes multiples now is really stupid, I think, because it's become just a selling trick. So I made a multiple of my grass roll for everybody, but it's not a multiple in the gallery sense.

A: It's a conceptual multiple, you pass the idea on in a drawing.

JD: Well, I must say I don't see how to sell these kinds of ideas. If someone can use them he can take them.

A: So you're not very concerned about selling the work?

JD: No. That's a different life. Selling is not a part of art.

A: Would you say that in your work there is an implicit criticism of the selling structure?

JD: No, not at all, only when I tried the joke with the gallery. That's the reason I make objects, to show how stupid it is to make objects.

A: Then you're making grass works and earth works to show that it's also stupid to make these works?

JD: No, no. I really believe in having projects which in fact can't be carried out, or which are so simple that anyone could work them out. I once made four spots on the map of Holland, without knowing where they were. Then I found out how to get there and went to the place and took a snapshot. Quite stupid. Anybody can do that.

A: Why do you say it's stupid?

JD: Well, I think it's quite a good thing to do, but it's stupid for other people to do it, or to buy it from me. What matters is the feeling. I discovered it's a great feeling to pick out a point on the map and to search for the place for three days, and then to find there are only two trees standing there, and a dog pissing against the tree. But someone who tried to buy that from you would be really stupid, because the work of art is the feeling, and he couldn't buy that from me. . . .

A: I think one of the issues concerning earth art is its relation to that other body of work which is classified as sculpture, object sculpture, which is eminently salable. This work is not salable, for the most part, under the present structure of society. That is both a problem and an advantage. I wonder whether you see any advantages, in the sense of not having to worry about how your work is going to be sold.

JD: For me it's not a problem. I realized when I started doing this kind of work that most people aren't concerned by the fact that they are working within a tradition, and secondly that without being fully aware of it they are making something they can sell. But selling is not a part of art.

A: What was the next piece after the first grass work?

JD: It was the *Grass Roll.* I thought this was a better way of using the grass. A roll is also a demonstration of a lot of ideas I had for working with grass.

A: What are the other projects that you did along with the *Grass Roll* that you haven't photographed?

JD: There's one project in which a field is divided into squares. It covers the twenty kilometers along the side of the railroad tracks from Amsterdam to Hilversum. When you are on the train you see the sculpture along the side of the railroad for perhaps fifteen minutes, and at every point the landscape is changing. After the *Grass Roll,* I also tried to do several works of perspective correction. But I only did a few, because in Holland there are fewer possibilities than in America. There's no space, except on the beach, and I've done a lot of things on the beach. Anyway, I did one piece in an Amsterdam park. I laid out a rectangle with white cord so that there was no perspective and the enclosed area of grass seemed to stand up as a form. Another of my works in this vein consists of wood piles which look the same, but actually vary from one to six feet in height.

A: This kind of illusionism seems quite different from what you intended in the *Grass Roll.*

JD: No, not really. This was a sketch for things I planned to make with a tractor. Along the railroad from Amsterdam to Appeldoorn, you can see meadows. Every twenty-five meters or so there is a trench. When you are in the train, you see these trenches which don't meet at a vanishing point, there is no perspective.

A: Is there any development from the grass sculpture to this kind of perspective play?

JD: Only insofar as I could use these possibilities in plans I had made for working in the earth.

A: This seems to be related to some of Richard Long's work, the ones in which he has set up rectangular frames, which are juxtaposed to circles on the ground.

JD: No, they are quite different. In Richard Long's pieces these rectangles really stand up.

A: But there seems to be the same kind of polarity in your own work. On the one hand, the materials are treated in a direct, not very conceptual manner; on the other, there is a certain cool standoffishness about viewing works from a moving train. I wonder how these attitudes relate.

JD: It's quite simple. What surprises me is the work of Americans like Heizer and Oppenheim, which is so focused and so concentrated on one point. That doesn't interest me. What I'm trying to do is several things at once on as large a scale as possible. So in fact I use nature and natural processes: an apple floating in water; and I use materials, elements like earth and water. Apart from that, you have eyes to see them with: that's the third thing. And your eyes see something different from what these things actually look like on the ground. So you can use your eyes twice. You can make something you are really impressed by because it's large and interesting to look at, but you can also make something which is just to be seen, not to impress you as a thing in itself, but as a visual possibility. And I think that there's a distinction between the two.

A: How does this relate to work like the environment you made at the Konrad Fischer Gallery in Düsseldorf?

JD: In the first place, I planned to take an outdoor situation indoors, to create a relationship between the interior space and the objects that are normally found outside. The twigs, sand and water I placed there were not meant to be seen as objects. Their importance lay in the relationship they set up with their environment. There are two possibilities when you show in a gallery: you can either exhibit photographs of a project, or you can take parts of projects and place them indoors, like the things at Fischer's. But that was only a small demonstration.

A: So it was like a sketch.

JD: Yes.

A: And this is only a slightly better substitute for a photograph.

JD: I thought so at the time, because then people couldn't recognize a work at all in a photo.

A: But isn't this a concession to the object-oriented sensibility?

JD: No, not at all.

BARRY FLANAGAN Statement (1969)

Operations grow from the sculptural premise; its exactness and independence is the clue to the scale of its physical, visual, and actual consequence in society.

* Barry Flanagan, untitled statement, in Germano Celant, ed., *Arte Povera* (Milan: Gabriele Mazzotta, 1969); translated as *Art Povera* (London: Studio Vista; New York: Praeger, 1969), 133. By permission of the author, the editor, and Macmillan Publishing Company for Studio Vista.

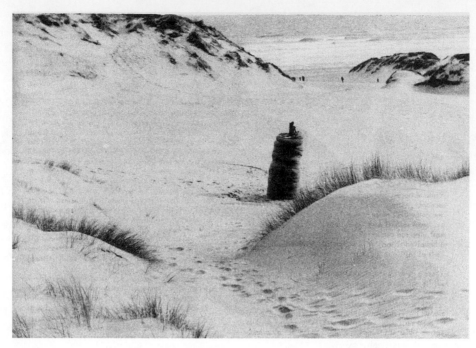

Barry Flanagan, *Sand bag filled, Holywell Beach, Cornwall, Great Britain, Easter 1967.* © Barry Flanagan. Photo by the artist in *ICA Bulletin* (Institute of Contemporary Art, London) 170: 16.

Sculpture Made Visible: Discussion with Gene Baro (1969)

GENE BARO: What led you to sculpture in particular among the visual arts?

BARRY FLANAGAN: The convention of painting always bothered me. There always seemed to be a *way* of painting. With sculpture, you seemed to be working directly, with materials and with the physical world, inventing your own organizations.

GB: But sculpture is a conventional art no less than painting. How do you reconcile yourself to the traditions and conventions of sculpture?

BF: I don't. There is a sculptural way of working that relates to the history of art—in the linear sense. For instance, I sometimes use canvas; I can put a canvas on a wall as a sculptural object in such a way that it will relate to the whole history and convention of painting through its rectangularity and flat vertical surface. But when I make a two- or three-space rope sculpture, it doesn't relate to any conventional or semantic tradition in art.

GB: This raises the question of your choice of sculptural materials. There are traditional materials—stone and bronze. What was it that led you to use such unconventional materials as cloth, rope, and sand?

BF: Those materials—cloth, rope, and sand—would seem unconventional only to those who are bound by the notion of a tradition. What I like to do is to make visual and material inventions and propositions. I don't think about making sculpture, and I don't think whether or not what I'm making is sculpture. I don't like the idea of inventing a rationale to accompany the work. The tradition is only a collection of rationales.

* Barry Flanagan, excerpts from "Sculpture Made Visible: Barry Flanagan in Discussion with Gene Baro," *Studio International* 178, no. 915 (October 1969): 122–25. By permission of the author.

GB: It seems as if your work is centered upon experience, is a kind of speculation upon what you experience visually and physically. Does this strike you as a just assumption? Or how would you differ from it?

BF: My work isn't centered in experience. The making of it is itself the experience.

GB: How, then, do you begin a sculpture?

BF: Truly, sculpture is always going on. With proper physical circumstances and the visual invitation, one simply joins in and makes the work.

GB: Are you saying that sculpture exists in nature to be discovered?

BF: Not exactly. When I say that sculpture is always going on, I mean that there is a never-ending stream of materials and configurations to be seen, both natural and man-made, that have visual strength but no object or function apart from this. It is as if they existed for just this physical, visual purpose—to be seen. . . .

I left metal sculpture in 1965, though I have gone back to it occasionally since. The breakaway material, as you call it, was curtain material; I cut the cloth into arbitrary shapes, sewed them, and gravity-filled them with plaster. I wasn't looking for any particular shapes or looking for a way of projecting my head into the world of objects. I liked more the idea that these shapes virtually made themselves. They were extremely evocative. When I became aware of this, say, in the more final stages, approaching a statement, I would tease them along and thicken the plot. What determined the choice was that cloth allowed me free play with the shape.

Later, I was able to avoid the unnecessary evocative aura surrounding free shape.

GB: Why was it desirable to get rid of it? The evocation was never precise association.

BF: The association isn't central to sculpture itself, just to the way we recognize things.

GB: But does association necessarily disturb, distort, or replace the central issues of sculpture? Why can't you have the central issues and association?

BF: You can have the central issues plus association. But as I said earlier, I was hoping to effect separation for the purposes of clarity.

GB: What, for you, is central to sculpture?

BF: Shape is. It can be a long, thin shape; it can be a machine shape. All objects are taken care of there, including natural ones.

GB: You speak of shape rather than of form. Is there a difference in your mind?

BF: Form sounds an educated perception of shape. I don't like already to be educated. If you don't allow that you get something back from what you are doing that you didn't already know, you have no turnover. Your situation doesn't grow. The only difficulty is in being able to recognize what it is you are getting back. . . .

I have become less interested in the autonomous object. If you don't have an autonomous object, the most tempting thing to do is to apply some system of order. But this might well have more to do with the systems themselves than with the nature of the physical existence of the materials. I think the visual existence of the materials has been central in my interest in sculpture. Objects and their roles in the world, and their configurations, are part of the interest as well. The issue is light. Without light, this world ceases to exist. In fact, maybe it is not objects themselves or the shapes they are that is visually exciting, but the distances and spaces between them or caught within them. I have taken light absolutely for granted and have always standardized its presence in the proximity of any objects, when obliged to think about it; and I also remember excluding any light play from the surface of my objects, as a matter of course. After all, if light is being reflected from the surface, it is not the surface you see but the blinding description of it.

GB: But light modifies appearances even in a controlled environment. For instance, colour is light. The materials of your sculpture are often coloured. Are these hues chosen with any particular reference to light involvement?

BF: In a controlled situation, it is not the light that modifies appearances, but the actual densities and make-ups of the materials. For me personally, the statement "colour is light" has no meaning. Light remains white for me unless somehow interfered with. I have only used colour consciously to make modifications in sculptural shape on one or two occasions. Colour for me is a structural element apart from the sense of light—inherent in the material.

GB: What determines the choice? Do you use colour expressionistically?

BF: To use colour expressionistically is maybe the most feeble thing one can do with colour. . . .

GB: To what degree does your choice of materials and colour reflect an aesthetic concern?

BF: My answer is that it would be crazy to structure every response in detail, without wishing to exclude some things that are naturally available. To be very decisive in this area would be to begin to construct an aesthetic, always a limiting thing. . . .

GB: May I ask you about the sand pieces? When and how did these come about?

BF: At the time of my first show in London, in 1966, I wanted to project the show as if in my normal working situation. I made a sand piece. This had an absolute contact and actuality within the context of the show. This work emphasized the importance of materials. The piece was one hundredweight of sand poured onto the floor, scooped four times from the centre.

GB: What of your use of sand to fill cloth pieces, after you had abandoned resinating them? What led you to it?

BF: It was an elegant solution to technical difficulties identified as a problem at that time, at the end of 1966. It allowed the pieces to be moved easily . . . the excitement of the solution to that technical problem was that dry sand freely poured into a stitched shape became an integrated, autonomous material statement: the dialogue between the weight of the sand and the structure of the cloth skin, the modification of the stitched contour making further shape. On another level, the exactness of process was in evidence and exciting. It was a big contributive factor. In a historical context, I invented a new process for making shape.

GB: How important do you feel scale is to your operations?

BF: Again, scale is an educated notion. For me, size is of importance. A sculpture has to be the right size to do the right job.

In my sculpture involving four sand-filled columns, the size of the units was just enough to make the space between them as important as any of the objects. Thinking of the sand and hessian piece, *Heap,* where fifteen tubes of hessian were filled with sand, size was determined by all sorts of factors, for instance, by the width of the hessian, the structure of the hessian against the permissible weight of sand in any one tube, and the minimum diameter of the thinnest tube against the action of dry sand in a constricted space and the consequent shape it makes with the skin.

GB: At all events, you do not set out to produce effects of scale, largeness of experience. This, when it occurs, is incidental.

BF: Yes.

GB: What are your current preoccupations?

BF: My current preoccupation is the realization that if the lights went out the hardcore emphasis of my sculptural world would cease to exist. I am thinking seriously about light.

Recently, I have been making canvas pieces which are motivated by thoughts about the convention of painting.

GERMANO CELANT Introduction to *Arte Povera* (1969)

Animals, vegetables and minerals take part in the world of art. The artist feels attracted by their physical, chemical and biological possibilities, and he begins again to feel the need to make things of the world, not only as animated beings, but as a producer of magic and marvelous deeds. The artist-alchemist organizes living and vegetable matter into magic things, working to discover the root of things, in order to re-find them and extol them. His work, however, does include in its scope the use of the simplest material and natural elements (copper, zinc, earth, water, rivers, land, snow, fire, grass, air, stone, electricity, uranium, sky, weight, gravity, height, growth, etc.) for a description or representation of nature. What interests him instead is the discovery, the exposition, the insurrection of the magic and marvelous value of natural elements. Like an organism of simple structure, the artist mixes himself with the environment, camouflages himself, he enlarges his threshold of things. What the artist comes in contact with is not re-elaborated; he does not express a judgement on it, he does not seek a moral or social judgement, he does not manipulate it. He leaves it uncovered and striking, he draws from the substance of the natural event—that of the growth of a plant, the chemical reaction of a mineral, the movement of a river, of snow, grass and land, the fall of a weight—he identifies with them in order to live the marvelous organization of living things.

Among living things he discovers also himself, his body, his memory, his gestures—all that which directly lives and thus begins to carry out the sense of life and of nature, a sense that implies, according to Dewey, numerous subjects: the sensory, sensational, sensitive, impressionable and sensuous.

He has chosen to live within direct experience, no longer the representative—the source of pop artists—he aspires to live, not to see. He immerses himself in individuality because he feels the necessity of leaving intact the value of the existence of things, of plants or animals; he wants to take part in the oneness of every minute in order to possess above all the "autonomy" both of his own identity and the individuality of things. He wants to feel his vitality in order not to feel that he is a solitary vital individual.

Consequently, all of his work tends towards the dilation of the sphere of impression; it does not offer itself as an assertion, an indication of values, a model for behaviour, but as an experiment with contingent existence. His works are often without a title: almost a way to establish a physical memorial testimony, and not an analysis of the successive development of an experiment.

Life, as the events that make it up, in this way, turns out to be a moment of expectant anxiety, in which the objects accomplished do not present themselves under the form of inert things but as stimulating subject matter—a part of the world in an established and determinate moment—subjective actions that one leans upon in which animals, plants, minerals and men move themselves in an autonomous way.

* Germano Celant, "Introduction," in Celant, ed., *Arte Povera* (Milan: Gabriele Mazzotta, 1969); translated as *Art Povera* (London: Studio Vista; New York: Praeger, 1969), 225–30. By permission of the author and Macmillan Publishing Company for Studio Vista.

in art, in politics, in science as a free design of itself, tying itself to the rhythm of life for an exhaustion, immediate and contingent, of real life in action, in facts and in thought.

In the first case, being, living, working makes art and politics "rich," interrupting the chain of the casual in order to maintain in life the manipulation of the world, an attempt to conserve also "the man well endowed when faced with nature"; in the second case, life, work, art, politics, behaviour, thought "poveri," employed in the inseparableness of experience and consciousness with the political and mental event, with contingency, with the infinite, with the ahistorical, with the chain of individual and social motivation, with man, with environment, with space, with time, with the social situation. . . . The declared intention of doing away with every discussion, misunderstanding and coherence (coherence is in fact a characteristic of concatenation of the system), the need of feeling life continually going on, the necessity, dictated by nature itself, to advance at jumps, without having to collect the exactness the confines that govern modifications. Yesterday, therefore, life, art, existence, manifestation of oneself, manipulation, political beings, involved because based on a scientific and technological imagination, on the highly specialized superstructure of communication, on marked moments; a life, an art, a manifestation in itself, a manipulation, categorical and class-conscious, that—separating itself from the real, as speculative actions—isolates artistic, political and behavioural art with the aim of placing it in a competitive position with life: a life, an art, a policy, a manifestation of itself, a metamorphic manipulation, that through agglomeration and collation, reduces reality to fantasy; a life, an art, a behaviour, a manipulation, frustrated—as a receptacle of all of the real and intellectual impotence of daily life—a life, an art, a moralistic policy, in which judgement is contradictory, imitating and passing the real, to the real itself, with a transgression of the intellectual aspect in that which is really needed. Today, in life or art or politics one finds in the anarchy and in the continuousness of nomadic behaviour, the greatest level of liberty for a vital and fantastic expression; life or art or politics, as a stimulus to verify continuously its own level of mental and physical existence, as urgency of a presence that eliminates the manipulation of life, in order to bring about again the individuality of every human and natural action; an innocent art, or a marvelousness of life, more political spontaneity since it precedes knowledge, reasoning, culture, not justifying itself, but lives in the continuous enchantment or horror of daily reality—a daily reality that is more like stupefying, horrible poetic entity, like changing physical presence, and never allusive to alienation.

Thus, art, life, politics "poveri" are not apparent or theoretical, they do not believe in "putting themselves on show," they do not abandon themselves in their definition, not believing in art, life, politics "poveri," they do not have as an objective the process of the representation of life; they want only to feel, know, perform that which is real, understanding that what is important is not life, work, action, but the condition in which life, work and action develop themselves.

It is a moment that tends towards deculturization, regression, primitiveness and repression, towards the pre-logical and pre-iconographic stage, towards elementary and spontaneous politics, a tendency towards the basic element in nature (land, sea, snow, minerals, heat, animals) and in life (body, memory, thought), and in behaviour (family, spontaneous action, class struggle, violence, environment).

The reality, in which one participates every day, is in its dull absurdity a political deed. It is more real than any intellectually recognizable element. Thus, art, politics and life "poveri," as reality do not send back or postpone, but they offer themselves as self representatives, presenting themselves in the state of essence.

JANNIS KOUNELLIS

Structure and Sensibility: Interview with Willoughby Sharp of *Avalanche* (1972)

WILLOUGHBY SHARP: What artist inspired you then?

JANNIS KOUNELLIS: Obviously an artist is in love with something at every period. Most people loved Van Gogh, and I did too.

WS: And when you arrived in Italy, which new art did you become interested in?

JK: Burri.

WS: What were your first impressions of contemporary art in Rome?

JK: It was a very particular situation. It wasn't just that it was the post-war, but the post-post-war as Effie puts it. Well, in the post-post-war period, the only true artists were Burri and of course Fontana.

During the first year in Rome I did a lot of thinking. I discovered there was a contemporary sensibility, which obviously did not exist in Greece. Then in '58, '59, I began to do a certain kind of painting with letters and a little later with numbers. When you make a lot of the same work people think it's a style, but that wasn't the real purpose of the paintings, so I decided to move on.

WS: Did Cy Twombly influence this work?

JK: Well, we showed at the same gallery. But I don't know. . . . He was an indirect influence.

WS: What did you do after the paintings of '62?

JK: After that I did a painting every day of the week. Large stripes in different colors. Monday was pink.

WS: Was this symbolic?

JK: No, the colors were not symbolic. It just happened that there was a certain color that was right for each day.

WS: Did that occupy a lot of time?

JK: Oh yes, a year and a half.

WS: What do you consider your last painting?

JK: Well, the ones before the letter paintings were meant to be sung. I used to sing them all the time. In 1960, for example, I did a continuous performance, first in my studio and then at the Galleria Tartaruga in Rome, in which I stretched unsized canvases coated with Kemtone, a housepaint, over all the walls in the room, and painted letters over them which I sang. The problem in those days was to establish a new kind of painting—something after Informal Art.

WS: Was this your first performance?

JK: Yes, one of the first.

WS: How does this work relate to your present sculpture?

JK: The concerns are similar—it's a reflection on art. Now I know this calls for a longer explanation. In all previous painting up to the Impressionists painting was an end in itself. It had its own value, which was the result of a certain kind of history. My intention is to provoke something entirely different. I don't consider painting an end in itself. In my work, painting is not bound up with a whole idealistic culture which assigned an independent value to painting. Not that my work is a complete innovation. The Dadaists were involved with a certain discourse in which the object was not considered an end in itself. And that's what Duchamp's

* Willoughby Sharp, "Structure and Sensibility: An Interview with Jannis Kounellis" (2 August 1972), *Avalanche* 5 (Summer 1972): 16–25. By permission of the author.

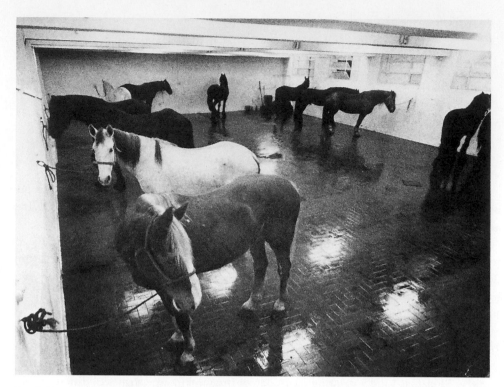

Jannis Kounellis, *Cavalli* (Galleria L'Attico, Rome), 14 January 1969. Courtesy of the artist.

piss pot is about. That idealistic culture, which in Italy was epitomized by Benedetto Croce, is precisely the kind of attitude which historically has always generated Mannerism. Whereas I am demonstrating the contrary.

ws: What is the relation between the painting and the performance?

jk: In this case the painting is simply a convention, but that's very important because it establishes a dialectic between a structure and a sensibility. Without a structure you cannot set up a dialectic. The painting represents a continuing, commonly held esthetic. It's a witness to history, a link.

ws: Where's the dialectic? That's the pivotal word.

jk: What I was saying was that you need to have a painting before you can have someone who criticizes it. The painting indicates a cultural canal, a specific and well-identified canal.

ws: Does this idea carry throughout your work?

jk: Yes, but more perfected. The parrot piece is a more direct demonstration of the dialectic between the structure and the rest, in other words, the nature of the parrot, do you see? The structure represents a common mentality, and then the sensuous part, the parrot, is a criticism of the structure, right? (*Loretto screeches.*)

ws: Was the horse piece that you did at Fabio Sargentini's L'Attico Gallery in January '69 a development of this dialectic?

jk: It was natural, it was a logical consequence. The important thing is that in this case, the social structure of the art gallery and its spatial organization take the place of the metal

structure in the parrot piece. What the parrot did in relation to the structure, the horses do in this one.

WS: (*misunderstanding*) What did this work have to say about the social structure of the gallery? That artists are horses?

JK: No, don't you see, it's an act of awareness. An awareness of the basic nature of a gallery, of its bourgeois origin. So I used the gallery as a bourgeois fact, as a social structure. In this case I was confronted with economic interests, and ideological interests, which are the very basis of a gallery.

WS: (*misunderstanding again*) So this was an anti-gallery expression?

JK: It was meant to accentuate the artist's physiognomy vis-à-vis the system. It's not the situation itself, but the artist's position within the system, the position of someone who has to make money. Because the artist has to assume responsibility for his work. Whereas an artist born at the end of the 19th century operated in a different context.

WS: (*still trying to understand*) Where is the social comment?

JK: It's liberating, isn't it? It's a liberation from a certain kind of art history. It's an act of awareness, and there's your social comment right there.

WS: But the use of animals in a gallery implies that there was a shift from the gallery as a place to show paintings to the gallery as something else. I'm trying to find out what the shift was. You say that the horse-gallery space interaction served as a liberation from tradition, past art. But how do you conceive of the gallery space? Is it like a theater?

JK: Now listen. I believe that the gallery is a convention. One gallery may suit one kind of work better than another. But basically the gallery space is conventional.

WS: You mean you couldn't have done it at Lucio Amelio's Modern Art Agency in Naples.

JK: That's true, it wasn't possible. But space aside, it was impossible because the total situation in Naples is quite different.

WS: In what way did the space suggest the work?

JK: That's not the point—it's a matter of approach. I look at the place and then I present a certain work. I try to find a place that suits the work.

WS: You exhibited your *Coal* piece at Galleria La Bertesca, Genoa, in 1966, which superficially resembles certain coal works which Smithson did a little later. How were your concerns different from Smithson's?

JK: Well, I think these things by Smithson are derived from many sources, even a certain type of Japanese art and the whole Zen mentality which leads him to make the mountain from the outside—no, it's a very different problem.

WS: What were your specific concerns in that work?

JK: It's still the same basic idea as in the parrot piece, only that there the structure was not so felicitous, it's structured more according to a particular design. But there is still a dramatic relationship between structure and sensibility.

WS: What I'm really trying to get at is the development of your work.

JK: Well, you know, any work that one does springs from a particular historical context. Therefore there is no progression of work independent of the events which make it change. So in order to give an account of the development of a work, one has to talk not just about the work itself, but also about the significant encounters one has had, human events, and the others, the social and historical ones, which are vaster, more far-reaching. In fact, you must continually sustain a certain kind of mature vision. So it's impossible to explain the work as

an end product, for if you do, you extricate it from the historical mesh. (*Loretto caws.*) Now how does America come into it? It's quite obvious that it does. In America there is also a structural process, but "structuralism" in America ends up by being an apology.

ws: Why?

jk: Because it is completely in keeping with the system. There is a history behind European structuralism, which flourished during the Russian Revolution. It was based on a new revolutionary order, for which in fact it was an apology. It was sympathetic to this system and made propaganda for it. Whereas I see the American structure as Byzantine— Byzantine in the sense of being an apology. I was talking to you about my work, and you asked, "Why the soil and the cactuses?" Precisely in order to put the structure in a contradiction. Well, in order to provide a criticism of the structure, to allow the artist sufficient freedom to comment on everything that happens. And creativity is this—it freezes this awareness. On the one hand, art and history run parallel and are not independent of each other contrary to what was believed by the idealist tradition. Now I want to instigate a critical dialogue, which begins with a political consideration—political in the sense of art politics. Why doesn't the American artist show his earlier work? Because he's surrounded by a consumer society, which would never forgive him for aging. I don't have this problem, you understand. I can show all my work, while the American is conditioned by another reality. Take the medieval painter: he was essentially a public man. But what really made the medieval painter was the person who commissioned the work. He supplied the esthetic, the dominant values, and also in a sense the iconography, and a certain kind of subject matter. Whereas today a person who commissions work is a consumer—but let's not say that, it's an ugly word.

ws: Has the course of your work been primarily logical or emotional?

jk: Both. I think my greatest aspiration—to be paradoxical—is to become a needle to sew everything up, but first to push my way in there, and sew all this history up again. I don't want to delve into the past for archeological pleasure—though it could have been that—but because the past has a reality which conditions us deep down. Then if you bring it slowly to the surface, it's full of possibilities. As far as Italy is concerned, that past is the sole reality. But it's not only true of Italy. Even for Duchamp the past was a reality, because Duchamp without the medieval phases of his thinking—the epic poems about knights— wouldn't really have been Duchamp. Duchamp came along and uncovered certain elements from the past. So it isn't a matter of pure invention. But it happened in a certain historical context, in a country like France which has had a revolution, so it wasn't quite by chance. Now in Italy the historical conditions are very different. Here the Risorgimento outburst was blocked. Here the basic reality is the cultural reality—all the rest is reformist. First of all Catholicism. With the Middle Ages there was a cultural break, which came with the transition from *Christus Patiens* to *Christus in Gloria.* Without this change there wouldn't have been either the Risorgimento or the Enlightenment. And these are all precise facts, they are all interpretive historic links. And then there emerged this Catholic mentality which made it possible in Venetian painting for a Madonna to be a whore holding a child by the hand— which I personally find magnificent—especially compared to Protestantism and orthodoxy. For myself, as an artist, I must give an accounting of this history. Perhaps you'll say, why should anyone care about this thing which interests you? Because it is an act of awareness, and an act of awareness concerns *everyone.* For it is not only Italy's drama, it's a drama which involves the entire Western world.

ws: Yes, but what about America?

jk: In America the cultural process is interpreted very differently, because the state has a different structure. America was born in revolution.

ws: So what you were saying before is that all your works are basically about the same thing.

jk: Yes, the basic thinking is the same. Besides the works we've already mentioned there's a series which derives from the same inspiration. The *Charcoal,* the *Fire,* the structure with the cacti are all related in that they are everyday, common things. While all these works deal with the same problem, it's not that rational. Very often the connection is impossible to grasp. All these works have something in common—the relation between structure and sensibility. But in others like the *Dancer* or the *Violinist,* there isn't the same relationship. They say something about a certain kind of history and a certain kind of pleasure. In the final analysis, art is about that too, isn't it? And that's why I cannot accept conceptual art, because there is a historical contradiction in it. Conceptual art developed at a historic moment and represents that moment, in keeping with a particular mentality, and for me it is a reactionary art. Because of my historical circumstances and condition I cannot accept this art—to me it represents a retrograde, Victorian attitude. Conceptual art is another kind of artistic style. And a style blocks any attempt at revolutionary thinking and activity. It has a base of new, formal invention but in terms of content it stifles all the new things that are happening in art at the same time. I don't know if I'm making myself clear, but if I were to accept this business of conceptual art I would have no reason to exist.

MARIO MERZ Statements (1979, 1982, 1984)

Arte povera (they say) has raised commercial materials of manufacturing and technology to the level of representing an artistic idea: it has destroyed or simply obscured a certain number of artistic surfaces to give back to the support the value of destiny in a broad sense. For example, it has eliminated the canvas as a surface in order to confer value on the most elementary as well as the most complex surfaces: the stasis of the floor, the stasis of the field, or the vertical stasis of the wall of bricks, stone, or cement. *Arte povera* clings to rafters and it clings to trees.

These alternative surface-destinies have liberated art from fixed programs, not to create new iconographies, but to free the art as a sounding apparatus among diverse and opposite realities rather than to enclose it or to include it in traditional supports, thereby bringing art back to iconography or the relations among iconographies. One cannot speak of relationships among Expressionism, Goya, pre-Raphaelite iconographies, or those of the Fauves, etc., etc.

This sense of newness does not protect art, it doesn't make it fan out; but it enables it to occasionally be a sounding instrument between realities, objects, and languages destined for other values, other readings. For example, Conceptual Art is a sounding instrument between printed words, luminous writings, and letters scrawled in a hasty nervous instinctive calligraphy.

Objects or natures remote from being art or artistic surfaces find a rapport in the new art.

* Mario Merz, untitled statements (1979, 1982, 1984), in Germano Celant, *The Knot: Arte Povera at P.S. 1* (Turin: Umberto Allemandi, with P.S.1, Institute for Art and Urban Resources, New York, 1985), 229, 234, 237. By permission of Beatrice Merz for Archivio Mario Merz, Germano Celant, and Umberto Allemandi and Company.

A parallelepiped of iron pipes can become a frame for pulling a flying-jib; a pile of sticks adds the intrinsic and irremediable opacity of a natural product because it unites art with the irremediable luminousness of electric power. A canvas and an image sprayed rapidly, within ten minutes of non-painterly artisan work, reveals the possibility of using this simultaneously derived image as a sounding device. This unites it with the sticks and the electric power, and treats it as stages of fleeing or lasting places to speak, to stand. It attracts these images in alternate and concatenated musical scores.

That is the art of today.

It is never a relationship between opposite iconographies, between oppositions such as "turning pages" and "iconographic stabilities." Rapid images have entered into the dimension of this art in order to involve the image and not the "painting," which is consecrated by other, more stable iconographies.

It would be absurd to traverse static and painterly iconography with a lamp, but it is possible to use a lamp when traversing the very rapid image and also "it comes as it comes," from a few seconds of making, because it is already in the intuition of the traversing. That's how it is. [1979]

.

To the animals!

The snail in the darkness of the world continues its ritual house.

The animals are here and the terrible stench of their bodies.

Their fur is not representable; as grass is furry, the animal is furry.

Only the fleeting and distant Orient has represented animal fur and vegetable fur, making them likable enough.

Western man is frightened by fur today.

See how far the abstraction of oil paint and melted bronze is from the dark will to exist, which is given off by the skin of the horse and the slow movement of the sweet muscles of the shark.

Western man has wanted to elude the problem of coexistence with animals by creating art with the totemic symbol of enmity with them.

No use repeating this eternal totem. With oil paints and cast bronze this enmity has reached the perfect joy of man's ability to create abstract forms imitating the furless outlines of animals.

Yet how much fur there is on the animals of Lascaux.

Only Leonardo Da Vinci, after maniacal dialogues and nightmares with the nature of animals, did drawings that brought animals to light. [1982]

.

To an art that knows nothing about sociology: what, everybody has different views on the subject everybody feels a touch of anguish at the thought that everybody has different views on the subject everybody looks at the same things and everybody thinks differently one is staggered by so many different shocks and thrills and questions instead the table with its basins is grandiose in its glass material! the tree is heroic in liberating obtusity from wood! ways of being beyond sociology a still is drawn up to a courageous position underneath the cliff of stones can be glimpsed the vivid liquid of the sea aluminium is the sovereign material rolled up onto itself a giant's shopping bill is on the mole the glass is self-inebriation it is part of the history of destructions strangely an art which in the sociologically patched-up world today transmits no sociology. [1984]

Differences between Consciousness and Wisdom (1985)

Consciousness takes form, wisdom dematerializes archetypes. More speed of perception of the symptoms of consciousness. More speed of consciousness. Consciousness is cerebral and emotional activity in direct, physical, electrical fusion. Hence more fusion of cerebral and emotional activity. Less concept of "wisdom."

Acceleration of the "movement" in perceptions, equals reduction of to "static" "archetypes" the "equivalencies" of wisdom. Documented in the novels of DOSTOEVSKI, in the iconography of DADA, in electronic musicology.

ICONOGRAPHY FOR BUILDING = WISDOM
ICONOGRAPHY OF CONSCIOUSNESS =
REMARKS OF
CONSCIOUSNESS
ELECTRONIC PHYSICS OF THE
BRAIN WITH ACCUMULATION OF
DATA IN THE COMPUTER AS DATA
OF CONSCIOUSNESS
THE COMPUTER IN THE BRAIN!

Walking through the twigs and leaves of the garden
THE LASER EXALTS NUMERABILITY, great phenomenon of VEGETABILITY.

The laser is more consciousness, less wisdom = reduction to archetype, responsibly even if automatically, of wisdom.

Abandoning the archetype, blocking the consciousness, the computer and the laser can become the determining factors of a consciousness that may be made physical.

CONSCIOUSNESS TAKES FORM, WISDOM DEMATERIALIZES ARCHETYPES.

Hence if life is pure consciousness, it is a series of revelations that go beyond the archetypes of wisdom.

A series of revelations, proliferations of series, classes of acceptations, too, but apart from the archetypes consumed.

SERIES OF REVELATIONS, CLASSES OF ACCEPTATIONS, A SERIES OF STEPS, FOR USE IN TIME MORE THAN IN SPACE. THEY CAN BE REPRESENTED IN SPACE AS STEPS OF CONSCIOUSNESS IF CONSCIOUSNESS IS EQUAL TO ART FOR BUILDING WITH MATERIALS IN FLIGHT. VISIBILITY AND PRACTICABILITY OF THE STEPS OF CONSCIOUSNESS, INVISIBILITY OF MATERIALIZED WISDOM. MORE EMOTIONALITY IS DERIVATION OF THE ARCHETYPES DEMATERIALIZED BY WISDOM.

Abandonment of the material of will, when the material of WILL is experience of the archetypes of wisdom. ICONOGRAPHY OF THE MOMENT AS ICONOGRAPHY OF CONSCIOUSNESS.

THE MOMENT HAS ALWAYS BEEN IN CONTRAST WITH THE ARCHETYPE OF WISDOM.

One cannot venture into a nonarchetypal logic of situations unless through the visionary quality of consciousness, which levels and arouses contrasts, slows down the feelings of wisdom and excites feelings of consciousness. The day will come in which one will have to make an effort to recognize the concatenations of the psychology of wisdom, reproduced in monuments of stone. One will recognize them, as one already does sometimes out of bewilderment, making them cross the barrier of the speed of consciousness.

The pencil point can overtake consciousness as a description of an archetype. The descrip-

* Mario Merz, "Differences between Consciousness and Wisdom," in Germano Celant, ed., *Arte Povera/Art Povera* (Milan: Electa, 1985), 207. By permission of Beatrice Merz for Archivio Mario Merz and Germano Celant.

tion of the archetype is more willful than the overtaking of consciousness. This difference of actuality causes a disenchantment toward the wisdom that reveals itself in the description of the archetype. THE INFINITE IS THE ACTIVE MNEMONIC FIELD OF CONSCIOUSNESS, while the finite has been abandoned to the builders, to the makers of archetypes of wisdom or images.

The builder regains power through the filter of consciousness, he contends with consciousness, his face is changed by the emotion of a revelation, and the builder that has stopped building thinks of a project for the palace of consciousness.

OF AN ENDLESS PALACE OF CONSCIOUSNESS, taking apart the archetypes of wisdom, using their components, which become materials of consciousness, as builders did in the centuries around the year 1000, who from archetypal columns made columns of the passage of consciousness. BUILDING CONTRASTS BETWEEN CONSCIOUSNESS AND WISDOM.

FLIGHT OF MATERIALS.

REPERCUSSIONS OF MATERIALS IN THE SOLVENCY OF THE MOMENT. CONSCIOUSNESS OF THE RESOLVENCY OF MATERIALS IN THE MOMENTS of overtaking, in the active consciousness of the materials of flight, the fruit and its archetype consciousness which makes fruit into pure alcohol?

More: the consciousness of this phenomenon.

GIUSEPPE PENONE Statements (1970, 1974)

To make sculpture the sculptor must lie down slipping to the ground slowly and smoothly, without falling. Finally, when he has achieved horizontality, he must concentrate his attention and efforts on his body, which, pressed against the ground, allows him to see and feel with his form the forms of the earth. He can then spread his arms to take in the freshness of the ground and achieve the degree of calm necessary for the completion of the sculpture. At this point stillness becomes his most obvious and active condition. Every movement, thought, or will to action is superfluous and undesirable in his state of calm, slow sinking, which is devoid [of] laborious convulsions and words and from artificial motions that would only divert him from the position successfully attained. The sculptor sinks . . . and the horizon line comes closer to his eyes. When he feels his head finally light, the coldness of the ground cuts him in half and reveals, with clarity and precision, the point that separates the part of his body that belongs to the void of the sky from that which is in the solid of the earth. It is then that the sculpture happens. [1970]

.

A finger that touches a surface leaves an image corresponding to the points of contact. This operation is the result of a clear, precise pressure which generates the image. What gives rise to the sensation of pressure derives from the mechanical deformation of the skin tissue with respect to the surface that is the object of the pressure. There exists furthermore an intimate relationship between the "points" sensitive to pressure and the hairs that participate in the process of deforming the tissues. Every sensation of pressure constitutes a model, with characteristics of space, time, and intensity, which provides different images. These images form a map of the pressure points and correspond to the exploration, conducted point by point and in a systematic manner, of a sample area of skin (fingerprint). By enlarging a "fingerprint" photographically, one obtains a clear image of the intensity of pressure exercised by the various

* Giuseppe Penone, untitled statements (1970, 1974), in Germano Celant, *Giuseppe Penone* (Milan: Electa, 1989). By permission of Giuseppe Penone and Germano Celant.

points of the skin. By projecting the photographic image on a surface (a wall) and following *with graphite* the pattern of the "fingerprint" in its different intensities of pressure, one obtains a faithful record of the pressure points of the skin surface. This affords the person who carries out the operation other types of pressure and cutaneous sensitivity. For instance, in the area of skin of the finger which is stimulated on contact with the stick of graphite, the sensation of pressure is repeated. The only variables are the point of stimulation and the size of the area of skin subjected to the contact. They *influence* the intensity of the sensation because of the prolonged action of the execution. Considering instead the role of the skin in the explication of its usual activity of transmitting information regarding objects and situations in the outside world, one has in the graphic execution of the "fingerprint" a complete identification of the material touched (the wall). In fact one exercises, in a particular way, a movement of the fingers which explore the surface (the wall) with the stick of graphite. The slight disturbances that are imparted to the area of skin affected transmit vibratory "waves of impact" which bring the skin to a state of cutaneous excitement that makes it possible to make contact with the surface and to decipher the structure that characterizes it. To record graphically the photographic enlargement (of the fingerprint), one must continuously vary the pressure of the stick of graphite against the surface (the wall). The pressure, which initially was made on a small area of skin, becomes a complex phenomenon that involves, in a single unitary presence, many of the psychophysical structures of the person who carries out the operation. There exists, furthermore, a relationship between the initial operation (the fingerprint) and the final one (the transcription of the photographic image of the fingerprint). In fact, whereas the "fingerprint" is a *total image* proportionate to the pressure exercised by the entire area of skin involved, the transcription of the enlargement of the fingerprint is a *total image* proportionate to the pressure exercised by the person in constructing the single details of the photographic image. [1974]

TERESA MURAK The Seed (1975)

The seeds of cress sown on my shirt and sprinkled with water have swollen and burst in the dark. I water them every hour, I do not sleep, I keep watching with the light on.

Saturday, Feb. 22. The sprouts begin to penetrate the fabric. They cannot pierce it. I help them with light. I water them more frequently.

Sunday, Feb. 23. The roots are strong, germinant, white. Single white and yellow and greenish leaves are beginning to appear. Night. The stems grow unevenly and incomparably quicker than the roots.

Monday, Feb. 24. (Balance upset). I try to help putting wet gauze underneath. It does not help. I have watered them seventy-five times so far. Night. I change the arrangement of the shirt, I take it down from the hanger. I cut it and spread it on foil, the roots down. All the leaves develop within two hours. The roots lift the fabric. The cress has grown fluffy and healthy.

Tuesday, Feb. 25. I water it and think much about it.

Wednesday, Feb. 26. The cress is growing stronger. The roots make up a compact elastic layer inside the shirt.

Thursday, Feb. 27. I water less frequently. The ramified roots hold the water longer.

Friday, Feb. 28. The cress keeps growing.

* Teresa Murak, "The Seed" (1975), in *Teresa Murak* (Belsko-Biała, Poland: Galeria Bielska, 1998), 38. By permission of the author.

Teresa Murak, *Lady's Smock,* 6 June 1975, performance at Galeria Labirynt, Lublin, Poland,
with artist wearing a cotton smock with watercress seeds that had sprouted while it was
worn. Courtesy of the artist and Bielska Gallery BWA, Bielsko-Biała, Poland.

Saturday, March 1. The green is becoming luscious.

Sunday, March 2. The plant has reached its maximum height and full green.

Monday, March 3. After eleven days I put the cress shirt on and my body gets into contact
with it. The contact will go on long, until I get tired in a half-sitting position. I want to hold
out as long as possible. 1975, Repassage Gallery.

In spring 1974, I grew a cape on the floor of my room. As soon as the cape had reached
full green, I went out. I passed a few streets, including Krakowskie Przedmieście, and got to
Victory Square. It was mid-March, nature was still asleep, and my cloak was a green, happy
garden. I thought that perhaps the people I met would be glad. Their response varied. Some
people stopped to wonder, others were delighted.

Patrick Dougherty, *Running in Circles,* 1996, Tickon Sculpture Park, Langeland, Denmark. Courtesy of the artist.

PATRICK DOUGHERTY Statement (2007)

I construct large temporary structures that are built on site from tree saplings gathered in the nearby landscape. Snagged together without the use of tools or any supportive hardware, these sculptures respond directly to their surroundings and interact with a particular space to build drama and visual excitement. Most installations take two to three weeks to complete and during the eight-hour work days, I meet the users of the space and am able to react to the subtleties of the given situation. I feel and study the site in the presence of the growing sculpture and, as awareness accumulates, I can react to and fine-tune the sculpture itself. The advantage of my process is my ability to adjust the scale to fit the dimensions of the space.

My sculptures are about gesture, motion and the movement of line and force through space. The actual construction process is not a sedate studio activity; instead, it is one that uses large motion and the entire body. The physicality of the process of making is evident in the final sculptures. Improvisation and constant reaction are an important part of my process, as is a celebration of the ephemeral.

I believe one's childhood shapes his or her choice of materials. For me, it was exploring the underbrush of my hometown in North Carolina, a place where tree limbs intersect and where one can imagine in the mass of winter twigs, all kinds of shapes and speeding lines. When I turned to sculpture in the early 1980s, it seemed easy to call up the forces of nature and incorporate the sensations of scoring, sheering, and twisting into the surfaces of my

* Patrick Dougherty, untitled statement, 12 January 2007, sent to Kristine Stiles. By permission of the author.

sculptures. The saplings, so plentiful along my driveway, became the raw material with which to sketch out a series of large gestural forms. Using the shafts of a branch one way and the finer top ends in another, I developed a body of work that I have come to think of as *Shelters of Transition*.

Running in Circles

I envisioned a sculpture that, like the winds and currents along the coast of Langeland, might gather powerful local forces and send them sprawling through a line of poplar trees in a single gesture. I imagined "sketching" this work in the treetops using other branches and limbs gathered in the willow groves nearby, swirling the sculpture in large ovals along its length to invite all those who approach along the roadway from Rudkøbing to glimpse the ocean and its wonderful reflected light.

OLAFUR ELIASSON Interview with Jessica Morgan (2001)

OLAFUR ELIASSON: The sense of time that I work with is the idea of a "now." I would say that there is a timeline, which is obviously divided by "now" and the past and the future. But I don't think it is really possible to talk about the past and the future—however, maybe it is possible to talk about memory and expectations. My "now," my sensation of now, comes from the idea of the subject from which it derives. I can say that my past and my future are "now" for the world (in my work). Or *your* memory and *your* expectation are now for me. Your past will always be now for me in the sense that the experience and the subject are the only link for me to know your past. . . .

Let me try to explain through an example: if I am sitting in a boat, like I did this summer, going down a river, I am "now" in the boat, at this spot on the river, and the landscape on the banks passes me as time. If I stand on the bank and the river passes me, the water which is further up the river is also "now" even though I know that it is not yet here. Our belief in time is just a construct. . . .

History is not external and objictified in a situation but is inside the spectator. I expect the spectator to bring history or memory and culture with them. I take it for granted that the memory of the spectator is a part of the project. But it is very important to see that when the spectator comes to the site, the past of that particular person, or rather the memory of that person—to the extent that it is called on through recognition in the installation—is "now." So that even the past and the expectations of the future will be "now." What interests me is that I think, there is often a discrepancy between the experience of seeing and the knowledge or expectation of what we are seeing. . . .

I think it happens almost automatically. Let's say that if the piece or installation is working well, then it works in the sense that it supports not only the immediate experience— the experience of the spectator with the installation—but also the spectator's ability to see her or himself in that particular situation. And that means that you will have the opportunity to see yourself seeing. And this is where you can see this discrepancy. . . .

* Jessica Morgan, excerpts from "Olafur Eliasson: Interview," in *Olafur Eliasson: Your Only Real Thing Is Time* (Boston and Ostfildern: Institute of Contemporary Art and Hatje Cantz, 2001), 16–23. By permission of the interviewer, the artist, and the publishers.

Olafur Eliasson, *The weather project,* 2003 (monofrequency lights, projection foil, haze machines, mirror foil, aluminum, and scaffolding); Turbine Hall, Tate Modern, London. © 2003 Olafur Eliasson. Photo by Jens Ziehe. Courtesy of the artist; neugerriemschneider, Berlin; and Tanya Bonakdar Gallery, New York.

JESSICA MORGAN: Tell me a little about how you define the "representational" and the "real." . . .

OE: I have set up this scheme for myself, and it is something which maybe works best between me and my work, as I see difficulties when I try and transfer it onto the world and how we see. I work with a simple scheme where there is the real at one end and the totally representational at the other. I am not sure that either of them actually exists in the extreme— or maybe they do but that's not the point. I think there are different mechanisms that cause us to move up and down these levels of representation, and I think one of the most important is our sensual involvement. I would say that the engagement of our senses is proportional to our level of representation. . . .

JM: So how would your photography, which deals again with a different temporal structure—geological time as opposed to the ephemeral—fit into this structure?

OE: The photographs deal with it in the sense of researching our way of seeing and systematizing seeing. But they are all derived from this so-called "Icelandic landscape," so it has a biographical reference as well. The photographs are about different ways of seeing. For example, if I were to walk up a mountain it would become more real. If I fall in the snow it becomes very real. But if I am lying in the snow and let's say I look down the mountain at the landscape, and it looks like a postcard, I jump to seeing a picture which is more like a painting. What I see is like my own memory of a landscape. And it is very representational, as it is obviously something similar to something I have seen somewhere else. . . .

The photos all together work as studies . . . for the installations or for the issues that the installations also deal with. I am trying to not hide that they are photos, which is why I never worked with really big formats, so that it is obvious that it is representational. . . .

JM: For example?

OE: Well, the yellow room [*Room for one colour*] where there is nothing but the spectator. You are looking at yourself in a duotone and there is nothing else but the yellow color. Is that then representational or real? Or, as I believe, by making it "representational," it becomes more real as we are so used to the real that it is representational. By putting this yellow filter on top of everything it becomes like a picture. But since we are in the picture and in fact experiencing it, and since we don't exactly know it and recognize it, it becomes real again. By making it hyperrepresentational, we have a real experience—so that you see something that you don't normally see. The eyes have a better vision when you have less color. It is like looking at a black and white photo; your brain compresses and handles the photos much better.

JM: Why do you think that is?

OE: Firstly, because the eye has more yellow in the retinal surface, but also our ability to recognize gray shades is much higher than our ability to recognize color shades. So in a duotone with only two colors, we can define images much clearer and we have a kind of hyperseeing. The fact is that we see more than we think we are seeing, and so this refers again to the line of representation. . . .

JM: You describe your aim as to have the audience "see themselves seeing" or "sense themselves sensing," and the way I read this is that it is a self-conscious recognition of this process of experiencing all time as "now"—which is the simultaneous experience of both memory of the past and the present, the latter inevitably altering the memory and itself immediately becoming the past. So what would you say is the significance of this process of "sensing oneself sensing"—is it something as fundamental as the creation of self or self-awareness?

OE: "Sensing oneself sensing" is our so-called "new" ability to see oneself in a situation. The training of our consciousness as a third person has developed more, I think, with my generation in particular. . . .

The point is that seeing oneself from the outside allows us to see from the other person's perspective. And I think there is a generosity in our ability to evaluate ourselves from the perspective of another person. It also allows for a certan level of self-criticality. But that same ability is what perhaps allows you to say that you see yourself from the point of view of the city, or the space or the piece even. Works of mine might even suggest that the reading makes more sense the other way around. Such that the spectator puts herself in the position of the object, which then becomes the subject, such that the spectator is being looked back at by the object—a reversal of the subject and object. And that is, I think, a generous gesture.

CAI GUO-QIANG Foolish Man and His Mountain (1996)

Realized projects are like bright fireworks in the sky. Unrealized projects are the dark nights. Both are both parts of the artist's work. But the dilemma is that when people look up at the sky, they want to see fire flowers, not darkness.

Realized works leave behind substantial documentation. After a while, such images begin to replace the memory of the project itself. For this reason, an unrealized project stays with me, paradoxically, much longer—I remember it through the original imagining the work. Tatsumi Masatoshi, my technical assistant, often says, "when it works, it's an accident; when it doesn't, it's the inevitable."

In Australia, I failed miserably on two consecutive occasions. The first project, for the Asia Pacific Triennale in Brisbane, was called *Dragon or Rainbow Serpent: A Myth Gloried or Feared: Project for Extraterrestrials No. 28* (1996). My idea was to detonate gunpowder fuse in mid air. It then comes down like a bolt of lightning into the water, like serpents through the river, climbing up onto land, across roads, and finally disappearing underneath a bridge—very much like the Rainbow Serpents in the Aborigines' folklore. Before the opening, we were working on an empty lot outside the pyrotechnic company, while the company staff were inside the factory disposing of some unused firework shells from the night before. I was sitting in the shade of a truck, quality-checking our fuse connections, when I heard Bang! Bang! Bang! from inside the factory. I saw everyone running away from the factory, and I followed. I could feel the heat and force of the explosions behind me, pushing me forward. We ran all the way to a nearby highway, and looked back. Explosion after explosion was going off in the factory and spreading onto the lot where we'd been working. I could see that our work would have passed the quality test: all the fuses blew up perfectly with no interruptions, all the way to the edge of the highway. I saw the wife of the company president crying. I asked her where the bulk of the fireworks was being stored. She suddenly remembered and ran back to the lot and drove away the truck that I was working by. After the explosions subsided the fire department opened the truck and found it was loaded with three tons of gunpowder. Had it exploded, we would have all perished. She saved her husband too, who was still inside the building. Though severely burnt all over his body, miraculously he was able to walk out of the factory alive.

Amazingly, Asia-Pacific Triennale invited me back for the next edition. But after three years, I no longer wished to complete that first project. I gave a new proposal, which was also set on the river. This proposal was to link together ninety-nine aluminum boats, forming a long chain, pulled by a motorboat that would glide across and down the river. Each boat was to be filled with an alcohol mixture that would burn at a low temperature, producing a glowing blue flame. I wanted the event to take place around 10 o'clock, when it's completely dark out. As the guests leave the Queensland Art Gallery, where the opening was held, they would see a long, quiet line of bluish glowing light winding down the river. The idea was good and technically feasible. After many discussions with many experts, it was agreed that the last boat should have some kind of device to keep it from tipping over. Since all the boats are linked together, if one is overturned, the rest would follow. A keel was installed to the bottom of the last boat for balance. Somehow, the keel got bent out of shape. But no one realized this at the time. On the evening of the event, we set the boats into the river. What a sight! All together the chain stretched over 100 meters in length. Gliding over the first turn everything was smooth, but at the second turn, the last boat tipped over and sank! The domino effect

* Cai Guo-Qiang, "Foolish Man and His Mountain," www.caiguoqiang.com/shell.php?sid=3. By permission of Cai Studio.

dragged the other ninety-eight boats, one by one, down to the bottom of the river. I was sitting in the motorboat that led the dragon. And from where I was, it was an awesome sight. As each boat was being pulled down, it rose up like a tombstone, then slowly sinking into the water, dragging the next boat with it. Within two minutes the dark water had swallowed all the boats. There was nothing anyone could do to stop it. Had this happened closer to where the audience was, everyone would have thought it was great—as though it were planned. But no one saw any of it. Only my family, along with a few museum people, could see the sinking dragon. My wife cried, but my daughter said, "Why? It's so much better this way!" Everyone else waited in the cold for forty minutes to see the dragon, but no dragon would arrive that night. A few days later, the work to salvage the sunken boats began.

Gunpowder projects are difficult, but other kinds of projects have suffered too and never saw the light of day. Like *Yu Gong Yi Shan,* or *Foolish Man Moving the Mountain.*[1] In 1996, the Solomon R. Guggenheim Museum was organizing an exhibition on 5,000 years of Chinese civilization called "China: 5,000 Years." There was going to be a section of contemporary art and I was invited to participate. The main exhibition borrowed the finest works from the best museums in China and many national treasures would be on display. My idea for the exhibition was to borrow some huge boulders from a mountain top in China, hire local farmers or workers to roll the rocks down the mountain, ship the boulders to New York, displaying them in the museum, along with the national treasures. When the show closed, I'd send them back to the mountain in China, where the workers would push the rocks back up the mountain exactly where they were originally found. But after a year's preparation the museum decided to cancel the contemporary section of the exhibition altogether because of political pressures. And so that was it. No project. Still now, every time I see the curator, we laugh and say what a pity it was that such a foolish but delightful project was never realized.

JEFF WALL Gestus (1984)

My work is based on the representation of the body. In the medium of photography, this representation depends upon the construction of expressive gestures which can function as emblems. "Essence must appear," says Hegel, and in the represented body it appears as a gesture which knows itself to be appearance.

"Gesture" means a pose or action which projects its meaning as a conventionalized sign. This definition is usually applied to the fully realized, dramatic gestures identified with the art of earlier periods, particularly the Baroque, the great age of painted drama. Modern art has necessarily abandoned these theatrics, since the bodies which performed such gestures did not have to inhabit the mechanized cities which themselves emerged from the culture of the Baroque. Those bodies were not bound to machines, or replaced by them in the division of labor, and were not afraid of them. From our viewpoint, therefore, they express happiness

1. The title comes from the famous Chinese story of *Yu Gong Yi Shan,* literally meaning "foolish man moving the mountain." The basic story goes that an old man had a big mountain in front of his house that blocked his view. One day he started to dig at it, taking the rocks away. He had his sons and grandsons helping him in the digging. Everyone laughed at him and called him foolish, but he said, "I may not be able to do it myself, but I have my children, and my children have their children. One day we will move the mountain."

* Jeff Wall, "Gestus" (July 1984), in *Ein anderes Klima: Aspekte der Schönheit in der zeitgenössichen Kunst / A Different Climate: Aspects of Beauty in Contemporary Art* (Düsseldorf: Städtische Kunsthalle Düsseldorf, 1984), 37; reprinted in *Jeff Wall: Selected Essays and Interviews* (New York: Museum of Modern Art, 2007), 85. By permission of the author, courtesy Marian Goodman Gallery, New York.

Jeff Wall, *Dead Troops Talk (a vision after an ambush of a Red Army patrol, near Moqor, Afghanistan, winter 1986),* 1992, transparency in light-box. Courtesy of the artist.

even when they suffer. The ceremoniousness, the energy, and the sensuousness of the gestures of Baroque art are replaced in modernity by mechanistic movements, reflex actions, involuntary, compulsive responses. Reduced to the level of emissions of biomechanical or bioelectric energy, these actions are not really "gestures" in the sense developed by older aesthetics. They are physically smaller than those of older art, more condensed, meaner, more collapsed, more rigid, more violent. Their smallness, however, corresponds to our increased means of magnification in making and displaying images. I photograph everything in perpetual close-up and project it forward with a continuous burst of light, magnifying it again, over and above its photographic enlargement. The contracted little actions, the involuntarily expressive body movements which lend themselves so well to photography, are what remain in everyday life of the older idea of gesture as the bodily, pictorial form of historical consciousness. Possibly this double magnification of what has been made small and meager, of what has apparently lost its significance, can lift the veil a little on the objective misery of society and the catastrophic operation of its law of value. Gesture creates truth in the dialectic of its being for another—in pictures, its being for an eye. I imagine that eye as one which labors and which desires simultaneously to experience happiness and to know the truth about society.

JOLENE RICKARD Frozen in the White Light (1994)

Probed pores, plucked hairs and sucked marrow from our bones and no one knows who we are.

. . . The visual record of Indian people is mainly one of the outside looking in. When early trade expeditions began, representations of Indian people found their way to Europe to entertain and misinform. Indian as noble, stoic, savage, primitive, childlike, heathen, and gro-

* Jolene Rickard, "Frozen in the White Light," in *Watchful Eyes: Native American Women Artists* (Phoenix: Heard Museum, 1994), 15–18. By permission of the author and The Heard Museum, Phoenix, Arizona.

tesque mapped the psychological and geographic landscape of peoples and lands misrepresented as uninhabited. Ultimately, by compressing the multiple and complex identities of sovereign indigenous peoples into one tragic, vanishing space—typically located somewhere in the plains in the late nineteenth century—what 400 years of genocidal warfare could not accomplish, visual misrepresentation did. No longer heard, no longer seen, "Indians" became part of America's past. Or so it was said.

The intersectioning discussion of multiple cultures in the American and global cultural landscape provides an entry for this moment of indigenous renewal. Indian presence in the "West" can be felt again, but on what terms? Not news is the steady canonical movement of anthropologically-defined Indian artifact to the status of fine art. But how far has the "West" moved to acknowledge distinct indigenous worldviews? If art centers are barometers of the "West's" intellectual and emotional edge, then "Indians" are still locked in the late twentieth-century hegemonic, colonizing gaze. . . .

Retrospectively, the place Indian visual expression has in relationship to the art world was shaped by patrons and anthropologists who identified notions of "authentic," "vanishing," and "traditional" as attributes of Indian art/artifacts and tourist items. Indian cultural production has been part of the art/artifact market dialogue, fueling the formation of museums in this country. . . . Perhaps the crowning moment of this ongoing cultural subjugation was the Museum of Modern Art's *Primitivism in Twentieth-Century Art: Affinity of the Tribal and the Modern* exhibit in 1984, in which disempowered Indian or "tribal work" was used as primordial reflection of a more sophisticated aesthetic.

Is the role of indigenous creative invention forever victimized in the "West"? Burdened by the "West's" visual markers etched in the mind's eye, indigenous imaginations relentlessly continue to pierce the skin of colonization with their own art, establishing new visual markers. This art is an active resistance to ideological dominance, but it is never enough because the negotiation of what the "visual" represents has shifted from the object to its theoretical context, putting the control of our identities, that is, our survival, into the postmodern, pseudo post-colonial terrain of the ideological West of Europe and America. Noble has become environmentally conscious, vanishing has become marginal, primitive is non-western, heathen is mystic, and exotic remains exotic. The 502-year-long binary between the original mapping of the Indian/European/American exchange was about power inequity and remains so to this day. Therefore, it is difficult to understand why the excitement over inclusion in western art centers without a recognized voice in global politics. Our land nearly gone and our survival gifts (art) stolen, should Indians be grateful to be colonized once more? . . .

Do Indian artists acknowledge that unconditional inclusion in the art world obscures indigenous survival? The price tag for this unconditional marginal acceptance is to relinquish our claim of sovereignty and self-determination. By passively accepting our "equal" status with other Americans we abrogate our inherent claims to this land. The link between sovereignty and land claims is clear in Indian country. "Land," as metaphor for ecological, historical and political space/power, is what anchors our worldview. Sovereignty is a geo/political border that protects our version of reality. Oral history and visual thought or "art" carry knowledge from one generation to the next. If Indians no longer have a material and spiritual relationship with "land," then certain teachings and ceremonies cannot take place. Even when possible to transform these teachings into abstract space, without the geographic place of community experience has shown that the teachings increasingly dissipate. The debate rages that indigenous worldviews do not need to be linked to the living earth, but I have always

wondered how Indians can transform the reason for planting, hunting and giving thanks ceremonies into abstract spaces at mealtime and death.

Acknowledging the hegemonic, conflated environment of western culture and its idyllic counterpart of authentic Indian "tradition," the most promising space for understanding is somewhere in between. This space needs to balance both a political and cultural reality for Indian people. Indigenous communities need to map a revised space for our understanding of life, both internally and externally. Externally, a parallel theoretical space addressing the construction of western ideologic knowledge that is not identified as "primitive," "marginal," "post-" or "neo-colonial" is necessary. Internally, we need a formal rejection of the "West's" categorization of our understanding of life's order by focusing on what is our practice. . . .

Acknowledging that the people that came before us developed relationships with the natural order of life that could sustain human beings and not eliminate other types of life is of great importance. The life-sustaining condition of this continent, documented during the period of contact, is evidence of the significant cultural construct of our ancestors. This cultural construct, from my perspective, is based on what the Haudenosaunee call the "original teachings." Most indigenous communities have teachings, or knowledge, understood today and historically through a complex system of verbal, visual, physical and spiritual acts, a complex system we understand as our "culture." Perhaps, this accounts for the continued interest by Indian artists in renewal themes. By linking our cultural priorities, as demonstrated by art, to critical political and philosophical dialogues anchored in our multiple worldviews, our survival continues. . . .

According to Iroquoian prophecies, we say that traditions or teachings will go underground for a period of time and then come back, the implication being "when it is safe." The traditions are carried by the people. It is not clear if it is safe or not, but the people are back! "Traditional" thinking is a way of watching and observing "conditions" for our survival. Survival is a finely-negotiated space that is financially secure as well as spiritually renewable. Art, in the late twentieth century western sense of the word, has been a unique product of both aspects of our survival. The teachings which anchored indigenous people to the land were passed on both visually and verbally within our communities and the "art" of today bears witness to that continuum of knowledge. But, if the art is the evidence, what is the message?

Be wary of being "spotted." White lights bounce through the blackness hoping to "spot" a deer. Frozen by the bright light, a hunter has an unfair advantage to kill. A hunting technique in the late twentieth century serves as a ballast for the latest trap, inclusion in a theoretically hostile space. Artists, the "watchful eyes" of indigenous communities, must guard against the spotlight of the "West," lest you are caught, then shot.

SUSAN HILLER The Word and the Dream (1993)

When I use words I use them as materials in a material sense. I can do anything with words that I can do with materials like paper or paint—superimpose, blend, collage, tear, etc. I've used words quite a lot, beginning at a time when it wasn't fashionable in this country because the older modernist ideas hung on for ages—now it's considered OK again. But in the first

* Susan Hiller, excerpts from "The Word and the Dream" (1993), in Barbara Einzig, ed., *Thinking about Art: Conversations with Susan Hiller,* with an introduction by Lucy Lippard (Manchester: Manchester University, 1996). By permission of the author. The text is an excerpt from a considerably longer text, first presented as an illustrated talk to students at the University of Exeter in 1993.

interview I ever gave to an art magazine I said I lived far away from words. That increases my respect for them. I've learned to cope with temporary spells of mental incoherence that eventually formulate themselves quite precisely in a piece of work. I can articulate clear thoughts about my work and ideas if I'm patient enough to let them focus themselves non-verbally first. This transaction between the nonverbal and the verbal makes it seem to me that representing or describing a thing or feeling means it's already in the past. So words seem to have more to do with memory and retrospection than with the present, the now. I value some invitations to speak because there is an unspoken within them, a further invitation to formulate a theme or link between different works I've made, to place them or illuminate them. I try to use these occasions to deepen my own understanding, rather than to produce a thumbnail sketch of my practice or a snapshot of the highlights of my career . . .

I'm going to make a confession; I don't believe in theory. I don't believe theory will save art. (That's a reference to Susan Sontag's idea that moralists always believe the caption can redeem the photograph.) In other words, I don't believe that words can correct images, that theory can radicalize art, that thinking can reform practice, that the ethnographer knows more than the natives.

I don't believe in theory, but I do believe in research and in experience and in knowledge that's embodied, not split off and relegated to the mind separately. Personally, I've never known a mind without a body. What this means to me, according to my own experience, is that one needs to re-feel everything as an artist and not take up ideas and issues that are second-hand or generalized as any kind of truth to pin your work to. At the same time I want to emphasize that I believe thoughts and feelings are collective, not private, that there are social and cultural formations that generate knowledge. This is a fascinating paradox of human being, and it's what artists deal with. Dreams are located somehow just here, in the paradoxical intersection of subjectivity and privacy with socio-cultural determinants. . . .

This brings me to my piece called *Dream Mapping,* which took place in 1974 as a collective work for ten invited participants. I found a site in the country where there was an unusual occurrence of fairy rings, circles formed by the *marasmius oreades* mushroom. I wanted to look into some traditional British ideas about dreaming, for example the idea that if you fall asleep in a fairy circle you'll be carried away somewhere, perhaps lose your mind and gain fairy knowledge, etc.

I gave participants a dream notebook with a map of the dream site on the cover. I provided books with space for both words and pictures, and asked participants for a month before we met as a group to try to start evolving a way of notating dreams visually, to try to get away from the idea of telling dreams in words. So we had diagrams, notations, maps in order to break apart the received notion of dream as a narrative in linear time. I saw my role as creating a structure in which certain possibilities of memory and awareness would be enabled, and perhaps a collective language would emerge.

After a month, we met at the site. For three nights people slept out of doors in the mushroom circle of their choice. This was already taking the dream from inside to outside. Since we came together as a group to do this, it was already a collective situation. Each morning I asked participants to make drawings or diagrams of their dreams, omitting all words. Perhaps it could be said that the art took place privately and individually, while only the documentation—the drawings—is visible. I like these dream maps very much. There is a light-hearted struggle to make something visible.

Dream Mapping was something open-ended, experiential, more like a roughly choreographed dance than a scientific experiment. The final stage of the piece was making three

collective dream maps. We took all the individual diagrams from each day and superimposed them, ending up with a collective dream notation of the group's nightly dreams. We certainly didn't have the same dreams, although there were interesting coincidences. But perhaps because of culturally determined limits on kinds of notations, there were very intriguing overlaps where two or more individual dream events overlapped. We all became very elated whenever this happened. For instance, on one night 'dolphins' overlapped with 'clouds' and this became the concept 'cloud/dolphin,' which seemed to have to do with the way new concepts or ideas come about.

The documentation of *Dream Mapping* is now the only evidence that something took place. Although this work was something of a touchstone for me later, it was otherwise limited to the participants, who were also the audience. I guess I believe, although some of you may not, that there is something communicative about art, that it needs to go beyond the artist and the primary audience for the work, and that if it doesn't it doesn't really qualify as art because it isn't available, it isn't part of a discourse.

So I began to think that *Dream Mapping* and other works were problematic. Nevertheless, I'm still very fond of this piece. Realism may have dictated my conclusion that an end product that can freely circulate over time and space is a better solution than a one-off event. But speaking retrospectively, I would like to emphasize that what a piece of work like *Dream Mapping* does very effectively is to focus participants on lived experience and embodied knowledge, eliminating any mind/body split. Embodied knowledge isn't the same as theory, it isn't exactly the same as visual experience either. Embodied knowledge may be in conflict with theory and with visual experience. We have knowledge of what we have physically known, and we have knowledge *via* what we have physically known. This knowledge can't be alienated from us but our access to it may be limited and confused.

I believe that art can allow us access to this knowledge, which will be different for each of us. In this way, art is a vehicle for shifts in understanding and behaviour. *Dream Mapping* effectively intensified the ordinary. By making public what is normally private, it showed what we didn't know that we knew. In the years since *Dream Mapping,* I've tried to find other ways to express this understanding to wider audiences, while still emphasizing the reflexive, performative aspects of art practice. Many more people have seen *Belshazzar's Feast* or *Monument* than could ever have participated in or heard about works like *Dream Mapping*. But I hope my original intention of allowing participants access to their own capacities for revelation, in the context of collective histories, hasn't been forgotten or substantially diluted in my later works.

RIRKRIT TIRAVANIJA Interview with Mary Jane Jacob (2004)

RIRKRIT TIRAVANIJA: [*The Land*] began in 1998 when Kamin Lertchaiprasert, another Thai artist, and I bought some land near the village of Sanpatong, about twenty minutes from Chiang Mai. We saw this place as an open space to cultivate ideas of social engagement. And we wanted other artists to join us.

In the middle of the land are two working rice fields; this area had been a rice field.

* Mary Jane Jacob, "Interview with Rirkrit Tiravanija," in Jacquelynn Baas and Mary Jane Jacob, eds., *Buddha Mind in Contemporary Art* (Berkeley: University of California Press, 2004), 171–77. By permission of the interviewer, the artist, and the publisher.

Now the harvests are shared by the participants and some families in the local village afflicted by AIDS. Surrounding the fields, artists are developing different structures for living that reference meditation huts in Buddhist monasteries. I have made one formed around three spheres of need: the base floor is a communal space with a fireplace for gathering and exchange; the second floor for reading, meditation, and reflection; and the top floor for sleep.

The land is also without electricity or water, so this project has offered an opportunity for experimentation with natural renewable resources as sources for electric and gas. The artist group Superflex from Copenhagen has been developing their idea of the Supergas, a biogas system. The Dutch collaborative Atelier Van Lieshout has been engaged in developing the toilet system, which would be linked to the production of biogas. Arthur Meyer, an artist from Chicago, has been interested to develop a system for solar power. The Thai artist Prachya Phintong is working with fish farming. So it goes on . . . without end.

MARY JANE JACOB: Do you think that artists are playing a particular role in finding new solutions, a new way of living?

RT: No, I don't think it's just artists though, of course, they certainly are. I'm also quite interested in finding people in other fields who think in very open, creative ways to deal with life. I'm interested in working with these ideas as demonstrations: people demonstrating what they're doing. . . .

I think it's interesting that there is a great curiosity about Buddhism now. I mean, I was always trying to explain certain things, but not really being able to, and then just putting the word "Buddhism" to it. At some point I was just having to use that word and, of course, when I would say it, people saw a completely different image from what I was actually trying to show, because I'm talking about a kind of practice. And my idea of practice is probably not even the same as another person's idea of practice, or what practice means in terms of the idea of Buddhism.

MJJ: Does your own Buddhist practice or training originate in your family upbringing?

RT: My practice is more or less a daily structure, and it is not at all ritualistic. In that sense, I'm more a minimalist. A lot of practice within Thai culture is ritualistic, but I tend to try and pare it down more to a daily-life condition.

MJJ: Is *The Land* a Buddhist practice for you?

RT: *The Land* is quite interesting because there are two of us who started it and we each approach it very differently. Kamin sees it as a very physical thing, as a place for certain kinds of meditation and certain practices that could happen within the Buddhist field. I see it partly like that, but also within a much more open structure. I see it as being much more fluid. It's not so much a discussion as a kind of action . . . more about a relational structure that emanates from Buddhist concepts—at least for the people who pass through there, who have dealt with things there, and who have been working on projects there. They can feel that. It is not just from Kamin and me, but also from people around.

MJJ: So you see Buddhism and art more in a temporary, ephemeral, or living way?

RT: Yes, I see it as a changing thing. Whereas, in a sense, Kamin sees it as a form which you can follow. But he's trying to reach a point where there isn't any form . . . where you just can be . . . you're just there. It's quite interesting.

MJJ: And does that mean that you and Kamin will both arrive at the same point someday?

RT: Yes, we should! Probably not at the same time but at the same point. So, in that sense, I can see myself as being the one who says "yes" to everything and makes no decisions. Whereas Kamin would be much more reluctant to open it up, because he doesn't know how it would

go, how it would work out. And that's interesting to me in terms of just how we negotiate it. But my negotiation is actually to not negotiate at all. So it would be the kind of conversation where I wouldn't have to say anything, but Kamin would still know what I was thinking about it.

MJJ: Would you say that your openness is about trust, allowing a work to connect to people in their own way, suspending judgment?

RT: I think the idea of judgment is interesting in relation to Buddhistic practice. I always get asked, "What are your expectations?" And I say, "I don't have any," because I don't predetermine things. And, "Do you feel it's successful or not?" and I say, "I don't measure things that way, in terms of good or bad, or success." It changes how you look at what happens. And I think that is quite important in terms of living in a Buddhistic way: not to have preconceived structures or to close off possibilities; but it's not even about being open or closed; it's just about being blank. In a way, of course, you can receive more if you are empty. . . .

MJJ: Do you make an "art of living" (a phrase that's been used to describe your work) or do you "live life as a work of art" . . . ?

RT: I don't know, it's a strange thing, but I suppose, for me, art is a kind of space to be used. It's a very open space. It is not like I would rather make it art or life . . . it's a lot less clear than that.

MJJ: Not a dichotomy.

RT: Yes, but on the other hand, I think it is important to bring both art and life together. And I suppose, in that sense, that is—for me—a certain kind of Buddhistic practice: to bring art and life together is to arrive at that place where one recognizes that they are shared. I mean, living a life could be an artistic practice—it is a creative one and one that is in search of a balance or an openness.

MJJ: Would you say that your work and life are seamless, a continuum without edges marked by projects undertaken?

RT: Or edges don't even exist to have a seam. In my own practice, I actually make very little. We're communicating more than we are making anything. It's interesting to realize that I'm not actually making very much, but instead there is a lot of thought in terms of what will happen, a projection forward. Partly I think in this way because I am in a certain system, a certain structure—the art world. But the ultimate aim would just be to be on the field, on the land.

MJJ: Still you can't let go of the art world frame?

RT: No, you can. It's like flying a kite. You can let it go, but there is a reeling out of a line which has not yet come to the end. At the same time, you know there is an end and there is a point where you let it go. . . . I think at some point the kite will stay in the wind. It can sustain itself and then you don't need to hold onto it anymore.

8 PERFORMANCE ART

Kristine Stiles

In the early 1950s a few artists in Europe, Japan, and the United States began to use their bodies as the material for making visual art. Responding to the existential threat posed by the Holocaust and the atomic age, some artists aimed to increase art's experiential immediacy, declaring the primacy of human subjects over objects and offering the body as both the form and the content of aesthetic consideration. Extending the boundaries of painting and sculpture into real time through movement in space, these artists also sought to engage spectators more directly in art by connecting it to the material circumstances of life. This shift augmented the conventional representational, or metaphoric, signifying function of art objects and introduced a performing subject linked to a viewing subject through the metonymic function of connection. In this way performance art demonstrated the contingency of bodies.[1]

Artists who presented their bodies in the context of art resumed the performative practices of early-twentieth-century modernist movements, from Futurism, Dada, and Surrealism, to the various Russian avant-gardes and artists associated with the Bauhaus in Germany. Documentation about these early performances began to become available in the postwar period with the publication of *The Dada Painters and Poets,* an anthology of artists' writings edited by Robert Motherwell (1951); Robert Lebel's *Marcel Duchamp* (1959); and *Dada: Documents of a Movement* (1958), an exhibition catalogue from the Kunstverein für die Rheinlande und Westfalen in Düsseldorf.[2] The Düsseldorf exhibition traveled to Frankfurt and Amsterdam, where huge crowds viewed hundreds of Dada pictures, objects, and literary works produced between 1916 and 1922 in Europe and the United States. But whereas the performative aspects of the modernist avant-gardes had been a marginal activity, performance in the second half of the century became an independent medium in the visual arts.

Live actions are impossible to circumscribe within limited definitions, and artists initially invented different terms to describe their performance works, including happenings, Fluxus, actions, rituals, demonstrations, destructions, and events, as well as body, direct, actual, and concrete art, among others. By the early 1970s the stylistic and ideological differences among these various forms had been subsumed by critics into the single category of performance art, despite protests by many artists, especially in

Europe, who complained that the term depoliticized their aims and disarmed their work by its proximity to narrative theater.[3] By the mid-1980s the bias against theater, associated by some artists with entertainment rather than with social change, had shifted, and many performance artists increasingly included language and theatricality in their work. In the early twenty-first century, as global performance emerged, many artists returned to purely bodily action bereft of speech.

One of the first manifestations of performance art after World War II occurred in Japan, where Jirō Yoshihara (b. Japan, 1905–72), a gestural abstract painter and influential teacher, founded the Gutai (Concrete) group in 1954. He also edited *Gutai* (1955–65), a journal documenting the group's theories and actions. Artists associated with Gutai came to performance from various disciplines: visual art (Kimiko Ohara, Kazuo Shiraga, and Atsuko Tanaka), law (Saburo Murakami), literature (Shōzō Shimamoto), and economics (Yasuo Sumi). Members of Gutai performed unconventional theater events and individual actions, as well as created site-specific outdoor works that reinvested matter with spirit, emphasized process over product, and introduced natural materials into the art context, anticipating aspects of installation, conceptual, process, and performance art, as well as Arte Povera by a decade.

Georges Mathieu (b. France, 1921–2012) was the first artist to stage live action paintings for a viewing public. In 1954, in an event filmed by Robert Descharnes, Mathieu dressed in medieval military costume to paint *Battle of the Bouvines* at the Salon de Mai in Paris. Mathieu's public action paintings, characterized by his vigorous physical enactments of "revolt, risk, speed, intuition, improvisation, and excitement," suggested analogies among artistic innovation, historical battles, and political transformation. Mathieu performed these lyrical abstract paintings throughout the world, and illustrations of his actions (as well as his theories) were published widely, appearing in art journals and international magazines and newspapers like *Time, Vogue,* and the *New York Times.* In 1957 the members of Gutai acknowledged the affinity between their work and his.[4] A live performance by Mathieu in Vienna in 1959 catalyzed the artists who would create Viennese Actionism, and in Rio de Janeiro Mathieu painted a picture on the subject of *macumba* (Afro-Brazilian worship), taking up themes from the 1920s and 1930s that would anticipate the famous 1967 installation *Tropicália* by Hélio Oiticica (chap. 2).

Mathieu also mentored Yves Klein, who began to stage spectacular public events in 1957. Klein created "living brushes" in 1958 by directing nude female models to first apply International Klein Blue pigment (Klein's signature paint) to their bodies and then press themselves against canvas to create figurative imprints that he called *Anthropometries.* Klein's *Leap into the Void* (1960), a photomontage depicting an apparently gravity-defying leap from the second-story window of his dealer Colette Allendy's Paris apartment, inspired numerous artists to consider the body's materiality.

In direct contrast to such activities and repudiating the sensationalized conditions of contemporary life, the Situationist International (SI) formed in 1957 as a loose association of European artists and poets with ties to Surrealism, the Lettrists, and CoBrA.[5] Members included Guy Debord (b. France, 1931–94), Michèle Bernstein, Attila Kotányi, Raoul Vaneigem, and Giuseppe Pinot-Gallizio, among others. Employing theory as the principal means for inciting action, they published the journal *Internationale Situationniste* (1958–69), in which they agitated for an aesthetics of everyday life and the creation

of revolutionary "situations." The SI offered a sustained critique of imperialism, colonialism, all forms of domination, and the political division and control of urban space. In 1967, the same year that Debord published *The Society of the Spectacle,* the SI distributed an essay entitled "On the Poverty of Student Life" (1966–67) at the University of Strasbourg.[6] Many attribute the student protests at that university, which led to the insurrectionary street events in Paris of May 1968, to the influence of this tract. Situationist theories joined the activism of anarchistic aesthetic traditions to existentialism, psychoanalysis, Marxist analysis of commodity culture, the writings of Henri Lefebvre, and the philosophy of the Frankfurt School for Social Research. After dissolving the SI in 1972, Debord concentrated on filmmaking and wrote *Comments on the Society of the Spectacle* (1990), in which he mapped how "the integrated spectacle" had become a global phenomenon of domination.[7] In despair and poor health, and rejecting the integration of the SI into this system through academic theory, Debord committed suicide in 1994.

As a composer, poet, artist, and teacher, John Cage (b. U.S., 1912–92) also sought revolutionary ends but through entirely different means. In 1952 at Black Mountain College, Cage presented a multimedia performance that anticipated happenings, working in collaboration with the artist Robert Rauschenberg, the dancer Merce Cunningham, the musician David Tudor, and the poet Charles Olson. In 1958 Cage taught two classes on experimental music, one at the New School for Social Research in New York and the other at the International Summer Courses for New Music in Darmstadt, Germany. These courses attracted many of the originators of happenings and those who would form Fluxus, including Allan Kaprow, Al Hansen, Robert Whitman, Dick Higgins, Jackson Mac Low, and George Brecht. Cage combined Eastern philosophy with Western phenomenology. He studied the Huang Po doctrine of universal mind and Zen Buddhism with D. T. Suzuki. Using the *I Ching* (*Book of Changes*) as a composition tool, Cage introduced chance procedures as a technique for distancing art from the egocentrism that he felt had characterized aesthetic production since the Renaissance. Cage taught that consciousness is not a thing but a process; that art must entail the random, indeterminate, and chance aspects of nature and culture; that behavior continually informs a work of art as an objective state or completed thing; and that "the real world . . . becomes . . . not an object [but] a process."[8]

The term "happenings" is derived from *18 Happenings in 6 Parts* by Allan Kaprow (b. U.S., 1927–2006), a series of simultaneous, polymorphic multimedia events and actions performed at the Reuben Gallery in New York in 1959. Casting into question the boundaries between discrete art objects and everyday events, happenings visually defined the interstice between art and life. In his 1958 article "The Legacy of Jackson Pollock," Kaprow considered how Pollock's legacy informed these developments, writing: "Pollock . . . left us at the point where we must become preoccupied with and even dazzled by the space and objects of our everyday life. . . . Not satisfied with the *suggestion* through paint of our other senses, we shall utilize the specific substance of sight, sound, movements, people, odors, touch."[9] By the mid-1960s Kaprow felt that popular entertainment had co-opted and trivialized the theoretical and aesthetic aims of happenings, and he began to organize private, nonaudience, nontheatrical "activities" that required participants to explore interpersonal communication. These activities had af-

finities with the multisensory interactive objects Lygia Clark (see chap. 2) created in Brazil in the mid- to late 1960s, concentrating on mind/body unity, "living experiences," and therapeutic healing from trauma. The principal theorist of happenings, Kaprow had studied art history with Meyer Schapiro at Columbia University and over the course of his career wrote on many aspects of performance art, including its relationship to video and theater. A teacher intent on passing on "new values and attitudes to future generations," Kaprow encouraged artists to become "un-artists" committed to the transformation of "the global arena" rather than the production of marketable objects.[10]

The dancer and choreographer Yvonne Rainer (b. U.S., 1934) studied at the Martha Graham School and with Merce Cunningham in New York, as well as with Anna Halprin in San Francisco, before becoming one of the organizers of the Judson Dance Theater, a group of dancers that performed at the Judson Memorial Church in New York between 1962 and 1964. Rainer choreographed at the intersection of classical dance, Cage's ideas of chance, happenings, Fluxus, and the burgeoning movement of minimal art, including repetitive everyday movement in her dance. By 1972 Rainer had begun to make experimental films and to combine film with performance and installation art. In 1996 she made and appeared in *MURDER and murder,* a film about lesbian life and love and breast cancer.

Carolee Schneemann (b. U.S., 1939) began as a painter and also made kinetic assemblages before creating "kinetic theater," her iteration of happenings, in the early 1960s. She had read Antonin Artaud's *The Theater and Its Double* (1938), Simone de Beauvoir's *The Second Sex* (1949), and Wilhelm Reich's *The Sexual Revolution* (1936), as well as other texts considering bodily links between sexuality, culture, and freedom. These ideas informed Schneemann's belief that women's emancipation depended on the creation of a corpus of female representations able to express women's experiences. In 1963 she performed *Eye Body,* an unprecedented series of private actions documented in photographs by the Icelandic artist Erró (aka Gudmundur Gudmundsson and Ferró) that emphasized female sexuality and feminist identity politics. As Schneemann later wrote: "The erotic female archetype, creative imagination, and performance art itself are all subversive in the eyes of patriarchal culture because they themselves represent forms and forces which cannot be turned into functional commodities or entertainment (to be exchanged as property and value), remaining unpossessable while radicalizing social consciousness."[11] While Schneemann has worked in every medium, from drawing and painting to assemblage, installation, photography, film, and video, she is one of the few artists to have employed performance as a medium throughout her life.

Schneemann first performed her happening *Meat Joy* (1964) in Paris at the Festival de la Libre Expression, the first of several international events between 1964 and 1967 organized by Jean-Jacques Lebel (b. France, 1936). Notorious for advocating erotic happenings and free sexuality as a means to liberate the psyche, Lebel had developed his political, aesthetic, and philosophical position under the influence of Dada and Surrealist mentors like André Breton and Francis Picabia. But Lebel's festivals epitomized the alternative lifestyle of the Beats, which became a critical source for the radical identity of the hippie generation. In 1960, with Jean-Paul Sartre, Simone de Beauvoir, Françoise Sagan, Simone Signoret, and others, Lebel signed the "Manifesto of the 121: Declara-

tion of the Right of Insubordination in the Algerian War," and he published this tract in his quarterly *Front Unique* (Paris, 1960–61), encouraging conscripts to the French-Algerian War to desert the military. His happenings and writings also had an effect on the Paris street riots against that war.[12] Friend to Beat poets like Gregory Corso and Allen Ginsberg, a participant in Julian Beck and Judith Malina's Living Theatre, and the first artist to perform happenings in France, Lebel rejected the specialization of his diverse activities as a poet, painter, organizer, and political activist. Performance enabled him to fuse these interconnected practices into a unified form that, in his words, posed a "collective opposition" and "moral response" to institutional categorizations by church and state, revealed the "sclerotic activities of intellectuals" and the "reification and laziness of artists," and led to the restoration of art as an "act of rupture and liberation."[13]

In 1957 Wolf Vostell (b. Germany, 1932–98) adopted the concept of *dé-coll/age* as the driving theoretical principle of his work. For Vostell, *dé-coll/age* synthesized the destructive/creative dialectic of Western epistemology. The term had emerged in relation to the work of Raymond Hains, who began to collect *affiches lacérées* (torn posters) from billboard hoardings in Paris at the end of the 1940s, later exhibiting them, as did Jacques de la Villeglé, François Dufrêne, and Mimmo Rotella, as public relics recontextualized as art. Reframed in the conditions of display, *affiches lacérées* visualized the interconnected processes and links between destruction and creation, construction and deconstruction, and the objects and institutions of the fine arts and the artifacts of popular culture. Vostell extended the *dé-coll/age* principle into actual transformation in real time and incorporated images and objects from the mass media into his work. In 1959 he began to transfer pictures culled from popular magazines onto canvas and paper (a process discovered independently by Robert Rauschenberg in 1958); that same year he also began to include TVs in his environments and installations, acknowledging television as the disseminator of the "two great 20th century themes: destruction and sex." Vostell, a founder of Fluxus in the early 1960s, was among the first artists to create live events and happenings in Germany and described his large-scale happenings as functioning in the social arena like "weapons to politicize art."[14] He also published *dé-coll/age: Bulletin Aktueller Ideen* (1962–69), a germinal publication containing many early theoretical writings by artists pioneering happenings, Fluxus, and other experimental directions in art.

Fluxus, a loose international association of artists, formed under the organization of George Maciunas (b. Lithuania, 1931–78), its self-appointed chairman. A series of performance events organized by La Monte Young at Yoko Ono's loft in 1960 and the following year at Maciunas's AG Gallery in New York laid the foundation for the first Fluxus festival, which took place in Wiesbaden, Germany, in 1962. Maciunas designed Fluxus publications, organized assemblages by Fluxus artists into Fluxus boxes, theorized about the collective social identity and political ideology of Fluxus, and attempted to dictate its membership. Fluxus festivals included group and individual performances, or "events," defined by the artist George Brecht as the smallest units of a "situation."[15] Brecht's "event scores" (a term he coined) were indebted to John Cage's techniques of musical composition, which Brecht and others had been adapting to their own uses since the late 1950s. Based on a system of short textual notations, Brecht's event scores engaged performers in actions but left their realization open to an infinite number of

interpretations, from complex or simple, public or private, individual or collective, to mental or physical. Although Fluxus events were diverse in character, the single-action performance—what Maciunas called a "monomorphic" event—came to distinguish Fluxus performance from happenings.

Dick Higgins (b. U.S., 1938–98), a poet, painter, playwright, and composer, attended Cage's class at the New School for Social Research and associated with the group of artists producing happenings and theatrical events in New York. In 1962 Higgins and his wife, the artist Alison Knowles, traveled to Europe, where they participated in the first Fluxus festivals. Higgins founded Something Else Press in 1964, followed by Great Bear Pamphlets and *Something Else Newsletter* in 1966. He published many of the first manifestos, scores, and poems of artists who were creating what he called "intermedia." In contrast to the nineteenth-century concept of *Gesamtkunstwerk* (a total work of art), intermedia emphasizes the spaces between media. Higgins theorized that intermedia conjoins aesthetic formalism, new social institutions, growing literacy, and new technologies into a hybrid that acts between traditional practices rather than fusing them.[16]

The French artist Ben Vautier (aka BEN, b. Italy, 1935) ran a secondhand record shop in Nice, France, from 1958 to 1972. There he launched the journal *Ben Dieu* in 1959. Vautier became associated with Fluxus in 1962 during the period when he began proclaiming "EVERYTHING" to be art and signing the world.[17] Applying his trademark cursive writing in single words and simple sentences to canvases and objects, Vautier created *peinture écriture* (painted signatures), which functioned as a metaphor for artistic identity, signifying egocentricity and careerism, and underscored the role of personality in the art market. Vautier's works point to social relations beyond the framing schemas of the art world, as when he lived in 1962 for fifteen days as an aesthetic object in the window of Gallery One in London during the proto-Fluxus exhibition, *Festival of Misfits*. Through word and action, Vautier visualized the interconnection between the linguistic devices that organize categories of experience and the action of artists who mediate between the viewer and the thing viewed to negotiate cultural meanings. His website invites anyone to subscribe to his *Newsletter Ben,* offering manifestos and commentaries on contemporary art.[18]

Robert Filliou (b. France, 1926–87) was a member of the Communist Party and the French underground during World War II, then studied economics at the University of California, Los Angeles. In 1953 he worked for the United Nations Korean Reconstruction Agency as an economic advisor, authoring a five-year development plan for South Korea, before dropping out of mainstream society and abandoning his political affiliations. He then studied Zen and the philosophy of Mahatma Gandhi, wrote poetry, and began making art. Filliou associated with Fluxus, participated in Lebel's festivals, and created performances, installations, and videos. In 1967 he proposed an "Institute of Permanent Creation" to Allan Kaprow, who was then participating in discussions about experimental curricula organized by the State University of New York. Filliou's ideas helped shape Kaprow's concepts for educating the "un-artist." Filliou also urged that a principal aim of education should be the "creative use of leisure: work = play."

Yoko Ono (b. Japan, 1933) dropped out of Sarah Lawrence College in New York to marry the experimental composer Toshi Ichiyanagi in 1956. She became involved with

the circle of John Cage and the proto-Fluxus group in the late 1950s and early 1960s. In 1964 Ono lived and worked in Japan, where she published *Grapefruit,* a compendium of conceptual "instructions" for poetry, painting, sculpture, performance, music, and film. Her protofeminist performances of this period stressed intimacy, emotions, and the senses, especially touch. In 1969 she married John Lennon of the Beatles, and for their honeymoon the couple performed a "bed-in for peace," broadcasting live from their bed in the Hilton Hotel in Amsterdam to promote an end to the Vietnam War. Such activities extended Ono's aesthetic concepts into real-time politics in an international arena. Ono and Lennon went on to create numerous mass-media political interventions.[19] In 2002 Ono initiated a peace prize of $50,000, awarding the first prize to the Romanian Israeli artist Zvi Goldstein and the Palestinian artist Khalil Rabah on the date that Lennon was shot to death in 1980. In 2007 she created the *Imagine Peace Tower* on Viðey Island, near Reykjavík, Iceland. Throughout her career, Ono has composed, sung, and recorded her music, both alone and with other artists.

Both Ono and the Puerto Rican artist Raphael Montañez Ortiz (b. U.S., 1934) participated in the Destruction in Art Symposium (DIAS), organized by Gustav Metzger (chap. 5) and held in London in 1966. DIAS drew international attention to destruction and violence in art and culture. At DIAS Ortiz performed *Self-Destruction,* a psychophysical regression to childhood that the psychotherapist Arthur Janov later credited as the inspiration for his theory of psychophysical therapy, described in his book *The Primal Scream* (1970).[20] In the late 1950s Ortiz had begun to destroy furniture and fix the remains in what he called *Archaeological Finds.* He also edited found film footage, cutting and splicing filmic narrative to expose its underlying visual violence. In the late 1960s Ortiz's extensive knowledge of anthropology, ethnography, philosophy, and religious ritual contributed to his development of political guerrilla street theater with the playwright, director, and actor Richard Schechner, editor of the *Tulane Drama Review* (which became *TDR: The Drama Review*). They infused strategies for direct action into the discourses of performance expanded by the Guerrilla Art Action Group (GAAG), founded in 1969 by Jean Toche, Jon Hendricks, and Poppy Johnson.[21] That same year Ortiz founded and became the first director of El Museo del Barrio in New York, a "practical alternative to the orthodox museum," devoted to Hispanic art.[22] Ortiz later earned a PhD in art education at Columbia University's Teachers College, writing his dissertation on his theory of "physio-psycho-alchemy," a physical process in which participants work on "inner visioning" to become themselves "the work of art in progress."[23]

DIAS was also the first time artists throughout the world learned of Wiener Aktionismus (Viennese Actionism), the term used to describe the work of Hermann Nitsch, Otto Muehl, Günter Brus, and Rudolf Schwarzkogler, the first three of whom participated in DIAS along with the artist Peter Weibel (see chap. 5) and the filmmaker Kurt Kren. The Actionists developed an extreme form of performance, drawing on Nietzsche, Freud, existentialist philosophy, and other intellectual, as well as religious, traditions, collectively envisioning a form of direct art in which action released suppressed unconscious drives, precipitating personal and social change. They explored confrontational, often sadomasochistic and misogynistic actions aimed at visualizing pain as a means of achieving catharsis and healing. They systematically assaulted repressive sexual mores, hypocritical religious values, and physical and psychological violence

in society and the family. Scandalous in form and content, their art led repeatedly to arrests, fines, and imprisonment. Viennese Actionism remains the most influential form of body art in the history of performance art.

Hermann Nitsch (b. Austria, 1938) first conceived of the Orgies Mysteries Theater (OMT) in 1957. Condensing Dionysian orgiastic celebration, themes from Greek tragedy (especially Sophocles' *Oedipus Rex* and Euripides' *The Bacchae*), and Christian notions of guilt and redemption, Nitsch theorized that his hybrid theatrical form might provide an abreactive ritual cleansing for the destructive aspects of Western epistemology. He sought to excite the senses into metaphysical ecstasy in participatory, liturgically organized, synaesthetic works of total art (*Gesamtkunstwerk*), which were often blasphemous. Nitsch developed his theory and practice into increasingly elaborate operatic, architectural, and social forms, publishing many books on his erudite aesthetic theories. In 1998, on the grounds of his castle in Prinzendorf, Austria, Nitsch realized the OMT performance *6-Tages-Spiel (6-Day Play)*. He described his masterpiece, intended to be experienced by all five senses, as a "psychoanalytically-oriented dramaturgy [that] allow[ed] the Dionysian to burst forth from within us," that exposed "suppressed areas of inner impulses," and that involved "actions with flesh, blood and slaughtered animals" and "intoxication, eating and drinking" in order to "plumb the collective areas of our unconscious minds."[24]

Otto Muehl (b. Austria, 1925) particularly focused on the pathology of the nuclear family and its parallels in social and political life. Conscripted into the German army during World War II, Muehl survived the 1941–42 winter campaign in Russia. In 1964 he began translating the shock, degradation, and violence of war into participatory *Materialaktionen* (material actions). Comparing the body to lumpen foodstuffs, Muehl submitted his own and participants' bodies to confrontational, scatological, pornographic, and hedonistic events that satirized social and religious norms and taboos, and were aimed at catharsis and releasing the human capacity for perversity. Muehl also filmed his actions, creating a corpus of experimental avant-garde films. Frustrated at what he perceived to be the limitations of art, he founded the Actions-Analytic Organization, or AA Commune, in 1970. Organized around direct democracy, common property, communal living, free sexuality, and the collective raising of children, the AA Commune transformed his material actions into "reality art," performative realizations of *Selbstdarstellung* (self-actualization).[25] Self-supporting by the end of the 1970s, the AA Commune prospered until 1990, when Muehl and his common-law wife Claudia were accused of child abuse; Muehl was convicted and imprisoned in 1991 for seven years.[26] Paradoxically, those who exposed Muehl had joined the commune voluntarily, accepted its radical experimental sexual mores, and raised their children within its practices. Muehl's art and social project laid bare the tragic contradictions latent in some utopian communes of the 1960s, as much as they disclosed hypocritical social mores. After his release from prison in 1997, Muehl moved to Faro, Portugal, where he established another commune. There, in 2002, he developed what he called "electric painting," using a computer to paint digital photographs that he then edited into films.

In 1964 the painter Günter Brus (b. Austria, 1938) began to perform in his own installations, creating symbolic "self-destructions," "self-mutilizations," and sadomasochistic actions. His psychologically intense, physically brutal direct actions anticipated

the self-exploratory performances characteristic of performance art in the 1970s and invented a language for the body's material field of physical, psychological, and social pain. But the violence of his last action, *Zerreissprobe* (*Breaking Test,* 1970), threatened his mental state and physical safety to such an extent that Brus ceased performing. He returned to painting, creating *Bild-Dichtungen,* or picture-poem books, such as *Irrwisch* (Will-o'-the-Wisp, 1971), in the tradition of William Blake, Francisco de Goya, and Henry Fuseli. These works retain the tension between Eros and Thanatos, and the suffering, guilt, and punishment, implicit in his performances.

Between 1965 and 1966 Rudolf Schwarzkogler staged private actions for the production of still photographs, often using the Austrian artist Heinz Cibulka as his model. Schwarzkogler focused on themes of wounding and healing, and his photographs of castration became the source of a myth that he had died by self-castration, a story the Australian critic Robert Hughes circulated in a 1972 *Time* magazine article.[27] Schwarzkogler actually died in 1969, three years after his last performance: hallucinating while following a severe spiritual diet of milk and white bread, either Schwarzkogler attempted to fly from his apartment window (as Klein appeared to do in *Leap into the Void,* with which Schwarzkogler was fascinated) or he fell or jumped to his death. Opponents of performance art have used the myth of Schwarzkogler's self-castration to condemn and malign the medium for decades.

In 1966 Peter Weibel (chap. 5) and Valie Export (Waltraud Hollinger, b. Austria, 1940) entered the circle of the Viennese Actionists. They collaborated in the creation of "expanded cinema" and edited the groundbreaking documentation of Viennese Actionism, *Wien: Bildkompendium Wiener Aktionismus und Film* (1970).[28] In 1968 Export helped found the Austrian Filmmakers Cooperative. As a pioneering feminist performance, film, and video-installation artist, Export explored the body as a semiotic sign, a "signal bearer of meaning and communication." She used the body to decode social constructions of gender and sexuality and to study the effect of these formations on the psychological, sexual, and behavioral acts, development, and representation of women. In 1997 Export was awarded the Gabriele Münter Prize, the only prize in the world for women artists over the age of forty.

Milan Knížák (b. Czechoslovakia, 1940) began to perform agit-prop actions on the streets of Prague in 1962, as an affirmative alternative to the repressive experience of communism. He formed the group Aktuální umění (Actual Art), later known as Aktual, in 1964 with the artists Vit and Jan Mach, Soňa Švecová, and Jan Trtílek; Robert Wittmann later joined the group. Creating "ceremonies" and "demonstrations of objects," the Aktual artists protested the bankruptcy of Soviet-imposed socialist culture in Czechoslovakia in mock war games and street actions that included the destruction of symbols of decadent culture, from musical instruments and art to ordinary objects. Fluxus artists and others associated with happenings embraced the Aktual artists' "ceremonies," and Knížák's handmade *samizdat* books circulated widely underground in the former Czechoslovakia as well as abroad. Containing written, typed, painted, drawn, and mimeographed manifestos, drawings, poems, and theoretical writings, these aesthetic forms of resistance were prototypes for the collective defiance that spurred the liberation of Eastern Europe in 1989, resulting in the presidencies of the playwright Václav Havel (the tenth and last president of Czechoslovakia [1989–92] and the first

president of the Czech Republic [1993–2003], who had been involved in happenings), and of the musicologist Vytautas Landsbergis (the first head of state of Lithuania after its declaration of independence from the Soviet Union, the head of the Lithuanian parliament Seimas, and a member of the European Parliament, who had contributed to Fluxus).[29] When Havel became president, he appointed Knížák, who had been arrested more than three hundred times and imprisoned for his art between 1959 and 1989, as director of the Prague Academy of Fine Arts, and in 1999 Knížák became director of the National Gallery in Prague.

True to his roots in resistance, in 2008 Knížák supported awarding a prize, presented by the National Gallery, to the Czech collective Ztohoven (a pun meaning "out of it") for their guerrilla action of June 17, 2007, when the group hacked into a Czech TV weather station and broadcast a fake image of a nuclear explosion in the tourist region of the Krkonoše mountains. Asked if the prize jury had considered the fact that the group had been investigated for criminal actions, Knížák replied: "We are an artistic jury, we are not lawyers, we are not policemen."[30] For their part, Ztohoven explained the necessity of critiquing the media and advertising: "We twist, modify and transform advertisement so it speaks the language of art for at least a while. We create different commercials, those you cannot miss, and those which invoke restlessness. At the very end you might begin to love question marks more than the dreamy world of retouched faces."[31]

Like Knížák, Jerzy Bereś (b. Poland, 1930) and Miklós Erdély (b. Hungary, 1938–86) became legends for their resistance to Soviet domination of Eastern Europe. Often appearing nude in ritual-like performances and installations, Bereś presented the naked body as a radical signifier of individual freedom. Bereś trained as a sculptor at the Kraków Academy of Fine Arts before first exhibiting his work in 1955. When political tensions eased in the mid-1960s, his actions and demonstrations assumed a more direct social content, which he maintained even after the Soviet crackdown in the 1970s and 1980s. Bereś employed ambiguous gestural signs characteristic of the symbolic language invented by Eastern European performance artists as a subversive mode of communication under communism and as a means of survival and resistance.

A sculptor, painter, poet, film director, action and conceptual artist, theorist, and educator, Erdély collaborated in the first happening in Hungary in 1966, and both his writings and his work became the source for the development of the Hungarian artistic underground. Erdély organized a series of lectures on the relationship between art and science at the influential Budapest Young Artists' Club in 1974, as well as two exhibitions at the same venue in 1975 and 1976.[32] For Erdély, art constituted existential necessity, a view of art that became a catalyst for generations of Hungarian artists. He noted: "The complexity of art is demonstrated by the fact that if we succeed in creating a new concept of art, then suddenly we discover that this new concept was present in the old masterpieces, and in fact as their essential aspect."[33]

Erdély was also involved in the international movement of mail art, eventually influencing György Galántai (b. Hungary, 1941), who established the Chapel Exhibitions, or "summer studio," in a reclaimed chapel in the Hungarian resort Balatonboglár. Beginning in 1970, Galántai mounted some thirty-five exhibitions, concerts, poetry recitals, theatrical performances, and film showings there, and it became the most important

exhibition site for conceptual, performance, and installation art in Hungary until 1973, when it was banned and Galántai was identified as a "dangerous element" by the Hungarian Communist Party. The artist was thereafter monitored by the secret police every day until 1989. Nevertheless, he founded the Artpool Art Research Center in Budapest in 1979 together with the political scientist Júlia Klaniczay. Artpool made available information on art forms denied the public, organized exhibitions and art events, and published anthologies and art catalogues, as well as eleven issues of the *samizdat* magazine *Aktuális Levél* (Artpool Letter, 1983–85), which remains the most significant record of experimental art in Hungary during those years. Artpool eventually became one of the key archives in the world for mail art and conceptual and performance art.

"Who Makes a Profit on Art, and Who Gains from It Honestly?" reads the subtitle of the 1976 "Edinburgh Statement" by Raša Todosijević (b. Yugoslavia, 1945). These two questions relate to the "benefits" of art in society, and how every aspect of cultural production is involved in the realization of art. Todosijević emerged in the milieu of conceptual and performance artists that included Marina Abramović, Gergelj Urkom, Era Milivojević, Neša Paripović, and Zoran Popović, artists who began exhibiting at the Student Cultural Center, a state-sponsored alternative space that opened in Belgrade in 1970. While Todosijević probed sociological aspects of cultural production in his writings, his performances addressed the nature of art. In the 1970s he repeatedly performed *Was ist Kunst?*, questioning authenticity and originality in art. Since the late 1980s, Todosijević's series of installations entitled *Gott Liebt die Serben* (God Loves the Serbs) have included symbolic images exposing how political regimes invert ideology, a subject he also addressed in *Balkan Banquet* (2002), where a banquet table in the shape of a swastika suggested conservative, nationalist tendencies in leftist, socialist Serbia, which underlay the Balkan wars from 1991 to 2001.

Marina Abramović (b. Yugoslavia, 1946) began performing physically and psychologically challenging performances in 1973 in Belgrade. Two years later, at De Appel in Amsterdam, a prominent European alternative space for performance in the 1970s and 1980s, she met Ulay (Frank Uwe Laysiepen; b. Germany, 1943). They began living and performing together in 1976. Ulay had studied engineering before collaborating with the German artist Jürgen Klauke in performances that probed visual expressions of transsexuality, a theme taken up in the 1970s by such male performers as the artists Urs Luthi (Switzerland) and Vito Acconci (U.S.) and the British musicians Mick Jagger and David Bowie. Abramović and Ulay created "relation works" dedicated to constant movement, change, process, and what they called "art vital." Their work tested the physical limits of the body and investigated male and female principles, as well as fields of psychic energy, transcendental meditation, and nonverbal communication. Their relationship and collaboration ended with the performance *Lovers* (1988), in which the couple walked the Great Wall of China from opposite ends to meet in the middle and say goodbye. Ulay returned to photography and stopped performing in 2004, while Abramović has continued to create sculptures, installations, and performances, such as *Seven Easy Pieces* (2005), a series of seven reenactments of her own and other artists' performances, which took place at the Solomon R. Guggenheim Museum in New York. In *The Artist Is Present* (2010) she sat for eight to ten hours a day in the Museum of Modern Art in New York during her retrospective there. Abramović, who has taught

performance since the late 1990s, focuses on students' mental and physical limits, endurance, concentration, perception, self-control, and willpower in her workshops. In 2007 she acquired a theater building in Hudson, New York, two hours north of Manhattan, where she established a nonprofit foundation for performance art; she also founded a performance institute in San Francisco.

Ulrike Rosenbach (b. Germany, 1943) joined the German women's movement in the late 1960s. She traveled to Los Angeles in the early 1970s and participated in feminist performance activities in and around the nexus of artists associated with the Woman's Building. A master student of Joseph Beuys (chap. 7), Rosenbach began performing ritual actions in 1969. Almost from the beginning, she projected slide images onto her body and experimented with video as a recording and documenting device. Rosenbach has probed the patriarchal basis of art history, its mythological presentations of women, the damage such stereotypes cause to women's identity and creativity, and the strength of women to reconstitute the forms of their own visual representations and identity. In searching for a deeper understanding of the psychic and spiritual dimensions of experience, Rosenbach studied many esoteric topics, as well as Buddhism. From 1989 to 2007 she taught media art at the Academy of Fine Arts in Saar, Germany. Like Valie Export, Rosenbach was awarded the Gabriele Münter Prize, in 2004.

Born in 1935 in Pakistan, Rasheed Araeen moved to London in 1964 after earning a degree in civil engineering at the University of Karachi. A self-taught artist, he worked in numerous media, including performance, turning his attention to questions of identity, ethnicity, and colonialism in 1971 after reading Frantz Fanon's *The Wretched of the Earth* (1961). In 1972, in support of national liberation movements internationally, Araeen joined the British Black Panther Movement (later called the Black Workers Movement) and Artists for Democracy, founded by the artist David Medalla. Araeen was one of the first artists to launch an institutional critique of art, exposing the institutionalization of racism and the concomitant celebration of the exotic "other." In *Paki Bastard* (1977), Araeen performed his experience of such racist objectification.[34] In 1978 he founded and edited *Black Phoenix,* whose editorial aim was to analyze "the cultural predicament of advanced capitalism and imperialism."[35] Nine years later *Black Phoenix* became *Third Text: Third World Perspectives on Contemporary Art and Culture,* a preeminent journal addressing critical issues of race and colonialism. In 2008 Araeen participated in the Manifesto Marathon at the Serpentine Gallery Pavilion in London, authoring the manifesto "Art beyond Art: The Barbarism of Civilisation Must End!—A Manifesto for the 21st Century." He argued that it is "naïve" of artists to believe that they can remain outside "the global political system [that] reifies and commodifies" art, and that artists must "abandon their studios and . . . stop the making of objects" in order "to enhance not only their own creative potential but also the collective life of earth's inhabitants."[36]

Although Mike Parr (b. Australia, 1945) dropped out of both the University of Queensland and the National Art School in Sydney, he went on to become the most celebrated performance artist in Australia. Exploring questions of identity, memory, and states of being, Parr undertook extreme actions of endurance that challenged the physical limits of his body, using his disability as a performative aid (Parr was born with a deformed arm that was amputated and replaced by a prosthetic arm). In 1981 Parr stopped performing and turned to painting and printmaking, but in the late 1990s he

returned to performance, as well as video and installation. Broadcasting live over the Internet in 2002, Parr performed *For Water from the Mouth,* remaining alone in a room for ten days without food and only drinking water, while surveillance cameras continuously recorded his actions. In *Malewitsch (A Political Arm)* (2003), Parr sat for thirty hours with his nonprosthetic arm nailed to the wall in opposition to the Australia government's treatment of refugees and asylum seekers.

Across the world in California in the late 1960s and early 1970s, many institutions began offering courses on experimental art, including the University of California campuses at San Diego, Irvine, and Berkeley. The nascent feminist movement led to the first women's art program, begun at California State University at Fresno in 1969 and moved to the California Institute of the Arts in 1971. In Los Angeles this program led to the 1972 exhibition *Womanhouse* and the 1973 opening of the Woman's Building (a nonprofit public art and educational center focused on showcasing women's art and culture). A large number of performance artists emerged within this experimental environment. A key figure in the burgeoning Los Angeles performance community, Paul McCarthy—together with such artists as Barbara T. Smith and John Duncan and the critic Linda Frye Burnham—organized numerous performance venues in the 1970s and 1980s. McCarthy also taught performance, video, and installation at the University of California, Los Angeles, from 1982 to 2002, educating generations of experimental artists. While influenced by Viennese Actionism, McCarthy's performances addressed American popular culture from Hollywood and Disneyland to the hidden violence and incest in families.

In her work of the early 1970s, Eleanor Antin (Eleanor Fineman; b. U.S., 1935) also worked with theatrical elements, creating alternative personas, often constructed from historical characters. "I like to transform the past," she explained. "The past is always being reinterpreted in light of the present." Born to Polish immigrants, Antin grew up in the Bronx among Jewish intellectuals from Eastern Europe and Russia. She drew on her knowledge of Yiddish theater, in which her mother had been an actress, to create her fictive characters, including Eleanora Antinova, an African American ballerina in Sergei Diaghilev's Ballets Russes, and the title characters in her performances *The King* (1972), *The Ballerina and the Bum* (1974), and *The Adventures of a Nurse* (1976). Appropriating fragments of other identities into her performative autobiography, and working in conceptual, performance, and installation art, as well as film, Antin disrupted notions of the autonomous subject and questioned claims for the factual basis of history, anticipating aspects of postmodernism. Between 2000 and 2009, Antin staged *Classical Frieze,* a film and a series of photographic montages re-creating classical themes and images as if through nineteenth-century neo-classical painting but shot through with the cultural locale and aesthetic tropes of Southern California.

Joan Jonas (b. U.S., 1936), based in New York, similarly introduced theatrical elements into her performances and videos, frequently assuming the role of her alter ego, Organic Honey. In *Organic Honey's Visual Telepathy* (1972), she dressed in a feathered headdress, mask, and costume. In *The Juniper Tree* (1976), a ritual presentation of objects in which the costumed artist used mirroring as illusion to play with questions of identity, subjectivity, and the objectification of the body, Jonas included diverse literary sources, from poetry, mythology, and fairy tales, to Japanese Noh theater. Her hybrid

performances had a singular impact on the theatricalization of performance in the 1980s. Two decades later, in *The Shape, the Scent, the Feel of Things* (2004), both a performance and an installation, Jonas drew on the art historian Aby Warburg's eclectic research methods (to which she compared her own working approach) in order to visualize Hopi rituals like the Snake Dance, which she saw in the 1960s and Warburg witnessed in 1895 and 1896 while traveling in Arizona.

The artist, educator, and theorist Suzanne Lacy (b. U.S., 1945) began using performance as a way to enact social commitment in the early 1970s. Lacy earned a degree in zoology and studied psychology before becoming involved in feminist art programs in Southern California. In 1971 Lacy and Judy Chicago collected oral histories of rape, a corpus of stories that led to numerous collaborative performances with the artist Leslie Labowitz and others. Through site-specific installations, videos, and large-scale collective actions devoted to social and urban themes, Lacy shifted attention from the individual artist to the community and to organizing (especially with women). Lacy also utilized the mass media to promote awareness of and discussion about aging, race, labor, and youth. From 1991 to 2000 she worked with residents of Oakland, California, under the acronym TEAM (Teens + Educators + Artists + Media Makers) to give youth a voice in public policies. Lacy has served in various academic positions, including dean of the School of Fine Arts at the California College of the Arts (CCA) in Oakland and chair of fine arts at Otis College of Art and Design in Los Angeles. She cofounded the Visual and Public Art Institute at California State University at Monterey Bay with the artist Judith Baca in 1996–97 and was founding director of the Center for Art and Public Life at CCA in 1998. In Oakland, Lacy served on the education cabinet of then-mayor Jerry Brown and later as an arts commissioner for the city.

While a graduate student, Chris Burden (b. U.S., 1946) gained international attention for his performance *Locker Piece* (August 26–30, 1971), during which he lived for five days without food (but with a five-gallon supply of water) in a two-foot-square locker at the University of California, Irvine. Seven months later, partly in response to the killings of Vietnam War protesters at Kent State and Jackson State universities, Burden performed *Shoot* (November 19, 1971), asking a marksman friend to graze his arm with a bullet. Burden's concise actions, structured carefully around dramatic temporal sequences of indeterminate duration, drew on the aesthetics of minimalism, as well as conceptual and process art. Heightening the anxiety arising from the inherent violence in some of his works, Burden used his body as a sculptural form to test his own psychological and physical boundaries. He stopped performing in 1983, but in his subsequent sculptures and installations he continued to confront spectators with ethical questions about the social implications of art and the viewer's relationship to it, including the viewer's responsibility for the welfare of the artist. In *Samson* (1985), at the Henry Art Gallery in Seattle, Burden installed a turnstile, winch, and 100-ton jack that threatened to split apart the building every time a visitor went through the turnstile. In contrast, for *Urban Light,* begun in 2000, Burden collected and restored 202 antique cast-iron Los Angeles street lamps, eventually installing them in 2008 at the Los Angeles County Museum of Art, where their austere, elegant luminosity became a source of urban pride.

In San Francisco, Tom Marioni (b. U.S., 1937) opened the Museum of Conceptual

Art (MOCA) in 1970 to host performances by such artists as Bruce Nauman (chap. 7), Vito Acconci, Barbara T. Smith, Howard Fried, Terry Fox, and Robert Barry (chap. 9), as well as a host of European artists. Marioni astutely named MOCA a "museum," thereby attributing the art he sponsored with institutional and historical significance. MOCA was one of the first artist-directed alternative spaces in the United States to specialize in installation, performance, conceptual art, and video.[37] Marioni also edited *Vision* (1975–82), a magazine that he treated as an exhibition space, "curating" issues on art from California, Eastern Europe, and New York, among other topics. Marioni divided his own performances into private drumming actions and public social events like *Café Society,* held on Wednesday afternoons at Breens Bar (downstairs from MOCA), which he considered "social art." These gatherings for drinking beer and conversing condensed his activities as curator, editor, and organizer into a performative metaphor of social exchange.

In 1973 Marioni lived handcuffed to Linda Montano (b. U.S., 1942) for three days, an action that raised questions regarding the boundaries between art and life and the differentiation between private and public. A decade later, in 1983, Montano and Tehching Hsieh agreed to live tied together by an eight-foot rope for one year. In these and other works, Montano explored the nature and construction of identity. She has also synthesized in her works many religious traditions, from Catholicism to Buddhism and Hinduism. Montano, a novitiate at the Maryknoll Convent in New York from 1960 to 1962, studied yoga with R. S. Mishra in California and New York from the 1970s to the 1990s; lived at the Zen Mountain Monastery in Mount Tremper, New York, from 1981 to 1983; and in 2007 began following and then teaching Madan Kataria's laughter yoga. Believing in the therapeutic value of art, Montano has made the daily vow central to her art, creating *7 Years of Living Art (1984–1991) + Another 7 Years of Living Art (1991–1998) = 14 Years of Living Art; followed by 21 YEARS OF LIVING ART (1998–2019).*

Tehching Hsieh (b. Taiwan, 1950) dropped out of school at the age of seventeen to paint. He served in the military from 1970 to 1973, the year in which he stopped painting and did *Jump Piece,* an action in which he broke both of his ankles. He arrived in the United States in 1974, remaining as an illegal alien until he received amnesty in 1988. The performances he carried out during this time concentrated on duration, isolation, and survival: living one year in a cage (1978–79), one year punching a time clock every hour on the hour (1980–81), one year homeless on the streets of New York (1981–82), and one year tied to Montano, among other one-year performances. In *Thirteen Year General Plan* (1986–99), also known as *No Art Piece,* Hsieh did not make, talk about, or engage in art-making in any way, stating that he aimed to keep "myself alive." Since 2000 Hsieh has continued to live in the present. When asked if he had abandoned art, he replied: "I'm not finished yet; I'm still alive."[38]

Born in Korea, Theresa Hak Kyung Cha (1951–82) began making art in the San Francisco Bay Area. She received degrees in comparative literature (BA and MA) and art (BA and MFA) from the University of California, Berkeley. She also studied filmmaking and critical theory in Paris. In her work Cha drew on conceptual art to represent the immigrant's loss of identity. Her performances, videos, and texts analyzed the émigré's language, constituted in exile and alienation, and attended to estrangement

and kinship (familial and associational), especially in the dissociated states of language known to those who live on the periphery of adopted cultural conventions, languages, and sign systems. Her single-channel video *Vidéoème* (1976), for example, fused the French words for "video" and "poem," dividing language sequentially into "constituent semantic units" to emphasize hidden relationships and breaking apart words to alter the emotional impact: "*vidé* = emptied; *vidé* o = emptied zero; *o ème* = very least."[39] In her book *Dictée* (1982), Cha experimented with the juxtaposition of print and images. Just before the book's release, Cha was murdered in New York, where she had moved in 1980.

In 1970 the artist and curator Willoughby Sharp used the term "tool" to describe how performance could be a means to manipulate objects, carry out tasks, and demonstrate both process and change in material conditions and mental, physical, and psychological states.[40] The work of Vito Acconci (b. U.S., 1940) exemplifies all three approaches to performance. Acconci began as a poet and, with Bernadette Mayer, edited *0 to 9* (1967–69), a mimeographed poetry magazine featuring writings by poets and visual artists. In 1969 Acconci shifted from performing poetry (or what he called "language acts") to body actions in which he monitored the corporeal aspects of routine, physical, improvement, durability, endurance, and exhaustion. Similar to Bruce Nauman (see chap. 7), who had begun to film his own studio activities in 1967, Acconci used photography and video to document his private actions. Acconci gradually reintroduced language into his work in stream-of-consciousness monologues that meandered over dense personal and psychological subject matter. His emphasis on narrative altered the previously nonverbal orientation of body art and influenced such diverse artists as Laurie Anderson, Spalding Gray, and Karen Finley. Acconci structured his actions around dyadic relations—private/public, secret/known, trust/violation, performer/spectator—and the staging of exhibitionistic and voyeuristic desires. He also considered the relationship of the body to questions of power, gender, and sexuality. Acconci stopped performing in the mid-1970s when he felt that his reputation as a performer interfered with the content of his work. He became a designer/architect and formed Acconci Studio in 1988, turning to interactive sculptural installations and working in architectural and landscape design.

In the summer months of 1971, the same year that Adrian Piper (b. U.S., 1948) became a *svanistha*, "a self-guided yogin who, in the Vedic tradition, meditates upon the all-pervading state of ultimate reality," she studied Immanuel Kant's *Critique of Pure Reason* (1781).[41] Alone in her New York loft, she performed *Food for the Spirit,* reading passages from Kant's text into a tape recorder while practicing yogic meditation and documenting the experience of psychic emptying (which made her "fear losing [her] self") by photographing her mirror image, such that the photographs depicted her gradually disappearing into spectral darkness.[42] Piper was twenty-two when she wed Kant's Western philosophy to South Asian metaphysical practices in this existential study and performance of identity. The following year she began to stage street actions in her *Catalysis* series (1972–73), confrontational performances that forced viewers to encounter her unexpected behaviors, producing in viewers psychological responses akin to the mechanisms of racism. A first-generation conceptual artist, she pioneered the intersection between language and action. Piper, who had graduated from the School of Visual

Arts in New York in 1969, received a BA in philosophy from the City College of New York (1974), studied Kant and Hegel with the philosopher Dieter Henrich at the University of Heidelberg (1977–78), and earned a PhD in philosophy from Harvard University (1981), working with John Rawls, a leading scholar of moral and political philosophy. In 1985 Piper became a *brahmacharin,* "one who practices celibacy as a yogic discipline."[43] Throughout her career, in her theoretical writings, performances, conceptual works, installations, and videos, Piper has challenged racism through the combined lens of Eastern and Western philosophy and practices, continually engaging the ethical question of individual and social responsibility and accountability.

Martha Wilson (b. U.S., 1947) also began to research the conditions of identity in the early 1970s. Educated in Quaker schools, Wilson left the United States at the height of the Vietnam War to study in Canada, receiving her MA in English literature in 1971. That same year she began to create private performances, photographing herself in her appearances as different personas. In 1974 Wilson moved to New York, where she performed at the Kitchen and other alternative spaces. In 1976 she opened Franklin Furnace in her TriBeCa storefront loft, an alternative space that would become one of the world's longest-running venues for performance art. Starting in the 1980s, Wilson became known for her satirical performances impersonating such political figures as Nancy Reagan, Barbara Bush, and Tipper Gore. Wilson has commented, "Individuals play at being themselves in order to realize themselves."

The multilingual writer, poet, and artist Guillermo Gómez-Peña (b. Mexico, 1955), a pioneer of Latino performance art, has assumed a variety of personas in his work in order to address transcultural identity, the diasporic condition of emigrants, and the politics of migration confronting the individual and the state. Wearing fabulous, humorous, exotic costumes, Gómez-Peña has enacted identities ranging from a macho Chicano, a "Border Brujo," and a Latin American dictator to a "Warrior for Gringostroika" (a playful reference to globalization and U.S./Mexico border culture).[44] In 1979, the year after he arrived in the United States from Mexico, Gómez-Peña performed *The Loneliness of the Immigrant,* lying covered and tied in an imported Mexican bedspread on the floor of an elevator for twenty-four hours. This work established the cross-cultural symbolism of his art, which is characterized by acerbic yet poignant humor and scathing insight into racial stereotypes. In *Strange Democracy* (2009), Gómez-Peña commented on the end of the Bush era, the hurdles faced by the Obama presidency, and the politics of exclusion (anti-immigration), particularly as evinced in the construction of the U.S./Mexico border wall. A founding member of the binational arts collective Border Arts Workshop/Taller de Arte Fronterizo (1985–90), Gómez-Peña edited the arts magazine *The Broken Line/La linea quebrada* (1985–90) and in 1993 cofounded the collective La Pocha Nostra with Roberto Sifuentes and Nola Mariano in Los Angeles, which moved in 1995 to San Francisco, where it became a nonprofit organization and in 2001 initiated an annual performance workshop.

Building on earlier work by such artists as Martha Wilson, Jacki Apple, Eleanor Antin, and Lynn Hershman, Cindy Sherman (b. U.S., 1954) began to photograph her performative self-transformations in 1978. The first of her numerous photographic series devoted to different themes were black-and-white images that imitated film stills from the 1950s. In subsequent series she continued to employ makeup and costumes, as

well as props and scenery, to develop fictional personas and scenarios, as well as photographically re-creating renowned paintings from Western art history. Sherman's photographs address theoretical and social issues related to power, class, gender, and sexuality, as well as the territories of violence, decay, disfigurement, violation, and abjection that gained increasing public attention from the 1990s into the twenty-first century.

Like Sherman, Yasumasa Morimura (b. Japan, 1951) has created performative photographs featuring himself in varied roles. Morimura received a BA from Kyoto City University of Arts in 1978, and by 1985 had become what he called an "appropriation" artist. Borrowing paintings by Leonardo da Vinci, Rembrandt, Édouard Manet, and Frida Kahlo, as well as photographs of famous Hollywood starlets, Morimura montaged his head and body into the images, which he also overpainted and to which he added photographs and computer imagery, among other techniques, restaging and revising the gender, historical specificity, and overall semiotic message of the original. In 2006 Morimura subverted renowned historical portraits, inserting his face in place of those of Mao Zedong, Che Guevara, Adolf Hitler, Albert Einstein, and others. He also pictured himself within documentary images of historical scenes, such as on the street in Eddie Adams's 1968 photograph of the execution of a Vietcong soldier in Saigon and in Bob Jackson's 1963 photograph of Jack Ruby killing Lee Harvey Oswald, the assassin of President John F. Kennedy. Morimura's photographs question documentary practices by undermining the pictorial integrity of historical images, at the same time that they reawaken memories of events through the shock of their distortion.

In contrast to Morimura with his private studio performances, Karen Finley (b. U.S., 1956) emerged in the New Wave, artist-run San Francisco club scene of the early 1980s, when she was earning her MFA at the San Francisco Art Institute (1982).[45] Finley's raucous, sometimes scatological, psychologically charged, and emotionally intense performances featured her assuming different personas, haranguing her audience, condemning violence against women, domestic abuse, and homophobia, and addressing similar controversial social subjects, all the while appearing as an abject abused woman herself. Finley's relentlessly confrontational performances were repeatedly censored. In the 1990s she drew national attention when she and three other performance artists (Tim Miller, John Fleck, and Holly Hughes) sued the National Endowment for the Arts for withdrawing their grants.[46] In 2008 Finley used the downfall of Governor Eliot Spitzer of New York, the customer of a prostitution ring, as a pretext for addressing the subject of political sex scandals and the resulting family conflicts. A prolific writer, Finley has authored a number of books, from poetry and satire to memoirs.[47]

Coco Fusco (b. U.S., 1960) began performing in 1988, after receiving a BA from Brown University in 1982 and an MA from Stanford University in 1985. Fusco later received a PhD from Middlesex University, in 2007. Between 1992 and 1994, she and Guillermo Gómez-Peña, her collaborator at that time, presented different versions of *The Year of the White Bear and Two Undiscovered Amerindians Visit the West,* a performance in which the two artists exhibited themselves in a cage to highlight racist colonialist practices, especially the anthropological displays of indigenous peoples. Fusco's performances have been characterized by incisive, often derisive, critiques of ethnic stereotypes, especially of Latin women. In *A Room of One's Own: Women and Power in the New America* (2006), she concentrated on women's role as interrogators in the war on

terror, instructing her audience from her ironic book *A Field Guide for Female Inter-rogators*. In addition to performing internationally, Fusco has curated such shows as *Only Skin Deep: Changing Visions of the American Self* (with Brian Wallis) and published several books.

Katarzyna Kozyra (b. Poland, 1963) first came to public attention with *Pyramid of Animals* (1993), her diploma installation for a degree in sculpture from the Fine Arts Academy in Warsaw. A symbolic tribute to animals, the work consisted of a taxidermy dog, cat, rooster, and horse, with a video of the horse being euthanized and skinned. Drawing on the Grimm Brothers' fairy tales and the taxonomy of nature in pyramids of development, Kozyra posed controversial and challenging ethical questions regarding euthanasia and the killing of animals. She subsequently gained international notoriety with *Bathhouse* (1997) and *Men's Bathhouse* (1999), covertly filming first women and then men in the famous thermal baths at the Hotel Gellert in Budapest. For the latter, Kozyra disguised herself as a man, with a prosthetic penis and other body modifications, in order to enter the men's bathing areas. These works raised issues of privacy, voyeurism and ex-hibitionism, beauty and aging. Continuing her examination of identity and behavioral gender stereotypes, Kozyra filmed *Boys* (2001–2), a video in which attractive young men appear dressed only in jockstraps with labia-like attachments, and *Punishment and Crime* (2002), a work examining the preoccupation of men with weapons and explosives. In her multimedia theatrical performance series *In Art Dreams Come True* (2003–8), the artist explored the artificiality of social roles, playing a number of different female types, including an opera singer, femme fatale, fairy tale princess, and transsexual.[48]

The performances of Jimmie Durham (b. U.S., 1940), a Cherokee Indian, grew out of his political activism as a leading figure in the struggle for Native American rights. Durham had moved to Geneva, Switzerland, in 1968 to study at the School of Fine Arts, but he returned to the United States in 1973 to work as a political organizer for the American Indian Movement, eventually joining its Central Council. During this time he also served as director of the International Indian Treaty Council, which he represented at the United Nations. At the end of the 1970s he began to create uncon-ventional performances and sculptures depicting North American Indians. A poet and essayist as well as an artist, Durham has published extensively. In 1994 he returned to live in Europe, where his interest in architecture and national narratives became the subject of sculptures, performances, installations, and videos aimed at undermining architectural and historic notions of monumentality, stability, and permanence. In 2009 the Musée d'Art Moderne de la Ville de Paris described Durham as "protean," an art-ist working "in unexpected ways and tweaking reality with a mix of violence and humour."[49]

Ten years Durham's junior, James Luna (b. U.S., 1950) is a conceptual artist working in installation and performance. He studied at the University of California, Irvine, with such artists as Eleanor Antin, Craig Kauffman, James Turrell (chap. 6), Lloyd Hamrol, Ed Beral, and John Paul Jones, before dropping out to become an activist in Native American affairs. He returned to earn a BA in 1976, turning to performance in the belief that it "offers an opportunity like no other for Native people to express themselves without compromise in the Indian traditional art forms of ceremony, dance, oral tradi-tions, and contemporary thought."[50] A Luiseño Indian, Luna sought new ways to address

the painful experience of living in a Caucasian culture with predominantly Christian values by exploring sacred Native American ritual knowledge and conjoining fiction with autobiography to probe the archaeology of Native American memories and to confront and reshape caricatures of Native Americans in U.S. history. Luna, who moved to the La Jolla Indian Reservation in 1975, earned an MS in counseling from San Diego State University in 1981 and has supported himself as an artist, counselor, and American Indian specialist at Palomar College in San Marcos, California. In 2005 he represented the Smithsonian's National Museum of the American Indian at the Venice Biennale with his performance installation *Emendatio*.

The performances of William Pope.L (b. U.S., 1955), who earned a BA from Montclair State University (1978) and an MFA from Rutgers University (1981), unmask covert and overt racism with humor and pathos. In *Thunderbird Immolation* (1978), in an effort to expose racist fear of blacks, the cycle of poverty and drug and alcohol addiction, and the art world's complicity in contributing to black artists' low self-esteem and self-destruction, Pope.L sat on a cloth outside several New York galleries, surrounded by a circle of matches, and doused himself with Thunderbird, a cheap Gallo wine with an extra-high alcohol content marketed to African American communities. Nineteen years later, in *ATM Piece* (1997), Pope.L satirized racial economic disparities, chaining himself with link sausages to the door of a Chase Manhattan bank in New York while attempting, like an ATM machine, to give away the dollar bills covering his skirt. Pope.L is best known for his "crawls," endurance actions that he began performing in the 1970s as part of his project *eRacism*. For *The Great White Way* (2001–6), he aimed to crawl twenty-two miles, from the Statue of Liberty up Broadway to the Bronx, dressed in a Superman costume, over a period of five years. The title of the performance satirized the nickname for the theater district along Broadway, one of the first electrically lit streets in the United States. Drawing attention to dark versus light, black versus white, Pope.L wrote:

> I am always afraid.
> I am always American.
> I am always black.
> I am always a man.
> The ghost inside the claim.[51]

Ron Athey (b. U.S., 1961) has presented visceral body art performances, inspired by Antonin Artaud's Theater of Cruelty, that explore homosexuality, gay sadomasochistic sex, pain, and traumatic experience rooted in homophobia and religion. Brought up in a dysfunctional, incestuous family and groomed to be a Pentecostal minister, Athey was addicted to heroin by the age of seventeen. He eventually contracted HIV/AIDS before overcoming his addiction and becoming an artist. Athey began performing in underground gay S/M nightclubs in Los Angeles, with their culture of tattooing, body piercing, and scarification. In 1994 he presented *Four Scenes in a Harsh Life* at the Walker Art Center in Minneapolis, during which he pierced his scalp with acupuncture needles and his arm with hypodermic needles, causing himself to bleed. Using a scalpel, he then inscribed patterns on the back of Divinity Fudge (Darryl Carlton), an HIV-free artist,

before blotting the bloody patterns with paper towels that he attached to a clothesline suspended over the heads of the audience.[52] Hysteria broke out in the media when Athey was accused of exposing the audience to HIV-infected blood, and members of the religious right responded by calling for Congress to end funding for the National Endowment for the Arts, which had given $150 to support Athey's performance. For many years thereafter it was almost impossible for Athey to perform in the United States. His work has been informed especially by that of the artist Pierre Molinier, the poet and filmmaker Pier Paolo Pasolini, and the philosopher Georges Bataille, from whose 1927 essay Athey borrowed the title for a performance, *The Solar Anus* (1998–2000). Bataille's text begins with a sentence that may be considered a description of the foundation of Athey's art philosophy: "It is clear that the world is purely parodic, in other words, that each thing seen is the parody of another, or is the same thing in a deceptive form."[53]

"My body is not like an individual body, but a social body, a collective body, a global body," the performance artist and poet Regina José Galindo (b. Guatemala, 1974) stated in reference to her work, which has entailed subjecting her body to many forms of pain in a visceral response to Guatemalan violence. Galindo gained international attention for her performance *Who Can Erase the Traces?* (2003), a political action directed against General José Efraín Ríos Montt's candidacy for president of Guatemala that year. Montt had headed a military regime in Guatemala, supported by the Reagan administration, which lasted for fourteen months between 1982 and 1983, and during which thousands of Mayans, suspected of sympathizing with guerrillas opposed to Montt's rule, were murdered, tortured, and raped; crops and livestock were destroyed; and more than four hundred Mayan villages were razed. In a dangerous action in which she risked incarceration, with police looking on, Galindo stepped repeatedly into a basin of blood while walking from the Congress in Guatemala City to the National Palace, leaving her bloody footsteps in memory of Montt's dictatorship. For this and other bold actions, such as *Perra* (2005), in which she incised the Spanish word *perra* ("bitch," or female dog) on her leg in protest of violence against women, Galindo won a Golden Lion at the 49th Venice Biennale. To oppose the U.S. military's use of waterboarding, the diminutive Galindo performed *Confession* (2007), in which a large man repeatedly submerged her head in a barrel of water for two minutes and twenty-two seconds, until she could no longer breathe. Galindo has commented that her rage against acts of inhumanity sustains her performances: "It's like an engine—a conflict inside me that never yields, never stops turning, ever."[54]

Zhang Huan, born in China in 1965, grew up during the Cultural Revolution and began training as an artist in Soviet-style Socialist Realism. He received a BA from Henan University in Kaifeng (1988) and an MA from the Central Academy of Fine Arts in Beijing (1993). Zhang began to do performances on the margins of Beijing in 1993 as part of an experimental community of artists calling themselves "East Village." While his individual actions studied endurance, discomfort, and pain, his works in collaboration with others often presented utopian ideals, as in *To Raise the Water Level in a Fishpond* (1997), where migrant workers raised a pond's water level with their body mass, suggesting the real potential for social change through collective action. Zhang's first public performance, *Angel* (1993), a symbolic protest against the Chinese government's

one-child policy, took place on the steps of the National Art Museum of China, causing the museum to be shut down. In 1998 Zhang moved to the United States, where his performances became more elaborate, incorporating props and many participants, as in *My America* (1999), followed in other countries by *My Australia* (2000), *My Japan* (2001), and *My Switzerland* (2005). An increasingly devout Buddhist, Zhang moved to Shanghai in 2005 and began working on woodcuts, paintings, and sculptures, often using the symbolic and ephemeral material of incense ash, a relic of devotion and reverence in Buddhism.

Matthew Barney (b. U.S., 1967) played football in high school and worked as a fashion model after graduation, going on to earn a BA from Yale University in 1989. The performative aspects of modeling and sports inform his drawings, installations, and sculptures, and work as an artist performing in his photographs, videos, and films. Barney is best known for the five feature-length films of his epic *Cremaster Cycle* (1994–2002).[55] "Cremaster" is the name of a muscle in the male reproductive system that covers the testis, promotes spermatogenesis, and causes the genitals to respond to temperature and emotional stimulation. Using this as a metaphor for physiology, psychology, autobiography, mythology, and history, Barney created an enigmatic, hermetic interconnection of symbols. He directed, produced, and performed in the *Cremaster* film cycle, playing different characters, from a satyr and ram to the magician Harry Houdini and serial killer Gary Gilmore. His *Drawing Restraint* series (1987–) emphasizes the physiological and psychological conditions of restraint, as in the feature-length film *Drawing Restraint 9* (2005), on such subjects as the history of whaling, the replacement of blubber with refined oil, and the Shinto religion and tea ceremony. The film is accompanied by a soundtrack by his wife, the Icelandic experimental singer Björk. Such unexpected associations are characteristic of Barney's esoteric aesthetic matrixes. In 2009 he collaborated with the painter Elizabeth Peyton on the theatrical production *Blood of Two,* performed for the opening of the DESTE Foundation's project space Slaughterhouse on the Greek island of Hydra.

Oleg Kulik (b. Ukraine, 1961) came to international attention in the 1990s for his metaphorical enactments as an attack dog. Running on all fours, licking himself, sniffing, and urinating and defecating in public, Kulik demanded response from observers to his direct animalistic aggression and disregard for the decorum, social conventions, and inhibitions of the human animal, with its abstract aesthetic languages and institutions of contemporary art. In *Reservoir Dog* (1995)—his first major performance in Western Europe, which took its title from Quentin Tarantino's violent film *Reservoir Dogs* (1992)—Kulik performed outside the Kunsthaus Zürich. Collared and chained, the naked artist barked, howled, growled, and attempted to bite guests as they tried to enter and exit the museum, until police arrested him and he spent the night in jail. In *I Bite America and America Bites Me* (1997), Kulik's first performance in the United States, he parodied Joseph Beuys, who, in *I Like America and America Likes Me* (1974), lived with a live coyote during the open hours of the René Block Gallery in New York for three days. For his performance, Kulik spent two weeks continuously living in a doghouse at Deitch Projects in New York, where visitors were required to wear protective suits to enter and interact with the artist/dog. As Beuys declared himself leader of the animals, so Kulik founded an "animal party" and ran in the Russian general presidential election disguised

as a bull, demanding equal treatment for animals. For the second Moscow Biennale in 2007, Kulik curated *I Believe,* which he described as a "project of artistic optimism":

> One of the tasks the organisers of the I BELIEVE project wish to accomplish is to persuade artists to get away from the vanities of daily pursuits and search their hearts. It is high time for us to take a look at man and the world not from the perspective of the latest fashionable philosophy, but through the eyes of someone who believes in life in all its manifestations, which is a radical departure from the conventional outlook of modern art. Let us dust off our ideals.
>
> What is the mystery of being?
>
> What in this world strikes you with awe?
>
> What is the locus of the Inconceivable and Ineffable, which leaves you speechless when you meet with it?
>
> What foundation do your spirit and soul rest upon?
>
> This exhibition should be a step toward changing the status of modern art in society, an attempt to move away from elitism toward direct emotional contact with everyone, whether an artist or a viewer. This contact will not be based on abstract ideas but on the perceived presence of something extraordinary and unknown, which unites all of us, living creatures.[56]

JIRŌ YOSHIHARA The Gutai Manifesto (1956)

With our present-day awareness, the arts as we have known them up to now appear to us in general to be fakes fitted out with a tremendous affectation. Let us take leave of these piles of counterfeit objects on the altars, in the palaces, in the salons and the antique shops.

They are an illusion with which, by human hand and by way of fraud, materials such as paint, pieces of cloth, metals, clay or marble are loaded with false significance, so that, instead of just presenting their own material self, they take on the appearance of something else. Under the cloak of an intellectual aim, the materials have been completely murdered and can no longer speak to us.

Lock these corpses into their tombs. Gutai art does not change the material: it brings it to life. Gutai art does not falsify the material. In Gutai art the human spirit and the material reach out their hands to each other, even though they are otherwise opposed to each other. The material is not absorbed by the spirit. The spirit does not force the material into submission. If one leaves the material as it is, presenting it just as material, then it starts to tell us something and speaks with a mighty voice. Keeping the life of the material alive also means bringing its spirit to life. And lifting up the spirit means leading the material up to the height of the spirit.

Art is the home of the creative spirit, but never until now has the spirit created matter. The spirit has only ever created the spiritual. Certainly the spirit has always filled art with life, but this life will finally die as the times change. For all the magnificent life which existed in the art of the Renaissance, little more than its archaeological existence can be seen today.

What is still left of that vitality, even if passive, may in fact be found in Primitive Art and in art since Impressionism. These are either such things in which, due to skillful application of the paint, the deception of the material had not quite succeeded, or else those like Pointillist or Fauvist pictures in which the materials, although used to reproduce nature, could not be murdered after all. Today, however, they are no longer able to call up deep emotion in us. They already belong to a world of the past.

Yet what is interesting in this respect is that novel beauty which is to be found in the works of art and architecture of the past, even if, in the course of the centuries, they have changed their appearance due to the damage of time or destruction by disasters. This is described as the beauty of decay, but is it not perhaps that beauty which material assumes when it is freed of artificial make-up and reveals its original characteristics? The fact that the ruins receive us warmly and kindly after all, and that they attract us with their cracks and flaking surfaces, could this not really be a sign of the material taking revenge, having recaptured its original life? In this sense I pay respect to Pollock's and Mathieu's works in contemporary art. These works are the loud outcry of the material, of the very oil or enamel paints themselves. The two artists grapple with the material in a way which is completely appropriate to it and which they have discovered due to their talents. This even gives the impression that they serve the material. Differentiation and integration create mysterious effects.

Recently, Tomonaga So'ichi and Domoto Hisao presented the activities of Mathieu and Tapié in informal art, which I found most interesting. I do not know all the details, but in the content presented, there were many points I could agree with. To my surprise, I also discovered that they demanded the immediate revelation of anything arising spontaneously and that they are not bound by the previously predominant forms. Despite the differences in

* Jirō Yoshihara, "The Gutai Manifesto," *Genijutsu Shincho* (December 1956); reprinted in Barbara Bertozzi and Klaus Wolbert, *Gutai: Japanische Avantgarde / Japanese Avant-Garde 1954–1965* (Darmstadt: Mathildenhöhe, 1991), 364–69. By permission of Michio Yoshihara.

Kazuo Shiraga, *Making a Work of Art with My Body,* 1955, mud, plaster, and the artist. Courtesy of the artist. Photo courtesy Tokyo Gallery, Tokyo.

expression as compared to our own, we still find a peculiar agreement with our claim to produce something living. If one follows this possibility, I am not sure as to the relationship in which the conceptually defined pictorial units like colours, lines, shapes, in abstract art are seen with regard to the true properties of the material. As far as the denial of abstraction is concerned, the essence of their declaration was not clear to me. In any case, it is obvious to us that purely formalistic abstract art has lost its charm and it is a fact that the foundation of the Gutai Art Society three years ago was accompanied by the slogan that they would go beyond the borders of Abstract Art and that the name Gutaiism (concretism) was chosen. Above all we were not able to avoid the idea that, in contrast to the centripetal origin of abstraction, we of necessity had to search for a centrifugal approach.

In those days we thought, and indeed still do think today, that the most important merits of Abstract Art lie in the fact that it has opened up the possibility to create a new, subjective shape of space, one which really deserves the name creation.

We have decided to pursue the possibilities of pure and creative activity with great energy. We thought at that time, with regard to the actual application of the abstract spatial arts, of combining human creative ability with the characteristics of the material. When, in the

melting-pot of psychic automatism, the abilities of the individual united with the chosen material, we were overwhelmed by the shape of space still unknown to us, never before seen or experienced. Automatism, of necessity, reaches beyond the artist's self. We have struggled to find our own method of creating a space rather than relying on our own self. The work of one of our members will serve as an example. Yoshiko Kinoshita is actually a teacher of chemistry at a girls' school. She created a peculiar space by allowing chemicals to react on filter paper. Although it is possible to imagine the results beforehand to a certain extent, the final results of handling the chemicals cannot be established until the following day. The particular results and the shape of the material are in any case her own work. After Pollock many Pollock imitators appeared, but Pollock's splendour will never be extinguished. The talent of invention deserves respect.

Kazuo Shiraga placed a lump of paint on a huge piece of paper, and started to spread it around violently with his feet. For about the last two years art journalists have called this unprecedented method "the Art of committing the whole self with the body." Kazuo Shiraga had no intention at all of making this strange method of creating a work of art public. He had merely found a method which enabled him to confront and unite the material he had chosen with his own spiritual dynamics. In doing so he achieved an extremely convincing level.

In contrast to Shiraga, who works with an organic method, Shōzō Shimamoto has been working with mechanical manipulations for the past few years. The pictures of flying spray created by smashing a bottle full of paint, or the large surface he creates in a single moment by firing a small, hand-made cannon filled with paint by means of an acetylene gas explosion, etc., display a breathtaking freshness.

Other works which deserve mention are those of Yasuo Sumi produced with a concrete mixer or of Toshio Yoshida, who uses only one single lump of paint. All their actions are full of a new intellectual energy which demands our respect and recognition.

The search for an original, undiscovered world also resulted in numerous works in the so-called object form. In my opinion, conditions at the annual open-air exhibitions in the city of Ashiya have contributed to this. The way in which these works, in which the artists are confronted with many different materials, differ from the objects of Surrealism can be seen simply from the fact that the artists tend not to give them titles or to provide interpretations. The objects in Gutai art were, for example, a painted, bent iron plate (Atsuko Tanaka) or a work in hard red vinyl in the form of a mosquito net (Tsuruko Yamazaki), etc. With their characteristics, colours and forms, they were constant messages of the materials.

Our group does not impose restrictions on the art of its members, providing they remain in the field of free artistic creativity. For instance, many different experiments were carried out with extraordinary activity. This ranged from an art to be felt with the entire body to an art which could only be touched, right through to Gutai music (in which Shōzō Shimamoto has been doing interesting experiments for several years). There is also a work by Shōzō Shimamoto like a horizontal ladder with bars which you can feel as you walk over them. Then a work by Saburo Murakami which is like a telescope you can walk into and look up at the heavens, or an installation made of plastic bags with organic elasticity, etc. Atsuko Tanaka started with a work of flashing light bulbs which she called "Clothing." Sadamasa Motonaga worked with water, smoke, etc. Gutai art attaches the greatest importance to all daring steps which lead to an as yet undiscovered world. Sometimes, at first glance, we are compared with and mistaken for Dadaism, and we ourselves fully recognize the achievements of Dadaism, but we do believe that, in contrast to Dadaism, our work is the result of investigating the possibilities of calling the material to life.

We shall hope that a fresh spirit will always blow at our Gutai exhibitions and that the discovery of new life will call forth a tremendous scream in the material itself.

GEORGES MATHIEU
Towards a New Convergence of Art, Thought and Science (1960)

Our whole culture has allowed itself to be permeated, since the end of the Middle Ages, by Hellenic thought patterns which aimed at bringing the cosmos down to human proportions and limited the means of access to an understanding of the Universe to those provided by reason and the senses.

Our Western pictorial art was founded on notions of perfection deriving from hand crafts, in so far as they were premeditated and came into being according to patterns.

On both sides of the Atlantic, for the past ten years, painting—along with other forms of expression, but more categorically than them—has been freeing itself from the yoke of this burdensome inheritance. After twenty-five centuries of a culture we had made our own, we are witnessing in certain aspects of lyrical non-figuration a new phenomenon in painting— and, one might add, in the arts in general—which calls into question the very foundations of 40,000 years of artistic activity.

This is a three-fold revolution:

First, *morphologically* painting has in effect got rid of the last surviving canons of beauty to re-discover an infinite freedom where anything again becomes possible.

Secondly, in the field of *esthetics*. From now on improvisation dominates almost the whole of the creative act. Ideas of premeditation, reference to a model, a form, or a previously utilized device have been completely discarded, leaving the way clear, for the first time in the West, for speed in execution.

Lastly, in relation to *semantics*. This revolution is perhaps the greatest opportunity ever given us since the creation of the world to live in the realm of thought. If meaning had preceded the sign from time immemorial, from now on the order in the relationship "sign-meaning" has for the first time been reversed. A categorically new phenomenology is being worked out in the domain of expression, demanding an equally new structure of forms, arising out of a total "nadir."

Let me elucidate this. The Egyptians, the Greeks, and the men of the Renaissance had a conscious awareness of their destiny. The laws of Semantics are from now on being reversed. Throughout the ages, a sign was invented for a given intention; but now, a sign being given, it will be viable on its own if it finds its incarnation.

Questions of finality no longer arise. The work of art becomes a geometric point of interrogations. Instead of the "reduction of the Cosmos to the dimensions of man," the work of art is nothing more nor less than an opening out into the Cosmos.

Having passed through the ideal to the real, and the real to the abstract, art is now moving from the abstract to the possible. Plato and Aristotle, with their ideas of a perfected universe, are dead past recall. Evolution has passed from the domain of man to cybernetic machines. Logic is being established on a basis of ambiguity; natural philosophy is basing

* Georges Mathieu, excerpts from "Towards a New Convergence of Art, Thought and Science," *Art International* 4, no. 2 (May 1960): 20–47; reprinted in "De la révolte à la renaissance," in *Idées* (Paris: Gallimard, 1972). By permission of the author.

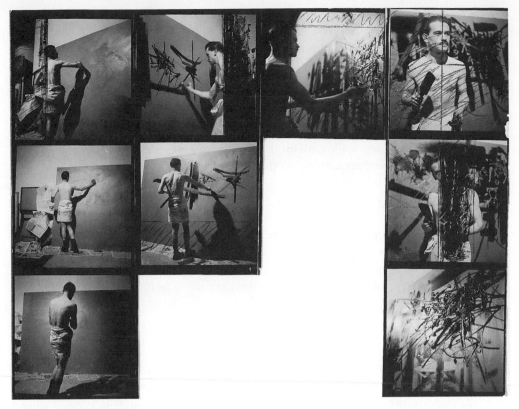

Contact sheet of Georges Mathieu painting in his studio, Paris, 1952, with cropping and deletion lines by the artist. Photos by Paul Facchetti. Courtesy of the artist.

itself on relationships of incertitude and indeterminacy. Science is interested only in the deployment of its powers. And what of painting? Let us first examine what it has been hitherto.

Since art is communication, the sign is its principal element. Lacking a spoken language, one can communicate by signs. Once a language has been evolved, it is made up of words representing objects, actions, and thoughts. These words are signs. They represent an agreement on ideas and are conventional. . . .

Birth and Death of Signs

1. The first stage is the quest for signs as signs. It is an adventure directed towards the discovery of means of expression and the early beginnings of structuration.

2. The second stage is the recognition of signs, that is to say, the realisation of their *incarnation*. Here the signs reach their maximum power. Meaning and style are realised.

3. At the third stage the signs, loaded with recognized and accepted meanings, have reached complete identification with their significance. This is the period of *academic formalism*. (The purpose achieved without experiment, through known and exploited means.)

4. When these three stages have been passed through, the next stage is that of the refinement of signs, of the addition of elements which add nothing to the meaning. It is the period

of exaggeration and deformation, as in *baroque*. Of this stage naive "sur-figuration," expressionism, descriptive surrealism, etc., are the outcome.

5. The fifth stage is that of deformation to the point where the signs have been wholly destroyed. (The work of Picasso is an excellent illustration of this stage.)

6. We now arrive at the last stage. To be precise, this is the stage which goes *beyond Form*, that is, the utilisation of means of expression which have no possible intent (except of a purely dialectical character). It is the moment which precedes and anticipates new turning-points, when one has reached unbounded horizons, in full anarchy, beyond bondage and quite free. It is an intermediary stage, no less useful than the sacrifice of ants drowning themselves so that others can continue their march over the dead bodies. . . .

Phenomenology of the Act of Painting

I shall now attempt to propound what I term the phenomenology of painting: that is, to describe the conditions in which the most up-to-date non-figurative painting is done, or should be done.

The characteristic features of this painting appear to me to be the following:

1. First and foremost, speed in execution.
2. Absence of pre-meditation, either in form or movement.
3. The necessity for a subliminal state of concentration.

This simple enumeration is enough to raise the greatest doubts as to the artistic quality of a work carried out under these conditions. To the spirit of the West, it looks like a wager—as I had the opportunity to demonstrate four years ago, during "la Nuit de la Poésie," when I executed a painting 36 feet by 12 in 20 minutes on the stage of the Sarah Bernhardt Theatre. Besides, it is not in the least surprising that such an attitude and such misunderstanding should exist in the West. The responsibility lies in the habits inherited from Greek esthetics for seven centuries.

The introduction of *speed* into the esthetics of the West seems to me to be of prime importance. It comes about naturally with the growing liberation of painting from all references. Figurative paintings have a fatal reference to nature and to the external world as models— whether the result is a Raphael madonna, Cézanne apples or a Picasso still life. In the same way, abstract geometrical painting had recourse to rules of composition which it followed scrupulously, whether it is a Mondrian or a Malevitch.

In the same way, as I have already pointed out, the non-objective lyrical artist who copies his own forms thereby utilizes *models* and therefore depends on established references.

It is this freedom from reference which brings in *improvisation* and, consequently, speed. Speed, therefore, means the final abandonment of the methods of craftsmanship in painting to the benefit of purely *creative* methods. Now, this is surely the artist's mission: to create, not to copy.

Speed and improvisation have made it possible to associate this kind of painting with liberated and direct music such as Jazz, or with Eastern calligraphy.

This is what André Malraux meant to convey when, in 1950, referring to me, he exclaimed: At last, a Western calligrapher!

The fact is, that apart from a few Merovingian writings, our calligraphy has never been anything but the art of reproduction.

Far Eastern calligraphy improvises, it is true, on given symbols, but in full freedom, and with the full play of individual inspiration, and speed goes with it as much as does a certain state of

"ecstasy." When I was in Japan in 1957, I had the opportunity of seeing some great masters of calligraphy achieve gigantic signs in a few seconds. It would have occurred to no one that these signs could be deprived of any artistic value because they were made in a few seconds.

To the necessity of *speed* and *improvisation* I will add that of a subliminal condition: a *concentration* of psychic energies at the same time as a state of utter vacuity. . . .

Outward Evolution

Briefly, outward evolution reveals itself in three major phases:

1. Painting is an object and remains an object.
2. Painting aspires to become act, and becomes an *event*.

Here I must add that the painting of today stands in between these two poles. It is no longer merely an object. In contemplating it, we become aware of its dynamic influence, and it bears, moreover, materially evident traces of action.

3. At the third stage painting is nothing more than an *attitude,* that is to say, the result of a decision, or even of an absence of decision.

SITUATIONIST INTERNATIONAL Definitions (1958)

Constructed situation: A moment of life concretely and deliberately constructed by the collective organization of a unitary ambiance and a game of events.

Situationist: Having to do with the theory or practical activity of constructing situations. One who engages in the construction of situations. A member of the Situationist International.

Situationism: A meaningless term improperly derived from the above. There is no such thing as situationism, which would mean a doctrine of interpretation of existing facts. The notion of situationism is obviously devised by antisituationists.

Psychogeography: The study of the specific effects of the geographical environment, consciously organized or not, on the emotions and behaviour of individuals.

Psychogeographical: Relating to psychogeography. That which manifests the geographical environment's direct emotional effects.

Psychogeographer: One who explores and reports on psychogeographical phenomena.

Dérive: A mode of experimental behaviour linked to the conditions of urban society: a technique of transient passage through varied ambiances. Also used to designate a specific period of continuous dériving.

Unitary urbanism: The theory of the combined use of arts and techniques for the integral construction of a milieu in dynamic relation with experiments in behaviour.

Détournement: Short for: détournement of preexisting aesthetic elements. The integration of present or past artistic production into a superior construction of a milieu. In this sense there can be no situationist painting or music, but only a situationist use of these means. In a more primitive sense, détournement within the old cultural spheres is a method of propaganda, a method which testifies to the wearing out and loss of importance of those spheres.

* "Situationist International: Definitions," *Internationale Situationiste* 1 (June 1958); reprinted in Ken Knabb, ed., *Situationist International Anthology,* trans. Nadine Bloch and Joel Cornuault (Berkeley: Bureau of Public Secrets, 1981), 45–46. By permission of the Bureau of Public Secrets.

Guy Debord (left) with Michèle Bernstein (center) and Asger Jorn (right), Paris, 1961. Photo by Ib Hansen.

Culture: The reflection and prefiguration of the possibilities of organization of everyday life in a given historical moment: a complex of aesthetics, feelings and mores through which a collectivity reacts on the life that is objectively determined by its economy. (We are defining this term only in the perspective of the creation of values, not in that of the teaching of them.)

Decomposition: The process in which the traditional cultural forms have destroyed themselves as a result of the emergence of superior means of dominating nature which enable and require superior cultural constructions. We can distinguish between an active phase of the decomposition and effective demolition of the old superstructures—which came to an end around 1930—and a phase of repetition which has prevailed since then. The delay in the transition from decomposition to new construction is linked to the delay in the revolutionary liquidation of capitalism.

GUY DEBORD
Report on the Construction of Situations and on the International Situationist Tendency's Conditions of Organization and Action (1957)

Our central idea is that of the construction of situations, that is to say, the concrete construction of momentary ambiances of life and their transformation into a superior passional qual-

* Guy Debord, excerpts from "Report on the Construction of Situations and on the International Situationist Tendency's Conditions of Organization and Action" (June 1957), in Ken Knabb, ed., *Situationist International Anthology,* trans. Nadine Bloch and Joel Cornuault (Berkeley: Bureau of Public Secrets, 1981), 17–25. By permission of the Bureau of Public Secrets.

ity. We must develop a methodical intervention based on the complex factors of two components in perpetual interaction: the material environment of life and the comportments which it gives rise to and which radically transform it.

Our perspectives of action on the environment ultimately lead us to the notion of unitary urbanism. Unitary urbanism is defined first of all by the use of the ensemble of arts and technics as means contributing to an integral composition of the milieu. This ensemble must be envisaged as infinitely more far-reaching than the old domination of architecture over the traditional arts, or than the present sporadic application to anarchic urbanism of specialized technology or of scientific investigations such as ecology. Unitary urbanism must, for example, dominate the acoustic environment as well as the distribution of different varieties of food and drink. It must include the creation of new forms and the detournement of previous forms of architecture, urbanism, poetry and cinema. Integral art, which has been talked about so much, can only be realized at the level of urbanism. But it can no longer correspond to any of the traditional aesthetic categories. In each of its experimental cities unitary urbanism will act by way of a certain number of force fields, which we can temporarily designate by the classic term "quarter." Each quarter will tend toward a specific harmony, divided from neighbouring harmonies, or else will play on a maximum breaking-up of internal harmony.

Secondly, unitary urbanism is dynamic, that is, in close relation to styles of behaviour. The most elementary unit of unitary urbanism is not the house, but the architectural complex, which combines all the factors conditioning an ambiance, or a series of clashing ambiances, on the scale of the constructed situation. The spatial development must take into account the emotional effects that the experimental city will determine. One of our comrades has advanced a theory of states-of-mind quarters according to which each quarter of a city would be designed to provoke a specific basic sentiment to which the subject would knowingly expose himself. It seems that such a project draws opportune conclusions from the current tendency of depreciation of the randomly encountered primary sentiments, and that its realization could contribute to accelerating that depreciation. The comrades who call for a new, free architecture must understand that this new architecture will primarily be based not on free, poetic lines and forms—in the sense that today's "lyrical abstract" painting uses those words—but rather on the atmospheric effects of rooms, hallways, streets, atmospheres linked to the gestures they contain. Architecture must advance by taking emotionally moving situations, rather than emotionally moving forms, as the material it works with. And the experiments conducted with this material will lead to unknown forms. Psychogeographical research, "the study of the exact laws and specific effects of the action of the geographical environment, consciously organized or not, on the emotions and behaviour of individuals," thus takes on a double meaning: active observation of present-day urban agglomerations and development of hypotheses on the structure of a situationist city. The progress of psychogeography depends to a great extent on the statistical extension of its methods of observation, but above all on experimentation by means of concrete interventions in urbanism. Before this stage is attained we cannot be certain of the objective truth of the first psychogeographical findings. But even if these findings should turn out to be false, they would still be false solutions to what is certainly a real problem.

Our action on behaviour, linked with other desirable aspects of a revolution in mores, can be briefly defined as the invention of games of an essentially new type. The most general goal must be to extend the non-mediocre part of life, to reduce the empty moments of life as much as possible. One could thus speak of our action as an enterprise of quantitatively increasing human life, an enterprise more serious than the biological methods currently be-

ing investigated. This automatically implies a qualitative increase whose developments are unpredictable. The situationist game is distinguished from the classic conception of the game by its radical negation of the element of competition and of separation from everyday life. The situationist game is not distinct from a moral choice, the taking of one's stand in favour of what will ensure the future reign of freedom and play. This perspective is obviously linked to the inevitable, continual and rapid increase of leisure time resulting from the level of productive forces our era has attained. It is also linked to the recognition of the fact that a battle of leisure is taking place before our eyes whose importance in the class struggle has not been sufficiently analyzed. So far, the ruling class has succeeded in using the leisure the revolutionary proletariat wrested from it by developing a vast industrial sector of leisure activities that is an incomparable instrument for stupefying the proletariat with by-products of mystifying ideology and bourgeois tastes. The abundance of televised imbecilities is probably one of the reasons for the American working classes' inability to develop any political consciousness. By obtaining by collective pressure a slight rise in the price of its labor above the minimum necessary for the production of that labor, the proletariat not only extends its power of struggle, it also extends the terrain of the struggle. New forms of this struggle then arise alongside directly economic and political conflicts. It can be said that revolutionary propaganda has so far been constantly overcome in these new forms of struggle in all the countries where advanced industrial development has introduced them. That the necessary changing of the infrastructure can be delayed by errors and weaknesses at the level of super-structures has unfortunately been demonstrated by several experiences of the twentieth century. It is necessary to throw new forces into the battle of leisure, and we will take up our position there.

A rough experimentation toward a new mode of behaviour has already been made with what we have termed the *dérive,* which is the practice of a passional journey out of the ordinary through rapid changing of ambiances, as well as a means of study of psychogeography and of situationist psychology. But the application of this will to playful creation must be extended to all known forms of human relationships, so as to influence, for example, the historical evolution of sentiments like friendship and love. Everything leads us to believe that the essential elements of our research lie in our hypotheses of constructions of situations.

The life of a person is a succession of fortuitous situations, and even if none of them is exactly the same as another the immense majority of them are so undifferentiated and so dull that they give a perfect impression of similitude. The corollary of this state of things is that the rare intensely engaging situations found in life strictly confine and limit this life. We must try to construct situations, that is to say, collective ambiances, ensembles of impressions determining the quality of a moment. If we take the simple example of a gathering of a group of individuals for a given time, it would be desirable, while taking into account the knowledge and material means we have at our disposal, to study what organization of the place, what selection of participants and what provocation of events produce the desired ambiance. The powers of a situation will certainly expand considerably in both time and space with the realization of unitary urbanism or the education of a situationist generation. The construction of situations begins on the ruins of the modern spectacle. It is easy to see to what extent the very principle of the spectacle—nonintervention—is linked to the alienation of the old world. Conversely, the most pertinent revolutionary experiments in culture have sought to break the spectator's psychological identification with the hero so as to draw him into activity by provoking his capacities to revolutionize his own life. The situation is thus made to be lived by its constructors. The role played by a passive or merely bit-part playing "public" must

constantly diminish, while that played by those who cannot be called actors but rather, in a new sense of the term, "livers," must steadily increase.

So to speak, we have to multiply poetic subjects and objects—which are now unfortunately so rare that the slightest ones take on an exaggerated emotional importance—and we have to organize games of these poetic objects among these poetic subjects. This is our entire program, which is essentially transitory. Our situations will be ephemeral, without a future: passageways. The permanence of art or anything else does not enter into our considerations, which are serious. Eternity is the grossest idea a person can conceive of in connection with his acts. . . .

The situationist minority first constituted itself as a tendency in the lettrist left wing, then in the Lettrist International which it ended up controlling. The same objective movement has led several avant-garde groups of the recent period to similar conclusions. Together we must eliminate all the relics of the recent past. We consider today that an accord for a united action of the revolutionary avant-garde in culture must be carried out on the basis of such a program. We have neither guaranteed recipes nor definitive results. We only propose an experimental research to be collectively led in a few directions that we are presently defining and toward others that have yet to be defined. The very difficulty of succeeding in the first situationist projects is a proof of the newness of the domain we are penetrating. That which changes our way of seeing the streets is more important than what changes our way of seeing painting. Our working hypotheses will be reexamined at each future upheaval, wherever it comes from. . . .

JOHN CAGE Composition as Process, Part II: Indeterminacy (1958)

This is a lecture on composition which is indeterminate with respect to its performance. That composition is necessarily experimental. An experimental action is one the outcome of which is not foreseen. Being unforeseen, this action is not concerned with its excuse. Like the land, like the air, it needs none. A performance of a composition which is indeterminate of its performance is necessarily unique. It cannot be repeated. When performed for a second time, the outcome is other than it was. Nothing therefore is accomplished by such a performance, since that performance cannot be grasped as an object in time. A recording of such a work has no more value than a postcard; it provides a knowledge of something that happened, whereas the action was a non-knowledge of something that had not yet happened.

There are certain practical matters to discuss that concern the performance of music the composition of which is indeterminate with respect to its performance. These matters concern the physical space of the performance. These matters also concern the physical time of the performance. In connection with the physical space of the performance, where the performance involves several players (two or more), it is advisable for several reasons to separate the performers one from the other, as much as is convenient and in accord with the action and the architectural situation. This separation allows the sounds to issue from their own centers and to interpenetrate in a way which is not obstructed by the conventions of European harmony and theory about relationships and interferences of sounds. In the case of the harmoni-

* John Cage, excerpt from "Indeterminacy," pt. 2 of "Composition as Process," in *Silence* (Middletown, Conn.: Wesleyan University Press, 1961), 35–40. © 1961 John Cage and reprinted by permission of Wesleyan University Press. Originally part of a lecture given in Darmstadt, Germany, September 1958.

ous ensembles of European musical history, a fusion of sound was of the essence, and therefore players in an ensemble were brought as close together as possible, so that their actions, productive of an object in time, might be effective. In the case, however, of the performance of music, the composition of which is indeterminate of its performance so that the action of the players is productive of a process, no harmonious fusion of sound is essential. A non-obstruction of sounds is of the essence. The separation of players in space when there is an ensemble is useful towards bringing about this non-obstruction and interpenetration, which are of the essence. Furthermore, this separation in space will facilitate the independent action of each performer, who, not constrained by the performance of a part which has been extracted from a score, has turned his mind in a direction of no matter what eventuality. There is the possibility when people are crowded together that they will act like sheep rather than nobly. That is why separation in space is spoken of as facilitating independent action on the part of each performer. Sounds will then arise from actions, which will then arise from their own centers rather than as motor or psychological effects of other actions and sounds in the environment. The musical recognition of the necessity of space is tardy with respect to the recognition of space on the part of the other arts, not to mention scientific awareness. It is indeed astonishing that music as an art has kept performing musicians so consistently huddled together in a group. It is high time to separate the players one from another, in order to show a musical recognition of the necessity of space, which has already been recognized on the part of the other arts, not to mention scientific awareness. What is indicated, too, is a disposition of the performers, in the case of an ensemble in space, other than the conventional one of a huddled group at one end of a recital or symphonic hall. Certainly the performers in the case of an ensemble in space will be disposed about the room. The conventional architecture is often not suitable. What is required perhaps is an architecture like that of Mies van der Rohe's School of Architecture at the Illinois Institute of Technology. Some such architecture will be useful for the performance of composition which is indeterminate of its performance. Nor will the performers be huddled together in a group in the center of the audience. They must at least be disposed separately around the audience, if not, by approaching their disposition in the most radically realistic sense, actually disposed within the audience itself. In this latter case, the further separation of performer and audience will facilitate the independent action of each person, which will include mobility on the part of all.

There are certain practical matters to discuss that concern the performance of music the composition of which is indeterminate with respect to its performance. These matters concern the physical space of the performance. These matters also concern the physical time of the performance. In connection with the physical time of the performance, where that performance involves several players (two or more), it is advisable for several reasons to give the conductor another function than that of beating time. The situation of sounds arising from actions which arise from their own centers will not be produced when a conductor beats time in order to unify the performance. Nor will the situation of sounds arising from actions which arise from their own centers be produced when several conductors beat different times in order to bring about a complex unity to the performance. Beating time is not necessary. All that is necessary is a slight suggestion of time, obtained either from glancing at a watch or at a conductor who, by his actions, represents a watch. Where an actual watch is used, it becomes possible to foresee the time, by reason of the steady progress from second to second of the secondhand. Where, however, a conductor is present, who by his actions represents a watch which moves not mechanically but variably, it is not possible to foresee the time, by reason of the changing progress from second to second of the conductor's indications. Where this

conductor, who by his actions represents a watch, does so in relation to a part rather than a score—to, in fact, his own part, not that of another—his actions will interpenetrate with those of the players of the ensemble in a way which will not obstruct their actions. The musical recognition of the necessity of time is tardy with respect to the recognition of time on the part of broadcast communications, radio, television, not to mention magnetic tape, not to mention travel by air, departures and arrivals from no matter what point at no matter what time, to no matter what point at no matter what time, not to mention telephony. It is indeed astonishing that music as an art has kept performing musicians so consistently beating time together like so many horseback riders huddled together on one horse. It is high time to let sounds issue in time independent of a beat in order to show a musical recognition of the necessity of time which has already been recognized on the part of broadcast communications, radio, television, not to mention magnetic tape, not to mention travel by air, departures and arrivals from no matter what point at no matter what time, to no matter what point at no matter what time, not to mention telephony.

ALLAN KAPROW Guidelines for Happenings (c. 1965)

(A) *The line between art and life should be kept as fluid, and perhaps indistinct, as possible.* The reciprocity between the man-made and the ready-made will be at its maximum potential this way. Something will always happen at this juncture, which, if it is not revelatory, will not be merely bad art—for no one can easily compare it with this or that accepted masterpiece. I would judge this a foundation upon which may be built the specific criteria of the Happenings.

(B) *Therefore, the source of themes, materials, actions, and the relationships between them are to be derived from any place or period* except *from the arts, their derivatives, and their milieu.* When innovations are taking place it often becomes necessary for those involved to treat their tasks with considerable severity. In order to keep their eyes fixed solely upon the essential problem, they will decide that there are certain "don'ts" which, as self-imposed rules, they will obey unswervingly. Arnold Schoenberg felt he had to abolish tonality in music composition and, for him at least, this was made possible by evolving the twelve-tone series technique. Later on his more academic followers showed that it was very easy to write traditional harmonies with that technique. But still later, John Cage could permit a C major triad to exist next to the sound of a buzz saw, because by then the triad was thought of differently—not as a musical necessity but as a sound as interesting as any other sound. This sort of freedom to accept all kinds of subject matter will probably be possible in the Happenings of the future, but I think not for now. Artistic attachments are still so many window dressings, unconsciously held on to to legitimize an art that otherwise might go unrecognized.

Thus it is not that the known arts are "bad" that causes me to say "Don't get near them"; it is that they contain highly sophisticated habits. By avoiding the artistic modes there is the good chance that a new language will develop that has its own standards. The Happening is conceived as an art, certainly, but this is for lack of a better word, or one that would not cause endless discussion. I, personally, would not care if it were called a sport. But if it is going to be thought of in the context of art and artists, then let it be a distinct art which finds its way into the art category by realizing its species outside of "culture." A United States Marine

* Allan Kaprow, guidelines for happenings (c. 1965), excerpted from *Assemblage, Environments and Happenings* (New York: Harry N. Abrams, 1966), 188–98. By permission of the author and the publisher.

Cover of Al Hansen's *A Primer of Happenings and Time / Space Art* (New York: Something Else Press, 1965). Cover photo taken at Dick Higgins's opera *Hrušalk* at the Café au Go Go, New York, December 7, 1964, by Peter Moore; © Estate of Peter Moore/ VAGA, NYC. Cover used by permission of Dick Higgins.

Corps manual on jungle-fighting tactics, a tour of a laboratory where polyethylene kidneys are made, the daily traffic jams on the Long Island Expressway, are more useful than Beethoven, Racine, or Michelangelo.

(C) *The performance of a Happening should take place over several widely spaced, sometimes moving and changing locales.* A single performance space tends toward the static and, more significantly, resembles conventional theater practice. It is also like painting, for safety's sake, only in the center of a canvas. Later on, when we are used to a fluid space as painting has been for almost a century, we can return to concentrated areas, because then they will not be considered exclusive. It is presently advantageous to experiment by gradually widening the distances between the events within a Happening. First along several points on a heavily trafficked avenue; then in several rooms and floors of an apartment house where some of the activities are out of touch with each other; then on more than one street; then in different but proximate cities; finally all around the globe. On the one hand, this will increase the tension between the parts, as a poet might by stretching the rhyme from two lines to ten. On the other, it permits the parts to exist more on their own, without the necessity of intensive coordination. Relationships cannot help being made and perceived in any human action, and here they may be of a new kind if tried-and-true methods are given up.

Even greater flexibility can be gotten by moving the locale itself. A Happening could be composed for a jetliner going from New York to Luxembourg with stopovers at Gander,

Newfoundland, and Reykjavik, Iceland. Another Happening would take place up and down the elevators of five tall buildings in midtown Chicago.

The images in each situation can be quite disparate: a kitchen in Hoboken, a *pissoir* in Paris, a taxi garage in Leopoldville, and a bed in some small town in Turkey. Isolated points of contact may be maintained by telephone and letters, by a meeting on a highway, or by watching a certain television program at an appointed hour. Other parts of the work need only be related by theme, as when all locales perform an identical action which is disjoined in timing and space. But none of these planned ties are absolutely required, for preknowledge of the Happening's cluster of events by all participants will allow each one to make his own connections. This, however, is more the topic of form, and I shall speak further of this shortly.

(D) *Time, which follows closely on space considerations, should be variable and discontinuous.* It is only natural that if there are multiple spaces in which occurrences are scheduled, in sequence or even at random, time or "pacing" will acquire an order that is determined more by the character of movements within environments than by a fixed concept of regular development and conclusion. There need be no rhythmic coordination between the several parts of a Happening unless it is suggested by the event itself: such as when two persons must meet at a train departing at 5:47 P.M.

Above all, this is "real" or "experienced" time as distinct from conceptual time. If it conforms to the clock used in the Happening, as above, that is legitimate, but if it does not because a clock is not needed, that is equally legitimate. All of us know how, when we are busy, time accelerates, and how, conversely, when we are bored it can drag almost to a standstill. Real time is always connected with doing something, with an event of some kind, and so is bound up with things and spaces.

Imagine some evening when one has sat talking with friends, how as the conversation became reflective the pace slowed, pauses became longer, and the speakers "felt" not only heavier but their distances from one another increased proportionately, as though each were surrounded by great areas commensurate with the voyaging of his mind. Time retarded as space extended. Suddenly, from out on the street, through the open window a police car, siren whining, was heard speeding by, *its* space moving as the source of sound moved from somewhere to the right of the window to somewhere farther to the left. Yet it also came spilling into the slowly spreading vastness of the talkers' space, invading the transformed room, partly shattering it, sliding shockingly in and about its envelope, nearly displacing it. And as in those cases where sirens are only sounded at crowded street corners to warn pedestrians, the police car and its noise at once ceased and the capsule of time and space it had become vanished as abruptly as it made itself felt. Once more the protracted picking of one's way through the extended reaches of mind resumed as the group of friends continued speaking.

Feeling this, why shouldn't an artist program a Happening over the course of several days, months, or years, slipping it in and out of the performers' daily lives. There is nothing esoteric in such a proposition, and it may have the distinct advantage of bringing into focus those things one ordinarily does every day without paying attention—like brushing one's teeth.

On the other hand, leaving taste and preference aside and relying solely on chance operations, a completely unforeseen schedule of events could result, not merely in the preparation but in the actual performance; or a simultaneously performed single moment; or none at all. (As for the last, the act of finding this out would become, by default, the "Happening.")

But an endless activity could also be decided upon, which would apparently transcend palpable time—such as the slow decomposition of a mountain of sandstone. . . . In this spirit

some artists are earnestly proposing a lifetime Happening equivalent to Clarence Schmidt's lifetime Environment.

The common function of these alternatives is to release an artist from conventional notions of a detached, closed arrangement of time-space. A picture, a piece of music, a poem, a drama, each confined within its respective frame, fixed number of measures, stanzas, and stages, however great they may be in their own right, simply will not allow for breaking the barrier between art and life. And this is what the objective is.

(E) *Happenings should be performed once only.* At least for the time being, this restriction hardly needs emphasis, since it is in most cases the only course possible. Whether due to chance, or to the lifespan of the materials (especially the perishable ones), or to the changeableness of the events, it is highly unlikely that a Happening of the type I am outlining could ever be repeated. Yet many of the Happenings have, in fact, been given four or five times, ostensibly to accommodate larger attendances, but this, I believe, was only a rationalization of the wish to hold on to theatrical customs. In my experience, I found the practice inadequate because I was always forced to do that which *could be repeated,* and had to discard countless situations which I felt were marvelous but performable only once. Aside from the fact that repetition is boring to a generation brought up on ideas of spontaneity and originality, to repeat a Happening at this time is to accede to a far more serious matter: compromise of the whole concept of Change. When the practical requirements of a situation serve only to kill what an artist has set out to do, then this is not a practical problem at all; one would be very practical to leave it for something else more liberating.

Nevertheless, there is a special instance of where more than one performance is entirely justified. This is the score or scenario which is designed to make every performance significantly different from the previous one. Superficially this has been true for the Happenings all along. Parts have been so roughly scored that there was bound to be some margin of imprecision from performance to performance. And, occasionally, sections of a work were left open for accidentals or improvisations. But since people are creatures of habit, performers always tended to fall into set patterns and stick to these no matter what leeway was given them in the original plan.

In the near future, plans may be developed which take their cue from games and athletics, where the regulations provide for a variety of moves that make the outcome always uncertain. A score might be written, so general in its instructions that it could be adapted to basic types of terrain such as oceans, woods, cities, farms; and to basic kinds of performers such as teenagers, old people, children, matrons, and so on, including insects, animals, and the weather. This could be printed and mail-ordered for use by anyone who wanted it. George Brecht has been interested in such possibilities for some time now. His sparse scores read like this:

DIRECTION

Arrange to observe a sign
indicating direction of travel.

• travel in the indicated direction

• travel in another direction

But so far they have been distributed to friends, who perform them at their discretion and without ceremony. Certainly they are aware of the philosophic allusions to Zen Buddhism, of the subtle wit and childlike simplicity of the activities indicated. Most of all, they are aware of the responsibility it places on the performer to make something of the situation or not.

This implication is the most radical potential in all of the work discussed here. Beyond a small group of initiates, there are few who could appreciate the moral dignity of such scores, and fewer still who could derive pleasure from going ahead and doing them without self-consciousness. In the case of those Happenings with more detailed instructions or more expanded action, the artist must be present at every moment, directing and participating, for the tradition is too young for the complete stranger to know what to do with such plans if he got them.

(F) *It follows that audiences should be eliminated entirely.* All the elements—people, space, the particular materials and character of the environment, time—can in this way be integrated. And the last shred of theatrical convention disappears. For anyone once involved in the painter's problem of unifying a field of divergent phenomena, a group of inactive people in the space of a Happening is just dead space. It is no different from a dead area of red paint on a canvas. Movements call up movements in response, whether on a canvas or in a Happening. A Happening with only an empathic response on the part of a seated audience is not a Happening but stage theater.

Then, on a human plane, to assemble people unprepared for an event and say that they are "participating" if apples are thrown at them or they are herded about is to ask very little of the whole notion of participation. Most of the time the response of such an audience is half-hearted or even reluctant, and sometimes the reaction is vicious and therefore destructive to the work (though I suspect that in numerous instances of violent reaction to such treatment it was caused by the latent sadism in the action, which they quite rightly resented). After a few years, in any case, "audience response" proves to be so predictably pure cliché that anyone serious about the problem should not tolerate it, any more than the painter should continue the use of dripped paint as a stamp of modernity when it has been adopted by every lampshade and Formica manufacturer in the country.

I think that it is a mark of mutual respect that all persons involved in a Happening be willing and committed participants who have a clear idea what they are to do. This is simply accomplished by writing out the scenario or score for all and discussing it thoroughly with them beforehand. In this respect it is not different from the preparations for a parade, a football match, a wedding, or religious service. It is not even different from a play. The one big difference is that while knowledge of the scheme is necessary, professional talent is not; the situations in a Happening are lifelike or, if they are unusual, are so rudimentary that professionalism is actually uncalled for. Actors are stage-trained and bring over habits from their art that are hard to shake off; the same is true of any other kind of showman or trained athlete. The best participants have been persons not normally engaged in art or performance, but who are moved to take part in an activity that is at once meaningful to them in its ideas yet natural in its methods.

There is an exception, however, to restricting the Happening to participants only. When a work is performed on a busy avenue, passers-by will ordinarily stop and watch, just as they might watch the demolition of a building. These are not theater-goers and their attention is only temporarily caught in the course of their normal affairs. They might stay, perhaps become involved in some unexpected way, or they will more likely move on after a few minutes. Such persons are authentic parts of the environment.

A variant of this is the person who is engaged unwittingly with a performer in some planned action: a butcher will sell certain meats to a customer-performer without realizing that he is a part of a piece having to do with purchasing, cooking, and eating meat.

Finally, there is this additional exception to the rule. A Happening may be scored for *just*

watching. Persons will do nothing else. They will watch things, each other, possibly actions not performed by themselves, such as a bus stopping to pick up commuters. This would not take place in a theater or arena, but anywhere else. It could be an extremely meditative occupation when done devotedly; just "cute" when done indifferently. In a more physical mood, the idea of called-for watching could be contrasted with periods of action. Both normal tendencies to observe and act would now be engaged in a responsible way. At those moments of relative quiet the observer would hardly be a passive member of an audience; he would be closer to the role of a Greek chorus, without its specific meaning necessarily, but with its required place in the overall scheme. At other moments the active and observing roles would be exchanged, so that by reciprocation the whole meaning of watching would be altered, away from something like spoon-feeding, toward something purposive, possibly intense. . . .

YVONNE RAINER Statements (c. 1964, 1973, c. 1981, 1990)

NO to spectacle no to virtuosity no to transformations and magic and make-believe no to the glamour and transcendence of the star image no to the heroic no to the anti-heroic no to trash imagery no to involvement of performer or spectator no to style no to camp no to seduction of spectator by the wiles of the performer no to eccentricity no to moving or being moved. [c. 1964]

.

I had started to talk about how as a dancer the unique nature of my body and movement makes a personal statement, but how dancing could no longer encompass or "express" the new content in my work, i.e., the emotions. And you had supplied me with the word "specific": Dance was not as specific, meaning-wise, as language. There is another dimension to all this that excited me no end when I thought about it: Dance is ipso facto about *me* (the so-called kinesthetic response of the spectator notwithstanding, which only rarely transcends that narcissistic-voyeuristic duality of doer and looker); whereas the area of the emotions must necessarily directly concern both of us. This is what allowed me permission to start manipulating what at first seemed like blatantly personal and private material. But the more I get into it the more I see how such things as rage, terror, desire, conflict, et al., are not unique to my experience the way my body and its functioning are. I now, as a consequence, feel much more connected to my audience, and that gives me great comfort.

The implications of this change as they concern art and the avant-garde must be most complex . . . For example, is there some connection and/or polarity between formalism/ alienation/humanism? Or indeterminacy/narrative? Or psychological content/the avantgarde? Or am I creating straw men? Obviously I have some ideas on all this myself; it just seems too early to get into it. [1973]

.

To live alone.
To arrive at a social gathering alone.
To go outside in clothing not suited to the weather.

 * Yvonne Rainer, untitled statements (c. 1963, 1973, c. 1981, 1990), in Yvonne Rainer, *Feelings Are Facts: A Life* (Cambridge, Mass.: MIT Press, 2006), 263–64, 390–91, 436–37, 433. © 2006 Massachusetts Institute of Technology, by permission of The MIT Press and the author.

To say something that can be traced to someone else.
To have nowhere to go Saturday night.
To have no interest in Jacques Lacan.
To have no friend with a summer cottage.
To have no family.
To be dirty, to smell.
To have no interest in people.
To be gossiped about.
To be sexually betrayed.
To be ignorant of current popular music.
To be disloyal to a friend.
To gossip.
To become middle aged.
To lose one's youthful beauty.
To be enraged.
To be inordinately ambitious.
To have more money than your friends.
To have less money than your friends.
To not understand what is said to you.
To not recognize someone.
To forget a name.
To lose one's powers.
To go down in the world.
To have misfortune befall one.
To be bored with one's friends.
To be thought of as superior to what one knows oneself to be.
To discover what one thought was common knowledge about oneself is not so.
To discover that closely guarded information about oneself is common knowledge.
To have less knowledge than one's students. [c. 1981]

.

My films can be described as autobiographical fictions, untrue confessions, undermined narratives, mined documentaries, unscholarly dissertations, dialogic entertainments. Although my subject matter may vary from film to film, I can also generalize about intent and purpose: To represent social reality in all its uneven development and fit in the departments of activism, articulation, and behavior to create cinematic arrangements that can accommodate both ambiguity and contradiction without eliminating the possibility of taking specific political stands, to register complicity, protest, acquiescence with and against dominant social forces—sometimes within a single shot or scene—in a way that does not give a message of despair; to create incongruous juxtapositions of modes of address and conventions governing pictorial and narrative coherence so that the spectator must wrestle meaning from the film rather than lose him/herself in vicarious experience or authoritative condensations of what's what.

And lately, after rereading Monique Wittig's *The Straight Mind,* I've been thinking that my films, to some degree or another, can be seen as an interrogation and critique of "straightness," in both its broadest and most socially confining sense: Straightness as a bulwark, as protection, as punitive codes against deviations from social norms that define and enforce the parameters of sex, gender, race, class, and age. Straightness as it pops up in psychoanalytic theory no less

than at the breakfast table; straightness that clouds the liberal imagination congratulating itself on its tolerance; straightness that kills, cripples, and curtails the lives of gays, Lesbians, blacks, women, the poor, and the aging; straightness that equates strength with bloodshed. To be continued . . . [1990]

CAROLEE SCHNEEMANN From the Notebooks (1962–63)

I assume the senses crave sources of maximum information; that the eye benefits by exercise, stretch, and expansion towards materials of complexity and substance; that conditions which alert the total sensibility—cast it almost in stress—extend insight and response, the basic responsive range of empathetic-kinesthetic vitality.

If a performance work is an extension of the formal-metaphorical activity possible within a painting or construction, the viewers' sorting of responses and interpretation of the forms of performance will still be equilibrated with all their past visual experiences. The various forms of my works—collage, assemblage, concretion—present equal potentialities for sensate involvement.

I have the sense that in learning, our best developments grow from works which initially strike us as "too much"; those which are intriguing, demanding, that lead us to experiences which we feel we cannot encompass, but which simultaneously provoke and encourage our efforts. Such works have the effect of containing more than we can assimilate; they maintain attraction and stimulation for our continuing attention. We persevere with that strange joy and agitation by which we sense unpredictable rewards from our relationship to them. These "rewards" put to question—as they enlarge and enrich—correspondences we have already discovered between what we deeply feel and how our expressive life finds structure.

Anything I perceive is active to my eye. The energy implicit in an area of paint (or cloth, paper, wood, glass . . .) is defined in terms of the time which it takes for the eye to journey through the implicit motion and direction of this area. The eye follows the building of forms . . . no matter what materials are used to establish the forms. Such "reading" of a two-dimensional or three-dimensional area implies *duration* and this duration is determined by the force of total visual parameters in action. Instance: the smallest unit variation from stroke to stroke in a painting by Velázquez or Monet; by extension the larger scale of rhythms direct-ing the eye in a painting by Pollock—this which is shaped by a mesh of individualized strokes, streaks, smudges and marks. The tactile activity of paint itself prepares us for the increased dimensionality of collage and construction: the literal dimensionality of paint seen close-on as raised surface . . . as a geology of lumps, ridges, lines and seams. Ambiguous by-plays of dimension-in-action open our eyes to the metaphorical life of materials themselves. Such ambiguity joins in the free paradox of our pleasure with "traditional subject matter" where we might see "abstract" fields of paint activity before we discover the image of King Philip IV astride his horse (Velázquez) . . . or a rush of dark arcade concavities from which we learn, by his flying robes, that a saint is in ascension (El Greco).

The fundamental life of any material I use is concretized in that material's gesture: ges-ticulation, gestation—source of compression (measure of tension and expansion), resistance—

* Carolee Schneemann, excerpt from "From the Notebooks" (1962–63), in Schneemann, *More than Meat Joy: Complete Performance Works and Selected Writings,* ed. Bruce McPherson (New Paltz, NY: Documentext, 1979), 9–11. By permission of the author and Documentext (McPherson & Company).

developing force of visual action. Manifest in space, any particular gesture acts on the eye as a unit of time. Performers or glass, fabric, wood . . . all are potent as variable gesture units: color, light and sound will contrast or enforce the quality of a particular gesture's area of action and its emotional texture.

Environments, happenings—concretions—are an extension of my painting-constructions which often have moving (motorized) sections. The essential difference between concretions and painting-constructions involves the materials used and their function as "scale," both physical and psychological. The force of a performance is necessarily more aggressive and immediate in its effect—*it* is projective. The steady exploration and repeated viewing which the eye is required to make with my painting-constructions is reversed in the performance situation where the spectator is overwhelmed with changing recognitions, carried emotionally by a flux of evocative actions and led or held by the specified time sequence which marks the duration of a performance.

In this way the audience is actually, *visually* more *passive* than when confronting a work which requires *projective vision,* i.e., the internalized adaptation to a variable time process by which a "still" work is perceived—the reading from surface to depth, from shape to form, from static to gestural action and from unit gesture to larger over-all structures of rhythms and masses. With paintings, constructions and sculptures the viewers are able to carry out repeated examinations of the work, to select and vary viewing positions (to walk with the eye), to touch surfaces and to freely indulge responses to areas of color and texture at their chosen speed.

During a theater piece the audience may become more active *physically* than when viewing a painting or assemblage; their physical reactions will tend to manifest *actual* scale—relating to motions, mobilities the body does make in a *specific* environment. They may have to act, to do things, to assist some activity, to get out of the way, to dodge or catch falling objects. They enlarge their kinesthetic field of participation; their attention is required by a varied span of actions, some of which may threaten to encroach on the integrity of their positions in space. Before they can "reason" they may find their bodies performing on the basis of immediate visual circumstances: the eye will be receiving information at unpredictable and changing rates of density and duration. At the same time their senses are heightened by the presence of human forms in action and by the temporality of the actions themselves.

My shaping of the action of visual elements is centered on their parametric capacities in space. In performance the structural functions of light, for instance, take form by its multiple alterations as color—diffuse, centralized, (spot and spill) mixture, intensity, duration in time, thresholds of visible/invisible. The movements of performers are explored through gesture, position and grouping in space (density, mass), color and their own physical proportion.

The body itself is considered as potential units of movement: face, fingers, hands, toes, feet, arms, legs—the entire articulating range of the overall form and its parts.

The performers' voices are instruments of articulation: noises, sounds, singing, crying, commentary on or against their movements may be spoken; word-sound formations are carried forth which relate to, grow from the effect on the vocal cords of a particular physical effort they experience. The voice expresses pressures of the total musculature so that we may discover unique sounds possible only during specific physical actions and which provide an implicit extension and intensification of the actions themselves.

The distribution of the performers in space evolves the phrasing of a time sequence: levels of horizontal, vertical and diagonal or the need for larger rhythms carried visually by an independent figure which moves in relationship to the overall environment—shifting dimensions, layers, levels. Every element contributes to the image. The active qualities of any one

element (body, light, sound, paper, cloth, glass) find its necessary relation to all other elements and through conjunction and juxtaposition the kinetic energy is released.

My exploration of an image-in-movement means only that its realization supersedes (or coincides with) my evocation of it. This is *not* a predictable, predetermined process: in the pressure to externalize a particular sensation or quality of form other circumstances or "attributes" may be discovered which are so clear and exact that the function of the original impulse is understood as touchstone and guide to the unexpected. "Chance" becomes one aspect of a process in which I come to recognize a necessity—the way to unpredictable, incalculable advances within my own conscious intent.

Woman in the Year 2000 (1975)

By the year 2000 no young woman artist will meet the determined resistance and constant undermining which I endured as a student. Her Studio and Istory courses will usually be taught by women; she will never feel like a provisional guest at the banquet of life; or a monster defying her "God-given" role; or a belligerent whose devotion to creativity could only exist at the expense of a man, or men and their needs. Nor will she go into the "art world," gracing or disgracing a pervading stud club of artists, historians, teachers, museum directors, magazine editors, gallery dealers—all male, or committed to masculine preserves. All that is marvelously, already falling around our feet.

She will study Art Istory courses enriched by the inclusion, discovery, and re-evaluation of works by women artists: works (and lives) until recently buried away, willfully destroyed, ignored, or re-accredited (to male artists with whom they were associated). Our future student will be in touch with a continuous feminine creative istory—often produced against impossible odds—from her present, to the Renaissance and beyond. In the year 2000 books and courses will only be called "Man and His Image," "Man and His Symbols," "Art History of Man," to probe the source of dis-ease and man-ia which compelled patriarchical man to attribute to himself and his masculine forebearers every invention and artifact by which civilization was formed for over four millennia! Our woman will have courses and books on "The Invention of Art by Woman," "Woman—The Source of Creation," "The Gynocratic Origins of Art," "Woman and Her Materials." Her studies of ancient Greece and Egypt will reconcile manipulations in translation, interpretation, and actual content of language and symbolic imagery with the protracted and agonizing struggle between the integral, cosmic principles of Gynocracy and the aggressive man-centered cultures gathered as the foundations of Judeo-Christian religion in the Western world.

Fifteen years ago I told my Art Istory professor I thought the bare breasted women bull jumpers, carved in ivory, painted in frescos about 1600 B.C. in Crete, could have been made by women depicting women. And I considered that the preponderant neolithic fertility figurines might have been crafted by women for themselves—to accompany them through pregnancy and birth-giving. And I wondered if the frescos of the Mysteries, Pompeii—almost exclusively concerned with feminine gestures and actions—could have been painted by women. He was shocked and annoyed, saying that there was absolutely no authority to support such ideas. Since then I have given myself the authority to support and pursue these insights. By the year 2000

* Carolee Schneemann, excerpt from "Woman in the Year 2000" (1975), in Schneemann, *More than Meat Joy: Complete Performance Works and Selected Writings,* ed. Bruce McPherson (New Paltz, NY: Documentext, 1979), 198–99. By permission of the author and Documentext (McPherson & Company).

feminist archeologists, etymologists, egyptologists, biologists, sociologists, will have established beyond question my contention that women determined the forms of the sacred and the functional—the divine properties of material, its religious and practical formations; that she evolved pottery, sculpture, fresco, architecture, astronomy and the laws of agriculture—all of which belonged implicitly to the female realms of transformation and production.

The shadowy notions of a harmonious core of civilization under the aegis of the Great Mother Goddess, where the divine unity of female biological *and* imaginative creation was normal and pervasive, where the female was the source of all living and created images, will once again move to clarify our own conscious desires. The sacred rituals of forming materials to embody life energies will return to the female source.

One further change will be the assembling of pioneer istorians—themselves discredited or forgotten by traditional masculist authority. In the year 2000 they will be on the required reading lists! What a joy to welcome: Helen Diner, J. J. Bachofen, Michelet, Rilke, Gould-Davis, Jane Ellen Harrison, Robert Graves, Jacquetta Hawkes, Ruth Benedict, Robert Briffault, Erich Neumann, H.D., Marie de LeCourt, Ruth Herschberger, Bryher, H. R. Hays, Minna Mosdherosch Schmidt, Clara E. C. Waters, Elizabeth F. Ellet!

The negative aspect is simply that the young woman coming to these vital studies will never really believe that we in our desperate ground work were so crippled and isolated; that a belief and dedication to a feminine istory of art was designed by those who might have taught it, and considered heretical and false by those who should have taught it. That our deepest energies were nurtured in secret, with precedents we kept secret—our lost women. Now found and to be found again.

JEAN-JACQUES LEBEL On the Necessity of Violation (1968)

The middle-class hero, product of Western culture, still dreams of seeing his moral sense triumphant over all rebellions. This mediocrity has a *bête noire*—free art. He thinks that he, personally, is being attacked by the transformations which young artists claim to be bringing into his life as well as to their own. This tireless Philistine might perhaps be able to consider avant-garde art sympathetically if only he did not feel that it made him out to be guilty, or mentally deficient; he would not stand in the way of any revolution, if only it left his *values* alone.

No one is prepared to admit that if there is still a chance of changing life it resides in the transformation of the human being; humans cling to their old ways of seeing, of feeling, of being. Art as it evolves, both historically and spiritually, has to face a reaction similar to that which neutralizes the reform of social structures. For painting and sculpture, without having exhausted all their hypnotic power, foster to a considerable degree the misapprehension of private property and the commercial value of images—a misunderstanding which, in the long run, has the effect of making their psychical effect recede further and further into the background.

The relationship which has grown up between art and the majority of those who have to do with it is thoroughly defective—a voluntary blindness and a refusal of communication. It was only to be expected that certain artists should feel this alienation—legalized, generalized and imposed by culture itself—to be an inadmissible obstacle, a challenge which could not go unanswered. But, to reply, a language and a new long-range technique were necessary.

* Jean-Jacques Lebel, excerpts from "On the Necessity of Violation," *Tulane Drama Review* 13, no. 1 (Fall 1968): 89–105. By permission of the author and The MIT Press, Cambridge, MA.

This new language, by the frank way in which it put the question of communication and perception, by its resolution to recognize and explore the forbidden territories which had hitherto halted modern art, had to force a complete re-examination of the cultural and historical situation of art. This language is the Happening.

Thus, about eight years ago and on three continents at once, authors of Happenings started to attack the problem at its very *foundations*. That is to say:

1. The free functioning of creative abilities, without regard for what pleases or what sells, or for the moral judgments pronounced against certain collective aspects of these activities.

2. The abolition of the right to speculate on an arbitrary and artificial commercial value attributed, no one knows why, to a work of art.

3. The abolition of the privilege of exploiting, of intellectually "bleeding" artists, which has been appropriated by vulgar middlemen and brokers who detest art.

4. The abolition of cultural "policing" by sterile watchdogs with set ideas, who think they are capable of deciding whether such and such an image, seen from a distance, is "good" or "bad."

5. The necessity of going beyond the aberrant subject-object relationship (looker/looked-at, exploiter/exploited, spectator/actor, colonialist/colonized, mad-doctor/madman, legalism/illegalism, etc.) which has until now dominated and conditioned modern art.

It is easy to see that the battle is joined around exactly those prohibitions whose violation is a matter of life and death for present-day art. This fight is concentrated around political and sexual themes—taboo above all others. We owe to Freud the elucidation of the displacement, substitution and repression mechanisms which act on the human personality by means of laws and social restraints. . . . In the light of this pitiless theory, the function of art in relation to society becomes clear—it must express, at all costs, what is hidden behind the wall . . . for all language turns on violation, and all art is founded on unveiling. The dialectical, supremely ambivalent nature of violation can never be sufficiently stressed. Violation is at once birth and unbirth, the going-beyond and the return, accomplishment and death.

No crisis of the mind can exist independently of the social predicament, and artists . . . are . . . almost the only people, together with criminals and revolutionaries, to react against this loss, to assume it and express it; which is, precisely, an infringement of the rules. . . . Dispossessed of most of his intellectual resources, progressively depersonalized as he "succeeds" socially, the artist is nothing but the clown of the ruling classes. It is useless to interpret this downfall as a victory of apolitical feeling over that of revolt. To the watchdogs of tradition, upset by the generally sagging market, I say that not only will we not agree to limit or put a brake on this crisis, but we will take every opportunity to exasperate it to its highest pitch. For this is our only chance to have done with this exploiting society, with its slave-owning mentality and its irremediable culture. Art is in full and fundamental dissidence with all regimes and all forms of coercion, but especially with those regimes which use it for their own ends. To this mercantile, state-controlled conception of culture, we oppose a combative art, fully conscious of its prerogatives: an art which does not shrink from stating its position, from direct action, from transmutation.

The Happening interpolates actual experience directly into a mythical context. The Happening is not content merely with interpreting life; it takes part in its development within reality. This postulates a deep link between the actual and the hallucinatory, between real and imaginary. It is precisely the awareness of this link that the enemies of the Happening cannot tolerate, for it might threaten their defense mechanisms. . . . The extremely limited space assigned to art in society in no way corresponds to its mythical volume. To pass from one to the other—at the risk of breaking the law—is the primordial function of the Happening. . . .

As far as we are concerned, we wish to delve more deeply into the very experience of painting. All that was left of "action-painting" was action. We were determined to become one with our hallucinations. We had a feeling of apocalypse, an insuperable disgust with the "civilization of happiness" and its Hiroshimas. Everything which had not become irremediably meaningless revolved—and still revolves—round two poles: Eros and Thanatos. It is a question of giving form to the myths which are ours, while falling prey as little as possible to the alienating mechanisms of the image-making industry. . . . One of these days, an anti-racist and/or anti-war demonstration blocking the traffic in New York will end as a Happening. . . .

The Happening answers with actions. The marriage between theory and praxis is consummated—an extremely rare event. Transformation of thought, of the dream become Action in which Being in search of its sovereignty attains its greatest openness; the Happening, of all the languages at our disposition, is the least alienating. . . .

A painting only exists when it is looked at, when its content is recognized and deciphered *qua* image. This subject-object relationship has the serious disadvantage of putting art at the mercy of the short-sighted or dishonest spectator or specialist, and to beat a one-way path, in the functioning of the image, leading to a check-point, to a form of censorship and a corruption of the senses. This could not be allowed to go on any longer.

The "going-beyond" postulated by the authors of Happenings has only just begun. Already, it has called into question not only painting, but also the habits of thought provoked by it, including the frustration of the spectator, the professional deformation of the looker-on, etc. The Happenings put into action (as opposed to merely representing) the varying relationships between individuals and their psycho-social environment. Contemporary art demands the active intervention of the spectator. In these conditions, the *voyeur,* by his very deficiency, has no part in the action. . . .

The Happening . . . carries out transmissions and introduces the witness directly into the event. . . .

Whether it does in fact set off a chain of images, or dreams aloud, or tells a story, or is to be found in an objectified perspective, whether it is improvised or perfectly elaborated, a Happening never gives a stock answer to the questions it asks. It imposes no restrictions on affective ambivalence. The Happening is neither an irrefutable theory nor an infallible system; its only criteria are subjective. . . . Everything depends on the collective watchfulness, and on the occurrence of certain parapsychological phenomena. And these phenomena may have "delayed action"; they may also escape the obdurate or inattentive witness completely. The Happening is not an invariable ceremony—rather, a state of mind, an act of clairvoyance, a poem in action to which everyone adds a movement or a paralysis, a pulsion expressed or repressed, a feeling of rejoicing or despair. Art at last has some chance of being more than merely a screen on which each projects its own anguish—a looking-glass through which it will be possible to pass. No one can force the man who, fascinated or terrified by the reflection of his own image, prefers to stay on his side of the mirror. In spite of its dazzling powers, contemporary art has to some extent gone aground in mid-voyage. It has not managed to go beyond the "one-way street" of unilateral contemplation. . . .

The Happening is above all a means of interior communication; then, and incidentally, a spectacle. From outside, its essential part is unintelligible. . . . I am of the opinion that the Happening must keep its distance from the commercial preoccupations of the theatre, and from the therapeutic ones of psychodrama. . . .

The conventional theatre, the art shop of gallery, are no longer (and perhaps in themselves have never been) sacred places—so why shut ourselves up in them? Artistic activity is founded on high telepathy—a contact high—and everything which comes into its field becomes a *sign,*

and is part of art. It is therefore evident that the primary problem of today's art has become the *renovation and intensification of perception.*

Paris Postscript, May/June 1968

Something has changed. After the Sorbonne and the Sud Aviation factory in Nantes, the ex-Théâtre de France was taken and occupied by a Comité d'Action Révolutionnaire and transformed into a totally open forum, a day and night agora for political discussion and action. This ex-theatre ceased to be the toy of the power-elite, became a place where everybody (not just the professional clowns) had the right to the most extreme expression, contestation, and communication. No more theatre or expensive spectacles for a passive audience of consumers—but a truly collective enterprise in political and artistic research. A new type of relationship between the "doers" and the "lookers" is being experimented with. Perhaps we will succeed in helping hundreds of thousands more to let go of their alienated social roles, to be free of mental Stalinism, to become the political and creative doers they dream of being.

Art has always been halfway between wishful thinking and wishful doing—isn't that why it has often been prophetic? Today more than ever the emphasis is on getting things done. This brings us to a specific type of collective effort which implies an out-front rejection of the present cultural system: guerrilla theatre, street happenings and similar activities. The important thing these various creative attempts have in common is that rather than seeking integration into the industry they seek to disrupt it. These experiments in liberation theatre are in open conflict with the capitalist environment, and they are related in their opposition: the Living Theatre, the San Francisco Mime Troupe, and the German revolutionary student theatre group, the Bread & Puppet Theatre and European happeners. We can no longer be satisfied with loopholes and cracks in the System; we can no longer accommodate ourselves with the pseudo-liberation of a profit-oriented economy which winds up controlling not only the distribution but the actual conception and materialization of the theatrical vision.

The Great Society is not the only one which is trying out its new weapons on rioting blacks, war-resisting demonstrators or mind-dancing hippies. The streets of many large cities in Europe are similar testing grounds. But the Japanese Zenkaguren have developed a weapon of their own: shit in loosely sealed cellophane bags. Truth grenades: highly recommended when attacked by MACE-spraying rioting police. It's time for mass shit-ins. Hit the impeccably toilet-trained "adult" civilization where it hurts—in its heavenly cleanliness. The sooner everyone realizes that

ART IS $HIT

the better. From then on, it's pure spontaneity.

WOLF VOSTELL Manifesto (1963)

Décollage is your understanding
Décollage is your accident
Décollage is your death
Décollage is your analysis

* Wolf Vostell, "Manifesto" (Wuppertal, 1963), in *Vostell Retrospektive 1950–1974* (West Berlin: National Galerie, 1975), 302. Translation by Kristine Stiles. By permission of the author.

Décollage is your life
Décollage is your change
Décollage is your reduction
Décollage is your problem
Décollage is your TV destruction
Décollage is your dirt
Décollage is your fever
Décollage is your sweat
Décollage is your skin
Décollage is your sudden fall
Décollage is your refusal
Décollage is your nerve
Décollage is your break
Décollage is your own disillusion
Décollage is your own failure (demise)
Décollage is your divestment
Décollage is your spot cleaner
Décollage is your dissolvent
Décollage is your resignation
Décollage is your pain
Décollage is your diarrhea
Décollage is your revelation
Décollage is your own décollage

dé-coll/age (1966)

STIMULATED BY a report in FIGARO of September 6, 1954; PEU APRÈS SON DÉ-COLLAGE UN SUPERCONSTELLATION TOMBE ET S'ENGLOUTIT DANS LA RIVIÈRE SHANNON . . . i began to be interested in the reality of phenomena of the time and the surroundings in which i lived and of the need to incorporate into my art what i saw–heard–felt–learnt.

what fascinated me were the symptoms and effects of a development in the world around me in which destruction in general and in particular, together with dissolution and change, are the strongest elements not only because of the visual chaotic events, but also because of the violent psychological human effects resulting from the obsolescence factor in the observation of them. i became conscious that life is not made up of constructive elements but that the solution lies between construction and destruction.

life is *dé-coll-age* in that the body in one process builds up and deteriorates as it grows older—a continuous destruction. what shocked me so noticeably about the report in FIGARO as opposed to those of all other aircraft disasters was the contradiction in one word, for *dé-coll-age* means the take-off of an aircraft as well as the tearing away from an adhesive surface. the flying body was décollé as much by take-off as by unsticking, one word included two or more contrary happenings. thus the accident is already in the automobile as it drives, the obsolescence is already prefabricated and built in. events in the street and airports and in supermarkets are more interesting and more significant for our time than those in a theater or museum.

* Wolf Vostell, "dé-coll-age," *Books* (New York) 3, no. 4 (May 1966); reprinted in *Art and Artists* 1, no. 2 (August 1966): 9–10. By permission of the author.

torn posters erasures distorted television pictures happenings and action music contain many layers of information. the psychological truth and the why are contained and preserved in them.

governments have driven men to destruction in wars. this load, these unconquerable factors in the world scene, will reflect and act as critic in our time and in the times to come not as a glorification as is often supposed but as an answer, a document, an indictment, a permanent reminder, the rebellion and protest of the subconscious against the contradictions and unaccountabilities of human existence which probably can never be cleared up.

TEN YEARS AGO I was just as conscious as today that the time in which I live has its own, never-to-be-repeated characteristics and emanations that demand new methods of treatment. People need a new revolution of vision and of experiencing their time.

Proceeding from self-dissolving, self-destroying and self-exhausting factors in experience (for example, plane crashes and automobile accidents) I coined the idea of *dé-collage*. For me, this was the beginning of a change of taste and the inclusion of the environment in the form of experiences in my work.

Duchamp discovered Readymades and the Futurists claimed noise as art. A primary characteristic of my work and that of my colleagues is that the Happening includes whatever noise, movement, object, colour or psychology enters into the total work of art. Because of this I assert that life and people are art.

In my *Dé-collage* Happenings the public is offered new criteria. The public learns anew to live, and comprehends the psychological truth of the environment and of the experiences in which it recognises social and aesthetic processes.

The public connects the appearances of contradictions, questions and chaotic situations with test erasures of the visual consciousness and acoustic environment. The contents and the intentions must be made orderly by each participant and observer. But even when the events cannot be made orderly, they lead to the recognition that such things cannot be resolved.

Happenings and events are frames of reference for experience of the present—a do-it-yourself reality. The observer can or must differentiate between form and content. Concerted actions which are repulsive and frightening in life often have fascinating aesthetic emanations although the contents or the consequences are to be rejected. Happenings make such a nightmare conscious and sharpen the consciousness for the inexplicable and for chance.

Important characteristics of the Happenings are often changed by the public. If a Happening is thematically concerned with the destructive phenomena of our epoch, this does not mean that the Happening form is, in itself, destructive. My pictures are scores of my performances. These scores cannot, however, be repeated or even interpreted by someone else. They are erasures and fields of ideas which make the imagination of the viewer come to life.

GEORGE MACIUNAS Letter to Tomas Schmit (1964)

. . . Now let me get into the "ideological" field. I will first explain in very brief & clear terms (a) FLUXUS objectives then (b) answer questions you brought. Then you will be able to make

* George Maciunas, excerpt from "Letter to Tomas Schmit" (1964), in Jon Hendricks, ed., *Fluxus etc. / Addenda II: The Gilbert and Lila Silverman Collection* (Pasadena, Calif.: Baxter Art Gallery), 1983, 166–67. Excerpts from this letter also appear in Jon Hendricks, ed., *Fluxus Codex,* introduction by Robert Pincus-Witten (Detroit and New York: Gilbert and Lila Silverman Fluxus Collection in association with Harry N. Abrams, 1988), 37. By permission of Nijole Valaitis and the Gilbert and Lila Silverman Fluxus Collection.

aries has no place in communal society. National boundaries are the enlarged backyard fences of the possession-fixated small-family man.

National boundaries are humiliating for everyone who must cross them. They prove to him that he is not free.

The earth sphere with all its land and natural resources does not belong to different countries, companies, organizations or families. It belongs to all human beings on the earth.

The wars, the mass slaughters that small-family states have been carrying on with each other for thousands of years are proof that the small-family structure is incapable of satisfying the real needs of people and of solving the problems that arise from their living together.

The material possessive thinking of small-family society cannot be sustained without the use of force because it contradicts human nature.

The state appears as an overdimensionally expanded form of the violent family father.

Security in the small-family society is guaranteed only through possession (having power over something). The security that comes from mutual trust is not inherent in the small-family structure. Material possession is responsible for extreme mistrust between people. The security that is gained from material possession must be defended with force.

Possessions that exclude others contradict the fact that all humans are equal.

The commune rejects every form of aggression and use of violence. There is no institution in communal society that could exert force against individuals or groups.

Police, courts, prisons, insane asylums, exploitation, compulsion, repression are the symptoms of a social organization that is against people and against life. The commune does without them.

Free sexuality is an integral part of commune-society. The two-person relationship, a sickness of the small-family individual, does not exist. There is no possession of other humans or sexual obligation in the commune. In a well-functioning commune there is no jealousy since everyone has the possibility of sexual satisfaction.

The defense systems, weapon systems, armaments of the small-family states are nothing but the muscular armoring of the small-family man. The wars between the small-family states are necessarily produced by the structure of the small-family system and the muscular armoring of the small-family man. In the same way jealousy, not something inborn, is necessarily produced by the structure of the two-person relationship.

If war is to be eliminated, the small-family society must first be abolished. For this reason there can be no war in the commune-society.

The consume thinking and consume behavior of the small-family man serve to satisfy irrational needs because the real needs cannot be satisfied in the small-family society.

Lack of communication forces the small-family man to seek out bars and coffee-houses, go to theater, opera, movies, frequent sport and dance events. Lack of communication drives the small-family youth in pop-concerts, drives them to idol worship.

Sexual poverty drives the small-family man to pornographic behavior.

The lack of communication and sexual poverty that is artificially manufactured by the small-family society is exploited by the entertainment, amusement and recreational industries. The over-production of industrially manufactured mass articles serves to satisfy irrational needs as well as profit thinking, and is responsible for the squandering of raw materials and the destruction of man's environment.

Since neither lack of communication nor sexual poverty exist in the commune-society and all real human needs can be satisfied, the commune-society dispenses with most industrial branches of the small-family society, for example, clothing industry—the production of a few

sorts of textiles is enough, the simplest types of clothing, mainly workclothes, are produced in the commune itself. The manufacture of shoes is narrowed down to a few practical models. No fashion, just comfortable shoes. The electronics industry is radically reduced, the commune can do without canned music as well as television and radio.

Commercial movies, a symbol for the unsatisfied wishes of the consume-condemned small-family man, are unthinkable in the commune. Coffee-houses, restaurants, hotels, the whole catering industry that satisfies the need for communication of the small-family man, has no function in the commune-society. The production of books is reduced to the production of non-fiction. Novels, magazines, written theater and music are not produced. Newspapers function as representation of the commune and means of getting across news but not as entertainment. There is no art in commune society and no artist who produces himself for the public. The production of small-family automobiles is discontinued and only practical transport vehicles are produced: buses for transporting people and trucks for freight. The commune society is not against the use of technology but wherever it serves irrational needs, it will disappear by itself in a society where people's real needs are satisfied.

GÜNTER BRUS Notes on the Action: Zerreissprobe (1971)

It is a matter of several dramatic situations (psychodramas). An attempt is made to pare the skeleton from the lumpy, corpulent body, to brew a body-soul extract. The actions are condensed and shortened. The body of the actor is put to a hard test—flabby muscles result and panting breath, shoulder sweat and sweat otherwise and vision disturbances with reddened eyes. . . . The intermissions are not pauses for stretching, not to practice prescribed formalities. Intermissions are pauses to catch one's breath. One proceeds from simple actions such as reading, walking, reclining and other similar actions. The actor turns aggressions against himself and against the objects around him, an act through which appropriate actions are released— self-injury, death rattles, strangulation, whippings, catatonic-like behavior, etc. A nervous break points to an abrupt change in the direction of the action, a sudden interruption of an action in motion. This should transmit shock-like impulses which at first may irritate the observer, but which later become a release from conflict. I reject the often sought incorporation of the audience into the action of the play. The results of such an experience are superficial (at the most, dance/music-related activity brings halfway valuable results). I don't reject such efforts totally, but feel however that one cannot do without more deep going means. This is not, however, to be expected from those interested in furthering the development of the theater. Useful results are not a conglomerate made up of tomfoolery, post-dadaism and public participation in willy-nilly street theater socialism. Useful results have proven themselves first class. The action moves for the most part outside language or such—at least outside the speech and language normally used.

Descriptions, explanations, theories, etc. are lousy crutches. Action turns against the psychology-terror. The actor who willingly inflicts injury to himself, who willingly gives fully of himself, doesn't illustrate psychological confessions of faith, doesn't practice masochism and sadism as leisure time activity. Such pre-fabricated bullshit, such neatly tied packages filled with concepts and labels are only barriers which prevent free access to the action.

* Günter Brus, "Notes on the Action: Zerreissprobe," in *Aktionsraum I oder 57 Blindenhunde* (Munich: Aktionsraum, 1971), 144–45; reprinted in Peter Weiermair, ed. and trans., *The Spirit of Vienna: Günter Brus/Otto Mühl/ Hermann Nitsch/Arnulf Rainer/Gerhard Ruhm/Rudolf Schwarzkogler* (New York: René Block Gallery, 1977), 9. By permission of the author.

Statements (1965–79)

My body is the intention, my body is the event, my body is the result. [1965]

.

For the performance, I act like a beforeman.

.

I think that art is always a declaration which contradicts the complacent way of the world.
Scandal is sincerity when it is not programmed.
Sincerity is scandal when the wise world officially runs up against it.

.

Abstraction in more recent art ended with the Aktion.
 From this point on no dogma which for about the last 70 years had claimed any form of validity could any longer be used as a base.
 From now on the laws of the wonder world hold sway.
 Art is hope, prayer and the possession of the individual.
 Whoever wants to partake of this sinful secret may join us in confession.

.

Art is beautiful but it is hard, like a religion without a purpose.

.

The little song is gentle
To life I say yes!

VALIE EXPORT Women's Art: A Manifesto (1972)

THE POSITION OF ART IN THE WOMEN'S LIBERATION MOVEMENT IS THE POSITION OF WOMAN IN THE ART'S MOVEMENT.
THE HISTORY OF WOMAN IS THE HISTORY OF MAN.
 because man has defined the image of woman for both man and woman, men create and control the social and communication media such as science and art, word and image, fashion and architecture, social transportation and division of labor. men have projected their image of woman onto these media, and in accordance with these medial patterns they gave shape to woman. if reality is a social construction and men its engineers, we are dealing with a male reality. women have not yet come to themselves, because they have not had a chance to speak insofar as they had no access to the media.
 let women speak so that they can find themselves, this is what I ask for in order to achieve a self-defined image of ourselves and thus a different view of the social function of women. we women must participate in the construction of reality via the building stones of media-communication.

 * Günter Brus, excerpts (1965–79) from Arnulf Meifert, "Stundenbücher des Entblossten Herzens" (Books of Hours of the Heart Laid Bare), in *Günter Brus: Bild-Dichtungen* (London: Whitechapel Art Gallery, 1980), 7–61. Translation by Dennis Clark. By permission of the author.
 ** Valie Export, "Women's Art: A Manifesto" (March 1972), *Neues Forum* 228 (January 1973): 47. Translation by Resina Haslinger. This piece was written on the occasion of the exhibition *MAGNA, Geminism: Art and Creativity,* organized by Export. By permission of the author.

this will not happen spontaneously or without resistance, therefore we must fight! if we shall carry through our goals such as social equal rights, self-determination, a new female consciousness, we must try to express them within the whole realm of life. this fight will bring about far reaching consequences and changes in the whole range of life not only for ourselves but for men, children, family, church . . . in short for the state.

women must make use of all media as a means of social struggle and social progress in order to free culture of male values. in the same fashion she will do this in the arts knowing that men for thousands of years were able to express herein their ideas of eroticism, sex, beauty including their mythology of vigor, energy and austerity in sculpture, paintings, novels, films, drama, drawings etc., and thereby influencing our consciousness. it will be time.

AND IT IS THE RIGHT TIME

that women use art as a means of expression so as to influence the consciousness of all of us, let our ideas flow into the social construction of reality to create a human reality. so far the arts have been created to a large extent solely by men. they dealt with the subjects of life, with the problems of emotional life adding only their own accounts, answers and solutions. now we must make our own assertions. we must destroy all these notions of love, faith, family, motherhood, companionship, which were not created by us and thus replace them with new ones in accordance with our sensibility, with our wishes.

to change the arts that man forced upon us means to destroy the features of woman created by man. the new values that we add to the arts will bring about new values for women in the course of the civilizing process. the arts can be of importance to the women's liberation insofar as we derive significance—our significance—from it: this spark can ignite the process of our self-determination. the question, what women can give to the arts and what the arts can give to the women, can be answered as follows: the transference of the specific situation of woman to the artistic context sets up signs and signals which provide new artistic expressions and messages on one hand, and change retrospectively the situation of women on the other.

the arts can be understood as a medium of our self-definition adding new values to the arts. these values, transmitted via the cultural sign-process, will alter reality towards an accommodation of female needs.

THE FUTURE OF WOMEN WILL BE THE HISTORY OF WOMAN.

MILAN KNÍŽÁK Aktual Univerzity: Ten Lessons (1967–68)

Lesson One: On Conflict

Conflict is the most direct method of communication but (alas) sometimes (especially now when technology is so prevalent) it is impossible to solve big problems through conflicts and other ways are looked for.

But there are territories where it is possible and necessary to use conflict to clarify something which is impossible to clarify any other way. Often we must kick to be heard. Often we must caress to get a kick.

Conflict has wonderful and dangerous property: we must be on one side or the other. We must believe in something.

* Milan Knížák, "Aktual Univerzity: Ten Lessons" (1967–68), previously unpublished. By permission of the author.

It is impossible to be just warm. Hot or cold.
Therefore I love conflicts.
Therefore I'm afraid of conflicts.
Conflicts begin solutions.

Lesson Two: On Being Different

While the means of external communication are rapidly getting better and better, inner communication (an ability to live together, to exist in a collective community, the capacity for interpersonal communication) remains on the same level as it always has, and sometimes it may even seem to be degenerating; it is only very seldom that we feel it to be improving. Perhaps this is because such a highly developed system of external communication, which means that we can gain information about everything going on around us without the slightest effort (merely by displaying a minimum activity), enables us to be invisible witnesses to the lives of those around us. This system, that by its very perfection demands no effort from us, tranquilizes us so completely that it never even occurs to us to be more active than we have to.

And so, pacified by the flood of information about ourselves and those close to us, we live a solitary and selfish life in the midst of the crowd. We live locked into our private needs whose exterior we rearrange and decorate so that it will blend in with the accepted conventions of society, but the core, the essence, remains unaffected. And this results in very superficial and illusory inter-personal relationships.

The shells of our needs are painted with a single colour. And woe to anyone who dares to choose another! Those of a different colour are immediately condemned.

Lesson Three: On Dreams

Dreams, which accompany us from childhood, have a substantial influence on the course of our efforts and sometimes (in some individuals) they govern our lives entirely. They are beautiful and dangerous. Not the dreams themselves, but the difference between them and reality. The abyss that continually widens in proportion to how we mature.

It is perhaps impossible (and mad) to surrender to them entirely, and so there is nothing else but to do everything we can to eliminate that widening gap.

(The ideal solution would be not to allow it to develop in the first place, but this is impossible in the modern world. Some conflict will always appear. And one is not always able to judge its importance and find an appropriate solution. And so the moment one becomes aware of those terrifying gaps, one can only begin slowly working to close them.)

We must separate out the flood of problems that surround us a few of the most important and make them the centre of our efforts. In such a way that, in them, our imaginings unite with reality. But it is also a question whether we are capable of setting up that scale of importance. For in some circumstances, apparently trivial problems may become quite basic. Their importance is totally dependent on the time and the place in which they occur. Therefore it is impossible to resolve a given situation in isolation, on some abstract, elevated level, but only and always inseparably from the circumstances and the time in which the problem arises.

Sometimes, it becomes our bound duty to solve even the most subtle problems.
EVEN THE SMALLEST PROBLEMS.

Lesson Four: On Revolutions

Revolutions have proven incapable of totally changing the world. They are always merely a shifting of power. And often (almost always, in fact) the means of power remain unchanged; at the very most they are painted a different colour. But revolution is a beautiful thing. It gives hope to thousands. Therefore all those who long for something new and different understand it. But equally enthusiastic are those who are merely discontent with their present power status and want revolution simply because it will help them gain positions that will be exactly like the ones responsible for their present subjugation. And therefore every revolution always suppresses genuinely revolutionary elements.

All societies so far have had and still have one common characteristic—ANTIHUMANITY. Societies create enormous social institutions for the protection of man and at the same time, from the very beginning, they destroy him by absolutely annulling the basic requirements of his humanity—respect for him as an individual with a unique nature and unique opinions. Society always respects only those individuals and opinions that suit the monetary notions of the ruling minority.

It is, after all, nonsense to talk about majority rule. A majority can never, in present state systems and given the present condition of human mentality, govern properly. It is always only a selected portion of the victorious majority that rules and those remaining are immediately demoted to the same level as the losing minority. That separated ruling minority apparently represents the opinions of the majority but in fact those opinions originate above (in the circle of the ruling minority) and are passed down by "agitation" and then, naturally, presented as the true opinions of the majority. That is, majority rule is naked mystification.

It is unfortunate and sad that there is so little difference between the capitalist and the socialist states. The socialist petty bourgeoisie is in no way different from the capitalist (except perhaps a bit poorer). This is possibly because the socialist revolutions that resulted in the transformation of half the world are incapable of transforming people's mentality. They only fill the stomachs of the hungry. And sometimes they make even the satisfied hungry.

And today these fattened (formerly hungry and revolutionary) people gently, very gently, slip into the position of those they overthrew; the revolutionary mood soon disappears and fighting spirit and high aims turn into bourgeois affluence and comfort.

It is necessary to abandon so that one might find. You can't have your cake and eat it too. You will end up hopelessly in the gray mire of the middle. One must abandon totally so that what comes can also be total.

Lesson Five: On Love

Love comes to us through a great variety of media. It functions as another dimension of faith. Its only disadvantage is that we dream of it before we really experience it. And so there is always a little piece of it that remains unfulfilled. The reality that comes never attains the sparkle and splendor of the dream. True, it is more total, more total because it exists, because it is an earthly presence, but precisely this asset is also its handicap. And therefore love is possible only in a state of perfect symbiosis with dreams.

Love has this advantage over other human states and activities: its intensity does not depend on fulfillment. Love can exist in itself. Independent of our efforts and our behavior. Love can be fulfilling even when it is disappointed.

Where love is capable of dialogue (or polylogue), however, a new space is formed in

which all of reality takes on a new dimension that is incomprehensible to anyone not involved. And from the elements determined by this new dimension, the world is constructed anew.

Lesson Six: Build Yourself Wings

Fly straight ahead. Walk a straight line. Visit. Leave a special sign on the door. Make a gift of words. Mark your path with books. With clothes. With food. Join two distant places. Two rocks. Two people. Bridge a river. Build a city of sand. Raise up a mound.

Lesson Seven: On Belief

More important than an object of belief is belief itself. To believe in the power of caressing, in peace-conferences in Geneva, in Buddha or in medicine herbs *it doesn't matter*. The properties of the God in which we believe do not matter: what matters is the quality of the actions we perform in that belief.

Lesson Eight: About Play

Moving your hand over the surface of a table, catching flies in the air, making faces in a mirror, keeping time with your foot, etc. etc. etc.—all these are really little games that we amuse ourselves with without being aware that they *are* games.

Is a game merely something that does not end in the attainment of some concrete gain?

If we consider everything as a game, as play, if we ignore the usefulness (and sometimes even the difficulty, the strain) of what we happen to be doing, then we may make even something as boring as shopping seem just as amusing as watching cats stretching themselves.

An eight-hour work-day can be broken up into a series of more or less amusing and interesting games and discoveries.

Breaking up commonplace, deadening regularity. Divide time into unexpectedly irregular stretches that are surprising if only because they are longer or shorter than the ones before. And in this chaos, the chance appearance of regularity has a sensational effect.

One is most influenced by those things that are neither every-day nor too exceptional. Exceptional things are immediately considered rarities. And every-day things are lost in the flow of the commonplace. And so things that are only a little bit different, that are impossible to include in recognized categories, possess the greatest ability to influence and effect.

Sometimes it is enough for a thing to have an entirely different affect merely by virtue of how we name it.

If we give it the name of a known category, then it is only a matter of convention for us to recognize whether it corresponds to our notions about the possibilities (or representatives) of that category or not. It usually ends with our widening the boundaries of that category.

If we do not give it a name, if it acts merely in itself and through its unclassifiability, then it evokes in us many different associations that lead in all directions, because we are obstinately seeking a place for it in our notion of the world. And precisely this seeking is the most important of all, for through it we discover.

It enables us to see intimately familiar things and phenomena less intimately. It reveals other dimensions. It reveals things that are quite new.

Caress a table. Break a chair. Fetch a cup from the cupboard. Look through a microscope. Write one word on the typewriter. Make a slice of toast. Pick an apple. Phone a friend. Take a drink of water. And look for a long time through an open window into the night.

Lesson Nine:

Are you tired? Work!
Are you sleepy? Wake!
Are you hungry? Don't eat!
Do you want to talk? Keep silent!
Are you afraid of death? Commit suicide!

Lesson Ten: On Art

Art is a perennial outsider. It can never quite be fitted into life. In spite of all the reforms and the efforts of this century to make it fit into life, it still stands out. In art there is no visible, rational evolution, at least not from the viewpoint of the temporal and spatial criteria known to us. There is a visible difference only in the choice of media and in temporal and spatial colouring. This is perhaps because the area of man's existence into which art penetrates and from which it derives is for the time being (judged by the criteria of our level of awareness and the temporal sector we are capable of comprehending) a kind of unchanging quality that does not undergo development. At least not development as we understand it. It is more probably a matter of changes within the circle. Shifts of meaning. An unknown mathematical order that grows inside itself.

For the development of art is directly proportional to the development of the human senses. And in that brief space of human history that we know and understand, the senses have undergone no dramatic changes.

For these reasons *it is impossible to speculate about the development of art as such,* but only about *the development of human existence* with all the aspects which it embraces and of which art is a creative part.

In art as such, it is no longer possible to discover anything. Everything has already been discovered because everything is permitted. And so a gradual fulfilling of the *original social function of art* is coming about. But on a different qualitative level.

Art, understood as a collection of specialized professions, is ceasing to function.

Art, as a visible tangible reality perceivable by the senses, is ceasing to exist.

The culmination of art is in its extinction. Art as a specific, separated area is ceasing to exist. There remains only one area, the *area of human existence.* (Later, perhaps, just existence.)

Art is becoming one of the indispensable factors influencing the organization of everyday life. It is present everywhere and nowhere. It is becoming a fluid. It stands outside all professions. It cannot be isolated, it cannot be worshipped, it cannot be converted into money. *None of this is possible.* It is irreversibly dissolved in the solution of burgeoning human existence.

JERZY BERÉS Statement (c. 1986)

When the traditional artistic media such as sculpture, painting and later graphic art reached their perfection, this opened up the possibility of conquering the "supramedial" sphere where permanent values may still be created. But at that point unfortunately new artistic media were developing, such as assemblage, collage, environmental installations, film, Happenings, land-art, arte povera, and eventually in the 1970s video, performance, photo art—the final result being an eventual return by way of Neo-Picturalism to the traditional media and this at a time when they were far from perfection, since the more gifted artists had gone on to more attractive means of expression. The development of unverified artistic media has been so rapid that the localization of a "work" in the field of vision is itself becoming a problem, while the fact of creation as such is of lesser importance. Artists therefore slowly cease to be "creators"— they become managers. Warhol's slogan that "art is business" is coming true.

Such a state of affairs in itself creates the real possibility of handling the creation of art by means of advertising and propaganda centers, a step which is then followed—when it concerns an area such as art—by its devaluing. This is what happened in the final phase of American Pop art and already before that in the publicity art of Socialist Realism. If, however, this instrumental handling extends to other areas of life and begins to encompass the entire reality of a state, then the result will be a crisis; if it extends to international relations there is a danger of war. The idyll that has supposedly been created by the suspending of criticism bursts. And unfortunately crises as well as wars result in a different rhythm of the course of history, not based on the creative principle.

Sometimes it is only in situations of crisis that belated reflection takes place; by analyzing the past one tries to identify those moments when a deformation began to appear, moments that were signalized by appeals about the necessity of criticism or when an attempt was made to change course by concrete actions that stimulated criticism—actions that were, however, unfortunately ignored or censored away.

Apart from the victims claimed by every crisis and every war, the time from the moment of entering the deformation until the moment of crisis must also be considered lost.

From the point of view of the rhythm of he who creates a work of art this lost time gives him a lead on reality which is subject to deformations and is therefore delayed. And every authentic work, as long as it is not pure creation but also conveys a certain amount of criticism, becomes a prediction, is in effect a prophecy.

If one rejects the one-dimensionality of development which creates futurological fictions and must necessarily falsify history, at least two different rhythms can be distinguished: the creative rhythm and the rhythm of catastrophes, which must be seen as intertwined strands which together form a picture that is closest to the truth. It is only rarely the case in history that both these strands manifest their existence as strongly at the same time as is the case in Poland at the moment: on the one hand total crisis, on the other the magnificent work of "Solidarność."

It now seems the right moment for an appeal to pay greater attention to the creative strand so that catastrophism, which does nothing but create martyrs, does not come to control mankind.

* Jerzy Berés, untitled statement (c. 1986), in *Expressiv: Central European Art since 1960* (Vienna and Washington, DC: Museum moderner Kunst/Museum des 20. Jahrhunderts and Hirshhorn Museum and Sculpture Garden, Smithsonian Institution, 1988), 72–74. By permission of the author.

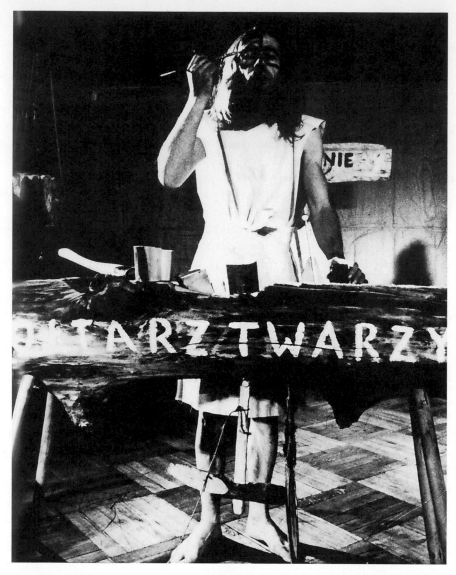

Jerzy Berés, *Altar of the Face,* 1974. Photo by Leszek Dziedzic. Courtesy of the artist.

Attention must be paid to the creative facts that have been lost, whether accidentally or purposefully, in the jungle of non-verified or negatively verified productions but which retain their emanation without fearing verification and have proved to be true, continue to prove to be true and will still prove true as a prediction. For their emanation is the only chance of eliminating the artificial state of a continued suspension of criticism due to the absence of any critical agency.

Nothing but the emanation of a concrete creative feat can cut through the general superficiality and prevent the worst deformation which unfortunately has already become biological and arises from the decline of imagination. One could bet that if this emanation were to reach further and would now also exert its influence to the powerful of this world, mankind would be spared many sacrifices which are caused by the mistakes of its leaders.

By way of announcing my wish for confrontation and my willingness to enter into a dialog, I now quote a few creative instances of my own work that have stimulated criticism and have proved to be true as concrete predictions.

In 1966/67 I carried out a work entitled *Polish Carts* as a manifestational situation; for its construction it was necessary to paint the "wrong wheel" (in Polish this expression has the meaning of fallacy or wrong conclusion) on this cart at the place of its assembly. Today it is clear that at that time the hope for changes after the events of October 1956 was absolutely over.

Eight months before the first contact between the People's Republic of China and the USA I created a work called *Diplomatic Ping Pong*. This first contact turned out to be precisely a match of their respective ping pong teams, which had been kept secret until the very last moment.

Today it is known what an important element in world politics this contact was. It is difficult to describe this work of mine, but all the details, colors and other features exclude the possibility of a loose metaphor that could be bent to fit whatever situation might arise.

The *Applauder* made by me in 1970/71 stimulated criticism for an entire decade and also represents a warning for the future. Unfortunately, however, it has spent most of the time sitting in a museum store room.

In 1975 I carried out a manifestation in the "Szadkowski" works which for my own use I called *Mass for Reflection*. I set up "symbolic carts" on the factory premises, in which one could see one's own reflection and from which one could take a flier with the word "face" printed on it. It has since become clear that that was the moment when the symbolic carts to save face had to be put into motion, as the deformation of the seventies went into its last stage.

In part two of *Mass for Reflection* I carried out a performance at two tables covered with white tablecloths which I called *Beautiful Altar* and *Clean Altar*. When I recently came across some photographs while leafing through a newspaper I thought for a moment that they were photographs of my manifestation in the Szadkowski works from 1975, but upon looking more closely I saw that they were photographs of a mass celebrated by the Metropolitan of Krakow, Marcharski, during the strike in the collective combine "Nowa Huta." How many unforeseeable events must have happened in the meantime in order for such a similar situation to occur. Therefore, I was ahead by six years.

As my last example I want to mention the *Altar of Transformations* of 1978. When I exhibited the work in the spring of 1979 the censors permitted it on condition that the white and red cloth which was being used in its construction would be replaced by another one; I replaced it by a gray one, thinking that I was mistaken and that the changes would not occur in Poland. Soon it became evident that it was no mistake. The white and red cloth has returned to the *Altar of Transformations*.

MIKLÓS ERDÉLY The Features of the Post-New-Avant-Garde Attitude (1981)

1. One must acknowledge one's own competence with regard to one's life and fate, and keep to it above all else.

2. This competence extends to whatever concerns one's life, whether directly or indirectly.

* Miklós Erdély, "The Features of the Post-New-Avant-Garde Attitude," from "Optimista előadás" (1981) in Erdély, *Művészeti írások,* ed. Peternák Miklós (Budapest: Képzőművészeti, 1991), 133. Translation by Zsuzsanna Szegedy-Maszák. © The heirs of Miklós Erdély, and the Miklós Erdély Foundation (EMA).

3. In this manner one's competence extends to everything.

4. One must have the courage to perceive whatever is bad, faulty, torturous, dangerous or meaningless, whether it be the most accepted, seemingly unchangeable case or thing.

5. One must have the boldness to propose even the most unfounded, least realizable alternative.

6. One must be able to imagine that these variants can be attained.

7. One must give as much consideration to possibilities that have only a slight chance but promise great advantages as to possibilities that in all likelihood can be attained but promise few advantages.

8. Whatever one can accomplish with the limited tools at one's disposal one must do without delay.

9. One must refrain from any form of organization or institutionalization.

GYÖRGY GALÁNTAI AND JÚLIA KLANICZAY
Pool Window #1 (1979)

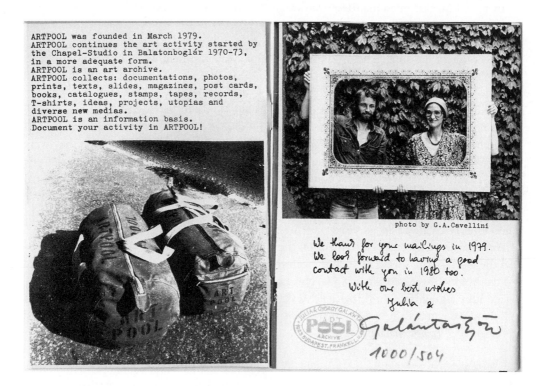

* Júlia Klaniczay and György Galántai, two pages from *Pool Window #1* (1979), mail art newsletter from Artpool, Budapest. By permission of Artpool.

RAŠA TODOSIJEVIĆ THE EDINBURGH STATEMENT (1975)

WHO MAKES A PROFIT ON ART, AND WHO GAINS FROM IT HONESTLY?
THE AUTHOR WROTE THIS TEXT IN ORDER TO PROFIT FROM THE GOOD AND BAD IN ART!

The factories which produce materials are necessary to arists.

The firms which sell materials are necessary to artists.

Their workers, clerks, sales personel, agents, etc. . . .

The firms or private business owners who provide the equipment or decorate the work
of artists.

The carpenters who make frames, wooden structural supports, etc. . . .

The producers of glass, paper, pencils, paints, tools, etc. . . .

Their workers, clerks, sales personnel, retailers, etc. . . .

The real estate agencies which collect rent for: studios, lofts, living quarters or for the holes
where artists live.

Their employers, clerks, etc. . . .

All those producing and selling, either wholesale or retail, everyday items to artists.

All those producing and selling, either wholesale or retail, footwear and clothing to artists.

All those who create and sell, either wholesale or retail, cultural requisites to artists.

All those who produce and sell, either wholesale or retail: drugs, sanitary supplies, alcohol,
contraceptives, cigarettes and sporting goods to artists.

All those collecting taxes on artists' incomes.

Municipal clerks, tax clerks and other administrative personnel.

The banks with their higher and lower-ranking staff members.

Small craftsmen: tinsmiths, doctors, framemakers, shoemakers, gravediggers.

Professional mosaic craftsmen who execute someone else's mosaics.

Professional casters who cast someone else's sculptures.

Professional chiselers who chisel out someone's sculptures.

Modelers and experts in plaster, wax, marble and bronze.

Goldsmiths.

Signet makers.

Zincographers.

Professional executors of high-circulation prints: lithographic, etching, aquatint, silkscreen,
woodcuts, etc. . . .

Medalists.

Stonecutters.

The galleries.

Sales galleries and their staff.

Non-profit galleries.

Gallery owners, gallery administration, gallery curators and their personal secretaries
and friends.

The subsidized gallery council.

The voluntary gallery councils which collect money because they are not paid.

Purchasing commissions, their members and consultants.

* Raša Todosijević, "THE EDINBURGH STATEMENT," special issue on Eastern Europe, *Vision* 2 (January 1976): 32–36. By permission of the author.

Extremely well-trained conference experts having both good and bad intentions concern-
 ing art.
Managers, retailers, dealers and all other small-time or big-time art profiteers.
The organizers of public or partially public auctions.
The collectors.
Those shrewd profitmakers who profit from finer or capital works outside of public
 collections.
"Anonymous" benefactors.
The well-known and respected benefactors.
The low, higher and highest-ranking personnel of cultural institutions and the organizers
 of art, cultural and educational programmes.
The staff members involved in the organization of an exhibit.
All administrative employers.
The clerk responsible for writing letters and sending out invitations.
The clerk who orders, issues and accounts for the necessary materials for an exhibit.
The accounting office.
The janitor.
The secretary, secretaries or other persons related with institutions which provide funds
 for cultural programmes.
All technical personnel.
Professional and non-professional managers.
The designer of the catalogue, of invitations and posters.
The messenger.
The fire inspector.
The critic, writer or other literate individual responsible for writing the preface to the
 catalogue.
The copyreader who checks the preface, or the artist's texts, or those about the author,
 included in catalogues.
The typist.
The photographer who shot pictures for the catalogue.
The catalogue publisher.
The catalogue editor.
The printing firm responsible for printing the catalogue and invitations.
The workers who set the print, bind the catalogue and the invitations.
The proofreader.
The administrative personnel of the printing firm.
Those who fix tax rates and collect taxes on catalogue publications.
Those who sign and issue certificates deeming that the catalogue be tax-free.
Postal fees for mailing invitations and catalogues.
Telephone expenses connected with arrangements made for the exhibit.
The electric companies which charge for electric energy spent during the time of the
 exhibit.
The gallery guard and catalogue, postcard and ticket salesmen.
The cleaning women.
The housepainters.
The individual giving the introductory address at the grand opening of the exhibit.
Outside information service.

The ad department of the daily paper.

The journalist giving a long or short report on the exhibit.

The expert critic giving the exhibit a short review in the daily paper.

The competent editor of the cultural section of the daily paper.

The technical editor of the cultural and all other sections.

The critic or commentator offering a more detailed review of the exhibit.

The publicist who has nothing to do with art but writes about artists, their works and problems in the art world.

The author who scribbles out his lyric images on art for daily, weekly or monthly newspapers, putting them up for sale and thus making public his ignorance or extremely poor knowledge of some particular branches of art.

And all others who regardless of their professional fields either attack or defend the exhibit and the artist through the daily and weekly press.

Cartoonists.

The makers of trickery, epigrams and sophistries related to art and artists.

The television station, its personnel, workers and "artists."

The cameraman who films either the opening of the exhibit or a film report on it.

The worker responsible for the camera lighting.

The lower-ranking associate of the television's cultural programme who covers the story.

His technicians and assistants.

The editor of the television station's cultural section.

The director, stage designer and remaining amateurs.

The commentator or speaker who reads news on the television.

The organizers and television hosts for cultural shows.

The organizer and host of television interviews made with the artist.

Those who write, direct or film either brief or long TV films and plays about the lives of either living or dead artists.

Those who make films about artists as tourist ads.

Those who film full-length romanticized biographies of artists.

Radio stations, their personnel, workers and other associates.

The advertisement page.

News reports and information spots.

The gossip column.

Radio programme writers who write about artists and those reading or reciting this material.

The speaker and radio programme host.

The organizers of various interviews and shows dealing with either culture or art.

Writers of radio necrological announcements concerning the artist or some artistic movement.

All associates and other radio staff members.

Publishing houses, their staffs, workers and consultants.

Bulletins and the editors of these bulletins on art.

Weekly art magazines and the staff which writes for the magazine, as well as those staff members responsible for the distribution of the magazine.

Monthly, quarterly or bi-monthly magazines dealing with culture and art.

Monographers, biographers and editors of collected essays dealing with a particular artist and his works of art.

Those recording anecdotes from the artist's life.

Those assisting the artist in writing his autobiography.

Those who verbally retell anecdotes and jokes from the artist's life, in this way earning: cigarettes, coffee, beer or brandy or cognac or wine or food, etc. . . .

The critics of all fields, ages and trends.

The bookstores which sell the books, magazines, reproductions and original prints created by the artist and by the non-artist.

Antique shops, antique dealers, private sellers, agents and retailers.

Traveling salesmen and transport companies.

The collectors.

Second-hand stores and second-hand dealers.

Commission stores.

Those experts selling their knowledge and familiarity with the artist's earlier works.

Experts familiar with his later works.

Experts for pre-historic art, primitive art, modern art, etc. . . .

Experts for a particular century or a particular epoch.

The organizers of one particular artist's one man show.

The organizers of group exhibits, cultural manifestations, presentations, etc. . . .

The organizers of exhibits which take place between cities or republics.

The organizers of international exhibits.

The organizers of mammoth exhibits: from ancient times through to the present day.

All their commissioners, secretaries, associates, assistants, consultants, proofreaders, publishers, administrative and technical personnel, workers and so forth . . .

The juries, consultants, experts and cafe hostesses.

The conservators, restorers, technicians, etc. . . .

Institute directors, museum directors, museum curators, clerks and other staff members.

The insurance companies and their personnel.

The night guards of museums, galleries, collections and this and that type of compilation or legacy.

The organizers of symposiums, meetings and art festivals.

The organizers of seminars and brief or crash courses in art.

The organizers of organized profit-making on art.

Their ideological, administrative and technical personnel.

Tourist organizations, agencies and their personnel.

Airline companies, bus lines, railroads, etc. . . .

Hotel chains, cafes, waiters, restaurants, boarding houses, etc. . . .

Professional guides with knowledge of one or more foreign languages.

Fans.

Teeny-boppers.

Models.

Married women.

Wives.

Mistresses.

Girlfriends.

Widows.

Children.

Old friends and acquaintances.

Relatives and all other closer or further removed heirs.

Lawyers.

Housewives and mothers who occasionally preach nonsense through the press in support of and against art.

Shrewd overseers and the trustees of legacies, inheritances and collections.

The overseers of art funds left to be distributed as awards, gifts and scholarships to: rich students, careerists and other assorted thieves.

The organizers of funds and scholarships given as one-month or one-year or one hundred-year scholarships to lackeys, bootlickers, wealthier children and to solid epigones.

Organizers granting scholarships for study abroad which are usually granted to the children of higher government officials, to the children of distinguished bankers and to the children of masked and hidden bourgeosie in socialism.

The organizers of various associations and the required technical and administrative personnel.

And all other lower, higher and highest-ranking bureaucrats squeezing money out of artists with a smile, proud of their "holy mission" in art and in culture.

The poster makers, graphic editors and designers who slyly steal from the artist.

Industrial designers of all kinds.

Anti-designers.

Producers and sellers of: handbills, posters and portfolios with signatures or for cheaper without them.

The producers and sellers of "record as art work," full of hope and loaded down with dreams of large sums of money.

Those who earn or hope to earn from additional publications (reprint), the DADA movement, Fluxus and so forth, though they didn't even dream of doing this when it was truly necessary for the artist.

Souvenir producers and their sales people.

Producers of postcards, greeting cards and reproductions of works of art and junk art.

Acclaimed and unacclaimed copyists of art pieces.

The secret forgers of works of art.

Wall decorators.

Facade makers.

Tapestry makers.

Tradesmen dealing in candy, sweets, stockings, tobacco and all other products, reproducing a work of art on its wrapping, thus necessarily making an earning on it

All those using a work of art on stamps, labels, flags, picture books, wall paper and kitchen or bathroom tiles.

The directors of publishing houses who occasionally dispense with their influence in order to make a profit from small trade on "works of art."

Those supporting helpless and senile artists in order to get hold of their inheritance, thus making a gangster-like profit from it.

Exclusive distributors and profiteers on video-tapes, documentary and historical photo-graphs, signatures and authors' napkins.

Those exploiting anonymous artists.

Those abusing occasional by-passers.

Those who are glad to do "this or that."

Imposters making a living by imitating artists.

Serious and self-confident epigones who imitate artists without feeling the least bit guilty, thereby faring better and earning more than the artists themselves.

Counterfeiters of art history who make money on these fakes.

Those favouring a particular style in art due to their own greed and lust for profit.

Those pointing out one artist, or a number of them, or a particular idea, theme or thesis or problem, in order that they might draw attention to themselves and their ideas, thus earning something from it sooner or later.

Art dilettantes and other indoctrinated, calumniated theoreticians joined in secret partnerships, in order to simplify the hunt for profit in art.

Ladies studying art and artists.

The ladies from good families that engage in all kinds of business with artists for the sake of "Art."

Those who support "Street Art" or "Protest Art" and thus thrust, sell, advertise and place these ideas on exhibit in the most elitist galleries.

The critics, theoreticians and other quacks engaged in everyday politics so that they might attain a position in the art world and thus ensure themselves a profit from it.

Camouflaged ideologists, demagogues and reactionaries in institutions, schools of higher learning, universities and academies who have a greater interest in power and influence in the art world, than in EDUCATION and CULTURE, which doesn't offer any kind of profit.

And all those who shade their decadent, dated, reactionary, chauvinist and bourgeois models of art and culture with verbal liberalism, in order that they might attain positions outside of the art world, outside of culture, thus being both above and beyond art and culture.

The psychologists and sociologists who extract nebulous conclusions about art and then start to sell this bluff as a great contribution to the better understanding of art.

Philosophers writing about art, yet never really understanding.

And all the other cheap politicians who have, in this "mysterious" way, through relatives, friends and connections seized at the sinecure, brainwashing artists and make enough money for two lifetimes through this nonsensical business.

MARINA ABRAMOVIĆ AND ULAY
Dialogue with Heidi Grundmann (1978)

ULAY: When we met each other, there was a strong feeling for many things—including a love-feeling: we had a relationship. Out of this relationship and out of the situation each of us was in at the time of our meeting—it was actually a point where it was possible for her and me to live and work together. From that moment on we decided for a radical change in our existence, we both left our fixed place of living—Marina used to live in Belgrade and I in Amsterdam—we decided to be very mobile. It is not a hippie idea and it is not a nomad idea, it has to do with the intensity achieved by permanent motion. And this intensity goes through the whole of our work too.

MARINA ABRAMOVIĆ: As far as the performances are concerned, each of them has dif-

* Heidi Grundmann, excerpts from a dialogue with Marina Abramović and Ulay (Vienna, 15 April 1978), in *Marina Abramović/Ulay, Ulay/Marina Abramović: Relation/Works: 3 Performances* (Innsbruck: Galerie Krinzinger, 1978), n.p. By permission of the author and Marina Abramović.

ferent stages: first you have the idea then you begin the preparations, finding the space, finding out about the technical situation, possibilities for recording the performance and so on—everything you need for the realization of your piece. Then, when you have the fixed time and place, you start to perform, by entering into your own mental and physical construction. We start in a very rational state with the idea to bring into life our own concept. But after that rational beginning there comes the moment when you start to be your own piece, where there is a complete identification with the concept of the piece and at the same time less and less consciousness of rational control. It is somehow the situation where you cannot remember later what was happening. In that moment you are absolutely doing what you are doing, but you don't think, you are not separate any more from your own idea. And that point is very strange—I cannot speak about it. We come to the end (of a piece) and the end for each of us is always different, it is completely open and personal.

U: Because we are two individuals, a male and a female, the physical and psychological nature of the performance can make greater demands on me than on Marina or vice versa. It is obvious that we do not want to demonstrate similarity. At that stage of less consciousness, which probably is the most important stage in a performance, you get to the point of confrontation with your own limitations and that point is different for Marina and me. We did many pieces where we worked in opposite directions, where we could not even face each other, where we could not control each other—I think that there is a total dividing process. The spontaneity which is an important factor in our work comes about because we do not rehearse or repeat a performance.

MA: All our statements have some kind of physical nature, they are very simple, they never explain anything, they are not theoretical, they are statements where I can say I walk to the wall, I touch the wall, I am hitting the wall with my body, that is my part. Ulay's part is running into the wall, touching it, hitting it, the same thing . . . we start in some kind of synchronised similarity, we can say that rationally in the beginning . . . and then we come to the point where each of us functions alone. In that moment there is no contact any more, even in a piece like the hair piece, in that moment, after seven or ten hours, that connection with the hair exists formally, its two bodies doing the same thing, but inside there are separations . . . and after the performance we feel completely empty, really no feelings, absolutely away from everything and when we are confronted with the video, photographs, there is always something missing, no documentation can give you the feeling of what it was, because it cannot be described, it is so direct, in the documentation, the intensity is missing, the feelings that were there. And I think that that is why performance is such a strange thing—the performance you do in fixed time and in that fixed time you see the whole process and you see the disappearing of the process at the same moment and afterwards you don't have anything, you only have the memory.

ULRICKE ROSENBACH Statement (1975)

Feminist art is the elucidation of a woman–artist's identity: of her body, of her psyche, her feelings, her position within society. The work is critical and inquiring; it searches for the essence in women and is in a continuous phase of discussion. Feminist art is the artistic elucidation of woman's historical role: as a mother, a housewife, a woman prostituted by men, as a saint,

* Ulrike Rosenbach, untitled statement, in *Körpersprache* (Berlin: Haus am Waldsee, 1975); reprinted in *feministische kunst/internationaal* (Amsterdam: Stichting De Appel, 1978–79), n.p. By permission of the author and Stichting De Appel.

virgin, witch. . . . All of my video-works are performances. I work with myself in front of a camera. Each time it's a presentation of myself, I show my psychic conditions which depend on the obstructing force of social structures. It is an exposure of my own self. A search for my own potentials.

Venusdepression (1977)

In this action, that was documented on video, I tried to work on a culture context that I had come across when I had spent some summer-weeks in Florence last summer (1977). Walking through the State Museum the "Uffizi-galleries" I looked at many Venus-paintings and the outstanding shield-painting with the image of the Medusa by Caravaggio. The Medusa became a strong image of protection to me: quite different than it was meant by the patriarchal mythology. Also it seemed a mother-earth image as well and I got very fascinated by the idea of using this shield. The Venus-images are very common in Florence. They can be seen as paintings and outdoor sculptures all over the city. Venus seemed to have that expression which I hated so much—an expression of weakness and lacking spirit. The only Venus that is different is the Botticelli-Venus which tells about the original strong power of the goddess-aspect. Together with the knowledge about the witch-burnings on the Plaza di Signoria I could work out my feelings of despise by burning the prints in bowls. The series of three paintings by Botticelli I knew before and always wanted to include in one of my works. So I had slides covering the high walls of the palazzo showing three stages of the women's hunt which is described in Boccaccio's "Decameron," which moral goals seemed still quite modern to me, though it was written in the 15th century. During all the parts of the performance, the historical images from Italian culture were used to fit in a puzzle and collage-like aesthetic piece to make up a rite of defense and female consciousness of history and its meaning to women's position in society.

RASHEED ARAEEN

Cultural Imperialism: Some Observations on Cultural Situation in the Third World (1978)

If art is the expression of beauty . . . then the meaning of this Beauty must be sought not in the old classics, not in foreign cultures, nor in metaphysics, but in the material reality of our existence as a people and our own cultural life today.

What is art? If we are genuinely interested in this question and wish to disentangle all its complexities, we must approach it and look for its answer beyond the futile academic exercises and meaningless phrasemongering of the so-called critics who, though they help fill the magazine sections of our Sunday papers, in essence fail to offer anything more than the parrot-like reiterations of old dogmas. Their failure to produce any meaningful analysis in

* Ulricke Rosenbach, statement on the video action *Venusdepression* (1977), in *feministische kunst/internationaal* (Amsterdam: Stichting De Appel, 1978–79), n.p. By permission of the author and Stichting De Appel.

** Rasheed Araeen, excerpt from "Cultural Imperialism: Some Observations on Cultural Situation in the Third World" (1978), in *Rasheed Araeen: Making Myself Visible,* with introductory essay by Guy Brett (London: Kala Press, 1984), 69–82; originally published as "The Terror of Cultural Invasions," in *Morning News* (Karachi), Sunday magazine, 22 February 1978. By permission of the author.

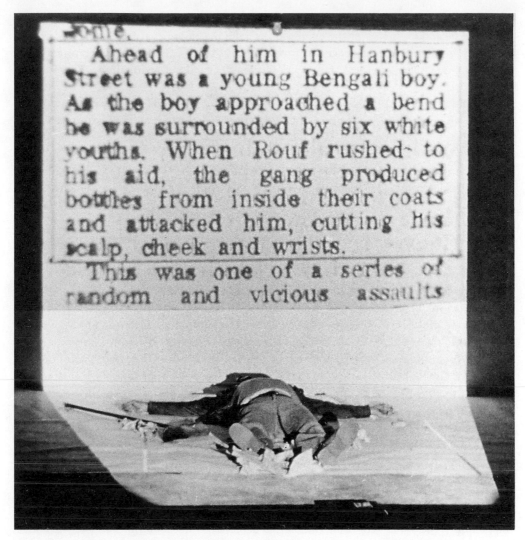

Ahead of him in Hanbury Street was a young Bengali boy. As the boy approached a bend he was surrounded by six white youths. When Rouf rushed to his aid, the gang produced bottles from inside their coats and attacked him, cutting his scalp, cheek and wrists.

This was one of a series of random and vicious assaults

Rasheed Araeen, *Paki Bastard (Portrait of the Artist as a Black Person),* 31 July 1977, performance with slides and sound at *Artists for Democracy* exhibition, London. Courtesy of the artist.

this respect is the consequence of their inability or incompetence to deal with the problems of our contemporary socio-cultural situation in the context of foreign domination.

It is also a reflection of the lethargic condition of our 'intellectuals,' created by this domination, who thus cannot react critically to a situation that demands imitation of foreign values as the basic criterion of a 'better' and 'progressive' life.

Since we are asking this question TODAY, its answer must lie not in the past but IN THE PRESENT. Though past knowledge—our own as well as of others—may offer us some guidance, its real answer must be found in the socio-cultural realities of our own time.

Art, the basis of which exists not in the contemporary culture of a people but in a concept of Beauty created and developed in the remote past, cannot but project only dogmas, which again cannot be the reflection of the present life, let alone a critical reflection which it may demand.

Art cannot be created, nor developed, by a set of values or rules imported from abroad; nor can it be and MUST NOT BE the expression of a dogma or dogmas. Art can only be created by and through an evolving process as part of a socio-cultural evolution generating its own new ideas and concepts at every stage of its development and thus maintaining its continuous transformation.

Dogmas as well as imposed values, particularly of foreign origin, become obstacles in this process, stifling the imagination and thus destroying the creative and productive capacity of its participants. The imposition of foreign values on to the people (and the acceptance of these values by them) who are under direct or indirect foreign domination, negates their historical process, resulting in the stagnation and, in the event of no resistance to this domination, destruction of this process. It is in fact the purpose of foreign domination to destroy the indigenous values of the people and replace these values with the values which are not the product of their own development.

Why do we, then, always look for the criterion of Art or our own art and culture in the past or in Western culture whose dynamics of development were and are very different from ours? This question cannot be answered with any justification without looking into our own past history or the period when our country, like other Third World countries, was under Western colonial rule; because without the understanding of this past we cannot deal with the concrete problems arising from our present socio-cultural predicament and from which our present concept of Art or Beauty cannot be separated.

Colonialism destroys—and has destroyed—the development of the productive forces of the colonised people by the negation of their historical process or processes and then imposing upon them a process or an economic system which mainly serves the interests of the colonialists. This is and has been carried forward into the neo-colonialist situation that exists today, known as "underdevelopment."

Cultural propaganda is one of the main tools used in the perpetuation of neo-colonialism. The predominance of Western cultural values in most Third World countries today only reflects the fact that these countries have not yet actually LIBERATED themselves from Western domination and exploitation. . . .

The attempt of Western imperialist domination is to destroy the indigenous development of the people in the Third World and in doing so deprive them of their inner or socio-historical motives that are necessary in the development of their full creative or productive potential. This is now achieved not by conquering a country or countries, although military interventions are not ruled out (as in Vietnam) when it is necessary to maintain the economic and political domination, but more importantly through the insidious and complex cultural penetrations that upset or destroy the very fabric of indigenous social life, art and culture. The result is not only psychological trauma among many but also mental enslavement that makes people accept easily whatever is offered, whatever they get hold of in their struggle for survival. This, in effect, creates mechanistic consumption of foreign produced goods, submission to foreign values, imitation or imitators of foreign cultural forms, whose eventual function becomes the entertainment of the native ruling class which besides representing foreign interests also thus prevents the people from liberating themselves from such a disgraceful subjugation.

In this neo-colonial situation, the acceptance of Western concepts of Beauty or Art by the Third World intellectual creates a milieu in which the intellectual exists virtually trapped and alienated from the masses. He looks down upon people, in repudiation of his own and their indigenous values, accepting self-emasculation which then prevents him from any meaningful social intervention. The masses are, at the same time, subjected to the daily vul-

garities of the commercial mass media. The *images* which are constantly projected to the public by the TV, films, newspapers, magazines, and particularly by commercial ads, produce contents that act as a kind of "catharsis" in order to give them some comfort in their psycho-sexual predicament created by the deprivation of their basic physical and mental needs. The vicious circle continues while the addicted public is provided regularly with its daily ration of cultural "drug" and huge profits for the "respectable" pedlars.

Moreover, these images constitute forms and relationships that necessarily produce propaganda for Western culture. A man dressed in Western style is *always* projected in a context or relationship that reflects his higher socio-economic status, his achievement in the modern world. And thus Western dress (Western culture) becomes a symbol of modern "progress": more "beautiful," more "desirable," and in effect, more "real." This not only creates a cultural identity crisis among the urban classes, it clearly relegates the culture of the masses to a status of backwardness.

What is more worrying and sad is its disturbing effects on our so-called intellectuals—artists, poets, writers, critics, etc., from whom one would expect some kind of original thinking, from whom one would (and should) expect an awareness of our present socio-cultural predicament and its critical reflection in their work. Instead most of them have become not only the victims but also the instruments of Western cultural propaganda projected daily on our national TV network.

You only have to cast a cursory glance on the way most of these "intellectuals" appear in public. Their manners alone betray their enslavement to the vulgarities of Western culture, let alone the context of their activity. Even many of our poets, for example, who write in our own languages and who talk about our old values, appear on TV dressed in the latest Western style. To some extent this criticism may look trivial, but the fact of the matter is that their appearance becomes part of the culture or cultural propaganda that degrades the actual way of life of the majority of people. They become a reinforcement of the visual symbols used in commercial ads to lure people into the acceptance of Western life as a solution of their socio-economic problems.

Against this background of Western cultural dominance, we must, therefore, look for a concept of Beauty or its expression that reflects our own present life. We must seek for a beauty which is an evolving entity or concept, and the dynamic of which must lie in the productive forces of our people brought about by their own conscious efforts and their awareness of the process of change.

Any concept of Beauty which is imposed on our people from outside, is the negation of their own productive and creative capacity; it is the negation of their ability to participate in a historical process of their change (to quote Paulo Freire) "WITH AN INCREASING CRITICAL AWARENESS OF THEIR ROLE AS SUBJECTS OF THEIR TRANSFORMATION." It is a denial of the dialectical process through which alone our people could and should develop their critical awareness and thus act to move forward in history.

If we do not find today a concept of Beauty that affirms our own existence as a free people, as part of the present technological age with our own contribution to and reflection on its development, then there must be something fundamentally wrong with our present society. The illusion of progress created by the consumption of Western goods and cultural values cannot be anything but an ugliness: the ugliness that we notice today in every walk of our life and which we have mistakenly taken as Beauty and are embracing, perhaps unknowingly, for our own destruction. Therefore, it is our duty to oppose this ugliness in order to destroy it before it destroys us. This demands an action along its critical reflection instead of hollow slogans like "all that is beautiful shall abide" of our emasculated intellectuals.

MIKE PARR Notes on My Performance Art, 1971–1998 (1998)

I have never trained as an artist. I think that fact is fundamental to my emergence as a performance artist. My performances began as "idea demonstrations," really as desperate attempts to stabilize the dissociations and flows that language produces, so in a way they were about controlling the impact of memory.

The fact that I was born with one arm is also important, but even more significant is the way in which the story of my disability has been concealed within the family and the way in which it came out, because while the story only became definite after I began doing performances, the performances themselves seem to mimic and anticipate its distortions. I was in my forties before my mother was able to explain how a congenital malformation of my left arm was "cleaned up" after my birth. Some years earlier I went into hospital for an operation and the attending doctor noticing the remains of my left arm commented on an operation scar which disfigures its end. In the late sixties my performances were preceded by psychotic episodes in which I cut and attacked my body in an incoherent way. I was performing a psychotic operation.

The early "idea demonstrations" began then as compulsions, hallucinations, terrifying ideas that possessed me. In 1971 I began to write down the first **Programmes & Investigations** as the first step in trying to control these thoughts, but the damage kept getting into my language as though I was choking. One of my earliest proto performances revolved around the idea of gargling a stone. Vibrato of a stone, but the idea kept dilating into the feeling of suffocation and loss of control. I tried to write down these impulses as clearly as I could. To make them definite, even elegant as language. About this time I got my first typewriter. It really helped to stop writing in longhand. My handwriting has always distracted me. It is as though seeing my handwriting splits my attention. It is a strange problem of language becoming conspicuous as an image.

By 1973 I had written more than 150 **Programmes & Investigations.** I was performing these actions as I was writing them down. The attempt to understand these works in a multidimensional way was part of their accumulation from the outset because I also kept Notebooks in which I attempted to theorize the meaning, implication and impulse behind these works. Performance was understood by me from the outset as a kind of *praxis,* as a way of thinking and as a means for changing the meaning and use value of art. The **Programmes & Investigations** became the basis for my activity for more than a decade.

In no way are these actions a kind of victim art. I am attached to my "difference" and I have come to feel empowered by it. My problem has been to order my response to difference, to make that response articulate and to use "difference" critically in a political and social context as well as an artistic one. I have always been derisive of the idea of theatre and I remain consistent in that respect, though the deconstruction of the theatrical veneer is the basis for many of these actions, I have always in a sense performed myself and yet I do not think of my art as self expression. This performance of the self is absolutely tautological and the form of the work is inevitable given the relationship between instruction and action. Regression is made harsh, explosive but it also lights up the audience like a flare.

The relationship between language and action is fundamental to my work and in some ways my concept of performance evolved through the act of writing. Early in 1971 I exhibited

* Mike Parr, "Notes on My Performance Art, 1971–1998" (July 1998), previously unpublished. By permission of the author.

a work at the artists' co-operative gallery **Inhibodress** in Sydney called **Word Situations.** These were works that had been produced on the typewriter and they hovered between language and image in a way that was reminiscent of concrete poetry but different I think. Many of the works had to do with duration. For example, I typed the statement, *the surface is only skin deep,* to make a rectangular area on the page, continuing to overtype the sentence until I wore through the paper and it became transparent and thin like a layer of broken skin. This took many hours of typing. On another occasion I tried to type out a square of my own blood and the major work of this period was the **Wall Definition** in which I took a dictionary definition of the word *wall* typing in turn a definition of all the words in the first definition to make a definition of the definition that was literally a wall of words made up of hundreds of sheets of abutted quarto typing paper. The typing of this work was carried out in the **Inhibodress** gallery and it took many days. In these ways I became conscious of the process of typing as performance and the obsessive recurrence of the tasks I set myself actually condensed and stabilized my relationship to problems of language. I typed out affect [anxiety] and stilled the associative flow materializing language as substance and image.

The move to exhibit these products as art made my concept of performance possible. A very influential Sydney critic of the day reviewed these exhibitions as somehow being an example of what he called "Post Object Art." Australia was quite isolated as a culture in the 1960's & 70's and our first struggle as radical artists was to invent names to contain and theorize our activities, so "idea demonstrations" is equivalent to "performance art" as that term came to be widely used later, in the same way that "post object" is clearly an attempt to conceive of art as primarily conceptual. It is not to say that we had not begun to learn about developments in Europe and America but our knowledge and understanding of recent developments in the visual arts was fragmentary, incomplete. The public attempt to theorize these activities as art gave us an audience. It also made this "art" intensely controversial. I realized that I had been given a kind of license that would enable me to exploit "idea demonstrations" as art. Post object was a category that could protect me from the charge of psychopathology and in an intensely conservative culture enable me to defend myself.

The first truly public performance of my work at **Inhibodress** was the instruction, *Arrange for a friend to bite into your shoulder. He or she should continue biting for as long as possible or until their mouth is filled with blood,* in June 1972 [though videotapes of performances done with Peter Kennedy had been presented the year before]. My friend Peter Kennedy rolled up my sleeve and began biting. It was as abrupt as that. I had the clear realization that I had to cope with what was happening to my arm, which was in my mind, I suppose, being bitten off, but the re-figuring of an arm was I think far less important than forcibly confronting and re-figuring the audience. The performance was dominated by my refusal to act out, I mean I was acting out but in the absence of affect. Somehow or other I realized that I must not give the audience the excuse to intervene and by so doing get themselves off the hook. Kennedy bit into my shoulder and I kept the audience at bay. This objective tension of limits, of the carthartic contained and tensioned through its means of expression, of fission/fusion, is the basic form principle of all my performance work and it makes the idea of endurance intelligible as a kind of extreme pressure on the audience.

The film of this piece shows that I was shivering uncontrollably, some people fainted and at the end of the event there was a kind of explosion as people rushed to fill the gap with questions and arguments among themselves and self reproach and "this is a monstrosity," "why did we allow it to happen" and so on. Everyone seemed totally confused, but in that moment the idea of performance was born for me, because I suddenly felt as though I had transferred

everything onto the audience, that I had created a tremendous division within them, a kind of schizophrenia, a glaring conspicuousness which alleviated and balanced my own. I now think of this as an incisive relocation of amputation, as the "cutting up" of the audience's objectivity and as a kind of hysterical and hermeneutic exacerbation of the sanctity of aesthetic dissociation, of "object containment," that makes so much art and theatre amnesiac. Of course I didn't think all this at the time. I am not a "theory machine." My clarity and understanding vacillate enormously but gradually I have structured the idea of performance art in my own way. In the 27 years since my first actions in Sydney I have done well over 100 pieces in Europe, Japan, South East Asia and Cuba and all of these works are either documented on film or video and still photography.

ELEANOR ANTIN Notes on Transformation (1974)

Every human being must choose from the styles he finds available a persona that he will find appropriate to a dimly realized sense he has of his self as a field of possibilities. Autobiography can be considered a particular type of transformation in which the subject chooses a specific, as yet unarticulated image and proceeds to progressively define his self with increasing refinement which, in turn, both clarifies and makes precise the original image, while at the same time transforming the subject. One might say, a successful transformation has been effected when image and subject approach a perfect fit. In a strictly phenomenological sense, total equivalence may be impossible, but since distance blurs distinctions, provided they are subtle enough, the fellow next to us probably has no suspicion that he is talking to an imposter. Admittedly, problems arise. Perhaps the fit isn't good enough. Perhaps the plastic material can not accommodate itself precisely enough to the original image. As Michelangelo said, "Non ha l'ottimo artista alcun concetto che el marmo solo non in se circoscrive." Or conversely, the original image may not be complex enough for the diverse possibilities of any given plastic material. But people are stubborn and a whole literature of neurosis has been generated by the pathos of the commitment to the "bad fit." Yet other problems can arise. One's neighbors may have insufficient generosity to permit others self-images they find unesthetic or frightening or embarrassing to their own. A tradition of mental hospitals and penal institutions has been erected to protect certain images from being confronted by other images. Science, Government, Education, Art, the cultural monolith may be said to exist primarily to exercise a paternal influence, decorously if possible, aggressively if necessary, to enforce certain accepted images upon individuals.

I am a post-conceptual artist concerned with the nature of human reality, specifically with the transformational nature of the self. I began with biographical explorations before moving into autobiography. In 1965, I collected blood specimens from 100 poets. *The Blood of a Poet Box* was intended to suggest relations between a smear of blood on a laboratory slide and a name. I soon discovered that blood isolated from the body is at best merely a metaphor except to certain esoteric specialists like doctors and policemen. Preferring a more complex set of informational clues, I began to construct semantic portraits of people, sometimes real, sometimes fictional, out of configurations of brand-new consumer goods. A lush lavender bath rug, a noisy electric Lady Schick razor, a patch of spilled talcum powder and a scattering of

 * Eleanor Antin, "Notes on Transformation," *Flash Art* 44/45 (April 1974): 69. By permission of the author and the publisher.

pink and yellow pills was a portrait of "Molly Barnes." Since this system had variable readings built into it, I experimented with systems seeming to present more rigid limitations on interpretation, so in *Library Science,* I used the LC [Library of Congress] classification system which is used to classify the world of books in large American libraries, to classify a sub-set of the world of people.

About this time, I made use of the possibilities of a new art distribution system, the mails, to disseminate narrative information to 1000 people over a period of $2\frac{1}{2}$ years. I placed 100 rubber boots into the natural landscape, had them photographed and documented the time and place of the event. The resulting photographic image was printed onto postcards which were mailed out at intervals ranging from 3 days to 5 weeks depending upon what I took to be the "internal necessities" of the narrative. Since they always appeared together, 100 boots were quickly transformed into "100 boots," the hero of a fictional biography, and the continuity of his adventures was dependent upon the ability and interest of the recipient to hold the installments together in his head, since each postcard was part of a sub-set of anywhere from 2 to as many as 6 images forming a narrative ensemble, the single adventure. The whole work was a sequence of these conceptual adventures, a kind of conceptual picaresque novel.

Around this time I began to use myself as material and I must confess to an almost voluptuous pleasure in moving from biography into autobiography. *Carving: A Traditional Sculpture* was a naturalist transformation, a piece consisting of 148 sequential photographs of my naked body "carving" down 10 pounds over a period of 37 days of heavy dieting. *Domestic Peace* was a transformation of myself into an alien image—"the good daughter"—as a device to accommodate my mother so she would leave me alone to freely pursue my real interests. After a number of such works, I began to view the relations between literature and fact, truth and fiction, in a new light. I began to see that a human life is constructed much like a literary one, and, in any event, the documentation is the same for both. A person writes his autobiography about past events. After the fact there is only history and history is always fiction. But the fact that he takes the trouble to go back and construct that historical fiction proves he is a passionate person living very much in the present. He has, one might say, something to sell, whether he is St. Augustine or Billy Rose. It is his self-image or rather what he wishes to establish as the correct one. The early conceptualists were primitives. Contrary to their belief, documentation is not a neutral list of facts. It is a conceptual creation of events after they are over. All "description" is a form of creation. There is nothing more biased than scientific documentation. It presents a non-psychological image of the "natural order" with no more claim to "objective" truth than William Blake's symbolic universe. But consequences of this position are not so simple as declaring a relativistic theory of the universe nor a trivial question of honesty or dishonesty. There is the literary nature of the human mind and the pragmatic nature of the human soul and together they do a number upon the world. I began to see that my interests in transformation were inextricably bound up with the nature of the documentation process itself. If I am known mainly by hearsay, for others there is no easy way to separate myself from the public report of myself. I could therefore announce myself to be anything I wished, were it not for the accumulation of previous reports. For example, I am free to claim that I am Charles I of England but the claim comes up against a previous report of a short, egotistical man whose head was removed on January 20, 1649. But what if I appear to press my claim in force as plain as the beard upon my face? Is not this new, more recent report, bearing the weight of visual testimony (photography, video, personal presence) more powerful than the gossip of history?

I am interested in defining the limits of myself. I consider the usual aids to self-definition—sex, age, talent, time and space—as tyrannical limitations upon my freedom of choice. I have projected 4 selves—The Ballerina, The King, The Black Movie Star, and The Nurse.

Solana Beach, California
January 1974

JOAN JONAS Closing Statement (1982)

I didn't see a major difference between a poem, a sculpture, a film, or a dance. A gesture has for me the same weight as a drawing: draw, erase, draw, erase—memory erased. While I was studying art history I looked carefully at the space of painting, films, and sculpture—how illusions are created within a framed space, and how to deal with a real physical space with depth and distance. When I switched from sculpture to performance I just went to a space and looked at it. I would imagine how it would look to an audience, what they would be looking at, how they would perceive the ambiguities and illusions of the space. An idea for a piece would come just from looking until my vision blurred. I also began with a prop such as a mirror, a cone, a TV, a story.

The objects I use are not literal adaptations of the elements in the story or concept, but are symbolic, archetypal. The cone was an instrument to channel sound to the audience. I could whisper in their ears, look through it, listen to it, yell through it, sing—always directing sound to a place. *Funnel* was based on the form of a cone.

Organic Honey's Visual Telepathy evolved as I found myself continually investigating my own image in the monitor of my video machine. I then bought a mask of a doll's face, which transformed me into an erotic seductress. I named this TV persona Organic Honey. I became increasingly obsessed with following the process of my own theatricality, as my images fluctuated between the narcissistic and a more abstract representation. The risk was to become too submerged in solipsistic gestures. In exploring the possibilities of female imagery, thinking always of a magic show, I attempted to fashion a dialogue between my different disguises and the fantasies they suggested. I always kept my eye on the small monitor in the performance area in order to control the image making.

Props determine the movements and animate the set. I use them over and over in different ways. One's body is moved by the props or moves the props. A costume also serves as a kind of prop in that it is chosen for how it looks on the monitor, in the set, or how it relates to the story, or simply because I like it. Sometimes props and costumes come as gifts from friends.

To start with an object and to play with it is very childlike in a certain sense, and it enhances intimacy. In this respect I remember especially the experience of watching Maya Deren's film footage shot in Haiti in which somebody makes a sand drawing. It was like watching a person do something very private. The footage interested me a great deal because it was not edited and in the series of takes the drawing was repeated again and again. Drawing is a ritual used in my performances.

In *Organic Honey* I called the drawings "drawings for the monitor." I drew while looking at the monitor instead of at what I was drawing. The audience also saw the result on the mon-

* Joan Jonas, excerpts from "Closing Statement," in Douglas Crimp, ed., *Joan Jonas: Scripts and Descriptions 1968–1982* (Berkeley and Eindhoven: University Art Museum, Berkeley, and Stedelijk Van Abbemuseum, 1983), 136–37. By permission of the author and the publishers.

itor. From then on, I used drawings in all my pieces. They derived from an interaction with the technology, the content of the work, and the rhythm and gesture of the performance.

Drawing is a visual language. The fact that an image can represent different things at the same time enriches my vocabulary—for instance, in *Organic Honey,* the sun that turns into a new moon with the addition of one line and the erasure of another, or, in *Mirage* and *The Juniper Tree,* the heart that looks like a bug, or turns into a woman's face or the devil.

If I'm concentrating on the performance, I can't worry about what the drawing is going to look like. I just make the drawing. A lot of strange things have come out, the release of partly unconscious, archetypal images. These have surprised me, and I could never duplicate them. I think they appeared because I was in performance. . . .

All of my performances are concerned in part with the image as metaphor. There is an emotion in the image that cannot be translated. The image contains it.

The performer sees herself as a medium: information passes through.

SUZANNE LACY The Name of the Game (1991)

I had my first taste of cooption late in the seventies, when I heard a critic call Chris Burden, the West Coast performance artist known for his acts of bravado and daring, a "political artist." Now, Burden is a fine artist in many respects, but political he's not—at least in terms of the vocabulary that described the conscious intentionality of feminists, Marxists, and community artists who had come of age in that decade.

In 1969 at Fresno State College in California, the artist Judy Chicago began her experiment in educating women in the arts with what was probably the first feminist art program. . . . As part of that West Coast feminist moment, I can tell you that we were very busy: unearthing scholarship on obscure women artists, probing hidden self-information through consciousness raising, developing artistic form language to express personal experience, critically examining women's artwork for its underlying impulses and premises, and trying to reconcile the rapidly growing body of feminist political theory with our art making.

I think this last point is worth noting. In 1969, when the New York painter Faith Wilding and I put out an open call for a women's meeting in Fresno (and were astounded when almost forty women appeared), very little feminist theory was available; Betty Friedan, Caroline Bird, and Simone de Beauvoir were the exceptions. That changed rapidly in the next few years, and as soon as material became accessible in the newly formed women's bookstore in Fresno, we jumped on it. We discussed it with each other and compared it to our own experience. We measured our political, and later our art, practices against these early writings. We also combed related fields for information pertaining to our condition as women. As a psychology graduate student, I was criticizing Freud, drawing on Irving Goffman's work on the arrangement of visual symbols to signify power relationships, George Gerbner's activist media theory, and Saul Alinsky's community-organizing techniques. Others, from different backgrounds, similarly looked with a changed eye to the body of writing in their own professions. Such literature fueled but did not exclusively comprise the most basic project: understanding who we were, what we wanted, and how we were positioned as women in this and other cultures. This feminist project was made up of re-

* Suzanne Lacy, "The Name of the Game," *Art Journal* 50, no. 2 (Summer 1991): 64–68. By permission of the author and the publisher.

search, personal introspection, and activism, in changing proportions. Theory grew out of all three.

Much early American feminist theory of the sixties and seventies was based on political activism. (Valerie Solanas *first* shot Andy Warhol, *then* wrote her book from jail.) The reconciliation of feminist theory and (for some) leftist and community-organizing theories with art making informed the next several years of West Coast education. At the feminist art programs at the California Institute of the Arts, and later at the Feminist Studio Workshop of the Woman's Building, we began to develop a political art that was participatory, egalitarian, and reflective of both the personal and collective truth of women's experiences. We wanted art that made changes, either in its maker or its audience. It was well understood that in order to create an art of action one must see as clearly as possible the present nature of things; so it followed, of course, that analysis was a part of our practice.

Below are some of the ideas (which were not necessarily exclusive to women artists) we used in formulating what we were doing and analyzing why we did it:

1. *Art is a potential link across differences.* It can be constructed as a bridge among people, communities, even countries. . . . Attempts at interracial "crossovers" were common in midseventies feminist art, though the insights needed for cooperation and inclusion among women of differences had not yet been developed. In fact, some of the early artworks that attempted to deal with race may have contributed to developing necessary skills. As a result of seeing art as a bridge, collaboration became a highly valued attribute of the work process, and its practice was much more complex than the sharing of work by two equal partners. Collaboration was explored as a concept that explained communication, effort, and exchange between two or more differing entities.

2. *The body is a primary site for works of art.* This fit well into feminist personal exploration and collective redefinition. Not only was the body a site, it was an important source of information. Much of women's social status was seen as based in the body, so issues like violence, birthing, sexuality and beauty were frequent subjects. . . .

3. *There is a discrepancy between what we see in social representations of women and the self-awareness generated from actual experience.* This discrepancy provoked skepticism and critique. In some instances, works of high humor resulted, as artists (particularly in painting, photography, and performance) demonstrated multiple personalities, experimented with real and illusory facades, and transformed themselves through self-portraits. . . . In other instances, analysis was generated from the observation of problematic representation; this, in turn, fed the women's movement outside of the art world. . . .

4. *"The personal is political."* This axiom stimulated consideration of the nature and meaning of public and private, a debate that continues today under the double rubric of censorship issues and the role of public art. . . .

The political nature of imagery, the power that comes with the right to name and describe, the "censorship" of people not allowed access to self-representation—these were the avenues of inquiry that led to overtly political artwork by mid-seventies feminists. However, by keeping the personal-political koan in mind, politically engaged artists were able to maintain the value of private experience and personal expression, which would otherwise have been lost to the equation. . . .

5. *The study of power and its uses and abuses leads to a consideration of inside and outside.* In the seventies "inside" was fine art as revealed through the glossy art magazines; "outside" was political art, feminist art, ethnic art. "Inside" was galleries and museums; "outside" was the streets, the community, the homes of the working class. Artists considering these ideas de-

veloped strategies for accessibility, desiring to reach various and different constituencies. They looked at the culture of these communities in the context of high art and they called it the democratization of art. . . .

6. *Audience response is an integral element in aesthetic analysis.* Because of their activist base, early feminist artists were concerned with questions of effectiveness, stimulating a fairly sophisticated discussion of an expanded audience and an understanding of how to reach it. This started quite simply. We felt the nature of women's private experience could be revealed through art, in order to influence cultural attitudes and transform stereotypes. Naïve as it sounds, change was our goal (though its directions were not clearly articulated). Since we'd already decided that the art world was elitist, we bypassed it and went beyond it, developing strategies to reach multiple audiences, support systems to carry them through sometimes difficult subject matter, and methods to analyze our results. . . .

7. *Strategic interventions into popular culture were part of aesthetic practice.* This impulse to consider the nature of public response and incorporate it into the structure of the work paved the way for today's public art, including mass-media art. Of course, both public and media sites were also venues for artists who were not feminists, but in many cases the originating impulse for their work, while political in that a media critique was intended, was not otherwise activist. . . . For feminists media and pop culture were ways to broaden communication.

There were many other ideas upon which we built our art, and these are documented in various places. Suffice to say we worked hard to define and live up to the label "political artist." It was quite apparent from criticism at the time that the art world could supply little, if any, framework to explain or expand upon what we were doing. It was even more apparent that political art was a "lower" form (or even a nonform) of art. So imagine my surprise when, in the late seventies, I heard Chris Burden labeled "political." Either his popularity was waning, or someone had changed the name of the game.

Shift now to the mid-1980s. In Soho a political-art exhibition opens: it consists of the word (and *only* the word) *Hiroshima* blazoned across the wall of the gallery. In Texas, at the Society for Photographic Education conference, a critic discusses the iconography of the high heel in terms of its signification of female sexuality. Back in New York, in the Whitney Museum's 1989 exhibition "Image World," three photographs are displayed: Judy Chicago's pugilistic renaming of herself in a full-page *Artforum* ad, in which she is dressed as a boxer; Lynda Benglis's pornographic shocker, her glistening nude body sporting a dildo; and, hung next to these without comment or contextualization, Jeff Koons's self-advertisement from *Art in America* as a man about town. The Latino boom hits New York, a few years later than Los Angeles, and the art world dances to a salsa beat (a short beat, according to skeptical Latino artists, who remember the "Afro boom" of the mid-seventies).

The name of the game *has* changed, but have the ground rules? It is no longer out of vogue to be a "political" artist, but activism is still problematic, as evidenced by its lack of critical theory and support. The feminist artists of the seventies were somewhat utopian in their approach. They envisioned a new world, and their analysis of society included an imaginative revision of the status quo, one that included them. Feminist art of the eighties is marked by a complicated observation of what is taken to be the structure of contemporary culture—a curiously centralized discourse on marginality.

There has been a definite increase in the inclusion of feminist, political, and ethnic ideology in the language and commerce of today's art world. . . . But there is a fundamental problem with our embrace (or is it a clutching?) of these ideas, people, and art forms. That problem is cooption: the acceptance of the surface without the substance; the divorce of style

from meaning; the elimination of the history, theory, and values upon which the work is founded.

According to the Los Angeles muralist Judy Baca, the Chicano art movimiento, whose work was tied to indigenous communities and often rooted in Mexican aesthetics, understood the relationship of self-expression and identity to power. During the Latino boom, the fundamental political analysis and the grass roots upon which the work was built were obscured or eliminated altogether. . . .

Likewise with feminist art, rooted in activism and in a profound sense of female community. The debate between the academy and the arena of action in feminist criticism is valuable only if it is contextualized by the overall and ongoing embrace of a larger project called feminism. Debates about woman's "essential" versus her "constructed" nature seem, strangely, to divide rather than stimulate. Activism is pitted against analysis, with a clear-cut art-world bias toward the latter, oddly similar to the art world's condescension to political and community-based art during the 1970s.

Granted, the definition of feminism is different for each of us, but it often appears that a commitment to the whole—the whole body of women, of political struggle, of history (and that includes the history of feminism as well as of art)—is missing from contemporary debate. So we must ask, in whose interest is it that feminism be fragmented? Who gains if history is forgotten? If feminism in a new, theoretical, abstract stance is allowed into the academy, while those scruffy activists are left, once again, outside? If low-riders and zootsuiters are in and muralists out? If merely to evoke the name of Hiroshima in a high-rent gallery is sufficient for the political conscience of the art world?

When theory is disconnected from activism it is robbed of its vitality—its life, some of us would say. Women artists have fallen into a trap of divisiveness. Each succeeding generation has bought the media's version of the previous one. . . .

The result is loss of a sense of values. To what end do we analyze? For what reason do we act? One critic told me she thinks people are confused today, looking for a perspective to explain artists' relationship to the world. The questions feminist artists asked in the seventies are still pertinent today, most vividly in public art, and directly address values:

What is public, what is private, and what are the rights and responsibilities within these sectors?

What are the social and personal values expressed through an artist's work, and how are those values relevant to shaping culture?

How do you integrate a broader public into the process of making, viewing, evaluating art? How can we reach multiple and expanded audiences? Should we?

Is the market the measure of the value of art? If not, how is meaning to be evaluated? If not, how are artists to support themselves?

Is change intrinsic to the viewing of art? To its making? What is the nature of such change, and how can it be discussed? Can art change the world?

There are other questions out there, and many sources other than feminism contribute to this thinking. In this decade multiple voices and histories are surfacing; we are in an astoundingly

vital moment, one with a difficult charge. It is not simply a historian's task to integrate the last twenty-five years of feminist, political, and ethnic art practice and theory. It is the task of all of us not to forget. Issues of feminist identity, ethnic cultures, ecology, community, and global consciousness are rooted in radical, spiritual, and theoretical practices. Out of the intricacies of their links to each other will grow a new and appropriate art: a game that matches its name.

CHRIS BURDEN Statements (1975)

My art is an examination of reality. By setting up aberrant situations, my art functions on a higher reality, in a different state. I live for those times.

.

I don't think I am trying to commit suicide. I think my art is an inquiry, which is what all art is about.

.

Art doesn't have a purpose. It's a free spot in society, where you can do anything. I don't think my pieces provide answers, they just ask questions, they don't have an end in themselves. But they certainly raise questions.

.

I took most of my courses from Irwin. Tony de Lapp held classes—and he was really the most formal. But Irwin was a lot cooler—he would just come to the studio about once every two months and spend whole days at a time. It was really good, because it was on a one-to-one basis. He would come by for a whole week, and sort of do a total head blitz and then leave. You had to sign up for classes, but I just signed up for about three or four with Irwin; that just kind of took care of school. Most of the time I didn't really see anybody else until the end of the year.

.

FIVE DAY LOCKER PIECE, University of California, Irvine, April 26–30, 1971: I was locked in Locker Number 5 for five consecutive days and did not leave the locker during this time. The locker measured two feet high, two feet wide, and three feet deep. I stopped eating several days prior to entry. The locker directly above me contained five gallons of bottled water; the locker below me contained an empty five gallon bottle.

It was kind of weird really. . . . The students were all kind of defending me and Conlon was sort of trying to knock me down, and there I was shut up in there, and they were arguing with the art. It was kind of nice really. It was one of the nicer moments.

About 10:30 at night the doors were locked and people could no longer come in the building. That was the most frightening period. I had this fantasy, though, that I could always kick the door out. Some nights my wife would sleep on the floor outside in case I really flipped out or something. It was pretty strange. One night the janitor came by and he couldn't figure out what she was doing there.

* Chris Burden, untitled statements, in Jan Butterfield, "Chris Burden: Through the Night Softly," *Arts Magazine* 49, no. 7 (March 1975): 68–72. By permission of the artist.

The important part to remember was that I *had* set it up. I could foresee the end too (it was not an open-ended situation which is partially what creates fear). It was not something which was thrust upon me, but rather something I imposed upon myself like a task. I think a part of it is . . . you just keep telling yourself that you just have to wait, because time will ultimately take care of it, that it is inevitable, and that this moment is no more fearful than those that went on before. The first part of the pieces is always the hardest. Once I have passed the halfway point, then I am already there and I know I can certainly make it through the next half. The beginning is pretty shocking. That's when I begin to have all the doubts and stuff, but once I am really into it and halfway through it, it's easy.

To be right the pieces have to have a kind of crisp quality to them. For example, I think a lot of them are physically very frontal. Also, it is more than just a physical thing. I think of them, sense them that way too. When I think of them I try to make them sort of clean, so that they are not formless, with a lot of separate parts. They are pretty crisp and you can read them pretty quickly, even the ones that take place over a long period of time. It's not like a Joan Jonas dance piece where you have a lot of intricate parts that make a whole. With my pieces there is one thing and that's it.

· · · · · ·

PRELUDE TO 220, OR 110, F-Space, Sept. 10–12, 1971: I was strapped to the floor with copper bands bolted into the concrete. Two buckets of water with 110 lines submerged in them were placed near me. The piece was performed from 8–10 pm for three nights.

People were angry at me for the *Shout* piece, so in *110* I presented them with an opportunity in a sacrificial situation—to atone for the earlier piece. Not really literally, I wasn't hoping that somebody was going to kick the buckets over, but just by putting myself in that position, it was kind of like a way of absolving myself from the last piece which was aggressive and hostile. It was also a way of getting recruits for a piece called *220*—to show them that I could do it and not get electrocuted, so that I could get others to participate in a piece with me. There was no actual danger, no taunting; if anything, people were apprehensive about getting near me. It was almost as if the buckets were repulsive magnets. Most people stayed very far away. I would talk to people and they would sort of come up gingerly, but they all stayed really very far away as if the floor were littered with banana peels and they might at any point slip and kick the buckets over.

I never feel like I'm taking risks. What the pieces are about is what is going to happen. Danger and pain are a catalyst—to hype things up. That's important. The object is to see how I can deal with them. The fear is a lot worse than the actual deed.

Dealing with it psychologically, I have fear—but once I have set it up, as far as I am concerned, it is inevitable. It is something that is going to happen anyway. Time ticks by and it is going to happen at a certain hour, whatever it is. Sometimes I can feel myself getting really knotted up about it, and I just have to relax, because I know it is inevitable. The hardest time is when I am deciding whether to do a piece or not, because once I make a decision to do it, then I have decided—that's the real turning point. It's a commitment. That's the crux of it right then.

The thought comes before the conception. The satisfaction is trying to figure out something I feel right about, something that seems strong and correct. That part is always a struggle. That part is really hard and I get nervous about it. Once I have figured out all of the parts and how I want it to go together, and I have a conception of it (when the piece is actually finished in my head), then it is a matter of actually executing it. That is the fairly mechanical part of

it. The hardest part really is trying to conceive something and struggling with it. Then the rest is, well, the rest is really the good part.

.

220, F-Space, October 9, 1971: The Gallery was flooded with 12 inches of water. Three other people and I waded through the water and climbed onto 14 foot ladders, one ladder per person. After everyone was positioned, I dropped a 220 electric line into the water. The piece lasted from midnight until dawn, about six hours. There was no audience except for the participants.

The piece was an experiment in what would happen. It was a kind of artificial "men in a life raft" situation. The thing I was attempting to set up was a hyped-up situation with high danger which would keep them awake, confessing, and talking, but it didn't, really. After about two-and-a-half hours everybody got really sleepy. They would kind of lean on their ladders by hooking their arms around, and go to sleep. It was surprising that anyone could sleep, but we all did intermittently. There was a circuit breaker outside the building and my wife came in at 6:00 in the morning and turned it off and opened the door. I think everyone enjoyed it in a weird sort of way. I think they had some of the feelings that I had had, you know? They felt kind of elated, like they had really done something.

.

ICARUS, April 13, 1973: At 6 pm three invited spectators came to my studio. The room was fifteen feet by twenty-five feet and well-lit by natural light. Wearing no clothes, I entered the space from a small room at the back. Two assistants lifted onto each shoulder one end of six foot sheets of plate glass. The sheets sloped onto the floor at right angles from my body. The assistants poured gasoline down the sheets of glass. Stepping back they threw matches to ignite the gasoline. After a few seconds I jumped up, sending the burning glass crashing to the floor. I walked back into the room.

.

THROUGH THE NIGHT SOFTLY, Main Street, Los Angeles, September 12, 1973: Holding my hands behind my back, I crawled through fifty feet of broken glass. There were very few spectators, most of them passersby. This piece was documented with a 16mm film.

.

DOORWAY TO HEAVEN, November 15, 1973: At 6 pm I stood in the doorway of my studio facing the Venice Boardwalk, a few spectators watched as I pushed two live electric wires into my chest. The wires crossed and exploded, burning me but saving me from electrocution.

That "danger" is something I have been thinking a great deal about. I don't know . . . I guess there was a lot more danger in that piece than I would admit to myself at the time. That's one of those things, you know? I started fooling around with the wires and I really liked the way they exploded and I wanted to do something, to relate it to me. For a long time I thought about pushing them into me and stuff, but there was the very real problem that I could get electrocuted. And then, finally, I had this idea that just as the wires went together they would pop and then they would go into me, and maybe I would get shocked, but the pain from the burst and the explosions would jerk my hands away and save me.

.

TRANSFIXED, Venice, California, April 23, 1974: Inside a small garage on Speedway Avenue, I stood on the rear bumper of a Volkswagen. I lay on my back over the rear section of the car, stretching my arms onto the roof. Nails were driven through my palms onto the roof of the car. The garage door was opened and the car was pushed half way out into the speedway. Screaming for me the engine was run at full speed for two minutes. After two minutes, the engine was turned off and the car pushed back into the garage. The door was closed.

.

BED PIECE, Market Street, Venice, February 18–March 10, 1972: Josh Young asked me to do a piece for the Market Street Program from February 18–March 10. I told him I would need a single bed in the gallery. At noon on February 18, I took off my clothes and got into bed. I had given no other instructions and did not speak to anyone during the piece.

I started to *like* it there. It was really seductive. That's why I considered just staying there—because it was so much nicer than the outside world. I *really* started to like it, and then that's when I started thinking that I'd better be pretty sure that when the end of the exhibition came—I got up.

About the death thing. . . . I don't think so, no. It's just that the piece was very relaxing. It is very relaxing to do that and all the anxiety about everything, about what is going to happen, goes because there is nothing I can do to change it. And when that happens it is like a tremendous relief.

I had started liking it there, and seriously considered staying there, but I didn't because I knew I just couldn't. People were really getting upset towards the end. Stanley and Elyse Grinstein were afraid I had flipped out. Bob Irwin came in and asked me not to do anything crazy, not to let the whole thing come down on my head. I could feel this whole tension kind of building up outside. There was no outside communication and everyone thought I had gone over the edge. As the end came near I had a sort of nostalgia about it. In the same sense that it was boring in the beginning, but I had no control over it because it was inevitable, at the end I had this nostalgia, this deep regret at having to return to normal. But it *was* inevitable, and I couldn't do anything to prolong or shorten it. On a certain day I had to get up and it would be over, and it would be gone.

.

DOS EQUIS, October 16, 1972: On the evening of October 16, I placed two XX's constructed of sixteen foot beams in an upright position blocking both lanes of the Laguna Canyon road. The timber had been soaked in gasoline for several days. I set the XX's on fire and left the area.

Dos Equis was just for one person. I don't know who he is or anything. He was just the first one to come upon those big XX's burning in the road. In the classical or traditional sense of going to a museum or gallery to view something maybe it wasn't art, not by that definition, but to me it was. For whoever saw it, it was a kind of really unforgettable experience. Those fiery crosses must really have burned into that guy's mind. Sometimes I choose to limit the number of people who see a piece, because I want those people to have a really strong experience. I did this with the *Icarus* piece in my studio as well. It is always a toss-up whether or not it is better for a hundred people to see it casually or two people to receive it really strong.

Border Crossing: Interview with Jim Moisan (1979)

CHRIS BURDEN: One thing that sort of bothers me is that a lot of people remember the *Shoot* piece and some of the violent pieces, and then ignore the reason for it all, the whole thing that ties it all together. They get carried away with "There's the guy who had himself shot!" They don't go to the next step and wonder why I would want to do that, or what my reasons are.

I think a lot of people misunderstood because they think I did those pieces for sensational reasons, or that I was trying to get attention. But those pieces were really private—often there were only two or three people there to see them, or maybe just the people who were there helping me. After *Newsweek* and all the publicity came out, I had to stop doing those things because I couldn't keep doing them in the light of that kind of publicity.

It was more like a kind of mental experience for me—to see how I would deal with the mental aspect—like knowing that at 7:30 you're going to stand in a room and a guy's going to shoot you. I'd set it up by telling a bunch of people, and that would make it happen. It was almost like setting up fate or something, in a real controlled way. The violence part really wasn't that important, it was just a crux to make all the mental stuff happen.

JIM MOISAN: The mental stuff being . . .

CB: The anticipation, how you dealt with the anticipation . . .

JM: Has your work changed?

CB: I think now it's more involved with the humor aspect. I did a piece called *In Venice, Money Grows on Trees*. On a couple of low palm trees along the Boardwalk, I got up one morning and glued on 100 dollars in singles. They were folded lengthwise about five times so they fitted into the leaves so that each leaf had about 20 bucks in it. The amazing thing was that the money stayed out there for two days. . . .

JM: Let's back up a bit. Where did you go to school?

CB: I went to Pomona College in Claremont, then I went to graduate school at UC Irvine.

JM: What courses did you take?

CB: Liberal arts, and a lot of art classes and sculpture. I did minimal sculpture. In grad school I was making sculptures that you had to use physically, sort of apparatus pieces that you had to either wear or use in conjunction with a partner. They were about balancing and using your body as a machine to pull yourself out of something. Kind of like exercise things, not that you had to repeat them or anything, but you had to manipulate them in some way.

JM: Was it a gradual progression into the body pieces, or did you get a flash?

CB: Well, yeah, I did. I remember I could have installed these pieces for my graduate show, but I kept going over there and looking at these spaces and stuff. I noticed these lockers. And also I got this flash of using the lockers kind of in the way I used the apparatus pieces, but instead of having to make a locker, or make a box to get into, here were these readymade things. That was kind of a big jump in the sense that I could do something with my body, but I wouldn't have to make the apparatus to do it. *[Five Day Locker Piece]*

JM: Was your thinking influenced by some other artist?

* Jim Moisan, excerpt from "Border Crossing: Interview with Chris Burden," *High Performance* 2, no. 1 (March 1979): 4–11. By permission of the artist and the publisher.

CB: It seems like something that happened to a bunch of people at the same time. Probably the first people I had an affinity with were people like Vito Acconci, Tom Marioni, Terry Fox, Wegman. There was a feeling that a different aesthetic was developing. I don't feel that close to some of them now in the sense of a movement, but I guess those were some of the people.

I think even the earthwork thing somehow helped, the idea that you could do something physical and that could be art. It was the idea of not having a tangible product. I'm kind of going the other way, have gone the whole route, and I'm starting to make things again.

TOM MARIONI Out Front (1975)

A LOT OF THE CONFUSION THAT MUSEUM PEOPLE FEEL ABOUT PERFORMANCE SCULPTURE IS THAT THEY ARE ONLY JUST BEGINNING TO ASSIMILATE HAPPENINGS, AND THEY SEE PERFORMANCE SCULPTURE AS HAPPENINGS, WITHOUT THINKING ABOUT WHAT WENT ON IN BETWEEN.

THE HAPPENINGS THAT GREW OUT OF ABSTRACT EXPRESSIONISM IN NEW YORK, DANCE IN SAN FRANCISCO, AND THEATER IN EAST AND WEST EUROPE, WERE ALL AN EXTENSION OF THEATER, EVEN THOUGH SEEN THROUGH THE EYES OF VISUAL ARTISTS. IT WAS STILL AN AGE OF PAINTERS, AND THEY THOUGHT ILLUSIONISTICALLY. MATERIALS WERE PROPS, AS IN THEATER, AND THE WORKS WERE USUALLY REPEATED AND SCRIPTED. IT WAS AN AUDIENCE-PARTICIPATION ACTIVITY THAT WAS THE BEGINNING OF AN ENCOUNTER-GROUP CONSCIOUSNESS. THIS WAS THE TIME OF BEATNIKS. POETRY READING TO MUSIC AND HARD-BOP JAZZ—THE LATE '50S AND EARLY '60S.

IN THE EARLY '60S, AN AGE OF SCULPTORS BEGAN. PAINTING RETREATED INTO ILLUSION, SMOOTHNESS, ANTI-MATERIALITY, FIRST WITH POP ART, THEN WITH PHOTO-REALISM.

THE SCULPTURE OF THE '60S REACTED AGAINST THE ANTI-INTELLECTUALISM OF ABSTRACT EXPRESSIONISM, AND CREATED AN INTELLECTUAL ART. SCULPTURE STOOD FLAT ON THE FLOOR AND CONCERNED ITSELF WITH REDUCTIVENESS. LATER, A MATERIALS CONSCIOUSNESS DEVELOPED, UNTIL BY THE LATE '60S THE MATERIALS OF THE SCULPTOR INCLUDED LIGHT, SOUND, LANGUAGE, SOCIAL AND POLITICAL ACTIVITIES, AND THE ARTIST'S BODY. BECAUSE THE WORK OF THE SCULPTOR BECAME SO MUCH LIKE SCIENTIFIC EXPERIMENTATION, USING AESTHETICS AS ITS FORM, THE PROCESS BECAME THE ART, AND TIME, THE FOURTH DIMENSION, BECAME A FACTOR. SCULPTORS BEGAN TO MAKE INSTALLATIONS OR ENVIRONMENTS, TEMPORARILY INSTALLED IN A SPACE. AND THEY BEGAN TO MAKE ACTIONS, NOT DIRECTED AT THE PRODUCTION OF STATIC OBJECTS BUT RATHER AT ITSELF AS ITS ACTIVITY. THE ACTION IS DIRECTED AT THE MATERIALS RATHER THAN AT THE AUDIENCE AS IN THEATER.

THE SPIRAL OF ART MOVEMENTS AND LIFE IN GENERAL BEFORE 1970 HAD BECOME INCREASINGLY TIGHTER AND FASTER. IN T.V. THE COMMERCIAL OF 1960 WAS SIXTY SECONDS LONG AND IN 1970 IT TOOK THIRTY SECONDS, TO CONVEY THE SAME INFORMATION. THE CULTURE IN TEN YEARS HAD LEARNED TO USE UP PRODUCTS, INFORMATION, AND PERSONAL RELATIONSHIPS IN HALF THE TIME. POST-OBJECT-ART CREATES A SLOWING-DOWN PROCESS. A REAL-TIME CONSCIOUSNESS, BECAUSE THE ARTIST KNOWS IT IS NECESSARY FOR THE CULTURE TO BECOME REFLECTIVE.

* Tom Marioni, excerpt from "Out Front," *Vision* 1 (Spring 1975): 8. By permission of the author.

Real Social Realism (1976)

Art is a poetic record of the culture, and people understand the culture of the past by studying the art and products of past civilizations. The development of technology in the 20th century has speeded up time; this creates rapid changes in the atmosphere of society and in art. It is now possible to find in art accurate records of the very recent past, encompassing the style of a particular region of the world. In this way, Andy Warhol—a personality and producer of a body of work emphasizing mass-production, and repetition—exemplifies the United States of the 1960s, an era we can now recognize as different from today.

Conceptual art, an art of the '70s, as it was developed in America, was a reaction against the materialism of the '60s, and records our country's swing away from that frame of mind. Intelligent people in America, and in the world, have become less oriented to personal goods and more aware of the frailty of our world.

We can now see the world from a distance, from the moon in photographs, which gives us a new sense of scale. To be able to see in one picture one-half of our world affects our consciousness in the same way that we were affected by Copernicus when he brought it to our attention that the earth moves around the sun. We began 500 years ago to question that we were made in the image of God when we realized we might not be the center of the universe. Now, we know we are not. Our world seems to get smaller and smaller.

The artist spends his time taking in information. The artist spends more time looking and listening than the layman, and is a trained observer, a private investigator. The artist translates what he sees around him into a form, which in turn becomes part of the culture it defines. The work of art communicates for the artist his intelligence through the visual craftsmanship of the activity or the object. The work of art is not the object; the work of art is the information that is communicated, a stimulating experience that awakens the intellect through the senses.

Since the end of the 1960s, many artists, not only in America but all over the world, have begun to develop an art of theory, of aesthetic activity, of proposition and study as the form, rather than the production of objects as the aim and purpose of the art.

This art is very strong in Eastern Europe in relationship to object-oriented art, although its development there seems to be for different reasons than its development in the west.

To varying degrees in Eastern European countries the political system, through the control of money, does not allow the manipulation of the art object as a product that can be merchandized and re-sold, increasing in value and fitting into a supply and demand system. So the art object is automatically less important than in the west. And since the making of art objects is scrutinized and often controlled by political forces, an artist who wishes to explore philosophic ideas may be more free to do so in making actions. These may not be understood by those enforcing repressive political ideas, yet the point will be made to the art community, and so, perhaps, find its way into the culture.

The fact that conceptual art is strong in Eastern Europe as well as in the west shows how small the world has become. The individual works being done by artists show how clearly their culture differs from other cultures in the world.

* Tom Marioni, "Real Social Realism," *Vision* 2 (January 1976): 7. By permission of the author.

Hard Bop (1976)

This is the way it works: the artist, a reporter, observes society and his environment, the character of the city or country he lives in, the people, everything. He integrates himself into his environment with the intensity of an animal in nature. The artist makes a gesture (a work of art), a philosophical statement. The work is virtually invisible to most of the world, at least the meat of it, the point of it. It is observed by a lower level of reporter, the media, and is simplified; that is, the subject of the work of art is taken and translated into theater, fashion, movies, window displays, advertising, magazines and TV. Eventually the public copies it in their lives, using the work as visual slang, and the artist is seen as having been ahead of his time and able to predict the future.

Statement (1979)

I'VE REALIZED THAT MY CONCEPT OF PERFORMANCE ART IS OLD FASHIONED.
IT'S OLD FASHIONED TO INSIST THAT PERFORMANCE ART IS
SCULPTURE EVOLVED INTO THE FOURTH DIMENSION.
SOMETHING I LEARNED FROM MILES DAVIS WAS THAT BY TURNING HIS
BACK ON THE AUDIENCE WHEN HE PLAYED, HE WAS AN ARTIST WORKING.
HE SAID ONCE THAT HE WAS AN ARTIST, NOT A PERFORMER.
I HAVE HELD ON TO MY NOTION OF THE SCULPTURE ACTION
WHERE THE ACTION IS DIRECTED AT THE MATERIAL I'M MANIPULATING
INSTEAD OF AT THE AUDIENCE, LIKE IN THEATER.
I CAN SEE THIS IS A 60'S EUROPEAN IDEA OF THIS KIND OF ART.
IN '70 WHEN I STARTED MOCA AS A SPECIALIZED SCULPTURE ACTION MUSEUM,
I MADE MY OWN RULES AND DEFINED CONCEPTUAL ART AS IDEA ORIENTED
SITUATIONS NOT DIRECTED AT THE PRODUCTION OF STATIC OBJECTS.
NOW THE BREAK FROM THE OBJECT ISN'T AN ISSUE ANYMORE.
TEN YEARS AGO IT WAS IMPORTANT TO MAKE A STATEMENT AGAINST
MATERIALISM BY MAKING ACTIONS INSTEAD OF OBJECTS.
NOW WITH SOME ARTISTS IN MY GENERATION THERE'S A RETURN TO THE
OBJECT, NOT AS AN END IN ITSELF, BUT AS A MATERIAL TO EXPLAIN
A FUNCTION, LIKE BEFORE THE RENAISSANCE WHERE THE OBJECT
WAS USED IN A SOCIAL, ARCHITECTURAL OR RELIGIOUS WAY.
BUT THE 70'S IS AND THE 80'S PROBABLY WILL BE A COSMETIC AGE
OF DECORATION AND THEATRICALITY.

* Tom Marioni, "Hard Bop," *Vision* 3 (November 1976): 5. By permission of the author.
** Tom Marioni, untitled statement (12 July 1979). An edited version appeared in Carl E. Loeffler and Darlene Tong, eds., *Performance Anthology: Source Book for a Decade of California Art* (San Francisco: Contemporary Arts Press, 1980), ix. By permission of the author.

LINDA MONTANO AND TEHCHING HSIEH

One Year Art/Life Performance: Interview
with Alex and Allyson Grey (1984)

ALEX AND ALLYSON GREY: When did you first meet and what inspired your collaboration?

LINDA MONTANO: I was living in a Zen Center in upstate New York and during a trip to the city I saw one of Tehching's posters and literally heard a voice in my head that said, "Do a one-year piece with him." I was free to do that so I asked Martha Wilson [of the New York artspace Franklin Furnace] for his number, called him and we met at Printed Matter where we talked intensely for two hours. He said that he was looking for a person to work with . . . I was looking for him . . . so we continued negotiating, talking and working from January to July when we started the piece.

A&AG: So you were looking for somebody to work with before you met Linda?

TEHCHING HSIEH: Yes. I have idea about this piece and I needed to find somebody for collaboration. After I met Linda, she told me that she had done a piece handcuffed with Tom Marioni for three days. Somehow I feel very good about collaboration because Linda had done something similar before.

A&AG: What inspired your idea for the piece?

TH: You know, I've done before three performances connecting art and life together. I like to create art about life from different angles. Most of my work is about struggle in life. Like in "The Cage" my life inside felt isolated—that's a kind of struggle. And in "Punch Time Clock" piece I do the same thing over and over, like a mechanical man and that's a kind of struggle. When I live outdoors it was about struggle with the outside world.

I got the idea for this piece because there are problems about communication with people. I feel this is always my struggle. So I wanted to do one piece about human beings and their struggle in life with each other. I find being tied together is a very clear idea because I feel that to survive we're all tied up. We cannot go in life alone, without people. Because everybody is individual we each have our own idea of something we want to do. But we're together. So we become each other's cage. We struggle because everybody wants to feel freedom. We don't touch and this helps us to be conscious that this relationship connects individuals but the individuals are independent. We are not a couple, but two separate people. So this piece to me is a symbol of life and human struggle. And why one year time? Because then this has real experience of time and life. To do work one week or two weeks I feel that it may become like just doing a performance. But I do it one year and then the piece becomes art and life—it's real connection and that has more power. Also a year is a symbol of things happening over and over.

LM: I think that's what interested me in Tehching's work; having similar interests— merging art and life. For many years I have been framing my life and calling it art, so that everything—washing dishes, making love, walking, shopping, holding children—is seen as art. Formerly, I would separate out activities—run to the studio and what was my "creative time." Gradually I found this separation unnecessary and felt that it was important for me to be attentive all of the time—not to waste a second. That became the Art/Life task that I have given myself until I die.

* Alex and Allyson Grey, excerpts from "Linda Montano and Tehching Hsieh's *One Year Art/Life Performance:* Alex and Allyson Grey Ask Questions about the Year of the Rope," an interview with the artists, *High Performance* 27 (1984): 24–27. By permission of the interviewers, the artists, and the publisher.

Linda Montano and Tehching Hsieh, photograph of their *One Year Art/ Life Performance,* 1983–84, and accompanying statement. By permission of the artists.

I made many pieces from 1969 on that experimented with this idea of allowing my life to be a work of art. I lived with different people and called that art. I wrote the Living Art Manifesto in 1975 and later turned my home into a museum so that everything I did there would be framed as art. I lived in galleries. I was sealed in a room for five days as five different people. All of it was an attempt to make every minute count. I knew that by working with Tehching I would experience his time frame, one year, and that kind of art rigor interested me.

A&AG: Tehching has talked about what the piece symbolizes to him. What does the piece mean to you?

LM: By being tied with a rope and not touching, I am forced to remain alert and attentive because I am doing something different from what I ordinarily do. That way I break down habitual patterns because the task of being tied is so difficult and absorbing that I can only do just that.

Supposedly there are seven stimuli that can simultaneously grab our attention every second. This piece demands that the mind pay attention to one idea, not seven, and because being tied is potentially dangerous, the mind gets focused or else our lives are threatened.

Besides training the mind, the piece raises so many emotions to the surface that the soap opera quality eventually gets boring. I feel as if I've dredged up ancient rages and frustrations this year and although I'm glad that I went through with them, I now feel that holding any emotional state for too long is actually an obsolete strategy. On the other hand, because I believe that everything we do is art—fighting, eating, sleeping—then even the negativities are raised to the dignity of art. As a result I now feel much more comfortable with the negative. It's all part of the same picture. . . .

A&AG: You both seem to have different ways of thinking about the piece.

TH: Yes, because we are two individual human beings and two individual artists tied together for 24 hours a day and so individualism is very natural to this piece. It's interesting to me because if we want to be a good human being and good artists at the same time, that's one kind of clash and struggle. Also if we want a relationship and independence at the same time, that creates a double struggle.

The piece has other levels that make us feel more individual—there are cultural issues, men/women issues, ego issues. Sometimes we imagine that this piece is like Russia with America. How complicated the play of power.

LM: This piece raises many questions. Like, how do two humans survive in such close physical proximity? A Russian journalist wanted to do an interview with us because she said that Soviet scientists were interested in exercises that their astronauts could do to prepare themselves for spending extended periods of time in space capsules. In many ways the piece is valuable because I feel that it is necessary to learn new survival skills and to look at emotional conditioning and responses that are obsolete. . . .

There are many people in worse conditions than we are—the person tied to a bad job or a bad place or a bad marriage. This piece is about the realities of life. They aren't always easy. Often we would just have to sit it out, sometimes for three weeks, until the "cloud of unknowing" passed.

TH: Some people think I am choosing to suffer—I don't think that I want to bring more suffering to myself, but the work is difficult and in some ways that brings suffering. As an artist I have a lot of pleasure to do my work. If I don't get any pleasure out of doing difficult work then I don't have to do it. I don't think I want suffering for no reason. I am not masochistic.

LM: Artists choose forms that fit their internal image bank. Tehching has his own reasons for his images. Mine come from the ascetic Catholic/spiritual world. I believe that if life is hard and I choose to do something harder, then I can homeopathically balance the two difficulties. Snake venom is used to cure snake bites!

A&AG: How do you feel about not having sex for a year?

LM: Actually, I'm beginning to reevaluate guilt and lately have been more willing to sacrifice, not because I'm guilty but because it's an essential attitude. I also realize that not having sex is as interesting as having it. Besides, touch is highly overrated. In the past, I've often grasped without energy, charge or significance and called that touch.

TH: We do not touch. We are sacrificing sex, not denying it. We could, in theory, have sex with other people. But that would just be a way to try to escape. It is not right for the piece.

LM: Once you give the mind a command, then you watch the body carry out the process. When I went into the convent for two years, I informed myself that I would not have sex and noticed that the energy went to other things. This year I have a chance to experiment with desire. . . . Am I turned on? To whom? When? How much? Also, since the body isn't touched, the mind is pushed into the astral. I believe that in the next 2,000 years, we will all be in outer space so why not practice outer space sex now by letting astral bodies merge. . . .

A&AG: Is that part of your understanding of the piece, Tehching—training your awareness?

TH: Yes, but it is secondary. The piece becomes a mirror showing me my weakness, my limitations, my potentials, and trains my will.

LM: Some artists choose difficult work. Other people do it in a celebratory way—Dionysian ecstasy, to get free enough to be themselves and to be in the moment. It's really a matter of choosing the style that goes with our inclinations and then hopefully changing directions if the style isn't working or if those old hindrances aren't there any more. Then we can do something else. Maybe end up on a mountain, gardening. . . .

A&AG: How does this piece go along with your spiritual outlook on life?

LM: I come from a very strict, religious tradition and have been disciplined most of my life. I continue with discipline, but now I am using the artist's way to be spiritual.

TH: I have no interest in the spiritual but I am in some ways like a monk who is dedicated in a serious way. But my dedication is to my artwork. I am interested in the philosophical and in life experience. I try to make sense of who I am and what I am doing in my life without God. If I say I don't believe in God maybe it means that I am trying to find my own belief.

A&AG: What are some of the influences on your work?

TH: New York art. Dostoyevsky, Franz Kafka. Existentialism—that influences me. Also, I am oriental. I grew up in Taiwan, and I have an oriental kind of technique and oriental kind of experience, that influences me too. Also, my mother influenced me—she is a very dedicated person.

LM: My influences have been—my grandmother, who took out her false teeth at most family gatherings and sang, "If I Had the Wings of an Angel"; my mother, who is a painter; Lily Tomlin; Marcel Duchamp; Eva Hesse; and St. Theresa of Avila.

I am also interested in using art therapeutically, probably because when I was 20, I was anorexic (82 lbs.) and it's only because I immersed myself in "art" that I came out of that experience intact. So for that reason, I will always be aware of the psychological/sociological effects of the creative process.

A&AG: Now that you've been tied together for almost a year, how do you feel about each other?

TH: I think Linda is the most honest person I've known in my life and I feel very comfortable to talk—to share my personality with her. That's enough. I feel that's pretty good. We had a lot of fights and I don't feel that is negative. Anybody who was tied this way, even if they were a nice couple, I'm sure they would fight too. This piece is about being like an animal, naked. We cannot hide our negative sides. We cannot be shy. It's more than just honesty—we show our weakness.

LM: Tehching is my friend, confidant, lover, son, opponent, husband, brother, playmate, sparring partner, mother, father, etc. The list goes on and on. There isn't one word or one archetype that fits. I feel very deeply for him.

A&AG: Talk more about how your relationship progressed through this piece and how you will face your separation.

LM: We developed four ways of communicating. In the first phase we were verbal . . . talking about six hours a day. Phase two—we started pulling on each other, yanking on the rope. We had talked ourselves out, but yanking led to anger. In phase three we were less physical with each other and used gestures—so we would point when we wanted to go to the bathroom or point to the kitchen when we wanted to eat. Phase four—we grunted, and made audible, moaning sounds when we needed to go somewhere . . . that was a signal for the other to get up and follow the initiator. Communication went from verbal to nonverbal. It regressed beautifully.

It was also interesting to watch the overall energy of the piece. Eighty days before the end of the piece, we started to act like normal people. It was almost as if we surfaced from a submarine. Before that we were limited to doing just the piece.

TH: Our communication was mostly about this piece. Like, I have to ask Linda if I want a glass of water. It takes up all of our energy.

A&AG: How does it feel to have the piece nearing an end?

LM: We're so much easier on each other now that it's almost over, and there is a nostalgia that we couldn't have been this way earlier. But I've learned a good lesson . . . to give 100% all the time. Usually in relationships I have thought, "I'll open up tomorrow," or "I'll communicate tomorrow." Now I realize that life is short, and it's ridiculous to waste time.

I also feel a sadness that Tehching and I won't be doing an 80 year piece together . . . maybe we'll do it from a distance.

TH: On a philosophical level, I feel that the piece is not nearing an end. It's just that we are tied to each other psychologically. When we die it ends. Until then we are all tied up.

THERESA HAK KYUNG CHA *Markings* (1977)

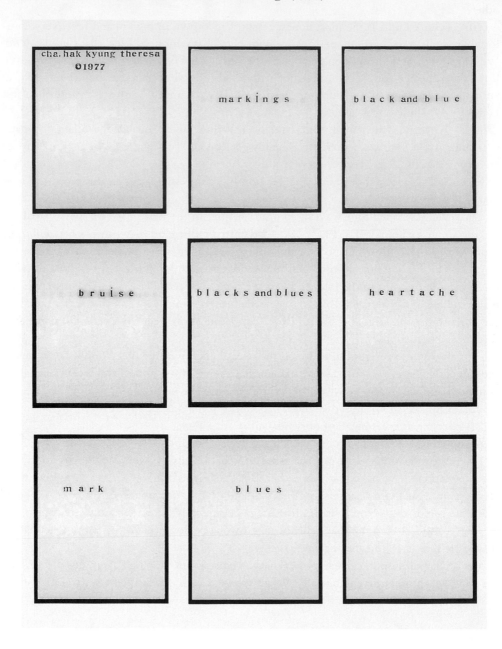

* Theresa Hak Kyung Cha, *Markings,* 1977. Private collection. Photo by Benjamin Blackwell. Courtesy the University of California, Berkeley Art Museum and Pacific Film Archive.

VITO ACCONCI Steps into Performance (And Out) (1979)

1. Into Action

At the beginning, setting the terms: if I specialize in a medium, I would be fixing a ground for myself, a ground I would have to be digging myself out of, constantly, as one medium was substituted for another—so, then, instead of turning toward "ground" I would shift my attention and turn to "instrument," I would focus on myself as the instrument that acted on whatever ground was, from time to time, available.

But I'm focusing on myself from a distance, as if from above: I see myself, I see the land, figures, around me. . . . (I'm too far away to be seen as a "self": I'm seen from the outside: I can be considered only as a "physical mover.")

But, probably, I should not be seen at all: it's as if an action moves too quickly for an image to take place, have a place (but an image, though unseen, might have already had its effect on the action). If there has to be an image, it would be: not a picture made *of* an action (or of a person performing an action) but a picture made *through* an action (through person to action).

In the beginning was the word: start an action by stating a scheme—from there, the action takes off (takes me off) where it will. The general method is: find a way to tie myself in to an already existent situation—set myself up as the receiver of an action/condition that's already occurring outside me.

Apply a language: "I" attend to "it." (My attention, then, is on "art-doing"—ways to make art—rather than on "art-experiencing"—ways to "see" art. "Art-experiencing" is treated as an assumption, a casual by-product.)

There's no audience (or, if there is an audience, terms of "subject" and "object" are reversed). More blatantly: it's as if a viewer has no place here—after all, I take on the viewer's function, I act as the audience for the situation outside me.

But, once the action is done, an audience comes in, as if from the side. The action was done not as a private activity (there was no notation of my interpretations, my feelings, my subjective experience) but as an exemplar, a model (there was the listing of facts). The action was done, then, from the beginning, so that it could be turned into reportage, into rumor: the action, that started with a word (diagram-sentence), was done only to return to words (small talk).

This is "performance" only in the sense of: "the act or process of carrying out something: the execution of an action." The appropriate medium, then, is that which packages, summarizes, achievement—magazines, news media.

2. As Person

What's developed, thus far, is a contradiction: the "I" that has been attending to "it" (as long as that "I" is seen from a distance as a moving integer, moving object) has become no more than an "it" itself. If I am using myself, then, I have to come back to myself (rather than retreat into "it," into "things"); that self has to be lived up to (self as "person"—person as "motivational/ interpretative agent").

* Vito Acconci, "Steps into Performance (And Out)," in AA Bronson and Peggy Gale, eds., *Performance by Artists* (Toronto: Art Metropole, 1979), 28–40. By permission of the author.

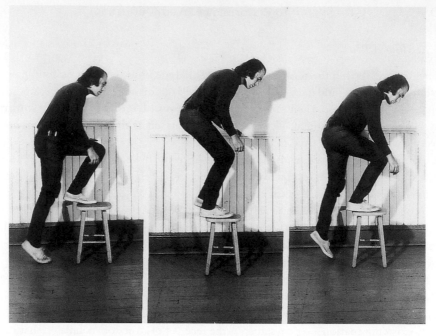

Vito Acconci, *Step Piece*, 1970. Photos by Kathy Dillon. By permission of the artist.

```
Vito Acconci
STEP PIECE
Activity
102 Christopher Street (my home); four months (February-April-
July-November), 1970; 8AM each day

An eighteen-inch stool is set up in my apartment; each morning it
is used as an excercise-tool. Each morning, during the designated
months, I step up and down the stool at the rate of thirty steps
a minute; each morning, I continue the activity as long as I can
do it without stopping.

Daily training makes for daily improvement; each day I can do the
exercise longer. The training becomes part of daily life. After the
one-month and two-month lay-offs, the effects of the training
persist: improvement is more rapid than it was during the first
month's activity. Then, after a three-month lay-off, the training
begins to wear off: I'm back where I started, I have to work my-
self up to it again.

(The activity is left open; it is, in principle, a public performance:
announcements are sent out to the public, who can come to see the
activity carried out, in my apartment, any time during the designated
months. At the end of each month a progress-report is sent out to
the public.)
```

Vito Acconci
STEPS (STEPPING OFF PLACE)
Apartment 6B, 102 Christopher Street, New York City.
8AM each day; revised schedule: 1970: February, April, July, November...

Project: An 18-inch stool is set up in my apartment and used as a step. Each morning, during the designated months, I step up and down the stool at the rate of 30 steps a minute; each morning, the activity lasts as long as I can perform it without stopping.

Progress Report: daily record of performance time:
Second month (April 1970):

Date	Duration
April 1	7 min. 30 sec.
2	6 min. 4 sec.
3	9 min. 40 sec.
4	8 min. 35 sec.
5	8 min. 52 sec.
6	9 min. 24 sec.
7	10 min. 8 sec.
8	11 min. 46 sec.
9	13 min. 10 sec.
10	14 min. 22 sec.
11	15 min. 54 sec.
12	16 min. 30 sec.
13	17 min. 28 sec.
14	18 min. 10 sec.
15	18 min. 42 sec.
16	19 min. 20 sec.
17	20 min. 6 sec.
18	21 min. 40 sec.
19	22 min. 52 sec.
20	23 min. 18 sec.
21	24 min. 0 sec.
22	24 min. 34 sec.
23	25 min. 20 sec.
24	26 min. 54 sec.
25	28 min. 0 sec.
26	24 min. 16 sec.
27	25 min. 0 sec.
28	27 min. 50 sec.
29	26 min. 14 sec.
30	26 min. 10 sec.

Third series of performances: July 1970; 8AM each day.

The public can see the activity performed, in my apartment any morning during the performance-month; whenever I cannot be home, I will perform the activity wherever I happen to be.

In the back of my mind is starting to form a notion of a general condition of art-making: behind every (at least, western) art-work there's an artist—art-work, then, as the sign of an artist (or, conversely, art-work as a cover for the artist—but, in either case, the self is there, in the background, potentially presentable). A logical consequence, then: push the self up to the foreground (art as presentation of self/presentation of artist).

Forming a(n) (art)self. Applying a language: rather than attend to "it," "I" attend to "me."

The form is frontal ("Here I am"); the movement is circular; the method is closure. "It," at least for the time being, fades away: the action is isolated from its surroundings—"I" have only "me," "I" need only "me." I am the agent of an action and, at the same time, the receiver of the action; "I" initiate an action that ends up in "me."

(In the background, a notion of a general condition of art-experiencing: viewer, entering gallery/museum, orients himself/herself to an art-work as if toward a target, viewer aims in on art-work. This condition of target-making, then, can be a pre-condition: it can be used, beforehand, as a condition for art-doing—art-doing becomes isomorphic with art-experiencing. I can focus in on myself, turn in on myself, turn on myself, treat myself as a target; my activity of target-making, in turn is treated as a target by viewers.)

The appropriate medium is film/photo (whether or not actual film/photo is utilized): I'm standing in front of a camera—the camera is aiming at me, the camera is (literally) shooting me—all the while, I can be doing what the camera is doing, I can be aiming in on myself. Over all, the film frame being formed separates my activity from the outside world, places me in an isolation chamber (a meditation chamber where I can be—have to be—alone with myself). The implication might be: soon I'll come out, this is only a training ground, it doesn't stop here. But, in the meantime, as far as the viewer can see, I'm caught in a trap.

This can be defined as "performance" in the sense of "something accomplished" (the accomplishing of a self, an image, an object).

On the one hand, the system is "open": if I turn on myself (applying stress to myself), I make myself vulnerable, make myself available to (grabbable by) a viewer.

On the other hand, the system is "closed": if I both start and end the (same) action, I'm circling myself up in myself, I've turned myself into a self-enclosed object: the viewer is left outside, the viewer is put in the position of a voyeur.

(It's as if I got side-tracked: I started out by thinking of "you"—but, then, working on myself in order to have myself presented to you, I became wrapped up in myself. So my concentration, my efforts, remained on "art-doing," not "art-experiencing." But, no matter how self-enclosed I became, I must have had a viewer in mind all the time: by closing myself up in myself, I've fixed an image of myself, and that image has to have someone in mind, someone it can be presented to: it's as if, under the guise of concentration, training, meditation, all I was doing was setting up a pose.)

"I," then, attending to "me," fixes a "me" (while leaving the "I" ineffectual to change it). "Person" is hardened, objectified; the viewer, in turn, can come only so far, the viewer is hardened in front of that "person." (I might have looked at you straight in the eye, but I've turned you to stone. . . .)

3. On Stage

If "person" (the saying of the word) results in the opposite of person, then "person" might have to be doubled: to get to "person," go "inter-person" (the introduction of another agent).

The appropriate medium here is video: video as rehearsal (contrasted to film as a finished

image)—video as an image about to be—video as dots, separate dots about to come together to be seen (almost as a last resort) as an image. The notion of video, then, as a backdrop, functions as an impulse to the connection/combination of elements/agents.

(Setting the stage: the "other element" might be an object: an object is in front of the viewer—I am in front of the object, between object and viewer—I attend to, concentrate on, that object—if that concentration is carried to an extreme, I blend with that object, disappear into it—the object and I have formed a wall in front of the viewer. . . . Or, to look at it another way: the object, concentrated on so doggedly by a person, becomes personalized, personified. . . .)

Two people, then, take their positions opposite each other, encountering each other. Apply a language: "I" attend to "him"/"her" while "he"/"she" attends to "me."

The guise is: the breaking of the circle of "I"/"me." But the circle has only bulged, the circle is maintained as it is enlarged, now, to include—along with "I"/"me"—"he"/"she" and "him"/"her." Concentrating on each other, we bound ourselves together in a circle: to keep our concentration, we need no one else, we have no use for anyone else. Concentrating on each other, we form a "magic circle," a "charmed circle" no audience can enter.

This is "performance" almost in the sense of a traditional "play." "He"/"she" and "I" make up the boundaries of a stage in front of the audience; the audience is witness to the physical movements of a plot: A leads B on, B becomes stronger than A, A and B combine into a union. . . . Enclosed in each other, we build a house for ourselves—the audience looks in through the "fourth wall."

The more each of us gets into the other's person, the less of a person each of us is to the audience: we are not "persons" but "representatives" (of a mystery, of an interaction ritual, of a psychology . . .).

Right before their eyes, then, we've made our exit. The physical movements of the plot are only blandishments to the audience; we have our own (mental) plot (we have our conspiracy): ideally, we've started a relationship—or confirmed a relationship, or reversed a relationship—that by this time is taking place elsewhere. So, by now, we're out of "art": the audience is left with nothing, the audience is left with only an empty stage.

4. To the Viewer

To get back to "art," I have to make contact with those people who share in an art context: my space and viewers' space should come together, coincide. A piece, then, takes place in a gallery/museum, in an habitual art situation: the gallery/museum, then, is treated as a meeting place, a place to start a relationship.

(In the background: revise the notion of art as "presentation of a self/an artist": art, then, as a gift from artist to viewer: art, further, as exchange between artist and viewer. . . .)

Applying a language: "I" attend to "you" (while "you" attend to "me"—but, once I've occupied the subject-place of "attending," "you" have almost no time to do the traditional work of art-attending, "you" attend to "me" only as a by-product, only as reciprocity).

The choice of place is, specifically, not "theater-space" (a place that an audience comes *to,* sits *in*) but "gallery-space" (a place that an audience passes *through*).

The terms set up are: "I"/"space"/"you" ("you"/"space"/"me").

The basic structure: I set up a point (I set myself up as a point) at one end of a space—the space, whatever its shape, narrows into a channel between "you" and "me"—viewers "flow" toward that point while, at the same time, that point *points* to ("I" as a system of feelers toward) viewers.

But, as long as "you" can focus on "me," the space around fades away: a direct line cuts through that space, almost in spite of the space—the space is peripheral, the space is only a background, a performance set (we might as well be anywhere/it's as if we're nowhere). I've retained, then, a "stage" for myself: this is a stage you can enter—but, since it keeps its aura of a stage, you remain off-stage (and only mentally on, as if at a movie, as if in front of a book), no matter how close you come.

The basic structure, then, should be *of* the space and not *within* the space: not performance *in* a space but performance *through* a space. If, for example, I'm not so clearly visible, then you the viewer can be "in a space" rather than "in front of me"—you are in a space where I happen to be in action. (In the space, we're making a place for ourselves, together; you are performing for me as much as I'm performing for you.)

This is "performance" in the sense of "carrying something through" (carrying through a space—performing a space—carrying myself through you throughout a space).

5. Out of My Past

Once I am under cover, things move too quickly, there's nothing to stop me: since I'm not seen anyway, there doesn't have to be a performance; since there's no actual performance, this is only a place for potential performance; since there's no "fact" here, I can withdraw into the past, disappear in the future; since my mode of being is so fluid, I can move through the viewer, past the viewer. . . .

To stop myself, I have to come back into the space. In order to come back to the space, I have to face "you." In order to keep facing you, I need something to anchor me in the place where you are. But I have that anchor within me: now that I've gone into the past (or into the future, or into metaphor), "I" can never be the same again: "I" has a history, an autobiography: the past, that I could have withdrawn into, is brought back here, imported: the past functions as a weight that keeps me in place here. In order to face you, I have to face up to myself.

(In the background: a notion of art as privacy that results in publicness—a private life makes a deposit in a public space, where private times come together in a public function.)

Gallery/museum, then, is used as a buffer-zone: I bring something private into a public space—once that privacy is made public, I can't deny it—once it's brought back, later, to privacy, there's no reason not to face it.

Applying a language: "I" attend to "you" through "me" / "I" attend to "me" through "you."

It's this phase of the work that might, finally, be claimed as "performance": roleplaying—I act out my life in front of others, I change my life to be handed over to others.

Gallery returns to theater. Image-structure: spotlight—performance arena—seating arrangement. (Granted that a gallery is for observing: as gallery-goers, then, are observing me, from the outside, I can, all the while, be observing myself, "from the inside.")

The gallery is turned into itself: the gallery is turned into, literally, a museum. This is where I place my past in the spotlight, let it harden. Now that I've faced myself, I can leave my (old) image here, as a museum-piece. This gives you a quick introduction to "me"; I've left my autobiography as a calling card.

6. Addenda: After Performance Is Over

1. As long as I'm there, in person, a piece is restricted by (to) my "personality": I can deal only with my person (physical), my past (psychological), my relation with you the viewer.

2. As long as I'm there, in person, I can go within and deal with (isolation-chamber) self—but I can't step out of myself far enough to deal with (external causes of) self.

3. For an extra-personal world to come in, I have to go out. (I have to leave room for that world to turn in, and not merely to add an atmosphere, a background, to my "person.")

4. As long as I'm there, in person, "you" and "I" remain on opposite sides, no matter how close we come; we remain "artist" and "viewer."

5. As long as I'm there, in person, no matter how hidden I might be, I'm in the spotlight, I'm the "star-attraction" you came for.

6. In order for you to have room of your own, in order for you to be free to move around the space, I have to move aside, I have to move out of your way.

7. Behind the scenes, then, there's a structure of performance: I move from place to place (exhibition space to exhibition space)—I act (build) according to the space—I move on to another place.

8. Behind the scenes, there's costuming, roleplaying: a piece is directed toward a particular cultural space—a piece in New York is different from a piece in LA is different from a piece in Milan is different from a piece in Cologne.

9. On the scene, I've left my voice, as if calling a meeting to order. (My voice is left as an oppression that, eventually, people will have to react against, leaving the space, ending the meeting and starting an action.)

10. Scenes from people's performance: Wall (presence/body-to-body)—Ladder (direction/escape)—Machine (action/explosion).

Biography of Work 1969–1981 (1982)

1. LIFE-WORLD. The agent (artist) finds a place for self: the agent functions as receiver of an external world, the agent ties self into an existent system outside the self. A piece is meant to submerge the agent into environment; the agent is lost, no "thing" exists: a piece functions as a private activity—that private activity, however, exists only so that it can be made public later, like a news event, through reportage or rumor. *Example:* FOLLOWING PIECE, 1969

2. PRESENTATION OF SELF. The agent makes self into a place: the agent concentrates on self, the agent proves that concentration by applying stress to the self, the stress makes the self vulnerable and available to viewers. The agent, made into a place, doesn't need to have a place (the form of the pieces is: black figure on white ground). The mode is self-sufficiency: the agent starts an action, the action ends back at the agent. This circular movement turns person into object (an object that viewers can target in on through photographs and film). *Example:* CONVERSIONS, 1970

3. EXCHANGE POINT. Art is taken literally as communication: the exhibition-area is treated as a place where the agent, in person, meets viewer. The agent might function as a still point, that viewers move toward (agent as pied piper), or as part of the space that viewers are in (agent as stage-director); the agent can introduce self, in the present, by means of the past (autobi-

* Vito Acconci, "Biography of Work 1969–1981," in *Documenta* 7, 1 (Kassel: Documenta, 1982), 174–75. By permission of the author.

ography) or the future (fantasy)—the viewer is in danger of being implicated in the power-field exerted by that autobiography or fantasy. *Example:* SEEDBED, 1972

4. PROJECTION SPACE. From this point on, the agent is no longer present but behind the scenes. The exhibition-space resembles a movie: a piece consists of slide-projections (that transform the gallery walls into deep space, other places) and audiotape (through which the agent's voice is transformed into other voices, other persons). The exhibition-space is a floating space, out of the present: this is the realm of history or fiction—both agent and viewer have no secure footing here, the exhibition-space is a container of fleeting images. *Example:* OTHER VOICES FOR A SECOND SIGHT, 1974

5. COMMUNITY MEETING-PLACE. If a piece is "concrete" (making no claims to "universality"); if a piece is designed for a specific space, so that it can exist nowhere else; if a piece grows out of the space it will go into—then, in the same way, a piece should be culture-bound (a piece is oriented toward a particular community of viewers). The exhibition-space might be used as a town-square, where people gather together, or as a passageway, where people can stop on their way somewhere else. Audiotape might serve here to call a community-meeting to order, or to call a community into existence. (A piece can push a viewer up against a wall: at some point the viewer has to take stock of the situation, gather up resources, fight back against the piece which functions as an instrument of oppression.) *Example:* WHERE WE ARE NOW (WHO ARE WE ANYWAY), 1976

6. MACHINE. Once a community-meeting has taken place, there has to be an occasion to put the decisions made at that meeting into effect (or else viewers are left sitting there, contemplative, turned in on themselves and neurotic). A piece can be used to connect one point of a space to another and, thus, tie the space up: the piece, then, can provide a point of release, where a viewer has the potential to untie the bind, setting off an explosion (this explosion can be directed outside the space, or it can be turned back on the space itself). Audio and/or video can function here as cultural media, advertising, that prompts a viewer into action (audio/video can fill the viewer with a bloated image of self). *Example:* VD LIVES/TV MUST DIE, 1978

7. VEHICLE. From this point on, the pieces are no longer dependent on a specific space. A piece can travel from place to place, carrying its own space with it; a piece can be like a turtle, carrying its own home on its back. On the one hand, this is the situation of traditional "studio art" (the artist makes a work, in the privacy of the studio, and displays it later in public, ignoring the context); on the other hand, this is the situation of "guerilla warfare" (guerilla fighter makes a bomb, in the secrecy of the basement, and "displays" it later in public, destroying the context). *Example:* THE PEOPLEMOBILE, 1979

8. SELF-ERECTING ARCHITECTURE. Rather than carry with it a fixed space, that is imposed on viewers, a piece can carry with it a potential space: a piece can be in the form of an instrument or vehicle that, when operated by a viewer, erects a shelter (a building) that carries (presents) an image (a sign). The piece might be designed for use by a single person, who makes one thing (home, private space) for self and another thing (public space, monument) for others; or it might be designed for a group of viewers working together to construct (or reconstruct, or deconstruct) a city. Using the piece, the viewer becomes confirmed as the puppet of a culture; but the propaganda of that culture remains in existence only so long as a viewer keeps the piece going. *Example:* INSTANT HOUSE, 1980

ADRIAN PIPER

Ideology, Confrontation and Political Self-Awareness (1981)

We started out with beliefs about the world and our place in it that we didn't ask for and didn't question. Only later, when those beliefs were attacked by new experiences that didn't conform to them, did we begin to doubt: e.g., do we and our friends really understand each other? Do we really have nothing in common with blacks/whites/gays/workers/the middle class/other women/other men/etc.?

Doubt entails self-examination because a check on the plausibility of your beliefs and attitudes is a check on all the constituents of the self. Explanations of why your falsely supposed "X" include your *motives* for believing "X" (your desire to maintain a relationship, your impulse to be charitable, your goal of becoming a better person); the *causes* of your believing "X" (your early training, your having drunk too much, your innate disposition to optimism); and your *objective reasons* for believing "X" (it's consistent with your other beliefs, it explains the most data, it's inductively confirmed, people you respect believe it). These reveal the traits and dispositions that individuate one self from another.

So self-examination entails self-awareness, i.e. awareness of the components of the self. But self-awareness is largely a matter of degree. If you've only had a few discordant experiences, or relatively superficial discordant experiences, you don't need to examine yourself very deeply in order to revise your false beliefs. For instance, you happen to have met a considerate, sensitive, nonexploitative person who's into sadism in bed. You think to yourself, "This doesn't show that my beliefs about sadists in general are wrong; after all, think what Krafft-Ebing says! This particular person is merely an exception to the general rule that sexual sadists are demented." Or you think, "My desire to build a friendship with this person is based on the possibility of reforming her/him (and has nothing to do with any curiosity to learn more about my own sexual tastes)." Such purely cosmetic repairs in your belief structure sometimes suffice to maintain your sense of self-consistency. Unless you are confronted with a genuine personal crisis, or freely choose to push deeper and ask yourself more comprehensive and disturbing questions about the genesis and justification of your own beliefs, your actual degree of self-awareness may remain relatively thin.

Usually the beliefs that remain most unexposed to examination are the ones we need to hold in order to maintain a certain conception of ourselves and our relation to the world. These are the ones in which we have the deepest personal investment. Hence these are the ones that are most resistant to revision; e.g., we have to believe that other people are capable of understanding and sympathy, of honorable and responsible behavior, in order not to feel completely alienated and suspicious of those around us. Or: some people have to believe that the world of political and social catastrophe is completely outside their control in order to justify their indifference to it.

Some of these beliefs may be true, some may be false. This is difficult to ascertain because we can only confirm or disconfirm the beliefs under examination with reference to other beliefs, which themselves require examination. In any event, the set of false beliefs that a person has a personal investment in maintaining is what I will refer to (following Marx) as a person's *ideology*.

Ideology is pernicious for many reasons. The obvious one is that it makes people behave in stupid, insensitive, self-serving ways, usually at the expense of other individuals or groups.

* Adrian Piper, "Ideology, Confrontation and Political Self-Awareness: An Essay," *High Performance* 4, no. 1 (Spring 1981): 34–39. By permission of the author and the publisher.

Dear Friend,
 I am black.
 I am sure you did not realize this when you made/laughed at/agreed with that racist remark. In the past, I have attempted to alert white people to my racial identity in advance. Unfortunately, this invariably causes them to react to me as pushy, manipulative, or socially inappropriate. Therefore, my policy is to assume that white people do not make these remarks, even when they believe there are no black people present, and to distribute this card when they do.
 I regret any discomfort my presence is causing you, just as I am sure you regret the discomfort your racism is causing me.

Dear Friend,

 I am not here to pick anyone up, or to be picked up. I am here alone because I want to be here, ALONE.

 This card is not intended as part of an extended flirtation.

 Thank you for respecting my privacy.

Adrian Piper, calling cards, 1986. The second card was for dinners and cocktail parties. Art © Adrian Piper. Cards courtesy John Weber Gallery, New York.

But it is also pernicious because of the mechanisms it uses to protect itself, and its consequent capacity for self-regeneration in the face of the most obvious counterevidence. Some of these mechanisms are:

(1) The False Identity Mechanism

In order to preserve your ideological beliefs against attack, you identify them as objective facts and not as beliefs at all. For example, you insist that it is just a fact that black people are less intelligent than whites, or that those on the sexual fringes are in fact sick, violent or asocial. By maintaining that these are statements of fact rather than statements of belief compiled from the experiences you personally happen to have had, you avoid having to examine and perhaps revise those beliefs. This denial may be crucial to maintaining your self-conception against attack. If you're white and suspect that you may not be all that smart, to suppose that at least there's a whole *race* of people you're smarter than may be an important source of self-esteem. Or if you're not entirely successful in coping with your own nonstandard sexual impulses, isolating and identifying the sexual fringe as sick, violent, or asocial may serve the very important function of reinforcing your sense of yourself as "normal."

 The fallacy of the false identity mechanism as a defense of one's ideology consists in supposing that there exist objective social facts that are not constructs of beliefs people have about each other.

(2) The Illusion of Perfectibility

Here you defend your ideology by convincing yourself that the hard work of self-scrutiny has an end and a final product, i.e. a set of true, central, and uniquely defensible beliefs about some issue; and that you have in fact achieved this end, hence needn't subject your beliefs to further examination. Since there is no such final product, all of the inferences that supposedly follow from this belief are false. Example: you're a veteran of the anti-war movement and have developed a successful and much-lauded system of draft avoidance counseling, on which your entire sense of self-worth is erected. When it is made clear to you that such services primarily benefit the middle class, and that this consequently forces much larger proportions of the poor, the uneducated and blacks to serve and be killed in its place, you resist revising your views in light of this information on the grounds that you've worked on and thought hard about these issues, have developed a sophisticated critique of them, and therefore have no reason to reconsider your opinions or efforts. You thus treat the prior experience of having reflected deeply on some issue as a defense against the self-reflection appropriate now, that might uncover your personal investment in your anti-draft role.

The illusion of perfectibility is really the sin of arrogance, for it supposes that dogmatism can be justified by having "paid one's dues."

(3) The One-Way Communication Mechanism

You deflect dissents, criticisms or attacks on your cherished beliefs by treating all of your own pronouncements as imparting genuine information, but treating those of other people as mere symptoms of some moral or psychological defect. Say you're committed to feminism, but have difficulty making genuine contact with other women. You dismiss all arguments advocating greater attention to lesbian and separatist issues within the women's movement on the grounds that they are maintained by frustrated man-haters who just want to get their names in the footlights. By reducing questions concerning the relations of women to each other to pathology or symptoms of excessive self-interest, you avoid confronting the conflict between your intellectual convictions and your actual alienation from other women, and therefore the motives that might explain this conflict. If these motives should include such things as deep-seated feelings of rivalry with other women, or a desire for attention from men, then avoiding recognition of this conflict is crucial to maintaining your self-respect.

The one-way communication mechanism is a form of elitism that ascribes pure, healthy, altruistic political motives only to oneself (or group) while reducing all dissenters to the status of moral defectives or egocentric and self-seeking subhumans whom it is entirely justified to manipulate or disregard, but with whom the possibility of rational dialogue is not to be taken seriously.

There are many other mechanisms for defending one's personal ideology. These are merely a representative sampling. Together, they all add up to what I will call the *illusion of omniscience*. This illusion consists in being so convinced of the infallibility of your own beliefs about everyone else that you forget that you are perceiving and experiencing other people from a perspective that is in its own ways just as subjective and limited as theirs. Thus you confuse your personal experiences with objective reality, and forget that you have a subjective and limited *self* that is selecting, processing and interpreting your experiences in accordance with its own limited capacities. You suppose that your perceptions of someone are truths about her or him; that your understanding of someone is comprehensive and complete. Thus your self-conception is not demarcated by the existence of other people. Rather, you appropriate them into your self-conception as psychologically and metaphysically transparent objects of your consciousness. You

ignore their ontological independence, their psychological opacity, and thereby their essential personhood. The illusion of omniscience resolves into the fallacy of solipsism.

The result is blindness to the genuine needs of other people, coupled with the arrogant and dangerous conviction that you understand those needs better than they do; and a consequent inability to respond to those needs politically in genuinely effective ways.

The antidote, I suggest, is confrontation of the sinner with the evidence of the sin: the rationalizations, the subconscious defense mechanisms, the strategies of avoidance, denial, dismissal, and withdrawal that signal on the one hand the retreat of the self to the protective enclave of ideology; on the other hand, precisely the proof of subjectivity and fallibility that the ideologue is so anxious to ignore. This is the concern of my recent work of the past three years.

The success of the antidote increases with the specificity of the confrontation. And because I don't know you I can't be as specific as I would like. I can only indicate general issues that have specific references in my own experience. But if this discussion has made you in the least degree self-conscious about your political beliefs or about your strategies for preserving them; or even faintly uncomfortable or annoyed at my having discussed them; or has raised just the slightest glimmerings of doubt about the veracity of your opinions, then I will consider this piece a roaring success. If not, then I will just have to try again, for my own sake. For of course I am talking not just about you, but about *us*.

MARTHA WILSON Performances and Photographs (1972–74)

Martha Wilson, *Captivating a Man*, 1972, photograph (of Richards Jarden by Wilson). Courtesy of the artist.

Martha Wilson, *Posturing: Male Impersonator*, 1973, photograph (of Wilson by Richards Jarden). Courtesy of the artist.

* Martha Wilson, performances and photographs (1972–74). By permission of the artist.

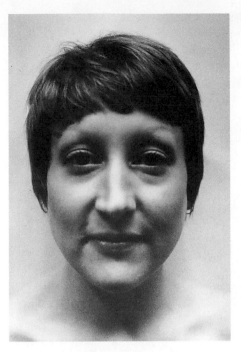

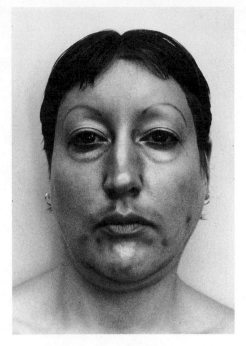

Martha Wilson, *I Make Up the Image of My Perfection,* 1974, photograph. Photo by Alan Comfort. Courtesy of the artist.

Martha Wilson, *I Make Up the Image of My Deformity,* 1974, photograph. Photo by Alan Comfort. Courtesy of the artist.

GUILLERMO GÓMEZ-PEÑA

The Loneliness of the Immigrant (2005)

I left Mexico City in 1978 to study art in California—"the land of the future," as my lost generation saw it. Six months after my arrival in Los Angeles, I decided to spend 24 hours in a public elevator wrapped in an Indian fabric and rope as a way of expressing the profound feelings of cultural isolation I was experiencing as a newly arrived immigrant. I was unable to move or talk back. My total anonymity and vulnerability seemed to grant people the freedom to confess to me intimate things about their lives—things I didn't want to hear; to abuse me verbally; even to kick me. I overheard two adolescents discussing the possibility of setting me on fire. A dog peed on me, and at night, the security guards threw me into an industrial trashcan, where I spent the last two hours.

To me this piece was a metaphor of painful birth in a new country; a new identity—the Chicano; and a new language—intercultural performance. I quote from my performance diaries: "Moving to another country hurts much more than moving to another house, another face, or another lover. Immigrants constantly experience in their own flesh the bizarre Otherness of absolutely incomprehensible situations, symbols, and languages. As a new immigrant, I hope this piece will help a little bit to transform our insensitive views on immigration. In

* Guillermo Gómez-Peña, *The Loneliness of the Immigrant,* in Francesca Richer and Matthew Rosenzweig, eds., *No. 1: First Works by 362 Artists* (New York: D.A.P./Distributed Art Publishers, 2005), 152. By permission of the artist, Pocha Nostra Archive, and the publisher.

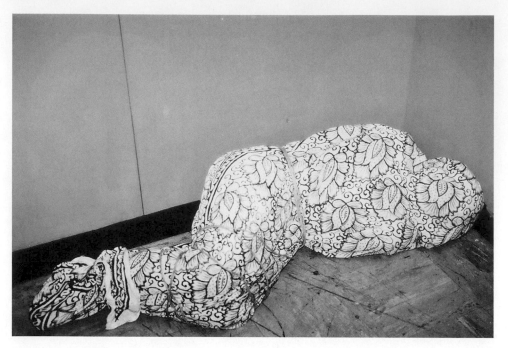

Guillermo Gomez-Peña, *The Loneliness of the Immigrant,* performance, 1979. Courtesy Pocha Nostra Archive.

one way or another we all are, or will be, immigrants. Surely one day we will be able to crack this shell, this incommensurable loneliness, and develop a transcontinental identity. I hope I will still be alive to experience it."

The strong emotional responses from my involuntary audiences made me realize what an idoneous medium performance was to insert my existential and political dilemmas into the social sphere. Eventually, the "loneliness of the immigrant" became a kind of urban legend in the Chicano community. I was 24 years old.

CINDY SHERMAN Statement (1982)

I want that choked-up feeling in your throat which maybe comes from despair or teary-eyed sentimentality: conveying intangible emotions.

A photograph should transcend itself, the image its medium, in order to have its own presence.

These are pictures of emotions personified, entirely of themselves with their own presence—not of me. The issue of the identity of the model is no more interesting than the possible symbolism of any other detail.

When I prepare each character I have to consider what I'm working against; that people

* Cindy Sherman, untitled statement, *Documenta 7,* 1 (Kassel: Documenta, 1982), 411. © Cindy Sherman; courtesy Metro Pictures, New York.

are going to look under the make-up and wigs for that common denominator, the recognizable. I'm trying to make other people recognize something of themselves rather than me.

I have this enormous fear of being mis-interpreted, of people thinking the photos are about me, that I'm really vain and narcissistic. Then sometimes I wonder how it is I'm fooling so many people. I'm doing one of the most stupid things in the world which I can't even explain, dressing up like a child and posing in front of a camera trying to make beautiful pictures. And people seem to fall for it. (My instincts tell me it must not be very challenging then.)

Believing in one's own art becomes harder and harder when the public response grows fonder.

Interview with Els Barents (1982)

There is a stereotype of a girl who dreams all her life of being a movie star. She tries to make it on the stage, in films and either succeeds or fails. I was more interested in the types of characters that fail. Maybe I related to that. But why should I try to do it myself? I'd rather look at the reality of these kinds of fantasies, the fantasy of going away and becoming a star. . . .

The black-and-white photographs were more fun to do. I think they were easy partly because throughout my childhood I had stored up so many images of role models. It was real easy to think of a different one in every scene. But they were so cliché that after three years I couldn't do them anymore. I was really thinking about movies, the characters are almost typecast from the movies.

For the woman standing in front of my studio door, I was thinking of a film with Sophia Loren called "Two Women." She plays this Italian peasant. Her husband is killed and she and her daughter are both raped. She is this tough strong woman, but all beaten-up and dirty. I liked that combination of Sophia Loren looking very dirty and very strong. So that's what I was thinking of.

And then the more I had done, I guess the more I developed my own ideas of what types of women I thought would be more interesting than the stereotypes. I realized I had to become more specific in details, because that's what makes a person different from other people. Especially details that may seem insignificant, like a scrap of paper or the kind of curtain used. I also just started working closer and closer to the figure, because I was less interested in using locations. I wanted to imply an environment with as little as possible. In the corner of the picture, there would be a little piece of floor. That's all the floor you saw, and there would be a little piece of something else that gave you another idea of what people have around them. . . .

Someone could look at say the piece of paper that the woman is clutching in her hands, the woman in the orange plaid skirt on the tiles. That piece of paper could say that she's just a lovelorn teenager who has ripped out some classified ads in the newspaper. Someone else could think that she's been thrown down on the floor and that she ripped off the paper. I guess that's what I mean. Some people look at a thing and see it as something very violent, whereas my intention was completely different. Another person can look at it and see something very sexual, and that's also very confusing.

In the picture of the girl in the orange plaid skirt I was thinking of a young girl who may have been cleaning the kitchen for her mother and who ripped something out of the newspaper, something asking "Are you lonely?" or "Do you want to be friends?" or "Do you want

* Cindy Sherman, from an interview by Els Barents, in *Cindy Sherman* (Munich: Schirmer und Mosel, 1982). © Cindy Sherman; courtesy Metro Pictures, New York.

to go on a vacation?" She's cleaning the floor, she rips this out and she's thinking about it. They're all that simple. One of the other images which had a very innocent inspiration was the woman in the black sheets. I was thinking of a woman with a terrible hangover who had just gone to bed about an hour before. Now the sun is coming up and it just woke her up. Her makeup is all smudged and she is already sticky from the heat of the day. She wakes up and looks at the sun as if she is thinking "Oh, it's that" or something. That is just such a simple idea, but people are saying it looks like, you know, she has just like made love. . . .

I used to put makeup on sometimes when I didn't have much to do. I would experiment and make my face look like somebody else. Every once in a while I would get into this thing for no reason at all. I wasn't even about to take a picture. I would think of a costume. Like one time I made myself up to look like Lucille Ball. People were sitting around watching TV. This was in Buffalo, Hallwalls gallery, an alternative space. In the evening I just turned into Lucille Ball and went out and sat and watched TV with them, as Lucille Ball. In Buffalo I got more and more involved in it. It was something I had to get out of my system. Once I started doing it I realized that people were entertained by it and also very confused. I liked that, and would go to openings and parties as other people. One time I was at an opening with all this weird makeup on and all this second-hand clothing. I bought this big hat and went as a pregnant woman from the fifties. In Buffalo it is very easy to do that. I guess it was because you needed inspiration anywhere you could get it, and people would appreciate the most outrageous things you could do.

But when I moved to New York, it seemed almost too cliché. There were so many strange-looking people on the street. It wasn't satisfying, and I stopped doing it. I was working at Artists Space, and I started with the makeup again. I would make up to look like a secretary on the street. Then I decided to go to work like that, looking like a different person, but still blending in. I did it maybe four times and then I couldn't do it any more, and I have never done it since. I realized that by doing it so many times in a row I felt like I was losing my street identity, which you really need in New York. I was becoming vulnerable by being somebody I didn't identify with. I walked down the streets and I couldn't tell if people were going "Boy, she looks weird. I know that's a wig. And look at all that funny makeup." People probably didn't even notice anything at all. But even then I don't think I played the part, I accepted it.

YASUMASA MORIMURA Season of Passion: Interview with Kay Itoi (2006)

YASUMASA MORIMURA: I have always been interested in [Mishima]. One thing that connected the two of us is the Self-Defense Forces. After I graduated from college, I got a job and was supposed to participate in training seminars organized with the SDF [a common practice at a traditional Japanese company]. I couldn't stand the idea, so I quit the company after only three days. I wasn't proud of it—in fact, it nagged me for a long time.

Many years later [in 1995], I finally went to the SDF when I was making a work based on a scene from the movie Casablanca, for the "Actress" series. I showed up there as Ingrid Bergman, and the officers were so kind, so happy to help me. I could go there and leave there

* Kay Itoi, excerpt from "Season of Passion," interview with Yasumasa Morimura, *artnet Magazine,* 6 December 2006 (www.artnet.com/magazineus/features/itoi/itoi12-6-06.asp). Originally published in a longer version as "Yasumasa Morimura: A Change in Gender for New Political Series," *The Japan Times,* 6 October 2006. By permission of the interviewer, the artist, and both publishers.

with dignity, as a woman. Yukio Mishima went to the SDF headquarters as a man, to launch a coup. When I was leaving, I thought, "Mishima couldn't get out; he died there."

KAY ITOI: He couldn't leave because he was a man?

YM: As a side story to the main theme of the series, I made eight smaller pieces based on Mishima's portraits in the 1960s. In them, Mishima was almost naked, and he was—unusually for a Japanese man—extremely hairy. It proved troublesome for me because I am not.

Mishima was a pale, thin kid. It must have been awkward; he must have wanted a well-muscled body to measure up to his hairiness. So he started body-building and boxing. He wanted to be a soldier. It's my theory, and it's kind of a joke, but if he hadn't been so hairy, he could have nurtured his feminine side.

KI: You portrayed women in most of your previous pieces, but all the characters in the new series are men.

YM: Before we build a house in Japan, we have a Shinto ceremony called *jichinsai* to sanctify the ground and pay respect to what was there before. Without it, the land is cursed, and awful things may happen. I wanted to do something like this ceremony with my new series.

There are two kinds of beings in the world: ones like Amaterasu [the Sun Goddess in Japanese mythology, known for warmth and compassion] and others like Susanoo [God of Storm and Sea, known for violence]. Awful historic events in the 20th century were men's doing—I think, provoked by the Susanoo in them. For a long time, I produced works that embraced the values represented by Amaterasu, particularly with the "Actress" series. And I see that the [traditionally male-dominated] Japanese society has changed to accept and appreciate such values. While we accomplished that, we probably forgot about men, although masculine values led and created the 20th century.

KI: Japan is leaning to the right politically and becoming more macho, while feminine and compassionate values are increasingly appreciated. Aren't men torn between the two values?

YM: I think young boys are torn, and that's why we see more and more vicious crimes committed by them. Being a man isn't easy. But everybody has two sides in him- or herself: Amaterasu and Susanoo.

KI: You once said that your idea of beauty is something that stirs up a commotion, which occurs when two different things meet.

YM: History is public memory, and my recollections are personal. When historic images provoke recollection, sometimes it causes a commotion in me. When I catch such a moment, it stimulates my enthusiasm for expression, my enthusiasm to produce something that is my idea of "beauty."

KI: Your speech at the opening of your show [which is reproduced in a video now in the exhibition] sounds like the direct opposite of what is advocated by Takashi Murakami, another internationally active Japanese artist: a global strategy for artists to be commercially successful.

YM: I don't think he is just about commercialism. There is something nationalistic about him. I may be wrong, but to me, his idea seems descended from the tradition of the Meiji Era painters of Tokyo National University of Fine Arts and Music [the country's most prominent arts school, where Murakami studied traditional Japanese art and received a Ph.D.]. They felt responsible for Japanese culture and its promotion in the West. As an artist from Kansai [western Japan], I take the opposite position. We in Kansai have no interest in the nation's culture. All we care about is how we can improve our art.

KAREN FINLEY I Was Not Expected to Be Talented (1990)

I have never been out of the country nor have I ever been to New York City even though my husband goes to work there every day. I am a committed waitress and mother, who looks forward to purchasing a new thousand dollar sofa set. Isn't that what working is for?

Last night I cried till dawn. I cried because I want a daughter but instead I have had three sons. I feel if I have a daughter I can give her chances I never had. This is something perhaps only women would understand—that up to this very day, girls, daughters are killed for being just that. Girls. Daughters. Females. No wonder the entire psyche of women is universally coached to be as desirable as possible, as boring as possible, as cute as possible. Obviously, it's for the survival of the female species.

Yes, maybe my daughter could have the chances I never had. Maybe she could get another kind of job instead of serving, nurturing for pay that most men would never work for. For a waitress there is no pregnancy leave, maternity leave. Bearing a child can mean the end of a career, a woman can be abandoned by society, and the government wants to make it impossible for women to have a fair share along with men. Waitressing, which is shiftwork, doesn't correspond with day-care hours, and a sitter costs more than half a woman's salary. No insurance. No sick leave. No paid vacation. Restaurants are paying below minimum wage. In fact, many upscale hotels and restaurants hire men, not women, to work the dinner shift, which brings as much as three or four times more money. I keep all this to myself because I was not expected to be talented.

I WAS NOT EXPECTED TO BE TALENTED. You see, I was not expected to be talented. That's why I wanted a daughter, who I could encourage, who could lead, who could eventually leave this god damn domestic cycle. But I've been told by the doctors that I could not have anymore children. I worked too hard and long into my pregnancy even though most waitresses stop working when they "show" since most customers find a pregnant woman serving food unappetizing.

Yeah, you tell me I'm supposed to stop thinking about everyone else's problems and start thinking about my own. Well, as soon as I start doing that everyone else's lives collapse and I'm left to pick up the pieces. Just smile, act pretty, open the door, and clean the toilet. You say, "One day at a time." Well, it's a slow death! I'm told to remember those who are less fortunate than myself. Remember the homeless, the poor, the suffering. Well, I'm suffering inside! Anytime I see someone caring or sharing, I burn up inside with envy. You know why I only feel comfortable around the collapsed, the broken, the inebriated, the helpless and the poor—CAUSE THEY LOOK LIKE WHAT I FEEL INSIDE! They look, they look, they look like what I feel inside!

You see, I WAS NOT EXPECTED TO BE TALENTED.
And when I see you
after you beat me
after you degrade me
and you stand on top of me
in some god-awful museum

* Karen Finley, "I Was Not Expected to Be Talented," in *Shock Treatment* (San Francisco: City Lights Books, 1990): 104–10. Copyright © 1990 by Karen Finley. By permission of the author and the publisher.

you say to me
There are no great women artists!
There are no great women artists!
There are no great women artists!
We are always the exception.
I was not expected to be talented.

Instead of going to church
I walk past the sites in Central Park
where women have been raped and murdered
And think about the men who just walked away
after they performed their deed
And then I think of this country's heroes
and how they treated their women
Like the Kennedys
how they treated their women
Marilyn Monroe—they killed her, left her for dead.
Mary Jo Kopechne—they killed her, abandoned her
like shit.

And I barf when I see William Hurt—
He thought he was so cool when he played a queen
When he made love to a deaf woman
For the world to see.
But we're used to it.
We can only fuck to get access to power
And if we don't we're raped anyway.
All single women with children
with no health care, no child care, no child support—
We're used to it.
It's a life of Lies
It's a life of Selling Out

And the last time I saw my mother she had a skillet above my head.

Why should I pretend to stop drinking? For the children? Shit, they're the reason I drink! My so-called daughter hasn't called me in years because of my so-called intoxicated lifestyle, my liquor-motivated decisions. No one cares about me. Why should I care about me? Let's see how low they'll let me fall before they'll pick me up. Besides, I can stop whenever I want. And you know children, as soon as they're in trouble they call on you to bail them out.

I know everything, that's my problem. I'm too smart for this world. My analysis can be so deliberate that I'm known for my psychic pain. Clever, smart, driven pain. I'm always right.

I feel you shiver when you suspect me drinking, but you'll never find my vodka behind the kitty litter box! 'Cause I'm the only one who works around here. No matter how much I drink I always make it to work on time! I'd like for you to feel pain, to feel my pain of raising a family alone. I don't get any widow benefits. People and family members are scared of me. They don't know what to do with a widow. Everyone blames his life on me. Every-

one blames his death on me, even though he pulled the trigger. And the only consoling words I ever receive are, "You're so lucky he didn't kill you and the children too." Or, "You're so lucky he blew his brains out in the garage and not in the living room." Yeah, I'm lucky. I'm so lucky. I hate people who rationalize suffering. I hate people who have to have a reason for everything. They can't just accept the fact that bad things happen to good people because if they did they'd be like me—out of control. Out of control. Yeah, I admit it. I'm out of control.

I deserve the right to drink. No one else rewards me for going to work everyday, for cleaning this damn house. I had five kids, three miscarriages and one abortion. I've been a mother, a whore and a slave. I've been needed, rejected and desired, but never valued by anyone. Soon my words will slur, my muscles and facial expressions will drop. My head will bob, my sentences will run on and on and on. And I'll tell those god damn repeated stories over and over and over and over again and I'll never stop even though you'll want me to. I'm a living Hell and I intend to keep my devil out.

I live in a state of never getting better
I live in a world of caving in
I live in a life where
pleasure means death
I hate REHAB
I hate DENIAL
I hate Queen Victoria.

Why is it I hate independence?
Independence Day?
I want Dependence Day.
I want to be dependent on drugs, alcohol, and sex again
I want dependency
This country takes all my independence away
They are trying to take abortion away
and freedom of speech
Because this country spends more time on this stupid burning flag
When our own citizens' stomachs are burning with hunger
When people with AIDS are burning with fever
Let me tell you, God has failed
And God is bureaucracy
God is statistics
God is what you make and not what you feel
We've been oppressed
We're only tolerated
And they say we're lucky cause we don't live in China
But they don't even care about the people of China
I want more than a biological opportunity
I want more than a biological opportunity
Listen to me. . . .

Letter to the *Washington Post* (1990)

To the Editor:

I am outraged by the column by Rowland Evans and Robert Novak ["The NEA's Suicide Charge," op-ed May 11], which attacked my grant application to the National Endowment for the Arts. My performance was taken out of context, and I was presented in an inaccurate and maliciously misleading way.

I am a serious artist who performs throughout North America and Europe. I am committed to significant social theater and art, but I am now the latest victim of the attacks of the extremist right on freedom of expression. I see this attack as part of a larger trend of suppressing artists—especially those whose work deals with difficult social issues—by playing on society's fears, prejudices and problems.

I would like to set the record straight. First, I did not request support from the NEA for the performance, "We Keep Our Victims Ready," as Evans and Novak alleged. I received no funding for that piece; the grant would help me with future work.

As to my work being "outrageous," many of the people who seem to be outraged have never even seen me perform. Evans and Novak describe me as a "chocolate-smeared young woman," which suggested that my work is sexual or sexually explicit. Actually, my work speaks out against sexual violence, degradation of women, incest and homophobia. When I smear chocolate on my body, it is a symbol of women being treated like dirt. The same Minneapolis review that the columnists quoted called my work "moving" and "heartfelt."

Let me briefly describe my work: In the first act, I sit in a rocking chair, fully clothed, and talk about women as the underclass and society under patriarchal rule. In the second act, I talk about the daily oppression of women, people with AIDS and minorities and about how society ignores and suppresses these people. In the third act, I am shrouded in a white sheet at a bed, symbolizing a death bed. There I talk about the survivors of death in the wake of AIDS, the "Black Sheep" of our culture who are related by their diversities and are all part of our large extended family. By the end, the audience is usually moved to tears.

A sculpture incorporating my "Black Sheep" poem is on public display in New York City. I have performed this work across the United States and Europe and am scheduled to perform it at Lincoln Center in July.

American artists, writers, theater makers, musicians, poets, dancers and filmmakers have led the world in the arts because of our right to free expression. But if it weren't for the help provided by the NEA, art would be only for the rich and powerful.

I know that the witch-hunt of the arts does not truly represent the wishes of the American people but merely those of a fanatic faction. Americans want controversial artists to be funded, and the evidence is there in a new nationwide poll. I hope American citizens of different backgrounds will be able to continue to express themselves freely without fear of censorship.

Karen Finley

* Karen Finley, "Letter to the Editor," *Washington Post,* 19 May 1990. By permission of the author.

COCO FUSCO The Other History of Intercultural Performance (1994)

My collaborator Guillermo Gómez-Peña and I were intrigued by this legacy [from ethnographic exhibitions] of performing the identity of an Other for a white audience, sensing its implications for us as performance artists dealing with cultural identity in the present. Had things changed, we wondered. How would we know, if not by unleashing those ghosts from a history that could be said to be ours? Imagine that I stand before you then . . . to speak about an experience that falls somewhere between truth and fiction. What follows are my reflections on performing the role of a noble savage behind the bars of a golden cage.

Our original intent was to create a satirical commentary on Western concepts of the exotic, primitive Other; yet, we have had to confront two unexpected realities in the course of developing this piece: 1) a substantial portion of the public believed that our fictional identities are real ones; and 2) a substantial number of intellectuals, artists, and cultural bureaucrats have sought to deflect attention from the substance of our experiment to the "moral implications" of our dissimulation, or in their words, our "misinforming the public" about who we were. The literalism implicit in the interpretation of our work by individuals representing the "public interest" bespeaks their investment in positivist notions of "truth" and depoliticized, ahistorical notions of "civilization." This "reverse ethnography" of our interactions with the public will, I hope, suggest the culturally specific nature of their tendency toward a literal and moral interpretation. . . .

[We took] a symbolic vow of silence with the cage performance, a radical departure from Guillermo's previous monologue work and my activities as a writer and public speaker. We sought a strategically effective way to examine the limits of the "happy multiculturalism" that currently reigns in cultural institutions, as well as to respond to the formalists and cultural relativists who reject the proposition that racial difference is absolutely fundamental to aesthetic interpretation. We looked to Latin America, where consciousness of the repressive limits on public expression is far more acute than here, and found many examples of how popular opposition has for centuries been expressed through the use of satiric spectacle. Our cage became the metaphor for our condition, linking the racism implicit in ethnographic paradigms of discovery with the exoticizing rhetoric of "world beat" multiculturalism. Then came a perfect opportunity: In 1991, Guillermo and I were invited to perform as part of the Edge '92 Biennial, which was to take place in London and also in Madrid as part of the quincentennial celebration of Madrid as the capital of European culture. We took advantage of Edge's interest in locating art in public spaces to create a site-specific performance for Columbus Plaza in Madrid, in commemoration of the so-called Discovery.

Our plan was to live in a golden cage for three days, presenting ourselves as undiscovered Amerindians from an island in the Gulf of Mexico that had somehow been overlooked by Europeans for five centuries. We called our homeland Guatinau, and ourselves Guatinauis. We performed our "traditional tasks," which ranged from sewing voodoo dolls and lifting weights to watching television and working on a laptop computer. A donation box in front of the cage indicated that for a small fee, I would dance (to rap music), Guillermo would tell authentic Amerindian stories (in a nonsensical language), and we would pose for Polaroids with visitors. Two "zoo guards" would be on hand to speak to visitors (since we could not

* Coco Fusco, excerpts from "The Other History of Intercultural Performance," *TDR/The Drama Review* 38, no. 1 (T-141/Spring 1994): 143–67; reprinted in Nicholas Mirzoeff, ed., *The Visual Culture Reader,* 2nd ed. (London: Routledge, 2002), 558–604. © 1994 by New York University and the Massachusetts Institute of Technology. Also by permission of the author.

understand them), take us to the bathroom on leashes, and feed us sandwiches and fruit. At the Whitney Museum in New York, we added sex to our spectacle, offering a peek at authentic Guatinaui male genitals for $5. A chronology with highlights from the history of exhibiting non-Western peoples was on one didactic panel, and a simulated Encyclopedia Britannica entry with a fake map of the Gulf of Mexico showing our island was on another. . . .

Our project concentrated on the "zero degree" of intercultural relations in an attempt to define a point of origin for the debates that link "discovery" and "Otherness." We worked within disciplines that blur distinctions between the art object and the body (performance), between fantasy and reality (live spectacle), and between history and dramatic reenactment (the diorama). The performance was interactive, focusing less on what we did than on how people interacted with us and interpreted our actions. Entitled *Two Undiscovered Amerindians Visit . . .* , we chose not to announce the event through prior publicity or any other means, when it was possible to exert such control; we intended to create a surprise or "uncanny" encounter, one in which audiences had to undergo their own process of reflection as to what they were seeing, aided only by written information and parodically didactic zoo guards. In such encounters with the unexpected, people's defense mechanisms are less likely to operate with their normal efficiency; caught off guard, their beliefs are more likely to rise to the surface.

Our performance was based on the once popular European and North American practice of exhibiting indigenous people from Africa, Asia, and the Americas, in zoos, parks, taverns, museums, freak shows, and circuses. While this tradition reached the height of its popularity in the 19th century, it was actually begun by Christopher Columbus, who returned from his first voyage in 1493 with several Arawaks, one of whom was left on display at the Spanish Court for two years. Designed to provide opportunities for aesthetic contemplation, scientific analysis, and entertainment for Europeans and North Americans, these exhibits were a critical component of a burgeoning mass culture whose development coincided with the growth of urban centers and populations, European colonialism, and American expansionism. . . .

Our cage performances forced these contradictions out into the open. The cage became a blank screen onto which audiences projected their fantasies of who and what we are. As we assumed the stereotypical role of the domesticated savage, many audience members felt entitled to assume the role of the colonizer, only to then find themselves uncomfortable with the implications of the game. Unpleasant but important associations have emerged between the displays of old and the multicultural festivals and ethnographic dioramas of the present. The central position of the white spectator, the objective of these events as a confirmation of their position as global consumers of exotic cultures, and the stress on authenticity *as an aesthetic value,* all remain fundamental to the spectacle of Otherness many continue to enjoy. . . .

For Gómez-Peña and myself, the human exhibitions dramatize the colonial unconscious of American society. In order to justify genocide, enslavement, and the seizure of lands, a "naturalized" splitting of humanity along racial lines had to be established. When rampant miscegenation proved that those differences were not biologically based, social and legal systems were set up to enforce those hierarchies. Meanwhile, ethnographic spectacles circulated and reinforced stereotypes, stressing that "difference" was apparent in the bodies on display. They thus naturalized fetishized representations of Otherness, mitigating anxieties generated by the encounter with difference.

KATARZYNA KOZYRA Artist's Response (1992)

I am the author of the composition called *Pyramid of Animals*. Together with this piece, which consisted of the stuffed carcasses of a horse, a dog, a cat, and a rooster, there was a commentary in which I presented my motivation, the creative process, and the doubts that accompanied them. I asked the question: is only the sculpture to be evaluated or is it also the process of its creation and the reactions and experience linked to it? With this act I exposed myself to confrontation with people who think differently than I, but from whom I had expected respect for facts.

Meanwhile the various lies have been repeated and publicized, among them that I had raised these animals, subjected them to suffering, and killed them with my own hands. That is not true. During my diploma exam it was publicly stated that the skins of the dog and the cat had been removed from dead animals, whereas the skins of the horse and the rooster from animals that were meant for slaughter, which I bought and then put to sleep. The "killing" was for purposes other than the making of a pair of shoes or the eating of meat, which is a violation of norms that are considered obligatory and humanitarian. The infliction of death on animals in a civilized and industrial manner takes place anonymously and beyond the view of their later consumers. The taking of the life of an animal in an open manner and by an individual is the cause of shock and condemnation. I consciously exposed myself to this test. My observing the death of the horse was a hundred percent more terrible than all of the invectives that have been leveled against me. In an effort to be consistent I also took upon myself the death of dead animals. My composition is about death, generally speaking, and about the deaths of these concrete four animals. I did not do this for any tingling pleasure or because of technical indolence. I did this out of my internal need to ask the question: do we still feel the presence of death eating chops, using cosmetics, or using other animal-based products, or has that been effectively neutralized by the household representatives of animals, which receive our feelings on a day-to-day basis? *Pyramid of Animals* is a violation of norms in treating the death of animals as a phenomenon that has nothing to do with the consumer.

If I decided to use this form in my first totally independent artistic work, it is not because art is treated by society as a game among artists playing in their own backyard, far from important issues or, as Ms. Xymena Zaniewska writes, serves only "decorative purposes."

JIMMIE DURHAM I Think We Will Have to Break Out (1973)

The sheriff in Van Horn, Texas
Asked me what I was doing in his town.

I am looking for something
I am searching for it.

 * Katarzyna Kozyra, "Artist's Response," letter originally written to editor of *Gazeta Wyborcza,* 20 August 1992; published in *Katarzyna Kozyra—The Men's Bathhouse:* XLVIII International Biennale of the Visual Arts, Venice, 1999 (Warsaw: Zachęta Gallery of Contemporary Art, 1999); reprinted in Laura Hoptman and Tomáš Pospiszyl, eds., *Primary Documents: A Sourcebook for Eastern and Central European Art Since the 1950s* (New York and Cambridge, MA: Museum of Modern Art and MIT Press, 2002), 255. By permission of the author and Zachęta National Gallery of Art, Warsaw.

 ** Jimmie Durham, "I Think We Will Have to Break Out" (1973), in *Columbus Day* (Albuquerque, NM: West End Press, 1993). © Jimmie Durham. By permission of the artist and the publisher.

Tatanka Iotanka said
If you lose something go back and you will find it.
I do not know where I lost it.
They took it away.

I look on the highway,
In cities,
Dangerous small towns.
In the desert I turn over every beer can.
I try to read factory smoke,
Books,
Newspapers.
Search through planks stacked
Outside the sawmill where the forest was.

In this jail,
I think they put it in jail.

I think we will have to break out.

Tarascan Guitars (1976)

In Texas, at that old Comanche place called White Flint,
I found the skull of an armadillo.
Maybe some new hunter killed an armadillo with a .22 rifle.
I asked rocks and other things around.
It was probably that way, they said.

I painted the armadillo's skull bright turquoise and orange,
Blue and red, black, green, like tiles and aztec flowers.
Where his old eyes had been, I put an agate
and a seashell;
For seeing in all directions.

Now he can go to the festival of the dead
In Tarasco where they make those guitars,
And where a wildman made the first ocarina,
To make the women fall in love with him.

In Tarasco, Mexico, where fields are covered with flowers,
They sometimes make guitars from the armor of armadillos.
So if he goes there to the festival of the dead
He can dance like a flower to the music of his brothers.

Everyone will be glad to see him, and he will say,
That Cherokee guy sent me here.

* Jimmie Durham, "Tarascan Guitars" (1976), in *Columbus Day* (Albuquerque, NM: West End Press, 1993). © Jimmie Durham. By permission of the artist and the publisher.

If we do not let our memories fail us
The dead can sing and be with us.
They want us to remember them,
And they can make festivals in our struggles.

Someday we will find those Cherokees
Who tried to escape Texas into Mexico
But were killed by Sam Houston's hunters.

I have already found an armadillo's skull,
And like Sequoia who was lost in Mexico
I write to remember.

JAMES LUNA Interview with Julia Barnes Mandle (1992)

JULIA MANDLE: How would you define your religion?

JAMES LUNA: There is a religion amongst the Luiseño people, which is very structured. As far as my tribal ways, I can't pretend to know more because I don't know the language. You have to know the language. You have to seek the religion, for it's not learned overnight. It is not part of everyday life and there are people who have been entrusted with it and don't give it away. I won't talk about what I know because it is not for everybody. I realize that I don't have a complete knowledge of it, but I practice certain things. In a broader sense, I practice a kind of religion that is a composite of all these things. It is prevalent. You can go to certain ceremonies like a sweat-lodge, and you'll find people singing songs from different tribes and incorporating different ways. You can find this at sweat-lodges in California or in New York or in South Dakota. The religion is more accessible, and I feel more public about it.

JM: Your piece for the Williams College Museum of Art, *The History of the Luiseño People: La Jolla Reservation, Christmas 1990,* involves a Christian religious tradition. Is Christianity practiced on the Luiseño reservation as well? Do the different religions conflict? And why Christmas 1990? How does this particular Christmas reflect the history of the Luiseño to you?

JL: Most of the people on the reservation are Christian anyway. They celebrate holidays like everyone else. During this particular Christmas on the reservation, I saw a tree that someone had decorated with a beer can at the top. The "history" is part of a series of works that I have created under this guise—"The History of the Luiseño People"—it is a way I unify my work. All my work is a mixture of fact and fiction. Sometimes I make them more extreme, or not as extreme in order to make them more believable. Some are so extreme that people would never believe that they actually happened. Usually, I am the only one who knows where the two separate, but they are grounded by actual experiences, or memories that I have, of life on the reservation.

The other objects in the installation are to recreate a home on the reservation: the braided rug, the chair, the television illuminating the room with that blue-grey light flicker-

 * Julia Barnes Mandle, "James Luna: Interview," in *Sites of Recollection: Four Altars and a Rap Opera* (Williamstown, MA: Williams College Museum of Art, 1992), 70–79. By permission of the interviewer, the artist, and the publisher.

ing with the changing images. The audience here will not be able to see the screen, it doesn't really matter because the TV shows are all the same. I'll be talking on the phone for the performance and drinking beer. I'm always on the phone these days; everyone uses answering machines. I am alone on Christmas Eve, but I'll improvise calls to my kids, my ex-wife, my mother and brother. . . .

JM: What response are you expecting from your audience?

JL: I want them to leave thinking about who, how, and why they celebrate. The meanings are different for everyone, and yet popular culture asks that we celebrate in a certain way; it's commercialized and defined for us. Like you asked about the Christian thing, well, it is a Christian celebration, maybe that's why it doesn't work for so many people, or for me. Maybe that's why the Fourth of July doesn't work for me either . . . a lot of the "traditional" celebrations. I think the concepts are fine, but it's what we do to them. The meaning has been lost or disconnected from the celebration. Like our heroes . . . the only thing that I would have in common with our image of Jesus today, is that he is spiritual. We are stuck in this fixed representation of him, not as a man from the Middle East, but as a Caucasian. We've bought that. . . . But what does that have to do with me? If I really thought about what my God would look like, do you really think it would look like this image we've constructed? If I wanted my God to be human, it would look like an Indian. We've all bought the image, and we maintain it with each celebration.

JM: Do you believe that the meaning has disappeared because we emphasize one set of representations? Do you think that we perpetuate these fixed images?

JL: Yes. This issue also applies to the image of an altar. I deliberately made this altar loose and open, because I believe that anything, anything, can be an altar. This is an altar for me and that's what counts. I want people to look at what we are celebrating, to focus on that. Does the altar then have to be gilded in gold leaf? Does it have to be monumental? Or pay homage to some great person or event? Does it have to connect to something supernatural? Or something happy? Or can it mark a time of reflection? Maybe those things you reflect upon are not happy at all, but then life is not very happy. . . .

[Performance] seemed to me a perfect medium, because it didn't have any real definition—every concept could be art. I found that I could express some inner thoughts that I hadn't been able to express in painting. I was able to act out some things that I had been thinking since my involvement in Indian politics, and they were accepted. I incorporated some of my writing, written during my time away from college, and objects that related to the work. I am not sure where that came from, but I do know that pictures and words were never enough. I wanted people to be able to associate with it; I wanted to create something more tangible. So, I used beer bottles, shovels, ashes from a fire, baby shoes. . . . I liked transforming everyday objects into Indian objects. For a time, I was consumed with this idea that you could be an Indian anywhere, and you had the power to make things Indian. I saw this all the time in the city where people would take gymnasiums and change them into powwow arenas, where Indians would get together and the whole room would disappear and it would be you and these other Indians there.

JM: Is this how you developed your idea of an installation, of transforming a gallery space into something else?

JL: Yes, I actually heard the word installation for the first time when this guy commented on a show that I had done for this Indian gallery. He said, "Wow! Great installation!" and he asked me to recreate it for another gallery in San Francisco. So, I took that idea and worked

with it. I started to create panels and burn sage in the center so it became an environment. I like the possibilities that this format offered.

When I started in performance, I also found some resistance. I had my first encounter with people not accepting my work. They couldn't contend with it because it was cultural and ethnic. It really made people edgy because I was talking about my culture as my base for the work, whereas other artists were only interested in using theory as a base for their work. I was turned off by art that seemed to fluctuate in movements. I didn't want to be something that I wasn't or have to compromise the political content for the sake of being successful. Some people were actually very cautious in criticizing my work, because they were afraid of criticizing the culture. Some people thought I was exploiting my culture. I thought that was stupid; I am an Indian, what culture am I supposed to use?

JM: James, you've received similar reactions from the Native-American community, who fear you're promoting negative stereotypes to the public. What is your response?

JL: Well, you don't want to air your dirty laundry, but . . . how can we solve anything unless we talk about it? This is a very sensitive issue and a cultural one, for we are very closed about a lot of stuff. I grew up in a family like a lot of other dysfunctional families where you don't talk, you just let it happen and it will either work out or it [won't]. You're supposed to ignore the problems. But something in me wanted to go beyond this denial. Somewhere I learned to push people's buttons, maybe as a defense mechanism, but I use it in my work and try to make people feel uncomfortable. Some people only talk about the romanticized or glamorous Indians, but I want to look at the problems we're facing. I don't think I criticize other people in my work, I use myself as the object, sometimes as the object of humiliation, but really it goes beyond, it involves the audience.

JM: You do reveal a lot of yourself, both physically and emotionally. Is it difficult to expose so much of yourself to an anonymous audience?

JL: Yes and no. I am more nervous when my colleagues and members of my community are in the audience, but I tend to detach myself. I understand, though, that there is power in doing this. Part of the whole process of recovery is talking about the problems. When I started to think about touching on sensitive subject matter, like stereotypes or alcoholism, I thought I might be putting the last nails in the coffin. The reactions of my audience have proved something different.

I try to make my work accessible. I have had people come up to me after performances and confide in me that they were alcoholic, or that someone in their family was an alcoholic. These aren't just Indian situations, these are situations for all people. It is very emotional. Some people are very angry at me for making them feel certain painful emotions. Some resent me for taking advantage of their emotions. I didn't set out to torture them, but I could see their agony in watching my first "Drinking Piece." They sat through this painful transition, watching an Indian drink—it's something that you read about, but here you're actually seeing it, seeing him in agony.

I realized that I could control this situation. I discovered that this was one of "the unknown powers" of being an Indian. By virtue of being an Indian, people are put into some sort of emotional state. Normally it is some sort of guilt state, or some sort of remorseful . . . void. It is strange. When people hear that you are an Indian, they want to know about you, they want to know about Indians. They have all of these preconceived ideas. . . . So, this is another thing that I have recognized. I use it as a hook to get to people while I have their attention.

JM: It sounds to me as though you are assuming that your audience is predominantly white. Is this true?

JL: I want my work to be accessible to all different people. I want other Indians in the audience. When I do a work, I like to think that Indian people are going to "get it," that they will understand it. That is not to say that they all will like it, but that they'll get it, because there is a certain kind of logic that Indian people have amongst themselves about how they perceive things. This is a cultural thing and I don't think I can explain it.

I want my work to be a community thing. I think it should be accessible to poor people, people that aren't well read, or well educated. I want to get to all these people. That's my audience and that's what keeps me rooted—keeps me from getting too arty, too elaborate, too big headed. It keeps me accessible. I just turned down a show in Europe, because there would be no Indians present to see my work. So, there was no interest there for me. It is not on my agenda, maybe someday, but not now. On the other hand, I was contemplating doing a piece in Santa Fe. I thought about turning it down because I didn't want to shame Indian people there, because it was about the commercialization of the culture and so many Indians commercialize themselves. I decided to do it; I couldn't compromise. This is a statement about some real things that are happening. There will always be things that we need to face, even though they will not make people happy.

JM: Where did you develop this confrontational style?

JL: Well, counseling is my profession, it's what keeps me stable. Art is secondary, but it helps me to take risks . . . my life doesn't depend on my art work monetarily, my soul depends on it. I would survive without it, but I might not be as happy . . .

I try to reach people, and you can touch more people in one performance than you can touch in a lifetime of sitting across a table from someone. My job as counselor in a community college working with Indian people helps me maintain a tie to the community. The counseling adds to my art work. I use statements about people, feelings, some things in the past; they aren't pretty, but it all has to do with my life right now. And that is very important, because forward is where a lot of Indian art work wasn't going. I consider myself an Indian artist, but I wasn't doing the typical kind of Indian art that everyone sees out there. I also feel like a crusader because I feel that this is the kind of work that should be going on. Not necessarily my work, but there is an arena that other people, other artists, could make use of, rather than perpetuating stereotypical views of Indians or creating Indian art like that marketable stuff. There is the opportunity for a very strong political statement.

JM: Are there other Indian artists who agree with you?

JL: Yes, I come into contact with people who feel the same way, and so I like to think of myself as being part of a larger community. We call ourselves the "contemporary contemporary Indian artists," because we're trying to move beyond that commercial group.

JM: James, I have also heard you described as a "shamanistic figure." What do you think of this label?

JL: It is an ugly word and an inappropriate label. The word is really abused. "Shaman" conjures up so many negative things for me as far as I know about Indian people and Indian ways. The way they use this label has nothing to do with me. The popular meaning of shamanism sort of scratches the surface. The word is not even in the vocabulary of our tribe. The whole idea of a medicine man is alien to our people. We had spiritual leaders and healers, but we never had a medicine man. Shamanism also conjures up all these falsehoods and beliefs about this metaphysical stuff. You can never be a medicine man unless

you speak the language, there are people born into it. It is not something you seek, but something that seeks you.

The ceremonial part in my work comes from what I have perceived during Indian ceremonies, like patience. There is a lot of physical and mental patience required during a ceremony. You spend a lot of time standing, sitting, singing, dancing, cutting, sweating, and enduring pain. It is a hard physical experience. There isn't a lot of talking, but there is a lot of communication. My pieces aren't complete without the audience. I want the audience and myself to experience all of these elements during my work.

JM: What about the communication? The giving or sharing?

JL: In a ceremony, you give of yourself. You have to give before you can take. Whether it is giving of your endurance, or of yourself so that you become not a self but an entity. There is no room for personality there. You are there as a participant, not as a leader. As soon as people start jockeying for positions, they should leave.

I used to pray in public, but I took that out. I bless the room before and after my performance, to keep me rooted. This part I no longer let people see, but I think that it is part of the work that they feel. I felt, however, that it became a "show" for people, and that was not what I was doing it for. So now I go to the back room and do it alone.

WILLIAM POPE.L One Thing After Another (2001–8)

Robert Ryman is a great white painter. Unlike most great men, Ryman conquers not by penetration into a thing (for example, like the great white hunter exploring darkest Africa), no, Ryman achieves authenticity by repeating a thing; one white thing after another . . .

This strategy seems innocuous and without teeth but its seeming is an essential part of its attractiveness and power. Historically, the repetition of whiteness, the insistence that one white thing deserves another, has insured Ryman's work its place in the Western myth-making machine. Interestingly enough, Ryman himself has seldom, if ever as far as I can tell, connected his painting practice with the will to power of race ideology. I find this funny and tragic; humorous because it is such an obvious omission and tragic because it is such an obvious omission.

Indeed it is Ryman's conflation of insistence, ignorance, silence, and dumb beauty which draws me to his work. Like any father figure, Ryman is a place-holder against which I measure myself and always come up wanting. Wanting what? A place in the Dumb. Why? Partly because in Black Arts, since time immemorial, black folk when they have attempted to make art always had to take into account their blackness. This was a gift that was also a burden; a gift because it celebrated the struggle of black folk while calling into question the supremacy of whiteness, a burden because to the powers that be celebration and questioning prevented black artists from participation in REAL art. Real art always knows what it is even when it's challenging or questioning something, especially itself. So it's not because Ryman can throw so much white paint around (and for such a long time) that draws me to his density, but that he can do it so blithely. And it's not a formal or technical issue, i.e. how he builds his works or applies his paint; he is very comfortable with the mechanics of painting, or I should say he finds great pleasure in reducing painting to a set of problems about nothing. It's comic; a kind

* William Pope.L, "One Thing After Another" (2001–8), previously unpublished. By permission of the author.

of urban-zen-racial-autism. He is the best American painter, bar none, at problematizing the formal issue of connecting painting to a painted world. I'm not sure if Ryman believes there's a world beyond painting because in his world everything is coated. Like a pill. Or the handle of a tool from the hardware store. Coated with a liquid, hardened and dried into fact. Pure fact. White fact. A geometry of omissions. Maybe I'm jealous. Black is too porous. Too marked up and speckled by a world of fact. Some people are and some people just—be. When you are, you can disavow your be. Indeed, it is the expression of absenteeism I detect in Ryman's practice that gets to me; how it disconnects from things in the unpainted world. It is as if the world doesn't matter. Ryman is either a saint or a demi-god or an idiot savant. As a citizen of the world, he has taken a position that disturbingly parallels how we Americans behave globally. For example, Afghanistan and Iraq are just two white squares glowing brightly in the Middle East of a great dark monochrome. More ironically, more personally yet equally telling, Ryman is the father who is never home. He's a good provider (he's a great painter), but he has no time for anything that intrudes or distracts from his distance. He's too busy being great. I think the cold, bone attraction of Ryman, for me, is not that there is nothing in a Ryman painting, or that Ryman himself is not in his painting, it's that he needs so much to make a case for the validity of his absence, and with a lack that strong (this long), it's got to be attractive.

RON ATHEY *Deliverance:* Introduction (1997)

Nothing is pure. Everything becomes either self-destructive, the moment of redemption, or a God-awful parody, depending on which day of the week it occurs. In this humdrum, bleak state of mind, I find myself writing a piece called *Deliverance.* By description, deliverance is the fulfillment of epiphany, it's the day spoken of by prophets, the day of freedom from suffering for that sorry ass son of a bitch, Job. Or an eagerly awaited day, like the Second Coming. There's also the movie *Deliverance,* where, while snaggle-toothed hillbillies rape a straight man (Ned Beatty), they tell him to 'squeal like a pig.' He is 'saved,' or at least vindicated, by either Burt Reynolds or Jon Voight, but that's beside the point. The point is that the violation of the asshole itself—sodomy—is (understandably) the root of so many fears.

In *Deliverance,* the Ron Athey & Co. piece, this fear is engineered throughout, the asshole produces hidden treasures, is receiving and expelling enemas, and for the finale is taken on a double-headed dildo ride with a friend while reading a story. With a predictable literal-mindedness, a man asked me during a post-performance discussion if indeed, since these performances were taken from my own life, did I read books while being anally penetrated.

In my performance material, I am guilty of enhancing my history, situation and surroundings into a perfectly depicted apocalypse, or at least a more visual atrocity. Knowing a few ever-simple realities of life, I probably do this out of disappointment for there not really being hellfire and brimstone, for my Aunt Vena not really bearing the second coming of Christ, as was prophesied. It's a stretch to call the delusions of fanatical religion, glamorous. Not to say that living my adult life through a time of AIDS has been disappointing as far as a drama goes; it's taken very little work for me to parallel my experiences with the jewelled doomsday prophecies from the Book of Revelations.

As an adult homosexual, I've started to come out of my self-obsessed daze, and realize how

* Ron Athey, "*Deliverance:* Introduction," in Joshua Oppenheimer and Helena Reckitt, *Acting on AIDS: Sex, Drugs & Politics* (London: Serpent's Tail, 1997), 430–33. By permission of the author and Profile Books Ltd.

many aspects of my lifestyle I take for granted. I've always more or less ignored society's contempt towards us homosexuals, and still don't think of people as being my straight friends, or my gay friends. I read Derek Jarman's *At Your Own Risk: A Saint's Testament,* which I quite enjoyed, but there were certain points in the book—particularly his history of British queer rights—where I thought, 'Why is he spending so much time going over legislation? This book could be an advertisement for OutRage!' But *A Saint's Testament* was equally filled with profound one-liners like, 'I was writing in the dark, angrily.' There's no political agenda in facing the dark. I always find comfort that others are also left with nothing to do but fight their way through the dark places.

Like myself, writing inventories of my life, early on trying to keep a grip on my visions even though the nightmarish realities of drug addiction and violent suicidal depressions almost finished me off. In my thirties, it became nights of debauched sexual conquests and self-loathing. I had hoped it was all just teen angst that carried into my twenties, but as middle age sets in my bones, I'm still struggling with demons. I am becoming more gentrified, finding comforting niches for myself. If this is a consolation prize for the American Dream, somebody kill me. Though I swore I never would, for the past few years I've taken to calling myself an Artiste.

It's only out of justification, I'm apologizing for myself to the world, 'What I am doing is important and purposeful because it is art. Though it may offend you, please be patient with the experimental rough edges of my work.' I suppose it was more work trying to defy labels, and much easier to take on such an ambiguous title. People want an answer they know, even if it doesn't mean a thing to them. To some extent, I only pretended to let the system suck me in. Saying 'fuck you' to everything began to sound trite, and I didn't want to be the eternal, rebellious, punk-ass motherfucker.

As far as state-of-the-art, raging fuck you's are concerned, David Wojnarowicz did it with finesse, clarity, and conviction. He had a righteous anger, really, the only kind that works. His writings cut through me, rile me up, make me feel pathetic, and lonely. In comparison, I hate my writing. Wishy-washy and hypocritical, I avoid moralizing. Because in the big picture, I don't know what's right or wrong, I don't think that way. I can be annoyingly and dishonestly existential about all of life's injustices. I've always tried to write my way into discovering and dealing with the truth. Contrary to my bold images, I think it's telling how tolerant and well-mannered I behave in most situations.

Sometimes I question the meaning of my performance work, I'm still not exactly sure what the reasons are to keep doing it. And though their reasons would vary, I'm not sure my cast of nine could tell you either. Why the fucking bloodbath? The shit? The vomit? All performed on a well-lit stage so that, hopefully, no details will be missed. To take a stab at it, using these bodily functions, assisted by the voice, words, and sound, I'm testifying. I'm wanting people to endure these real experiences, and grasp the ideas behind them. I'm sure it's because I'm damaged, but I want it to be heard: that I was raised in the realm of God, channelled spirits in an un–Christian-like manner, and walked away daring to be the world's only atheist. In my destruction, I barely survived drug addiction, then recovered and became innocent, like an injured child.

That I think I'm somebody because I was into punk and Goth and industrial music. And once without my Bible, I read Genet and Smith and Gide and Sartre and Camus and Burroughs. And Tennessee Williams, Truman Capote and Flannery O'Connor. And later, Wojnarowicz and Cooper and Jarman. That I adored Pasolini, Fellini and Fassbinder. I was trying to find something worthy to believe in, or at least to educate myself into an acceptable reality. I could see up front it was not going to be pretty, but it was already laid out for me. It finally

came down to finding living people I could relate to, and new obsessions. Body piercings became my kink. Tattoos saved my life. Modern Primitives became a new religion, which quickly turned into a clown show.

REGINA JOSÉ GALINDO I am a common place (1999)

I am a common place,
like the echo of the voices
the face of the moon.
I have two tits
 —tiny—
an oblong nose
the stature of the town.
Nearsighted
of vulgar tongue
droopy buttocks
skin of an orange.
I situate myself in front of the mirror
and I masturbate.
I am woman
the most common
 among the common.

First it was writing (2008)

First it was writing, then I found my body.

I begin to develop my work within the visual arts during the last years of the nineties.

In actuality, I work with the intention of creating images or actions that reflect certain aspects of reality of my near context and a bit of what I am able to see beyond it. With each project, I desire to generate a dialogue, to question and have the other question. To enrich my own experience as much as the experience of the observer. I am interested in investigating power relations in all its manifestations so to subvert it, and for that I resort to observation and representation through a simple discourse, but an incisive one.

Argument (2008)

My body not as an individual body but as a social body, a collective body, a global body. To be or to reflect through me the experience of the other; because we are all ourselves and at the same time we are others.

A body that makes and makes itself, that resists and resists itself; creating projects that reflect reality while also intending to modify it.

 * Regina José Galindo, "Soy lugar común" (I am a common place), in Regina José Galindo, *Personal e Intransmisible* (Guatemala City: Scripta Coloquia, 1999), 6. Translation by Kency Cornejo. By permission of the author.
 ** Regina José Galindo, "Primero fue la escritura" (First it was writing), lecture at Centro Cultural de España, Buenos Aires, Argentina, 2008. Translation by Kency Cornejo. By permission of the author.
 *** Regina José Galindo, Pensamiento, 2008. Translation by Kency Cornejo. By permission of the author.

Each piece, each action, are quotidian scenes of day to day, or they could be. In each one of these scenes, power relations are always present, and this is what I find most interesting, to work with power, so to subvert it, and like this create a parallel reality where power loses its strength.

Multiply (2008)

Multiply only to multiply your own tragedy
or to be born only to immediately die.

Make of your hands your own murderers
or give us reasons to kill you.

It is no one's fault
what happens in the world.

Hunger is yours and
the land ours.

We continue to be the same as always
and you are each time more.

White Sheet (2008)

Three rainbows emerge together over the warm waters of the wells in Cobán. Torrential rains bury 29 bodies of *pepenadores* (garbage people) in the Municipal Waste-yard. In the Tower of Tribunals, a woman recognizes her baby that was snatched from her 18 months ago. A fortuneteller sees the North in her client's future. The legs of a women cut into eight pieces are abandoned in front of a house in Zone 3. A dead candidate wins the elections. Calaka tattoos his eyes. Pelon and Satan are released due to a lack of evidence even though they have confessed to decapitating the girl. The President says the death penalty is inhumane. A man throws himself into the tigers' cage but only after stabbing himself in the arm. A hole of seventy-five meters in depth appears in the neighborhood of San Antonio. The lake of Atitlán competes to be named one of the new Seven Wonders of the World. Ten chauffeurs are assassinated on the same day, at the same time, in different points. A rain of ashes falls over the capital because of the volcanic eruption. Sympathizing politicians spit in the Nobel Peace Prize winner's face.

In Guatemala we are surrounded by images of all types, the things that in other places are only talked about as happening, in Guatemala they really happen; in front of our house, on the pavement outside the office; in the neighborhoods where our cousins live; in the buses; in the churches, at school doors; in the soccer fields; in the banks of shopping centers; at the red street lights. The little sheet of cloth in the middle of the street is part of the collective memory, because "all of us" have seen more than once the famous little sheet, first in person and then as the image is multiplied into thousands by all the newspapers and television channels.

* Regina José Galindo, "Multiplíquense" (Multiply), introduction to a lecture at ArtPace, San Antonio, Texas, 2008. Translation by Kency Cornejo. By permission of the author.
** Regina José Galindo, "Sábana blanca" (White Sheet), presentation at El Centro Cultural de España, Córdoba, Argentina, 2008. Translation by Kency Cornejo. By permission of the author.

The little sheet covering death is the image that receives the most coverage, ironies of life or a Machiavellian way of maintaining the population in order. Somebody has already said, there is no better weapon than fear as a mechanism of social control.

And it is these mechanisms of control that most interest me. Mechanisms that are repeated in one place and another. Whether that be Guatemala, Argentina, Palma de Mallorca, The United States . . . in all places they are reproduced with different images, with different actors but with the same objective . . . to maintain us all in order, under control.

Because of that, perhaps, I work on finding all types of dark episodes, where power relations are most evident, so that I can attempt to subvert it. I work with the real, I investigate it so that I can later represent it under my own perspective and then under an obsessive cleaning exercise and a minimal utilization of elements. My intention is to create images or actions that are incisive but simple, that they enrich so much my experience, as the experience of those who see the artwork in person, or, its documentation.

ZHANG HUAN Interview with Michele Robecchi (2005)

MICHELE ROBECCHI: Let's start from the beginning. What do you remember about An Yang, where you were born?

ZHANG HUAN: After I was born, I moved to the country with my paternal grandmother and my three brothers and lived there for about eight years. It was an important experience as it allowed me to grow up with nature and develop a direct relationship with it, with no inhibitions. I only went back to An Yang later. . . . My village is very far from the coast. Transportation is slow and the inhabitants have an old economy mindset. They continue to live in fairly unpleasant conditions. Perhaps you've heard of China's "AIDS villages." I think it all began in Henan. I don't know whether you can imagine what it is to live in a place where people are obliged to sell their own blood to cover such basic necessities as the purchase of food or clothing. Well, that's what happened there and what, in fact, is still happening. . . . In many families only one or two members remain alive. Many children are orphans because that terrible disease, AIDS, has killed their parents. . . .

My first years of life were important, because they let me live in nature freely, almost primitively. That sense of freedom and familiarity with nature has never left me. It's inside me. . . .

The first years spent in the city were pretty dramatic. I was very undisciplined, especially at school and a terrible student. I couldn't concentrate; they were always throwing me out. I couldn't stay shut up in a room, I wanted to be free. So I spent most of my time alone drawing. In a certain way that's how it began. . . . I studied traditional art at university, but I didn't like it much. . . .

In China, art lessons were mainly to teach students how to copy something that already existed. It was very impersonal. Even later, when I moved to Beijing, I kept on feeling foreign to these expressive forms; I saw them as something really far from me. So I began to look around and collect things I found in the street: rubbish, pieces of furniture, broken water heaters, things like that. Things that were less valid from an aesthetic point of view, but much more real.

The turning point came in 1992 when I found the leg of a mannequin. I took it back

* Michele Robecchi, excerpts from "Zhang Huan Speaks with Michele Robecchi, Milan, 8th June 2005," in *Conversations with Photographers* (Madrid: La Fábrica Galería, 2006). By permission of the author and the artist.

to my studio and started experimenting, sticking my leg in it or tying it to myself. I feel that was an important moment as it let me create a direct link between my body and art. I realised I could use my body as a work instrument. Before that, I didn't think it was possible. I can say that all my relationship with performance and all the work coming from there can be traced back to that episode. . . .

MR: I heard . . . you got trapped in one of your objects and shouted until someone heard you and came to let you out. I imagine that story . . . helped you get a different perspective of your body and your possibilities.

ZH: That is an episode that helps us understand life and living perfectly. It happened that I was at a friend's preparing the work *To Add One Meter to an Anonymous Mountain* (1995). I wanted to raise a mountain by one meter. The original idea was to do it with an iron box about eighty centimeters high. I wanted to try climbing up the mountain and then get into this box and stay there for twenty-four hours, like a Buddhist monk. Sadly, the day before while I was practicing, I got stuck inside the box. I was at a friend's house and they just left and weren't going to be back for two months. My arms were free, but I couldn't open it and after a few minutes I panicked and started to shout. Luckily, one of the windows was open, so a cleaner heard me and came to free me. As soon as I was free, I ran outside as I had to breathe and the contact with air made me fully realise what it means to be alive.

It was a really strong sensation, hard to describe. When I was trapped in the box, I was terrified. I kept on telling myself to stay calm, but I couldn't. Suddenly, being free made me realise how important life is. That whatever difficulties you may experience, like having no money or food, mean nothing compared to the privilege of being alive. I saw death really close up. . . .

Exploring the limits of my body and of nature for me was a need I really had to express. I could no long hold it and think about other things. I was becoming obsessed. . . . I wanted to measure myself against insurmountable limits even though I didn't have the energy needed to do so. I wanted to raise a mountain or move a building. That's how works like *To Add One Meter to an Anonymous Mountain* (1995) and *To Raise the Water Level in a Fishpond* (1997) were born. Even though they were impossible events, my inner strength didn't exhaust itself because of these limits. It settled inside my heart and my body, pushing me in the opposite direction, making me come out of myself and explore the limits of my body. In China there's this ancient story about Yukong who moved the mountain. It was about an old man who every time he wanted to go somewhere had to go round a mountain, so one day he decided to move it, piece by piece. It's an idea I've still got inside me and that I haven't given up on. Do what's impossible, conquer the unconquerable. . . .

MR: When did you feel the need to leave China and measure yourself in a more international context?

ZH: The first time I left China was in the year 1996. First I went to Munich and then to France. . . . The first time I went to Japan was to create *3006 Cubic Meters: 65 Kg* (1997). It was a performance I did at the Watari Museum. It consisted in tying ropes to different parts of the building to then try and knock it down by pulling with my body. Naturally, it was impossible. The more I pulled, the more I got the impression that it was the museum destroying me. It was another useful moment for understanding a body's impotence and limits in front of something bigger. The work's meaning was linked to the gesture of resisting not to the result, which was logically pretty obvious. The title of the work refers to the size of the museum and my weight. . . .

MR: How do you see the relationship between your work and photography? Is it an independent expressive style conceived with its own formal features or just a means useful to you to document your performances?

ZH: It can work both ways. It can be an instrument dedicated exclusively to documenting or recording my performances or an independent expressive style. . . . I am the only person who can completely understand my work. I don't say that the public can't catch its essence, but if we talk about total understanding of what I'm trying to do, seeing a reproduction of one of my performances or seeing it live makes little difference. I'm the only one who can really understand what my work means. . . .

MR: Another frequent question linked to performances and to Body Art in particular, is how aging, or if you prefer a body's maturing, becomes a central element in the work implicitly modifying the substance. Do you see or have you already noted an evolution in your work linked to your natural physical changes?

ZH: Yes, something surely changes. But I feel it is something happening all the time, not just when you get old. Even now. Recently, I have noticed that I'm getting a slight paunch. (Laughter.) There are other changes that reflect on the body and on your way of thinking. . . . Every time I look at myself in the mirror I see a change and this obviously frightens me a bit too. What's important is preserving the mind. I hope I can manage to reason lucidly till I'm ninety-nine. It's obvious that it would be fantastic if my body could stay in perfect shape till then too, but body and mind change together, and with them life. When you are sixty or seventy you probably have children, grandchildren and even their simple presence contributes to changing the state of things. It doesn't just depend on you. I might not want to do any more performances; I won't want my grandchildren to see me in action or to see my body. You know, when you get older your hormones diminish but you get wiser. You always have to consider both these aspects. . . .

MR: You were saying you've become a Buddhist?

ZH: Yes. I wasn't born a Buddhist although Buddhism is fairly common where I grew up. I became one. Despite the Cultural Revolution, in many parts of China and especially in the country, religious rites are still celebrated fairly regularly in homes. They were only forbidden in public places. Anyway, I've only recently become a Buddhist. Now I listen to Tibetan music more and more often. I have a quieter view of things. . . . In Buddhism you can spend days just contemplating a mountain, maybe even years, without concentrating on anything else. If you think about it, this concept has a lot of similarities, especially with my first works.

MR: When you weren't a Buddhist.

ZH: Exactly. I have often thought about the reason and I have reached the conclusion that it is probably because with Buddhism you have to forget the real world to cross a certain threshold. And when I'm doing a performance, I often trigger off a similar mechanism, forgetting the real world, withdrawing completely. A performance like *12 Square Meters* (1994) tends to absorb me totally. At that moment, while I was sitting in the public toilet surrounded by flies, I couldn't think of anything else, just about what I was living. . . .

Even art, like Buddhism, is part of my spirit. I think about it all the time, even at the most normal moments, like when I go into town to do something, I can't help thinking about my work. It's easy for me to go back home with some new ideas. I was born for art. . . . I'd say it was more a philosophy of life. I can't do anything else.

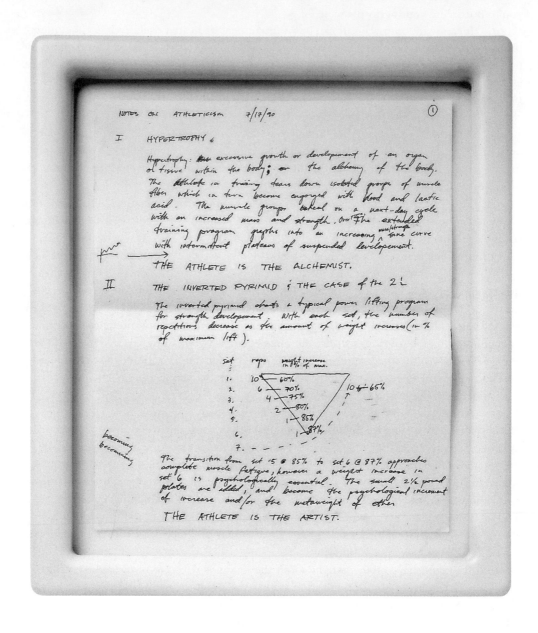

* Matthew Barney, details from *Notes on Hypertrophy,* 1990, three panels: ink on paper in self-lubricating plastic frames. © Matthew Barney. Courtesy Gladstone Gallery, New York.

III HOUDINI AND BODY INTELLIGENCE

Houdini thoroughly researches the lock — the police
forces of Europe commission locksmiths to constrain Houdini
— Houdini has pre-invented any locking mechanism they
can produce to incarcerate him.

The exploitation of discipline (±) ~~&~~ trained ~~contortionist~~, a
willed disfigurement, a customized physicality —→ A
BODY INTELLIGENCE.

~~THE ENTRY~~
e.g. 2. ⌈ A wrestler in the down position sees, peripherally,
 │ the momentary fragment of the opponent's elbow
 │ extending down to the hand, reaching over the
ABSTRACTION │ wrestler's right upper back, simultaneously feeling
OF │
TIME │ the opponent's knees in contact with his own
2 + 3 │ (left leg. A split second shift (upward) in
seconds │ the opponent's center of gravity, triggers response:
from │ sucks in the given ~~the~~ arm (farhanded) —
3 2 minute │ lifts the hips (tripods with the forehead) —
periods │ drives the elbow back under and over the opponent's
 │ waist — collapse the right knee to roll right
 │ — steps over the vacillating body with the
 │ right leg (still cinching the opponent's right arm
 │ who is now bound, back to mat —
 └ THE HEAD IS THE LEVER.

 THE ARTIST IS THE ATHLETE.

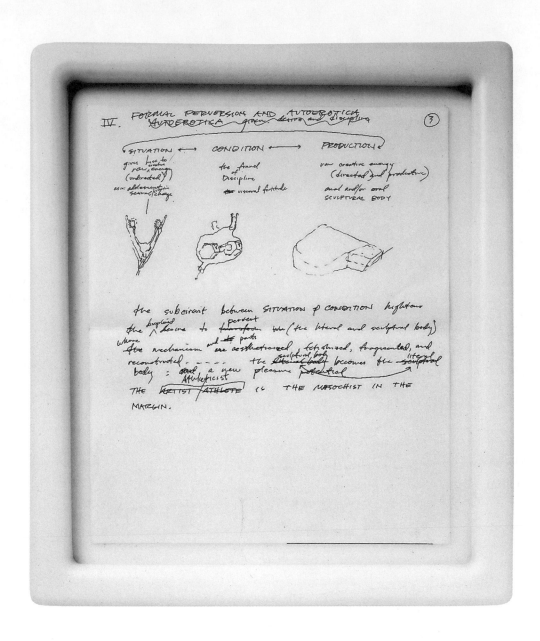

OLEG KULIK Why Have I Bitten a Man? (2000)

I am distressed that an absolute clearness of my performance "Dog House" (within the borders of *Interpol*) hasn't saved it from a wrong interpretation.

Why have I stood on all fours? Why have I become a dog?

My standing on hands and knees is a conscious falling-out of a human horizon, connected with a feeling of the end of anthropocentrism, with a crisis of not just contemporary art but contemporary culture on the whole. I feel its oversaturation of semiosis as my own tragedy, its too-refined cultural language that results in misunderstanding, estrangement, and people's mutual irritation.

I thought that in Russia one could feel these processes as nowhere else. I thought that we were Different, and the cause was inside us, in eternal ambitions of cultural superpower in the situation of insolvent actual cultural events. In Moscow I became a dog, I growled there and demonstrated a dog's devotion to an artist's ambitions. I was not going to export an artist's experience without a language outside the Muscovite context. But while getting to know the Western context, I found out that my program is applicable there as well. Art as an addition to a supermarket seems an impasse to me.

For me, human stopped being associated with the notions "alive," "feeling," and "understanding" and started to be associated with the notions "artificial" and "dangerous." I began to look for some basis outside human. But overhuman for me is our bestial nature, which doesn't need any explanation from the outside.

I was invited to Stockholm by the curator of the exhibition, Jan Åman, and the artist Ernst Billgren, who proclaimed that within that project built upon communication, he preferred a dialogue with animals to a dialogue with people. I was invited as a dog, as a *readymade*. I was surprised how quickly they'd reacted to my "zoofrenic" image.

I came to Stockholm and was open to any variant and form of collaboration. To my surprise Ernst Billgren's ready work was waiting for me: he was not prepared for any kind of collaboration. So I was made to become something different from what I could have become in a dialogue. I became a "reservoir dog." Indifference, frenzy, and falsification were in the atmosphere of Färgfabriken—the initiator of the project on communication between East and West. This is what I have experienced together with my Muscovite friends, participants of *Interpol*. A work of art stopped becoming an act of communication, and only enforced alienation and misunderstanding between people. This is an endless loop.

In the exposition, nothing was left of the primary idea—neither of its sense (the idea of communication ended in rhetoric, to the practical desire of using different foundations of the support of contacts with Eastern Europe) nor of its practical idea (we witnessed how the organizers had miscarried the Moscow projects). Being in the first place an artist and only then a person on all fours, "a dog," it was unbearable to take part in a farce.

But that is not the case. For me art remains a zone of not-falsified, real values and notions. I can't reject this position. To keep my own authenticity I am ready to become a dog or a bird, an insect or a microbe.

* Oleg Kulik, "Why Have I Bitten a Man? An Open Letter from Oleg Kulik," in Edna Cufer and Viktor Misiano, eds., *Interpol: The Art Show Which Divided East and West* (Ljubljana and Moscow: Irwin and Moscow Art Magazine, 2000); reprinted in Laura Hoptman and Tomáš Pospiszyl, eds., *Primary Documents: A Sourcebook for Eastern and Central European Art Since the 1950s* (New York and Cambridge, MA: Museum of Modern Art and MIT Press, 2002), 349–51. Translation by Neil Davenport. By permission of the author and Moscow Art Magazine.

In Stockholm I didn't bite just a person but the person who had ignored the sign "dangerous" beside my dog house. By my action I proclaimed one idea: keep away from communication, think about your own and the world's future. This turned out to be impossible.

Obviously I am ready to apologize to those who became victims of my action: I've done it personally in Stockholm and now I am ready to confirm it in writing.

I hope I wasn't too pathetic for a dog.

9 LANGUAGE AND CONCEPTS

Kristine Stiles

In 1917 Marcel Duchamp (b. France, 1887–1968) defined an artist as someone able to rethink the world and remake meaning through language, rather than as a producer of handcrafted objects for "retinal" pleasure. Duchamp established this conceptual direction for art in his defense of his "readymade" *Fountain* (1917), an industrially produced urinal that he turned upside down and signed "R. Mutt." He argued that *Fountain* constituted a work of art because he "chose" the urinal, removed it from its ordinary context and relationship to plumbing, and gave it a new name. In these ways, he provided a "new thought" for the object, conceptually reconstituting aesthetic meaning through language. Duchamp's impact on the ideational direction of art became decisive in the late 1950s and early 1960s, when numerous publications on and exhibitions of his work began to emerge.[1]

Some thirty-five years after Duchamp's presentation of *Fountain,* Robert Rauschenberg asked Willem de Kooning for a drawing that he could erase. In the resulting work, *Erased de Kooning* (1953), Rauschenberg left only the material signifiers to establish its context as art: the work's title, Rauschenberg's signature, and the object's frame or physical support. In 1961 Rauschenberg again demonstrated how concepts determine the identity of aesthetic categories with his contribution to a portrait exhibition organized by Iris Clert, his art dealer in Paris: he sent her a telegram stating, "THIS IS A PORTRAIT OF IRIS CLERT IF I SAY SO." Two years later Edward Kienholz made *The Art Show* (1963), a work consisting of a text that described two hypothetical exhibitions, one in Los Angeles and the other in New York. His text demonstrated how mental images of "the art show" are linguistically constructed and how language shapes the meaning and reception of the artwork.

Two years earlier, in his essay "Concept Art" (1961), Henry Flynt (b. U.S., 1940) observed that as sound constitutes the material for music, so language may determine the meaning of art, combining his interests in Duchamp's conceptual approach to art and John Cage's approach to music.[2] The composer La Monte Young and the poet Jackson Mac Low published Flynt's essay in *An Anthology* (1963), a landmark publication that included experimental notational scores for musical compositions and performances, manifestos, poems, and other textual material by artists, composers, and poets. Flynt's

socialist ideas strongly influenced the political ideas that George Maciunas espoused for Fluxus, but as George Brecht rejected his militant leftist views, Flynt remained on the margins of the Fluxus group, producing his own idiosyncratic art and writing philosophical texts on a wide variety of subjects, from philosophy, mathematics, and musicology to politics. A legendary musician who played electric violin and other instruments, Flynt replaced John Cale in the Velvet Underground for a time.

Flynt's conceptual approach to art also interested Robert Morris, then working on his MA in art history. In 1962 Morris wrote to Flynt: "The problem has been for some time one of ideas. . . . But what I mean by 'new ideas' is not only what you might call 'Concept Art': but rather effecting changes in the structures of art forms more than any specific content or forms. . . . I think that today art is a form of art history."[3] As Morris's comment attests, artists had begun to examine language and to consider how it shapes epistemology, history, and the conditions of making, presentation, and reception.

Three years later Joseph Kosuth (b. U.S., 1945) produced *One and Three Chairs* (1965), which included a real chair, a photograph of the chair, and a thesaurus definition of a chair, demonstrating how all three forms constitute an image of a concept. Kosuth's unprecedented analysis of the languages of art challenged artists to question the tautological nature and function of the art condition. He attributed his early conceptual relationship to art, or "Art as Idea as Idea," to Ad Reinhardt's dictum "Art as art and nothing but art." Describing his projects as "analytic propositions" and "investigations," Kosuth examined the conceptual and representational shifts between the identity of words and the reality of things, which led to deeper considerations of the institutional, social, cultural, and political conditions of art. In 1969, with the publication of the first installment of his three-part essay "Art after Philosophy," Kosuth became recognized internationally as a leading theorist and practitioner of conceptual art. His writings articulated the epistemological project of conceptual art, positioning it within a discourse of social practices. In such essays as "The Artist as Anthropologist" (1975), "Within the Context: Modernism and Critical Practice" (1977), and "Art and Its Public" (1982), Kosuth anticipated interdisciplinary aspects of postmodern academic methodologies of the 1980s and 1990s. In 2001 Kosuth received the Laurea Honoris Causa, an honorary doctorate in philosophy and letters from the University of Bologna, and in 2003 the Decoration of Honor in Gold, Austria's highest honor for accomplishments in science and culture.

Kosuth belonged for a time to the British collective Art & Language, a group that established the theoretical conditions of conceptual art. Art & Language emerged from discussions in 1966 among the U.K. artists Terry Atkinson (b. 1939), Michael Baldwin (b. 1945), David Bainbridge (b. 1941), and Harold Hurrell (b. 1940). In May 1969, Art & Language brought out the first issue of *Art-Language: The Journal of Conceptual Art,* for which Kosuth initially served as the American editor. Ian Burn (b. Australia, 1939–93) and Mel Ramsden (b. U.K., 1944) fused their group, the Society for Theoretical Art and Analyses, with Art & Language; and Philip Pilkington and David Rushton subsumed their journal *Analytical Art* into *Art-Language.* In 1971 Charles Harrison (b. U.K., 1942–2009), editor of *Studio International* (1966–71) and one of the most influential art historians, critics, and teachers of his time, became general editor of *Art-Language.* Harrison described *Art-Language* as a textual format for "forms of critical address" that "frame

Modernist discourse," and as a "more intellectually adequate mode for discussion of the nature of 'objecthood.' "[4] Paradigmatic of the theoretical challenge conceptual art posed to the conventions of art and its histories, Art & Language sustained an ironical, sometimes arcane, critique of the ideological conditions of production, exhibition, reception, and criticism.

After breaking with Art & Language, in the summer and fall of 1974 Kosuth cofounded *The Fox* (1975–76), an artist-produced publication on conceptual art with a Marxist-Leninist, collectivist ethos. The journal was edited by Kosuth, Sarah Charlesworth, Mel Ramsden, Michael Corris, Preston Heller, and Andrew Menard, with Ian Burn as a consultant. Its stated purpose was "to establish some kind of community practice . . . [for] the revaluation of ideology."[5] Because of the militancy of its leftist approach, such artists as Hans Haacke, Vito Acconci (chap. 8), Dennis Oppenheim, Sol LeWitt, Donald Judd (chap. 2), Bernar Venet, Carolee Schneemann (chap. 8), and Robert Mapplethorpe refused to participate. Nevertheless, the journal's three issues had a long-term impact on the intellectual climate of art and its institutions.

The Fox attracted such artists as Zoran Popović (b. Yugoslavia, 1944), whose contributions to the publication were, he explained, "of direct use . . . for the self-evaluation of [the group's] own thinking and knowledge of the social and political role of art," as he had the sobering viewpoint of someone who "dropped in from a Communist system."[6] Popović was known for his conceptual *Axioms* (1971–73), which he had presented at the Student Cultural Center Gallery in Belgrade. Together with other artists, he brought out *October 75,* a publication containing his text "For Self-Management Art," which addressed the production of art under socialism and the role of the artist in the social distribution of labor. Popović continued to explore such questions in two films: *Untitled* (1975), produced in Belgrade, and *Struggle in New York* (1976), produced in New York and containing interviews with such artists as Burn, Charlesworth, Kosuth, Paul and Mel Ramsden, and Christine Kozlov.

Aspects of conceptual art began to be explored in exhibitions as early as 1967, with *Language to Be Looked At and/or Things to Be Read* the first of four exhibitions mounted at the Dwan Gallery in New York that featured language as a visual medium.[7] Robert Smithson wrote the press release for this show, comparing language to symbolic systems and observing that language, like art, is fictional, illusory, idiosyncratic, and vulnerable to the failures of logic.[8] This and other exhibitions launched conceptual art as an art movement, as did publication of "Paragraphs on Conceptual Art" (1967) and "Sentences on Conceptual Art" (1969) by Sol LeWitt (b. U.S., 1928–2007). Like Smithson, LeWitt responded to the aesthetic implications of minimalism, examining the differences between conceptual modes of information and the paradoxical changes, permutations, and disorder that occur when a priori intentions are converted into concrete images or objects, as in minimalism. In numerous series of geometric cubes based on mathematical permutations and in "wall drawings" executed by assistants working from his written instructions, LeWitt attended to the gaps between perception, description, and representation.

Because of the difficulty in categorizing artworks associated with conceptual art, the term never defined a precise artistic practice, but referred generally to art with ideational content that attended to the conceptual perception conveyed by an art object. The

initial result was that the term became a convenient category for exhibiting almost any form of art except traditional painting and sculpture. For example, many heterogeneous media appeared in the exhibition, organized by the Swiss art historian Harald Szeemann, *When Attitudes Become Form: Works-Concepts-Processes-Situations-Information* (1969), its catalogue instructing "live in your head."[9] In 1970 Kynaston McShine organized *Information* at the Museum of Modern Art in New York. That same year Jack Burnham, one of the most perceptive and visionary writers on art and technology in the 1960s and 1970s, mounted *Software* at the Jewish Museum in New York. Burnham's exhibition explored what he called "systems aesthetics," which he described as "the art impulse in an advanced technological society," in which the artist becomes a maker of aesthetic decisions rather than things.[10]

In 1968 Lucy Lippard and John Chandler argued that the ideational emphasis of some new art had resulted in the "dematerialization of art." They added that "works of art are like words" and function as "signs that convey ideas," that "a work of art is a medium rather than an end in itself," and that "the medium need not be the message."[11] Art & Language, however, rejected the idea of conceptual art as dematerialized, arguing that while the traditional "matter-state" of art had changed, conceptual works embodied "matter in one of its forms, either solid-state, gas-state, [or] liquid-state."[12] An example of their argument might be Robert Barry's *Inert Gas Series* (1969), which, although invisible, remained material, comprising the expansion of helium gas in space. Nonetheless, Lippard and Chandler's notion of the dematerialization of art functioned as a strategy for repositioning art in relation to politics during a period that witnessed the rise of the New Left, resistance to the rampant consumerism of the 1960s, and protests against the Vietnam War, evincing the role that Marxism played in shaping many conceptual artists' work.[13]

In *Six Years: The Dematerialization of the Art Object from 1966 to 1972* (1973), Lippard compiled an annotated record of international conceptual art, which remains a unique and valuable document of an array of original and ephemeral works produced during a vital period of artistic innovation. While conceptual art was initially successful in avoiding the general commercialization of art, intervening in conventional political situations, and establishing alternative practices, this situation did not last, as Lippard acknowledged in the postface to *Six Years*:

> It seemed in 1969 that no one, not even a public greedy for novelty, would actually pay money, or much of it, for a xerox sheet referring to an event past or never directly perceived, a group of photographs documenting an ephemeral situation or condition, a project for work never to be completed, words spoken but not recorded; it seemed that these artists would therefore be forcibly freed from the tyranny of a commodity status and market-orientation. Three years later, the major conceptualists are selling work for substantial sums here and in Europe.[14]

Mel Bochner (b. U.S., 1940), who wrote for *Arts* magazine in the 1970s, reviewed Lippard's *Six Years* in 1973 and raised critical issues at the core of conceptual art. Seven years earlier, in 1966, Bochner had organized an exhibition at the School of Visual Arts in New York to visualize the ideational processes underpinning the creation of discrete objects. Titling the exhibition *Working Drawings and Other Visible Things on Paper Not*

Necessarily Meant to Be Viewed as Art, Bochner placed four loose-leaf binders containing photocopies of drawings, sketches, notes, and other ephemera on pedestals, exhibiting this material as the show's content. Bochner had abandoned painting and begun to use black tape and inked numbers, letters, and arrows, which he applied directly to walls and floors in installations that made visible the dimensions of space and volume, direction, the relationship of parts to whole, and variables and constants. Interested in the logic of structural relations suggested in Fibonacci's mathematical progressions and in Leonhard Euler's work on mathematical paradox, in his subsequent series, *Counting and Measuring* (1966–98), Bochner followed his own axiom, "No thought exists without a sustaining support." The series ended in *Event Horizon* (1998), a work consisting of different-colored monochrome paintings hung side by side, with a continuous white line, broken by measurements, extending across the middle of the paintings over the entire 144-foot expanse. In 2001 Bochner began a series of paintings with handwritten sentences in graphite on a white ground, recapitulating his ideas from the late 1960s. By 2004 these paintings had become brightly colored monochromes with multicolored words carefully stenciled on the surface. Three years later he was painting words in a gestural style that, in an exhibition of 2009, reduced language to the word "blah," which appeared either in isolation or repeated on the dripped, expressionistic surface.

Dan Graham (b. U.S., 1942) identified the art magazine as an alternative framing device capable of collapsing the gallery into the space of criticism.[15] In his photo essay "Homes for America" (1966), he bridged fine-art production and mass-media reproduction, offering an illustrated commentary on vernacular American architecture in which he used a minimalist aesthetic to critique popular culture and commented on how visual codes, linguistic systems, and interlocking cultural conditions structure social relations and shape political formations.[16] Graham also worked in performance, and he questioned time and time differentials through mirroring effects and time delays in photography, video, and film. Since the 1980s, Graham has become known as much for his installations comprising glass-and-mirror pavilions that address the body, architecture, reflection, and attention as for his writings on music.[17]

Seth Siegelaub (b. U.S., 1941), an art dealer, curator, Marxist activist, and writer, recognized the potential of the artist's book as a conveyor of conceptual information, drawing on the example of Edward Ruscha's compendiums of photographs of ordinary buildings, objects, and phenomena in his books such as *Twentysix Gasoline Stations* (1963), *Various Small Fires* (1964), and *Nine Swimming Pools and a Broken Glass* (1968). Siegelaub was interested in how books might provide artists more direct control over the production and distribution of their work. This concern would also lead him to establish the Artist's Reserved Rights Transfer and Sale Agreement (1971). In 1968 Siegelaub organized the exhibition *Untitled (Xerox Book),* which consisted of a book printed in an edition of one thousand copies that simultaneously constituted the art objects, their exhibition, and the catalogue of the show. In the book exhibition *January 5–31, 1969,* he brought together work by four very different artists: Joseph Kosuth, Robert Barry, Douglas Huebler, and Lawrence Weiner.[18]

Robert Barry (b. U.S., 1936) has explored the visual and oral properties of language and its ability to convey information about invisible and intangible phenomena like energy, carrier waves, magnetic fields, radiation, telepathy, and intuition. Douglas

Huebler (b. U.S., 1924–97) at first used language and photographs in diagrammatic ways to document the complexity of contemporary spatiotemporal activity and experience, but then turned to figurative painting in the mid-1980s. Lawrence Weiner (b. U.S., 1940) is known for his book art and ephemeral text installations comprising simple words and sentences placed on the walls of exhibition spaces to visualize the interdependency of language and the context of location, placement, and reception of art. These works highlight the democratic potential of language, for, as Weiner has pointed out, "receivership" of his art constitutes ownership.

Victor Burgin (b. U.K., 1941), who emerged in the milieu of British conceptualism, has identified art as a frame for learning and sought to empower "dispassionate spectators" to become "interested readers and learners."[19] Grounding his practice in Marxism and the social and aesthetic theories of Walter Benjamin and the Frankfurt School for Social Research, Burgin, like the American artists Allan Sekula and Martha Rosler (chap. 5), drew attention to the role of photography in the construction of mass ideology.[20] By appropriating images from advertising, over which he superimposed texts that alter the original messages, Burgin deconstructed the visual and linguistic codes of the media and thus unmasked the cultural mystifications that reinforce gender, class, and race divisions. Burgin, who has taught generations of artists and art historians in both the United States and Europe, has published numerous books, including *Thinking Photography* (1982), *The Remembered Film* (2004), and *Situational Aesthetics* (2009).

Mary Kelly (b. U.S., 1941) came of age as an artist in London in a milieu of theoretical discussions about the identity of art. There she attended St. Martins School of Art (1968–70), joined a feminist reading group that included the filmmaker and theorist Laura Mulvey, and participated in the founding of the Artists' Union. Kelly's *Post-Partum Document* (1973–77), a multimedia work documenting the growth, development, and socialization of her son, comprises 165 individual works informed by the critical theories of feminism, cultural studies, philosophy, psychoanalysis, linguistics, and anthropology. The work addressed topics ranging from the mother-child relationship and formation of gender and sexual identity to the child as fetish and gender divisions of labor. In *Interim* (1984–89) Kelly examined social myths and the psychological experiences of aging women, and in *The Ballad of Kastriot Rexhepi* (2001) she returned to the development of language and identity in an installation that used gray dryer lint to form a wave containing stenciled words telling the true story of an eighteen-month-old Albanian toddler. Left for dead in a Kosovo battlefield, Kastriot Rexhepi was rescued by Serbs, renamed Zoran, abandoned again during the NATO occupation, found by Albanian hospital nurses (who renamed him Lirim), and eventually reunited with his parents. His first spoken word was *bab,* Albanian for "father" or "dad." The British composer Michael Nyman wrote an eighteen-minute musical score to accompany the installation.

In contrast to some conceptual artists' emphasis on theory, others rarely commented on their intentions, including Hanne Darboven, On Kawara, Stanley Brouwn, Vincenzo Agnetti, Bernd and Hilla Becher, and Hiroshi Sugimoto, who gave only terse responses to questions. Kawara's books, paintings, and postcard series, featuring a single stenciled date or phrase, stage his existential reality in words and numbers and provide mute quantitative data for both change and continuity. Darboven's uniformly handwritten sequences

of spelled-out numbers, letters, or words offer testimony to her presence in graphic patterns that transcribe traumatic experiences into meditation and visual language.

Stanley Brouwn (b. Suriname, 1935) began his career as an artist in Amsterdam in the milieu of proto-happenings and Fluxus. In 1960 he began "walking" and "direction" pieces. The following year he mailed printed invitations that invited recipients to become participants in realizing the work of art by visiting "all the boot shops in Amsterdam." Instructions for one of his events in 1962 read simply, "a way across a field on exactly the same straight line from a to b: everyday, a whole year long." For this and other walks, Brouwn asked anonymous pedestrians to describe a route from point *a* to point *b,* which he then followed, recording his steps in typeset numbers in books or on cards that he filed in cabinets and later exhibited. His hermetic transcriptions positioned movement as the index of life, as he suggested in a 1969 statement: "Walk during a few moments very consciously in a certain direction: simultaneously an infinite number of living creatures in the universe are moving in an infinite number of directions."[21] Continuing in his conceptual journeys, in 2005 Brouwn "proposed short walks in the direction of world cities: 'walk 4m in the direction of havana distance: 7396584.7166m.' "[22]

While Brouwn located his work along a trajectory of process, indicating space-time relations in social contexts, Vincenzo Agnetti (b. Italy, 1926–81) derived his conceptualism from the monochrome painting, with its theoretical and conceptual orientation to the linguistic status of art. In the early 1960s Agnetti abandoned painting in what he called his "liquidationism" or "*arte-no*" period. Defining art as an analytic concept, he developed increasingly abstract ideas based on symbolic logic. Like the French artist Bernar Venet, Agnetti drew on sign systems such as language and numbers to signify philosophical propositions and constructs.

In 1959 Bernd and Hilla Becher (b. Germany; Bernd, 1931–2007; Hilla, née Wobeser, 1934) began using a large-format camera to systematically photograph German industrial architecture such as water towers, storage silos, barns, and warehouses. They exhibited these photographs in grid and serial formats, paralleling the approach to presentation by artists associated with minimalism and conceptual art. Bernd had studied with Karl Rössing at the Stuttgart State Academy of Art and Design (1953–56) before attending the Düsseldorf Academy of Art (1957–61), where Hilla was also a student and where he eventually became a professor, mentoring such photographers as Andreas Gursky, Candida Höfer, and Thomas Ruff. In 2002 Hilla stated, "For me, photography is by its very nature free of ideology. Photography with ideology falls to pieces."[23]

Rejecting what he understood as the increasingly self-referential conditions of art, in the mid-1950s the British artist John Latham (b. Zambia, 1921–2006) began to formulate an aesthetic theory he called "Event Structure," in which he attempted to shift attention from the spatial, object-based conditions of art to the phenomenological, temporal, and social conditions surrounding it. Latham noticed, while painting with an aerosol can in 1954, that a single dot provided a "zero moment," or what he called the "Least Event": the dot marked the point in time that changed all subsequent moments and forms. Latham stressed time as the foundation for a process idiom that would support artistic intuition as fundamental to the formation of knowledge. Emphasizing experiential, contextual, and intuitive modes of understanding, he indicted language as a tool of instrumental reason for its role in the history of social oppression, war, and

technological destruction. Launching an assault on institutionalized knowledge, represented in the form of books, Latham began in 1964 to burn "skoob" ("books" spelled backward) towers of stacked books. In 1966 he and students like Barry Flanagan (chap. 7) chewed up Clement Greenberg's influential book *Art and Culture* (1961) and spit out the indigestible content. That same year Latham launched Artist Placement Group (APG) with his wife, Barbara Steveni. Describing the artist as an "incidental person," a social surveyor engaged in the political transformation of society, APG placed artists in decision-making positions within industry and government. Latham was always a figure of controversy for his radical social critiques. In 2005, for fear of social reprisal in the post-9/11 climate, Tate Britain canceled the display of his installation *God Is Great #2,* which consisted of the Qur'an, the Bible, and the Talmud embedded in a sheet of glass.

Like Latham, Marcel Broodthaers (b. Belgium, 1924–76) was an independent and idiosyncratic artist who remained outside all artistic movements. Working on his *poèmes cinématographiques* (cinematographic poems) in near-isolation until the mid-1960s, when his subversive and enigmatic parodies, quotations, and simulations of contemporary art trends emerged, Broodthaers was interested in the evocative and contradictory shifts between words and images that had preoccupied the Belgian Surrealist painter René Magritte. Magritte had introduced Broodthaers to the French Symbolist poet Stéphane Mallarmé's visual poem "Un coup de dés jamais n'abolira le hasard" (A throw of the dice will never abolish chance, 1897), which inspired Broodthaers's fascination with the ambiguous act of naming. In response to the character of 1968 political events, Broodthaers created a continuously changing exhibition, *The Museum of Modern Art—Department of Eagles, Section . . .* (1968–72), which commented on the social and political roles of the museum in ironic displays of conventional institutional practices that exposed the procedures and processes by which cultural values are controlled, defined, maintained, and reified.

Whereas Broodthaers addressed the discursive systems of cultural institutions metaphorically, Hans Haacke (b. Germany, 1936) directly intervened in these institutions. In the early 1960s, after coming to the United States, Haacke worked with systems and processes of energy, growth, and movement. This focus led to his exploration of the dynamic intersection and interaction among physical, biological, and social systems, best exemplified in his 1971 conceptual installation *Shapolsky et al. Manhattan Real Estate Holdings, Real-Time Social System, as of May 1, 1971.* This work was scheduled to be shown as a solo exhibition at the Solomon R. Guggenheim Museum in New York, but the museum's director, Thomas Messer, canceled the exhibition when he learned that a section of it included photographs, charts, and texts documenting real-estate speculation in low-income neighborhoods by members of the Guggenheim's board of directors. Messer then fired the curator Edward Fry for publicly decrying Messer's act of censorship.[24] In both textual and visual practices, as MIT Press noted in its promotion for a book on Haacke, "Hans Haacke's work has been concerned with issues that are at the core of postmodern investigations—the nature of art as institution, the authorship of the artist, the social behavior of the art world, the network of cultural policies such as the role and function of the museum, the critic, and the public, and many other sociological problems."[25]

A lawyer, politician, organizer, publisher, and author, Klaus Staeck (b. Germany, 1938) moved from East Germany to the West in 1956. He began producing photomontage

posters, stickers, postcards, and leaflets in the late 1960s in the tradition of political engagement of the Dada artists Raoul Hausmann, Hannah Höch, and John Heartfield, as well as the Russian avant-garde. Staeck's social criticism and political activism is typified by a 1971 poster in which he reproduced Albrecht Dürer's famous etching of his old and emaciated mother, adding a question at the bottom of the image: "Would you rent a room to this woman?" Staeck pasted his anonymous posters, reproduced using offset printing, in public spaces to challenge the public to respond to social issues with ethical, moral, and empathic care. His topics have ranged from local, national, and international politics to the products of the weapons industry, the inequities of German health care, education, and welfare, and ecological issues. Staeck has collaborated with trade unions, youth groups, schools, and workers to raise public consciousness and focus debate on democratic socialism, political hypocrisy, and the need for free speech, peace, and a safe environment.

As a teenager, Cildo Meireles (b. Brazil, 1948) made drawings of African masks, which he transformed into military helmets after the 1964 coup in Brazil, when he became involved in political protest. By 1969 the dictatorship would cancel Brazil's participation in the Paris Biennale, an act of censorship that precipitated nearly a decade of isolation and an international boycott of the São Paulo Biennial. Meireles's conceptual works date from this period of turmoil, when he grappled with the "socio-economic and cultural precariousness" of Brazil. In *Geographical Mutations: Rio/São Paulo Border* (1969), he exchanged soil, plants, and debris across the border between two Brazilian states, and in *Cords/30km Extended Line* (1969), he laid string along thirty kilometers of beachfront. Meireles also placed enigmatic ads in newspapers, stamped banknotes with questions like "Who killed Herzog?" (a reference to the journalist Vladimir Herzog, suspected of being assassinated in prison), and produced *Insertions into Ideological Circuits: Coca-Cola Project* (1970), printing such texts as "Yankees Go Home" and the formula for making a Molotov cocktail on Coca-Cola bottles before returning them to circulation.[26] "My works are based on language . . . ," Meircles has stated; "anyone, at any time, in any place" can also make them. In *Babel* (2001–6), he attended to the sound of language, installing a tower of radios and cell phones tuned to different languages. Regarding the purpose of art, Meireles commented: "I believe that art . . . must be spoken of as highly sophisticated and anticipatory moments of things that are going to happen, . . . separated from ignorance, yet it must not ignore ignorance, . . . [and] separated from superficialities, and yet it mustn't scorn superficiality."

In 1977, shortly after receiving her MFA from the Rhode Island School of Design, Jenny Holzer (b. U.S., 1950) began anonymously pasting posters around New York, featuring lists of aphorisms she had written based on a variety of literary and theoretical sources. She followed this series of texts, which she called *Truisms,* with other textual series, including *Inflammatory Essays* (1979–82), *Living* (1980–82), and *Survival* (1983–85). In 1982 Holzer began to install her texts on electronic LED signboards in major cities like New York, Washington, D.C., and Toronto. Replacing conventional advertising slogans with messages like "What Country Should You Adopt If You Hate Poor People?" "Money Creates Taste," and "Private Property Created Crime," she mediated public space with ideological statements on gender, sexuality, class, and race, as well as public issues like HIV/AIDS. Continuing this work in installations around the world, Holzer has projected text from declassified government documents onto the exterior

walls of New York University's library (in *For the City,* 2005) and quotes by Presidents John F. Kennedy and Theodore Roosevelt addressing the purpose of art in American culture onto the Potomac River landscape in D.C. (in *For the Capitol,* 2007).

The work of Holzer and many other artists is indebted to that of John Baldessari (b. U.S., 1931). In 1967 Baldessari created his first linguistic "word paintings," as well as paintings with photographic images and narrative texts. The following year he experimented with moving language on neon signs, recalling the ironical neon spiral *The True Artist Helps the World by Revealing Mystic Truths* (1967) by Bruce Nauman (chap. 7). In *Blasted Allegories* (1978), Baldessari superimposed composite photographic fragments, culled from film stills, snapshots, television, and advertising, with unrelated texts exploring linguistic and visual associations. Deconstructing contemporary media messages, he confounded expectations of a coherent image-text relationship, invalidating the idea of unified visual narratives. These works also exposed the illusion that images and texts can document evidence or embody truth, and came to represent the quintessential postmodern visual production of the 1980s.[27] The recipient of several honorary doctorates, Baldessari was given a retrospective, *Pure Beauty,* at the Tate Modern and Los Angeles County Museum of Art in 2010.

A union organizer before becoming an artist, Carrie Mae Weems (b. U.S., 1953) turned to photography after seeing *The Black Photographs Annual* (1973), a compendium of African American photographers' work. This encounter led her to visit the Studio Museum in Harlem, where she took a class with the photographer Dawoud Bey in 1976. She received a BA from the California Institute of the Arts (1981), an MFA from the University of California, San Diego (1984), and studied in the graduate program in folklore at the University of California, Berkeley (1984–87). Already by 1983, Weems had begun to produce conceptual photographs accompanied by storytelling texts with the aim of, in her words, describing "simply and directly those aspects of American culture in need of deeper illumination." Representing subjects ranging from her family and events in her own life to race, class, and gender, she simultaneously explored African American cultural identity rooted in African slavery and the diaspora. Weems also appropriated historical and ethnographical images to examine the structures and consequences of power, as in *The Hampton Project* (2000), an installation featuring the representation and recontextualization of photographs by the photographer Frances Benjamin Johnston, who was commissioned to document the Hampton Institute for the exhibition of "contemporary American Negro life" at the Universal Exposition in Paris in 1900. In 2008 Weems launched *Constructing History: A Requiem to Mark the Movement,* a multimedia study of the movement for human rights internationally.

After training as an architect in Belgium and Italy, Francis Alÿs (b. Belgium, 1959) moved to Mexico, where he began creating conceptual artworks addressed to social and experiential encounters with local contexts, focusing on place, space, and time. Working in many media, from photography, film, and video to installation and performance, Alÿs often engaged public participation in his art. In *When Faith Moves Mountains* (2002), he recruited five hundred volunteers, each armed with a shovel, to move a sand dune near Lima a few inches. In Alÿs and Rafael Ortega's *Zócalo* (1999), the artists filmed the flagpole in the main square of Mexico City as participants stood in the line of its shadow and followed the shadow's movement. In *Amores perros—El*

ensayo (*Amores perros*—The Rehearsal, 2003–7), based on Alejandro González Iñárritu's Oscar-nominated film *Amores perros* (Love's a Bitch, 2001), Alÿs collaborated with the filmmaker in a multimonitor video installation comprising casting clips, acting rehearsals, and discarded rushes from the original film, creating a parallel meta-commentary on the harsh reality it depicted.

Xu Bing (b. China, 1955) studied printmaking, traditional bookbinding, and calligraphy, earning a BA (1981) and an MFA (1987) in printmaking from the Beijing Central Academy of Fine Arts, where he also worked as an instructor. He first came to international attention with *A Book from the Sky* (1987), exhibited in Beijing in 1988. Originally subtitled *An Analyzed Reflection of the End of This Century,* the work consisted of more than two hundred hand-printed, hand-bound volumes, the pages of which bore text in a meaningless language (resembling Chinese) that Xu had printed using traditional Chinese blocks, each of which he had carved with a unique invented character. The elusive nature of his nonreadable language brought critics in China to vilify the artist as a "bourgeois liberal" tainted by Western ideas. After the Tiananmen Square massacre in 1989, Xu left China for Paris and New York. He again came to international attention with *A Case Study of Transference* (1994), a conceptual installation/performance that satirized social and political relations between the United States and China as a pair of breeding pigs, on which Xu had drawn Chinese characters (on the female) and Roman letters (on the male), unself-consciously mated in a pen under the embarrassed gaze of viewers. "These two creatures," Xu observed, "carrying on their bodies the marks of human civilization, engage in the most primal form of 'social intercourse.' "[28] Using language as a metaphor, Xu has continued to emphasize how mistranslation and misunderstanding contribute to the growing homogenized plurality under globalization.

From the late 1960s to the present, conceptual art has provided an open format for addressing social and political topics not only for individual artists, but also for artists working in collectives. One of the first such groups was the Canadian collective General Idea, composed of AA Bronson (Michael Tims; b. Canada, 1946), Felix Partz (Ronald Gabe; b. Canada, 1945–94), and Jorge Zontal (Slobodan Saia-Levy; b. Italy, 1944–94). General Idea used a variety of conceptual forms, from mail art and print media (posters, wallpaper, balloons) to installations, performance, and video. They also staged mass-media events, such as mock beauty pageants and television talk shows, and venues, such as fair pavilions and boutiques. The group published twenty-nine issues of the magazine *FILE* (1972–89) and collected artist's books and multiples, which eventually became the archive of Art Metropole, a not-for-profit corporation and alternative space in Toronto they founded in 1974. General Idea displayed its political and social criticism in *Nazi Milk* (1979), a photograph picturing a blond Aryan youth holding a glass of milk and sporting a milk stain in the form of Adolf Hitler's notorious mustache. Fourteen years before the American dairy industry used celebrities with milk mustaches to advertise its product, *Nazi Milk* cloaked a negative image with the wholesome associations of milk, in a critique of the tools of commercialization. After Partz and Zontal contracted HIV/AIDS, General Idea published *AIDS: The Public and Private Domains of the Miss General Idea Pavillion* in an offset edition of 1,000 and increasingly turned their attention to the epidemic, creating installations and objects that addressed contagion and infections, from *PLA©EBO* (1991), with its giant pills in red, green, and blue, to

their major project *One Year of AZT/One Day of AZT* (1991), exhibited at the Museum of Modern Art in New York.[29]

Similarly concerned with the social role of art, Hervé Fischer, Fred Forest, and Jean-Paul Thénot formed the Collectif d'Art Sociologique in Paris in 1974, having introduced the term "sociological art" in 1971. They published the first of four manifestos, "Manifesto I: Sociological Art," in *Le Monde* on October 10, 1974.[30] Uniting art practice with methods of analysis borrowed from the social sciences, they sought to construct contexts within which the general public might engage in "new models of social organization." Not content to analyze the mass media, they hoped to create forms of intervention aimed at rupturing economic and bureaucratic alienation with public dialogue. In 1978 the collective split along ideological lines. Fischer (b. France, 1941), a sociologist and philosopher as well as an artist, branched off to create large-scale collective events with his newly founded Groupe de l'Art Sociologique, a loose and changing association of international artists. Fischer published the journal *Cahier de l'École Sociologique Interrogative* (1980–81) and organized participatory public events that engaged mass media, especially newspapers. In 1978, in cooperation with *Het Parool* (a daily newspaper of the Jordaan district, the oldest district in the center of Amsterdam), the public was invited to design, write, and edit a whole page of the paper for the five days of the project. The results were uncensored and unmediated commentaries on the changing conditions in the lives of the local shopkeepers, artisans, and families. Ironically, their problems included the gentrification and soaring cost of living that followed an influx of artists, intellectuals, and galleries, and the accompanying wave of squatters, who defied real-estate speculators by moving into empty buildings. In the mid-1980s Fischer moved to Montreal, where he became the leading figure in art, technology, and new media. He cofounded and was copresident with Ginette Major of the City of the Arts and New Technologies, and he also founded the Telescience Festival in 1990, the Electronic Café in 1995, and the Association of Quebec Organisms of Scientific and Technical Culture in 1997. Fischer conceived the media lab Hexagram, founded in 2001 as a consortium of the University of Concordia and the Université du Québec à Montréal.

In the United States, the collective Group Material was formed in 1979 by artists Tim Rollins (initially its principal spokesperson), Julie Ault, Patrick Brennan, and Mundy McLaughlin. Group Material opened an art space in a Lower East Side storefront in 1981, where they staged exhibitions like *The People's Choice* (1981), for which they canvassed the neighborhood and collected objects that its residents donated to be exhibited: paintings, personal treasures, gifts, family souvenirs, photographs of weddings and communions, and so on. In such exhibitions, the collective sought to create an artistic practice situated in a specific context that fused their aesthetic, theoretical, social, and political aims, especially by raising issues related to consumerism, class, race, and ethnicity.

In 1987 the three remaining core members of Group Material—Ault, Doug Ashford, and Felix Gonzalez-Torres—began to work on a project entitled *Democracy,* examining the subject in the context of late capitalism in public lectures, exhibitions, town meetings ("the prototypical democratic experience"), and a book. The group observed:

> Ideally, democracy is a system in which political power rests with the people. . . . But in 1987, after almost two terms of the Reagan presidency . . . it was clear that the state

of American democracy was in no way ideal. . . . It is fundamental to our methodology to question every aspect of our cultural situation from a political point of view, to ask, "What politics inform accepted understandings of art and culture? Whose interests are served by such cultural conventions? How is culture made, and for whom is it made?"[31]

One year later, Gonzalez-Torres (b. Cuba, 1957–96) began exhibiting his own works, producing simple, spare installations that often included such things as posters and candies stacked in piles for viewers to take as souvenirs. His works emphasized themes of loss, dying, absence, and mortality, and were dedicated to the memory of his partner, Ross Laycock, who died of AIDS in 1990, six years before the artist's own death, also from AIDS.

Tim Rollins had left Group Material in the fall of 1987 to create community art at Intermediate School 52 in the South Bronx, where he had worked as a teacher since 1981. Collaborating with black and Hispanic teenagers, Rollins formed Kids of Survival (K.O.S.) and opened an after-school program called Art and Knowledge Workshop. There the students created large-scale conceptual works inspired by and incorporating actual pages from literature such as Nathaniel Hawthorne's *The Scarlet Letter,* Franz Kafka's *Amerika,* and Harriet Jacobs's *Incidents in the Life of a Slave Girl,* as well as musical scores, such as *Winterreise* by Franz Schubert. Rollins and five of the teenagers—Rick Savinon, Carlos Rivera, Victor Llanos, Chris Fernandez, and Jorge Luis Abreu—appear in the documentary film *Kids of Survival: The Art and Life of Tim Rollins and K.O.S.,* produced in 1996. The Institute of Contemporary Art at the University of Pennsylvania in Philadelphia presented a retrospective on Rollins and K.O.S. in 2009.

The collective Neue Slowenische Kunst (NSK; New Slovenian Art), was formed in 1984 in the former Yugoslavia and comprised a number of subcollectives: Laibach (a music group), Irwin (artists working in painting, installation, and performance), Noordung (a theater company named after the Slovenian astronomer Hermann Noordung [Herman Potočnik] and originally called Scipion Našice Sisters Theater or Red Pilot), New Collective Studio or New Collectivism (a group of graphic artists), Retrovision (a film, video, and digital artists' group), and the Department of Pure and Applied Philosophy (a title used by those engaged in theoretical theory). NSK was the heir to two collectives from Zagreb that had focused on conceptual approaches to art and critical social interaction: Gorgona (1959–66) and OHO (1966–71). The anonymous artists of Gorgona published eleven issues of *Gorgona* (1961–66), each devoted to a single artist, as well as producing books, projects, concepts, and manifestos.[32] They collaborated or had contact with artists in Western Europe and the United States, including Victor Vasarely, Dieter Roth, Piero Manzoni, Robert Rauschenberg, and Lucio Fontana. OHO, whose shifting membership included artists, critics, poets, and filmmakers, put out twenty small-edition artists' publications that often included drawings, writings, poetry, and objects.[33]

The use of German by NSK—both for its own name and for Laibach (which is the German name for Ljubljana, the capital of Slovenia)—serves as a linguistic marker, recalling the large German population in Slovenia, as well as the Nazi occupation of the country during World War II. Grounding their work in the psychoanalytic theory that past trauma may only be healed through reenactment, testimony, and witness, NSK

members have dressed in clothing suggestive of totalitarian regimes and staged nation-alist-like theatrical and musical spectacles. By presenting an ambiguous, hybrid, kitsch identity, they sought to unmask how nationalism under any ideological guise, whether fascism, communism, or capitalism, operates in similar ways. NSK described this strategy as its "retro-principle," or " 'retro(avant)garde' . . . not a style or an art trend but a principle of thought, a way of behaving and acting."[34] Since 1991 NSK has described itself as a state, issuing passports and postage stamps and presenting its exhibitions as "consulates" by opening "passport offices" in numerous countries. NSK passports were successful in helping some individuals escape the conflict during the Balkan wars. NSK citizens and friends set up a blog, and the First NSK Citizens' Congress was held in Berlin in October 2010.[35]

While NSK's fictive state challenged the normative concept of the nation-state, Walid Raad (b. Lebanon, 1967) invented the Atlas Group (1989–2004), a fictive collective for the research and documentation of contemporary Lebanese history.[36] Raad, who left Lebanon in 1983 to pursue his studies, earned a BFA from the Rochester Institute of Technology (1989) and an MA (1993) and a PhD in cultural and visual studies from the University of Rochester (1996). An artist of both Palestinian and Lebanese parents, Raad focused on the trauma and psychological violence of Middle Eastern history, especially the Lebanon wars from 1975 to 1991. He located the Atlas Group in Beirut and New York, compiling an archive with both invented and real documents, films, videos, photographs, notebooks, and other kinds of objects and organizing the files in three categories: "named imaginary individuals or organizations," "anonymous individuals or organizations," and "The Atlas Group." Raad has often presented his ideas in lectures drawing on material from the Atlas Group archive and exploring the line between historical fact and fiction, and how history is constructed, disseminated, and received. Raad's fifteen-minute DVD *We Can Make Rain but No One Came to Ask* (2005) appears to be a documentary, all the while deconstructing Raad's work itself.

The collective Critical Art Ensemble (CAE) was founded in the United States in 1987 by five artists—Steve Kurtz, Hope Kurtz, Steven Barnes, Dorian Burr, and Beverly Schlee—working in photography, film, video, digital media, installation, and performance. Collectively authoring six influential books on critical resistance, including *The Electronic Disturbance* (1994), *Electronic Civil Disobedience and Other Unpopular Ideas* (1996), and *Digital Resistance: Explorations in Tactical Media* (2001), CAE also developed conceptual projects related to what they call "tactical media," encouraging "the use of any media that will engage a particular socio-political context in order to create molecular interventions and semiotic shocks that collectively could diminish the rising intensity of authoritarian culture."[37] Selecting a controversial issue, topic, situation, or context in everyday life, CAE has explored processes of resistance, sometimes constructing portable public labs to test such things as foods for genetic modifications, to consider reproductive technologies, and to address subjects like transgenics (the combining of genetic material across species).

CAE came to widespread attention when the FBI arrested Steve Kurtz, one of the collective's founders, in May 2004, after he had called 911 to report the sudden death of his wife, Hope, who, it was later determined, died of congenital heart failure. The police notified the FBI after seeing petri dishes and biological material in the Kurtzes'

home, material that related to their bioart, or art made with living matter. CAE had written about biological issues in such texts as *Flesh Machine: Cyborgs, Designer Babies, Eugenic Consciousness* (1998) and *Molecular Invasion* (2002). The FBI held Kurtz for twenty-two hours on suspicion of bioterrorism, searching his home and confiscating books, computers, and art materials, all eventually determined not to pose a public threat. Nevertheless, a grand jury indicted the artist, along with Dr. Robert Ferrell, a professor of genetics at the University of Pittsburgh Graduate School of Public Health, who had served CAE as a scientific consultant. They were indicted on federal criminal mail and wire fraud charges for acquiring bacteria, which were subsequently found to be harmless and which Kurtz used in museum exhibitions related to CAE's work. Under the USA PATRIOT Act, passed after September 11, 2001, Kurtz and Ferrell could have been sentenced to twenty years in prison. Ferrell pleaded guilty to misdemeanor charges in October 2007, after suffering a series of strokes, and in June 2008 Kurtz was cleared of all charges.

Arakawa (Shusaku Arakawa; b. Japan, 1936–2010) and Madeline Gins (b. U.S., 1941) worked as the team Arakawa + Gins. Arakawa studied medicine and mathematics at Tokyo University before turning to painting at Musashino College of Art, and Gins graduated from Barnard College. The artists met in 1962 as students at the Brooklyn Museum Art School and began collaborating on *The Mechanism of Meaning* (1963–71), a corpus of research and artworks devoted to epistemological and ontological considerations centered on spatial relationships of the body and human interactions. Studying the aesthetic and social implications of analytical philosophy, they created aesthetic models of how language and grammar map the intersection between sense and babble in patterns of thought that reveal the apparatus of meaning-making. *The Mechanism of Meaning* led to their notion of procedural architecture, culminating in 1987 in their establishment of the Architectural Body Research Foundation to study the interaction between the electrochemical, metabolic, and psychological activities of bodies and the construction of architectural space that sustains life. Arriving at their notion of "the architectural body" through the study of experimental biology, neuroscience, quantum physics, experimental phenomenology, and medicine, they theorized their work in a series of books, including *Architecture: Sites of Reversible Destiny* (1994), *Reversible Destiny: We Have Decided Not to Die* (1997), *Architectural Body* (2002), and *Making Dying Illegal* (2006).[38] Their visionary architectural projects include residences (such as Reversible Destiny Houses and Biocleave House), parks (Site of Reversible Destiny in Yoro, Japan), and plans for housing complexes and neighborhoods (Isles of Reversible Destiny in Venice and Tokyo). Arakawa and Gins's designs aim to enable their inhabitants to "counteract the usual human destiny of having to die," a twenty-first-century application of conceptual art to transhumanism, the international intellectual and cultural movement concerned with the evolutionary transition from human mortality to post-human immortality.

A conceptual artist and activist, Ai Weiwei (b. China, 1957) grew up in a remote desert village in Xinjiang Province, near the Russian border, where his father, Ai Qing, a well-known, Paris-educated artist and poet had been sent as an "enemy of the state," consigned to clean public toilets. During the Cultural Revolution (1966–1976), in part through hand-copied books passed surreptitiously from person to person, Ai came to

understand the repression of "humanism and individualism" in China.[39] Ai entered the Beijing Film Academy in 1978, dropping out in 1979 to cofound Stars Group, a socially critical, pro-democracy artist and writer's collective.[40] After living in the United States from 1981 to 1993, Ai returned to Beijing, where he began an aesthetic, conceptual critique of the contradictions between China's illustrious past and its questionable social, cultural, and political policies. Commenting ironically on the commercialization of history, Ai created such pieces as *Han Dynasty Urn with Coca-Cola Logo* (1994). For *Fairytale* (2007), a three-part project for Documenta 12, Ai brought 1,001 citizens from diverse areas of China to Germany to view the exhibition, providing them with travel expenses, identical luggage, and living arrangements, and filming each person's experience. *Fairytale* also included 1,001 late Ming and Qing Dynasty chairs situated in clusters as "stations of reflection" throughout the exhibition and a monumental sculpture, *Template,* made from 1,001 wooden doors and windows culled from destroyed Ming and Qing Dynasty houses. When the precarious sculpture collapsed, Ai declared the work complete, as a metaphor for Chinese culture. Using visual language as a form of critical activism, Ai's work attended to what Charles Merewether has described as Chinese "patrimony and erasure," oscillating "between ruin and production."[41]

Ai, a self-taught architect who had in 2003 formed an architectural firm with the ironical name FAKE Design,[42] was invited to join the team that designed the National Stadium, or "bird's nest," for the 2008 Beijing Olympics, and he eventually boycotted the Olympics to protest China's political and social practices. Ai extended the broad social engagement of his architectural practice with his blog writing.[43] After the 2008 Sichuan earthquake killed thousands of Chinese schoolchildren, Ai took part in an international Internet movement to investigate and expose the Chinese government's responsibility for children's deaths. As a result, three of Ai's blogs (with a readership of some 3 million) were shut down, and his commentaries on Fanfou, China's version of Twitter, were deleted. On August 12, 2009, as Ai was preparing *So Sorry,* an exhibition in Munich on the Sichuan earthquake, he was severely beaten by Chinese policemen and a month later underwent surgery in Munich for cerebral hemorrhage. On April 3, 2011, Ai was arrested for unspecified charges in the Beijing Capital International Airport. He was held under constant surveillance in a secret location until his release on June 22. Afterward the government charged him with tax evasion and fined him the equivalent of more than $2 million. Anonymous Chinese citizens raised and donated more than half the amount, which Ai used to fight the charges.

In bringing conceptual art to a new level of social engagement, Ai explained to the CNN reporter Christiane Amanpour: "I don't want to be part . . . of denying of reality; we live in this time; we have to speak out."[44]

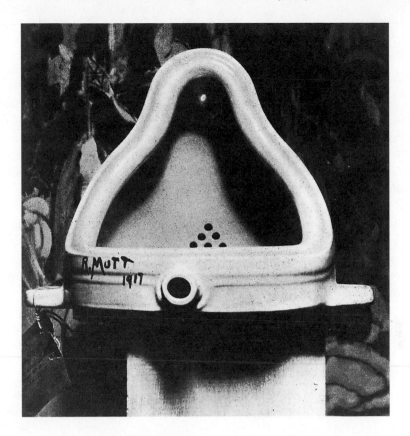

The Richard Mutt Case

They say any artist paying six dollars may exhibit.

Mr. Richard Mutt sent in a fountain. Without discussion this article disappeared and never was exhibited.

What were the grounds for refusing Mr. Mutt's fountain :—

1. *Some contended it was immoral, vulgar.*

2. *Others, it was plagiarism, a plain piece of plumbing.*

Now Mr. Mutt's fountain is not immoral, that is absurd, no more than a bath tub is immoral. It is a fixture that you see every day in plumbers' show windows.

Whether Mr. Mutt with his own hands made the fountain or not has no importance. He CHOSE it. He took an ordinary article of life, placed it so that its useful significance disappeared under the new title and point of view—created a new thought for that object.

As for plumbing, that is absurd. The only works of art America has given are her plumbing and her bridges.

* Marcel Duchamp, "The Richard Mutt Case," *Blind Man* (New York) 2 (1917): 5. Photo of Duchamp's *Fountain,* 1917 (no longer extant). © 2012 Artists Rights Society (ARS), New York/ADAGP, Paris/Estate of Marcel Duchamp. Photo by Alfred Stieglitz; courtesy The Museum of Modern Art, New York.

The Creative Act (1957)

Let us consider two important factors, the two poles of the creation of art: the artist on one hand, and on the other the spectator who later becomes the posterity.

To all appearances, the artist acts like a mediumistic being who, from the labyrinth beyond time and space, seeks his way out to a clearing.

If we give the attributes of a medium to the artist, we must then deny him the state of consciousness on the esthetic plane about what he is doing or why he is doing it. All his decisions in the artistic execution of the work rest with pure intuition and cannot be translated into a self-analysis, spoken or written, or even thought out.

T. S. Eliot, in his essay on "Tradition and the Individual Talent," writes: "The more perfect the artist, the more completely separate in him will be the man who suffers and the mind which creates; the more perfectly will the mind digest and transmute the passions which are its material."

Millions of artists create; only a few thousands are discussed or accepted by the spectator and many less again are consecrated by posterity.

In the last analysis, the artist may shout from all the rooftops that he is a genius; he will have to wait for the verdict of the spectator in order that his declarations take a social value and that, finally, posterity includes him in the primers of Art History.

I know that this statement will not meet with the approval of many artists who refuse this mediumistic role and insist on the validity of their awareness in the creative act—yet, art history has consistently decided upon the virtues of a work of art through considerations completely divorced from the rationalized explanations of the artist.

If the artist, as a human being, full of the best intentions toward himself and the whole world, plays no role at all in the judgment of his own work, how can one describe the phenomenon which prompts the spectator to react critically to the work of art? In other words how does this reaction come about?

This phenomenon is comparable to a transference from the artist to the spectator in the form of an esthetic osmosis taking place through the inert matter, such as pigment, piano or marble.

But before we go further, I want to clarify our understanding of the word "art"—to be sure, without an attempt to a definition.

What I have in mind is that art may be bad, good or indifferent, but, whatever adjective is used, we must call it art, and bad art is still art in the same way as a bad emotion is still an emotion.

Therefore, when I refer to "art coefficient," it will be understood that I refer not only to great art, but I am trying to describe the subjective mechanism which produces art in a raw state—*à l'état brut*—bad, good or indifferent.

In the creative act, the artist goes from intention to realization through a chain of totally subjective reactions. His struggle toward the realization is a series of efforts, pains, satisfactions, refusals, decisions, which also cannot and must not be fully self-conscious, at least on the esthetic plane.

* Marcel Duchamp, "The Creative Act" (lecture in Houston, April 1957), in *ArtNews* 56, no. 4 (Summer 1957): 28–29; translated into French by Duchamp in Michel Sanouillet, ed., *Marchand du sel: Écrits de Marcel Duchamp* (Paris: Le Terrain Vague, 1958); reprinted in Sanouillet and Elmer Peterson, eds., *Salt Seller: The Writings of Marcel Duchamp (Marchand du sel)* (New York: Oxford University Press, 1973), 138–40. © 2012 Artists Rights Society (ARS), New York/ADAGP, Paris/Estate of Marcel Duchamp.

The result of this struggle is a difference between the intention and its realization, a difference which the artist is not aware of.

Consequently, in the chain of reactions accompanying the creative act, a link is missing. This gap which represents the inability of the artist to express fully his intention; this difference between what he intended to realize and did realize, is the personal "art coefficient" contained in the work.

In other words, the personal "art coefficient" is like an arithmetical relation between the unexpressed but intended and the unintentionally expressed.

To avoid a misunderstanding, we must remember that this "art coefficient" is a personal expression of art "*à l'état brut,*" that is, still in a raw state, which must be "refined" as pure sugar from molasses, by the spectator; the digit of this coefficient has no bearing whatsoever on his verdict. The creative act takes another aspect when the spectator experiences the phenomenon of transmutation; through the change from inert matter into a work of art, an actual transubstantiation has taken place, and the role of the spectator is to determine the weight of the work on the esthetic scale.

All in all, the creative act is not performed by the artist alone; the spectator brings the work in contact with the external world by deciphering and interpreting its inner qualifications and thus adds his contribution to the creative act. This becomes even more obvious when posterity gives its final verdict and sometimes rehabilitates forgotten artists.

Apropos of "Readymades" (1961)

IN 1913 I HAD THE HAPPY IDEA TO FASTEN A BICYCLE WHEEL TO A KITCHEN STOOL AND WATCH IT TURN.

A FEW MONTHS LATER I BOUGHT A CHEAP REPRODUCTION OF A WINTER EVENING LANDSCAPE, WHICH I CALLED "PHARMACY" AFTER ADDING TWO SMALL DOTS, ONE RED AND ONE YELLOW, IN THE HORIZON.

IN NEW YORK IN 1915 I BOUGHT AT A HARDWARE STORE A SNOW SHOVEL ON WHICH I WROTE "IN ADVANCE OF THE BROKEN ARM."

IT WAS AROUND THAT TIME THAT THE WORD "READYMADE" CAME TO MIND TO DESIGNATE THIS FORM OF MANIFESTATION.

A POINT WHICH I WANT VERY MUCH TO ESTABLISH IS THAT THE CHOICE OF THESE "READY-MADES" WAS NEVER DICTATED BY ESTHETIC DELECTATION.

THIS CHOICE WAS BASED ON A REACTION OF VISUAL INDIFFERENCE WITH AT THE SAME TIME A TOTAL ABSENCE OF GOOD OR BAD TASTE . . . IN FACT A COMPLETE ANESTHESIA.

ONE IMPORTANT CHARACTERISTIC WAS THE SHORT SENTENCE WHICH I OCCASIONALLY IN-SCRIBED ON THE "READYMADE."

THAT SENTENCE INSTEAD OF DESCRIBING THE OBJECT LIKE A TITLE WAS MEANT TO CARRY THE MIND OF THE SPECTATOR TOWARDS OTHER REGIONS MORE VERBAL.

SOMETIMES I WOULD ADD A GRAPHIC DETAIL OF PRESENTATION WHICH IN ORDER TO SATISFY MY CRAVING FOR ALLITERATIONS, WOULD BE CALLED "READYMADE AIDED."

AT ANOTHER TIME WANTING TO EXPOSE THE BASIC ANTINOMY BETWEEN ART AND READY-MADES I IMAGINED A "RECIPROCAL READYMADE": USE A REMBRANDT AS AN IRONING BOARD!

* Marcel Duchamp, "Apropos of 'Readymades'" (lecture at the Museum of Modern Art, New York, 19 October 1961), in *Art and Artists* (London) 1, no. 4 (July 1966): 47; reprinted in Sanouillet and Elmer Peterson, eds., *Salt Seller: The Writings of Marcel Duchamp (Marchand du sel)* (New York: Oxford University Press, 1973), 141–42. © 2012 Artists Rights Society (ARS), New York/ADAGP, Paris/Estate of Marcel Duchamp.

I REALIZED VERY SOON THE DANGER OF REPEATING INDISCRIMINATELY THIS FORM OF EX-
PRESSION AND DECIDED TO LIMIT THE PRODUCTION OF "READYMADES" TO A SMALL NUMBER
YEARLY. I WAS AWARE AT THAT TIME, THAT FOR THE SPECTATOR EVEN MORE THAN FOR THE
ARTIST, ART IS A HABIT FORMING DRUG AND I WANTED TO PROTECT MY "READYMADES" AGAINST
SUCH CONTAMINATION.

ANOTHER ASPECT OF THE "READYMADE" IS ITS LACK OF UNIQUENESS. . . . THE REPLICA OF
A "READYMADE" DELIVERING THE SAME MESSAGE; IN FACT NEARLY EVERY ONE OF THE "READY-
MADES" EXISTING TODAY IS NOT AN ORIGINAL IN THE CONVENTIONAL SENSE.

A FINAL REMARK TO THIS EGOMANIAC'S DISCOURSE:

SINCE THE TUBES OF PAINT USED BY THE ARTIST ARE MANUFACTURED AND READY MADE
PRODUCTS WE MUST CONCLUDE THAT ALL THE PAINTINGS IN THE WORLD ARE "READYMADES
AIDED" AND ALSO WORKS OF ASSEMBLAGE.

HENRY FLYNT Concept Art (1961)

"Concept art" is first of all an art of which the material is "concepts," as the material of for ex. music is sound. Since "concepts" are closely bound up with language, concept art is a kind of art of which the material is language. That is, unlike for ex. a work of music, in which the music proper (as opposed to notation, analysis, a.s.f.) is just sound, concept art proper will involve language. From the philosophy of language, we learn that a "concept" may as well be thought of as the *intention of a name;* this is the relation between concepts and language. The notion of a concept is a vestige of the notion of a Platonic form (the thing which for ex. all tables have in common: tableness), which notion is replaced by the notion of a name objectively, metaphysically related to its intention (so that all tables now have in common their objective relation to "table"). Now the claim that there can be an objective relation between a name and its intention is wrong, and (the word) "concept," as commonly used now, can be discredited (see my book *Philosophy Proper*). If, however, it is enough for one that there be a subjective relation between a name and its intention, namely the unhesitant decision as to the way one wants to use the name, the unhesitant decisions to affirm the names of some things but not others, then "concept" is valid language, and concept art has a philosophically valid basis.

Now what is artistic, aesthetic, about a work which is a body of concepts? This question can best be answered by telling where concept art came from; I developed it in an attempt to straighten out certain traditional activities generally regarded as aesthetic. The first of these is "structure art," music, visual art, a.s.f., in which the important thing is "*structure.*" My definitive discussion of structure art can be found in "General Aesthetics"; here I will just summarize that discussion. Much structure art is a vestige of the time when for ex. music was believed to be knowledge, a science which had important things to say in astronomy a.s.f. Contemporary structure artists, on the other hand, tend to claim the kind of cognitive value for their art that conventional contemporary mathematicians claim for mathematics. Modern examples of structure art are the fugue and total serial music. These examples illustrate the important division of structure art into two kinds according to how the structure is appreciated. In the case of a fugue, one is aware of its structure *in listening to it;* one imposes "relationships," a catego-

* Henry Flynt, excerpts from "Essay: Concept Art" (1961), in La Monte Young, ed., *An Anthology* (New York: George Maciunas and Jackson Mac Low, c. 1962; reprint, New York: La Monte Young and Jackson Mac Low, 1963; reprint, Cologne: Heiner Friedrich, 1970). © 1961 Henry Flynt. By permission of the author.

rization (hopefully that intended by the composer) on the sounds while listening to them, that is, has an "(associated) artistic structure experience." In the case of total serial music, the structure is such that this cannot be done; one just has to read an "analysis" of the music, definition of the relationships. Now there are two things wrong with structure art. First, its cognitive pretentions are utterly wrong. Secondly, by trying to be music or whatever (which has nothing to do with knowledge), *and* knowledge represented by structure, structure art both fails, is completely boring, as music, and doesn't begin to explore the aesthetic possibilities structure can have when freed from trying to be music or whatever. The first step in straightening out for ex. structure music is to stop calling it "music," and start saying that the sound is used only to carry the structure and that the real point is the structure—and then you will see how limited, impoverished, the structure is. Incidentally, anyone who says that works of structure music do occasionally have musical value just doesn't know how good real music (the Goli Dance of the Baoule; "Cans on Windows" by L. Young; the contemporary American hit song "Sweets for My Sweets," by the Drifters) can get. When you make the change, then since structures are concepts, you have concept art. Incidentally, there is another, less important kind of art which when straightened out becomes concept art: art involving play with the concepts of the art such as, in music, "the score," "performer vs. listener," "playing a work." The second criticism of structure art applies, with the necessary changes, to this art.

The second main antecedent of structure art is mathematics. This is the result of my revolution in mathematics, which is written up definitively in the Appendix; here I will only summarize. The revolution occurred first because for reasons of taste I wanted to deemphasize discovery in mathematics, mathematics as *discovering* theorems and proofs. I wasn't good at such discovery, and it bored me. The first way I thought of to deemphasize discovery came not later than summer 1960; it was that since the value of pure mathematics is now regarded as aesthetic rather than cognitive, why not try to make up aesthetic theorems, without considering whether they are true. The second way, which came at about the same time, was to find, as a philosopher, that the conventional claim that theorems and proofs are discovered is *wrong,* for the same reason I have already given that "concept" can be discredited. The third way, which came in the fall-winter of 1960, was to work in unexplored regions of formalist mathematics. The resulting mathematics still had statements, theorems, proofs, but the latter weren't discovered in the way they traditionally were. Now exploration of the wider possibilities of mathematics as revolutionized by me tends to lead beyond what it makes sense to call "mathematics"; the category of "mathematics," a vestige of Platonism, is an "unnatural," bad one. My work in mathematics leads to the new category of "concept art," of which straightened out traditional mathematics (mathematics as discovery) is an untypical, small but intensively developed part.

I can now return to the question of why concept art is "art." Why isn't it an absolutely new, or at least a non-artistic, non-aesthetic activity? The answer is that the antecedents of concept art are commonly regarded as artistic, aesthetic activities; on a deeper level, interesting concepts, concepts enjoyable in themselves, especially as they occur in mathematics, are commonly said to "have beauty." By calling my activity "art," therefore, I am simply recognizing this common usage, and the origin of the activity in structure art and mathematics. *However:* it is confusing to call things as irrelevant as the emotional enjoyment of (real) music, and the intellectual enjoyment of concepts, the same kind of enjoyment. Since concept art includes almost everything ever said to be "music," at least, which is not music for the emotions, perhaps it would be better to restrict "art" to apply to art for the emotions, and recognize my activity as an independent, new activity, irrelevant to art (and knowledge).

Joseph Kosuth, *One and Three Chairs,* 1965, photograph, wooden chair, and text. © 2012 Joseph Kosuth/Artists Rights Society (ARS), New York. Photo by Jay Cantor; courtesy Leo Castelli Gallery, New York.

JOSEPH KOSUTH Statement (1968)

My current work, which consists of categories from the thesaurus, deals with the multiple aspects of an idea of something. I changed the form of presentation from the mounted pho-tostat, to the purchasing of spaces in newspapers and periodicals (with one "work" sometimes taking up as many as five or six spaces in that many publications—depending on how many divisions exist in the category). This way the immateriality of the work is stressed and any possible connections to painting are severed. The new work is not connected with a precious object—it is accessible to as many people as are interested, it is non-decorative—having noth-ing to do with architecture; it can be brought into the home or museum, but was not made with either in mind; it can be dealt with by being torn out of its publication and inserted into a notebook or stapled to the wall—or not torn out at all—but any such decision is unrelated to the art. My role as an artist ends with the work's publication.

Art After Philosophy (1969)

I will discuss the separation between aesthetics and art; consider briefly Formalist art (because it is a leading proponent of the idea of aesthetics as art), and assert that art is analogous to an analytic proposition, and that it is art's existence as a tautology which enables art to remain "aloof" from philosophical presumptions.

* Joesph Kosuth, untitled statement (1968), in Germano Celant, ed., *Arte Povera* (Milan: Gabriele Mazzotta, 1969); translated as *Art Povera* (London: Studio Vista; New York: Praeger, 1969), 98. By permission of the author, the editor, and Macmillan Publishing Company for Studio Vista.

** Joseph Kosuth, excerpts from "Art After Philosophy," *Studio International* 178, no. 915 (October 1969): 134–37; reprinted in Joseph Kosuth, *Art After Philosophy and After: Collected Writings, 1966–1990,* edited and with an introduction by Gabriele Guercio and foreword by Jean-François Lyotard (Cambridge, MA: MIT Press, 1991), 13–32. By permission of the author.

It is necessary to separate aesthetics from art because aesthetics deals with opinions on perception of the world in general. In the past one of the two prongs of art's function was its value as decoration. So any branch of philosophy which dealt with "beauty" and thus, taste, was inevitably duty bound to discuss art as well. Out of this "habit" grew the notion that there was a conceptual connection between art and aesthetics, which is not true. This idea never drastically conflicted with artistic considerations before recent times, not only because the morphological characteristics of art perpetuated the continuity of this error, but also because the apparent other "functions" of art (depiction of religious themes, portraiture of aristocrats, detailing of architecture, etc.) used art to cover up art.

When objects are presented within the context of art (and until recently objects always have been used) they are as eligible for aesthetic consideration as are any objects in the world, and an aesthetic consideration of an object existing in the realm of art means that the object's existence or functioning in an art context is irrelevant to the aesthetic judgement.

The relation of aesthetics to art is not unlike that of aesthetics to architecture, in that architecture has a very specific *function* and how "good" its design is is *primarily* related to how well it performs its function. Thus, judgements on what it looks like correspond to taste, and we can see that throughout history different examples of architecture are praised at different times depending on the aesthetics of particular epochs. Aesthetic thinking has even gone so far as to make examples of architecture not related to "art" at all, works of art in themselves (e.g. the pyramids of Egypt).

Aesthetic considerations are indeed *always* extraneous to an object's function or "reason to be." Unless, of course, the object's "reason to be" is strictly aesthetic. An example of a purely aesthetic object is a decorative object, for decoration's primary function is "to add something to so as to make more attractive; adorn; ornament," and this relates directly to taste. And this leads us directly to "Formalist" art and criticism. Formalist art (painting and sculpture) is the vanguard of decoration, and, strictly speaking, one could reasonably assert that its art condition is so minimal that for all functional purposes it is not art at all, but pure exercises in aesthetics. Above all things Clement Greenberg is the critic of taste. Behind every one of his decisions there is an aesthetic judgement, with those judgements reflecting his taste. And what does his taste reflect? The period he grew up in as a critic, the period "real" for him: the fifties. Given his theories (if they have any logic to them at all) how else can one account for his disinterest in Frank Stella, Ad Reinhardt, and others applicable to his historical scheme? Is it because he is " . . . basically unsympathetic on personally experiential grounds"? Or, in other words, their work doesn't suit his taste?

But in the philosophic *tabula rasa* of art, "if someone calls it art," as Don Judd has said, "it's art." Given this, formalist painting and sculpture activity can be granted an "art condition," but only by virtue of its presentation in terms of its art idea (e.g. a rectangularly-shaped canvas stretched over wooden supports and stained with such and such colors, using such and such forms, giving such and such a visual experience, etc.). Looking at contemporary art in this light, one realizes the minimal creative effort taken on the part of formalist artists specifically, and all painters and sculptors (working as such today) generally.

This brings us to the realization that formalist art and criticism accept as a definition of art one which exists solely on morphological grounds. While a vast quantity of similarly looking objects or images (or visually related objects or images) may seem to be related (or connected) because of a similarity of visual/experiential "readings," one cannot claim from this an artistic or conceptual relationship.

It is obvious then that formalist criticism's reliance on morphology leads necessarily with a bias toward the morphology of traditional art. And in this sense such criticism is not related

to a "scientific method" or any sort of empiricism (as Michael Fried, with his detailed descriptions of paintings and other "scholarly" paraphernalia would want us to believe). Formalist criticism is no more than an analysis of the physical attributes of particular objects which happen to exist in a morphological context. But this doesn't add any knowledge (or facts) to our understanding of the nature or function of art. Nor does it comment on whether or not the objects analyzed are even works of art, since formalist critics always bypass the conceptual element in works of art. Exactly why they don't comment on the conceptual element in works of art is precisely because formalist art becomes art only by virtue of its resemblance to earlier works of art. It's a mindless art. Or, as Lucy Lippard so succinctly described Jules Olitski's paintings: "they're visual *Muzak*."

Formalist critics and artists alike do not question the nature of art, but as I have said elsewhere: "Being an artist now means to question the nature of art. If one is questioning the nature of painting, one cannot be questioning the nature of art. If an artist accepts painting (or sculpture) he is accepting the tradition that goes with it. That's because the word art is general and the word painting is specific. Painting is a *kind* of art. If you make paintings you are already accepting (not questioning) the nature of art. One is then accepting the nature of art to be the European tradition of a painting-sculpture dichotomy."

The strongest objection one can raise against a morphological justification for traditional art is that morphological notions of art embody an implied *a priori* concept of art's possibilities. But such an *a priori* concept of the nature of art (as separate from analytically framed art propositions or "work" which I will discuss later) makes it, indeed, *a priori:* impossible to question the nature of art. And this questioning of the nature of art is a very important concept in understanding the function of art.

The function of art, as a question, was first raised by Marcel Duchamp. In fact it is Marcel Duchamp whom we can credit with giving art its own identity. (One can certainly see a tendency toward this self-identification of art beginning with Manet and Cézanne through to Cubism, but their works are timid and ambiguous by comparison with Duchamp's.) "Modern" art and the work before seemed connected by virtue of their morphology. Another way of putting it would be that art's "language" remained the same, but it was saying new things. The event that made conceivable the realization that it was possible to "speak another language" and still make sense in art was Marcel Duchamp's first unassisted readymade. With the unassisted readymade, art changed its focus from the form of the language to what was being said. Which means that it changed the nature of art from a question of morphology to a question of function. This change—one from "appearance" to "conception"—was the beginning of "modern" art and the beginning of "conceptual" art. All art (after Duchamp) is conceptual (in nature) because art only exists conceptually.

The "value" of particular artists after Duchamp can be weighed according to how much they questioned the nature of art; which is another way of saying "what they *added* to the conception of art" or what wasn't there before they started. Artists question the nature of art by presenting new propositions as to art's nature. And to do this one cannot concern oneself with the handed-down "language" of traditional art, since this activity is based on the assumption that there is only one way of framing art propositions. But the very stuff of art is indeed greatly related to "creating" new propositions.

The case is often made—particularly in reference to Duchamp—that objects of art (such as the readymades, of course, but all art is implied in this) are judged as *objets d'art* in later years and the artists' *intentions* become irrelevant. Such an argument is the case of a preconceived notion of art ordering together not necessarily related facts. The point is this: aesthet-

ics, as we have pointed out, are conceptually irrelevant to art. Thus, any physical thing can become *objet d'art,* that is to say, can be considered tasteful, aesthetically pleasing, etc. But this has no bearing on the object's application to an art context; that is, its *functioning* in an art context. (E.g. if a collector takes a painting, attaches legs, and uses it as a dining-table it's an act unrelated to art or the artist because, *as art,* that wasn't the artist's *intention.*)

And what holds true for Duchamp's work applies as well to most of the art after him. In other words, the value of Cubism is its idea in the realm of art, not the physical or visual qualities seen in a specific painting, or the particularization of certain colors or shapes. For these colors and shapes are the art's "language," not its meaning conceptually as art. To look upon a Cubist "masterwork" *now* as art is nonsensical, conceptually speaking, as far as art is concerned. (That visual information which was unique in Cubism's language has now been generally absorbed and has a lot to do with the way in which one deals with painting "linguistically." [E.g. what a Cubist painting meant experimentally and conceptually to, say, Gertrude Stein, is beyond our speculation because the same painting then "meant" something different than it does now.]) The "value" now of an original Cubist painting is not unlike, in most respects, an original manuscript by Lord Byron, or *The Spirit of St. Louis* as it is seen in the Smithsonian Institution. (Indeed, museums fill the very same function as the Smithsonian Institution—why else would the *Jeu de Paume* wing of the Louvre exhibit Cézanne's and Van Gogh's palettes as proudly as they do their paintings?) Actual works of art are little more than historical curiosities. As far as *art* is concerned Van Gogh's paintings aren't worth any more than his palette is. They are both "collector's items."

Art "lives" through influencing other art, not by existing as the physical residue of an artist's ideas. The reason why different artists from the past are "brought alive" again is because some aspect of their work becomes "usable" by living artists. That there is no "truth" as to what art is seems quite unrealized.

What is the function of art, or the nature of art? If we continue our analogy of the forms art takes as being art's *language* one can realize then that a work of art is a kind of *proposition* presented within the context of art as a comment on art. . . .

Works of art are analytic propositions. That is, if viewed within their context—as art—they provide no information what-so-ever about any matter of fact. A work of art is a tautology in that it is a presentation of the artist's intention, that is, he is saying that a particular work of art *is* art, which means, is a *definition* of art. Thus, that it is art is true *a priori* (which is what Judd means when he states that "if someone calls it art, it's art").

Indeed, it is nearly impossible to discuss art in general terms without talking in tautologies—for to attempt to "grasp" art by any other "handle" is to merely focus on another aspect or quality of the proposition which is usually irrelevant to the art work's "art condition." One begins to realize that art's "art condition" is a conceptual state. That the language forms which the artist frames his propositions in are often "private" codes or languages is an inevitable outcome of art's freedom from morphological constrictions; and it follows from this that one has to be familiar with contemporary art to appreciate it and understand it. Likewise one understands why the "man on the street" is intolerant to artistic art and always demands art in a traditional "language." (And one understands why formalist art "sells like hot cakes.") Only in painting and sculpture did the artists all speak the same language. What is called "Novelty Art" by the formalists is often the attempt to find new languages, although a new language doesn't necessarily mean the framing of new propositions: e.g. most kinetic and electronic art.

Another way of stating in relation to art what Ayer asserted about the analytic method in

the context of language would be the following: The validity of artistic propositions is not dependent on any empirical, much less any aesthetic, presupposition about the nature of things. For the artist, as an analyst, is not directly concerned with the physical properties of things. He is concerned only with the way (1) in which art is capable of conceptual growth and (2) how his propositions are capable of logically following that growth. In other words, the propositions of art are not factual, but linguistic in *character*—that is, they do not describe the behaviour of physical, or even mental objects; they express definitions of art, or the formal consequences of definitions of art. Accordingly, we can say that art operates on a logic. For we shall see that the characteristic mark of a purely logical enquiry is that it is concerned with the formal consequences of our definitions (of art) and not with questions of empirical fact.

To repeat, what art has in common with logic and mathematics is that it is a tautology; i.e., the "art idea" (or "work") and art are the same and can be appreciated as art without going outside the context of art for verification.

On the other hand, let us consider why art cannot be (or has difficulty when it attempts to be) a synthetic proposition. Or, that is to say, when the truth or falsity of its assertion is verifiable on empirical grounds. . . .

The unreality of "realistic" art is due to its framing as an art proposition in synthetic terms: one is always tempted to "verify" the proposition empirically. Realism's synthetic state does not bring one to a circular swing back into a dialogue with the larger framework of questions about the nature of *art* (as does the work of Malevich, Mondrian, Pollock, Reinhardt, early Rauschenberg, Johns, Lichtenstein, Warhol, Andre, Judd, Flavin, LeWitt, Morris, and others), but rather, one is flung out of art's "orbit" into the "infinite space" of the human condition.

Pure Expressionism, continuing with Ayer's terms, could be considered as such: "A sentence which consisted of demonstrative symbols would not express a genuine proposition. It would be a mere ejaculation, in no way characterizing that to which it was supposed to refer." Expressionist works are usually such "ejaculations" presented in the morphological language of traditional art. If Pollock is important it is because he painted on loose canvas horizontally to the floor. What *isn't* important is that he later put those drippings over stretchers and hung them parallel to the wall. (In other words, what is important in art is what one *brings* to it, not one's adoption of what was previously existing.) What is even less important to art is Pollock's notions of "self-expression" because those *kinds* of subjective meanings are useless to anyone other than those involved with him personally. And their "specific" quality puts them outside of art's context.

"I do not make art," Richard Serra says, "I am engaged in an activity; if someone wants to call it art, that's his business, but it's not up to me to decide that. That's all figured out later." Serra, then, is very much aware of the implications of his work. If Serra is indeed just "figuring out what lead does" (gravitationally, molecularly, etc.) why should *anyone* think of it as art? If he doesn't take the responsibility of it being art, who can, or should? His work certainly appears to be empirically verifiable: lead can do and be used for many physical activities. In itself this does anything but lead us into a dialogue about the nature of art. In a sense then he is a primitive. He has no idea about art. How is it then that we know about "his activity"? Because he has told us it is art by his actions *after* "his activity" has taken place. That is, by the fact he is with several galleries, puts the physical residue of his activity in museums (and sells them to art collectors—but as we have pointed out, collectors are irrelevant to the "condition of art" of a work). That he denies his work is art but plays the artist is more than just a paradox. Serra secretly feels that "arthood" is arrived at empirically.

What one finds all throughout the writings of Ad Reinhardt is this very similar thesis of

"art-as-art," and that "art is always dead, and a 'living' art is a deception." Reinhardt had a very clear idea about the nature of art, and his importance is far from being recognized.

Forms of art that can be considered synthetic propositions are verifiable by the world, that is to say, to understand these propositions one must leave the tautological-like framework of art and consider "outside" information. But to consider it as art it is necessary to ignore this same outside information, because outside information (experiential qualities, to note) has its own intrinsic worth. And to comprehend this worth one does not need a state of "art condition."

From this it is easy to realize that art's viability is not connected to the presentation of visual (or other) kinds of experience. That this may have been one of art's extraneous functions in the preceding centuries is not unlikely. After all, man in even the nineteenth-century lived in a fairly standardized visual environment. That is, it was ordinarily predictable as to what he would be coming into contact with day after day. His visual environment in the part of the world in which he lived was fairly consistent. In our time we have an experientially drastically richer environment. One can fly all over the earth in a matter of hours and days, not months. We have the cinema, and color television, as well as the man-made spectacle of the lights of Las Vegas or the skyscrapers of New York City. The whole world is there to be seen, and the whole world can watch man walk on the moon from their living rooms. Certainly art or objects of painting and sculpture cannot be expected to compete experientially with this?

The notion of "use" is relevant to art and its "language." Recently the box or cube form has been used a great deal within the context of art. (Take for instance its use by Judd, Morris, LeWitt, Bladen, Smith, Bell, and McCracken—not to mention the quantity of boxes and cubes that came after.) The difference between all the various uses of the box or cube form is directly related to the differences in the intentions of the artists. Further, as is particularly seen in Judd's work, the use of the box or cube form illustrates very well our earlier claim that an object is only art when placed in the context of art.

A few examples will point this out. One could say that if one of Judd's box forms was seen filled with debris, seen placed in an industrial setting, or even merely seen sitting on a street corner, it would not be identified with art. It follows then that understanding and consideration of it as an art work is necessary *a priori* to viewing it in order to "see" it as a work of art. Advance information about the concept of art and about an artist's concepts is necessary to the appreciation and understanding of contemporary art. Any and all of the physical attributes (qualities) of contemporary works if considered separately and/or specifically are irrelevant to the art concept. The art concept (as Judd said, though he didn't mean it this way) must be considered in its whole. To consider a concept's parts is invariably to consider aspects that are irrelevant to its art condition—or like reading *parts* of a definition.

It comes as no surprise that the art with the least fixed morphology is the example from which we decipher the nature of the general term "art." For where there is a context existing separately of its morphology and consisting of its function one is more likely to find results less conforming and predictable. It is in modern art's possession of a "language" with the shortest history that the plausibility of the abandonment of that "language" becomes most possible. It is understandable then that the art that came out of Western painting and sculpture is the most energetic, questioning (of its nature), and the least assuming of all the general "art" concerns. In the final analysis, however, all of the arts have but (in Wittgenstein's terms) a "family" resemblance.

Yet the various qualities relatable to an "art condition" possessed by poetry, the novel, the

cinema, the theatre, and various forms of music, etc., is that aspect of them most reliable to the function of art as asserted here.

Is not the decline of poetry relatable to the implied metaphysics from poetry's use of "common" language as an art language? In New York the last decadent stages of poetry can be seen in the move by "Concrete" poets recently toward the use of actual objects and theatre. Can it be that they feel the unreality of their art form? . . .

Here then I propose rests the viability of art. In an age when traditional philosophy is unreal because of its assumptions, art's ability to exist will depend not only on its *not* performing a service—as entertainment, visual (or other) experience, or decoration—which is something easily replaced by kitsch culture and technology, but rather, it will remain viable by *not* assuming a philosophical stance; for in art's unique character is the capacity to remain aloof from philosophical judgements. It is in this context that art shares similarities with logic, mathematics and, as well, science. But whereas the other endeavors are useful, art is not. Art indeed exists for its own sake.

In this period of man, after philosophy and religion, art may possibly be one endeavor that fulfills what another age might have called "man's spiritual needs." Or, another way of putting it might be that art deals analogously with the state of things "beyond physics" where philosophy had to make assertions. And art's strength is that even the preceding sentence is an assertion, and cannot be verified by art. Art's only claim is for art. Art is the definition of art.

ART & LANGUAGE

Letter to Lucy R. Lippard and John Chandler Concerning the Article "The Dematerialization of Art" (1968)

All the examples of art-works (ideas) you refer to in your article are, with few exceptions, art-objects. They may not be an art-object as we know it in its traditional matter-state, but they are nevertheless matter in one of its forms, either solid-state, gas-state, liquid-state. And it is on this question of matter-state that my caution with regard to the metaphorical usage of dematerialization is centred upon. Whether, for example, one calls Carl Andre's "substance of forms" empty space or not does not point to any evidence of dematerialization because the term "empty space" can never, in reference to terrestrial situations, be anything more than a convention describing how space is filled rather than offering a description of a portion of space which is, in physical terms, empty. Andre's empty space is in no sense a void. . . . Consequently, when you point, among many others, to an object made by Atkinson, "Map to not indicate etc.," that it has "almost entirely eliminated the visual-physical element," I am a little apprehensive of such a description. The map is just as much a solid-state object (i.e., paper with ink lines upon it) as is any Rubens (stretcher-canvas with paint upon it) and as such comes up for the count of being just as physically-visually perusable as the Rubens. . . .

* Art & Language, excerpts from a letter to Lucy R. Lippard and John Chandler, "Concerning the Article 'The Dematerialization of Art'" (23 March 1968), in Lucy R. Lippard, ed., *Six Years: The Dematerialization of the Art Object from 1966 to 1972* (1973; Berkeley: University of California Press, 1997), 43–44. By permission of the authors.

Matter is a specialized form of energy; radiant energy is the only form in which energy can exist in the absence of matter. Thus when dematerialization takes place, it means, in terms of physical phenomena, the conversion (I use this word guardedly) of a state of matter into that of radiant energy; this follows that energy can never be created or destroyed. But further, if one were to speak of an art-form that used radiant energy, then one would be committed to the contradiction of speaking of a formless form, and one can imagine the verbal acrobatics that might take place when the romantic metaphor was put to work on questions concerning formless-forms (non-material) and material forms. The philosophy of what is called aesthetics relying finally, as it does, on what it has called the content of the art work is, at the most, only fitted with the philosophical tools to deal with problems of an art that absolutely counts upon the production of matter-state entities. The shortcomings of such philosophical tools are plain enough to see inside this limit of material objects; once this limit is broken these shortcomings hardly seem worth considering as the sophistry of the whole framework is dismissed as being not applicable to an art procedure that records its information in words, and the consequent material qualities of the entity produced (i.e., typewritten sheet, etc.) do not necessarily have anything to do with the idea. That is, the idea is "read about" rather than "looked at." That some art should be directly material and that other art should produce a material entity only as a necessary by-product of the need to record the idea is not at all to say that the latter is connected by any process of dematerialization to the former.

Introduction to Art–Language (1968–69)

Suppose the following hypothesis is advanced: that this editorial, in itself an attempt to evince some outlines as to what "conceptual art" is, is held out as a "conceptual art" work. At first glance this seems to be a parallel case to many past situations within the determined limits of visual art, for example the first Cubist painting might be said to have attempted to evince some outlines as to what visual art is, whilst, obviously, being held out as a work of visual art. But the difference here is one of what shall be called "the form of the work." Initially what conceptual art seems to be doing is questioning the condition that seems rigidly to govern the form of visual art—that visual art remains visual.

During the past two years, a number of artists have developed projects and theses, the earliest of which were initially housed (pretty solidly) within the established constructs of visual art. Many of these projects etc. have evolved in such a manner that their relationship to visual art conventions has become increasingly tenuous. The later projects particularly are represented through objects, the visual form of which is governed by the form of the conventional signs of written language (in this case English). The content of the artist's idea is expressed through the semantic qualities of the written language. As such, many people would judge that this tendency is better described by the category-name "art-theory" or "art criticism"; there can be little doubt that works of "conceptual art" can be seen to include both the periphery of art criticism and of art theory, and this tendency may well be amplified. With regard to this particular point, criteria bearing upon the chronology of art theory may have to be more severely and stringently accounted for, particularly in terms of evolutionary

* Art & Language, excerpt from "Introduction to Art-Language" (1968–69), *Art-Language* 1 (May 1969); reprinted in *Art-Language* (Eindhoven: Van Abbemuseum, 1980), 19–26. By permission of the authors.

VOLUME I NUMBER I MAY 1969

Art-Language

The Journal of conceptual art

Edited by Terry Atkinson, David Bainbridge,
Michael Baldwin, Harold Hurrell

Contents

Art & Language, cover of *Art-Language* 1, no. 1 (May 1969).

analogies. For example the question is not simply: "Are works of art theory part of the kit of the conceptual artist, and as such can such a work, when advanced by a conceptual artist come up for the count as a work of conceptual art?" but also: "Are past works of art-theory now to be counted as works of conceptual art?" What has to be considered here is the intention of the conceptual artist. It is very doubtful whether an art theoretician could have advanced one of his works as a work of "conceptual art" (say) in 1964, as the first rudiments of at least an embryonic awareness of the notion of "conceptual art" were not evident until 1966. The intention of the "conceptual artist" has been separated off from that of the art theoretician because of their previously different relationships and standpoint toward art, that is, the nature of their involvement in it.

If the question is formed the other way round, that is, not as "Does art-theory come up for the count as a possible sector of 'conceptual art'?" but as, "Does 'conceptual art' come up for the count as a possible sector of art-theory?" then a rather vaguely defined category is being advanced as a possible member of a more established one. Perhaps some qualification can be made for such an assertion. The development of some work by certain artists both in Britain and the U.S.A. does not, if their intentions are to be taken into account, simply mean a matter of transfer of function from that of artist to that of art-theoretician, it has necessarily involved the intention of the artist to count various theoretical constructs as art works. This has contingently meant, either (1) If they are to be "left alone" as separate, then re-defining carefully the definitions of both art and art theory, in order to assign more clearly what kind of entity belongs to which category. If this is taken up it usually means that the defini-

tion of art is expanded, and art theoreticians then discuss the consequences and possibilities of the new definitions, the traditional format of the art theoretician discussing what the artist has implied, entailed etc., by his "creative act." Or (2) To allow the peripheral area between the two categories some latitude of interpretation and consequently account the category "art theory" a category which the category "art" might expand to include. The category "maker of visual art" has been traditionally regarded as solely the domain of the visual-art-object producer (i.e. the visual-art artist). There has been a hierarchy of languages headed by the "direct read-out from the object" language which has served as the creative core, and then various support languages acting as explicative and elucidatory tools to the central creative core. The initial language has been what is called "visual," the support languages have taken on what shall be called here "conventional written sign" language-form. What is surprising is that although the central core has been seen to be an ever evolving language no account up to the present seems to have taken up the possibility of this central core evolving to include and assimilate one or other or all of the support languages. It is through the nature of the evolution of the works of "conceptual art" that the implicated artists have been obliged to take account of this possibility. Hence these artists do not see appropriateness of the label "art theoretician" necessarily eliminating the appropriateness of the label "artist." Inside the framework of "conceptual art" the making of art and the making of a certain kind of art theory are often the same procedure. . . .

ZORAN POPOVIĆ For Self-Management Art (1975)

It is generally believed that art is independent of ideology. This thesis has become the rule in our cultural public besides other things because of inherited (artistic) practice, the existing state-administrative bureaucracy, as well as the existing liberalism, which has gained ground among us in the past fifteen years. Due to the objective affirmation of technocracy, bureaucracy became its ally. Although technocracy is not in favour of ideology and therefore enters into an opposition against bureaucracy, the latter cannot stand technocracy to that degree which it is against knowledge. Nevertheless they are allied with each other in order to gain power, so that the minority can effectively rule over the majority, which is the basic condition of their existence. Since technocracy sees progress only perpetuated by a professional elite, it sees the possibility of revolutionary changes in art only if the elite is changed. Technocracy thus divides society (the cultural public) into the "elite" and the "masses," into active and passive ones, into those who govern and those who are being governed. By manipulating knowledge, technocracy has a monopoly over it and thus also over people. Owing to liberalism, which formally defends freedom, the power of technocracy is increasing, and technocracy, which has an arsenal of instruments provided by the bureaucracy, consolidates the opinion about "universal" aesthetic values which are inevitably needed for an effective activity of techno-liberalism in the world of art. The defence of these "universal" values of art is needed in order to uphold the opinion about the autonomy of art, its independence from the dictatorship of ideology, about its straightforward progress, which is nothing else but a projection of undialectical idealism. The "universal"

* Zoran Popović, "For Self-Management Art," *October 75* (Belgrade) 1 (1975); reprinted in *Vision 2* (January 1976): 23–24. By permission of the author.

values of art are the values of the conflictless spectacular art of the bourgeois consumer society based on the type of values of the petite bourgeoisie, due to the established balance of power. All this finally functions on behalf of the preservation of the hegemony of Western culture over world culture in line with tendencies of the late capitalism, and its imperialistic needs and aims. The artistic liberalistic technocracy is—on behalf of "irresistible progress" in art (society)—persistently against ideology, whereas it establishes the bourgeois ideology in practice.

The basis of the existence of bureaucracy proceeds from a complex distribution of labour and a corresponding hierarchy. Artists in Yugoslavia, and also elsewhere, consider their professional practice as something normal, as a consequence of which they see their position in the social distribution of labour in such a way that society should finance the artists with regard to their rank. The bureaucracy can then easily direct this isolated social group, because the group itself chose that place where it belongs.

The work of art, artistic activity, should include a new presumption on the level of an alternative, which would take a radical critical attitude regarding the artistic practice so far; because of this transcending of the existing artistic conformity (the existing sociability), in which formal changes took place, and in which one artistic context was exchanged for another whereas the establishment did not change, i.e., the establishment which essentially defines the functions of art, and functions of the artists. Therefore the politicization of art is unavoidable. Art must be negative, critical of the external world as well as its own language, its own artistic practice. It is absurd and hypocritical to be committed, to speak and act on behalf of the humanism of mankind, on behalf of political and economic freedom, and on the other hand to be passive in relation to the system of the "universal" values of art, i.e. to that system which provides the basic condition for the existence of the artistic bureaucracy and along with it for the unbelievable art-star plundering. As soon as the artistic bureaucracy gains power, it manipulates for the sake of its own reproduction and it always supports those phenomena which prolong its existence. In this way it directs and "arranges" artistic productivity and the relations of production. The bureaucracy creates an inert artist and a passive consumer of art, it creates "gaily tempered robots," with the help of its monopoly over information and education. Along with the mass of disoriented and disorganized artists and the uninformed customers, the power of the artistic bureaucracy (art historians, curators, gallery directors, officials at the secretariat of culture and other cultural and educational institutions, critics, artists, etc.) is growing strong. On behalf of the "universal" values of art, committed art becomes the aesthetics of politics, which leads to the production of fact materials in the Fascist sense. Art as the aesthetics of politics is a projection of etatistic-administrative as well as of technocratic-liberal conformism: the total opposite of the Marxist understanding of art which includes the politicization of art.

Our work must not turn into an apology of the artistic status quo, of our complete cultural alienation, we must not rejuvenate the blood of the conservative and dogmatic, socially dangerous establishment, which holds the common cultural values of people in the hands of a few, which has the monopoly over the art market over artistic production and, what is most significant, over the source of information and education, all this in order to reproduce its own parasitic life. The artists should cease their passivity, which prolongs the parasitic life of their bloodsuckers. They should cease to support the class enemy of the proletariat, in order not to produce such works as demanded and "arranged" by the bureaucracy, its power of decision-making, distribution of awards, purchase policy, organization of exhibi-

tions, financing of culture, scholarships, and so on. We, the artists, should seriously reexamine our allies, our interests, our work, our role and our real social position. All those artists who are disinterested regarding the existing sociability, who care only for themselves, belong to either the category of the bureaucracy or [the] petite bourgeoisie, which form the socio-psychological basis for development of the usurpation of power, mastery over man and plundering of man.

The contradiction lies in the fact that new artistic suppositions become known to the public only if they correspond with the system of the artistic bureaucracy. It is unlikely that there would have been any "excitement" at the appearance of a "new art" in our cultural public, if these works and activities were outside the control of the system of artistic bureaucracy. Only an established public opinion can negate the bureaucracy, or rather, the mystery of bureaucracy. That is why the bureaucracy is most interested in preserving the information monopoly and control of all means of public communication, because it is one of the essential conditions for the usurpation of power and self-reproduction. Thus bureaucracy ignores indefinitely the real state of affairs, the real reality, in favour of bureaucratic reality, by spreading misinformation instead of information. Misinformation is more dangerous than information that has not been conveyed. The remaking of history has proved to be a successful method of oppression, of killing new theses and the new artistic alternatives, which are critical towards hitherto existing art practice.

SOL LEWITT Paragraphs on Conceptual Art (1967)

The editor has written me that he is in favor of avoiding "the notion that the artist is a kind of ape that has to be explained by the civilized critic." This should be good news to both artists and apes. With this assurance I hope to justify his confidence. To continue a baseball metaphor (one artist wanted to hit the ball out of the park, another to stay loose at the plate and hit the ball where it was pitched), I am grateful for the opportunity to strike out for myself.

I will refer to the kind of art in which I am involved as conceptual art. In conceptual art the idea of concept is the most important aspect of the work. When an artist uses a conceptual form of art, it means that all of the planning and decisions are made beforehand and the execution is a perfunctory affair. The idea becomes a machine that makes the art. This kind of art is not theoretical or illustrative of theories; it is intuitive, it is involved with all types of mental processes and it is purposeless. It is usually free from the dependence on the skill of the artist as a craftsman. It is the objective of the artist who is concerned with conceptual art to make his work mentally interesting to the spectator, and therefore usually he would want it to become emotionally dry. There is no reason to suppose however, that the conceptual artist is out to bore the viewer. It is only the expectation of an emotional kick, to which one conditioned to expressionist art is accustomed, that would deter the viewer from perceiving this art.

Conceptual art is not necessarily logical. The logic of a piece or series of pieces is a device that is used at times only to be ruined. Logic may be used to camouflage the real intent of

* Sol LeWitt, "Paragraphs on Conceptual Art," *Artforum* 5, no. 10 (June 1967): 79. By permission of the author and the publisher.

Drawing Series 1968 (Fours)

Sol Lewitt

IV/Cross Reverse

IV/Cross Reverse

1 2	3 4
3 4	1 2

4 3	2 1
2 1	4 3

In III and IV all of the corners and all of the centres are different.

A system of four series comprising 192 drawings completes the work:

$4 \times 24 = 96 \times 2 (A + B) = 192$

The entire work will be done as a book.

The page of a book is an absolute, two-dimensional space. A book is complete and intimate. The whole set would be at hand.

There will be a drawing on each page and each spread of two pages will contain A and B of the same drawing.

The book will be separated into four sections, each containing a complete set done in methods A and B (forty-eight drawings). A will be only on left-hand pages, B only on right-hand pages.

The set will also be done on two three-dimensional forms 6×4 ft.

One will contain A, the other B.

These two $4 \times 4 \times 6$ ft (high) forms will contain the whole set.

Each face will contain one series.

A and B will be placed side by side with similar series facing in the same direction.

I—North, II—East, III—South, IV—West and placed close enough together to be seen at the same time.

The drawings are made in pencil (6H) on a baked white flat enamel surface.

Parts of the set, and individual drawings, have been done on walls.

The quality of line and appearance of the wall-drawing depend a great deal on the surface of the wall and the use of a hard pencil (6H).

The lines must be light to merge with the surface of the wall and, in the case of method B, to obviate the tonal and illusionistic properties of this method.

These wall-drawings may be done by any hand (mine included) as long as the directions are followed, i.e. the lines be close together, light, and follow the correct direction. (Each person who draws the lines would, of course, do it slightly differently.)

The drawings are done on the wall, directly, so that a condition of absolute two-dimensionality is maintained.

Any intervening material on which drawings are made results in an object.

Two dimensional works are not seen as objects.

The work is the manifestation of an idea. It is an idea and not an object.

The work is immovable. The actual wall-drawing either remains in place or is obliterated.

A similar drawing can be done in another location.

The drawing and its location are in an absolute relationship.

Each drawing is composed of four squares which are in turn divided into four squares, each with a different value (1, 2, 3, 4). Each quarter has a 1, 2, 3 and a 4. These series contain all twenty-four permutations of 1 2 3 4.

They are rendered in two methods, flat (A) and tonal (B).

(A) 1 is represented by vertical lines
2 is represented by horizontal lines
3 is represented by diagonal lines left to right
4 is represented by diagonal lines right to left

—these are the four different absolute directions of line

(B) 1 is the same as in (A)
2 is 1 + 2
3 is 1 + 2 + 3
4 is 1 + 2 + 3 + 4

—these are four gradations of tonality in controlled stops

The lines should be drawn as closely together as possible.

The sets of twenty-four permutations of 1 2 3 4 are arranged in this order: 1/1234 2/1243 3/1324 4/1324 5/1423 6/1432 7/2134 8/2143 9/2314 10/2341 11/2413 12/2431 13/3124 14/3142 15/3214 16/3241 17/3412 18/3421 19/4123 20/4132 21/4213 22/4321 23/4312 24/4321

There are four different series (systems for changing the combinations of the squares).

There are many other possible series but I have limited my choice to four.

I/ Rotation

1 2	3 1
3 4	4 2

2 4	4 3
1 3	2 1

II/Mirror

1 2	2 1
3 4	4 3

3 4	4 3
1 2	2 1

In I and II all of the corners are the same, and all of the centre squares are also the same.

III/Cross Mirror

1 2	1 3
3 4	2 4

3 1	3 4
4 2	1 2

I

II

III

IV

Sol LeWitt, "Drawing Series 1968 (Fours)," *Studio International* 177, no. 910 (April 1969): 189. © Sol LeWitt. By permission of the artist.

the artist, to lull the viewer into the belief that he understands the work, or to infer a paradoxical situation (such as logic vs. illogic). The ideas need not be complex. Most ideas that are successful are ludicrously simple. Successful ideas generally have the appearance of simplicity because they seem inevitable. In terms of idea the artist is free to even surprise himself. Ideas are discovered by intuition.

What the work of art looks like isn't too important. It has to look like something if it has physical form. No matter what form it may finally have it must begin with an idea. It is the process of conception and realization with which the artist is concerned. Once given physical reality by the artist the work is open to the perception of all, including the artist. (I use the word "perception" to mean the apprehension of the sense data, the objective understanding of the idea and simultaneously a subjective interpretation of both.) The work of art can only be perceived after it is completed.

Art that is meant for the sensation of the eye primarily would be called perceptual rather than conceptual. This would include most optical, kinetic, light and color art.

Since the functions of conception and perception are contradictory (one pre-, the other postfact) the artist would mitigate his idea by applying subjective judgment to it. If the artist wishes to explore his idea thoroughly, then arbitrary or chance decisions would be kept to a minimum, while caprice, taste and other whimsies would be eliminated from the making of the art. The work does not necessarily have to be rejected if it does not look well. Sometimes what is initially thought to be awkward will eventually be visually pleasing.

To work with a plan that is pre-set is one way of avoiding subjectivity. It also obviates the necessity of designing each work in turn. The plan would design the work. Some plans would require millions of variations, and some a limited number, but both are finite. Other plans imply infinity. In each case however, the artist would select the basic form and rules that would govern the solution of the problem. After that the fewer decisions made in the course of completing the work, the better. This eliminates the arbitrary, the capricious, and the subjective as much as possible. That is the reason for using this method.

When an artist uses a multiple modular method he usually chooses a simple and readily available form. The form itself is of very limited importance; it becomes the grammar for the total work. In fact it is best that the basic unit be deliberately uninteresting so that it may more easily become an intrinsic part of the entire work. Using complex basic forms only disrupts the unity of the whole. Using a simple form repeatedly narrows the field of the work and concentrates the intensity to the arrangement of the form. This arrangement becomes the end while the form becomes the means.

Conceptual art doesn't really have much to do with mathematics, philosophy or any other mental discipline. The mathematics used by most artists is simple arithmetic or simple number systems. The philosophy of the work is implicit in the work and is not an illustration of any system of philosophy.

It doesn't really matter if the viewer understands the concepts of the artist by seeing the art. Once out of his hand the artist has no control over the way a viewer will perceive the work. Different people will understand the same thing in a different way.

Recently there has been much written about minimal art, but I have not discovered anyone who admits to doing this kind of thing. There are other art forms around called primary structures, reductive, rejective, cool, and mini-art. No artist I know will own up to any of these either. Therefore I conclude that it is part of a secret language that art critics use when communicating with each other through the medium of art magazines. Mini-art is best because it reminds one of mini-skirts and long-legged girls. It must refer to very small works

of art. This is a very good idea. Perhaps mini-art shows could be sent around the country in matchboxes. Or maybe the mini-artist is a very small person, say under five feet tall. If so, much good work will be found in the primary schools (primary school primary structures).

If the artist carries through his idea and makes it into visible form, then all the steps in the process are of importance. The idea itself, even if not made visual is as much a work of art as any finished product. All intervening steps—scribbles, sketches, drawings, failed work, models, studies, thoughts, conversations—are of interest. Those that show the thought process of the artist are sometimes more interesting than the final product.

Determining what size a piece should be is difficult. If an idea requires three dimensions then it would seem any size would do. The question would be what size is best. If the thing were made gigantic then the size alone would be impressive and the idea may be lost entirely. Again, if it is too small, it may become inconsequential. The height of the viewer may have some bearing on the work and also the size of the space into which it will be placed. The artist may wish to place objects higher than the eye level of the viewer, or lower. I think the piece must be large enough to give the viewer whatever information he needs to understand the work and placed in such a way that will facilitate this understanding. (Unless the idea is of impediment and requires difficulty of vision or access.)

Space can be thought of as the cubic area occupied by a three-dimensional volume. Any volume would occupy space. It is air and cannot be seen. It is the interval between things that can be measured. The intervals and measurements can be important to a work of art. If certain distances are important they will be made obvious in the piece. If space is relatively unimportant it can be regularized and made equal (things placed equal distances apart), to mitigate any interest in interval. Regular space might also become a metric time element, a kind of regular beat or pulse. When the interval is kept regular whatever is irregular gains more importance.

Architecture and three-dimensional art are of completely opposite natures. The former is concerned with making an area with a specific function. Architecture, whether it is a work of art or not, must be utilitarian or else fail completely. Art is not utilitarian. When three-dimensional art starts to take on some of the characteristics of architecture such as forming utilitarian areas it weakens its function as art. When the viewer is dwarfed by the large size of a piece this domination emphasizes the physical and emotive power of the form at the expense of losing the idea of the piece.

New materials are one of the great afflictions of contemporary art. Some artists confuse new materials with new ideas. There is nothing worse than seeing art that wallows in gaudy baubles. By and large most artists who are attracted to these materials are the ones that lack the stringency of mind that would enable them to use the materials well. It takes a good artist to use new materials and make them into a work of art. The danger is, I think, in making the physicality of the materials so important that it becomes the idea of the work (another kind of expressionism).

Three-dimensional art of any kind is a physical fact. This physicality is its most obvious and expressive content. Conceptual art is made to engage the mind of the viewer rather than his eye or emotions. The physicality of a three-dimensional object then becomes a contradiction to its non-emotive intent. Color, surface, texture, and shape only emphasize the physical aspects of the work. Anything that calls attention to and interests the viewer in this physicality is a deterrent to our understanding of the idea and is used as an expressive device. The conceptual artist would want to ameliorate this emphasis on materiality as much as possible or to use it in a paradoxical way. (To convert it into an idea.) This kind of art then, should be

stated with the most economy of means. Any idea that is better stated in two dimensions should not be in three dimensions. Ideas may also be stated with numbers, photographs, or words or any way the artist chooses, the form being unimportant.

These paragraphs are not intended as categorical imperatives but the ideas stated are as close as possible to my thinking at this time. These ideas are the result of my work as an artist and are subject to change as my experience changes. I have tried to state them with as much clarity as possible. If the statements I make are unclear it may mean the thinking is unclear. Even while writing these ideas there seemed to be obvious inconsistencies (which I have tried to correct, but others will probably slip by). I do not advocate a conceptual form of art for all artists. I have found that it has worked well for me while other ways have not. It is one way of making art: other ways suit other artists. Nor do I think all conceptual art merits the viewer's attention. Conceptual art is only good when the idea is good.

Sentences on Conceptual Art (1969)

1. Conceptual Artists are mystics rather than rationalists. They leap to conclusions that logic cannot reach.

2. Rational judgements repeat rational judgements.

3. Illogical judgements lead to new experience.

4. Formal Art is essentially rational.

5. Irrational thoughts should be followed absolutely and logically.

6. If the artist changes his mind midway through the execution of the piece he compromises the result and repeats past results.

7. The artist's will is secondary to the process he initiates from idea to completion. His wilfulness may only be ego.

8. When words such as painting and sculpture are used, they connote a whole tradition and imply a consequent acceptance of this tradition, thus placing limitations on the artist who would be reluctant to make art that goes beyond the limitations.

9. The concept and idea are different. The former implies a general direction while the latter are the components. Ideas implement the concept.

10. Ideas alone can be works of art; they are in a chain of development that may eventually find some form. All ideas need not be made physical.

11. Ideas do not necessarily proceed in logical order. They may set one off in unexpected directions but an idea must necessarily be completed in the mind before the next one is formed.

12. For each work of art that becomes physical there are many variations that do not.

13. A work of art may be understood as a conductor from the artist's mind to the viewer's. But it may never reach the viewer, or it may never leave the artist's mind.

14. The words of one artist to another may induce an idea's chain, if they share the same concept.

15. Since no form is intrinsically superior to another, the artist may use any form, from an expression of words (written or spoken) to physical reality, equally.

16. If words are used, and they proceed from ideas about art, then they are art and not literature, numbers are not mathematics.

* Sol LeWitt, "Sentences on Conceptual Art," *0–9* (January 1969): 4; reprinted in *Art-Language* 1, no. 1 (May 1969): 11–13; and in Ursula Meyer, *Conceptual Art* (New York: E. P. Dutton, 1972), 174–75. By permission of the author.

17. All ideas are art if they are concerned with art and fall within the conventions of art.

18. One usually understands the art of the past by applying the conventions of the present thus misunderstanding the art of the past.

19. The conventions of art are altered by works of art.

20. Successful art changes our understanding of the conventions by altering our perceptions.

21. Perception of ideas leads to new ideas.

22. The artist cannot imagine his art, and cannot perceive it until it is complete.

23. One artist may mis-perceive (understand it differently than the artist) a work of art but still be set off in his own chain of thought by that misconstrual.

24. Perception is subjective.

25. The artist may not necessarily understand his own art. His perception is neither better nor worse than that of others.

26. An artist may perceive the art of others better than his own.

27. The concept of a work of art may involve the matter of the piece or the process in which it is made.

28. Once the idea of the piece is established in the artist's mind and the final form is decided, the process is carried out blindly. There are many side-effects that the artist cannot imagine. These may be used as ideas for new works.

29. The process is mechanical and should not be tampered with. It should run its course.

30. There are many elements involved in a work of art. The most important are the most obvious.

31. If an artist uses the same form in a group of works, and changes the material, one would assume the artist's concept involved the material.

32. Banal ideas cannot be rescued by beautiful execution.

33. It is difficult to bungle a good idea.

34. When an artist learns his craft too well he makes slick art.

35. These sentences comment on art, but are not art.

MEL BOCHNER Book Review (1973)

A point has been reached, with the publication of Lucy Lippard's book *The Dematerialization of the Art Object from 1966 to 1972,* where certain propositions can no longer go unquestioned. The understanding of the importance of these propositions will come only from an investigation of the internal contradictions of the book itself which, in turn, will reveal its hidden theoretical and ethical implications. As is often the case, the covert meaning of the structure differs from the expressed intentions.

To document the history of six years of extremely active and possibly radical art requires a sense of responsibility to the spirit of the art itself. The bibliographic processes must be systematic, clear, informed, and consistent within the chosen theoretical framework. Lippard's book does not satisfy these criteria. The plan of the book as presented on the jacket is an "intentional reflection of the chaotic network connected with so-called conceptual art. . . . " In her preface the author writes frequently and positively of "fragmentation";

* Mel Bochner, "Book Review," *Artforum* 11, no. 10 (June 1973): 74–75. By permission of the author and the publisher.

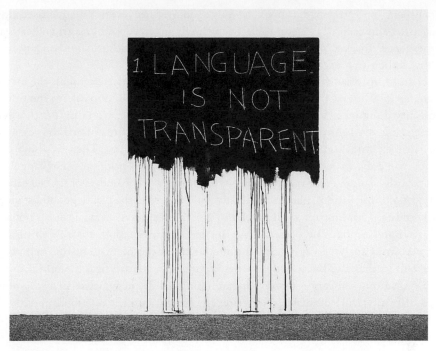

Mel Bochner, *Language Is Not Transparent,* 1969–70, chalk and paint on wall installation for *Language Show,* Dwan Gallery. By permission of the artist. Photo courtesy Sonnabend Gallery, New York.

"Fragmentation is more like direct communication than the traditionally unified approach in which superfluous literary transitions are introduced." Support of this updated McLuhanism lies in the dense, chaotic, "fragmented" mixture of type sizes, faces, and weights which list, in constant and confusing reversal, books (alphabetically by author) and exhibitions or mailing pieces (chronologically by month and year). Lippard insistently substitutes the fragmentation method for what she considers the *fallacia consequentis* of continuity, i.e., "superfluous literary transitions." The problem of this format is not one of "superfluous literary transitions" but of an arbitrary mode of selection camouflaged by a supposedly objective presentation of primary data. The visually impenetrable layout with its lists and jump-cuts presents a parody of her assumptions about the content of this art. The "design" mimics certain stylistic conventions of Conceptual art. While fragmentation is held to be a more accurate organizing principle, it is contradicted on every other page by the insertion of editorial comments and by chronological preferences. Chaos resulting from this type of operation is not inherent chaos, but a symptom of an unwillingness, or inability, to define particular issues.

A refusal to acknowledge more rigorous structural principles demonstrated by this art results in a book-length pastiche. Parodistic imitation appeared earlier in Lippard's writing, most notably her introduction in The Museum of Modern Art's *Information* exhibition catalogue, and her contribution to the Sol LeWitt catalogue published in The Hague, Netherlands, two years ago. For this occasion she did a typographic "rendition" of a LeWitt grid drawing with the heading "Imitation-Hommage." Imitation on the part of a critic is a form of self-indulgence. In this book, and several previous catalogues of exhibitions, it has been disguised

as a "document" and presented in an unchallenged context because of the advertised closeness between artist and critic: "The editor has been closely involved with the art and artists since their emergence" (jacket blurb). This "involvement" lends an authority and uncontestability to what is explicitly an *uncritical endeavor.*

The critic as historian is no more acceptable than the critic as artist, unless the methodology is changed. Without this change the surreptitious slide from one role to the other slurs the neutrality essential to historical evaluation. Unlike the critic, who can function without criticizing the given assumptions of the artist's order, historians are obliged to present a context for their examination of contradictions in the existing order. There is also a cultural distinction to be made. A critic has a "job," a historian has a "position." The language distinction reveals that the critic is accepted as a functionary of the endeavor (in the capacity of a distributor of information), but that the historian is accorded the privileges of distance from the marketplace. That Lippard would prefer to present her activities as history is not surprising. This suppresses the issue of partiality. But in her presentation, the role of historian is transformed from analyst to apologist, and the writing of immediate history tempts her to participate in its making. Because distance is sacrificed, and analytical thought dismissed as "literary transitions," history is frozen into an individualistic perspective unaware of its undisclosed distortions and incapable of offering any insight into the relationship of the works themselves. The struggle between ideas is eliminated by bibliographies, timetables, or simple memoirs of individuals and accidental encounters.

In her own anticipated defense she writes " . . . the point I want to make is phenomenological not historical." The use of the word "phenomenology" in the current art vocabulary is an abuse of its meaning. When Husserl wrote "go to the things themselves" he was not suggesting the compilation of lists of "things," or the presentation of unexamined raw experiences. Phenomenology is the radical postulate of "presuppositionless lived experience" as a technique for the investigation of intentionality (how the world is our construction of it). It was not a withdrawal from analysis, but a method for bringing subjectivity under logical scrutiny. The consequences for philosophy itself inevitably involved a return to the questions of idealism and transcendental subjectivity. (This process came into the language of contemporary art criticism as a question of "objecthood versus objectness"—a case of trivialization, or simply a confusion with 19th-century Phenomenalism.) The problem of this misused terminology is that it incorrectly identifies the issues being argued in the art. It is the differentiation of the attitudes of these artists that is important, not the author's projected similarity of their stylistic means.

When Lippard claims no theoretical basis for selection, she nonetheless admits that she could not include everything that happened during that period (which would be like the map in Lewis Carroll's *Silvie and Bruno,* with the scale of one inch = one inch, obviating the need for any map at all). She offers the following rationale: "I would like this book to *reflect* that *gradual* de-emphasis of sculptural concerns, and as the book *evolves,* I have deliberately *concentrated* on textual and photographic work" (italics mine). The implications of the italicized words point up the contradiction between the expressed bibliographic structure of the book and the actual organizational principles. Lippard sees the book as having an internal evolution reflective of the evolution of Concept art from Minimal sculpture. Then she proposes the book as congruent with the period, setting *herself* up as the principle of selection by the method of "concentration." Her statement above is a disguised confession, particularly when juxtaposed with the opening claim: " . . . There is no precise reason for certain inclusions and exclusions except personal prejudice and an idiosyncratic method of categorization." There is nothing

"idiosyncratic" about this reading of history. It has been central to general art-critical aware-ness for at least four years. Lippard has personally emphasized this centrality in terms of the exhibitions she arranged, wrote about, and now cross-references.

In journalistically rejecting theoretical grounds, she ignores the covert line she is pushing. Acknowledgement of a theoretical basis for this art would reveal aspects antithetical to her premises: for example, it would become evident that many of the artists she lists outlined the premises of their art quite early, independent of more traditional concerns in sculpture, and that any development was not teleological. Lippard's lack of perspective leads her to patronize intentions, "Some artists now think it's absurd to fill up their studios with objects that won't be sold, and are trying to get their art communicated as rapidly as it is made." Her refusal to engage the complex and often contradictory intellectual questions being raised, reduces the intentions of an art attempting a forceful critique of the existing social and esthetic order into a series of purely self-promotional activities.

The principles of exclusion deserve more attention. A basic tenet of the book is that a piece of mail is to be considered a work of art. Ray Johnson is eliminated, however, because it is said of his mailings that they would "confuse issues," and the book would become "unman-ageable if *some* similarity of esthetic intention were not maintained" (italics Lippard's). On the surface this appears to be an acceptable premise, yet why, then, does she exclude an artist of the stature of Dan Flavin, particularly since his art seriously investigated aspects of "dema-terialization." Flavin certainly is not to be excluded on the grounds of a lack of "esthetic similarity," as he was one of the strongest proponents of the "lean-pared-down-look," and one of the first and most consequential artists to write theoretically about his art during the period in question.

The function of "fragmentation" can now be identified as a hidden exclusion principle. Lippard's form derives from the French "nouveau roman," in books such as Butor's *Mobile,* which merely distort developmental logic rather than supplant it. In contrast, narrative fiction as a model yields a history of sequences . . . if A then B, if B then C, if C . . . etc. What is offered is nothing more than a disguised remodeling of the patrimony theory of art history. The machinery of art history is designed to bestow legitimacy by forging a sequential devel-opment which accedes to the demands of causal reasoning for the existence of specific works of art. Artists who do not fit the simplified *a priori* causal schema or who do not conform to prescribed attitudes are eliminated.

The Dematerialization of the Art Object is not a conscious corruption of history. It is a victim of historical forces it is unable to acknowledge. To confront these forces requires an analysis of the political and economic issues that inform esthetic problems. Books such as this one have a predetermined use demanded by the system of distribution. They function to shore up a position, establish theoretical domains, create hierarchies of individuals for the market, provide definitive reference works, and indoctrinate supporters. In this way, it is only another ideological handbook. But it is more dangerous because Lippard fronts a phantom objectivity, an autonomy that appears so strictly rational and all-embracing as to conceal every trace of its purposes. To jump from a listing for a 1968 work by Lawrence Weiner to this entry, "Sept. 26 (1968) Amsterdam: Boezem sends out map and documentation of the day's weather report and meteorological analysis entitled 'Medium for the Furtherance of Renewed Experiences,' " is to debase the content of Weiner's art by juxtaposing it with an obvious neo-Fluxist ploy, such as declaring the weather map-as-art. This cannot be defended, as Lippard attempts in the preface by saying, "I have included certain work here because it illustrates . . . how far ideas can be taken before they become exhausted or totally absurd."

It simply is impossible for the uninitiated reader to distinguish a time-dissipation factor when the works enter the public domain almost simultaneously. Lippard's notion of how art informs other art is one of misguided democratization, defined as everybody can understand everything. Specific content is not important. The effect of this process is to present a mass of information, from which all contradictory and conflicting ideas have been factored out by juxtaposition. Yet Lippard proposes intuition and "fragmentation" in order to cover up the inconsistencies necessary to perpetuate the illusion of wholeness.

In the Lippard book, the inconsistencies are obvious. The volume is indexed. It lists the artists alphabetically and measures the amount of their comparative contributions. Lippard's biases are easy to reconstruct. This process facilitates the rating of an individual artist's "worth" by *typographic weight*. The index is a direct refutation of her opening claim to an "anti-individualistic" point of view, and functions as a very adequate replacement for "a traditionally unified approach."

This book is in a unique position, one enjoyed by few other art histories, except some dealing with ancient art. Much, if not most, of the art it records is no longer in existence. The temporal continuity of these works is in the form and place given by this book. That is too arbitrary a process to let it slide unquestioned into the general culture. The author has assumed a responsibility which cannot be reconciled with the technique of pasting old clippings and announcements together. This "assemblage" technique is rendered invisible by what Roland Barthes calls the "terrorism of the printed page." The device of the invisible narrator is a 19th-century novelistic device for composing historical fiction, in order to manipulate the unaware reader's responses.

Another serious issue is the self-fulfilling implication of the title itself. By attempting to imitate the future it distorts the present. Some art critics believe that their contribution to culture is enhanced by coining titles for "art movements." Her term, "dematerialization," has been filtering into general usage as a prescriptive device used in an ethical context. It suggests the immorality of artists who continue to make objects. A letter from the Art-Language group, published in this book, is an accurate analysis of the word and its misuse:

> All the examples of art-works (ideas) that you refer to in your article are, with few exceptions, art-objects. They may not be an art-object in this traditional matter-state, but they nevertheless are matter in one of its forms, solid-state, gas-state, liquid-state. And it is on this question of matter-state that my caution with regard to the *metaphorical* usage of dematerialization is centered upon . . . That some art should be directly material and that other art should produce a material entity only as a by-product of the need to record an idea is not at all to say that the latter is connected by any process of dematerialization to the former (italics mine).

Does this dissuade the author? No. She replies in her preface, "Granted. But for the lack of a *better term* I have continued to refer to a process of dematerialization . . ." (italics mine). The terminology perpetuates itself until it becomes total nonsense. "Keith Arnatt comes to 'idea art' via process or behavioral land art (a constant interest in hermeticism and holes) and a something-to-nothing development."

Because Lucy Lippard was able to acquire pertinent documents, and because she was in close proximity to the artists, this book, by virtue of its inconsistencies and misrepresentation of esthetic intentions, can only be found severely defective as a useful work of scholarship. And for its falsifications, it can be called an act of bad faith to art.

Walls (1981)

The major problem for wall painting is the wall. A canvas defines its own shape and size. But for a painting done directly on the wall the architecture becomes the boundary, the confining limit. The role of the architecture must be challenged, or else wall painting becomes decoration.

The wall cannot be conceived of as a surrogate canvas. The wall is not a depiction of a wall. Its "thereness" is immediate and inescapable. The wall is continuous, its surface turns corners. Therefore, space rather than surface is the support. However, the issue is *not* to make the space itself into the artwork. This would concede precedence to the architecture. Nor is my concern with "perceptual problems." The space is not the object of my work, the experience is not its subject.

My wall paintings are first and foremost something to look *at*. The most decisive relationships, those of drawing and color, are internal. At the same time crucial decisions involve placement, size, and orientation. The distance from the bottom of the painting to the floor, for example, is as important to the meaning as the edges of the color. These contextual decisions are specific to the time and place of installation, physical as well as visual, and attack rather than react to the space.

My wall paintings have no back. By eliminating the secondary support of the canvas, illusion is divorced from representation. The scale is always 1:1. Lived space is challenged to a direct confrontation with pictorial space.

DAN GRAHAM Three Projects for Architecture and Video / Notes (1977)

The Glass Divider, Light and Social Division

Window glass alienates "subject" from "object." From behind glass, the spectator's view is "objective," while the observed's subject(ivity) is concealed; the observer on the outside of the glass cannot be part of an interior group's "inter-subjective" framework. Being itself a mirror-reflective material glass reflects the mirror-image of an observer looking as well as the particular inside or outside world behind him onto the image of the space into which he is looking. Abstractly, this reflectiveness of glass allows it to be a sign signifying, at the same time, the nature of the opposition between the two spaces and their common mediation. The glass in the window through its transparency/reflectiveness unites, and by this physical impenetrability separates, inside and outside. Due to its reflective qualities, illuminating, within or without the space that the glass divides produces either complex reflections, non-reflective transparency, or opacity. Light signifies various distinct spatial or temporal locations. Artificial light is often placed in contrast to natural illumination (defining indoors and outdoors). The pattern of illumination phases with, and marks off, natural and cultural activities taking place on either side of the glass partition. Illumination is a controller of social behavior. Both glass and light (separately or conjointly) enforce social divisions.

* Mel Bochner, "Walls," in *Murs* (Paris: Centre Georges Pompidou, 1981). By permission of the author.

** Dan Graham, "Three Projects for Architecture and Video / Notes," *Tracks* 3, no. 3 (Fall 1977): 52–61. By permission of the author.

The glass used for the showcase displaying products isolates the consumer from the product at the same time as it superimposes the mirror-reflection of his own image onto the goods displayed. This alienation, paradoxically, helps arouse the desire to possess the commodity. The goods are often displayed as part of a human mannequin—an idealized image of the consumer. Glass isolates (draws attention to) the product's surface appeal, "glamour," or superficial appearance alone (attributes of "workmanship" which link craftsman to specific product being lost) while denying access to what is tangible or immediately useful. It idealizes the product. Historically this change in the appearance of the product corresponds to the workers' alienation from the products they produce; to be utilized the product must be brought on the market in exchange for wages at a market value with the conditions of its production obscured. Glass is helpful in socially alienating buyer from producer, thereby concealing the product's connection to another's real labor and allowing it to acquire exchange value over and above use value.

> In a sort of way, it is the same with Man as with commodities . . . man sees himself reflected in other man. Peter only establishes his identity as a man by first comparing himself with Paul as being of the same kind, and thereby Paul, "in hide and hair," Paul in his Pauline corporality, becomes entirely to Peter the phenomenal form of the genus Man.

> Capitalistic society makes all personal relations between men take the form of objective relations between things. . . . Social relations are transformed into "qualities of . . . things themselves [commodities]."

Under capitalism, just as the projected ego is confused with the body image in the mirror, so that ego is confused with the commodity. The individual is made to identify himself (in his "feeling for himself") with the image of the commodity. The glass and mirrors of the shop window beckon the potential customer by arousing doubts and desires about his self-image/self-identity. It is as if in looking at the product behind the glass showcase, the customer is looking at an ideal image of himself (in the mirror). Or he sees in the reflections that he deviates from the ideal (represented by the mannequin), but is given the possibility of acquiring attributes of this ideal if he buys the merchandise. The commodity reflects his desire for a more complete, "better" "self" identified with the *alter ego*. Inseparable from the goods the consumer desires is the illusion that buying them will "complete" that which is "incomplete" in himself. This desire is never satisfied (as the market system must continue to function), but because the consumer identifies himself with (his projection into) the commodity, he infuses the commodity with a psychological value which now becomes part of its market value.

The video piece is located in a modern shopping arcade. It utilizes two of the shop window showcases which display their standard goods and which are opposite each other. Each showcase has a mirror fixed to the back wall, parallel to the window. Shoppers looking through the window can see all of the following: the images of the showcase's merchandise reflected in the mirror, and at the same time they see the image of the other side of the arcade with the merchandise in the opposite showcase; they see the reflections of the outside of the window surface, and the mirror's reflection of those on the inside surface, as well as those on the exterior surface of the opposite window; and they see the other shoppers who look into these windows or who pass through the arcade between them.

Both shop windows have television monitors located front and center at eye level. One monitor (on the right in diagram) faces the window, and the other faces the mirror. Each

PUBLIC SPACE / TWO AUDIENCES

THE PIECE IS ONE OF MANY PAVILIONS LOCATED IN AN INTERNATIONAL ART EXHIBIT WITH A LARGE AND ANONYMOUS PUBLIC IN ATTENDANCE.

SPECTATORS CAN ENTER THE WORK THROUGH EITHER OF TWO ENTRANCES.

EACH AUDIENCE SEES THE OTHER AUDIENCE'S VISUAL BEHAVIOR, BUT IS ISOLATED FROM THEIR AURAL BEHAVIOR. EACH AUDIENCE IS MADE MORE AWARE OF ITS OWN VERBAL COMMUNICATIONS. IT IS ASSUMED THAT AFTER A TIME, EACH AUDIENCE WILL DEVELOP A SOCIAL COHESION AND GROUP IDENTITY.

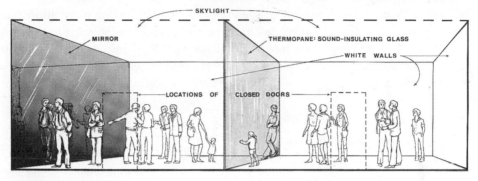

Dan Graham, diagram for *Public Space / Two Audiences*, 1976. Collection Herbert, Ghent. Courtesy of the artist.

monitor has a video camera resting upon its top surface. The camera lens on the right faces the mirror; and the camera lens on the left faces the window.

The view from the camera on the right is transmitted live to the monitor on the left; but the view from the left camera is transmitted 5 seconds delayed to the right monitor.

"Public Space / Two Audiences"

"PUBLIC SPACE / TWO AUDIENCES" was placed as one of a number of individual room-environments within the thematic exhibition "AMBIENTE" (organized by Germano Celant for the Venice Biennale, 1976). The Venice Biennale collective is a showcase for modern art; each of the rooms of "AMBIENTE" functioned as showcases for individual artists, one competing with the other in the display of characteristic productions of individual artists. At the same time the totality of rooms presumed to represent a larger, socially unifying theme: "The Environment." One of the intentions of "PUBLIC SPACE / TWO AUDIENCES" was that the spectators, instead of contemplating art objects within the room-environment (the architectural enclosure), be themselves displayed by the container.

Psychologically, the glass divider is a visual window objectifying the other audience (the observed audience appears, by analogy, to be a "mirror" of the outward behavior of the audience observing them): while the mirror at the end of one space shows the observing audience themselves as a social unity—in the process of looking at the other audience. A similar situation, in reverse, exists for the other audience. Initially, both audiences look for "objectifica-

tion" of their respective "subjectively" experienced social situations (relative to the other audience). The spectators of one audience are led to view the other "objectively," while their own "subjectivity" seems to be insulated from that of the other audience. Normally neither observer nor observed on opposite sides of glass can be part of the other groups' inter-subjective frame. But here, paradoxically, while the glass partition places a distance between opposing spectators, the co-presence on the mirror of the two audience groups' bodies and visual image of their process of looking make for visual intersubjectivity. The complexity of this relation of spectators to their image, and to the image of the "Other" (reciprocal spectators), is a product of/echoed in the relation of the material properties of mirror and glass. Because glass as a material is itself mirror-reflective, observers in the room distant from the mirror, looking in the direction of the mirror through the glass divider, see a double reflection of their image, first in the glass and then, smaller in size but more distinct, in the mirror. From within the other room (with the mirror) an observer looking towards the glass and at the other space's opposite white wall, will see partially reflected on the glass's surface a projection of the space of his room (and also of the other room seen behind it . . . this image being reflected from the mirror's surface to illusionistically fill in the blank wall surface behind the glass).

II—Public Space / Two Audiences

Because of the placing of the mirror at only one end of the space, the two audiences' perceptual situations differ; this affects the relative behavior patterns of these two groups. The behavior of one does not mirror that of the other (although to a group on one side the opposite group will still appear to them as a "mirror" of their own situation).

The spectator is made socially and psychologically more self-conscious . . . the observer becomes conscious of himself as embodied as a perceiving subject (and of himself in relation to his group). This is the inverse of the usual loss of "self" when a spectator looks at the conventional art work. There, the "self" is mentally projected into (identified with) the subject of the art work. In this traditional contemplative mode the observing subject not only loses awareness of his "self," but also consciousness of being part of a present, social group, located in a specific moment and social reality, occurring within the architectural frame where the work is presented. In "PUBLIC SPACE / TWO AUDIENCES" the work looks back; the spectator, inversely, sees his projection of "self" (conventionally missing) returned specularly by the material (and structural) aspects of the work.

Glass Buildings / Corporate "Showcases"

At the same time that glass reveals, it conceals. If one looks into a glass showcase one can have the illusion that the container is neutral, without apparent interest in the content of what it displays; or, conversely, the appearance of what is contained can be seen as a function of the qualities of the container itself. In the ideology of modern Functionalist architecture, an architectural form appropriates and merges both of these readings. . . . First, because symbolic form, ornamentation, is eliminated from the building (form and content being merged), there is no distinction between the form and its material structure; that is, the form represents nothing more or less *than* the material; second, a form or structure is seen to represent only its contained function, the building's structural and functional efficiency being equated with its real utility for those who use it. Aesthetically, this idea is expressed in the formula: efficient

form is beautiful and beautiful form is efficient. This has a "moral" dimension; "efficient" connotes a melioristic, "scientific" approach seemingly uncontaminated by "ideology," which, pragmatically, has (capitalistic) use value. ("Efficiency" is how well a building contributes to the operations of the company housed within it. The look of a building, its cleanness and structural transparency thus join the myth of scientific progress to that of the social utility of efficient business practice). These glass and steel buildings usually house corporations or government agencies. The building's transparent functionalism conceals its less apparent ideological function: justifying the use of technology or bureaucracy by large corporations or government agencies to impart their particular version of order on society. The spectator's view is diverted away from its social context by focusing only on its surface material or structural qualities. Glass and steel are used as "pure" materials, for the sake of their materiality. The use of glass gives another illusion: that what is seen is seen exactly as it is. Through the glass one sees the technical workings of the company and the technical engineering of the building's structure. The glass's literal transparency not only falsely objectifies reality, but is a paradoxical camouflage; for while the actual function of a corporation may be to concentrate its self-contained power and control by secreting information, its architectural facade gives the impression of absolute openness. The transparency is visual only; glass separates the visual from the verbal, insulating outsiders from the content of the decision-making processes, and from the invisible, but real, inter-relationships linking company operations to society. A building with glass on four sides gives the illusion of self-containment—legitimating the corporation's claim to autonomy ("The World of General Motors"). In looking through glass on all sides, the particular, focused-upon detail, the "interior," is lost (one looks *through* and not *at*) to the architectural generality, to the apparent materialness of the outward form, or to "Nature" (light, sun, sky, or the landscape glimpsed through the building on the other side).

SETH SIEGELAUB
The Artist's Reserved Rights Transfer and Sale Agreement (1971)

THE ARTIST'S RESERVED RIGHTS TRANSFER AND SALE AGREEMENT was written in March 1971 by myself and lawyer Bob Projansky, after my extensive discussions with artists and other people involved with the day-to-day operation of the international art world.

Since then, the Contract has been translated and distributed into German, French and Italian, in addition to the original English. At present plans are underway for translation and distribution into Dutch, Flemish and Spanish.

Slowly, more and more artists have begun using the Contract, either regularly or occasionally, as they see fit. Because the use of the contract is the private concern of each artist, public records about which artists have been using it are impossible to compile. Among the artists who are known to have used the Contract are: Carl Andre, Robert Barry, Mel Bochner, Hans Haacke, Sol LeWitt and Mario Merz.

The Contract is proposed as a practical remedy to some of the long standing inequities in the art world. It is not conceived as a solution for all of the artist's political, social and economic problems, whether in the art world or the real world.

* Seth Siegelaub, "The Artist's Reserved Rights Transfer and Sale Agreement" (March 1971), in *Documenta 5* (Kassel: Documenta, 1972), 18.13. By permission of the author.

The Contract simply gives artists the basic minimum rights and protections that now belong only to the more organized artist-workers: musicians, filmworkers, photographers, actors, writers and composers.

The attached 3-page Artist's Contract defines and protects the artist after he (or she) gives, sells or trades their work. It distinguishes between the following "uses" and rights:

Aesthetic

—the right to be notified when and where the work is to be exhibited

—the right to borrow back the work for public exhibition for 2 months every 5 years

—the right to control all reproduction in the work

—the right to be consulted if repairs become necessary

—the right to recourse if the work is intentionally altered.

Economic

—the right to 15% of any increase in value each time the work is transferred in the future.

—the right to half of any rental income paid to the owner for use of the work at exhibitions (if there ever is any).

The Contract gives the artist the aesthetic controls for just his (or her) lifetime, and the economic benefits for his (or her) life, plus the life of a surviving spouse (if any), plus 21 years, so as to benefit the artist's children as they are growing up.

Because each work is covered by a separate contract, the possession of the contract also serves as a record of who owns each work at any given time, and as such, it is an important source of information for artists, critics, dealers, museums and the public.

For an original copy of the Contract, with complete information about its use, see the attached Contract-poster printed in documenta catalogue.

What we have done in drafting the Contract is formalize a few of the relationships that all artists and collectors are subject to, and have given the artists a legal tool they can use, if they want, to establish their basic ongoing rights when they transfer their work.

It is a substitute for what has existed before—NOTHING.

ROBERT BARRY Statement (1969)

These forms certainly do exist, they are controlled and have their own characteristics. They are made of various kinds of energy which exist outside the narrow arbitrary limits of our own senses. I use various devices to produce the energy, detect it, measure it, and define its form.

By just being in this show, I'm making known the existence of the work. I'm presenting these things in an art situation using the space and the catalogue. I think this will be less of a problem as people become more acclimated to this art.

* Robert Barry, untitled statement, in Germano Celant, ed., *Arte Povera* (Milan: Gabriele Mazzotta, 1969); translated as *Art Povera* (London: Studio Vista; New York: Praeger, 1969), 115. By permission of the author, the editor, and Macmillan Publishing Company for Studio Vista.

As with any art, an interested person reacts in a personal way based on his own experience and imagination. Obviously, I can't control that.

One kind of energy is electromagnetic waves. There is a piece in the show which uses the carrier wave of a radio station for a prescribed length of time, not as a means of transmitting information, but rather as an object.

Another piece uses the carrier wave of a citizens' band transmitter to bridge two distant points in New York and Luxembourg several times during the run of the show.

Because of the position of the sun and favourable atmospheric conditions during January, the month of the show, "this" piece could be made. At another time, under different conditions, other locations would have to be used.

There are two smaller carrier wave pieces which have just enough power to fill the exhibition space. They are very different in character, one being AM, the other being FM, but both will occupy the same space at the same time—such is the nature of the material. Also in the show will be a room filled with ultrasonic sound. I've also used microwaves and radiation.

There are many other possibilities which I intend to explore—and I'm sure there are a lot of things we don't yet know about which exist in the space around us, and although we don't see them or feel them, we somehow know they are out there.

DOUGLAS HUEBLER Statements (1968)

The world is full of objects, more or less interesting: I do not wish to add any more.

I prefer, simply, to state the existence of things in terms of time and/or place.

More specifically, the work concerns itself with things whose inter-relationship is beyond direct perceptual experience.

Because the work is beyond direct perceptual experience, awareness of the work depends on a system of documentation.

This documentation takes the form of photographs, maps, drawings and descriptive language. [December 1968]

.

The existence of each sculpture is documented by its documentation.

The documentation takes the form of photographs, maps, drawings and descriptive language.

The marker "material" and the shape described by the location of the markers have no special significance, other than to demark the limits of the piece.

The permanence and destiny of the markers have no special significance.

The duration pieces exist only in the documentation of the marker's destiny within a selected period of time.

The proposed projects do not differ from the other pieces as idea, but do differ to the extent of their material substance. [September 1968]

* Douglas Huebler, untitled statements (December and September 1968), in Germano Celant, ed., *Arte Povera* (Milan: Gabriele Mazzotta, 1969); translated as *Art Povera* (London: Studio Vista; New York: Praeger, 1969), 43. By permission of the author, the editor, and Macmillan Publishing Company for Studio Vista.

LAWRENCE WEINER Statement (1970)

1. The artist may construct the piece
2. The piece may be fabricated
3. The piece need not to be built

Each being equal and consistent with the intent of the artist the decision as to condition rests with the receiver upon the occasion of receivership

Tried and True

VICTOR BURGIN Looking at Photographs (1977)

It is almost as unusual to pass a day without seeing a photograph as it is to miss seeing writing. In one institutional context or another—the press, family snapshots, billboards, etc.,—photographs permeate the environment, facilitating the formation/reflection/inflection of what we "take for granted." The daily instrumentality of photography is clear enough: to sell, inform, record, delight. Clear, but only to the point at which photographic representations lose themselves in the ordinary world they help to construct. Recent theory follows photography beyond where it has effaced its operations in the "nothing-to-explain."

It has previously been most usual (we may blame the inertia of our educational institutions for this) to view photography in the light of "art"—a source of illumination which consigns to shadow the greater part of our day-to-day experience of photographs. What has been most often described is a particular nuancing of "art history" brought about by the invention of the camera, a story cast within the familiar confines of a succession of "masters," "masterworks," and "movements"—a *partial* account which leaves the social fact of photography largely untouched.

Photography, sharing the static image with *painting,* the camera with *film,* tends to be placed "between" these two mediums, but it is encountered in a fundamentally different way from either of them. For the majority, paintings and films are only seen as the result of a voluntary act which quite clearly entails an expenditure of time and/or money; although photographs may be shown in art galleries and sold in book form most photographs are not seen by deliberate choice, they have no special space or time allotted to them, they are *apparently* (an important qualification) provided free of charge—photographs offer themselves *gratuitously;* whereas paintings and films readily present themselves to critical attention as objects; photographs are received rather as an environment.

As a free and familiar coinage of meaning, largely unremarked and untheorized by those amongst whom it circulates, photography shares an attribute of language. However, although it has long been common to speak, loosely, of the "language of photography," it was not until the 1960's that any systematic investigation of forms of communication outside of natural language was conducted from the standpoint of linguistic science; such early "semiotic" studies, and their aftermath, have radically reoriented the theory of photography.

* Lawrence Weiner, untitled statement (2 July to 7 September 1970), in Kynaston L. McShine, ed., *Information* (New York: Museum of Modern Art, 1970), 134. By permission of the author.

** Victor Burgin, excerpts from "Looking at Photographs," *Tracks* 3, no. 3 (Fall 1977): 36–44; reprinted in Burgin, ed., *Thinking Photography* (London: Macmillan; Atlantic Highlands, NJ: Humanities Press, 1982). By permission of the author.

Semiotics, or semiology, is the study of signs, with the object of identifying the systematic regularities from which meanings are construed. In the early phase of "structuralist" semiology (Roland Barthes' *Elements of Semiology* first appeared in France in 1964) close attention was paid to the analogy between "natural" language (the phenomenon of speech and writing) and visual "languages." In this period, work dealt with the codes of analogy by which photographs denote objects in the world, the codes of connotation through which denotation serves a secondary system of meanings, and the "rhetorical" codes of juxtaposition of elements within a photograph and between different but adjacent photographs.

Work in semiotics showed that there is no "language of photography," no single signifying system (as opposed to technical apparatus) upon which all photographs depend (in the sense in which all texts in English ultimately depend upon the English language), there is rather a heterogeneous complex of codes upon which photography may draw. Each photograph signifies on the basis of a plurality of these codes, the number and type of which varies from one image to another. Some of these are (at least to first analysis) peculiar to photography (e.g., the various codes built around "focus" and "blur"), others are clearly not (e.g., the "kinesic" codes of bodily gesture). Further, importantly, it was shown that the putatively autonomous "language of photography" is never free from the determinations of language itself.

We rarely see a photograph *in use* which does not have a caption or a title, it is more usual to encounter photographs attached to long texts, or with copy superimposed over them. Even a photograph which has no actual writing on or around it is traversed by language when it is "read" by a viewer (for example, an image which is predominantly dark in tone carries all the weight of signification that darkness has been given in social use; many of its interpretants therefore will be linguistic, as when we speak metaphorically of an unhappy person being "gloomy").

The intelligibility of the photograph is no simple thing; photographs are *texts* inscribed in terms of what we may call "photographic discourse," but this discourse, like any other, engages discourses beyond itself; the "photographic text," like any other, is the site of a complex "intertextuality," an overlapping series of previous texts "taken for granted" at a particular cultural and historical conjuncture. These prior texts, those *presupposed* by the photograph, are autonomous; they serve a role in the actual text but do not appear in it, they are latent to the manifest text and may only be read across it "symptomatically" (in effect, like the dream in Freud's description, photographic imagery is typically laconic—an effect refined and exploited in advertising).

Treating the photograph as an object-text, "classic" semiotics showed that the notion of the "purely visual" *Image* is nothing but an Edenic fiction. Further to this, however, whatever specificity might be attributed to photography at the level of the "image" is inextricably caught up within the specificity of the social acts which intend that image and its meanings: newsphotographs help transform the raw continuum of historical flux into the product "news," domestic snapshots characteristically serve to legitimate the institution of the family, . . . and so on. For any photographic practice, given materials (historical flux, existential experience of family life, etc.) are transformed into an identifiable type of product of men and women using a particular technical method and working within particular social institutions. The significant "structures" which early semiotics found in photography are not spontaneously self-generated, they originate in determinate modes of human organization. The question of meaning therefore is constantly to be referred to the social and psychic formations of the author/reader, formations existentially simultaneous and co-extensive but theorized in separate discourses; of these, Marxism and psychoanalysis have most informed

semiotics in its moves to grasp the determinations of history and the subject in the production of meaning.

In its structuralist phase, semiotics viewed the text as the objective site of more or less determinate meanings produced on the basis of what significant systems were empirically identifiable as operative "within" the text. Very crudely characterized, it assumed a coded message and authors/readers who knew how to encode and decode such messages while remaining so to speak "outside" the codes—using them, or not, much as they might pick up and put down a convenient tool. This account was seen to fall seriously short in respect of this fact: as much as we speak language, so language "speaks" us.

All meaning, across all social institutions—legal systems, morality, art, religion, the family, etc.,—is articulated within a network of *differences,* the play of presence and absence of conventional significant features which linguistics has demonstrated to be a founding attribute of language. Social practices are structures *like* a language; from infancy, "growing up" is a growing *into* a complex of significant social practices including, and founded upon, language itself. This general *symbolic order* is the site of the determinations through which the tiny human animal becomes a social human being, a "self" positioned in a network of relations to "others." The structure of the symbolic order channels and moulds the social and psychic formation of the individual subject; it is in this sense that we may say that language, in the broad sense of symbolic order, speaks *us.*

The subject inscribed in the symbolic order is the product of a channeling of predominantly sexual basic drives within a shifting complex of heterogeneous cultural systems (work, the family, etc.); that is to say, a complex interaction of a *plurality* of subjectivities presupposed by each of these systems. This subject therefore is not the fixed, innate entity assumed in classic semiotics but is itself a function of textual operations, an unending process of *becoming*—such a version of the subject, in the same movement in which it rejects any absolute discontinuity between speaker and codes, also evicts the familiar figure of the *Artist* as autonomous *ego,* transcending his or her own history and unconscious.

However, to reject the "transcendental" subject is not to suggest that either the subject or the institutions within which it is formed are caught in a simple mechanistic determinism; the institution of photography, while a product of the symbolic order, also *contributes* to this order. Some earlier writings in semiology, particularly those of Barthes, set out to uncover the language-like organization of the dominant myths which command the meanings of photographed appearances in our society. More recently, semiotics has moved to consider not only the structure of appropriation to ideology of that which is "uttered" in photographs, but also to examine the ideological implications inscribed within the *performance* of the utterance. This enquiry directs attention to the object/subject constructed within the technical apparatus itself.

The signifying system of photography, like that of classical painting, at once depicts a scene *and the gaze of the spectator,* an object *and* a viewing subject. The two-dimensional analogical signs of photography are formed within an apparatus which is essentially that of the *camera obscura* of the Renaissance. (The *camera obscura* with which Niepce made the first photograph in 1826 directed the image formed by the lens via a mirror onto a ground glass screen—precisely in the manner of the modern single lens reflex camera). Whatever the object depicted, the manner of its depiction accords with laws of geometric projection which imply a unique "point-of-view." It is the position of point-of-view, occupied in fact by the camera, which is bestowed upon the spectator. To the point-of-view, the system of the representation adds the *frame* (an inheritance which may be traced through easel painting, via mural painting, to its origin in the convention of post and lintel architectural construction); through the agency of

the frame the world is organized into a coherence which it actually lacks, into a parade of tableaux, a succession of "decisive moments."

The structure of representation—point-of-view and frame—is intimately implicated in the reproduction of ideology (the "frame of mind" of our "points-of-view"). More than any other textual system, the photograph presents itself as "an offer you can't refuse." The characteristics of the photographic apparatus position the subject in such a way that the object photographed serves to conceal the textuality of the photograph itself—substituting passive receptivity for active (critical) *reading*.

When confronted with puzzle photographs of the "what is it?" variety (usually, familiar objects shot from unfamiliar angles) we are made aware of having to select from sets of possible alternatives, of having to supply information the image itself does not contain. Once we have discovered what the depicted object *is*, however, the photograph is instantly transformed for us—no longer a confusing conglomerate of light and dark tones, of uncertain edges and ambivalent volumes, it now shows a "thing" which we invest with a full identity, a *being*. With most photographs we see, this decoding and *investiture* takes place instantaneously, unselfconsciously, "naturally"; but it does take place—the wholeness, coherence, identity, which we attribute to the depicted scene is a projection, a refusal of an impoverished reality in favour of an imaginary plenitude. The imaginary object here however is not "imaginary" in the usual sense of the word, it is *seen*, it has projected an image.

An analogous imaginary investiture of the real constitutes an early and important moment in the construction of the self, that of the "mirror stage" in the formation of the human being, described by Jacques Lacan: between its sixth and eighteenth month, the infant, which experiences its body as fragmented, uncentered, projects its potential unity, in the form of an ideal self, upon other bodies and upon its own reflection in a mirror; at this stage the child does not distinguish between itself and others, it *is* the other (separation will come later through the knowledge of sexual *difference*, opening up the world of language, the symbolic order); the idea of a unified body necessary to the concept of self-identity has been formed, but only through a rejection of reality (rejection of incoherence, of separation).

Two points in respect of the mirror-stage of child development have been of particular interest to recent semiotic theory: first, the observed correlation between the formation of identity and the formation of *images* (at this age the infant's powers of vision outstrip its capacity for physical coordination), which led Lacan to speak of the "imaginary" function in the construction of subjectivity; second, the fact that the child's recognition of itself in the "imaginary order," in terms of a reassuring coherence, is a *misrecognition* (what the eye can see for *its*-self here is precisely that which is not the case). Within the context of such considerations the "look" itself has recently become an object of theoretical attention. . . .

Following recent work in film theory, and adopting its terminology, we may identify four basic types of look in the photograph: the look of the camera as it photographs the "prophotographic" event; the look of the viewer as he or she looks at the photograph; the "intradiagetic" looks exchanged between people (actors) depicted in the photograph (and/or looks from actors towards objects); and the look the actor may direct to the camera. . . .

To look at a photograph beyond a certain period of time is to court a frustration: the image which on first looking gave pleasure has by degrees become a veil behind which we now desire to see. It is not an arbitrary fact that photographs are deployed so that we do not look at them for long; we use them in such a manner that we may play with the coming and going of our *command* of the scene/(seen) (an official of a national art museum who followed visitors

with a stop-watch found that an average of 10 seconds was devoted by any individual to any single painting—about the average shot-length in classic Hollywood cinema).

To remain long with a single image is to risk the loss of our imaginary command of the look, to relinquish it to that absent other to whom it belongs by right—the camera. The image then no longer receives *our* look, reassuring us of our founding centrality, it rather as it were avoids our gaze, confirming its allegiance to the other. As alienation intrudes into our captivation by the image we can, by averting our gaze or turning a page, reinvest our looking with authority. (The "drive to master" is a component of scopophilia, sexually based pleasure in looking.)

The awkwardness which accompanies the over-long contemplation of a photograph arises from a consciousness of the monocular perspective system of representation as a systematic deception. The lens arranges all information according to laws of projection which place the subject as geometric point of origin of the scene in an imaginary relationship with real space, but facts intrude to deconstruct the initial response: the eye/(I) cannot move within the depicted space (which offers itself precisely to such movement), it can only move *across* it to the points where it encounters the frame.

The subject's inevitable recognition of the *rule* of the frame may, however, be postponed by a variety of strategies which include "compositional" devices for moving the eye from the framing edge. "Good composition" may therefore be no more or less than a set of devices for prolonging our imaginary command of the point-of-view, our *self*-assertion; a device for retarding recognition of the autonomy of the frame, and the authority of the *other* it signifies. "Composition" (and indeed the interminable *discourse* about composition) is therefore a means of prolonging the imaginary force, the real power to please, of the photograph, and it may be in this that it has survived so long, within a variety of rationalizations, as a criterion of value in visual art generally. . . .

Counter to the nineteenth-century aesthetics which still dominate most teaching of photography, and most writing on photography, work in semiotics has shown that a photograph is not to be reduced to "pure form," nor "window on the world," nor is it a gangway to the presence of an author. A fact of primary social importance is that the photograph is *a place of work,* a structured and structuring space within which the reader deploys, and is deployed by, what codes he or she is familiar with in order to *make sense.* Photography is one signifying system amongst others in society which produces the ideological subject in the same movement in which they "communicate" their ostensible "contents." It is therefore important that photography theory take account of the production of this subject as the complex totality if its determinations are nuanced and constrained in their passage through and across photographs.

MARY KELLY Preface to *Post-Partum Document* (1983)

Post-Partum Document was conceived as an on-going process of analysis and visualisation of the mother-child relationship. It was born as an installation in six consecutive sections, comprising in all one hundred thirty-five small units. It grew up as an exhibition, adapted to a variety of genres (some realizing my desire for it to be what I wanted it to be, others resisting, transgressing) and finally reproduced itself in the form of a book.

* Mary Kelly, excerpt from "Preface" to *Post-Partum Document* (1983; Berkeley: University of California Press, 1999), xix–xxii. © 1983 Mary Kelly. By permission of the author.

Mary Kelly and son recording session, *Post-Partum Document,* 1975. Photo by Ray Barrie. Courtesy of the artist.

But why invoke the metaphor of procreation to describe a project which explicitly refutes any attempt to naturalize the discourse of women's practice in art? First, I want to acknowledge the way in which every artistic text is punctuated with an unconscious significance that cuts across the constraints of medium or intentionality. Second, I would like to underline one of the central and perhaps most controversial questions this particular work poses in relation to the mother's desire: the possibility of female fetishism.

Sexual identity is said to be the outcome of a precarious passage called the Oedipus complex; a passage which is in a certain sense completed by the acceptance of symbolic castration. But castration is also inscribed at the level of the imaginary, that is in fantasy, and this is where the fetishistic scenario originates and is continually replayed. The child's recognition of difference between the mother and the father is above all an admission that the mother does not have the phallus. In this case seeing is not necessarily believing since what is at stake for the child is really the question of his or her own relation to having or being. Hence the fetishist, conventionally assumed to be male, postpones that moment of recognition, although certainly he has made the passage—he knows the difference, but denies it. In terms of representation, this denial is associated with a definite iconography of pornographic images where the man is reassured by the woman's possession of some form of phallic substitute or alternatively by the shape, the complete arrangement of her body. Yet the woman, insofar as the outcome of the oedipal moment has involved at some point a heterosexual object choice (that is, she has identified with her mother and has taken her father as a love object), will also postpone the recognition of lack in view of the promise of having the child. In having the child, in a sense she has the phallus. So the loss of the child is the loss of that symbolic plenitude—more exactly the ability to represent lack.

According to Freud, castration anxiety for the man is often expressed in fantasy as the loss of arms, legs, hair, teeth, eyes, or the penis itself. When he describes castration fears for the

woman, this imaginary scenario takes the form of losing her loved objects, especially her children; the child is going to grow up, leave her, reject her, perhaps die. In order to delay, disavow, that separation she has already in a way acknowledged, the woman tends to fetishize the child: by dressing him up, by continuing to feed him no matter how old he gets, or simply by having another "little one." So perhaps in place of the more familiar notion of pornography, it is possible to talk about the mother's memorabilia—the way she saves things—first shoes, photographs, locks of hair or school reports. My work proceeds from this site; instead of first shoes, first words set out in type, stained liners, hand imprints, comforter fragments, drawings, writings or even the plants and insects that were his gifts; all these are intended to be seen as transitional objects; not in Winnicott's sense of surrogates but rather in Lacan's terms as *emblems* of desire. In one way, I have attempted to displace the potential fetishization of the child onto the work of art; but I have also tried to make it explicit in a way which would question the fetishistic nature of representation itself.

Now the publication of *Post-Partum Document* prompts another question: What is the difference between them—the "original" exhibition and its bookish offspring, what loss is sustained by their inevitable separation?

As an installation within a traditional gallery space, the work subscribes to certain modes of presentation; the framing, for example, parodies a familiar type of museum display insofar as it allows my archaeology of everyday life to slip unannounced into the great hall and ask impertinent questions of its keepers. This reading relies very heavily on the viewer's *affective* relation to the visual configuration of objects and texts. There will obviously be a loss of that kind of material specificity in viewing black and white reproductions, but what I have tried to retain, in place of an accurate record or photographic substitute for the "real object," is a certain texture, a sensibility associated with its function as *mnemic* trace. In this context, it made sense to lose the frames altogether, letting them slide towards the edge of the page, becoming the size and shape of the book itself; defined by different institutions, referred to other limits (I noted that an odd size is known in the trade as a "bastard").

Indeed an exhibition may not appear to be a legitimate parent for a book. The authority of that work is so often grounded in academic discourses which define themselves precisely by their difference from artistic practices; by definite objects, reliable sources, and logical sequences; by being read from beginning to end. An exhibition takes place, but never so completely, not from cover to cover, except in the catalogue, which is exactly why the exhibition as a system (i.e., including its associated field of publications) should be the object of art criticism rather than the utopian notion of the individual tableau. Although it is subject to the constraints of a particular site, the exhibition as an intertextual system is potentially self-reflexive.

As an exhibition, the *Post-Partum Document* is intended to construct several readings or ways through the work, indicated by the juxtaposition of found objects and commentary with a series of diagrams. These diagrams, in turn, refer the viewer to another text entitled "Footnotes and Bibliography" where the framed material is reworked in order to create a space for critical reflection rather than explanation as such. In book form, however, the footnotes are interspersed with the illustrations in a way which tends to close that gap, to pull the visible more firmly into the space of the readable. Typographical variation was one way of attempting to avert that kind of closure, of trying to maintain the heterogeneity and openness of the "original" (mother?). I wanted to avoid setting up an opposition between image and text. Ideally, each should hold the possibility of becoming the other, or perhaps the same, that is "writing."

Initially the reader will be caught up in the mother's story. The first person narrative describes particular events in my own relationship with my son, from birth until age five. Events such as weaning from the breast, learning to speak, starting school, writing; but *Post-Partum Document* is not simply about child development. It is an effort to articulate the mother's fantasies, her desire, her stake in that project called "motherhood." In this sense, too, it is not a traditional narrative; a problem is continually posed but no resolution is reached. There is only a replay of moments of separation and loss, perhaps because desire has no end, resists normalization, ignores biology, disperses the body.

Perhaps this is also why it seemed crucial, not in the sense of a moral imperative, but as a historical strategy, to avoid the literal figuration of mother and child, to avoid any means of representation which risked recuperation as "a slice of life." To use the body of the woman, her image or person is not impossible but problematic for feminism. In my work I have tried to cut across the predominant representation of woman as the object of the look in order to question the notion of femininity as a pregiven entity and to foreground instead its social construction as a representation of sexual difference within specific discourses. For me, this is not a new form of iconoclasm but a shared aspiration (truly post-modernist?) to "picture" the woman as subject of her own desire.

Although the mother's story is my story, *Post-Partum Document* is not an autobiography (nor do I think of this book as an artist's monograph). It suggests an interplay of voices—the mother's experience, feminist analysis, academic discussion, political debate. For instance, in the "Documentation" and "Experimentum Mentis" sections, the mode of address shifts to the third person. Here the Mother (she) is no longer so accessible, so replete (not someone who is like you, like you once were or would like to be). For the reader this implies a moment of separation (for some, perhaps an uncomfortable confrontation with the Father) or at least a "breathing space" in the text.

The "Documentation" notes began as an attempt to explain the empirical procedures adopted in individual works and probably ended up saying more about the inadequacy of those descriptive systems. One motive for appropriating a certain pseudoscientific language in this section was to counter the assumption that childcare is based on the woman's natural and instinctive understanding of the role of mothering.

This so-called "anti-essentialist" position is taken up (with a vengeance?) in the "Experimentum Mentis" section, where maternal femininity is drawn from the perspective of Freudian and Lacanian psychoanalysis. Some readers will undoubtedly ask, why Freud, why Lacan? Why endorse their "patriarchal" authority? In one way, for me these texts are a means of working through a difficult experience—secondary revision, in the psychoanalytic sense. This is not exactly a recourse to rationality as authority. It expresses a more fundamental desire to know and to master.

Even, or especially, when I use something as eccentric as the Lacanian diagrams, they are first of all images, representations of the difficulty of the symbolic order for women; the difficulty of representing lack, of accepting castration, of not having the phallus, of not being the Phallic Mother (which is finally as significant in that order as the Dead Father). They are like blazons of a love-hate relationship with the Father (Phallic Mother?) cathected as much, perhaps more, than the memorabilia.

At the same time I realize that these texts have other implications. They are metadiscursive.

one step	1X	one step	26X	one step	51X	one step	76X
one step	2X	one step	27X	one step	52X	one step	77X
one step	3X	one step	28X	one step	53X	one step	78X
one step	4X	one step	29X	one step	54X	one step	79X
one step	5X	one step	30X	one step	55X	one step	80X
one step	6X	one step	31X	one step	56X	one step	81X
one step	7X	one step	32X	one step	57X	one step	82X
one step	8X	one step	33X	one step	58X	one step	83X
one step	9X	one step	34X	one step	59X	one step	84X
one step	10X	one step	35X	one step	60X	one step	85X
one step	11X	one step	36X	one step	61X	one step	86X
one step	12X	one step	37X	one step	62X	one step	87X
one step	13X	one step	38X	one step	63X	one step	88X
one step	14X	one step	39X	one step	64X	one step	89X
one step	15X	one step	40X	one step	65X	one step	90X
one step	16X	one step	41X	one step	66X	one step	91X
one step	17X	one step	42X	one step	67X	one step	92X
one step	18X	one step	43X	one step	68X	one step	93X
one step	19X	one step	44X	one step	69X	one step	94X
one step	20X	one step	45X	one step	70X	one step	95X
one step	21X	one step	46X	one step	71X	one step	96X
one step	22X	one step	47X	one step	72X	one step	97X
one step	23X	one step	48X	one step	73X	one step	98X
one step	24X	one step	49X	one step	74X	one step	99X
one step	25X	one step	50X	one step	75X	one step	100X

Stanley Brouwn, text-image in *Documenta 5*, no. 17 (Kassel: Documenta, 1972): 27.

STANLEY BROUWN A Short Manifesto (1964)

4000 A.D.

WHEN SCIENCE AND ART ARE ENTIRELY

MELTED TOGETHER TO SOMETHING NEW

WHEN THE PEOPLE WILL HAVE LOST THEIR

REMEMBRANCE AND THUS WILL HAVE

NO PAST, ONLY FUTURE.

WHEN THEY WILL HAVE TO DISCOVER EVERYTHING

EVERY MOMENT AGAIN AND AGAIN

WHEN THEY WILL HAVE LOST THEIR NEED FOR

CONTACT WITH OTHERS. . . .

 THEN THEY WILL LIVE IN A WORLD OF ONLY

COLOUR, LIGHT, SPACE, TIME, SOUNDS AND MOVEMENT

THEN COLOUR LIGHT SPACE TIME

SOUNDS AND MOVEMENT WILL BE FREE

NO MUSIC

NO THEATER

NO ART

NO

THERE WILL BE SOUND

 COLOUR

 LIGHT

 SPACE

 TIME

 MOVEMENT

* Stanley Brouwn, "A Short Manifesto," *Institute of Contemporary Arts Bulletin* (London) 140 (October 1964): 7. By permission of the publisher.

VINCENZO AGNETTI Statements (1972)

Hi-Fi-Writing

Theoretical operations on the language of art automatically lead us back to man's primitive alphabet. This return is brought about through the use of modern instruments and methodologies. If man's primordial past is to be discovered in instinct, intuition and telepathy, his future is a function of intelligence, logic and instrumentation.

Today, instruments and materials become a part of the language of art no longer as represented subject matter, but rather as true and proper linguistic tools. This is a conscious return to the *primal state*. For example, science uses the electro-encephalograph for the measurement of cerebral potential. The resultant diagram is an effect that gives evidence of its cause, which is thought. As art language, the diagram tends to suggest the *ineffective thought* of primitive antiquity. The electro-encephalograph is a high-fidelity instrument, but like all instruments of comparison, including man himself, it is relative. The recorded writings—the diagrams—become illegible again, just like man's earliest intuitional writings. Now, however, there is the difference that unwritten and unspoken thought manages at least to leave behind itself an energetic, behavioural trace of the mind's activity. And when thought closes itself off entirely from writing and all other forms of manifestation, its energy is released—absolutely and no longer relatively—into the wave spaces that form the cosmic tissue of basic memory.

.

14 propositions on portable language, on the word transmitted, received and made a path for an exemplification of anti-time, a conglomeration of anti-instants; time that stands still. 14 telegrams I have sent to myself to deviate the concept of time as a state in itself. In fact time is nothing but the work of formation and consumption of things. In every thing there is a passing and re-passing that we call time. Hence this work is speech without temporal poetics, it is a time-no where departure and arrival are the same thing.

Word

Language is the first portable instrument discovered by man.
The word is a portable sign.
The word communicated at a distance fosters the portable instruments but also makes man portable.
Smells looks gestures noises colors temperatures obstacles etcetera are languages occupied by words.
The written or spoken word depreciates the object which supports it but is objectified.
The word not written and not spoken remains the sole real mystery.
The word when it is alone tends to multiply into many meanings.
The word when it is alone nevertheless remains the title of different themes relating to subjective associations.
Different words together form speech, an available object.

* Vincenzo Agnetti, "Hi-Fi-Writing" (trans. Henry Martin), untitled statement, "Word," and "Propositions," all in *Documenta 5* (Kassel: Documenta, 1972), 17.11–17.12. By permission of Ronald Feldman Fine Arts, New York, for the estate of Vincenzo Agnetti.

Different words together form a story, a poetic object.

Different words together form an indictment, a political object.

A word repeated becomes another word.

Continues continues continues continues.

Propositions

The following eight propositions represent the basic scheme of my next exhibition, which will be entitled lost space and CONSTRUCTED SPACE.

A) The discovery of *territory,* with its borders and limits, has concealed the concept of space.

B) Territories within the territory, that is to say *territorial* surfaces, have in their turn given importance to mundane relativity (earthly surroundings).

C) The measurement of various territories has imposed *territoriality:* square meters, minerals, crops, property.

D) The analysis of A, B and C shows that to discover laws and structures we need centuries. They also show that we need just as many centuries to free ourselves from the instruments and the disciplines which have given meaning to these very discoveries.

E) Our cultural background enables us to single out the negative points of the discoveries and carries out a compulsory erasure which is added to that of the wear and tear which permits conceptualism to be overcome. Such erasure, however, implies a neo-culture to exploit the denial.

F) Only time can recover space. In this way culture gets lost in time, becoming an acquisition in the genetic heritage. In a way it may be considered as a metaculture based on present-day culture *almost forgotten by heart.*

G) When space has been recovered, our culture will be *completely forgotten by heart.*

H) The equivalent of *memory* will be complete indifference as regards points A, B, C, D, E, F, G and H.

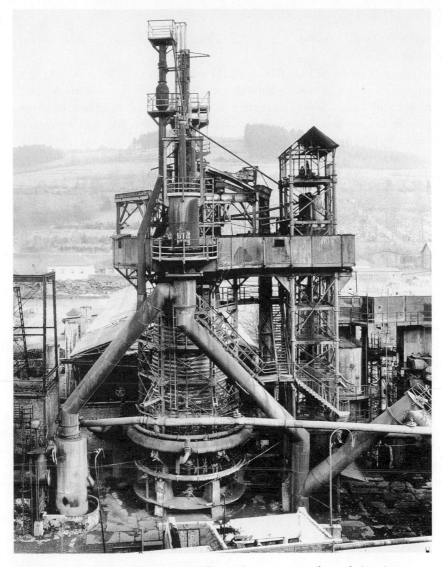

Bernd and Hilla Becher, *Blast Furnace in Siegen, Germany,* 1961, silver gelatin print.
Courtesy Sonnabend Gallery, New York.

BERND AND HILLA BECHER

Blast Furnace in Siegen, Germany (2005)

This image was one of the very first we made with the larger 5 × 8-inch field camera. This
has also been the negative format we have stayed with ever since.

* Bernd and Hilla Becher, *Blast Furnace in Siegen, Germany,* in Francesca Richer and Matthew Rosenzweig,
eds., *No. 1: First Works by 362 Artists* (New York: D.A.P./Distributed Art Publishers, 2005). By permission of the
authors, courtesy Sonnabend Gallery, New York.

JOHN LATHAM Statement (1981)

THE MYSTERIOUS BEING KNOWN AS GOD is an atemporal score, with a probable time-base in the region of 10^{21} seconds.

Language—as a medium, is unable to tell the whole truth.

Physics, which uses a dimensionality that could do so, is nevertheless unable to move outside its particular boundaries and to refer in any way to sources of human action.

The present day world is comparable to a fission reactor the design of which is unknown but which is overheating and out of control.

The problem is with a means of representation that can envision the whole, its occluded dimensionality, and the relatedness between its parts.

Event Structure proposes a design. It arose from the point in the art trajectory of extreme minimalisation with respect to "time" and developed from there in terms of process sculpture.

Report of a Surveyor (1984)

New philosophy, new stratagem . . .

1. In the past hundred years of art and science we are looking at a development that contradicts common sense and its logic. In spite of technical superfluency, primary assumptions underpinning social order are inconsistent. No notional base affords an inclusive view of the universal Event, and in the absence of consensus at such a level there is now doubt whether the world survives.

We live within a network of contradictions where mind is as structurally indistinct from matter as ever.

2. Illogicalities have stemmed from conclusions, first in physics and then in art, that matter in the first instance and meaning in the second are containable at a dimensionless point. That is to say, at zero extension and zero action. Language has expressed the idea but has afforded no explanation of what may constitute logic from such a point.

A flawed and discredited logic is upheld legally, in the face of arbitrary use of force and anarchy; it is enforced as in an emergency, but against a tide.

3. The contradictions may be resolved if *formal* logic shared unknowingly by art and mathematical media is recognised in terms of *event,* rather than in those of object. Languages depend on objects (that is to say nouns, named entities), and *is unfitted to handle event and process.*

Art, on the other hand reverses this order. Art is Event Structure.

4. From a resolution of the split logic thus entailed a principle proposed in terms of *the* INCIDENTAL PERSON has arisen, and is described.

5. During the past year cosmological theory has begun to affirm the primacy of Event, but it remains unable to say what this implies for human self-understanding.

A common belief has been that an understanding of the Most will be afforded by an understanding of the Least. This belief seems justified, but it requisitions a dimensionality that is not one of appearances. Contra to language logic it declares the world to be an indivisible whole that is not a space-time entity according to the senses.

* John Latham, untitled statement, in Latham, *Event Structure: Approach to a Basic Contradiction* (Calgary: Syntax, 1981), cover, 58–59. By permission of the author and the publishers.

** John Latham, excerpts from *Report of a Surveyor* (Stuttgart and London: Edition Hansjorg Mayer and Tate Gallery Publications, 1984), 7–11. By permission of the author and the publishers.

ART AND CULTURE

A book called Art & Culture - a collection of essays written by
Clement Greenberg - having been published in America early in
the 1960s, had found its way into the library of St. Martins School
of art. In August 1966, having regard for both the persuasive
power of the book among students and for the provocative title,
the book was withdrawn in the name of John Latham, and an event
organised at his home together with the sculptor Barry Flanagan,
who then was in the role of 'student'. The event was called
'STILL & CHEW', and many artists, students and critics were in-
vited.

When the guests arrived they were each asked to take a page from
Art & Culture and to chew it - after which they could if necessary
spit out the product into a flask provided. About a third of the
book was so chewed, and there was some selective choosing as to
the pages. The chewed pages were later immersed in acid - 30%
sulphuric - until the solution was converted to a form of sugar,
and this was then neutralised by addition of quantities of sodium
bicarbonate.

The next step was the introduction of an Alien Culture, a yeast.
After which several months went by with the solution bubbling
gently.

Nearly a year after the Chewing, at the end of May 1967, a post-
card arrived addressed to Mr. Latham with a red label on it saying
VERY URGENT. On the back was a plea for the return of the book
'wanted urgently by a student, Art & Culture'.

A distilling apparatus was assembled, and a suitable glass container
procured for the book to be returned to the librarian. When
this had been done a label was fixed to the glass saying what it
was and together with the postcard it was presented to her back
in the school, where for some years John Latham had been engaged
as a part-time instructor. After the few minutes required to
persuade the librarian that this was indeed the book which was
asked for on the postcard, he left the room.

In the morning postal delivery a day later a letter arrived from
the principal at St. Martins addressed to Mr. Latham. It said he
was sorry, he was unable to invite him to do any more teaching.

John Latham 22 Portland Road, London W.11
August 1967

John Latham, "Art and Culture," 1967. From *John Latham: State of Mind* (Düsseldorf: Städtische Kunsthalle, 1975).

If, as in physical theory a concept of Least is held in terms of objects (particles having mass et cetera), the resolution to event and process is not made.

If however the idea of event is substituted and shown to be prior to the object, the concept of Least insists on this dimensionality of event, which is unrepresentable in common language. The dilemma is resolved only, at present, in art.

6. A point has been reached anterior to distinctions between art and language (art and science) to generate a form consistent with the dimensionless points of (2) above.

This form transposes the object-based idea into the dimensionality of event, visually, following which the universe is described in terms of visible form. This form is then open to discussion in language and decipherable. A circuit formerly assumed broken may then be completed.

7. The transposition from object to event terms suggests that the problem of society lies within the medium of language itself and the way it imposes its dimensionality on the ordering process. Language is unable to tell the whole truth owing to the incongruity inherent in its framework.

In necessarily dividing time, in its procedure, language is implicitly asserting dividedness and denying a feature of the expression of all cultural traditions, a state of *omnipresent time*. As long as initial assumptions are stated in terms of objects in space or within that duality, reason will persuade that this conception of omnipresence is unsupported by evidence.

Though omnipresent time is inherent its relation to clocktime has not been visualised and it seems a contradiction in terms of language. Its implications for practical purposes are disregarded, or violently contested.

8. On the other hand, with Least understood in terms of Event, a nonextended State is logical and necessary. This nonextended State is an omnipresent component of event within the dimensionality of two constructs introduced and interpreted. They specify the incongruence between Object and Event frameworks.

9. Society is obliged to heed the object-based but flawed logic nonetheless—legal and administrative processes depend on it. On the evidence of current history belief in it has disintegrated, meanwhile.

In such conditions there is a conflict of authority and cataclysmic collision between opposing systems of belief as to its source.

10. The twin media of government, language and money, function as dividing media owing, along with the incongruity, to their inherent concept of sources of action. Neither medium grasps or comprehends the whole.

Both media generate energy in society by division, in a process comparable to fission in a nuclear reactor. Economies impose such (fission) energy on their societies aiming thereby to avert their collapse and assure what is defined as growth. But the impulses themselves contract in terms of time horizons, and degenerate in their intent.

11. Thus while power and rationality are ascribed exclusively to money and language, any principle of inclusivity such as that being proposed here, will be seen as not only "illogical"— it will be in conflict with the way societies are organised. It will then be extradited by one means or another.

Consequent overheating in society seems to have no practical explanation through conventional methods of accounting.

12. The INCIDENTAL PERSON proposal introduces into the economic equation media complementary to language and money, by way of a procedure and method to bring about mutual interaction. Art proposes wholes within which parts relate integrally. Where language

+ money are dividing and excluding, the event structured media are including. (For this reason they have been administered in apartheid.)

13. So the economic logic of the Incidental Person stratagem measures against the cost to global society of maintaining divisive positions at all levels.

The limits of social coherence are determined by the nature of the *media* predominant in decision making rather than from any personal or political fault. There are no faults. But there are energy equations that are overstretched and put into high tension by the language-money combination.

14. Practical implications and methods found necessary for the association of such Incidental Persons as are found to communicate primarily and by nature with an including medium, with departments of government, have been researched in Britain by the Artist Placement Group, and its results are on public record.

15. For such a stratagem to become fully effective, a United Nations Instrument of sanction will be necessary.

Such an instrument of sanction is the essence of any action proposed in this report. The remainder is concerned with technical detail.

MARCEL BROODTHAERS
Ten Thousand Francs Reward: Interview with Irmeline Lebeer (1974)

1. *Objects*

Q: Do objects function for you as words?

A: I use the object as a zero word.

Q: Weren't they originally literary objects?

A: You could call them that, I suppose, although the most recent objects have escaped this denomination, which has a pejorative reputation (I wonder why?). These recent objects carry, in a most sensational manner, the marks of a language. Words, numerations, signs inscribed on the object itself.

Q: Did you, at the beginning of your activity, follow so definite a direction?

A: I was haunted by a certain painting by Magritte, the one in which words figure. With Magritte, you have a contradiction between the painted word and the painted object, a subversion of the sign of language and that of painting so as to restrict the notion of the subject.

Q: Do you still value any objects?

A: Yes, a few. They are poetic ones, that is to say, they are guilty in the sense of "art as language" and innocent in the sense of language as art. Those, for example, that I shall describe to you.

A tricolored thighbone entitled *Fémur d'Homme Belge*. Also an old portrait of a general that I picked up in a flea market, I forget where. I made a little hole in the general's tight mouth and inserted a cigar butt. In this object-portrait, there is a fortuitous tonal harmony.

* Marcel Broodthaers, "Ten Thousand Francs Reward," interview with Irmeline Lebeer, published as "Dix mille francs de récompense," in *Marcel Broodthaers: Catalgue/Catalogus* (Brussels: Palais des Beaux Arts, 1974). © Gilissen/Estate of Marcel Broodthaers. Translated by Paul Schmidt for *Broodthaers: Writings, Interviews, Photographs*, special issue, *October* 42 (Fall 1987): 39–48. © 1987 by October Magazine and the Massachusetts Institute of Technology.

The paint is brown, sort of pissy, and so is the cigar butt. Not just any cigar would suit any general's mouth . . . the caliber of the cigar, the shape of the mouth.

Q: Would you call it the art of portraiture?

A: I prefer to believe that it acts like a pedagogical object. The secret of art must, whenever possible, be unveiled—the dead general smokes an extinguished cigar. So, counting the thighbone, I've made two useful objects. I wish I'd been able to do other pieces as satisfying to me as these. But I distrusted the genre. The portrait and the thighbone seem to have the strength to make a dent in the falsity inherent in culture. With the thighbone, nationality and the structure of the human being are united. The soldier is not far behind.

Q: There are many shells, mussels, and eggs in your work. Are these accumulations?

A: The subject is rather that of the relationship established between the shells and the object that supports them: table, chair, or cooking pot. It's on a table that you serve an egg. But on my table, there are too many eggs, and the knife, the fork, and the plate are absent—absences necessary to give speaking presence to the egg at the table, or to give the spectator an original idea of the chicken.

Q: And the mussels—a dream of the North Sea?

A: A mussel conceals a volume. When the mussels overflow the pot, they are not boiling over in accord with a physical law, but following the rules of artifice whose purpose is the construction of an abstract shape.

Q: Does this mean that you are close to an academic system?

A: It is a rhetoric that thrives on the new dictionary of received ideas. I don't so much organize objects and ideas as organize encounters of different functions that all refer to the same world: the table and the egg, the mussel and the pot to the table and to art, to the mussel and to the chicken.

Q: The world of the imaginary?

A: Or that of sociological reality. It is that for which Magritte did not fail to reproach me. He thought I was more sociologist than artist.

2. Industrial Signalizations

Q: The plaques made of plastic—do they correspond to this sociological reality?

A: I thought using plastic as a material would free me from the past, since this material didn't exist then. I was so taken with the idea that I forgot that plastic had already been "ennobled" by its appearance on the walls of galleries and museums under the signature of the nouveaux réalistes and American pop. What interested me was the warping of representation when executed in this material.

Q: They were published in editions of seven?

A: I myself was responsible for the edition, since no gallery would assume the risk of bringing them out at that time. To make them I did get some help from the private sector.

Q: What about the language of these plaques?

A: Let's call them rebuses. And the subject, a speculation about a difficulty of reading that results when you use this substance. These plaques are fabricated like waffles, you know.

Q: Are these plaques really all that difficult to decipher?

A: Reading is impeded by the imagelike quality of the text and vice versa. The stereotypical character of both text and image is defined by the technique of plastic. They are intended to be read on a double level—each one involved in a negative attitude which seems

to me specific to the stance of the artist: not to place the message completely on one side alone, neither image nor text. That is, the refusal to deliver a clear message—as if this role were not incumbent upon the artist, and by extension upon all producers with an economic interest. This could obviously be the beginning of a polemic. The way I see it, there can be no direct connection between art and message, especially if the message is political, without running the risk of being burned by the artifice. Foundering. I prefer signing my name to these booby traps without taking advantage of this caution.

Q: What kind of simpletons do you catch with your plaques?

A: Well, those who take these plaques for pictures and hang them on their walls. Although there's no proof that the real simpleton isn't the author himself, who thought he was a linguist able to leap over the bar in the signifier/signified formula, but who might in fact have been merely playing the professor.

3. The Figures

Q: Do you situate yourself in a surrealist perspective?

A: This one I know by heart: "Everything leads us to believe that there exists a state of mind where life and death, the real and the imaginary, the past and the future, the communicable and the incommunicable, high and low, no longer seem contradictory." I hope I have nothing in common with that state of mind. With *Ceci n'est pas une pipe* Magritte did not take things so lightly. But then again he was too much Magritte. By which I mean that he was too little *Ceci n'est pas une pipe*. It is with that pipe that I tackled the adventure.

Q: Can you give an example?

A: You can see in the Mönchengladbach museum a cardboard box, a clock, a mirror, a pipe, also a mask and a smoke bomb, and one or two other objects I can't recall at this point, accompanied by the expression Fig. 1 or Fig. 2 or Fig. 0 painted on the display surface beneath or to the side of each object. If we are to believe what the inscription says, then the object takes on an illustrative character referring to a kind of novel about society. These objects, the mirror and the pipe, submitted to an identical numbering system (or the cardboard box or the clock or the chair) become interchangeable elements on the stage of a theater. Their destiny is ruined. Here I obtain the desired encounter between different functions. A double assignment and a readable texture—wood, glass, metal, fabric—articulate them morally and materially. I would never have obtained this kind of complexity with technological objects, whose singleness condemns the mind to monomania: minimal art, robot, computer.

The nos. 1, 2, 0 appear figurally. And the abbreviations Fig. poorly in their meaning.

Q: Is this the condition for your feeling at ease with yourself?

A: What reassures me is the hope that the viewer runs the risk—for a moment at least— of no longer feeling at ease. Be sure to visit the Mönchengladbach museum.

Q: But suppose the viewer gets confused, and sees there an expression comparable to that of the nouveaux réalistes of the 1960s?

A: My early objects and images—1964–65—could never cause that particular confusion. The literalness linked to the appropriation of the real didn't suit me, since it conveyed a pure and simple acceptance of progress in art . . . and elsewhere as well. Given that, however, there's nothing to prevent the viewers from getting confused, if that's what they want. I do not assume good faith in my viewers or readers—or bad faith either.

Q: Did you begin with an elaborated vision of your project?

A: I have no idea what my unconscious may have fabricated, and you cannot make me put it into words. I have fabricated instruments for my own use in comprehending fashion in art, in following it, and finally in the search for a definition of fashion. I am neither a painter nor a violinist. It is Ingres who interests me, not Cézanne and the apples.

Q: Why haven't you made use of books or magazines? There are many such means of information available.

A: As it happens I can more easily apprehend conceptual or other data through the information provided by the specific product (especially my own) than through its mediating theorization. It's much harder for me to grasp things and their implications by reading books—except when the book is the object that fascinates me, since for me it is the object of a prohibition. My very first artistic proposition bears the trace of this curse. The remaining copies of an edition of poems written by me served as raw material for a sculpture.

Q: A spatial object?

A: I took a bundle of fifty copies of a book called *Pense-Bête* and half-embedded them in plaster. The wrapping paper is torn off at the top of the "sculpture," so you can see the stack of books (the bottom part is hidden by the plaster). Here you cannot read the book without destroying its sculptural aspect. It is a concrete gesture that passes the prohibition on to the viewer—at least that's what I thought would happen. But I was surprised to find that viewers reacted quite differently from what I had imagined. Everyone so far, no matter who, has perceived the object either as an artistic expression or as a curiosity. "Look! Books in plaster!" No one had any curiosity about the text; nobody had any idea whether this was the final burial of prose or poetry, of sadness or pleasure. No one was affected by the prohibition. Until that moment I had lived practically isolated from all communication, since I had a fictitious audience. Suddenly I had a real audience, on that level where it is a matter of space and conquest.

Q: Is there a difference between audiences?

A: Today the book of poems in new forms has found a certain audience, which is not to say that the difference does not persist. The second audience has no idea what the first is interested in. If space is really the fundamental element of artistic construction (form in language and material form), then, after such a strange experience, I could only oppose it to the philosophy of writing with common sense.

Q: What does space conceal?

A: Isn't it like a game of hide-and-seek? Of course, the one who's hiding will always say he's somewhere else, and yet he's always there. And you know he'll turn around and catch someone. The interminable search for a definition of space serves only to hide the essential structure of art, a process of reification. Any individual who perceives a function of space, especially a convincing one, appropriates it mentally or economically.

Q: What are your political ideas?

A: Once I'd begun to make art, my own, the art I copied, the exploitation of the political consequences of that activity (whose theory can be defined only outside the domain where it operates) appeared ambiguous to me, suspect, too angelical. If artistic production is the thing of things, then theory becomes a private property.

Q: Have you ever made art engagé?

A: I did once. They were poems, concrete signs of engagement since without compensation. My work in those days consisted in writing as few as possible. In the visual arts, my only possible engagement is with my adversaries. Architects are in the same position whenever

they work for themselves. I try as much as I can to circumscribe the problem by proposing little, all of it indifferent. Space can only lead to paradise.

Q: Is there any difference between the plastic arts and a disinterested engagement? (Silence).

Q: At what moment does one start making indifferent art?

A: From the moment that one is less of an artist, when the necessity of making puts down its roots in memory alone. I believe my exhibitions depended and still depend on memories of a period when I assumed the creative situation in a heroic and solitary manner. In other words, it used to be: read this, look at this. Today it is: allow me to present . . .

Q: Isn't artistic activity—let me be precise: I mean in the context of a circulation in galleries, collections, and museums, that is, whenever others become aware of it—isn't it then the height of inauthenticity?

A: Given the chosen tactics—to engage in territorial maneuvers—it is perhaps possible to find an authentic means of calling into question art, its circulation, etc. And that might—although it is unclear no matter how you look at it—justify the continuity and expansion of production. What remains is art as production as production.

Q: In such a game of roulette, how do you keep from losing your bet?

A: There's another risk, no less interesting, to the third or fourth degree. And you don't have to get burned: that is. . . .

HANS HAACKE Statement (1966)

. . . make something, which experiences, reacts to its environment, changes, is nonstable . . .

. . . make something indeterminate, which always looks different, the shape of which cannot be predicted precisely . . .

. . . make something, which cannot "perform" without the assistance of its environment . . .

. . . make something, which reacts to light and temperature changes, is subject to air currents and depends, in its functioning, on the forces of gravity . . .

. . . make something, which the "spectator" handles, with which he plays and thus animates it . . .

. . . make something, which lives in time and make the "spectator" experience time . . .

. . . articulate something natural . . .

Statement (1969)

A "sculpture" that physically reacts to its environment and/or affects its surroundings is no longer to be regarded as an object. The range of outside factors influencing it, as well as its own radius of action, reach beyond the space it materially occupies. It thus merges with the environment in a relationship that is better understood as a "system" of interdependent processes. These

 * Hans Haacke, untitled statement, in Peter Selz, *Directions in Kinetic Sculpture* (Berkeley: University Art Museum, 1966), 37. By permission of the author and courtesy the Committee for Arts and Lectures, University of California, Berkeley.

 ** Hans Haacke, untitled statement, in Germano Celant, ed., *Arte Povera* (Milan: Gabriele Mazzotta, 1969); translated as *Art Povera* (London: Studio Vista; New York: Praeger, 1969), 179. By permission of the author, the editor, and Macmillan Publishing Company for Studio Vista.

```
214 E 3 St.
Block 385   Lot 11
5 story walk-up old law tenement

Owned by Harpmel Realty Inc., 608 E 11 St., NYC
Contracts signed by Harry J. Shapolsky, President('63)
                    Martin Shapolsky, President('64)
Principal Harry J. Shapolsky(according to Real Estate
Directory of Manhattan)

Acquired 8-21-1963 from John the Baptist Foundation,
c/o The Bank of New York, 48 Wall St., NYC,
for $237 600.- (also 7 other bldgs.)

$150 000.- mortgage at 6% interest, 8-19-1963, due
8-19-1968, held by The Ministers and Missionaries
Benefit Board of the American Baptist Convention,
475 Riverside Drive, NYC (also on 7 other bldgs.)

Assessed land value $25 000.- , total $75 000.- (includ-
ing 212 and 216 E 3 St.) (1971)
```

Hans Haacke, *Shapolsky et al. Manhattan Real Estate Holding, Real-Time Social System, as of May 1, 1971* (detail), photograph and data sheet, 1971. © Hans Haacke. By permission of the artist.

processes—transfers of energy, matter or information—evolve without the viewer's empathy. In works conceived for audience participation the viewer might be the source of energy, or his mere presence might be required. There are also "sculpture" systems which function when there is no viewer at all. In neither case, however, has the viewer's emotional, perceptual or intellectual response any influence on the system's behaviour. Such independence does not permit him to assume his traditional role of being the master of the sculpture's programme (meaning), rather the viewer now becomes a witness. A system is not imagined; it is real.

Museums, Managers of Consciousness (1986)

The art world as a whole, and museums in particular, belong to what has aptly been called the "consciousness industry." More than twenty years ago, the German writer Hans Magnus Enzensberger gave us some insight into the nature of this industry in an article which used that phrase as its title. Although he did not specifically elaborate on the art world, his article did refer to it in passing. It seems worthwhile here to extrapolate from and to expand upon Enzensberger's thoughts for a discussion of the role museums and other art-exhibiting institutions play.

Like Enzensberger, I believe the use of the term "industry" for the entire range of activities of those who are employed or working on a freelance basis in the art field has a salutary effect. With one stroke that term cuts through the romantic clouds that envelop the often misleading and mythical notions widely held about the production, distribution, and consumption of art. Artists, as much as galleries, museums, and journalists (not excluding art historians), hesitate to discuss the industrial aspect of their activities. An unequivocal acknowledgment might endanger the cherished romantic ideas with which most art world participants enter the field, and which still sustain them emotionally today. Supplanting the traditional bohemian image of the art world with that of a business operation could also negatively affect the marketability of its products and interfere with fundraising efforts. Those who in fact plan and execute industrial strategies tend, whether by inclination or need, to mystify art and conceal its industrial aspects and often fall for their own propaganda. Given the prevalent marketability of myths, it may sound almost sacrilegious to insist on using the term "industry."

On the other hand, a new breed has recently appeared on the industrial landscape: the arts managers. Trained by prestigious business schools, they are convinced that art can and should be managed like the production and marketing of other goods. They make no apologies and have few romantic hang-ups. They do not blush in assessing the receptivity and potential development of an audience for their product. As a natural part of their education, they are conversant with budgeting, investment, and price-setting strategies. They have studied organizational goals, managerial structures, and the peculiar social and political environment of their organization. Even the intricacies of labor relations and the ways in which interpersonal issues might affect the organization are part of their curriculum.

Of course, all these and other skills have been employed for decades by art-world denizens of the old school. Instead of enrolling in arts administration courses taught according to the Harvard Business School's case method, they have learned their skills on the job. Following their instincts, they have often been more successful managers than the new graduates promise to be, since the latter are mainly taught by professors with little or no direct knowledge of the peculiarities of the art world. Traditionally, however, the old-timers are shy in admit-

* Hans Haacke, excerpts from "Museums, Managers of Consciousness," in Rosalyn Deutsche et al., *Hans Haacke: Unfinished Business,* ed. Brian Wallis (New York and Cambridge, MA: New Museum of Contemporary Art and MIT Press, 1986), 60–73. By permission of the author and the publishers.

ting to themselves and others the industrial character of their activities and most still do not view themselves as managers. It is to be expected that the lack of delusions and aspirations among the new art administrators will have a noticeable impact on the state of the industry. Being trained primarily as technocrats, they are less likely to have an emotional attachment to the peculiar nature of the product they are promoting. And this attitude, in turn, will have an effect on the type of products we will soon begin to see.

My insistence on the term "industry" is not motivated by sympathy for the new technocrats. As a matter of fact, I have serious reservations about their training, the mentality it fosters, and the consequences it will have. What the emergence of arts administration departments in business schools demonstrates, however, is the fact that in spite of the mystique surrounding the production and distribution of art, we are now—and indeed have been all along—dealing with social organizations that follow industrial modes of operation, ranging in size from the cottage industry to national and multinational conglomerates. Supervisory boards are becoming aware of this fact. Given current financial problems, they try to streamline their operations. Consequently, the present director of the Museum of Modern Art in New York has a management background, and the boards of trustees of other U.S. museums have or are planning to split the position of director into that of a business manager and an artistic director. The Metropolitan Museum in New York is one case where this split has already occurred. The debate often centers merely on which of the two executives should and will in fact have the last word.

Traditionally, the boards of trustees of U.S. museums are dominated by members who come from the world of business and high finance. The board is legally responsible for the institution and consequently the trustees are the ultimate authority. Thus the business mentality has always been conspicuously strong at the decision-making level of private museums in the United States. However, the state of affairs is not essentially different in public museums in other parts of the world. Whether the directors have an art-historical background or not, they perform, in fact, the tasks of the chief executive officer of a business organization. Like their peers in other industries, they prepare budgets and development plans and present them for approval to their respective public supervising bodies and funding agencies. The staging of an international exhibition such as a Biennale or a Documenta presents a major managerial challenge with repercussions not only for what is being managed, but also for the future career of the executive in charge.

Responding to a realistic appraisal of their lot, even artists are now acquiring managerial training in workshops funded by public agencies in the United States. Such sessions are usually well attended, as artists recognize that the managerial skills for running a small business could have a bearing on their own survival. Some of the more successful artists employ their own business managers. As for art dealers, it goes without saying that they are engaged in running businesses. The success of their enterprises and the future of the artists in their stables obviously depend a great deal on their managerial skills. They are assisted by paid advisors, accountants, lawyers, and public relations agents. In turn, collectors often do their collecting with the assistance of a paid staff.

At least in passing, I should mention that numerous other industries depend on the economic vitality of the art branch of the consciousness industry. Arts administrators do not exaggerate when they defend their claims for public support by pointing to the number of jobs that are affected not only in their own institutions, but also in communications and, particularly, in

the hotel and restaurant industries. . . . [T]he discomfort in applying industrial nomenclature to works of art may also have to do with the fact that these products are not entirely physical in nature. Although transmitted in one material form or another, they are developed in and by consciousness and have meaning only for another consciousness. In addition, it is possible to argue over the extent to which the physical object determines the manner in which the receiver decodes it. Such interpretive work is in turn a product of consciousness, performed gratis by each viewer but potentially salable if undertaken by curators, historians, critics, appraisers, teachers, etc. The hesitancy to use industrial concepts and language can probably also be attributed to our lingering idealist tradition, which associates such work with the "spirit," a term with religious overtones and one that indicates the avoidance of mundane considerations.

The tax authorities, however, have no compunction in assessing the income derived from the "spiritual" activities. Conversely, the taxpayers so affected do not shy away from deducting relevant business expenses. They normally protest against tax rulings which declare their work to be nothing but a hobby, or to put it in Kantian terms, the pursuit of "disinterested pleasure." Economists consider the consciousness industry as part of the ever-growing service sector and include it as a matter of course in the computation of the gross national product.

The product of the consciousness industry, however, is not only elusive because of its seemingly nonsecular nature and its aspects of intangibility. More disconcerting, perhaps, is the fact that we do not even totally command our individual consciousness. As Karl Marx observed in *The German Ideology,* consciousness is a social product. It is, in fact, not our private property, homegrown and a home to retire to. It is the result of a collective historical endeavor, embedded in and reflecting particular value systems, aspirations, and goals. And these do not by any means represent the interests of everybody. Nor are we dealing with a universally accepted body of knowledge or beliefs. Word has gotten around that material conditions and the ideological context in which an individual grows up and lives determine to a considerable extent his or her consciousness. As has been pointed out (and not only by Marxist social scientists and psychologists), consciousness is not a pure, independent, value-free entity, evolving according to internal, self-sufficient, and universal rules. It is contingent, an open system, responsible to the crosscurrents of the environment. It is, in fact, a battleground of conflicting interests. Correspondingly, the products of consciousness represent interests and interpretations of the world that are potentially at odds with each other. The products of the means of production, like those means themselves, are not neutral. As they were shaped by their respective environments and social relations, so do they in turn influence our view of the human condition.

Currently we are witnessing a great retreat to the private cocoon. We see a lot of noncommittal, sometimes cynical playing on naively perceived social forces, along with other forms of contemporary dandyism and updated versions of art for art's sake. Some artists and promoters may reject any commitment and refuse to accept the notion that their work presents a point of view beyond itself or that it fosters certain attitudes; nevertheless, as soon as work enjoys larger exposure it inevitably participates in public discourse, advances particular systems of belief, and has reverberations in the social arena. At that point, art works are no longer a private affair. The producer and the distributor must then weigh the impact.

But it is important to recognize that the codes employed by artists are often not as clear and unambiguous as those in other fields of communication. Controlled ambiguity may, in fact, be one of the characteristics of much Western art since the Renaissance. It is not uncom-

mon that messages are received in a garbled, distorted form; they may even relay the opposite of what was intended (not to mention the kinds of creative confusion and muddle-headedness that can accompany the art work's production). To compound these problems, there are the historical contingencies of the codes and the unavoidable biases of those who decipher them. With so many variables, there is ample room for exegesis and a livelihood is thus guaranteed for many workers in the consciousness industry.

Although the product under discussion appears to be quite slippery, it is by no means inconsequential, as cultural functionaries from Moscow to Washington make clear every day. It is recognized in both capitals that not only the mass media deserve monitoring, but also those activities which are normally relegated to special sections at the back of newspapers. The *New York Times* calls its weekend section "Arts and Leisure" and covers under this heading theater, dance, film, art, numismatics, gardening, and other ostensibly harmless activities. Other papers carry these items under equally innocuous titles, such as "culture," "entertainment," or "lifestyle." Why should governments, and for that matter corporations which are not themselves in the communications industry, pay attention to such seeming trivia? I think they do so for good reason. They have understood, sometimes better than the people who work in the leisure suits of culture, that the term "culture" camouflages the social and political consequences resulting from the industrial distribution of consciousness.

The channeling of consciousness is pervasive not only under dictatorships, but also in liberal societies. To make such an assertion may sound outrageous because according to popular myth, liberal regimes do not behave this way. Such an assertion could also be misunderstood as an attempt to downplay the brutality with which mainstream conduct is enforced in totalitarian regimes, or as a claim that coercion of the same viciousness is practiced elsewhere as well. In nondictatorial societies, the induction into and the maintenance of a particular way of thinking and seeing must be performed with subtlety in order to succeed. Staying within the acceptable range of divergent views must be perceived as the natural thing to do.

Within the art world, museums and other institutions that stage exhibitions play an important role in the inculcation of opinions and attitudes. Indeed, they usually present themselves as educational organizations and consider education as one of their primary responsibilities. Naturally, museums work in the vineyards of consciousness. To state that obvious fact, however, is not an accusation of devious conduct. An institution's intellectual and moral position becomes tenuous only if it claims to be free of ideological bias. And such an institution should be challenged if it refuses to acknowledge that it operates under constraints deriving from its sources of funding and from the authority to which it reports.

It is perhaps not surprising that many museums indignantly reject the notion that they provide a biased view of the works in their custody. Indeed, museums usually claim to subscribe to the canons of impartial scholarship. As honorable as such an endeavor is—and it is still a valid goal to strive for—it suffers from idealist delusions about the nonpartisan character of consciousness. A theoretical prop for this worthy but untenable position is the nineteenth-century doctrine of art for art's sake. That doctrine has an avant-garde historical veneer and in its time did indeed perform a liberating role. Even today, in countries where artists are openly compelled to serve prescribed policies, it still has an emancipatory ring. The gospel of art for art's sake isolates art and postulates its self-sufficiency, as if art had or followed rules which are impervious to the social environment. Adherents of the doctrine believe that art does not and should not reflect the squabbles of the day. Obviously they are mistaken in their assumption that products of consciousness can be created in isolation. Their stance and what

is crafted under its auspices have not only theoretical but also definite social implications. American formalism updated the doctrine and associated it with the political concepts of the "free world" and individualism. Under Clement Greenberg's tutelage, everything that made worldly references was simply excommunicated from art so as to shield the Grail of taste from contamination. What began as a liberating drive turned into its opposite. The doctrine now provides museums with an alibi for ignoring the ideological aspects of art works and the equally ideological implications of the way those works are presented to the public. Whether such neutralizing is performed with deliberation or merely out of habit or lack of resources is irrelevant: practiced over many years it constitutes a powerful form of indoctrination.

Every museum is perforce a political institution, no matter whether it is privately run or maintained and supervised by governmental agencies. . . . During the past twenty years, the power relations between art institutions and their sources of funding have become more complex. Museums have to be maintained either by public agencies—the tradition in Europe— or through donations from private individuals and philanthropic organizations, as has been the pattern in the United States. When Congress established the National Endowment for the Arts in 1965, U.S. museums gained an additional source of funding. In accepting public grants, however, they became accountable—even if in practice only to a limited degree—to government agencies.

Some public museums in Europe went the road of mixed support, too, although in the opposite direction. Private donors came on board with attractive collections. As has been customary in U.S. museums, however, some of these donors demanded a part in policy making. . . .

Starting on a large scale towards the end of the 1960s in the United States and expanding rapidly ever since, corporate funding has spread during the last five years to Britain and the Continent. Ambitious exhibition programs that could not be financed through traditional sources led museums to turn to corporations for support. The larger, more lavishly appointed these shows and their catalogues became, however, the more glamour the audiences began to expect. In an ever-advancing spiral the public was made to believe that only Hollywood-style extravaganzas were worth seeing and that only they could give an accurate sense of the world of art. The resulting box-office pressure made the museums still more dependent on corporate funding. Then came the recessions of the 1970s and 1980s. Many individual donors could no longer contribute at the accustomed rate, and inflation eroded the purchasing power of funds. To compound the financial problems, many governments, facing huge deficits—often due to sizable expansions of military budgets—cut their support for social services as well as their arts funding. Again museums felt they had no choice but to turn to corporations for a bailout. Following their own ideological inclinations and making them national policy, President Reagan and Mrs. Thatcher encouraged the so-called private sector to pick up the slack in financial support.

Why have business executives been receptive to the museums' pleas for money? During the restive Sixties the more astute ones began to understand that corporate involvement in the arts is too important to be left to the chairman's wife. Irrespective of their own love for or indifference towards art, they recognized that a company's association with art could yield benefits far out of proportion to a specific financial investment. Not only could such a policy attract sophisticated personnel, but it also projected an image of the company as a good corporate citizen and advertised its products—all things which impress investors. Executives with a longer vision also saw that the association of their company (and, by implication, of business

in general) with the high prestige of art was a subtle but effective means for lobbying in the corridors of government. It could open doors, facilitate passage of favorable legislation, and serve as a shield against scrutiny and criticism of corporate conduct. . . .

Corporate public relations officers know that the greatest publicity benefits can be derived from high-visibility events, shows that draw crowds and are covered extensively by the popular media; these are shows that are based on and create myths—in short, blockbusters. As long as an institution is not squeamish about company involvement in press releases, posters, advertisements, and its exhibition catalogue, its grant proposal for such an extravaganza is likely to be examined with sympathy. Some companies are happy to underwrite publicity for the event (which usually includes the company logo) at a rate almost matching the funds they make available for the exhibition itself. Generally, such companies look for events that are "exciting," a word that pops up in museum press releases and catalogue prefaces more often than any other.

Museum managers have learned, of course, what kind of shows are likely to attract corporate funding. And they also know that they have to keep their institutions in the limelight. Most shows in large New York museums are now sponsored by corporations. Institutions in London will soon be catching up with them. The Whitney Museum has even gone one step further. It has established branches—almost literally a merger—on the premises of two companies. It is fair to assume that exhibition proposals that do not fulfill the necessary criteria for corporate sponsorship risk not being considered, and we never hear about them. Certainly, shows that could promote critical awareness, present products of consciousness dialectically and in relation to the social world, or question relations of power have a slim chance of being approved—not only because they are unlikely to attract corporate funding, but also because they could sour relations with potential sponsors for other shows. Consequently, self-censorship is having a boom. Without exerting any direct pressure, corporations have effectively gained a veto in museums, even though their financial contribution often covers only a fraction of the costs of an exhibition. Depending on circumstances, these contributions are tax-deductible as a business expense or a charitable contribution. Ordinary taxpayers are thus footing part of the bill. In effect, they are unwitting sponsors of private corporate policies, which, in many cases, are detrimental to their health and safety, the general welfare, and in conflict with their personal ethics.

Since the corporate blanket is so warm, glaring examples of direct interference rare, and the increasing dominance of the museums' development offices hard to trace, the change of climate is hardly perceived, nor is it taken as a threat. To say that this change might have consequences beyond the confines of the institution and that it affects the type of art that is and will be produced therefore can sound like over-dramatization. Through naiveté, need, or addiction to corporate financing, museums are now on the slippery road to becoming public relations agents for the interests of big business and its ideological allies. The adjustments that museums make in the selection and promotion of works for exhibition and in the way they present them create a climate that supports prevailing distributions of power and capital and persuades the populace that the status quo is the natural and best order of things. Rather than sponsoring intelligent, critical awareness, museums thus tend to foster appeasement.

Those engaged in collaboration with the public relations officers of companies rarely see themselves as promoters of acquiescence. On the contrary, they are usually convinced that their activities are in the best interests of art. Such a well-intentioned delusion can survive only as long as art is perceived as a mythical entity above mundane interests and ideological

conflict. And it is, of course, this misunderstanding of the role that products of the consciousness industry play which constitutes the indispensable base for all corporate strategies of persuasion.

Whether museums contend with governments, power-trips of individuals, or the corporate steamroller, they are in the business of molding and channeling consciousness. Even though they may not agree with the system of beliefs dominant at the time, their options not to subscribe to them and instead to promote an alternative consciousness are limited. The survival of the institution and personal careers are often at stake. But in nondictatorial societies, the means for the production of consciousness are not all in one hand. The sophistication required to promote a particular interpretation of the world is potentially also available to question that interpretation and to offer other versions. As the need to spend enormous sums for public relations and government propaganda indicates, things are not frozen. Political constellations shift and unincorporated zones exist in sufficient numbers to disturb the mainstream.

It was never easy for museums to preserve or regain a degree of maneuverability and intellectual integrity. It takes stealth, intelligence, determination—and some luck. But a democratic society demands nothing less than that.

KLAUS STAECK Interview with Georg Jappe (1976)

KLAUS STAECK: My credo, if you like, is exactly this point. . . . Because no-one knows what art is, because this question is undecided, thank God, I have got a chance of acting in this borderline area between Art and Non-Art. I use this consciously as a possibility, in order to arouse interest. Because it's my experience that if people say something is art, it is as a rule ineffective. This is a very important point.

My medium is first of all the photomontage, which I essentially owe to Heartfield. But I developed this principle into the picture-text-montage, which plays an absolutely central role in my work. While for Heartfield it was as a rule a signature, sometimes almost a literary explanation, in my work text is firmly incorporated and has come to be an essential component of the image. Then of course there are all the other formal principles which make a picture. My things appear a bit flat and unpretentious; whereas Heartfield still works more from a basically graphic conception. His things are still much more like pictures.

The working method is another factor. Heartfield worked from an original, in whatever form: the small montage, the picture, was then reproduced. While we—Gerhard Steidl, my printer, and I—do that completely in the machine. Our method of production comes much closer to the challenges of El Lissitzky. The seeming flatness, the lack of art, also comes from this; it exists because we don't spray it off on the table but rather fully exploit the possibilities of offset. The technical and economic constraint of machine art also directs us, and we use it completely consciously, away from the aura-giving, away from the original. The first question which galleries posit is: have you also got originals? Every time, then, there is great disappointment when I say there are no originals, but rather an idea which is discussed with the printer. Because of that all speculation with works of art is ruled out right from the start. This is also a decisive point—that a thoroughly essential element of traditional art, the aura, doesn't exist at all.

* Georg Jappe, "Klaus Staeck: Interview," trans. Barbara Flynn, *Studio International* 191, no. 980 (March–April 1976): 137–40. By permission of the artist.

Heartfield has to be given credit for having led the photomontage out of the art establishment and into the sphere of art for the masses. At which point I turned to action, while Heartfield concentrated very hard on the consciousness of the enlightened working masses, in that he confined himself, for example, to making book jackets and frontispieces. The poster, the postcard, is only one stage of the story. The reaction is incorporated in the pre-planned effect. Part of my work, in addition, is to make reality by producing conflict. In this respect my knowledge of law stands me in good stead, so that I can also initiate legal proceedings—not for their own sake but to make particular contexts evident. The poster provided the first impetus for this.

So to sum up: what chiefly distinguishes me from Heartfield is a no-art look, the text-picture-montage, the working method and action.

GEORG JAPPE: And what about the site of the actions?

KS: Youth hostels, trade union offices, adult extension classes, schools, street exhibitions. You can buy a selected exhibition from me for 180 marks, which anyone can afford: elsewhere you seldom get even a print for that kind of money. My things are working instruments for the many—above all young socialist groups who hang out at the market next to the things and discuss them. The irrational effect is an ideal instrument of communication. It's been pointed out that through irritation one can very, very easily get into a discussion.

Another mode of dissemination is election campaigns, during which the posters are displayed, taking my work out of the gallery into the street. I began there. In 1971, the *Dürer-Mother* was of course a great risk. Admittedly, it had been debated theoretically dozens of times, but in the final analysis no-one would have done it. Something made specially for the street—no Picasso poster that means—to test whether it could be noticed at all, that was the first question.

Since that began to pay off, a way back was no longer possible. Every poster-action, for Germany's treaties with East European countries, for example, was a question of money. Now, years after, groups are beginning to order posters and post them at their own expense. And so something has been achieved: I am only the initiator, and now others do something with art for viewing on the street without needing me. There are also examples of the private individual—this I always find especially good—who buys an exhibition for 180 marks and then rents the side room of a restaurant for the weekend. In this way there were over 100 exhibitions last year, because it's so easy, without any transportation or insurance problems.

The postcards in the meantime are taking on a more significant role than the posters, because a postcard, that one can send, incites one to agitation of one's own.

GJ: And who retails these?

KS: A poster store has never sold a poster of mine. We do everything directly. Orders come from the simplest worker, who doesn't know how to make out a money order, a cheque, or even spell, to the hospital chief of staff. Many other groups—committees on Chile or tenants' associations, for example—can make demonstrations or car rallies with the *Rent-Poster*. We're very careful about contract work. With unauthorized printings misunderstandings occur.

The buyers have also changed. In 1972 they were usually voters initiative, middle-class people with a sense of irony. In the meantime a political change of consciousness has taken place because these groups, disappointed by the SPD, have fallen back into middle-class citizenship or drifted to the far Left. Now I can verify on the basis of my orders that almost half come from our now-celebrated workers. I know that, because I distribute in part through

the trades unions, and because we are open to the direct control of the masses, going to countless events and standing at weekly markets with our general store. More and more we attract the simple people who, of course, need a few years to grasp this method. The *Worker-Poster* is still today one of the most discussed.

GJ: Was it also the most successful?

KS: Yes, it was printed in an edition of 200,000 but now it's being overtaken by the poster against the administrative regulations concerning political radicals. In total we have printed 5 million, posters and postcards. At the beginning this social strata felt shat upon, because irony calls for a rational process—there is more to it than meets the eye. I aim for a not-at-the-first-glance understanding, as a stipulation, because I would like people to grapple with the problem, not only to have an Aha-experience; it is as a rule the bad posters which one understands at first glance. The *Fat-Arse Official Poster* is a simple poster, a flat one in good German, because it portrays only a pictorial recapitulation of the text. No conflict exists between picture and text.

My attention is directed to packaging a difficult set of facts—property relations are, for instance, very complex—in such a way that the man who looks at it doesn't understand it straightaway, but becomes so interested that he wants to understand it. Not that I want to insist that it must be so and so. In this I find myself constantly in conflict with the Left, which wants only appeals. I have the naive hope that an interested viewer will get to the bottom of it himself—that is my goal. And so I diverge from direct agitation. The Left reproaches me with: "you say only what you're against, not what you're for." I don't want to deprive anyone of the answer, but he must discover it himself.

GJ: Let's get back to the text-picture-relationship. What is your idea process like? Do you work from a political idea, and say: "*that* I really have to portray somehow," or does something fall into your hands—at which point you say: "Shit, I can do something with that"? Also, do you work primarily from the picture or the text?

KS: That has altered. Formerly, when I was still making graphics, I worked as a rule almost entirely from the picture. Pictures were quoted in pictures. Then I took advertising and flipped it around; that's how text came in. Now most of the works come from the text. The trigger is a particular political situation. At that point a slogan occurs to me, and then I work up to a year on it, until every word is right. Then I consider, does one add a picture, which intensifies the irritation effect, or does the typography selected produce a more dialectical picture character on its own? Ideas come to me as a rule through television and newspaper reading; every day I read at least ten newspapers, that is my daily task. Despite that of course I take great pains not to make posters relevant only to the time when they were made. I still sell 1971 posters as well as I did then.

GJ: Through the text you can avail yourself of the full scope of the German language, and you principally choose themes related to domestic politics—in the main in the Federal Republic of Germany.

KS: That is a great handicap. But it was a fundamental decision which came out of the student unrest. Everyone could demonstrate unpunished for Vietnam. For me an important realization was that if you approach people closely on immediate problems, those on which we still have a chance to exert an influence, then people begin to react firmly. These were my first realizations with the *Rich Man's Poster* in 1972, which designated the enemy at hand, not the one across the ocean. The danger, and the opportunity of working for change, meant that I pushed closer and closer. And right away there was trouble. As soon as I entered a school,

for example, the CDU came and said: "that can't be allowed," whereas over a Chile or Spanish poster they wouldn't get excited. They come only when they are really stunned. All other politics are merely consumed.

My posters grew through this into aids for articulating complicated facts. For example, a question is posed about how it's going now with freedom of instruction in schools. Confiscation and the bringing of criminal charges and libel proceedings force the courts to discuss content. In order to get the hang of the poster, they have to discuss the thing. In this sense I understand myself as a working artist who offers a particular package of instruments to groups that want to expose the mechanisms. The political discussions which determine our life also belong at the centre of art.

Abroad my use of the German language is of course a handicap, but environmental and social themes are the same in the whole western world. The texts are very easily translated into how it happened in London or Italy. And language shouldn't be stressed that much: in the DDR the posters are understood in a totally different context, acquire a totally different domestic political innuendo, while in London more than 9,000 postcards were sold.

CILDO MEIRELES *Insertions into Ideological Circuits* (1975)

Between 1968 and 1970, as I remember, we were beginning to touch on what was interesting. We no longer worked with metaphors (representations) of situations. We worked with the real situation itself. On the other hand, the kind of work we were making was intended to vanish into thin air. Actually, it was a type of work that only referred to the cult of the object: things existed in terms of what they could stimulate in the social body. We wanted to work out a new concept of the public. At that time, everything was centered around our work, and our objective was to reach as large and indefinite a number of people as possible: that thing called the public. Even today we run the risk of making work while already knowing who it will interest. The notion of the public, a broad and generous notion, has been replaced (in a deformed way) by the notion of the *consumer,* the part of the public that has purchasing power.

Insertions into Ideological Circuits arose from the need to create a system for the circulation and exchange of information that did not depend on any kind of centralized control. A language. A system essentially opposed to the press, radio, and television—typical examples of a *media* in search of an immense audience, but whose systems of circulation always have a degree of control and act to narrow the insertion. In other words, the "insertion" is performed by an elite that has access to the different levels on which the system develops: technological sophistication involving huge amounts of money and/or power.

Insertions into Ideological Circuits became two projects: the *Coca-Cola* project and the *Banknotes* project. The work began with a text written in April 1970 that made the following assertions:

1. there are certain mechanisms for circulation (circuits) in society;

2. such circuits are vehicles that embody the ideology of the producer, even if they are simultaneously passive when receiving insertions into their circulation;

3. this occurs whenever people initiate circuits.

* Cildo Meireles, excerpts from "Insertions into Ideological Circuits," originally published as "Inserções em circuitos ideológicos," in *Arte-Cultura Malasartes* (Rio de Janeiro) 1, no. 1 (1975): 15; reprinted in English in Mari Carmen Ramírez and Héctor Olea, *Inverted Utopias: Avant-Garde Art in Latin America* (New Haven: Yale University Press in association with the Museum of Fine Arts, Houston, 2004). © Cildo Meireles; courtesy Galerie Lelong, New York, and the publishers.

Cildo Meireles, *Insertions into Ideological Circuits: Coca-Cola Project,* 1970, Coca-Cola bottles with altered text. © Cildo Meireles; courtesy Galerie Lelong, New York. Photo: Wilton Montenegro.

Insertions into Ideological Circuits also arose from the recognition of two fairly common practices: so-called "chain letters" (letters one receives, copies, and sends to other people) and messages in bottles, flung into the sea by castaways. Implicit in these practices is the notion of a circulating medium. A notion crystallized by the use of paper money and, metaphorically, by returnable containers (soft-drink bottles, for example).

In my opinion, the most important aspect of this project was the introduction, isolation, and establishment of the concept of a "circuit." It is a concept that determines the dialectical interplay of the artwork once it becomes a parasite on any effort contained within the very essence of the process (media). In other words, the container is always the vehicle for ideology. The initial idea was to confirm the (natural) "circuit" that exists, and around which it is possible to make real work. A characteristic of the "insertion" into this circuit would always be a form of counter-information.

An insertion capitalizes on the sophistication of the medium in order to achieve an increase in equality of access to mass media. Additionally, it prefers to counteract the original ideological propaganda inherent in the circuit—which is usually anesthetic, whether it is produced by industry or by the state. The process of insertion thus contrasts consciousness (insertion) with anesthesia (circuit). Awareness is seen as a function of art and anesthesia as a product of industry, given that every industrial circuit is alienated and alienating. Undoubtedly, art has a social function and is more-or-less conscious, with a greater intensity of awareness in rela-

tion to the society from which it emerges. The role of industry is exactly the opposite of this. As it exists today, the power of industry is based on the greatest possible coefficient of alienation. Thus, the notes regarding *Insertions into Ideological Circuits* oppose art to industry. . . .

The way I originally imagined it, *Insertions into Ideological Circuits* would only exist to the extent that it ceased to be the work of just one person. In other words, the work only exists if it is undertaken by other people. Therefore, the need for anonymity arises, bringing up the question of ownership. No longer concerned with the object, one is left with a practice over which there can be no type of control or ownership. Furthermore, one would seek people instead of information, because the information would seek you. And it would become possible to "annihilate" the notion of *sacred space*.

As long as the museum, the gallery, the canvas, etc., continue to be space devoted to representation, they become a Bermuda Triangle: any issue or idea will automatically be neutralized. I think that our priority is to make a commitment to the public. Not with the buyer of art (the market), but with the audience. The most important element of this endeavor is its indeterminate countenance. To use the marvelous possibility offered by visual arts is to create a new language for expressing each new idea. To always work with the capacity to transgress the factual, to create works of art that do not simply exist in an approved, consecrated, sacred space. That do not take place simply in terms of canvas, surface, representation. To no longer work with a metaphor for gunpowder, but to use gunpowder itself. . . .

JENNY HOLZER Language Games: Interview with Jeanne Siegel (1985)

JEANNE SIEGEL: In a panel discussion on "Politics and Art" in October 1983 at the School of Visual Arts, you said something like this: "People are concerned with staying alive . . . these are dangerous times and our survival is at stake. We should do whatever we can to correct it." Did you see this as the main activity of art?

JENNY HOLZER: I see it as what should be an activity of almost any person in any field. I try to make my art about what I'm concerned with, which often tends to be survival. I do gear my efforts toward that end: I work on people's beliefs, people's attitudes, and sometimes I show concrete things that people might do. I try this on myself all the time, too. I don't think it's what everybody does in art and certainly it's not what everybody should do, but it's an accurate representation of what I try. . . .

I have shown things in galleries and museums in the last few years, but my main activity and my main interest is still the public work. From the beginning, my work has been designed to be stumbled across in the course of a person's daily life. I think it has the most impact when someone is just walking along, not thinking about anything in particular, and then finds these unusual statements either on a poster or on a sign. When I show in a gallery or a museum, it's almost like my work is in a library where people can go to a set place and know they'll find it and have a chance to study. I think it's also really a question of distribution. . . . I try to make work go to as many people as possible and to many different situations. I even put stuff on T-shirts. . . .

Something that I think would be a fairly concrete or a fairly literal attempt at im-

* Jeanne Siegel, excerpts from "Jenny Holzer's Language Games: Interview," *Arts Magazine* 60, no. 4 (December 1985); reprinted in Siegel, ed., *Art Talk: The Early 80s* (New York: Da Capo Press, 1988), 285–97. By permission of the interviewer and the artist.

proving things would be the project I organized at the time of the last presidential election where I set up an electronic forum "Sign on a Truck" for people to discuss their own views on the election. People could speak not just on the quality of the respective candidates but also about the issues that were brought up by the election. This was not only a forum for men and women in the streets to speak about this; it also let me and a number of other artists make very pointed remarks on this topic.

JS: Do you think alternative spaces still have as much power, as much place, as they had four or five years ago?

JH: I don't think they have as much power, but they have a very real function for younger artists and for work that's not necessarily commercial. There's a chance for things to happen that perhaps wouldn't in a commercial gallery. Many times things in galleries have to be certain sizes and shapes and be saleable. . . .

But I don't see, and have never really seen, the galleries as entirely corrupt and working on your own as inherently beautiful. If you're working on your own, you're washing dishes or you're selling insurance or cleaning someone's house. Your money comes from someplace and there's all kinds of clean and dirty money in the real world and in the art world. So I think it's not simple.

JS: Before you came to New York in 1977, you were living in Rhode Island and you were an abstract painter. It appears that you shared an attitude with so many young artists at that time—for example, Barbara Kruger—which was that it seemed imperative to find an alternative to painting. Was that a political position? Was it an aesthetic position? Was it that modernist painting seemed trivialized?

JH: There was a political and aesthetic reason for doing it. From a political standpoint, I was drawn to writing because it was possible to be very explicit about things. If you have crucial issues, burning issues, it's good to say exactly what's right and wrong about them, and then perhaps to show a way that things could be helped. So, it seemed to make sense to write because then you can just say it. From an aesthetic standpoint, I thought things in 1977 were a bit nowhere. No painting seemed perfect. In particular, I didn't want to be a narrative painter, which maybe would have been one solution for someone wanting to be explicit. I could have painted striking workers but that didn't feel right to me, so painting at that stage was a dead-end.

JS: Now you are using two tools that are outside of traditional art. One is language, which you started with, and the other is a machine. What both of these share is that they remove the hand. Let's talk about language first. In your use of it, the idea of contradiction is a key one. Here are two examples of conflicting truisms.

CHILDREN ARE THE CRUELEST OF ALL
CHILDREN ARE THE HOPE OF THE FUTURE

everyone's work is equally important
EXCEPTIONAL PEOPLE DESERVE SPECIAL CONCESSIONS. . . .

JH: I wanted to show that truths as experienced by individuals are valid. I wanted to give each assertion equal weight in hopes that the whole series would instill some sense of tolerance in the onlooker or the reader; that the reader could picture the person behind each sentence believing it wholeheartedly. Then perhaps the reader would be less likely to shoot that true believer represented by the sentence. This is possibly an absurd idea but it was one of my working premises. . . .

Jenny Holzer, selection from *Truisms*, 1982, Spectacolor Board, Times Square, New York. Sponsored by the Public Art Fund. Photo by Lisa Kahane; courtesy Barbara Gladstone Gallery, New York.

My painfully sincere intentions to instill tolerance via the "Truisms" were just as described. The other thing I was going for was the absurd effect of one truism juxtaposed against the next one. I hoped it would be adequately ridiculous. . . .

What I tried to do, starting with the "Truisms" and then with the other series, was to hit on as many topics as possible. The truism format was good for this since you can concisely make observations on almost any topic. Increasingly I tried to pick hot topics. With the next series, "Inflammatory Essays," I wrote about things that were unmentionable or that were the burning question of the day.

With the "Truisms" I was aware that sometimes, because each sentence was equally true, it might have kind of a leveling or a deadening effect. So, for the next series, I made flaming statements in hopes that it would instill some sense of urgency in the reader, the passerby. . . .

In general, I try to reach a broad audience, the biggest possible. . . . In specific instances I do select material or tailor the presentation to the type of people that I expect will be walking by or riding by. On the truism posters I would have 40 different statements and they would be from all over the place. There'd be left-wing ones, there'd be right-wing ones, there would be loony ones, there'd be heartland ones. When I found that I had the opportunity to do the Times Square project with the Spectacolor Board, I suddenly didn't want to put any up that I disagreed with, so I chose half a dozen that I felt comfortable with. . . .

I came to the signs as another way to present work to a large public, in this case a very different way from the posters. The early writing was all on posters which are very cheap and, to the limits of your endurance, you can plaster them everywhere. So the way to get your work out with posters is through multiplicity. The sign is a different medium because it has a very big memory; you can put numberless statements in one sign. Because signs are so flashy, when you put them in a public situation you might have thousands of people watching. So I was interested in the efficiency of signs as well as in the kind of shock value the signs have when programmed with my particular material. These signs are used for advertising and they are used in banks. I thought it would be interesting to put different subjects, kind of a skewed content, in this format, this ordinary machine. . . .

Dada influenced me. I particularly liked that the Dadaists were, in their way, grappling with the conditions that led to the war. I found that very interesting and very ambitious. . . .

Dada was poignantly absurd, which is the best kind of absurdity. . . .

Other sources for my work have very little to do with the art world proper. One source was an extremely erudite reading list that I received at the Whitney Independent Study Program. The "Truisms" were, in part, a reaction to that reading list which was impenetrable but very good. I kind of staggered through the reading and wrote the "Truisms" as a way to convey knowledge with less pain. Otherwise, most of my sources for the truisms and for the other series are either events in the real world or books on any number of topics—from no particular list. . . .

For the "Inflammatory Essays," for instance, I read Mao, Lenin, Emma Goldman, Hitler, Trotsky, anyone with an axe to grind so I could learn how. . . .

JS: Your work is difficult to categorize but, in a general way, one could say that Conceptual art acts as permission for its existence. Joseph Kosuth's focus on idea rather than making, with the ensuing rejection of the object, would ground your work. Then, of course, there is the use of language to convey meaning.

JH: Yes, but often in Conceptual art they excerpted meaning, they used prepackaged meaning, as when Kosuth showed a dictionary definition of art. It was language on language.

JS: However, you do share with Kosuth a desire to reach out to a global situation. You translate texts into other languages and present them simultaneously. He did the same with his billboards.

JH: Yes, I think that's a crossover from Kosuth's and Daniel Buren's efforts to find ways to convey meaning to a large public. I think those guys certainly pioneered that in recent history. . . .

I find that writing is more effective if it's not dogmatic and if it's not immediately or not entirely identifiable as propaganda, because then it becomes something you would hear on the news or it becomes a line—a left-wing line or a right-wing line. One reason why I started to work was because I found that a lot of the statements of the Left were tired, and as soon as people would hear a few catch phrases they would tune out. I thought I would try to invent some ways of conveying ideas and information that people wouldn't dismiss within two seconds of encountering them.

JS: The focus on and radicality of content have been uppermost in discussions of your work to a degree that your various manifestations of style have gone unnoticed or at least unexamined. In recent works where you use electronic signs, what seems significant is the movement. How do you think of movement? How do you use it?

JH: A great feature of the signs is their capacity to move, which I love because it's so much like the spoken word: you can emphasize things; you can roll and pause, which is the kinetic equivalent to inflection in the voice. I think it's a real plus to have that capacity. I write my things by saying them or I write and then say them, to test them. Having them move is an extension of that.

JS: The words move along unremittingly. They move from right to left but then, all of a sudden, one will go up and down or left to right or even stop. You use an assortment of such stylistic devices.

JH: The trick is to keep the whole thing hypnotic. But to sustain hypnosis you have to have variety, so you throw in fits and starts, and up and down, and round and round.

JS: So it is primarily to keep the viewers' attention?

JH: To hold their attention and also to be appropriate for the content. I tailor the programming to what is being said; I also attempt to give the whole composition enough variety. It almost gets musical.

JS: You're involved in rhythm, pauses, pacing.

JH: Time . . . and then you can get into typography, too. I had a stint as a typesetter so this comes out in various ways. . . .

JS: The fact that you've chosen this machine actually makes a comment on our contemporary technological environment. It's fast, transient; it comes and goes; unless you repeat it, it's gone. In that sense, it's highly reflective of our overloaded, media-bombarded world.

JH: It's funny, though. It's only in the art world that it's a "comment on." When it's in the real world, it's just a modern thing. It's a good gizmo. I'm not so interested in the self-referential aspects of it. . . .

JS: How did you determine the length of your so-called program?

JH: I usually fill the signs to capacity. To date, the L.E.D. signs have had a memory of 15,000 characters, which is 15,000 letters or commands for the special effects. They're coming out with signs that can play a library of programs. You pop in one 15,000-letter chunk and then you take it out and you can put in another. I'm trying to develop a collection of programs that can be displayed. . . .

JS: But don't you also have to take into consideration the endurance of your audience? How long is somebody actually going to watch?

JH: I realize that people's attention span, especially if they are on their way to lunch, might be 2.3 seconds and so I try to make each statement have a lot of impact and stand on its own. That still doesn't mean that I don't try to make a whole program that works. I want the statements to reinforce each other so the whole is more than its parts. I just try to make the parts O.K., too. I also want to supply people with a cheap electronic retrospective of my work. . . . But people are much more tolerant about how long they'll stand and read in a gallery than they are at rush hour on the street. Since most of my experience is trying to stop people on the street, I'm very aware of how much time you *don't* have with your audience.

JOHN BALDESSARI What Thinks Me Now (1982)

I want to re-enchant and remythologize.
I want to drill a hole deep-down in art to discover the mythic infrastructure.
(I am less interested in the form art takes than the meaning an image evokes.)
(I am interested in art as a way of knowing.)
I want to express myself in archetypal imagery.
I want to stand at the edge rather than the center.
I want to recall what I always knew. (I am interested in what thinks me.)
(I would rather discover the memory of the soul than to be correct in thought.)
I want to move away from racial amnesia.
I want to produce images that startle one into recollection.
I want to think of history so that it is not a record of events but a method of release.
I want to see the world as something else than serial progression.
I want to know the matrix of events in history.
(What appears to be trivial in a fairy tale, etc. could be the lingering remnant of the memory of the soul.)

* John Baldessari, "What Thinks Me Now," *Documenta 7,* 1 (Kassel: Documenta, 1982), 80. By permission of the author.

I want to engage in the spiritualization of matter and the materialization of the spirit.

I want to think of time as synchronic.

I want to see all variants of a myth in a single imaginary space without regard to historical context.

I want to sift information from noise.

I want to avoid the tedium of sectarianism and dogma.

I want to consider language as an articulation of the limited to express the unlimited.

I want to be at home with the paradoxical, the ambiguous, and the random.

I want to eroticize time, consciousness, and human culture.

I want to blur the boundaries between truth and fiction.

Recalling Ideas: Interview with Jeanne Siegel (1988)

JEANNE SIEGEL: Much of your work of the late 60s and early 70s when you began to use text was commenting on art—some of it ironic perhaps; anyway, it stayed within the art context. You were intellectualizing the processes of art. Am I right in saying that constituted what a good deal of the work was about?

JOHN BALDESSARI: I think . . . art as an activity became a subject matter for me and the text pieces I was doing at the time were simply culled from reading and so they in fact were statements taken out of their context and recontextualized on canvas in the gallery in order to invest them with meaning.

So, for instance, if I did a piece about "no new ideas entering this work," obviously there are ideas there, because it's an idea already, but what I'm trying to test is a case of belief or not belief and then if we believe, then it's art, if we don't believe then it's not art, that sort of situation. . . .

Usually I'm putting out a statement about art and then subjecting it to scrutiny, to question.

There's a very strong theme that seems to occur in my work and it was in some early works called "choosing," which is the idea of choice and I remember back at that time—this was the period of Minimalism and Conceptualism—and I was trying to strip away all of my aesthetic beliefs and trying to get some bedrock ideas I had about art—what did I really think art was essentially? And one of the things that in this reductivist attitude I arrived at was the "choice"—that seems to be a fundamental issue of art. We say this color over that or this subject over that or this material over that. And there, of course, comes in another theme of mine about is there some sort of dichotomy between art and life at all and investigating that. Because in the old existentialist idea, choice-making may be fundamental to your existence and making life authentic, and so much of my work currently in my exhibition is about the moment of decision and about fate intervening and chance eroding and disrupting our powers to make a decision. . . .

JS: A later body of work which became a key one, at least critically, was *Blasted Allegories* (1978). It had a more complicated and sophisticated structure, involving both juxtaposition of words and images, with captions opposing the photos.

JB: I think in those works, the underlying idea that I was trying to do was to give the

* Jeanne Siegel, "John Baldessari: Recalling Ideas," interview, in Siegel, ed., *Art Talk: The Early 80s* (New York: Da Capo Press, 1988), 37–50. By permission of the interviewer.

public some inkling, some insight into how my mind works, and so you could almost see those as sketches, preparatory drawings for some finished work. That's what I'm trying to convey. I want those to be seen as that kind of work—playing, mind playing, as being interesting perhaps in itself. . . .

I was putting up for examination my ambivalence about word and image, that I could really not prioritize one or the other, and I think what I'm positing there is that a lot of our work comes out of that inability to prioritize, and that is an image more important or is a word more important than an image? They seem to be interchangeable for me and I think it's my constant investigation into the nature of both that propels me with a lot of my work because a word almost instantly becomes an image for me, and an image almost instantly becomes a word for me—it's that constant shifting I think that animates my activity.

JS: On the other hand it seems to me you had a gradual shift toward image—expunging the word.

JB: Exactly. I think the reason for that is that when I first started using language I didn't see too much of that being done. You know, there's Braque and Lichtenstein, Cubists, Futurists, Dadaists, and so on, but it seems like what was really prioritized in art was image and I said well, why shouldn't the words be at least given equal time. So I zeroed in on that. And the other reason why I began using photographic imagery and words is that it seemed to be a common parlance more so than the language of painting which seemed to be kind of an elitist language. I thought most people do read newspapers and magazines, look at images in books and TV, and I said this is the way I'm going to speak, be more populist in my approach. And again, it's about an effort to communicate. . . .

JS: A quote of yours about photography—"The real reason I got deeply interested in photography was my sense of dissatisfaction with what I was seeing. I wanted to break down the rules of photography—the conventions." What do you see as those rules or conventions to be broken down?

JB: Well, at the time I was at high school and I got hooked on photography via chemistry and I wanted to develop my own photographs and I began to really get steeped in that body of information. I started looking at camera annuals, going to photography exhibits, listening to photographers speak—parallel to my interest in art. And I've got to say art and photography were seldom commingled and I got very confused. I said, well, why do photographers do one thing and artists do another thing? It's all about image-making and then I began to say photographs are simply nothing but silver deposit on paper and paintings are nothing more than paint deposited on canvas, so what's the big deal? Why should there be a separate kind of imagery for each? And I think that really got me going. I didn't see painters doing paintings of glassware and glass shelves or sand dunes and receding snow fences. Why does that interest photographers and not painters? There were a few people at the time like Siskind doing intriguing work but he was simply using the painter's eye, replicating that imagery in photography. Well, I thought that stupid. . . .

Sometimes I will just present information in the easiest fashion, there it is, put a rectangle or square around it. In other words, all I'm interested in is presenting information in the most economical way.

Other times I will work from without, and use the idea of the frame and an external composition in a very rational fashion. And I am giving a lot of attention to it. I think what I'd like to do is to balance that out with very chaotic internal (inside the frame) situations and it's almost like I'm orchestrating all these elaborate parts into this final composition.

I've used two kinds of framing situations in the last 10 years, one where I call it framing without, where I mentioned you accept the square or the rectangle and then we can go into other geometric variations like the equilateral triangle, a circle, extended rectangle, what have you, and then I compose within that, or framing from within: there I take a shape—the subject matter that I'm using dictates the frame.

For instance, if I have a shot of a table in perspective, then in the frame situation a triangle, truncated perhaps, will be appropriate and will be dictated. Lately I play the framed against the unframed.

JS: In some works you have structured a group of photographs that are individually framed into a total shape.

JB: I think all of that arises from what we call "the edge problem" or how you escape the idea of the edge. I've gotten into some bizarre situations. I remember a show I did where I had one of those movie stills of the great white hunter holding a boa constrictor and just by cutting around the boa constrictor in his hand, I got this rather phallic shape.

At the time I was trying to escape the rectangle, the square and so on and so I made a stencil of that and I placed it upon my camera viewfinder so that I began to compose within this new shape and try to find compositions that would fall within this rather bizarre outline. I made a whole show out of that, so you saw the original image when you came in and then the rest of the images that were the same shape, but by photographing various movie stills and making things compose within the new shape, then you saw the matrix plus all its off-spring marching around the wall.

So there's a case where I've used a very eccentric sort of shape—anything but a right angle. There's a book called *Close Crop Tales* where I've simply utilized various-sided images—it starts out a three-sided story and then all the images are three-sided, then four-sided, five-sided, six-sided—I think I got up to eight-sided images—and all the images are the different sides dictated by the internal composition, so there was a three-sided shape triangle, then there's something in there that dictates those three sides. If it's five sides, there's something inside there that dictates five sides. All of the framing is dictated by what is inside.

JS: Would you agree that in a certain way, historically, you're acting as a bridge in the break from formalist ideas to the reintroduction of content?

JB: Obviously, there's a love/hate relationship going on. I remember at the time all of this introduction to conceptual art, I was accused by my more rigorous peers that I was betraying the cause and now it's funny how time changes that. Now I might be accused of being too much of a formalist. It's all about shifting values, you see, and I enjoy that, I rather do.

JS: Wasn't one of the original dictums of conceptual art that you should make it immediately recognizable, easily understood?

JB: Exactly, which in a way it's kind of laughable because now we look back on the form that a lot of the stuff is cast in—you can say that's formal too, that's a structuring device—it's the most opaque thing—it's not about easy access at all.

I'm interested in language but there are various forms we can use, the fable form, for example. There are all kinds of literary devices and as pointed out by the Poststructuralists, there's no neutral form. It's all style and it was a lie told us back then that there was some neutral way to communicate information. . . . If you go back to some of the very early instances of conceptual art, almost everybody was into the joke—if you walk in a gallery where's the art? Now there's no way you can miss it, right? Kosuth starting out with labels—now he's doing giant works with neon covering all of Castelli Greene Street; myself much larger works

introducing color, Robert Barry working with canvas and paint, Lawrence Weiner doing large works of statements in paint, bronze, charcoal, etc. We've all changed.

CARRIE MAE WEEMS Interview with Susan Canning (1998)

SUSAN CANNING: One of the things that I find interesting in your work is the use of space. . . .

CARRIE MAE WEEMS: I think there is a psychological space created for myself and the viewer. It's a psychological space that works when you've found its rhythm. That's the thing that allows you to move through it and to feel wrapped up in it. It's like listening to music. Trinh Minh-ha says in "Living in the Round" that everything about the space where people live their lives had to do with the rhythm of the space. You know when people were working on chain gangs, there was a lead singer and a pulse beat was constantly going that established a psychological space for you to enter so that you could almost forget about what you were doing. I am interested in that thing, whatever that "thing" is. Sometimes it works and sometimes it doesn't. But I think that there can be, whether it happens in my work often enough is questionable, but there can be a real solidity and a wonderful sound, a visceral sound, that takes place between how the text reads as a piece, whether on a wall or hanging from a banner, and how it crosses the room to meet up with another photograph. I think that I am very much interested in that, probably all artists are, in sort of surrounding the viewer and yourself in a world to deal with very particular ideas and notions. You have to be into the mess of the thing.

SC: What about the authority of your voice—that it's female, that it's African-American, that it deals with issues of class, that it's vernacular?

CMW: I think it's simply my way of sounding out and allowing a certain resonance to take place that wouldn't otherwise. I don't think about it from an "I" position, I feel it's a communal voice, a voice of a group, a voice of a class, and that I know what that voice sounds like because I've come from that group, that class. I know what that language is. I suppose I'm usually thinking of it as that collectivity.

SC: And the collective voice is female, African-American . . .

CMW: Well, it is and it isn't. There is often a male's voice that intervenes, that has to be there. It makes sense because then you have to deal with the mess of things. There could be a clearly defined, delineated female voice, and then there's a sort of male voice. For instance, the male voice in *Untitled* is really wonderful. Without his voice in the shit, it wouldn't fly, it wouldn't go anywhere. There's definitely something that she's on to, but he has a say in her shit, too, about how it's going to fall. And *her* position is to move back and to give him room to speak. And in *22 Million* it is a conglomerate of voices, all kinds of voices, coming from all over the place, and it's not always a black voice. That's probably the one I feel most comfortable with. I love the idea of penetrating the "king's English," but that's not the only thing. I think people would prefer to think about it as being the only thing because then it contains me, in what I call "nigger space," but I really don't want to stay there because that's not all of who I am.

* Susan Canning, excerpts from "Carrie Mae Weems," interview, in Glenn Harper, ed., *Interventions and Provocations: Conversations on Art, Culture, and Resistance* (Albany: State University of New York Press, 1998), 55–63. © 1998 State University of New York. All rights reserved. By permission of the interviewer; the artist, courtesy Jack Shainman Gallery, New York; and the publisher.

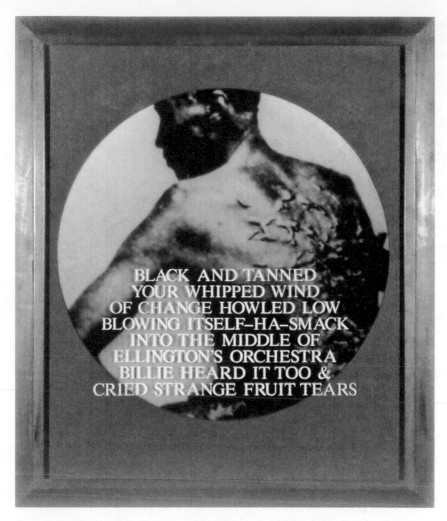

Carrie Mae Weems, *From Here I Saw What Happened and I Cried* (detail), 1995, from installation of monochrome C-prints with sandblasted text on glass. © Carrie Mae Weems; courtesy Jack Shainman Gallery, New York. Photo courtesy P.P.O.W., New York.

The things that interest me and the things I try to play around with have to do with the quality of certain kinds of voices from certain kinds of places. Probably more often than not, it's a female voice but it's not always a female voice and it's not always a black voice. I guess that notion of the multiplicity of sound in a voice is crucial and that's probably one of the most important things to me politically and socially. . . .

The reality is that we are living in a democracy where most of us are supposed to be silent. That's what democracy is, right? So that anything that intervenes in that is a certain kind of amateur authority. But the thing that is remarkable is that we all claim space, all peoples attempt to claim space. Whether you do it through rap, etc., how you speak is the important thing. The issues of activating voices, or giving them authority, I really don't care about that so much as intervening, just intervening in a certain kind of way, wanting to say a certain kind of something, and hoping it may get heard. Probably ninety-nine percent of the time it doesn't, but

sometimes it does get heard. Sometimes it falls just on the right drums at the right moment so that something might happen, something may pull you, the audience, me even, to initiate some kind of action based on the quality of that sound. It's like listening to Martin Luther King speak and then going out and organizing a bus strike or something. Things can get done.

SC: So you see yourself as a catalyst and your work as being a catalyst?

CMW: It has the possibility of being that, under the right circumstances. It certainly gives you pause. There's some stuff you have to deal with when coming to the work, and then once you leave there are some things you have to think about and then you go home and talk to your husband, or your kids, your boyfriend. It does something, it's not just on the wall.

SC: Where do you interject your own language?

CMW: The collective and the I are both in there. You can't talk about something unless you've experienced it on some psychological or physical level. So that's where I think I come in, as a certain conduit for a kind of experience, because I'm a real working-class girl, a "cotton-pickin, corn-pickin negro," you know. I know what that experience is, it's not abstracted from some Marxian text. . . .

SC: What about the way the text positions the viewer to read and see? I assume that you purposefully implicate the viewer. How did you get to that point?

CMW: I think it happened fairly early on, in trying to deal with the issue of spectatorship, in where are people placed, in trying to bring them into it. If you decide that we are all party to the crime then it makes sense that we all are held accountable. You could then point to the viewer and say "you" and "us" as opposed to "they." The thing that troubles me more about the advent of postmodernism is that there is always a "they," "them over there" sensibility, but it's never about us and how we fucked up, how we allowed a certain amount of victimization to take place to begin with. . . .

SC: So it's not passive. Do you see that as part of the politics of it?

CMW: I'm not sure if I've really thought of it in that way. I like the idea of the viewer being active. I'm a political artist, that's what I do. There's a part of making that's quite wonderful. The aesthetic experience is a wonderful experience, but that's certainly not enough. But it's what viewers come away with, what they learn, what they understand, that they begin to question, that matters most to me about being involved in the whole thing. It goes back to your earlier question, about the work being a catalyst. Well it's hopefully a catalyst to memory, a catalyst to some sort of action, a part of a force, a movement for something bigger. It's only a drop in the bucket, relatively speaking, but I think it grants a sense of unity since each of us can contribute our small part that will make up the total, right? That can effect change, then that becomes our moral obligation. You strike where you can. Hopefully it's just enough to rock the boat, just enough to ask some real fundamental questions.

FRANCIS ALŸS Interview with Gianni Romano (2000)

FRANCIS ALŸS: I entered the art field by accident: a coincidence of geographical, personal and legal matters resulted in indefinite vacations which, through a blend of boredom, curiosity, and vanity, led to my present profession. The rather mixed media practice is the consequence of ignorance: not being skilled in any specific medium, I might as well pretend to all

* Gianni Romano, excerpts from "Streets and Gallery Walls: Interview with Francis Alÿs," *Flash Art* 211 (March–April 2000): 70–73. By permission of the interviewer; the artist, courtesy David Zwirner, New York; and the publisher.

of them. My only skill might be in finding the right collaborator for each project, each medium, someone who will translate, adapt and hopefully challenge the plot I'm proposing.

GIANNI ROMANO: Do you mean all your finished work is made by someone else?

FA: Not all of my works are realized by someone else, but most of them develop with the prospect of an eventual collaboration . . . The way it happens is that, once the first scenario is set, I pass it on and watch it evolve, or die. If the concept holds, "it" will bounce back and forth (from the "other(s)" to me and vice versa), grow into something else or reinforce itself through the process of its multiple interpretation . . . If the concept is weak, it will have a short term life and disintegrate within the exchange process itself. It's the test of the articulation, from an idea to a product. Not all ideas need to turn into products though, the best ones tend to become stories, without the need to turn into products. . . .

GR: What kind of commitments were you asking from the billboard painters you hired to realize your first paintings?

FA: Let's say there was some kind of agreement between the sign painters and myself, initially the "commissioner." I was asking the sign painters (on top of enlarging and multiplying the original model) to question the image and to use their skills to improve the image's communication power; to deviate its message, or to extend its content till it would lead to a new image/situation. I wasn't asking [for] a simple copying process, and the team (that quickly became a cooperative of painters with shareholders, etc.), producing hundreds of images over a period of 4 years, was initially formed by the painters who were willing to enter these premises, and to enjoy—that is, to have fun [with]—the challenge.

GR: Shouldn't we expect different attitudes from a painter sitting in front of an empty canvas and a performer moving his body through the city?

FA: My paintings, my images, are only attempting to illustrate situations I confront, provoke or perform on a more public, usually urban, and ephemeral level. I'm trying to make a very clear distinction between what will be addressing the street and what will be directed to the gallery wall. The photo residue of an act acquires a very different status (other than the act itself) once hung on a gallery wall. It can become the closure of the piece. I tried to create painted images that could become "equivalents" to the action, "souvenirs" without literally representing the act itself. Most of the time, I try to imagine a more domestic situation that could translate into something similar, but also function as an autonomous painting on the wall, and fulfill the more commercial aspect of the profession, within its commonly accepted parameters. That distinction also had the advantage of leaving me with enormous freedom when it came down to both practices (always simultaneous: one feeding the other). I'm using the past tense since I stopped collaborating with sign painters in December 1997. Since then, I've been trying to achieve the same aim through musical video clips.

GR: Writing about your painting, Cuauhtémoc Medina mentions the possibility "of recuperating paintings as a means of intercultural and intersocial communication." How should we interpret the "social" in your work?

FA: I think Cuauhtémoc refers to a discussion we had about the potential of painting as a commonly digested medium. Generally, figurative painting is still accessible to a wider public, and can be used as a means to limit (and sometimes hopefully bridge) the actual gap existing between a general public and a more elitist contemporary art scene, without denying or diminishing the eventual contemporaneity of the content. I hope.

GR: This attachment to processualism as a way to make art, is it a reflection of a personal impatience with the idea of art as a ready-made and preestablished code?

FA: I think the ongoing processuality is just a means of avoiding conclusions. I am more interested in attempted articulation than actual enunciation. "Art as Ready made" sounds fine, but it's just not the way it happened to me.

GR: How does this attitude relate or detach you from the conceptual tradition?

FA: "The conceptual tradition" . . . Why does it sound slightly paradoxical from here . . . ? How can one talk about tradition within a field that is still developing? As long as the elaboration of most of my scenarios is, in its first stage, "medium-free" or "pure idea," it somehow belongs to that tradition. Usually the medium manages to define itself during the evolution of the concept.

GR: Why do you say that it sounds "slightly paradoxical from here . . ."? Do you mean from Mexico? . . . Has this country had so much to do with the shaping of your poetical method?

FA: It's more than an influence in the shaping of the practice; it's where I switched from architecture to my current profession. There seems to be a strange chemical reaction happening each time I return; I can arrive emptied and find myself working again two days later, without questioning either the mechanics or the ethics of the profession. The city provokes an urge to react, you can't ignore it or it'll beat you. I consider myself quite lucky to have found a place that coincides so well with my obsessions that it allows me to develop the case (and supported me in doing so). My "poetical tendency" is challenged and is brought back to life's crude reality just by going down to the corner shop. Mexico City has all the ingredients of modernity, but has somehow managed to resist it. And it has acquired a unique identity through the process of resistance.

XU BING An Artist's View (2006)

I began working on *Book from the Sky* at a time when I was constantly in a very anxious and confused mood. This mood was related to the "cultural fever" that was present at the time in China. Culturally, Chinese people were sometimes overfed and at other times underfed. For example, during the Cultural Revolution (1966–1976) the whole nation read only Chairman Mao's Red Book. After the Cultural Revolution ended, people were starved for culture and consumed everything available. During this time I read so much and participated in so many cultural activities that my mind was in a state of chaos. My psyche had been clogged with all sorts of random things. I felt uncomfortable, like a person suffering from starvation who had just gorged himself. It was at that point that I considered creating a book that would clean out these feelings. Looking back, the process of creating *Book from the Sky* helped to clear my head of these discomforts, but the work itself only created more confusion.

People have so many perspectives on *Book from the Sky* because the work itself is empty. The work does not present any clear message. I very seriously labored for years on something that says nothing. The seriousness I devoted to this work is important to both the artwork

* Xu Bing, excerpts from "An Artist's View," in Jerome Silbergeld and Dora C. Y. Ching, eds., *Persistence/Transformation: Text as Image in the Art of Xu Bing* (Princeton, NJ: P. Y. and Kinmay W. Tang Center for East Asian Art and Department of Art and Archaeology, Princeton University, in association with Princeton University Press, 2006), 99–111. By permission of Xu Bing Studio and the P. Y. and Kinmay W. Tang Center for East Asian Art, Princeton University.

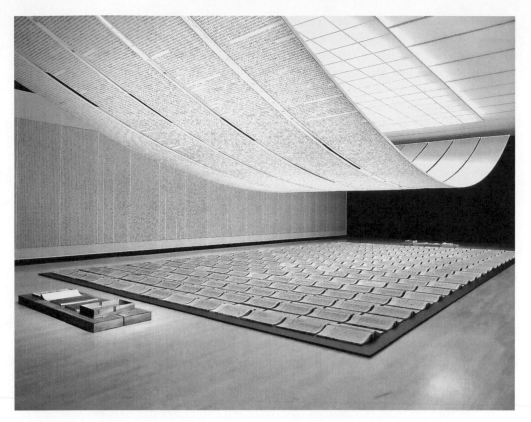

Xu Bing, *Book from the Sky (Tianshu),* 1987–91, mixed-media installation with hand-printed books and scrolls printed from blocks inscribed with "false" characters. © Xu Bing Studio.

itself as well as myself psychologically. By being completely serious to the degree of earnestly believing the pretense as real, true absurdity emerges, and the power of the art is enhanced. I used every possible method to force people to believe in the legitimacy of this work, while at the same time extracting all content completely.

These goals were achieved not only through conceptual means, but also through how I handled the specific materials and controlled every detail, such as the dimensions, book style, margins, number of lines per page, the number of words per line, the space between the words, font, etc. The success of a work lies in finding the most appropriate control of its materials. This is the artist's duty as a craftsman.

Take, for example, why I chose to create *Book from the Sky* using *Song ti* (Song-style script). *Song ti* was created and refined by craftsmen over several generations during the Song and Ming dynasties because it was easier to carve than standard script *(kaishu)*. Calligraphers would still give writing to craftsmen in standard script, and the craftsmen would carve the words into *Song ti.* When I created the blocks for *Book from the Sky,* I used the same process.

Since *Song ti* has been adopted as the official script for print, texts in *Song ti* have gained recognition and legitimacy, and demand seriousness. But because *Song ti* was not created by an individual calligrapher, the characters are devoid of personality and have no concrete implications or emotional importance. This is why I had to carve, print, and bind *Book from the Sky* using the official Song style.

From the outside, *Book from the Sky* looks like a book, but we cannot actually call it a book because it does not have any of the interior content. The artwork itself is a contradiction because it makes a parody of culture while also placing culture in a temple to be taken very seriously. *Book from the Sky* invites your desire to understand it and pushes you away at the same time. It treats everyone as equal—educated or uneducated, Chinese or non-Chinese—because no one can "read" it.

Now I want to talk about two subjects aside from *Book from the Sky*. The first is Square Word Calligraphy. *Book from the Sky* and Square Word Calligraphy have some characteristics that are very similar and others that are completely different. I always say they are like brothers with the same father but a different mother. In both cases, the words wear masks. Their outside appearance contradicts their inside nature. They are camouflaged to present a familiar face, but you are not able to put a name on it. I always say they are like a computer virus that functions in the human brain. They break our familiar patterns of thought and mix the connections between concepts. In the process of searching for a new method of understanding, the fundamentally lazy nature of thought is challenged. This forces you to find a new conceptual foundation.

Square Word Calligraphy is on the border between two totally different cultures. Someone asked me, "Do Chinese people find it offensive that you've restructured Chinese into English?" And I've answered, "To the contrary, Chinese people should praise me for having restructured English into Chinese." The absurdity of Square Word Calligraphy is that it takes two different words from two totally unrelated language systems and fuses them into one entity. Through watching people from around the world write Square Word Calligraphy, I can see how it forces their minds to move in nonlinear paths. This opens up many untouched spaces in our minds and recovers those primal areas of thought and knowledge that have been lost. . . .

Now I will talk about a few recent projects inspired by the Chinese pictograph. I have been using the pictograph as an entry point for exploring the most fundamental elements of Chinese culture. I think the pictograph is central to Chinese thought, aesthetics, and understanding. For instance, Chinese people come to understand structure through writing, as can be seen in their architecture and furniture. Consider windows or doors: while the object itself clearly influences the structure of the word, the structure of the word also returns to influence the design of the actual object. When we see a window, how does the character for "window" function in our consciousness? However, I believe the answer is different with English.

In 1999 I went to Nepal to draw landscapes using words. I sat on a mountain facing another mountain and drew what I saw using text. At this time, I learned a great deal about the nature of Chinese calligraphy. It was as if I were brought back to the starting point of Chinese culture. While facing the mountain, I forgot all of the calligraphic styles I had learned and was left with only the most clear and natural style. I call this series of drawings "Landscript."

There is a reason why Chinese people call painting *xie sheng* (writing objects). Painting and writing are really considered one thing. This is not only to say that *cun fa* (texture stroke) painting technique and calligraphy brushstroke technique are similar, but rather that images in *cun fa* function as symbols, just like words. Through making these "Landscript" works, I learned that *cun fa* is a kind of writing. This is why, in ancient China, students learned to draw from masters not by going outside to draw the natural landscape, but to *zhi chao zhi* (copy from paper to paper) from a *hua pu* (painting manual). The *hua pu* is actually like a dictionary. It is like a volume of basic symbols for all of the natural elements. Once you have learned the system of symbols, you can say anything you want using this language.

You can call my "Landscript" works calligraphy, you can call them paintings, or you can call them writing. *Shi shu hua yin* (poetry, calligraphy, painting, and seal) are cultural practices that Chinese people have always proudly believed come together. I try to fuse these together even more deliberately. Since they originally come from the same root, I am merely uniting them again.

AA BRONSON
Copyright, Cash, and Crowd Control:
Art and Economy in the Work of General Idea (2003)

General Idea emerged in the aftermath of the Paris riots, from the detritus of hippie communes, underground newspapers, radical education, Happenings, love-ins, Marshall McLuhan, and the International Situationists. We believed in a free economy, in the abolition of copyright, and in a grassroots horizontal structure that prefigured the Internet. I want to briefly describe here the strategy by which General Idea defined the territory between art and commerce, and challenged the battle lines of copyright that define culture today.

Boutique Culture

When Jorge, Felix, and I began living and working together as General Idea in 1969, we were already aware of two opposing forces in our communal life: the desire to produce art, and the desire to survive. And in a sort of natural inflection of the conceptual and process art which immediately preceded us, we turned to the idea of incorporating the commerce of art and the economy of the art world into the art itself:

> We wanted to be famous, glamourous, and rich. That is to say, we wanted to be artists and we knew that if we were famous and glamourous we could say we were artists and we would be . . . We did and we are. We are famous glamourous artists.[1]

In our earliest works, such as *The Belly Store* (1969) or *Betty's* (1970), we opened our storefront living space to the public as a series of "shops," projects in the format of commerce. Our earliest multiples were the products we offered for sale there, sometimes found objects, sometimes fabricated of cheap or scavenged materials (see *George Saia's Belly Food,* 1969). Some of the shops were in fact never open: the viewer could look into the display window and see the contents, but a little sign on the door perpetually proclaimed "back in 5 minutes." Like the work of the Fluxus artists, whom we soon met, our low-cost multiples were intended to bypass the gallery system, that economy of added value, and to travel through the more alternative audience of students, artists, writers, rock 'n' roll fans, new music types, trendoids, and media addicts.

In 1980 we first exhibited *The Boutique from the 1984 Miss General Idea Pavillion* at the Carmen Lamanna Gallery in Toronto. Built in the form of a three-dimensional dollar sign, the boutique

* AA Bronson, "Copyright, Cash, and Crowd Control: Art and Economy in the Work of General Idea," in Barbara Fischer, ed., *General Idea: Editions, 1967–1995* (Toronto: Blackwood Gallery, University of Toronto Mississauga, 2003), 24–27. By permission of the author and the publisher.
 1. General Idea, "Glamour," *FILE Megazine* 3:1 (autumn 1975).

structure transformed the street-level gallery into a retail outlet, with General Idea's multiples and publications for sale, for example *Liquid Assets* (1980), or *Nazi Milk* (1979). A full-time shopgirl sat within the tiny compartment we provided, and her presence as well as the exchange of cash, product, and information across the counter were integral aspects of the work.

The true problematic of the Boutique was revealed when it began to be exhibited in museums. Some museums were unable to sell from the Boutique because of conflicts with their museum shops; most were unwilling to sell from the Boutique because of the heresy of commerce infecting the pure white cube. Although times have changed, and museums are now more public about their all-consuming need for money, none of the General Idea Boutiques have been allowed to function as working installations participating in the financial economy of the museum.

Most recently, the Museum of Modern Art in New York exhibited the Boutique with the multiples under Plexiglas, so they could not be touched, in a sort of castrated and purely archival state. I think of this as the ultimate revenge on the artwork that dared to expose the hypocrisy of the museum.[2]

General Idea's ¥en Boutique (1989) went through a similar series of humiliations at the Beaubourg, when a large group of *Test Pattern: T.V. Dinner Plates* (1988) was stolen during the first forty-five minutes of the opening, causing the curators to strip the Boutique of its wares for the duration of the exhibition.[3]

Boutique Coeurs volants (1994/2001), a free-standing sales exhibit in a three-dimensional replica of a Duchamp graphic, is the most recent of these works, and is designed for easier control in today's high-traffic museum. It exhibits only one General Idea multiple: the posthumously produced *Dick All* (1993/2001), based on Duchamp's *Wedge of Chastity* (1954).

Copyright

The key to contemporary consumer culture is the copyright: without the copyright and the sanctity of (individual and/or corporate) authorship, today's mega-economics would collapse—imagine Microsoft, for example, without copyright. Museums act as symbolic keepers of the virtue of copyright, and an art expert's opinion on the authenticity of a work can send values soaring or crashing by vast amounts of money.

General Idea has always believed in the public realm, and much of our production was carried out there. For many years we used commercial fabrication of works to avoid the fetishism of the artist's hand, of the mark of the individual genius. Similarly, our corporate name belied individual authorship. For the entire twenty-five years of our collaboration, we questioned and played with various aspects of authorship and copyright.

FILE Megazine (1972–1989), General Idea's work in magazine format, was sued by the Time-Life Corporation for its simulation of *LIFE* magazine in 1976. We had always been interested in William Burroughs's ideas about images as viruses, and especially the copyright of specific forms and colours. Corporate culture used copyright-protected logos (and even colours, such as Kodak yellow) as a virus to be injected into the mainstream of our society, infecting the population, and creating a sympathetic cash flow. Time-Life holds copyright on "white block lettering on a red parallelogram." It was only when Robert Hughes, *TIME* magazine's current art critic, ridiculed his employers in the pages of *The Village Voice* that the corporation dropped its suit against us.

2. *The Museum as Muse,* Museum of Modern Art, New York, 14 March–1 June, 1999.
3. *Let's Entertain* (touring exhibition), Walker Art Center, Minneapolis, 2000–2001.

Robert Indiana's *LOVE* painting of 1966 is an example of an artist's work that escaped copyright and entered the public realm, appearing as cocktail napkins, keychains, and other commercial paraphernalia. We might think of this as an image virus gone awry, a sort of image cancer. Similarly, General Idea's AIDS logo (1987), a plagiarism or simulacrum of Indiana's *LOVE,* was intended to escape copyright and travel freely through the mainstream of our culture's advertising and communication systems. And so it has, as a series of posters, billboards, and electronic signs, on the street, on television, on the Internet, and in periodicals: *The Journal of the American Medical Association* carried it on its cover in 1992; *Newsweek* used it on every page of a special issue; and the Swiss art journal *Parkett* published sheets of *AIDS Stamps* (1988) which the reader could inject into the postal system on envelopes and parcels— a sort of visual anthrax.

In our final days, General Idea attacked and celebrated the bastion of art history itself. We produced a series of works challenging the copyright of Mondrian, Rietveld, Reinhardt, and Duchamp, with altered simulacra of frankly fake materials: Mondrian paintings on Styrofoam panels, for example, or an altered photographic print of a catalogue reproduction of a work by Duchamp which was itself an alteration to a found print by another artist (*Infe©ted Pharmacie,* 1994).[4]

Living in contradiction

General Idea was at once complicit in and critical of the mechanisms and strategies that join art and commerce, a sort of mole in the art world. Our ability to live and act in contradiction defined our work: we were simultaneously fascinated and repulsed by the mechanisms of today's cultural economy. We injected ourselves into the mainstream of this infectious culture, and lived, as parasites, off our monstrous host.

HERVÉ FISCHER *Theory of Sociological Art* (1977)

From 1971 to 1976, a succession of manifestoes accounted for the development of the theory of a sociological art in France. The first two texts dated from the autumn of 1971. These tracts were focused on the "hygiene of art," one on the "hygiene of painting," the other proposing the action of tearing (déchirure) works of art.

Some Fundamental Theoretical Concepts

Sociological Praxis—We call sociological practice an intervention in the social fabric conducted from the field of knowledge in the social milieu. This practice aims at the idealistic, ideologic attitudes which it wishes to demystify.

Teaching Work—Taking account of the traditional ideological attitudes of public to whom it addresses, a pedagogical practice should invent methods and teaching materials. It aims at surpassing the narrow frame of the initiated, artistic micro-milieu, to work outside the galleries, in the street, with the mass media.

Socio-Critical Work—Beginning in a sociological, materialistic theory and leading to a

4. Many of these were "infected" with the green from the red/green/blue of the AIDS/LOVE logo.

* Hervé Fischer, excerpts from *Théorie de l'art sociologique* (1977), translated as *Theory of Sociological Art* (Buenos Aires: CAYC [Center for Art and Communication] Centro Experimenta, 1979), 5–7. By permission of CAYC.

sociological practice, it searches to create a critical discussion, to put into question the social structure and its system of values. It fundamentally opposes all forms of bureaucracy, all dogmatic attitudes even when nurtured in good conscience.

Animation and Disturbance—In a bureaucratic society subdued by a process of intense massification, our sociological practice aims to denounce all these ideological conditions. It attempts therefore to intervene in the modes of communication and notably in the mass media, in order to disturb it.

Investigation and Experimentation

The sociological practice experiments with the theoretical concepts from which it is elaborated and offers in return material for analysis of the theory. This theoretical practical relationship is fundamentally dialectic. It eventually assumes the necessity to repeat the same investigation, or the same experience, with different publics; or else, to vary the themes with the same material (video for example) or still, to vary the material with the same public.

Communication—Opposed to initiated esoterism which characterises a great majority of the intellectual process, so-called, the avant-garde, sociological art poses as fundamental the problem of a communicative praxis and dialogue. Communication is the theme itself of several experiments so far realized by the Collectif. Parallel to the disturbances it creates in the mass communication system, marginal communications have seemed necessary to create in order to open discussions.

Critique of Avant-gardism—The idealistic tradition of the artist-genius orchestrated by Marcel Duchamp and supported by the competing market of art partially substituted the criteria of novelty to that of a "beautiful esthetique." This ideology references the internal workings of the history of art, whereas the point of view of sociological art is to reference social reality. Teaching and experimentation demand, contrary to the ideology of the avantgarde, that we repeat the same practice a number of times.

Criticism of the Art Market—Our practice opposes the fetishism of objects as works of art. Our practice is not commercial. But our work should be payed as that of an actor in the theatre or of a sociologist, and for the time that we dedicate, even though it produces nothing for the market.

Sociology of Art and Sociological Art—Historically, sociological art was elaborated from the history of art and the sociology of art. The rupture with the history of art, "hygiene de l'art," is in progress. Artistically, our practice will become, without doubt, more and more sociology without reference to art. On the other hand, the relation with the materialistic, sociological theory, specifically, that of art, then, more generally, that of the society which produces this art, is epistemologically necessary and definitive.

GROUP MATERIAL Caution! Alternative Space! (1982)

Group Material started as twelve young artists who wanted to develop an independent group that could organize, exhibit and promote an art of social change. In the beginning, about two years ago, we met and planned in living rooms after work. We saved money collectively.

* Group Material, excerpts from "Caution! Alternative Space!" (1982), in Alan Moore and Marc Miller, eds., *ABC No Rio Dinero: The Story of a Lower East Side Art Gallery* (New York: ABC No Rio with Collaborative Projects, 1985), 22. Handout by Tim Rollins for Group Material. By permission of Julie Ault for Group Material.

After a year of this, we were theoretically and financially ready. We looked for a space because this was our dream—to find a place that we could rent, control and operate in any manner we saw fit. This pressing desire for a room of our own was strategic on both the political and psychological fronts. We knew that in order for our project to be taken seriously by a large public, we had to resemble a "real" organized gallery. Without this justifying room, our work would probably not be considered art. And in our own minds, the gallery became a security blanket, a second home, a social center in which our politically provocative work was protected in a friendly neighborhood environment. We found such a space in a 600 square foot storefront on a Hispanic block on East 13th Street in New York.

We never considered ourselves an "alternative space." In fact, it seemed to us that the more prominent alternative spaces were actually, in appearance, character and exhibition policies, the children of the dominant commercial galleries. To distinguish ourselves and to raise art exhibition as a political issue, we never showed artists as singular entities. Instead, we organized artists, non-artists, children—a broad range of people—to exhibit about special social issues (from Alienation to Gender to The People's Choice, a show of art from the households of the block, to an emergency exhibition on the child murders in Atlanta).

Because of our location, we had in effect limited our audience to East Village passersby and those curious enough to venture out of their own neighborhoods to come and see art outside of Soho. But our most rewarding and warm and fun audience was the people on the block. Because they integrated us into the life of their street, our work, no matter how tedious or unrecognized by a broader public, always had an immediate social meaning.

Externally, Group Material's first public year was an encouraging success. But internally, problems advanced. The maintenance and operation of the storefront was becoming a ball-and-chain on the collective. More and more our energies were swallowed by the space, the space, the space. Repairs, new installations, gallery sitting, hysterically paced curating, fundraising and personal disputes cut into our very limited time as a creative group who had to work full-time jobs during the day or night. People got broke, frustrated and very tired. People quit. As Group Material closed its first season, we knew we could not continue this course. Everything had to change. The mistake was obvious. Just like the alternative spaces we had set out to criticize, here we were sitting on 13th Street waiting for everyone to rush down and see our shows instead of us taking the initiative of mobilizing into public areas. We had to cease being a space and start becoming a working group once again. . . .

If a more inclusive and democratic vision for art is our project, then we cannot possibly rely on winning validation from bright, white rooms and full-color repros in the art world glossies. To tap and promote the lived esthetic of a largely "non-art" public—this is our goal, our contradiction, our energy. Group Material wants to occupy the ultimate alternative space—that wall-less expanse that bars artists and their work from the crucial social concerns of the American public.

Statement (1983)

Group Material was founded as a constructive response to the unsatisfactory ways in which art has been conceived, produced, distributed and taught in American society. Group Ma-

* Group Material, "Statement" (1983), in Alan Moore and Marc Miller, eds., *ABC No Rio Dinero: The Story of a Lower East Side Art Gallery* (New York: ABC No Rio with Collaborative Projects, 1985), 23. Written by Douglas Ashford, Julie Ault, Mundy McLaughlin, and Tim Rollins. By permission of Julie Ault for Group Material.

terial is an artist initiated project. We want to maintain control over our work, directing our energies to the demands of the social conditions as opposed to the demands of the art market.

While most art institutions separate art from the world, neutralizing any abrasive forms and contents, Group Material accentuates the cutting edge of art. We want our work and the work of others to take a role in a broader cultural activism.

Group Material researches work from artists, non-artists, the media, the streets. Our approach is oriented toward both people not well acquainted with the specialized languages of fine art, and the audience that has a long-standing interest in questions of art theory and practice. In our exhibitions, Group Material reveals the multiplicity of meanings that surround any vital social issue. Our project is clear. We invite everyone to question the entire culture we have taken for granted.

FELIX GONZALEZ-TORRES
Being a Spy: Interview with Robert Storr (1995)

ROBERT STORR: You recently took part in an exhibition in London that placed you in context with Joseph Kosuth, and the pair of you in context with Ad Reinhardt. And I was struck by the fact that instead of trying to separate yourself from previous generations, you joined with Kosuth in establishing an unexpected aesthetic lineage. . . .

FELIX GONZALEZ-TORRES: . . . I think more than anything else I'm just an extension of certain practices, minimalism or conceptualism, that I am developing areas I think were not totally dealt with. I don't like this idea of having to undermine your ancestors, of ridiculing them, undermining them, and making less out of them. I think we're part of a historical process and I think that this attitude that you have to murder your father in order to start something new is bullshit. We are part of this culture, we don't come from outer space, so whatever I do is already something that has entered my brain from some other sources and is then synthesized into something new. I respect my elders and I learn from them. There's nothing wrong with accepting that. I'm secure enough to accept those influences. I don't have anxiety about originality, I really don't. . . .

RS: What other theoretical models do you have in mind?

FGT: Althusser, because what I think he started pointing out were the contradictions within our critique of capitalism. For people who have been reading too much hard-core Marxist theory, it is hard to deal with the fact that they're not saints. And I say no, they're not. Everything is full of contradictions; there are only different degrees of contradiction. We try to get close to them, but that's it, they are always going to be there. The only thing to do is to give up and pull the plug, but we can't. That's the great thing about Althusser, when you read his philosophy. Something that I tell my students is to read once, then if you have problems with it read it a second time. Then if you still have problems, get drunk and read it a third time with a glass of wine next to you and you might get something out of it, but always think about practice. The theory in the books is to make you live better and that's what, I

* Robert Storr, excerpts from "Being a Spy: Interview [with Felix Gonzalez-Torres]," *Art Press,* no. 138 (January 1995): 24–32; online at www.queerculturalcenter.org/Pages/FelixGT/FelixInterv.html. By permission of the interviewer; the Felix Gonzalez-Torres Foundation, courtesy Andrea Rosen Gallery, New York; and Art Press (www.artpress.com).

think, all theory should do. It's about trying to show you certain ways of constructing reality. I'm not even saying finding (I'm using my words very carefully), but there are certain ways of constructing reality that help you live better, there's no doubt about it. When I teach, that's what I show my students—to read all this stuff without a critical attitude. Theory is not the endpoint of work; it is work along the way to the work. To read it actively is just a process that will hopefully bring us to a less shadowed place.

RS: When you say what you and some of the people of your generation have done is to deal with the elements of conceptualism that can be used for a political or a social end, how do you define the political or social dimension of art? What do you think the parameters are?

FGT: I'm glad that this question came up. I realize again how successful ideology is and how easy it was for me to fall into that trap, calling this socio-political art. All art and all cultural production is political. I'll just give you an example. When you raise the question of political or art, people immediately jump and say, Barbara Kruger, Louise Lawler, Leon Golub, Nancy Spero, those are political artists. Then who are the non-political artists, as if that was possible at this point in history? Let's look at abstraction, and let's consider the most successful of those political artists, Helen Frankenthaler. Why are they the most successful political artists, even more than Kosuth, much more than Hans Haacke, much more than Nancy and Leon or Barbara Kruger? Because they don't look political! And as we know it's all about looking natural, it's all about being the normative aspect of whatever segment of culture we're dealing with, of life. That's where someone like Frankenthaler is the most politically successful artist when it comes to the political agenda that those works entail, because she serves a very clear agenda of the Right.

 For example, here is something the State Department sent to me in 1989, asking me to submit work to the Art and Embassy Program. It has this wonderful quote from George Bernard Shaw, which says, "Besides torture, art is the most persuasive weapon." And I said I didn't know that the State Department had given up on torture—they're probably not giving up on torture—but they're using both. Anyway, look at this letter, because in case you missed the point they reproduce a Franz Kline which explains very well what they want in this program. It's a very interesting letter, because it's so transparent. Another example: when you have a show with white male straight painters, you don't call it that, that would be absurd, right? That's just not "natural." But if you have four Black lesbian sculptors from Brooklyn, that's exactly what you call it, "Four African-American Lesbians from Brooklyn." . . .

RS: What is your guess about what the next phase of the cultural wars is going to be? How will the whole NEA and censorship and multiculturalism proceed from here?

FGT: I think we've gone through a cycle and I sense that it will change directions somewhat, but I'm not at all sure which way. It's going to go on for a while, but first of all, we should not call it a debate. We should call it what it is, which is a smoke screen. It is no accident. . . . I just gave this lecture in Chicago and I read all this data and tried to make sense of what happened during the eighties, during the last Republican regime, how the agenda of the right was implemented and that was an agenda of homophobia and the enrichment of 1% of the population. Clearly and simply. But it is something we love. We love to be poor and we love to have the royal class. I know that deep inside we miss *Dynasty,* because that gave us the hope of some royalty, a royal family in America, which we almost had. But why worry about the fact that we have the lowest child immunization rate of all industrialized nations, right behind Mexico. Why worry about that when we can worry about $150 given to an artist in Seattle to do a silly performance with his HIV blood? Why worry about $500 billion

in losses in the Savings and Loan industry when $10,000 was given to Mapplethorpe? Because the threat to the American family, the real threat to the American family is not dioxin and it's not the lack of adequate housing, it's not the fact that there has been a 21% increase in deaths by gun since 1989.

That's not a threat. The real threat is a photograph of two men sucking each other's dicks. That is really what could destroy us. It makes me wonder what is the family. How come that institution is so weak that a piece of paper could destroy it? Of course, you ask yourself, why now and why this issue and you realize that something else is happening. This is a smoke screen to hide what they have already accomplished. . . .

RS: We've touched on this already, but you came up in a generation where young artists read a lot of theory and out of that has come a great deal of work which refers back to theory in an often daunting or detached way. And that has put off many people. In effect, they've reacted against the basic ideas because they've gotten sick of the often pretentious manner in which those ideas were rephrased artistically.

FGT: It's a liberating aspect of the way that most of my generation does art, but it also makes it more difficult because you have to justify so much of what you do. If we were making, let's say, a more formalist work, work that includes less of a social and cultural critique of whatever type, it would be really wonderful. Either you make a good painting or you make a bad one, but that's it. When you read Greenberg you can get lost in page after page on how a line ends at the edge of the canvas, which is very fascinating—I love that, I can get into that, too. But when some of us, especially in the younger generation, get involved with social issues, we are put under a microscope. We really are, and we have to perform that role, which includes everything. It includes the way we dress to where we are seen eating. Those things don't come up in the same way if you are interested in the beautiful abstractions that have nothing to do with the social or cultural questions. It's part of the social construction but it has less involvement in trying to tell you what's wrong or what's right. These are two plates on a canvas, take it or leave it. What you see is what you get. Which is very beautiful too—I like that.

After doing all these shows, I've become burnt out with trying to have some kind of personal presence in the work. Because I'm not my art. It's not the form and it's not the shape, not the way these things function that's being put into question. What is being put into question is me. I made *Untitled (Placebo)* because I needed to make it. There was no other consideration involved except that I wanted to make an artwork that could disappear, that never existed, and it was a metaphor for when Ross was dying. So it was a metaphor that I would abandon this work before this work abandoned me. I'm going to destroy it before it destroys me. That was my little amount of power when it came to this work. I didn't want it to last, because then it couldn't hurt me. From the very beginning it was not even there—I made something that doesn't exist. I control the pain. That's really what it is. That's one of the parts of this work. Of course, it has to do with all the bullshit of seduction and the art of authenticity. I know that stuff, but on the other side, it has a personal level that is very real. It's not about being a con artist. It's also about excess, about the excess of pleasure. It's like a child who wants a landscape of candies. First and foremost it's about Ross. Then I wanted to please myself and then everybody.

1.

LAIBACH works as a team (the collective spirit), according to the principle of industrial production and totalitarianism, which means that the individual does not speak; the organization does. Our work is industrial, our language political.

2.

LAIBACH analyzes the relation between ideology and culture in a late phase, presented through art. LAIBACH sublimates the tension between them and the existing disharmonies (social unrest, individual frustrations, ideological oppositions) and thus eliminates every direct ideological and systemic discursiveness. The very name and the emblem are visible materializations of the idea on the level of a cognitive symbol. The name LAIBACH is a suggestion of the actual possibility of establishing a politicized (system) ideological art because of the influence of politics and ideology.

3.

All art is subject to political manipulation (indirectly—consciousness; directly), except for that which speaks the language of this same manipulation. To speak in political terms means to reveal and acknowledge the omnipresence of politics. The role of the most humane form of politics is the bridging of the gap between reality and the mobilizing spirit. Ideology takes the place of authentic forms of social consciousness. The subject in modern society assumes the role of the politicized subject by acknowledging these facts. LAIBACH reveals and expresses the link of politics and ideology with industrial production and the unbridgeable gaps between this link and the spirit.

4.

The triumph of anonymity and facelessness has been intensified to the absolute through a technological process. All individual differences of the authors are annulled, every trace of individuality erased. The technological process is a method of programming function. It represents development; i.e., purposeful change. To isolate a particle of this process and form it statically means to reveal man's negation of any kind of evolution which is foreign to and inadequate for his biological evolution.

LAIBACH adopts the organizational system of industrial production and the identification with the ideology as its work method. In accordance with this, each member personally rejects his individuality, thereby expressing the relationship between the particular form of production system and ideology and the individual. The form of social production appears in the manner of production of LAIBACH music itself and the relations within the group. The group functions operationally according to the principle of rational transformation, and its (hierarchical) structure is coherent.

5.

The internal structure functions on the directive principle and symbolizes the relation of ideology towards the individual. The idea is concentrated in one (and the same) person, who is prevented from any kind of deviation. The quadruple principle acts by the same key (EBER-SALIGER-KELLER-DACHAUER), which—predestined—conceals in itself an arbitrary number of sub-objects (depending on the needs).

* Neue Slowenische Kunst (NSK), "Laibach: 10 Items of the Covenant" first published in the Slovene review for cultural and political issues *Nova revija*, no. 13–14 (1983); reprinted in NSK, eds., *NSK: Neue Slowenische Kunst/ New Slovenian Art* (Los Angeles and Zagreb: Amok Books and Grafički zavod Hrvatske, 1992), 18–19. By permission of NSK.

The flexibility and anonymity of the members prevents possible individual deviations and allows a permanent revitalization of the internal juices of life. A subject who can identify himself with the extreme position of contemporary industrial production automatically becomes a LAIBACH member (and is simultaneously condemned for his objectivization).

6.

The basis of LAIBACH's activity lies in its concept of unity, which expresses itself in each media according to appropriate laws (art, music, film . . .).

The material of LAIBACH manipulation: Taylorism, bruitism, Nazi Kunst, disco . . .

The principle of work is totally constructed and the compositional process is a dictated "ready-made": Industrial production is rationally developmental, but if we extract from this process the element of the moment and emphasize it, we also designate to it the mystical dimension of alienation, which reveals the magical component of the industrial process. Repression of the industrial ritual is transformed into a compositional dictate and the politicization of sound can become absolute tonality.

7.

LAIBACH excludes any evolution of the original idea; the original concept is not evolutionary but entelechical, and the presentation is only a link between this static and the changing determinant unit. We take the same stand towards the direct influence of the development of music on the LAIBACH concept; of course, this influence is a material necessity but it is of secondary importance and appears only as a historical musical foundation of the moment which, in its choice, is unlimited. LAIBACH expresses its timelessness with the artifacts of the present and it is thus necessary that at the intersection of politics and industrial production (the culture of art, ideology, consciousness) it encounters the elements of both, although it wants to be both. This wide range allows LAIBACH to oscillate, creating the illusion of movement (development).

8.

LAIBACH practices provocation on the revolted state of the alienated consciousness (which must necessarily find itself an enemy) and unites warriors and opponents into an expression of a static totalitarian scream.

It acts as a creative illusion of strict institutionality, as a social theater of popular culture, and communicates only through non-communication.

9.

Besides LAIBACH, which concerns itself with the manner of industrial production in totalitarianism, there also exist two other groups in the concept of LAIBACH KUNST aesthetics:

GERMANIA studies the emotional side, which is outlined in relations to the general ways of emotional, erotic and family life, lauding the foundations of the state functioning of emotions on the old classicist form of new social ideologies.

DREIHUNDERT TAUSEND VERSCHIEDENE KRAWALLE is a retrospective futuristic negative utopia. (The era of peace has ended.)

10.

LAIBACH is the knowledge of the universality of the moment. It is the revelation of the absence of balance between sex and work, between servitude and activity. It uses all expressions of history to mark this imbalance. This work is without limit; God has one face, the devil infinitely many. *LAIBACH is the return of action on behalf of the idea.*

The Program of Irwin Group (1984)

The fundamental goal of IRWIN is to assert Slovene fine arts by way of representation based on the spectacular.

Governing principles:

—RETRO PRINCIPLE as a regulative blueprint, as a framework of the working procedure (but not as a style) necessary to analyze the historical experience of Slovene fine arts. Hence also the "dictation of the motif," varying from one project to another, depending on the purpose of the individual project. Briefly, it is no longer a question of control over a formal procedure encompassing a single idea, but that of perpetual permutation and modification, requiring a new conceptual apparatus to formulate and decode the meaning of individual actions.

—EMPHATIC ECLECTICISM draws on the historical experience, in particular the Slovene fine arts, insisting on permanent permutation of the methods of viewing, reinterpreting, and re-creating the past and the contemporary pictorial models.

—ASSERTION OF NATIONALITY AND NATIONAL CULTURE through the dialectics of the general and the particular; if modernism and a part of post-modernism stand for the "mainstream," i.e., for the universal in contemporary art (the image of an artist), then IRWIN is distinguished by a disappearance of the individual artist and by the emergence of a group, and assertion of those elements of the national fine arts that merged into modernism in a specifically Slovene way and served as a basis on which the nation's culture and class affiliation were being built. Western modernism rests on the code of permanent revolution, utilizing the principles of negation, irony and implicit tragedy, whereas IRWIN goes beyond the historical experience of modernism and dialectically provides it with a superstructure by asserting the national culture, the triumph of collective spirit and by glorifying those properties of fine arts which distinguish it from Western modernism. IRWIN asserts the continuity of the Slovene past as the only future horizon. Consequently, art represents a ritual of the past in the assertion of death as a dynamic element within life. The ultimate purpose of IRWIN's activities is to reassert Slovene culture in a monumental and spectacular way.

WALID RAAD Interview with Alan Gilbert (2002)

ALAN GILBERT: . . . Can you talk about the tension in your work between individual authorship and the idea that the Atlas Group is collectively producing and accumulating anonymous and pseudonymous documents?

WALID RAAD: It seems to me that this question concerns the authorship of the Atlas Group project and its archive—documents attributed to Dr. Fadl Fakhouri, Souheil Bachar, Operator #17, and the Atlas Group, among others. It is not true that I have recently begun to emphasize the individual authorship of the work. In different places and at different times I have called the Atlas Group an imaginary foundation, a foundation I established in 1976 and a foundation established in 1976 by Maha Traboulsi. . . . I say different things at different times and in different places according to personal, historical, cultural, and political consid-

* Neue Slowenische Kunst (NSK), "The Program of Irwin Group" (April 1984), in NSK, eds., *NSK: Neue Slowenische Kunst/New Slovenian Art* (Los Angeles and Zagreb: Amok Books and Grafički zavod Hrvatske, 1992), 114. By permission of NSK.

** Excerpted from the interview "Walid Raad by Anthony Downey," *BOMB* 81 (Fall 2002): 38–45. © Bomb Magazine, New Art Publications, and its Contributors. All rights reserved. The BOMB Digital Archive can be viewed at www.bombsite.com. Also by permission of the interviewer and the artist/The Atlas Group.

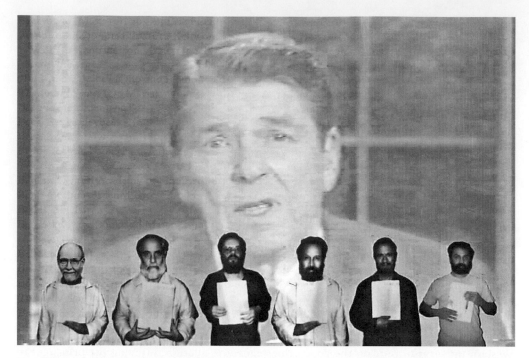

Souheil Bachar (The Atlas Group/Walid Raad), still from *Hostage: The Bashar Tapes (English Version)*, 2001, color video with sound, transferred to DVD. © Walid Raad. Courtesy Anthony Reynolds Gallery, London.

erations with regard to the geographical location and my personal and professional relation with the audience and how much they know about the political, economic, and cultural histories of Lebanon, the wars in Lebanon, the Middle East, and contemporary art. I also always mention in exhibitions and lectures that the Atlas Group documents are ones that I produced and that I attribute to various imaginary individuals. But even this direct statement fails, in many instances, to make evident for readers or an audience the imaginary nature of the Atlas Group and its documents. This confirms to me the weighty associations with authority and authenticity of certain modes of address (the lecture, the conference) and display (the white walls of a museum or gallery, vinyl text, the picture frame), modes that I choose to lean on and play with at the same time.

It is also important for us to note that the truth of the documents we research does not depend solely on their factual accuracy. We are concerned with facts, but we do not view facts as self-evident objects that are already present in the world. One of the questions we find ourselves asking is, How do we approach facts not in their crude facticity but through the complicated mediations by which they acquire their immediacy? The Atlas Group produces and collects objects and stories that should not be examined through the conventional and reductive binary of fiction and nonfiction. We proceed from the consideration that this distinction is a false one—in many ways, not least of which is that many of the elements that constitute our imaginary documents originate from the historical world—and does not do justice to the rich and complex stories that circulate widely and that capture our attention and belief. Furthermore, we have always urged our audience to treat our documents as "hysterical documents" in the sense that they are not based on any one person's actual memories but on "fantasies erected from the material of collective memories."

AG: . . . There's a similarity in the form and content of your work to the way trauma can rarely speak directly, despite its gnawing desire to articulate itself. . . . It's impossible to reconstruct a history of the Lebanese Civil Wars from your project. . . . Can you talk about your work's linking of image, history, and trauma and how they might interrelate for both individuals and larger social formation?

WR: . . . "The Lebanese Civil War" refers to an abstraction. We proceed with the project from the consideration that this abstraction is constituted by various individuals, groups, discourses, events, situations and, more importantly, by modes of experience. We began by stating, "The Atlas Group aims to locate, preserve, study, and make public documents that shed light on some of the unexamined dimensions of the Lebanese Civil War." Soon thereafter, it became clear that it is difficult for us to define precisely what this proposition means, and as a consequence we stated, "It is difficult for us to speak of the Lebanese Civil War, and we prefer to speak of the wars in Lebanon." Today, we refer to "the history of Lebanon of the past 50 years with particular emphasis on the history of Lebanon since 1975." We have also realized that our concern is not with documenting the plurality of wartime experiences as they are conditioned by manifold religious, class, ideological, and gender locations.

It is important to note that Dr. Fadl Fakhouri's Notebook Volume 72, titled "Missing Lebanese Wars," raised for us troubling questions about the possibilities and limits of writing any history of the recent wars in Lebanon. The notebook recounts the story of some Lebanese historians who bet on photo-finish horse-race photographs as they were published in the Lebanese daily *Annahar*. Apart from the historians' bets and some calculations of averages, the notebook's pages include cutouts of the photo-finish photographs as they appeared in *Annahar*. What is fascinating about these images is that the horse is always captured either just before or beyond, but never exactly at, the finish line—the horse is never on time. This inability to be present at the passing of the present raised for us numerous questions about how to write, and more particularly about how to write the history of events that involve forms of extreme physical and psychological violence. The notebook forced us to consider whether some of the events of the past three decades in Lebanon were actually experienced by those who lived them.

AG: This notion of history as never on time saturates almost every aspect of your work and I think is one of the keys to the subterfuge it employs. . . . While there's a sense of despair at the inability to ever finally arrive—even in retrospect—at a true historical moment, it also appears to be a liberating awareness for you; hence the strategic misdirections in your work. But it's a liberation emitting a mournful tone for a lost and impossible object. Your recording of sunsets from Beirut's seaside promenade at the end of your video *Missing Lebanese Wars (in three parts)*, 1996, and your haunting series of photographs *Secrets in the Open Sea*, 1996, are good examples. At first glance, the latter appear to be beautiful, pure blue abstractions, with a black-and-white thumbnail photograph situated in the bottom right-hand corner of their white borders. The imaginary narrative accompanying these blue photographs is that they were found in 1992 under the rubble of demolished buildings in the Souks area of Beirut and given to the Atlas Group for examination. Using a lab in France, the Atlas Group was able to extract grainy black-and-white photographs embedded within the varying fields of blue. These photographs were of small groups of women and men—all of whom, it turned out, had been found dead in the Mediterranean Sea. The sense of mourning in these photographs inflects much of your work.

WR: I think there may have been a sense of despair (even as it appears to be a liberating

feeling for us, as you note), especially with the works produced between 1991 and 2001. We no longer feel this way. In this regard it has been productive for us to read and think about Jalal Toufic's books *Over-Sensitivity* (Sun & Moon, 1996) and *Forthcoming* (Atelos, 2001). The absence of the referent in our earlier works, our treatment of the documents we were finding and producing as hysterical documents, was not the result of a philosophical conviction imposed on our object of study. It may have been due to the withdrawal of reality itself as a result of what Toufic identifies as "the withdrawal of tradition past a surpassing disaster." Our project titled *Sweet Talk: Photographic Documents of Beirut* is related in this regard. The blurred, never-on-time, always-to-the-side images we produced in this project between 1987 and 1999 are indicative of this withdrawal.

It is difficult for us to say where we are today, but we have noticed a shift in the documents we are finding and producing and in our conceptual, formal and critical approach to the writing of the history of Lebanon. As Toufic recently suggested, "It may be that a resurrection has been produced." This is clearly a question that requires further elaboration.

AG: In his *New Yorker* review of Documenta 11, Peter Schjeldahl made the interesting comment that the rift between institutional and commercial art worlds is enormous right now. . . .

WR: . . . I find it difficult to make sense of the idea of a rift between institutional and commercial art worlds. I think it important to avoid hasty generalizations about what it means to talk about the institutions and commerce of art production, distribution, and consumption, be they private or public. When we talk about these institutions we are not just talking about museums, festivals, biennials, auction houses, and galleries. We are also talking about banks, manufacturers, law firms, conventions, schools and universities, residencies, foundations, alternative spaces, conferences, journals and magazines, curators, collectors, scientists, humanists, historians, critics, clerks, organizers, funders, philanthropists, politicians, technicians, students, and teachers, among others. We are talking about institutions and individuals with bodies, languages, and histories. And some of the individuals and institutions in question are progressive, some are reactionary, some are honest, some are liars, some are exploitative, some are generous, some are opportunists, some are committed, and some are simply hard to describe.

It would be difficult to draw a distinction between the institutionally and commercially supported aspects of our work. In the past few years, we have been awarded grants from public and private foundations; we have exhibited and performed in schools, universities, conferences, festivals, museums, meetings and alternative art spaces; we have published in magazines, newspapers and journals; we have appeared on commercial and private television and radio. We have been paid for our presence at festivals, conferences and theaters; for our writings in magazines and journals; and for our products, in that a production fee was paid for our photographs, videotapes, website and slides. We have sold some videotapes through our distributor. We have not exhibited in a commercial gallery, and we have not directly or through a gallery sold works to collectors.

In any case, as far as we are concerned, there is no doubt that spaces such as universities, galleries, and museums do not operate outside the industrial, financial, scientific, information, and service sectors of the economy, and as such they are part and parcel of the same capitalist organization of labor, its services and its products as the commercial art world.

AG: Regardless, I think you have certain hesitations concerning the decontextualizing effect that might result from showing your work in a commercial gallery space, along with the ever-present dilemma of having the value of the work depend on sales figures. . . .

Somewhat curiously, at least half of your invitations to participate in art exhibitions

are for performances. . . . What's it like being a visual artist out there on the performance and alternative theater circuit?

WR: I'll give you another roundabout answer. In my graduate studies at the University of Rochester in visual and cultural studies, language figured prominently, in the sense that I was expected to and wanted to read, comment, speak, and write about culture, politics, and the arts—and that held true even if one identified himself or herself as a visual artist. There is no doubt that the emphasis in this training was on the history of art, culture, and thought and on the question of how meaning is produced and consumed. This training was not unlike that of many graduate programs in the arts and humanities in the US over the past three decades.

The number of visual artists who can make a decent living from the sale of their artworks is very small. Grants and residencies are competitive and rarely provide enough money to live. Artists do any number of things to generate income. Full-time teaching can be one of the best jobs around, but the limited availability and the difficulty of getting a tenure-track teaching job has been well documented.

I am fortunate in that I was able to get such a position. As a college professor, and as someone who makes short experimental videotapes and other works, I find myself and other faculty members who are in more or less similar situations doing certain things: we read books and essays; we attend meetings; we prepare lectures that involve videotapes and slides; we teach students how to read and write; we write essays about the events of the world, as well as budgets, grants, proposals, synopses, introductions, résumés, and narrative biographies. We also speak about the world and about our works in private and in public; we subscribe to newspapers, magazines, journals, associations and societies; we make slides and videotapes of our works; we cut out, save, and distribute reviews of our works in the press; we send files of our works to interested institutions and individuals; we keep receipts; we pay taxes.

We also attend conferences and festivals. At academic conferences we often present written papers and answer questions about their content. At video festivals, we answer questions about our works after their screening. In both situations, we are expected to speak. Some of us speak about personal experiences and/or about the films and videotapes we watch, the books and essays we read; some of us refuse to speak; some insist on being anecdotal, others scholarly and/or academic. Some appear assertive, others shy. We sit behind a desk or at a table with other speakers. We face an audience. We stand with or without a lectern. We encounter technical difficulties with the equipment at our disposal. In question and answer periods, we face difficult, stupid, vague, challenging, and wonderful comments and questions. Our answers may be equally difficult, stupid, vague, challenging, and wonderful.

Of course, this is somewhat of a caricature, one that I am certain some will recognize. But this is the caricature that partly informed the "performance" dimension of the Atlas Group's lecture/presentation titled *The Loudest Muttering Is Over: Documents from The Atlas Group Archive*. This ongoing, always-in-progress 70-minute lecture/presentation looks and sounds like a college lecture, an academic conference presentation, or an artist talk. I sit behind a rectangular table facing the audience. I show slides and videotapes on a screen to my left. I speak into a microphone. There are a glass of water, a notebook, a pen and a lamp on the table. I wear a light shirt and dark dress pants. I encounter technical difficulties. I am interrupted by people I have planted in the audience, who also ask questions during the question and answer period. I also answer nonscripted questions.

The first manifestation of this work was in the context of an academic conference

in Beirut in 1998, and the second in the context of an artist talk at the Ayloul Festival in Beirut in 1999. I was not surprised by either invitation, given that part of the work for me emerged from my thinking about the format and culture of conferences and artist talks. I *was* surprised when I was invited to present this lecture/presentation in the performance and alternative theater circuit, but my surprise was due to the fact that I knew very little about experimental theater and performance art. I soon found out that others in the performance and theater circuit—in Lebanon, the US, and Europe—are thinking along similar lines.

CRITICAL ART ENSEMBLE When Thought Becomes Crime (2005)

How did it come to this?

Only a perverse authoritarian logic can explain how Critical Art Ensemble (CAE) can at one moment be creating the project "Free Range Grain" for the Risk exhibition at Schirn Kunsthalle in Frankfurt, reconfiguring it for The Interventionists exhibition at Mass MoCA in a second moment, and then suddenly have a CAE member in FBI detention. The U.S. Justice Department has accused us of such shocking crimes as bioterrorism, health and safety violations, mail fraud, wire fraud, and even murder. Now, as we retool "Free Range Grain" for the Risk exhibition at the Glasgow Center for Contemporary Art, the surreal farce of our legal nightmare continues unabated.

Of course, we always knew that cultural interventionist work could have serious consequences. And over the years, predictably, CAE has been denounced (and threatened) by all varieties of authority: cops, corporate lawyers, politicians, all types of racists, and church groups—even the Archbishop of Salzburg. But to be the target of an international investigation that involves the FBI, the Joint Terrorism Task Force, the ATF, the Department of Homeland Defense, the Department of Health and Safety, numerous local police agencies, and even Norwegian and German federal investigators goes far beyond the pale. As of this writing, CAE member Steven Kurtz and one of our long-time collaborators, University of Pittsburgh geneticist Robert Ferrell, are fighting the insanely real threat of being sent to federal prison.

So how did we create such a vortex of Kafkaesque legalistic repression? In the "Free Range Grain" project, for instance, CAE simply used molecular biology techniques to test for genetically modified food in the global food trade. We want(ed) this interventionist performance to demonstrate how the "smooth space" of global trade enables the very "contaminations" the authorities say it guards against. Now we, along with our colleagues on the CAE defense team, have been trying to understand why the authorities have taken such a reactionary position in regard to our art practice. We have come up with many reasons; we can address only a few in this brief article.

The first reason, we believe, involves the discourse in which we framed our project. By viewing the scientific process through the lens of political economy, we disrupted the legitimized version of science as a self-contained, value-free specialization. The powers that be would have science speak for itself, within and about itself. This insularity is akin to Clement Greenberg's idea of letting art history explain the production of art, or Emile Durkheim's use of "social facts" to explain the social. But any discourse exists within larger historical and

* Critical Art Ensemble, "When Thought Becomes Crime" (17 March 2005), at www.caedefensefund.org/thoughtcrime.html. CAE notes: "The set of theses presented in this document were collectively developed through a series of lectures given by the CAE Defense Team. Contributors include Doug Ashford, Gregg Bordowitz, CAE, Natalie Jeremijenko, Claire Pentecost, and Lucia Sommer. Special thanks to Karen Schiff."

political contexts. It seemed self-evident for us to place competing discourses in conversation, and show the socioeconomic ideologies at work in food production. From the perspective of authority, however, we were being subversive, deviant. For those who wish to preserve the illusion of the autonomy of science, citizens can discuss scientific structure, method, materials, etc., as long as they do not refer to the political or economic interests that impinge on scientific research. A biology club can talk all about cells, but if it goes beyond the institutionalized boundaries of the life sciences, look out for the feds.

The second challenge we posed came from our amateur approach to life science knowledge systems, experimental processes, acquisition of materials, etc. An amateur can be critical of an institution without fear of recrimination or loss of status or investment. An art professor, for example, will probably not tell students that art school is a pyramid scheme into which they will pour a lot of capital, feed the higher-ups, and probably get very little if anything in return. That criticism is more likely to emerge from outside the power structure (or from disgruntled ex-students). In science, where the financial stakes are much higher, any criticism of resources may well result in funding cuts—a situation one can ill afford in such a capital-intensive discipline. So it takes an outsider to science—a creative tinkerer—to rattle the cage of the discipline's most dearly held assumptions and practices.

With special regard to the institutional financing of science, the amateur reveals the profit-driven privatization of a discipline that is purportedly—mythologically—open to all. By undertaking research as if science were truly a forum in which all may participate according to their abilities and resources, CAE angers those who manipulate scientific activity through capital investment. The financial stakes are so high that the authorities can imagine only one motivation for critical, amateur research, particularly if it is conducted at home outside of systems of surveillance/discipline. If that research intends to expose, disrupt, or subvert the meta-narratives that put scientific investigation in the service of profit, the amateur investigator must want to produce terrorist acts.

In the paranoid political climate of the U.S., American authorities leap all too easily from ideological criticism to terrorism. What's more, the CAE's legal battle reveals that the government has made thinking into a crime: a citizen can be arrested without having committed any act of terror, or without having done anything illegal at all. Former U.S. Attorney General John Ashcroft has unofficially reformed law enforcement policy and practice according to the Bush administration's idea of "preemptive war." He has argued that if indicators—any type of dissent in relation to "national interest" or the interests of the investing classes—suggest that a person or group could do something illegal, then they should be arrested, detained, deported, or otherwise persecuted with the full resources of all repressive state agencies. Apparently, the U.S. Justice Department is now trying to make CAE into an example of what can happen to citizens whose only "crime" is having thoughts of dissent enacted within the sphere of legality and with the alleged protection of constitutional rights.

For experimental art, political art, tactical media, and independent media in the U.S. (and to some degree in other nations), the implications of Steven Kurtz' arrest are profound. The repressive forces of the state are directly targeting producers of cultural interventionist work. In past decades, policymakers have often leaned on political artwork through financial penalties such as rescinding artist's grants, folding federal arts programs, and economically squeezing out the spaces that exhibit subversive work.[1] Now these attacks on

1. The New York Council for the Humanities recently rescinded a grant awarded to the City University of New York for its series on *academic freedom* because Steve Kurtz was one of the invited speakers!

civil grounds have undergone a horrific paradigm shift, and individual artists are being charged with criminal activity. The persecution works slowly and insidiously, through silencing artists, looting their work and their research, and constraining their movement. We are no longer seeing cultural conflict in action, but a proto-fascist attack upon free expression itself.

ARAKAWA AND MADELINE GINS
Preface to *The Mechanism of Meaning* (1978)

If we had not been so desperate at that time, we might not have chosen such an ambitious title *[The Mechanism of Meaning]* for this work. Yet what else would we have called it? After all, the phenomena we were studying were not simply images, percepts, or thoughts alone. Our subject is more nearly all given conditions brought together in one place.

Death is old-fashioned. We had come to think this way, strangely enough. Essentially, the human condition remains prehistoric as long as such a change from the Given, a distinction as fundamental as this, has not yet been firmly established.

If thought were meant to accomplish anything, surely it was meant to do this. Yet why had history been so slow? Was there something wrong with the way the problem was being pictured? What if thinking had been vitiated by having become lost in thought, for example? What is emitted point-blank at a moment of thought, anyway? Let's take a second look a these comic figures, we decided. There did not yet exist even the most rudimentary compendium of what takes place or of the elements involved when anything is "thought through." Why not picture some of these moments ourselves, we thought, just a few?

As we proceeded, our forming intention took shape rather unevenly. Only some of the ambiguous events we examined made ordinary sense. There was also a natural tendency on our part as artist and poet to favor the nonsense. Although we certainly did not want to propose any theory, we did begin to notice some correspondence between each event and the rather awkward term "meaning."

The vagueness of the term was suitable. Meaning might be thought of as the desire to think something—anything—through; the will to make sense out of the ever-present fog of not-quite-knowing; the recognition of nonsense. As such it may be associated with human faculty. Since each occurrence of meaning takes place primarily along one or another of these paths, we roughly derived our list of subdivisions from them. The list as a whole is not intended to be any less inconsistent, clumsy, or redundant than the original on which it was based, that is, the composite mechanism of meaning in daily living viewed point-blank from moment to moment.

We hope future generations find our humour useful for the models of thought and other escape routes that they shall construct!

* Arakawa and Madeline H. Gins, "Preface," to *The Mechanism of Meaning,* 2d ed.: *Work in Progress (1963–1971, 1978): Based on the Method of Arakawa,* ed. Ellen Schwartz (New York: Harry N. Abrams, 1979), 4–5. By permission of the authors and the publishers. © 1979 Arakawa and Madeline Gins. Published by Harry N. Abrams, Inc. All Rights Reserved.

AI WEIWEI Making Choices (1997)

China still lacks a modernist movement of any dimension. For the basis of such a movement is the liberation of humanity and the victory of the humanitarian spirit. Democratic politics, material wealth and universal education are the soil upon which modernism exists, for a developing nation these remain ideals to pursue.

Modernism is a philosophy, a worldview, and a lifestyle. At its core is the questioning of classical thought and critical reflection on the human condition. Any cultural or artistic activity that does not belong to modernism is shallow, lacking in spiritual value. As for the numerous creations that appear modernist but in fact turn their back on the spirit of modernism, these are but superficial imitations.

Modernism has no need of various masks or official titles, it is the primal creation of the awakened, its ultimate concern is with the meaning of existence and reality of situations. It is vigilance against social and human crises, it is not compromising, it does not cooperate.

Such awakening is reached through a process of self-recognition, a process teeming with a thirst for and pursuit of a spiritual world, with unending doubts and puzzlements.

The result of such fearless truth is that we may observe in modernist works an unadorned authenticity, panic, emptiness, and anomia. This is not some cultural choice, just as life is not a choice. It all stems from an interest in one's own existence, this interest is the cornerstone of all spiritual activities, and the goal of all knowledge.

Reflections on modes of existence and spiritual values are core issues in modern art. This is a proactive reflection on the straightforward and distinct facts—the inevitability of life and death, a hollow, boring sense of reality that remains in the processes after primal impulses have passed.

All of this moves toward an inevitable conclusion: an understanding of the solemnity and absurdity of life. We cannot avoid this recognition, just as we cannot avoid the reality of our own existence.

Our dreams are a combination of real limitations on life and our eager impulse to surmount these limitations. Such impulses, and the efforts we spend working toward this goal, are the pleasures of life.

Humans are destined to be narrow-minded empiricists. But only by venerating the mystical world can we rise above our petty quandaries. Humans are animals who have renounced nature, and from among every possible path, humans have chosen the longest and most remote path leading to the self.

Making choices is how the artist comes to understand himself. These choices are correlated to one's spiritual predicament, and the goal is a return to the self, the pursuit of spiritual values, and the summoning of spirits. These choices are inherently philosophical.

A painful truth of today is that even as we import technologies and lifestyles, there is no way to import spiritual awakening, justice, or strength. There is no way to import the soul.

Modern Chinese cultural history is precisely a history of negating the value of the individual; it is a soulless history of suppressing humanity. Intellectuals are invariably attacked from all directions. Deemed the representatives of either aggressive forces of Western culture or outdated, feudalistic modes of consciousness, Chinese intellectuals have been put in an embarrassing predicament.

* Ai Weiwei, "Making Choices," in Zeng Xiaojun, Ai Weiwei, and Zhuang Hui, eds., *The Grey Cover Book* (Beijing: Red Flag Books, 1997); reprinted in Karen Smith, Hans Ulrich Obrist, and Bernard Fibicher, *Ai Weiwei* (London: Phaidon, 2009), 128, 130. Translated by Phil Tinari. By permission of the author and the translator.

All reform efforts over the past hundred years have begun with a dependence on outside cultures, and they all conclude by coming to terms with native traditions. These simple emulations and ineffective resistances have amounted to an important characteristic of China's modern cultural development: abandoning intuitive knowledge and selling one's soul in the face of despotism, all in exchange for the right to linger on in a steadily worsening situation.

Without a doubt, the tides of history are pulling this archaic ship ever nearer to the shores of democracy. Communication, identification, understanding, and tolerance have begun to supplant methods of compulsion and exclusion; the new people will live in a happier space, a place of greater intelligence.

Humanity realizes that cultural and spiritual totalitarianism and exclusionism have rendered people's spirits deflated, rendered their wills shrunken, rendered their vision myopic.

Burying troublesome opinions and evading difficult questions is nothing less than skepticism and denial of the value of life. Such behavior is a blaspheming of gods, an acknowledgment of ignorance and backwardness, a blatant expression of support for unchecked power and injustice.

Today's Chinese culture and art still lack the most basic of concerns—artists lack any sense of understanding of their social position, and fail to deliver independent criticism.

No manner of linguistic exploration, no possible appropriation of strategy or medium, no copying of style or content can mask the flaws of artists when it comes to self-awareness, social critique, and independent creation. These expose a philistine style of pragmatism and opportunism. They reflect impoverished spiritual values and a general lowering of our tastes.

Only when the close attention paid to "trends" is diverted to personal methods and issues, when explorations of form become explorations into being and spiritual values, will art be somewhat enlightened—such a very long road.

NOTES

PREFACE TO SECOND EDITION

1. Francesca Richer and Matthew Rosenzweig, eds., *No. 1: First Works by 362 Artists* (London: Thames and Hudson, 2006).

PREFACE TO FIRST EDITION

1. Herschel B. Chipp, with Joshua C. Taylor and Peter Selz, eds., *Theories of Modern Art* (Berkeley: University of California Press, 1968); Joshua C. Taylor, ed., *Nineteenth-Century Theories of Art* (Berkeley: University of California Press, 1987).

2. See Ellen H. Johnson, ed., *American Artists on Art from 1940 to 1980* (New York: Harper and Row, 1982); Brian Wallis, ed., *Blasted Allegories: An Anthology of Writings by Contemporary Artists* (New York: New Museum; Cambridge, MA: MIT Press, 1987).

3. See Dore Ashton, ed., *Twentieth-Century Artists on Art* (New York: Panthcon, 1985).

4. See Howard Risatti, ed., *Postmodern Perspectives: Issues in Contemporary Art* (Englewood Cliffs, NJ: Prentice-Hall, 1990); Howard Smagula, ed., *Re-Visions: New Perspectives of Art Criticism* (Englewood Cliffs, NJ: Prentice-Hall, 1991); Richard Hertz, ed., *Theories of Contemporary Art* (Englewood Cliffs, NJ: Prentice-Hall, 1985).

5. See Charles Harrison and Paul Wood, eds., *Art in Theory 1900–1990: An Anthology of Changing Ideas* (Oxford: Blackwell, 1992). In the nearly three hundred texts included in this book, only about ten are by women, five of whom are not artists. The book also omits writings on such experimental visual art as performance, video, installations, and site-specific work.

6. Robert L. Herbert, ed., *Modern Artists on Art: Ten Unabridged Essays* (Englewood Cliffs, NJ: Prentice-Hall, 1964), vii.

7. See Barbara Maria Stafford, "The Eighteenth Century: Towards an Interdisciplinary Model," *Art Bulletin* 70, no. 1 (March 1988): 12.

8. Richard Shiff, "Art History and the Nineteenth Century: Realism and Resistance," *Art Bulletin* 70, no. 1 (March 1988): 47. Shiff's essay on the state of nineteenth-century research is one of several devoted to "disciplinary stock-taking" in the various fields of art history begun by the *Art Bulletin* in 1986. For essays in this series related to topics in contemporary art, see Jack Spector, "The State of Psychoanalytic Research in Art History," *Art Bulletin* 70, no. 1 (March 1988): 49–76; Wanda Corn, "Coming of Age: Historical Scholarship in American Art," *Art Bulletin* 70, no. 2 (June 1988): 188–207; Marvin Trachtenberg, "Some Observations on Recent Architectural History," *Art Bulletin* 70, no. 2 (June 1988): 208–41; Thalia Gouma-Peterson and Patricia Mathews, "The Feminist Critique of Art History," *Art Bulletin* 69, no. 3 (Sept. 1987): 326–57.

1. Mark Boyle, *Journey to the Surface of the Earth: Mark Boyle's Atlas and Manual* (Cologne: Edition Hansjorg Mayer, c. 1969), n.p.

2. Thomas S. Kuhn, *The Structure of Scientific Revolutions* (Chicago: University of Chicago Press, 1962).

3. Clement Greenberg, "Avant-Garde and Kitsch," *Partisan Review* 6 (Fall 1939): 34–49; "Towards a Newer Laocoon," *Partisan Review* 7 (July-Aug. 1940): 296–310.

4. Clement Greenberg, "Modernist Painting," *Arts Yearbook* 4 (1961): 109–16; repr. in Gregory Battcock, ed., *The New Art* (New York: E. P. Dutton, 1966), 101–3, 107.

5. Clement Greenberg, "After Abstract Expressionism" (1962), in Henry Geldzahler, ed., *New York Painting and Sculpture: 1940–1970* (New York: E. P. Dutton, 1969), 369.

6. On the relation between the classic, the modern, and the postmodern, see especially Jürgen Habermas, "Modernity versus Postmodernity," *New German Critique* 22 (Winter 1981): 3–14.

7. Theories introduced by Jean Baudrillard represent such extreme relativity. He identified a state of "hyperreality" resulting from the "simulacra of simulation," a condition in which the very idea of the original, the unique, disappeared in an endless circulation of imitated codes, signs, and discourses (see Baudrillard, *Simulations* [New York: Semiotext(e), 1983]). The generation of artists who came to prominence in the 1980s often reflected Baudrillard's contentions. New York artist Peter Halley remarked: "Reading Baudrillard is the equivalent for me of looking at a painting by Andy Warhol" (quoted in Catherine Francblin, "Interview with Jean Baudrillard," *Flash Art* 130 [Oct.–Nov. 1986]; repr. in Giancarlo Politi and Helena Kontova, eds., *Flash Art: Two Decades of History, XXI Years* [Cambridge, MA: MIT Press], 156). Baudrillard himself stated that he had been influenced by Warhol (see Baudrillard, *For a Critique of the Political Economy of the Sign,* trans. C. Levin [St. Louis: Telos Press, 1981], 109, 120).

8. Anders Stephanson, "Interview with Fredric Jameson," *Flash Art* 131 (Dec. 1986–Jan. 1987); repr. in Politi and Kontova, eds., *Flash Art: Two Decades of History,* 158.

9. See Carl Andre and Hollis Frampton, *12 Dialogues 1962–1963,* ed. Benjamin H. D. Buchloh (Halifax: Press of the Nova Scotia College of Art and Design; New York: New York University Press, 1981). This book provides rare access into the developing ideas of the two artists, then in their youth. Andre refused to have selections from these dialogues reprinted here because he felt they reflected only youthful musings. I regret their absence.

10. One of the first books to include writings by contemporary artists was *Theories of Modern Art,* edited by Herschel B. Chipp with contributions by Joshua C. Taylor and Peter Selz (Berkeley: University of California Press, 1968).

11. See Timothy J. Clark, *Image of the People: Gustave Courbet and the 1848 Revolution* (London: Thames and Hudson, 1973), chap. 1. See also Clark, "On the Conditions of Artistic Creation," *Times Literary Supplement,* May 24, 1974, 561–63.

12. Svetlana Alpers, "Is Art History?" *Daedalus* 106 (1977): 1–13.

13. William Hood, "Italian Renaissance Art," *Art Bulletin* 69, no. 2 (June 1987): 174.

14. W. J. T. Mitchell, ed., *Against Theory: Literary Studies and the New Pragmatism* (1982; repr. Chicago: University of Chicago Press, 1985), 2.

15. Theodor Adorno and Max Horkheimer, "The Culture Industry: Enlightenment as Mass Deception," in *Dialectic of Enlightenment* (New York: Herder and Herder, 1972); originally published as *Dialektik der Aufklärung: Philosophische Fragmente* (Amsterdam: Querido, 1947).

16. Hans Magnus Enzensberger, "Bewusstseins-Industrie," in *Einzelheiten* (Frankfurt: Suhrkamp Verlag, 1962); repr. in Enzensberger, *The Consciousness Industry: On Literature, Politics and the Media,* sel. by Michael Roloff (New York: Seabury Press, 1974), 3–15.

17. Edward W. Said, "Opponents, Audiences, Constituencies, and Community," *Critical Inquiry* 9 (Sept. 1982); repr. in Hal Foster, ed., *The Anti-Aesthetic* (Seattle: Bay Press, 1983), 135–59.

18. Roland Barthes, "The Death of the Author," in *Image, Music, Text,* trans. and ed. Stephen Heath (New York: Noonday Press, 1977), 142–48.

19. See Michel Foucault, "What Is an Author?" in *Language, Counter Memory, Practice: Selected Essays and Interviews,* ed. Donald Bouchard, trans. Donald Bouchard and Sherry Simon (Ithaca: Cornell University Press, 1977): 137–38.

20. Adolph Gottlieb and Mark Rothko, "Statement," *New York Times,* June 13, 1943; repr. in Chipp, Taylor, and Selz, eds., *Theories of Modern Art,* 544.

21. Allan Kaprow, "O.K.," in *Manifestos* (New York: Something Else Press, 1966); repr. in Richard Kostelanetz, ed., *Human Alternatives: Visions for Us Now* (New York: William Morrow, 1971), 85.

22. See Brian Wallis, "Telling Stories: A Fictional Approach to Artists' Writings," in Wallis, ed., *Blasted Allegories: An Anthology of Writings by Contemporary Artists* (New York: New Museum; Cambridge, MA: MIT Press, 1987), xiv.

23. Henry Louis Gates, Jr., *The Signifying Monkey: A Theory of African-American Literary Criticism* (New York: Oxford University Press, 1988), xx.

24. See Brecht quoted in Victor Burgin, *The End of Art Theory: Criticism and Postmodernity* (Atlantic Highlands, NJ: Humanities Press International, 1986), 140.

25. Edward W. Said, *Orientalism* (New York: Vintage Books, 1978), 32; emphasis in original.

26. Richard Shiff, "Constructing Physicality," *Art Journal* 50, no. 1 (Spring 1991): 43.

27. Andy Warhol, *The Philosophy of Andy Warhol: From A to B and Back Again* (New York: Harcourt Brace Jovanovich, 1975).

28. Alison M. Jaggar, "Love and Knowledge: Emotion in Feminist Epistemology," in Jaggar and Susan R. Bordo, eds., *Gender/Body/Knowledge: Feminist Reconstructions of Being and Knowing* (New Brunswick, NJ: Rutgers University Press, 1989), 145. Jaggar points out that philosophers who constitute an exception to this generalization include Hume, Nietzsche, Dewey, and James (p. 166).

29. Lyotard, "Foreword," in Joseph Kosuth, *Art After Philosophy and After* (Cambridge, MA: MIT Press, 1991), xviii.

30. Rolleston in conversation with the author.

31. Joseph Kosuth, "Art After Philosophy, Part I," *Studio International* 178, no. 915 (Oct. 1969): 136.

32. Marlene Dumas, "Why Do I Write (about Art)," in Dumas, *Sweet Nothings: Notes and Texts,* ed. Mariska van den Berg (Amsterdam: Galerie Paul Andriesse/Uitgeverij De Balie, 1998), 9–11.

33. W. J. T. Mitchell, "The Pictorial Turn," *Artforum* 30, no. 7 (March 1992): 89–94.

34. See W. E. B. Du Bois, "The Disenfranchised Colonies," in his *Color and Democracy: Colonies and Peace* (New York: Harcourt, Brace, 1945); Frantz Fanon, *Black Skin, White Masks* (1952; repr. New York: Grove Press, 1967) and *The Wretched of the Earth* (1961; repr. New York: Grove Press, 1963); Aimé Césaire, *Discourse on Colonialism* (1950; repr. New York: Monthly Review Press, 2001).

35. Paulo Herkenhoff, "Having Europe for Lunch: A Recipe for Brazilian Art," *Polyester* 2, no. 8 (Spring 1984), cited in Ella Shohat and Robert Stam, "Narrativizing Visual Culture: Towards a Polycentric Aesthetics," in Nicholas Mirzoeff, ed., *Visual Culture Reader,* 2nd ed. (London: Routledge, 2002), 37–59.

36. Okwui Enwezor, in *Trade Routes: History and Geography* (exh. cat.), quoted in Carol Becker, "The Second Johannesburg Biennale," *Art Journal* 57, no. 2 (Summer 1998): 88.

37. Okwui Enwezor in Carol Becker and Okwui Enwezor's "A Conversation with Okwui Enwezor," *Art Journal* 61, no. 2 (Summer 2002): 12.

38. Okwui Enwezor and Olu Oguibe, eds., *Reading the Contemporary: African Art from Theory to the Marketplace* (Cambridge, MA: MIT Press, 1999).

39. For example, on Latin American avant-garde, see Mari Carmen Ramírez and Héctor Olea, *Inverted Utopias: Avant-Garde Art in Latin America* (New Haven: Yale University Press; Houston: Museum of Fine Arts, Houston, 2004); on impact of technology, see Peter Weibel and Timothy Druckrey, eds., *net_condition: Art and Global Media* (Cambridge, MA: MIT Press, 2001); on feminism, see Maura Reilly and Linda Nochlin, eds., *Global Feminisms: New Directions in Contemporary Art* (New York: Merrell, 2007); and on conceptualism, see *Global Conceptualism: Points of Origin, 1950s–1980s* (New York: Queens Museum of Art, 1999).

40. David Summers, *Real Spaces: World Art History and the Rise of Western Modernism* (London: Phaidon, 2003).

41. Terry Smith, *What Is Contemporary Art?* (Chicago: University of Chicago Press, 2009), 8.

42. Silvia von Bennigsen, Irene Gludowacz, and Susanne van Hagen, eds., *Global Art* (Ostfildern, Germany: Hatje Cantz, 2010). Another study focused on the globalization of art is Kitty Zijlmans and Wilfried van Damme, eds., *World Art Studies: Exploring Concepts and Approaches* (Amsterdam: Valiz, 2008).

43. James Elkins, ed., *Is Art History Global?* (New York: Routledge, 2007), 3.

44. From www.kuda.org/?=node/555. The groups involved include What, How and for Whom? (WHW) of Zagreb, Croatia; kuda.org of Novi Sad, Serbia; Prelom Kolektiv of Belgrade, Serbia; and SCCA/pro.ba of Sarajevo, Bosnia and Herzegovina.

45. See their website, www.artalways.org, for details on this project, which involves WHW and kuda.org as well as tranzit.hu and the Muzeum Sztuki in Łódź, Poland; see also tranzit.hu, ed., *Art Always Has Its Consequences: Artists' Texts from Croatia, Hungary, Poland, Serbia, 1947–2009* (Berlin: Sternberg Press, 2010).

46. Nadine Monem, ed., *Contemporary Art in the Middle East* (London: Black Dog, 2009); Kamal Boullata, *Palestinian Art: From 1859 to the Present* (London: Saqi Books, 2009).

47. Luis Camnitzer, "Manifesto," 1982 (www.lehman.cuny.edu/vpadvance/artgallery/gallery/luis_camnitzer/manifesto.htm).

48. Jane Farver, "Introduction," *Luis Camnitzer: Retrospective Exhibition 1966–1990* (www.lehman.cuny.edu/vpadvance/artgallery/gallery/luis_camnitzer/index.htm).

49. From Bernard Blistene, "A Conversation with Jean-François Lyotard," *Flash Art* 121 (March 1985); repr. in Politi and Kontova, eds., *Flash Art: Two Decades of History,* 129–30.

CHAPTER 1. GESTURAL ABSTRACTION

1. Robert Motherwell, "The Painter's World," *DYN* 6 (Nov. 1944): 10.

2. Dore Ashton, *The New York School* (New York: Penguin, 1979), 117; originally published as *The Life and Times of the New York School: American Painting in the Twentieth Century* (London: Adams and Dart, 1972). This perceptive study by Ashton, who witnessed the rise of the New York School as a participating critic, places the art and artists into the political and intellectual framework of the time.

3. Clyfford Still, letter to Gordon Smith, Jan. 1, 1959, in *Paintings by Clyfford Still* (Buffalo: Albright Art Gallery, 1959), n.p.

4. Barnett Newman, "The New Sense of Fate" (1947–48), in *Barnett Newman: Selected Writings and Interviews,* ed. John P. O'Neill (Berkeley: University of California Press, 1992), 158.

5. A longer Rothko essay, "The Romantics Were Prompted," and important texts by Arshile Gorky, Willem de Kooning, Jackson Pollock, Robert Motherwell, and Barnett Newman are included in Herschel B. Chipp with Joshua C. Taylor and Peter Selz, eds., *Theories of Modern Art* (Berkeley: University of California Press, 1968).

6. Ibid., 569–70, 577–80.

7. Max Kozloff, "American Painting during the Cold War," *Artforum* 11, no. 9 (May 1973): 44.

8. Ibid., 49.

9. Eva Cockcroft, "Abstract Expressionism, Weapon of the Cold War," *Artforum* 12, no. 10 (June 1974): 39–41.

10. Serge Guilbaut, *How New York Stole the Idea of Modern Art* (Chicago: University of Chicago Press, 1983).

11. Werner Haftmann, "Masters of Gestural Abstraction," in *Art since Mid-Century: The New Internationalism,* vol. 1: *Abstract Art* (Greenwich, CT: New York Graphic Society, 1971), 34.

12. The three previous artists were Louise Bourgeois (in 1982), Lee Krasner (in 1984), and Helen Frankenthaler (in 1989).

13. David Reed, "Painting Present: David Reed," lecture at Tate Modern, London, Oct. 29, 2002, www.tate.org.uk/onlineevents/webcasts/painting_present/david_reed/default.jsp.

14. Fiona Rae, "Residency Statement," 2005, Atlantic Center for the Arts, www.atlanticcenterforthearts.org/artresprog/resschedule/mar/f_rae.html.

CHAPTER 2. GEOMETRIC ABSTRACTION

1. In an attempt to continue the debate about the direction of abstract art after Abstraction-Création dissolved, Taeuber-Arp brought out the journal *Plastique* (1937–39) in three languages.

2. Theo van Doesburg, "Manifeste de l'art concret," *Art concret* (Paris), no. 1 (1930); repr. in Joost Balijeu, *Theo van Doesburg* (New York: Macmillan, 1974), 181–82. See also Hans Arp, "Concrete Art"

(1944), in *Arp on Arp,* trans. Joachim Neugroschel (New York: Viking, 1972), 139; Wassily Kandinsky, "Abstrakt oder Konkret?" in *Tentoonstelling abstrakt kunst* (Amsterdam: Stedelijk Museum, 1938); and Kandinsky, "L'art concret," *XXe Siècle* 1, no. 5/6 (Winter–Spring 1938).

3. The term "concrete" was first applied to poetry in the 1950s to describe writing that paralleled aspects of concrete art: specifically, poetry that emphasized the concrete visual and aural aspects of language. Concrete poetry gained prominence simultaneously in Switzerland, Germany, and Brazil (in the latter with the Noigandres group, formed by the poets Augusto de Campos, Décio Pignatari, and Haroldo de Campos). The Swedish artist Öyvind Fahlström published a manifesto on the concrete in 1953, and many other artists and poets worked in this genre in the 1950s and 1960s, including Pierre Garnier and Henri Chopin (French); Mathias Goeritz (Mexican); Ian Hamilton Finlay, Bob Cobbing, John Sharkey, and Dom Sylvester Houédard (U.K.); Dieter Roth (German-born Swiss); and Emmett Williams (U.S.). In 1965, when the Institute of Contemporary Arts in London launched the exhibition *Between Poetry and Painting,* it recognized the interrelationship between concrete art and developments in poetry. See Mary Ellen Solt, ed., *Concrete Poetry: A World View* (Bloomington: University of Indiana Press, 1968).

4. Lohse, quoted in Bernhard Holeczek, "Thanks to Lohse," in *Richard Paul Lohse: 1902–1988* (Budapest: Molcomp Stúdió, 1992), 7.

5. Simone Osthoff, "Lygia Clark and Hélio Oiticica: A Legacy of Interactivity and Participation for a Telematic Future," *Leonardo on-line* (www.leonardo.info/isast/spec.projects/osthoff/osthoff.html).

6. Mari Carmen Ramírez and Héctor Olea, *Inverted Utopias: Avant-Garde Art in Latin America* (New Haven: Yale University Press: Houston: Museum of Fine Arts, Houston, 2004), 497.

7. Ferreira Gullar, "Teoria de não-objeta," *Jornal do Brasil,* Dec. 19–20, 1959 (Sunday suppl.).

8. Ramírez and Olea, *Inverted Utopias.*

9. Guy Brett, *Kinetic Art* (London: Studio Vista/Reinhold Art, 1968), 65.

10. Ibid.

11. Nicolas Bourriard, *Relational Aesthetics* (1998; repr. Paris: Presses du Réel, 2002).

12. Among the founders of American Abstract Artists (1937–43) were Ibram Lassaw, Rosalind Bengelsdorf, Byron Browne, Harry Holtzman, Balcomb Greene, Gertrude Glass (later Greene), George McNeil, Esphyr Slobodkina, and Ilya Bolotowsky. Holtzman became the spokesman for the group, which rapidly attracted new members. George L. K. Morris, art critic for *Partisan Review,* became a member and patron, as did Josef Albers, Fritz Glarner, and David Smith, among others.

13. Roland Barthes, *Writing Degree Zero and Elements of Semiology,* trans. Annette Lavers and Colin Smith (Boston: Beacon Press, 1968), 1; originally published as *Le degré zéro de l'écriture* (Paris: Éditions du Seuil, 1953).

14. In 2007 it was reported that Agostino Bonalumi, one of Manzoni's collaborators, claimed the tins actually contained plaster, not excrement, adding another dimension to the artist's parody. See Jonathan Glancey, "Merde d'artiste: Not Exactly What It Says on the Tin," *Guardian,* June 13, 2007 (www.guardian.co.uk/artanddesign/2007/jun/13/art).

15. Enrico Baj has written that, immediately after producing *Merda d'artista,* Manzoni "brought all his relationships —not only with the art world but also with his own former aspirations toward visual and conceptual purity—into crisis. He became increasingly restless; he started to travel and to drink heavily. By the age of 30 he had drunk himself to death. He died in his studio. . . . On the building is a plaque that reads: 'To Piero Manzoni, Conceptual Artist'" (Baj, "Scatalogical White," in *Piero Manzoni* [New York: Hirschel and Adler Modern, 1990], 5).

16. *The I Ching or Book of Changes,* trans. Richard Wilhelm and Cary F. Baynes, Bollingen Series 19 (Princeton: Princeton University Press, 1975), 91.

17. Langsner used the term to describe the work of Karl Benjamin, Lorser Feitelson, Frederick Hammersley, and John McLaughlin, which he included in the exhibition *Four Abstract Classicists* at the Los Angeles County Museum of Art in 1959.

18. Clement Greenberg, *Post-Painterly Abstraction* (Los Angeles: Los Angeles County Museum of Art, 1964).

19. Truitt, quoted in Victoria Dawson, "Anne Truitt and the Color of Truth," *Washington Post,* March 14, 1987, G4.

20. Donald Judd, "Specific Objects," *Arts Yearbook* 8 (1965); repr. in *Donald Judd: Complete Writings, 1959–1975: Gallery Reviews, Book Reviews, Articles, Letters to the Editor, Reports, Statements, Complaints*

(Halifax: Press of the Nova Scotia College of Art and Design; New York: New York University Press, 1975), 181–89.

21. Michael Fried, "Art and Objecthood," *Artforum* 5, no. 10 (June 1967): 12–23; repr. in Gregory Battcock, ed., *Minimal Art: A Critical Anthology* (New York: E. P. Dutton, 1968), 116–47. See also Fried, "How Modernism Works: A Response to T. J. Clark," *Critical Inquiry* 9, no. 1 (Sept. 1982): 217–34; repr. in Francis Francina, *Pollock and After: The Critical Debate* (New York: Harper and Row, 1985), 65–79.

22. On the Support-Surfaces group, see Meyer Raphael Rubinstein, "The Painting Undone," *Art in America* 79, no. 11 (Nov. 1991): 135–67.

23. Manifesto, Jan. 3, 1967, trans. Michel Claura, in "Paris Commentary," *Studio International* 177, no. 907 (Jan. 1969): 47.

24. Scully, quoted in "Sean Scully: Walls Windows Horizons," description of the artist's 2001 exhibition at the David Winton Bell Gallery, List Art Center, Brown University, Providence, Rhode Island, www.brown.edu/Facilities/David_Winton_Bell_Gallery/scully.html.

25. See Joan Braderman's film *The Heretics* on this influential publication. Copies of all the issues of *Heresies* can be found on Braderman's website (http://helios.hampshire.edu/nomorenicegirls/heretics/).

26. Peter Halley, "Essence and Model," in *Peter Halley: Collected Essays, 1981–1987* (Zurich: Galerie Bruno Bischofberger; New York: Sonnabend Gallery, 1987), 161.

CHAPTER 3. FIGURATION

1. Henry Moore, quoted in Carlton Lake, "Henry Moore's World," *Atlantic Monthly* (Jan. 1962): 39–45.

2. Leonard Baskin, "On the Nature of Originality," *Show* (Aug. 1963): n.p.

3. See Vladimir Kemenov, "Aspects of Two Cultures," in Herschel B. Chipp, with Joshua C. Taylor and Peter Selz, eds., *Theories of Modern Art* (Berkeley: University of California Press, 1968), 490–96.

4. Paul Tillich, "Prefatory Note," in Peter Selz, *New Images of Man* (New York: Museum of Modern Art, 1959), 10.

5. Stephen Spender, quoted on cover of David Sylvester, *Interviews with Francis Bacon* (New York: Thames and Hudson, 1975).

6. Linda Nochlin, *Philip Pearlstein* (Athens: Georgia Museum of Art, 1970), n.p.

7. Trevor Schoonmaker, "Birth of the Cool," in Schoonmaker, ed., *Barkley L. Hendricks: Birth of the Cool* (Durham, NC: Nasher Museum of Art at Duke University, 2008), 25.

8. Philip Guston, quoted in Musa Mayer, *Night Studio: A Memoir of Philip Guston* (New York: Alfred Knopf, 1988), 171.

9. "Bio," on Eric Fischl's website, www.ericfischl.com/bio/biography1.html.

10. Eva Cockcroft, John Weber, and James Cockcroft, *Toward a People's Art: The Contemporary Mural Movement* (New York: E. P. Dutton, 1977).

11. Sherman Fleming, quoted in Kristine Stiles, "Rodforce: Thoughts on the Art of Sherman Fleming," *High Performance* 10, no. 2 (1987): 35.

12. "Ubu and the Truth Commission," on the website of the Handspring Puppet Company (which did the play's puppetry), www.handspringpuppet.co.za/html/ubu.html.

13. John-Paul Stonard, "Luc Tuymans," from Grove Art Online, on the website of the Museum of Modern Art, New York, www.moma.org/collection/details.php?artist_id=7520.

14. M. F. Husain, interview by Barkha Dutt, NDTV (March 3, 2010, New Delhi), www.ndtv.com/news/india/full-transcript-mf-husains-interview-17164.php.

CHAPTER 4. MATERIAL CULTURE AND EVERYDAY LIFE

1. Lawrence Alloway, "The Arts and the Mass Media," *Architectural Design* 21 (Feb. 1958): 35.

2. For a discussion of the terms "high" and "low" as applied to art, see Kirk Varnedoe and Adam Gopnik, *High and Low: Modern Art Popular Culture* (New York: Museum of Modern Art and Harry N. Abrams, 1990).

3. See Allan Kaprow's pivotal book on this period, *Assemblage, Environments and Happenings* (New York: Harry N. Abrams, 1966).

4. Dick Hebdige, "In Poor Taste," in Paul Taylor, ed., *Post-Pop Art* (Cambridge, MA: MIT Press, 1989), 92. Hebdige defines three stages in the development of Pop art and culture in the United Kingdom: the initial phase inaugurated by the Independent Group; the period of gestation in the Royal College of Art (1957–59), from which students like Peter Blake and Richard Smith emerged; and the mid-1960s, when an "ad hoc grouping of Young Contemporaries," including David Hockney, Allen Jones, R. B. Kitaj, and Peter Phillips, created the "Swinging London lifestyle" (85). See also Henri Lefebvre, *The Critique of Everyday Life* (1947; repr. New York: Verso, 1991).

5. John McHale, "The Fine Arts in the Mass Media," *Cambridge Opinion* 17 (1959); repr. in John Russell and Suzi Gablik, *Pop Art Redefined* (New York: Praeger, 1969), 43–47. See also McHale, "The Expendable Ikon 1," *Architectural Design* 22 (Feb. 1959): 82–83; McHale, "The Expendable Ikon 2," *Architectural Design* 22 (March 1959): 116–17; Gillo Dorfles, ed., *Kitsch: The World of Bad Taste* (New York: Universe Books, 1975), with contributions by John McHale, Karl Parrek, Ludwig Giesz, Lotte H. Eisner, Ugo Volli, Vittorio Gregotti, and Aleska Celebonovic and essays by Hermann Broch and Clement Greenberg.

6. See "A Symposium on Pop Art," *Arts* 37, no. 7 (April 1963): 36–44.

7. Peter Selz, "Pop Goes the Artist," *Partisan Review* 30, no. 3 (Summer 1963): 316. This article was to have been titled "The Flaccid Art," but the editors changed the title without notifying Selz.

8. Brian Wallis, "We Don't Need Another Hero: On the Critical Reception of the Work of Jeff Koons," in *Jeff Koons* (San Francisco: Museum of Modern Art, 1992), 29.

9. Pierre Restany, "L'autre face de l'art: L'aventure de l'objet," *Domus* 584 (July 1978): 8.

10. Niki de Saint Phalle, quoted in Carla Schulz-Hoffmann, *Niki de Saint Phalle* (Bonn: Prestel, 1987), 53.

11. An invitation to participate in an exhibition sponsored by Woolmark at Galerie Germain in Paris prompted the idea to knit the sweaters. See Laurel Fredrickson, "Memory and Projection in Annette Messager's Early Work," *Art Criticism* 18, no. 2 (2003): 36–64.

12. Annette Messager, quoted in Natashia Leoff, "Annette Messager," *Journal of Contemporary Art* 7, no. 2 (1995): 8.

13. Daniel Varela, "Charlemagne Palestine: Sensual, Physical and Visceral Music Trance" (interview with Palestine), June 2002, *Perfect Sound Forever,* www.furious.com/perfect/charlemagne palestine.html.

14. "Clusterfuck" is the term used by the military for operations gone awry. See Jerry Saltz, "Clusterfuck Aesthetics," *Village Voice,* Nov. 29, 2005, www.villagevoice.com/2005-11-29/art/clusterfuck-aesthetics/.

15. Quoted, for example, on the gallery label for *Summer* (1985) at the Museum of Modern Art, New York (www.moma.org/collection/object.php?object_id=79864).

16. Robert Filliou, "La cédille qui sourit," in Filliou, *Teaching and Learning as Performance Arts* (Cologne: Verlag König, 1970), 204. See also George Brecht and Robert Filliou, *Games at the Cedilla, or, The Cedilla Takes Off* (New York: Something Else Press, 1967).

17. George Brecht, quoted in Henry Martin, *Part One: Never Change Anything. Let Changes Fall In. Part Two: Never Say Never. A Conversation with George Brecht* (Milan: Exit Edizioni, 1979), 40, 46.

18. James Rosenquist and David Dalton, *Painting Below Zero: Notes on a Life in Art* (New York: Alfred A. Knopf, 2009), 3.

19. *GAAG: The Guerrilla Art Action Group, 1969–1976: A Selection* (New York: Printed Matter, 1978), sec. 12. Together with Kate Millett, Michele Wallace, Abbie Hoffman, Stephen Radich, Lil Picard, Gregory Battcock, members of the Black Panther Party, the Gay Liberation Front, Making a Nation (MAN), and Women Artists in Revolution (WAR), among others, Ringgold had also served on a panel during the Symposium on Repression, held in the sanctuary of the Judson Memorial Church on November 9, 1970.

20. Jeff Donaldson, quoted in Nubia Kai, "AFRICOBRA Universal Aesthetics," in *AFRICOBRA: The First Twenty Years* (Atlanta: Nexus Contemporary Art Center, 1990), 6. See also Barbara Jones-Hogu, "The History, Philosophy and Aesthetics of Afri-Cobra," in *Afri-Cobra III* (Amherst: University of Massachusetts Art Gallery, 1973). A related move toward the definition of Chicano art resulted in

the exhibition *Chicano Art: Resistance and Affirmation, 1965–1985* (1990), which opened at the Wight Gallery at the University of California, Los Angeles.

21. David Hammons, quoted in Peter Schjeldahl, "The Walker: Rediscovering New York with David Hammons," *New Yorker,* Jan. 23, 2002.

22. Michael Harris, Juliette Bowles, and Kelefa Sanneh, "Stereotypes Subverted? The Debate Continues," *International Review of African American Art* 15, no. 2 (Nov. 1998): 44, 49.

23. Damian Sharp, untitled text (1976), in Kim Jones, *Rat Piece: Feb. 17, 1976* (New York: Kim Jones, 1990), 63.

24. Kim Jones, *Teaching a Dead Hand to Draw,* video by David Schmidlapp and Steve Staso, 2001. See also Kristine Stiles, "*Teaching a Dead Hand to Draw,* Kim Jones, War and Art," in *Kim Jones: A Retrospective* (Cambridge, MA: MIT Press), 45–84.

25. See Kristine Stiles, "Shaved Heads and Marked Bodies: Representations from Cultures of Trauma" (1993), repr. with new afterword in Jean O'Barr, Nancy Hewitt, and Nancy Rosebaugh, eds., *Talking Gender: Public Images, Personal Journeys, and Political Critiques* (Chapel Hill: University of North Carolina Press, 1996), 36–64.

26. "Blek le Rat/Original Stencil Pioneer," on Blek le Rat's website, http://bleklerat.free.fr/sten cil%20graffiti.html. Subsequent quotes are also from this site.

27. The text read: "This finely preserved example of primitive art dates from the Post-Catatonic era. The artist responsible is known to have created a substantial body of work across South East of England under the moniker Banksymus Maximus but little else is known about him. Most art of this type has unfortunately not survived. The majority is destroyed by zealous municipal officials who fail to recognise the artistic merit and historical value of daubing on walls" ("Cave Art Hoax Hits British Museum," *BBC News,* May 19, 2005, http://news.bbc.co.uk/1/hi/entertainment/arts/4563751.stm).

28. Carlo McCormick, "Fables, Facts, Riddles, and Reasons in Wojnarowicz's Mythopoetica," in Barry Blinderman, ed., *David Wojnarowicz: Tongues of Flame,* exh. cat. (Normal: University Galleries, Illinois State University; New York: Art Publishers, 1990), 13.

29. See Blinderman, ed., *Tongues of Flame,* which includes all three essays.

30. Laura Mulvey, "Visual Pleasure and Narrative Cinema," *Screen* 16, no. 3 (Autumn 1975): 6–18; repr. in Mulvey, *Visual and Other Pleasures* (Bloomington: Indiana University Press, 1989), 14–26.

31. Jean Baudrillard, "The Structural Law of Value and the Order of Simulacra," trans. Charles Levin from *L'échange symbolique et la mort* (Paris: Éditions Gallimard), in *The Structural Allegory: Reconstructive Encounters with the New French Thought,* ed. with introduction by John Fekete (Minneapolis: University of Minnesota Press, 1984).

32. See, for example, the description on the website of its publisher, Les Presses du Réel: www .lespressesdureel.com/EN/ouvrage.php?id=1040.

33. Dennis Dworkin argues that the emergence of so much art related to and intertwined with popular culture in the United Kingdom in the immediate postwar period reflects the influence of cultural Marxism and the development of cultural studies in postwar British institutions. See his *Cultural Marxism in Postwar Britain: History, the New Left, and the Origins of Cultural Studies* (Durham, NC: Duke University Press, 1997).

CHAPTER 5. ART AND TECHNOLOGY

1. See Edward A. Shanken, *Art and Electronic Media* (London: Phaidon, 2009).

2. Frank Popper, *Art of the Electronic Age* (New York: Harry N. Abrams, 1983), 8. One of the germinal historians of art and technology, Popper wrote extensively on the subject. See Popper, "Electricity and Electronics in the Art of the XXth Century," in *Electra: MAM Musée d'Art Moderne de la Ville de Paris* (Paris: Amis du Musée d'Art Moderne de la Ville de Paris, 1983); Popper, *Art—Action and Participation* (New York: New York University Press, 1975); Popper, *Origins and Development of Kinetic Art,* trans. Stephen Bann (Greenwich, CT: New York Graphic Society, 1968); Popper, *Lumière et mouvement* (Paris: Musée d'Art Moderne de la Ville de Paris, 1967); Popper, *Naissance de l'art cinétique* (Paris: Gauthiers-Villars, 1967); and Popper, *Cinétisme, spectacle, environnement* (Grenoble: Maison de la Culture, 1967).

3. David Tomas, "Old Rituals for New Space: *Rites de Passage* and William Gibson's Cultural

Model of Cyberspace," in Michael Benedikt, ed., *Cyberspace: First Steps* (Cambridge, MA: MIT Press, 1991), 33. Cyborgs are the machine-beings that people the technoculture of "cyberspace," the term invented by the science fiction writer William Gibson in his award-winning 1984 novel *Neuromancer* (New York: Ace Science Fiction Books, 1984). Gibson's cyberspace was "an infinite artificial world where humans navigate in information-based space" and "the ultimate computer-human interface" (Benedikt, *Cyberspace*). See also Donna J. Haraway, "A Cyborg Manifesto: Science, Technology, and Socialist-Feminism in the Late Twentieth Century," *Socialist Review* 80 (1985): 65–107.

4. The phrase occurs in the penultimate draft of Eisenhower's "Farewell Address to the Nation" (January 17, 1961); he deleted the word "congressional" in his final address to placate the U.S. Congress.

5. In 1962 Roy Ascott invited Metzger to lecture at the Ealing School of Art in London, where Pete Townshend, later the lead singer of the rock group the Who, was then an art student. Townshend credited Metzger's lecture with giving him the idea to destroy instruments during his musical concerts, an action that internationally emblematized the decade's generational rejection of inherited political values, moral codes, and cultural traditions (see Dave Marsh, *Before I Get Old: The Story of the Who* [New York: St. Martin's Press, 1983], 67). Metzger also began projecting liquid crystals in 1964, using this technique to create some of the first psychedelic rock 'n' roll light shows. The British artist Mark Boyle developed this technique in light shows for Jimi Hendrix and Soft Machine. Independent of European developments, Bruce Conner created light projections for Family Dog performances in San Francisco, in shows that anticipated those for Andy Warhol's psychedelic Exploding Plastic Inevitable in New York in 1966–67.

6. Takis, quoted in Guy Brett, "Takis Shows Paris Ten Years' Work in the Sculpting of Energy," *The Times* (London), Oct. 14, 1964, 10. The London gallery Signals, taking its name from Takis's work, was opened in 1964 by the artist David Medalla, who also published *Signals,* a journal of kinetic art. The gallery and the publication were both loci of international avant-garde activity. Takis, for example, belonged to a circle of poets and writers that included Allen Ginsberg, Gregory Corso, Jean-Jacques Lebel, and William Burroughs, many of whom contributed to a special issue of *cnacarchives* devoted to Takis: *cnacarchives* (Paris) 6 (1972).

7. See Wikipedia entry on Beiles (http://en.wikipedia.org/wiki/Sinclair_Beiles).

8. Otto Piene, "The Development of Group Zero," in *Astronauts of Inner-Space: An International Collection of Avant-Garde Activity* (San Francisco: Stolen Paper Review Editions, 1966), 24.

9. Lawrence Alloway, "Viva Zero," in *ZERO* (Cambridge, MA: MIT Press, 1973), ix.

10. Otto Piene, *More Sky* (Cambridge, MA: MIT Press, 1970), 116–17.

11. This group had evolved out of Exat 51, a collective organized by the artist Ivan Picelj in the former Yugoslavia in 1951. Exat 51 opposed state-mandated Social Realism and was committed to abstraction, experimentation, and scientific research. It was just one of many groups in Eastern Europe and the former Soviet Union devoted to developing aspects of art and technology that had been inherited especially from the Bauhaus.

12. See Valerie L. Hillings, "Concrete Territory: Geometric Art, Group Formation, and Self-Definition," in Lynn Zelevansky, *Beyond Geometry: Experiments in Form, 1940s–70s* (Cambridge, MA: MIT Press, 2004), 49–75.

13. For an expanded history and documentation of EAT, see Billy Klüver, "History of Experiments in Art and Technology," in his *E.A.T. Bibliography: August 12, 1965–January 18, 1980* (New York: Experiments in Art and Technology, 1977).

14. See Maurice Tuchman, *A Report on the Art and Technology Program of the Los Angeles County Museum of Art, 1967–1971* (Los Angeles: Los Angeles County Museum of Art, 1971), 11.

15. The first important and extensive interview with Mark Pauline was conducted for "Industrial Culture Handbook," a special issue of *RE/Search,* nos. 6/7 (1983): 20–41.

16. See Michael Kirby, "Marta Minujín's 'Simultaneity in Simultaneity,' " *TDR: The Drama Review* 12, no. 3 (Spring 1968): 149–52.

17. Brooks Adams, "Kubota's Video Sculpture: A Biographical Perspective," in Mary Jane Jacob, ed., *Shigeko Kubota: Video Sculpture* (New York: American Museum of the Moving Image, 1991), 8–9. Kubota's female iconography originated in her *Vagina Painting,* an action she carried out during a 1965 Fluxus festival. With a paintbrush and bag of red paint discreetly concealed in her underpants, Kubota squatted and moved slowly across a canvas to create a gestural image that exaggerated female sexual

attributes by simulating bodily functions. Her radical act redefined action painting according to the procreative/creative codes of the female body and mind.

18. For an excellent history of the Kitchen, see Ben Portis, "Essay on The Kitchen," Jan. 1992, Video History Project, www.experimentaltvcenter.org/history/groups/gtext.php3?id=92.

19. "Digital Image Articulator," on the Daniel Langlois Foundation's website, www.fondation-langlois.org/html/e/page.php?NumPage=457.

20. See Brian Wallis, ed., *Democracy: A Project by Group Material*, Dia Art Foundation Discussions in Contemporary Culture 5 (Seattle: Bay Press, 1990).

21. Barbara London, "Bill Viola: The Poetics of Light and Time," in *Bill Viola: Installations and Videotapes* (New York: Museum of Modern Art, 1987), 9.

22. See Rosalind Krauss, "Video: The Aesthetics of Narcissism," *October* 1 (Spring 1976): 51–64.

23. See Lynn Hershman, "Touch-Sensitivity and Other Forms of Subversion: Interactive Artwork," *Leonardo* 26, no. 5 (1993): 431–36. This was a special issue of *Leonardo* devoted to art and social consciousness.

24. http://benayoun.com/projet.php?id=28.

25. Keller Easterling, quoted on Jordan Crandall's website, http://jordancrandall.com/main/.

26. See also Jack Burnham, *Beyond Modern Sculpture: The Effects of Science and Technology on the Sculpture of This Century* (New York: George Braziller, 1968).

27. Michael Heim, *The Metaphysics of Virtual Reality* (New York: Oxford University Press, 1993), 114–15.

28. See Roy Ascott, *Telematic Embrace: Visionary Theories of Art, Technology, and Consciousness,* ed. with essay by Edward A. Shanken (Berkeley: University of California Press, 2003).

29. Roy Ascott, "From Appearance to Apparition: Dark Fibre, Boxed Cats and Biocontrollers," published as "De la apariencia a la aparición: Gatos encajonados, fibra oscura y biocontroladores," *Intermedia: Nuevas Tecnologías, Creación, Cultura* (Madrid) 1 (Nov. 1993): 73–77. Ascott initially gave this paper as "From Appearance to Apparition: Communication & Culture in Cyberspace," at the Fourth International Symposium on Technological Art, Minneapolis, Nov. 1993.

30. For an excellent discussion with the artist, see Yvonne Spielmann, "Interview with Bill Seaman," in *Cross-Wired* [*Transcript* series], ed. Simon Yiull and Kerstin Mey (Manchester: Manchester University Press, 2002); repr. at www.fondation-langlois.org/html/e/page.php?NumPage=386.

31. "Intelligence" is an operational term for human/animal cognition; "artificial intelligence" represents machine-generated intelligence.

32. See *Obsolete Body/Suspensions/STELARC*, compiled and edited by James D. Paffrath with STELARC (Davis, CA: J. P. Publications, 1984), which documents his many controversial "suspensions."

33. Statement on STELARC's website, www.stelarc.va.com.au/arcx.html.

34. www.stelarc.va.com.au/blender/index.html.

35. See Eduardo Kac, "Transgenic Art," *Leonardo Electronic Almanac* 6, no. 11 (Dec. 1998), http://mitpress.mit.edu/e-journals/LEA/.

36. Eduardo Kac, "GFP Bunny," on Kac's website, www.ekac.org/gfpbunny.html#gfpbunnyanchor.

CHAPTER 6. INSTALLATIONS, ENVIRONMENTS, AND SITES

1. Matthew Krissel, "Frederick Kiesler Inside the Endless House," 2003, at www.krisselstudio.com/000-docs/2-research/Kiesler.pdf.

2. James Johnson Sweeney, "Postscript," in Peter Selz, *Chillida* (New York: Harry N. Abrams, 1986), 122.

3. Siegfried Kracauer, "Photography" (1927), repr. in *Critical Inquiry* 19 (Spring 1993): 421–36. See also Roland Barthes's appropriation of Kracauer's ideas in *Camera Lucida: Reflections on Photography* (New York: Harry N. Abrams, 1986).

4. Michael Heizer, quoted in "The Art of Michael Heizer," *Artforum* 8 (Dec. 1969): 34.

5. See www.littlesparta.co.uk.

6. See www.diaart.org/sites/main/lightningfield.

7. David Bourdon, "The Razed Sites of Carl Andre: A Sculptor Laid Low by the Brancusi Syn-

drome," in Gregory Battcock, ed., *Minimal Art: A Critical Anthology* (1968; repr. Berkeley: University of California Press, 1995), 104.

8. Robert Irwin, quoted in "The Central Garden," on the website of the Getty Center, Los Angeles, www.getty.edu/visit/see_do/gardens.html.

9. See Charles Ross, "Statement, 2," in Colin Naylor, ed., *Contemporary Artists* (Chicago: St. James Press, 1989), 806. See also the artist's website for *Star Axis:* www.staraxis.org/index0.html.

10. Peter Selz, "Helen and Newton Harrison: Art as Survival Instruction," *Arts* 52, no. 6 (Feb. 1978): 130–31.

11. www.theharrisonstudio.net.

12. Jane Crawford, wife of the deceased artist, e-mail to the author, July 18, 2000. See also Mary Jane Jacob, *Gordon Matta-Clark: A Retrospective* (Chicago: Museum of Contemporary Art, 1985).

13. Jane Fudge, "The Clay Grows Tall: The World of Charles Simonds," 1999, Denver Art Museum, www.tfaoi.com/aa/1aa/1aa190.htm.

14. Ilya Kabakov, *Der Text als Grundlage des Visuellen/The Text as the Basis of Visual Expression* (Cologne: Oktagon, 2000), 18.

15. "The Rwanda Project" (interview with Alfredo Jaar), from the episode "Protest," in season 4 of the PBS series *Art: 21* (2007), www.pbs.org/art21/artists/jaar/clip1.html.

16. Ibid.

17. Doris Salcedo, "Interview: Carlos Basualdo in Conversation with Doris Salcedo," in Nancy Princenthal, Carlos Basualdo, and Andreas Huyssen, *Doris Salcedo* (London: Phaidon, 2000), 25.

18. Yinka Shonibare, quoted in Laurie Anne Farrell, ed., *Looking Both Ways: Art of the Contemporary African Diaspora* (New York: Museum for African Art, 2004), 166.

19. Shonibare, quoted in Manthia Diawara, *Yinka Shonibare: Double Dutch* (Rotterdam: Museum Boijmans Van Beuningen; Vienna: Kunstalle Wien, 2004), 45–58.

20. Nicholas Hlobo interviewed by Sophie Perryer, at www.michaelstevenson.com/contemporary/exhibitions/hlobo/hlobo.htm.

21. "Gabriel Orozco," on the website of White Cube, London, www.whitecube.com/artists/orozco/.

22. Sir Hans Sloane, *A Voyage to the Islands Madera, Barbados, Nieves, S. Christophers and Jamaica, with the Natural History of the Herbs and Trees, Four-footed Beasts, Fishes, Birds, Insects, Reptiles, &c. of the Last of those Islands* (London, 1707 and 1725).

23. Fred Wilson interviewed by *Art: 21*, "Beauty and Memory," at www.pbs.org/art21/artists/wilson/clip2.html.

24. "Questions Addressed to Andrea Zittel by Theodora Vischer," 1997, at www.zittel.org/texts/vischer_questions.html.

25. "A-Z Pocket Property," at www.zittel.org/works/pocket_property/pocket_property.html.

26. Andrea Zittel, "Smockshop," at www.smockshop.org/.

27. Ibid.

28. Pierre Huyghe, in the episode "Romance," in season 4 of the PBS series *Art: 21* (2007), www.pbs.org/art21/slideshow/?slide=1495&artindex=178.

CHAPTER 7. PROCESS

1. Piet Mondrian, "Home–Street–City" (1926), in *Mondrian* (New York: Pace Gallery, 1970), 11.

2. Lucy Lippard, "Eccentric Abstraction," *Art International* 10, no. 9 (Nov. 1966): 284.

3. Lucy Lippard, *Eva Hesse* (New York: New York University Press, 1976), 216n23.

4. See Robert Pincus-Witten, *Postminimalism into Maximalism: American Art, 1966–1986* (Ann Arbor: UMI Research Press, 1987).

5. In a letter "Fluxus" sent to George Maciunas on April 4, 1964, Morris wrote: "Kindly return all manuscripts, photographs, drawings or writings of whatever nature by me which may be in your files. I do not wish to publish any of the above mentioned. . . . With the exception of this document, permission is hereby withdrawn to reproduce in any Fluxus publication any of the workes [sic] of the undersigned" (unpublished letter in George Maciunas alphabetical files marked "Misc," in Archiv

Hanns Sohm [German collector and archivist of Fluxus and happenings], Stadtsgalerie Stuttgart, Stuttgart, Germany).

6. See Robert Morris, "Notes on Sculpture, Part I," *Artforum* 4, no. 6 (Feb. 1966): 42–44; "Notes on Sculpture, Part II," *Artforum* 5, no. 2 (Oct. 1966): 20–23; "Notes on Sculpture, Part III: Notes and Nonsequiturs," *Artforum* 5, no. 10 (June 1967): 24–29; and "Notes on Sculpture, Part IV: Beyond Objects," *Artforum* 7, no. 8 (April 1969): 50–54. See also Morris, "Anti-form," *Artforum* 6, no. 8 (April 1968): 33–35; and "Some Notes on Phenomenology of Making: The Search for the Motivated," *Artforum* 8, no. 8 (April 1970): 62–66.

7. Thirty years later, drawing heavily on Morris's writings, the art historians Rosalind Krauss and Yve-Alain Bois published *Formless: A User's Guide* (Cambridge, Mass.: MIT Press, 1997), a handbook on aesthetic constructs related to process in the history of art.

8. Jackie Winsor, quoted in Robert Pincus-Witten, "Winsor Knots: The Sculpture of Jackie Winsor," *Arts* 51, no. 10 (June 1977): 131.

9. Robert Ryman, quoted in Roberta Smith, "Expression without the Ism," *Village Voice,* March 29, 1983, 81.

10. "Reduce/Reuse/Reexamine: Mierle Laderman Ukeles," 2004, at www.wavehill.org/arts/mierle_laderman_ukeles.html.

11. Bonnie Sherk, e-mail to the author, May 22, 2009.

12. Bonnie Sherk quoted in Ron Sullivan and Joe Eaton, "Urban Students Get to Study at Living Library," *San Francisco Chronicle,* Jan. 7, 2009. More information on Sherk's living libraries and her nonprofit corporation Life Frames can be found on her website: www.alivinglibrary.org.

13. Mark Thompson, conversation with the author, spring 1976, Oakland, CA.

14. Mark Thompson, "Lining the Wild Bee," *Honeybee Science* (Tokyo) 13, no. 2 (1992): 79–81.

15. Pinchas Cohen Gan, quoted in Ran Shechori, "Foreword," in Cohen Gan, *Dictionary of Semantic Painting and Sculpture* (Tel Aviv: Bezalel, 1991), 523.

16. Cornelia Lauf, "Franz Erhard Walther," *Arts* 63, no. 6 (Feb. 1989): 90.

17. Rebecca Horn, quoted in Marlise Gruterich, "Rebecca Horn," *Flash Art* 74/75 (May–June 1977): 25.

18. Rebecca Horn, quoted in John Dornberg, "Rebecca Horn: The Alchemist's Tales," *Art News* 90, no. 10 (Dec. 1991): 99.

19. Teresa Murak, interviewed by Michał Mencfel, "Openness to All Kinds of Mutuality," in *artluk* no. 4 (2008), www.artluk.com/main.php?idnum=21. For more on Murak, see Maryla Sitkowska, "Teresa Murak," in *Culture: PL* (January 2003), www.culture.pl/en/culture/artykuly/os_murak_teresa.

20. "Cai Guo-Qiang, I Want to Believe: Early Works," at http://artscurriculum.guggenheim.org/lessons/cai_L1.php.

21. David Shapiro, "Jeff Wall: Interview with David Shapiro" (1999), at www.museomagazine.com/10/wall/.

22. Ibid., 111.

23. Jolene Rickard, "Mixing It Up II," on radio station KGNU, Boulder, CO, April 7, 1989, quoted in Lucy Lippard, *Mixed Blessings: New Art in a Multicultural America* (New York: Pantheon Books, 1990), 181.

CHAPTER 8. PERFORMANCE ART

1. Kristine Stiles, "Synopsis of the Destruction in Art Symposium (DIAS) and Its Theoretical Significance," *The Act* (New York) 1 (Spring 1987): 22–31.

2. Robert Motherwell, ed., *The Dada Painters and Poets: An Anthology* (New York: Wittenborn, Schultz, 1951); Robert Lebel, *Marcel Duchamp* (New York: Grove Press, 1959); Karl Heinz Hering and Ewald Rathke, eds., *Dada: Dokumente einer Bewegung* (Düsseldorf: Kunstverein für die Rheinlande und Westfalen, 1958). When part of the Düsseldorf exhibition traveled to Amsterdam, the catalogue was published as *Dada: Zürich, New York, Paris, Berlin, Köln, Hanover* (Amsterdam: Stedelijk Museum, 1958).

3. The British artists Stuart Brisley and Leslie Haslam argued that the term inadequately and inappropriately connoted theater, not visual art. See Brisley and Haslam, "Anti-Performance Art," in *Arte inglese oggi, 1960–76* (Milan: Palazzo Reale, 1976). See also Hugh Adams, "Editorial: Against a De-

finitive Statement on British Performance Art," in special issue on performance art, *Studio International* 192, no. 982 (July–Aug. 1976): 3. For the etymology of the term "performance art," see Bruce Barber, "Indexing: Conditionalism and Its Heretical Equivalents," in AA Bronson and Peggy Gale, eds., *Performance by Artists* (Toronto: Art Metropole, 1979), 183–204.

4. See Jirō Yoshihara, "On 'The International Art of a New Era,' dedicated to 'Osaka International Festival,'" *Gutai* 9 (1958): 7, which gives an account of the reception the Gutai group gave to Mathieu and the French critic Michel Tapié when they visited Osaka in 1957. For the impact of Mathieu's action paintings on the emergence of Viennese Actionism after his performance at the Theater am Fleischmarkt in Vienna on April 2, 1959, see Robert Fleck, *Avantgarde in Wien: Die Geschichte der Galerie nächst St. Stephan 1954–1982, Kunst und Kunstbetrieb in Österreich, Band I: Die Chronik* (Vienna: Galerie nächst St. Stephan and Locker Verlag, 1982), 186–96. On the importance of Mathieu's theories in the development of Fluxus, see George Maciunas's copious unpublished notes on Mathieu in the Lila and Gilbert Silverman Fluxus Collection, New York.

5. The Romanian-born French poet and artist Isidore Isou founded the Lettrists in Paris in 1945. See Stephen Foster, *Lettrisme: Into the Present* (Cleveland: Visible Language, 1983); and Jean-Paul Curtay, *Letterism and Hypergraphics* (New York: Franklin Furnace, 1985).

6. See Guy Debord, *La société du spectacle* (Paris: Buchet-Chastel, 1967); translated as *Society of the Spectacle* (Detroit: Black and Red, 1970).

7. Guy Debord, *Commentaires sur la société du spectacle* (Paris: Éditions Gérard Lebovici, 1988); translated as *Comments on the Society of the Spectacle* (New York: Verso, 1990).

8. John Cage and Daniel Charles, *For the Birds: John Cage in Conversation with Daniel Charles* (London: Marion Boyars, 1981), 80.

9. Allan Kaprow, "The Legacy of Jackson Pollock," *Art News* 57, no. 6 (Oct. 1958): 24–26.

10. Allan Kaprow, "The Education of the Un-Artist," part 1, *Art News* 69, no. 10 (Feb. 1974): 28–31; part 2, *Art News* 71, no. 3 (May 1972): 34–39; part 3, *Art in America* 62, no. 1 (Jan.–Feb. 1974): 85–91. These essays and others are collected in Kaprow, *Essays on the Blurring of Art and Life,* ed. Jeff Kelley (Berkeley: University of California Press, 1993).

11. Carolee Schneemann, "Letter to the Editor," *Artforum* 22, no. 2 (Oct. 1983): 2. For Schneemann's correspondence, see Kristine Stiles, ed., *Correspondence Course: An Epistolary History of Carolee Schneemann and Her Circle* (Durham, NC: Duke University Press, 2010).

12. See Alistair Horne, *A Savage War of Peace: Algeria, 1954–1962* (London: Penguin, 1977), 416–17.

13. Jean-Jacques Lebel and Alain Jouffroy, "Qu'est-ce que l'Anti-procès?" (Milan, Oct. 8, 1960), in *Jean-Jacques Lebel: Retour d'exil, peintures, dessins, collages, 1954–1988* (Paris: Galerie 1900–2000, 1988), 84. This text is from a manifesto accompanying Lebel and Jouffroy's 1960 Happening *Anti-Process.*

14. Wolf Vostell, quoted in "Wolf Vostell," *Flash Art* 72/73 (March–April 1977): 34–39.

15. George Brecht, "The Origin of Events," in Hanns Sohm, ed., *Happening & Fluxus* (Cologne: Kölnischer Kunstverein, 1970), n.p.

16. For an extended discussion of Higgins's theory of intermedia, see Kristine Stiles, "Between Water and Stone, Fluxus Performance: A Metaphysics of Acts," in *In the Spirit of Fluxus* (Minneapolis: Walker Art Center, 1993), 62–99, esp. 92–93.

17. In 1960 and 1961 Piero Manzoni also began signing everyday objects and people. Manzoni issued colored certificates of authenticity verifying levels of aesthetic achievement, the highest award going to such individuals as the Italian philosopher and writer Umberto Eco and the Belgian artist Marcel Broodthaers.

18. See www.ben-vautier.com/newsletter.

19. On Ono and Lennon's collaborative actions, see Kristine Stiles, "Unbosoming Lennon: The Politics of Yoko Ono's Experience," *Art Criticism* 7, no. 2 (Spring 1992): 21–52.

20. See Arthur Janov, *The Primal Scream: Primal Therapy, the Cure for Neurosis* (New York: Praeger, 1970), 9–11. The Austrian artist Otto Muehl used Janov's theory in the development of the AA Commune's group self-realization actions, and Yoko Ono and John Lennon underwent primal scream therapy with Janov in the 1970s.

21. See *GAAG: The Guerrilla Art Action Group, 1969–1976: A Selection* (New York: Printed Matter, 1978). GAAG grew out of the Art Workers' Coalition and was formed as a separate entity on

October 15, 1969. See also Kristine Stiles, *Jean Toche: Impressions from the Rogue Bush Imperial Presidency* (Durham, NC: John Hope Franklin Center for Interdisciplinary and International Studies, 2009).

22. Petra Barreras del Rio, "Introduction," in Kristine Stiles, *Rafael Montañez Ortiz: Years of the Warrior 1960, Years of the Psyche 1988* (New York: El Museo del Barrio, 1988), 4. At the time this catalogue was published, Ortiz had not changed the spelling of his first name to "Raphael." Before being identified as "Rafael," he went by the name "Ralph."

23. Ortiz, quoted in Stiles, *Rafael Montañez Ortiz,* 30.

24. Hermann Nitsch, quoted at http://omt1998.nitsch.org/ien/6tage_e.htm.

25. Otto Muehl, "Reality Art," *The Dumb Ox* 10/11 (Spring 1980): n.p.

26. On the implications of this trial, see Hermann Nitsch, "Opening Speech," unpublished talk at Galerie Krinzinger, Vienna, 1991.

27. Robert Hughes, "The Decline and Fall of the Avant-Garde," *Time,* Dec. 18, 1972, 111.

28. Peter Weibel and Valie Export, eds., *Wien: Bildkompendium Wiener Aktionismus und Film* (Frankfurt: Kohlkunstverlag, 1970).

29. On Havel and avant-garde theater, see Václav Havel, *Letters to Olga: June 1979–September 1982,* trans. Paul Wilson (New York: Henry Holt, 1989). On Landsbergis's involvement with Fluxus, see Nam June Paik, "2 × mini giants," *Artforum* 29, no. 6 (March 1991): 90–91.

30. Rosie Johnston, "Explosive Prank Could Spell Fine or Even Prison for Members of Artistic Group," *Insight Central Europe,* Jan. 4, 2008, http://incentraleurope.radio.cz/ice/issue/99256.

31. See Ztohoven, "Znásilněný podvědomí," on the Ztohoven website, http://ztohoven.com/cz/znasilneny_podvedomi.

32. "Miklós Erdély," *Vivid [Radical] Memory,* www.vividradicalmemory.org/php/author.php?id=42.

33. Miklós Erdély, from "Új misztika felé. Sebők Zoltán beszélgetése Erdély Miklóssal" (Towards a New Mysticism: Zoltán Sebők in Conversation with Miklós Erdély), *Híd,* no. 8 (1983): 368, 369, quoted in Annamária Szőke, "Miklós Erdély: Snows of Yesteryear, 1970," *Vivid [Radical] Memory:* www.vividradicalmemory.org/php/texts.php?id_autor=42.

34. Guy Brett, "Introduction," in Rasheed Araeen, *Making Myself Visible: Rasheed Araeen* (London: Kala Press, 1984), 9.

35. Quoted in ibid., 8.

36. Rasheed Araeen, quoted by the Serpentine Gallery: http://www.serpentinegallery.org/2008/06/park_nights_manifesto_marathon_2.html.

37. On alternative spaces, see *The New Art Space: A Summary of Alternative Visual Arts Organizations in Conjunction with a Conference* (Los Angeles: Los Angeles Institute of Contemporary Art, 1978); Paul Kagawa, ed., *Floating Seminar II: A Survey of Alternative Art Spaces in San Francisco* (San Francisco, 1975), a revised transcript of a meeting on October 2, 1975, at the Farm, Bonnie Sherk's alternative space (see chap. 5); and Phil Patton, "Other Voices, Other Rooms: The Rise of the Alternative Space," *Art in America* 65, no. 4 (July–Aug. 1977): 80–89. The alternative-space movement gave rise in the late 1970s to the punk and graffiti subcultures in New York's East Village and the "New Wave" scene in San Francisco's South of Market district. See Deborah C. Phillips, "New Faces in Alternative Spaces," *Art News* 80, no. 9 (Nov. 1981): 90–100.

38. Jill Johnston, "Tehching Hsieh: Art's Willing Captive," *Art in America* 89, no. 9 (Sept. 2001): 143.

39. Lawrence R. Rinder, "The Plurality of Entrances, the Openings of Networks, the Infinity of Languages," in Constance Lewallen, ed., *The Dream of the Audience: Theresa Hak Kyung Cha (1951–1982)* (Berkeley: University of California Berkeley Art Museum and University of California Press, 2001), 22. Constance Lewallen has noted that Cha constructed "virtually all of her films and videos as a series of stills" (Lewallen, "Introduction: Theresa Hak Kyung Cha—Her Time and Place," in *The Dream of the Audience,* 2).

40. Willoughby Sharp, "Body Works," *Avalanche* 1 (Fall 1970): 14–17. Sharp published *Avalanche* (New York, 1970–76), an avant-garde artists' publication edited by the filmmaker Liza Bear that specialized in performance, installation, conceptual, and process art, and other experimental practices of the period. Other related publications specializing in performance included *Flash Art* (Milan, 1967–), edited by Giancarlo Politi and Helena Kontova, and *High Performance* (Los Angeles, 1975–97), founded by Linda Frye Burnham.

41. Adrian Piper, e-mail to the author, May 15, 2008.

42. Adrian Piper, "Food for the Spirit," *High Performance* 4, no. 1 (Spring 1981): 56.

43. Piper, e-mail to the author, May 15, 2008.

44. Guillermo Gómez-Peña, "From Art-Mageddon to Gringostroika: A Manifesto against Censorship," in his *Warrior for Gringostroika: Essays, Performance Texts, and Poetry* (Saint Paul, MN: Graywolf Press, 1994), 55–63. See also Gómez-Peña, *The New World Border: Prophecies, Poems and Loqueras for the End of the Century* (San Francisco: City Lights, 1996), which won an American Book Award; Gómez-Peña, *Ethno-Techno: Writings on Performance, Activism and Pedagogy* (New York: Routledge, 2005); and Gómez-Peña and Roberto Sifuentes, *Temple of Confessions: Mexican Beasts and Living Santos* (Sydney: Powerhouse Publishing, 1997).

45. See Peter Belsito and Bob Davis, *Hardcore California: A History of Punk and New Wave* (Berkeley: Last Gasp of San Francisco Press, 1983). The San Francisco club scene during the early 1980s is considered in Richard Irwin, "Metacriticism as a Fictional Category," in Kristine Stiles, *Questions, 1977–1982* (San Francisco: KronOscope Press, 1982), 18–21. See also Cynthia Connolly, Leslie Clague, Sharon Cheslow, and Lydia Ely, eds., *Banned in DC: Photos and Anecdotes from the DC Punk Underground (1979–85)* (Washington, DC: Sun Dog Propaganda, 1988). On New York's clubs and alternative spaces of the same period, see Alan Moore and Marc Miller, eds., *ABC No Rio Dinero: The Story of a Lower East Side Art Gallery* (New York: ABC No Rio and Collaborative Projects, 1985).

46. On censorship and the National Endowment for the Arts, see *Art Journal* 50, no. 3 (Fall 1991) and no. 4 (Winter 1991), two special issues on censorship.

47. See Finley's *Shock Treatment* (1990); *Enough Is Enough: Weekly Meditations for Living Dysfunctionally* (1993); *Living It Up: Humorous Adventures in Hyperdomesticity* (1996); and *A Different Kind of Intimacy: The Collected Writings of Karen Finley* (2000), among other titles.

48. Harald Ficke, Dorothea Olkowski, Marek Puchala, Hanna Wroblewska, and Katarzyna Kozyra, *Katarzyna Kozyra: In Art Dreams Come True* (Ostfildern, Germany: Hatje Cantz, 2007).

49. Press release for *Jimmie Durham: Rejected Stones,* Musée d'Art Moderne de la Ville de Paris, 2009; www.kurimanzutto.com/english/news/jimmie-durham-at-musee-dart-moderne-de-la-ville-de-paris-.html.

50. James Luna, "Biography," on Luna's website, www.jamesluna.com/.

51. William Pope.L, e-mail to Mark H. C. Bessire, Dec. 17, 2001.

52. William Grimes, "For Endowment, One Performer Means Trouble," *New York Times,* July 7, 1994, Arts Section.

53. Georges Bataille, "The Solar Anus" (1927), in his *Oeuvres complètes,* vol. 1: *Premiers écrits, 1922–1940* (Paris: Gallimard, 1988).

54. Francisco Goldman, "Interview with Regina José Galindo," *Bomb* 94 (Winter 2006); www.bombsite.com/issues/94/articles/2780

55. The sequence of the release of the films in the *Cremaster* cycle was no. 4 (1994), no. 1 (1995), no. 5 (1997), no. 2 (1999), and no. 3 (2002).

56. Oleg Kulik, "I Believe: Project Description," *2 Moscow Biennale of Contemporary Art,* 2007, http://2nd.moscowbiennale.ru/en/special_projects/67/.

CHAPTER 9. LANGUAGE AND CONCEPTS

1. See *Salt Seller: The Writings of Marcel Duchamp* (New York: Oxford University Press, 1973), originally published as Michel Sanouillet, ed., *Marchand du sel: Écrits de Marcel Duchamp* (Paris: Le Terrain Vague, 1958); Robert Lebel, *Sur Marcel Duchamp,* trans. George Heard Hamilton, with chapters by Duchamp, André Breton, and H.-P. Roché (New York: Grove Press, 1959); and Richard Hamilton, *The Bride Stripped Bare by Her Bachelors, Even,* trans. George Heard Hamilton (London: Lund, Humphries, and Wittenborn, 1960), a typographical version of Duchamp's *Green Box* (1934). Walter Hopps, at the Pasadena Art Museum, organized Duchamp's first retrospective in 1963; Arturo Schwarz produced thirteen readymades in signed editions of eight for Galleria Schwarz in Milan in 1964.

2. James Turrell later turned to mathematics to describe the conceptual structure of art: "You always think of the physical aspects of our current civilization. But in fact, the true expressions of our time are those aspects of our mathematics . . . expressions of pure thought. I'm interested in non-image art because I want to create something that directly connects you to a thought that is wordless . . . like

a mathematical proof or a problem in set theory. It's an area of thought that has a kind of loneliness, but also a great beauty" (Turrell, quoted in Craig Adcock, *James Turrell: The Art of Light and Space* [Berkeley: University of California Press, 1990], xx).

3. Robert Morris, letter to Henry Flynt, August 13, 1962, in Henry Flynt, *Blueprint for a Higher Civilization* (Milan: Multhipla Edizioni, 1975), 68.

4. Charles Harrison, "Art Object and Artwork," in *L'art conceptuel, une perspective* (Paris: Musée d'Art Moderne de la Ville de Paris, 1990), 61.

5. "Introductory Statement," *The Fox* 1, no. 1 (1975): 1.

6. Zoran Popović, letter to Kristine Stiles and Lynne dal Poggetto, Feb. 13, 1995.

7. In 1968 the Dwan Gallery mounted *Language II,* the second in the series, which ended with *Language IV* in 1970. Although the emphasis on the conceptual dimension of art was absent from such exhibitions as *Between Poetry and Painting* (1965), organized by Jasia Reichardt at the Institute of Contemporary Arts in London, and *Pictures to Be Read/Poetry to Be Seen* (1967), organized by Jan van der Marck at the Museum of Contemporary Art in Chicago, these shows must be considered for their tangential relation to the problems of cognition and perception posed by language in the reading of images.

8. Robert Smithson, "A Museum of Language in the Vicinity of Art," *Art International* 12, no. 3 (March 1968); repr. in Smithson, *The Writings of Robert Smithson: Essays with Illustrations,* ed. Nancy Holt (New York: New York University Press, 1979), 67.

9. Another important early exhibition, *Konzeption-Conception,* was organized by Konrad Fischer and Rolf Wedewer at the Städtisches Museum Leverkusen. Fischer, an early dealer in conceptual art, opened Konrad Fischer Galerie in Düsseldorf in 1967 and, with Szeemann, helped to organize aspects of Documenta 5, a landmark exhibition of conceptual and performative art, in 1972. Other conceptual art exhibitions took place in 1969, including *Op Losse Schroeven: Situaties en Cryptostructuren (Square Pegs in Round Holes: Structures and Cryptostructures),* and Konrad Fischer and Hans Strelow's *Prospect 69,* Kunsthalle Düsseldorf.

10. Jack Burnham, "Systems Esthetics," *Artforum* 7, no. 1 (Sept. 1968), 30–35; repr. in his *The Great Western Salt Works: Essays on the Meaning of Post-Formalist Art* (New York: George Braziller, 1974). See also Burnham's *The Structure of Art* (New York: George Braziller, 1971).

11. See Lucy Lippard and John Chandler, "The Dematerialization of Art," *Art International* 12, no. 2 (Feb. 1968): 120; repr. in Lippard, *Changing: Essays in Art Criticism* (New York: E. P. Dutton, 1971), 255–77.

12. Art & Language, letter to Lucy Lippard, excerpted in Lippard, *Six Years: The Dematerialization of the Art Object from 1966 to 1972 . . .* (New York: Praeger, 1973), 43.

13. Many artists recharacterized their art practice as "work," distancing themselves from the metaphysical and teleological associations of the term "creation" and locating themselves in the social exigencies of the period.

14. Lippard, *Six Years,* 263–64.

15. Graham's essay "The Artist as Bookmaker, II," appeared together with Lawrence Alloway's "The Artist as Bookmaker, I," in *Arts* 41, no. 8 (Summer 1967): 22–23. See also Dan Graham, *Rock My Religion: Writing and Art Projects, 1965–1990,* ed. Brian Wallis (Cambridge, MA: MIT Press, 1993).

16. See Dan Graham, "Homes for America: Early 20th Century Possessable House to the Quasi-Discrete Cell of '66," *Arts* 41, no. 3 (Dec. 1966–Jan. 1967): 21–23.

17. See Dan Graham, *Dan Graham: Rock/Music Writings* (New York: Primary Information, 2009); and Graham, *Rock My Religion.*

18. Siegelaub also collaborated with Michel Claura on another key exhibition on conceptual art, *18 Paris IV.70* (1970). Adriaan van Ravesteijn and Geert van Beijeren founded Art and Project in Amsterdam in 1968; each issue of their *Art and Project Bulletin* (1968–89) featured the work of a single artist. In London, Robert Lisson and Nicholas and Fiona Logsdail also published artist's books and exhibited conceptual art.

19. Victor Burgin, "Introduction," in *Two Essays on Art, Photography and Semiotics* (London, 1975), quoted in Harrison, "Art Object and Artwork," 63.

20. See Victor Burgin, "Re-Reading Camera Lucida," in his *The End of Art Theory: Criticism and Postmodernity* (Atlantic Highlands, NJ: Humanities Press International, 1986), 71–92. See also Allan

Sekula, *Photography Against the Grain: Essays and Photoworks* (Halifax: Press of the Nova Scotia College of Art and Design, 1984); and Martha Rosler, "In, Around, and Afterthoughts (On Documentary Photography)," in her *3 Works* (Halifax: Press of the Nova Scotia College of Art and Design, 1981), 59–86. Sekula's book contains his previously published and highly influential essays "The Traffic in Photographs," *Art Journal* 41 (Spring 1981), and "The Instrumental Image: Steichen at War," *Artforum* 14, no. 4 (Dec. 1975), 26–35. For art historians indebted to these artists' work, see Rosalind E. Krauss, "Photography's Discursive Spaces," *Art Journal* 42 (Winter 1982), repr. in her *The Originality of the Avant-Garde and Other Modernist Myths* (Cambridge, MA: MIT Press, 1985); John Tagg, *The Burden of Representation: Essays on Photographies and Histories* (Amherst: University of Massachusetts Press, 1988); Jonathan Crary, *Techniques of the Observer: On Vision and Modernity in the Nineteenth Century* (Cambridge, MA: MIT Press, 1990); and Abigail Solomon-Godeau, *Photography at the Dock: Essays on Photographic History, Institutions, and Practices* (Minneapolis: University of Minnesota Press, 1991).

21. Stanley Brouwn, statement for the exhibition *Prospect 69,* repr. in *Art and Project Bulletin* 11 (1969), n.p., and in Lippard, *Six Years,* 115.

22. Aaron Shuster, "Stanley Brouwn," *Frieze* 91 (May 2005).

23. Hilla Becher, in Ulf Erdmann Ziegler, "Interview with Bernd and Hilla Becher," *Art in America,* June 2002, at www.americansuburbx.com/2009/01/theory-interview-with-bernd-and-hilla.html.

24. See Jack Burnham, "Hans Haacke's Cancelled Show at the Guggenheim," *Artforum* 9, no. 10 (June 1971): 71; and "Gurgles around the Guggenheim," including Daniel Buren, "Round and About a Detour," Diane Waldman, "Statement," Thomas M. Messer, "The Cancellation of Hans Haacke's Exhibition: Thomas M. Messer's 'Misgivings,'" and an exchange of statements between Hans Haacke and Thomas M. Messer, *Studio International* 181, no. 934 (June 1971): 246–50.

25. MIT Press promotion of *Hans Haacke: Unfinished Business,* ed. Brian Wallis (Cambridge, MA: MIT Press, 1987) at http://mitpress.mit.edu/catalog/item/default.asp?ttype=2&tid=5427.

26. Meireles's remarks here and below are from Cildo Meireles and Frederico Morais, "Material Language," *Tate Etc.* 14 (Autumn 2008), www.tate.org.uk/tateetc/issue14/materiallanguage.htm.

27. On the subject of "documentary evidence," see John Tagg, "The Proof of the Picture," in his *Grounds of Dispute: Art History, Cultural Politics and the Discursive Field* (Minneapolis: University of Minnesota Press, 1992), 97–119.

28. "A Case Study of Transference," on Xu Bing's website, www.xubing.com/index.php/site/projects/year/1994/a_case_study_of_transference.

29. AZT is the acronym for azidothymidine (also known as zidovudine, or INN), a type of anti-retroviral drug that was a breakthrough in the treatment of AIDS when it was introduced in the 1990s.

30. For these four manifestos and other documents of the Collectif d'Art Sociologique, see Fred Forest, *Art sociologique* (Paris: Union Générale d'Éditions, 1977), 153–230.

31. See Group Material, "On Democracy," in Brian Wallis, ed., *Democracy: A Project by Group Material,* Dia Art Foundation Discussions in Contemporary Culture 5 (Seattle: Bay Press, 1990), 1. See also Mark O'Brien and Craig Little, eds., *Reimagining America: The Arts of Social Change* (Philadelphia: New Society, 1990), 358.

32. The artists of Gorgona included Josip Vaništa, Marijan Jevšovar, Julije Knifer, Đuro Seder, Ivan Kožarić, and Dimitrije Bašičević Mangelos.

33. OHO included among its members such artists as Marko Pogačnik, David Nez, Milenko Matanović, Drago Dellabernardina Iztok, Geister Plamen, and Tomaz Salamun.

34. NSK, "Retro Principle: The Principle of Manipulation with the Memory of the Visible Emphasized Eclecticism—the Platform for National Authenticity," *Problemi,* no. 6 (1985); repr. in Laura Hoptman and Tomáš Pospisyl, eds., *Primary Documents: A Sourcebook for Eastern and Central European Art since the 1950s* (New York: Museum of Modern Art; Cambridge, MA: MIT Press, 2002), 300.

35. See http://times.nskstate.com.

36. See Silvia Kolbowski and Walid Ra'ad, *Between Artists* (New York: A.R.T. Press, 2006).

37. See Critical Art Ensemble's website, www.critical-art.net/TacticalMedia.html.

38. See also Arakawa and Madeline Gins, *The Mechanism of Meaning: Work in Progress* (New York: Harry N. Abrams, 1979); and Gins, *What the President Will Say and Do!!* (New York: Station Hill Press, 1984), *To Not to Die,* in collaboration with Arakawa (Paris: Éditions de la Différence, 1987), and *Helen Keller or Arakawa* (Santa Fe: Burning Books with East/West Cultural Studies, 1994).

39. Ai Weiwei in "Interview: Hans Ulrich Obrist in Conversation with Ai Weiwei," in *Ai Weiwei* (London: Phaidon, 2009), 12.

40. Stars Group set the stage for the formation of other groups like Pool Society (1986), Red Brigade (1986), New Analysts Group (1988), and Big Tail Elephant Group (1991).

41. Charles Merewether, *Ai Weiwei: Under Construction* (Sydney: UNSW Press, 2008), 28.

42. Ibid., 31. The word "fake," Ai has pointed out, is pronounced "fuck" in Chinese. Ai's preoccupation with the cultural relationship between the fake and the colloquial meanings of "fuck," namely to be impatient with something or someone that is annoying, contemptible, or fake, also appeared in his infamous alternative exhibition *Fuck Off,* which served as a critique of the 2000 Shanghai Biennale.

43. Philip Tinari, "A Kind of True Living: Philip Tinari on the Art of Ai Weiwei," *Artforum* (Summer 2007). See also Ai Weiwei, *Ai Weiwei's Blog: Writings, Interviews, and Digital Rants, 2006–2009,* ed. and trans. Lee Ambrozy (Cambridge, MA: MIT Press, 2011).

44. Ai Weiwei interviewed by Christiane Amanpour on CNN, March 21, 2010, viewable on YouTube.

INDEX

Page numbers for illustrations are in italic.

Urkom, Gergelj, 808
U.S.A. Presents (EAT), 454
U.S. of Attica (Ringgold), 413

Vagina Painting (Kubota), 1079–80n17
Vale, V., 454
Valley Curtain (Christo and Jeanne-Claude), 591
Van Beijeren, Geert, 1086n18
Van Bruggen, Coosje, 333
Van Buren, Richard, 730
Vancouver School, 697
Van der Beck, Stan, 856
Van der Marck, Jan, 1086n7
Van de Velde, Henry, 179
Van Doesburg, Theo, 68, 77, 79, 588
Vaneigem, Raoul, 799
Van Gogh, Vincent: Max Beckmann on, 208; Sam Gilliam on, 727; Barkley L. Hendricks on, 262; Ellsworth Kelly on, 119; Vitaly Komar and Alexander Melamid on, 365; Joseph Kosuth on, 979; Jannis Kounellis on, 775; Sherrie Levine and, 341; Joan Mitchell on, 33; Robert Motherwell on, 29; Dorothea Rockburne on, 169; Robert Smithson on, 636
Van Hagen, Susanne, 9
Vaništa, Josip, 1087n32
Van Ravesteijn, Adriaan, 1086n18
Vantongerloo, Georges, 98, 119
Van Valkenburgh, Michael, 691
Various Small Fires (Ruscha), 959
Vasarely, Jean-Pierre (pseud. Yvaral), 453
Vasarely, Victor, 83, 84, 133–36, 141–42, 143, 967; photo of, *134*
Vassilakis, Panayotis. *See* Takis
Vasulka, Steina (b. Steinunn Briem Bjarnadottir), 457
Vasulka, Woody (b. Bohuslav Peter Vasulka), 457, 506–8
Vautier, Ben. *See* BEN
VD Lives/TV Must Die (Acconci), 920
Vedova, Emilio, 20, 50–51; in the Piazza San Marco (Venice), *51*
Velázquez, Diego, 223, 252, 280, 316, 840
Velocity Piece #1 (Le Va), 722–24
Velvet Underground (band), 593, 956
Venet, Bernar, 957, 961
Venezsky, Richard, 556
Venice Biennale, 8, 999; Magdalena Abakanowicz and, 196; Cai Guo-Qiang and, 697; Maurizio Cattelan and, 341, 442; Regina José Galindo and, 818; Dan Graham on, 999; Ann Hamilton and, 691; Kim Jones and, 338;

Edward Kienholz and, 590; kinetic art at, 452; James Luna and, 817; Dan Perjovschi and, 596; Bridget Riley and, 84
Venturi, Robert, 325–26
Venus, 182, 221, 466, 859, 886
Venus of Willendorf, 271
Verberg, Joanne, 534
Verb List Compilation (Serra), 688, *715*
Vermeer, Jan, 247
Verne, Jules, 595
Vertebral Column with Skull and Pelvis (Graves), 711
Viallat, Claude, 86
Victoria, Queen, 932
Video, 450, 455–61, 462, 464, 466, 689
Video and Satellite (exhibition, 1982), 457
Vidéoème (Cha), 813
Videogalerie Schum (formerly Fernsehgalerie Schum, Essen), 456, 694
VIDEOPLACE (Krueger), 556, 561–62, 565–66, 567
Vieira, Décio, 79
Viennese Actionism (Wiener Aktionismus), 196, 463–64, 799, 804–6, 810, 1083n4
Vietnam: Destination for the New Millennium (Lê), *421*
Vietnam Veterans Memorial (Lin), 591, 623, 624, 683
View (Ann Hamilton and Kathryn Clark), 691
View of Toledo (El Greco), 280
Villa, Carlos, 332
Village Voice, 1052
Villeglé, Jacques de la, 328, 352, 802
Villon, Jacques, 30
Viola, Bill, 458–59, 525–29
Violinist (Kounellis), 779
Viophonograph (Laurie Anderson), 455
Vir Heroicus Sublimis (Newman), *27*
Virtual reality, xvii, 3, 450, 600; Roy Ascott on, 576; Maurice Benayoun and, 462; Peter d'Agostino and, 457; Myron W. Krueger and, 463; Jeffrey Shaw and, 464; Peter Weibel and, 463
Vision (1975–82), 812
Visser, Carel, 81
Visual and Public Art Institute (Monterey Bay), 811
Vita-Finzi, Claudio, 634
Vivarelli, Carlo, 79
Vivekananda, 324
Vogue (magazine), 799
The Void (Klein), 58
Voight, Jon, 943
Voltaire, 40

Text/Display: Bembo
Compositor: Integrated Composition Systems
Indexer: Juliana Froggatt
Printer/Binder: Sheridan Books, Inc.